# CRITICAL VISIONS IN FILM THEORY

# CRITICAL VISIONS IN FILM THEORY

## CLASSIC AND CONTEMPORARY READINGS

Edited by

**Timothy Corrigan**
University of Pennsylvania

**Patricia White**
Swarthmore College

*with*

**Meta Mazaj**
University of Pennsylvania

BEDFORD/ST. MARTIN'S
Boston • New York

**For Bedford/St. Martin's**

*Publisher for Communication:* Erika Gutierrez
*Developmental Editor:* Ada Fung Platt
*Production Editor:* Peter Jacoby
*Production Supervisor:* Andrew Ensor
*Marketing Manager:* Adrienne Petsick
*Art Director:* Lucy Krikorian
*Text Design:* Henry Rachlin
*Copy Editor:* Denise Quirk
*Indexer:* Melanie Belkin
*Cover Design:* Billy Boardman
*Cover Art:* Scene still, *Das Leben der Anderen/The Lives of Others,* 2006; © Creado Film/
  BR/Arte/The Kobal Collection. Scene still, *Killer of Sheep,* 1977; © Milestone Films/
  The Kobal Collection. Scene still, *Belle de Jour,* 1966; © Paris Film/Five Film/The Kobal
  Collection
*Composition:* MPS Limited, a Macmillan Company
*Printing and Binding:* RR Donnelley and Sons

*President:* Joan E. Feinberg
*Editorial Director:* Denise B. Wydra
*Director of Development:* Erica T. Appel
*Director of Marketing:* Karen R. Soeltz
*Director of Production:* Susan W. Brown
*Associate Director, Editorial Production:* Elise S. Kaiser
*Managing Editor:* Shuli Traub

Library of Congress Control Number: 2010939975

Manufactured in the United States of America.

*For information, write:* Bedford/St. Martin's, 75 Arlington Street,
Boston, MA 02116    (617-399-4000)

ISBN: 978-0-312-44634-5

*Acknowledgments*
Acknowledgments and copyrights appear at the back of the book on pages 1145–1150,
which constitute an extension of the copyright page.

# PREFACE

Whenever we teach a film theory course, one of the first questions students ask us is, What is film theory, and why should we study it? As longtime scholars of film and theory, we have a very personal stake in this question, and it's one we relish answering, given the many years of intellectual endeavor, excitement, and sheer joy we have experienced studying and thinking deeply about the work of brilliant theorists—and the wonderful films that are the subjects of their study.

Our answer to this pressing question begins with identifying the two concerns that have been at the heart of film theory since its emergence: cinema's specificity and its interdisciplinary nature. By specificity, we mean that which makes the medium of film distinct as a form of communication or an aesthetic form. And by considering film's interdisciplinary nature, we recognize that film, characterized early on as "the seventh art," represents a combination of other art forms as well as commercial, artistic, and social interests. The excitement, and the challenge, of film theory lie in the urge to illuminate these two seemingly contradictory dimensions of cinema. Sustained critical interrogations of films or of the medium—such as the writings by filmmakers, philosophers, and academics that constitute film theory—help us see the specificities of cinema as an aesthetic form and social institution, as well as its commonalities with other arts and cultural experiences.

A common first response from students to this answer is that such critical reflection on the film experience diminishes the pleasure they get from watching movies. But we strongly feel that a critical understanding of films can enhance—and in fact, may already be a large part of—that pleasure. Of course, films offer *entertaining* visions of other lands, great adventures, fantastic settings, virtuoso performances, and compelling characters. But movies—shaped to fit specific genre conventions, audience tastes, political viewpoints, or artistic expressions—are also *critical* visions of the world around us. Theory helps viewers grasp this level of understanding; it is the exploration of the spaces and relationships within the films themselves, and between the movies and the "real world," that provides viewers with a more critical and profound understanding of the cinema. Like all disciplines, film theory has a specialized vocabulary, though it also draws from many different areas of thought, such as philosophy and technology. While we recognize that reading film theory means calling upon considerable background knowledge, we believe wholeheartedly that working through the difficulty of film theory is rewarded not only by the pleasure derived from a deeper understanding of a particular movie, auteur, or genre, but also by the insight it gives us into the broad and multifaceted film experience.

While our experience indicates that the questions and debates of film theory are best illuminated by bringing into conversation different theorists across different periods in time, an overview of the development of film theory since its inception can be helpful in understanding the historical and social contexts from which those questions and debates evolved. Reflection upon the medium began almost

immediately after the invention of cinema in the 1890s, and the first books and journals expressing wonder at the artistic and sensory possibilities afforded by the new technology appeared in the 1910s. By the 1920s, writers like Béla Balázs were categorizing their work on film as *theory*. Traditionally, film theory has been divided into two overarching periods; "classical" (roughly from the 1920s through the post–World War II period) and "contemporary" (from post-World War II to the present day). But to draw more helpful distinctions among the wide-ranging concerns in film theory, we isolate four phases within those two larger eras. The last three of these eras map roughly onto the broader category of "contemporary" theory, and their overlapping concerns become more concentrated through the course of the twentieth century and into the twenty-first.

The first period, classical film theory, emerged in the heyday of the silent film era in the 1920s and 1930s—along with the organization of artistic film industries in the Soviet Union, Germany, and France—and continues into the post–World War II period. Some theorists in this phase, such as Béla Balázs and Sergei Eisenstein, were mainly concerned with film form, including montage (which preoccupied the Soviet school in the 1920s), while others like Siegfried Kracauer and André Bazin focused on the relationship between film and photographic realism (propelled by the introduction of sound in 1920s). This dichotomy between approaching cinema either as a formal construction of sounds, images, and movement or as a revelation of the realities of the world is a hallmark debate of classical film theory.

The second phase, spanning the 1950s and 1960s, encompasses the transition from classical film theory into the period more broadly known as contemporary film theory. Though film appreciation courses were taught in some universities since the 1930s, the revitalization of postwar film culture propelled the emergence of film and film theory as an academic discipline. Film criticism emerged as a vital arena in France and elsewhere with its own journals (such as *Cahiers du cinéma*, *Movie* in the United Kingdom, and *Film Culture* in the United States), scholarly associations, and publishing lists. This key transitional era in the history of film theory balances itself between a journalistic heritage, exemplified by Andrew Sarris's essays in the *Village Voice*, and an academic future articulated in the more philosophical writing of Stanley Cavell. The cultural and political crises of the 1960s also resulted in a climate that looked both backwards and forwards—evident in the considerable attention to the older tradition of genre theory and to the emerging tradition of auteur theory. While genre theories, summed up in this volume by Thomas Schatz's piece from *Hollywood Genres*, allowed theorists to investigate the relation of film to larger social systems and rituals, auteurism, addressed by writers from Alexandre Astruc to Peter Wollen, emphasized a kind of postwar existential freedom and individualism as the source of a film's meaning.

In the 1970s and 1980s, film theory began to be challenged and redefined from numerous directions. The question of the "language of cinema," asked since the early days of the medium, received renewed attention from theorists employing structuralist and poststructuralist linguistic theory to analyze how film, like other cultural forms of representation, provides crucial ways of understanding and communicating about a changing world. Invigorated by such philosophical and political movements as psychoanalysis, feminism, and cultural studies, this third phase of film theory also interrogated the ideologies informing the film experience, including

the process of spectatorship. Under the editorship of Jean-Louis Comolli and Jean Narboni, *Cahiers du cinéma* continued to be a key forum, and the British journal *Screen* published influential work by Christian Metz, Laura Mulvey, and others on the problem of the spectator's gaze and on the textuality of film—defining what was later collectively known as Grand Theory. These writings of the 1970s, along with Richard Dyer's pioneering cultural studies approach to stardom, questioned both classical film theory's assumptions about film form and realism, and the postwar canonization of certain genres and directors. During this period, film studies engaged intensely with theory as a way to articulate why the cinema remained so crucial to contemporary knowledge.

Beginning in the 1980s, we entered what we might consider film theory's fourth phase. Not as easily classified as the classical theory of the 1930s and 1940s, the "cinephile" theories of the 1950s and 1960s, or the "gaze theory" of the 1970s, this fourth phase of film theory has been as dynamic as, and possibly more various, than any of the three preceding periods. As television, and later digital media, challenged the movies for audiences' attention, the two concerns that have been at the heart of film theory since the 1910s—specificity and interdisciplinarity—once again became the focus of the discussion. But along with the proliferation of film and media studies in academia, contemporary film theory diversified and expanded upon those age-old concerns by drawing upon history, economic and industrial analysis, national and transnational cinema cultures, and other screen media. Contemporary scholars such as David Bordwell, Trinh T. Minh-ha, Hamid Naficy, B. Ruby Rich, and Lev Manovich have embraced the ever-growing scope of film and media theory, exploring cinema from a variety of approaches—from analyzing specific historical practices and the revolutionary changes brought on by digital technologies and new media to investigating the representations of race, nation, and queer identities onscreen.

## *Why* Critical Visions *Now?*

Even with these expansions in the field, there has not been a new and comprehensive collection of classical and contemporary readings in film theory for more than thirty-five years. And in recent years, we've felt a keen lack among the available introductory texts. While past anthologies did a solid job of covering classical film theory and the earlier phases of contemporary theory, we still always found it necessary to augment these anthologies significantly, not only by providing our students with additional essays—especially more recent offerings—but also by giving students deeper background information on the collected theorists and selections, and by helping them understand important connections among the various selections and theoretical approaches.

With *Critical Visions*, then, our goal has been to create a new text that addresses the issues we found in our own classrooms and heard about from colleagues in their own teaching. We believe the field is ready for a fresh and inclusive anthology, one that fully reflects the diversification of film theory over the last twenty years and offers students useful ways into ideas that can often seem intimidating, while still illuminating key historical roots.

Because critical essays form the lifeblood of any introductory theory course and thus any strong theory anthology, *Critical Visions* includes the broadest range of selections available in an introductory anthology. Along with presenting the most significant work of contemporary scholars who are responding to our visibly diverse world and technologically innovative media practices, *Critical Visions* includes the canonical works in film theory that remain fundamental as historical precedents along with the polemics that inform modern day theoretical positions. Why is this important? Because, for instance, without reading Christian Metz's or Jean-Louis Baudry's position on psychoanalysis and cinema or the apparatus theory, it would be difficult for students to understand fully the nuances of Judith Mayne's or Vivian Sobchack's reconsiderations of film spectatorship. To appreciate Bill Nichols's elaboration of different documentary practices, it is imperative to understand John Grierson's pioneering comments on the genre. As *Critical Visions* demonstrates, film and media theory represent, like other intellectual and cultural endeavors, a historical dialogue that crosses eras, cultures, and disciplines. In order to participate in that dialogue, it is crucial to see it unfold across decades and geographical boundaries, and to map its many exchanges and differences.

In addition, *Critical Visions* recognizes that film theory owes much to the thinkers and scholars outside of the film discipline. By including foundational texts from such thinkers as Plato, Walter Benjamin, Roland Barthes, and Frantz Fanon—readings that go beyond the traditional boundaries of film studies but have greatly influenced the field—*Critical Visions* offers a crucial and expanded perspective on the study of film theory.

Along with providing a broad and well-balanced blueprint for organizing the vast and complex field of film theory, our goal with *Critical Visions* is to help students navigate that blueprint through sophisticated yet incisive explanations and supporting materials. Extensive part introductions and substantive author headnotes situate each selection within a larger cultural and historical backdrop; Reading Cues & Key Concepts serve as pre-reading guides; and a unique appendix, Film Pairings for Studying Film Theory, demonstrates the relationship between the theory we read and the films we watch.

## *The Organization of* Critical Visions

While a strictly historical approach can be helpful in mapping the overarching phases in the development of film theory—and can reveal how the questions of film theory are intertwined with the pressing issues of modernity and postmodernity— we believe that the study of film theory comes most alive through thoughtful juxtapositions. Thus, we have organized the selections in *Critical Visions* by topic— to adequately represent the robust debates and ongoing insights of film theory by bringing the voices of different theorists across different eras into productive dialogue.

Part 1 starts broadly by addressing the idea of the film experience itself, looking at the relationship between film and spectator, and issues of perception and reception. Part 2 explores the formal aspects of film, its sights, sounds, and signs. Part 3 focuses on the key debates of modernism and realism in classical film theory. Part 4 is devoted to those who make movies—the directors, stars, and studios.

Part 5 addresses genres—that is, how we classify stories—while Part 6 concentrates on narrative, or how we *tell* those stories.

Parts 7 through 11 are unique to *Critical Visions*, addressing the newer areas of contemporary film theory that receive little dedicated coverage in other comprehensive anthologies. Part 7 recognizes alternative modes of cinema, the documentary and the experimental film. Part 8 deals with issues of performing sexuality and gender on screen, while Part 9 speaks to issues of representing race and ethnicity in cinema. Part 10 contemplates the difficulty of defining the concept of "the nation," and thus, "national cinema." Part 11 confronts the challenge to cinema by newer screen cultures (television, video games, and digital media), considering both the commonalities among these screen cultures and what makes cinema unique.

As editors, we have aimed to create a collection that represents the breadth, depth, and dynamism of film theory. In examining the rich and varied terrain of our field, we have chosen essays for their perspective and influence as well as for the way they complement and connect to other selections. Inevitably, we have had to make difficult editorial decisions to exclude many important theorists and to excerpt some essays and book chapters due to limited space. Omissions are indicated with bracketed ellipses, and some discursive footnotes have been excised. Spelling, punctuation, capitalization, and citation styles have been retained from publication sources; American spelling has been reinstated in essays by American authors drawn from British sources.

## *Features of* Critical Visions

While reading film theory is a vital experience that can illuminate our understanding of film, we as teachers recognize that the unfamiliar and relatively complex ideas and language of film theory can be difficult for many students to grasp, and that instructors may not have the time to fully address these challenges in class. Our hope, then, is that *Critical Visions* can shoulder some of that burden by providing the best possible instructor support and by giving students the context and support they need to move past the challenges of studying film theory and on to its pleasures and discoveries.

- **The best and most inclusive anthology, with unique coverage of classical and contemporary film theory.** *Critical Visions* corrects the narrowness of past anthologies by providing fresh and updated perspectives on classic areas such as perception and reception, film form, genre theory, and auteurism. And it is the only comprehensive anthology with sections dedicated to discussions of sexuality and gender, race and ethnicity, national and transnational film histories, and documentary and experimental film, as well as other screen cultures.

- **The broadest range of selections, representing a diverse and winning combination of classic thinkers and newer voices.** With more than eighty readings, *Critical Visions* offers more selections than any competing introductory text. With a cast of theorists ranging from Lev Kuleshov, Christian Metz, and Jean-Louis Baudry to Richard Dyer, Manthia Diawara, Laura Mulvey, and Dudley Andrew, *Critical Visions* presents the most balanced and comprehensive picture of film theory available.

- **Part introductions show students the big picture.** Organized around a central film, each part introduction draws connections among selections, providing students with cultural and historical context, as well as a clear narrative of the key debates and schools of thought covered in that part.

- **Detailed author headnotes give students better insight into each theorist and selection.** More extensive and more useful than the strictly biographical introductory notes in competing anthologies, the author headnotes in *Critical Visions* give students a deep understanding of the experiences, people, and work that inform each theorist's writing, as well as a brief preview of each selection.

- **Unique Reading Cues & Key Concepts highlight major concepts and questions.** Functioning as a pre-reading guide, the Reading Cues & Key Concepts help spur deeper critical thinking and in-class discussions by focusing on the main ideas and questions in each reading.

- **Alternative tables of contents helps *Critical Visions* work well with any teaching style and in any classroom.** Whether you take a historical approach to film theory, or wish to supplement a different course such as Introduction to Film or American Cinema with important theoretical readings, *Critical Visions* provides you with suggestions for how you can adapt and mold our anthology to fit any course.

- **Unique "Film Pairings for Studying Film Theory" appendix helps students apply the theory they read to the films they watch.** Organized around common approaches to film theory, this appendix pairs readings from *Critical Visions* with complementary films that enhance students' understanding of the relationship between theory and cinema.

## Acknowledgments

First and foremost, we would like to thank all of the authors for their contributions and particularly those, like Miriam Hansen and Trinh T. Minh-ha, who helped with obtaining permission for their selections. We also owe a great deal of gratitude to the friends and colleagues who gave us their input and insight.

A big thank you goes to everyone at Bedford/St. Martin's who championed this book and helped make it possible, including President Joan Feinberg, Editorial Director Denise Wydra, and Director of Development Erica Appel, and to our crack editorial team. Thanks to Publisher Erika Gutierrez and Executive Editor Simon Glick for their sage advice and guidance, and a special thank you to Ada Fung Platt, our savvy, sane, and supportive development editor. Without the production team at Bedford St. Martin's, this book would simply be a collection of Word files and PDFs. So, we thank Managing Editor Shuli Traub for her tireless leadership; Project Editor Peter Jacoby for his dedication to the project and incredible organizational skills, as well as for staying calm, cool, and collected; and Production Supervisor Andrew Ensor for keeping us on task and on schedule. We also credit our excellent copyeditor Denise Quirk for reading through thousands of pages and catching our typos. Many thanks also to Senior Marketing Manager Adrienne Petsick for helping us get the word out. Last but certainly not least, we would like to thank the permissions team,

Kalina Hintz, Linda Winters, and Warren Drabek, without whom this book would be much smaller and a lot less useful.

Thank you also to the many reviewers for their thoughtful suggestions and ideas: David Anshen, University of Texas–Pan American; Chris Cagle, Temple University; Jon Cavallero, Penn State University–University Park; Mary Dalton, Wake Forest University; Roy Grundmann, Boston University; Eileen Jones, University of California, Berkeley; Jyotsna Kapur, Southern Illinois University; James Kendrick, Baylor University; David King, Kennesaw State University; Robert Kolker, University of Virginia; Mildred Lewis, Chapman University; Hugh McCarney, Western Connecticut State University; Walter Metz, Montana State University; James Morrison, Claremont McKenna College; Wayne Munson, Fitchburg State College; Hilary Neroni, University of Vermont; Richard Neupert, University of Georgia; Patrice Petro, University of Wisconsin–Milwaukee; Joanna Rapf, University of Oklahoma; Harris Ross, University of Delaware; Gregory Schufreider, Louisiana State University; Hunter Vaughan, Washington University in St. Louis; Paula Willoquet-Maricondi, Marist College; Pamela Wojcik, University of Notre Dame.

*Special thanks from Timothy Corrigan:* I would like to thank Marcia Ferguson, Karen Beckman, Peter Decherney, and Nicola Gentili for their always generous and always important support. Timothy Murray has been a source of inspiration on many fronts. Maggie Borden, Sara Brenes-Akerman, Sarah Stoecker, and Anthony Xie have been much appreciated research assistants.

*Special thanks from Patricia White:* I would like to thank my students in Film Theory and Culture over the years and my colleagues at Swarthmore College for their inspiration; Homay King, Edward O'Neill, Dana Polan, Bob Rehak, and D. N. Rodowick for their advice on selections; Robert Alford, Brandy Monk-Payton, Natan Vega Potler, and Renée Sevier for invaluable research assistance; Nicola Gentili, Karen Beckman, and my co-editors for being so welcoming at the University of Pennsylvania in 2009–2010; and George and Donna White, Cynthia Schneider, and Max Schneider-White for everything else.

*Special thanks from Meta Mazaj:* I would like to thank my co-editors for being an invaluable source of inspiration and support. Thank you to my colleagues at University of Pennsylvania, Karen Beckman, Tim Corrigan, Peter Decherney, and Nicola Gentili, for their support and advice, and for making Cinema Studies the most pleasurable and inspiring place to be. Last but not least, thanks to Shekhar Deshpande and Taja Mazaj, for always being there and making sense of it all.

Finally, all three editors would like to especially thank each other for being such a remarkable team.

We hope our readers will find using this collection as exciting and illuminating as we have found collaborating on it to be.

# CONTENTS

# PART 1

# EXPERIENCING FILM: FROM PERCEPTION TO RECEPTION

*World War III has occurred. The earth is devastated, and the protagonist's ability to retain visual images of the prewar past is highly prized. Subjected to time-traveling experiments, he brings back memories of encounters with a woman in concrete places and specific moments. One set of images haunts the protagonist—at the end of the film it is revealed that he has been doomed to revisit—and witness—the moment of his own death.*

Synopsis of Chris Marker's *La Jetée* (France, 1962)

The medium of film cannot be considered apart from its message—that is, apart from the multidimensional and diverse experience of viewers. Exploring the interaction of medium and viewer is one of the primary concerns of film theory. There are many aspects to what one might call the film experience. Film is an aesthetic medium that affects a viewer's senses and judgment. In addition, we experience film in time and place: we spend ninety minutes or so in a darkened room, perceiving sounds and images almost as if their sources were present. While the perceptual experience is philosophically and psychologically central to the appeal of the movies, there are many distinctly *social* dimensions to film viewing that are worth considering. Film is a communicative act; filmmakers and

1

filmgoers share the particular conventions or codes that structure a movie and make it intelligible. We are not mere blank screens upon which the film's images are projected; we arrive with expectations before we enter the movie theater—expectations created by publicity, reviews, previously viewed films, genre conventions, and so forth. We arrive to sit in the dark with other people, often with popcorn in hand. Moreover, our movie-going experience does not end when the lights go on. We might continue it with the purchase of the soundtrack album, the DVD, or toy tie-ins. Finally, the images, sounds, stories, and characters we experience tend to resonate in our memories and in our vocabulary.

From the earliest commentaries on the new medium to debates about digital technology today, theorists have contemplated the essential nature of the film experience. While film is perceptually immersive—almost hallucinatory—in a way that other media are not, the social dimension, that is, the experience of a mass audience consuming a mass entertainment, cannot be ignored. The critical essays in this section address the psychological, perceptual, and social dimensions of the film experience. First, we consider the nature of perception at the cinema and how it fits with our philosophical and cultural traditions concerning presence, absence, and illusion. Next, we attend to how prominent theorists have framed the psychological and phenomenological aspects of spectatorship as a key concept in film theory. Finally, we look at social and historical dimensions of the film experience, considering, for example, how different modes of film exhibition, or different cultural contexts, shape media reception.

The film described above, Chris Marker's *La Jetée*, is a poetic, black-and-white, 16mm short that both comments on the experience of film viewing and provides a profound viewing experience itself. The jetty of the film's title refers to the airport location where its most significant scene takes place. *La Jetée* is a rare film in that it is composed almost exclusively of still images, which feel distant in space and time. This formal decision encourages the viewer to reflect on the nature of the more usual cinematic illusion, which depends on the perception of movement to make images and scenes seem like they are really taking place. From the very beginning, the film medium has been associated with a curious sensation of presence, although the scenes it depicts are in fact absent. In 1896, Maxim Gorky described a demonstration of the Lumière Cinématographe as, "Not life, but the shadow of life. Not life's movement, but a sort of mute specter." Gorky's words recall quite strikingly the scenario described in the section of PLATO's *Republic* known as "The Allegory of the Cave," included as the first work in this section. In this founding text of Western philosophy, Socrates (the protagonist) tells the story of humans literally chained to their seats, mistaking a spectacle of shadows for reality. A resonant image of the viewer's bondage is offered in *La Jetée*, in which time-traveling experiments are performed on the main character while he is bound and blindfolded.

While Plato's allegory has been used to indict cinema as the most illusionist, and therefore deceptive, of art forms, it also supports film theory's more celebratory claim that cinema is the fulfillment of an age-old artistic dream of transcending space and time. For example, Harvard psychologist HUGO MÜNSTERBERG gives an enthusiastic account of the relatively young medium in our second selection, "Why We Go to the Movies." Written for the *Cosmopolitan* in 1915, the piece anticipates his 1916 full-length study, *The Photoplay: A Psychological Study*, regarded as the earliest book of film theory. For Münsterberg, the film experience was distinct from that of other arts, including theater, because of film's ability to manipulate space and time. He asserted that cinema's purpose was not to imitate nature

but rather to provide a new way of looking at it. This view was echoed in the debates soon to emerge between formalist and realist approaches to the movies that are presented in Part 3. Exploring analogies between such mental processes as emotion and the movies, Münsterberg suggests that the movies are in some sense an exteriorization of the mind.

Similar analogies are used by theorists writing since the 1970s, the period generally referred to as contemporary film theory. CHRISTIAN METZ, who established a reputation as one of the most influential thinkers in the field with his work on film semiology (cinema's specific forms of signification), became interested in the psychoanalytic theories of his contemporary Jacques Lacan. Metz took on the challenge of providing a "metapsychological" explanation—that is, a psychological account that transcends the individual—of the film experience. In his provocative, often poetic work *The Imaginary Signifier*, Metz makes an important distinction between "the cinema institution," which for him includes our desire to attend the movies and the pleasure we get from the perceptual experience, and the specific films one might want to analyze. In *La Jetée*, for example, the protagonist feels compelled to experience the past again and again, much as we return to the movies. Metz argues that what makes us so powerfully attached to cinematic figments is their evocation of both the picture-language of dreams and the profound visual experience of recognizing one's own face in a mirror. Lacan identifies the infantile "mirror stage" as the basis of the psychic register dominated by images that he calls "the imaginary," and Metz uses this term in the same sense. He also draws on the psychoanalytic concepts of voyeurism and fetishism to preserve a sense of eroticism and transgression in his description of cinema's appeal. Certainly both terms have everyday resonance—film fans and cinephiles are often considered fetishistic in their zeal, and films like *Rear Window* (1954) indict spectators as "peeping toms." Metz argues we watch the movies with a measure of fetishistic disavowal, that is, the balance of knowledge and belief, an attitude of: "I know very well" that the image projected onscreen is not real, "but just the same, I believe it, I love it."

In a related work, the extremely influential "Ideological Effects of the Basic Cinematographic Apparatus," JEAN-LOUIS BAUDRY points out the striking resemblance between the physical configuration of the film projection equipment and Plato's allegorical cave. We do not crave just any illusion, but one that involves projection, immobile spectators, and a deliberate concealing of the equipment required to produce the illusion. Baudry regards this illusionism suspiciously; he feels the cinematic experience is fundamentally deceptive and its participants are ideological dupes. Certainly this view resonates with the penal and painful view of spectatorship in *La Jetée*, in which the main character is forced to produce images by the authorities. These images, at first pleasurable, are ultimately fatal for him to experience.

To an extent, Baudry's position is an exaggeration of Metz's—film form is neglected, as is the social or individual experience of the viewer—in favor of an abstract view of spectatorship understood mainly in terms of unconscious, though socially influenced, processes. The method by which movies stimulate mental functioning is of primary concern to recent writers working at the intersection of philosophy and film. Two approaches that have emerged in recent years include cognitivism and phenomenology. David Bordwell, a profound influence on the former approach as well as on contemporary film studies more generally, understands film style as affording particular cues to viewers who then, through cognitive functioning, respond to those cues by assigning meaning and forming impressions. In "Film, Reality, and Illusion," an essay that appears in *Post-Theory*, an important collection

edited by Bordwell and Noël Carroll, philosopher GREGORY CURRIE argues a very specific point of cognitive film theory: viewers perceive actual motion, not apparent motion, at the movies. The puzzle *La Jetée* poses about the status of the images perceived by the protagonist is of considerable interest to such a proposition.

Although cognitivism attempts to understand film experience in its specificity, it holds that viewers' response to film stimuli is predictable. In contrast, a phenomenological approach argues that concrete perception is central to spectatorship and an experience in its fullest sense is particular to space, time, and subject. In "Phenomenology and the Film Experience" from her book *The Address of the Eye*, VIVIAN SOBCHACK urges us to think of the spectator's body as directly engaged with film viewing. Sobchak draws on the work of philosopher Maurice Merleau-Ponty to challenge the abstract understandings connected to the Platonic tradition and the apparatus theory of Metz and Baudry. Yet, even such philosophical emphasis on the particular leaves aside some very salient, in fact obvious, aspects of spectatorship. How does social experience affect viewing, and how do we account for spectators from different backgrounds and contexts?

One important strand in recent film studies looks at modes of spectatorship historically. TOM GUNNING's "The Cinema of Attractions" recognizes the importance of direct address and exhibitionism in early film, challenging dominant concepts of subject positioning and voyeurism, which Gunning sees as specific to later periods of film history with their more elaborated film grammars. For Gunning, the early experience of going to the cinema was much like going to the dance hall and the fairgrounds; that is, the space was public, shared, participatory, and even contestatory. While Gunning's essay is often positioned as a turn to the historical and away from the theoretical in contemporary film studies, it is in fact very much a theoretical intervention. While advancing a hypothesis about what the film experience might have been like in the early days of the medium, it proposes that certain elements of that experience continue to inform our astonished reactions to cinema and the development of alternative cinematic techniques throughout film history.

The social positioning of a particular viewer in terms of national identity, class, gender, or generation obviously influences his or her reception of film and media. With this as a basic assumption, STUART HALL's essay "Encoding/Decoding" considers how television's messages are communicated. Hall insists on a cycle of producing meaning; he rejects the idea of a reflectionist process in which the spectator simply mimes the meanings already set out in the text. For Hall, viewers' socialization and relative social power influence their reception of media texts—they might accept dominant messages, oppose them, or "negotiate" a response to them by rejecting some elements and accepting others. This conception of actual viewers interacting with preferred textual positions has had an enormous impact that we can designate more broadly as a "cultural studies" paradigm. Holding a view of culture as everyday experience as well as art and leisure, this approach urges consideration of many aspects of viewers' interaction with the movies, including stars and fandoms, fashion, music, and subcultures. The uniqueness of the film experience in the cultural studies model lies not in the psychic impact of taking in real-seeming images on a luminous large screen while plunged in darkness, but rather in the array of shared elements—conversations, memories, home or repeat viewings, awards shows, spin-offs and spoofs—spread across the social realm. Such an approach could illuminate the social ties formed between admirers of *La Jetée* as a work of science fiction and source text for

cult director Terry Gilliam (*12 Monkeys*, 1995), or the networks of art production and critique through which its director Chris Marker and his followers travel.

In order to give as full as possible an understanding of the fundamental viewer experience that is the object of so many theories, the section concludes with JUDITH MAYNE's "Paradoxes of Spectatorship," which synthesizes many accounts, pointing out their uses as well as their omissions. First, she points to the discrepancy between the way a film addresses a potential viewer and how it's received by an actual one. Second, she complicates deterministic psychoanalytical explanations of film viewing with another psychoanalytic concept, fantasy; we entangle the stories of films with the stories in our heads, hence our responses are not entirely predictable. Finally, she expands on Hall's concept of negotiation, noting that the fact that we do not swallow media messages whole does not necessarily mean that we are engaging in something radical with our individualized "film experience." Mayne's overview frames earlier (classical) questions of perception and links them with recent ones of reception, which advance a more social concept of human interaction with the sets of images and sounds we call "film." While "spectatorship" is not the only word for the film experience, Mayne's overview of this topic is indicative of its defining role in the field of film studies. As the medium changes, it is experienced differently: we use new technologies and interfaces and engage new relations of time and space to encounter digital versions of cinema as it converges with other media. The philosophical questions that we outline in this section—grounded as they are in bodies, social circumstances, and different histories— bear asking repeatedly, in new ways.

# PLATO

## The Allegory of the Cave

FROM *Republic*

Classical philosopher and mathematician Plato (427–347 B.C.E.) was the founder of the Academy in Athens, considered the first institution of higher education, and established his enduring influence through his thirty-five renowned philosophical dialogues. Mentored by Socrates, he established the foundations of Western philosophy and acted, in turn, as the mentor of Aristotle (p. 446), who would become the third major foundational figure in Western thought.

Though it was conceived centuries before the advent of film technology, Plato's philosophy has influenced the way many twentieth-century film scholars understand and interpret the movie image. In the shadow of the Peloponnesian War, Plato became increasingly disillusioned with practical politics. Influenced by Socrates, he practiced a life based in philosophy rather than the vagaries of an ever-fluctuating world. His writings employed the "Socratic

method," investigating questions of ethics and knowledge through an evolving fictional dialogue meant to refine those questions and their answers in a way that would ultimately reveal the truth. Plato's celebrated mandate that the only life worth living is a reflective or philosophical life generated the dialogical and critical thinking that would influence much philosophy and criticism for the next two millennia. Through his twenty-six dramatic dialogues, Plato ranged over the central concerns of humanity: from justice and truth to love, beauty, and "goodness." The concept of "mimesis," or imitation, was central in all of Plato's inquiries, reflecting his understanding that artists and poets create images or representations of the material world. But the concept also indicates Plato's preoccupation with how the material world is itself a mere reflection of universal and immutable "Forms" or "Ideas." What has become known as "The Allegory of the Cave" (from book 7 of Plato's *Republic*, believed to have been written ca. 380–360 B.C.E.) is a key example of Plato's quest for knowledge in a world of appearances.

In this dialogue between Socrates and Glaucon, Plato argues a fundamentally idealist perspective of the image, meaning that although we often assume we see the reality of the world, in fact we only see projections, shadows, or images of reality—we rarely look directly at it. We are like prisoners who cannot move their heads, viewing "shadows of artifacts" that have "no substance," projected on a cave wall in front of us. If, for Plato, this predicament describes an intellectual position, modern film theorists would see in it both a physical and psychological version of how spectators view movies. Plato's allegory became a crucial touchstone for film theory, particularly in the 1970s. For critics interested in film spectatorship and psychoanalytic and ideological issues, the allegory provides an important starting point for theorizing the complex epistemological issues surrounding how we watch movies. Writers such as Christian Metz (p. 17) and Jean-Louis Baudry (p. 34) see in "The Allegory of the Cave" an early philosophical model that helps explain a visual dynamics that blurs distinctions between reality and images, and allows films to distort the truth of our lives. Others, such as Vivian Sobchack (p. 62), suggest that Plato's position initiates a long tradition of *iconophobia*, a tradition that implicitly suspects all images as incapable of providing real knowledge or truth.

## READING CUES & KEY CONCEPTS

■ Examine and compare Plato's allegory with the physical position of a traditional filmgoer's experience. To what extent can we be compared to "prisoners" with "heads motionless in the dark" when we watch movies in a movie theater? In what ways does this analogy not hold up in comparison with different kinds of film viewing (i.e., watching a film in a movie theater versus watching a film on DVD at home)?

■ Plato claims that images are merely a reflection of the material world and that the material world is only a reflection of a higher intelligence. Examine the notions of "reflection" and "imitation" as they apply to the movies.

■ In what ways are Plato's questions about the relation of images to reality or "truth" pertinent to debates about film images as illusions? What are the implications for a more critical engagement with films as a way of "forming judgments"? How might some filmmakers and film audiences see the "Ideas" that Plato sees as superior to film images?

■ **Key Concepts:** Mimesis; Projections; Dialectics; Iconophobia

# The Allegory of the Cave

· · · · · · · · · · · · ·

[Socrates:] Next, I said, compare the effect of education and of the lack of it on our nature to an experience like this: Imagine human beings living in an underground, cavelike dwelling, with an entrance a long way up, which is both open to the light and as wide as the cave itself. They've been there since childhood, fixed in the same place, with their necks and legs fettered, able to see only in front of them, because their bonds prevent them from turning their heads around. Light is provided by a fire burning far above and behind them. Also behind them, but on higher ground, there is a path stretching between them and the fire. Imagine that along this path a low wall has been built, like the screen in front of puppeteers above which they show their puppets.

[Glaucon:] *I'm imagining it.*

Then also imagine that there are people along the wall, carrying all kinds of artifacts that project above it—statues of people and other animals, made out of stone, wood, and every material. And, as you'd expect, some of the carriers are talking, and some are silent.

*It's a strange image you're describing, and strange prisoners.*

They're like us. Do you suppose, first of all, that these prisoners see anything of themselves and one another besides the shadows that the fire casts on the wall in front of them?

*How could they, if they have to keep their heads motionless throughout life?*

What about the things being carried along the wall? Isn't the same true of them?

*Of course.*

And if they could talk to one another, don't you think they'd suppose that the names they used applied to the things they see passing before them?[1]

*They'd have to.*

And what if their prison also had an echo from the wall facing them? Don't you think they'd believe that the shadows passing in front of them were talking whenever one of the carriers passing along the wall was doing so?

*I certainly do.*

Then the prisoners would in every way believe that the truth is nothing other than the shadows of those artifacts.

*They must surely believe that.*

Consider, then, what being released from their bonds and cured of their ignorance would naturally be like. When one of them was freed and suddenly compelled to stand up, turn his head, walk, and look up toward the light, he'd be pained and dazzled and unable to see the things whose shadows he'd seen before. What do you think he'd say, if we told him that what he'd seen before was inconsequential, but that now—because he is a bit closer to the things that are and is turned towards things that are more—he sees more correctly? Or, to put it another way, if we pointed to each of the things passing by, asked him what each of them is, and compelled him to answer, don't you think he'd be at a loss and that he'd believe that the things he saw earlier were truer than the ones he was now being shown?

*Much truer.*

And if someone compelled him to look at the light itself, wouldn't his eyes hurt, and wouldn't he turn around and flee towards the things he's able to see, believing that they're really clearer than the ones he's being shown?

*He would.*

And if someone dragged him away from there by force, up the rough, steep path, and didn't let him go until he had dragged him into the sunlight, wouldn't he be pained and irritated at being treated that way? And when he came into the light, with the sun filling his eyes, wouldn't he be unable to see a single one of the things now said to be true?

*He would be unable to see them, at least at first.*

I suppose, then, that he'd need time to get adjusted before he could see things in the world above. At first, he'd see shadows most easily, then images of men and other things in water, then the things themselves. Of these, he'd be able to study the things in the sky and the sky itself more easily at night, looking at the light of the stars and the moon, than during the day, looking at the sun and the light of the sun.

*Of course.*

Finally, I suppose, he'd be able to see the sun, not images of it in water or some alien place, but the sun itself, in its own place, and be able to study it.

*Necessarily so.*

And at this point he would infer and conclude that the sun provides the seasons and the years, governs everything in the visible world, and is in some way the cause of all the things that he used to see.

*It's clear that would be his next step.*

What about when he reminds himself of his first dwelling place, his fellow prisoners, and what passed for wisdom there? Don't you think that he'd count himself happy for the change and pity the others?

*Certainly.*

And if there had been any honors, praises, or prizes among them for the one who was sharpest at identifying the shadows as they passed by and who best remembered which usually came earlier, which later, and which simultaneously, and who could thus best divine the future, do you think that our man would desire these rewards or envy those among the prisoners who were honored and held power? Instead, wouldn't he feel, with Homer, that he'd much prefer to "work the earth as a serf to another, one without possessions,"[2] and go through any sufferings, rather than share their opinions and live as they do?

*I suppose he would rather suffer anything than live like that.*

Consider this too. If this man went down into the cave again and sat down in his same seat, wouldn't his eyes—coming suddenly out of the sun like that—be filled with darkness?

*They certainly would.*

And before his eyes had recovered—and the adjustment would not be quick—while his vision was still dim, if he had to compete again with the perpetual prisoners in recognizing the shadows, wouldn't he invite ridicule? Wouldn't it be said of him that he'd returned from his upward journey with his eyesight ruined and that it isn't worthwhile even to try to travel upward? And, as for anyone who tried to free them and lead them upward, if they could somehow get their hands on him, wouldn't they kill him?

*They certainly would.*

This whole image, Glaucon, must be fitted together with what we said before. The visible realm should be likened to the prison dwelling, and the light of the fire inside it to the power of the sun. And if you interpret the upward journey and the study of things above as the upward journey of the soul to the intelligible realm, you'll grasp what I hope

to convey, since that is what you wanted to hear about. Whether it's true or not, only the god knows. But this is how I see it: In the knowable realm, the form of the good is the last thing to be seen, and it is reached only with difficulty. Once one has seen it, however, one must conclude that it is the cause of all that is correct and beautiful in anything, that it produces both light and its source in the visible realm, and that in the intelligible realm it controls and provides truth and understanding, so that anyone who is to act sensibly in private or public must see it.

## NOTES

1. Reading *parionta autous nomizein anomazein*. E.g. they would think that the name "human being" applied to the shadow of a statue of a human being. [Tr.]

2. *Odyssey* 11.489–90. The shade of the dead Achilles speaks these words to Odysseus, who is visiting Hades. Plato is, therefore, likening the cave dwellers to the dead. [Tr.]

# HUGO MÜNSTERBERG

· · · · · · · · · · · · · · · · · · · · · · · · · · · · · · · · · · · · · · · · · · · · · · · · ·

## Why We Go to the Movies

During his lifetime, Hugo Münsterberg (1863–1916) was best known for such scholarly studies of psychology as *The Activity of the Will* (1889) and *Business Psychology* (1915), books that established his reputation as one of the founding fathers of applied psychology. A Harvard University professor who taught classes in psychology and sociology, Münsterberg was also deeply interested in the movies. Combining his academic background with his interest in the movies, Münsterberg's 1916 work, *The Photoplay: A Psychological Study*, is often considered the first serious work of film theory.

First published as an article in the *Cosmopolitan* in 1915, "Why We Go to the Movies" appears at a critical turning point in film history. In fact, Münsterberg's use of the term "photoplay" suggests the still-novel place of the movies, situated somewhere between photography and plays, even as he works determinedly to distinguish film practice from those precedents. That D. W. Griffith's monumental and controversial *The Birth of a Nation* (1915) and Charlie Chaplin's mythic *The Tramp* (1915) appear the same year as Münsterberg's essay is one sign of how rapidly the movies were advancing technologically, formally, and intellectually. With these advances came questions and fears about the social effects and aesthetic value of movies: were they education, art, or entertainment?

In "Why We Go to the Movies," Münsterberg attempts to answer these questions and anticipates the case for cinematic specificity and the antirealist position that future theorists would espouse. Münsterberg definitively states that film is a unique artistic practice—quite different from other arts like photography and drama—that profoundly influences how audiences see and understand their world. His statement foreshadows, among others, Rudolf Arnheim (p. 279) and Noël Carroll's work on the original nature of the film medium. Münsterberg also resists common assumptions that the primary

strength of the movies is to reproduce the physical world; instead, he locates the power of movies in the psychological realm of the mind. With this argument, we see a forerunner of Christian Metz (p. 17), Laura Mulvey (p. 713), and other film theorists developing different psychoanalytical or psychological models of the movies.

## READING CUES & KEY CONCEPTS

■ According to Münsterberg, the movies "democratize" the theater. At the same time, he states that "the general public would need slowly to be educated toward the higher and higher forms of the photoplayers' art." What does he mean by this, and how does he reconcile the two seemingly contradictory thoughts?

■ More than ten years before synchronous sound came to the cinema, Münsterberg argued that the "Edison scheme of connecting the camera with the graphophone . . . interfered with the chance of the moving pictures to develop their original nature." What is the basis for his position? How might the use of sound be integrated into Münsterberg's vision of the cinema?

■ For Münsterberg, the close-up is the heart of the cinema. Why?

■ Münsterberg states that film uniquely shapes our perception as attention, memory, imagination, and emotion. What does he mean by this? Examine a film or part of a film, and demonstrate how it reflects Münsterberg's view.

■ **Key Concepts:** Aesthetics; Mechanical Imitation; Mental Interpretation; Photoplay; Space Reality; Thought-Effect

# Why We Go to the Movies

· · · · · · · · · · · · · ·

The "movies" themselves are moving all the time. To be sure, they move on different roads. One road is that of education and instruction. How modest were the means with which the kinematoscope of fifteen years ago showed us the happenings of the world and gave us glances at current events and exhibited a little of animal life! It was a long way indeed from there to the marvelous pictures of the European war or to those fascinating moving-picture journeys to the Antarctic and to the beasts of the African desert. We all have seen the wonders of the deep sea and the splendor of foreign worlds. Whatever is worth learning in the realm of visible things, from the microscopic Infusoria in the drop of water to the most colossal works of man and of nature, all can be made interesting and stimulating in the moving films. Millions have learned in the dark houses their geography and history and natural science.

---

This first article appeared in *The Cosmopolitan* 60, no. 1 (December 15, 1915): 22–32. The original article was accompanied by several photographs both of Münsterberg and of images from movies used to illustrate the editing and dramatic principles he is explaining.

Yet this power of the moving pictures to supplement the schoolroom and the newspaper and the library is, after all, much less important than its chief task—to bring entertainment and enjoyment and happiness to the masses. The theater and the vaudeville and the novel must yield room—and ample room—to the art of the pictures.

But can we really say that the film brings us art in the higher sense of the word? Was it not for quite a while the fashion among those who love art to look down upon the tricks of the film and to despise them as inartistic? Those who could afford to visit the true theater felt it as below their level to indulge in such a cheap substitute which lacked the glory of the stage with spoken words. But that time lies far behind us. Even the most artistic public has learned to enjoy a high-class photoplay.

I may confess frankly that I was one of those snobbish late-comers. Until a year ago I had never seen a real photoplay. Although I was always a passionate lover of the theater, I should have felt it as undignified for a Harvard Professor to attend a moving-picture show, just as I should not have gone to a vaudeville performance or to a museum of wax figures or to a phonograph concert. Last year, while I was travelling a thousand miles from Boston, I and a friend risked seeing *Neptune's Daughter*, and my conversion was rapid. I recognized at once that here marvelous possibilities were open, and I began to explore with eagerness the world which was new to me. Reel after reel moved along before my eyes—all styles, all makes. I went with the crowd to Anita Stewart and Mary Pickford and Charles Chaplin; I saw Pathé and Vitagraph, Lubin and Essanay, Paramount and Majestic, Universal and Knickerbocker. I read the books on how to write scenarios; I visited the manufacturing companies, and, finally, I began to experiment myself. Surely I am now under the spell of the "movies" and, while my case may be worse than the average, all the world is somewhat under this spell.

## A New Form of Art

Why did this change come? Was it because the more and more improved technique brought the imitation of the theater nearer and nearer to the impression of the real stage and thus made the substitute almost as good as the original? Not at all. The real reason was just the opposite. The more the photoplays developed, the more it was felt that it was not their task simply to be an inexpensive imitation of the theater, but that they should bring us an entirely new form of art. As long as the old belief prevailed that the moving-picture performances were to give us the same art which the drama gave, their deficiencies were evident. But if they have an original task, if they offer an art of their own, different from that of the theater, as the art of the painter is different from that of the sculptor, then it is clear that the one is not to be measured by the other. Who dares to say that the marble bust is a failure because it cannot show us the colors which give charm to the portrait painting? On the contrary, we destroy the beauty of the marble statue as soon as we paint the cheeks of a Venus.

It is never the purpose of an art simply to imitate nature. The painting would not be better if the painted flowers gave us fragrance. It is the very essence of art to give us something which appeals to us with the claims of reality and yet which is entirely different from real nature and real life and is set off from them by its artistic means. For this reason we put the statue on a pedestal and the painting into a frame and the dramatic play on a stage. We do not want them to be taken as parts of the

real world, and the highest art of all, music, speaks a language which has not even similarity to the happenings of the world.

If the aim of every art were simply to come as near as possible to reality, the photoplay would stand endlessly far behind the performances of real actors on the stage. But when it is recognized that each art is a particular way of suggesting life and of awaking interest, without giving life or nature themselves, the moving pictures come into their own. They offer an entirely new approach to beauty. They give an art which must develop in paths quite separate from those of the stage. It will reach the greater height the more it learns to free itself from the shackles of the theater and to live up to its own forms.

It is only natural that it began with a mere imitation of the theater, just as the automobiles were at first simple horse-carriages moved by machinery. Any new principle finds its own form slowly. The photoplay of today is already as different from those theater imitations as a racing automobile is from a buggy. As soon as the two forms of art are recognized as belonging to two entirely different spheres, they do not disturb each other. Even the most ideal moving picture can never in the least give that particular artistic pleasure which a dramatic theater performance offers. But, on the other hand, even the best drama on the stage will not replace the photoplay as soon as this has reached its ideal perfection.

## True Meaning of the Photoplay

What is the true meaning of the "movies"? What are their special ways of showing us the world? In the beginning, the public enjoyed simply the surprising tricks of a technique which showed actual movement in a photograph. But this purely technical interest has long since faded away. What remains, then, as the lasting source of enjoyment? The color is lacking and so is the depth of the stage; above all, the tone of the voice is absent. Yet we do not miss the color, the depth, or the words. We are fully under the spell of this silent world, and the Edison scheme of connecting the camera with the graphophone, and so to add spoken words to the moving pictures, was not successful for very good reasons. It really interfered with the chance of the moving pictures to develop their original nature. They sank back to the level of mere mechanical imitation of the theater.

But while so much was taken away from the offering of every theater stage, how much has come instead! The most evident gain of the new scheme is the reduction of expenses. One actor is now able to entertain a hundred and a thousand audiences at the same time; one stage-setting is sufficient to give pleasure to millions. The theater is thus democratized. Everybody's purse allows him to see the greatest artists, and in every village a stage can be set up. With twenty thousand picture-theaters in this country alone, the hope that the bliss of art may come to everyone has been fulfilled.

But this mere spreading over the globe is not in itself an enrichment of the artistic means. The graphophone brings music into every cottage, but no one can claim that the musical disks have brought us a new art. Their rendering of orchestra or opera is nothing but a mechanical repetition of the free musical art and does not add anything to the symphony or the song.

With the photoplay it is entirely different. It shows us far more than any stage can show, or, rather, it shows us something fundamentally different. The first step

away from the theater was soon made. The moving pictures allow a rapidity in the change of scenes which no stage manager could imitate. At first, these possibilities were used only for humorous effects. We enjoyed the lightening quickness with which we could follow the eloper over the roofs of the town, up-stairs and down, into cellar and attic, and jump with him into the motor-car and race over the country roads, changing the background a score of times in a few minutes, until the culprit falls over a bridge into the water and is caught by the police.

This slap-stick humor has not disappeared, but the rapid change of scenes has meanwhile been put into the service of much higher aims. The true development of an artistic plot has been brought to possibilities which the real drama does not know by allowing the eye to follow the hero and heroine continuously from place to place. Now he leaves his room, now we see him passing along the street, now he enters the house of his beloved, now he is led into the parlor, now she is hurrying to the library of her father, now they all go to the garden. New stage-settings are ever sliding into one another; the limitations of space are overcome. It is as if the laws of nature were overwhelmed and, through this liberation from space, a freedom gained which gives new wings to the artistic imagination. This perfect independence from the narrow ties of space-reality gives to the photoplay a new life-chance which alone would secure it the right of a new form of art.

But with the quick change of background, the photoartist also gained the power of a rapidity of motion which leaves actual men behind. And from here it was only a step to the performance of actions which could not be carried out in nature at all. This, too, was made serviceable at first to a rather rough humor. The policeman who climbed up the solid stone front of a high building was in reality photographed creeping over a flat picture of a building spread on the floor. Every day brought us new tricks. We saw how the magician breaks one egg after another and takes out of each egg a little fairy and puts one after another on his hand and how they begin to dance. For the camera, such magical wonders are not difficult, but no theater could ever try to match them. Rich artistic effects are secured, and while on the stage every fairy-tale is clumsy and hardly able to create an illusion, in the film we really see the man transformed into a beast and the flower into a girl.

## The Close-Up

But while, through this power to break down the barriers of space and to make the impossible actions possible, new fascinating effects could be reached, the whole still remained in the outer framework of the stage, inasmuch as everything was the presentation of an action in its successive stages. The photoplay showed a performance, however rapid or impossible, as it would go on in the outer world. An entirely new perspective was opened when the managers of the film-play introduced the "close-up" and similar new methods. The close-up, first made familiar to every friend of the photoplay by the Vitagraph artists, is indeed most characteristic of the emancipation of the moving pictures. As everybody knows, this is the scheme by which a particular part of the picture, perhaps only the face of the hero or his hand or only a ring on his finger, becomes greatly enlarged and replaces, for an instant, the whole stage.

But while everyone is familiar with the method, too few are aware that here indeed we have crossed a great aesthetic line of demarcation and have turned to a

form of expression which is entirely foreign to the real stage. Even the most won-derful creations, the great historical plays, where thousands fill the battle-fields, or the most fantastic caprices, where fairies fly over the stage, could be performed in a theater. But this close-up leaves all stagecraft behind. The stage can give us only changes in the outer world; but if we suddenly neglect everything in the room and look only at the hand which carries the dagger, the change is not one outside but inside our mind. It is a turning of our attention. We withdraw our attention from all which is unimportant and concentrate it on that one point on which the action is focussed. The photoplay is an art in which not only the outer events but our own inner actions become effective. Our own attention is projected into the life around us.

## *Novel Methods of Presentation*

But attention is not the only function of our mind which becomes effective in the moving pictures. Let us think of another action of our mind, the act of memory. When we go through an experience in practical life, we are constantly remembering happenings of the past. The photoplay can overcome the limits of time just as easily as those of space. In many of the newer plays, an unusual fascination is secured by interrupting the pictures of the present events with quickly passing images of ear-lier scenes. It is as if a quick remembrance were flitting through our mind.

Two passengers are sitting in the smoking-room of a ship; we see them talking about their adventurous life-experiences. The one makes the gesture of speaking; in the next instant we see him climbing the glacier, and then crossing the jungle and shooting tigers, and then fighting in the Boer War, and then strolling through Paris; but every few seconds we return to the smoking-room and keep thus the background of the story before us. Yet our mind does not only combine memories; our thought wanders from one event to another which runs parallel. Here is a dancing-hall in which a man and a girl are flirting; the girl's mother sits at home in a modest attic room and waits for her anxiously; the man's wife is unhappy in her luxurious parlor. Now the three scenes are interwoven: the dancing-hall is seen for ten seconds, then the attic scene for five seconds, the parlor scene for five seconds, then the dancing-hall again, and so on. They chase one another like the tones of an orchestra.

The order of the pictures on the screen is no longer the order of events in nature, but rather that of our own mental play. Here lies the reason why this new art has such peculiar interest for the psychologist. It is the only visual art in which the whole richness of our inner life, our perceptions, our memory, and our imagination, our expectation and our attention can be made living in the outer impressions them-selves. As long as the photoartist made no use of these possibilities, his play lagged far behind that of the real theater. But since he has conquered these new methods of mental interpretation, he has created an art which is a worthy rival of the drama, entirely independent from and in not a few respects superior to the theater.

As soon as the original character of the photoplay is understood, it can eas-ily be grasped that we are only at the beginning of a great aesthetic movement. The technical development of the photo-stage and of the camera will go on, and yet that is entirely secondary to the much more essential progress of the new art toward its highest fulfillment. The producer of the photoplays must free himself more and more from the idea with which he started to imitate the stage—and must

more and more win for the new art its own rights. How reluctant as yet, for instance, are the efforts to introduce the power of the imagination! In many a photoplay the murderer sees the ghost of his victim. But such devices are, after all, not unfamiliar on the regular stage. Just here the possibilities of the camera are unlimited. The girl in her happy first love sees the whole world in a new glamour and a new radiant beauty. The poet can make her speak so; only the photoplay could show her in this new jubilant world. This is something very different from the charming plays which we already possess today in which Princess Nicotina bewitches us or Neptune's daughter arises from the waves. Such fantastic plays tell us a pretty story, but what we must expect from the photoplay of the future is that the pictures reveal to us our own imaginative play as music can do with its magic tones.

From an artistic point of view, it is entirely wrong to fancy that such imaginative molding of the world must be confined to fairy-tales because it does not correspond to the reality of the world. As long as we argue from such a point of view we have not reached true art. Even the most realistic art always gives us something different from reality. As long as the artistic means harmonizes with our inner view of an experience, it is welcome in the world of art. Even the most rapturous flights of the imagination projected on the screen may have as much inner truth as any melodramatic story. The photoartist needs only the courage to make the spectator feel that he is truly in a temple of art.

## *How the Film Expresses Emotions*

But even memory, attention, and imagination do not tell the whole story of our inner mind. The core of man lies in his feelings and emotions. As soon as the photoplay moves along its own way, the expression of feelings and emotions will come to the foreground. Of course the producer would say that he shows love and hate and fear and delight and envy and disgust and hope and enthusiasm all in his reels. Certainly he shows them, but simply with the methods of the ordinary stage. The angry man clenches his fist and the frightened man shows signs of terror. We see the gestures and the actions; and yet how inferior is all that to the emotional words which the dramatist can put into the mouth of his persons on the stage! What Romeo and Juliet have to express is, after all, better said by Shakespeare's words than by any mere gestures of tenderness. As long as the photoplay works only with the methods of the theater, we must regret that we are deprived of the words.

But what a different perspective is opened if we think of the unlimited means with which the film may express feeling and sentiment through means of its own. We saw that, in the close-up, the camera can do what in our mind our attention is doing; the camera goes nearer to the object and thus concentrates everything on one point. In our feelings and emotions, the mind takes a sort of stand toward the surroundings. Again, the camera must be made to imitate such a mental action. In the excited mind, the smooth flow of impressions is interrupted. Let the camera break the flow of the pictures. Give us a thought-effect which the musician calls "staccato." We can produce it in the film by omitting certain pictures so that the action seems to jump from one stage to another. Or let the pictures vibrate. We can do this by quickly reversing the order of the pictures which follow one another with the rapidity of sixteen photograms to the second. After pictures 1, 2, 3, 4, 5, 6, we give once more 6, 5, 4, turn then from 4 to picture 9, go back from 9 to 6, then from 6 to 12, and the effect will be

that a trilling, vibrating motion goes through the surroundings. Or let the camera turn the straight lines into curves, or the rhythm slow down like a musical adagio, or become rapid like an allegro or presto. In every case effects are produced in which changes of inner excitement seem to take hold of the surrounding world.

## *Imitating Mental Action*

The violinist may play one piece after another and we may see in the film the sentiments of those various pieces through the melodious movements around him. His own face may remain unchanged, but everything around him may enter into the mood of the tones and chords. It is in the spirit of the theater to express horror by the wild gestures of the body. It would be in the spirit of the photoplay to make the world around the terrified person change in a horrifying, ghastly way. The camera can do that, and the spectator would come deeply under the spell of the emotion to be expressed. It becomes his emotion, just as in the close-up it is his attention which is forced on the single detail. If a man is hypnotized in the scene, the change of his feelings can only clumsily be shown in his face, but his surroundings may take uncanny forms until a kind of hypnotic spell lies over the whole audience.

Of course the general public would need slowly to be educated toward the higher and higher forms of the photoplayers' art. The masses prefer Sousa's Band to the Boston Symphony Orchestra. It needs a certain training to appreciate the highest forms of art, but nobody doubts that the symphony program, from Beethoven to Debussy, stands on a much higher artistic level than the marches and dances which the unmusical hearers love best. The straight melodrama of the film, offering nothing which the drama of the theater could not present better, will attract the "unmusical" minds more than the true high art of the photoplay. But he who believes the message of beauty for the masses of the people will not yield to such superficial desires. He will unceasingly lift the photoplay to higher and higher art, and to do so he must become conscious of the principles which are involved. But this can be done only if he breaks with the tradition of the theater and understands that the photoplay expresses the action of the mind as against the mere action of the body. Of course the drama presents this inner side of the spoken word which is missing in the pantomime of the film. The inner mind which the camera exhibits must lie in those actions of the camera itself by which space and time are overcome and attention, memory, imagination, and emotion are impressed on the bodily world.

The photoplay of the future, if it is really to rise to further heights, will thus become more than any other art the domain of the psychologist who analyzes the working of the mind. We have seen in recent years how the work of the modern psychologist has become influential and helpful in many different spheres of practical life. Education and medicine, commerce and industry, law and social reform have been greatly aided by the contact with the psychologist, who has put the results of his psychological laboratory into the service of daily life. In the film-world, the only scientist who has been consulted in the past has been the physicist, who prepared the technical devices for the work of the camera. The time seems ripe for his scientific brother, the psychologist, to enter the field and to lead the photoplay to those wonders which its progress has begun to suggest since the leaders dared to leave the paths of mere theatrical performance. The more psychology enters into the sphere of the moving pictures, the more they will be worthy of an independent place in the world

of true art and become really a means of cultural education to young and old. The presentations of the films will never supersede those of the theater any more than sculpture can supersede painting or lyrics can supersede music, but they will bring us the noble fulfillment of an artistic desire which none of the other arts can bring.

This is truly the art of the future.

# CHRISTIAN METZ

## Loving the Cinema; Identification, Mirror; Disavowal, Fetishism

FROM *The Imaginary Signifier*

A leading film theoretician in France, Christian Metz (1931–1993) opened the way in the 1960s to the establishment of film theory as a new intellectual discipline. Metz attended the École Normale Supérieure, along with other intellectuals of his generation who were inspired by the structuralist movement (a study of human culture as a system of signs), including Jacques Derrida and Pierre Bourdieu. He received his doctorate in general linguistics at the Sorbonne. Metz's earlier work, most notably *Essais sur la signification au cinéma* (1968; translated as *Film Language* in 1974), defined film as a language by using structural linguistics, or semiology, based on the work of Ferdinand de Saussure.

With an awareness of language and a critical distance from the object of study that characterized many twentieth-century thinkers, Metz turned away from the classical film theory of Siegfried Kracauer (p. 289) and André Bazin (p. 309), and disengaged with then-current auteurist models that were seen as impressionistic and subjective. Instead, he focused on the question of how films in general are understood, and he investigated film as one of many structures of signification that can be decoded by the linguistic model.

By the mid-1970s, the influence of Louis Althusser's work on ideology and Jacques Lacan's psychoanalysis, as well as the cultural impact of the 1968 revolutions, prompted the shift in Metz's work from structuralist and formalist analysis to theories of signification, ideology, and psychoanalysis. This shift parallels two trends in film theory and practice during this period: the filmic medium became an object of ideological analysis, and films themselves (such as François Truffaut's *Day for Night* [1973] and Marguerite Duras's *India Song* [1975]) offered a critique of dominant ideology through reflexivity and political engagement. Metz's *The Imaginary Signifier*, the 1986 translation of essays written between 1973 and 1976, signals the theoretical impulse of this moment to identify and deconstruct the ideological structures implied in commercial narrative cinema.

In these exerpts, Metz begins (in "Loving the Cinema") with outlining the methodological need for a film theorist to remain detached from the beloved object of study in order to analyze its objective conditions—a scientific distance he believes is lacking in most classical approaches to film, such as Bazin's phenomenological treatment of the filmic image. He

continues with the notion of perception in cinema, drawing particularly on Lacan's concep-
tion of the imaginary, the symbolic, and the real in understanding the nature of perception.
Metz distinguishes cinema from other arts by saying that while it is "more perceptual" than
other arts, these perceptions are marked by "unreality to an unusual degree," since what
we perceive on screen are not actual objects but rather images that refer to their absence.
Cinema, therefore, is an imaginary signifier, existing exclusively in the imaginary activity of
the spectator. Metz connects the simultaneous perceptual wealth and absence of cinema
to Lacan's notion of the absent object that grounds desire in lack and to the "mirror stage"
in which the human subject (mis)recognizes itself. To explain the means by which cinema at-
tempts to make up for this lack and create a state of wholeness for the spectator, Metz uses
three fundamental psychoanalytic processes—identification, voyeurism, and fetishism—
which he expands to the effects and attractions of the cinematic apparatus.

*The Imaginary Signifier* remains one of the most important works in film theory. It
makes the classical question about the impression of reality inseparable from the question
of spectatorial positioning, and spectatorial positioning inseparable from the question of
cinema as an institution. Metz's work not only cemented the significance of psychoana-
lytic film theory but also became important to many key movements such as feminist and
postcolonial film theory.

## READING CUES & KEY CONCEPTS

■ Describing the power of cinema as an institution, Metz says that "loving the cinema
and understanding film are no more than two closely mingled aspects of one vast
socio-psychical machinery." At the same time, he tries to make a clear distinction
between a spectator, or what he considers a "deluded subject ego," and a film theorist,
someone with a distant and scientific approach to the medium. What does he mean by
these two seemingly different arguments, and how does he reconcile them?

■ For Metz, the meaning of film is systemic, defined within the conventions and codes of
the institution. To what extent, if at all, does this position allow for subjective (and
interpretative) freedom for the spectator?

■ The conditions of film reception, such as the darkness of the cinema, seem integral to
Metz's notions of voyeurism, fetishism, and scopic fascination. Consider the relevance
of these psychoanalytic notions in the context of more recent technological changes
and altered conditions of film reception.

■ **Key Concepts:** The Imaginary; Fetishism; Jouissance; Primary Identification;
Mirror Stage

# Loving the Cinema

. . . . . . . . . . . . . .

What is it in the end that I want to say about these writings whose approach is
that of a love? Certainly not that their authors are "wrong" all the time, or that
what they say is always false. That is not the point. Wishing to get rid of the affective

gets one nowhere, nor would it get this article anywhere. Even less is it my purpose to forget that these *assertive affects* are the reversed consequence of the opposite cultural prejudice, still alive today, that sees in the cinema a low-level distraction (and which thus starts by thinking in levels). In a history of contemporary culture the concern for the good object which I have tried to bring out can only be understood in relation to the bad-object status that society initially conferred on the cinema and to which it still confines it to some extent. In doing so it has considerably set back the possibility of a knowledge of the cinematic fact: directly (by neglect or disdain), but also by reaction (which concerns me here), by exacerbating in those concerned with the cinema the persistent drama of an *adherence* that sometimes becomes a kind of entanglement—the revolt against an enforced marginalization.

Discourse about the cinema is too often part of the institution, whereas it should be studying it and believes or pretends that it is doing so. It is, as I have said, its third machine: after the one that manufactures the films, and the one that consumes them, the one that *vaunts* them, that valorizes the product. Often, by unexpected paths, unperceived by those who have quite unintentionally taken them, paths which manifest the radical exteriority of effects to conscious intentions, writings on film become another form of cinema advertising and at the same time a linguistic appendage of the institution itself. Like those alienated sociologists who unknowingly repeat the pronouncements of their society, it extends the object, it *idealizes* it instead of turning back on to it, it makes explicit the film's inaudible murmuring to us of "Love me": a mirror reduplication of the film's own ideological inspiration, already based on the mirror identification of the spectator with the camera (or secondarily with the characters, if any).

Discourse about the cinema then becomes a dream: an uninterpreted dream. This is what constitutes its symptomatic value; it has already said everything. But it is also what makes it obligatory to turn it inside out like a glove, to return it like the gauntlet on accepting a challenge; it does not know what it is saying. Knowledge of the cinema is obtained via a *reprise* of the native discourse, in two senses of the word: taking it into consideration and re-establishing it.

The turning I am discussing is never anything but a return. In the cinema, too, the product presents us with a reversed image of the production, as it does in the materialist conception of ideologies, or in neurotic rationalizations, as in the *camera obscura* which, with its 180-degree-turned optical image, is the very starting-point of cinematic technique. The effort towards knowing is necessarily sadistic insofar as it can only grasp its object against the grain, re-ascend the slopes of the institution (whereas the latter is designed for one to "follow" them, to descend them), like the interpretation that goes back along the path of the dream-work, acting by nature in the manner of a counter-current.

To be a theoretician of the cinema, one should ideally no longer love the cinema and yet still love it: have loved it a lot and only have detached oneself from it by taking it up again from the other end, taking it as the target for the very same scopic drive which had made one love it. Have broken with it, as certain relationships are broken, not in order to move on to something else, but in order to return to it at the next bend in the spiral. Carry the institution inside one still so that it is in a place accessible to self-analysis, but carry it there as a distinct instance which does not over-infiltrate the rest

of the ego with the thousand paralyzing bonds of a tender unconditionality. Not have forgotten what the cinephile one used to be was like, in all the details of his affective inflections, in the three dimensions of his living being, and yet no longer be invaded by him: not have lost sight of him, but be keeping an eye on him. Finally, be him and not be him, since all in all these are the two conditions on which one can speak of him.

This balance may seem a somewhat acrobatic one. It is and it is not. Of course no one can be sure to attain it perfectly, everyone is in danger of slipping off on one side or the other. And yet, in principle, considering the very possibility of *maintaining* such a position, it is not true that it is so very acrobatic, or rather it is no more so than the other (really very similar) mental postures required for tasks more ordinarily evoked. This is forgotten because it is not customary (it is one of the great taboos of scientism, one of its terrors) to mention the metapsychological preconditions of scientific work. But for anyone who is prepared to consider them, the kind of deliberate ambivalence I am trying to describe, this special variety of splitting, at once salutary and fragile, this minimum of flexibility in one's relations to oneself, this economic conversion by which a strong object cathexis (here attraction to the cinema), initially molar and opaque, subsequently undergoes an instinctual vicissitude that bifidates it and arranges it like a pair of pliers, one pincer (voyeuristic sadism sublimated into epistemophilia) coming to meet the other in which the original imaginary of the dual effusion with the object is retained as a (living, surviving) witness—in short, this itinerary and the present configuration that results from it are not in the end especially exceptional or contorted (even if for some "scientists" they are among those things that must not be stated). It is itineraries and economies of the same kind (tendentially, still, never as a finished result) that also define the objective conditions of the subjective possibility of the ethnologist's work, or that of the analysand in the cure, ultimately of all work of *interprétance* in the semiotic and Peircean sense of the word (= translation from one system into another). What really is uncommon is not the thing itself, but simply the idea that cinematic studies are not in themselves blessed with any special privilege of exemption, any *magical extra-territoriality*, any adolescent immunity from the common requirements of knowledge and symbolic cathexis which are (sometimes) more clearly perceived in other fields.

# Identification, Mirror

. . . . . . . . . . . . . .

"What contribution can Freudian psychoanalysis make to the knowledge of the cinematic signifier?": that was the question-dream I posed (the scientific imaginary wishing to be symbolized), and it seems to me that I have now more or less *unwound* it; unwound but no more; I have not given it an answer. I have simply paid attention to what it was I wished to say (one never knows this until one has written it down), I have only questioned my question: this unanswered character is one that has to be deliberately accepted, it is constitutive of any epistemological procedure.

Since I have wished to mark the places (as empty boxes some of which are beginning to fill without waiting for me, and so much the better), the places of different directions of work, and particularly of the last, the psychoanalytic exploration of the signifier, which concerns me especially, I must now begin to inscribe something in this

last box; must take further, and more plainly in the direction of the unconscious, the analysis of the investigator's desire that makes me write. And to start with, of course, this means asking a new question: among the specific features of the cinematic signifier that distinguish the cinema from literature, painting, etc. which ones by nature call most directly on the type of knowledge that psychoanalysis alone can provide?

## Perception, Imaginary

The cinema's signifier is *perceptual* (visual and auditory). So is that of literature, since the written chain has to be *read*, but it involves a more restricted perceptual register: only graphemes, writing. So too are those of painting, sculpture, architecture, photography, but still within limits, and different ones: absence of auditory perception, absence in the visual itself of certain important dimensions such as time and movement (obviously there is the time of the look, but the object looked at is not inscribed in a precise and ordered time sequence forced on the spectator from outside). Music's signifier is perceptual as well, but, like the others, less "extensive" than that of the cinema: here it is vision which is absent, and even in the auditory, extended speech (except in song). What first strikes one then is that the cinema is *more perceptual*, if the phrase is allowable, than many other means of expression; it mobilizes a larger number of the axes of perception. (That is why the cinema has sometimes been presented as a "synthesis of all the arts"; which does not mean very much, but if we restrict ourselves to the quantitative tally of the registers of perception, it is true that the cinema contains within itself the signifiers of other arts: it can present pictures to us, make us hear music, it is made of photographs, etc.)

Nevertheless, this as it were numerical "superiority" disappears if the cinema is compared with the theater, the opera and other spectacles of the same type. The latter too involve sight and hearing simultaneously, linguistic audition and non-linguistic audition, movement, real temporal progression. Their difference from the cinema lies elsewhere: they do not consist of *images*, the perceptions they offer to the eye and the ear are inscribed in a true space (not a photographed one), the same one as that occupied by the public during the performance; everything the audience hear and see is actively produced in their presence, by human beings or props which are themselves present. This is not the problem of fiction but that of the definitional characteristics of the signifier: whether or no the theatrical play mimes a fable, its *action*, if need be mimetic, is still managed by real persons evolving in real time and space, *on the same stage or "scene" as the public*. The "other scene," which is precisely not so called, is the cinematic screen (closer to phantasy from the outset): what unfolds there may, as before, be more or less fictional, but the unfolding itself is fictive: the actor, the "décor," the words one hears are all absent, everything is *recorded* (as a memory trace which is immediately so, without having been something else before), and this is still true if what is recorded is not a "story" and does not aim for the fictional illusion proper. For it is the signifier itself, and as a whole, that is recorded, that is absence: a little rolled up perforated strip which "contains" vast landscapes, fixed battles, the melting of the ice on the River Neva, and whole life-times, and yet can be enclosed in the familiar round metal tin, of modest dimensions, clear proof that it does not "really" contain all that.

At the theater, Sarah Bernhardt may tell me she is Phèdre or, if the play were from another period and rejected the figurative regime, she might say, as in a type

of modern theater, that she is Sarah Bernhardt. But at any rate, I should see Sarah Bernhardt. At the cinema, she could make the same two kinds of speeches too, but it would be her shadow that would be offering them to me (or she would be offering them in her own absence). Every film is a fiction film.

What is at issue is not just the actor. Today there are a theater and a cinema without actors, or in which they have at least ceased to take on the full and exclusive function which characterizes them in classical spectacles. But what is true of Sarah Bernhardt is just as true of an object, a prop, a chair for example. On the theater stage, this chair may, as in Chekhov, pretend to be the chair in which the melancholy Russian nobleman sits every evening; on the contrary (in Ionesco), it can explain to me that it is a theater chair. But when all is said and done it is a chair. In the cinema, it will similarly have to choose between two attitudes (and many other intermediate or more tricky ones), but it will not be there when the spectators see it, when they have to recognize the choice; it will have delegated its reflection to them.

What is characteristic of the cinema is not the imaginary that it may happen to represent, but the imaginary that it *is* from the start, the imaginary that constitutes it as a signifier (the two are not unrelated; it is so well able to represent it because it is it; however it is it even when it no longer represents it). The (possible) reduplication inaugurating the intention of fiction is preceded in the cinema by a first reduplication, always-already achieved, which inaugurates the signifier. The imaginary, by definition, combines within it a certain presence and a certain absence. In the cinema it is not just the fictional signified, if there is one, that is thus made present in the mode of absence, it is from the outset the signifier.

Thus the cinema, "more perceptual" than certain arts according to the list of its sensory registers, is also "less perceptual" than others once the status of these perceptions is envisaged rather than their number or diversity; for its perceptions are all in a sense "false." Or rather, the activity of perception which it involves is real (the cinema is not a fantasy), but the perceived is not really the object, it is its shade, its phantom, its double, its *replica* in a new kind of mirror. It will be said that literature, after all, is itself only made of replicas (written words, presenting absent objects). But at least it does not present them to us with all the really perceived detail that the screen does (giving more and taking as much, i.e. taking more). The unique position of the cinema lies in this dual character of its signifier: unaccustomed perceptual wealth, but at the same time stamped with unreality to an unusual degree, and from the very outset. More than the other arts, or in a more unique way, the cinema involves us in the imaginary: it drums up all perception, but to switch it immediately over into its own absence, which is nonetheless the only signifier present.

## The All-Perceiving Subject

Thus film is like the mirror. But it differs from the primordial mirror in one essential point: although, as in the latter, everything may come to be projected, there is one thing and one thing only that is never reflected in it: the spectator's own body. In a certain emplacement, the mirror suddenly becomes clear glass.

In the mirror the child perceives the familiar household objects, and also its object par excellence, its mother, who holds it up in her arms to the glass. But above

all it perceives its own image. This is where primary identification (the formation of the ego) gets certain of its main characteristics: the child sees itself as an other, and beside an other. This other other is its guarantee that the first is really it: by her authority, her sanction, in the register of the symbolic, subsequently by the resemblance between her mirror image and the child's (both have a human form). Thus the child's ego is formed by identification with its like, and this in two senses simultaneously, metonymically and metaphorically: the other human being who is in the glass, the own reflection which is and is not the body, which is like it. The child identifies with itself as an object.

In the cinema, the object remains: fiction or no, there is always something on the screen. But the reflection of the own body has disappeared. The cinema spectator is not a child and the child really at the mirror stage (from around six to around eighteen months) would certainly be incapable of "following" the simplest of films. Thus, what *makes possible* the spectator's absence from the screen—or rather the intelligible unfolding of the film despite that absence—is the fact that the spectator has already known the experience of the mirror (of the true mirror), and is thus able to constitute a world of objects without having first to recognize himself within it. In this respect, the cinema is already on the side of the symbolic (which is only to be expected): the spectator knows that objects exist, that he himself exists as a subject, that he becomes an object for others: he knows himself and he knows his like: it is no longer necessary that this similarity be literally *depicted* for him on the screen, as it was in the mirror of his childhood. Like every other broadly "secondary" activity, the practice of the cinema presupposes that the primitive undifferentiation of the ego and the non-ego has been overcome.

But *with what*, then, does the spectator identify during the projection of the film? For he certainly has to identify: identification in its primal form has ceased to be a current necessity for him, but he continues, in the cinema—if he did not the film would become incomprehensible, considerably more incomprehensible than the most incomprehensible films—to depend on that permanent play of identification without which there would be no social life (thus, the simplest conversation presupposes the alternation of the *I* and *you*, hence the aptitude of the two interlocutors for a mutual and reversible identification). What form does this *continued* identification, whose essential role Lacan has demonstrated even in the most abstract reasoning[1] and which constituted the "social sentiment" for Freud[2] (= the sublimation of a homosexual libido, itself a reaction to the aggressive rivalry of the members of a single generation after the murder of the father), take in the special case of one social practice among others, cinematic projection?

Obviously the spectator has the opportunity to identify with the *character* of the fiction. But there still has to be one. This is thus only valid for the narrative-representational film, and not for the psychoanalytic constitution of the signifier of the cinema as such. The spectator can also identify with the actor, in more or less "a-fictional" films in which the latter is represented as an actor, not a character, but is still offered thereby as a human being (as a perceived human being) and thus allows identification. However this factor (even added to the previous one and thus covering a very large number of films) cannot suffice. It only designates secondary identification in certain of its forms (secondary in the cinematic process itself, since

in any other sense all identification except that of the mirror can be regarded as secondary).

An insufficient explanation, and for two reasons, the first of which is only the intermittent, anecdotal and superficial consequence of the second (but for that reason more visible, and that is why I call it the first). The cinema deviates from the theater on an important point that has often been emphasized: it often presents us with long sequences that can (literally) be called "inhuman"—the familiar theme of cinematic "cosmomorphism" developed by many film theorists—sequences in which only inanimate objects, landscapes, etc. appear and which for minutes at a time offer no human form for spectator identification: yet the latter must be supposed to remain intact in its deep structure, since at such moments the film *works* just as well as it does at others, and whole films (geographical documentaries, for example) unfold intelligibly in such conditions. The second, more radical reason is that identification with the human form appearing on the screen, even when it occurs, still tells us nothing about the *place of the spectator's ego* in the inauguration of the signifier. As I have just pointed out, this ego is already formed. But since it exists, the question arises precisely of *where it is* during the projection of the film (the true primary identification, that of the mirror, forms the ego, but all other identifications presuppose, on the contrary, that it has been formed and can be "exchanged" for the object or the fellow subject). Thus when I "recognize" my like on the screen, and even more when I do not recognize it, where am I? Where is that someone who is capable of self-recognition when need be?

It is not enough to answer that the cinema, like every social practice, demands that the psychical apparatus of its participants be fully constituted, and that the question is thus the concern of general psychoanalytic theory and not that of the cinema proper. For my *where is it?* does not claim to go so far, or more precisely tries to go slightly further: it is a question of the *point* occupied by this already constituted ego, occupied during the cinema showing and not in social life in general.

The spectator is absent from the screen: contrary to the child in the mirror, he cannot identify with himself as an object, but only with objects which are there without him. In this sense the screen is not a mirror. The perceived, this time, is entirely on the side of the object, and there is no longer any equivalent of the own image, of that unique mix of perceived and subject (of other and I) which was precisely the figure necessary to disengage the one from the other. At the cinema, it is always the other who is on the screen; as for me, I am there to look at him. I take no part in the perceived, on the contrary, I am *all-perceiving*. All-perceiving as one says all-powerful (this is the famous gift of "ubiquity" the film makes its spectator); all-perceiving, too, because I am entirely on the side of the perceiving instance: absent from the screen, but certainly present in the auditorium, a great eye and ear without which the perceived would have no one to perceive it, the instance, in other words, which *constitutes* the cinema signifier (it is I who make the film). If the most extravagant spectacles and sounds or the most unlikely combination of them, the combination furthest removed from any real experience, do not prevent the constitution of meaning (and to begin with do not *astonish* the spectator, do not really astonish him, not intellectually: he simply judges the film as strange), that is because he knows he is at the cinema.

In the cinema the *subject's knowledge* takes a very precise form without which no film would be possible. This knowledge is dual (but unique). I know I am perceiving something imaginary (and that is why its absurdities, even if they are extreme, do not seriously disturb me), and I know that it is I who am perceiving it. This second knowledge divides in turn: I know that I am really perceiving, that my sense organs are physically affected, that I am not fantasizing, that the fourth wall of the auditorium (the screen) is really different from the other three, that there is a projector facing it (and thus it is not I who am projecting, or at least not all alone), and I also know that it is I who am perceiving all this, that this perceived-imaginary material is deposited in me as if on a second screen, that it is in me that it forms up into an organized sequence, that therefore I am myself the place where this really perceived imaginary accedes to the symbolic by its inauguration as the signifier of a certain type of institutionalized social activity called the "cinema."

In other words, the spectator *identifies with himself,* with himself as a pure act of perception (as wakefulness, alertness): as the condition of possibility of the perceived and hence as a kind of transcendental subject, which comes before every *there is.*

A strange mirror, then, very like that of childhood, and very different. Very like, as Jean-Louis Baudry has emphasized,[3] because during the showing we are, like the child, in a sub-motor and hyper-perceptive state; because, like the child again, we are prey to the imaginary, the double, and are so paradoxically through a real perception. Very different, because this mirror returns us everything but ourselves, because we are wholly outside it, whereas the child is both in it and in front of it. As an *arrangement* (and in a very topographical sense of the word), the cinema is more involved on the flank of the symbolic, and hence of secondariness, than is the mirror of childhood. This is not surprising, since it comes long after it, but what is more important to me is the fact that it is inscribed in its wake with an incidence at once so direct and so oblique, which has no precise equivalent in other apparatuses of signification.

## Identification with the Camera

The preceding analysis coincides in places with others which have already been proposed and which I shall not repeat: analyses of *quattrocento* painting or of the cinema itself which insist on the role of monocular perspective (hence of the *camera*) and the "vanishing point" that inscribes an empty emplacement for the spectator-subject, an all-powerful position which is that of God himself, or more broadly of some ultimate signified. And it is true that as he identifies with himself as look, the spectator can do no other than identify with the camera, too, which has looked before him at what he is now looking at and whose stationing (= framing) determines the vanishing point. During the projection this camera is absent, but it has a representative consisting of another apparatus, called precisely a "projector." An apparatus the spectator has behind him, *at the back of his head,*[4] that is, precisely where fantasy locates the "focus" of all vision. All of us have experienced our own look, even outside the so-called *salles obscures* [= cinemas], as a kind of searchlight turning on the axis of our own necks (like a pan) and shifting when we shift (a tracking shot now): as a cone of light (without the microscopic dust scattered through it

and streaking it in the cinema) whose vicariousness draws successive and variable slices of obscurity from nothingness wherever and whenever it comes to rest. (And in a sense that is what perception and consciousness are, a *light*, as Freud put it,[5] in the double sense of an illumination and an opening, as in the arrangement of the cinema, which contains both, a limited and wandering light that only attains a small part of the real, but on the other hand possesses the gift of casting light on it.) Without this identification with the camera certain facts could not be understood, though they are constant ones: the fact, for example, that the spectator is not amazed when the image "rotates" (= a pan) and yet he knows he has not turned his head. The explanation is that he has no need to turn it really, he has turned it in his all-seeing capacity, his identification with the movement of the camera being that of a transcendental, not an empirical subject.

All vision consists of a double movement: projective (the "sweeping" search-light) and introjective: consciousness as a sensitive recording surface (as a screen). I have the impression at once that, to use a common expression, I am "casting" my eyes on things, and that the latter, thus illuminated, come to be deposited within me (we then declare that it is these things that have been "projected," on to my retina, say). A sort of stream called the look, and explaining all the myths of magnetism, must be sent out over the world, so that objects can come back up this stream in the opposite direction (but using it to find their way), arriving at last at our perception, which is now soft wax and no longer an emitting source.

The technology of photography carefully conforms to this (banal) fantasy accompanying perception. The camera is "trained" on the object like a fire-arm (= projection) and the object arrives to make an imprint, a trace, on the receptive surface of the film-strip (= introjection). The spectator himself does not escape these pincers, for he is part of the apparatus, and also because pincers, on the imaginary plane (Melanie Klein), mark our relation to the world as a whole and are rooted in the primary figures of orality. During the performance the spectator is the searchlight I have described, duplicating the projector, which itself duplicates the camera, and he is also the sensitive surface duplicating the screen, which itself duplicates the film-strip. There are two cones in the auditorium: one ending on the screen and starting both in the projection box and in the spectator's vision insofar as it is projective, and one starting from the screen and "deposited" in the specta-tor's perception insofar as it is introjective (on the retina, a second screen). When I say that "I see" the film, I mean thereby a unique mixture of two contrary currents: the film is what I receive, and it is also what I release, since it does not pre-exist my entering the auditorium and I only need close my eyes to suppress it. Releasing it, I am the projector, receiving it, I am the screen; in both these figures together, I am the camera, which points and yet which records.

**[ · · · ]**

Now for looks. In a fiction film, the characters look at one another. It can happen (and this is already another "notch" in the chain of identifications) that a charac-ter looks at another who is momentarily out-of-frame, or else is looked at by him. If we have gone one notch further, this is because everything out-of-frame *brings us closer to the spectator*, since it is the peculiarity of the latter to be out-of-frame (the out-of-frame character thus has a point in common with him: he is looking

at the screen). In certain cases the out-of-frame character's look is "reinforced" by recourse to another variant of the subjective image, generally christened the "character's point of view": the framing of the scene corresponds precisely to the angle from which the out-of-frame character looks at the screen. (The two figures are dissociable moreover: we often know that the scene is being looked at by someone other than ourselves, by a character, but it is the logic of the plot, or an element of the dialogue, or a previous image that tells us so, not the position of the camera, which may be far from the presumed emplacement of the out-of-frame onlooker.)

In all sequences of this kind, the identification that founds the signifier is *twice relayed*, doubly duplicated in a circuit that leads it to the heart of the film along a line which is no longer hovering, which follows the inclination of the looks and is therefore governed by the film itself: the spectator's look (= the basic identification), before dispersing all over the surface of the screen in a variety of intersecting lines (= looks of the characters in the frame = second duplication), must first "go through"—as one goes through a town on a journey, or a mountain pass—the look of the character out-of-frame (= first duplication), himself a spectator and hence the first delegate of the true spectator, but not to be confused with the latter since he is inside, if not the frame, then at least the fiction. This invisible character, supposed (like the spectator) to be seeing, will collide obliquely with the latter's look and play the part of an obligatory intermediary. By offering himself as a crossing for the spectator, he inflects the circuit followed by the sequence of identifications and it is only in this sense that he is himself seen: as we see through him, we see ourselves not seeing him.

Examples of this kind are much more numerous and each of them is much more complex than I have suggested here. At this point textual analysis of precise film sequences is an indispensable instrument of knowledge. I just wished to show that in the end there is no break in continuity between the child's game with the mirror and, at the other extreme, certain localized figures of the cinematic codes. The mirror is the site of primary identification. Identification with one's own look is secondary with respect to the mirror, i.e. for a general theory of adult activities, but it is the foundation of the cinema and hence primary when the latter is under discussion: it is *primary cinematic identification* proper ("primary identification" would be inaccurate from the psychoanalytic point of view; "secondary identification," more accurate in this respect, would be ambiguous for a cinematic psychoanalysis). As for identifications with characters, with their own different levels (out-of-frame character, etc.), they are secondary, tertiary cinematic identifications, etc.; taken as a whole in opposition to the identification of the spectator with his own look, they constitute secondary cinematic identification in the singular.[6]

## *"Seeing a Film"*

Freud noted, *vis-à-vis* the sexual act[7] that the most ordinary practices depend on a large number of psychical functions which are distinct but work consecutively, so that all of them must be intact if what is regarded as a normal performance is to be

possible (it is because neurosis and psychosis dissociate them and put some of them out of court that a kind of commutation is made possible whereby they can be listed retrospectively by the analyst). The apparently very simple act of *seeing a film* is no exception to this rule. As soon as it is subjected to analysis it reveals to us a complex, multiply interconnected imbrication of the functions of the imaginary, the real and the symbolic, which is also required in one form or another for every procedure of social life, but whose cinematic manifestation is especially impressive since it is played out on a small surface. (To this extent the theory of the cinema may some day contribute something to psychoanalysis, even if, through force of circumstances, this "reciprocation" remains very limited at the moment, the two disciplines being very unevenly developed.)

In order to understand the fiction film, I must both "take myself" for the character (= an imaginary procedure) so that he benefits, by analogical projection, from all the schemata of intelligibility that I have within me, and not take myself for him (= the return to the real) so that the fiction can be established as such (= as symbolic): this is *seeming-real*. Similarly, in order to understand the film (at all), I must perceive the photographed object as absent, its photograph as present, and the presence of this absence as signifying. The imaginary of the cinema presupposes the symbolic, for the spectator must first of all have known the primordial mirror. But as the latter instituted the ego very largely in the imaginary, the second mirror of the screen, a symbolic apparatus, itself in turn depends on reflection and lack. However, it is not fantasy, a "purely" symbolic-imaginary site, for the absence of the object and the codes of that absence are really produced in it by the *physis* of an equipment: the cinema is a body (a *corpus* for the semiologist), a fetish that can be loved.

# Disavowal, Fetishism

. . . . . . . . . . . . . .

As can be seen, the cinema has a number of roots in the unconscious and in the great movements illuminated by psychoanalysis, but they can all be traced back to the specific characteristics of the institutionalized signifier. I have gone a little way in tracing some of these roots, that of mirror identification, that of voyeurism and exhibitionism. There is also a third, that of fetishism.

Since the famous article by Freud that inaugurated the problem,[1] psychoanalysis has linked fetish and fetishism closely with castration and the fear it inspires. Castration, for Freud, and even more clearly for Lacan, is first of all the mother's castration, and that is why the main figures it inspires are to a certain degree common to children of both sexes. The child who sees its mother's body is constrained by way of perception, by the "evidence of the senses," to accept that there are human beings deprived of a penis. But for a long time—and somewhere in it for ever—it will not interpret this inevitable observation in terms of an anatomical difference between the sexes (= penis/vagina). It believes that all human beings originally have a penis and it therefore understands what it

has seen as the effect of a mutilation which redoubles its fear that it will be subjected to a similar fate (or else, in the case of the little girl after a certain age, the fear that she has already been subjected to it). Inversely, it is this very terror that is projected on to the spectacle of the mother's body, and invites the reading of an absence where anatomy sees a different conformation. The scenario of castration, in its broad lines, does not differ whether one understands it, like Lacan, as an essentially symbolic drama in which castration takes over in a decisive metaphor all the losses, both real and imaginary, that the child has already suffered (birth trauma, maternal breast, excrement, etc.), or whether on the contrary one tends, like Freud, to take that scenario slightly more literally. Before this *unveiling of a lack* (we are already close to the cinema signifier), the child, in order to avoid too strong an anxiety, will have to double up its belief (another cinematic characteristic) and from then on forever hold two contradictory opinions (proof that in spite of everything the real perception has not been without effect): "All human beings are endowed with a penis" (primal belief) and "Some human beings do not have a penis" (evidence of the senses). In other words, it will, perhaps definitively, retain its former belief *beneath* the new one, but it will also hold to its new perceptual observation while *disavowing* it on another level (= denial of perception, disavowal, Freud's "*Verleugnung*"). Thus is established the lasting matrix, the affective prototype of all the splittings of belief which man will henceforth be capable of in the most varied domains, of all the infinitely complex unconscious and occasionally conscious interactions which he will allow himself between "believing" and "not believing" and which will on more than one occasion be of great assistance to him in resolving (or denying) delicate problems. (If we were all a little honest with ourselves, we would realize that a truly integral belief, without any "underside" in which the opposite is believed, would make even the most ordinary everyday life almost impossible.)

At the same time, the child, terrified by what it has seen or glimpsed, will have tried more or less successfully in different cases, to *arrest* its look, for all its life, at what will subsequently become the fetish: at a piece of clothing, for example, which masks the frightening discovery, or else precedes it (underwear, stockings, boots, etc.). The fixation on this "just before" is thus another form of disavowal, of retreat from the perceived, although its very existence is dialectical evidence of the fact that the perceived has been perceived. The fetishistic prop will become a precondition for the establishment of potency and access to orgasm [*jouissance*], sometimes an indispensable precondition (true fetishism); in other developments it will only be a favorable condition, and one whose weight will vary with respect to the other features of the erotogenic situation as a whole. (It can be observed once again that the defense against desire itself becomes erotic, as the defense against anxiety itself becomes anxiogenic; for an analogous reason: what arises "against" an affect also arises "in" it and is not easily separated from it, even if that is its aim.) Fetishism is generally regarded as the "perversion" par excellence, for it intervenes itself in the "tabulation" of the others, and above all because, they, like it (and this is what makes it their model), are based on the avoidance of castration. The fetish always represents the penis, it is always a substitute for it, whether metaphorically (= it masks its absence) or metonymically (= it is contiguous with

its empty place). To sum up, the fetish signifies the penis as absent, it is its negative signifier; supplementing it, it puts a "fullness" in place of a lack, but in doing so it also affirms that lack. It resumes within itself the structure of disavowal and multiple belief.

These few reminders are intended above all to emphasize the fact that the dossier of fetishism, before any examination of its cinematic extensions, contains two broad aspects which coincide in their depths (in childhood and by virtue of structure) but are relatively distinct in their concrete manifestations, i.e. the problems of belief (= disavowal) and that of the fetish itself, the latter more immediately linked to erotogenicity, whether direct or sublimated.

[ · · · ]

## *The Cinema as Technique*

As for the fetish itself, in its cinematic manifestations, who could fail to see that it consists fundamentally of the equipment of the cinema (= its "technique"), or of the cinema as a whole as equipment and as technique, for fiction films and others? It is no accident that in the cinema some cameramen, some directors, some critics, some spectators demonstrate a real "fetishism of technique," often noted or denounced as such ("fetishism" is taken here in its ordinary sense, which is rather loose but does contain within it the analytical sense that I shall attempt to disengage). As strictly defined, the fetish, like the apparatus of the cinema, is a *prop*, the prop that disavows a lack and in doing so affirms it without wishing to. A prop, too, which is as it were placed on the body of the object; a prop which is the penis, since it negates its absence, and hence a partial object that makes the whole object lovable and desirable. The fetish is also the point of departure for specialized practices, and as is well known, desire in its modalities is all the more "technical" the more perverse it is.

Thus with respect to the desired body—to the body of desire rather—the fetish is in the same position as the technical equipment of the cinema with respect to the cinema as a whole. A fetish, the cinema as a technical performance, as prowess, as an *exploit*, an exploit that underlines and denounces the lack on which the whole arrangement is based (the absence of the object, replaced by its reflection), an exploit which consists at the same time of making this absence forgotten. The cinema fetishist is the person who is enchanted at what the machine is capable of, at the *theater of shadows* as such. For the establishment of his full potency for cinematic enjoyment [*jouissance*] he must think at every moment (and above all *simultaneously*) of the force of presence the film has and of the absence on which this force is constructed.[2] He must constantly compare the result with the means deployed (and hence pay attention to the technique), for his pleasure lodges in the gap between the two. Of course, this attitude appears most clearly in the "connoisseur," the cinephile, but it also occurs, as a partial component of cinematic pleasure, in those who just go to the cinema: if they do go it is partly in order to be carried away by the film (or the fiction, if there is one), but also in order to *appreciate* as such the machinery that is carrying them away: they will say, precisely when they have been carried

away, that the film was a "good" one, that it was "well made" (the same thing is said in French of a harmonious body).

It is clear that fetishism, in the cinema as elsewhere, is closely linked to the good object. The function of the fetish is to restore the latter, threatened in its "goodness" (in Melanie Klein's sense) by the terrifying discovery of the lack. Thanks to the fetish, which covers the wound and itself becomes erotogenic, the object as a whole can become desirable again without excessive fear. In a similar way, the whole cinematic institution is as it were *covered* by a thin and omni-present garment, a stimulating prop through which it is consumed: the ensemble of its equipment and its tricks—and not just the celluloid strip, the "*pellicule*" or "little skin" which has been rightly mentioned in this connection[3]—of the equipment which *needs* the lack in order to stand out in it by contrast, but which only affirms it insofar as it ensures that it is forgotten, and which lastly (its third twist) needs it also not to be forgotten, for fear that at the same stroke the fact that *it* caused it to be forgotten will be forgotten.

The fetish is the cinema in its *physical* state. A fetish is always material: insofar as one can make up for it by the power of the symbolic alone one is precisely no longer a fetishist. At this point it is important to recall that of all the arts the cinema is the one that involves the most extensive and complex equipment; the "technical" dimension is more obtrusive here than elsewhere. Along with television, it is the only art that is also an industry, or at least is so from the outset (the others become industries subsequently: music through the gramophone record or the cassette, books by mass printings and publishing trusts, etc.). In this respect only architecture is a little like it; there are "languages" that are *heavier* than others, more dependent on "hardware."

At the same time as it localizes the penis, the fetish represents by synecdoche the whole body of the object as desirable. Similarly, interest in the equipment and technique is the privileged representative of *love for the cinema.*

The Law is what permits desire: the cinematic equipment is the instance thanks to which the imaginary turns into the symbolic, thanks to which the lost object (the absence of what is filmed) becomes the law and the principle of a specific and instituted signifier, which it is legitimate to desire.

For in the structure of the fetish there is another point on which Mannoni quite rightly insists and which directly concerns my present undertaking. Because it attempts to disavow the evidence of the senses, the fetish is evidence that this evidence has indeed been *recorded* (like a tape stored in the memory). The fetish is not inaugurated because the child still believes its mother has a penis (= order of the imaginary), for if it still believed it completely, as "before," it would no longer need the fetish. It is inaugurated because the child now "knows very well" that its mother has no penis. In other words, the fetish not only has disavowal value, but also *knowledge value.*

That is why, as I said a moment ago, the fetishism of cinematic technique is especially well developed among the "connoisseurs" of the cinema. That is also why the theoretician of the cinema necessarily retains within him—at the cost of a new

backward turn that leads him to interrogate technique, to symbolize the fetish, and hence to maintain it as he dissolves it—an interest in the equipment without which he would not be motivated to study it.

Indeed, the equipment is not just physical (= the fetish proper); it also has its discursive imprints, its extensions in the very text of the film. Here is revealed the specific movement of theory: when it shifts from a fascination with technique to the critical study of the different *codes* that this equipment authorizes. *Concern for the signifier* in the cinema derives from a fetishism that has taken up a position as far as possible along its cognitive flank. To adapt the formula by which Octave Mannoni defines disavowal (= "I know very well, but all the same . . ."), the study of the signifier is a libidinal position which consists in weakening the "but all the same" and profiting by this saving of energy to dig deeper into the "I know very well," which thus becomes "I know nothing at all, but I desire to know."

## *Fetish and Frame*

Just like the other psychical structures that constitute the foundation of the cinema, fetishism does not intervene only in the constitution of the signifier, but also in certain of its more particular configurations. Here we have *framings* and also certain *camera movements* (the latter can anyway be defined as progressive changes in framing).

Cinema with directly erotic subject matter deliberately plays on the edges of the frame and the progressive, if need be incomplete revelations allowed by the camera as it moves, and this is no accident. Censorship is involved here: censorship of films and censorship in Freud's sense. Whether the form is static (framing) or dynamic (camera movements), the principle is the same; the point is to gamble simultaneously on the excitation of desire and its non-fulfillment (which is its opposite and yet favors it), by the infinite variations made possible precisely by the studios' technique on the exact emplacement of the *boundary* that bars the look, that puts an end to the "seen," that inaugurates the downward (or upward) tilt into the dark, towards the unseen, the guessed-at. The framing and its displacements (that determine the *emplacement*) are in themselves forms of "suspense" and are extensively used in suspense films, though they retain this function in other cases. They have an inner affinity with the mechanisms of desire, its postponements, its new impetus, and they retain this affinity in other places than erotic sequences (the only difference lies in the *quantum* which is sublimated and the *quantum* which is not). The way the cinema, with its wandering framings (wandering like the look, like the caress), finds the means to reveal space has something to do with a kind of permanent undressing, a generalized strip-tease, a less direct but more perfected strip-tease, since it also makes it possible to dress space again, to remove from view what it has previously shown, to *take back* as well as to retain (like the child at the moment of the birth of the fetish, the child who has already seen, but whose look beats a rapid retreat): a strip-tease pierced with "flash-backs," inverted sequences that then give new impetus to the forward movement. These veiling-unveiling procedures can also be compared with certain cinematic

"punctuations," especially slow ones strongly marked by a concern for control and expectation (slow fade-ins and fade-outs, irises, "drawn out" lap-dissolves like those of Sternberg).[4]

## NOTES

**Identification, Mirror**

1. "Le temps logique et l'assertion de certitude anticipée," *Ecrits*, pp. 197–213.
2. "The Ego and the Id," in J. Strachey (ed.) *Standard Edition of the Complete Psychological Works of Sigmund Freud*, 24 volumes (London: The Hogarth Press, 1953–66), vol. xix, pp. 26 and 30 (on "desexualized social sentiment"); see also (on the subject of paranoia) "On Narcissism: an Introduction" (vol. xiv) pp. 95–6, 101–2.
3. "Cinéma: effets idéologiques produits par l'appareil de base," *Cinéthique*, 7–8, pp. 1–8 (translated as "Ideological Effects of the Basic Cinematographic Apparatus," *Film Quarterly*, XXVII, 2 (1974–5) 39–47 [see p. 34 in this volume]), "Le dispositif: approches métapsychologiques de l'impression de réalité," *Communications* 23 (1975) 56–72 (translated as "The Apparatus," *Camera Obscura* 1 (1976) 104–26).
4. See André Green, "L'Ecran bi-face, un œil derrière la tête," *Psychanalyse et cinéma*, 1 January 1970 (no further issues appeared), pp. 15–22. It will be clear that in the passage that follows my analysis coincides in places with that of André Green.
5. "The Ego and the Id" (vol. xix) p. 18; *The Interpretation of Dreams* (vol. v) p. 615 (= consciousness as a sense organ) and p. 574 (= consciousness as a dual recording surface, internal and external), "The Unconscious" (vol. xiv) p. 171 (psychical processes are in themselves unconscious, consciousness is a function that *perceives* a small proportion of them), etc.
6. On these problems see Michel Colin, "Le Film: transformation du texte du roman," unpublished thesis (Mémoire de troisième cycle) 1974.
7. *Inhibitions, Symptoms and Anxiety* (vol. xx) pp. 87–8.

**Disavowal, Fetishism**

1. "Fetishism" (vol. xxi) pp. 152–7. See also Octave Mannoni's important study, "Je sais bien, mais quand même . . ." *Clefs pour l'imaginaire ou l'autre scène*.
2. I have studied this phenomenon at slightly greater length in "Trucage et cinéma" in *Essais sur la signification au cinéma*, vol. II (Paris: Klincksieck, 1972) pp. 173–92.
3. Roger Dadoun, " 'King Kong': du monstre comme démonstration," *Littérature*, 8 (1972) p. 109; Octave Mannoni, *Clefs pour l'imaginaire ou l'autre scène*, p. 180.
4. Reading this article in manuscript, Thierry Kuntzel has pointed out to me that in this paragraph I perhaps lean slightly too far toward fetishism and fetishism alone in discussing filmic figures that depend just as much on *cinematic perversion* in general: the hypertrophy of the perceptual component drive with its *mises-en-scène*, its progressions-retentions, its calculated postponements, etc. This objection seems to me (after the event) to be correct. I shall have to come back to it. Fetishism, as is well known, is closely linked to perversion (cf. pp. 69–71), although it does not exhaust it. Hence the difficulty. For the cinematic effects I am evoking here (playing on the framing and its displacements), the properly fetishistic element seems to me to be the "*bar*," the edge of the screen, the separation between the seen and the unseen, the "arrestation" of the look. Once the seen or the unseen are envisaged rather than their intersection (their edge), we are dealing with scopic perversion itself, which goes beyond the strict province of the fetish.

# JEAN-LOUIS BAUDRY

# Ideological Effects of the Basic Cinematographic Apparatus

Jean-Louis Baudry (b. 1930), a dentist by profession, is a "man of letters" who has published seminal essays in film theory. He was an editor of the avant-garde journal *Tel Quel*, participating in one of the most important Parisian intellectual movements to emerge out of the turmoil of the protest movements of 1968. At *Tel Quel*, Baudry worked with, and was inspired by, thinkers who linked political activism to the uses of language and avant-garde art, including poststructuralists Julia Kristeva, Roland Barthes, Michel Foucault, and Jacques Derrida. Baudry's work on cinema was heavily influenced by Louis Althusser, a French Marxist who considered ideology to be an unconscious acceptance of the status quo effected through what he calls Ideological State Apparatuses—institutions like churches and schools that seem noncoercive but nevertheless form individuals as "subjects" of dominant power. Combining Althusser's work on ideology with Jacques Lacan's psychoanalytic theories about subject construction, Baudry's apparatus theory examines the ideological role of cinema as an institution—a role that is not imposed on cinema but is an integral part of its nature.

In a departure from the semiotic film theory of the late 1960s, Baudry treats not the film text itself but rather the cinematic apparatus—that is, the conditions under which cinematic effects are produced. According to Baudry, these conditions— which include the mechanics of representation, material aspects of projection (the dark, enclosed viewing conditions of the theater that for Baudry are analogous to Plato's cave), the camera, and film editing—influence the spectator much more than an individual film itself. Baudry's emphasis on the ideological effects of the cinematic apparatus can be seen as a reaction against the then-dominant theoretical position of André Bazin (p. 309), for whom the film screen was an unmediated window to the world. For Baudry, film functions more as a metapsychological "mirror" that fulfills the spectator's wish for fullness, transcendental unity, and meaning. It is important to note that Baudry formulated his theories on the cinematic apparatus in the early 1970s, when the economic and ideological dominance of Hollywood was asserted around the world, and before the rise of multiplexes and video, which, along with TV technologies, radically altered and expanded the experience of film viewing beyond theatrical projection.

In the 1970 essay "Ideological Effects of the Basic Cinematographic Apparatus," Baudry explains the ideological mechanism at work in cinema by discussing the deterministic relationship between the camera and the subject/spectator. Although the camera records a series of static and fragmented images, the projection of these images on a screen restores the illusion of continuous movement and linear succession. This, along with the material conditions of cinematographic projection, ensures the central position of the spectator, enabling the "transcendental subject" to unite the dislocated fragments into a coherent

meaning. In such a way, the cinematic apparatus conceals its work and imposes an idealist ideology, rather than producing critical awareness in a spectator. Since the instruments on which the cinematic apparatus depends have to remain hidden and repressed to maintain the illusion, Baudry argues that the only way to break through this "phantasmification" in cinema is to make its production obvious—as Baudry mentions Dziga Vertov does in his 1929 film *The Man with a Movie Camera*. This essay became an important source for critics like Christian Metz (p. 17) and Laura Mulvey (p. 713), who concerned themselves with exploring the relationship between ideology, the human psyche, and cinema.

## READING CUES & KEY CONCEPTS

■ For Baudry, an important element in the ideology of the apparatus is its masking of the means of the illusion's production, a process which for Baudry is analogous to Plato's cave and Marxist notions of ideology. Consider the effectiveness of these analogies.

■ According to Baudry, the "subject" effect in cinema is also its "reality" effect. What is the relevance of this position beyond the conditions of reception in the movie theater? Can the effects of cinema also be produced and felt in the social sphere, where other discourses come into effect?

■ How does Baudry's equation of cinema with dominant ideology accommodate the notion of subversive, political cinema? Note that he does not address the content or form of films themselves.

■ **Key Concepts:** Ideology; Apparatus; Renaissance Perspective; Camera Obscura; Transcendental Subject; Mirror Stage; Continuity; Impression of Reality

# Ideological Effects of the Basic Cinematographic Apparatus[1]

. . . . . . . . . . . . . .

A t the end of *The Interpretation of Dreams*, when he seeks to integrate dream elaboration and its particular "economy" with the psyche as a whole, Freud assigns to the latter an optical model: "Let us simply imagine the instrument which serves in psychic productions as a sort of complicated microscope or camera." But Freud does not seem to hold strongly to this optical model, which, as Derrida has pointed out,[2] brings out the shortcoming in graphic representation in the area earlier covered by his work on dreams. Moreover, he will later abandon the optical model in favor of a writing instrument, the "mystic writing pad." Nonetheless this optical choice seems to prolong the tradition of Western science, whose birth coincides exactly with the development of the optical apparatus which will have as a consequence the decentering of the human universe, the end of geocentrism (Galileo).

But also, and paradoxically, the optical apparatus *camera obscura* will serve in the same period to elaborate in pictorial work a new mode of representation,

*perspectiva artificalis.* This system, a recentering or at least a displacement of the center (which settles itself in the eye), will assure the setting up of the "subject" as the active center and origin of meaning. One could doubtless question the privileged position which optical instruments seem to occupy on the line of intersection of science and ideological products. Does the technical nature of optical instruments, directly attached to scientific practice, serve to conceal not only their use in ideological products but also the ideological effects which they may provoke themselves? Their scientific base assures them a sort of neutrality and avoids their being questioned.

But already a question: if we are to take account of the imperfections of these instruments, their limitations, by what criteria may these be defined? If, for example, one can speak of a restricted depth of field as a limitation, doesn't this term itself depend upon a particular conception of reality for which such a limitation would not exist? Signifying productions are particularly relevant here, to the extent that instrumentation plays a more and more important role in them and that their distribution is more and more extensive. It is strange (but is it so strange?) that emphasis has been placed almost exclusively on their influence, on the effects they have as finished products, their content, the field of what is signified, if you like; the technical bases on which these effects depend and the specific characteristics of these bases have been ignored, however. They have been protected by the inviolability that science is supposed to provide. We would like to establish for the cinema a few guidelines which will need to be completed, verified, improved.

We must first establish the place of the instrumental base in the set of operations which combine in the production of a film (we omit consideration of economic implications). Between "objective reality" and the camera, site of the inscription, and between the inscription and projection are situated certain operations, a *work*[3] which has as its result a finished product. To the extent that it is cut off from the raw material ("objective reality") this product does not allow us to see the transformation which has taken place. Equally distant from "objective reality" and the finished product, the camera occupies an intermediate position in the work process which leads from raw material to finished product. Though mutually dependent from other points of view, *découpage* [shot breakdown before shooting] and *montage* [editing, or final assembly] must be distinguished because of the essential difference in the signifying raw material on which each operates: language (scenario) or image. Between the two complementary stages of production a mutation of the signifying material takes place (neither translation nor transcription, obviously, for the image is not reducible to language) precisely where the camera is. Finally, between the finished product (possessing exchange value, a commodity) and its consumption (use value) is introduced another operation effected by a set of instruments. Projector and screen restore the light lost in the shooting process, and transform a succession of separate images into an unrolling which also restores, but according to another scansion, the movement seized from "objective reality."

Cinematographic specificity (what distinguishes cinema from other systems of signification) thus refers to a *work*, that is, to a process of transformation. The question becomes, is the work made evident, does consumption of the product bring about a "knowledge effect" [Althusser], or is the work concealed? If the latter,

consumption of the product will obviously be accompanied by ideological surplus value. On the practical level, this poses the question of by what procedures the work can in fact be made "readable" in its inscription. These procedures must of necessity call cinematographic technique into play. But, on the other hand, going back to the first question, one may ask, do the instruments (the technical base) produce specific ideological effects, and are these effects themselves determined by the dominant ideology? In which case, concealment of the technical base will also bring about a specific ideological effect. Its inscription, its manifestation as such, on the other hand, would produce a knowledge effect, as actualization of the work process, as denunciation of ideology, and as critique of idealism.

## *The Eye of the Subject*

Central in the process of production[4] of the film, the camera—an assembly of optical and mechanical instrumentation—carries out a certain mode of inscription characterized by marking, by the recording of differences of light intensity (and of wavelength for color) and of differences between the frames. Fabricated on the model of the *camera obscura*, it permits the construction of an image analogous to the perspective projections developed during the Italian Renaissance. Of course the use of lenses of different focal lengths can alter the perspective of an image. But this much, at least, is clear in the history of cinema: it is the perspective construction of the Renaissance which originally served as model. The use of different lenses, when not dictated by technical considerations aimed at restoring the habitual perspective (such as shooting in limited or extended spaces which one wishes to expand or contract) does not destroy [traditional] perspective but rather makes it play a normative role. Departure from the norm, by means of a wide-angle or telephoto lens, is clearly marked in comparison with so-called "normal" perspective. We will see in any case that the resulting ideological effect is still defined in relation to the ideology inherent in perspective. The dimensions of the image itself, the ratio between height and width, seem clearly taken from an average drawn from Western easel painting.

The conception of space which conditions the construction of perspective in the Renaissance differs from that of the Greeks. For the latter, space is discontinuous and heterogeneous (for Aristotle, but also for Democritus, for whom space is the location of an infinity of indivisible atoms), whereas with Nicholas of Cusa will be born a conception of space formed by the relation between elements which are equally near and distant from the "source of all life." In addition, the pictorial construction of the Greeks corresponded to the organization of their stage, based on a multiplicity of points of view, whereas the painting of the Renaissance will elaborate a centered space. ("Painting is nothing but the intersection of the visual pyramid following a given distance, a fixed center, and a certain lighting."—Alberti.) The center of this space coincides with the eye which Jean Pellerin Viator will so justly call the "subject." ("The principal point in perspective should be placed at eye level: this point is called fixed or subject."[5]) Monocular vision, which as Pleynet points out, is what the camera has, calls forth a sort of play of "reflection." Based on the principle of a fixed point by reference to which the visualized objects are organized, it specifies in return the position of the "subject,"[6] the very spot it must necessarily occupy.

In focusing it, the optical construct appears to be truly the projection-reflection of a "virtual image" whose hallucinatory reality it creates. It lays out the space of an ideal vision and in this way assures the necessity of a transcendence—metaphorically (by the unknown to which it appeals—here we must recall the structural place occupied by the vanishing point) and metonymically (by the displacement that it seems to carry out: a subject is both "in place of" and "a part for the whole"). Contrary to Chinese and Japanese painting, Western easel painting, presenting as it does a motionless and continuous whole, elaborates a total vision which corresponds to the idealist conception of the fullness and homogeneity of "being,"[7] and is, so to speak, representative of this conception. In this sense it contributes in a singularly emphatic way to the ideological function of art, which is to provide the tangible representation of metaphysics. The principle of transcendence which conditions and is conditioned by the perspective construction represented in painting and in the photographic image which copies from it seems to inspire all the idealist paeans to which the cinema has given rise [such as we find in Cohen-Séat or Bazin].[8]

## *Projection: The Difference Negated*

Nevertheless, whatever the effects proper to optics generally, the movie camera differs from still photography by registering through its mechanical instrumentation a series of images. It might thus seem to counter the unifying and "substantializing" character of the single-perspective image, taking what would seem like instants of time or slices from "reality" (but always a reality already worked upon, elaborated, selected). This might permit the supposition, especially because the camera moves, of a multiplicity of points of view which would neutralize the fixed position of the eye-subject and even nullify it. But here we must turn to the relation between the succession of images inscribed by the camera and their projection, bypassing momentarily the place occupied by montage, which plays a decisive role in the strategy of the ideology produced.

The projection operation (projector and screen) restore continuity of movement and the temporal dimension to the sequence of static images. The relation between the individual frames and the projection would resemble the relation between points and a curve in geometry. But it is precisely this relation and the restoration of continuity to discontinuous elements which poses a problem. The meaning effect produced does not depend only on the content of the images but also on the material procedures by which an illusion of continuity, dependent on the persistence of vision, is restored from discontinuous elements. These separate frames have between them differences that are indispensible for the creation of an illusion of continuity, of a continuous passage (movement, time). But only on one condition can these differences create this illusion: they must be effaced as differences.[9]

Thus on the technical level the question becomes one of the adoption of a very small difference between images, such that each image, in consequence of an organic factor [presumably persistence of vision] is rendered incapable of being seen as such. In this sense we could say that film—and perhaps in this respect it is exemplary—lives on the denial of difference: the difference is necessary for it to live, but it lives on its negation. This is indeed the paradox that emerges if we look directly at a strip of processed film: adjacent images are almost exactly repeated,

their divergence being verifiable only by comparison of images at a sufficient distance from each other. We should remember, moreover, the disturbing effects which result during a projection from breakdowns in the recreation of movement, when the spectator is brought abruptly back to discontinuity—that is, to the body, to the technical apparatus which he had *forgotten*.

We might not be far from seeing what is in play on this material basis, if we recall that the "language" of the unconscious, as it is found in dreams, slips of the tongue, or hysterical symptoms, manifests itself as continuity destroyed, broken, and as the unexpected surging forth of a marked difference. Couldn't we thus say that cinema reconstructs and forms the mechanical model (with the simplifications that this can entail) of a system of writing[10] constituted by a material base and a counter-system (ideology, idealism) which uses this system while also concealing it? On the one hand, the optical apparatus and the film permit the marking of difference (but the marking is already negated, we have seen, in the constitution of the perspective image with its mirror effect).[11] On the other hand, the mechanical apparatus both selects the minimal difference and represses it in projection, so that meaning can be constituted: it is at once direction, continuity, movement. The projection mechanism allows the differential elements (the discontinuity inscribed by the camera) to be suppressed, bringing only the relation into play. The individual images as such disappear so that movement and continuity can appear. But the movement and continuity are the visible expression (one might even say the projection) of their relations, derived from the tiny discontinuities between the images. Thus one may assume that what was already at work as the originating basis of the perspective image, namely the eye, the "subject," is put forth, liberated (in the sense that a chemical reaction liberates a substance) by the operation which transforms successive, discrete images (as isolated images they have, strictly speaking, no meaning, or at least no unity of meaning) into continuity, movement, meaning; with continuity restored both meaning and consciousness are restored.[12]

## The Transcendental Subject

Meaning and consciousness, to be sure: at this point we must return to the camera. Its mechanical nature not only permits the shooting of differential images as rapidly as desired but also destines it to change position, to move. Film history shows that as a result of the combined inertia of painting, theater, and photography, it took a certain time to notice the inherent mobility of the cinematic mechanism. The ability to reconstitute movement is after all only a partial, elementary aspect of a more general capability. To seize movement is to become movement, to follow a trajectory is to become trajectory, to choose a direction is to have the possibility of choosing one, to determine a meaning is to give oneself a meaning. In this way the eye-subject, the invisible base of artificial perspective (which in fact only represents a larger effort to produce an ordering, regulated transcendence) becomes absorbed in, "elevated" to a vaster function, proportional to the movement which it can perform.

And if the eye which moves is no longer fettered by a body, by the laws of matter and time, if there are no more assignable limits to its displacement—conditions fulfilled by the possibilities of shooting and of film—the world will not only be constituted by this eye but for it.[13] The movability of the camera seems to fulfill the most

favorable conditions for the manifestation of the "transcendental subject." There is both fantasmatization of an objective reality (images, sounds, colors) and of an objective reality which, limiting its powers of constraint, seems equally to augment the possibilities or the power of the subject.[14] As it is said of consciousness—and in point of fact we are concerned with nothing less—the image will always be image *of* something; it must result from a deliberate act of consciousness [*visée intentionelle*]. "The word intentionality signifies nothing other than this peculiarity that consciousness has of being consciousness *of* something, of carrying in its quality of *ego* its *cogitatum* within itself."[15] In such a definition could perhaps be found the status of the cinematographic image, or rather of its operation, the mode of working which it carries out. For it to be an image of something, it has to constitute this something as meaning. The image seems to reflect the world but solely in the naive inversion of a founding hierarchy: "The domain of natural existence thus has only an authority of the second order, and always presupposes the domain of the transcendental."[16]

The world is no longer only an "open and unbounded horizon." Limited by the framing, lined up, put at the proper distance, the world offers up an object endowed with meaning, an intentional object, implied by and implying the action of the "subject" which sights it. At the same time that the world's transfer as image seems to accomplish this phenomenological reduction, this putting into parentheses of its real existence (a suspension necessary, we will see, to the formation of the impression of reality) provides a basis for the apodicity[17] of the ego. The multiplicity of aspects of the object in view refers to a synthesizing operation, to the unity of this constituting subject: Husserl speaks of "'aspects,' sometimes of 'proximity,' sometimes of 'distance,' in variable modes of 'here' and 'there,' opposed to an absolute 'here' (which is located—for me—in 'my own body' which appears to me at the same time), the consciousness of which, though it remains *unperceived*, always accompanies them. [We will see moreover what happens with the body in the *mise-en-scène* of projection.—J. L. B.] Each 'aspect' which the mind grasps is revealed in turn as a unity synthesized from a multiplicity of corresponding modes of presentation. The nearby object may present itself as the same, but under one or another 'aspect.' There may be variation of visual perspective, but also of 'tactile,' 'acoustic' phenomena, or of other 'modes of presentation'[18] as we can observe in directing our attention in the proper direction."[19]

For Husserl, "the original operation [of intentional analysis] is to *unmask the potentialities implied* in present states of consciousness. And it is by this that will be carried out, from the noematic point of view, the eventual *explication, definition, and elucidation* of what is meant by consciousness, that is, its *objective meaning*"[20] And again in the *Cartesian Meditations:* "A second type of polarization now presents itself to us, another type of synthesis which embraces the particular multiplicities of *cogitationes*, which embraces them all and in a special manner, namely as *cogitationes* of an identical self which, *active* or *passive*, lives in all the lived states of consciousness and which, through them, relates to all objects."[21]

Thus is articulated the relation between the continuity necessary to the constitution of meaning and the "subject" which constitutes this meaning: continuity is an attribute of the subject. It supposes the subject and it circumscribes his place. It appears in the cinema in the two complementary aspects of a "formal" continuity established through a system of negated differences and narrative continuity

in the filmic space. The latter, in any case, could not have been conquered without exercising violence against the instrumental base, as can be discovered from most of the texts by film-makers and critics: the discontinuity that had been effaced at the level of the image could have reappeared on the narrative level, giving rise to effects of rupture disturbing to the spectator (to a *place* which ideology must both conquer and, in the degree that it already dominates it, must also satisfy: fill). "What is important in a film is the feeling of continuity which joins shots and sequences while maintaining unity and cohesion of movements. This continuity was one of the most difficult things to obtain."[22] Pudovkin defined montage as "the art of assembling pieces of film, shot separately, in such a way as to give the spectator the impression of continuous movement." The search for such narrative continuity, so difficult to obtain from the material base, can only be explained by an essential ideological stake projected in this point: it is a question of preserving at any cost the synthetic unity of the locus where meaning originates [the subject]—the constituting transcendental function to which narrative continuity points back as its natural secretion.[23]

## *The Screen-Mirror:*
## *Specularization and Double Identification*

But another supplementary operation (made possible by a special technical arrangement) must be added in order that the mechanism thus described can play its role effectively as an ideological machine, so that not only the reworked "objective reality" but also the specific type of identification we have described can be represented.

No doubt the darkened room and the screen bordered with black like a letter of condolences already present privileged conditions of effectiveness—no exchange, no circulation, no communication with any outside. Projection and reflection take place in a closed space and those who remain there, whether they know it or not (but they do not), find themselves chained, captured, or captivated. (What might one say of the function of the head in this captivation: it suffices to recall that for Bataille materialism makes itself headless—like a wound that bleeds and thus transfuses.) And the mirror, as a reflecting surface, is framed, limited, circumscribed. *An infinite mirror would no longer be a mirror.* The paradoxical nature of the cinematic mirror-screen is without doubt that it reflects *images* but not *"reality"*; the word reflect, being transitive, leaves this ambiguity unresolved. In any case this "reality" comes from behind the spectator's head and if he looked at it directly he would see nothing except the moving beams from an already veiled light source.

The arrangement of the different elements—projector, darkened hall, screen—in addition [to] reproducing in a striking way the *mise-en-scène* of Plato's cave (prototypical set for all transcendence and the topological model of idealism[24]) reconstructs the situation necessary to the release of the "mirror stage" discovered by Lacan. This psychological phase, which occurs between six and eighteen months of age, generates *via* the mirror image of a unified body the constitution or at least the first sketches of the "I" as an imaginary function. "It is to this unreachable image in the mirror that the specular image gives its garments."[25] But for this imaginary constitution of the self to be possible, there must be—Lacan strongly emphasizes

this point—two complementary conditions: immature powers of mobility and a precocious maturation of visual organization (apparent in the first few days of life). If one considers that these two conditions are repeated during cinematographic projection—suspension of mobility and predominance of the visual function—perhaps one could suppose that this is more than a simple analogy. And possibly this very point explains the "impression of reality" so often invoked in connection with the cinema for which the various explanations proposed seem only to skirt the real problem. In order for this impression to be produced, it would be necessary that the conditions of a formative scene be reproduced. This scene would be repeated and reenacted in such a manner that the imaginary order (activated by a specularization which takes place, everything considered, in reality) fulfills its particular function of occultation or of filling the gap, the split, of the subject on the order of the signifier.[26]

On the other hand, it is to the extent that the child can sustain the look of another in the presence of a third party that he can find the assurance of an identification with the image of his own body. From the very fact that during the mirror stage is established a dual relationship, it constitutes, in conjunction with the formation of the self in the imaginary order, the nexus of secondary identification.[27] The origin of the self, as discovered by Lacan, in pertaining to the imaginary order effectively subverts the "optical machinery" of idealism which the projection room scrupulously reproduces.[28] But it is not as specifically "imaginary," nor as a reproduction of its first configuration, that the self finds a "place" in the cinema. This occurs, rather, as a sort of proof or verification of that function, a solidification through repetition.

The "reality" mimed by the cinema is thus first of all that of a "self." But, because the reflected image is not that of the body itself but that of a world already given as meaning, one can distinguish two levels of identification. The first, attached to the image itself, derives from the character portrayed as a center of secondary identifications, carrying an identity which constantly must be seized and reestablished. The second level permits the appearance of the first and places it "in action"—this is the transcendental subject whose place is taken by the camera which constitutes and rules the objects in this "world." Thus the spectator identifies less with what is represented, the spectacle itself, than with what stages the spectacle, makes it seen, obliging him to see what it sees; this is exactly the function taken over by the camera as a sort of relay.[29] Just as the mirror assembles the fragmented body in a sort of imaginary integration of the self, the transcendental self unites the discontinuous fragments of phenomena, of lived experience, into unifying meaning. Through it each fragment assumes meaning by being integrated into an "organic" unity. Between the imaginary gathering of the fragmented body into a unity and the transcendentality of the self, giver of unifying meaning, the current is indefinitely reversible.

The ideological mechanism at work in the cinema seems thus to be concentrated in the relationship between the camera and the subject. The question is whether the former will permit the latter to constitute and seize itself in a particular mode of specular reflection. Ultimately, the forms of narrative adopted, the "contents" of the image, are of little importance so long as an identification remains possible.[30] What emerges here (in outline) is the specific function fulfilled by the cinema as support

and instrument of ideology. It constitutes the "subject" by the illusory delimitation of a central location—whether this be that of a god or of any other substitute. It is an apparatus destined to obtain a precise ideological effect, necessary to the dominant ideology: creating a fantasmatization of the subject, it collaborates with a marked efficacity in the maintenance of idealism.

Thus the cinema assumes the role played throughout Western history by various artistic formations. The ideology of representation (as a principal axis orienting the notion of aesthetic "creation") and specularization (which organizes the *mise-en-scène* required to constitute the transcendental function) form a singularly coherent system in the cinema. Everything happens as if, the subject himself being unable—and for a reason—to account for his own situation, it was necessary to substitute secondary organs, grafted on to replace his own defective ones, instruments or ideological formations capable of filling his function as subject. In fact, this substitution is only possible on the condition that the instrumentation itself be hidden or repressed. Thus disturbing cinematic elements—similar, precisely, to those elements indicating the return of the repressed—signify without fail the arrival of the instrument "in flesh and blood," as in Vertov's *Man With a Movie Camera*. Both specular tranquillity and the assurance of one's own identity collapse simultaneously with the revealing of the mechanism, that is of the inscription of the film-work.

The cinema can thus appear as a sort of psychic apparatus of substitution, corresponding to the model defined by the dominant ideology. The system of repression (primarily economic) has as its goal the prevention of deviations and of the active exposure of this "model."[31] Analogously one could say that its "unconscious" is not recognized (we speak of the apparatus and not of the content of films, which have used the unconscious in ways we know all too well). To this unconscious would be attached the mode of production of film, the process of "work" in its multiple determinations, among which must be numbered those depending on instrumentation. This is why reflections on the basic apparatus ought to be possible to integrate into a general theory of the ideology of cinema.

[TRANSLATED BY ALAN WILLIAMS]

## NOTES

1. Translated from *Cinéthique*, No. 7/8 (1970), pp. 1–8.

2. Cf. on this subject Derrida's work "La Scène de l'écriture" in *L'Ecriture et la Différence* (Paris: Le Séuil).

3. [*Travail*, the process—implying not only "work" in the ordinary sense but as in Freud's usage: the dream*work*.—TR.]

4. Obviously we are not speaking here of investment of capital in the process.

5. Cf. L. Brion Guerry, *Jean Pellerin Viator* (Paris: Belles Lettres, 1962).

6. We understand the term "subject" here in its function as vehicle and place of intersection of ideological implications which we are attempting progressively to make clear, and not as the structural function which analytic discourse attempts to locate. It would rather take partially the place of the ego, of whose deviations little is known in the analytic field.

7. The perspective "frame" which will have such an influence on cinematographic shooting has as its role to intensify, to increase the effect of the spectacle, which no divergence may be allowed to split.

8. [See Cohen-Séat, *Essai sur les principes d'une philosophie du cinéma* (Paris: Corti) and Bazin, *What Is Cinema?* (Berkeley & Los Angeles: University of California Press).—Tr.]

9. "We know that the spectator finds it impossible to notice that the images which succeed one another before his eyes were assembled end-to-end, because the projection of film on the screen offers an impression of continuity although the images which compose it are, in reality, distinct, and are differentiated moreover by variations in space and time.

   "In a film, there can be hundreds, even thousands of cuts and intervals. But if it is shown for specialists who know the art, the spectacle will not be divulged as such. Only an error or lack of competence will permit them to seize, and this is a disagreeable sensation, the changes of time and place of action." (Pudovkin, "Le Montage" in *Cinéma d'aujourd'hui et de demain*, [Moscow, 1956].)

10. [*Écriture*, in the French, meaning "writing" but also "schematization" at any given level of material or expression.—Tr.]

11. [Specular: a notion used by Althusser and above all by Lacan; the word refers to the "mirror" effect which by reflection (specularization) constitutes the object reflected to the viewer and for him. The body is the most important and the first of these objects.—Tr.]

12. It is thus first at the level of the apparatus that the cinema functions as a language: inscription of discontinuous elements whose effacement in the relationship instituted among them produces meaning.

13. "In the cinema I am simultaneously in this action and *outside* of it, in this space and out of this space. Having the power of ubiquity, I am everywhere and nowhere." (Jean Mitry, *Esthetique et Psychologie du Cinéma* (Paris: Presses Universitaires de France, 1965), p. 179.

14. The cinema manifests in a hallucinatory manner the belief in the omnipotence of thought, described by Freud, which plays so important a role in neurotic defense mechanisms.

15. Husserl, *Les Méditations Cartesiennes* (Paris: Vrin, 1953), p. 28.

16. *Ibid.*, p. 18.

17. [Apodicity, in phenomenological terminology, indicates something of an ultimately irrefutable nature. See Husserl, *op.cit.*—Tr.]

18. On this point it is true that the camera is revealed as incomplete. But this is only a technical imperfection which, since the birth of cinema, has already in large measure been remedied.

19. *Ibid.*, p. 34, emphasis added.

20. *Ibid.*, p. 40.

21. *Ibid.*, p. 58.

22. Mitry, *op.cit.*, p. 157.

23. The lens, the "objective," is of course only a particular location of the "subjective." Marked by the idealist opposition interior/exterior, topologically situated at the point of meeting of the two, it corresponds, one could say, to the empirical organ of the subjective, to the opening, the fault in the organs of meaning, by which the exterior world may penetrate the interior and assume meaning. "It is the interior which commands," says Bresson. "I know this may seem paradoxical in an art which is all exterior." Also the use of different lenses is already conditioned by camera movement as implication and trajectory of meaning, by this transcendental function which we are

attempting to define: it is the possibility of choosing a field as accentuation or modification of the *visée intentionelle.*

No doubt this transcendental function fits in without difficulty the field of psychology. This, moreover, is insisted upon by Husserl himself, who indicates that Brentano's discovery, intentionality, "permits one truly to distinguish the method of a descriptive science of consciousness, as much philosophical and transcendental as psychological."

24. The arrangement of the cave, except that in the cinema it is already doubled in a sort of enclosure in which the camera, the darkened chamber, is enclosed in another darkened chamber, the projection hall.

25. Lacan, *Ecrits* (Paris: Le Seuil, 1966). See in particular "Le Stade du miroir comme formateur de la fonction du je."

26. We see that what has been defined as impression of reality refers less to the "reality" than to the apparatus which, although being of an hallucinatory order, nonetheless founds this possibility. Reality will never appear except as relative to the images which reflect it, in some way inaugurated by a reflection anterior to itself.

27. We refer here to what Lacan says of identifications in liaison with the structure determined by an optical instrument (the mirror), as they are constituted, in the prevailing figuration of the ego, as lines of resistance to the advance of the analytic work.

28. "That the ego be 'in the right' must be avowed, from experience, to be a function of misunderstanding." (Lacan, *op. cit.*, p. 637.)

29. "That it sustains itself as 'subject' means that language permits it to consider itself as the stagehand or even the director of all the imaginary capturings of which it would otherwise only be the living marionette." (*Ibid.*, p. 637.)

30. It is on this point and in function of the elements which we are trying to put in place that a discussion of editing could be opened. We will at a later date attempt to make some remarks on this subject.

31. *Mediterranée,* by J.-D. Pollet and Phillipe Sollers (1963), which dismantles with exemplary efficiency the "transcendental specularization" which we have attempted to delineate, gives a manifest proof of this point. The film was never able to overcome the economic blockade.

# GREGORY CURRIE

. . . . . . . . . . . . . . . . . . . . . . . . . . . . . . . . . . . . . . . . . . . . . . . . . . . . . . . . . .

# Film, Reality, and Illusion

Philosopher Gregory Currie (b. 1950), currently a professor at the University of Nottingham, England, has taught in Australia and New Zealand and as visiting faculty at a number of prestigious institutions. He is primarily interested in theories of mind, imagination, and narrative. His books include *The Nature of Fiction* (1990), *Image and Mind: Film, Philosophy, and Cognitive Science* (1995), and *Arts and Minds* (2004), and he is a spirited contributor to what can broadly be characterized as the "cognitive turn" in film studies of the mid-1980s. Cognitivist film theorists draw on science and logical argument to study and explicate how viewers make sense of the film medium through rationally motivated perceptual and information/knowledge processes.

Situating himself in the tradition of Anglo-American analytic philosophy, Currie joins fellow critics in pointing out the flawed premises and overarching claims of "grand theory" (a term coined by film theorists David Bordwell and Noël Carroll, editors of the collection in which Currie's essay appeared). Dominating film studies in the 1970s and extending its influence long after, "grand theory" drew its inspiration from continental theories of language, ideology, and subjectivity—often characterizing cinematic signification and spectatorship in abstract, monolithic terms. Cognitivist critics reject the analogy between cinema and language and between spectatorship and the imaginary found in the semiotic and psychoanalytic theories of Christian Metz (p. 17), Jean-Louis Baudry (p. 34), and others and advocate more pragmatic and rigorous research into aspects of perception, cognition, emotion, and identification experienced at the movies. The many cognitivists and analytic philosophers contributing to these debates do not share a single position; some draw on evolutionary biology and the psychology of perception, others on the philosophy of language of Ludwig Wittgenstein. Together they have pressed the question of the relationship of film theory to the disciplines of cognitive science, psychology, and philosophy, infusing the field with lively debate.

In this 1996 essay, Currie holds that film is a realistic medium, rejecting what he calls the doctrine of "illusionism" that claimed that movies "dupe" spectators into believing what they see on screen as real. Currie argues that movement is a real, if response-dependent, property of the cinema, which viewers perceive in the same way they perceive real motion. Film viewing is neither cognitively nor perceptually illusory; that is, we don't falsely believe the onscreen image to be real, nor do we mistake apparent motion for real motion. He calls this position "Perceptual Realism," stating that "film watching is similar to the originary perceptual experience of the world." Other cognitive critics extend this inquiry to include viewer perception and the processing of narrative cues or emotional responses. Such questions can be traced back to the psychological theories of Hugo Münsterberg (p. 9) and have applications beyond film to understanding interactions with new media forms like video games. Currie's piece is interesting to consider in light of Plato's "Allegory of the Cave," and it also brings a different dimension to the realist aesthetic theories of cinema covered in Part 3.

## READING CUES & KEY CONCEPTS

■ What is Currie's critique of the conflation of Perceptual Realism and Illusionism in dominant film theory?

■ What is Currie's distinction between Cognitive Illusionism and Perceptual Illusionism, and how does he argue against each?

■ Currie claims that "it is realism, not illusionism, that needs to play a central role in film theory." What kind of inquiry does this position favor?

■ **Key Concepts:** Transparency; Perceptual Realism; Illusionism; Cognition; Grand Theory

# Film, Reality, and Illusion
. . . . . . . . . . . . . .

## Introduction

It has been said that film is both a realistic and an illusionistic medium; indeed, these claims have often been treated as if they were indistinguishable. I wish to distinguish them, for I hold that film is a realistic medium—in a certain sense—and I deny that it is an illusionistic medium. I shall elaborate and defend a version of realism about cinema, and I shall identify two versions of illusionism, both of which I shall reject. In recent years these issues have most often been discussed within the framework of Marxist, psychoanalytic, or semiotic principles. I shall draw instead on recent Anglo-American philosophy of mind and language, within which there has been considerable debate about the nature and viability of realism. Since my concern is with cinema, I want to discuss a specifically representational form of realism that sheds light on the nature of film—and incidentally on other "pictorial" modes of representation. I do not aim at a systematic theory of cinema—not here, anyway. What I intend to do instead is to show how ways of thinking from within the broadly analytical tradition of philosophy can help us get a better grip on the issues of realism and illusion as they relate to film. I begin, in good analytic style, with some distinctions. I hope to end with something more speculative and challenging. I shall argue that we see movement on the cinema screen in the same sense that we see colors when we look at ordinary objects in the world under normal conditions. That is, we literally see movement on the screen, just as we literally see color. Colors are real, and so is cinematic motion. There is therefore no "illusion" of movement, and it is literally true that films are moving pictures.

## Transparency, Realism, and Illusionism

Let us start by distinguishing three doctrines about cinema, all of which have been called "realism." They are, however, quite distinct, and to underline their distinctness I shall call only one of them "realism."

There is first the claim that film, because of its use of the photographic method, reproduces rather than merely represents the real world; this view is associated most notably with André Bazin.[1] Following Kendall Walton,[2] I shall call this the doctrine of *Transparency*; film is transparent in that we see "through" it to the real world, as we see through a window or a lens. Next is the idea that the experience of film watching approximates the normal experience of perceiving the real world. We might call this *Perceptual Realism*, since it says that film is, or can be, realistic in its recreation of the experience of the real world. This doctrine has been asserted, again by Bazin, in connection with long-take, deep-focus style. But, as I shall argue, this kind of realism is a matter of degree, and long-take style is merely more realistic in this sense than is, say, montage style. Perceptual Realism, as a thesis about cinema, is the thesis that film is, in general, more realistic than certain other modes of representation. Finally, there is the claim that film is realistic in its capacity to engender in the viewer an illusion of the reality and presentness of fictional characters and events portrayed. Let us call this view, which seems to be held by studio

publicity writers as well as by the sternest Marxist critics of the Hollywood film, *Illusionism.*

Much of the history of film and film theory is reconstructible as a debate about the relations between these three doctrines. Some theorists—I am thinking of the early montagists and, more recently, the friends of Godard—have argued that Transparency requires us to play down the perceptual realism which film makes possible; film achieves the status of art (or subversion) when it employs mechanisms that go beyond the mere reproduction of reality. Others, like Bazin, say that film's dependence on Transparency *requires* the filmmaker to exploit to the full the possibilities for perceptual realism inherent in film; film presents the real world, so it should do so in a way which approximates as closely as possible to our experience of the real world. Some theorists have agreed—at least they can be read as agreeing—that Perceptual Realism makes for Illusionism. They agree, in other words, that the closer the experience of film watching approximates to the experience of seeing the real world, the more effectively film engenders in the viewer the illusion that he or she is actually watching the real world.[3] The disagreement between these theorists has concerned the question whether this is a desirable goal. Other theorists have taken a more radical view, and have argued that the very notion of realism in film is suspect or even incoherent.

If my absurdly brief account of the history of film theory is close to being right, the discipline has been to a large extent predicated on the assumption of a close connection between these three doctrines. I, on the other hand, take these doctrines to be independent, both logically and causally. Adopting any one of them, we are free to adopt or reject the others. I reject Illusionism, I accept Perceptual Realism, and I am neutral, for present purposes, about Transparency, which I shall ignore hereafter, having had my say on it elsewhere.[4] I want to defend Perceptual Realism, which has been under attack for a while now from those who reject the notion of likeness or resemblance between images and the things they are images of, and who stress instead the artifice, the conventionality, the "codedness" as they put it, of cinema. But I wish to avoid a misunderstanding about what I am claiming here. My defense of Perceptual Realism is a metaphysical and not an aesthetic defense. I am not advocating that filmmakers adopt styles which, like long-take, deep-focus style, attempt to exploit the possibilities for perceptual realism in film. I am arguing that Perceptual Realism is a coherent thesis, and that it is possible to achieve a considerable degree of this kind of realism in film. Whether you think that is a worthwhile project is another matter.

About Illusionism I want to say two things. First, I wish to argue that it is a mistaken doctrine. Second, I want to hazard a guess at why this doctrine, which strikes me as completely implausible, should have such a tenacious grip on the minds of many who concern themselves with film. My hypothesis is that its strength derives in part (and certainly only in part) from its being conflated with another doctrine which is even more widely believed and which has a certain plausibility. This is the thesis that the basic mechanism of film creates an illusion of *movement.* Sorting out these two doctrines will lead us to make a distinction between cognitive and perceptual illusions.

## Perceptual Realism

Let us say that a mode of representation is realistic when, or to the degree that, we employ the same capacities in recognizing its representational content as we employ

in recognizing the (kind of) objects it represents. A good-quality, well-focused, middle-distance photograph of a horse is realistic in this sense: you employ your visual capacity to recognize horses so as to determine that this is, indeed, a photograph of a horse. Roughly speaking, you can recognize a photograph, a cinematic image, or other kind of picture of a horse if and only if you can recognize a horse.[5] By contrast, a linguistic description of a horse is not realistic in the sense just specified, for the capacity visually to recognize horses is neither sufficient nor necessary to enable you to recognize the description as a description of a horse; recognizing the description requires a knowledge of the conventions of language. (There probably are *other* senses in which a description can be said to be realistic.)

Realism of the kind I am concerned with here is a matter of degree. Suppose we have a representation, $R$, of an object, $A$, and $R$ represents $A$ as having properties $F$ and $G$. $R$ might represent $F$ realistically, and $G$ in some other way. That is, $R$ may be such that you are able to recognize $R$ as representing the $F$ness of $A$ in virtue of your capacity visually to recognize the $F$ness of an $A$ when you see one, but you recognize $R$ as representing the $G$ness of $A$ in virtue of your knowledge of some convention of language, or perhaps in virtue of your knowledge of someone's intention. In that case, when we say that this representation, or mode of representation, is realistic and that one is not we probably mean that this one is *more* realistic than that one. It will be important to bear this in mind in what follows.

It is in this sense of realism—the sense which I have given to the phrase "Perceptual Realism"—that film is a realistic medium, and deep-focus, long-take style is an especially realistic style within that medium. We recognize that people, houses, mountains, and cars are represented on screen by exercising the capacities we have to recognize those objects, and not by learning a set of conventions that associate cinematic representations of these objects with the objects themselves. (There is, in other words, nothing comparable in cinema to learning the vocabulary of a language.[6]) And when objects and events are represented on screen within a single shot, we come to know what spatial and temporal relations the film represents as holding between those objects and events by using our ordinary capacities to judge the spatial and temporal relations between objects and events themselves. We judge the spatial relations between objects represented in the same shot by seeing that they are spatially related thus and so; we judge the temporal properties of and relations between events represented within the take by noting that this event took (roughly) so long to observe, while that one was experienced as occurring later than the other one. That is exactly how we judge the spatial and temporal properties of things and events as we perceive them in the real world. In that way, long-take, deep-focus style extends the possibilities for the perceptual realism of film. (Length of take and depth of focus are independent of one another and do not always go together, as David Bordwell pointed out to me. But if I am right about their capacity to enhance perceptual realism in film, the combination of these two features constitutes something like a stylistic "natural kind.")

In montage style, on the other hand, where there is quick cutting between very distinct spatial (and sometimes temporal) perspectives, the spatial and temporal properties and relations depicted have, with greater frequency, to be judged by means of inference from the overall dramatic structure of the film. As my earlier remarks were intended to suggest, this is a matter of degree; long-take, deep-focus

style is *more* realistic than montage style, and montage style can itself be said to be more realistic than some other modes of representation: more realistic certainly than linguistic description. Unqualified claims that long-take, deep-focus style is realistic should be taken as implicitly relativized to the class of artistic styles with which it is most naturally compared, namely other cinematic styles, just as the claim that elephants are large will be understood as relativized to the class of mammals.

It is often remarked that deep-focus style is unrealistic in that it presents us with an image in which objects are simultaneously in sharp focus when they are at considerably different distances from the camera, whereas objects at comparable distances from the eye could not be seen in focus together.[7] But this does not seriously detract from the perceptual realism of deep focus. Deep focus, particularly when used in conjunction with a wide screen, enables us to concentrate our attention on one object, and then to shift our attention at will to another object, just as we are able to do when perceiving the real world. Since we are usually not very conscious of refocusing our eyes, the similarities between viewing deep-focus style and perceiving the real world are more striking than the differences. With montage style on the other hand, we are severely limited by shot length and depth of field in our capacity to shift our attention from one object to another at will—though as I have said, this feature is not entirely absent in montage style.

Explicating the idea of perceptual realism in this way helps us avoid an error that has dogged theorizing about the cinema: that realism in film can be attacked on metaphysical grounds because it postulates an observer-independent world—an idea which is then further associated by some theorists with a politically conservative agenda of submission to prevailing conditions. But Perceptual Realism as I have explicated it here appeals to no such postulate of an observer-independent world (though one might argue that such a postulate is both philosophically respectable and politically neutral). The claim of Perceptual Realism is not the claim that cinema presents objects and events isomorphic to those that exist in an observer-independent world, but the claim that, in crucial respects, the experience of film watching is similar to the ordinary perceptual experience of the world, irrespective of whether and to what extent that world is itself independent of our experience of it.

When I say "the experience of film watching is similar to the ordinary perceptual experience of the world," I mean that *our* experience of film watching is similar to *our* ordinary perceptual experience of the world. There might be creatures as intelligent and perceptually discriminating as we are but who experience the world in ways rather different from us. They might not be able to deploy their natural recognitional capacities in order to grasp what is depicted in film, and in our other pictorial forms of representation. Richard Dawkins raises the possibility that bats might have visual experiences qualitatively similar to our own, but caused by their very different perceptual systems, which depend on bouncing sound waves off solid objects.[8] I understand this is not likely to be true of bats,[9] but we can imagine batlike creatures complex enough for this to be a plausible story. They wouldn't have much success detecting the spatial properties of objects as they are represented on a flat screen, and film would be a medium with little appeal for them. So there is a definite relativity about my conception of realism; what is realistic for us might not be realistic for other creatures. My concept of realism is what people these days are calling a response-dependent concept; it is a concept applicable to things in virtue

of the responses to it of a certain class of intelligent agents, namely ourselves.[10] It is like the concept *being funny* or *being red*. Things are funny if people respond to them in certain ways (it's not easy to say exactly what ways); things are red if they look red to normal humans in normal conditions. So it is with Perceptual Realism.

Some people will find this relativistic concept of realism jarring, perhaps oxymoronic. Among them are those who, as I mentioned earlier, object to realism because they think realism presupposes some sort of absolutist conception of the world and all its aspects. They think that realism postulates a world describable without reference to any subjective point of view. But this is a mistake. Colors are real, relational properties of things: properties they have in virtue of our responses to them. Response-dependence is going to come up again, when we discuss the supposed illusion of movement in film. For the record, let us have a tolerably precise characterization of Perceptual Realism:

> A representation $R$ is realistic in its representation of feature $F$ for creatures of kind $C$ if and only if
>
> (i) $R$ represents something as having $F$;
>
> (ii) $C$s have a certain perceptual capacity $P$ to recognize instances of $F$;
>
> (iii) $C$s recognize that $R$ represents something as having $F$ by deploying capacity $P$.

This characterization of realism has important consequences when applied to film. One is that there is a sense in which film is both a spatial and a temporal medium. Film represents space by means of space, and time by means of time. It is spatial (temporal) properties of the cinematic representation that we observe and rely on in order to figure out what spatial (temporal) properties of the fictional characters and events are portrayed. It is correctly said that painting and still photography are capable of representing the temporal. They may do so in a variety of ways: by encouraging the viewer to make an inference from what is explicitly depicted to what came before and what will come after; by juxtaposition of distinct static images, as when we are shown a series of temporally related photographs; by transforming temporal properties into spatial ones (as in Filippo Lippi's tondo in the Pitti Palace, wherein events earlier in the life of the Virgin are represented deeper within the picture space); by special techniques such as blurring and multiple exposure. But these possibilities do not constitute grounds for calling painting and still photography arts of time in the way that cinema is, for with them time is not represented by means of time.[11]

## Illusionism

Having said that film is realistic in that it deploys our natural recognitional capacities, it may seem as if I am thereby committed to illusionism. If a cinematic image of a horse triggers my horse recognition capacity, doesn't that mean that I take the image to be a horse, thereby falling victim to an illusion? No. I say that my horse recognition capacity and my capacity to judge whether there is a horse in front of me (rather than, say, an image of one) are two different things. Indeed, they operate at different cognitive levels. Judging that there is a horse in front of me is something I do; it takes place at the *personal* level. Having my horse recognition capacity triggered—by a horse or by an image of one—is something that goes on in me, at

some level within my visual processing system; it is a *subpersonal* process. Once we distinguish between these capacities and the levels at which they operate, we can be perceptual realists without falling into the trap of illusionism.

So I may be a perceptual realist and deny that film is illusionistic, which I do deny. I do not deny that it is *possible* for film to engender this sort of an illusion on the part of a viewer; on a liberal enough view of possibility, it is possible for anything to create an illusion of anything else. But this mere possibility is not what is at issue when people claim that film is illusionistic. Rather, they claim that the standard mechanism by means of which film engages the audience is illusionistic, that the creation of an illusion of reality is a standard feature of the transaction between film and viewer.[12] That is what I deny.

The claim that film creates an illusion of the reality of the fiction it presents can take a number of forms. So far as I can see, film theorists have tended to opt for a particularly strong version of that claim. They have tended to say that the illusion is not merely that the fictional events are real, but that the viewer is present at those events, observing them from within the world of the fiction, thinking of him- or herself as placed where the camera is, experiencing those events with the visual perspective of the camera. There are other, more moderate versions of illusionism one might hold to, but I believe that in the end we shall find no more use for them than for the strong version. Anyhow, it is the strong version I shall concentrate on here.

There are two serious objections to the idea that film induces the illusion that fictional events are real and that the viewer is directly witnessing them. The first derives from a functionalist view about the nature of beliefs: that beliefs are, essentially, states apt to cause certain kinds of behavior.[13] Of course we know that there is no simple, invariant correlation between having a certain belief and engaging in a certain kind of behavior. But we can say this: there are certain kinds of beliefs which are such that, where they are not accompanied by the relevant behavior, their disconnection from behavior is to be explained by appeal to other, countervailing beliefs. Someone who believes herself in danger may take no evasive action, but that will be explained by reference to some other belief: that evasion will have unacceptable costs in terms of peer appraisal, that staying put will be the best way to avoid the danger, and so on. Now film watchers do not behave like people who really believe, or even suspect, that they are in the presence of ax murderers, world-destroying monsters, or nuclear explosions, which is what the films they see frequently represent. And in their cases, appeal to the sorts of countervailing beliefs just mentioned sound rather hollow. The real reasons people stay in movie theaters or in front of videos during frightening films are, for example, because they want to see the rest of the film, or because they have paid their money, or because they want to experience the sensations of fear. None of these explanations sits comfortably with the view that patrons believe, even partially or "with part of the mind," as people sometimes say, that they are really in the presence of dangerous, catastrophic, or tragic events. Explanations of our responses to cinematic fictions in terms of belief work only so long as we do not take the notion of belief, and its connection with behavior, seriously.[14] Of course we do need a psychological explanation of our sometimes very intense responses to film. In the absence of an explanation in other terms, an explanation that appeals to belief can seem attractive, for all its evident drawbacks. Elsewhere I have given an explanation of our

responses to fictions, in terms of imagining.[15] I shall say here only that I believe this account applies as well to cinematic as to other kinds of fictions.

The second objection to Illusionism is that it is at odds with much of the experience of film watching.[16] Consider what would be involved in the film viewer believing that she is watching real events. The viewer would have to suppose that her perspective is that of the camera, that she is positioned within and moves through the film space as the camera is positioned and moved. Indeed, there have been elaborate attempts to argue that the viewer does identify with the camera, and Christian Metz has gone so far as to assert that without identification there would be no comprehension of film.[17] But this is psychologically implausible. Identification with the camera would frequently require us to think of ourselves in peculiar or impossible locations, undertaking movements out of keeping with the natural limitations of our bodies, and peculiarly invisible to the characters. None of this seems to be part of the ordinary experience of film watching. In the attempt to associate the camera with some observer within the world of the action with whom the viewer can in turn identify, film theorists have exaggerated the extent to which shots within a film can be thought of as point-of-view shots, and have sometimes postulated, quite ad hoc, an invisible narrator from whose position the action is displayed and with whom the viewer may identify. For example, Jacques Aumont asserts very confidently that "... the frame in narrative cinema is always more or less the representation of a gaze, the auteur's or the characters'."[18] Here, I believe, we are in the grip of a manifestly false theory. It would be better to acknowledge that cinematic shots are only rarely from a psychological point of view, and to abandon the thesis that the viewer identifies with an intelligence whose point of view is the camera.

A variant of Illusionism, and one which might be thought to take some account of the objections just propounded, says that the situation of the film watcher approximates to that of a dreamer. During our dreams we remain physically passive, yet we are convinced of the reality of the dream. In that case the camera would correspond to a supposed "inner eye" by means of which we perceive the images of dreams. This analogy has been a powerful stimulus to the development of psychoanalytic theories of film and film experience. In fact, as Noël Carroll has shown, the analogy with dreaming proceeds by systematically failing to compare like with like.[19] Dreamers, like film watchers, usually are physically passive while watching or dreaming. But the *experience* of dreaming is usually one that involves action—sometimes ineffectual—on the dreamer's part, while the experience of film watching, our reflex responses aside, rarely moves us to physical action. And it is the experience of film watching and the experience of dreaming that are claimed by the advocates of the dream/film analogy to be alike. The fact that both dreaming and film watching typically take place in the dark is another irrelevant consideration often raised, since darkness is not typically part of the experience of dreaming, though it does typically accompany the experience of film watching. There are other notable dissimilarities between film watching and dreaming. In dreams, our own actions and sufferings are of central concern to us, but the experience of film watching makes us largely forgetful of ourselves while we concentrate on the fate of the characters. Perhaps in some way film watching is like dreaming; perhaps everything is in some way like everything else. There does not seem to be any substantial, systematic likeness between film experience and dreaming that holds out promise of serious explanatory gains.

## Cognitive and Perceptual Illusions

The version of Illusionism I have been considering so far is a very strong one; it commits the Illusionist to saying that film viewers are systematically caused to have false beliefs. It is interesting to argue that a strong view is true, but less interesting to argue that it is false, as I have done. By definition, strong views are more *likely* to be false than weak ones. Might there be some weaker, apparently more plausible, version of Illusionism? If so, and if we could show that this weaker version is also wrong, that would be a result of considerable interest. I believe that there is a weaker, more plausible version of Illusionism, and I shall argue against it.

First I need to distinguish between two kinds of illusions: cognitive and perceptual illusions. I mean by a cognitive illusion a state of mind essentially involving a false belief. Thus if someone sees an oasis in the desert and there is no oasis there (at least not where it seems to be), and comes thereby falsely to believe that there is an oasis there, she is subject to a cognitive illusion. Similarly, when someone sees two lines of equal length, but provided with "arrowheads" pointing in different directions so that the lines seem to be of different lengths, she might believe the lines to be of different lengths. This person is also suffering a cognitive illusion. But not all illusions are cognitive. You may know that the two lines are of equal length and still be subject to the so-called Muller-Lyer illusion which I have just described: the lines just *look* as if they are of different lengths. Zenon Pylyshyn has introduced the term "cognitively impenetrable" to describe mental processes which operate independently of our beliefs. For example, if someone moves his fist quickly toward your face you will recoil even though you know he won't hit you. Visual illusions involve processes which are cognitively impenetrable: belief doesn't make any difference to the way the illusory phenomenon looks.

An illusion of this kind, which is what I am going to call a perceptual illusion, occurs when experience represents the world as being a certain way, when in fact the world is not that way and the subject knows it. And experience may represent the world as being a way it isn't, as when it represents the two lines as being of unequal length, even though the subject knows that experience is misrepresenting the world.[20]

Now someone might claim that cinema is illusionistic in this perceptual sense, and not in the cognitive sense I have been considering up until now. My arguments so far presented against Illusionism are ineffective against Perceptual Illusionism, because they are arguments designed to show that we lack the beliefs necessary to underwrite the claim of Cognitive Illusionism. So I need quite different arguments if I am going to oppose Perceptual Illusionism. I shall provide some. But we should bear in mind a point I have already made: that Perceptual Illusionism is a distinctly weaker thesis about cinema than Cognitive Illusionism, and one with quite different consequences. There has been, I think, a tendency to assume that the truth (the alleged truth) of Perceptual Illusionism somehow supports the claim of Cognitive Illusionism. Perhaps Perceptual Illusionism is the Trojan horse by means of which advocates of Cognitive Illusionism hope to gain their victory. It needs to be said, therefore, that Perceptual Illusionism, even if true, does not in itself provide an argument for Cognitive Illusionism, though of course it might provide such an argument in conjunction with other premises. So it is not essential to my case against

Cognitive Illusionism that I oppose Perceptual Illusionism as well. Nonetheless, I am inclined to oppose Perceptual Illusionism. I do not claim to be able to refute it; at most I shall sow the seeds of doubt about it.

What merely perceptual illusion is cinema said to create? A very common view is that the technical mechanism that film employs is itself productive of an illusion— this supposed illusion being that the viewer sees a moving image or sequence of such images, when in fact there is no moving image to be seen. All there "really" is is light projected through an aperture against which are laid, in quick succession, a series of still photographs (the standard rate of succession being 24 frames per second). So what we see is a series of projected static images, and not the moving image that we seem to see. Francis Sparshott writes that "A film is a series of motionless images projected onto a screen so fast as to create in the mind of anyone watching the screen an impression of continuous motion"—an impression Sparshott goes on to call "the basic illusion of motion."[21] On this view, our experience when watching a film represents the world as containing movement of a certain kind: movement of images. And this is an illusion, according to Sparshott and others, because the world in fact contains no such movement of images; there is, to repeat, only a succession of static images.

I had better clarify exactly what I mean when I speak of "moving images." Strictly speaking, the cinematic image is the whole area of illumination on the screen during projection. We all agree, I take it, that this does not move, unless the projection equipment starts to shift around. What moves, on my account, is a part or parts of this image; if we are watching a shot of a man walking along a street, the part of the image which represents the man will move from one side of the screen to the other. Movement of this kind, which is what I am concerned with here, needs to be distinguished from the movement which occurs as a result of a continuous change in the position of the camera during a single shot. This latter kind of movement introduces somewhat complex considerations which I shall not attempt to deal with here. Also, the movement with which I am concerned here is to be distinguished from the radically discontinuous movement which might be said to occur across shots: we see the image of the man in one place on the screen in one shot, and in another place on the screen in the next shot. All I am claiming here is that there really is movement within a single shot taken from a fixed perspective. That, obviously, is enough to contradict the claim that movement in film is an illusion produced by the juxtaposition of static images.

Someone might argue that this supposed illusion of cinematic motion is a cognitive, and not merely a perceptual illusion, because most people who watch films actually believe that they are watching moving images; it is only when one reflects on the technical mechanisms of cinema that one realizes that this is not the case. That may be true, but the fact is that the appearance of cinematic motion does not go away for those people who convince themselves that it is, indeed, an illusion. If cinematic motion is illusory, then it is essentially a perceptual illusion and only incidentally a cognitive one. That is why I shall [not] treat it simply as a cognitive illusion.

Before I consider the case for Perceptual Illusionism, a word on metaphysical background. Arguments about motion, and about change generally, sometimes raise deep questions about what motion and change actually are. There are two basic and mutually incompatible positions on this. One, which I shall call three dimensionalism, says that change takes place when a thing has a property at one time which it, that very same thing, lacks at another time. The other view, four

dimensionalism, says that change occurs when a certain temporal stage possesses a property, and another temporal stage lacks that property, where those temporal stages are so related to constitute temporal stages of the same object. I don't myself believe that there is anything in our common belief about change which decides one way or the other between these two theories, and nothing I shall say about cinematic movement here is intended to prejudge which is correct.[22] So while I shall speak of our cinematic experience as representing to us that an image moves from one place to the other, this is to be taken as neutral between the view that there is one thing which is in one place at one time and in another place at another time, and the view that there are distinct but suitably related temporal parts that are in different places. Obviously, both construals are inconsistent with the view that there is, literally, no movement of an image on the screen.

<div align="center">[ · · · ]</div>

So my thesis is just that a certain, restricted kind of apparent motion in cinema is, in fact, not merely apparent, but real. I shall call that motion simply "cinematic motion." But I shall not be looking for a positive argument in favor of the reality of cinematic motion. In debates over whether some type of experience is illusory, it seems to me that the burden of proof, or perhaps merely of argument, lies with the party who asserts that the experience in question is illusory, just as it does with someone who asserts that a certain belief is false. In both cases—belief and perception—we have grounds for treating veridical and nonveridical states asymmetrically, since states of belief and perception are states we have *because* they tend to be veridical. In that case, we should hold that cinematic experience of movement is veridical unless there is a significant weight of evidence and argument against that view.

What is the argument for saying that the experience of cinema involves a perceptual illusion of movement? I have the impression that the argument sometimes appeals to the fact that there is no movement on the cinematic film roll itself, that there is just a sequence of static images. This is true, but it does nothing to establish the unreality of cinematic movement. After all, when we listen to a tape or other kind of sound recording, there is no sound literally *on the tape itself*; what is on the tape is just a pattern of selective magnetization, or whatever. But we would not conclude from this that when we listen to a tape recording of music, we are subject to an auditory illusion. The claim of Perceptual Illusionism is the claim that there is no movement *on the screen*, for this, after all, is where we seem to see movement.

An argument which might seem to favor Perceptual Illusionism is the following: the supposed movement that there is on the screen is the product of our perceptual system, and cannot be thought to exist independent of it. Suppose you described the goings-on on the screen from the kind of objective viewpoint we try to occupy in physical science: you exhaustively describe the impact of particles or waves of light on the screen, and you therefore describe all the relevant physical goings-on at that surface. But you do not describe any movement of the kind we claim to observe there; you do not describe any object as moving from one place on the screen to another. So there simply isn't any movement here, since the objective description comprehends all the relevant physical facts but describes no movement. It is only when you take a subjective point of view, and include in the description the viewer's subjective experience of the screen, that movement enters your description.

I hope that by now warning bells are going off all over the place. This argument is parallel to a class of other arguments that would establish the illusory nature of all our experience of what are called secondary qualities. Consider the case of color: we describe the object from a physical point of view exhaustively, including everything about the spectral reflectance profile of its surface, but we say nothing about the way it looks; color enters our vocabulary only when we include the observer's subjective point of view in the story. Now there are those, like Paul Boghossian and J. David Velleman, who relish this conclusion, and say that the experience of color is indeed illusory; experience represents things as having color properties when in fact they do not have them.[23] But on the whole philosophers resist such starkly revisionist conclusions, and I go along with them. What a realist about color should say is what we have already said: colors and other secondary properties are real, response-dependent properties of things. Perhaps, then, the "apparent motion" of projected film is not merely apparent; perhaps it is real, response-dependent motion.

One common and natural thought in response to this proposal is that the proposal can succeed only at the cost of destroying the distinction between real and merely apparent phenomena, or that it will, at the very least, intolerably expand the class of phenomena we shall have to count as real. It is worth seeing that this is not so. First of all, someone might claim that, by an argument parallel to the one I have given for the reality of cinematic motion, we can establish that the experience induced by the Muller-Lyer phenomenon is veridical. Just say that in those cases of experience singled out as exemplifying the Muller-Lyer illusion, what experience represents is the holding, between two lines, of the relation *being longer * than*, where length * is not the metrical property of objects we measure with rigid rods, but rather a response-dependent length: a length that stands to metrical length as the response-dependent movement I have been describing stands to the movement we measure by tracking physical objects across space. In that case there is no illusion involved in the Muller-Lyer phenomenon, but merely the veridical experience of one line being longer * than another.

This objection fails. Our experience in the Muller-Lyer illusion represents the lines as standing in the relation longer than, not the relation longer * than. The visible appearance of the lines suggests that, were you to measure them in the conventional way, the result would be that one was measurably longer than the other. That is why this is genuinely a case of an illusion, rather than a veridical experience of a response-dependent property. With the experience of screen watching, however, it is doubtful whether the movement that our experience represents as taking place is of a kind that would be undermined by independent checks analogous to the measuring check we can carry out in the case of the Muller-Lyer illusion. For example, I do not think that our experience of screen watching is an experience which has as its representational content: There are reidentifiable physical objects moving in front our our eyes. Rather, its content is: There are *images* of reidentifiable physical objects moving in front of our eyes. In this respect the experience seems not to be undercut by information from other sources, and therefore to be crucially different from that induced by the Muller-Lyer setup.

[ · · · ]

There are a number of other apparent motions which are normally classed as merely apparent and which retain their status as mere appearances on my account. For example, psychologists speak of *induced* motion, a phenomenon noticeable when we see clouds drifting across the face of the moon; if the clouds drift slowly to the left, the moon appears to be drifting to the right. And tall buildings viewed from below against a background of moving clouds seem to be falling.[24] In these and like cases we have a perceptual illusion of movement: experience represents something moving which is not moving. But these cases, I shall argue, are unlike the case of cinematic motion. And there are kinds of motion which cinema sometimes gives us and which are or can be illusory, rather than real motions. For example, films in 3-D display an illusion of depth; our experience of watching 3-D is one in which objects are represented as moving toward or away from the viewer when in fact no object is moving toward or away from the viewer. The cinematic motion I claim to be real belongs to the kind which psychologists call "motion in the frontal plane."

[ ··· ]

So I say that part of the content of cinematic experience is that there is movement of images, and there really is such movement. We see the cinematic image of a man, and we see that it is in one place on the screen, and we later see that it is in another; indeed, we see—really see—that image move from one place to another on the screen. That image is not to be identified with some particular physical object. It is not like the image in a painting which consists of a certain conglomeration of physical pigments, at least relatively stable over time. It is an image sustained by the continuous impact of light on the surface of the screen, and no particular light wave or particle is more than minutely constitutive of it. Nonetheless, that image is a particular, reidentifiable thing, and a thing which moves.

At a minimum, motion involves change over time in the position of a reidentifiable object (or, for four dimensionalists, the location of distinct temporal parts of an object at distinct places). If cinematic motion is real, it must be possible to reidentify cinematic images over time. How? One initially plausible answer is that images get their identity conditions from their causal antecedents. This image and that one are both cinematic images *of* the same man, so they are the same image (or on the four-dimensionalist view, they are temporal parts of the same image). But this answer strikes me as unsatisfactory. First of all, I would make the same claim for the reality of movement in animated cartoons, and there the argument from sameness of causal antecedents will not allow us to reidentify images over time: cartoon images do not have the kind of causal antecedents required to make the argument from common causal origin work. The better criterion for the identity of cinematic images across time is their relation to the mental states of the viewer. This image is the same as that one because both are identified by normal viewers in normal conditions as being images of the same individual. Here again, as with color, the concept we appeal to is response-dependent. Identity between images is itself a response-dependent concept, because questions about how to reidentify images across time are answered by appeal to facts about the psychological responses of the viewer to those images. But just as with colors, this response-dependence is perfectly compatible with the reality of the images concerned.

In arguing against perceptual illusionism, I have been insisting that cinematic motion is real, using that term to contrast, naturally enough, with "illusory." You may think this taxonomy is insufficiently refined. After all, we commonly contrast reality with appearance; my dichotomy will then have us identify that which belongs to the realm of mere appearances with that which is illusory. That seems hard on appearances. There ought to be room for a position which says that colors and other secondary properties belong to the realm of appearances, but which denies that the experience of color is illusory. (Perhaps in the end this position will turn out to be incoherent; I just don't want to rule it out at this stage.) On that view, the real contrasts with the illusory and with the apparent. Equivalently, we could say there are two senses of "real": a weak sense, which has as the complement of its extension the illusory, and a stronger sense, which has as the complement of its extension the illusory and the apparent, which we can then lump together under the heading "antirealism." If we adopt that labeling system, my view is simply that cinematic motion is real in the weak sense. I can then agree that in a strong, metaphysical sense we ought to be antirealists about cinematic motion, and perhaps about color as well. But we shall need to make a distinction between, on the one hand, antirealist concepts, for the application of which we are in the realm of mere appearances, and, on the other, antirealist concepts for the application of which we are in the realm of illusion. Whatever your view on color, there is surely a difference, for example, between ascribing blueness to a U.S. mailbox, and ascribing greenness to the (actually white) stripes displayed in a McCullough aftereffect experiment. The difference, I submit, is that in the second case but not in the first, you are subject to an illusion. So, if my parallel between cinematic motion and color does not persuade you to be a strong realist about cinematic motion, it may still be enough to undermine illusionism about cinematic motion.

To underline this last point, let us notice a feature of response-dependent concepts sometimes thought to be grounds for being an *antirealist* about such concepts. Realists sometimes emphasize the radical fallibility of our beliefs about a domain to which they claim realism applies; if it's possible, even under epistemically ideal circumstances, for us to be mistaken in our beliefs about that domain, that is a sign that we are in the realm of reality. But with certain kinds of response-dependent concepts, radical fallibility is ruled out.[25] If a normal observer in normal circumstances judges that something is red, it is red; similarly, if a normally sighted person, sitting in a darkened cinema at the appropriate distance and attending to the screen as the projector rolls, judges that the cinematic image is moving, then it is. That, as I say, might be grounds for rejecting metaphysical realism about color, and about cinematic motion. But it cannot be grounds for thinking that cinematic movement is an illusion. Where there is no possibility of error, there can be no illusion.

## Conclusion

Grand theories of film—like grand theories of anything else—are always prone to catastrophic error: get the basic conceptual priorities and relations wrong, and the whole system collapses. That, I believe, is how it has been with semiotically and psychoanalytically oriented film theories. These theories have simply presupposed that film is in some way or other an illusionistic medium. I have argued here that

the concept of illusion is in fact entirely irrelevant to understanding the nature and function of film. It is realism, not illusionism, that needs to play a central role in film theory. But the realism we need is not just anti-illusionistic, it is anti-absolutist as well; the realist need not believe that the world is fully describable without taking into account subjective points of view.

The conclusions of this paper go beyond film theory to embrace general metaphysics. It is traditional to regard motion as a paradigmatically primary quality, to be contrasted with those secondary qualities which are in some sense observer-dependent, like color. If what I have said here about cinematic motion is correct, we shall have to acknowledge a kind of motion which takes its place among the secondary qualities.

## NOTES

1. See, for example, André Bazin, *What Is Cinema?* vol. 1, trans. and ed. Hugh Gray (Berkeley: University of California Press, 1971). For an analysis of Bazin's view and of other relevant aspects of the history of film theory, see Noël Carroll, *Philosophical Problems of Classical Film Theory* (Princeton: Princeton University Press, 1988).

2. Kendall Walton, "Transparent Pictures: on the Nature of Photographic Realism," *Critical Inquiry* 11, 2 (1984): 246–77. For Walton, and also for Bazin, the transparency of film is a consequence of its mechanicity, a thesis which Walton explicates in terms of patterns of counterfactual dependence between the photograph and the photographed scene which are independent of the photographer's mental states. For an analysis of the argument from mechanicity to transparency, see my "Photography, Painting, and Perception," *Journal of Aesthetics and Art Criticism* 49 (1991): 23–29.

3. Christian Metz, for example, discusses how film creates "a certain degree of *belief* in the reality of an imaginary world" (*The Imaginary Signifier: Psychoanalysis and the Cinema* (Bloomington: Indiana University Press, 1982), pp. 118 and 72; emphasis in the original). This view is by now more or less standard; see for example, Robert B. Ray, *A Certain Tendency of the Hollywood Cinema* (Princeton: Princeton University Press, 1985), p. 38. Metz's formulation suggests a certain hesitancy about exactly how much belief there really is here, a hesitancy displayed in other remarks of his on the same subject: "somewhere in oneself one believes that [the events of the fiction] are genuinely true" (*Imaginary Signifier*, p. 72).

4. See my "Photography, Painting, and Perception."

5. I think Noël Carroll was the first person to give this characterization of realism. See his "The Power of Movies," *Daedalus* 114, 4 (1985): 79–103. See also Flint Schier, *Deeper into Pictures* (New York: Cambridge University Press, 1986).

6. For more on this see my "The Long Goodbye: On the Imaginary Language of Film," *British Journal of Aesthetics* 33 (1993): 207–19.

7. See, for example, Patrick Ogle, "Technological and Aesthetic Influences on the Development of Deep-Focus Cinematography in the United States," in *Movies and Methods*, vol. 2, ed. Bill Nichols (Berkeley: University of California Press, 1985).

8. Richard Dawkins, *The Blind Watchmaker* (Harlow: Longman Scientific and Technical, 1986).

9. See Kathleen A. Akins, "What Is It Like to Be Boring and Myopic?" in *Dennett and His Critics: Demystifying Mind*, ed. B. Dahlbom (Oxford: Basil Blackwell, 1993).

10. The term "response-dependence" is due to Mark Johnston. See his "Dispositional Theories of Value," *Proceedings of the Aristotelian Society*, supplementary volume, 63 (1989):

139–74. See also Philip Pettit, "Realism and Response-Dependence," *Mind* 100 (1991): 587–623; and Mark Johnston, "Objectivity Refigured," and Crispin Wright, "Order of Determination, Response-Dependence and the Eurythro Contrast," both in *Realism and Reason*, ed. J. Haldane and C. Wright (Oxford: Basil Blackwell, 1992).

11. See my *Image and Mind: Film, Philosophy, and Cognitive Science* (New York: Cambridge University Press, forthcoming), chapter 3; and Jerrold Levinson and Philip Alperson, "What Is a Temporal Art?" in *Midwest Studies in Philosophy*, vol. 16, *Philosophy and the Arts*, ed. P. French, T. Uehling, and H. Wettstein (Notre Dame: Notre Dame University Press, 1991).

12. "The predominant myth of cinema, fostered by cinema itself, is that its images and sounds present reality" (John Ellis, *Visible Fictions: Cinema, Television, Video* [London: Routledge and Kegan Paul, 1982], p. 77). ". . . conditions of screening and narrative conventions give the spectator an illusion of looking in on a private world" (Laura Mulvey, "Visual Pleasure and Narrative Cinema," in *Film Theory and Criticism* 4th ed., edited by Gerald Mast, Marshall Cohen, and Leo Baudry [Oxford: Oxford University Press, 1992] p. 749). "The camera becomes the mechanism for producing an illusion of Renaissance space" (ibid., p. 757).

13. Functionalism in the philosophy of mind is best viewed as the successor to behaviorism. The behaviorists said that mental states are items of behavior or, on a more sophisticated conception, dispositions to behave. Functionalism rejects this idea, but holds to the idea that behavior is still constitutive of mental states. For example, a (grossly simplified) functionalist definition of pain might say that pain is the mental state which is typically caused by bodily damage and typically causes avoidance behavior.

14. Many writers on film emphasize the partial nature of the illusion that film creates, and how it competes with our knowledge that it is an illusion. Jean-Louis Comolli, for example, says that "We want to be . . . both fooled and not fooled [by cinema]" ("Machines of the Visible," in *Film Theory and Criticism*, p. 759). See also Metz's qualifications, n. 4 above. But such admissions do little to make the illusionist view more plausible. Film viewers do not behave like people who even partially believe in the reality of what they see, or who are torn between belief and disbelief. See Kendall Walton, "Fearing Fictions," *Journal of Philosophy* 75 (1978): 5–27.

15. See my *The Nature of Fiction* (New York: Cambridge University Press, 1990), chapter 5, and my "Imagination and Simulation: Aesthetics Meets Cognitive Science," in *Mental Simulation*, ed. M. Davies and A. Stone (Oxford: Basil Blackwell, 1994). See also Kendall Walton, *Mimesis as Make-Believe: On the Foundation of the Representational Arts* (Cambridge: Harvard University Press, 1990).

16. On this, see also William Rothman, "Against 'The System of the Suture,'" in *Movies and Methods*, vol. 1, ed. Bill Nichols (Berkeley: University of California Press, 1976).

17. ". . . [the viewer] certainly has to identify . . . if he did not the film would become incomprehensible" (Metz, *The Imaginary Signifier*, p. 46). See also Nick Brown, *The Rhetoric of Filmic Narration* (Ann Arbor, Mich.: UMI Research Press, 1976), chapter 1.

18. Jacques Aumont, "The Point of View," *Quarterly Review of Film and Video* 11 (1989), p. 2. On shot/reverse-shot editing as a means of maintaining the illusionism of film, see Kaja Silverman, *The Subject of Semiotics* (New York: Oxford University Press, 1983), p. 202.

19. Noël Carroll, *Mystifying Movies: Fads and Fallacies in Contemporary Film Theory* (New York: Columbia University Press, 1988).

20. See Christopher Peacocke, *Sense and Content: Experience, Thought, and Its Relations* (Oxford: Clarendon Press, 1983), pp. 5–6.

21. "Basic Film Aesthetics," in *Film Theory and Criticism*. See also Haig Khatchadourian, "Remarks on the 'Cinematic/Uncinematic Distinction' in Film Art," in his *Music, Film, and Art* (New York: Gordon and Breach, 1985), p. 134: "a film . . . is necessarily a sequence of visual images that create the illusion of movement."

22. See Frank Jackson, "Metaphysics by Possible Cases," in *1992 ANU Metaphysics Conference*, ed. Brian Garrett and Peter Menzies. Working Papers in Philosophy no. 2, Research School of Social Sciences, Australian National University (Canberra, 1992).

23. Paul A. Boghossian and J. David Velleman, "Colour as a Secondary Quality," *Mind* 98 (1989): 80–103.

24. Stuart Anstis, "Motion Perception in the Frontal Plane," in *Handbook of Perception and Human Performance*, vol. 1, ed. K. Boff, L. Kaufman, and J. Thomas (New York: Wiley, 1986).

25. See Richard Holton, "Intentions, Response-Dependence, and Immunity from Error," in *Response-Dependent Concepts*, ed. Peter Menzies (Research School of Social Sciences, Australian National University: Canberra, 1991).

# VIVIAN SOBCHACK

## Phenomenology and Film Experience

### FROM *The Address of the Eye*

Vivian Sobchack (b. 1940) is Professor Emerita of Critical Studies in the Department of Film, Television and Digital Media at UCLA, where she also served as Associate Dean before her retirement. A leader in film studies throughout her career, Sobchack was the first woman elected president of the Society for Cinema Studies (the national scholarly organization in the field); she has also been a member of the American Film Institute's Board of Trustees since 1989. Sobchack's film criticism has consistently offered fresh perspectives on film genres, new media, and gender theory. In addition to *The Address of the Eye* (1992), Sobchack also explores film and media theory and its intersections with philosophy and cultural studies in her other work, including *Screening Space: The American Science Fiction Film* (1987) and *Carnal Thoughts: Bodies, Texts, Scenes and Screens* (2004).

Concerned with the dynamics of film spectatorship and reception, Sobchack's work both parallels and engages with important trends in contemporary film practice and theory. Since the 1970s, numerous filmmakers have questioned realist and classical film traditions through analytical and reflexive strategies. The films of Jean-Luc Godard, Yvonne Rainer, and Rainer Werner Fassbinder all unsettle and distance spectators by foregrounding the "language" of cinema, albeit using very different approaches. These filmmakers "deconstruct" cinematic illusions, while provoking more active and reflective viewers. For example, Godard's films since the 1960s continually call attention to how images are being constructed as forms through which we see and understand the world; they are less about an individual, an action, or a story than about how editing and sound construct those realities. Film scholarship and criticism have also followed a similar vein in the last thirty years, promoting a comparable deconstructive criticism, underpinned by structuralist, poststructuralist, and feminist methodologies grounded in linguistic, Brechtian, and Marxist aesthetic theories.

The excerpt from "Phenomenology and Film Experience," is clearly based on the work of French philosopher Maurice Merleau-Ponty; in it Sobchack argues how our experience of the movies is first and foremost an "embodied" experience enacted simultaneously as a perception and an expression. For Sobchack, meaning and significance at the movies entail emotional and bodily experiences as well as intellectual and psychological ones, and her work consistently emphasizes an "embodied" relationship with films that is less analytical and distanced and more kinetic and dynamic. To some extent, Sobchack's phenomenological film viewer recalls earlier notions of the film viewer, including the idea of spectatorial "shocks" in Sergei Eisenstein's montage theories (p. 262) and André Bazin's notions of the positions of "uncertainty" and "ambiguity" that viewers inhabit in some films (p. 309). Despite her clear polemic with many contemporaries, Sobchack's position does align with recent scholarly work that has similarly considered film viewing as a more dynamic activity, such as Tom Gunning's "The Cinema of Attractions" (p. 69) and Carol J. Clover's arguments in "Her Body, Himself" (p. 511).

## READING CUES & KEY CONCEPTS

■ Sobchack notes that film theory has commonly employed three metaphors to describe the film experience: "the *picture frame*, the *window*, and the *mirror*." Explain how each of these metaphors works to describe our movie experiences—and why, for Sobchack, each proves inadequate.

■ Consider Sobchack's idea of audiences having an "embodied" relationship with a film. How might a particular movie become an embodied activity? Are there some kinds of films—such as horror movies or thrillers—in which this activity more obviously occurs?

■ One of Sobchack's more complex formulations concerns the "intersubjective" communication of films as the simultaneous "perception of expression" and "expression of perception." How would you explain this interaction of visual perception and expression at the movies?

■ **Key Concepts:** Phenomenology; Transcendental Idealism; Transcendental Realism; Transcendental Determinism; Intentionality; Embodied Viewing; Intersubjectivity

# Phenomenology and Film Experience

. . . . . . . . . . . . . .

## *Film Theory and the Objectification of Embodied Vision*

The reversibility of cinematic perception and expression is the "enabling structure" of cinematic communication.[1] In semiotic terms, it constitutes what Umberto Eco calls an "s-code": the system-code that "makes a situation comprehensible and comparable to other situations, therefore preparing the way for a possible coding correlation."[2] Without such a systemic exchange of cinematic perception and expression (one comparable to and comprehensible as such an exchange in the human situation), other secondary and more systematic cinematic coding correlations

would not be possible and comprehensible. There could be no narrative codes, no codes of subjective vision, no editorial codes, and their like. Nonetheless, the cinematic system-code constituted by the exchange and reversibility of perception and expression has been almost completely neglected by the respective analytic and synthetic emphases of classical and contemporary film theory.[3]

Three metaphors have dominated film theory: the *picture frame*, the *window*, and the *mirror.*[4] The first two, the frame and the window, represent the opposing poles of classical film theory, while the third, the mirror, represents the synthetic conflation of perception and expression that characterizes most contemporary film theory. What is interesting to note is that all three metaphors relate directly to the screen rectangle and to the film as a static *viewed object*, and only indirectly to the dynamic activity of viewing that is engaged in by both the film and the spectator, each as *viewing subjects*. The exchange and reversibility of perception and expression (both in and as the film and spectator) are suppressed, as are the intrasubjective and intersubjective foundations of cinematic communication.

Most often identified with the binary poetics of a sufficiently opposed but necessarily linked *formalism* and *realism*, classical film theory has argumentatively and analytically severed expression from perception in its inquiries into the "true nature" or ontology of the cinema. That is, cinematic "language" (here we might think of montage) and cinematic being (and here of mise-en-scène) have been contrasted categorically and set against each other as opposing poles of a single, digital, two-valued system—each, in opposing the other, affirming it by implication and dependent upon it by necessity. The formalists, seeking to transform and restructure the "brute" referentiality and "wild" meaning of cinematic images into personally determinate and expressive signification (hence the metaphor of the frame), acknowledge the camera's perceptive nature as they celebrate the artist's triumph over it. On the other side, the realists, seeking to reveal and discover the world's expression in all its "wild" meaning (hence the metaphor of the window), acknowledge the camera's expressive nature in its selective and shifting vision, even as they celebrate the medium's perceptual purity and openness. For the most part, however, this dependence on and suppression of one of the necessary conditions for the existence of a film has not been overtly articulated as the infrastructure that binds formalism and realism into a single theoretical system.[5] Instead, the emphasis has been on a dual poetics— one valorizing cinematic expression and the other, cinematic perception.

Opposing each other, both formalist and realist arguments converge in their assumption that meaning is located in the text as a significant object, and in their assumption of that text's transcendence of its origin and location either in the world or in persons. The metaphor of the frame is emblematic of the *transcendental idealism* that infuses classical formalism and its belief in the film object as *expression-in-itself*—subjectivity freed from worldly constraint. In contrast, the window as metaphor is emblematic of the *transcendental realism* that informs realist film theory and its belief in the film object as *perception-in-itself*—objectivity freed from entailment with the prejudicial investments of human being. The first belief leads to the formalist celebration of what phenomenology criticizes as "subjective psychologism," the second to the realist celebration of what it decries as "objective empiricism."[6]

In an attempt to correct this tidy theoretical opposition and its contradiction by actual cinematic practice, contemporary theorists have tended to synthesize perception and expression, categorically collapsing and confusing them in an analogue relation in which they are distinguishable only by degree, not by modality. The nature of film is considered as neither perceptive nor expressive. Rather, both modalities of existential experience are conflated as a synthesis of the *refractive*, *reflexive*, and *reflective* (hence the metaphor of the mirror). Drawing primarily upon linguistically oriented psychoanalytic and neo-Marxist paradigms (the former already privileging the metaphor of the mirror for its own purposes), the resultant theories of cinematic communication have emerged not as a celebratory poetics, but as a critical rhetoric, charging cinematic communication with some equivalent to sophistry.

That is, contemporary theory (most of it feminist and/or neo-Marxist in approach) has focused on the essentially deceptive, illusionary, tautologically recursive, and coercive nature of the cinema, and on its psychopathological and/or ideological functions of distorting existential experience. Such theory elaborately accounts for cinematic representation but cannot account for the originary activity of cinematic signification. Thus, it is hardly surprising, if poignant, that, attempting to liberate female spectatorship and spectators of color from linguistically determined psychic structures and colonial discursive structures, psychoanalytically based feminist film theory and ideologically based film theory so often bemoan the impossibility of a "new" language to express the specificity of their excluded experience and the lack of an uncolonized "place" from which to speak. Articulated in various ways and amid a number of highly sophisticated arguments, what contemporary film theory stresses and decries in its variations on the metaphor of the mirror is the totalitarian transcendence of either psychic or ideological structures over the signifying freedom of individual viewers in their concrete, contingent, existential situation. As perception and expression are confused with each other in the deceptive processes of the cinematic apparatus and the seamless and conventional unfolding of a privileged (if reviled) "classical narrative cinema," the possibility of dialogic and dialectical communication is suppressed and the film experience is seen as grounded in a false and sophistic rhetoric that essentially distorts the possibility of any "real" communication.

Thus, the metaphor of the mirror entails a critical judgment of the cinema that is as damning as it is descriptive. It condemns the very ontological being of cinema as substitutive (rather than expansive) and deceptive (rather than disclosing). It reflects the viewer only to point to his or her subjection to signs and meanings produced by an always already dishonest and subjugating "other." Idealist in its utopian longings for liberatory signification while losing itself in a labyrinth of representation, contemporary film theory is informed by a *transcendental determinism*—based on the belief in the film object as *mediation-in-itself.* In the one instance, signification and significance are seen as always predetermined by apparatus and ideology; the film object as it is experienced invisibly and rhetorically interpellates the spectator and speaks the culture, producing cinematic language and its norms of usage as a *given.* In the other instance, signification and significance are predetermined by psychic structures; the camera's and spectator's vision are confused and bound

together in a false and distorted primary identification that cannot be denied, only disavowed. In sum, in most contemporary theory, viewing in the cinema leads to no good—or, at best, to the remedial practice of demystifying the cinema's material, structural, and ideological pathology and, at worst, to a pleasure that is guilty and must be adjudged "perverse."

In most of its classical and contemporary articulations, then, film theory has focused not on the *whole correlational structure* of the film experience, but has abstracted and privileged only one of its *parts* at a time: expression-in-itself, perception-in-itself, and mediation-in-itself, respectively. Although the next section of this chapter will introduce the reader to phenomenology as the philosophy and research procedure that informs the remainder of this study, film theory's abstraction and fragmentation of the correlational structure that is the film experience can be criticized against the main phenomenological theme of *intentionality*: the invariant, pervasive, and immanent correlational structure of consciousness. Intentionality is "the unique peculiarity of experiences 'to be the consciousness *of* something.'"[7] That is, the act of consciousness is never "empty" and "in-itself," but rather always intending toward and in relation to an object (even when that "object" is consciousness, reflexively intended). The invariant correlational structure of consciousness thus necessarily entails the *mediation* of an *activity* and an *object*. If we substitute the specificity of the film experience as a reversible structure correlating the activity of perception and expression and commuting one to the other, the whole of the structure could, and later will more elaborately, be mapped as follows: *the perception* (act of consciousness) *of* (mediation) *expression* (object of consciousness) *and/as the expression* (act of consciousness) *of* (mediation) *perception* (object of consciousness). In relation to my previous thematization of classical and contemporary film theory, formalist theory can be linked to a focus on the cinematic *expression* (of perception)—perception here represented as the suppressed part of the entire relation; realist theory to a focus on the cinematic *perception* (of expression)—expression here represented as the suppressed part of the entire relation; and contemporary theory to a focus on the mediating copula (perception) *of* (expression)—with perception and expression represented as the suppressed part of the entire relation.

Whatever their respectively different foci, classical and contemporary film theory have pursued their inquiry into the nature of cinematic signification sharing three crucial and largely uninterrogated presuppositions. First, film theory has presupposed *the act of viewing*. Certainly, there have been some considerations of the anatomical, mechanical, and psychic aspects of vision that characterize and differentiate the human and camera eye.[8] As well, a major portion of contemporary film theory dwells on the psychoanalytic aspects of the spectator's visual engagement with the cinema. Nonetheless, film theory has generally assumed as given the act of viewing in its totality, that is, as *the constituting condition of the film experience* in each and all of its aspects and manifestations, and as the nexus of communication among the filmmaker, film, and spectator.

Second, film theory has presupposed the cinema's and spectator's *communicative competence*. Discussions of cinematic codes and their entailments are all based on the assumption that a film is intelligible as the imaging and expression of experience—something that "counts" and has a particular kind of significance above

the random projection and play of brute light and shadow. That is, although film theory has attempted to describe and explain cinematic signification or "language" in great detail, it has assumed the cinema's power to signify and the spectator's power to see this signification as significant. It has assumed *the fundamental intelligibility of the film experience.* Whether fragmenting its analyses of cinematic semiosis into a syntactics (primarily revealed in the formalist emphasis on structuring), a semantics (primarily revealed in the realist emphasis on content), or a pragmatics (primarily revealed in the contemporary theorist's emphasis on relational functions), film theory has assumed rather than accounted for the film experience's intrasubjective and intersubjective nature and its transitive function or performance.

Third, film theory has presupposed that a film is a *viewed object.* Whether it has been considered the aesthetic and expressive object of the formalist; the empirical and perceptive object of the realist; or the cultural, rhetorical, and reflexive object of the contemporary theorist; the film has been regarded as merely, if complexly, a vehicle through which meaning can be represented, presented, or produced; a visible object in the manner of the frame, the window, and the mirror. That a film, as it is experienced, might be engaged as something *more* than just an object of consciousness is a possibility that has not been entertained.

These three presuppositions have informed almost all film theory and directed its fragmented course and conclusions. That the act of viewing constitutes cinematic communication, that communication occurs, and that the communication is effected by a viewed object on a viewing subject (despite contemporary theory's objectification of the viewing subject as the predicate of cinematic vision)—these are the givens of the film experience and the ground upon which various theories of film base themselves and from which they proceed.

However, these presuppositions are themselves open to investigation and, indeed, require it if we are to understand the original power of the cinema to signify, its genesis of meaning and ability to communicate, its "expression of experience by experience." In this regard, both classical and contemporary theory have provided us only partial descriptions and abstract formulations that have detached cinematic signification from its origin in concrete sense and significance. As Dudley Andrew points out:

> We can speak of codes and textual systems which are the results of signifying processes, yet we seem unable to discuss that mode of experience we call signification. More precisely, structuralism and academic film theory in general have been disinclined to deal with the "other-side" of signification, those realms of pre-formulation where sensory data congeals into "something that matters" and those realms of post-formulation where that "something" is experienced as mattering. Structuralism, even in its post-structural reach toward psychoanalysis and intertextuality, concerns itself only with that something and not with the process of its congealing nor with the event of its mattering.[9]

Previous discussion has introduced the exchange or reversibility of perception and expression in the film experience as the commutative basis for the emergence of cinematic signification and significance. Focus on this exchange is a focus on both the process that constitutes "something that matters" and the "event of its mattering." It points to and describes the radical and existential ground for both a

theory of sign production and a theory of meaning as they are always entailed in the lived-body experience. Thus, relative to cinema, the *existential and embodied act of viewing* becomes the paradigm of this exchange of perception and expression. That is, the act of viewing provides both the necessary and sufficient conditions for the commutation of perception to expression and vice-versa. It also communicatively links filmmaker, film, and spectator by means of their respective, separate, and yet homeomorphic existential performance of a shared (and possibly universal) competence: the capacity to localize and unify (or "center") the invisible, intrasubjective commutation of perception and expression and make it visible and intersubjectively available to others.

Filmmaker, film, and spectator all concretely use the agency of visual, aural, and kinetic experience to express experience—not only to and for themselves, but also to and for others. Each engaged in the visible gesture of viewing, the filmmaker, film, and spectator are all able to commute the "language of being" into the "being of language," and back again. Dependent upon existence and embodiment in the world for its articulation as an activity, the act of viewing as the commutation of perception and expression is both an intrasubjective and intersubjective performance equally performable by filmmaker, film, and spectator.

## NOTES

1. The phrase "enabling structure" is borrowed from Wolfgang Iser, *The Act of Reading: A Theory of Aesthetic Response* (Baltimore, MD: The Johns Hopkins Univ. Press, 1978), p. 230. The reader is also directed to Iser's discussion of "negativity" (pp. 225–231), which parallels Merleau-Ponty's discussion of reversibility or the "chiasm" in *The Visible and the Invisible*, pp. 130–155.

2. Umberto Eco, *A Theory of Semiotics* (Bloomington: Indiana Univ. Press, 1979), pp. 40, 43–44.

3. In the following paragraphs, I thematize the work of traditional and contemporary film theorists too numerous to cite. The reader unfamiliar with the field who wishes to follow the arguments advanced here is urged to seek out specific theorists and their texts with the help, perhaps, of J. Dudley Andrew, *The Major Film Theories: An Introduction* (New York: Oxford Univ. Press, 1976) and *Concepts in Film Theory* (New York: Oxford Univ. Press, 1984).

4. This formulation was first emphasized in Charles F. Altman, "Psychoanalysis and Cinema: The Imaginary Discourse," *Quarterly Review of Film Studies* 2 (August 1977), pp. 260–264.

5. One of the earliest explicit statements of this systemic interdependence appears in Jean-Luc Godard, "Montage My Fine Care," in *Godard on Godard*, trans. Tom Milne (New York: Viking Press, 1972), pp. 39–41.

6. For basic description and phenomenological critique of the limitations of "subjective psychologism" and "objective empiricism," see the preface to Merleau-Ponty, *Phenomenology of Perception*, pp. vii–xxi. This preliminary discussion is deepened in Chapters 1–3, pp. 3–51.

7. Edmund Husserl, *Ideas: General Introduction to Pure Phenomenology*, trans. W. R. Boyce Gibson (New York: Collier Books, 1962), p. 223.

8. See, for example, Barbara Anderson, "Eye Movement and Cinematic Perception," *Journal of the University Film Association* 32 (Winter-Spring 1980), pp. 23–26.

9. Dudley Andrew, "The Neglected Tradition of Phenomenology in Film Theory," *Wide Angle* 2, No. 2 (1978), pp. 45–46.

# TOM GUNNING

. . . . . . . . . . . . . . . . . . . . . . . . . . . . . . . . . . . . . . . . . . . . .

## The Cinema of Attractions:
## Early Film, Its Spectator
## and the Avant-Garde

With a vast knowledge of early film as well as avant-garde, studio, and art cinemas, Tom Gunning (b. 1949) is one of the foremost figures in cinema studies today. Gunning received his degree from NYU and currently teaches at the University of Chicago, at the center of a group of prominent scholars of the intersection of cinema and modernity in the early twentieth century. Gunning is the author of an important work on the filmic style of D. W. Griffith (1991) and a magisterial study of Fritz Lang (2008), but he may be best known for this short essay on early cinema.

Gunning's 1989 essay "The Cinema of Attractions" combines theoretical reach and originality with well-founded, creative historical claims about how viewers encountered the cinema in its first decade. Together with Gunning's many other pieces on early cinema, his collaborative work with André Gaudreault, and the work of other historians, his essay prompted a paradigm shift in film studies in the 1980s toward the study of film history, particularly the period before the dominance of narrative film. Such research was catalyzed after the pivotal 1978 meeting of the FIAF (Federation of International Film Archives) in Brighton, England, at which hundreds of films from the cinema's first decade were screened. After the dominance of psychoanalytically influenced film theory in the 1970s, which tended to offer an abstract model of spectatorship, many researchers welcomed a return to the study of the concrete historical situations in which audiences responded to the cinema and to particular films. Gunning combined such detail with a theoretical challenge to the reigning story of film history in which narrative films quickly and inevitably achieved dominance.

Gunning asserts that before about 1906 films were unconcerned with storytelling; rather, they simply aimed to establish contact with the audience. The bows and gestures of such onscreen magicians as Méliès, the exotic or everyday views captured by the Lumière brothers, the wink at the camera, and the pie in the face all screamed, "look at me!" Rather than considering early films as "primitive" in technique, Gunning is interested in "the way taking account of this heterogeneity signals a new conception of film history and film form"—and, we might add, of film experience. Gunning contrasts the exhibitionism of these earlier films with later codes of cinematic storytelling that favored viewers' voyeurism, inviting the spectator in as an invisible guest, and compares it to the responses elicited by avant-garde experimentation in film. He extends his observations to the contexts in which films were exhibited—fairgrounds, vaudeville programs, and kinetoscope parlors. Gunning's term "cinema of attractions," is based on Sergei Eisenstein's proposition of cinema as a "montage of attractions" that grabs an audience, mediating the stimulating yet alienating experience of mechanical modernity. Gunning's interpretation of the historical record is interested not only in differences in film style, but also in a fundamentally different mode

of enjoying cinema—one that resonates with audiences' pleasure in contemporary special-effects-dominated cinema. "[E]very change in film history implies a change in its address to the spectator, and each period constructs its spectator in a new way," Gunning claims. His essay, with its forthright style and sense of possibility, has generated several vigorous strains of research. Some of the best of the now-extensive work on early cinema extends his interest in its heterogeneity to film traditions outside the Euro-American canon.

## READING CUES & KEY CONCEPTS

■ How does Gunning rethink the standard account of cinema that opposes the realist films of the Lumière brothers to the fantastical ones of Georges Méliès?

■ What is Gunning's proposed periodization of silent cinema, and what are some of the characteristics of "early cinema" as he defines it?

■ How do certain features of recent blockbusters relate to Gunning's concept of "the cinema of attractions," and how do they differ?

■ How does Gunning's argument bridge theory and history through its focus on the avant-garde?

■ **Key Concepts:** Cinema of Attractions; Exhibitionism; Early Cinema; Modernity

# The Cinema of Attractions: Early Film, Its Spectator and the Avant-Garde

. . . . . . . . . . . . . .

Writing in 1922, flushed with the excitement of seeing Abel Gance's *La Roue*, Fernand Léger tried to define something of the radical possibilities of the cinema. The potential of the new art did not lie in "imitating the movements of nature" or in "the mistaken path" of its resemblance to theater. Its unique power was a "matter of *making images seen*."[1] It is precisely this harnessing of visibility, this act of showing and exhibition, which I feel cinema before 1906 displays most intensely. Its inspiration for the avant-garde of the early decades of this century needs to be re-explored.

Writings by the early modernists (Futurists, Dadaists and Surrealists) on the cinema follow a pattern similar to Léger: enthusiasm for this new medium and its possibilities; and disappointment at the way it has already developed, its enslavement to traditional art forms, particularly theater and literature. This fascination with the *potential* of a medium (and the accompanying fantasy of rescuing the cinema from its enslavement to alien and passé forms) can be understood from a number of viewpoints. I want to use it to illuminate a topic I have also approached before, the strangely heterogeneous relation that film before 1906 (or so) bears to the films that follow, and the way a taking account of this heterogeneity signals a new conception of film history and film form. My work in this area has been pursued in collaboration with André Gaudreault.[2]

The history of early cinema, like the history of cinema generally, has been written and theorized under the hegemony of narrative films. Early film-makers like Smith, Méliès and Porter have been studied primarily from the viewpoint of their contribution to film as a storytelling medium, particularly the evolution of narrative editing. Although such approaches are not totally misguided, they are one-sided and potentially distort both the work of these film-makers and the actual forces shaping cinema before 1906. A few observations will indicate the way that early cinema was not dominated by the narrative impulse that later asserted its sway over the medium. First there is the extremely important role that actuality film plays in early film production. Investigation of the films copyrighted in the US shows that actuality films outnumbered fictional films until 1906.[3] The Lumière tradition of "placing the world within one's reach" through travel films and topicals did not disappear with the exit of the Cinématographe from film production. But even within non-actuality filming—what has sometimes been referred to as the "Méliès tradition"—the role narrative plays is quite different from in traditional narrative film. Méliès himself declared in discussing his working method:

> As for the scenario, the "fable," or "tale," I only consider it at the end. I can state that the scenario constructed in this manner has *no importance*, since I use it merely as a pretext for the "stage effects," the "tricks," or for a nicely arranged tableau.[4]

Whatever differences one might find between Lumière and Méliès, they should not represent the opposition between narrative and non-narrative film-making, at least as it is understood today. Rather, one can unite them in a conception that sees cinema less as a way of telling stories than as a way of presenting a series of views to an audience, fascinating because of their illusory power (whether the realistic illusion of motion offered to the first audiences by Lumière, or the magical illusion concocted by Méliès), and exoticism. In other words, I believe that the relation to the spectator set up by the films of both Lumière and Méliès (and many other film-makers before 1906) had a common basis, and one that differs from the primary spectator relations set up by narrative film after 1906. I will call this earlier conception of cinema, "the cinema of attractions." I believe that this conception dominates cinema until about 1906–7. Although different from the fascination in storytelling exploited by the cinema from the time of Griffith, it is not necessarily opposed to it. In fact the cinema of attractions does not disappear with the dominance of narrative, but rather goes underground, both into certain avant-garde practices and as a component of narrative films, more evident in some genres (e.g. the musical) than in others.

What precisely is the cinema of attractions? First, it is a cinema that bases itself on the quality that Léger celebrated: its ability to *show* something. Contrasted to the voyeuristic aspect of narrative cinema analyzed by Christian Metz,[5] this is an exhibitionist cinema. An aspect of early cinema which I have written about in other articles is emblematic of this different relationship the cinema of attractions constructs with its spectator: the recurring look at the camera by actors. This action, which is later perceived as spoiling the realistic illusion of the cinema, is here undertaken with brio, establishing contact with the audience. From comedians smirking at the camera, to the constant bowing and gesturing of the conjurors in magic films, this is

a cinema that displays its visibility, willing to rupture a self-enclosed fictional world for a chance to solicit the attention of the spectator.

Exhibitionism becomes literal in the series of erotic films which play an important role in early film production (the same Pathé catalogue would advertise the Passion Play along with "scènes grivoises d'un caractère piquant," erotic films often including full nudity), also driven underground in later years. As Noël Burch has shown in his film *Correction Please: How We Got into Pictures* (1979), a film like *The Bride Retires* (France, 1902) reveals a fundamental conflict between this exhibitionistic tendency of early film and the creation of a fictional diegesis. A woman undresses for bed while her new husband peers at her from behind a screen. However, it is to the camera and the audience that the bride addresses her erotic striptease, winking at us as she faces us, smiling in erotic display.

As the quote from Méliès points out, the trick film, perhaps the dominant non-actuality film genre before 1906, is itself a series of displays, of magical attractions, rather than a primitive sketch of narrative continuity. Many trick films are, in effect, plotless, a series of transformations strung together with little connection and certainly no characterization. But to approach even the plotted trick films, such as *Voyage dans la lune* (1902), simply as precursors of later narrative structures is to miss the point. The story simply provides a frame upon which to string a demonstration of the magical possibilities of the cinema.

Modes of exhibition in early cinema also reflect this lack of concern with creating a self-sufficient narrative world upon the screen. As Charles Musser has shown,[6] the early showmen exhibitors exerted a great deal of control over the shows they presented, actually re-editing the films they had purchased and supplying a series of off-screen supplements, such as sound effects and spoken commentary. Perhaps most extreme is the Hale's Tours, the largest chain of theaters exclusively showing films before 1906. Not only did the films consist of non-narrative sequences taken from moving vehicles (usually trains), but the theater itself was arranged as a train car with a conductor who took tickets, and sound effects simulating the click-clack of wheels and hiss of air brakes.[7] Such viewing experiences relate more to the attractions of the fairground than to the traditions of the legitimate theater. The relation between films and the emergence of the great amusement parks, such as Coney Island, at the turn of the century provides rich ground for rethinking the roots of early cinema.

Nor should we ever forget that in the earliest years of exhibition the cinema itself was an attraction. Early audiences went to exhibitions to see machines demonstrated (the newest technological wonder, following in the wake of such widely exhibited machines and marvels as X-rays or, earlier, the phonograph), rather than to view films. It was the Cinématographe, the Biograph or the Vitascope that were advertised on the variety bills in which they premièred, not *Le Déjeuner de bébé* or *The Black Diamond Express*. After the initial novelty period, this display of the possibilities of cinema continues, and not only in magic films. Many of the close-ups in early film differ from later uses of the technique precisely because they do not use enlargement for narrative punctuation, but as an attraction in its own right. The close-up cut into Porter's *The Gay Shoe Clerk* (1903) may anticipate later continuity techniques, but its principal motive is again pure exhibitionism, as the lady lifts her skirt hem, exposing her ankle for all to see. Biograph films such as *Photographing a Female Crook* (1904) and *Hooligan in Jail* (1903) consist of a single shot in which the

camera is brought close to the main character, until they are in mid-shot. The enlargement is not a device expressive of narrative tension; it is in itself an attraction and the point of the film.[8]

To summarize, the cinema of attractions directly solicits spectator attention, inciting visual curiosity, and supplying pleasure through an exciting spectacle—a unique event, whether fictional or documentary, that is of interest in itself. The attraction to be displayed may also be of a cinematic nature, such as the early close-ups just described, or trick films in which a cinematic manipulation (slow motion, reverse motion, substitution, multiple exposure) provides the film's novelty. Fictional situations tend to be restricted to gags, vaudeville numbers or recreations of shocking or curious incidents (executions, current events). It is the direct address of the audience, in which an attraction is offered to the spectator by a cinema showman, that defines this approach to film-making. Theatrical display dominates over narrative absorption, emphasizing the direct stimulation of shock or surprise at the expense of unfolding a story or creating a diegetic universe. The cinema of attractions expends little energy creating characters with psychological motivations or individual personality. Making use of both fictional and non-fictional attractions, its energy moves outward toward an acknowledged spectator rather than inward towards the character-based situations essential to classical narrative.

The term "attractions" comes, of course, from the young Sergei Mikhailovich Eisenstein and his attempt to find a new model and mode of analysis for the theatre. In his search for the "unit of impression" of theatrical art, the foundation of an analysis which would undermine realistic representational theater, Eisenstein hit upon the term "attraction."[9] An attraction aggressively subjected the spectator to "sensual or psychological impact." According to Eisenstein, theater should consist of a montage of such attractions, creating a relation to the spectator entirely different from his absorption in "illusory depictions."[10] I pick up this term partly to underscore the relation to the spectator that this later avant-garde practice shares with early cinema: that of exhibitionist confrontation rather than diegetic absorption. Of course the "experimentally regulated and mathematically calculated" montage of attractions demanded by Eisenstein differs enormously from these early films (as any conscious and oppositional mode of practice will from a popular one).[11] However, it is important to realize the context from which Eisenstein selected the term. Then, as now, the "attraction" was a term of the fairground, and for Eisenstein and his friend Yutkevich it primarily represented their favorite fairground attraction, the roller coaster, or as it was known then in Russia, the American Mountains.[12]

The source is significant. The enthusiasm of the early avant-garde for film was at least partly an enthusiasm for a mass culture that was emerging at the beginning of the century, offering a new sort of stimulus for an audience not acculturated to the traditional arts. It is important to take this enthusiasm for popular art as something more than a simple gesture to *épater les bourgeois*. The enormous development of the entertainment industry since the 1910s and its growing acceptance by middle-class culture (and the accommodation that made this acceptance possible) have made it difficult to understand the liberation popular entertainment offered at the beginning of the century. I believe that it was precisely the exhibitionist quality of turn-of-the-century popular art that made it attractive to the avant-garde—its freedom from the creation of a diegesis, its accent on direct stimulation.

Writing of the variety theater, Marinetti not only praised its aesthetics of aston-ishment and stimulation, but particularly its creation of a new spectator who con-trasts with the "static," "stupid voyeur" of traditional theater. The spectator at the variety theater feels directly addressed by the spectacle and joins in, singing along, heckling the comedians.[13] Dealing with early cinema within the context of archive and academy, we risk missing its vital relation to vaudeville, its primary place of exhibition until around 1905. Film appeared as one attraction on the vaudeville pro-gram, surrounded by a mass of unrelated acts in a non-narrative and even nearly illogical succession of performances. Even when presented in the nickelodeons that were emerging at the end of this period, these short films always appeared in a va-riety format, trick films sandwiched in with farces, actualities, "illustrated songs," and, quite frequently, cheap vaudeville acts. It was precisely this non-narrative va-riety that placed this form of entertainment under attack by reform groups in the early 1910s. The Russell Sage Survey of popular entertainments found vaudeville "depends upon an artificial rather than a natural human and developing interest, these acts having no necessary and as a rule, no actual connection."[14] In other words, no narrative. A night at the variety theater was like a ride on a streetcar or an active day in a crowded city, according to this middle-class reform group, stimulating an unhealthy nervousness. It was precisely such artificial stimulus that Marinetti and Eisenstein wished to borrow from the popular arts and inject into the theater, orga-nizing popular energy for radical purpose.

What happened to the cinema of attractions? The period from 1907 to about 1913 represents the true *narrativization* of the cinema, culminating in the appear-ance of feature films which radically revised the variety format. Film clearly took the legitimate theater as its model, producing famous players in famous plays. The transformation of filmic discourse that D. W. Griffith typifies bound cinematic signi-fiers to the narration of stories and the creation of a self-enclosed diegetic universe. The look at the camera becomes taboo and the devices of cinema are transformed from playful "tricks"—cinematic attractions (Méliès gesturing at us to watch the lady vanish)—to elements of dramatic expression, entries into the psychology of character and the world of fiction.

However, it would be too easy to see this as a Cain and Abel story, with nar-rative strangling the nascent possibilities of a young iconoclastic form of enter-tainment. Just as the variety format in some sense survived in the movie palaces of the 20s (with newsreel, cartoon, sing-along, orchestra performance and some-times vaudeville acts subordinated to, but still coexisting with, the narrative *fea-ture* of the evening); the system of attraction remains an essential part of popular filmmaking.

The chase film shows how, towards the end of this period (basically from 1903 to 1906), a synthesis of attractions and narrative was already underway. The chase had been the original truly narrative genre of the cinema, providing a model for causality and linearity as well as a basic editing continuity. A film like Biograph's *Personal* (1904, the model for the chase film in many ways) shows the creation of a narrative linearity, as the French nobleman runs for his life from the fiancées his personal column ad has unleashed. However, at the same time, as the group of young women pursue their prey toward the camera in each shot, they encounter

some slight obstacle (a fence, a steep slope, a stream) that slows them down for the spectator, providing a mini-spectacle pause in the unfolding of narrative. The Edison Company seemed particularly aware of this, since they offered their plagiarized version of this Biograph film (*How a French Nobleman Got a Wife Through the New York Herald "Personal" Columns*) in two forms, as a complete film or as separate shots, so that any one image of the ladies chasing the man could be bought without the inciting incident or narrative closure.[15]

As Laura Mulvey has shown in a very different context, the dialectic between spectacle and narrative has fueled much of the classical cinema.[16] Donald Crafton in his study of slapstick comedy, "The Pie and the Chase," has shown the way slapstick did a balancing act between the pure spectacle of gag and the development of narrative.[17] Likewise, the traditional spectacle film proved true to its name by highlighting moments of pure visual stimulation along with narrative. The 1924 version of *Ben Hur* was in fact shown at a Boston theater with a timetable announcing the moment of its prime attractions:

8.35  *The Star of Bethlehem*

8.40  *Jerusalem Restored*

8.59  *Fall of the House of Hur*

10.29  *The Last Supper*

10.50  *Reunion*[18]

The Hollywood advertising policy of enumerating the features of a film, each emblazoned with the command, "See!" shows this primal power of the attraction running beneath the armature of narrative regulation.

We seem far from the avant-garde premises with which this discussion of early cinema began. But it is important for the radical heterogeneity which I find in early cinema not to be conceived as a truly oppositional program, one irreconcilable with the growth of narrative cinema. This view is too sentimental and too ahistorical. A film like *The Great Train Robbery* (1903) does point in both directions, toward a direct assault on the spectator (the spectacularly enlarged outlaw unloading his pistol in our faces), and toward a linear narrative continuity. This is early film's ambiguous heritage. Clearly in some sense recent spectacle cinema has reaffirmed its roots in stimulus and carnival rides, in what might be called the Spielberg-Lucas-Coppola cinema of effects.

But effects are tamed attractions. Marinetti and Eisenstein understood that they were tapping into a source of energy that would need focusing and intensification to fulfill its revolutionary possibilities. Both Eisenstein and Marinetti planned to exaggerate the impact on the spectators, Marinetti proposing to literally glue them to their seats (ruined garments paid for after the performance) and Eisenstein setting firecrackers off beneath them. Every change in film history implies a change in its address to the spectator, and each period constructs its spectator in a new way. Now in a period of American avant-garde cinema in which the tradition of contemplative subjectivity has perhaps run its (often glorious) course, it is possible that this earlier carnival of the cinema, and the methods of popular entertainment, still provide an

unexhausted resource—a Coney Island of the avant-garde, whose never dominant but always sensed current can be traced from Méliès through Keaton, through *Un Chien andalou* (1928), and Jack Smith.

## NOTES

First published in *Wide Angle* vol. 8 no. 3/4, Fall 1986.

1. Fernand Léger. "A critical essay on the plastic qualities of Abel Gance's film *The Wheel*," in Edward Fry (ed.), *Functions of Painting*, trans. Alexandra Anderson (New York: Viking Press, 1973), p. 21.

2. See my articles "The non-continuous style of early film," in Roger Holman (ed.), *Cinema 1900–1906* (Brussels: FIAF, 1982), and "An unseen energy swallows space: the space in early film and its relation to American avant garde film" in John L. Fell (ed.), *Film Before Griffith* (Berkeley: University of California Press, 1983), pp. 355–66, and our collaborative paper delivered by A. Gaudreault at the conference at Cerisy on Film History (August 1985) "Le cinéma des premiers temps: un défi à l'histoire du cinéma?" I would also like to note the importance of my discussions with Adam Simon and our hope to investigate further the history and archaeology of the film spectator.

3. Robert C. Allen, *Vaudeville and Film: 1895–1915, A Study in Media Interaction* (New York: Arno Press, 1980), pp. 159, 212–13.

4. Méliès, "Importance du scénario," in Georges Sadoul, *Georges Méliès* (Paris: Seghers, 1961), p. 118 (my translation).

5. Metz, *The Imaginary Signifier: Psychoanalysis and the Cinema*, trans. Celia Britton, Annwyl Williams, Ben Brewster and Alfred Guzzetti (Bloomington: Indiana University Press, 1982), particularly pp. 58–80, 91–7.

6. Musser, "American Vitagraph 1897–1901," *Cinema Journal*, vol. 22 no. 3, Spring 1983, p. 10.

7. Raymond Fielding, "Hale's tours: Ultrarealism in the pre-1910 motion picture," in Fell, *Film Before Griffith*, pp. 116–30.

8. I wish to thank Ben Brewster for his comments after the original delivery of this paper which pointed out the importance of including this aspect of the cinema of attractions here.

9. Eisenstein, "How I became a film director," in *Notes of a Film Director* (Moscow: Foreign Language Publishing House, n.d.), p. 16.

10. "The montage of attractions," in S. M. Eisenstein, *Writings 1922–1934*, edited by Richard Taylor (London: BFI, 1988), p. 35.

11. Ibid.

12. Yon Barna, *Eisenstein* (Bloomington: Indiana University Press, 1973), p. 59.

13. "The variety theater 1913" in Umbro Apollonio (ed.), *Futurist Manifestos* (New York: Viking Press, 1973), p. 127.

14. Michael Davis, *The Exploitation of Pleasure* (New York: Russell Sage Foundation, Dept. of Child Hygiene, Pamphlet, 1911).

15. David Levy, "Edison sales policy and the continuous action film 1904–1906," in Fell, *Film Before Griffith*, pp. 207–22.

16. "Visual pleasure and narrative cinema," in Laura Mulvey, *Visual and Other Pleasures* (London: Macmillan, 1989).

17. Paper delivered at the FIAF Conference on Slapstick, May 1985, New York City.

18. Nicholas Vardac, *From Stage to Screen: Theatrical Method from Garrick to Griffith* (New York: Benjamin Blom, 1968), p. 232.

# STUART HALL

## Encoding/Decoding

Jamaican-born and Oxford-educated, Stuart Hall (b. 1932) served as director of the Centre for Contemporary Cultural Studies (CCCS) at the University of Birmingham from 1968 to 1979. CCCS was established by sociologist Richard Hoggart, whose work, along with that of Raymond Williams and other prominent British Marxists, turned critical attention to the concept of "culture" in the postwar period amid the rapid expansion of mass media and consumer society, the breakup of colonial empires, and disillusionment with the Soviet Union. Many of the central figures in British cultural studies, including Dick Hebdige, Paul Gilroy, and Angela McRobbie, studied at the center during Hall's tenure. Although Hall is perhaps best known for his work on race and cultural identity, essays like "Encoding/Decoding" demonstrate the centrality of film and media to his work. Hall was the recipient of an achievement award from the Society of Cinema and Media Studies in 2005.

British cultural studies challenged the nineteenth-century idea of "culture" promulgated by Matthew Arnold as "the best that is thought and known" with a more anthropological understanding of culture as a "whole way of life." Rooted in sociology as well as the humanities, it drew on the writings of the Italian Marxist Antonio Gramsci and focused on working class, youth, and immigrant subcultures as well as the mass media. Hall's approach to television differs from that of sociologically oriented American communications studies in its Marxist politics, interdisciplinary methods, and the profound influence of such French theorists as Roland Barthes, whose writings on semiotics provide a model for "Encoding/Decoding" (1973).

Hall's study of televisual discourse arises from the British context of nationalized broadcasting, which is seen as having a more "official" voice than commercially supported U.S. media. "Encoding/Decoding" reads at first like a technical article on communications, but important aspects of Hall's argument belie this neutrality and explain the essay's extremely influential status. Hall is concerned with how messages like television news are conveyed in the "language" of a culture's dominant—or in Gramsci's term, "hegemonic"—power relations. In semiotics, a "code" must be shared by senders and receivers of messages for signification to occur. Hall emphasizes that the social context in which a message is exchanged (for example social hierarchies or political events) makes the moment of decoding open to various new meanings provided by audiences—they "get the message," but the message is influenced and may be altered by their specific situations. Thus some audiences might produce "oppositional" readings of official messages, while others might provide "negotiated" interpretations, in which some parts of the dominant message are rejected and some retained. Hall's essay has provided the basis for several decades of work on reception as it varies among locales, generations, communities, and subcultures.

## READING CUES & KEY CONCEPTS

▪ Hall states that production and reception are two distinct but mutually determined moments in the communication process. Note his emphasis on the relative autonomy of the audience's process of decoding and consider how it opens up room for critique of dominant meanings.

▪ Hall draws on the vocabulary of semiotics—codes and messages, connotation and denotation—to discuss how meaning is shaped in television. Consider his discussion of visual messages and how they are more easily taken for "reality" than verbal ones.

▪ The terms "dominant," "negotiated," and "oppositional" are used by Hall to talk about different points on a spectrum of response to the media. Think of an example of a current news media event, and consider how hypothetical audience members might produce these three types of responses.

▪ **Key Concepts:** Code/Message; Ideology; Articulation; Discourse; Hegemony; Connotation/Denotation; Production/Reception; Determination; Polysemy; Preferred Reading; Dominant/Negotiated/Oppositional

# Encoding/Decoding

Traditionally, mass-communications research has conceptualized the process of communication in terms of a circulation circuit or loop. This model has been criticized for its linearity—sender/message/receiver—for its concentration on the level of message exchange and for the absence of a structured conception of the different moments as a complex structure of relations. But it is also possible (and useful) to think of this process in terms of a structure produced and sustained through the articulation of linked but distinctive moments—production, circulation, distribution/consumption, reproduction. This would be to think of the process as a "complex structure in dominance," sustained through the articulation of connected practices, each of which, however, retains its distinctiveness and has its own specific modality, its own forms and conditions of existence. This second approach, homologous to that which forms the skeleton of commodity production offered in Marx's *Grundrisse* and in *Capital,* has the added advantage of bringing out more sharply how a continuous circuit—production–distribution–production—can be sustained through a "passage of forms."[1] It also highlights the specificity of the forms in which the product of the process "appears" in each moment, and thus what distinguishes discursive "production" from other types of production in our society and in modern media systems.

The "object" of these practices is meanings and messages in the form of sign-vehicles of a specific kind organized, like any form of communication or language, through the operation of codes within the syntagmatic chain of a discourse. The apparatuses, relations and practices of production thus issue, at a certain moment (the moment of "production/circulation") in the form of symbolic vehicles constituted within the rules of "language." It is in this discursive form that the circulation of the "product" takes place. The process thus requires, at the production end, its material

instruments—its "means"—as well as its own sets of social (production) relations—the organization and combination of practices within media apparatuses. But it is in the *discursive* form that the circulation of the product takes place, as well as its distribution to different audiences. Once accomplished, the discourse must then be translated—transformed, again—into social practices if the circuit is to be both completed and effective. If no "meaning" is taken, there can be no "consumption." If the meaning is not articulated in practice, it has no effect. The value of this approach is that while each of the moments, in articulation, is necessary to the circuit as a whole, no one moment can fully guarantee the next moment with which it is articulated. Since each has its specific modality and conditions of existence, each can constitute its own break or interruption of the "passage of forms" on whose continuity the flow of effective production (that is, "reproduction") depends.

Thus while in no way wanting to limit research to "following only those leads which emerge from content analysis,"[2] we must recognize that the discursive form of the message has a privileged position in the communicative exchange (from the viewpoint of circulation), and that the moments of "encoding" and "decoding," though only "relatively autonomous" in relation to the communicative process as a whole, are *determinate* moments. A "raw" historical event cannot, *in that form*, be transmitted by, say, a television newscast. Events can only be signified within the aural-visual forms of the televisual discourse. In the moment when a historical event passes under the sign of discourse, it is subject to all the complex formal "rules" by which language signifies. To put it paradoxically, the event must become a "story" before it can become a *communicative event*. In that moment the formal sub-rules of discourse are "in dominance," without, of course, subordinating out of existence the historical event so signified, the social relations in which the rules are set to work or the social and political consequences of the event having been signified in this way. The "message form" is the necessary "form of appearance" of the event in its passage from source to receiver. Thus the transposition into and out of the "message form" (or the mode of symbolic exchange) is not a random "moment," which we can take up or ignore at our convenience. The "message form" is a determinate moment; though, at another level, it comprises the surface movements of the communications system only and requires, at another stage, to be integrated into the social relations of the communication process as a whole, of which it forms only a part.

From this general perspective, we may crudely characterize the television communicative process as follows. The institutional structures of broadcasting, with their practices and networks of production, their organized relations and technical infrastructures, are required to produce a programme. Using the analogy of *Capital*, this is the "labour process" in the discursive mode. Production, here, constructs the message. In one sense, then, the circuit begins here. Of course, the production process is not without its "discursive" aspect: it, too, is framed throughout by meanings and ideas: knowledge-in-use concerning the routines of production, historically defined technical skills, professional ideologies, institutional knowledge, definitions and assumptions, assumptions about the audience and so on frame the constitution of the programme through this production structure. Further, though the production structures of television originate the television discourse, they do not constitute a closed system. They draw topics, treatments, agendas, events, personnel, images of

the audience, "definitions of the situation" from other sources and other discursive formations within the wider socio-cultural and political structure of which they are a differentiated part. Philip Elliott has expressed this point succinctly, within a more traditional framework, in his discussion of the way in which the audience is both the "source" and the "receiver" of the television message. Thus—to borrow Marx's terms—circulation and reception are, indeed, "moments" of the production process in television and are reincorporated, via a number of skewed and structured "feedbacks," into the production process itself. The consumption or reception of the television message is thus also itself a "moment" of the production process in its larger sense, though the latter is "predominant" because it is the "point of departure for the realization" of the message. Production and reception of the television message are not, therefore, identical, but they are related: they are differentiated moments within the totality formed by the social relations of the communicative process as a whole.

At a certain point, however, the broadcasting structures must yield encoded messages in the form of a meaningful discourse. The institution-societal relations of production must pass under the discursive rules of language for its product to be "realized." This initiates a further differentiated moment, in which the formal rules of discourse and language are in dominance. Before this message can have an "effect" (however defined), satisfy a "need" or be put to a "use," it must first be appropriated as a meaningful discourse and be meaningfully decoded. It is this set of decoded meanings which "have an effect," influence, entertain, instruct or persuade, with very complex perceptual, cognitive, emotional, ideological or behavioural consequences. In a "determinate" moment the structure employs a code and yields a "message": at another determinate moment the "message," via its decodings, issues into the structure of social practices. We are now fully aware that this re-entry into the practices of audience reception and "use" cannot be understood in simple behavioural terms. The typical processes identified in positivistic research on isolated elements—effects, uses, "gratifications"—are themselves framed by structures of understanding, as well as being produced by social and economic relations, which shape their "realization" at the reception end of the chain and which permit the meanings signified in the discourse to be transposed into practice or consciousness (to acquire social use value or political effectivity).

Clearly, what we have labelled in the diagram "meaning structures 1" and "meaning structures 2" may not be the same. They do not constitute an "immediate identity." The codes of encoding and decoding may not be perfectly symmetrical. The degrees of symmetry—that is, the degrees of "understanding" and "misunderstanding" in the communicative exchange—depend on the degrees of symmetry/asymmetry (relations of equivalence) established between the positions of the "personifications," encoder-producer and decoder-receiver. But this in turn depends on the degrees of identity/non-identity between the codes which perfectly or imperfectly transmit, interrupt or systematically distort what has been transmitted. The lack of fit between the codes has a great deal to do with the structural differences of relation and position between broadcasters and audiences, but it also has something to do with the asymmetry between the codes of "source" and "receiver" at the moment of transformation into and out of the discursive form. What are called "distortions" or "misunderstandings" arise precisely from the *lack of equivalence* between the two sides in

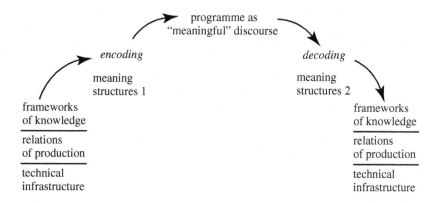

the communicative exchange. Once again, this defines the "relative autonomy" but "determinateness," of the entry and exit of the message in its discursive moments.

The application of this rudimentary paradigm has already begun to transform our understanding of the older term, television "content." We are just beginning to see how it might also transform our understanding of audience reception, "reading" and response as well. Beginnings and endings have been announced in communications research before, so we must be cautious. But there seems some ground for thinking that a new and exciting phase in so-called audience research, of a quite new kind, may be opening up. At either end of the communicative chain the use of the semiotic paradigm promises to dispel the lingering behaviourism which has dogged mass-media research for so long, especially in its approach to content. Though we know the television programme is not a behavioural input, like a tap on the knee cap, it seems to have been almost impossible for traditional researchers to conceptualize the communicative process without lapsing into one or other variant of low-flying behaviourism. We know, as Gerbner has remarked, that representations of violence on the TV screen "are not violence but messages about violence":[3] but we have continued to research the question of violence, for example, as if we were unable to comprehend this epistemological distinction.

The televisual sign is a complex one. It is itself constituted by the combination of two types of discourse, visual and aural. Moreover, it is an iconic sign, in Peirce's terminology, because "it possesses some of the properties of the thing represented."[4] This is a point which has led to a great deal of confusion and has provided the site of intense controversy in the study of visual language. Since the visual discourse translates a three-dimensional world into two-dimensional planes, it cannot, of course, *be* the referent or concept it signifies. The dog in the film can bark but it cannot bite! Reality exists outside language, but it is constantly mediated by and through language: and what we can know and say has to be produced in and through discourse. Discursive "knowledge" is the product not of the transparent representation of the "real" in language but of the articulation of language on real relations and conditions. Thus there is no intelligible discourse without the operation of a code. Iconic signs are therefore coded signs too—even if the codes here work differently from

those of other signs. There is no degree zero in language. Naturalism and "realism"— the apparent fidelity of the representation to the thing or concept represented— is the result, the effect, of a certain specific articulation of language on the "real." It is the result of a discursive practice.

Certain codes may, of course, be so widely distributed in a specific language community or culture, and be learned at so early an age, that they appear not to be constructed—the effect of an articulation between sign and referent—but to be "naturally" given. Simple visual signs appear to have achieved a "near-universality" in this sense: though evidence remains that even apparently "natural" visual codes are culture-specific. However, this does not mean that no codes have intervened; rather, that the codes have been profoundly *naturalized*. The operation of naturalized codes reveals not the transparency and "naturalness" of language but the depth, the habituation and the near-universality of the codes in use. They produce apparently "natural" recognitions. This has the (ideological) effect of concealing the practices of coding which are present. But we must not be fooled by appearances. Actually, what naturalized codes demonstrate is the degree of habituation produced when there is a fundamental alignment and reciprocity—an achieved equivalence—between the encoding and decoding sides of an exchange of meanings. The functioning of the codes on the decoding side will frequently assume the status of naturalized percep-tions. This leads us to think that the visual sign for "cow" actually *is* (rather than *represents*) the animal, cow. But if we think of the visual representation of a cow in a manual on animal husbandry—and, even more, of the linguistic sign "cow"—we can see that both, in different degrees, are *arbitrary* with respect to the concept of the animal they represent. The articulation of an arbitrary sign—whether visual or verbal—with the concept of a referent is the product not of nature but of conven-tion, and the conventionalism of discourses requires the intervention, the sup-port, of codes. Thus Eco has argued that iconic signs "look like objects in the real world because they reproduce the conditions (that is, the codes) of perception in the viewer."[5] These "conditions of perception" are, however, the result of a highly coded, even if virtually unconscious, set of operations—decodings. This is as true of the photographic or televisual image as it is of any other sign. Iconic signs are, however, particularly vulnerable to being "read" as natural because visual codes of perception are very widely distributed and because this type of sign is less arbitrary than a lin-guistic sign: the linguistic sign "cow" possesses *none* of the properties of the thing represented, whereas the visual sign appears to possess *some* of those properties.

This may help us to clarify a confusion in current linguistic theory and to define precisely how some key terms are being used in this article. Linguistic theory fre-quently employs the distinction "denotation" and "connotation." The term "denota-tion" is widely equated with the literal meaning of a sign: because this literal meaning is almost universally recognized, especially when visual discourse is being employed, "denotation" has often been confused with a literal transcription of "reality" in language—and thus with a "natural sign," one produced without the intervention of a code. "Connotation," on the other hand, is employed simply to refer to less fixed and therefore more conventionalized and changeable, associative meanings, which clearly vary from instance to instance and therefore must depend on the intervention of codes.

We do *not* use the distinction—denotation/connotation—in this way. From our point of view, the distinction is an *analytic* one only. It is useful, in analysis, to be able to apply a rough rule of thumb which distinguishes those aspects of a sign which

appear to be taken, in any language community at any point in time, as its "literal" meaning (denotation) from the more associative meanings for the sign which it is possible to generate (connotation). But analytic distinctions must not be confused with distinctions in the real world. There will be very few instances in which signs organized in a discourse signify *only* their "literal" (that is, near-universally consensualized) meaning. In actual discourse most signs will combine both the denotative and the connotative *aspects* (as redefined above). It may, then, be asked why we retain the distinction at all. It is largely a matter of analytic value. It is because signs appear to acquire their full ideological value—appear to be open to articulation with wider ideological discourses and meanings—at the level of their "associative" meanings (that is, at the connotative level)—for here "meanings" are *not* apparently fixed in natural perception (that is, they are not fully naturalized), and their fluidity of meaning and association can be more fully exploited and transformed.[6] So it is at the connotative *level* of the sign that situational ideologies alter and transform signification. At this level we can see more clearly the active intervention of ideologies in and on discourse: here, the sign is open to new accentuations and, in Vološinov's terms, enters fully into the struggle over meanings—the class struggle in language.[7] This does not mean that the denotative or "literal" meaning is outside ideology. Indeed, we could say that its ideological value is strongly *fixed*—because it has become so fully universal and "natural." The terms "denotation" and "connotation," then, are merely useful analytic tools for distinguishing, in particular contexts, between not the presence/absence of ideology in language but the different levels at which ideologies and discourses intersect.[8]

The level of connotation of the visual sign, of its contextual reference and positioning in different discursive fields of meaning and association, is the point where *already coded* signs intersect with the deep semantic codes of a culture and take on additional, more active ideological dimensions. We might take an example from advertising discourse. Here, too, there is no "purely denotative," and certainly no "natural," representation. Every visual sign in advertising connotes a quality, situation, value or inference, which is present as an implication or implied meaning, depending on the connotational positioning. In Barthes's example, the sweater always signifies a "warm garment" (denotation) and thus the activity/value of "keeping warm." But it is also possible, at its more connotative levels, to signify "the coming of winter" or "a cold day." And, in the specialized sub-codes of fashion, sweater may also connote a fashionable style of *haute couture* or, alternatively, an informal style of dress. But set against the right visual background and positioned by the romantic sub-code, it may connote "long autumn walk in the woods."[9] Codes of this order clearly contract relations for the sign with the wider universe of ideologies in a society. These codes are the means by which power and ideology are made to signify in particular discourses. They refer signs to the "maps of meaning" into which any culture is classified; and those "maps of social reality" have the whole range of social meanings, practices, and usages, power and interest "written in" to them. The connotative levels of signifiers, Barthes remarked, "have a close communication with culture, knowledge, history, and it is through them, so to speak, that the environmental world invades the linguistic and semantic system. They are, if you like, the fragments of ideology."[10]

The so-called denotative *level* of the televisual sign is fixed by certain, very complex (but limited or "closed") codes. But its connotative *level*, though also bounded, is more open, subject to more active *transformations*, which exploit its

polysemic values. Any such already constituted sign is potentially transformable into more than one connotative configuration. Polysemy must not, however, be confused with pluralism. Connotative codes are *not* equal among themselves. Any society/culture tends, with varying degrees of closure, to impose its classifications of the social and cultural and political world. These constitute a *dominant cultural order*, though it is neither univocal nor uncontested. This question of the "structure of discourses in dominance" is a crucial point. The different areas of social life appear to be mapped out into discursive domains, hierarchically organized into *dominant or preferred meanings*. New, problematic or troubling events, which breach our expectancies and run counter to our "common-sense constructs," to our "taken-for-granted" knowledge of social structures, must be assigned to their discursive domains before they can be said to "make sense." The most common way of "mapping" them is to assign the new to some domain or other of the existing "maps of problematic social reality." We say *dominant*, not "determined," because it is always possible to order, classify, assign and decode an event within more than one "mapping." But we say "dominant" because there exists a pattern of "preferred readings"; and these both have the institutional/political/ideological order imprinted in them and have themselves become institutionalized.[11] The domains of "preferred meanings" have the whole social order embedded in them as a set of meanings, practices and beliefs: the everyday knowledge of social structures, of "how things work for all practical purposes in this culture," the rank order of power and interest and the structure of legitimations, limits and sanctions. Thus to clarify a "misunderstanding" at the connotative level, we must refer, *through* the codes, to the orders of social life, of economic and political power and of ideology. Further, since these mappings are "structured in dominance" but not closed, the communicative process consists not in the unproblematic assignment of every visual item to its given position within a set of prearranged codes, but of *performative rules*—rules of competence and use, of logics-in-use—which seek actively to *enforce* or *pre-fer* one semantic domain over another and rule items into and out of their appropriate meaning-sets. Formal semiology has too often neglected this practice of *interpretative work*, though this constitutes, in fact, the real relations of broadcast practices in television.

In speaking of *dominant meanings*, then, we are not talking about a one-sided process which governs how all events will be signified. It consists of the "work" required to enforce, win plausibility for and command as legitimate a *decoding* of the event within the limit of dominant definitions in which it has been connotatively signified. Temi has remarked:

> By the word *reading* we mean not only the capacity to identify and decode a certain number of signs, but also the subjective capacity to put them into a creative relation between themselves and with other signs: a capacity which is, by itself, the condition for a complete awareness of one's total environment.[12]

Our quarrel here is with the notion of "subjective capacity," as if the referent of a televisional discourse were an objective fact but the interpretative level were an individualized and private matter. Quite the opposite seems to be the case. The televisual practice takes "objective" (that is, systemic) responsibility precisely for the relations which disparate signs contract with one another in any discursive instance, and

thus continually rearranges, delimits and prescribes into what "awareness of one's total environment" these items are arranged.

This brings us to the question of misunderstandings. Television producers who find their message "failing to get across" are frequently concerned to straighten out the kinks in the communication chain, thus facilitating the "effectiveness" of their communication. Much research which claims the objectivity of "policy-oriented analysis" reproduces this administrative goal by attempting to discover how much of a message the audience recalls and to improve the extent of understanding. No doubt misunderstandings of a literal kind do exist. The viewer does not know the terms employed, cannot follow the complex logic of argument or exposition, is unfamiliar with the language, finds the concepts too alien or difficult or is foxed by the expository narrative. But more often broadcasters are concerned that the audience has failed to take the meaning as they—the broadcasters—intended. What they really mean to say is that viewers are not operating within the "dominant" or "preferred" code. Their ideal is "perfectly transparent communication." Instead, what they have to confront is "systematically distorted communication."[13]

In recent years discrepancies of this kind have usually been explained by reference to "selective perception." This is the door via which a residual pluralism evades the compulsions of a highly structured, asymmetrical and non-equivalent process. Of course, there will always be private, individual, variant readings. But "selective perception" is almost never as selective, random or privatized as the concept suggests. The patterns exhibit, across individual variants, significant clusterings. Any new approach to audience studies will therefore have to begin with a critique of "selective perception" theory.

It was argued earlier that since there is no necessary correspondence between encoding and decoding, the former can attempt to "pre-fer" but cannot prescribe or guarantee the latter, which has its own conditions of existence. Unless they are wildly aberrant, encoding will have the effect of constructing some of the limits and parameters within which decodings will operate. If there were no limits, audiences could simply read whatever they liked into any message. No doubt some total misunderstandings of this kind do exist. But the vast range must contain *some* degree of reciprocity between encoding and decoding moments, otherwise we could not speak of an effective communicative exchange at all. Nevertheless, this "correspondence" is not given but constructed. It is not "natural" but the product of an articulation between two distinct moments. And the former cannot determine or guarantee, in a simple sense, which decoding codes will be employed. Otherwise communication would be a perfectly equivalent circuit, and every message would be an instance of "perfectly transparent communication." We must think, then, of the variant articulations in which encoding/decoding can be combined. To elaborate on this, we offer a hypothetical analysis of some possible decoding positions, in order to reinforce the point of "no necessary correspondence."[14]

We identify *three* hypothetical positions from which decodings of a televisual discourse may be constructed. These need to be empirically tested and refined. But the argument that decodings do not follow inevitably from encodings, that they are not identical, reinforces the argument of "no necessary correspondence." It also helps to deconstruct the common-sense meaning of "misunderstanding" in terms of a theory of "systematically distorted communication."

The first hypothetical position is that of the *dominant-hegemonic position.* When the viewer takes the connoted meaning from, say, a television newscast or current affairs programme full and straight, and decodes the message in terms of the reference code in which it has been encoded, we might say that the viewer *is operating inside the dominant code.* This is the ideal-typical case of "perfectly transparent communication"—or as close as we are likely to come to it "for all practical purposes." Within this we can distinguish the positions produced by the *professional code.* This is the position (produced by what we perhaps ought to identify as the operation of a "metacode") which the professional broadcasters assume when encoding a message which has *already* been signified in a hegemonic manner. The professional code is "relatively independent" of the dominant code, in that it applies criteria and transformational operations of its own, especially those of a technico-practical nature. The professional code, however, operates *within* the "hegemony" of the dominant code. Indeed, it serves to reproduce the dominant definitions precisely by bracketing their hegemonic quality and operating instead with displaced professional codings which foreground such apparently-neutral-technical questions as visual quality, news and presentational values, televisual quality, "professionalism" and so on. The hegemonic interpretations of, say, the politics of Northern Ireland, or the Chilean *coup* or the Industrial Relations Bill are principally generated by political and military elites: the particular choice of presentational occasions and formats, the selection of personnel, the choice of images, the staging of debates are selected and combined through the operation of the professional code. How the broadcasting professionals are able *both* to operate with "relatively autonomous" codes of their own *and* to act in such a way as to reproduce (not without contradiction) the hegemonic signification of events is a complex matter which cannot be further spelled out here. It must suffice to say that the professionals are linked with the defining elites not only by the institutional position of broadcasting itself as an "ideological apparatus,"[15] but also by the structure of *access* (that is, the systematic "over-accessing" of selective elite personnel and their "definition of the situation" in television). It may even be said that the professional codes serve to reproduce hegemonic definitions specifically by *not overtly* biasing their operations in a dominant direction: ideological reproduction therefore takes place here inadvertently, unconsciously, "behind men's backs."[16] Of course, conflicts, contradictions and even misunderstandings regularly arise between the dominant and the professional significations and their signifying agencies.

The second position we would identify is that of the *negotiated code* or position. Majority audiences probably understand quite adequately what has been dominantly defined and professionally signified. The dominant definitions, however, are hegemonic precisely because they represent definitions of situations and events which are "in dominance" (*global*). Dominant definitions connect events, implicitly or explicitly, to grand totalizations, to the great syntagmatic views-of-the-world: they take "large views" of issues: they relate events to the "national interest" or to the level of geo-politics, even if they make these connections in truncated, inverted or mystified ways. The definition of a hegemonic viewpoint is (a) that it defines within its terms the mental horizon, the universe, of possible meanings, of a whole sector of relations in a society or culture; and (b) that it carries with it the stamp of legitimacy—it appears coterminous with what is "natural," "inevitable," "taken for granted" about

the social order. Decoding within the *negotiated version* contains a mixture of adaptive and oppositional elements: it acknowledges the legitimacy of the hegemonic definitions to make the grand significations (abstract), while, at a more restricted, situational (situated) level, it makes its own ground rules—it operates with exceptions to the rule. It accords the privileged position to the dominant definitions of events while reserving the right to make a more negotiated application to "local conditions," to its own more *corporate* positions. This negotiated version of the dominant ideology is thus shot through with contradictions, though these are only on certain occasions brought to full visibility. Negotiated codes operate through what we might call particular or situated logics: and these logics are sustained by their differential and unequal relation to the discourses and logics of power. The simplest example of a negotiated code is that which governs the response of a worker to the notion of an Industrial Relations Bill limiting the right to strike or to arguments for a wages freeze. At the level of the "national interest" economic debate the decoder may adopt the hegemonic definition, agreeing that "we must all pay ourselves less in order to combat inflation." This, however, may have little or no relation to his/her willingness to go on strike for better pay and conditions or to oppose the Industrial Relations Bill at the level of shop-floor or union organization. We suspect that the great majority of so-called "misunderstandings" arise from the contradictions and disjunctures between hegemonic-dominant encodings and negotiated-corporate decodings. It is just these mismatches in the levels which most provoke defining elites and professionals to identify a "failure in communications."

Finally, it is possible for a viewer perfectly to understand both the literal and the connotative inflection given by a discourse but to decode the message in a *globally* contrary way. He/she detotalizes the message in the preferred code in order to retotalize the message within some alternative framework of reference. This is the case of the viewer who listens to a debate on the need to limit wages but "reads" every mention of the "national interest" as "class interest." He/she is operating with what we must call an *oppositional code.* One of the most significant political moments (they also coincide with crisis points within the broadcasting organizations themselves, for obvious reasons) is the point when events which are normally signified and decoded in a negotiated way begin to be given an oppositional reading. Here the "politics of signification"—the struggle in discourse—is joined.

## NOTES

This article is an edited extract from "Encoding and Decoding in Television Discourse," CCCS Stencilled Paper no. 7.

1. For an explication and commentary on the methodological implications of Marx's argument, see S. Hall, "A reading of Marx's 1857 *Introduction to the Grundrisse,*" in *WPCS* 6 (1974).

2. J.D. Halloran, "Understanding television," Paper for the Council of Europe Colloquy on "Understanding Television" (University of Leicester 1973).

3. G. Gerbner *et al., Violence in TV Drama: A Study of Trends and Symbolic Functions* (The Annenberg School, University of Pennsylvania 1970).

4. Charles Peirce, *Speculative Grammar,* in *Collected Papers* (Cambridge, Mass.: Harvard University Press 1931–58).

5. Umberto Eco, "Articulations of the cinematic code," in *Cinemantics*, no. 1.

6. See the argument in S. Hall, "Determinations of news photographs," in *WPCS* 3 (1972).

7. Vološinov, *Marxism And The Philosophy of Language* (The Seminar Press 1973).

8. For a similar clarification, see Marina Camargo Heck, "Ideological dimensions of media messages."

9. Roland Barthes, "Rhetoric of the image," in *WPCS* 1 (1971).

10. Roland Barthes, *Elements of Semiology* (Cape 1967).

11. For an extended critique of "preferred reading," see Alan O'Shea, "Preferred reading" (unpublished paper, CCCS, University of Birmingham).

12. P. Terni, "Memorandum," Council of Europe Colloquy on "Understanding Television" (University of Leicester 1973).

13. The phrase is Habermas's, in "Systematically distorted communications," in P. Dretzel (ed.), *Recent Sociology* 2 (Collier-Macmillan 1970). It is used here, however, in a different way.

14. For a sociological formulation which is close, in some ways, to the positions outlined here but which does not parallel the argument about the theory of discourse, see Frank Parkin, *Class Inequality and Political Order* (Macgibbon and Kee 1971).

15. See Louis Althusser, "Ideology and ideological state apparatuses," in *Lenin and Philosophy and Other Essays* (New Left Books 1971).

16. For an expansion of this argument, see Stuart Hall, "The external/internal dialectic in broadcasting," *4th Symposium on Broadcasting* (University of Manchester 1972), and "Broadcasting and the state: the independence/impartiality couplet," AMCR Symposium, University of Leicester 1976 (CCCS unpublished paper).

# JUDITH MAYNE

## Paradoxes of Spectatorship

The lucid writing of Judith Mayne (b. 1948), Distinguished Professor of Cinema Studies at the Ohio State University and recipient of a Guggenheim Fellowship, helps make even the most difficult concepts in film theory accessible. A specialist in French cinema and feminist film theory, she is the author of eight books, including *Kino and the Woman Question* (1989); *Private Novels, Public Films* (1988); *Directed by Dorothy Arzner* (1994); *Claire Denis* (2005); and *The Woman at the Keyhole* (1990), a selection from which appears in Part 4 of this volume.

The reception of French film theory during the 1970s and 1980s in England and the United States was enthusiastic, with critics in the emerging discipline especially attracted to the linkage of new ideas about subjectivity and ideology to the influential cultural institution of the cinema. These ideas were articulated most forcefully in the concept of spectatorship, through which individual viewers experience a film's unfolding. As the seminal essays by Christian Metz (p. 17) and Jean-Louis Baudry (p. 34) demonstrate, theories of spectatorship apply the insights of psychoanalysis and Marxist ideological critique to the cinematic apparatus or institution, positing an ideal viewer who is receptive to the psychic and social messages propagated by classical Hollywood films and the dominant

theatrical viewing situation. Such feminist theorists as Laura Mulvey (p. 713) explored this interaction further, making explicit the operation of male privilege in matters of the gaze, identification, and narrative centrality that was implicit in this model.

Mayne wrote *Cinema and Spectatorship* (1993), from which this selection is drawn, to introduce and explicate the concept of spectatorship as it was developed in the often-dense essays of the 1970s and elaborated thereafter. In this book, Mayne both synthesizes theories of the interaction between spectator and film and presents the many subsequent critiques of, as well as departures from, these theories. In "Paradoxes of Spectatorship," she synthesizes three different alternatives and correctives to earlier models of spectatorship, organizing them under the three categories of "address/reception," "fantasy," and "negotiation." Each of these alternatives challenges the homogeneous conceptualization of the cinema and its spectator.

Without abandoning ideological critique or psychoanalysis, the models Mayne discusses offer more flexible approaches to the film experience.

## READING CUES & KEY CONCEPTS

■ Mayne positions each of the models she introduces as a way of introducing heterogeneity to the understanding of spectatorship that prevailed in the 1970s. What are the risks associated with homogeneity?

■ Mayne differentiates between the *reception* of films and a particular film's *address* to a spectator. What different conceptualizations of the viewer do these terms imply?

■ How does the psychoanalytic concept of fantasy complicate previous understandings of the psychic process of identification and desire in spectatorship? Consider how gender and sexuality come into play in this new model.

■ **Key Concepts:** Subject; Spectatorship; 1970s Film Theory; Oedipal Desire; Apparatus; Cinematic Institution; Dominant Ideology; Address/Reception; Fantasy; Negotiation

# Paradoxes of Spectatorship

· · · · · · · · · · · · ·

No matter how controversial and contested theories of the cinematic institution have been, few would argue with their basic premise that the capacity of the cinema to seduce, entertain, or otherwise appeal to its audiences needs to be understood in ideological and psychic terms. The trick, however, is not only in understanding the relationship between the two realms of psychic and social life—a rather large undertaking in any case—but in defining with precision the ways in which the cinema is describable in terms of ideological and psychoanalytic theory, and the extent to which different types of cinema and varied contexts articulate spectatorship in different ways. Even the cognitive approach, which departs most sharply from the assumptions of 1970s film theory, is concerned with conditions of coherence and intelligibility which relate to the kind of ideological analysis central to 1970s film theory.

Does the analysis of the cinematic institution as a staging and restaging of the crises of male oedipal desire, as a regressive plenitude, apply only to a specific historical mode of the cinema—i.e., the classical, narrative Hollywood film? Or, rather, given that the emergence of the cinema is so closely linked to the fictions of Western patriarchal culture, is the cinematic apparatus as theorized in film theory bound to be the condition of *all* cinematic representation? Even within the classical Hollywood cinema, are female spectators thus bound by the Scylla of male spectatorial desire and the Charybdis of exclusion from cinematic fantasies? Given the extent to which analysis of spectatorship has focused on sexual difference (whether foregrounded or so blatantly ignored as to function as a symptom, as in Baudry's case), are other forms of spectator identity—race, class, sexual identity other than gendered identity, age, etc.—always built upon the model of sexual difference, or are they potentially formative in their own right? And to what extent is identity a misleading route toward understanding spectatorship, particularly if it is limited by literalist assumptions, i.e., that black audiences can only "identify" with black characters, female audiences with female ones, etc.? If apparatus theory displaced character identification as the central dynamic in understanding spectatorship, this does not mean that questions of identity have been in any way resolved. For the displacement of identification, however necessary and valuable to the project of 1970s film theory, was nonetheless accomplished at a price—a too easy equation between the "subject" and the attributes of dominance.

Perhaps one of the greatest ironies of contemporary film studies is that the obsessive attention devoted to the cinematic institution occurred at a time when there has perhaps existed more diversity than ever before insofar as modes of cinematic representation and address are concerned. In the United States alone, independent film and video, specifically addressed to a variety of markets—gay and lesbian, feminist, black, hispanic—continues to grow. One of the largest problems confronting spectatorship studies is the simultaneous affirmation of diversity and the recognition that "diversity" can easily function as a ploy, a way of perpetuating the illusions of mainstream cinema rather than challenging them. Put another way, there is no simple division between the cinema which functions as an instrument of dominant ideology, and the cinema which facilitates challenges to it. Now if you assume, as some theorists of the 1970s did, that there is nothing about cinema that is not saturated with ideology, then the radical or contestatory powers of the cinema were limited to those films which functioned to demonstrate the ideological complicity of film.

The most promising and influential work on spectatorship assumes the necessity for understanding cinema as ideologically influenced, but not necessarily monolithically so. Linda Gordon speaks of the necessity to hold competing claims of domination and resistance in unwavering tension, refusing to collapse one into the other (1986). In spectatorship studies, several concepts have emerged to engage with the tension between cinema as monolithic institution and cinema as heterogeneous diversity. The competing claims of homogeneity (of the cinematic apparatus) and heterogeneity (of the spectator and therefore of the different ways in which the apparatus can be understood) frame this chapter.

If the cinematic apparatus is as fully saturated with the ideology of idealism and oedipal desire as 1970s film theory would suggest, then there can be no real history of the cinema, except as variations on a common theme. Or rather, there can be no

history within the cinema, if all cinema is ideological in the same way. We have already encountered criticisms of models of the cinematic apparatus for establishing a monolithic role for the spectator, and for literalizing whatever analogy was articulated, from Plato's cave to the Lacanian imaginary. An opposition between homogeneity and heterogeneity underscores these criticisms, since most alternatives to 1970s film theory take the spectator, not as the effect of the cinema institution, but as a point of departure; and not the ideal spectator as theorized by the cinematic apparatus, but the socially defined spectator who is necessarily heterogeneous—i.e., addressed through a variety of discourses. In other words, responses to apparatus theory are founded on a gap between the ideal subject postulated by the apparatus and the spectator who is always in an imperfect relation to that ideal.

I will examine three terms which have emerged in spectatorship studies to conceptualize the competing claims of the homogeneous cinematic institution and heterogeneous responses to it: the gap between "address" and "reception"; fantasy; and negotiation. Linda Gordon speaks of the need to find a method "in between" the claims of domination and resistance, and the terms I will examine in this chapter are precisely that, concepts meant to convey the contradictory ways in which spectatorship functions. First, the relationship between cinematic address and cinematic reception opens up a space between the "ideal" viewer and the "real" viewer. Address refers to the ways in which a text assumes certain responses, which may or may not be operative in different reception conditions. Central to this apparent paradox is the role of the cinematic "text," whether defined as the individual film or as a set of operations which situate the spectator in certain ways. If spectators can and do respond to films in ways that contradict, reject, or otherwise problematize the presumably "ideal" spectator structured into the text, then the value of textual analysis—arguably the most significant methodological direction undertaken by 1970s film theory—needs to be seriously rethought or re-evaluated.

I noted previously that the version of psychoanalysis promoted within theories of the cinematic subject tends toward a uniform and totalizing version of the unconscious, almost always understood as the resurgence of various crises of (male) oedipal identity. The advantage of such a view, of course, is that the psychic foundations of the cultural order are open to investigation, but the disadvantages far outnumber such advantages. For the unconscious thus defined becomes one more totalizing system, and the work of the psychoanalytically inspired critic becomes just as framed by a master code as any other application of a method. In the context of these problems with psychoanalytic theory and criticism, the notion of *fantasy* has received increasing attention and is the second concept to be discussed in this chapter. An exploration of fantasy allows a far more radical exploration of psychic investment in the cinema, and suggests, as well, intersections between the psychic and the political. Yet it is not altogether clear whether the implications of fantasy for the cinema allow for an understanding of the social in terms that exceed the family romance so central to any psychoanalytic understanding of culture.

It is one thing to compare the claims that can be made for cinema as a homogeneous and homogenizing, versus a heterogeneous institution, and another thing to valorize heterogeneity as necessarily contestatory. The third concept I will discuss is the term "negotiation," which is used frequently to suggest that different texts can be "used," "interpreted," or "appropriated" in a variety of ways. Sometimes the

diversity thus postulated by "negotiated" readings or viewings is assumed to challenge the power of the institution. The sheer fact that a spectator or group of spectators makes unauthorized uses of the cinema is no guarantee that such uses are contestatory. Here, the central question has less to do with the status of the text, than with the value one assigns to differing modes of response—how those responses are assessed, and how film-going is "read" in relationship to other social, cultural, and psychic formations. Indeed, the emphasis on "negotiation" de-emphasizes the primacy of the cinematic text, focusing rather on how different responses can be read, whether critically, symptomatically, or otherwise.

## *Address and Reception*

A common characteristic of textual theories of the spectator was the assumption that the cinematic apparatus "situates," "positions," or otherwise assigns a position of coherence to the implied spectator. Now however much this implied spectator position functioned as something of a phantom, and not a person to be confused with real viewers, it nonetheless managed to marginalize any consideration of how real viewers might view films in ways considerably more various than any monolithic conception of the cinematic apparatus could imply. It is one thing to assume that cinema is determined in ideological ways, to assume that cinema is a discourse (or a variety of discourses), to assume, that is, that the various institutions of the cinema *do* project an ideal viewer, and another thing to assume that those projections *work*. One of the most significant directions in spectatorship studies has investigated the gap opened up between the ways in which texts construct viewers, and how those texts may be read or used in ways that depart from what the institution valorizes.

The operative assumption here is that apparatus theories are not completely wrong, but rather incomplete. The issue is one of flexibility, of recognizing that an apparatus can have unexpected effects, and that no apparatus can function quite so smoothly and efficiently as most film theory of the 1970s would suggest. That theory was most obviously lacking and problematic in the kinds of hypotheses it led to concerning any kind of alternative cinematic practice, particularly insofar as a deconstruction of so-called dominant modes and a presumable re-positioning of the spectator are concerned. Both assume a fairly stable, fixed, one-way, top-down model of agent and object, with a spectator still locked into a program of representation defined romantically and mechanistically according to the agenda of the filmmaker or the institution—an "active" viewer is still one "positioned" to be so by textual constructs.

Yet to go to the other extreme, and to define texts as only offering the positions that viewers create for them, and thereby to mediate *any* notion of the cinematic institution out of existence, substitutes one monolithic political notion for another. The challenge, then, is to understand the complicated ways in which meanings are both assigned and created. If apparatus theorists were overly zealous in defining all meanings as assigned ones, there has been considerable zeal at the other end of the spectrum as well, by virtually disavowing any power of institutions and conceptualizing readers/viewers as completely free and autonomous agents—a tendency that has been particularly marked, for instance, in some versions of reader-response theory and cultural studies (especially in the United States) (see Budd, Entman, and Steinman 1990). Since dominant ideology is neither a person nor a one-dimensional

set of concepts, it is virtually impossible to say with certainty that a particular effect is complicit with or resistant to the force of an institution. But one can assess the different effects of cinema in relationship to other discourses in order to assess the complicated ways in which the cinema functions, for instance.

One of the great difficulties here is a fairly obvious one. Individual films lend themselves to far neater and easier hypotheses about structure and excess than individual viewers or groups of viewers do. A mistrust of sociological surveys has been one of the most ingrained features of contemporary theoretical work, and so it is perhaps something of a surprise to see the analysis of "real viewers" return, in recent years, as a theoretically credible exercise. The influence of cultural studies, specifically as defined through the work of Stuart Hall and the Centre for Contemporary Cultural Studies at the University of Birmingham, and more generally by analyses of the ways different specific audiences respond to instances of mass culture, has been enormous.

In a series of interviews with teenage girls, for instance, Angela McRobbie concluded that their passion for a film like *Flashdance* had far more to do with their own desire for physical autonomy than with any simple notion of acculturation to a patriarchal definition of feminine desirability (1984). Now it seems to me that one can only be stunned by these tentative conclusions if the model of the cinematic institution one had in the first place corresponded to the "conspiracy theory" view of capitalism popular in some New Left circles in the 1960s. While I find McRobbie's study intriguing, and will turn to it in more detail later in this chapter, I am not convinced that her hypotheses lead necessarily to a dismissal of the power of the cinematic institution. Unfortunately, this type of work has led to a peculiar reading of the reception of mass culture, whereby any and all responses are critical ones. Some sort of understanding of the non-coincidence of address and reception is required in which power is analyzed rather than taken for granted.

One of the most influential studies along these lines is Janice Radway's *Reading the Romance*, an analysis of romance novels as they are read by a group of devoted women fans (1984). Because many of the issues that Radway raises have equal relevance to film studies, and in particular because her book has been cited many times as a model of how film researchers might rethink many of the theoretical assumptions that have been seen increasingly as limitations, her book merits examination for the questions it raises for film spectatorship (Bergstrom and Doane 1989). While Radway examines the structural and ideological features of the romance novel as a genre, she situates that analysis alongside of what is perhaps the most noteworthy achievement of the book, a complex profile of a group of eager and committed romance readers. The advantage of Radway's analysis is that she acknowledges the persuasive power of the romance novel as a genre, at the same time that she refuses to reduce the genre to a series of ideological complicities. Put another way, one senses throughout *Reading the Romance* that the textual evidence is put to the test of Radway's sample audience, and vice versa.

Radway's study focuses on a group of women fictitiously referred to as the "Smithton women," all of whom bought the majority of their romance-reading material from a salesclerk named Dorothy Evans ("Dot"), an expert on romance fiction. Radway's study of this group of women took the form of group and individual interviews (with sixteen women), as well as a lengthy questionnaire distributed to

forty-two women. Radway describes her sample as consisting for the most part of "married, middle-class mothers," and she notes that while "not representative of all women who read romances, the group appears to be demographically similar to a sizable segment of that audience as it has been mapped by several very secretive publishing houses" (12). Much of the force of Radway's analysis comes from a variety of juxtapositions of differing notions of the "ideal"—from the ideal reader as posited in much narrative analysis, to the "ideal romance" as postulated by the Smithton women, to a feminist ideal which seems to characterize much of how Radway approaches the women's responses to romance fiction.

Radway echoes much feminist analysis of mass cultural forms when she argues that romance novels function as "compensatory fiction," that is, "the act of reading them fulfills certain basic psychological needs for women that have been induced by the culture and its social structures but that often remain unmet in day-to-day existence as the result of concomitant restrictions on female activity" (112–13). Like Vladimir Propp in his famous analysis of the Russian folktale, Radway notes that romance fiction is composed of certain unchanging elements—notably patriarchy, heterosexuality, and male personality (143). But within those unchanging rules, romances offer the possibility of fantasizing solutions that are otherwise unavailable. Throughout *Reading the Romance*, the reading of romance fiction is portrayed as emblematic of the ambivalence which these particular women feel about themselves, not just in relationship to patriarchy, but in relationship to feminism as well. Indeed, the emphasis on female autonomy within a passionate relationship and the simultaneity of dependence and independence suggest that—to reiterate a phrase that appears frequently in Radway's analysis—romance readers want to have it both ways.

That Radway herself is ambivalent about how to read the results of her analysis is evident, especially in her conclusion. She says, "the question of whether the activity of romance reading does, in reality, deflect such change [i.e., the restructuring of sexual relations] by successfully defusing or recontaining this protest must remain unanswered for the moment" (213). I find it curious that such a dualistic political framework should be erected in this book, but in some ways this either/or—the either/or, that is, of a conservative status quo versus radical change, of celebration versus critique—remains as a stubborn reminder that the theoretical problem raised by the apparatus (cinematic or otherwise) has not been wished away. For the very notion of a cinematic apparatus suggests a rigid distinction between what is contaminated by dominant ideology and what is not, suggests the possibility of knowing with certainty whether an activity is contestatory or conservative. What always seems to happen with such dualisms is the hardening of one abstraction or another—only a deconstruction of the apparatus is genuinely revolutionary! Readers and viewers are always active producers of meaning!—before it has been possible to consider in more depth the complexity of the issues at hand.

The major problem in Radway's analysis is that for all of the criticism offered of theoretical modes which ignore real readers in favor of the critic's own projections, there is a fair share of projection and idealization going on here, as well. For the white, heterosexual, middle-class women that Radway discusses may well be complex agents who live the contradictions of middle-class patriarchal culture in equally complex ways, but they are also projections of American, middle-class, academic feminism. This is not meant in any way as a condemnation; far from it. But the desire to name "real readers" is neither transparent nor innocent, for the

women readers who appear in Radway's analysis are mediated by her questions, her analyses, and her narrative. It is inevitable that such projections exist in this kind of analysis, and unless those projections are analyzed, then we are left with an ideal reader who seems more real because she is quoted and referred to, but who is every bit as problematic as the ideal reader constructed by abstract theories of an apparatus positioning passive vessels.

It would, of course, be presumptuous of me to hypothesize what function the Smithton women have in Radway's imagination, but I can say what her analysis suggests quite strongly to me—a desire, on the part of feminists like myself, to see my mother and by extension members of my mother's generation as not so invested in patriarchy, as pre-feminist or proto-feminist, as a figure who nurtured feminism even while she argued otherwise, as someone who was really a feminist but didn't know it yet. Lest a particularly literal-minded soul wants to remind me that not all mothers of middle-class feminists fit this bill, I would say that this is precisely the point. For regardless of whether we are talking about literal mothers (as I am here), or mothers in the sense of a generation of women from whom the contemporary feminist movement developed and against whom it reacted, or a group of women who function as a horizon against which much feminist activity operates, we are talking about a construction. I doubt seriously, for instance, if the Smithton women would agree with the necessity of understanding the reading of romance fiction in the categorical terms of critique or celebration.

If analyses such as Radway's are to be based on taking other readers seriously then they must also mean taking ourselves seriously as readers—and by "seriously" here, I mean putting our own constructions to the test. Tania Modleski has argued that with the turn to ethnography as a revitalized strategy for the analysis of mass culture, a curious assumption has been made that critics and researchers are not valid readers or viewers of mass culture, but rather detached observers (1989). I think Modleski is correct in assuming that the analysis of spectatorship is an analysis of one's *own* fascination and passion. Unless this is acknowledged, then we are left with a series of fuzzily defined "ideal readers" in whom it is difficult to know how much of their responses are displaced representations of the critic's own.

From another perspective, it could be argued that the "ideal reader" has not been challenged so much as displaced from one realm, that of the textual properties of address, to another, that of the empirically observable woman. One of the most important strategies of Radway's analysis is, as I've indicated, the juxtaposition of the ideal reader assumed by the romance-fiction industry with women who *do* fit that profile, who are therefore the desired audience for romance novels, but who are also at the same time irreducible to structure, formula, or cliché. Unfortunately, however, this challenge to the presumed homogeneity of the ideal reader does not go quite far enough. One of Radway's most important sources is Nancy Chodorow's *The Reproduction of Mothering*, a study of the asymmetrical gender patterns whereby men learn to be mothered and nurtured and women learn to provide mothering and nurturing (1978). Whereas Chodorow argues that women are socialized into mothering precisely through the (often unfulfilled) promise that the pre-oedipal patterns so central to their own development will be recreated, Radway argues that romance fiction provides precisely the kind of nurturance otherwise absent or largely missing from these women's lives.

In the appeal to Chodorow's analysis I sense most strongly the need to specify the particular nature of the needs being fulfilled. To what extent are we talking about white women whose lives are missing the kind of community network and patterns often characteristic of the lives of black women, for instance? What kind of "middle-class" identity is at stake—the kind of precarious middle-class life characteristic of many white-collar workers? Or rather an economic identity defined largely by lifestyle? Is the heterosexual identity of the women as stable as they, and Radway as well, seem to take great pains to stress? I am aware that these questions will strike some readers as the kind of checklist of accountability that characterizes some holier-than-thou political criticism. But my goal here is not some kind of standard of inclusivity. Rather, it is the notion of an "ideal" reader—no matter who defines it as "ideal"—that I think is severely limiting.

Radway's study remains the most influential example of an analysis that attempts to account, simultaneously, for the power of institutions (what she calls an "institutional matrix") and the complex ways in which real women accomplish the "construction of texts" (11–12). The positive critical reception that Radway's book has received suggests at the very least enormous dissatisfaction with just those limitations of exclusive textually based theories of readership. I am wary, however, of some of this positive critical reception, since I am not convinced that the notion of the "ideal reader" has been problematized or undone so much as it has been displaced. What this suggests to me is the need to be careful of the appeals that are made in the name of empirical audiences or ethnography as the truth that will set us free from the overly abstract theorization of the past. I suspect that it may be impossible to do away entirely with the notion of an ideal reader, since we all live this culture's fictions and institutions and participate in them to some extent. I do not say this in order to imply cynically that no alternative positions of spectatorship are possible, but rather to suggest that one of the most persistent myths of spectatorship (and of theory) that has perturbed and in many ways hindered the analysis of spectatorship is the belief that it is not only possible, but necessary, to separate the truly radical spectator from the merely complicitous one. The recognition that we are all complicitous to some extent (and the "some" is clearly what needs to be investigated) does not mean that alternative positions are impossible. Rather, that recognition would make it possible to speak of readership or spectatorship not as the knowledge the elite academic brings to the people, nor as a coded language that can only be deciphered by experts, but as a mode of encounter—between, say, Radway and the women whose responses she collected and studied.

## Fantasy

While I share many of the criticisms of psychoanalytic theory that have been made in film studies in the past twenty years, the failure to take seriously psychoanalytic investigation can only lead to spectatorship studies that posit one limited definition of the subject in place of another. It is mistaken to assume, however, that all psychoanalytic film theorists subscribe to all aspects of apparatus theory, or that psychoanalytic investigations have remained unchanged in orientation since the early to mid–1970s. Indeed, one of the most significant rethinkings of psychoanalytic film theory has been in the area of fantasy, which Constance Penley specifically claims

as an alternative to the "bachelor machines" characteristic of Metz's and Baudry's approaches to the cinema. "The formulation of fantasy," she writes, "which provides a complex and exhaustive account of *the staging and imaging of the subject and its desire*, is a model that very closely approximates the primary aims of the apparatus theory: to describe not only the subject's desire for the film image and its reproduction, but also the structure of the fantasmatic relation to that image, including the subject's belief in its reality" (1985: 54).

Two essays in particular have been extremely influential in the development of a model of spectatorship which draws upon the psychoanalytic definition of fantasy. Freud's "A Child Is Being Beaten" (1919) has been read as offering a theory of multiple masculine and feminine positions, thereby lending itself to a definition of spectatorship as oscillation rather than "identification" in a univocal sense (Rodowick 1982, 1991; Doane 1984; Hansen 1986). The specific definition of fantasy upon which Penley draws is located in an extremely influential essay by Jean Laplanche and Jean-Bertrand Pontalis, "Fantasy and the Origins of Sexuality" (1964/1986). Elaborating upon their claim that "fantasy is the fundamental object of psychoanalysis" (1967/1973: 317), in this essay the authors explore a variety of components of fantasy which suggest, even more forcefully than the dream analogy so often claimed as the basis for psychoanalytic exploration of the cinema, a situation which is embodied in the cinema.

Laplanche and Pontalis distinguish three "original" fantasies, original in the sense that they are bound up with the individual's history and origins: "Like myths, they claim to provide a representation of, and a solution to, the major enigmas which confront the child. Whatever appears to the subject as something needing an explanation or theory, is dramatized as a moment of emergence, the beginning of a history." Hence, Laplanche and Pontalis define three such fantasies of origins: "the primal scene pictures the origin of the individual; fantasies of seduction, the origin and upsurge of sexuality; fantasies of castration, the origin of the difference between the sexes" (1964/1986: 19). These fantasies are "original" not in the sense that they always "produce" or "cause" a given scenario, but that they form the structure of fantasy which is activated in a variety of ways.

Three characteristics of fantasy as read by Laplanche and Pontalis are particularly crucial for an understanding of the cinema as fantasy, and toward a revision of theories of the apparatus whereby the subject of the cinematic fantasy can only always be male. First, the distinction between what is conscious and what is unconscious is less important in fantasy than the distinction between those original fantasies described above, and secondary fantasies. Laplanche and Pontalis stress what they describe as the "profound continuity between the various fantasy scenarios—the stage-setting of desire—ranging from the daydream to the fantasies recovered or reconstructed by the analytic investigation" (1964/1986: 28). As we have seen, one of the problems with much apparatus theory is a mechanistic notion of the unconscious, due largely to the fact that the desire for regression is always postulated as the repetition of the same oedipal scenario. The three original fantasies of which Laplanche and Pontalis speak are not so regimented. And given that fantasy occupies such a distinct place in psychoanalysis insofar as it extends across the boundaries of conscious and unconscious desires, then the analysis of the cinema as a form of fantasy does not require what almost inevitably amounts

to a decoding approach, a rigid distinction between manifest and latent content. The area of fantasy is one where the notion of homology operates quite differently than is the case with the cinematic apparatus, since here the homology is between different types of fantasy, of which cinematic spectatorship is one example (21). Put another way, fantasy is more useful for its implications than for its possible status as equivalent to or anticipatory of the cinema.

Second, it is the very nature of fantasy to exist for the subject across many possible positions. Noting that "'A father seduces a daughter'" is the skeletal version of the seduction fantasy, Laplanche and Pontalis describe this function as follows: "The indication here of the primary process is not the absence of organization, as is sometimes suggested, but the peculiar character of the structure, in that it is a scenario with multiple entries, in which nothing shows whether the subject will be immediately located as *daughter*; it can as well be fixed as *father*, or even in the term *seduces*" (22–3). Despite the claims to anti-essentialism of many apparatus theorists, there is a consistent tendency to conflate literal gender and address; to assume, that is, that if the film addresses its subject as male, then it is the male viewer who is thus addressed. The reading of cinematic fantasy allows no such reduction. Indeed, the notion of fantasy gives psychoanalytic grounding not only to the possibility, but to the inevitability and necessity, of the cinema as a form of fantasy wherein the boundaries of biological sex or cultural gender, as well as sexual preference, are not fixed.

Finally, emphasis is placed throughout Laplanche and Pontalis's discussion on fantasy as the *staging* of desire, fantasy as a form of mise-en-scène. "Fantasy . . . is not the object of desire, but its setting. In fantasy the subject does not pursue the object or its sign: he appears caught up himself in the sequence of images" (26). Elizabeth Cowie has noted that the importance of the emphasis on fantasy as a scene "cannot be overestimated, for it enables the consideration of film as fantasy in the most fundamental sense of this term in psychoanalysis" (1984: 77). While I am somewhat suspicious of any mimetic analogy, the understanding of film as fantasy does open the door to some questions and issues about spectatorship which apparatus theory tended to shut out. In any case, I think the value of fantasy for psychoanalytic readings of the cinema needs to be seen less in terms of a "better" analogy than dreams, the mirror stage, or the imaginary, and more in terms of the series of questions it can engender.

In Cowie's reading of fantasy in film which relies extensively on the Laplanche and Pontalis essay, two such questions are raised: "if fantasy is the *mise-en-scène* of desire, whose desire is figured in the film, who is the subject for and of the scenario? No longer just, if ever, the so-called 'author.' But how does the spectator come into place as desiring subject of the film? Secondly, what is the relation of the contingent, everyday material drawn from real life, i.e. from the *social*, to the primal or original fantasies?" (1984: 87). Cowie notes how, in *Now, Voyager,* there is an oedipal fantasy, "but where the subject positions are not fixed or completed, Charlotte is both mother and daughter, Mrs. Vale and Tina." In partial response to her first question, then, Cowie says that it is not enough to define the fantasy as Charlotte Vale's; rather, it must be defined as the spectator's:

> This is not Charlotte's fantasy, but the "film's" fantasy. It is an effect of its narration (of its *énonciation*). If we identify simply with Charlotte's desires, that series of social and erotic successes, then the final object, the child Tina, will be

unsatisfactory. But if our identification is with the playing out of a desiring, in relation to the opposition (phallic) mother/child, the ending is very much more satisfying, I would suggest. A series of "day-dream" fantasies enfold an Oedipal, original fantasy. The subject of this fantasy is then the spectator; inasmuch as we have been captured by the film's narration, its *énonciation*, we are the only place in which all the terms of the fantasy come to rest.

(1984: 91)

Cowie's response to her second question—concerning the relationship between the psychic and the social which the analysis of fantasy can comprehend—focuses on the illicit desires which the subject's pleasure in the fantasy fulfills. In *Now, Voyager*, this concerns the evacuation of the father; in another film discussed by Cowie, *The Reckless Moment*, what she describes as an "unstoppable sliding of positions" results in pairings and oppositions whereby a set of equivalences is set up, and an inference is made "which is an attack on the family as imprisoning" (1984: 101). These claims are reminiscent of the kinds of implications in "reading against the grain" arguments about the classical cinema—i.e., that what appears to be a smooth ideological surface is marred, rather, by rebellion, critique, or even implicit rejection of those norms. What the reading of fantasy brings to such claims, however, is the insistence that investment and pleasure in film watching involve a range of subject positions. Apparatus theory tends to pose a spectator so aligned with one subject position that anything departing from that position would have to seem radical or contestatory by definition. The exploration of the classical cinema in terms of fantasy enlarges considerably what possibilities are contained within the fantasy structures engaged by film viewing, and in so doing inflects differently the notion of a "reading against the grain." For from the vantage point of fantasy, the distinction between "with" and "against" the grain of the film becomes somewhat moot.

Constance Penley assesses the importance of Cowie's approach to fantasy in terms of its assumption that positions of sexual identification are not fixed: "Cowie's model of identification involves a continual construction of looks, ceaselessly varied through the organization of the narrative and the work of narration. The value of such a model is that it leaves open the question of the production of sexual difference in the film rather than assuming in advance the sexuality of the character or the spectator" (1988: 11). However, while it may be a matter of indifference in psychoanalytic terms whether the spectator encouraged or enabled to adopt a variety of positions is male or female, it is a matter of crucial importance within the context of spectatorship, to the extent that spectatorship involves a spectator who always brings with her or him a history, and whose experience of spectatorship is determined in part by the ways in which spectatorship is defined outside of the movie theater.

Cowie emphasizes that whatever shifting of positions occurs in the fantasies of the cinema, they "do so always in terms of sexual difference" (1984: 102). It is one thing to assume "sexual difference" to refer to the way in which any definition of "femininity" is inevitably bound to accompanying definitions of "masculinity," and another thing to assume that the only possible relationship between the two is in some version of heterosexuality. Put another way, the insistence upon sexual difference has had a curious history in film studies, by collapsing the shifting terms of masculinity and femininity into a heterosexual master code. Interestingly, the

model of fantasy elaborated by Laplanche and Pontalis has the potential to challenge film theory's own compulsory heterosexuality. In a study of Sheila McLaughlin's film *She Must Be Seeing Things*, for instance, Teresa de Lauretis argues that the film articulates a *lesbian* version of the primal scene, where the positions of onlooker and participant are occupied by women (1989).

Barbara Creed has observed that despite the fact that the castration scenario is but one of three originary fantasies in Laplanche and Pontalis's account, it has been the near-exclusive focus of 1970s film theory (1990: 135). Creed suggests that perhaps "the fantasy of castration *marks* all three primal fantasies to some degree" (135). The same could be said of any of the three fantasies. What might rather be the case is that the classical Hollywood cinema is made to the measure of the fantasy of sexual difference, which is of course what 1970s film theory claimed. It is unclear, in other words, just how much of a critical advantage the fantasy model offers, if it emerges as just another way of affirming the primacy of one particular configuration of desire. Alternatively, it could be argued that this is precisely where fantasy offers an understanding of the tension between the demands for regulation and homogeneity, on the one hand, and the mobility of spectatorial investment, on the other. The positions offered the spectator may be multiple, but the multiplicity finds its most cohesive articulation in the fantasy of sexual difference.

Jacqueline Rose has made a more pointed observation about the current interest in fantasy, particularly insofar as it functions as a "saving device" against the "depressing implications" of the psychoanalytic position that the classical cinema offers the female spectator only an impossible relation to its fictions (1990: 275).

> Unconscious fantasy can . . . be read in terms of a multiplicity of available positions for women (and men), but the way these positions work against and defensively exclude each other gets lost. . . . [W]hile we undoubtedly need to recognize the instability of unconscious fantasy and the range of identifications offered by any one spectator of film, this can easily lead to an idealization of psychic processes and cinema at one and the same time (something for everyone both in the unconscious and on the screen).
>
> (275)

Rose's warning echoes an earlier debate in film studies concerning the monolithic quality of film narrative, with psychoanalysis functioning as a nagging reminder that the "resistance" of the unconscious cannot in any easy or simple way be equated with "resistance" understood in political terms.

Fantasy does offer the possibility of engaging different desires, contradictory effects, and multiple stagings. A certain version of the scenario of sexual difference emerges again and again in film theory as obsessive structure and point of return, and it is not always clear when the obsession and return are an effect of the cinema or of the theorist. In any case, it appears as though the homogeneous effects of the cinematic apparatus are understood in limited terms in the fantasy model—limited to the extent that they have only one point of reference, a notion of sexual difference which assumes the kind of essentialist quality otherwise so disavowed by psychoanalytic critics. I have no intention of reviving the political fantasy of "integrating" Marxism and/or feminism and/or psychoanalysis; rather, it is psychoanalysis on its

own terms that requires investigation, not "rescue" by some other discourse. For it is questionable whether fantasy can engage with the complex effects of spectatorship without some understanding of how its own categories—of sexual difference, the couple, and desire—are themselves historically determined and culturally variable.

## Negotiation

To put this problem a bit differently, as well as to make the transition to the next tension I want to address, the institutional models of spectatorship have been read as so rigid that there has been a real temptation to see any response that differs slightly from what is assumed to be the norm or the ideal as necessarily radical and contestatory. Such claims to alternatives require that the theory of the institution that gave rise to it be challenged simultaneously. What remains nonetheless peculiar about many theories of the cinematic institution is that they give particular and sometimes exclusive signifying possibilities to the individual film. That is to say, the individual film is taken to be a well-functioning instance of the larger effects of the cinematic institution. When other practices are taken into account, like advertising or consumer tie-ins, they are assumed to create a narrative flow every bit as seamless as that of the classical scenario itself.

Once the cinematic institution is defined and analyzed as consisting of a number of different forms of address, however, it should be possible to unpack and question the excessive monolithic quality of the apparatus. But as I suggest above, I think it is crucial to resist the temptation to see difference or multiplicity as liberatory or contestatory qualities in themselves. This attention to difference (and simultaneous inquiry into the difference that difference makes) can be understood in a variety of ways, both in terms of a single film within which a variety of not necessarily harmonious discourses collide, and in terms of the various components that define film-going in a cultural and psychic sense.

One of the key terms that has emerged in this context is *negotiation.* In an influential essay associated with cultural studies, Stuart Hall's "Encoding/Decoding," three decoding strategies—that is, practices of reading and making sense of cultural texts—are proposed. The dominant reading is one fully of a piece with the ideology of the text, while the negotiated reading is more ambivalent; that is, the ideological stance of a product is adjusted to specific social conditions of the viewers. The oppositional reading is, then, one totally opposed to the ideology in question (Hall 1980).

As influential as this model has been, particularly in the foregrounding of reception contexts, it raises some problems of its own, particularly insofar as the "dominant" and "oppositional" readings are concerned. What is the relationship between activity and passivity in the reader/viewer, whether the reading is dominant or oppositional? If a reader/viewer occupies an oppositional stance, how does this square with the process of interpellation necessary for any response to a text? Dominant and oppositional readings may be more usefully understood, perhaps, as horizons of possibility, as tendencies rather than actual practices of reading. However, in order to foreground the activity of reading, viewing, and consuming mass culture, what Hall's model leaves relatively intact is the notion of a text's dominant ideology. This is peculiar insofar as the activity/passivity of the apparatus model

appears to be reversed in favor of an active reader/viewer and a relatively stable, if not completely passive, text.

It may well be more useful to designate all readings as negotiated ones, to the extent that it is highly unlikely that one will find any "pure" instances of dominant or oppositional readings. In other words, a purely dominant reading would presume no active intervention at all on the part of the decoder, while a purely oppositional reading would assume no identification at all with the structures of interpellation of the text. In that case, some notion of textual determination must still be necessary in order for the negotiation model to be useful.

I stress this because there is a tendency to assume that because the model of negotiation posits both the activity of the reader/viewer and the heterogeneity of the different elements of social formations, it conceives of a variety of readings, and that very heterogeneity, that very activity, is then taken to be indicative of a resistance to dominant ideology. Since I do not think that individual texts can be any more easily categorized as purely "dominant" than spectators or readers can, I find it difficult to be quite so enthused about different or unauthorized readings as necessarily contestatory. As I suggested earlier in this chapter, one of the problems in spectatorship studies is the desire to categorize texts *and* readings/responses as either conservative or radical, as celebratory of the dominant order or critical of it. This duality forecloses the far more difficult task of questioning what is served by the continued insistence upon this either/or, and more radically, of examining what it is in conceptions of spectators' responses and film texts that produces this ambiguity in the first place.

One of the severe limitations of much apparatus theory is the assumption that certain textual strategies will necessarily produce desired reassignations of dominant subject/object relationships and subject positions. A textual strategy does not *necessarily* produce anything. But if, consequently, there is no such thing as an inherently radical technique, then there is no such thing either as an inherently conservative one. While I think most contemporary film scholars would agree with the former— would agree, that is, that this particular aspect of 1970s film theory is in need of severe revision—I am not sure that the latter will meet with such agreement, since the notion of a dominant narrative structure still appears with great regularity.

I am alluding to two extreme positions which can be sketched as follows. For many textual theorists of the 1970s, Raymond Bellour and the editors of *Camera Obscura* in particular, the value of textual analysis was to demonstrate that classical narrative produces a variety of ruptures, deviations, and crises only to recuperate them in the name of a hierarchical closure or resolution. From this point of view, any validation of those ruptures is at best naive voluntarism and at worst a refusal to acknowledge what one does not want to know—that the cinematic apparatus works with great efficiency to channel all desire into male, oedipal desire. The apparatus works; closure and resolution are achieved. Inspired in many cases by the work of Hall and cultural studies, others, like John Fiske (1987), insist upon the social formations of audiences as the only ultimately determining factors. Both positions ascribe an unqualified power to the text, on the one hand, and socially defined readers/viewers on the other. The problem in each case is that the activity of making meaning is assumed to reside in one single source—either the cinematic apparatus, or the socially contextualized viewer. To be sure, variations are allowed in either case, but they are never significant enough to challenge the basic determinism of the model in question.

While there are advantages to both of these positions, I do not want to suggest that one can take what is most appealing about two different sets of assumptions and put them together in a happy integration. Unfortunately, while the notion of negotiation is potentially quite useful, it can inspire precisely a kind of Pollyanna dialectics—the institution remains monolithic, but never *so* monolithic that readers cannot be actively oppositional. Now I do think that spectatorship studies are most useful when "local," that is, when examined—as I suggest in the critique of Radway's book—insofar as they problematize the ideal reader or viewer. But there still needs to be some recognition of the theoretical questions at stake. There is no necessary discontinuity between theory and local analysis. Indeed, theory becomes much more challenging when contradiction and tension, for instance, exist not as textual abstractions but as complex entities which do not always lend themselves easily to one reading or another. Film theory of the 1970s erred in attempting to account for a cinematic subject in categories that are absolute. (Even when labeled "Western," this usually amounts to the same thing—e.g., some will confess that they speak only of the "Western" [white, male, etc.] subject and then proceed as if "Western" and "universal" were still fully commensurate terms.) But surely the conclusion is not that all theorizing is doomed to such levels of abstraction.

One particularly influential invocation of negotiation is instructive in this context, since it sets out the issues that the concept is meant to address. Indeed, in Angela McRobbie's essay "Dance and Social Fantasy," a study of how teenage girls respond to dance and how those responses read in relationship to the films *Flashdance* and *Fame*, negotiation seems to describe not only the teenage girls but McRobbie herself as a researcher (1984). Noting that the significance of extra-textual codes and knowledge in the reception of mass culture leads to the necessity for the researcher to "limit strictly the range of his or her analysis," McRobbie continues.

> It also means working with a consciously loose rather than tight relation in mind, one where an inter-discursive notion of meaning structures and textual experience leads to a different working practice or methodology. Instead of seeking direct causal links or chains, the emphasis is placed on establishing loose sets of relations, capillary actions and movement, spilling out among and between different fields: work and leisure, fact and fiction, fantasy and reality, individual and social experience.

(142)

Several negotiations form the core of McRobbie's analysis, not least of which is the juxtaposition of the responses of teenage girls to dancing as both a social and an individual activity, and the textual forms that seem to encourage such fantasies in two dance films, *Flashdance* and *Fame*. Within the two films, there are several processes of negotiation at work. In *Flashdance*, McRobbie notes that while the dance scenes are very much directed at that ubiquitous entity, the male spectator within the film, other narrative elements of the film are drawn so clearly from the woman's film that it is impossible to say with certainty that the address of the film is directed toward the woman defined unambiguously as the object of the male gaze (138). The process of negotiation here concerns, then, two different genres—the musical and the woman's film—the conventions of which may rub against each other rather than function compatibly. McRobbie also notes that in both films, there is a sometimes

peculiar juxtaposition of old and new elements; the films "place together images and moments of overwhelming conformity with those which seem to indicate a break with Hollywood's usual treatment of women" (150). In other words, the classical formulae of both films could be said to acknowledge and retreat from their own limitations insofar as representations of women are concerned.

McRobbie also insists upon the importance of understanding films like these in an intertextual network, and in the case of these two films, the expectations of dance culture can inflect the readings of the films, and vice versa. Thus the process of "negotiation" refers to how the films are structured as cinematic texts, as well as to how the meanings of these films are "negotiated" in relationship to one's knowledge of the dance scene outside of the movie theater. Noting that the dancehall or disco shares some similarities with the movie theater (a "darkened space" where the spectator/dancer "can retain some degree of anonymity or absorption"), McRobbie notes as well a significant difference: "Where the cinema offers a one-way fantasy which is directed solely through the gaze of the spectator toward the screen, the fantasy of dancing is more social, more reciprocated" (144). Such a mapping of one context onto the other may account for a reception of these films that departs sharply from the pronouncements of film theory about the inevitability of the colonization of the female body.

Two particular points of reference recur in McRobbie's essay, and they echo some of the questions I raised in relation to Radway's *Reading the Romance*. Richard Dyer has suggested that one of the basic appeals of the movie musical is the utopian dimension, a way of providing pleasures and satisfactions that are otherwise unavailable in the culture at hand, and yet which are defined in such a way as to suggest that they can only be satisfied within capitalism (1977). Radway suggests that this utopianism—defined within the context of Nancy Chodorow's reading of women's desires for re-creation of their pre-oedipal bond—is a function of the reading of romance novels, and McRobbie's reading of dance and dance films is equally suggestive of a utopian impulse.

I do not wish to evoke a traditional and moralistic Marxism, whereby art provides us with a glimpse of the truly integrated human beings we will all become in the communist future. But I find that sometimes the utopian dimension becomes clouded by the understanding of desire as always in conflict with the dominant culture. McRobbie notes, for instance, that *Fame* presents a desire for community and family as necessarily intertwined (158), and certainly an interesting area of research is the way in which films articulate definitions which both reflect dominant ideology (the family is the basis for all community) and challenge them (communities provide what families do not, or cannot, in our culture). What makes me somewhat suspicious is the way that the discussion of utopianism seems to fall into exactly the kind of large abstractions—having to do with the "human subject under capitalism and/or patriarchy"—that McRobbie sets out (specifically in the passage cited earlier) to challenge. In case I sound as if I am contradicting myself as far as the necessity of combining "local" analyses with theoretical reflection is concerned, let me say that I do not think that theory means falling back into large clichés about the human subject—or the female subject.

The second recurring point of reference in McRobbie's essay is an illustration of the first. Noting that dance "carries a range of often contradictory strands within

it," she affirms the conformity of dance with conventional definitions of femininity, but says that at the same time the pleasures of dance "seem to suggest a displaced, shared and nebulous eroticism rather than a straightforwardly romantic, heavily heterosexual 'goal-oriented' drive" (134). In another context, McRobbie describes the dance scene and suggests that as it offers a "suspension of categories, there is not such a rigid demarcation along age, class, ethnic terms. Gender is blurred and sexual preference less homogenously heterosexual" (146). Curiously, this "suspension of categories" is itself suspended when McRobbie reports that her sources on the pleasures of dance are "predominantly heterosexual;" hence "these fantasy scenarios make no claim to represent gay or lesbian experience" (145). While gay and lesbian experiences of dance may well be different, this disclaimer erects the categories of sexual preference just when the analysis of dance seems to put them into question.

I suspect that since the question of sexual preference is far more controversial than, say, the desire for a community (whether based on the family or not), and is perhaps threatening to those very viewers/participants whose desires one is attempting to take seriously, then the temptation is to shelve a consideration of it for some future analysis, or to open the question about the permeability of sexual boundaries without really pursuing it in any depth. But the deployment of gay and lesbian identities in popular culture, and the complicated responses the viewers bring to homosexuality as a moral, sexual, and political issue, seem to me just the kind of *specific* area of inquiry for investigation into the utopian impulse that desires for community avoid.

Film theory has been so bound by the heterosexual symmetry that supposedly governs Hollywood cinema that it has ignored the possibility, for instance, that one of the distinct pleasures of the cinema may well be a "safe zone" in which homosexual as well as heterosexual desires can be fantasized and acted out. I am not speaking here of an innate capacity to "read against the grain," but rather of the way in which desire and pleasure in the cinema may well function to problematize the categories of heterosexual versus homosexual. To be sure, this "safety zone" can also be read as a displacement, insurance that the happy ending is a distinctly heterosexual one. But as has been noted many times, the buddy film, if it affirms any kind of sexual identity aside from a narcissistic one, is as drawn to a homosexual connection as it is repelled by it.

Taking into account the complexity of the range of responses to the stability of sexual identities and sexual categories would require an approach to negotiation that specifies the psychic stakes in such a process, rather than just stating that the psychic remains significant or important. I am not referring here to the kind of psychoanalytic theorizing typical of much 1970s film theory, where the "unconscious" usually meant a master plot repeated again and again, an inevitable source of meaning and comprehensibility. What has been surprisingly absent from much psychoanalytic film theory is an investigation of the ways in which the unconscious refuses the stability of any categorization. The example of heterosexuality and its various "others" seems to me a particularly crucial one to take into account, since so much of the ideology of the cinematic institution is built simultaneously on the heterosexual couple as the common denominator, on the promise of romantic fulfillment, at the same time that that couple seems constantly in crisis, constantly in need of reassurance. One would have thought this an area where the concept of negotiation would provide a useful corrective.

To take this in a somewhat different direction: The notion of negotiation is only useful if one is attentive to the problematic as well as "utopian" uses to which negotiation can be put by both the subjects one is investigating and the researchers themselves. While I have not seen this spelled out in any detail, negotiation seems to be a variation of the Marxist notion of mediation—the notion, that is, of a variety of instances that complicate or "mediate" in various ways the relationship between individuals and the economic structure of capitalism. Raymond Williams has noted that while the concept of mediation has the advantage of complicating significantly the cause-and-effect notion of "reflection" so typical of a traditional Marxism, and of indicating an active process, it remains limited in its own way. Williams notes that "it is virtually impossible to sustain the metaphor of 'mediation' . . . without some sense of separate and pre-existent areas or orders of reality. . . . Within the inheritance of idealist philosophy the process is usually, in practice, seen as a mediation between categories, which have been assumed to be distinct" (1977: 99).

Negotiation can replicate the problems that inhere in the notion of mediation by replacing the language of "subjection" and "imposition" with that of "agency" and "contradiction" but without significantly exploring how the notion of an active subject can be just as open to projections and subjections as a passive subject can. While the field of cultural studies, with its emphasis on "negotiation" as the way readers/viewers shape mass culture to their own needs, has had an enormous impact on film studies, another direction in literary studies also makes persistent use of "negotiation" in a rather different way. The so-called "new historicism" has had only a limited relationship with film studies, yet some of the ways in which the concept of negotiation has emerged in new historicist studies offer a useful counterpoint to the inflection offered by cultural studies.

New historicism is most immediately associated with English Renaissance studies. But the problems new-historicist work addresses are not so different than those central to film studies, particularly insofar as a reckoning with both the advances and the limitations of 1970s film theory are concerned. Louis A. Montrose, for instance, has said that "the terms in which the problem of ideology has been posed and is now circulating in Renaissance literary studies—namely as an opposition between 'containment' and 'subversion'—are so reductive, polarized, and undynamic as to be of little or no conceptual value" (1989: 22). That this assessment "applies" to film studies, particularly in relation to spectatorship, may have less to do with a striking coincidence between film studies and the new historicism, and more to do with questions central to virtually all forms of cultural analysis in the 1980s and 1990s which attempt to develop new forms of criticism and theory at the same time that they engage with their own historical legacies, particularly insofar as the 1960s and 1970s are concerned in their status as simultaneous political turning points and mythological burden.

While it is not my purpose either to align myself with a new-historicist project or to provide an extended introduction to this field, it is noteworthy that the term *negotiation* in its new historicist usage tends more toward questioning those very possibilities of radical agency that the cultural-studies approach finds in its negotiations. Stephen Greenblatt notes that capitalism "has characteristically generated neither regimes in which all discourses seem coordinated, nor regimes in which they seem radically isolated or discontinuous, but regimes in which the drive toward

differentiation and the drive toward monological organization operate simultane-
ously, or at least oscillate so rapidly as to create the impression of simultaneity" (1989:
6). From the vantage point of this simultaneity, then, the immediate assumption that
all unauthorized uses of films, and therefore spectatorial positions that depart from
the presumed ideal of capitalist ideology, are virtually or potentially radical is a read-
ing of the nature of discourse and power in our culture as more dualistic than it is.

A large part of the problem here is that the analysis of spectatorship in film
studies has as a significant part of its legacy a commitment to the creation of al-
ternative cultures and political identities which refuse to comply with dominant
ideology. Phrases like "alternative cultures" and "refusal to comply" can of course
mean a variety of things, including contradictory things. The reactions of black
male spectators to the filmed popularization of Alice Walker's novel *The Color Pur-
ple* cannot be squared in any easy or even complex way with the feminist critique of
the "woman as object of the male look," yet both constitute claims to validation by
marginalized groups (see Bobo 1988). Part of the 1960s/1970s legacy of film studies
is a romanticized vision of the politicized past, based on the assumption (errone-
ous and inaccurate) that the common denominator "socialist" could account for
any and all kind of radical and progressive social change—a utopian definition of
socialism which was quickly enough put to rest by feminism and gay and lesbian
liberation movements. Curiously, what seems to have persisted is a vague discourse
of "subversion" and "alternative scenarios," amidst conceptual confusion about just
what is being subverted and for what.

Catherine Gallagher says—in what could easily function as a critique of the
tendencies present in much writing about spectatorship—that new historicists
have attempted to show "that under certain historical circumstances, the display
of ideological contradictions is completely consonant with the maintenance of
oppressive social relations" (1989: 44). It has been crucial to spectatorship studies to
understand that visions of the cinema as the inflexible apparatus of the ideological
subject are as much projections of theorists' own desires as they are hypothetically
interesting and useful and also historically conditioned postulates about going to
the cinema. But it is equally important for such an inquiry to take place in what
amounts to a new "stage" of spectatorship studies, where the model is no longer the
passive, manipulated (and inevitably white and heterosexual) spectator, but rather
the contradictory, divided and fragmented subject.

The new-historicist reminder that "negotiation" is a marketplace term tempers
too quick an enthusiasm about what may ultimately be strategies of consumerism.
But it is too easy to assume the cynical route (which is, after all, only the reverse of
romanticism), that is, to assume in a kind of more-Foucauldian-than-thou posture
that there are no alternative positions, only fictions of them. What remains vital, in
the critical examination of spectatorship, is the recognition that no "negotiation"
is inherently or purely oppositional, but that the desire for anything "inherent" or
"pure" is itself a fiction that must be contested.

What I am suggesting, in this extremely schematic encounter between new his-
toricism and cultural studies, is that a desire for unproblematized agency—whether
that of the critic or of the imaginary or real spectator(s) under investigation—persists.
Even though McRobbie does question the notion of the "ideal viewer" which, as I
suggest above, is one of the limitations of Radway's analysis, there remain some

echoes of an idealized female subject in her account. In an extremely provocative essay on the status of negotiation as a critical concept in studies on female spectatorship, Christine Gledhill sees negotiation as providing a possible way out of the limitations of the implications of feminist/psychoanalytic film theory and the attendant split between text and reception, particularly insofar as texts were seen as capable of situating alternative subjective positions. "The value of 'negotiation' . . . as an analytical concept is that it allows space to the subjectivities, identities and pleasures of audiences," writes Gledhill (1988: 72). But "subjectivity," "identity," and "pleasure" are here defined in a way that acknowledges the critique of the fictions of bourgeois identity that has been central to Lacanian-inspired film theory. At the same time, those critiques are fictions, too, in supposing that any notion of identity may supposedly be "done away with."

In a move somewhat reminiscent of Jane Gallop's claim that "identity must be continually assumed and immediately put into question" (1982: xii), Gledhill says that

> the concept of negotiation stops short at the dissolution of identity suggested by avant-garde aesthetics. For if arguments about the non-identity of self and language, words and meaning, desire and its objects challenge bourgeois notions of the centrality and stability of the ego and the transparency of language, the political consequence is not to abandon the search for identity. . . . The object of attack should not be identity as such but its dominant construction as total, non-contradictory and unchanging.
>
> (72)

I am suggesting, as is perhaps obvious by now, that this "dominant construction" enters into the ways in which researchers themselves construct their audiences. This should not, of course, come as startling news to anyone familiar with the dynamics of transference and counter-transference. But in order for studies of spectatorship to engage fully with the complex dynamics that define the process of negotiation, such constructions need to be accounted for.

As Gledhill's comments suggest, one of the key issues at stake here is the competing claims of "identity," which have been associated with some of the most fervent debates in film studies and related fields in the past two decades. Studies of reception and negotiation are often meant to challenge the ways in which post-structuralist theorists are seen to critique any notion of the self as an agent as an inevitable fiction of bourgeois/patriarchal/idealist culture. What becomes quite difficult in that process of challenge is acknowledging the necessity of the critique of the fictions of the self without resurrecting them yourself. Somewhat curiously, the challenges to apparatus theory described in this chapter return to the problem of identification, as if to suggest that however mobile and multiple subject positions may be, spectatorship still engages some notion of identity. But then theorists of the cinematic apparatus never banished identification from film theory, but rather redefined its terms beyond those of character or a one-to-one correspondence between viewer and screen. In any case, the current visibility of identity as a problem in film studies—whether as specter, curse, or positive value—speaks to the continued friction between subjects and viewers.

A colleague of mine once commented that much of what passes for film theory is a finger-wagging list of everything that is "wrong" with a given position or argument.

I recognize that I have indulged in some of that syndrome in this chapter, since I have focused critically on address/reception, fantasy, and negotiation as important concepts for spectatorship studies; that is, I have attempted to examine the concepts closely, in a symptomatic way, without simply assigning them positive or negative marks. Two criticisms have consistently emerged in my discussion of these concepts. First, I have suggested that there is a considerable reluctance on the part of theorists to acknowledge their own investment in the process of spectatorship analysis. I do not mean by this that all critics should write in a confessional mode, or impose a first-person account in every discussion of spectatorship. I see theoretical self-consciousness, rather, as an attention to how and why certain modes of theoretical discourse, certain tropes, certain preoccupations, are foregrounded in specific critical and cultural contexts.

Second, I return frequently in this chapter to the need for more specific, local studies, where the focus would be less on large theories that can account for everything, and more on the play and variation that exist at particular junctures between the competing claims of film spectatorship—as the function of an apparatus, as a means of ideological control, on the one hand, and as a series of discontinuous, heterogeneous, and sometimes empowering responses, on the other.

[ · · · ]

The point is not to construct yet another theory or concept of "the" cinematic spectator, but to suggest areas of inquiry which reveal both the importance of conceptualizing spectators, and some directions these conceptualizations can now take.

## WORKS CITED

Bergstrom, Janet, and Mary Ann Doane, eds. (1989) *Camera Obscura* 20–1: special issue on The Spectatrix.

Bobo, Jacqueline (1988) "*The Color Purple*: Black Women as Cultural Readers," in Deidre Pribram, ed., *Female Spectators*. London and New York: Verso, 90–109.

Budd, Mike, Entman, Robert M., and Steinman, Clay (1990) "The Affirmative Character of U.S. Cultural Studies," *Critical Studies in Mass Communication 7*, 2 (June): 169–84.

Chodorow, Nancy (1978) *The Reproduction of Mothering: Psychoanalysis and the Sociology of Gender*. Berkeley and Los Angeles: University of California Press.

Cowie, Elizabeth (1984) "Fantasia," *m/f* 9: 70–105.

Creed, Barbara (1990) "Response," *Camera Obscura* 20–1: 132–6.

Doane, Mary Ann (1984) "The 'Woman's Film': Possession and Address," in Mary Ann Doane, Patricia Mellencamp, and Linda Williams, eds., *Re-vision: Essays in Feminist Film Criticism*. Frederick, Maryland: The American Film Institute/University Publications of America, 67–80.

Fiske, John (1987) "British Cultural Studies and Televison," in Robert C. Allen, ed., *Channels of Discourse: Television and Contemporary Criticism*. Chapel Hill, North Carolina: University of North Carolina Press, 254–89.

Freud, Sigmund (1919; rpt. and trans. 1972) "'A Child is Being Beaten': A Contribution to the Origin of Sexual Perversions," in *Sexuality and the Psychology of Love*. New York: Collier, 107–32.

Gallagher, Catherine (1989) "Marxism and the New Historicism," in H. Aram Veeser, ed., *The New Historicism*. New York and London: Routledge, 37–48.

Gallop, Jane (1982) *The Daughter's Seduction: Feminism and Psychoanalysis.* London: Macmillan.

Gledhill, Christine (1988) "Pleasurable Negotiations," in E. Deidre Pribram, ed., *Female Spectators.* New York and London: Verso, 12–27.

Gordon, Linda (1986) "What's New in Women's History," in Teresa de Lauretis, ed., *Feminist Studies/Critical Studies,* Bloomington: Indiana University Press, 20–30.

Greenblatt, Stephen (1989) "Towards a Poetics of Culture," in H. Aram Veeser, ed., *The New Historicism.* New York and London: Routledge, 1–14.

Hall, Stuart (1980) "Encoding/Decoding," in Stuart Hall, D. Hobson, A. Lowe, and P. Willis, eds., *Culture, Media, Language.* London: Hutchinson, 128–38.

Hansen, Miriam (1986) "Pleasure, Ambivalence, Identification: Valentino and Female Spectatorship," *Cinema Journal* 25, 4: 6–32.

Laplanche, Jean, and Pontalis, Jean-Bertrand (1964; trans. 1986) "Fantasy and the Origins of Sexuality," in Victor Burgin, James Donald, and Cora Kaplan, eds., *Formations of Fantasy.* London and New York: Methuen, 5–34.

—— (1967; trans. 1973) *The Language of Psychoanalysis,* trans. D. Nicholson-Smith, London: Hogarth Press.

McRobbie, Angela (1980) "Settling Accounts with Subcultures: A Feminist Critique," *Screen Education,* 34: 37–49.

—— (1984) "Dance and Social Fantasy," in Angela McRobbie and Mica Nava, eds., *Gender and Generation.* London: Macmillan, 130–61.

Modleski, Tania (1989) "Some Functions of Feminist Criticism, or The Scandal of the Mute Body," *October* 49: 3–24.

Montrose, Louis A. (1989) "Professing the Renaissance: The Poetics and Politics of Culture," in H. Aram Veeser, ed., *The New Historicism.* New York and London: Routledge, 15–36.

Penley, Constance (1985) "Feminism, Film Theory and the Bachelor Machines," *m/f* 10: 39–59.

Radway, Janice (1984) *Reading the Romance: Women, Patriarchy, and Popular Literature.* Chapel Hill and London: University of North Carolina Press.

Rodowick, D.N. (1982) "The Difficulty of Difference" *Wide Angle* 5, 1: 4–15.

—— (1991) *The Difficulty of Difference.* New York and London: Routledge.

Rose, Jacqueline (1990) "Response," *Camera Obscura* 20–1: 274–9.

Williams, Raymond (1977) *Marxism and Literature.* New York and Oxford: Oxford University Press.

# PART 2

# THE SIGHTS, SOUNDS, AND SIGNS OF CINEMA

*Norman Bates removes a painting on the wall and peers through a small peephole at Marion Crane as she undresses to take a shower in an adjoining motel room. Shortly after, a series of close-ups of her face and body are shown, with only the sound of running water in the background. Suddenly a mysterious attacker interrupts the scene. The screeching staccato of violins mimics the rapid shots of a knife thrusting at body parts. The sequence concludes with juxtaposed close-ups of water and blood running down the drain hole and the open eye of the dead Marion, the last in a series of close-ups of circular forms in the sequence.*

Scene from Alfred Hitchcock's *Psycho* (USA, 1960)

While the sheer horror of what happens in this famous scene startles and frightens most viewers, another response, with some distance, is to marvel at the extraordinary compositional and editing mechanics that construct the sequence with such creative skill. If the film experience involves many different dimensions of spectatorship, as we saw in Part 1, such unconscious and conscious, cognitive, visceral, and social responses are often orchestrated by the nuts and bolts of film form, or the way a movie is constructed through images and sounds. A common, albeit imprecise, analogy is the literary experience, where our reading of a novel or poem is, at its most basic level, an encounter with the semantic and syntactical organization of a written language. Words, sentences, and

paragraphs produce a literary text and our experience of it; similarly, the four basic features of "film language" — mise-en-scène, cinematography, editing, and sound — provide the focal point of the movie experience. This textual model for film theory implies that audiences "read" a film as a way to follow its story, understand its message, or interpret its language and aesthetic effect. Examining the basic features of film carefully is a crucial step in appreciating and understanding a movie such as *Psycho*, since formal features such as the editing, the compositions of shots, and the use of sound shape our emotions of suspense and fear. The readings in this section represent a range of perspectives on film form and its complexities, demonstrating how the sights, sounds, and signs of cinema involve both technical and conceptual issues central to our experience of the movies. Considering how films like *Psycho* engage and manipulate the complexities of film forms is a fundamental way to understand those films better and to grasp how and why they move us in certain ways.

A key question in discussions of film form concerns the distinction between those characteristics inherited from other artistic practices and those that belong uniquely to film practice. In the opening selection from *Ways of Seeing*, JOHN BERGER makes the important connection between the film image and the larger history of the image that extends back through hundreds of years of paintings and other visual representations. For Berger, understanding the broader context of the image is crucial not only to recognizing the social and aesthetic heritage of the film image but also to considering the material and aesthetic differences between artistic productions like paintings that exist in unique form, and the mechanically reproduced images of film. Sensitivity to intertextual connections like these can productively guide readings of any film. For example, the shower scene from *Psycho* begins with Norman removing a reproduction of a classical painting whose subject matter is rape, thus foreshadowing the violence against Marion that is about to occur. Berger's discussion of classical traditions in art history, often based in voyeuristic points of view that objectify the female figure, can enrich a viewer's understanding of Hitchcock's use of the cinematic image.

Arguments for cinematic specificity emphasize the uniqueness or singularity of film form to define the essential character of film practice and thus challenge the notion of continuity between film and previous art forms. Any avid filmgoer knows that none of the basic features of film form can operate independently of the others — even silent films made before the introduction of synchronized sound in 1927 used piano or orchestral accompaniment. However, in interpreting and examining the significance of those features, theorists have focused on and valorized one over the others. For example, Hungarian BÉLA BALÁZS concentrates on the close-up as a demonstration of film's unique power to reveal "the physiognomy of things" and to capture deeper meanings in the human expression. For many critics, Hitchcock's films are ideal examples of cinematic specificity precisely because his uses of camera angles, editing, and sound could hardly be approximated by another art form. The rapid editing of the shower sequence in *Psycho* — rhythmically orchestrating seventy camera setups for forty-five seconds of footage — creates an experience uniquely situated in a cinematic tension between the visceral and the abstract.

When multiple theorists write on the same aspect of film form, they may assign different possibilities and meanings to that form, conceptualizing the significance of those

features in quite different ways. To compare and contrast these various critical stances on film form is not to suggest that forms can mean anything one chooses or to reach some decisive conclusion about which of these interpretations is correct; rather it is to recognize that the sights, sounds, and signs of the cinema can be effectively used and interpreted in different ways. LEV KULESHOV and MAYA DEREN champion editing for significantly different reasons. For Soviet filmmaker Kuleshov, editing can potentially provide a revolutionary reshaping of the world and an audience's perception of it or, as he notes in "The Principles of Montage," make visible the class relations often hidden behind daily perceptions. Experimental filmmaker Deren, on the other hand, celebrates the creative power of editing to transform bland notions of photographic realism and chronological temporality into far more imaginative and visionary structures. Hitchcock's editing of the shower sequence in *Psycho* does not seem at first glance to have much to do with Kuleshov's or Deren's stances, but, with some careful thought, significant connections can be found between their positions and Hitchcock's creative manipulation of psychological and emotional "time," or his exploration of the dark underside of the "everyday" world.

Film theories that concentrate specifically on how films are aesthetically constructed and read are considered types of formalism. Historically, film formalism grew out of the Russian Formalist movement in literary studies that emerged in the 1910s. Kuleshov, and his students Sergei Eisenstein and V. I. Pudovkin, took this focus on the "literariness" of literature and adapted it to theories on the specificity of film form in their writing and political filmmaking. The avant-garde and experimental movements of the 1930s and 1940s (exemplified by Deren's 1943 film *Meshes of the Afternoon*) merged their formalist concerns with the Freudian notion of the unconscious to indicate how film forms might access the complicated structures of dreams as texts to be deciphered.

By the 1960s, beginning in France, film semiotics (the study of signs and signification) and structuralism (attention to the deep structure, especially oppositions, that shapes myths and other formal systems), aggressively returned to the "film-as-language" model that underlies formalist attention to mise-en-scène, cinematography, editing, and sound. MICHEL CHION's theorizations of the formerly neglected dimension of film sound grow out of these almost scientific efforts to attend to the formal operations of a movie. Chion illustrates the power of the voice using psychoanalysis and coins a new term, "acousmêtre," to represent an unseen speaker in his *The Voice in Cinema* (1982). His work is indebted not only to the semiotic tradition of cinema studies but also to major advances in movie sound technology since the 1960s and their creative implementation in the films of Stanley Kubrick, Robert Altman, David Lynch, and others. CLAUDIA GORBMAN builds on Chion in her careful description of how background music produces meaning in classical Hollywood cinema. Another semiotic approach is followed by French philosopher GILLES DELEUZE in two unique and important books written on the cinema in the 1980s, *Cinema I: The Movement Image* and *Cinema II: The Time-Image*. As a philosopher, Deleuze is ultimately interested in the relationship between film and thought. Therefore, rather than considering how film's signs are like a language, as film theorist Christian Metz had done, Deleuze classifies images and signs in relation to movement and time, two concepts he considers central to the form and experience of cinema.

Related to the broader cultural and interdisciplinary perspectives on film form is cultural studies, a critical perspective that emphasizes social and historical contexts and explores dimensions of film form that extend beyond the film text itself. One of the most important and most suggestive of these forms has been film acting and performance. Acting has always been an object of attention and fascination in film studies, but in recent decades more scholars have concentrated on its larger theoretical concerns. In *Acting in the Cinema*, JAMES NAREMORE explores crucial literary connections that underlie film performances and discusses the relation of film acting to stage acting, the distinction between "presentational" versus "representational" acting styles, and how performances interact with the different social spaces of mise-en-scène.

Cultural studies has similarly expanded the formalist topics of film criticism to include a broader critical perspective based in popular culture. Animation studies, for example, has gradually become a major field in contemporary film theory. PAUL WELLS's "Notes Towards a Theory of Animation" balances the exacting attention to the specificity of this unique representational form with cultural and historical questions about the changing status of animation in film and television history. Along the way, this flexible framework allows him to discuss, side by side, flipbooks, cartoons, avant-garde films, Disney movies, and experiments with digital cinema.

All films offer many formal entryways into readings. Frequently a film will call attention to one or two salient formal features. For some, it may be a stunning use of sound; for others it may be lavish sets. In a film like *Psycho,* it is the virtuoso coordination of sound, editing, acting, and cinematography. How these formal features elicit and direct our reading of a film can still vary from viewer to viewer, but attending to these features precisely reminds us that good analysis, rich theory, and a productive film experience invariably begin with exactly what we see and hear on the screen.

# JOHN BERGER

. . . . . . . . . . . . . . . . . . . . . . . . . . . . . . . . . . . . . . . . . . . . . . . . . . . . . . . . . . . . . . . . . . .

## From *Ways of Seeing*

An art critic, painter, novelist, essayist, poet, and filmmaker, John Berger (b. 1926) is one of the most influential thinkers of the past fifty years. Educated as an artist in London, he started writing for London's *New Statesman* and quickly became an influential and controversial Marxist art critic. Beginning with his first novel in 1958, he has also produced a significant body of fiction, including *G.* (1972), winner of England's Booker Prize. A key figure of the 1950s New Left, Berger perfectly embodies a public intellectual, somebody whose work is integrally connected to his engagement with social issues. His strong belief in the organic connection between one's way of life and one's beliefs is illustrated in his writing as much as in his commitment to a life away in a small village in the French Alps, where he writes about rural peasant experience.

Motivated by exploring the connections between art and the consciousness of the people, rather than by specific themes or subject matter, Berger consistently eludes compartmentalizing and his huge body of work ranges across forms and disciplines, covering diverse subject matter from Picasso's painting to world poverty, from politics to memory, from photography to the political and economic displacement of European peasantry. He is best known, however, for the seminal book of art criticism, *Ways of Seeing* (1972), constructed to accompany, and amply illustrated with images from, a BBC television series.

The ideas expressed in *Ways of Seeing* can be traced back to the work of such critics as Theodor W. Adorno and Walter Benjamin, and it is one of the most lucid and persuasive works in the tradition of the Frankfurt School. Berger revolutionizes the paradigm for thinking about images, formulating a manifesto for how the relationship between art history and social conditions should be examined. The questions raised in *Ways of Seeing* have generated a whole academic industry, shaping in significant ways the work of criticism on literature, cinema, art, and history. The developments in the emerging field of visual culture studies may be strongly attributed to the lasting influence of this book that, despite other contributions in the field, remains a tour de force in the study of images. The book's significance for film studies is similarly far-reaching, positing the practice of film viewing as an ethical matter and placing the filmic image in the tradition of the conventions of seeing established in the Renaissance.

The first selection here is inspired by Walter Benjamin's "The Work of Art in the Age of Its Technological Reproducibility" (p. 229, more commonly known by the title of its original English translation, "The Work of Art in the Age of Mechanical Reproduction"). It offers an intense and incisive critique of how art remains the preserve of privileged classes, and how the mystification of the past is crucial in enforcing the uncritical reproduction of its images and conventions. It also clearly foregrounds two key transformations in the history of images: the emergence of the monocular, Renaissance perspective, and the reproduction of images. In the second selection, from Chapter 3, Berger analyzes tendencies prevalent in the Renaissance painting of female nudes, develops the concept of the "ideal spectator" and the object of the painting, and foregrounds a relationship between the two. This relationship between what Berger calls "the surveyor" and "the surveyed" invokes an argument that became one of the most influential ones in film studies when later contextualized in psychoanalytic terms by Laura Mulvey in "Visual Pleasure and Narrative Cinema" (p. 713).

## READING CUES & KEY CONCEPTS

■ What does Berger mean by the process of "mystification"?

■ What is the relationship between the Renaissance perspective described in Chapter 1, and the conventions of painting a female nude?

■ Consider the ways in which the conventions of the monocular, Renaissance perspective are manifested in film, especially in what we call "the classical narrative."

■ **Key Concepts:** Mystification; Renaissance Perspective; Reproduction

# From *Ways of Seeing*

. . . . . . . . . . . . . .

*Seeing comes before words. The child looks and recognizes before it can speak.*

But there is also another sense in which seeing comes before words. It is seeing which establishes our place in the surrounding world; we explain that world with words, but words can never undo the fact that we are surrounded by it. The relation between what we see and what we know is never settled. Each evening we *see* the sun set. We *know* that the earth is turning away from it. Yet the knowledge, the explanation, never quite fits the sight. The Surrealist painter [René] Magritte commented on this always-present gap between words and seeing in a painting called *The Key of Dreams.*

The way we see things is affected by what we know or what we believe. In the Middle Ages when men believed in the physical existence of Hell the sight of fire must have meant something different from what it means today. Nevertheless their idea of Hell owed a lot to the sight of fire consuming and the ashes remaining—as well as to their experience of the pain of burns.

When in love, the sight of the beloved has a completeness which no words and no embrace can match: a completeness which only the act of making love can temporarily accommodate.

Yet this seeing which comes before words, and can never be quite covered by them, is not a question of mechanically reacting to stimuli. (It can only be thought of in this way if one isolates the small part of the process which concerns the eye's retina.) We only see what we look at. To look is an act of choice. As a result of this act, what we see is brought within our reach—though not necessarily within arm's reach. To touch something is to situate oneself in relation to it. (Close your eyes, move round the room and notice how the faculty of touch is like a static, limited form of sight.) We never look at just one thing; we are always looking at the relation between things and ourselves. Our vision is continually active, continually moving, continually holding things in a circle around itself, constituting what is present to us as we are.

Soon after we can see, we are aware that we can also be seen. The eye of the other combines with our own eye to make it fully credible that we are part of the visible world.

If we accept that we can see that hill over there, we propose that from that hill we can be seen. The reciprocal nature of vision is more fundamental than that of spoken dialogue. And often dialogue is an attempt to verbalize this—an attempt to explain how, either metaphorically or literally, "you see things," and an attempt to discover how "he sees things."

In the sense in which we use the word in this book, all images are man-made.

An image is a sight which has been recreated or reproduced. It is an appearance, or a set of appearances, which has been detached from the place and time in which it first made its appearance and preserved—for a few moments or a few centuries. Every image embodies a way of seeing. Even a photograph. For photographs are not, as is often assumed, a mechanical record. Every time we look at a photograph, we are aware, however slightly, of the photographer selecting that sight from an infinity of other possible sights. This is true even in the most casual family snapshot. The

photographer's way of seeing is reflected in his choice of subject. The painter's way of seeing is reconstituted by the marks he makes on the canvas or paper. Yet, although every image embodies a way of seeing, our perception or appreciation of an image depends also upon our own way of seeing. (It may be, for example, that Sheila is one figure among twenty; but for our own reasons she is the one we have eyes for.)

Images were first made to conjure up the appearances of something that was absent. Gradually it became evident that an image could outlast what it represented; it then showed how something or somebody had once looked—and thus by implication how the subject had once been seen by other people. Later still the specific vision of the image-maker was also recognized as part of the record. An image became a record of how X had seen Y. This was the result of an increasing consciousness of individuality, accompanying an increasing awareness of history. It would be rash to try to date this last development precisely. But certainly in Europe such consciousness has existed since the beginning of the Renaissance.

No other kind of relic or text from the past can offer such a direct testimony about the world which surrounded other people at other times. In this respect images are more precise and richer than literature. To say this is not to deny the expressive or imaginative quality of art, treating it as mere documentary evidence; the more imaginative the work, the more profoundly it allows us to share the artist's experience of the visible.

Yet when an image is presented as a work of art, the way people look at it is affected by a whole series of learnt assumptions about art. Assumptions concerning:

Beauty

Truth

Genius

Civilization

Form

Status

Taste, etc.

Many of these assumptions no longer accord with the world as it is. (The world-as-it-is is more than pure objective fact, it includes consciousness.) Out of true with the present, these assumptions obscure the past. They mystify rather than clarify. The past is never there waiting to be discovered, to be recognized for exactly what it is. History always constitutes the relation between a present and its past. Consequently fear of the present leads to mystification of the past. The past is not for living in; it is a well of conclusions from which we draw in order to act. Cultural mystification of the past entails a double loss. Works of art are made unnecessarily remote. And the past offers us fewer conclusions to complete in action.

When we "see" a landscape, we situate ourselves in it. If we "saw" the art of the past, we would situate ourselves in history. When we are prevented from seeing it, we are being deprived of the history which belongs to us. Who benefits from this deprivation? In the end, the art of the past is being mystified because a privileged minority is striving to invent a history which can retrospectively justify the role

of the ruling classes, and such a justification can no longer make sense in modern terms. And so, inevitably, it mystifies.

[ · · · ]

In order to avoid mystifying the past (which can equally well suffer pseudo-Marxist mystification) let us now examine the particular relation which now exists, so far as pictorial images are concerned, between the present and the past. If we can see the present clearly enough, we shall ask the right questions of the past.

Today we see the art of the past as nobody saw it before. We actually perceive it in a different way.

This difference can be illustrated in terms of what was thought of as perspective. The convention of perspective, which is unique to European art and which was first established in the early Renaissance, centres everything on the eye of the beholder. It is like a beam from a lighthouse—only instead of light travelling outwards, appearances travel in. The conventions called those appearances *reality*. Perspective makes the single eye the centre of the visible world. Everything converges on to the eye as to the vanishing point of infinity. The visible world is arranged for the spectator as the universe was once thought to be arranged for God.

According to the convention of perspective there is no visual reciprocity. There is no need for God to situate himself in relation to others: he is himself the situation. The inherent contradiction in perspective was that it structured all images of reality to address a single spectator who, unlike God, could only be in one place at a time.

After the invention of the camera this contradiction gradually became apparent.

The camera isolated momentary appearances and in so doing destroyed the idea that images were timeless. Or, to put it another way, the camera showed that the notion of time passing was inseparable from the experience of the visual (except in paintings). What you saw depended upon where you were when. What you saw was relative to your position in time and space. It was no longer possible to imagine everything converging on the human eye as on the vanishing point of infinity.

This is not to say that before the invention of the camera men believed that everyone could see everything. But perspective organized the visual field as though that were indeed the ideal. Every drawing or painting that used perspective proposed to the spectator that he was the unique centre of the world. The camera—and more particularly the movie camera—demonstrated that there was no centre.

The invention of the camera changed the way men saw. The visible came to mean something different to them. This was immediately reflected in painting.

For the Impressionists the visible no longer presented itself to man in order to be seen. On the contrary, the visible, in continual flux, became fugitive. For the Cubists the visible was no longer what confronted the single eye, but the totality of possible views taken from points all round the object (or person) being depicted.

The invention of the camera also changed the way in which men saw paintings painted long before the camera was invented. Originally paintings were an integral part of the building for which they were designed. Sometimes in an early Renaissance church or chapel one has the feeling that the images on the wall are records of the building's interior life, that together they make up the building's memory—so much are they part of the particularity of the building.

The uniqueness of every painting was once part of the uniqueness of the place where it resided. Sometimes the painting was transportable. But it could never be seen in two places at the same time. When the camera reproduces a painting, it destroys the uniqueness of its image. As a result its meaning changes. Or, more exactly, its meaning multiplies and fragments into many meanings.

This is vividly illustrated by what happens when a painting is shown on a television screen. The painting enters each viewer's house. There it is surrounded by his wallpaper, his furniture, his mementoes. It enters the atmosphere of his family. It becomes their talking point. It lends its meaning to their meaning. At the same time it enters a million other houses and, in each of them, is seen in a different context. Because of the camera, the painting now travels to the spectator rather than the spectator to the painting. In its travels, its meaning is diversified.

[ · · · ]

This new status of the original work is the perfectly rational consequence of the new means of reproduction. But it is at this point that a process of mystification again enters. The meaning of the original work no longer lies in what it uniquely says but in what it uniquely is. How is its unique existence evaluated and defined in our present culture? It is defined as an object whose value depends upon its rarity. This value is affirmed and gauged by the price it fetches on the market. But because it is nevertheless "a work of art"—and art is thought to be greater than commerce—its market price is said to be a reflection of its spiritual value. Yet the spiritual value of an object, as distinct from a message or an example, can only be explained in terms of magic or religion. And since in modern society neither of these is a living force, the art object, the "work of art," is enveloped in an atmosphere of entirely bogus religiosity. Works of art are discussed and presented as though they were holy relics: relics which are first and foremost evidence of their own survival. The past in which they originated is studied in order to prove their survival genuine. They are declared art when their line of descent can be certified.

[ · · · ]

The bogus religiosity which now surrounds original works of art, and which is ultimately dependent upon their market value, has become the substitute for what paintings lost when the camera made them reproducible. Its function is nostalgic. It is the final empty claim for the continuing values of an oligarchic, undemocratic culture. If the image is no longer unique and exclusive, the art object, the thing, must be made mysteriously so.

[ · · · ]

Because works of art are reproducible, they can, theoretically, be used by anybody. Yet mostly—in art books, magazines, films or within gilt frames in living-rooms—reproductions are still used to bolster the illusion that nothing has changed, that art, with its unique undiminished authority, justifies most other forms of authority, that art makes inequality seem noble and hierarchies seem thrilling. For example, the whole concept of the National Cultural Heritage exploits the authority of art to glorify the present social system and its priorities.

The means of reproduction are used politically and commercially to disguise or deny what their existence makes possible. But sometimes individuals use them differently.

Adults and children sometimes have boards in their bedrooms or living-rooms on which they pin pieces of paper: letters, snapshots, reproductions of paintings, newspaper cuttings, original drawings, postcards. On each board all the images belong to the same language and all are more or less equal within it, because they have been chosen in a highly personal way to match and express the experience of the room's inhabitant. Logically, these boards should replace museums.

What are we saying by that? Let us first be sure about what we are not saying.

We are not saying that there is nothing left to experience before original works of art except a sense of awe because they have survived. The way original works of art are usually approached—through museum catalogues, guides, hired cassettes, etc.—is not the only way they might be approached. When the art of the past ceases to be viewed nostalgically, the works will cease to be holy relics—although they will never re-become what they were before the age of reproduction. We are not saying original works of art are now useless.

Original paintings are silent and still in a sense that information never is. Even a reproduction hung on a wall is not comparable in this respect for in the original the silence and stillness permeate the actual material, the paint, in which one follows the traces of the painter's immediate gestures. This has the effect of closing the distance in time between the painting of the picture and one's own act of looking at it. In this special sense all paintings are contemporary. Hence the immediacy of their testimony. Their historical moment is literally there before our eyes. Cézanne made a similar observation from the painter's point of view. "A minute in the world's life passes! To paint it in its reality, and forget everything for that! To become that minute, to be the sensitive plate . . . give the image of what we see, forgetting everything that has appeared before our time. . . ." What we make of that painted moment when it is before our eyes depends upon what we expect of art, and that in turn depends today upon how we have already experienced the meaning of paintings through reproductions.

Nor are we saying that all art can be understood spontaneously. We are not claiming that to cut out a magazine reproduction of an archaic Greek head, because it is reminiscent of some personal experience, and to pin it on to a board beside other disparate images, is to come to terms with the full meaning of that head.

The idea of innocence faces two ways. By refusing to enter a conspiracy, one remains innocent of that conspiracy. But to remain innocent may also be to remain ignorant. The issue is not between innocence and knowledge (or between the natural and the cultural) but between a total approach to art which attempts to relate it to every aspect of experience and the esoteric approach of a few specialized experts who are the clerks of the nostalgia of a ruling class in decline. (In decline, not before the proletariat, but before the new power of the corporation and the state.) The real question is: to whom does the meaning of the art of the past properly belong? To those who can apply it to their own lives, or to a cultural hierarchy of relic specialists?

The visual arts have always existed within a certain preserve; originally this preserve was magical or sacred. But it was also physical: it was the place, the cave, the building, in which, or for which, the work was made. The experience of art, which at first was the experience of ritual, was set apart from the rest of life—precisely in order to be able to exercise power over it. Later the preserve of art became a social one. It entered the culture of the ruling class, whilst physically it was set apart and isolated in their palaces and houses. During all this history the authority of art was inseparable from the particular authority of the preserve.

What the modern means of reproduction have done is to destroy the authority of art and to remove it—or, rather, to remove its images which they reproduce—from any preserve. For the first time ever, images of art have become ephemeral, ubiquitous, insubstantial, available, valueless, free. They surround us in the same way as a language surrounds us. They have entered the mainstream of life over which they no longer, in themselves, have power.

Yet very few people are aware of what has happened because the means of reproduction are used nearly all the time to promote the illusion that nothing has changed except that the masses, thanks to reproductions, can now begin to appreciate art as the cultured minority once did. Understandably, the masses remain uninterested and sceptical.

If the new language of images were used differently, it would, through its use, confer a new kind of power. Within it we could begin to define our experiences more precisely in areas where words are inadequate. (Seeing comes before words.) Not only personal experience, but also the essential historical experience of our relation to the past: that is to say the experience of seeking to give meaning to our lives, of trying to understand the history of which we can become the active agents.

The art of the past no longer exists as it once did. Its authority is lost. In its place there is a language of images. What matters now is who uses that language for what purpose. This touches upon questions of copyright for reproduction, the ownership of art presses and publishers, the total policy of public art galleries and museums. As usually presented, these are narrow professional matters. One of the aims of this essay has been to show that what is really at stake is much larger. A people or a class which is cut off from its own past is far less free to choose and to act as a people or class than one that has been able to situate itself in history. This is why—and this is the only reason why—the entire art of the past has now become a political issue.

[ · · · ]

According to usage and conventions which are at last being questioned but have by no means been overcome, the social presence of a woman is different in kind from that of a man. A man's presence is dependent upon the promise of power which he embodies. If the promise is large and credible his presence is striking. If it is small or incredible, he is found to have little presence. The promised power may be moral, physical, temperamental, economic, social, sexual—but its object is always exterior to the man. A man's presence suggests what he is capable of doing to you or for you. His presence may be fabricated, in the sense that he pretends to be capable of what he is not. But the pretence is always towards a power which he exercises on others.

By contrast, a woman's presence expresses her own attitude to herself, and defines what can and cannot be done to her. Her presence is manifest in her gestures, voice, opinions, expressions, clothes, chosen surroundings, taste—indeed there is nothing she can do which does not contribute to her presence. Presence for a woman is so intrinsic to her person that men tend to think of it as an almost physical emanation, a kind of heat or smell or aura.

To be born a woman has been to be born, within an allotted and confined space, into the keeping of men. The social presence of women has developed as a result of their ingenuity in living under such tutelage within such a limited space. But this has been at the cost of a woman's self being split into two. A woman must continually watch herself. She is almost continually accompanied by her own image of herself. Whilst she is walking across a room or whilst she is weeping at the death of her father, she can scarcely avoid envisaging herself walking or weeping. From earliest childhood she has been taught and persuaded to survey herself continually.

And so she comes to consider the *surveyor* and the *surveyed* within her as the two constituent yet always distinct elements of her identity as a woman.

She has to survey everything she is and everything she does because how she appears to others, and ultimately how she appears to men, is of crucial importance for what is normally thought of as the success of her life. Her own sense of being in herself is supplanted by a sense of being appreciated as herself by another.

Men survey women before treating them. Consequently how a woman appears to a man can determine how she will be treated. To acquire some control over this process, women must contain it and interiorize it. That part of a woman's self which is the surveyor treats the part which is the surveyed so as to demonstrate to others how her whole self would like to be treated. And this exemplary treatment of herself by herself constitutes her presence. Every woman's presence regulates what is and is not "permissible" within her presence. Every one of her actions—whatever its direct purpose or motivation—is also read as an indication of how she would like to be treated. If a woman throws a glass on the floor, this is an example of how she treats her own emotion of anger and so of how she would wish it to be treated by others. If a man does the same, his action is only read as an expression of his anger. If a woman makes a good joke this is an example of how she treats the joker in herself and accordingly of how she as a joker-woman would like to be treated by others. Only a man can make a good joke for its own sake.

One might simplify this by saying: *men act* and *women appear*. Men look at women. Women watch themselves being looked at. This determines not only most relations between men and women but also the relation of women to themselves. The surveyor of woman in herself is male: the surveyed female. Thus she turns herself into an object—and most particularly an object of vision: a sight.

In one category of European oil painting women were the principal, ever-recurring subject. That category is the nude. In the nudes of European painting we can discover some of the criteria and conventions by which women have been seen and judged as sights.

The first nudes in the tradition depicted Adam and Eve. It is worth referring to the story as told in Genesis:

> And when the woman saw that the tree was good for food, and that it was a delight to the eyes, and that the tree was to be desired to make one wise, she took of the fruit thereof and did eat; and she gave also unto her husband with her, and he did eat.
>
> And the eyes of them both were opened, and they knew that they were naked; and they sewed fig-leaves together and made themselves aprons. . . . And the Lord God called unto the man and said unto him, "Where are thou?" And he said, "I heard thy voice in the garden, and I was afraid, because I was naked; and I hid myself. . . ."
>
> Unto the woman God said, "I will greatly multiply thy sorrow and thy conception; in sorrow thou shalt bring forth children; and thy desire shall be to thy husband and he shall rule over thee."

What is striking about this story? They became aware of being naked because, as a result of eating the apple, each saw the other differently. Nakedness was created in the mind of the beholder.

The second striking fact is that the woman is blamed and is punished by being made subservient to the man. In relation to the woman, the man becomes the agent of God.

In the medieval tradition the story was often illustrated, scene following scene, as in a strip cartoon.

During the Renaissance the narrative sequence disappeared, and the single moment depicted became the moment of shame. The couple wear fig-leaves or make a modest gesture with their hands. But now their shame is not so much in relation to one another as to the spectator.

Later the shame becomes a kind of display.

When the tradition of painting became more secular, other themes also offered the opportunity of painting nudes. But in them all there remains the implication that the subject (a woman) is aware of being seen by a spectator.

She is not naked as she is.

She is naked as the spectator sees her.

[ · · · ]

The mirror was often used as a symbol of the vanity of woman. The moralizing, however, was mostly hypocritical. You painted a naked woman because you enjoyed looking at her, you put a mirror in her hand and you called the painting *Vanity*, thus morally condemning the woman whose nakedness you had depicted for your own pleasure.

The real function of the mirror was otherwise. It was to make the woman connive in treating herself as, first and foremost, a sight.

The Judgement of Paris was another theme with the same inwritten idea of a man or men looking at naked women.

But a further element is now added: The element of judgement. Paris awards the apple to the woman he finds most beautiful. Thus Beauty becomes competitive. (Today The Judgement of Paris has become the Beauty Contest.) Those who are not judged beautiful are *not beautiful*. Those who are, are given the prize.

The prize is to be owned by a judge—that is to say to be available for him. Charles the Second commissioned a secret painting from Lely. It is a highly typical image of the tradition. Nominally it might be a Venus and Cupid. In fact it is a portrait of one of the King's mistresses, Nell Gwynne. It shows her passively looking at the spectator staring at her naked.

This nakedness is not, however, an expression of her own feelings; it is a sign of her submission to the owner's feelings or demands. (The owner of both woman and painting.) The painting, when the King showed it to others, demonstrated this submission and his guests envied him.

It is worth noticing that in other non-European traditions—in Indian art, Persian art, African art, Pre-Columbian art—nakedness is never supine in this way. And if, in these traditions, the theme of a work is sexual attraction, it is likely to show active sexual love as between two people, the woman as active as the man, the actions of each absorbing the other.

We can now begin to see the difference between nakedness and nudity in the European tradition. In his book on the nude Kenneth Clark maintains that to be naked is simply to be without clothes, whereas the nude is a form of art. According to him, a nude is not the starting point of a painting, but a way of seeing which the painting achieves. To some degree, this is true—although the way of seeing "a nude" is not necessarily confined to art: there are nude photographs, nude poses, nude gestures. What is true is that the nude is always conventionalized—and the authority for its conventions derives from a certain tradition of art.

What do these conventions mean? What does a nude signify? It is not sufficient to answer these questions merely in terms of the art-form, for it is quite clear that the nude also relates to lived sexuality.

To be naked is to be oneself.

To be nude is to be seen naked by others and yet not recognized for oneself. A naked body has to be seen as an object in order to become a nude. (The sight of it as an object stimulates the use of it as an object.) Nakedness reveals itself. Nudity is placed on display.

To be naked is to be without disguise.

To be on display is to have the surface of one's own skin, the hairs of one's own body, turned into a disguise which, in that situation, can never be discarded. The nude is condemned to never being naked. Nudity is a form of dress.

In the average European oil painting of the nude the principal protagonist is never painted. He is the spectator in front of the picture and he is presumed to be a man. Everything is addressed to him. Everything must appear to be the result of his being there. It is for him that the figures have assumed their nudity. But he, by definition, is a stranger—with his clothes still on.

# BÉLA BALÁZS

## The Creative Camera;
## The Close-Up;
## The Face of Man

FROM *Theory of the Film*

Béla Balázs (b. Herbert Bauer, 1884–1949), a Hungarian-born writer and filmmaker, was one of the first comprehensive theorists of cinema, a cosmopolitan who partook of the intellectual culture of a number of European capitals of his era. His *Visible Man, or Film Culture* was published in German in 1924 and was followed by *The Spirit of Film*, which included a discussion of synchronous sound in 1930. *Theory of the Film* first appeared in Russian in 1945, followed by editions in Yugoslavian, Hungarian, German, and English. Exiled for political reasons from his native country—where he was among the circle of Marxist philosopher Georg Lukács and collaborated with composer Béla Bartók—he moved to Berlin, where he collaborated with Leni Riefenstahl on her first directorial effort, *Das Blaue Licht* (*The Blue Light*, 1932). With the rise of the Nazi Party in 1933, Balázs fled to Moscow, where he lived until the end of World War II, when he returned to Hungary. As a teacher at the state film school in Moscow he influenced such Soviet practitioners/ theorists as V. I. Pudovkin and developed the ideas set forth in *Theory of the Film*.

Balázs enumerated and heralded film's unique formal capacities (what he called a new "form-language"), arguing that the medium had already transformed our subjective capacity through "visual culture"—a term in use again today to encompass art, film, and other predominantly visual phenomena that shape our experience. Balázs's enthusiasm for theory energizes his writing on such topics as the aesthetic potential of camera placement, editing, and sound, as well as what he calls "the physiognomy of things," by which he attributes human expression to inanimate objects. Despite being associated with formalism, Balázs was not ideologically committed to avant-garde experimentation. He praised the refinements of Hollywood commercial production, noting that, "film is the only art born in the epoch of capitalism." Above all, he recognized and championed the opportunity for firsthand observation of aesthetic, subjective, and social transformation that the medium afforded.

In the first selection, from the chapter entitled "The Creative Camera," Balázs anticipates later psychoanalytic theories of cinema with his emphasis on the process of identification. In the second, "The Close-Up," Balázs is beguiled with the lyrical potential of the close-up, endowing such shots of the human face with almost mystical powers to reveal the soul. Similarly, he asserts that material reality is anthropomorphized by the camera's eye. His frequent example of the potential of screen acting, offered in "The Face of Man," was Danish actress Asta Nielsen. Balázs's passionate and sometimes idiosyncratic writings resonate with the ideas of such thinkers as Walter Benjamin (p. 229) and remain intriguing to contemporary readers reflecting on film form as a mode of producing, not reproducing, reality.

## READING CUES & KEY CONCEPTS

■ What does Balázs mean when he says that "we are in the picture"?

■ How does the close-up offer a perspective not otherwise available to the viewer?

■ Do you think contemporary acting and filming styles make use of film form in the ways that Balázs enumerates?

■ **Key Concepts:** Identification; Visual Life; Close-Up; Microphysiognomy

# The Creative Camera

. . . . . . . . . . . . . .

What we see on the screen is a photograph; that is, it was not created on the screen as a painting is created on the canvas but was already previously existent and visible in reality. It had to be enacted in front of the camera, otherwise it could not have been photographed. Thus the actual artistic creation, the original creative act is performed in the studio or on location; at all events before the camera in space and before the shooting in time. Then and there the actors acted and the technicians did their jobs. Everything had first to be reality before it could become a picture. Hence the film we see on the screen is merely a photographic reproduction, or to be exact, the reproduction of a histrionic performance.

Or do we see things in the film, on the screen, which we could not have seen in the studio even if we had been present when the film was made? What are the effects which are born only on the celluloid, are born only in the act of projecting the film on to the screen? What is it that the film does not reproduce but produce, and through which it becomes an independent, basically new art after all?

We have already said it: the changing distance, the detail taken out of the whole, the close-up, the changing angle, the cutting, and what is the most important: a new psychological effect achieved by the film through the devices just mentioned. This new psychological effect is identification.

Even if I am present at every shot, if I look on as every scene is enacted in the studio, I can never see or feel the pictorial effects which are the results of camera distances and angles, nor can I become aware of the rhythm which is their outcome. For in the studio I see each scene and each figure as a whole and am unable to single out details with my eye.

In reality we can never see the face of things in the microscopic detail of a close-up, even if we stand beside the camera when the shot is made. The cut-out of the close-up is a function akin to the composition in a painting. What is left out and what is included have a significance of their own and this significance is provided only by the camera and transmitted to us only by the picture projected on the screen.

The angle is what gives all things their shape and the same thing taken from different angles often gives a completely dissimilar picture. This is the strongest means of characterization the film possesses; and it is not reproduction but genuine production. The cameraman's vision, his artistic creative work, the expression of his personality, can be seen only in the screen projection.

Finally there is the cutting, the ultimate integrating work on the film, which is quite apart from the shooting of the picture and which creates the rhythm and that process of association of ideas which again cannot be reproduction, if for no other reason, because there is no original to reproduce in this phase of film creation, not even as much as the painter has in his model. Montage, the mobile architecture of the film's picture-material, is a specific, new creative art.

Such are the basically novel elements of film art. These are the things which the invention in France of the cinematographic camera did not automatically produce, but which were evolved in Hollywood decades later.

## We Are in the Picture

Some people think that the new means of expression provided by the camera are due only to its mobility, which not only shows us new things all the time but does so from incessantly changing angles and distances and that this constitutes the historical novelty of the film.

True, the film camera has revealed new worlds until then concealed from us: such as the soul of objects, the rhythm of crowds, the secret language of dumb things.

But all this provided only new knowledge, new themes, new subjects, new material. A more important, more decisive, more historical novelty was that the film showed not other things, but the same things shown in a different way — that in the film the permanent distance from the work fades out of the consciousness of the spectator and with it that inner distance as well, which hitherto was a part of the experience of art.

## Identification

In the cinema the camera carries the spectator into the film picture itself. We are seeing everything from the inside as it were and are surrounded by the characters of the film. They need not tell us what they feel, for we see what they see and see it as they see it.

Although we sit in our seats for which we have paid, we do not see Romeo and Juliet from there. We look up to Juliet's balcony with Romeo's eyes and look down on Romeo with Juliet's. Our eye and with it our consciousness is identified with the characters in the film, we look at the world out of their eyes and have no angle of vision of our own. We walk amid crowds, ride, fly or fall with the hero and if one character looks into the other's eyes, he looks into our eyes from the screen, for, our eyes are in the camera and become identical with the gaze of the characters. They see with our eyes. Herein lies the psychological act of "identification."

Nothing like this "identification" has ever occurred as the effect of any other system of art and it is here that the film manifests its absolute artistic novelty.

[ · · · ]

# The Close-Up

. . . . . . . . . . . . . . .

A s we have already said, the basis of the new form-language is the moving cinematographic camera with its constantly changing viewpoint. The distance from the object and with it the size and number of objects in the frame, the angle

and the perspective all change incessantly. This movement breaks up the object before the camera into *sectional pictures*, or "shots," irrespective of whether that object is moving or motionless. Sectional pictures are not details of a whole film. For what is being done is not to break up into its constituent parts a picture already taken or already envisaged. The result of this would be detail; in this case one would have to show every group and every individual in a crowd scene from the same angle as the one from which they are seen in the total picture; none of the people or things could move—if they did, they would no longer be details of the same total. What is done is not to break up into detail an already existent, already formed total picture, but to show a living, moving scene or landscape as a synthesis of sectional pictures, which merge in our consciousness into a total *scene* although they are not the parts of an existent immutable mosaic and could never be made into a total single *picture*.

## What Holds the Sectional Pictures Together?

The answer to this question is: the montage or cutting, the mobile composition of the film, an architecture in time, not space, of which much more is to be said later. For the time being we are interested in the psychological question of why a scene broken up into sectional pictures does not fall apart but remains a coherent whole, remains in the consciousness of the spectator a consistent unity in both space and time. How do we know that things are happening simultaneously and in the same place, even though the pictures pass before our eyes in temporal sequence and show a real passing of time?

This unity and the simultaneity of pictures proceeding in time is not produced automatically. The spectator must contribute an association of ideas, a synthesis of consciousness and imagination to which the film-going public had first to be educated. This is that visual culture of which we have spoken in previous chapters.

But the sectional picture (or "shot") must be correctly ordered and composed. There may be shots which slip out of the whole and in respect of which we no longer feel that we are in the same place and see the same scene as in the preceding shots. This is a matter for the director who can, if he chooses, make the spectator feel the continuity of the scene, its unity in time and space even if he has never once shown him a total picture of the whole scene for his orientation.

This is done by including in every shot a movement, a gesture, a form, a something which refers the eye to the preceding and following shots, something that protrudes into the next shot like the branch of a tree or a fence, like a ball that rolls from one frame to the other, a bird that flies across, cigar smoke that curls in both, a look or gesture to which there is an answer in the next shot. But the director must be on his guard not to change the angle together with the direction of movement—if he does, the change in the picture is so great as to break its unity. The sound film has simplified this job of remaining in step. For sound can always be heard in the whole space, in each shot. If a scene is enacted, say, in a night club, and we hear the same music we will know that we are in the same night club even if in the shot itself we see nothing but a hand holding a flower or something of the sort. But if we suddenly hear different sounds in this same shot of a hand we will assume, even if we don't see it, that the hand holding the flower is now in a quite different place. For instance, to continue the picture of the hand holding the rose—if instead of dance music we now hear the twittering of birds, we will not be surprised if, when the

picture widens into a long shot, we see a garden and the owner of the hand picking roses. This sort of change-over offers opportunities for good effects.

## Sound Is Indivisible

This totally different nature of sound has a considerable influence on the composition, montage and dramaturgy of the sound film. The sound camera cannot break up sound into sections or shots as the cinematographic camera can break up objects. In space, sound is always heard indivisibly and homogeneously; that is, it has the same character in one part of space as in any other; it can only be louder or softer, closer or more distant and mixed with other sounds in differing ways. In the night club, for instance, we may first hear only dance music and then the loud talking and laughter of a noisy company at one of the tables may almost drown it.

## Sound in Space

All sound has an identifiable place in space. By its pitch we can tell whether it is in a room, or a cellar, in a large hall or in the open air. This possibility of placing sound also helps to hold together shots the action of which takes place in the same space. The sound film has educated our ear—or might and should have educated it—to recognize the pitch (timbre) of sound. But we have made less progress in our aural than in our visual education. In any case, the sound film which could use sound as its artistic material in a similar way as the silent film had used the visual impression, was soon superseded by the talkie, which was in a sense a step backwards towards the photographed theatre.

## The Face of Things

The first new world discovered by the film camera in the days of the silent film was the world of very small things visible only from very short distances, the hidden life of little things. By this the camera showed us not only hitherto unknown objects and events: the adventures of beetles in a wilderness of blades of grass, the tragedies of day-old chicks in a corner of the poultry-run, the erotic battles of flowers and the poetry of miniature landscapes. It brought us not only new themes. By means of the close-up the camera in the days of the silent film revealed also the hidden mainsprings of a life which we had thought we already knew so well. Blurred outlines are mostly the result of our insensitive short-sightedness and superficiality. We skim over the teeming substance of life. The camera has uncovered that cell-life of the vital issues in which all great events are ultimately conceived; for the greatest landslide is only the aggregate of the movements of single particles. A multitude of close-ups can show us the very instant in which the general is transformed into the particular. The close-up has not only widened our vision of life, it has also deepened it. In the days of the silent film it not only revealed new things, but showed us the meaning of the old.

## Visual Life

The close-up can show us a quality in a gesture of the hand we never noticed before when we saw that hand stroke or strike something, a quality which is often more expressive than any play of the features. The close-up shows your shadow on the

wall with which you have lived all your life and which you scarcely knew; it shows the speechless face and fate of the dumb objects that live with you in your room and whose fate is bound up with your own. Before this you looked at your life as a concert-goer ignorant of music listens to an orchestra playing a symphony. All he hears is the leading melody, all the rest is blurred into a general murmur. Only those can really understand and enjoy the music who can hear the contrapuntal architecture of each part in the score. This is how we see life: only its leading melody meets the eye. But a good film with its close-ups reveals the most hidden parts in our polyphonous life, and teaches us to see the intricate visual details of life as one reads an orchestral score.

# The Face of Man

. . . . . . . . . . . . . .

*The basis and possibility of an art of the film is that everyone and everything looks what it is.*

Every art always deals with human beings; it is a human manifestation and presents human beings. To paraphrase Marx: "The root of all art is man." When the film close-up strips the veil of our imperceptiveness and insensitivity from the hidden little things and shows us the face of objects, it still shows us man, for what makes objects expressive are the human expressions projected on to them. The objects only reflect our own selves, and this is what distinguished art from scientific knowledge (although even the latter is to a great extent subjectively determined). When we see the face of things, we do what the ancients did in creating *gods* in man's image and breathing a human soul into them. The close-ups of the film are the creative instruments of this mighty visual anthropomorphism.

What was more important, however, than the discovery of the physiognomy of things, was the discovery of the human face. Facial expression is the most subjective manifestation of man, more subjective even than speech, for vocabulary and grammar are subject to more or less universally valid rules and conventions, while the play of features, as has already been said, is a manifestation not governed by objective canons, even though it is largely a matter of imitation. This most subjective and individual of human manifestations is rendered objective in the close-up.

## A New Dimension

If the close-up lifts some object or some part of an object out of its surroundings, we nevertheless perceive it as existing in space; we do not for an instant forget that the hand, say, which is shown by the close-up, belongs to some human being. It is precisely this connection which lends meaning to its every movement. But when Griffith's genius and daring first projected gigantic "severed heads" on to the cinema screen, he not only brought the human face closer to us in space, he also transposed it from space into another dimension. We do not mean, of course, the cinema screen and the patches of light and shadow moving across it, which being

visible things, can be conceived only in space; we mean the expression on the face as revealed by the close-up. We have said that the isolated hand would lose its meaning, its expression, if we did not know and imagine its connection with some human being. The facial expression on a face is complete and comprehensible in itself and therefore we need not think of it as existing in space and time. Even if we had just seen the same face in the middle of a crowd and the close-up merely separated it from the others, we would still feel that we have suddenly been left alone with this one face to the exclusion of the rest of the world. Even if we have just seen the owner of the face in a long shot, when we look into the eyes in a close-up, we no longer think of that wide space, because the expression and significance of the face has no relation to space and no connection with it. Facing an isolated face takes us out of space, our consciousness of space is cut out and we find ourselves in another dimension: that of physiognomy. The fact that the features of the face can be seen side by side, i.e. in space—that the eyes are at the top, the ears at the sides and the mouth lower down—loses all reference to space when we see, not a figure of flesh and bone, but an expression, or in other words when we see emotions, moods, intentions and thoughts, things which although our eyes can see them, are not in space. For feelings, emotions, moods, intentions, thoughts are not themselves things pertaining to space, even if they are rendered visible by means which are.

## *Melody and Physiognomy*

We will be helped in understanding this peculiar dimension by Henri Bergson's analysis of time and duration. A melody, said Bergson, is composed of single notes which follow each other in sequence, i.e. in time. Nevertheless a melody has no dimension in time, because the first note is made an element of the melody only because it refers to the next note and because it stands in a definite relation to all other notes down to the last. Hence the last note, which may not be played for some time, is yet already present in the first note as a melody-creating element. And the last note completes the melody only because we hear the first note along with it. The notes sound one after the other in a time-sequence, hence they have a real duration, but the coherent line of melody has no dimension in time; the relation of the notes to each other is not a phenomenon occurring in time. The melody is not born gradually in the course of time but is already in existence as a complete entity as soon as the first note is played. How else would we know that a melody is begun? The single notes have duration in time, but their relation to each other, which gives meaning to the individual sounds, is outside time. A logical deduction also has its sequence, but premise and conclusion do not follow one another in time. The process of thinking as a psychological process may have duration; but the logical forms, like melodies, do not belong to the dimension of time.

Now facial expression, physiognomy, has a relation to space similar to the relation of melody to time. The single features, of course, appear in space; but the significance of their relation to one another is not a phenomenon pertaining to space, no more than are the emotions, thoughts and ideas which are manifested in the facial expressions we see. They are picture-like and yet they seem outside space; such is the psychological effect of facial expression.

## Silent Soliloquy

The modern stage no longer uses the spoken soliloquy, although without it the characters are silenced just when they are the most sincere, the least hampered by convention: when they are alone. The public of to-day will not tolerate the spoken soliloquy, allegedly because it is "unnatural." Now the film has brought us the silent soliloquy, in which a face can speak with the subtlest shades of meaning without appearing unnatural and arousing the distaste of the spectators. In this silent monologue the solitary human soul can find a tongue more candid and uninhibited than in any spoken soliloquy, for it speaks instinctively, subconsciously. The language of the face cannot be suppressed or controlled. However disciplined and practisedly hypocritical a face may be, in the enlarging close-up we see even that it is concealing something, that it is looking a lie. For such things have their own specific expressions superposed on the feigned one. It is much easier to lie in words than with the face and the film has proved it beyond doubt.

In the film the mute soliloquy of the face speaks even when the hero is not alone, and herein lies a new great opportunity for depicting man. The poetic significance of the soliloquy is that it is a manifestation of mental, not physical, loneliness. Nevertheless, on the stage a character can speak a monologue only when there is no one else there, even though a character might feel a thousand times more lonely if alone among a large crowd. The monologue of loneliness may raise its voice within him a hundred times even while he is audibly talking to someone. Hence the most deep-felt human soliloquies could not find expression on the stage. Only the film can offer the possibility of such expression, for the close-up can lift a character out of the heart of the greatest crowd and show how solitary it is in reality and what it feels in this crowded solitude.

The film, especially the sound film, can separate the words of a character talking to others from the mute play of features by means of which, in the middle of such a conversation, we are made to overhear a mute soliloquy and realize the difference between this soliloquy and the audible conversation. What a flesh-and-blood actor can show on the real stage is at most that his words are insincere and it is a mere convention that the partner in such a conversation is blind to what every spectator can see. But in the isolated close-up of the film we can see to the bottom of a soul by means of such tiny movements of facial muscles which even the most observant partner would never perceive.

A novelist can, of course, write a dialogue so as to weave into it what the speakers think to themselves while they are talking. But by so doing he splits up the sometimes comic, sometimes tragic, but always awe-inspiring, unity between spoken word and hidden thought with which this contradiction is rendered manifest in the human face and which the film was the first to show us in all its dazzling variety.

## "Polyphonic" Play of Features

The film first made possible what, for lack of a better description, I call the "polyphonic" play of features. By it I mean the appearance on the same face of contradictory expressions. In a sort of physiognomic chord a variety of feelings, passions and

thoughts are synthesized in the play of the features as an adequate expression of the multiplicity of the human soul.

Asta Nielsen once played a woman hired to seduce a rich young man. The man who hired her is watching the results from behind a curtain. Knowing that she is under observation, Asta Nielsen feigns love. She does it convincingly: the whole gamut of appropriate emotion is displayed in her face. Nevertheless we are aware that it is only play-acting, that it is a sham, a mask. But in the course of the scene Asta Nielsen really falls in love with the young man. Her facial expression shows little change; she had been "registering" love all the time and done it well. How else could she now show that this time she was really in love? Her expression changes only by a scarcely perceptible and yet immediately obvious nuance—and what a few minutes before was a sham is now the sincere expression of a deep emotion. Then Asta Nielsen suddenly remembers that she is under observation. The man behind the curtain must not be allowed to read her face and learn that she is now no longer feigning, but really feeling love. So Asta now pretends to be pretending. Her face shows a new, by this time threefold, change. First she feigns love, then she genuinely shows love, and as she is not permitted to be in love in good earnest, her face again registers a sham, a pretence of love. But now it is this pretence that is a lie. Now she is lying that she is lying. And we can see all this clearly in her face, over which she has drawn two different masks. At such times an invisible face appears in front of the real one, just as spoken words can by association of ideas conjure up things unspoken and unseen, perceived only by those to whom they are addressed.

In the early days of the silent film Griffith showed a scene of this character. The hero of the film is a Chinese merchant. Lillian Gish, playing a beggar-girl who is being pursued by enemies, collapses at his door. The Chinese merchant finds her, carries her into his house and looks after the sick girl. The girl slowly recovers, but her face remains stone-like in its sorrow. "Can't you smile?" the Chinese asks the frightened child who is only just beginning to trust him. "I'll try," says Lillian Gish, picks up a mirror and goes through the motions of a smile, aiding her face muscles with her fingers. The result is a painful, even horrible mask which the girl now turns towards the Chinese merchant. But his kindly friendly eyes bring a real smile to her face. The face itself does not change; but a warm emotion lights it up from inside and an intangible nuance turns the grimace into a real expression.

In the days of the silent film such a close-up provided an entire scene. A good idea of the director and a fine performance on the part of the actor gave as a result an interesting, moving, new experience for the audience.

## Microphysiognomy

In the silent film facial expression, isolated from its surroundings, seemed to penetrate to a strange new dimension of the soul. It revealed to us a new world—the world of microphysiognomy which could not otherwise be seen with the naked eye or in everyday life. In the sound film the part played by this "microphysiognomy" has greatly diminished because it is now apparently possible to express in words much of what facial expression apparently showed. But it is never the same—many profound emotional experiences can never be expressed in words at all.

Not even the greatest writer, the most consummate artist of the pen, could tell in words what Asta Nielsen tells with her face in close-up as she sits down to her mirror and tries to make up for the last time her aged, wrinkled face, raddled with poverty, misery, disease and prostitution, when she is expecting her lover, released after ten years in jail; a lover who has retained his youth in captivity because life could not touch him there.

## Asta at the Mirror

She looks into the mirror, her face pale and deadly earnest. It expresses anxiety and unspeakable horror. She is like a general who, hopelessly encircled with his whole army, bends once more, for the last time, over his maps to search for a way out and finds there is no escape. Then she begins to work feverishly, attacking that disgustingly raddled face with a trembling hand. She holds her lipstick as Michelangelo might have held his chisel on the last night of his life. It is a life-and-death struggle. The spectator watches with bated breath as this woman paints her face in front of her mirror. The mirror is cracked and dull, and from it the last convulsions of a tortured soul look out on you. She tries to save her life with a little rouge! No good! She wipes it off with a dirty rag. She tries again. And again. Then she shrugs her shoulders and wipes it all off with a movement which clearly shows that she has now wiped off her life. She throws the rag away. A close-up shows the dirty rag falling on the floor and after it has fallen, sinking down a little more. This movement of the rag is also quite easy to understand—it is the last convulsion of a death agony.

In this close-up "microphysiognomy" showed a deeply moving human tragedy with the greatest economy of expression. It was a great new form of art. The sound film offers much fewer opportunities for this kind of thing, but by no means excludes it and it would be a pity if such opportunities were to be neglected, unnecessarily making us all the poorer.

**[ · · · ]**

## Mute Dialogues

In the last years of the silent film the human face had grown more and more visible, that is, more and more expressive. Not only had "microphysiognomy" developed but together with it the faculty of understanding its meaning. In the last years of the silent film we saw not only masterpieces of silent monologue but of mute dialogue as well. We saw conversations between the facial expressions of two human beings who understood the movements of each others' faces better than each others' words and could perceive shades of meaning too subtle to be conveyed in words.

A necessary result of this was—as I will show in detailed analysis later in connection with the dramaturgy of the film—that the more space and time in the film was taken up by the inner drama revealed in the "microphysiognomic" close-up, the less was left of the predetermined 8,000 feet of film for all the external happenings. The silent film could thus dive into the depths—it was given the possibility of presenting a passionate life-and-death struggle almost exclusively by close-ups of faces.

Dreyer's film *Jeanne d'Arc* provided a convincing example of this in the powerful, lengthy, moving scene of the Maid's examination. Fifty men are sitting in the same place all the time in this scene. Several hundred feet of film show nothing but big close-ups of heads, of faces. We move in the spiritual dimension of facial expression alone. We neither see nor feel the space in which the scene is in reality enacted. Here no riders gallop, no boxers exchange blows. Fierce passions, thoughts, emotions, convictions battle here, but their struggle is not in space. Nevertheless this series of duels between looks and frowns, duels in which eyes clash instead of swords, can hold the attention of an audience for ninety minutes without flagging. We can follow every attack and riposte of these duels on the faces of the combatants; the play of their features indicates every stratagem, every sudden onslaught. The silent film has here brought an attempt to present a drama of the spirit closer to realization than any stage play has ever been able to do.

[ · · · ]

# LEV KULESHOV

## The Principles of Montage

Russian filmmaker and theorist Lev Kuleshov (1899–1970) is a major figure in the golden age of Soviet cinema that flourished during the 1920s. The Russian Revolution of 1917 signaled the beginning of this period: this Marxist-inspired class rebellion was the defining event for Kuleshov and other important filmmakers Dziga Vertov (p. 257), V. I. Pudovkin, and Sergei Eisenstein (p. 262), who studied with Kuleshov. They identified film as the most important art and a powerful social tool capable of changing perceptions of the

world. However, by the time Kuleshov wrote "The Principles of Montage" in 1935, the unbounded energy and optimism of the revolution had settled into the considerably more bureaucratic and repressive Soviet Union under Stalin. Some consider Kuleshov the first major film theorist because of his early work on montage in the 1910s and 1920s; he was also an active filmmaker directing numerous films between 1918 and 1943, including the satire *The Extraordinary Adventures of Mr. West in the Land of the Bolsheviks* (1924).

Kuleshov's work from 1917 to 1935 spans the dynamic transition from silent to sound films at a time when international cinema was establishing certain national traditions. America and Hollywood cinema emerged as the most dominant and pervasive presence and frequently became the background against which other national cinemas were defined. At the same time, pressing questions about cinematic specificity (such as "Is cinema an art?") gave way to arguments about the impact of film on social and cultural values. For example, Kuleshov's own famous experiment tested audience reactions by interspersing the image of an actor's face with various images with specific connotations (a bowl of soup, a coffin, etc.) to demonstrate that the facial expression acquired different meanings through the editing itself. While the growing awareness of the social and psychological power of the movies eventually led to tighter institutional control and even censorship in both the United States and the Soviet Union, many filmmakers embraced the revolutionary potential of film editing and its ability to communicate ideological correctness.

The retrospective look at his earlier theories of cinema in "The Principles of Montage" partly explains the somewhat revisionist tone of the essay. Kuleshov replaces his earlier concerns with the aesthetic and psychological power of editing with the more acceptable argument that editing is primarily about class relations. He does maintain his argument that editing reveals the "essence of the phenomena around us," and he underlines its ability to communicate an ideology or "world-view." Equally noteworthy is his distinction between American, European, and Russian films based largely on editing style and how their individual historical ideologies are reflected as a particular "semantics." Although faith in the political power of editing has waned, Kuleshov's legacy of the politics of film form remains. Editing may be only one formal element for communicating political or social perspectives, but filmmakers from Jean-Luc Godard to Michael Moore and theorists from Walter Benjamin (p. 229) to Trinh T. Minh-ha (p. 691) have continued to see film as a medium for creating and changing how audiences see and think about their society.

## READING CUES & KEY CONCEPTS

■ Kuleshov distinguishes three kinds of editing associated with American cinema, European cinema, and Russian cinema. Explain those differences and the cultural assumptions that, for Kuleshov, underlie them.

■ Is, as Kuleshov claims, the cinema "more complicated than other forms of art"? In what ways does he mean this?

■ Claiming that the close-up is the heart of editing, Kuleshov argues that montage makes the expressions of the actor "irrelevant." How does his notion of internal montage complicate this idea? Support or counter this claim with an example from a specific film.

■ **Key Concepts:** Cinematic Specificity; Ideology; Internal Montage; Montage; Typage

# The Principles of Montage

. . . . . . . . . . . . . .

The theory of montage in the cinema is a very important and interesting theory. It has caused great concern even to me, as one who has occupied himself with this theory, as well as to critics and filmmakers. Extremely fiery disputes flared around the theory of montage from its very inception. The theory of montage demands a particularly attentive approach and study, because montage represents the essence of cinema technique, the essence of structuring a motion picture. Having worked a long time on the theory of montage, I committed a whole series of the crudest errors. Previously, I had both concluded and written that montage was so crucial to cinematography that everything else was secondary. Despite the fact that I had done much work on the very material of motion pictures, on the shots themselves, I still placed all my emphasis on montage, perfecting the entire conception of my theoretical work on it; and here lay my deepest mistake. The fact is that film material (the selection of which is determined by the ideological tendency of the artist) is the live person working on the screen, real life filmed for the screen. This material is so variegated, so significant, and so complex that to render it by mechanical juxtaposition through "film-specifics"—by means of montage—was utterly incorrect. It is here that the political and artistic error of my past years has been. But even these works contain their positive sides. From the viewpoint of these positive aspects we can also analyze the theory of montage, because it is extremely important in the work of the film director. Since the theme of this book is the practice of film direction, I shall touch upon the theory of montage as it concerns practical work, without going deeply into theoretical analyses. I shall, however, have to provide a few historical references so that the essence of the question is clear.

Montage first began in America. Prior to the Civil War and the Revolution, montage, as a consciously expressed artistic method, was virtually unused.

We are aware that the motion picture camera photographs its surrounding reality. By means of the cinema we can observe the world. Accordingly, the cinema shows us the conduct and activities of people, existing in the reality around us. The conduct of people principally results from their class interrelationships.

Thus, photographing separate actions and the various behavior of people on film, we record the real material which surrounds us. Having recorded this material, having shot it, we can show it on the screen. But this demonstration can be accomplished by various means. Before it is possible to show the different pieces photographed in reality, it is vital to edit them, to join them to each other so that the interrelationship demonstrates the essence of the phenomena around us.

The artist's relationship to his surrounding reality, his view of the world, is not merely expressed in the entire process of shooting, but in the montage as well, in the capacity to see and to present the world around him. A variety of social encounters, a class struggle takes place in reality, and the artist's existence within a particular social class influences his world-view. Artists with differing world-views each perceive the reality surrounding them differently; they see events differently, discuss them differently, show them, imagine them, and join them one to another differently.

Thus, film montage, as the entire work of filmmaking, is inextricably linked to the artist's world-view and his ideological purpose.

S. M. Eisenstein, during one of his lectures at the State Institute of Cinematography, presented a particularly vivid and interesting example of various different approaches to montage. Imagine that in a period of two or three days a series of events takes place throughout the entire world. These events are recorded by reporters, and news about them is published in various newspapers. We are aware that both capitalist and communist newspapers exist. The very same events that have taken place during the given three days are printed in both the capitalist and communist press. Even if these events are printed without commentaries, without editorial explanations and commentaries, but simply as a "dry chronicle," one's relationship to them, that is, the political world-view of the editor of the paper still determines the montage of one or another paper. In a capitalist paper all the events would be edited so that the bourgeois intention of the editor, and accordingly, of the paper, would be maximally expressed and emphasized through the character of the montage of the events, their arrangement on the newspaper page. The essential exploitativeness of the capitalist system would be clouded over in the bourgeois paper in every conceivable way, with the evils of the system concealed and the actuality embroidered. The Soviet paper is edited completely otherwise: the information about these very same events would be edited so as to illuminate the entire condition of things in the capitalist world, to reveal its essential exploitativeness, and the position of the workers as it is in reality. It can be proved, with the facts related to each other in this fashion, that the ideological sense of these facts would be differently apprehended by the reader of the paper. In the communist paper the class nature of the fact will be revealed, while in the bourgeois press this nature will be fogged over, perverted.

Thus, based on this example, it becomes clear that montage (the essence of all art) is inextricably tied to the world-view of the person who has the material at his disposal.

The account is evident to everyone. But in the beginning of my work in cinema the question of montage, the questions of aesthetic theory generally, were questions which were substantially murky for me, and I did not connect them with class interpretation, with the world-view of the artist.

In order that the development of my artistic direction, and the direction of my comrades who worked along with me, be clear, I shall describe my relationship to montage starting with the first steps on my work in film.

I began to work in the cinema in 1916. We were extremely helpless artistically at that time. The cinema was only halfway toward being an art form at that time, and, honestly speaking, it didn't really exist at all. We knew and heard nothing about montage. We only wondered about how to approach this new cinematographic art, so as to learn truly how to work with it artistically, so as to learn how to understand it seriously.

The war was still going on in 1916 and the international marketplaces were closed off to Russia. Because of this, Russian cinema began to develop quickly and independently. Swirling around the films were discussions, disputes, analyses; film gazettes and journals began to appear; in the pages of the theatrical journals a theoretical dispute emerged. The argument was whether film was an art form or not. We—the young generation of filmmakers—engaged in this dispute with the most active participation, despite the fact that we had no arguments, no evidence that film was an art. It was these disputes that led to the beginning of the genesis of the theory of montage. We developed a series of discussions and debates on the theme

of montage theory, and in a few years I began the book which is titled *Art of the Cinema*. It was published still later, in 1928, and subsequently it became an example of major arguments, major studies. Because of its foundation the book was deeply erroneous.

Since we ourselves did not know how to orient ourselves in the cinema, nor what cinema was—whether it was an art form or not—we decided to direct all our attention to motion picture production. We frequented motion picture theaters and looked at everything, whatever films were on the screen, and furthermore, we did not simply look at them, but we examined them with an eye toward their class appeal. Dividing the theaters into those in rich bourgeois neighborhoods and those of the working classes, we noticed that in the central theaters viewers' reactions to films were more reserved than in the working class theaters around the city's edge. And it was extremely important, during our investigation, for us to locate those isolated moments in a film which elicited a viewer's reactions to the particular action he is shown. It was important for us which films the viewer watched attentively, the particular moment the viewer would laugh, sigh, or groan. It was likewise important to us what was happening on the screen at that moment, how the film appeared to be made in that section, how it was constructed. Films made in different countries are differently perceived by the audience.

First of all, we divided the cinema into three basic types: the Russian film, the European, and the American. (In the European cinema at that time, films made by the Swedish firm, "Nordisk," were quite popular. This firm's films in no way resembled the European-type films, but resembled the American films much more.) When we began to compare the typically American, typically European, and typically Russian films, we noticed that they were distinctly different from one another in their construction. We noticed that in a particular sequence of a Russian film there were, say, ten to fifteen splices, ten to fifteen different set-ups. In the European film there might be twenty to thirty such set-ups (one must not forget that this description pertains to the year 1916), while in the American film there would be from eighty, sometimes upward to a hundred, separate shots.

The American films took first place in eliciting reactions from the audience; European films took second; and the Russian films, third. We became particularly intrigued by this, but in the beginning we did not understand it. Then we began to reason as follows: An argument ensues about cinema—is it or is it not an art? Let us set up a camera, actors, create decorations, play out a scene, and then let us examine the photographed segment from the viewpoint of the solution of this problem. If a good photograph results from the given piece—one which is well-shot, and beautifully and effectively conceived—then we can say: This is not cinematic art, this is merely an art of the photographer, the cameraman. If the actor performs well, we can say about the segment: Whatever the actor can do here, he also does in the theater. Where is the specificity of the cinema here? If the decor in the film is good, and the work of the designer good, then once more it can be said that there is not any cinema here: it is the work of the set designer.

However hard we tried, we could not find a fundamental, designative specificity of the art of cinema. What were we thinking about? We were thinking then about a very simple matter—every art form has two technological elements: material itself and the methods of organizing that material.

No art exists independently, by virtue of itself alone.

The problem of art is to reflect reality, to illuminate this reality with a particular idea, to prove something; and all this is only possible when one has something to evidence, and one knows how to go about it, that is, how to organize the material of the art form. Here the fact emerged that the artist, perceiving and generalizing reality, performs a definite, purposeful ideological work. Reflecting in his production an objective reality, the artist must express his ideas, demonstrate something, propagandize something: while all this is only possible when he has something to produce, and he knows how to work, that is, how the material of his art is to be organized.

In the cinema the understanding of the material and the understanding of the organization of this material are particularly complex, because the material of the cinema itself demands particular organization, demands particularly extensive and specifically cinematic treatment. The cinema is much more complicated than other forms of art, because the method of organization of its material and the material itself are especially "interdependent." Let us say, in the case of sculpture—having the fact and phenomenal appearance of reality, as well as the artistic idea, illuminating this reality with a particular object—we take a piece of marble, give it that form which is necessary for the expression of that appearance of reality, and the result is the production of a piece of sculpture. For the expression of that phenomenon in painting we take pigments and begin to organize them according to the demands of the best and most vivid expression of that phenomenon, and we get the production of a painted art work.

In the cinema the question of the constitution of a film is a far more complicated one. In the cinema, being possessed of an idea, taking the material—actual life or actors—and organizing it all by one or another method, is insufficient.

But more about this later. Thus, finding nothing in any particular segment of the film material specific to our art, consistent with the views of the time, we decided that the specifics of cinema were contained in the organization of the cinematic material (which meant separate shots and scenes), in the joining and alternation of scenes among themselves, in other words, in montage. It seemed to us at that time absolutely apparent that the American films achieved the greatest audience reactions, because they contained the greatest number of shots, from the greatest number of separate scenes, and accordingly, that montage, as the source of expression, as the artistic organization of material, affected the viewer more strongly and vividly in American films.

At that time we regarded the artistic effect of American film on the viewer very naively. The real essence of the American cinema, the real reason for its specific influence on the audience, escaped us.

But the matter, from my viewpoint, lay in the following: The flowering of American cinema was the result of the development of American capitalism. Capitalist America was being constructed, capitalist America developed, because the American society needed strong, energetic builders, fighters for the strengthening of the relics of capitalism. The Americans needed to utilize human resources at their disposal for the creation of a mighty capitalist order. This society required people of a strong bourgeois psychological orientation and world-view. Thus what was completely clear was that the task of American cinema was the education of the particular

sort of person who, by virtue of his qualities, would fit in with the epoch of the development of capitalism.

At the same time capitalism inevitably nurtured the development of a proletarian class, and the consciousness of this class must have been awakening and developing; and it is utterly apparent that capitalism had to cloud this consciousness, to distract it, to weaken it. American art inevitably had to become a "consoling" art, an art that lacquered reality, an art that diverted the masses from the class struggle, from an awareness of their own class interests; and, on the other hand, it had to be an art that directed energy to competitiveness, to enterprise, larded with bourgeois morality and bourgeois psychology.

That is how the "American detective" was created—the American adventure films. From one point of view, they brought attention to energy, to competitiveness, to action; they attracted attention to the type of energetic and strong "heroes" of capitalism, in whom strength, resourcefulness, and courage were always victorious. On the other hand, these films accustomed one to bigotry, to the lacquering of reality, "consoling" and educating one to the fact that with corresponding energy a person can achieve individual fortune, can provide rent for himself, and can become a happy landowner.

The dramatic line of energy of the competition, the action and victory of those who found the strength in American films (to achieve their ends), created the rapid American montage of incidents. The American viewer demanded that directors pack the greatest amount of action into a given length of film, the greatest number of events, the greatest possible energy, pitted characters against each other more vigorously, and built the entire construction of the film more energetically and dynamically. From this point of view, from the viewpoint of the construction of rapid action montage, American cinema was a progressive "presence" at that time.

In European films, produced in those countries where the growth of capitalism was not so stormy as in America, where the American struggle for survival did not exist, there were no conditions for the genesis of a rapid, energetic montage.

Thus the structure of American films of that time, the method of their editing, was, to a certain extent, a progressive occurrence. That is how we perceived it at that particular time. We decided that the American system of montage would give us the opportunity in our Futuristic works "to create" havoc, to break with the old world, the old petty bourgeois morality. That is where our deepest mistake lay. Perceiving the petty bourgeois axioms of American montage and American morality in their entirety, we introduced elements of bourgeois art into our own films unintentionally—a "consoling," bourgeois morality, and so on; and that is why, along with a certain benefit derived from the uncritical study of American montage, came great harm.

It seems to me that all the errors of my filmmaking during the ensuing years have their roots in this period—in the period of a blind acceptance of American film culture. This is explainable by the fact that, in our time, we were convinced that American montage invariably inculcated boldness and energy, indispensable to revolutionary struggle, to revolution.

We understood montage futuristically, but when it came to the negative aspects of its relationship to the bourgeois essence of American films, we were gulled.

I return to our "history." Studying montage we decided that in American films not only did the scenes change and alternate more rapidly than in European or

Russian films, but the majority of these scenes were likewise comprised of a whole order of elements, of separate pieces, separate compositions—that is, we classified the internal division of scenes into the now universally familiar close-up, medium-shot, long-shot, and the rest. At that time this convention was new to us, and it was most important for us to have discovered it in the American cinema. We could see that in individual scenes the Americans used so-called "close-ups"—that is, that at necessary, expressive moments, they showed things in large format, more distinctly, that in a given moment, they showed only what it was necessary to show. The close-up, the compositional expression of only the most important and necessary, proved to have a decided influence on our future work in montage.

The close-up established exceptionally broad possibilities for the future montage construction of motion pictures. By means of close-ups, we arrived at the study of the potentialities of montage, we determined what it was possible to achieve through montage, how expressive its artistic strengths were . . . and a whole order of other crucial and interesting moments for our work.

We ascertained what montage would permit while simultaneously depicting lines of action in different locations.

We likewise decided that montage had an enormous influence on the semantic comprehension of what is on the screen.

Let us say that an actor is performing some sort of dismal moment; you film his drawn face. The face is shot in a setting of "dismal context." But there are instances when this face within a "dismal" scene, by virtue of its compositional properties, is found to be suitable for a cheerful scene. With the help of montage, this face could be spliced into such a scene, and instances do occur when a particular performance by an actor is given a totally different meaning through montage. I recall, even in 1916–1917, how the then famous matinee idol, Vitold Polonsky, and I had an argument about this property of montage to override the actor's performance. Emphasizing that, however one edits, the actor's work will invariably be stronger than the montage, Polonsky asserted that there would be an enormous difference between an actor's face when portraying a man sitting in jail longing for freedom and seeing an open cell door, and the expression of a person sitting in different circumstances—say, the protagonist was starving and he was shown a bowl of soup. The reaction of the actor to the soup and to the open cell door would be completely different. We then performed an experiment. We shot two such scenes, exchanged the close-ups from one scene to the other, and it became obvious that the actor's performance, his reaction of joy at the soup and joy at freedom (the open cell door) were rendered completely unnoticeable by montage. We made use of this example to emphasize that, apart from montage, nothing exists in cinema, that the work of the actor is absolutely irrelevant, that with good montage it is immaterial how he works. This was incorrect because in a particular instance we have had dealings with the poor work of an actor; and, clearly, then, these two reactions are completely different, and it is not always possible to alter the semantic work of an actor. (In certain instances the cited property of montage can be used, say, to correct an error, to change a scene, to reconstruct the scenario. It is extremely important, however, that it be possible and necessary to use this property only if there is a shooting script, a specific purpose, not in the actor's

performance, but in the nature of the filming itself, in the type of face, or in the social concept.)

In this example, we taught that montage alternations are *not* only contained in the segments themselves, but in the very action that is being photographed. Imagine, if you will, that we have an alternation of segments through montage. I conceive them in terms of a line. (See below.)

A diagram of montage segments and intra-shot montage.

There are separate marks of A, B, C, D, E, F—places marking the splices of montage segments, establishing their interrelationships, their interactions. The rhythm and meaning of the montage is not only derived from the interaction and interrelationship of the given segments marked on the line, but the montage also resides within these shots, in the filmed action of the person, for example, in the actor's performance (this internal rhythm is also apparent in the drawing of the sinusoidal curve).

Within these segments, the actor somehow conveys himself, performs some sorts of emphases through movement; his work has its own montage curve, particularly in montage interactions and alternations. It is these very alternations, in meaning as in rhythm, which are inextricably connected with the alternation of the segments themselves—that is, the internal montage of the construction of the shot cannot be separated from the entire montage construction, from the montage of the shots. But at the same time, one must not forget that the location of the shot in a montage phrase is crucial, because it is the position that, more often than not, explains the essence of the meaning intended by the artist-editor, his purpose (often the position in the montage alters the content). Let us recall the example of the bourgeois and the Soviet newspapers about which Eisenstein spoke. The interaction of separate montage segments, their position, and likewise their rhythmic duration, become the contents of the production and world-view of the artist. The very same action, the very same event, set in different places with different comparisons, "works" differently ideologically. Accordingly, a montage of segments in its turn is related to an intra-shot montage, but at the same time, the shot position in the montage is inextricably tied to the ideological purpose of direction of the editor.

It is interesting that when the director does not know his work with actors well enough, when he does not have sufficient command of the technique of this work, he tries to rectify all his errors and tries to compensate for the inadequacies of his acting with montage; and when the director constructs the basis of his picture principally on montage, he gradually loses confidence in his work with the actor. This can be tested in a particularly vivid and revealing example. One of our distinguished directors—the director Pudovkin, working in his films principally on montage construction—loses his previous ability to work with actors more and more with each new film; and

Pudovkin generally always worked well with actors. In his own time he had command of acting technique, but because he often expressed ever more complex situations in his scenarios, not through the work of a living human being, but through various combinations of montage, it seems to me that gradually he began to lose the indispensable contact with the actor and the ability to direct him.

The director can always be put in a situation when it will be necessary for him to work with poor acting material, when it will be necessary to work with actor-mannequins in *typage*, when the person physically fits the role but is unable to perform as an actor. Furthermore, in films with large formats, in complex films, where there are many performing personnel, where *typage* is also important, it is inevitable that scenes are encountered in which one has to work with people who are unqualified as actors. Doubtless, the work of such an accidental actor (not an actor but a *type*) will be very poor in quality, and it is here that the role of montage, correcting and adjusting the actor's job, is highly significant. In the example of the selfsame Pudovkin, we can see how people who are utterly unable to work as actors, demonstrate what Pudovkin required, performing adequately in a whole host of scenarios and thematic situations.

We must remember once and for always that all artistic sources are fine for the achievement of a correct ideological position in a film, and that is why, when a vivid expression of an idea must be achieved through montage above all, one must work "on montage," and when an idea must be expressed through the actor's work above all, one must work "on the actor."

At all events, one must study montage, one must work on montage, because it has an extraordinary effect on the viewer.

In no case should one assume the entire matter of cinematography to be in montage. And when we conduct a brief survey of the material of cinema, because it is filmed in shots, we will see that film material is so varied, so complex, that the quality of films never depends entirely on montage. It is determined (by the way of the ideological purpose) by the material itself, especially since the material of cinema is reality itself, life itself, reflected and interpreted by the class consciousness of the artist.

# MAYA DEREN

## Cinematography:
## The Creative Use of Reality

Born Eleanora Derenowsky in Kiev, Ukraine, Maya Deren (1917–1961) was a pioneer in American experimental cinema, a film theorist, and a key figure in the development of New American Cinema. In 1922, Deren's family fled growing anti-Semitism and political persecution, settling in Syracuse, New York. After obtaining a master's degree in English literature from Smith College, she became secretary to the great African American choreographer Katherine

Dunham, traveling with her modern dance company to Los Angeles. There, Deren met Czech filmmaker Alexander Hammid, whom she married and collaborated with on *Meshes of the Afternoon* (1943), her first and most recognized film.

As a filmmaker, distributor, lecturer, theorist, and promoter working entirely outside the institutions of the American commercial film industry, Maya Deren was an archetypal example of independence. In 1946, she was the first filmmaker to receive a Guggenheim Fellowship, for her research on Vodou in Haiti. She established the nonprofit Creative Film Foundation at a time when the arts, and especially film, were suffering from a lack of funding. Her work ultimately led to the establishment of the Film-Makers' Co-Op in New York, which was key to the growth of the independent film movement in America.

*Meshes of the Afternoon*, self-financed and made with a hand-wound Bolex camera, provided a model for independent 16mm production. It was exhibited in film societies such as Cinema 16 that helped shape American underground cinema. Deren draws from the rhythms and stylized movement of modern dance in her experimental and poetic use of the film medium. With a dreamlike quality that recalls French poet and filmmaker Jean Cocteau, as well as a cyclical narrative and radical style that escapes the spatiotemporal logic of Hollywood realism, *Meshes of the Afternoon* provided an aesthetic model of the potential of cinema as a form of visual expression. The film inspired the early works of key American avant-garde filmmakers such as Kenneth Anger, Stan Brakhage (p. 667), and Shirley Clarke. Deren's influence extends to contemporary filmmakers like David Lynch, whose *Lost Highway* (1997) pays homage to Deren's experimentation with narration.

Deren's writing accentuated her status as an innovative filmmaker. In her essay "Cinematography: The Creative Use of Reality," published in 1960, she evokes key themes and cinematic innovations that are explored in her films, such as slow-motion, reverse motion, and other creative techniques that result in "a manipulation of time and space." Moreover, it is a unique contribution to one of the most important debates in film theory— the relationship of film to reality—with important implications for the evaluation of narrative films and approaches to alternative filmmaking. While Deren accepts, in a manner similar to Siegfried Kracauer (p. 289) and André Bazin (p. 309), the inherent realism of the photographic image and its authority, she believes that the essence of cinema is located in the creative use of this photographic reality. By altering the conventional spatiotemporal relationship within the sequential flow of images and thereby undermining our established knowledge of perceptual reality, Deren argues, cinema can avoid the narrative constraints of other art forms such as literature or theater and discover "its own structural modes," that is, realms of visual expression that are inherent to the medium of film.

## READING CUES & KEY CONCEPTS

■ When Deren describes creative action as consisting of a manipulation of time and space, she is talking about the kind of manipulation that "becomes itself part of the organic structure of a film." What does she mean by this?

■ For Deren, the "objective authority of reality" is essential for creatively exploiting the characteristics of the photographic image. Consider how such an approach to filmmaking would change if the supposed reality of the image itself is recognized as a conventionalized illusion.

■ The creative use of the medium of film, Deren says, was "interrupted by the intrusions" of theatrical and literary traditions into the film medium. Consider the relationship between film and other art forms; to what extent is this relationship necessary and when does it become "an intrusion"?

■ Key Concepts: Animated Painting; Plastic Media; Controlled Accident; Creative Act

# Cinematography: The Creative Use of Reality

The motion-picture camera is perhaps the most paradoxical of all machines, in that it can be at once independently active and infinitely passive. Kodak's early slogan, "You push the button, it does the rest," was not an exaggerated advertising claim; and, connected to any simple trigger device, a camera can even take pictures all by itself. At the same time, while a comparable development and refinement of other mechanisms has usually resulted in an increased specialization, the advances in the scope and sensitivity of lenses and emulsions have made the camera capable of infinite receptivity and indiscriminate fidelity. To this must be added the fact that the medium deals, or can deal, in terms of the most elemental actuality. In sum, it can produce maximum results for virtually minimal effort: it requires of its operator only a modicum of aptitude and energy; of its subject matter, only that it exist; and of its audience, only that they can see. On this elementary level it functions ideally as a mass medium for communicating equally elementary ideas.

The photographic medium is, as a matter of fact, so amorphous that it is not merely unobtrusive but virtually transparent, and so becomes, more than any other medium, susceptible of servitude to any and all the others. The enormous value of such servitude suffices to justify the medium and to be generally accepted as its function. This has been a major obstacle to the definition and development of motion pictures as a creative fine-art form — capable of creative action in its own terms — for its own character is as a latent image which can become manifest only if no other image is imposed upon it to obscure it.

Those concerned with the emergence of this latent form must therefore assume a partially protective role, one which recalls the advice of an art instructor who said, "If you have trouble drawing the vase, try drawing the space around the vase." Indeed, for the time being, the definition of the creative form of film involves as careful attention to what it is not as to what it is.

## Animated Paintings

In recent years, perceptible first on the experimental fringes of the film world and now in general evidence at the commercial art theaters, there has been an accelerated development of what might be called the "graphic arts school of animated film." Such films, which combine abstract backgrounds with recognizable but not realistic figures, are designed and painted by trained and talented graphic artists who make use of a sophisticated, fluent knowledge of the rich resources of plastic

media, including even collage. A major factor in the emergence of this school has been the enormous technical and laboratory advance in color film and color processing, so that it is now possible for these artists to approach the two-dimensional, rectangular screen with all the graphic freedom they bring to a canvas.

The similarity between screen and canvas had long ago been recognized by artists such as Hans Richter, Oscar Fishinger, and others, who were attracted not by its graphic possibilities (so limited at that time) but rather by the excitements of the film medium, particularly the exploitation of its time dimension—rhythm, spatial depth created by a diminishing square, the three-dimensional illusion created by the revolutions of a spiral figure, etc. They put their graphic skills at the service of the film medium, as a means of extending film expression.*

The new graphic-arts school does not so much advance those early efforts as reverse them, for here the artists make use of the film medium as an extension of the plastic media. This is particularly clear when one analyzes the principle of movement employed, for it is usually no more than a sequential articulation—a kind of spelling out in time—of the dynamic ordinarily implicit in the design of an individual composition. The most appropriate term to describe such works, which are often interesting and witty, and which certainly have their place among visual arts, is "animated paintings."

This entry of painting into the film medium presents certain parallels with the introduction of sound. The silent film had attracted to it persons who had talent for and were inspired by the exploration and development of a new and unique form of visual expression. The addition of sound opened the doors for the verbalists and dramatists. Armed with the authority, power, laws, techniques, skills, and crafts which the venerable literary arts had accumulated over centuries, the writers hardly even paused to recognize the small resistance of the "indigenous" film-maker, who had had barely a decade in which to explore and evolve the creative potential of his medium.

The rapid success of the "animated painting" is similarly due to the fact that it comes armed with all the plastic traditions and techniques which are its impressive heritage. And just as the sound film interrupted the development of film form on the commercial level by providing a more finished substitute, so the "animated painting" is already being accepted as a form of film art in the few areas (the distribution of 16 mm film shorts to film series and societies) where experiments in film form can still find an audience.

The motion-picture medium has an extraordinary range of expression. It has in common with the plastic arts the fact that it is a visual composition projected on a two-dimensional surface; with dance, that it can deal in the arrangement of movement; with theater, that it can create a dramatic intensity of events; with music, that it can compose in the rhythms and phrases of time and can be attended by song and instrument; with poetry, that it can juxtapose images; with literature generally, that it can encompass in its sound track the abstractions available only to language.

---

* It is significant that Hans Richter, a pioneer in such a use of film, soon abandoned this approach. All his later films, along with the films of Léger, Man Ray, Dali, and the painters who participated in Richter's later films (Ernst, Duchamp, etc.) indicate a profound appreciation of the distinction between the plastic and the photographic image, and make enthusiastic and creative use of photographic reality.

This very profusion of potentialities seems to create confusion in the minds of most film-makers, a confusion which is diminished by eliminating a major portion of those potentialities in favor of one or two, upon which the film is subsequently structured. An artist, however, should not seek security in a tidy mastery over the simplifications of deliberate poverty; he should, instead, have the creative courage to face the danger of being overwhelmed by fecundity in the effort to resolve it into simplicity and economy.

While the "animated painting" film has limited itself to a small area of film potential, it has gained acceptance on the basis of the fact that it *does* use an art form—the graphic art form—and that it does seem to meet the general condition of film: it makes its statement as an image in movement. This opens the entire question of whether a photograph is of the same order of image as all others. If not, is there a correspondingly different approach to it in a creative context? Although the photographic process is the basic building block of the motion-picture medium, it is a tribute to its self-effacement as a servant that virtually no consideration has been given to its own character and the creative implications thereof.

## The Closed Circuit of the Photographic Process

The term "image" (originally based on "imitation") means in its first sense the visual likeness of a real object or person, and in the very act of specifying resemblance it distinguishes and establishes the entire category of visual experience which is *not* a real object or person. In this specifically negative sense—in the sense that the photograph of a horse is not the horse itself—a photograph is an image.

But the term "image" also has positive implications: it presumes a mental activity, whether in its most passive form (the "mental images" of perception and memory) or, as in the arts, the creative action of the imagination realized by the art instrument. Here reality is first filtered by the selectivity of individual interests and modified by prejudicial perception to become experience; as such it is combined with similar, contrasting or modifying experiences, both forgotten and remembered, to become assimilated into a conceptual image; this in turn is subject to the manipulations of the art instrument; and what finally emerges is a plastic image which is a reality in its own right. A painting is not, fundamentally, a likeness or image of a horse; it is a likeness of a mental concept which may resemble a horse or which may, as in abstract painting, bear no visible relation to any real object.

Photography, however, is a process by which an object creates its own image by the action of its light on light-sensitive material. It thus presents a closed circuit precisely at the point where, in the traditional art forms, the creative process takes place as reality passes through the artist. This exclusion of the artist at that point is responsible both for the absolute fidelity of the photographic process and for the widespread conviction that a photographic medium cannot be, itself, a creative form. From these observations it is but a step to the conclusion that its use as a visual printing press or as an extension of another creative form represents a full realization of the potential of the medium. It is precisely in this manner that the photographic process is used in "animated paintings."

But in so far as the camera is applied to objects which are already accomplished images, is this really a more creative use of the instrument than when, in scientific

films, its fidelity is applied to reality in conjunction with the revelatory functions of telescopic or microscopic lenses and a comparable use of the motor?

Just as the magnification of a lens trained upon matter shows us a mountainous, craggy landscape in an apparently smooth surface, so slow-motion can reveal the actual structure of movements or changes which either cannot be slowed down in actuality or whose nature would be changed by a change in tempo of performance. Applied to the flight of a bird, for example, slow-motion reveals the hitherto unseen sequence of the many separate strains and small movements of which it is compounded.

By a telescopic use of the motor, I mean the telescoping of time achieved by triggering a camera to take pictures of a vine at ten-minute intervals. When projected at regular speed, the film reveals the actual integrity, almost the intelligence, of the movement of the vine as it grows and turns with the sun. Such telescoped-time photography has been applied to chemical changes and to physical metamorphoses whose tempo is so slow as to be virtually imperceptible.

Although the motion-picture camera here functions as an instrument of discovery rather than of creativity, it does yield a kind of image which, unlike the images of "animated paintings" (animation itself is a use of the telescoped-time principle), is unique to the motion-picture medium. It may therefore be regarded as an even more valid basic element in a creative film form based on the singular properties of the medium.

## Reality and Recognition

The application of the photographic process to reality results in an image which is unique in several respects. For one thing, since a specific reality is the prior condition of the existence of a photograph, the photograph not only testifies to the existence of that reality (just as a drawing testifies to the existence of an artist) but is, to all intents and purposes, its equivalent. This equivalence is not at all a matter of fidelity but is of a different order altogether. If realism is the term for a graphic image which precisely simulates some real object, then a photograph must be differentiated from it as *a form of reality itself.*

This distinction plays an extremely important role in the address of these respective images. The intent of the plastic arts is to make meaning manifest. In creating an image for the express purpose of communicating, the artist primarily undertakes to create the most effective aspect possible out of the total resources of his medium. Photography, however, deals in a living reality which is structured primarily to endure, and whose configurations are designed to serve that purpose, not to communicate its meaning; they may even serve to conceal that purpose as a protective measure. In a photograph, then, we begin by recognizing a reality, and our attendant knowledges and attitudes are brought into play; only then does the aspect become meaningful in reference to it. The abstract shadow shape in a night scene is not understood at all until revealed and identified as a person; the bright red shape on a pale ground which might, in an abstract, graphic context, communicate a sense of gaiety, conveys something altogether different when recognized as a wound. As we watch a film, the continuous act of recognition in which we are involved is like a strip of memory unrolling beneath the images of the film itself, to form the invisible underlayer of an implicit double exposure.

The process by which we understand an abstract, graphic image is almost directly opposite, then, to that by which we understand a photograph. In the first case, the aspect leads us to meaning; in the second case the understanding which results from recognition is the key to our evaluation of the aspect.

## Photographic Authority and the "Controlled Accident"

As a reality, the photographic image confronts us with the innocent arrogance of an objective fact, one which exists as an independent presence, indifferent to our response. We may in turn view it with an indifference and detachment we do not have toward the man-made images of other arts, which invite and require our perception and demand our response in order to consummate the communication they initiate and which is their *raison d'être*. At the same time, precisely because we are aware that our personal detachment does not in any way diminish the verity of the photographic image, it exercises an authority comparable in weight only to the authority of reality itself.

It is upon this authority that the entire school of the social documentary film is based. Although expert in the selection of the most effective reality and in the use of camera placement and angle to accentuate the pertinent and effective features of it, the documentarists operate on a principle of minimal intervention, in the interests of bringing the authority of reality to the support of the moral purpose of the film.

Obviously, the interest of a documentary film corresponds closely to the interest inherent in its subject matter. Such films enjoyed a period of particular pre-eminence during the war. This popularity served to make fiction-film producers more keenly aware of the effectiveness and authority of reality, an awareness which gave rise to the "neo-realist" style of film and contributed to the still growing trend toward location filming.

In the theater, the physical presence of the performers provides a sense of reality which induces us to accept the symbols of geography, the intermissions which represent the passage of time, and the other conventions which are part of the form. Films cannot include this physical presence of the performers. They can, however, replace the artifice of theater by the actuality of landscape, distances, and place; the interruptions of intermissions can be transposed into transitions which sustain and even intensify the momentum of dramatic development; while events and episodes which, within the context of theatrical artifice, might not have been convincing in their logic or aspect can be clothed in the verity which emanates from the reality of the surrounding landscape, the sun, the streets and buildings.

In certain respects, the very absence in motion pictures of the physical presence of the performer, which is so important to the theater, can even contribute to our sense of reality. We can, for example, believe in the existence of a monster if we are not asked to believe that it is present in the room with us. The intimacy imposed upon us by the physical reality of other art works presents us with alternative choices: either to identify with or to deny the experience they propose, or to withdraw altogether to a detached awareness of that reality as merely a metaphor. But the film image—whose intangible reality consists of lights and shadows beamed through the air and caught on the surface of a silver screen—comes to us as the reflection of another world. At that distance we can accept the reality of the most

monumental and extreme of images, and from that perspective we can perceive and comprehend them in their full dimension.

The authority of reality is available even to the most artificial constructs if photography is understood as an art of the "controlled accident." By "controlled accident" I mean the maintenance of a delicate balance between what is there spontaneously and naturally as evidence of the independent life of actuality, and the persons and activities which are deliberately introduced into the scene. A painter, relying primarily upon aspect as the means of communicating his intent, would take enormous care in the arrangement of every detail of, for example, a beach scene. The cinematographer, on the other hand, having selected a beach which, in general, has the desired aspect—whether grim or happy, deserted or crowded—must on the contrary refrain from overcontrolling the aspect if he is to retain the authority of reality. The filming of such a scene should be planned and framed so as to create a context of limits within which anything that occurs is compatible with the intent of the scene.

The invented event which is then introduced, though itself an artifice, borrows reality from the reality of the scene—from the natural blowing of the hair, the irregularity of the waves, the very texture of the stones and sand—in short, from all the uncontrolled, spontaneous elements which are the property of actuality itself. Only in photography—by the delicate manipulation which I call controlled accident—can natural phenomena be incorporated into our own creativity, to yield an image where the reality of a tree confers its truth upon the events we cause to transpire beneath it.

## Abstractions and Archetypes

Inasmuch as the other art forms are not constituted of reality itself, they create metaphors for reality. But photography, being itself the reality or the equivalent thereof, can use its own reality as a metaphor for ideas and abstractions. In painting, the image is an abstraction of the aspect; in photography, the abstraction of an idea produces the archetypal image.

This concept is not new to motion pictures, but its development was interrupted by the intrusions of theatrical traditions into the film medium. The early history of film is studded with archetypal figures: Theda Bara, Mary Pickford, Marlene Dietrich, Greta Garbo, Charles Chaplin, Buster Keaton, etc. These appeared as personages, not as people or personalities, and the films which were structured around them were like monumental myths which celebrated cosmic truths.

The invasion of the motion-picture medium by modern playwrights and actors introduced the concept of realism, which is at the root of theatrical metaphor and which, in the a priori reality of photography, is an absurd redundancy which has served merely to deprive the motion-picture medium of its creative dimension. It is significant that, despite every effort of pretentious producers, directors and film critics who seek to raise their professional status by adopting the methods, attitudes, and criteria of the established and respected art of theater, the major figures—both the most popular stars and the most creative directors (such as Orson Welles)—continue to operate in the earlier archetypal tradition. It was even possible, as Marlon Brando demonstrated, to transcend realism and to become an archetypal realist, but it would

appear that his early intuition has been subsequently crushed under the pressures of the repertory complex, another carry-over from theater, where it functioned as the means by which a single company could offer a remunerative variety of plays to an audience while providing consistent employment for its members. There is no justification whatsoever for insisting on a repertory variety of roles for actors involved in the totally different circumstances of motion pictures.

## Photography's Unique Images

In all that I have said so far, the fidelity, reality, and authority of the photographic image serve primarily to modify and to support. Actually, however, the sequence in which we perceive photography—an initial identification followed by an interpretation of the aspect according to that identification (rather than in primarily aspectual terms)—becomes irreversible and confers meaning upon aspect in a manner unique to the photographic medium.

I have previously referred to slow-motion as a time microscope, but it has its expressive uses as well as its revelatory ones. Depending upon the subject and the context, it can be a statement of either ideal ease or nagging frustration, a kind of intimate and loving meditation on a movement or a solemnity which adds ritual weight to an action; or it can bring into reality that dramatic image of anguished helplessness, otherwise experienced only in the nightmares of childhood, when our legs refused to move while the terror which pursues us comes ever closer.

Yet, slow-motion is not simply slowness of speed. It is, in fact, something which exists in our minds, not on the screen, and can be created only in conjunction with the identifiable reality of the photographic image. When we see a man in the attitudes of running and identify the activity as a run, one of the knowledges which is part of that identification is the pulse normal to that activity. It is because we are aware of the known pulse of the identified action while we watch it occur at a slower rate of speed that we experience the double-exposure of time which we know as slow-motion. It cannot occur in an abstract film, where a triangle, for instance, may go fast or slow, but, having no necessary pulse, cannot go in slow-motion.

Another unique image which the camera can yield is reverse motion. When used meaningfully, it does not convey so much a sense of a backward movement spatially, but rather an undoing of time. One of the most memorable uses of this occurs in Cocteau's *Blood of a Poet*, where the peasant is executed by a volley of fire which also shatters the crucifix hanging on the wall behind him. This scene is followed by a reverse motion of the action—the dead peasant rising from the ground and the crucifix reassembling on the wall; then again the volley of fire, the peasant falling, the crucifix shattering; and again the filmic resurrection. Reverse motion also, for obvious reasons, does not exist in abstract films.

The photographic negative image is still another striking case in point. This is not a direct white-on-black statement but is understood as an inversion of values. When applied to a recognizable person or scene, it conveys a sense of a critically qualitative change, as in its use for the landscape on the other side of death in Cocteau's *Orpheus*.

Both such extreme images and the more familiar kind which I referred to earlier make use of the motion-picture medium as a form in which the meaning of the

image originates in our recognition of a known reality and derives its authority from the direct relationship between reality and image in the photographic process. While the process permits some intrusion by the artist as a modifier of that image, the limits of its tolerance can be defined as that point at which the original reality becomes unrecognizable or is irrelevant (as when a red reflection in a pond is used for its shape and color only and without contextual concern for the water or the pond).

In such cases the camera itself has been conceived of as the artist, with distorting lenses, multiple superpositions, etc., used to simulate the creative action of the eye, the memory, etc. Such well-intentioned efforts to use the medium creatively, by forcibly inserting the creative act in the position it traditionally occupies in the visual arts, accomplish, instead, the destruction of the photographic image as reality. This image, with its unique ability to engage us simultaneously on several levels—by the objective authority of reality, by the knowledges and values which we attach to that reality, by the direct address of its aspect, and by a manipulated relationship between these—is the building block for the creative use of the medium.

## The Placement of the Creative Act and Time-Space Manipulations

Where does the film-maker then undertake his major creative action if, in the interests of preserving these qualities of the image, he restricts himself to the control of accident in the pre-photographic stage and accepts almost complete exclusion from the photographic process as well?

Once we abandon the concept of the image as the end product and consummation of the creative process (which it is in both the visual arts and the theater), we can take a larger view of the total medium and can see that the motion-picture instrument actually consists of two parts, which flank the artist on either side. The images with which the camera provides him are like fragments of a permanent, incorruptible memory; their individual reality is in no way dependent upon their sequence in actuality, and they can be assembled to compose any of several statements. In film, the image can and should be only the beginning, the basic material of the creative action.

All invention and creation consist primarily of a new relationship between known parts. The images of film deal in realities which, as I pointed out earlier, are structured to fulfill their various functions, not to communicate a specific meaning. Therefore they have several attributes simultaneously, as when a table may be, at once, old, red, and high. Seeing it as a separate entity, an antique dealer would appraise its age, an artist its color, and a child its inaccessible height. But in a film such a shot might be followed by one in which the table falls apart, and thus a particular aspect of its age would constitute its meaning and function in the sequence, with all other attributes becoming irrelevant. The editing of a film creates the sequential relationship which gives particular or new meaning to the images *according to their function*; it establishes a context, a form which transfigures them without distorting their aspect, diminishing their reality and authority, or impoverishing that variety of potential functions which is the characteristic dimension of reality.

Whether the images are related in terms of common or contrasting qualities, in the causal logic of events which is narrative, or in the logic of ideas and emotions which is the poetic mode, the structure of a film is sequential. The creative action in film, then, takes place in its time dimension; and for this reason the motion picture, though composed of spatial images, is primarily *a time form*.

A major portion of the creative action consists of a manipulation of time and space. By this I do not mean only such established filmic techniques as flashback, condensation of time, parallel action, etc. These affect not the action itself but the method of revealing it. In a flashback there is no implication that the usual chronological integrity of the action itself is in any way affected by the process, however disrupted, of memory. Parallel action, as when we see alternately the hero who rushes to the rescue and the heroine whose situation becomes increasingly critical, is an omnipresence on the part of the camera as a witness of action, not as a creator of it.

The kind of manipulation of time and space to which I refer becomes itself part of the organic structure of a film. There is, for example, the extension of space by time and of time by space. The length of a stairway can be enormously extended if three different shots of the person ascending it (filmed from different angles so that it is not apparent that the identical area is being covered each time) are so edited together that the action is continuous and results in an image of enduring labor toward some elevated goal. A leap in the air can be extended by the same technique, but in this case, since the film action is sustained far beyond the normal duration of the real action itself, the effect is one of tension as we wait for the figure to return, finally, to earth.

Time may be extended by the reprinting of a single frame, which has the effect of freezing the figure in mid-action; here the frozen frame becomes a moment of suspended animation which, according to its contextual position, may convey either the sense of critical hesitation (as in the turning back of Lot's wife) or may constitute a comment on stillness and movement as the opposition of life and death. The reprinting of scenes of a casual situation involving several persons may be used either in a prophetic context, as a *déjà-vu*; or, again, precise reiteration, by intercutting reprints, of those spontaneous movements, expressions, and exchanges, can change the quality of the scene from one of informality to that of a stylization akin to dance; in so doing it confers dance upon nondancers, by shifting emphasis from the purpose of the movement to the movement itself, and an informal social encounter then assumes the solemnity and dimension of ritual.

Similarly, it is possible to confer the movement of the camera upon the figures in the scene, for the large movement of a figure in a film is conveyed by the changing relationship between that figure and the frame of the screen. If, as I have done in my recent film *The Very Eye of Night*, one eliminates the horizon line and any background which would reveal the movement of the total field, then the eye accepts the frame as stable and ascribes all movement to the figure within it. The hand-held camera, moving and revolving over the white figures on a totally black ground, produces images in which their movement is as gravity-free and as three-dimensional as that of birds in air or fish in water. In the absence of any absolute orientation, the push and pull of their interrelationships becomes the major dialogue.

By manipulation of time and space, I mean also the creation of a relationship between separate times, places, and persons. A swing-pan—whereby a shot of one person is terminated by a rapid swing away and a shot of another person or place

begins with a rapid swing of the camera, the two shots being subsequently joined in the blurred area of both swings—brings into dramatic proximity people, places, and actions which in actuality might be widely separated. One can film different people at different times and even in different places performing approximately the same gesture or movement, and, by a judicious joining of the shots in such a manner as to preserve the continuity of the movement, the action itself becomes the dominant dynamic which unifies all separateness.

Separate and distant places not only can be related but can be made continuous by a continuity of identity and of movement, as when a person begins a gesture in one setting, this shot being immediately followed by the hand entering another setting altogether to complete the gesture there. I have used this technique to make a dancer step from woods to apartment in a single stride, and similarly to transport him from location to location so that the world itself became his stage. In my *At Land*, it has been the technique by which the dynamic of the *Odyssey* is reversed and the protagonist, instead of undertaking the long voyage of search for adventure, finds instead that the universe itself has usurped the dynamic action which was once the prerogative of human will, and confronts her with a volatile and relentless metamorphosis in which her personal identity is the sole constancy.

These are but several indications of the variety of creative time-space relationships which can be accomplished by a meaningful manipulation of the sequence of film images. It is an order of creative action available only to the motion-picture medium because it is a photographic medium. The ideas of condensation and of extension, of separateness and of continuity, in which it deals, exploit to the fullest degree the various attributes of the photographic image: its fidelity (which establishes the identity of the person who serves as a transcendent unifying force between all separate times and places), its reality (the basis of the recognition which activates our knowledges and values and without which the geography of location and dislocation could not exist), and its authority (which transcends the impersonality and intangibility of the image and endows it with independent and objective consequence).

## The Twentieth-Century Art Form

I initiated this discussion by referring to the effort to determine what creative film form is not, as a means by which we can arrive eventually at a determination of what it is. I recommend this as the only valid point of departure for all custodians of classifications, to the keepers of catalogues, and in particular to the harassed librarians, who, in their effort to force film into one or another of the performing or the plastic arts, are engaged in an endless Procrustean operation.

A radio is not a louder voice, an airplane is not a faster car, and the motion picture (an invention of the same period of history) should not be thought of as a faster painting or a more real play.

All of these forms are qualitatively different from those which preceded them. They must not be understood as unrelated developments, bound merely by coincidence, but as diverse aspects of a new way of thought and a new way of life—one in which an appreciation of time, movement, energy, and dynamics is more immediately meaningful than the familiar concept of matter as a static solid anchored to a stable cosmos. It is a change reflected in every field of human endeavor, for example,

architecture, in which the notion of mass-upon-mass structure has given way to the lean strength of steel and the dynamics of cantilever balances.

It is almost as if the new age, fearful that whatever was there already would not be adequate, had undertaken to arrive completely equipped, even to the motion-picture medium, which, structured expressly to deal in movement and time-space relationships, would be the most propitious and appropriate art form for express-ing, in terms of its own paradoxically intangible reality, the moral and metaphysical concepts of the citizen of this new age.

This is not to say that cinema should or could replace the other art forms, any more than flight is a substitute for the pleasures of walking or for the leisurely pan-orama of landscapes seen from a car or train window. Only when new things serve the same purpose better do they replace old things. Art, however, deals in ideas; time does not deny them, but may merely make them irrelevant. The truths of the Egyptians are no less true for failing to answer questions which they never raised. Culture is cumulative, and to it each age should make its proper contribution.

How can we justify the fact that it is the art instrument, among all that frater-nity of twentieth-century inventions, which is still the least explored and exploited; and that it is the artist — of whom, traditionally, the culture expects the most pro-phetic and visionary statements — who is the most laggard in recognizing that the formal and philosophical concepts of his age are implicit in the actual structure of his instrument and the techniques of his medium?

If cinema is to take its place beside the others as a full-fledged art form, it must cease merely to record realities that owe nothing of their actual existence to the film instrument. Instead, it must create a total experience so much out of the very nature of the instrument as to be inseparable from its means. It must relinquish the narra-tive disciplines it has borrowed from literature and its timid imitation of the causal logic of narrative plots, a form which flowered as a celebration of the earth-bound, step-by-step concept of time, space and relationship which was part of the primi-tive materialism of the nineteenth century. Instead, it must develop the vocabulary of filmic images and evolve the syntax of filmic techniques which relate those. It must determine the disciplines inherent in the medium, discover its own structural modes, explore the new realms and dimensions accessible to it and so enrich our culture artistically as science has done in its own province.

# MICHEL CHION

## The Acousmêtre

FROM *The Voice in Cinema*

French writer and composer Michel Chion (b. 1947) is the most widely published theo-rist on what was for a long time a relatively neglected topic: film sound. Chion, who teaches at the University of Paris III and maintains an active career in music, has written

more than two dozen books on topics in music and film sound, as well as on such film-makers as Jacques Tati, David Lynch, and Stanley Kubrick, all of whom have explored sound-image relations as a central preoccupation. Chion began his career as assistant to electronic music pioneer Pierre Schaeffer at the Paris Conservatoire, and Schaeffer's ideas on sound remain central to his work. Three of Chion's books — *The Voice in Cinema* (1999), *Audio-Vision* (1995), and *Film, A Sound Art* (2009) — have been translated into English by U.S. scholar of film sound Claudia Gorbman (p. 165), extending the productive relationship enjoyed in the 1970s and 1980s between French film theory and the U.S. academy into the present.

When synchronized sound was first introduced in the late 1920s, such prominent film theorists as Béla Balázs (p. 125), Sergei Eisenstein (p. 262), as well as filmmakers like René Clair, debated its expressive and ontological status. However, the semiological work of the 1970s, which emphasized how the "signs" used in cinema functioned like a language, was much more concerned with the image than the soundtrack. Chion's work addresses this imbalance, touching on the properties of the three basic units of the soundtrack: voice, music, and effects. He clarifies practices and terminology — such as the distinction between onscreen and offscreen sound, or between sounds arising from the world of the film's story (diegetic sound) and those that provide mood or commentary (nondiegetic sound) — not simply to classify their use but also to explore their implications for the cinematic experience as one of audition as well as vision.

Building on the admittedly archaic term *acousmatic* (meaning a sound that is heard although its source remains unseen), Chion coins the expression *acousmêtre* for the unseen speaker in "The Acousmêtre," the first chapter of *The Voice in Cinema*, originally published in French in 1982. Chion accords the figure of the acousmêtre with almost unlimited powers — not only does he depict it as godlike, but he also compares the acousmêtre to the mother figure, whose voice an infant encounters before the development of its visual capacity. Chion draws upon psychoanalysis in his description of the power of the voice, while grounding his speculations in concrete examples from a range of films that use offscreen speakers in different ways. His fascinating concept of the acousmêtre addresses the complexity of cinema's construction of space and subject positioning, as well as suggesting the range of sound-image relations available to the film artist.

## READING CUES & KEY CONCEPTS

▧ What are the distinctions that Chion makes between the sensory experiences of sound and vision?

▧ Consider Chion's claim that the "fate" of the acousmêtre is to be "neither inside nor outside." What does he mean by this?

▧ What are the four powers Chion attributes to the acousmêtre? Do you think the process of de-acousmatization has as radical an effect as Chion claims it does?

▧ **Key Concepts:** Onscreen/Offscreen Space; Acousmatic; Acousmêtre; Frame; Panopticism; De-Acousmatization

# The Acousmêtre

. . . . . . . . . . . . . .

## *A Primal Hide-and-Seek*

Human vision, like that of cinema, is partial and directional. Hearing, though, is omnidirectional. We cannot see what is behind us, but we can hear all around. Of all the senses hearing is probably the earliest to occur. The fetus takes in the mother's voice, and will recognize it after birth. Sight comes into play only after birth, but at least in our culture, it becomes the most highly structured sense. It takes on a remarkable variety of forms and disposes of a highly elaborated language, which dwarfs the vocabularies for phenomena of touch, smell, and even hearing. Sight is generally what we rely on for orientation, because the naming and recognition of forms is vastly more subtle and precise in visual terms than with any other channel of perception.

The sense of hearing is as subtle as it is archaic. We most often relegate it to the limbo of the unnamed; something you hear causes you to feel X, but you can't put exact words to it. As surprising as it may seem, it wasn't until the twentieth century that Pierre Schaeffer first attempted to develop a language for describing sounds *in themselves.*[1]

In the infant's experience, the mother ceaselessly plays hide-and-seek with his visual field, whether she goes behind him, or is hidden from him by something, or if he's right up against her body and cannot see her. But the olfactory and vocal continuum, and frequently tactile contact as well, maintain the mother's presence when she can no longer be seen (in fact, *seeing* her implies at least some distance and separation). This dialectic of appearance and disappearance is known to be dramatic for the child. The cinema transposes or crystallizes it into certain ways of mobilizing off-screen space (e.g., masking characters but keeping their presence perceivable through sound). In some ways, film editing has to do with the appearance-disappearance of the mother, and also with games like the "Fort-Da" game to which Freud refers and which Lacan analyzes as a model of the "repetitive utterances in which subjectivity brings together mastery over its abandonment and the birth of the symbol."[2]

Onscreen and offscreen space can thus be called by another name when what's involved is the voice "maintaining" a character who has left the screen, or better yet, when the film obstinately refuses to show us someone whose voice we hear: it's a game of hide-and-seek.

## *Neither Inside nor Outside*

We know that the invention of talking pictures allowed people to hear the actors' voices, for example to put a voice to the face of Garbo. Perhaps more interesting is that the sound film can show a closed door or an opaque curtain and allow us to hear the voice of someone supposedly behind it. Sound films can show an empty space and give us the voice of someone supposedly "there," in the scene's "here and now," but outside the frame. A voice may inhabit the emptiest image, or even the dark screen, as Ophuls makes it do in *Le Plaisir*, Welles in *The Magnificent Ambersons*, and Duras in *L'Homme Atlantique*, with an *acousmatic presence.*

Acousmatic, specifies an old dictionary, "is said of a sound that is heard without its cause or source being seen." We can never praise Pierre Schaeffer enough for having unearthed this arcane word in the 1950s. He adopted it to designate a mode of listening that is commonplace today, systematized in the use of radio, telephones, and phonograph records. Of course, it existed long before any of these media, but for lack of a specific label, wasn't obviously identifiable, and surely was rarely conceived as such in experience. On the other hand, Schaeffer did not see fit for his purposes (he was interested in *musique concrète*) to find a specific word for the flip side of acousmatic listening, the apparently trivial situation wherein we do see the sound source. He was content to speak in this case of "direct" listening. Since his term is ambiguous, we prefer to speak of *visualized listening*.[3]

The talking film naturally began with *visualized* sound (often called synchronous or onscreen sound). But it quickly turned to experimenting with acousmatic sound—not only music but more importantly the voice. Critics often cite an early scene in Fritz Lang's *M* (1930) as an example. The child-murderer's shadow falls on the poster that offers a reward for his capture, while his offscreen voice says to the little girl (she is also offscreen at this moment, contrary to the evidence of the famous production still): "You have a pretty ball!" The copresence in this shot of the voice and the shadow, as well as the use of the acousmatic voice to create tension, are eloquent enough. But fairly quickly in the development of sound film, the voice would stand alone without "needing" either the shadow or other narrative devices, such as superimposition, to present acousmatic characters.

We should emphasize that between one (visualized) situation and the other (acousmatic) one, it's not the sound that changes its nature, presence, distance, or color. What changes is the relationship between what we see and what we hear. The murderer's voice is just as well-defined when we don't see him as in any shot where we do. When we listen to a film without watching it, it is impossible to distinguish acousmatic from visualized sounds solely on the basis of the soundtrack. Just listening, without the images, "acousmatizes" all the sounds, if they retain no trace of their initial relation to the image. (And in this case, the aggregate of sounds heard becomes a true "sound track," a whole).[4]

To understand what is at stake in this distinction, let us go back to the original meaning of the word acousmatic. This was apparently the name assigned to a Pythagorean sect whose followers would listen to their Master speak *behind a curtain*, the story goes, so that the sight of the speaker wouldn't distract them from the message.[5] (In the same way, television makes it easy to be distracted from what a person onscreen is talking about; we might watch the way she furrows her eyebrows or fidgets with her hands; cameras lovingly emphasize such details.) This interdiction against looking, which transforms the Master, God, or Spirit into an acousmatic voice, permeates a great number of religious traditions, most notably Islam and Judaism. We find it also in the physical setup of Freudian analysis: the patient on the couch should not see the analyst, who does not look at him. And finally we find it in the cinema, where the voice of the acousmatic master who hides behind a door, a curtain or offscreen, is at play in some key films: *The Testament of Dr. Mabuse* (the voice of the evil genius), *Psycho* (the mother's voice), *The Magnificent Ambersons* (the director's voice).

When the acousmatic presence is a voice, and especially when this voice has not yet been visualized—that is, when we cannot yet connect it to a face—we get

a special being, a kind of talking and acting shadow to which we attach the name *acousmêtre*.[6] A person you talk to on the phone, whom you've never seen, is an acousmêtre. If you have ever seen her, however, or if in a film you continue to hear her after she leaves the visual field, is this still an acousmêtre? Definitely but of another kind, which we'll call the already visualized acousmêtre. It would be amusing to invent more and more neologisms, for example to distinguish whether or not we can put a face to the invisible voice.

However, I prefer to leave the definition of the acousmêtre open, to keep it generic on purpose, thus avoiding the tendency to subdivide *ad infinitum*. Let's say I am going to concentrate primarily on what may be called the *complete acousmêtre*, the one who is not-yet-seen, but who remains liable to appear in the visual field at any moment. The already visualized acousmêtre, the one temporarily absent from the picture, is more familiar and reassuring—even though in the dark regions of the acousmatic field, which surrounds the visible field, this kind can acquire by contagion some of the powers of the complete acousmêtre. Also more familiar is the commentator-acousmêtre, he who never shows himself but who has no personal stake in the image. Which powers and which stakes come into play, we shall examine further on.

But what of the acousmêtres of the radio, and the backstage voice in the theater and the opera? Are these not of the same cloth, and are we perhaps just pompously reinventing the radio announcer or the actor-in-the-wings?

### THE RADIO-ACOUSMÊTRE

It should be evident that the radio is acousmatic by nature. People speaking on the radio are acousmêtres in that there's no possibility of seeing them; this is the essential difference between them and the filmic acousmêtre. In radio one cannot play with showing, partially showing, and not showing.

In film, the acousmatic zone is defined as fluctuating, constantly subject to challenge by what we might see. Even in an extreme case like Marguerite Duras's film *Son nom de Venise dans Calcutta désert*, in whose deserted images we hardly ever see the faces and bodies that belong to the acousmêtres who populate the soundtrack (the same soundtrack as *India Song*'s), the principle of cinema is that at any moment these faces and bodies *might* appear, and thereby de-acousmatize the voices. Another thing: in the cinema, unlike on the radio, what we have seen and heard makes us prejudge what we don't see, and the possibility of deception always lurks as well. Cinema has a frame, whose edges are visible; we can see where the frame leaves off and offscreen space starts. In radio, we cannot perceive where things "cut," as sound itself has no frame.

### THE THEATER-ACOUSMÊTRE

Georges Sadoul, in his *History of Cinema*, yields to the temptation to associate experiments in "audio-visual counterpoint" in the early sound era with "traditional offstage sounds in the theater."[7] But between an offstage voice and a filmic acousmêtre there is more than a shade of difference.

In the theater, the offstage voice is clearly heard coming from another space than the stage—it's literally located elsewhere. The cinema does not employ a *stage*, even if from time to time it might simulate one, but rather a *frame*, with variable

points of view. In this frame, visualized voices and acousmatic voices are recognized as such only in the spectator's head, depending on what she sees. In most cases, offscreen sound comes from the same actual place as the other sounds—a central loudspeaker. There are of course ambiguous cases when we can't easily distinguish what is "offscreen" from what is in the visual field (Fellini's films are rich in examples). But it should go without saying that the presence of such ambiguity does not make the distinction between offscreen and onscreen any less pertinent.

So we are a long way from the theatrical offstage voice, which we concretely perceive at a remove from the stage. Unlike the film frame the theater's stage doesn't make you jump from one angle of vision to another, from closeup to long shot. For the spectator, then, the filmic acousmêtre is "offscreen," outside the image, and at the same time *in* the image: the loudspeaker that's actually its source is located behind the image in the movie theater.[8] It's as if the voice were wandering along the surface, *at once inside and outside*, seeking a place to settle. Especially when a film hasn't yet shown what body this voice normally inhabits.

Neither inside nor outside: such is the acousmêtre's fate in the cinema.

## What Are the Acousmêtre's Powers?

Everything hangs on whether or not the acousmêtre has been seen. In the case where it remains not-yet-seen, even an insignificant acousmatic voice becomes invested with magical powers as soon as it is involved, however slightly, in the image. The powers are usually malevolent, occasionally tutelary. Being involved in the image means that the voice doesn't merely speak as an observer (as commentary), but that it bears with the image a relationship of *possible inclusion,* a relationship of power and possession capable of functioning in both directions; the image may contain the voice, or the voice may contain the image.

The not-yet-seen voice (e.g. Mabuse's in *The Testament,* or Maupassant's in the first two parts of Ophuls' *Le Plaisir*) possesses a sort of virginity, derived from the simple fact that the body that's supposed to emit it has not yet been inscribed in the visual field. Its *de-acousmatization,* which results from finally showing the person speaking, is always like a deflowering. For at that point the voice loses its virginal-acousmatic powers, and re-enters the realm of human beings.

The counterpart to the not-yet-seen voice is the body that has not yet spoken— the silent character (not to be confused with the character in the silent movie). These two characters, the acousmêtre and the mute, are similar in some striking ways.

An entire image, an entire story, an entire film can thus hang on the epiphany of the acousmêtre. Everything can boil down to a quest to bring the acousmêtre into the light. In this description we can recognize *Mabuse* and *Psycho,* but also numerous mystery, gangster, and fantasy films that are all about "defusing" the acousmêtre, who is the hidden monster, or the Big Boss, or the evil genius, or on rare occasions a wise man. The acousmêtre, as we have noted, cannot occupy the removed position of commentator, the voice of the magic lantern show. He must, even if only slightly, have *one foot in the image*, in the space of the film; he must haunt the borderlands that are neither the interior of the filmic stage nor the proscenium—a place that has no name, but which the cinema forever brings into play.

Being in the screen and not, wandering the surface of the screen without entering it, the acousmêtre brings disequilibrium and tension. He invites the spectator to *go see*, and he can be an *invitation to the loss of the self, to desire, and fascination*. But what is there to fear from the acousmêtre? And what are his powers?

The powers are four: the ability to be everywhere, to see all, to know all, and to have complete power. In other words: ubiquity, panopticism, omniscience, and omnipotence.

*The acousmêtre is everywhere*, its voice comes from an immaterial and non-localized body, and it seems that no obstacle can stop it. Media such as the telephone and radio, which send acousmatic voices traveling and which enable them to be here and there at once, often serve as vehicles of this ubiquity. In *2001*, Hal, the talking computer, inhabits the entire space ship.

*The acousmêtre is all-seeing*, its word is like the word of God: "No creature can hide from it." The one who is not in the visual field is in the best position to see everything that's happening. The one you don't see is in the best position to see you—at least this is the power you attribute to him. You might turn around to try to surprise him, since he could always be behind you. This is the paranoid and often obsessional *panoptic fantasy*, which is the fantasy of total mastery of space by vision.

A good number of films are based on the idea of the all-seeing voice. In Fritz Lang's *Testament of Dr. Mabuse* the master's look pierces through an opaque curtain. In *2001* the computer Hal, a voice-being, uncannily starts reading the astronauts' lips even when they have incapacitated its hearing. Many films classically feature a narrator's voice which, from its removed position, can see everything. And there are the voices of invisible ghosts who move about wherever the action goes, and from whom nothing can be hidden (Ophuls' *Tendre Ennemie*). And of course thrillers often feature telephone voices that terrorize their victims to the tune of "you can't see me, but I see you."

A John Carpenter horror film, *The Fog*, enacts the panoptic fantasy in a particularly ingenious form. The film's heroine, played by Adrienne Barbeau, works as a disc jockey at a local radio station perched atop an old lighthouse, from where she can see the entire city. The film's other characters know her only as a voice that is uniquely in the position to see the predicament they are in (the town invaded by an evil cloud). The fog makes them lose their bearings and the only thing that cuts through it is the voice of the airwaves, which broadcasts from the lighthouse, materializing its panoptic power.

The all-seeing acousmêtre appears to be the rule. The exception, or anomaly, is the voice of the acousmêtre who does not see all; here we find the panoptic theme in its negative form. In Josef von Sternberg's *Saga of Anatahan*, the action takes place on an island where Japanese soldiers have been marooned; we hear them speaking in Japanese. For the Western spectator, these scenes, instead of being dubbed or subtitled, have an English-language voiceover commentary spoken by Sternberg himself. He speaks in the name of the band of soldiers, employing a strange "we." This "we" refers not to the entire group, but to most of them—the ones excluded from contact with the only woman on the island. In fact, when the image and synch dialogue in Japanese bring us into the shack to discover the woman with her partner of the moment, the narrator speaks with the voice of someone who cannot see what is before our eyes, and who only imagines it ("We were not able to find out").

Contrary to the camera's eye, the narrator has not gone inside the shack. The disso-ciation between the acousmetric narrator's voice and the camera's indiscreet gaze is all the more disconcerting in that the voice claiming not to be looking is in the very place from which film voices can normally see everything—i.e., offscreen—and it's hard to believe that the voice is not privy to the action onscreen. We'd prefer to sup-pose that it's a bit dishonest about its partial blindness. The "we" in whose name it speaks seems not to refer to anyone in particular; you cannot detect which specific individual among the soldiers has taken charge of the storytelling.

In much the same way, acousmatic voices heard as we see Marguerite Duras's *India Song* speak as unseeing voices. This not-seeing-all, not-knowing-all occurs first in connection with the couple consisting of the Vice-Consul and Anne-Marie Stretter, just like that of Sternberg's "we" applies to the couple in the hut. This and other examples we will examine suggest that the *partially-seeing acousmêtre* has something to do with the primal scene. *What it claims not to see* is what the couple is doing. Bertolucci's film *Tragedy of a Ridiculous Man* revolves around a perverse inversion of the primal scene. It is the father who does not see what the son is doing with . . . as I take it, the mother. The father has received as a present from the son a pair of binoculars with which, on the roof of his factory, he enjoys the power of look-ing at everything going on. Bertolucci has endowed the father (Ugo Tognazzi) with a singular "internal voice." We cannot tell where the father's voice's vision and knowl-edge end, especially with regard to the son whom "it" sees being kidnapped, and with regard to everything that happens behind his back of which "it" sees nothing.

The most disconcerting, in fact, is not when we attribute unlimited knowledge to the acousmêtre, but rather when its vision and knowledge have limits whose di-mensions we do not know. The idea of a god who sees and knows all (the gods of Judaism, Christianity, and Islam are acousmêtres) is perhaps an "indecent" idea, according to the little girl Nietzsche writes of, but it is almost natural. Much more disturbing is the idea of a god or being with only partial powers and vision, whose limits are not known.

## THE ACOUSMÊTRE'S OMNISCIENCE AND OMNIPOTENCE

By discussing the acousmêtre's supposed capacity to see all, we have set the stage for considering the powers that follow from this. Seeing all, in the logic of magical thought we are exploring, implies knowing all; knowledge has been assimilated into the capacity to see internally. Also implied is omnipotence, or at the least the pos-session of certain powers whose nature or extent can vary—invulnerability, control over destructive forces, hypnotic power, and so on.

Why all these powers in a voice? Maybe because this *voice without a place* that belongs to the acousmêtre takes us back to an archaic, original stage: of the first months of life or even before birth, during which the voice was everything and it was everywhere (but bear in mind that this "everywhere" quality is nameable only retrospectively—the concept can arise for the subject who no longer occupies the undifferentiated everywhere).

The sound film is therefore not just a stage inhabited by speaking simulacra, as in Bioy Casares' novella *The Invention of Morel*. The sound film also has an offscreen field that can be populated by acousmatic voices, founding voices, determining

voices—voices that command, invade, and vampirize the image; voices that often have the omnipotence to guide the action, call it up, make it happen, and sometimes lose it on the borderline between land and sea. Of course, the sound film did not invent the acousmêtre. The greatest Acousmêtre is God—and even farther back, for every one of us, the Mother. But the sound film invented for the acousmêtre a space of action that no dramatic form had succeeded in giving to it; this happened once the coming of sound placed the cinema *at the mercy of the voice.*

## De-Acousmatization

Such are the powers of the acousmêtre. Of course, the acousmêtre has only to show itself—for the person speaking to inscribe his or her body inside the frame, in the visual field—for it to lose its power, omniscience, and (obviously) ubiquity. I call this phenomenon de-acousmatization. *Embodying the voice* is a sort of symbolic act, dooming the acousmêtre to the fate of ordinary mortals. De-acousmatization roots the acousmêtre to a place and says, "here is your body, you'll be there, and not elsewhere." Likewise, the purpose of burial ceremonies is to say to the soul of the deceased, "you must no longer wander, your grave is here."

In how many fantasy, thriller, and gangster films do we see the acousmêtre become an ordinary person when his voice is assigned a visible and circumscribed body? He then usually becomes, if not harmless, at least human and vulnerable. When the heretofore invisible Big Boss appears in the image, we generally know that he's going to be captured or brought down "like just any imbecile" (as Pascal Bonitzer says in talking about Aldrich's *Kiss Me Deadly*).[9]

De-acousmatization, the unveiling of an image and at the same time a *place*, the human and mortal body where the voice will henceforth be lodged, in certain ways strongly resembles striptease. The process doesn't necessarily happen all at once; it can be progressive. In much the same way that the female genitals are the end point revealed by undressing (the point after which the denial of the absence of the penis is no longer possible), there is an end point of de-acousmatization—the *mouth* from which the voice issues. So we can have semi-acousmêtres, or on the other hand partial de-acousmatizations, when we haven't yet seen the mouth of a character who speaks, and we just see his hand, back, feet, or neck. A quarter-acousmêtre is even possible—its head facing the camera, but the mouth hidden! As long as the face and mouth have not been completely revealed, and as long as the spectator's eye has not "verified" the co-incidence of the voice with the mouth (a verification which needs only to be approximate), de-acousmatization is incomplete, and the voice retains an aura of invulnerability and magical power.

*The Wizard of Oz* (1939) has a lovely scene of de-acousmatization that illustrates these points well. "The Great Oz" is the name that author L. Frank Baum gave his magician character. He speaks with a booming voice in a sort of temple, hiding behind an apparatus of curtains, grimacing masks, and smoke. This thundering voice seemingly sees all and knows all; it can tell Dorothy and her friends what they have come for even before they've opened their mouths. But when they return to get their due once they've accomplished their mission, the wizard refuses to keep his promise and starts playing for time. Dorothy is indignant; her dog Toto wanders toward the voice, tears the curtain behind which the voice is hidden, and reveals an ordinary little fellow who's speaking

into a microphone and operating reverb and smoke machines. The Great Oz is nothing but a man, who enjoys playing God by hiding his body and amplifying his voice. And the moment this voice is "embodied," we can hear it lose its colossal proportions, deflate and become a wisp of a voice, finally speaking as a human. "You are a naughty man," says Dorothy. "Oh no, my dear," timidly replies the former magician, "I am a very nice man, but a very bad magician." For Dorothy this de-acousmatization marks the end of her initiation, this moment when she mourns the loss of parental omnipotence and uncovers the mortal and fallible Father.

## NOTES

1. See Schaeffer, *Traité des objets musicaux* (Paris: Le Seuil, 1966).

2. Jacques Lacan, *Ecrits* (Paris: Editions du Seuil, 1966), p. 318; Anthony Wilden, trans., *Speech and Language in Psychoanalysis* (Lacan's 1953 "Discours de Rome") (Baltimore: Johns Hopkins University Press, 1981 [1968]), p. 318.

3. Since the terms most often used, *offscreen* and *nondiegetic*, are much too ambiguous, I use acousmatic to replace them.
   [Schaeffer and Chion's "acousmatic" does not appear in English-language dictionaries. The word's source is the Greek "akousma," a thing heard. See also note 5. *Trans.*]

4. Cf. Prologue, "There Is No Soundtrack."

5. The history of the term is interesting. The French word *acousmate* designates "invisible" sounds. Apollinaire, who loved rare words, wrote a poem in 1913 entitled "Acousmate," about a voice that resonates in the air. The famous *Encyclopédie* of Diderot and d'Alembert (1751) cites the "Acousmatiques" as those uninitiated disciples of Pythagoras who were obliged to spend five years in silence listening to their master speak behind the curtain, at the end of which they could look at him and were full members of the sect. It seems that Clement of Alexandria, an ecclesiastic writing around 250 ac, may be the sole source of this story, in his book *Stromateis*.
   The writer Jérome Peignot called this term to the attention of Pierre Schaeffer.

6. The French term is a neologism made from "être acousmatique," or acousmatic being.

7. Sadoul, *Histoire du cinéma mondial* (Paris: Flammarion, 1963), p. 234.

8. Furthermore, we imagine it there in TV, at the drive-in, and so on.

9. Pascal Bonitzer, *Le Regard et la voix* (Paris: Union Générale d'Editions, 1976), p. 32.

# CLAUDIA GORBMAN

# Classical Hollywood Practice

FROM *Unheard Melodies*

Claudia Gorbman (b. 1948), currently Professor of Film Studies at the University of Washington-Tacoma, is a key figure in redressing a common omission in studies of cinema and signification: the soundtrack. In her own work and in her translations of several books

by French theorist Michel Chion (p. 156), Gorbman proves an erudite and accessible guide to how sound amplifies the image in narrative film practice.

Gorbman's work on film music is historical, theoretical, and practical. She brings attention to nondiegetic (background) music's violation of the basic principle of filmic verisimilitude. She also explores the reasons for the inclusion of music in the emerging art and institution of cinema — investigating whether the sole reason is that public spectacle was historically accompanied by music. Gorbman is particularly interested in the role and function of narrative film music in both silent and sound films. She draws on semiotic, ideological, and psychoanalytic theory to suggest that the music of Hollywood classics from *Gone with the Wind* (1939) to *Star Wars* (1977) anchors the film's meaning, highlights the spectacle, and provides pleasure and a bonding experience for the audience.

In this selection from her 1987 book *Unheard Melodies*, Gorbman investigates and explains the form of music typically employed in classical Hollywood cinema, using composer Max Steiner, credited with more than three hundred film scores over the course of his long career in Hollywood, as her example. Gorbman asserts that the principles of composition adhered to by Hollywood sound practitioners strikingly echo film theorists' observance that signs of a film's construction are subordinate to narrative coherence. Listing seven such principles and citing examples from such well-known films as *King Kong* (1933), Gorbman shows how Hollywood's orchestral soundtracks continuously reinforced classical principles of unity, balance, and clarity.

## READING CUES & KEY CONCEPTS

■ Explore the paradox of film music's "inaudibility."

■ Gorbman claims that Romanticism provides classical cinema with a vocabulary for emotion. Consider how pop songs fulfill a similar function in contemporary films.

■ Experiment by listening to a film scene with a different piece of music. Consider the principles that Gorbman lists in her essay. How many of these are violated?

■ **Key Concepts:** Nondiegetic Music; Narrative Cuing; Continuity; Connotation

# Classical Hollywood Practice

. . . . . . . . . . . . . .

In this chapter I shall describe the actual form music takes in Hollywood films, and the principles determining it. First, however, we must situate our investigation in the context of the "classical model" of narrative cinema in general, for the codification of mainstream film has everything to do with the musical language that goes with it.

To use the term "classical cinema" means understanding this cinema as an institution, and a class of texts which this institution produces. The classical film text (which at its most specific is a Hollywood feature film of the thirties and forties) is a conjuncture of several economies, a narrative discourse determined by the

organization of labor and money in the cinema industry, by/in ideology, and by the mechanisms of pleasure operating on subjects in this culture. Christian Metz reminds us of these interconnected aspects of the system:

> It is not enough for the studios to hand over a polished little mechanism labelled "fiction film"; the play of elements still has to be realised ... it has to *take place*. And this place is inside each one of us, in an economic arrangement which history has shaped at the same time as it was shaping the film industry.[1]

What are these texts produced by the classical cinematic institution? In the sense that we cannot identify *the one* prototypical classical film, no one textual model exists. Rather, there exists a pool of conventions, of options, whose combination and recombination constitute an easily recognized discursive field. We know that even allowing for a wide diversity of genres and studio and authorial styles, there is something identifiable as classical Hollywood cinema, an implicit model that determines the duration of a film, the possibilities of its narrative structure, and its organization of spatiotemporal dimensions via mise-en-scène, cinematography, editing (that is, the "continuity system"), and sound recording and mixing.

André Bazin's influential essay "The Evolution of the Language of Cinema" identified the classical age of the sound film as the late thirties.

> By 1938 or 1939 the talking film, particularly in France and in the United States, had reached a level of classical perfection as a result, on one hand, of the maturing of different kinds of drama developed in part over the past ten years and in part inherited from the silent film, and, on the other, of the stabilization of technical progress.[2]

Bazin likens the state of cinematic form to the equilibrium profile of a riverbed: just as geological equilibrium results from "the requisite amount of erosion," film genres and narrating techniques reached a new stability a decade after the coming of sound. He describes 1938–1939 as a moment of "classical perfection" of the feature film, exemplified by *Stagecoach, Jezebel,* and *Le Jour se lève.* What typifies the classical mode of narrative discourse? For Bazin, storytelling in this cinema is characterized by an editing whose purpose is *analytic, dramatic,* and *psychological.* The classical film ordinarily unfolds in several hundred shots, but these shots do not build up a narrative in the synthetic language of Soviet montage. Classical decoupage presupposes a unified scenic space. It renders this space via "establishing" (long) shots and subsequent breakdown; spatial intelligibility is safeguarded by such devices as the 180-degree rule, the eyeline match, and the shot reverse-shot pattern. Further, cutting is motivated by dramatic and/or psychological logic, accommodating to the spectator's need to see details of narrative importance.

Since Bazin, work on such films as *Stagecoach* (1939), *Young Mr Lincoln* (1939), *The Big Sleep* (1946), *Suspicion* (1941), *Mildred Pierce* (1945), and *The Maltese Falcon* (1941) has studied features of editing and narration in the context of Hollywood's strongly consolidated "classical" system. These interrelated "classical" features predominate in cinema as far back as the teens and into the commercial cinema of the present, as well as in commercial cinemas of many other countries.

Recent film scholarship has recast the Bazinian description of the classical filmic system in two major ways. First, his phenomenological conceptualization of the spectator as an autonomous perceiving subject—who "wants" to see dramatically important details, and whose perceptual demands cinema satisfies—has given way to an anti-idealist stance which regards as crucial the film's ideological and psychical positioning of its viewing subject. The film positions the spectator; it does the looking and listening for the spectator. Classical editing has been reconsidered and understood in light of its particularly compelling strategies of channeling the spectator's desires, giving the "impression of reality," and encouraging imaginary identification with the film.

The second change in critical emphasis goes hand in hand with the first. If story refers to the narrative world and what happens in it, and if discourse refers to all the means of articulating the story, classical Hollywood film works toward the goal of a transparent or invisible discourse, and promoting fullest involvement in the story. For instance, cutting is a potentially disruptive characteristic of filmic discourse; Hollywood "effaces" the discontinuity that is part and parcel of cutting by means of continuity editing. Continuity editing is a kind of work that masks its own traces, a highly coded symbolic discourse permitting the spectator's fullest identification with the film, as Metz explains:

> [T]he basic characteristic of this kind of discourse, and the very principle of its effectiveness as discourse, is precisely that it obliterates all traces of the enunciation, and masquerades as story. . . . [A] fundamental disavowal [the film "knows" and at the same time "doesn't know" it is being watched] has guided the whole of classical cinema into the paths of "story," relentlessly erasing its discursive basis. . . .[3]

Now, as part of this discourse, background music clearly constitutes a major element of the classical narrative filmic system. It persists across most genres, from musicals to detective films, science fiction, war, and adventure films, from screwball comedies to domestic melodrama. The very fact that theoreticians of classical filmic discourse, even those who write about the soundtrack, have slighted the specific uses of music in this cinema attests to the strength of music's resistance to analysis. Nonetheless, principles similar to those articulated with respect to classical editing (and other subsystems of Hollywood narrative film) underlie the composition, mixing, and audiovisual editing of film music. Manuals and articles on sound recording and mixing, and aesthetic and practical writings on music composition and mixing, as well as the films themselves, provide access to these principles.

What follows, then, is a synthetic outline of the principles of music composition, mixing, and editing in the classical narrative film. It describes a discursive field rather than a monolithic system with inviolable rules. While I shall not argue for equilibrium profiles or ripeness, I shall emphasize the period of the late thirties into the forties, in order to contribute to an established and growing body of knowledge about the field of classical cinema. Examples shall be drawn in particular from scores by Max Steiner—not to establish his work as a paradigm, but because of his voluminous presence and influence in the classical period. That many of the films he scored have been the object of analysis by contemporary film scholars also renders him central to the study of Hollywood's film music norms.

# Classical Film Music: Principles of Composition, Mixing, and Editing

I.   *Invisibility*: the technical apparatus of nondiegetic music must not be visible.

II.   *"Inaudibility"*: Music is not meant to be heard consciously. As such it should subordinate itself to dialogue, to visuals—i.e., to the primary vehicles of the narrative.

III.   *Signifier of emotion*: Soundtrack music may set specific moods and emphasize particular emotions suggested in the narrative (cf. #IV), but first and foremost, it is a signifier of emotion itself.

IV.   *Narrative cueing*:

   —*referential/narrative*: music gives referential and narrative cues, e.g., indicating point of view, supplying formal demarcations, and establishing setting and characters.

   —*connotative*: music "interprets" and "illustrates" narrative events.

V.   *Continuity*: music provides formal and rhythmic continuity—between shots, in transitions between scenes, by filling "gaps."

VI.   *Unity*: via repetition and variation of musical material and instrumentation, music aids in the construction of formal and narrative unity.

VII.   A given film score may violate any of the principles above, providing the violation is at the service of the other principles.

## I. INVISIBILITY

The physical apparatus of film music (orchestra, microphones, etc.), like the film's other technological apparatus, such as the camera, must under most circumstances not be visible on the screen. In an article on film sound technology, Charles F. Altman asserts,

> The assumption that all sound-collection devices must be hidden from the camera is . . .—along with the complementary notion that all image-collection noises (camera sounds, arc lamps, the director's voice, etc.) must be hidden from the sound track—the very founding gesture of the talkies.[4]

It is revealing to examine RKO's *King Kong* (1933, score by Max Steiner) with respect to the "rules" being formulated here. For *Kong* was one of the early 100 percent talkies to have a sustained dramatic score, and the very places in which it exhibits awkwardnesses help us recognize, in retrospect, what would soon become the smoothed-out version of classical film scoring and editing. Early in the film, when adventure filmmaker Carl Denham and a half dozen companions go ashore to investigate Skull Island, the principle of invisibility receives an interesting treatment.

A tribe of natives is staging a spectacular ritual at the foot of the enormous wall that separates the island's human denizens from its monstrous ones. Some natives, dressed in ape gear, dance. Others are draping flower garlands onto a native virgin

girl; we will learn that they are preparing her for sacrifice to appease the great ape Kong. Denham masses his companions behind some foliage and, as if plants could really hide him, stands behind a small palm; he parts some palm fronds to look. "Holy mackerel, what a show!" he exclaims. The spectacle, the excitement, the rising frenzy of the exhibition (natives) and the voyeurism (Denham & co.) build in tandem with the music.—What music? Well, indeed, music is overwhelming the soundtrack at this point. We can hear the tribal chanting and drum-beating, which we accept as diegetic—as well as the RKO studio orchestra (to be considered nondiegetic) playing a rhythmically repetitious figure in accompaniment.

Movie mogul Denham can't stand to "lose" this spectacle. He hauls his movie camera out into the open and starts cranking. The visual apparatus is exposed, made visible. The tribal chief sees that he's being filmed (or something like that; he has presumably never seen a movie camera). Like a huge black feathered orchestra conductor, the chief gives an imperious cutoff signal. The heretofore unselfconscious dancing, chanting, drumming, and nondiegetic orchestra stop abruptly.

Something—the force of convention, perhaps—made it acceptable for Denham to part the palm fronds, creating a keyhole through which to gaze (and hear) unseen (and unheard). But one cannot move one's kino-eye out into the open without being seen, without "breaking the diegetic illusion" (to make a parallel between the film spectator and the native folk). But the case of sound technology that *King Kong* puts forth is even more mystifying.

Are we to believe that Denham is shooting a *silent* film of all this dancing, chanting, drumming? No sound recording apparatus gets caught *in flagrante delicto* along with the camera. If a microphone and a soundman were accompanying Denham, what would the mike pick up? Would it record the drumming, the chanting, and the RKO orchestra? We know the "obvious" answer to this question, but this scene seems to test its very obviousness in eliminating, on the diegetic level, a soundman along with Denham and his camera. It is as if sound in a film has no technological base, involves no work, is natural, and will simply "show up," just like the spectacle Denham witnesses. Further, the classical paradigm would have us believe that no work has gone into the sound of what *we* witness. Sound is just there, oozing from the images we see. The principle of *invisibility of the sound-collecting apparatus* is inscribed more deeply into the fictional text than the corresponding visual principle of the camera's invisibility.

Some further remarks on the principle of invisibility are in order.

a. When the musical apparatus is visible, the music is "naturalized" as diegetic.[5] Exceptions tend to prove the rule. Eric Rohmer's *Perceval* (1978) shows us other possibilities, as medieval musicians are seen in frame accompanying the stylized actions. *Perceval* does not actually break the rule, as it is not by and large attempting to be a diegetic Hollywood film, but, to the contrary, is approximating conventions of medieval dramatic performance. Another exception occurs when the Godard of *Prénom: Carmen* (1984) intercuts segments showing a string quartet rehearsing Beethoven, with the fiction story of bank-robber Carmen and her companion. The quartet is situated problematically in the fiction via the female violinist who appears once or twice in minor scenes of the principal narrative. Otherwise, these shots of musicians have a wholly ambivalent status: are they

nondiegetic (outside the "story") or not? A third kind of example is often found in Hollywood film comedy and musicals: Mel Brooks and Woody Allen have made comic use of "diegetizing" background music by placing musicians in an unlikely mise-en-scène (e.g. Count Basie's jazz orchestra on the western plains of *Blazing Saddles*).

b. Ordinarily, then, the visual representation of music making signals a totally different narrative order, that is, the diegetic, governed by conventions of verisimilitude (e.g., a dance band playing in a nightclub scene). And this, even when the visual representation is not really the source of the music we hear. When Stefan, the Louis Jourdan character in *Letter from an Unknown Woman*, plays the piano, Louis Jourdan is not playing the piano; piano music has been dubbed onto the soundtrack to produce the illusion. A Hollywood music editor lays bare the artificiality of most diegetic music when he tries to describe a typical playback session on a set (where actors are filmed to synch with prerecorded "diegetic" music):

> You need also to watch for sideline musicians. They are actual musicians who are used in scenes where they are supposed to be playing, but like other performers they are just doing a playback. They may actually play at the same time but such a rendition is not recorded nor used.[6]

## II. "INAUDIBILITY"

I have set the term in quotes because, of course, film music can always be heard. However—and somewhat analogously to the "invisibility" of continuity editing on the image track—a set of conventional practices (discursive practices and viewing/listening habits) has evolved which result in the spectator not normally hearing it or attending to it consciously. Its volume, mood, and rhythm must be subordinated to the dramatic and emotional dictates of the film narrative. Leonid Sabaneev (or perhaps his translator) expresses this principle in particularly telling language:

> In general, music should understand that in the cinema it should nearly always remain in the background: it is, so to speak, a tonal figuration, the "left hand" of the melody on the screen, and it is a bad business when this left hand begins to creep into the foreground and obscure the melody.[7]

Bad business, precisely, for it is good business to give ticket-buyers what they have come for, namely a story, not a concert. This story is the right-hand melody, the focus of attention and desire; film music supports it with "harmony"—in fact, gives it signifying resonance.

Here are some practices dictated by the principle of inaudibility.

a. Musical form is generally determined by or subordinated to narrative form. The duration of a music cue is determined by the duration of a visually represented action or a sequence. Thus Sabaneev gives much practical advice about how to compose flexible and neutral music that may be stretched or trimmed, in the likely case that the studio should lengthen or shorten scenes in the final cut. "One might call it elastic or extensile music." He encourages composers to build pauses and sustained notes into the music, for one can draw them out further if the sequence is lengthened with added shots. The composer should write in short musical phrases, also for

ease of cutting. Sequential progressions are convenient and therefore encouraged. And "it will be well for the composer to have small pieces of neutral music ready for any emergency—sustained notes on various instruments, rolls on the drum or the cymbals, string pizzicati, chords of a recitatival type."[8]

*King Kong*'s score is largely constructed in this way, especially the central section where Denham, Jack Driscoll, and other crew members, themselves pursued by the island's fancifully created monsters, are attempting to find Ann and rescue her from Kong's clutches. Sequential progressions—each restatement of a motive beginning a step or a third higher than the last—build tension incessantly and relentlessly, and at the same time surely proved adaptable in fitting with the final cutting of the images. Steiner here anticipates Sabaneev's prescription for elastic, extensile film music, and this predilection for sequential repetition is a hallmark of his style throughout his career.

b. *Subordination to the voice.* "It should always be remembered, as a first principle of the aesthetics of music in the cinema, that logic requires music to give way to dialogue."[9] Sabaneev means narrative logic. Dialogue, or any narratively significant sounds for that matter, must receive first priority in the soundtrack mix, as composer Ernest Gold learned:

> What fiendish tortures await the composer at [dubbing] sessions! That tender cello solo, his favourite part of the entire score, lies completely obliterated by a siren which the director decided was necessary at that exact spot in order properly to motivate the reaction on the hero's face! Or that splendid orchestral climax . . . held down to a soft *pp* because of a line of narration that had to be added at the last moment in order to clarify an important story point.[10]

Pursuing the notion that music must not drown out speech, Sabaneev, already out-of-date by Hollywood standards, recommends in 1934 the total cessation of music while there is dialogue on the soundtrack, to rule out any aural "competition" and to ensure the dialogue's clarity. In the United States, the practice of lowering the volume of music behind dialogue, rather than eliminating it, was already *de rigueur*. A machine nicknamed the "up-and-downer," developed as early as 1934, had as its purpose to regulate music automatically. When dialogue signals entered the soundtrack, the up-and-downer reduced the music signal.[11] In an article about the up-and-downer, soundman Edward Kellogg gives a psychological rationale for the music-dimming practice it automated, claiming that it approximated the perceptual activity of attention:

> The system employed here attempts practically to imitate by changes of relative intensity the psychological effect of switching attention from one sound to another. In actual life we can usually take advantage of differences of direction in order to concentrate attention upon a particular sound. The result of concentrating upon one sound is, of course, not to make the sound louder; but with our directive sense to help, we can largely forget the other sounds, which accomplishes the same purpose as making them actually fainter. Since, in the present case [i.e., a film soundtrack with more than one type of sound], all the sound comes from one direction, and our directive sense cannot be brought into play,

the suppression of the sounds in which the listener is less interested is accomplished by making them fainter.[12]

The thirties also saw the development of guidelines for composing and orchestrating music to be placed behind dialogue. Musicians and soundmen felt that woodwinds create unnecessary conflict with human voices, and they stated a preference for strings. They concurred on questions of range, too: even in the seventies Laurence Rosenthal advised "keeping the orchestra well away from the pitch-range of the speaker—low instruments against high voices, and vice versa,"[13] although other composers note that combining voice and orchestra in the same register can sometimes be a creative move, if a sort of indistinguishable tone color is desirable.

c. For editing, certain points are "better" than others at which music may stop or start, for "music has its inertia: it forms a certain background in the subconsciousness of the listening spectator, and its sudden cessation gives rise to a feeling of aesthetic perplexity."[14] Typically, within a scene, music enters or exits on actions (an actor's movement, the closing of a door) or on sound events (a doorbell, a telephone ring). It may also begin or end by sneaking in or out under dialogue, or at the moment of a decisive rhythmic or emotional change in a scene. It goes relatively unnoticed in these cases because the spectator's attention focuses on the action, the sound, or the very narrative change the music is helping to dramatize. Finally, starting the music cue is considered more difficult than ending it; an entrance seems to be more conspicuous than an exit. Thus music almost never enters simultaneously with the entrance of a voice on the soundtrack, since it would drown out the words.

d. The music's mood must be "appropriate to the scene." Classical composers avoid writing music that might distract the viewer from his/her oneiric state of involvement in the story; the point is rather to provide a musical parallel to the action to reinforce the mood or tempo. A fast horse chase needs fast "Ride of the Valkyries" music; a death scene needs slow, somber music. Counterexamples—music inappropriate to the mood or pace—are usually comedic or self-reflexively modernist. In Godard's *Bande à part* (1964), a film abounding with Hollywood genre expectations gone wrong, brass instruments pleasantly execute a waltz as two would-be robbers tensely attempt to break into a house via a ladder to the upper floor.

Incidentally, this is one reason why the nineteenth-century Romantic orchestral idiom of Wagner and Strauss predominated for so long in classical cinema. It was (and is) tonal and familiar, with easily understood connotative values.[15] The gradual introduction of jazz and popular music to scores in the fifties and sixties provides further evidence of the stylistic conservatism of background music. A musical idiom must be thoroughly familiar, its connotations virtually reflexive knowledge, for it to serve "correctly," invisibly, in classical filmic discourse.

## III. EMOTION

Music appears in classical cinema as a signifier of emotion. Sabaneev describes the image-track, dialogue, and sound effects as "the purely photographic," objective elements of film, to which music brings a necessary emotional, irrational, romantic, or intuitive dimension. Music is seen as augmenting the external representation, the objectivity of the image-track, with its inner truth. We know that composers add

enthralling music to a chase scene to heighten its excitement, and a string orchestra inflects each vow of devotion in a romantic tryst to move spectators more deeply, and so on. Above and beyond such specific emotional connotations, though, music itself signifies emotion, depth, the obverse of logic.

*Music and representation of the irrational.* Following *King Kong*'s opening titles, music leaves the soundtrack altogether for a while. The film presents entrepreneur Denham and his "moving picture ship" making preparations to set sail. Denham makes a last trip into town, meets impoverished Ann Darrow, and hires her on for the mysterious and exciting adventure. The ship leaves; it crosses the ocean. On board, Denham administers to Ann her screen test/scream test, in apt foreshadowing of her rendezvous with Kong. All this expository material, from the opening shots to the ship's arrival at Skull Island, transpires with no background music.

Music finally appears with a fade-in to a shot of the ship approaching mist-enshrouded Skull Island. A harp in the low register plunks a tonally vague, repetitious motif, over sustained chords of a string orchestra. The music initiates us into the fantasy world, the world where giant apes are conceivable, the underside of the world of reason. It helps to hypnotize the spectator, bring down defenses that could be erected against this realm of monsters, tribesmen, jungles, violence. This association of music and the irrational predominates throughout the genres of horror, science fiction, and fantasy, as a catalyst in the textual process of slipping in and out of the discourse of realism. Max Steiner avers: "Some pictures require a lot of music and some of them *are so realistic that music would only hurt and interfere.*"[16] Thus, background music aligns with the paradigm of the right-hand column:

| Logic | The Irrational |
|---|---|
| Everyday Reality | Dream |
| Control | Loss of Control |

*Music and representation of Woman.* A film of the forties is airing on television. Even though you're in the next room, you are likely to find that a certain kind of music will cue you in correctly to the presence of Woman on screen. It is as if the emotional excess of this presence must find its outlet in the euphony of a string orchestra. I refer here to Woman as romantic Good Object, and not to old women, or humorous or chatty women, or femmes fatales (who possess their own musical conventions—jazz, brass, woodwinds . . .).[17] Sabaneev states categorically that films "with love episodes, would find it difficult to dispense with music."[18]

One finds an early—and curious—illustration of this principle in *King Kong.* The ship is anchored off Skull Island; it is evening. Alongside the ship's railing, Jack declares his love to Ann, while Denham and the skipper converse on the ship's bridge. Crosscutting between the two locales occurs as follows:

> [JACK, to Ann, concerned about her participation in the dangerous adventures on the island:] "I'm scared for you . . . I'm sort of scared *of* you, too. [Melodic background music, in strings and harp, through this monologue, which cuts once to a CU of Ann, then back to Jack.] Ann, uh . . . I . . . uh . . . uh . . . Say, I guess I love you."

[SKIPPER, in 2-shot with Denham on bridge:] "Mr. Driscoll: are you on deck?"
[No music during this shot.]
[JACK, embracing Ann:] "Yes, *sir*!" [Music plays.]
[SKIPPER:] "Then please come up on the bridge." [No music.]

Jack and Ann engage in romance; close-ups highlight them against the dark night sky. Denham and the skipper seem to be engaging in a discourse of work; medium-long shots show them in an evenly lit interior. The score reinforces the contrast: violins play sweetly behind the romantic duo's shots, while no music plays with the shots on the bridge. This auditory alternation, strictly aligned with the visual cutting, proves quite disconcerting. The score distinctly ends up violating the "inaudibility" and "continuity" principles in its intended mission to accompany/ illustrate the presence of Woman. (Abrupt stops and starts of music become rare after 1934. For a sequence like this, the composer would henceforth choose either a sustained musical cue throughout—its volume subdued as the men on the bridge are seen—or the less likely solution of eliminating music altogether.) The set of oppositions in this case can be drawn as follows:

| Man | Woman |
|---|---|
| Objectivity | Subjectivity |
| Work | Leisure |
| Reason | Emotion |
| Realism | Romantic Fantasy |

*Music and epic feeling.* Music, especially lushly scored late Romantic music, can trigger a response of "epic feeling." In tandem with the visual film narrative, it elevates the individuality of the represented characters to universal significance, makes them bigger than life, suggests transcendence, destiny. This phenomenon seems to point back to anthropological analyses of the ritual functions of rhythm and song in human groups. The sense of common destiny which fans at a football game might have as, "of one voice," they sing the national anthem or chant a slogan in support of the home team has something to do with the emotions inspired by group identity-inducing rituals in more primitive (or, as Eisler and Adorno put it, precapitalistic) groups.

In dominant cinema, this capacity of music to refer to commonality, destiny, and the like, is exploited for producing emotion and pleasure. The appropriate music will elevate the story of a man to the story of Man. When Mildred Pierce is stunned by a cruel argument with her ungrateful daughter, the reaction shot of her (a close-up in which she looks offscreen, suffering), backed by a loud and tragic rendition of the first three notes of her theme, becomes a statement not only of the condition of Mildred, but of the condition of Woman as Mother. At the film's end, as Mildred is reunited with her husband and walking from the police station into the sunrise, a full orchestra, with chimes and dominated by the brasses, restates her theme in a major key. Not only has the couple been reunited, but, in the words of Pam Cook, the patriarchal system (which the plot had threatened to dismantle) has been reconstructed, and "under the aegis of the Law . . . ambiguity is resolved

and the shadows dispersed by the light of the new day."[19] I would suggest, again, that music has played a considerable role in the process.

John Ford's historical films provide numerous examples of a related strategy, using music to give a fictional scene mythical significance. The editors of *Cahiers du cinéma* demonstrated how dialogue, cinematography, mise-en-scène, narrative, and the audience's retrospective "knowledge of history" mythify the protagonist's smallest actions in *Young Mr. Lincoln*. Music contributes significantly to this. The final scene, for example, has Lincoln alone, "going on a piece—maybe to the top of that hill." The camera's low angle, the painterly grandeur of the landscape—*and* the Battle Hymn of the Republic on the soundtrack—transform Lincoln's little walk (his constitutional?) to a prefigurement of his destiny as Civil War president. (While virtually any Romantic orchestral music might help here in transforming the everyday to the mythic, the additional reference of the Battle Hymn serves to pinpoint the character's destiny.)

Thus a third large category of "emotion" signified by classical film music can be charted in the following way, with music contributing to the values on the right.

| The Particular | The Universal |
| The Prosaic | The Poetic |
| The Present | Mythic Time |
| The Literal | The Symbolic |

### IV. NARRATIVE CUEING

We may divide the semiotic duties of music in classical film into two categories: (1) it refers the spectator to demarcations and levels of the narration; (2) it illustrates, emphasizes, underlines, and points, via what we shall call connotative cueing. Let us first consider some cases of the first type.

1a. *Beginnings and endings.* Music normally accompanies opening and end titles of a feature film. As background for opening titles, it defines the genre (*Mildred Pierce*'s title music signals a melodrama); and it sets a general mood (for *Mildred Pierce*, sweepingly emotional, tragic perhaps, as it plays over images of waves washing up on shore). Further, it often states one or more themes to be heard later accompanying the story; the distinctness of the melody can cue even the nonmusical listener into this promissory function, setting up expectations of the narrative events to follow. Finally, opening-title music signals that the story is about to begin, bids us to settle into our seats, stop chatting with fellow moviegoers, and drift into its daydream. Conventionally for melodramas, adventure films, and comedies, composers wrote opening music "full of joy and gladness." (Dimitri Tiomkin reveals that some studios actually forbade the use of minor keys for opening titles, "their reasoning being that 'minor' meant sad and 'major' denoted happiness.")[20]

Ending music tends to strike up in the final scene and continues (or modulates) behind the end credits. Musical recapitulation and closure reinforces the film's narrative and formal closure. Often, it consists of an orchestral swelling with tonal

resolution, sometimes involving a final statement of the score's main theme. At any rate, it typically provides a "rising crescendo," "loud and definite."[21]

1b. *Time, place, and stock characterization.* Music, via the well-established conventions, contributes to the narrative's geographical and temporal setting, at the beginning of a film or during a scene within it. The first diegetic shots of *Casablanca* are accompanied by a vaguely Middle-Eastern cue (a clarinet plays a minor-key melody with much ornamentation), to supply the impression of the exotic streets and markets of Casablanca, as if to situate *us* in *it* (when really it's the other way around), to create the sense of a world, even though no one in that world is (diegetically) playing the music.

Strongly codified Hollywood harmonies, melodic patterns, rhythms, and habits of orchestration are employed as a matter of course in classical cinema for establishing setting. A 4/4 allegretto drumbeat (or pizzicato in bass viols), the first beat emphatically accented, with a simple minor-modal tune played by high woodwinds or strings, signifies "Indian territory." A rumba rhythm and major melody played by either trumpet or instruments in the marimba family signifies Latin America. Xylophones and woodblocks, playing simple minor melodies in 4/4, evoke Japan or China. If one hears Strauss-like waltzes in the strings, it must be turn-of-the-century Vienna. Accordions are associated with Rome and Paris; harps often introduce us to medieval, Renaissance, or heavenly settings. The hustle and bustle of the big city, especially New York, is signified by rhythmic support of a jazzy or slightly discordant major theme played by brass instruments or strings, interrupted now and then by a brass automobile-horn imitation. Character types, too, have typical musical signifiers. The girl next door is graced with a sentimental tune in a major key; the seductress is often accompanied by a cocktail-lounge jazz clarinet or saxophone. Max Steiner gives virtually the same rhythmic, open-fifths theme to the Seminoles in Key Largo as he does to Apaches and Cheyennes out west. Woodwinds or xylophones often introduce comic characters in a major key with occasional "wrong"-sounding notes. The code and its constituent signs are well known to American filmgoers. Quincy Jones fantasizes the impossible (except in a comedy): "I've always wanted to see a juxtaposition of a Victorian setting with modern soul music. It would really crack me up to find, in the middle of a scene out of Dickens, James Brown screaming away as the town crier."[22]

1c. *Point of view.* The classical film may deploy music to create or emphasize a particular character's subjectivity. Several devices cue the spectator: the association of the music with the sight of the character in a shot, a thematic association repeated and solidified during the course of the narrative, orchestration of music that was previously sung by or to the character, and the marked addition of reverberation for suggesting strongly subjective experiences.

Steiner's score for *Of Human Bondage* (1933) provides some striking examples of early point-of-view music in film. The educated, upper-class, club-footed protagonist Philip Carey (played by Leslie Howard) develops a romantic obsession for the prosaic, uninterested cockney waitress Mildred (Bette Davis). He takes her to dine at a restaurant, where an offscreen piano, violin, and cello trio plays a waltz. Philip's line, "I love that music: it makes me think of you," consolidates this as the Philip-thinking-about-Mildred theme. The nondiegetic rendering of this waltz will

henceforth signify a romantic complicity with Philip's love/obsession for Mildred. This is not simply the Mildred theme. Significantly, it does *not* nondiegetically accompany scenes where Mildred actually is present: the cold reality of her emotional disinterest in Philip thus becomes clear, at some level, for the spectator.

Sometimes this musical theme turns into an index of strongly subjective point-of-view. As Philip takes a medical school examination, he absent-mindedly looks at a skeleton at the head of the classroom. A dissolve turns the skeleton into the shapely form of Mildred, and as it does, the scene's background music, a possibly diegetic calliope (outside the window?) playing the Mildred waltz, gives way to the waltz now played by a cello and string orchestra and recorded with an inordinate amount of reverberation. (This reverb contrasts markedly with the "dead" sound of the diegetic rendition in the restaurant.) One of Philip's classmates notices his distracted reverie, and as he coughs to bring Philip back to the business of exam-writing, the calliope tune returns to the auditory background. Earlier in the film he dreams of Mildred: they dance, he without his clubfoot, and they talk gaily, she without her nasal working-class accent. During this wish-fulfillment dream a string orchestra plays the familiar theme with a high degree of reverb.

2. *Connotative cueing.* Narrative film music "anchors" the image in meaning. It expresses moods and connotations which, in conjunction with the images and other sounds, aid in interpreting narrative events and indicating moral/class/ethnic values of characters. Further, attributes of melody, instrumentation, and rhythm imitate or illustrate physical events on the screen. Classical cinema, predicated as it is on telling a story with the greatest possible transparency, overdetermines these connotative values. Soundtrack music reinforces what is (usually) already signified by dialogue, gestures, lighting, color, tempo of figure movement and editing, and so forth.

*Caged*, a 1950 "realistic" prison melodrama, begins as a police van brings young and innocent Marie Allen (Eleanor Parker) to the women's prison to which she has been unjustly sentenced. As they are herded toward the door, another prisoner tells her to "grab your last look at freeside, kid." Marie turns around, and a last lingering shot follows of the "normal" world outside the prison gate: a city street, a building, a church spire, a few automobiles. At the film's end, a hardened Marie, headed for a criminal life, emerges from the prison door and takes her first look at "freeside" in over a year. Over the same shot—traffic, church—we now hear jazzy, sultry music on trumpet and saxophone. The whole meaning of the "normal" outside world has changed for her, and Steiner's score conveys this efficiently via musical conventions.

2a. Music has tremendous power to influence mood. The commutation experiment undertaken with a small segment of *Jules and Jim* establishes—albeit in a simplistic way comparable to Kuleshov's short editing experiments—that different music will cue the viewer to different interpretations of an image or scene. The associations that (Hollywood's, Tin Pan Alley's) conventions attach to particular musical instruments, rhythms, melody types, and harmony, form a veritable lexicon of musical connotation which the studio music department exploits.

Even before 1925, film-music lexicons (e.g., Giuseppe Becce's 1919 *Kinobibliothek*), which aided in compiling cue sheets for individual films, enjoyed popularity and profit; indeed, they became instrumental to the efficient functioning of the musical staff of movie houses. Musical "meaning" was codified and institutionalized well before the coming of sound. In turn, these meanings were inherited

from a long European tradition whose most recent forebears included theatrical, operatic, and popular music of the latter nineteenth century. Erno Rapee compiled the definitive lexicon of film-musical connotation in 1924, the *Motion Picture Moods for Pianists and Organists: A Rapid Reference Collection of Selected Pieces Adapted to Fifty-Two Moods and Situations*. The fifty-two subjects ranged from Aeroplane, Band, Battle, Birds, Calls, and Chase, through National, Neutral, Orgies, and Oriental, to Sea-Storm, Sinister, Wedding, and Western. The accompanist needing to supply "Sadness" during a film projection could select from among ten pieces, which included the first movement of Beethoven's Sonata no. 2 (Op. 27), Chopin Preludes 4 or 20 (Op. 28), Grieg's "Elegie" (Op. 47), and Gaston Borch's "Andante Patetico e Doloroso." The three selections available for wedding scenes were Mendelssohn's wedding march, Wagner's wedding march from *Lohengrin*, and "O Promise Me."

Classical film music scores that deviate from the standard stylistic repertoire—scores using jazz or electronic music, for example—end up participating in signification just as fully as scores written in the familiar Hollywood-Wagnerian idiom. The expression and connotation in Miklos Rozsa's electronic music in *Spellbound* (1945) might be a bit more difficult to characterize in words, but any moviegoer will tell you how eerie or spooky it sounds. This is precisely as it should be, since the electronic music cues accompany dream sequences, events in the film that bring the murky unconscious into play.[23] Likewise, jazz during the studio era often conveyed connotations such as sophistication, urban culture, nightlife, decadence.[24] In general, any musical language, other than the major nineteenth-century one, itself carried connotations simply by virtue of being unusual. Even music that attempts to subvert the principles of classical scoring will connote *something* when played with narrative images; and the reading position of spectators in the thirties and forties was so thoroughly defined by the classical norm that the rare music composed with subversive intentions was most probably perceived as conforming, by and large, to the established canon.[25]

Without trying to cover the entire range of standard connotation, which also includes conventions of range, of tempo, and of rhythm, let us at least consider two categories.

*Conventions of orchestration.* Film music calls upon traditional connotative associations evoked by instrumental colors. Eric Sarnette, in his book *Music for the Microphone*, gives examples.

> When the picture of an irate man appears, brass trumpets are heard; chubby-faced bassoons, when a fat man is seen coming along; oboes, when a quiet valley with cattle is shown on the screen; plaintive violins to accompany a picture of a pair of lovers, more like a sentimental postcard than anything else. . . .[26]

Eisler and Adorno identify many other conventions of instrumentation in their delightfully grumpy first chapter [of *Composing for the Films*], which zeroes in on Hollywood's "Prejudices and Bad Habits." They assert that "mountain peaks invariably invoke string tremolos punctuated by a signal-like horn motif." In another context, "The tremolo on the bridge of the violin, which thirty years ago was intended even in serious music to produce a feeling of uncanny suspense and to express an unreal atmosphere, today has become common currency."[27]

*Melodic conventions.* Certain melodic types characterize Westerns: either based on Western ballads, or the typical calls of bugles in the case of cavalry films, or "Western frontier" melodies in major keys with skips of perfect fourths and fifths, connoting the grandeur of the frontier landscape. Other melodic types illustrate another kind of "nature," the kind with birds, serene lakes, and virgin forests; these often present a stylization of bird calls or the major-key pastoral pleasantness of the first measures of Beethoven's Sixth Symphony.

Some Hollywood composers also made frequent use of stock music, musical clichés instantly recognizable by filmgoers and directly inherited from the lexicons. In *Of Human Bondage*, for example, a montage conveys Philip's confusion in London as his rival marries Mildred. When during the montage a single shot of the wedding is seen, the ongoing background score is briefly punctuated by a few seconds of Mendelssohn's wedding march—after which the music returns to its normal nondescript lushness. Eisler and Adorno again:

> . . . the scene of a moonlight night is accompanied by the first movement of the *Moonlight Sonata.* . . . For thunderstorms, the overture to *William Tell* is used; for weddings, the march from *Lohengrin* or Mendelssohn's wedding march. These practices—incidentally, they are on the wane and are retained only in cheap pictures—correspond to the popularity of trademarked pieces in classical music, such as Beethoven's E-flat Concerto, which has attained an almost fatal popularity under the apocryphal title *The Emperor*, or Schubert's *Unfinished Symphony.* . . .[28]

Sound film composers also quickly developed musical phrases, some extremely brief, to illustrate actions on the screen. For example, *King Kong* contains a scene in which Kong shakes several men off a large log, like so many ants, and sends them down a ravine to their death. From a niche in a wall of rock, hero Jack Driscoll manages to prick Kong's finger a couple of times with his knife. Kong's reaction, as he looks a bit sadly at his tiny wound, is accompanied by a pathetic-sounding violin glissando downward.

2b. *Illustration.* To a greater extent than other major Hollywood composers, Max Steiner synchronized musical effects closely with events on the screen. As one writer puts it, Steiner is legendary for a film-musical style intent on "*catching everything.*" A Steiner score accompanying an eventful sequence can sound like a hodgepodge of mixed thematic material, rapidly changing dynamics and orchestral texture, and rapid modulations, in its tendency to provide hyperexplicit, moment-by-moment musical illustration.

Witness this description of a brief but busy sequence from *The Adventures of Don Juan* (1948):

> While reminiscing with one of his past amours, Don Juan discovers to his horror that he has no real idea where and when he became acquainted with the lady. She is furious when she realizes this, but then determines to win his affections all over again. At this point her father and fiancé enter and confront the couple. Don Juan flees. The scene dissolves as he ponders his predicament, concluding, "Woman, thy name is trouble."

Steiner's accompaniment for this scene consists of a series of rapid-fire quotations of all the motifs identified with the various characters. The young woman's outburst of temper is accompanied by a woodwind glissando. When she exclaims, "This time you won't forget me," Steiner quotes the roguish, sauntering melody that serves as the Don Juan love theme. As the philanderer tries to disengage himself from her embrace, she calls to her father, "I'm trying to get away from him, but he's so strong." When Don Juan identifies himself, the composer quickly quotes the Don Juan hero motif. The girl pouts, "Stop being so Spanish!" Immediately, we hear a tambourine, castanets, and Castilian rhythms. Don Juan's rapid departure is accompanied by a typical Spanish march. The principal theme is stated as a lyrical melody when he contemplates his fate, and resolves in the stirring hero motif again. Hardly any of these themes lasts more than a few seconds; the entire scene is only 3 1/2 minutes long.[29]

To achieve to-the-second synchronization of score and film, Steiner adopted the click-track technique early in the thirties. This was developed for the animated cartoon: even before 1930, Disney's Silly Symphonies used the device for exact timing of music with images. The click-track consists of holes which the studio's music editor punches into the soundtrack at the edge of the film for the purpose of matching metronomic tempo to that of the projected film. As it is projected during a music dubbing session, the conductor and recording musicians hear these clicks through their headphones, and they record their music to its beat. The music editor can create a rhythmically regular click-track, or one to match rhythmically irregular actions on the screen (such as a character's uneven steps), should the composer wish to match the music exactly with the visuals.

So while illustration to the minutest detail was a hallmark of Steiner's style in particular, our overall model of classical-era film music also must include the general tendency toward musical illustration. Two frequently used dramaturgical techniques of illustration are mickey-mousing and the stinger.

*Mickey-mousing.* Music making actions on the screen explicit—"imitating" their direction or rhythm—is called mickey-mousing (after musical practices used in the early Disney sound cartoons). Click-tracks made this effective as early as *Of Human Bondage* (the "clubfooted" limping theme of Philp Carey) and *King Kong* (the tribal chief walking over to parlay with Denham). Music mickey-mouses the gait of Gypo Nolan in *The Informer.* Near the beginning of *Casablanca,* as an Allied resistance fighter is shot, the score imitates his fall to the ground. Near the opening of *The Big Sleep,* a harp glissando helps to mickey-mouse the feigned collapse of spoiled Carmen Sternwood into the arms of Philip Marlowe.

*The stinger.* A musical *sforzando* used to illustrate sudden dramatic tension is called a stinger. A couple of examples from *Mildred Pierce*—a melodrama virtually built upon stinging revelations to its suffering protagonist, and therefore replete with Steinerian stingers—will suffice. As newly successful restaurateur Mildred embraces playboy Monte Beragon after hours, Monte's theme appropriately plays in the background. Mildred's estranged husband Bert walks in on the scene; the sound of his closing the door, a cut to the startled couple, and a stinger in the score all coincide. Second, toward the end of the film, Mildred runs downstairs in Monte's beach house, and into a close-up showing her stunned revelation: as the orchestra does a glissando

to a stinger chord, we cut to a medium close-up profile of her daughter Veda in an embrace with Monte.

Silence can also "sting." Mildred pays a visit to her daughter Veda, having learned of her desire to marry the rich young bachelor Ted Forrester. She asks whether family friend Wally knows that Veda wants to marry Ted. A big close-up frames Veda as she says, "... *want* to get married? We *are* married." The film cuts at that moment to a close-up of Mildred's stunned reaction; also at that moment the background music ends on a quick crescendo to a high, dissonant chord. The stinger in this case is the silence that abruptly follows.

## V. FORMAL AND RHYTHMIC CONTINUITY

"At its most general functional level, film music serves as a kind of cohesive, filling in empty spaces in the action or the dialogue."[30] Virtually everyone who has written about standard film music agrees that music "fills the tonal spaces and annihilates the silences without attracting special attention to itself" (Sabaneev). Anti-Hollywood composers (e.g., Maurice Jaubert, Hanns Eisler) harp on this feature of classical film scores: the studio brings the composer in to "plug up the holes" in the soundtrack. Perhaps they are right: that the impulse behind using music this way arises from a fear of silence or of visual stasis, a fear that equates such absence with death. In soundmen's and musicians' discourse, music gives the soundtrack "life," "warmth," "color." Hollywood's narratives tend to be based on action, not reflection.[31] The classical film brings music into its service in particular ways we will now enumerate.

Music smooths discontinuities of editing within scenes and sequences. The discontinuity of a cheat cut or a temporal ellipse will be slightly less jarring or noticeable because of music, this flexible and pleasurable auditory substance (this "cohesive") in the background. As an auditory continuity it seems to mitigate visual, spatial, or temporal discontinuity. Montage sequences—calendar pages flipping, newspaper headlines spanning a period of time, citizen Kane and his wife growing apart at the breakfast table over the years—are almost invariably accompanied by music.

Music also bridges gaps between scenes or segments; the classical film uses it for transitions. Typically, music might begin shortly before the end of scene *A* and continue over into scene *B*. Or perhaps, scene *A*'s music will modulate into a new key as scene *B* begins. The beginning of *The Big Sleep* demonstrates how music functions as spatiotemporal connective tissue. Marlowe leaves the Sternwood mansion after having met Carmen, Colonel Sternwood, and Vivian in three successive conversations. Music strikes up as the butler escorts him to the door. The film cuts to a shot of a plaque that reads "Hollywood Public Library," then to a close-up of the documents Marlowe is taking notes on; then to longer shots reestablishing that Marlowe is doing research in the library. Steiner's transition music has no particularly musical form of its own, since it must obey the rhythm of the editing and the rapid change of locations it is illustrating and connoting. It modulates frequently, but it is still one uncut piece of music, a continuous substance that compensates for the spatiotemporal discontinuities—necessary for narrative coherence, efficiently getting Marlowe from one place to another.

In the *King Kong* sequence that crosscuts between Ann and Jack's romantic dialogue on one hand and Denham and the skipper's "work talk" on the other, the

presence of music signifies emotion. But it doesn't "work" there, precisely, because it violates the need for auditory continuity in which music is usually caught up. Strictly aligning music (or its absence) with the crosscut scenes only emphasizes a discontinuity which runs counter to classical soundtrack construction.

## VI. UNITY

Classical cinema, predicated as it is on formal and narrative unity, deploys music to reinforce this unity. We have already seen that opening and closing music encloses the film within a musical envelope, announcing genre, mood, and setting, and then providing musical recapitulation and closure to reinforce narrative closure.

Tonal relationships in the score are also managed so as to contribute to a sense of the film's unity. Sabaneev gives a typical rule of thumb: if music has been absent for more than fifteen seconds, the composer is free to start a new music cue in a different and even unrelated key, since the spectator/auditor will have sufficiently forgotten the previous cue's tonality. But if the gap has lasted less than the requisite time, the new cue must start in the same key (or a closely related one).

The major unifying force in Hollywood scoring is the use of musical themes, although it is by no means accurate to claim that all classical scores rely on themes. Max Steiner's film-composing method, however, relied on thematic structuring. After watching the rough cut, he devised the principal character and idea motifs, and then elaborated the score from there. The thematic score provides a built-in unity of statement and variation, as well as a semiotic subsystem. The repetition, interaction, and variation of musical themes throughout a film contributes much to the clarity of its dramaturgy and to the clarity of its formal structures.

## VII. BREAKING THE RULES

The principles of Hollywood scoring I have enumerated should not be considered as hard-and-fast rules. Enjoying a special status between conscious and unconscious perception, sometimes between diegetic, nondiegetic, and metadiegetic fictional levels, and between formal and narrative rhythms, music as a nonrepresentational "cohesive" mediates among many types of textual contradictions and itself participates in them. Thus, for instance, in its illustrative function (IV), mickey-mousing music often becomes noticeable, violating the principle of inaudibility (II). This is to say that certain conditions (the specificity of the text itself, the composer's personal style, the studio's practices of orchestrating, mixing, and editing, historical factors) may require one principle to take precedence over another.

[ · · · ]

## NOTES

1. Christian Metz, "Story/Discourse (A Note on Two Kinds of Voyeurism)," in *The Imaginary Signifier* (Bloomington: Indiana University Press, 1982), 93.
2. André Bazin, *What Is Cinema?* trans. Hugh Gray, vol. 1 (Berkeley: University of California Press, 1967), 30.

3. Metz, "Story/Discourse," 91 and 94.

4. Charles F. Altman, "The Technology of the Voice," Part II, *Iris* 4, 1 (1986), 110.

5. Tom Levin, "The Acoustic Dimension," *Screen* 25 (May–June 1984), 63: "By locating the source of sounds *within* the image or the diegesis, sound is once again subordinated to the visual. At the same time, by focusing attention on the image, the effect of the acoustic 'enigma' is to shift an analytic gaze *away* from the activity of the sound technology which can subsequently function with even less risk of exposure."

6. Milton Lustig, *Music Editing for Motion Pictures* (New York: Hastings House, 1980), 75.

7. Leonid Sabaneev, *Music for the Films: A Handbook for Composers and Conductors*, trans. S. W. Pring (London: Pitman, 1935), 22.

8. Sabaneev, 44–45.

9. Sabaneev, 19.

10. Quoted in Tony Thomas, *Music for the Movies* (S. Brunswick and New York: A. S. Barnes, 1973), 30.

11. W. A. Mueller, "A Device for Automatically Controlling Balance between Recorded Sounds," *Journal of the Society of Motion Picture Engineers* 25, 1 (July 1935), 79–86.

12. Response to W. A. Mueller, "A Device . . . ," p. 85. This model of film and perception, stemming from William James's writing on psychology, was elaborated upon in 1916 by Hugo Munsterberg, and by others, including Pudovkin, with respect to the image track.

13. Quoted in Tony Thomas, *Music for the Movies,* 34–35.

14. Sabaneev, 21.

15. Another reason for the prevalence of this idiom: the majority of the first wave of Hollywood film composers were thoroughly steeped in it, either because of national origin or by musical training.

16. Quoted in Manvell and Huntley, *The Technique of Film Music* (New York: Focal Press, 1957), 255. Emphasis mine.

17. See Kathryn Kalinak, "The Fallen Woman and the Virtuous Wife: Musical Stereotypes in *The Informer, Gone with the Wind*, and *Laura*," *Film Reader* 5 (1982), 76–82.

18. Sabaneev, 30.

19. Pam Cook, "Duplicity in *Mildred Pierce*," in E. Ann Kaplan, ed., *Women in Film Noir* (London: BFI, 1978), 79.

20. Quoted in Tony Thomas, *Music for the Movies,* 72.

21. Tiomkin, quoted in Thomas.

22. Quoted in Irwin Bazelon, *Knowing the Score: Notes on Film Music* (New York: Van Nostrand Reinhold, 1975), 112.

23. According to Rozsa, Selznick's studio executives summoned him saying "they had a psychological picture and that they wanted something unusual." Rozsa also used the theremin for Billy Wilder's *The Lost Weekend* "to denote [sic] Ray Milland's craving for alcohol." Roy Prendergast, *A Neglected Art* (New York: New York University Press, 1977), 69–70.

24. Alex North was actually one of the first film composers to use the jazz sound, in *A Streetcar Named Desire*—not until 1951. Elmer Bernstein accounts for his own choice of the jazz idiom four years later, for *The Man with the Golden Arm*, in these terms: "The script had a Chicago slum street, heroin, hysteria, longing, frustration, despair and finally death. . . . There is something very American and contemporary about all the characters and their problems. I wanted an element that could speak readily of hysteria and despair, an element that would localize these emotions to our country, to a large city if possible. Ergo,—jazz." Quoted in Prendergast, 109.

25. Eisler and Adorno's Brechtian project for film music is put forth in *Composing for the Films* (New York: Oxford University Press, 1947). Eisler did score a number of Hollywood films, of which the most well-documented is Fritz Lang's *Hangmen Also Die*. But their sermon on stripping film music bare of its tired connotations and its redundant function of illustration fell, as far as the public was concerned, on deaf ears.

26. Quoted in Kurt London, *Film Music*, 160–161.

27. Eisler and Adorno, *Composing for the Films*, 13 and 17.

28. Eisler and Adorno, 15.

29. Mark Evans, *Soundtrack: The Music of the Movies* (New York: Hopkinson and Blake, 1975), 226.

30. Tony Thomas, *Music for the Movies*, p. 17.

31. For Eisler, the Hollywood director "knows the danger of nonaction, of absence of suspense, and therefore prescribes music." Eisler, 12.

# GILLES DELEUZE

## Preface;
## Recapitulation of Images and Signs;
## Conclusions

FROM *Cinema II: The Time-Image*

Gilles Deleuze (1925–1995) is one of the most original and prolific philosophers of the second half of the twentieth century. In his early work, Deleuze re-read such philosophers as David Hume, Friedrich Nietzsche, Immanuel Kant, and Baruch Spinoza; it is to Nietzsche in particular that Deleuze's new understanding of the concepts of "difference" and "becoming" is indebted. After the student uprisings of May 1968 in France, Deleuze was offered an academic post at the new campus of the University of Paris at Vincennes, a center of poststructuralist thought, where he taught until his death. Deleuze's colleagues included Michel Foucault, Jean-François Lyotard, and the radical psychoanalyst Félix Guattari, with whom Deleuze began an extremely productive intellectual and writing partnership. Their 1972 book, *Anti-Oedipus: Capitalism and Schizophrenia* (followed eight years later by *A Thousand Plateaus*), is often taken as the epitome of the era's countercultural thought.

Deleuze was not concerned with discovering universals; rather, he focused on the creation of something new. Deleuze is a theorist of "multiplicity," "desire," and "becoming," and he engaged such concepts whether he was considering philosophical, literary, or cinematic texts. In the mid-1980s, he produced *Cinema I: The Movement-Image* and *Cinema II: The Time-Image*, two dense and original books that have energized recent film theory. Rather than attempting to explain the relationship of the cinematic medium to the real, Deleuze is interested in cinema as an image of thought. Inspired by the work of Henri Bergson, who sees time as an open durational whole rather than as sequence or

progression, Deleuze considers how different types of cinema organize the relationship of movement to time. Throughout both books, he treats the work of film directors almost as if they were philosophers working with such concepts.

In *Cinema I*, Deleuze proposes a new taxonomy of cinema's images and signs, drawing on the work of American pragmatic philosopher C. S. Peirce and critiquing previous film semiotics and their reliance on linguistic models of the sign. Classical cinema and Soviet montage feature what Deleuze calls the "movement-image," which conforms to what he refers to as the "sensory-motor schema," our commonsense perceptual orientation in space and time.

*Cinema II*, originally published in 1985, begins with what Deleuze describes as a "crisis" of the movement-image in post–World War II cinema. In Italian neo-realism and the French New Wave, or in the films of Japanese director Yasujiro Ozu, the sensory-motor schema is disrupted through the use of "irrational cuts" that break the rules of continuity and through the advent of unmoored "seer" or "mutant" protagonists who wander unfamiliar landscapes. Such new organizations achieve what Deleuze calls in his preface to the English edition (the first selection of the following reading) a "direct time-image," a moment that contains the past and the future as they coexist in the present. The second selection is from the end of Chapter 2, "Recapitulation of Images and Signs"; it reviews aspects of the movement-image and indirect and direct representations of time. In the selection from Chapter 10, "Conclusions," Deleuze summarizes his conception of the time-image as the breaking of the sensory-motor link and the advent of "pure optical and sound situations." Even for those familiar with reading philosophy, Deleuze's texts offer a different experience. Rather than providing a logical proof of his ideas, his writing utilizes a process of repetition in which concepts proliferate and enable new connections. As Deleuze himself notes, he shifts Bazin's question "What is cinema?" to explore in what ways cinema can address a new question: "What is philosophy?"

## READING CUES & KEY CONCEPTS

■ What historical events coincide with the "crisis" in the movement-image of classical cinema, and how might they have influenced the cinema?

■ Why and how does Deleuze link "aberrant movement" with the time-image?

■ Familiarize yourself with Deleuze's concepts by tracing the use of an unfamiliar term or of a familiar word used in a new way to see how it evolves over the course of his discussion.

■ **Key Concepts:** Movement-Image; Aberrant Movement; Time-Image; Opsign/Sonsign; Chronosign/Series

# Preface

. . . . . . . . . . . . . . .

Over several centuries, from the Greeks to Kant, a revolution took place in philosophy: the subordination of time to movement was reversed, time ceases to be the measurement of normal movement, it increasingly appears for itself and creates paradoxical movements. Time is out of joint: Hamlet's words signify that time is

no longer subordinated to movement, but rather movement to time. It could be said that, in its own sphere, cinema has repeated the same experience, the same reversal, in more fast-moving circumstances. The movement-image of the so-called classical cinema gave way, in the post-war period, to a direct time-image. Such a general idea must of course be qualified, corrected, adapted to concrete examples.

Why is the Second World War taken as a break? The fact is that, in Europe, the post-war period has greatly increased the situations which we no longer know how to react to, in spaces which we no longer know how to describe. These were "any spaces whatever," deserted but inhabited, disused warehouses, waste ground, cities in the course of demolition or reconstruction. And in these any-spaces-whatever a new race of characters was stirring, kind of mutant: they saw rather than acted, they were seers. Hence Rossellini's great trilogy, *Europe 51, Stromboli, Germany Year 0*: a child in the destroyed city, a foreign woman on the island, a bourgeoise woman who starts to "see" what is around her. Situations could be extremes, or, on the contrary, those of everyday banality, or both at once: what tends to collapse, or at least to lose its position, is the sensory-motor schema which constituted the action-image of the old cinema. And thanks to this loosening of the sensory-motor linkage, it is time, "a little time in the pure state," which rises up to the surface of the screen. Time ceases to be derived from the movement, it appears in itself and itself gives rise to *false movements*. Hence the importance of *false continuity* in modern cinema: the images are no longer linked by rational cuts and continuity, but are relinked by means of false continuity and irrational cuts. Even the body is no longer exactly what moves; subject of movement or the instrument of action, it becomes rather the developer [*révélateur*] of time, it shows time through its tirednesses and waitings (Antonioni).

It is not quite right to say that the cinematographic image is in the present. What is in the present is what the image "represents," but not the image itself, which, in cinema as in painting, is never to be confused with what it represents. The image itself is the system of the relationships between its elements, that is, a set of relationships of time from which the variable present only flows. It is in this sense, I think, that Tarkovsky challenges the distinction between montage and shot when he defines cinema by the "pressure of time" in the shot. What is specific to the image, as soon as it is creative, is to make perceptible, to make visible, relationships of time which cannot be seen in the represented object and do not allow themselves to be reduced to the present. Take, for example, a depth of field in Welles, a tracking shot in Visconti: we are plunged into time rather than crossing space. Sandra's car, at the beginning of Visconti's film, is already moving in time, and Welles's characters occupy a giant-sized place in time rather than changing place in space.

This is to say that the time-image has nothing to do with a flashback, or even with a recollection. Recollection is only a former present, whilst the characters who have lost their memories in modern cinema literally sink back into the past, or emerge from it, to make visible what is concealed even from recollection. Flashback is only a signpost and, when it is used by great authors, it is there only to show much more complex temporal structures (for example, in Mankiewicz, "forking" time: recapturing the moment when time could have taken a different course . . .). In any case, what we call temporal structure, or direct time-image, clearly goes beyond the purely empirical succession of time — past-present-future. It is, for example, a coexistence of distinct durations, or of levels of duration; a single event can belong to several levels: the sheets of past coexist in a non-chronological order. We see this in

Welles with his powerful intuition of the earth, then in Resnais with his characters who return from the land of the dead.

There are yet more temporal structures: the whole aim of this book is to release those that the cinematographic image has been able to grasp and reveal, and which can echo the teachings of science, what the other arts uncover for us, or what philosophy makes understandable for us, each in their respective ways. It is foolish to talk about the death of the cinema because cinema is still at the beginning of its investigations: making visible these relationships of time which can only appear in a creation of the image. It is not cinema which needs television—whose image remains so regrettably in the present unless it is enriched by the art of cinema. The relations and disjunctions between visual and sound, between what is seen and what is said, revitalize the problem and endow cinema with new powers for capturing time in the image (in quite different ways, Pierre Perrault, Straub, Syberberg . . . ). Yes, if cinema does not die a violent death, it retains the power of a beginning. Conversely, we must look in pre-war cinema, and even in silent cinema, for the workings of a very pure time-image which has always been breaking through, holding back or encompassing the movement-image: an Ozu still life as unchanging form of time?

# Recapitulation of Images and Signs

. . . . . . . . . . . . . .

[ · · · ]

The movement-image has two sides, one in relation to objects whose relative position it varies, the other in relation to a whole—of which it expresses an absolute change. The positions are in space, but the whole that changes is in time. If the movement-image is assimilated to the shot, we call framing the first facet of the shot turned towards objects, and montage the other facet turned towards the whole. Hence a first thesis: it is montage itself which constitutes the whole, and thus gives us the image *of* time. It is therefore the principal act of cinema. Time is necessarily an indirect representation, because it flows from the montage which links one movement-image to another. This is why the connection cannot be a simple juxtaposition: the whole is no more an addition than time is a succession of presents. As Eisenstein said over and over again, montage must proceed by alterations, conflicts, resolutions, and resonances, in short an activity of selection and co-ordination, in order to give time its real dimension, and the whole its consistency. This position of principle implies that the movement-image is itself in the present, and nothing else. That the present is the sole direct time of the cinematographic image seems to be almost a truism. Pasolini will again rely on it to maintain a very classical notion of montage: precisely because it selects and co-ordinates "significant moments," montage has the property of "making the present past," of transforming our unstable and uncertain present into "a clear, stable and desirable past," in short of achieving time. It is useless for him to add that this is the operation of death, not a death that is over and done with, but a death in life or a being for death ("death achieves a dazzling montage of our life").[1] This black note reinforces the classic, grandiose concept of the montage king: time as indirect representation that flows from the synthesis of images.

But this thesis has another aspect, which seems to contradict the first: the synthesis of movement-images *must* rely on characteristics intrinsic to each of them. Each movement-image expresses the whole that changes, as a function of the objects between which movement is established. The shot must therefore already be a potential montage, and the movement-image, a matrix or cell of time. From this point of view, time depends on movement itself and belongs to it: it may be defined, in the style of ancient philosophers, as the number of movement. Montage will therefore be a relation of number, variable according to the intrinsic nature of the movements considered in each image, in each shot. A uniform movement in the shot appeals to a simple measure, but varied and differential movements to a rhythm; intensive movements proper (like light and heat) to a tonality, and the set of all the potentialities of a shot, to a harmony. Hence Eisenstein's distinctions between a metrical, rhythmic, tonal and harmonic montage. Eisenstein himself saw a certain opposition between the synthetic point of view, according to which time flowed from the montage, and the analytic point of view, according to which the time set up was dependent on a movement-image.[2] According to Pasolini, "the present is transformed into past" by virtue of montage, but this past "still appears as a present" by virtue of the nature of the image. Philosophy had already encountered a similar opposition, in the notion of "number of movement," because number appeared sometimes like an independent instance, sometimes like a simple dependence on what it measured. Should we not, however, maintain both points of view, as the two poles of an indirect representation of time: time depends on movement, but through the intermediary of montage; it flows from montage, but as if subordinate to movement? Classical reflection turns on this kind of alternative, montage *or* shot.

It is still necessary for movement to be normal: movement can only subordinate time, and make it into a number that indirectly measures it, if it fulfils conditions of normality. What we mean by normality is the existence of centres: centres of the revolution of movement itself, of equilibrium of forces, of gravity of moving bodies, and of observation for a viewer able to recognize or perceive the moving body, and to assign movement. A movement that avoids centring, in whatever way, is as such abnormal, aberrant. Antiquity came up against these aberrations of movement, which even affected astronomy, and which became more and more pronounced when one entered the sub-lunar world of men (Aristotle). Now, aberrant movement calls into question the status of time as indirect representation or number of movement, because it evades the relationships of number. But, far from time itself being shaken, it rather finds this the moment to surface directly, to shake off its subordination in relation to movement and to reverse this subordination. Conversely, then, a direct presentation of time does not imply the halting of movement, but rather the promotion of aberrant movement. What makes this problem as much a cinematographic as a philosophical one is that the movement-image seems to be in itself a profoundly aberrant and abnormal movement. Epstein was perhaps the first to focus theoretically on this point, which viewers in the cinema experienced practically: not only speeded up, slowed down and reversed sequences, but the non-distancing of the moving body ("a deserter was going flat out, and yet remained face to face with us"), constant changes in scale and proportion ("with no possible common denominator") and false continuities of movement (what Eisenstein called "impossible continuity shots").[3]

More recently, Jean-Louis Schefer, in a book in which the theory forms a kind of great poem, showed that the ordinary cinema-viewer, the man without qualities, found his correlate in the movement-image as extraordinary movement. The movement-image does not reproduce a world, but constitutes an autonomous world, made up of breaks and disproportion, deprived of all its centres, addressing itself as such to a viewer who is in himself no longer centre of his own perception. The *percipiens* and the *percipi* have lost their points of gravity. Schefer draws the most rigorous consequence from this: the aberration of movement specific to the cinematographic image sets time free from any linkage; it carries out a direct presentation of time by reversing the relationship of subordination that time maintains with normal movement; "cinema is the sole experience where time is given to me as a perception." Certainly Schefer points to a primordial crime with an essential link to this condition of cinema, just as Pasolini invoked a primordial death for the other situation. It is a homage to psychoanalysis, which has only ever given cinema one sole object, one single refrain, the so-called primitive scene. But there is no other crime than time itself. What aberrant movement reveals is time as everything, as "infinite opening," as anteriority over all normal movement defined by motivity [*motricité*]: time has to be anterior to the controlled flow of every action, there must be "a birth of the world that is not completely restricted to the experience of our motivity" and "the most distant recollection of image must be separated from all movement of bodies."[4] If normal movement subordinates the time of which it gives us an indirect representation, aberrant movement speaks up for an anteriority of time that it presents to us directly, on the basis of the disproportion of scales, the dissipation of centres and the false continuity of the images themselves.

What is in question is the obviousness on the basis of which the cinematographic image is in the present, necessarily in the present. If it is so, time can be represented only indirectly, on the basis of a present movement-image and through the intermediary of montage. But is this not the falsest obviousness, in at least two respects? First, there is no present which is not haunted by a past and a future, by a past which is not reducible to a former present, by a future which does not consist of a present to come. Simple succession affects the presents which pass, but each present coexists with a past and a future without which it would not itself pass on. It is characteristic of cinema to seize this past and this future that coexist with the present image. To film what is *before* and what is *after* . . . Perhaps it is necessary to make what is before and after the film pass inside it in order to get out of the chain of presents. For example, the characters: Godard says that it is necessary to know what they were before being placed in the picture, and will be after. "That is what cinema is, the present never exists there, except in bad films."[5] This is very difficult, because it is not enough to eliminate fiction, in favour of a crude reality which would lead us back all the more to presents which pass. On the contrary, it is necessary to move towards a limit, to make the limit of before the film and after it pass into the film and to grasp in the character the limit that he himself steps over in order to enter the film and leave it, to enter into the fiction as into a present which is inseparable from its before and after (Rouch, Perrault). We shall see that this is precisely the aim of *cinéma-vérité* or of direct cinema: not to achieve a real as it would exist independently of the image, but to achieve a before and an after as they coexist with the image, as they are inseparable from the image. This is what direct cinema must

mean, to the point where it is a component of all cinema: to achieve the direct pre-
sentation of time.

Not only is the image inseparable from a before and an after which belong to it,
which are not to be confused with the preceding and subsequent images; but in ad-
dition it itself tips over into a past and a future of which the present is now only an
extreme limit, which is never given. Take, for example, the depth of field in Welles:
when Kane is going to catch up with his friend the journalist for the break, it is in time
that he moves, he occupies a place in time rather than changing place in space. And
when the investigator at the beginning of *Mr. Arkadin* emerges into the great court-
yard, he literally emerges from time rather than coming from another place. Take
Visconti's tracking shots: at the beginning of *Sandra*, when the heroine returns to the
house where she was born, and stops to buy the black headscarf that she will cover
her head with, and the cake that she will eat like magic food, she does not cover space,
she sinks into time. And in a film a few minutes long, *Appunti su un Fatto di Cronaca*,
a slow tracking shot follows the empty path of the raped and murdered schoolgirl,
and comes back to the fully present image to load it with a petrified perfect tense, as
well as with an inescapable future perfect.[6] In Resnais too it is time that we plunge
into, not at the mercy of a psychological memory that would give us only an indirect
representation, nor at the mercy of a recollection-image that would refer us back to
a former present, but following a deeper memory, a memory of the world directly
exploring time, reaching in the past that which conceals itself from memory. How
feeble the flashback seems beside explorations of time as powerful as this, such as
the silent walk on the thick hotel carpet which each time puts the image into the past
in *Last Year in Marienbad*. The tracking shots of Resnais and Visconti, and Welles's
depth of field, carry out a temporalization of the image or form a direct time-image,
which realizes the principle: the cinematographic image is in the present only in bad
films. "Rather than a physical movement, it is a question above all of a displacement
in time."[7] And undoubtedly there are many possible ways of proceeding: it is, on the
contrary, the crushing of depth and the planitude of the image, which, in Dreyer and
other authors, will directly open the image on to time as fourth dimension. This is,
as we shall see, because there are varieties of the time-image just as there were types
of the movement-image. But the direct time-image always gives us access to that
Proustian dimension where people and things occupy a place in time which is in-
commensurable with the one they have in space. Proust indeed speaks in terms of
cinema, time mounting its magic lantern on bodies and making the shots coexist
in depth.[8] It is this build-up, this emancipation of time, which ensures the rule of
impossible continuity and aberrant movement. The postulate of "the image in the
present" is one of the most destructive for any understanding of cinema.

But were these characteristics not clear in the cinema at an early stage (Eisenstein,
Epstein)? Is Schefer's theme not valid for the whole of the cinema? How are we to
delineate a modern cinema which would be distinct from "classical" cinema or
from the indirect representation of time? We might once more rely on an analogy
in thought: if it is true that aberrations of movement were recognized at an early
stage, they were in some sense corrected, normalized, "elevated," and brought into
line with laws which saved movement, extensive movement of the world or intensive
movement of the soul, and which maintained the subordination of time. In fact we
will have to wait for Kant to carry out the great reversal: aberrant movement became

the most everyday kind, everydayness itself, and it is no longer time that depends on movement, but the opposite . . . A similar story appears in cinema. For a long time aberrations of movement were recognized, but warded off. The intervals of movement first called its communication into question and introduced a gap or disproportion between a received movement and an executed one. Even so, related to such an interval, the movement-image finds in it the principle of its differentiation into the perception-image (received movement) and the action-image (executed movement). What was aberration in relation to the movement-image ceases to be so in relation to these two images: the interval itself now plays the role of centre, and the sensory-motor schema restores the lost proportion, re-establishes it in a new mode, between perception and action. The sensory-motor schema moves forward by selection and co-ordination. Perception is organized in obstacles and distances to be crossed, while action invents the means to cross and surmount them, in a space which sometimes constitutes an "encompasser," sometimes a "line of the universe": movement is saved by becoming relative. And this status, of course, does not exhaust the movement-image. As soon as it stops being related to an interval as sensory-motor centre, movement finds its absolute quality again, and every image reacts with every other one, on all their sides and in all their parts. This is the regime of universal variation, which goes beyond the human limits of the sensory-motor schema towards a non-human world where movement equals matter, or else in the direction of a super-human world which speaks for a new spirit. It is here that the movement-image attains the sublime, like the absolute condition of movement, whether in the material sublime of Vertov, in the mathematical sublime of Gance, or in the dynamic sublime of Murnau or Lang. But in any event the movement-image remains primary, and gives rise only indirectly to a representation of time, through the intermediary of montage as organic composition of relative movement, or supra-organic recomposition of absolute movement. Even Vertov, when he carries perception over into matter, and action into universal interaction, peopling the universe with micro-intervals, points to a "negative of time" as the ultimate product of the movement-image through montage.[9]

Now, from its first appearances, something different happens in what is called modern cinema: not something more beautiful, more profound, or more true, but something different. What has happened is that the sensory-motor schema is no longer in operation, but at the same time it is not overtaken or overcome. It is shattered from the inside. That is, perceptions and actions ceased to be linked together, and spaces are now neither co-ordinated nor filled. Some characters, caught in certain pure optical and sound situations, find themselves condemned to wander about or go off on a trip. These are pure seers, who no longer exist except in the interval of movement, and do not even have the consolation of the sublime, which would connect them to matter or would gain control of the spirit for them. They are rather given over to something intolerable which is simply their everydayness itself. It is here that the reversal is produced: movement is no longer simply aberrant, aberration is now valid in itself and designates time as its direct cause. "Time is out of joint": it is off the hinges assigned to it by behaviour in the world, but also by movements of world. It is no longer time that depends on movement; it is aberrant movement that depends on time. The relation, *sensory-motor situation → indirect image of time* is replaced by a non-localizable relation, *pure optical and sound situation*

→ *direct time-image.* Opsigns and sonsigns are direct presentations of time. False continuity shots are the non-localizable relation itself: characters no longer jump across them, they are swallowed up in them. Where has Gertrud gone? Into the false continuity shots. . . .[10] Of course they have always been there, in the cinema, like aberrant movements. But what makes them take on a specifically new value, to the point where *Gertrud* was not understood at the time and still offends perception? We can choose between emphasizing the continuity of cinema as a whole, or emphasizing the difference between the classical and the modern. It took the modern cinema to re-read the whole of cinema as already made up of aberrant movements and false continuity shots. The direct time-image is the phantom which has always haunted the cinema, but it took modern cinema to give a body to this phantom. This image is virtual, in opposition to the actuality of the movement-image. But, if virtual is opposed to actual, it is not opposed to real, far from it. Again, this time-image will be said to presuppose montage, just as much as indirect representation did. But montage has changed its meaning, it takes on a new function: instead of being concerned with movement-images from which it extracts an indirect image of time, it is concerned with the time-image, and extracts from it the relations of time on which aberrant movement must now depend. To adopt a word of Lapoujade's, montage has become "montrage."[11]

What seems to be broken is the circle in which we were led from shot to montage and from montage to shot, one constituting the movement-image, the other the indirect image of time. Despite all its efforts (and especially those of Eisenstein), the classical conception had difficulty in getting rid of the idea of a vertical construction going right to the edge in both directions, where montage worked on movement-images. It has often been pointed out, in modern cinema, that the montage was already in the image, or that the components of an image already implied montage. There is no longer an alternative between montage and shot (in Welles, Resnais, or Godard). Sometimes montage occurs in the depth of the image, sometimes it becomes flat: it no longer asks how images are linked, but "What does the image *show*?"[12] This identity of montage with the image itself can appear only in conditions of the direct time-image. In a text with important implications Tarkovsky says that what is essential is the way time flows in the shot, its tension or rarefaction, "the pressure of time in the shot." He appears to subscribe to the classical alternative, shot *or* montage, and to opt strongly for the shot ("the cinematographic figure only exists inside the shot"). But this is only a superficial appearance, because the force or pressure of time goes outside the limits of the shot, and montage itself works and lives in time. What Tarkovsky denies is that cinema is like a language working with units, even if these are relative and of different orders: montage is not a unit of a higher order which exercises power over unit-shots and which would thereby endow movement-images with time as a new quality.[13] The movement-image can be perfect, but it remains amorphous, indifferent and static if it is not already deeply affected by injections of time which put montage into it, and alter movement. "The time in a shot must flow independently and, so to speak, as its own boss": it is only on this condition that the shot goes beyond the movement-image, and montage goes beyond indirect representation of time, to both share in a direct time-image, the one determining the form or rather force of time in the image, the other the relations of time or of forces in the succession of images (relations that are no more reducible

to succession, than the image is to movement). Tarkovsky calls his text "On the cinematographic figure," because he calls figure that which expresses the "typical," but expresses it in a pure singularity, something unique. This is the sign, it is the very function of the sign. But, as long as signs find their material in the movement-image, as long as they form the singular expressional features, from a material in movement, they are in danger of evoking another generality which would lead to their being confused with a language. The representation of time can be extracted from this only by association and generalization, or as concept (hence Eisenstein's bringing together of montage and concept). Such is the ambiguity of the sensory-motor schema, agent of abstraction. It is only when the sign opens directly on to time, when time provides the signaletic material itself, that the type, which has become temporal, coincides with the feature of singularity separated from its motor associations. It is here that Tarkovsky's wish comes true: that "the cinematographer succeeds in fixing time in its indices [in its signs] perceptible by the senses." And, in a sense, cinema had always done this; but, in another sense, it could only realize that it had in the course of its evolution, thanks to a crisis of the movement-image. To use a formula of Nietzsche's, it is never at the beginning that something new, a new art, is able to reveal its essence; what it was from the outset it can reveal only after a detour in its evolution.

# Conclusions

. . . . . . . . . . . . .

[ · · · ]

We can now summarize the constitution of this time-image in modern cinema, and the new signs that it implies or initiates. There are many possible transformations, almost imperceptible passages, and also combinations between the movement-image and the time-image. It cannot be said that one is more important than the other, whether more beautiful or more profound. All that can be said is that the movement-image does not give us a time-image. Nevertheless, it does give us many things in connection with it. On one hand, the movement-image constitutes time in its empirical form, the course of time: a successive present in an extrinsic relation of before and after, so that the past is a former present, and the future a present to come. Inadequate reflection would lead us to conclude from this that the cinematographic image is necessarily in the present. But this ready-made idea, disastrous for any understanding of cinema, is less the fault of the movement-image than of an over-hasty reflection. For, on the other hand, the movement-image gives rise to an image *of* time which is distinguished from it by excess or default, over or under the present as empirical progression: in this case, time is no longer measured by movement, but is itself the number or measure of movement (metaphysical representation). This number in turn has two aspects, which we saw in the first volume: it is the minimum unity of time as interval of movement or the totality of time as maximum of movement in the universe. The subtle and the sublime. But, from either aspect, time is distinguished in this way from movement only as indirect representation. Time as progression derives from the movement-image or from successive shots. But time as unity or as totality depends on montage which still relates it back to movement or to the succession of shots. This is why the movement-image

is fundamentally linked to an indirect representation of time, and does not give us a direct presentation of it, that is, does not give us a time-image. The only direct presentation, then, appears in music. But in modern cinema, by contrast, the time-image is no longer empirical, nor metaphysical; it is "transcendental" in the sense that Kant gives this word: time is out of joint and presents itself in the pure state.[1] The time-image does not imply the absence of movement (even though it often includes its increased scarcity) but it implies the reversal of the subordination; it is no longer time which is subordinate to movement; it is movement which subordinates itself to time. It is no longer time which derives from movement, from its norm and its corrected aberrations; it is movement as *false movement*, as aberrant movement which now depends on time. The time-image has become direct, just as time has discovered new aspects, as movement has become aberrant in essence and not by accident, as montage has taken on a new sense, and as a so-called modern cinema has been constituted post-war. However close its relations with classical cinema, modern cinema asks the question: what are the new forces at work in the image, and the new signs invading the screen?

The first factor is the break of the sensory-motor link. For the movement-image, as soon as it referred itself back to its interval, constituted the action-image: the latter, in its widest sense, comprised received movement (perception, situation), imprint (affection, the interval itself), and executed movement (action properly speaking and reaction). The sensory-motor link was thus the unity of movement and its interval, the specification of the movement-image or the action-image *par excellence*. There is no reason to talk of a narrative cinema which would correspond to this first moment, for narration results from the sensory-motor schema, and not the other way round. But precisely what brings this cinema of action into question after the war is the very break-up of the sensory-motor schema: the rise of situations to which one can no longer react, of environments with which there are now only chance relations, of empty or disconnected any-space-whatevers replacing qualified extended space. It is here that situations no longer extend into action or reaction in accordance with the requirements of the movement-image. These are pure optical and sound situations, in which the character does not know how to respond, abandoned spaces in which he ceases to experience and to act so that he enters into flight, goes on a trip, comes and goes, vaguely indifferent to what happens to him, undecided as to what must be done. But he has gained in an ability to see what he has lost in action or reaction: he SEES so that the viewer's problem becomes "What is there to see in the image?" (and not now "What are we going to see in the next image?"). The situation no longer extends into action through the intermediary of affections. It is cut off from all its extensions, it is now important only for itself, having absorbed all its affective intensities, all its active extensions. This is no longer a sensory-motor situation, but a purely optical and sound situation, where the seer [*voyant*] has replaced the agent [*actant*]: a "description." We call this type of image opsigns and sonsigns, they appear after the war, through all the external reasons we can point to (the calling into question of action, the necessity of seeing and hearing, the proliferation of empty, disconnected, abandoned spaces) but also through the internal push of a cinema being reborn, re-creating its conditions, neo-realism, new wave, new American cinema. Now, if it is true that the sensory-motor situation governed the indirect representation of time as consequence of the movement-image, the purely optical and sound situation opens onto a direct time-image. The

time-image is the correlate of the opsign and the sonsign. It never appeared more clearly than in the author who anticipated modern cinema, from before the war and in the conditions of the silent film, Ozu: opsigns, empty or disconnected spaces, open on to still lifes as the pure form of time. Instead of "motor situation—indirect representation of time," we have "opsign or sonsign—direct presentation of time."

But what can purely optical and sound images link up with, since they no longer extend into action? We would like to reply: with recollection-images or dream-images. Yet, the former still come within the framework of the sensory-motor situation, whose interval they are content to fill, even though lengthening and distending it; they seize a former present in the past and thus respect the empirical progression of time, even though they introduce local regressions into it (the flashback as psychological memory). The latter, dream-images, rather affect the whole: they project the sensory-motor situation to infinity, sometimes by ensuring the constant metamorphosis of the situation, sometimes by replacing the action of characters with a movement of world. But we do not, in this way, leave behind an indirect representation, even though we come close, in certain exceptional cases, to doors of time that already belong to modern cinema (for instance, the flashback as revelation of a time which forks and frees itself in Mankiewicz, or the movement of world as the coupling of a pure description and dance in the American musical comedy). However, in these very cases, the recollection-image or the dream-image, the mnemosign or the onirosign, are gone beyond: for these images in themselves are virtual images, which are linked with the actual optical or sound image (description) but which are constantly being actualized on their own account, or the former in the latter to infinity. For the time-image to be born, on the contrary, the actual image must enter into relation with its *own* virtual image as such; from the outset pure description must divide in two, "repeat itself, take itself up again, fork, contradict itself." An image which is double-sided, mutual, both actual and virtual, must be constituted. We are no longer in the situation of a relationship between the actual image and other virtual images, recollections, or dreams, which thus become actual in turn: this is still a mode of linkage. We are in the situation of an actual image *and* its own virtual image, to the extent that there is no longer any linkage of the real with the imaginary, but *indiscernibility of the two*, a perpetual exchange. This is a progress in relation to the opsign: we saw how the crystal (the hyalosign) ensures the dividing in two of description, and brings about the exchange in the image which has become mutual, the exchange of the actual and the virtual, of the limpid and the opaque, of the seed and the surrounding.[2] By raising themselves to the indiscernibility of the real and the imaginary, the signs of the crystal go beyond all psychology of the recollection or dream, and all physics of action. What we see in the crystal is no longer the empirical progression of time as succession of presents, nor its indirect representation as interval or as whole; it is its direct presentation, its constitutive dividing in two into a present which is passing and a past which is preserved, the strict contemporaneity of the present with the past that it will be, of the past with the present that it has been. It is time itself which arises in the crystal, and which is constantly recommending its dividing in two without completing it, since the indiscernible exchange is always renewed and reproduced. The direct time-image or the transcendental form of time is what we see in the crystal; and hyalosigns, and crystalline signs, should therefore be called mirrors or seeds of time.

Thus we have the chronosigns which mark the various presentations of the direct time-image. The first concerns the *order of time*: this order is not made up of succession, nor is it the same thing as the interval or the whole of indirect representation. It is a matter of the internal relations of time, in a topological or quantic form. Thus the first chronosign has two figures: sometimes it is the coexistence of all the sheets of past, with the topological transformation of these sheets, and the overtaking of psychological memory towards a world-memory (this sign can be called sheet, aspect, or *facies*). Sometimes it is the simultaneity of points of present, these points breaking with all external succession, and carrying out quantic jumps between the presents which are doubled by the past, the future and the present itself (this sign can be called point or accent). We are no longer in an indiscernible distinction between the real and the imaginary, which would characterize the crystal image, but in undecidable alternatives between sheets of past, or "inexplicable" differences between points of present, which now concern the direct time-image. What is in play is no longer the real and the imaginary, but the true and the false. And just as the real and the imaginary become indiscernible in certain very specific conditions of the image, the true and the false now become undecidable or inextricable: the impossible proceeds from the possible, and the past is not necessarily true. A new logic has to be invented, just as earlier a new psychology had to be. It seemed to us that Resnais went furthest in the direction of coexisting sheets of past, and Robbe-Grillet in that of simultaneous peaks of present: hence the paradox of *Last Year in Marienbad*, which participates in the double system. But, in any event, the time-image has arisen through direct or transcendental presentation, as a new element in post-war cinema, and Welles was master of the time-image . . .

There is still another type of chronosign which on this occasion constitutes *time as series*: the before and after are no longer themselves a matter of external empirical succession, but of the intrinsic quality of that which becomes in time. Becoming can in fact be defined as that which transforms an empirical sequence into a series: a burst of series. A series is a sequence of images, which tend in themselves in the direction of a limit, which orients and inspires the first sequence (the before), and gives way to another sequence organized as series which tends in turn towards another limit (the after). The before and the after are then no longer successive determinations of the course of time, but the two sides of the power, or the passage of the power to a higher power. The direct time-image here does not appear in an order of coexistences or simultaneities, but in a becoming as potentialization, as series of powers. This second type of chronosign, the genesign, has therefore also the property of bringing into question the notion of truth; for the false ceases to be a simple appearance or even a lie, in order to achieve that power of becoming which constitutes series or degrees, which crosses limits, carries out metamorphoses, and develops along its whole path an act of legend, of story-telling. Beyond the true or the false, becoming as power of the false. Genesigns present several figures in this sense. Sometimes, as in Welles, they are characters forming series as so many degrees of a "will to power" through which the world becomes a fable. Sometimes it is a character himself crossing a limit, and becoming another, in an act of story-telling which connects him to a people past or to come: we have seen the paradox by which this cinema was called "*cinéma-vérité*" at the moment that it brought every model of the true into question; and there is a double becoming superimposed for the author

becomes another as much as his character does (as with Perrault who takes the character as "intercessor" or with Rouch who tends to become a black, in a quite different non-symmetrical way). It is perhaps here that the question of the author and the author's becoming, of his becoming-other, is already posed in its most acute form in Welles. Sometimes again, in the third place, characters dissolve of their own accord, and the author is effaced: there are now only attitudes of bodies, corporeal postures forming series, and a gest which connects them together as limit. It is a cinema of bodies which has broken all the more with the sensory-motor schema through action being replaced by attitude, and supposedly true linkage by the gest which produces legend or story-telling. Sometimes, finally, the series, their limits and transformations, the degrees of power, may be a matter of any kind of relation of the image: characters, states of one character, positions of the author, attitudes of bodies, as well as colours, aesthetic genres, psychological faculties, political powers, logical or metaphysical categories. Every sequence of images forms a series in that it moves in the direction of a category in which it is reflected, the passage of one category to another determining a change of power. What is said in the most simple terms about Boulez' music will also be said about Godard's cinema: having put everything in series, having brought about a generalized serialism. Everything which functions as limit between two series divided into two parts, the before and the after constituting the two sides of the limit, will also be called a category (a character, a gest, a word, a colour may be a category as easily as a genre, from the moment that they fulfil the conditions of reflection). If the organization of series generally takes place horizontally, as in *Slow Motion* with the imaginary, fear, business, music, it is possible that the limit or category in which a series is reflected itself forms another series of a higher power, henceforth superimposed on the first: as in the pictorial category in *Passion* or the musical one in *First Name Carmen*. There is in this case a vertical construction of series, which tends to return to coexistence or simultaneity, and to combine the two types of chronosigns.

The so-called classical image had to be considered on two axes. These two axes were the co-ordinates of the brain: on the one hand, the images were linked or extended according to laws of association, of continuity, resemblance, contrast, or opposition; on the other hand, associated images were internalized in a whole as concept (integration), which was in turn continually externalized in associable or extendable images (differentiation). This is why the whole remained open and changing, at the same time as a set of images was always taken from a larger set. This was the double aspect of the movement-image, defining the out-of-field: in the first place it was in touch with an exterior, in the second place it expressed a whole which changes. Movement in its extension was the immediate given, and the whole which changes, that is, time, was indirect or mediate representation. But there was a continual circulation of the two here, internalization in the whole, externalization in the image, circle or spiral which constituted for cinema, no less than for philosophy, the model of the True as totalization. This model inspired the noosigns of the classical image, and there were necessarily two kinds of noosign. In the first kind, the images were linked by rational cuts, and formed under this condition an extendable world: between two images or two sequences of images, the limit as interval is included as the end of the one *or* as the beginning of the other, as the last image of the first sequence or the first of the second. The other kind of noosign marked the integration of the sequences into a whole (self-awareness as internal representation),

but also the differentiation of the whole into extended sequences (belief in the external world). And, from one to the other, the whole was constantly changing at the same time as the images were moving. Time as measure of movement thus ensured a general system of commensurability, in this double form of the interval and the whole. This was the splendour of the classical image.

The modern image initiates the reign of "incommensurables" or irrational cuts: this is to say that the cut no longer forms part of one or the other image, of one or the other sequence that it separates and divides. It is on this condition that the succession or sequence becomes a series, in the sense that we have just analysed. The interval is set free, the interstice becomes irreducible and stands on its own. The first consequence is that the images are no longer linked by rational cuts, but are relinked on to irrational cuts. We gave Godard's series as an example, but they can be found everywhere, notably in Resnais (the moment around which everything turns and repasses in *Je t'aime je t'aime*, is a typical irrational cut). By relinkage must be understood, not a second linkage which would come and add itself on, but a mode of original and specific linkage, or rather a specific connection between de-linked images. There are no longer grounds for talking about a real or possible extension capable of constituting an external world: we have ceased to believe in it, and the image is cut off from the external world. But the internalization or integration of self-awareness in a whole has no less disappeared: the relinkage takes place through parcelling, whether it is a matter of the construction of series in Godard, or of the transformations of sheets in Resnais (relinked parcellings). This is why thought, as power which has not always existed, is born from an outside more distant than any external world, and, as power which does not yet exist, confronts an inside, an unthinkable or unthought, deeper than any internal world. In the second place, there is no longer any movement of internalization or externalization, integration or differentiation, but a confrontation of an outside and an inside independent of distance, this thought outside itself and this un-thought within thought. This is the unsummonable in Welles, the undecidable in Resnais, the inexplicable in the Straubs, the impossible in Marguerite Duras; the irrational in Syberberg. The brain has lost its Euclidean co-ordinates, and now emits other signs. The direct time-image effectively has as noosigns the irrational cut between non-linked (but always relinked) images, and the absolute contact between non-totalizable, asymmetrical outside and inside. We move with ease from one to the other, because the outside and the inside are the two sides of the limit as irrational cut, and because the latter, no longer forming part of any sequence, itself appears as an autonomous outside which necessarily provides itself with an inside.

The limit or interstice, the irrational cut, pass especially between the visual image and the sound image. This implies several novelties or changes. The sound must itself become image instead of being a component of the visual image; the creation of a sound framing is thus necessary, so that the cut passes between the two framings, sound and visual; hence even if the out-of-field survives in fact [*en fait*], it must lose all power by right [*de droit*] because the visual image ceases to extend beyond its own frame, in order to enter into a specific relation with the sound image which is itself framed (the interstice between the two framings replaces the out-of-field); the voice-off must also disappear, because there is no more out-of-field to inhabit, but two heautonomous images to be confronted, that of voices and that of views, each in itself, each for itself and in its frame. It is possible for the two kinds of

images to touch and join up, but this is clearly not through flashback, as if a voice, more or less off, was evoking what the visual image was going to give back to us: modern cinema has killed flashback, like the voice-off and the out-of-field. It has been able to conquer the sound image only by imposing a dissociation between it and the visual image, a disjunction which must not be surmounted: irrational cut between the two. And yet there is a relation between them, a free indirect or incommensurable relation, for incommensurability denotes a new relation and not an absence. Hence the sound image frames a mass or a continuity from which the pure speech act is to be extracted, that is, an act of myth or story-telling which creates the event, which makes the event rise up into the air, and which rises itself in a spiritual ascension. And the visual image for its part frames an any-space-whatever, an empty or disconnected space which takes on a new value, because it will bury the event under stratigraphic layers, and make it go down like an underground fire which is always covered over. The visual image will thus never show what the sound image utters. For example, in Marguerite Duras, the originary dance will never rise up again through flashback to totalize the two kinds of images. There will none the less be a relation between the two, a junction or a contact. This will be the contact independent of distance, between an outside where the speech-act rises, and an inside where the event is buried in the ground: a complementarity of the sound image, the speech-act as creative story-telling, and the visual image, stratigraphic or archaeological burying. And the irrational cut between the two, which forms the non-totalizable relation, the broken ring of their junction, the asymmetrical faces of their contact. This is a perpetual relinkage. Speech reaches its own limit which separates it from the visual; but the visual reaches its own limit which separates it from sound. So each one reaching its own limit which separates it from the other thus discovers the common limit which connects them to each other in the incommensurable relation of an irrational cut, the right side and its obverse, the outside and the inside. These new signs are lectosigns, which show the final aspect of the direct time-image, the common limit: the visual image become stratigraphic is for its part all the more readable in that the speech-act becomes an autonomous creator. Classical cinema was not short of lectosigns, but only to the extent that the speech-act was itself read in the silent film, or in the first stage of the talkie, making it possible to read the visual image, of which it was only one component. From classical to modern cinema, from the movement-image to the time-image, what changes are not only the chronosigns, but the noosigns and lectosigns, having said that it is always possible to multiply the passages from one regime to the other, just as to accentuate their irreducible differences.

[ · · · ]

The usefulness of theoretical books on cinema has been called into question (especially today, because the times are not right). Godard likes to recall that, when the future directors of the new wave were writing, they were not writing about cinema, they were not making a theory out of it, it was already their way of making films. However, this remark does not show a great understanding of what is called theory. For theory too is something which is made, no less than its object. For many people, philosophy is something which is not "made," but is pre-existent, ready-made in a prefabricated sky. However, philosophical theory is itself a practice, just as much

as its object. It is no more abstract than its object. It is a practice of concepts, and it must be judged in the light of the other practices with which it interferes. A theory of cinema is not "about" cinema, but about the concepts that cinema gives rise to and which are themselves related to other concepts corresponding to other practices, the practice of concepts in general having no privilege over others, any more than one object has over others. It is at the level of the interference of many practices that things happen, beings, images, concepts, all the kinds of events. The theory of cinema does not bear on the cinema, but on the concepts of the cinema, which are no less practical, effective or existent than cinema itself. The great cinema authors are like the great painters or the great musicians: it is they who talk best about what they do. But, in talking, they become something else, they become philosophers or theoreticians—even Hawks who wanted no theories, even Godard when he pretends to distrust them. Cinema's concepts are not given in cinema. And yet they are cinema's concepts, not theories about cinema. So that there is always a time, midday-midnight, when we must no longer ask ourselves, "What is cinema?" but "What is philosophy?" Cinema itself is a new practice of images and signs, whose theory philosophy must produce as conceptual practice. For no technical determination, whether applied (psychoanalysis, linguistics) or reflexive, is sufficient to constitute the concepts of cinema itself.

## NOTES

### Recapitulation of Images and Signs

1. Pier Paolo Pasolini, *L'expérience hérétique*, Paris: Payot, 1976, pp. 211–12. We already find in Epstein, from the same point of view, a fine discussion of cinema and death: "death makes its promises to us by cinematograph" (*Ecrits sur le cinéma*, Seghers, I, p. 199).

2. Eisenstein sometimes criticizes himself for having given too much importance to montage or co-ordination in relation to the parts co-ordinated and their "analytic deepening": as in the text "Montage 1938," *Film Form*. But we shall see how difficult it is, in Eisenstein's texts, to distinguish what is genuine and what is a show for Stalinist critics. In practice, from the outset, Eisenstein emphasized the need to consider the image or shot as an organic "cell," and not as an indifferent element: in a text from 1929, "Methods of montage," rhythmic, tonal and harmonic methods already consider the intrinsic content of each shot, according to deepening which takes increasing account of all the "potentialities" of the image. It none the less remains true that the two points of view—that of montage and that of image or shot—enter into an oppositional relation, even if this opposition has to be "dialectically" resolved.

3. Epstein, *Ecrits*, Seghers, pp. 184, 199 (and on "moving spaces," "floating periods" and "dangling causes," pp. 364–79). On "impossible continuity shots," cf. Eisenstein, p. 59. Noël Burch gives an analysis of the false continuities in the priest's scene in *Ivan the Terrible*, in *Praxis du cinéma*, Gallimard, pp. 61–3.

4. Jean-Louis Schefer, *L'homme ordinaire du cinéma*, Cahiers du cinéma/Gallimard.

5. Godard, in connection with *Passion*, *Le Monde*, 27 mai 1982.

6. cf. Claude Beylie's analysis in *Visconti, Etudes cinématographiques*.

7. René Prédal, *Alain Resnais, Etudes cinématographiques*, p. 120.

8. Proust, *A la recherche du temps perdu*, Pléiade, III, p. 924.

9. Vertov, *Articles, journaux, projets*, Paris: UGE, pp. 129–32. "Negative" is obviously not to be understood in the sense of negation, but of indirect or derived: it is the derivative of the

"visual equation" of movement, which also allows the resolution of this primitive equation. The solution will be "the communist deciphering of reality."

10. cf. Narboni, Sylvie Pierre and Rivette, "Montage," *Cahiers du cinéma*, no. 210, mars 1969.

11. Robert Lapoujade, "Du montage au montrage," in "Fellini," *L'Arc*.

12. Bonitzer, *Le champ aveugle*, Cahiers du cinéma/Gallimard, p. 130: "Montage becomes the order of the day again, but in an interrogative form that Eisenstein never gave it."

13. Tarkovsky, "De la figure cinématographique," *Positif*, no. 249, décembre 1981: "Time in cinema becomes the basis of bases, like sound in music, colour in painting . . . Montage is far from producing a new quality . . ." cf. Michel Chion's comments on this text of Tarkovsky, *Cahiers du cinéma*, no. 358, avril 1984, p. 41: "His profound intuition about the essence of cinema, when he refuses to assimilate it to a language which combines units such as shot, images, sounds, etc."

### Conclusions

1. Paul Schrader has spoken of a "transcendental style" in certain cinema-authors. But he uses this word to indicate the sudden arrival of the transcendent, as he thinks he sees it in Ozu, Dreyer, or Bresson (*Transcendental Style in Film: Ozu, Dreyer, Bresson*, extracts in *Cahiers du cinéma*, no. 286, mars 1978). It is thus not the Kantian sense, which in contrast opposes the transcendental and the metaphysical or transcendent.

2. More precisely, crystal-images are connected to the states of the crystal (the four states that we have distinguished), while crystalline signs or hyalosigns are connected to its properties (the three aspects of the exchange).

# JAMES NAREMORE

. . . . . . . . . . . . . . . . . . . . . . . . . . . . . . . . . . . . . . . . . . . . . . . . . . . . . . . . .

# Protocols

FROM *Acting in the Cinema*

Professor of Film Studies at Indiana University, and a founder of the program there, James Naremore (b. 1941) is also the author of numerous books in film studies, including *The Magic World of Orson Welles* (1978), *The Films of Vincente Minnelli* (1993), and the book from which this excerpt is drawn, *Acting in the Cinema* (1988). He is also the director of *A Nickel for the Movies* (1984), a short film on classical editing. As part of the generation that ushered in, and expanded, academic film study and scholarship in the 1970s, Naremore brings an extensive background in literary studies (specifically comparative literature), theater, and contemporary literary theory to his work on the cinema. Thus it is no surprise that he is consistently drawn to interdisciplinary questions about film authorship, adaptation, and acting in the cinema.

Like much of contemporary film criticism, Naremore's work demonstrates a broad interest in the full range of film forms, based in a wide historical and cultural spectrum. His discussion of acting reflects a common tendency in contemporary film to integrate modern and contemporary philosophical thought into film criticism, as demonstrated by his references to European theorists like Julia Kristeva and her notion of the "anaphoric" function in acting. Equally significant is the expansive reach of the examples in his work; he successfully harmonizes *Citizen Kane* (1941), *The Rocky Horror Picture Show* (1975), and

T. S. Eliot in a contemporary scholarly and film culture that gladly accepts the dissolution of disciplinary boundaries and hierarchies (such as high culture versus popular culture).

In this selection from the chapter "Protocols," Naremore explores how performative spaces can be managed differently by actors, as well as the crucial distinction between a presentational and representational style of acting. He provides a broad cultural and historical framework that sees film acting as part of a continuum that includes not only stage acting but also the theatrics of everyday life. Central to this selection is his emphasis on how acting is necessarily connected to its audience; a critical point that helps distinguish how we engage actors on the many stages and screens of contemporary life. Naremore's work is part of a historically consistent interest in film actors by film critics and theorists and one which has been especially energized in recent years. In the first decades of movie history, writers and critics often fixated on acting and on the distinction between film and theater, but contemporary criticism has been especially drawn to the actors themselves and star studies. For theorists like Christian Metz (p. 17) this central feature of narrative film raises key questions about audience identification; for feminist film scholars like Laura Mulvey (p. 713) and Carol J. Clover (p. 511), actresses and stars can usefully focus issues about the complicated place of gender in our understanding of a film.

## READING CUES & KEY CONCEPTS

▩ Naremore offers suggestive distinctions for thinking about the difference between stage and film acting. What are the two or three most important? What are others he does not address?

▩ Select two actors or performances that best illustrate the difference between a "presentational" and "representational" acting style. How does this style fit with the larger themes of the film?

▩ Are there contemporary styles of acting which seem especially suited to viewing technologies such as VCR and DVD players? For instance?

▩ **Key Concepts:** Anaphora; Fourth Wall; Mise-en-Scène; Presentational Theatrics; Representational Theatrics

# Protocols

. . . . . . . . . . . . . . .

[ · · · ]

## *What Is Acting?*

> *The actor can only be said to be reproducing something when he is copying another actor.*
>
> Georg Simmel, *On the Theory of Theatrical Performance*

In its simplest form [ . . . ], acting is nothing more than the transposition of everyday behavior into a theatrical realm. Just as the language of poetry is no different in kind from the language in a newspaper, so the materials and techniques used by players

on the stage are no different in kind from those we use in ordinary social intercourse. This may explain why the metaphor of life as theater is so ubiquitous and convincing. After all, in daily activity we constitute ourselves rather like dramatic characters, making use of our voices, our bodies, our gestures and costumes, oscillating between deeply ingrained, habitual acts (our "true mask") and acts we more or less consciously adopt to obtain jobs, mates, or power. There is no question of breaking through this condition to arrive at some unstaged, unimitated essence, because our selves are determined by our social relations and because the very nature of communication requires us, like Prufrock, to put on a face to meet the faces that we meet. Hence Lee Strasberg's notion that the stage actor does not need to "imitate a human being" is at one level entirely correct: to become "human" in the first place we put on an act.

As a result, words like "drama," "performance," and "acting" can designate a great variety of behavior, only some of which is theatrical in the purest sense. But given the affinity between theater and the world, how do we know this purity? How do we determine the important and obvious difference between performers in everyday life and performers who are behaving theatrically? The answer is not altogether clear, even though we often make such distinctions, and even though the basis on which we make them is crucial to the study of acting as an art or as a vehicle for ideology.

One solution to the problem has been offered by Erving Goffman, who defines theatrical performance as "an arrangement which transforms an individual into . . . an object that can be looked at in the round and without offense, and looked to for engaging behavior by persons in an audience role" (*Frame Analysis*, 124). The "arrangement" of which Goffman speaks may take a variety of forms, so long as it divides people into two fundamental groups, designating some as performers and others as watchers. Its purpose is to establish an unusually high degree of ostentation, a quality the actor Sam Waterston has called "visibility": "People can see you . . . all the lights are turned out, and there is nothing else to look at" (quoted in Kalter, 156).

This showing (or showing off) is the most elementary form of human signification, and it can turn any event into theater. For example, the New York performance artists of the fifties and sixties were able to stage "happenings" by standing on a street corner and waiting for an auto accident or any chance occurrence that their role as audience would transform into a show; their experiments demonstrated that anyone—a juggler, a dancer, or an ordinary passerby—who steps into a space previously designated as theatrical automatically becomes a performer. Furthermore, not much conscious artistic manipulation or special skill is required to provide some kinds of "engaging behavior." When art theatricalizes contingency, as in *Kid's Auto Race*, John Cage's music, or Andy Warhol's movies, it puts a conceptual bracket around a force field of sensations, an ever-present stratum of sound, shade, and movement that both precedes meaning and makes it possible. Julia Kristeva seems to be talking about such a process when she refers to a "geno-text" or an "other scene" made available to communication by "*significance*," a preverbal activity she equates with the "*anaphoric* function." "Before and after the *voice* and the *script* is the *anaphora*: the gesture which *indicates*, establishes *relations* and eliminates entities" (270). Meaningless in itself, the anaphora is a purely relational activity whose free play allows meaning to circulate, even when meaning is unintended. All forms of human and animal exchange involve anaphoric behavior, and the "arrangement" Erving Goffman calls a theatrical frame could be understood in exactly those terms, as a primary gesture. It might take

the form of a stage or a spot on the street; in the absence of these things, it could be a simple flourish of the hand or an indication to "look there." Whatever its shape, it always separates audience from performer, holding other gestures and signs up for show.

The motion picture screen is just such a theatrical anaphora, a physical arrangement that arrays spectacle for persons in an audience role. As in most types of theater, however, the actions and voices in movies are seldom allowed to "mean" by simply displaying themselves. This is especially true when the film involves *acting*—a term I shall use to designate a special type of theatrical performance in which the persons held up for show have become agents in a narrative.

At its most sophisticated, acting in theater or movies is an art devoted to the systematic ostentatious depiction of character, or to what seventeenth-century England described as "personation." Unplotted theatrics can partake of acting, as when rock musicians like Madonna or Prince develop a persona that has narrative implications; but to be called an actor in the sense I am using, a performer does not have to invent anything or master a discipline, so long as he or she is embedded in a story. The following example from the proscenium stage, cited by Michael Kirby, may serve to illustrate the point:

> Some time ago I remember reading about a play in which John Garfield—I am fairly sure it was he, although I no longer know the title of the play—was an extra. During each performance he played cards and gambled with friends on the stage. They really played, and the article emphasized how much money someone had won (or lost). At any rate, since my memory is incomplete, let us imagine a setting representing a bar. In one of the upstage booths, several men play cards throughout the act. Let us say that none of them has lines in the play; they do not react in any way to the characters in the story we are observing. . . . They merely play cards. And yet we also see them as characters, however minor, in the story and we say that they, too, are acting. ("On Acting and Not-Acting," Battcock and Nicas, 101)

This kind of "received" acting is fairly typical of theater, but in the movies it has much greater importance, extending even to the work of the star players, who sometimes perform gestures without knowing how they will be used in the story. For example, it is rumored that during the making of *Casablanca* (1942), director Michael Curtiz positioned Bogart in close-up, telling him to look off to his left and nod. Bogart did so, having no idea what the action was supposed to signify (the film, after all, was being written as it was shot). Later, when Bogart saw the completed picture, he realized his nod had been a turning point for the character he was playing: Rick's signal to the band in the Café Américain to strike up the *Marseillaise.*

A more "scientific" illustration of the same effect is the so-called Kuleshov experiment, in which an actor's inexpressive offscreen glance was intercut with various objects, thus creating the illusion that he was emoting. Kuleshov described the process as if he were a chemist working in a lab: "I alternated the same shot of Mozhukhin with various other shots (a plate of soup, a girl, a child's coffin), and these shots acquired a different meaning. The discovery stunned me" (200). There is, unfortunately, something disingenuous about Kuleshov's account, which has created what Norman Holland calls a "myth" of film history.[1] Even so, the "Kuleshov effect" is a useful term

in film criticism, and anyone who has ever worked at a movie-editing table knows that a wide range of meanings or nuances, none of them intended by the script, the playing, or the *découpage*, can be produced through the cutting. Audiences, too, are aware of a potential for trickery, and a certain genre of comedy or parody foregrounds the process: a recent TV commercial uses close-ups from the original "Dragnet," editing them to make Joe Friday and his partner seem to discuss the merits of a brand of potato chips; a video on MTV shows Ronald Reagan piloting a dive bomber, gleefully attacking a rock and roll band; and Paramount's *Dead Men Don't Wear Plaid* (1982) allows Steve Martin to play scenes with half the stars of Hollywood in the forties.

One reason these jokes are possible is that expression is polysemous, capable of multiple signification; its meaning in a film is usually narrowed and held in place by a controlling narrative, a context that can rule out some meanings and highlight others. As a result, some of the most enjoyable screen performances have been produced by nothing more than *typage*,[2] and it is commonplace to see dogs, babies, and rank amateurs who seem as interesting as trained thespians. In fact, the power of movies to recontextualize detail is so great that a single role frequently involves more than one player: Cary Grant acts the part of Johnny Case in *Holiday* (1938), but he performs only two of the character's many somersaults; Rita Hayworth does a "striptease" in *Gilda* (1946), but the voice that issues from the character's mouth as she sings "Put the Blame on Mame" belongs to Anita Ellis.

By slightly extending Walter Benjamin's well-known argument about painting in the age of photography, we could say that mechanical reproduction deprives performance of authority and "aura," even as it greatly enhances the possibility of stardom. Significantly, another of Kuleshov's "experiments" had involved the creation of a synthetic person out of fragmentary details of different bodies—a technique that undermines the humanist conception of acting, turning every movie editor into a potential Dr. Frankenstein. Nevertheless, Kuleshov was intensely concerned with the training of players, and audiences continue to make distinctions between figures on the screen, claiming that some of them are a bit more actorly than others.

[ · · · ]

In a more obvious form, acting in movies involves still another quality—a mastery, skill, or inventiveness that is implied in the normative use of the word performance. In fact all types of art or social behavior are concerned at some level with this sort of parading of expertise. Writing about Balzac, Roland Barthes remarks that "the classic author becomes a performer at the moment he evinces his power of *conducting* meaning" (*S/Z*, 174). One might say the same thing of a modernist like James Joyce, or of Barthes himself, whose verbal skill is foregrounded on every page and whose intellectual *tours de force* made him a celebrity. In literature, we can even speak of a "performative" sentence, as on the opening page of *Moby Dick*:

> Whenever I find myself growing grim about the mouth; whenever it is a damp, drizzly November in my soul; whenever I find myself pausing before coffin warehouses, and bringing up the rear of every funeral I meet; and especially whenever my hypos get such an upper hand of me, that it requires a strong moral principle to prevent me from deliberately stepping into the street, and methodically knocking people's hats off—then, I account it high time to get to sea as soon as I can.

Melville keeps the sentence in play, stringing out parallel constructions like a singer holding his breath, until that final moment when the period brings us to rest beside the sea. To read his words, we need to employ skills of our own, mentally repeating the rhythms, or perhaps interpreting them aloud so that our vocal cords participate in a dance of meaning. Oratory and most kinds of theatrical acting involve similar effects, and for that reason star performances in movies are often structured so as to give the audience a chance to appreciate the player's physical or mental accomplishments. Film problematizes our ability to measure these effects simply because it allows for so much manipulation of the image, throwing the power of "conducting" meaning into the hands of a director; nevertheless, one of the common pleasures of moviegoing derives from our feeling that an actor is doing something remarkable. Garfield playing poker, Bogart nodding his head, a minor player in a crowded scene—all these are clearly different from Chaplin/Hinkle in *The Great Dictator* (1940), bouncing a globe around a room in a long shot, executing a brilliant comic ballet while dressed as Hitler.

In succeeding chapters I spend a good deal of time illustrating or tracing out varieties of ostentatious, actorly expertise; but at the outset it is important to stress that deliberate imitation or theatrical mimesis is not necessary to acting or to the effect of a "good" performance. In one sense it is misleading to call even Chaplin a mimic when the materials of his art—his body, his gestures, his facial expression, and all the techniques he uses to create character—are the same materials we use in everyday life. We are all imitators, and the terms *mime* and *mimicry* come into play only at an extreme end of the scale of theatrical behavior, where the performer uses neither speech nor props or where the voice and body duplicate conventionalized stage gestures, creating recognizable stereotypes. Thus if a man shaves in front of a camera, he is transforming an everyday action into theater; if he shaves in the service of a story (like Nate Hardman in *Bless Their Little Hearts* [1985]), he is acting; if he goes through the same motions without a razor, he is miming, engaging in a "pure" imitation that A. J. Greimas has termed *mimetic gesturality* (35–37). Chaplin is an impressive performer in part because he is able to exploit the entire scale: at one moment in *The Gold Rush* (1925) he boils a shoe, but at the next he mimes eating, poking the laces into his mouth and chewing them as if they were spaghetti. During all this, he mimics a set of stereotypical characters, changing from cook to fussy waiter to gourmet as he moves through various stages of the meal.

The typical realist dramatic film affords few opportunities for such virtuoso imitation, although we occasionally see "copying" in naturalistic contexts: Belmondo mimics Bogart's gestures in *Breathless*, and in *Badlands* (1973) Martin Sheen takes on a remarkable resemblance to James Dean. To understand the skills involved in less visible forms of acting, it is necessary to examine behavior at a much more elementary level, analyzing the "transforming" elements or conventions that distinguish everyday utilitarian expressions from staged or scripted signs. One of the best ways to start such a project is to think of film in relation to the conventions that govern proscenium theater. Before that, however, I should like to add a few remarks about the motion picture screen, which creates a boundary between audience and performer unlike any other in theatrical history.

## The Actor and the Audience

*"Are you talkin' to me?"*

Robert De Niro/Travis Bickle in *Taxi Driver* (1976)

All public institutions—classrooms, churches, houses of government—have a quasi-theatrical structure, an architecture that creates a performing space. The space can take various forms, from lecture halls to roundtable discussions, allowing for more or less ambiguity in the relation between performer and audience. Even in the most formal situations, however, paying customers sometimes get into the act: professors call on students, magicians solicit volunteers, and stand-up comics endure hecklers. Where live theater is concerned, there are different degrees of freedom in the basic relation: at one extreme are the relatively participatory arrangements of circus, music hall, and most types of "epic theater." (The most completely open form is the theater of Jerzy Grotowski, in which a select group engages in communal activity, everyone becoming simultaneously audience and performer.) At the other extreme is the proscenium arch, which situates the audience in numbered rows of seats inside a darkened room, looking toward a rectangular opening on a lighted stage.

The proscenium, or "picture-frame" arrangement became the dominant form of Western theatrical architecture some time in the late seventeenth century, when theaters in England were permanently established indoors. At about that time—soon after the restoration of Charles II but coincident with the growth of a mercantile economy throughout Europe—playhouses underwent several other changes, all of them signaling the birth of modern drama: artificial lighting was introduced; female actors were allowed on the stage; extensive scenery and props were designed; and hidden wings were constructed at either side of the arch to permit movable sets. Such conventions fostered a "representational," illusionist theater, different from the relatively "presentational" style of Shakespeare and the Elizabethans. Eventually, the actor on the proscenium stage became a part of the decor—an object in a realist *mise-en-scène*—so that it was no longer necessary to describe elaborate settings with speeches or to invoke abstract spaces with gestures. Equally important, the actor's physical relation to the audience underwent subtle changes, as if an invisible "fourth wall" had descended between the drama and the auditorium. The public was seldom addressed directly; in fact, as increasingly sophisticated methods of stage lighting were developed, the audience became less visible to the actor, until it was simply out there somewhere, represented by a dark limbo, like the void that Susan Alexander sings to in *Citizen Kane.*

To some degree, the movement from presentational to representational theatrics corresponds to what Orson Welles, in a lecture on "The New Actor," delivered in 1940, described as a transition from "formal" to "informal" drama. The formal drama, Welles explained, belongs to rigidly hierarchical cultures; ritualistic in the true sense of the term, it inculcates no sense of actorly "style" or "personality." Informal drama, by contrast, grows out of a relatively flexible social organization; its actors are celebrated public figures who treat the audience on a somewhat personal basis. In the informal tradition, which for Welles included Shakespeare and all modern theater, "it is impossible to be a great actor unless you deal with your audience" (2). Before the establishment of fully representational, picture-frame techniques, this "dealing" took specific forms: "We know that Chaliapin adored the gallery and loathed the expensive

seats. The greatest moment for the Russian peasants was when Chaliapin sneered at the big people and played for the gallery when he did Boris Goudonof" (3). But in more recent times, Welles argued, the situation changed. "Even before the movies, actors stopped considering their audiences. It was the constant effort of people like Stanislavsky in a very serious way and John Drew in a frivolous way to pretend there is a fourth wall. This is death to acting style. It is practically impossible to create a new acting style which excludes the direct address to the audience" (3).

Even in the most pictorial proscenium drama, however, the audience remains present to the actor, sending out vibrations or signs that influence the intensity, pace, and content of a given performance. Live theater is always what Brecht described as "provisional," because it depends on an immediate interaction between two specific groups; and in the more presentational forms, this interaction is a major determinant of the show. Here is Mae West describing the vaudeville act she performed between 1912 and 1916:

> I used to have to work an audience, appeal to them with little private gestures, twists of my head, the way I spoke a word, or winked over a song line. . . . I brought my own sophisticated ideas and style to the vaudeville stage but I had to adjust it to the standard of each theater, and even to each night's audience in the theater. . . . I usually found that one night a week you would get a top society crowd, and another night you'd get mostly working-class people. Other nights there would be family groups—especially on Friday nights when the kids didn't have to go to school the next day. (quoted in Stein, 25)

At the movies, on the other hand, the existential bond between audience and performer is broken. The physical arrangement is permanently closed, and it cannot be opened even if the performer speaks to us directly or if we make catcalls back at the show. Audiences can sometimes become part of the spectacle, especially at cult films like *The Rocky Horror Picture Show* (1975), but the images never change to accommodate them. Likewise, movie performers can invite viewers to respond—as when James Cagney looks out at us in *Yankee Doodle Dandy* (1942), asking that we join him in singing "Over There," or when David Byrne ironically pokes a microphone at the camera during one of his numbers in *Stop Making Sense* (1984). Nevertheless Cagney and Byrne will never know if their invitation is accepted. The unique property of film as spectacle is that the two groups that constitute theatrical events cannot momentarily change social roles. To do so would involve a magical transformation, like the one in *Sherlock, Jr.* (1924), when the dreaming Buster Keaton walks down the aisle of a theater and steps right into the silver screen—or like the roughly similar one in *The Purple Rose of Cairo* (1985), when the figures in a movie begin chatting with Mia Farrow as she sits in the diegetic audience.

Clearly, the impenetrable barrier of the screen favors representational playing styles. (Presentational theatrics are possible in movies, but usually they are played for a fictional audience *inside* the film, a surrogate crowd.) The barrier also promotes a fetishistic dynamic in the spectator; the actor is manifestly *there* in the image, but *not there* in the room, "present" in a more intimate way than even the *Kammerspiel* could provide, but also impervious and inaccessible. Thus every filmed performance partakes of what John Ellis and other theorists have described as the "photo effect"—a teasing sense of presence and absence, preservation and

loss (Ellis, 58–61). And because the performance has been printed on emulsion, it evokes feelings of nostalgia as it grows old, heightening fetishistic pleasure.

[ · · · ]

Recent developments in technology allow us to evade such feelings, inserting ourselves into the act by taking control of the machinery. We can purchase a VCR or an analyzing projector, manipulating the images and repeating them forever; in doing so, however, we usually prolong the sense of private play, elaborating a *fort/da* game that film has always encouraged.[3] Consider, for example, Charles Affron's rapt discussion of what he calls the "power" and "dominion" given to spectators by the apparatus: "Garbo can die for me around the clock. I can stay her in that final moment of her life; I can turn off the sound and watch, turn off the picture and listen, work myriad transformations in speed and brilliance, and then restore the original without losing a particle of its intensity" (5). For all his emphasis on the power of the viewer, however, Affron is talking less about freedom than about the erotics of textual analysis. Garbo has become the perfect fetish object, the ultimate Romantic Image, her performance balanced between an imaginary plenitude and what Yeats described as "the cold snows of dream."

There is, of course, another side to this issue, and I think it is implicit in what Affron says. The same machinery that fetishizes performance also permits it to be deconstructed or replayed in ways that run counter to its original intentions; the apparatus (especially when joined with video technology) allows the audience to become postmodernists, alienating the spectacle, producing a heightened awareness of the artificiality in all acting—even the kind of acting that constitutes our daily life. By freezing the frames of a movie, by running them at different speeds, we can institute what Terry Eagleton has described as a "Derridian 'spacing,' rendering a piece of stage business exterior to itself . . . and thus, it is hoped, dismantling the ideological self-identity of our routine social behavior" (633). Here again Walter Benjamin's arguments about the effect of photography on painting seem to apply equally to the effect of media on acting. The performance, having become a text, is no longer part of a specific architecture; it now comes to people, who can glimpse it at home in bits and pieces. Under these circumstances, it has less to contribute toward the "theology of art."

The closed boundary between audience and performer has had similarly complex effects on society in the aggregate, partly because the actor's work is no longer "provisional" but fixed, geared toward an imaginary individual who represents the mass. Thus when Mae West brought her vaudeville persona to talking pictures, her old technique of adjusting to the makeup of a specific audience was useless. Like a writer imagining a reader, she had to play for an idealized viewer—or for her directors, producers, and fellow players. One result of this new arrangement was an increasing homogenization of the culture, which began to seem like a global village. "Today," West observed in 1959,

motion pictures, radio, and television have brought Broadway sophistication and big city ideas to even the remotest of green communities. Today there is no longer such a thing as a "hick" audience. Almost anything goes, anywhere, if it is good and fast and amusing. Risqué material is only offensive if badly done without style and charm. (Stein, 280)

But definitions of "style and charm" can vary, depending on the cycles of liberalism and conservatism in society at large—a fact West herself must have realized in the mid thirties, when the Production Code made her work in movies increasingly problematic.

Like West, film actors must respond indirectly to mass opinion; but cinema also "constructs" its spectators more rigorously than any other form of theater, so that both players and viewers ultimately resemble lonely individuals, looking into a mirror. This profound change in the dynamic of performance was a matter of great concern to the intellectuals who wrote about early movies, although they sometimes disagreed about its influence for good or for evil. Populist Americans like Vachel Lindsay and Hugo Münsterberg were optimistic; worshippers of the "universal language" of the silent screen, they believed mass media could democratize society—raising the level of sophistication, spreading sweetness and light, working as a force of education. By contrast, most Europeans and Anglophiles were pessimistic. In the twenties, T. S. Eliot was convinced that the rise of the movie house and the subsequent death of the English music hall would contribute to a deadening *embourgoisement* of English culture:

> With the death of the music-hall, with the encroachment of the cheap and rapid-breeding cinema, the lower classes will tend to drop into the same state of protoplasm as the bourgeoise. The working man who went to the music-hall and saw Marie Lloyd and joined in the chorus was himself performing part of the act; he was engaged in that collaboration of the audience with the artist which is necessary in all art and most obviously in dramatic art. He will now go to the cinema, where his mind is lulled by continuous senseless music and continuous action . . . , and will receive, without giving, in that same listless apathy with which the middle and upper classes regard any entertainment of the nature of art. He will have also lost some of his interest in life. (225)

Eliot's essentially right-wing argument has something in common with the left-wing responses of Adorno and the Frankfurt School, who regarded cinema as opiate for the masses. Among the Germans, Brecht was perhaps the most aware of mixed blessings in the new media. His short essay on radio, written in the thirties, could be used to summarize the concerns that lie behind all discussions of the relation between audience and performer in the age of mechanical reproduction:

> Radio is one-sided when it should be two-. It is purely an apparatus of distribution, for mere sharing out. So here is a positive suggestion: change the apparatus over from distribution to communication. The radio would be the finest possible communication apparatus in public life, a vast network of pipes. That is to say, it would be if it knew how to let the listener speak as well as hear, how to bring him into a relationship instead of isolating him. (52)

Unfortunately, Brecht's proposed solution cannot be applied to movies, and other types of "mass communication" have seldom realized their potential for democratic exchange: examples of "two-way" performances in America today would range from progressive broadcasts such as "The Phil Donahue Show" to various "prayerline" evangelists. Where ordinary film acting is concerned, the point to be remembered is that even though modern society has brought performers close to us, in many ways it has made them seem farther away, more fabulous than ever.

## NOTES

1. Holland has pointed out that Kuleshov and Pudovkin, who worked together to produce the famous sequence, disagreed about exactly what it contained. The original footage has not survived, and there is no evidence that it was shown to an innocent audience ("Psychoanalysis and Film: The Kuleshov Experiment," 1–2). The sequence therefore has dubious status as either history or science, although a formal experiment seems unnecessary when movies have always proved Kuleshov's point.

2. *Typage*, a term coined by Soviet directors in the twenties, should not be confused with "type casting." *Typage* depends on cultural stereotypes, but, more important, it emphasizes the physical eccentricities of actors (often, by preference, nonprofessionals). Kuleshov argued that "because film needs real material and not a pretense of reality . . . it is not theater actors but 'types' who should act in film — that is, people who, in themselves, as they were born, present some kind of interest for cinematic treatment. . . . A person with an ordinary, normal exterior, however good-looking he may be, is not needed in cinema" (63–4).

3. In *Beyond the Pleasure Principle*, Freud describes a game he once saw an infant playing. The child enjoyed "taking any small objects he could get hold of and throwing them away from him into a corner, under the bed, and so on." As he did this, he always shouted a syllable that Freud interpreted to mean "*fort*," the German word for "gone." One day Freud observed him playing with a wooden reel attached to a piece of string. Shouting "*fort*," the boy held the string and tossed the object away; he then pulled it back, celebrating its reappearance "with a joyful '*da*' ['there']." Freud called this the *fort/da* game, and used it to illustrate the "economics" of the libido. According to Freud, the child was compensating for the fact that his mother sometimes went away, "by himself staging the disappearance and return of objects within his reach" (XVIII, 14–16). For a commentary on this process in relation to cinema, see Stephen Heath, "*Anata mo*," *Screen* (Winter 1976–77): 49–66.

## BIBLIOGRAPHY

Affron, Charles. *Star Acting: Gish, Garbo, and Davis*. New York: Dutton, 1977.

Barthes, Roland. *S/Z: An Essay*. Trans. Richard Miller. New York: Hill and Wang, 1974.

Battcock, Gregory, and Robert Nickas. *The Art of Performance*. New York: Dutton, 1984.

Benjamin, Walter. *Illuminations*. Trans. Harry Zohn. Ed. Hannah Arendt. New York: Harcourt, Brace, and World, 1968.

Brecht, Bertolt. *Brecht on Theater*. Trans. John Willet. New York: Hill and Wang, 1964.

Eagleton, Terry. "Brecht on Rhetoric." *New Literary History* 16, no. 3 (Spring 1985).

Eliot, T. S. *Selected Prose*. Harmondsworth: Penguin, 1953.

Ellis, John. *Visible Fictions: Cinema, Television, Video*. London: Routledge and Kegan Paul, 1982.

Goffman, Erving. *The Presentation of Self in Everyday Life*. Garden City, N.Y.: Doubleday, 1959.

———. *Frame Analysis*. New York: Harper, 1974.

Greimas, A. J. *On Meaning*. Trans. Paul J. Perron and Frank H. Collins. Minneapolis: University of Minnesota Press, 1987.

Heath, Stephen. *Questions of Cinema*. Bloomington: Indiana University Press, 1981.

Holland, Norman N. "Psychoanalysis and Film: The Kuleshov Experiment." *IPSA Research Paper No. 1*. Gainesville: Institute for Psychological Study of the Arts, University of Florida, 1986.

Kalter, Joanmarie, ed. *Actors on Acting: Performance in Theatre and Film Today*. New York: Sterling, 1979.

Kristeva, Julia. "Gesture: Practice or Communication?" Trans. Johnathan Benthael. In *The Body Reader*, edited by Ted Polhemus. New York: Pantheon, 1977.

Kuleshov, Lev. *Kuleshov on Film*. Trans. and ed. Ronald Levaco. Berkeley and Los Angeles: University of California Press, 1974.

Stein, Charles W. *American Vaudeville as Seen by Its Contemporaries*. New York: Knopf, 1984.

Welles, Orson. "The New Actor." Typescript notes for a lecture, 1940. Orson Welles Collection (box 4, folder 26), Lilly Library, Bloomington, Indiana.

# PAUL WELLS

# Notes Towards a Theory of Animation

FROM *Understanding Animation*

A professor and director of the Animation Academy at Loughborough University, England, Paul Wells (b. 1961) is a leading contemporary scholar of animation and broadcast media. He has produced several radio programs on those topics, and, in addition to *Understanding Animation* (1998), from which this essay is drawn, he has published *Animation: Genre and Authorship* (2002) and *The Fundamentals of Animation* (2006). Like other British scholars of his generation attuned to debates about popular culture and the public sphere, his work responds to a broad cultural and social understanding of film, media, and the growing variety of technological representations available.

Both the subject and method of Wells's investigation here reflect the expansion of contemporary film and media studies in part in response to contemporary film practices, viewing situations, and new investigations in film history. Contemporary experiments in animation, such the Brothers Quay's *Street of Crocodiles* (1986) and digital experiments in film practice such as Richard Linklater's *Waking Life* (2001), have certainly contributed considerably to recent scholarly interest in theories and practices of animation, and Wells adds to this a keen historical perspective that ranges from early animated figures such as Koko the Clown and avant-garde and surrealist practices of the 1920s and 1930s to contemporary digital animation.

In Wells's "Notes Towards a Theory of Animation," his discussion of animation practices reflects the modern emphasis on structural and binary categories, an attention to the dynamics of reception, and an awareness of animation's relation to postmodern notions of hyper-realism. His concerns with narrative and non-narrative patterns and auteurist positions in animation further link these studies of animation to central questions in film theory. Although animation has been a central part of film history since 1895, animation studies have proliferated in recent years. The work on digital filmmaking by Lev Manovich (p. 1058) can be read alongside this selection, and Part 11 engages many of the issues raised by Wells's discussion of the role of hyper-realism more generally in animation.

## READING CUES & KEY CONCEPTS

■ Describe some specific kinds of "non-continuity" found in experimental animation. What is the particular logic that informs its "distinctive language"? Musical? Emotional? That of a "dream-state"?

■ What does Wells mean by "the literal evolution of materiality" in experimental films? How have different technologies changed what that means?

■ Wells suggests that "developmental animation" works between his two categories of animation. Offer an example of a film that might use "developmental animation," and indicate how it draws on those two categories.

■ **Key Concepts:** Cel Animation; Developmental Animation; Experimental Animation; Hyper-Realism; Orthodox Animation

# Notes Towards a Theory of Animation

. . . . . . . . . . . . . .

## *Styles and Approaches*

It may be argued that Disney's art and the hyper-realist animated film remain the dominant discourse of animation. The proliferation of mass-produced "cel" animation has done much to overshadow the styles and approaches adopted by other animators in other contexts. Inevitably, the amount of cheaply produced, highly industrialised cel animation made in the USA and Japan has colonised television schedules, and perhaps, more importantly, the imaginations of viewers. Although this is to discredit the quality and variety of work in cel animation, it seems necessary to reclaim, re-introduce and re-validate animation made with other materials, with different creative impulses and aesthetic interests, outside the context of mass production, to properly evaluate the achievements of the animated film. It also provides an opportunity to theorise the textual apparatus of different forms of animation which, for the purposes of this discussion, I haved called *orthodox animation.*

### DEVELOPMENTAL ANIMATION AND EXPERIMENTAL ANIMATION

These tentative definitions attempt to address certain modes of expression and construction in the animated film linking these aspects to the techniques employed.

The table on page 215 represents a definition of orthodox and experimental animation as opposing but related forms. Developmental animation operates as a mode of expression combining or selecting elements of both approaches, representing the aesthetic and philosophic tension between the two apparent extremes.

Cel animation remains the most convenient technique for the mass production of cartoons and, therefore, the most commonly seen form of animation. Consequently, it constitutes what may be understood as *orthodox* animation, and is most associated, even in its most anarchic or fantastical form, at the level of narrative, along with the hyper-realist style discussed earlier. This may seem extraordinary to the viewer

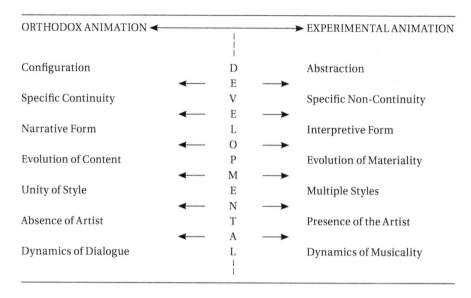

who sees the cartoon as an intrinsically non-realist form, but as will become clear, this sense of unreality only operates with regard to the representation of events in a cartoon, and not the "realist" conventions by which it is understood. Significantly, these kinds of films are usually storyboarded first; after the fashion of a comic strip (and thus, its linear mode of story-telling), and animated when synchronised to a pre-recorded soundtrack. The animation is achieved when "key drawings" are produced indicating the "extreme" first and last positions of a movement which are then "in-betweened" to create the process of the move. After "pencil-testing" (now often computerised), the images are drawn on separate sheets of celluloid, painted, and photographed frame-by-frame against the appropriate background. The music, dialogue and effects correspond to the images. This method enables a large number of animators to be involved and facilitates an industrial process. It also results in a certain creative intention which characterises the criteria for orthodox animation.

## *Terms and Conditions: Orthodox Animation*

### CONFIGURATION

Most cartoons featured "figures," i.e. identifiable people or animals who corresponded to what audiences would understand as an orthodox human being or creature despite whatever colourful or eccentric design concept was related to it, i.e. Donald was recognisable as a duck whether he wore a sailor's suit or khaki togs and a pith helmet!

### SPECIFIC CONTINUITY

Whether a cartoon was based on a specific and well known fairytale or story, or was based on a sequence of improvised sight gags, it had a logical continuity even within a madcap scenario. This was achieved by prioritising character and context.

For example, [ . . . ] Disney's Goofy was given an establishing premise for a following sequence of gags—most often his perpetual attempts to succeed at a task and his consistent failure. He is thus contextualised in the continuing imperative to complete the task, but simultaneously creating slapstick comedy through his failure. Further, and most important, he creates sympathy for, and understanding of, the fundamental aspects of his character, the chief bonding agent in the scenario.

## NARRATIVE FORM

It is important to stress the importance of narrative form. Most early cartoons echoed or illustrated the musical forms of their soundtracks. This provided proto-narrative before particular scenarios were later developed. These were most often based on character conflict and chase sequences, where common environments became increasingly destabilised as they became subject to destructive forces. However notional, the idea of "a story" was essentially held in place by the "specific continuity" of establishing a situation, problematising it, creating comic events and finding a resolution, mainly through the actions of the principal character that the audience had been encouraged to support and sympathise with throughout.

## EVOLUTION OF CONTENT

The orthodox cartoon only occasionally draws the audience's attention to its construction, especially in the case of the Disney hyper-realist text. Rarely also does it tell the audience of its interest in the colour, design and material of its making. Instead, it prioritises its content, concentrating specifically on constructing character, determining comic moments and evolving the self-contained narrative. This is not to say that the colour, design and so forth are irrelevant, but that they constitute a particular kind of style which merely reinforces the "cartoon-ness" of the animation and, thus, the "invisibility" of its aesthetic achievement and its industrial context.

## UNITY OF STYLE

The formal properties of the animated cartoon tend to remain consistent. Cel–animated or hand-drawn cartoons remain in a fixed two-dimensional style throughout their duration and do not mix with three-dimensional modes as later, more experimental, animation does. Visual conventions echo those of live-action cinema in the "hyper-realist" sense, deploying establishing shots, medium shots and close-ups etc., but camera movement tends to be limited to lateral left-to-right pans across the backgrounds or up-and-down tilts examining a character or environment. One consequence of camera movement across a drawing, though, can be the illusion of a change of perspective or angle to facilitate an unusual context for the character. This often happens; for example, when Wile E Coyote chases Road Runner and finds himself in an impossible predicament. An apparently safe rock formation suddenly presents itself at an impossible angle and becomes a dangerous landscape that defeats him once more. Narrative and design conventions like these inform most cartoons which mainly operate on the basis of a repeated formula—one of the most obvious of these is the chase.

The chase informs the pace of these narratives, privileging speed and frenetic action and creates its own action abstraction conventions, like visible movement lines around moving limbs and the blur of fast-moving bodies. Sound conventions (like "the crash" or "the boing" or the ascending and descending scale), orthodox cinematic conventions (like the cut, dissolve, use of ellipse etc.) and even conventions unique to the animated form (like "metamorphosis"), do not disrupt the unity of style and, despite using all these conventions, colour, scenic design, and character formation, tend to remain consistent.

## ABSENCE OF ARTIST

The early development of the cartoon form was characterised by an overtly signified tension between animation and its relationship to live-action. This resulted on many occasions in films combining animation and live-action, often depicting the creation of an animated character by the artist who drew it, and the activities of the animated character within the working environment of the artist. Clearly, these early efforts foreground the art of animation as an artist-led activity with a distinctive language—the Fleischer brothers enabled Koko the Clown to emerge "Out of the Inkwell" into the real world, while Disney's early work reversed the process, and showed "Alice" in an animated environment. Many of these imaginative initiatives were simply extensions of the work of the pioneers, who reconciled the idea of the live-action "lightning cartoonist" with the capacity of the medium to record and ultimately show the evolution of the cartoon itself. With the emergence of the industrial cel-animation process, the role and presence of the artist was essentially removed and, consequently, cartoons/orthodox animation prioritised narrative, character and style, rarely privileging the signification of their creation, unless as a system to create jokes (see the following analysis of Chuck Jones' *Duck Amuck* [1953]). Later cartoon animation but, most specifically, more personal "auteurist" animation, does signal its codes and conventions and thus reveals the presence of the individual artist in creating the work. Also, the reclamation and recognition of specific artists working at Disney, for example, Vlad Tytla and Warner Brothers, for example, Tex Avery and Frank Tashlin, have enabled interested viewers to relocate the artist in apparently conventional cartoons. For the purposes of this discussion, though, such initiatives will be used more in regard to the thematic or stylistic influence achieved by the artist, rather than as a mechanism by which the cartoon can be seen as an overtly personal film which obviously challenges the general criteria for orthodox animation defined here.

These general principles remain consistent even when the contributions of individual artists are acknowledged because the creation and perpetuation of a studio "style" became more important than those who created it.

## DYNAMICS OF DIALOGUE

Even though the fundamental appeal of the cartoon lies in its commitment to action, character is often defined by key aspects of dialogue. Disney's use of dialogue tends to initiate action or be used in moments of admonishment or conflict, chiefly when Mickey disciplines Pluto, or Donald rails against the world, but joke-orientated

dialogue was a particular feature of the characters created at Warner Brothers Studio for the "Looney Tunes" and "Merrie Melodies" cartoons. Bugs Bunny's laconic sense of superiority is established by his carrot-munching proposition, "What's up, doc?," or his call-to-arms when his current adversary temporarily gains the upper hand and he confirms: "You realise, this means war!"

Specifically based on the verbal dexterity and confident delivery of Groucho Marx, Bugs also qualifies any minor error in his plans by claiming: "I should have taken the right turn at Albuquerque!" Equally, Daffy is characterised by his consistent babble, arrested only when he has experienced complete humiliation and lispily claims "You're despicable!" Elmer Fudd always insists on quiet as he hunts "wabbits," while Yosemite Sam overstates his position when he says "I'm seagoing Sam, the blood-thirstiest, shoot-em firstiest, doggone worstiest, buccaneer that's ever sailed the Spanish Main!" All these verbal dynamics served to support the visual jokes and create a specific kind of "noise" which is characteristic of these films. Philip Brophy suggests that the Disney soundtrack moves towards the *symphonic* while the Warner soundtrack embodies the *cacophonic*. The symphonic is informed by classical aspirations towards the poetic, balletic and operatic, while the cacophonic is more urban, industrialised, beat-based and explosive in its vocabulary (see Cholodenko, 1991: 67–113). The role of sound is crucial in the animated film.

## Case Study: Deconstructing the Cartoon

*Duck Amuck* (1953), directed by Chuck Jones at Warner Brothers Studio, though in a sense untypical of the kind of style and unity in orthodox animation described earlier, is the perfect example of a cartoon subject to its own deconstruction. As Richard Thompson points out:

> It is at once a laff riot and an essay by demonstration on the nature and conditions of the animated film (from the inside) and the mechanics of film in general. (Even a quick checklist of film grammar is tossed in via the "Gimme a close-up" gag). (Thompson, 1980: 231)

Daffy Duck begins the cartoon believing himself to be in a musketeer picture and swashbuckles with due aplomb until he realises that he is not accompanied by suitable scenery. He immediately recognises that he has been deserted by the context both he, and we as the audience, are accustomed to.

He drops the character he is playing and becomes Daffy, the betrayed actor, who immediately addresses the camera, acknowledging both the animator and the audience. Perceiving himself as an actor as real as any in any live-action movie, he localises himself within the film-making process, and signals its creative and industrial mechanisms, all of which are about to be revealed to the audience.

Trooper that he is, Daffy carries on, adapting to the new farmyard scenery with a spirited version of "Old Macdonald had a farm" before adjusting once again to the arctic layout that has replaced the farmyard. The cartoon constantly draws attention to the relationship between foreground and background, and principally to the relationship between the character and the motivating aspects of the environmental context. Daffy's actions are determined by his comprehension of the space he inhabits. These tensions inform the basic narrative process of most cartoons. All

Daffy wants is for the animator to make up his mind! Each environment is illustrated by the visual shorthand of dominant cultural images—the Arctic is signified by an igloo, Hawaii by Daffy's grass skirt and banjo. The white space, however, becomes the empty context of the cartoon. Daffy is then erased by an animated pencil rubber and essentially only remains as a voice, but, as Chuck Jones has pointed out, "what I want to say is that Daffy can live and struggle on in an empty screen, without setting and without sound, just as well as with a lot of arbitrary props. He remains Daffy Duck." (Peary and Peary, 1980: 233)

This draws attention to the pre-determined understanding of Daffy as a character, and the notion that a whole character can be understood by any one of its parts. Daffy can be understood through his iconic elements, both visually and aurally. No visual aspects of Daffy need to be seen for an audience to know him through his lisping voice, characterised by Mel Blanc. We need only see his manic eyes or particularly upturned beak to distinguish him from Donald Duck and all other cartoon characters, all of which have similar unique and distinguishing dimensions in their design.

At the point when Daffy asks "Where am I?," even in his absence, the audience knows of his presence. When he is re-painted by the anonymous brush as a singing cowboy we anticipate, of course, that Daffy will sing, though the genre probably prohibits him singing "I'm just wild about Harry," which remains one of his favourites! Initially, Daffy experiences no sound and in post-Avery style, holds up a small sign requesting "Sound please," thus drawing the audience's attention to the explicit vocabulary of sound necessitated by the cartoon form, and one immediately familiar to the anticipated viewer. When Daffy attempts to play the guitar it sounds first like a machine gun, then a horn, then a donkey, which simultaneously shows the necessity of sound and image synchronisation for narrative and hyper-realist orthodoxy and the creation of comedy through the incongruous mismatching of sound and image. This is developed after Daffy breaks the guitar in frustration—a standard element of the cartoon is the process of destruction—and attempts to complain to the animator about his treatment, especially as he considers himself "a star." He is given the voice of a chicken and a cockatoo, and just when he is at his most hysterical with the attempt to speak, he is allowed his own voice, but at increased volume. Daffy is visibly humiliated and his attitude once again reveals to an audience his helplessness in the face of the power of the animator. The animator is at liberty to completely manipulate the image and create impossible and dynamic relations which need not have any connection with orthodox and anticipated relations.

This manipulation of Daffy's image and identity also tells an audience about his essential character traits—egotism, ambition, frustration, anger and willfulness. These traits are constantly challenged in most of the narratives involving Daffy by the resistance offered up by the world around him. In *Duck Amuck*, he is also defeated by the context he exists within. He pleads with the animator for orthodoxy and is greeted with a child's pencil drawing for a background, slapdash scenery painting and an absurd reconstruction of his own body in wild colours and a flag tied to his newly drawn tail indicating that he is a "screwball." Ironically, it is at this point that Daffy is arguing for Disneyesque hyper-realism in regard to the need for a linear narrative and consistency in the design of character and environment but, clearly, the condition of the cartoon here remains subject to the animator's desire to destabilise these orthodoxies.

Despite protestations that he has fulfilled his contract, Daffy continues to be treated with contempt. Just when he seems granted the legitimacy of "a sea picture"—an obvious reference to both Donald Duck and Popeye—Daffy is subjected to further humiliation. Jones self-consciously addresses the capacity of the cartoon to both disrupt orthodox hyper-realist conventions *and* enjoy predictable conventions that are a standard part of the cartoon vocabulary. For example, like Mutt in *Soda Jerks*, and hundreds of other cartoons, Daffy is suspended in mid-air, recognises that he is temporarily defying gravity, and drops into the sea as soon as he has realised. Seconds later he is on an island, but the image is merely a small frame within the normal frame, this time drawing the audience's attention to the compositional elements of the cartoon, and indeed, of film language itself. The audience can hardly hear Daffy as he calls for a close-up. He is then rapidly animated into an apparent close-up, as the frame fills only with Daffy's eyes.

Jones, once again, calls upon the audience's recognition of the frame as a potentially three-dimensional space as Daffy tries to cope with the sheer materiality of that physical space when he tries to support the black scenery that falls upon him like a heavy awning. He eventually tears up the "screen" in sheer frustration, and demands that the cartoon start even though it has already been running for several minutes. A screen card stating "The End" comes up accompanied by the Merrie Melodies theme. Whatever Daffy expects, or wishes to experience, he is countered by its opposite. Like a true professional, and in an apparently independent act that attempts to defy and refute the conditions to which he has been subjected, Daffy then attempts to take control of the film. He returns to the key notion of himself as an entertainer outside the context of a cartoon and performs a vaudevillian soft-shoe shuffle. He is, however, trying to reclaim the idea of the cartoon as a medium for entertainment. All this, of course, is another method by which Jones can establish further premises to deconstruct the cartoon. Daffy's song and dance routine is interrupted by the apparent slippage of the frame of film in the projector. It appears to divide the screen in half and exposes the celluloid frames of which the film is supposedly composed. The two frames, of course, reveal two Daffys, who immediately start to fight and disappear in a blur of drawn lines—the fight merely becomes a signifier of cartoon movement; a symbol of kineticism unique in embodying character and signifying form.

Narrative life improves for Daffy as "the picture" casts him as a pilot. This is merely another device, however, to demonstrate a series of conventional cartoon gags, including an off-screen air crash, the fall, the appearance of the ubiquitous anvil as a substitute for Daffy's parachute, and an explosion as Daffy tests some shells with a mallet. By this time, however, he is a gibbering heap, devoid of dignity or control, the two chief qualities Daffy most aspires to. As he tries to assert himself one last time, Daffy demands to know "Who is responsible for this? I demand that you show yourself!" The frame, as the audience perceives it, is then completely broken as the scene changes and the camera pulls back to reveal the drawing board and "the animator"—Bugs Bunny, Daffy's arch-rival. As Thompson remarks, "*Duck Amuck* can be seen as Daffy's bad trip; his self-destruction fantasies and delusions, with their rapid, unpredictable, disconcerting changes of scene and orientation, are the final extension of ego-on-the-line dreams" (Peary and Peary, 1980: 233). This is an important point in a number of respects. It locates Daffy as a character in his

own right, the subject of a relationship between form and meaning. In *Duck Amuck*, Jones demonstrates the dimensions of the animated form and shows its capacity to support a number of meanings, particularly with regard to character construction, modes of narrative expectation and plausibility, and the conditions of comic events. It is a model which usefully reveals the range of possibilities within the animated cartoon and, as such, the readily identifiable conventions of orthodox animation. These aspects will be interrogated further when placed in a different context of enquiry later but, in order to clarify the meaning of orthodox animation it is important to define and illustrate experimental animation as its antithesis.

Experimental animation embraces a number of styles and approaches to the animated film which inevitably cross over into areas which may also be termed *avant-garde* or "art" films (see Wees, 1992), which may only partially display aspects of animation in the form I have previously discussed. Of course, there has been experimentation in all areas of animation, as is clearly demonstrated by a cartoon as apparently orthodox as *Duck Amuck*, but in this area I am prioritising animation which has either been constituted in new forms (computer, xerox, sand-on-glass, direct on to celluloid, pinscreen, etc.) or resists traditional forms. The dominant aspects of experimental animation listed in the table on p. 215, provide useful criteria for further analysis.

## *Terms and Conditions: Experimental Animation*

### ABSTRACTION

This kind of animation tends to resist configuration in the way audiences most often see it (i.e. as an expression of character through the depiction of a human being or creature). Experimental animation either redefines "the body" or resists using it as an illustrative image. Abstract films are more concerned with rhythm and movement in their own right as opposed to the rhythm and movement of a particular character. To this end, various shapes and forms are often used rather than figures. As historian, William Moritz, suggests:

> Non-objective animation is without doubt the purest and most difficult form of animation. Anyone can learn to "muybridge" the illusion of representational life, but inventing interesting forms, shapes and colours, creating new, imaginative and expressive motions—"the absolute creation: the true creation" as Fischinger termed it—requires the highest mental and spiritual faculties, as well as the most sensitive talents of hand.

### SPECIFIC NON-CONTINUITY

While initially seeming a contradiction in terms, the idea of specific non-continuity merely signals the rejection of logical and linear continuity and the prioritisation of illogical, irrational and sometimes multiple continuities. These continuities are specific in the sense that they are the vocabulary unique to the particular animation in question. Experimental animation defines its own form and conditions and uses these as its distinctive language.

## INTERPRETIVE FORM

The bias of experimental animation is aesthetic and non-narrative, though sometimes, as I will illustrate, aesthetic conventions are deployed to reconstruct a different conception of narrative. Predominantly, though, experimental animation resists telling stories and moves towards the vocabulary used by painters and sculptors. Resisting the depiction of conventional forms and the assumed "objectivity" of the exterior world (and indeed, the conditions of hyper-realist animation), experimental animation prioritises abstract forms in motion, liberating the artist to concentrate on the vocabulary he/she is using *in itself* without the imperative of giving it a specific function or meaning.

This kind of subjective work has therefore necessitated that audiences respond differently. Instead of being located within the familiarity of formal narrative strategies (however illogical they are made by the inclusion of comic events), the audience are required to interpret the work on their own terms, or terms predetermined by the artist. As William Moritz insists, though, these acts of interpretation should not be inhibited by trying to force the abstraction to directly equate with some known quantity or meaning. He says:

> The true abstraction and the true symbol must have an intriguing spirit and integrity of its own, and it must suggest more meanings, various, almost contradictory depths and speculations beyond the surface value; otherwise, why bother to obfuscate? If the viewer comes to the point of saying, "Oh, that represents the police and that represents freedom," then that revelation is about as interesting as, "Gee, Donald Duck drives a car and mows his lawn just like an average American; he must represent the average irascible American!" (Moritz, 1988: 29)

Moritz, in determining the necessary requirements for the truly abstract film, and the role of its audience, simultaneously distinguishes the kind of film which, in my analysis, would constitute developmental animation in the sense that it would be deliberately using animation in a directly metaphoric way and not working in the realms of the purely abstract.

## EVOLUTION OF MATERIALITY

The experimental film concentrates on its very materiality, i.e. the forms in which it is being made, and the colours, shapes and textures which are being used in the creation of the piece. These colours, shapes and textures evoke certain moods and ideas but, once again, film-makers working in this way are suggesting that these aspects should give pleasure in their own right without having to be attached to a specific meaning or framework.

Experimental animation thus privileges the literal evolution of materiality instead of narrative and thematic content, showing us, for example, how a small handpainted dot evolves into a set of circles, where the audience recognises the physical nature of the paint itself, the colour of the dot and its background, and the shapes that emerge out of the initial design.

This sense of "materiality" goes hand-in-hand with the emergent technologies which have liberated more innovative approaches to animation.

## MULTIPLE STYLES

If orthodox animation is characterised by a unity of style, experimental animation often combines and mixes different modes of animation. This operates in two specific ways—first, to facilitate the multiplicity of personal visions an artist may wish to incorporate in a film, and second, to challenge and re-work orthodox codes and conventions and create new effects.

## PRESENCE OF THE ARTIST

These films are largely personal, subjective, original responses, which are the work of artists seeking to use the animated form in an innovative way.

Sometimes these "visions" are impenetrable and resist easy interpretation, being merely the absolutely individual expression of the artist. This in itself draws attention to the relationship between the artist and the work, and the relationship of the audience to the artist as it is being mediated through the work. The abstract nature of the films insists upon the recognition of their individuality. Sometimes, however, individual innovation is localised in more accessible ways which have a relationship with dominant forms, however tenuous the link. It may be, for example, that the experimental animation will try to create something aspiring to the condition of the dream-state, which, of course, has its own abstract logic, but conforms to a common understanding of "the dream," and thus may be subject to scrutiny through psychoanalysis. It is often the case that experimental animation is closely related to philosophic and spiritual concerns and seeks to represent inarticulable personal feelings beyond the orthodoxies of language.

## DYNAMICS OF MUSICALITY

Experimental animation has a strong relationship to music and, indeed, it may be suggested that if music could be visualised it would look like colours and shapes moving through time with differing rhythms, movements and speeds. Many experimental films seek to create this state, and as I have already suggested, some film-makers perceive that there is a psychological and emotional relationship with sound and colour which may be expressed through the free form which characterises animation. Sound is important in any animated film, but has particular resonance in the experimental film, as it is often resisting dialogue, the clichéd sound effects of the cartoon, or the easy emotiveness of certain kinds of music.

Silence, an *avant-garde* score, unusual sounds and redefined notions of "language" are used to create different kinds of statement. It may be said that if orthodox animation is about "prose," then experimental animation is more "poetic" and suggestive in its intention.

## *Case Study: Non-objective and Non-linear Animation*

### A *COLOUR BOX* (1935)

Len Lye's *A Colour Box,* is a completely abstract film in that it is created with lines and shapes stencilled directly on to celluloid, changing colour and form throughout its five-minute duration. It has dominant lines throughout with various circles,

triangles and grids interrupting and temporarily joining the image, until it reveals its sponsors, the GPO film unit, by including various rates for the parcel post (i.e. 3lbs for 6d, 6lbs for 9d etc.). Interestingly, the addition of the parcel post rates define the film as an advertising film, but its image system requires further interpretation. Films like *A Colour Box*, raise questions about purpose and intention which the glib coda of merely including obvious signs (i.e. numbers and letters) do not answer. It would appear that the film is more *about* the relationship between the artist and modes of expression than what is ultimately expressed.

The genuine abstraction within the film serves to provoke viewers, who must find "sense" in the imagery on a personal level, perhaps by association, perhaps by empathy with the rhythm of the piece or perhaps by something altogether more personal. Listeners have little trouble with the "abstraction" of music in this way: viewers must find their own relationship with imagery and its determinate meanings on their own terms.

## BIBLIOGRAPHY

Cholodenko, A. (ed.) (1991). *The Illusion of Life*. Sydney: Power Publications & The Australian Film Commission.

Moritz, W. (1988). "Some observations on non-objective and non-linear animation." In Canemaker (ed.) (1988) *Storytelling in Animation*. Los Angeles: AFI.

Peary, D. and Peary, G. (eds) (1980). *The American Animated Cartoon: A Critical Anthology*. New York: E.P. Dutton.

Thompson, R. (1980). "Pronoun trouble." In Peary, D. and Peary, G. (eds) *The American Animated Cartoon: A Critical Anthology*. New York: E.P. Dutton. 226–234.

Wees, W. (1992). *Light Moving in Time*. Berkeley: University of California Press.

# PART 3
# MODERNISM AND REALISM: DEBATES IN CLASSICAL FILM THEORY

*For viewers attention: This film presents an experiment in the cinematic communication of visible events. Without the aid of intertitles. (A film without intertitles.) Without the aid of a scenario. (A film without a scenario.) Without the aid of theater. (A film without sets, actors, etc.) This experimental work aims at creating a truly international absolute language of cinema based on its total separation from the language of theater and literature.*

Opening text from Dziga Vertov's *The Man with a Movie Camera* (1929), translated from Russian

Historically, modernity is characterized by broad changes in communications, population, production, consumption, and even human perception. Accompanying Western nations' rapid economic expansion through exploration and colonization in the early modern period (roughly from 1485 to 1660), faith in scientific progress and new ideas of democracy and humanism replaced older, religious worldviews. Visuality was central to the modern ethos in the sciences and in the arts, as evidenced by the emphasis placed on

direct observation of the world and the centrality of the human eye in Renaissance perspectival painting. In a sense, "man" (rather than God) became surveyor and possessor of all he could see. By the mid-nineteenth century, the invention of photography, and the world's fairs that presented spectacles of progress in London, Paris, and Chicago among other cities, confirmed the important role of visual culture.

The invention of cinema was part of these vast and convulsive social changes. Rapid industrialization and urbanization brought all kinds of people into contact with each other and with new technologies of labor and leisure. By the dawn of the twentieth century, the public consumption of moving images (with accompanying music adding to the sensory stimulus) became a way for audiences to make sense of a world that both celebrated human ingenuity and dissolved the individual into the mass. Perceptions of space and time, altered by such recent inventions as the railroad and the telegraph as well as by the speed and jumble of city life, were further transformed by the movies' rapidly changing images.

Although it was produced somewhat later in the evolution of the language of cinema, Dziga Vertov's *The Man with a Movie Camera* (1929), with its kaleidoscopic view of a day in the life of the modern city, is perhaps the movies' best representation of the frenetic pace and experience of early twentieth-century modernity. The cameraman of the title renders what Vertov calls "reality caught unawares" through the mechanical, truthful eye of his movie camera, and though the opening text boasts of the film's lack of script, the film does not shun cinematic technique in its observation of reality. Rapid montage links the shots; surprising sights of modern life from multiple cities convey a strong sense of documentary realism — there is even a scene of actual childbirth (albeit shot in fast motion). However, it is the self-reflexive representation of the filmmaking process itself—the editor and even the finished film's projection and scoring are shown onscreen—that is most memorably conveyed in this remarkable achievement of cinematic modernism.

The new ways of rendering and representing the changing reality that accompanied modernity are the subject of each of the essays in this section. Modernism forever changed the traditional art forms and ways of encountering art. Writers such as James Joyce and Virginia Woolf, painters such as Pablo Picasso and Salvador Dali, as well as composers, architects, and dancers of the time attempted to give aesthetic expression to the experience of modernity by emulating the fragmented patterns and pulses of the machine age and incorporating the streamlined forms of industry and transportation.

Arguably, photography and cinema possessed a special and even intrinsic relationship with modernity. In "The Work of Art in the Age of Its Technological Reproducibility," a seminal essay that we include here in its second, newly translated version, WALTER BENJAMIN, one of the most influential theorists of modernity, sees the inception of photography and cinema as revolutionizing the very concept of art: not only do they make use of the machines and technology of mass production, but they also address the masses rather than the privileged connoisseur of traditional art. According to Benjamin, the reproducibility of art renders the ideas of genius, eternal value, and mystery obsolete because there is no longer an original artwork or unique act of artistic expression or contemplation. Instead art in the age of technological reproducibility grapples with the realities of modern life and the democratic urge to "bring things closer." Benjamin's interest in mass culture and perceptual changes was shared by other theorists associated with the Frankfurt School, including his contemporary Siegfried Kracauer (p. 289), discussed below.

American mass culture—especially such physical genres as slapstick comedy or "serial queen" dramas—captured the imagination of worldwide audiences and served as an important inspiration for European modernists. By the 1910s and 1920s, modernist experimentation was incorporated directly into cinema by avant-garde filmmakers, and writers and theorists in France, Germany, and the Soviet Union began to explore cinema's unique relationship to the modern. Writing amid the first flowering of film culture in France in the 1920s, filmmaker JEAN EPSTEIN elaborates on the idea of *photogénie*—a term originally coined by pioneering film journalist Louis Delluc that describes the quality certain objects have that lends them to being filmed—in his essay "*Photogénie* and the Imponderable." Capable of magnifying the minute, capturing the crowd, speeding up natural processes, or slowing down actions, the movies were at once a scientific and an artistic wonder, and Epstein celebrates the otherwise imperceptible and thus unthinkable aspects of our world revealed by the motion-picture camera.

Avant-garde filmmakers across Europe explored new relations of space, time, and the politics of art, in one sense departing from realism with formal technique and in another enhancing it, probing what the fallible human eye cannot grasp. The Soviets considered cinema central to their new revolutionary society for its ability to reach each audience member with an unprecedented immediacy—urban workers, cultured classes, and illiterate peasants alike. Soviet filmmakers and theorists especially championed montage, cutting their films to shape space and time in a way that reproduced the shocks of modern life (see Kuleshov in Part 2). Besides making newsreels and documentary films like *The Man with a Movie Camera* with the Kino-Eye (Kinok) collective, DZIGA VERTOV produced manifestos and other experimental writings on cinema that championed the medium's realism by severing all connections to literary and theatrical influences. In "Film Directors: A Revolution," he even impersonates a machine: "I am the cinema-eye. I am a mechanical eye. I, a machine, can show you the world as only I can see it. . . . And this is how I can decipher anew a world unknown to you." His words convey an extreme view of the power of machines to transform perceptions of reality. While Vertov wrote in the context of a communist revolution, similar views were used to champion modern warfare in the writings of the Italian Futurists, allowing us to question whether there is any inherent connection between the new mechanical capacity to reveal the world and the meaning of such images.

The best known and most prolific of the filmmaker/theorists who shaped the Soviet montage school was SERGEI EISENSTEIN, who embraced fiction filmmaking over documentary. In "The Dramaturgy of Film Form," Eisenstein explains that for him, montage is based on conflict. He believes in the Marxist idea of dialectics—oppositional ideas synthesized into something new—as the basis for juxtaposing two montage elements (two shots, two aspects of a single shot, or sound and image) in a manner that can be transformed by the viewer's experience into something greater and more powerful.

Eisenstein's films, when they were first exhibited in Berlin, made a deep impression on Benjamin, Kraucauer, and Rudolf Arnheim. These German Jewish intellectuals were inspired to write on the modern mass media during the Weimar period before fleeing the Nazi regime. RUDOLF ARNHEIM was primarily interested in perception and aesthetics; in 1932 he published in German one of the first book-length studies of the film medium, from which "Film and Reality" is drawn. Confronted by the introduction of sound, and with it the capacity for both a heightened cinematic realism and a reduction of visual dynamism,

Arnheim explores the specific dimensions of film as an art form (including those of the film frame itself). For Arnheim, film's drive to reproduce the world deflects from what is unique to the medium's aesthetic and perceptual impact.

SIEGFRIED KRACAUER began writing about film and mass culture during the Weimar period, but his major books were written after the war when he had settled in the United States. In *From Caligari to Hitler: A Psychological History of the German Film* (1947), Kracauer explores parallels between the dark themes of German Expressionist film and the rise of fascism. In *Theory of Film: The Redemption of Physical Reality* (1960), Kracauer is a forceful advocate of cinematic realism, asserting that "films may claim aesthetic validity if . . . they record and reveal physical existence." Kracauer makes an influential distinction between the two general directions of filmmaking that were present from the earliest days of the medium: a realistic one typified by the slice-of-life films of the Lumière brothers, and a "formative" (or formalist) one, exemplified in the trick films of Georges Méliès. Interestingly, this distinction has often been extended and applied to the prominent positions in classical film theory itself. Realists like Kracauer locate the medium's specificity in its reliance on photography and duration; formalists like Eisenstein champion devices like montage. Although this is a meaningful framing of a key debate, overemphasizing the distinction between realists and formalists can obscure the ways these thinkers were responding to different aspects of the same capacity of film to mediate a changing reality. In this text we historicize this debate within the wider context of modernity and modernism.

Most influential and lucid in outlining the differences within dominant positions on film's relationship to reality is the French critic ANDRÉ BAZIN. In essays from the 1940s and 1950s posthumously collected in two volumes called *What Is Cinema?* Bazin explored many aspects of cinema's ontology (the study of the nature of existence). In "The Ontology of the Photographic Image," Bazin uncovers in the history of art a "mummy complex," a human drive to defend against death and the passage of time. He sees in cinema the ability to preserve not only image but duration. In "The Evolution of the Language of Cinema," Bazin makes an aesthetic distinction, not between silent- and sound-era films, but rather between "those directors who put their faith in the image and those who put their faith in reality." Bazin favors the latter, explicitly contesting Eisenstein's claim that the essence of cinema is to be found in montage. Technological innovations in deep-focus cinematography such as new lenses and film stocks, showcased by the long takes of William Wyler, Orson Welles, and Roberto Rossellini, served this "faith" by leaving the time and space of the film's action, and the world it references, intact.

Writing in the immediate wake of World War II, champions of film's capacity for realism like Kracauer and Bazin reflected on the destructive capacity of modernity, valuing the cinema's abilities to reflect and preserve everyday experience. Present-day theorists considering the legacies of artistic modernism (which were renewed in much political filmmaking of the 1960s and 1970s and in corresponding debates in film theory) have renewed interest in these writings and their relationship to Benjamin's understanding of the sensory and perceptual transformations effected by modern life and mass culture. In "The Mass Production of the Senses," the final reading in this section, MIRIAM HANSEN builds on Benjamin's ideas. She urges a rethinking of the mostly unquestioned concept of "classical cinema" in light of the recognition that however much cinema might strive to mimic the arts from previous historical periods—the realism and narrative structure of the novel, say,

or the moral lessons of tragedy—its mechanical means of production, its mass circulation, and the visceral way it is perceived make it modern—even modernist—at its core. Hansen also reminds us that movies made in the Hollywood studio system of the mid-twentieth century, and even the special-effects-driven films that dominate today, reflect the sensory saturation of everyday modern life. She thus displaces another opposition, that between classicism and modernism, that has structured film studies.

*The Man with a Movie Camera* (1929) vividly brings to life the ideas of Benjamin and the other theorists of modernity. In its emphasis on the recording of a fleeting reality through mechanical means, it raises questions of film's realist mandate. The film's intrepid camera-man lies down on the tracks to capture the shock of an oncoming train; the film's editing transmits this shock to us. Through rapid montage, a day in the life of the metropolis is intermixed with the making of a film, from shooting to screening in a theater. The energies of inanimate objects and people are juxtaposed; the movie camera itself performs a dance. A priceless documentation of actual people, places, and gestures from the height of 1920s urban mass society, the film shows filmmaking as an intervention in the world and depicts the movie audience as active participants in making sense of modern reality.

# WALTER BENJAMIN

# The Work of Art in the Age of Its Technological Reproducibility (Second Version)

Considered by many to be the most important German critic of the twentieth century, Walter Benjamin (1892–1940) settled in Berlin before fleeing the Hitler regime in 1933. He committed suicide after the Nazis occupied France. He was associated with the Frankfurt School that included such notable philosophers and social critics as Theodor W. Adorno and Max Horkheimer (p. 1015), Erich Fromm, and Herbert Marcuse. Faced with rising fears about fascism in Germany, Benjamin and his Frankfurt colleagues held out hope for a Marxist transformation of society, especially as that transformation might be accomplished through cultural experiences found in art, music, and the movies.

During the 1920s and 1930s, film practice and culture changed in three significant ways that inform this essay. The introduction of synchronous sound in 1927 added a new dimension to film's realism and indirectly helped to secure Hollywood's powerful studio and star system and its eventual global economic and cultural dominance. In Europe, German Expressionist films and various avant-garde cinemas asked audiences for more active involvement and response. Perhaps most important for Benjamin's essay, the Soviet cinema of the 1920s introduced a radical conception of political cinema meant to "shock" audiences into knowledge and action. Together these pointed, for Benjamin, to the potential for a more powerful cinematic realism that could awaken film audiences to a new political consciousness.

Benjamin's "The Work of Art in the Age of Its Technological Reproducibility" is one of the most original and influential in the history of film criticism and theory. Although the English translation by Harry Zahn, published in *Illuminations* (1968) as "The Work of Art in the Age of Mechanical Reproduction," has been widely circulated and cited, this fresh translation of the essay's second version offers new insights into Benjamin's thought. When Benjamin's essay was first published in Germany in 1935, it highlighted a trend through the 1920s and 1930s (especially in Europe) to recognize and understand the movies, not just as entertainment, but also as cultural experiences that shape society and communicate powerful political and ideological values. In the essay, Benjamin argues that cinema has the technological ability to transform traditional art forms, such as paintings hanging on a museum wall, by overcoming the aesthetic distances that isolate art from the real world. Breaking down art's "aura," film could instead offer audiences a more immediate engagement with their everyday realities. Due to its emphasis on ideology and audience dynamics, this essay has remained an important touchstone for contemporary critics such as John Berger (p. 114) and Miriam Hasen (p. 325) who are similarly concerned with spectators and cultural values.

## READING CUES & KEY CONCEPTS

- How does technological reproducibility make, according to Benjamin, concepts such as "authenticity," "originality," and "aura" potentially obsolete?

- According to Benjamin, film's unique technological qualities demand audience participation; film spectators effectively become "critics" who "test" reality through the movies. Consider how this testing of reality might give film a revolutionary potential.

- Toward the end of the essay, Benjamin offers a suggestive but elusive summary of his new film audience: "Reception in distraction . . . finds in film its true training ground." In light of what you have read, how do you understand this phrase?

- **Key Concepts: Aura; Exhibition Value/Cult Value; Film Reception; Technological Reproducibility; Optical Unconscious; Distraction**

# The Work of Art in the Age of Its Technological Reproducibility (Second Version)

· · · · · · · · · · · · · · ·

*The true is what he can; the false is what he wants.*

Madame de Duras

## I

When Marx undertook his analysis of the capitalist mode of production, that mode was in its infancy. Marx adopted an approach which gave his investigations prognostic value. Going back to the basic conditions of capitalist production, he presented them in a way which showed what could be expected of capitalism in the

future. What could be expected, it emerged, was not only an increasingly harsh exploitation of the proletariat but, ultimately, the creation of conditions which would make it possible for capitalism to abolish itself.

Since the transformation of the superstructure proceeds far more slowly than that of the base, it has taken more than half a century for the change in the conditions of production to be manifested in all areas of culture. How this process has affected culture can only now be assessed, and these assessments must meet certain prognostic requirements. They do not, however, call for theses on the art of the proletariat after its seizure of power, and still less for any on the art of the classless society. They call for theses defining the tendencies of the development of art under the present conditions of production. The dialectic of these conditions of production is evident in the superstructure, no less than in the economy. Theses defining the developmental tendencies of art can therefore contribute to the political struggle in ways that it would be a mistake to underestimate. They neutralize a number of traditional concepts—such as creativity and genius, eternal value and mystery—which, used in an uncontrolled way (and controlling them is difficult today), allow factual material to be manipulated in the interests of fascism. *In what follows, the concepts which are introduced into the theory of art differ from those now current in that they are completely useless for the purposes of fascism. On the other hand, they are useful for the formulation of revolutionary demands in the politics of art [Kunstpolitik].*

## II

In principle, the work of art has always been reproducible. Objects made by humans could always be copied by humans. Replicas were made by pupils in practicing for their craft, by masters in disseminating their works, and, finally, by third parties in pursuit of profit. But the technological reproduction of artworks is something new. Having appeared intermittently in history, at widely spaced intervals, it is now being adopted with ever-increasing intensity. Graphic art was first made technologically reproducible by the woodcut, long before written language became reproducible by movable type. The enormous changes brought about in literature by movable type, the technological reproduction of writing, are well known. But they are only a special case, though an important one, of the phenomenon considered here from the perspective of world history. In the course of the Middle Ages the woodcut was supplemented by engraving and etching, and at the beginning of the nineteenth century by lithography.

Lithography marked a fundamentally new stage in the technology of reproduction. This much more direct process—distinguished by the fact that the drawing is traced on a stone, rather than incised on a block of wood or etched on a copper plate—first made it possible for graphic art to market its products not only in large numbers, as previously, but in daily changing variations. Lithography enabled graphic art to provide an illustrated accompaniment to everyday life. It began to keep pace with movable-type printing. But only a few decades after the invention of lithography, graphic art was surpassed by photography. For the first time, photography freed the hand from the most important artistic tasks in the process of pictorial reproduction—tasks that now devolved upon the eye alone. And since the eye perceives more swiftly than the hand can draw, the process of pictorial reproduction

was enormously accelerated, so that it could now keep pace with speech. Just as the illustrated newspaper virtually lay hidden within lithography, so the sound film was latent in photography. The technological reproduction of sound was tackled at the end of the last century. *Around 1900, technological reproduction not only had reached a standard that permitted it to reproduce all known works of art, profoundly modifying their effect, but it also had captured a place of its own among the artistic processes. In gauging this standard, we would do well to study the impact which its two different manifestations—the reproduction of artworks and the art of film—are having on art in its traditional form.*

## III

In even the most perfect reproduction, *one* thing is lacking: the here and now of the work of art—its unique existence in a particular place. It is this unique existence—and nothing else—that bears the mark of the history to which the work has been subject. This history includes changes to the physical structure of the work over time, together with any changes in ownership. Traces of the former can be detected only by chemical or physical analyses (which cannot be performed on a reproduction), while changes of ownership are part of a tradition which can be traced only from the standpoint of the original in its present location.

The here and now of the original underlies the concept of its authenticity, and on the latter in turn is founded the idea of a tradition which has passed the object down as the same, identical thing to the present day. *The whole sphere of authenticity eludes technological—and of course not only technological—reproduction.* But whereas the authentic work retains its full authority in the face of a reproduction made by hand, which it generally brands a forgery, this is not the case with technological reproduction. The reason is twofold. First, technological reproduction is more independent of the original than is manual reproduction. For example, in photography it can bring out aspects of the original that are accessible only to the lens (which is adjustable and can easily change viewpoint) but not to the human eye; or it can use certain processes, such as enlargement or slow motion, to record images which escape natural optics altogether. This is the first reason. Second, technological reproduction can place the copy of the original in situations which the original itself cannot attain. Above all, it enables the original to meet the recipient halfway, whether in the form of a photograph or in that of a gramophone record. The cathedral leaves its site to be received in the studio of an art lover; the choral work performed in an auditorium or in the open air is enjoyed in a private room.

These changed circumstances may leave the artwork's other properties untouched, but they certainly devalue the here and now of the artwork. And although this can apply not only to art but (say) to a landscape moving past the spectator in a film, in the work of art this process touches on a highly sensitive core, more vulnerable than that of any natural object. That core is its authenticity. The authenticity of a thing is the quintessence of all that is transmissible in it from its origin on, ranging from its physical duration to the historical testimony relating to it. Since the historical testimony is founded on the physical duration, the former, too, is jeopardized by reproduction, in which the physical duration plays no part. And what is really

jeopardized when the historical testimony is affected is the authority of the object, the weight it derives from tradition.

One might focus these aspects of the artwork in the concept of the aura, and go on to say: what withers in the age of the technological reproducibility of the work of art is the latter's aura. This process is symptomatic; its significance extends far beyond the realm of art. *It might be stated as a general formula that the technology of reproduction detaches the reproduced object from the sphere of tradition. By replicating the work many times over, it substitutes a mass existence for a unique existence. And in permitting the reproduction to reach the recipient in his or her own situation, it actualizes that which is reproduced.* These two processes lead to a massive upheaval in the domain of objects handed down from the past—a shattering of tradition which is the reverse side of the present crisis and renewal of humanity. Both processes are intimately related to the mass movements of our day. Their most powerful agent is film. The social significance of film, even—and especially—in its most positive form, is inconceivable without its destructive, cathartic side: the liquidation of the value of tradition in the cultural heritage. This phenomenon is most apparent in the great historical films. It is assimilating ever more advanced positions in its spread. When Abel Gance fervently proclaimed in 1927, "Shakespeare, Rembrandt, Beethoven will make films. . . . All legends, all mythologies, and all myths, all the founders of religions, indeed, all religions, . . . await their celluloid resurrection, and the heroes are pressing at the gates," he was inviting the reader, no doubt unawares, to witness a comprehensive liquidation.[1]

## IV

*Just as the entire mode of existence of human collectives changes over long historical periods, so too does their mode of perception.* The way in which human perception is organized—the medium in which it occurs—is conditioned not only by nature but by history. The era of the migration of peoples, an era which saw the rise of the late-Roman art industry and the Vienna Genesis, developed not only an art different from that of antiquity but also a different perception. The scholars of the Viennese school Riegl and Wickhoff, resisting the weight of the classical tradition beneath which this art had been buried, were the first to think of using such art to draw conclusions about the organization of perception at the time the art was produced. However far-reaching their insight, it was limited by the fact that these scholars were content to highlight the formal signature which characterized perception in late-Roman times. They did not attempt to show the social upheavals manifested in these changes in perception—and perhaps could not have hoped to do so at that time. Today, the conditions for an analogous insight are more favorable. And if changes in the medium of present-day perception can be understood as a decay of the aura, it is possible to demonstrate the social determinants of that decay.

What, then, is the aura? A strange tissue of space and time: the unique apparition of a distance, however near it may be. To follow with the eye—while resting on a summer afternoon—a mountain range on the horizon or a branch that casts its shadow on the beholder is to breathe the aura of those mountains, of that branch. In the light of this description, we can readily grasp the social basis of the aura's present decay. It rests on two circumstances, both linked to the increasing emergence of the masses and the growing intensity of their movements. Namely: *the desire of*

*the present-day masses to "get closer" to things, and their equally passionate concern for overcoming each thing's uniqueness [Überwindung des Einmaligen jeder Gegebenheit] by assimilating it as a reproduction.* Every day the urge grows stronger to get hold of an object at close range in an image [Bild], or, better, in a facsimile [Abbild], a reproduction. And the reproduction [Reproduktion], as offered by illustrated magazines and newsreels, differs unmistakably from the image. Uniqueness and permanence are as closely entwined in the latter as are transitoriness and repeatability in the former. The stripping of the veil from the object, the destruction of the aura, is the signature of a perception whose "sense for all that is the same in the world" has so increased that, by means of reproduction, it extracts sameness even from what is unique. Thus is manifested in the field of perception what in the theoretical sphere is noticeable in the increasing significance of statistics. The alignment of reality with the masses and of the masses with reality is a process of immeasurable importance for both thinking and perception.

# V

The uniqueness of the work of art is identical to its embeddedness in the context of tradition. Of course, this tradition itself is thoroughly alive and extremely changeable. An ancient statue of Venus, for instance, existed in a traditional context for the Greeks (who made it an object of worship) that was different from the context in which it existed for medieval clerics (who viewed it as a sinister idol). But what was equally evident to both was its uniqueness—that is, its aura. Originally, the embeddedness of an artwork in the context of tradition found expression in a cult. As we know, the earliest artworks originated in the service of rituals—first magical, then religious. And it is highly significant that the artwork's auratic mode of existence is never entirely severed from its ritual function. In other words: *the unique value of the "authentic" work of art always has its basis in ritual.* This ritualistic basis, however mediated it may be, is still recognizable as secularized ritual in even the most profane forms of the cult of beauty. The secular worship of beauty, which developed during the Renaissance and prevailed for three centuries, clearly displayed that ritualistic basis in its subsequent decline and in the first severe crisis which befell it. For when, with the advent of the first truly revolutionary means of reproduction (namely photography, which emerged at the same time as socialism), art felt the approach of that crisis which a century later has become unmistakable, it reacted with the doctrine of *l'art pour l'art*—that is, with a theology of art. This in turn gave rise to a negative theology, in the form of an idea of "pure" art, which rejects not only any social function but any definition in terms of a representational content. (In poetry, Mallarmé was the first to adopt this standpoint.)

No investigation of the work of art in the age of its technological reproducibility can overlook these connections. They lead to a crucial insight: for the first time in world history, technological reproducibility emancipates the work of art from its parasitic subservience to ritual. To an ever-increasing degree, the work reproduced becomes the reproduction of a work designed for reproducibility.[2] From a photographic plate, for example, one can make any number of prints; to ask for the "authentic" print makes no sense. *But as soon as the criterion of authenticity ceases to be applied to artistic production, the whole social function of art is revolutionized. Instead of being founded on ritual, it is based on a different practice: politics.*

# VI

Art history might be seen as the working out of a tension between two polarities within the artwork itself, its course being determined by shifts in the balance between the two. These two poles are the artwork's cult value and its exhibition value.[3] Artistic production begins with figures in the service of magic. What is important for these figures is that they are present, not that they are seen. The elk depicted by Stone Age man on the walls of his cave is an instrument of magic, and is exhibited to others only coincidentally; what matters is that the spirits see it. Cult value as such even tends to keep the artwork out of sight: certain statues of gods are accessible only to the priest in the cella; certain images of the Madonna remain covered nearly all year round; certain sculptures on medieval cathedrals are not visible to the viewer at ground level. *With the emancipation of specific artistic practices from the service of ritual, the opportunities for exhibiting their products increase.* It is easier to exhibit a portrait bust that can be sent here and there than to exhibit the statue of a divinity that has a fixed place in the interior of a temple. A panel painting can be exhibited more easily than the mosaic or fresco which preceded it. And although a mass may have been no less suited to public presentation than a symphony, the symphony came into being at a time when the possibility of such presentation promised to be greater.

The scope for exhibiting the work of art has increased so enormously with the various methods of technologically reproducing it that, as happened in prehistoric times, a quantitative shift between the two poles of the artwork has led to a qualitative transformation in its nature. Just as the work of art in prehistoric times, through the exclusive emphasis placed on its cult value, became first and foremost an instrument of magic which only later came to be recognized as a work of art, so today, through the exclusive emphasis placed on its exhibition value, the work of art becomes a construct [*Gebilde*] with quite new functions. Among these, the one we are conscious of—the artistic function— may subsequently be seen as incidental. This much is certain: today, film is the most serviceable vehicle of this new understanding. Certain, as well, is the fact that the historical moment of this change in the function of art—a change which is most fully evident in the case of film—allows a direct comparison with the primeval era of art not only from a methodological but also from a material point of view.

Prehistoric art made use of certain fixed notations in the service of magical practice. In some cases, these notations probably comprised the actual performing of magical acts (the carving of an ancestral figure is itself such an act); in others, they gave instructions for such procedures (the ancestral figure demonstrates a ritual posture); and in still others, they provided objects for magical contemplation (contemplation of an ancestral figure strengthens the occult powers of the beholder). The subjects for these notations were humans and their environment, which were depicted according to the requirements of a society whose technology existed only in fusion with ritual. Compared to that of the machine age, of course, this technology was undeveloped. But from a dialectical standpoint, the disparity is unimportant. What matters is the way the orientation and aims of that technology differ from those of ours. Whereas the former made the maximum possible use of human beings, the latter reduces their use to the minimum. The achievements of the first technology might be said to culminate in human sacrifice; those of the

second, in the remote-controlled aircraft which needs no human crew. The results of the first technology are valid once and for all (it deals with irreparable lapse or sacrificial death, which holds good for eternity). The results of the second are wholly provisional (it operates by means of experiments and endlessly varied test procedures). The origin of the second technology lies at the point where, by an unconscious ruse, human beings first began to distance themselves from nature. It lies, in other words, in play.

Seriousness and play, rigor and license, are mingled in every work of art, though in very different proportions. This implies that art is linked to both the second and the first technologies. It should be noted, however, that to describe the goal of the second technology as "mastery over nature" is highly questionable, since this implies viewing the second technology from the standpoint of the first. The first technology really sought to master nature, whereas the second aims rather at an interplay between nature and humanity. The primary social function of art today is to rehearse that interplay. This applies especially to film. *The function of film is to train human beings in the apperceptions and reactions needed to deal with a vast apparatus whose role in their lives is expanding almost daily.* Dealing with this apparatus also teaches them that technology will release them from their enslavement to the powers of the apparatus only when humanity's whole constitution has adapted itself to the new productive forces which the second technology has set free.[4]

## VII

*In photography, exhibition value begins to drive back cult value on all fronts.* But cult value does not give way without resistance. It falls back to a last entrenchment: the human countenance. It is no accident that the portrait is central to early photography. In the cult of remembrance of dead or absent loved ones, the cult value of the image finds its last refuge. In the fleeting expression of a human face, the aura beckons from early photographs for the last time. This is what gives them their melancholy and incomparable beauty. But as the human being withdraws from the photographic image, exhibition value for the first time shows its superiority to cult value. To have given this development its local habitation constitutes the unique significance of Atget, who, around 1900, took photographs of deserted Paris streets. It has justly been said that he photographed them like scenes of crimes. A crime scene, too, is deserted; it is photographed for the purpose of establishing evidence. With Atget, photographic records begin to be evidence in the historical trial [*Prozess*]. This constitutes their hidden political significance. They demand a specific kind of reception. Free-floating contemplation is no longer appropriate to them. They unsettle the viewer; he feels challenged to find a particular way to approach them. At the same time, illustrated magazines begin to put up signposts for him— whether these are right or wrong is irrelevant. For the first time, captions become obligatory. And it is clear that they have a character altogether different from the titles of paintings. The directives given by captions to those looking at images in illustrated magazines soon become even more precise and commanding in films, where the way each single image is understood seems prescribed by the sequence of all the preceding images.

## VIII

The Greeks had only two ways of technologically reproducing works of art: casting and stamping. Bronzes, terra cottas, and coins were the only artworks they could produce in large numbers. All others were unique and could not be technologically reproduced. That is why they had to be made for all eternity. *The state of their technology compelled the Greeks to produce eternal values in their art.* To this they owe their preeminent position in art history—the standard for subsequent generations. Undoubtedly, our position lies at the opposite pole from that of the Greeks. Never before have artworks been technologically reproducible to such a degree and in such quantities as today. Film is the first art form whose artistic character is entirely determined by its reproducibility. It would be idle to compare this form in detail with Greek art. But on one precise point such a comparison would be revealing. For film has given crucial importance to a quality of the artwork which would have been the last to find approval among the Greeks, or which they would have dismissed as marginal. This quality is its capacity for improvement. The finished film is the exact antithesis of a work created at a single stroke. It is assembled from a very large number of images and image sequences that offer an array of choices to the editor; these images, moreover, can be improved in any desired way in the process leading from the initial take to the final cut. To produce *A Woman of Paris*, which is 3,000 meters long, Chaplin shot 125,000 meters of film. *The film is therefore the artwork most capable of improvement. And this capability is linked to its radical renunciation of eternal value.* This is corroborated by the fact that for the Greeks, whose art depended on the production of eternal values, the pinnacle of all the arts was the form least capable of improvement—namely sculpture, whose products are literally all of a piece. In the age of the assembled [*montierbar*] artwork, the decline of sculpture is inevitable.

## IX

The nineteenth-century dispute over the relative artistic merits of painting and photography seems misguided and confused today. But this does not diminish its importance, and may even underscore it. The dispute was in fact an expression of a world-historical upheaval whose true nature was concealed from both parties. Insofar as the age of technological reproducibility separated art from its basis in cult, all semblance of art's autonomy disappeared forever. But the resulting change in the function of art lay beyond the horizon of the nineteenth century. And even the twentieth, which saw the development of film, was slow to perceive it.

   *Though commentators had earlier expended much fruitless ingenuity on the question of whether photography was an art—without asking the more fundamental question of whether the invention of photography had not transformed the entire character of art—film theorists quickly adopted the same ill-considered standpoint.* But the difficulties which photography caused for traditional aesthetics were child's play compared to those presented by film. Hence the obtuse and hyperbolic character of early film theory. Abel Gance, for instance, compares film to hieroglyphs: "By a remarkable regression, we are transported back to the expressive level of the Egyptians. . . . Pictorial language has not matured, because our eyes are not yet adapted to it. There is not yet enough respect, not enough *cult*, for what it expresses."[5] Or, in the words

of Séverin-Mars: "What other art has been granted a dream . . . at once more poetic and more real? Seen in this light, film might represent an incomparable means of expression, and only the noblest minds should move within its atmosphere, in the most perfect and mysterious moments of their lives."[6] It is instructive to see how the desire to annex film to "art" impels these theoreticians to attribute elements of cult to film—with a striking lack of discretion. Yet when these speculations were published, works like *A Woman of Paris* and *The Gold Rush* had already appeared. This did not deter Abel Gance from making the comparison with hieroglyphs, while Séverin-Mars speaks of film as one might speak of paintings by Fra Angelico. It is revealing that even today especially reactionary authors look in the same direction for the significance of film—finding, if not actually a sacred significance, then at least a supernatural one. In connection with Max Reinhardt's film version of *A Midsummer Night's Dream*, Werfel comments that it was undoubtedly the sterile copying of the external world—with its streets, interiors, railway stations, restaurants, automobiles, and beaches—that had prevented film up to now from ascending to the realm of art. "Film has not yet realized its true purpose, its real possibilities. . . . These consist in its unique ability to use natural means to give incomparably convincing expression to the fairylike, the marvelous, the supernatural."[7]

## X

To photograph a painting is one kind of reproduction, but to photograph an action performed in a film studio is another. In the first case, what is reproduced is a work of art, while the act of producing it is not. The cameraman's performance with the lens no more creates an artwork than a conductor's with the baton; at most, it creates an artistic performance. This is unlike the process in a film studio. Here, what is reproduced is not an artwork, and the act of reproducing it is no more such a work than in the first case. The work of art is produced only by means of montage. And each individual component of this montage is a reproduction of a process which neither is an artwork in itself nor gives rise to one through photography. What, then, are these processes reproduced in film, since they are certainly not works of art?

To answer this, we must start from the peculiar nature of the artistic performance of the film actor. He is distinguished from the stage actor in that his performance in its original form, from which the reproduction is made, is not carried out in front of a randomly composed audience but before a group of specialists—executive producer, director, cinematographer, sound recordist, lighting designer, and so on—who are in a position to intervene in his performance at any time. This aspect of filmmaking is highly significant in social terms. For the intervention in a performance by a body of experts is also characteristic of sporting performances and, in a wider sense, of all test performances. The entire process of film production is determined, in fact, by such intervention. As we know, many shots are filmed in a number of takes. A single cry for help, for example, can be recorded in several different versions. The editor then makes a selection from these; in a sense, he establishes one of them as the record. An action performed in the film studio therefore differs from the corresponding real action the way the competitive throwing of a discus in a sports arena would differ from the throwing of the same discus from the same spot in the same direction in order to kill someone. The first is a test performance, while the second is not.

The test performance of the film actor is, however, entirely unique in kind. In what does this performance consist? It consists in crossing a certain barrier which confines the social value of test performances within narrow limits. I am referring now not to a performance in the world of sports, but to a performance produced in a mechanized test. In a sense, the athlete is confronted only by natural tests. He measures himself against tasks set by nature, not by equipment—apart from exceptional cases like Nurmi, who was said to run against the clock. Meanwhile the work process, especially since it has been standardized by the assembly line, daily generates countless mechanized tests. These tests are performed unawares, and those who fail are excluded from the work process. But they are also conducted openly, in agencies for testing professional aptitude. In both cases, the test subject faces the barrier mentioned above.

These tests, unlike those in the world of sports, are incapable of being publicly exhibited to the degree one would desire. And this is precisely where film comes into play. *Film makes test performances capable of being exhibited, by turning that ability itself into a test.* The film actor performs not in front of an audience but in front of an apparatus. The film director occupies exactly the same position as the examiner in an aptitude test. To perform in the glare of arc lamps while simultaneously meeting the demands of the microphone is a test performance of the highest order. To accomplish it is to preserve one's humanity in the face of the apparatus. Interest in this performance is widespread. For the majority of city dwellers, throughout the workday in offices and factories, have to relinquish their humanity in the face of an apparatus. In the evening these same masses fill the cinemas, to witness the film actor taking revenge on their behalf not only by asserting *his* humanity (or what appears to them as such) against the apparatus, but by placing that apparatus in the service of his triumph.

## XI

In the case of film, the fact that the actor represents someone else before the audience matters much less than the fact that he represents himself before the apparatus. One of the first to sense this transformation of the actor by the test performance was Pirandello. That his remarks on the subject in his novel *Sigira* [Shoot!] are confined to the negative aspects of this change, and to silent film only, does little to diminish their relevance. For in this respect, the sound film changed nothing essential. What matters is that the actor is performing for a piece of equipment—or, in the case of sound film, for two pieces of equipment. "The film actor," Pirandello writes, "feels as if exiled. Exiled not only from the stage but from his own person. With a vague unease, he senses an inexplicable void, stemming from the fact that his body has lost its substance, that he has been volatilized, stripped of his reality, his life, his voice, the noises he makes when moving about, and has been turned into a mute image that flickers for a moment on the screen, then vanishes into silence. . . . The little apparatus will play with his shadow before the audience, and he himself must be content to play before the apparatus."[8] The situation can also be characterized as follows: for the first time—and this is the effect of film—the human being is placed in a position where he must operate with his whole living person, while forgoing its aura. For the aura is bound to his presence in the here and now. There is no facsimile of the aura. The aura surrounding Macbeth on the stage cannot be divorced from

the aura which, for the living spectators, surrounds the actor who plays him. What distinguishes the shot in the film studio, however, is that the camera is substituted for the audience. As a result, the aura surrounding the actor is dispelled—and, with it, the aura of the figure he portrays.

It is not surprising that it should be a dramatist such as Pirandello who, in reflecting on the special character of film acting, inadvertently touches on the crisis now affecting the theater. Indeed, nothing contrasts more starkly with a work of art completely subject to (or, like film, founded in) technological reproduction than a stage play. Any thorough consideration will confirm this. Expert observers have long recognized that, in film, "the best effects are almost always achieved by 'acting' as little as possible. . . . The development," according to Rudolf Arnheim, writing in 1932, has been toward "using the actor as one of the 'props,' chosen for his typicalness and . . . introduced in the proper context."[9] Closely bound up with this development is something else. *The stage actor identifies himself with a role. The film actor very often is denied this opportunity.* His performance is by no means a unified whole, but is assembled from many individual performances. Apart from incidental concerns about studio rental, availability of other actors, scenery, and so on, there are elementary necessities of the machinery that split the actor's performance into a series of episodes capable of being assembled. In particular, lighting and its installation require the representation of an action—which on the screen appears as a swift, unified sequence—to be filmed in a series of separate takes, which may be spread over hours in the studio. Not to mention the more obvious effects of montage. A leap from a window, for example, can be shot in the studio as a leap from a scaffold, while the ensuing fall may be filmed weeks later at an outdoor location. And far more paradoxical cases can easily be imagined. Let us assume that an actor is supposed to be startled by a knock at the door. If his reaction is not satisfactory, the director can resort to an expedient: he could have a shot fired without warning behind the actor's back on some other occasion when he happens to be in the studio. The actor's frightened reaction at that moment could be recorded and then edited into the film. Nothing shows more graphically that art has escaped the realm of "beautiful semblance," which for so long was regarded as the only sphere in which it could thrive.[10]

## *XII*

*The representation of human beings by means of an apparatus has made possible a highly productive use of the human being's self-alienation.* The nature of this use can be grasped through the fact that the film actor's estrangement in the face of the apparatus, as Pirandello describes this experience, is basically of the same kind as the estrangement felt before one's appearance [*Erscheinung*] in a mirror—a favorite theme of the Romantics. But now the mirror image [*Bild*] has become detachable from the person mirrored, and is transportable. And where is it transported? To a site in front of the masses.[11] Naturally, the screen actor never for a moment ceases to be aware of this. While he stands before the apparatus, he knows that in the end he is confronting the masses. It is they who will control him. Those who are not visible, not present while he executes his performance, are precisely the ones who will control it. This invisibility heightens the authority of their control. It should not be forgotten, of course, that there can be no political advantage derived from this control until film has liberated

itself from the fetters of capitalist exploitation. Film capital uses the revolutionary op-
portunities implied by this control for counterrevolutionary purposes. Not only does
the cult of the movie star which it fosters preserve that magic of the personality which
has long been no more than the putrid magic of its own commodity character, but its
counterpart, the cult of the audience, reinforces the corruption by which fascism is
seeking to supplant the class consciousness of the masses.[12]

## XIII

It is inherent in the technology of film, as of sports, that everyone who witnesses
these performances does so as a quasi-expert. Anyone who has listened to a group
of newspaper boys leaning on their bicycles and discussing the outcome of a bicycle
race will have an inkling of this. In the case of film, the newsreel demonstrates un-
equivocally that any individual can be in a position to be filmed. But that possibility
is not enough. *Any person today can lay claim to being filmed*. This claim can best be
clarified by considering the historical situation of literature today.

For centuries it was in the nature of literature that a small number of writers
confronted many thousands of readers. This began to change toward the end of
the past century. With the growth and extension of the press, which constantly
made new political, religious, scientific, professional, and local journals available
to readers, an increasing number of readers—in isolated cases, at first—turned
into writers. It began with the space set aside for "letters to the editor" in the daily
press, and has now reached a point where there is hardly a European engaged in
the work process who could not, in principle, find an opportunity to publish some-
where or other an account of a work experience, a complaint, a report, or some-
thing of the kind. Thus, the distinction between author and public is about to lose
its axiomatic character. The difference becomes functional; it may vary from case
to case. At any moment, the reader is ready to become a writer. As an expert—
which he has had to become in any case in a highly specialized work process, even
if only in some minor capacity—the reader gains access to authorship. Work it-
self is given a voice. And the ability to describe a job in words now forms part of
the expertise needed to carry it out. Literary competence is no longer founded on
specialized higher education but on polytechnic training, and thus is common
property.

All this can readily be applied to film, where shifts that in literature took place over
centuries have occurred in a decade. In cinematic practice—above all, in Russia—this
shift has already been partly realized. Some of the actors taking part in Russian films
are not actors in our sense but people who portray *themselves*—and primarily in their
own work process. In western Europe today, the capitalist exploitation of film obstructs
the human being's legitimate claim to being reproduced. The claim is also obstructed,
incidentally, by unemployment, which excludes large masses from production—the
process in which their primary entitlement to be reproduced would lie. Under these
circumstances, the film industry has an overriding interest in stimulating the involve-
ment of the masses through illusionary displays and ambiguous speculations. To this
end it has set in motion an immense publicity machine, in the service of which it has
placed the careers and love lives of the stars; it has organized polls; it has held beauty
contests. All this in order to distort and corrupt the original and justified interest of

the masses in film—an interest in understanding themselves and therefore their class. Thus, the same is true of film capital in particular as of fascism in general: a compelling urge toward new social opportunities is being clandestinely exploited in the interests of a property-owning minority. For this reason alone, the expropriation of film capital is an urgent demand for the proletariat.

## XIV

The shooting of a film, especially a sound film, offers a hitherto unimaginable spectacle. It presents a process in which it is impossible to assign to the spectator a single viewpoint which would exclude from his or her field of vision the equipment not directly involved in the action being filmed—the camera, the lighting units, the technical crew, and so forth (unless the alignment of the spectator's pupil coincided with that of the camera). This circumstance, more than any other, makes any resemblance between a scene in a film studio and one onstage superficial and irrelevant. In principle, the theater includes a position from which the action on the stage cannot easily be detected as an illusion. There is no such position where a film is being shot. The illusory nature of film is of the second degree; it is the result of editing. That is to say: *In the film studio the apparatus has penetrated so deeply into reality that a pure view of that reality, free of the foreign body of equipment, is the result of a special procedure—namely, the shooting by the specially adjusted photographic device and the assembly of that shot with others of the same kind.* The equipment-free aspect of reality has here become the height of artifice, and the vision of immediate reality the Blue Flower in the land of technology.

This state of affairs, which contrasts so sharply with that which obtains in the theater, can be compared even more instructively to the situation in painting. Here we have to pose the question: How does the camera operator compare with the painter? In answer to this, it will be helpful to consider the concept of the operator as it is familiar to us from surgery. The surgeon represents the polar opposite of the magician. The attitude of the magician, who heals a sick person by a laying-on of hands, differs from that of the surgeon, who makes an intervention in the patient. The magician maintains the natural distance between himself and the person treated; more precisely, he reduces it slightly by laying on his hands, but increases it greatly by his authority. The surgeon does exactly the reverse: he greatly diminishes the distance from the patient by penetrating the patient's body, and increases it only slightly by the caution with which his hand moves among the organs. In short: unlike the magician (traces of whom are still found in the medical practitioner), the surgeon abstains at the decisive moment from confronting his patient person to person; instead, he penetrates the patient by operating.—Magician is to surgeon as painter is to cinematographer. The painter maintains in his work a natural distance from reality, whereas the cinematographer penetrates deeply into its tissue. The images obtained by each differ enormously. The painter's is a total image, whereas that of the cinematographer is piecemeal, its manifold parts being assembled according to a new law. *Hence, the presentation of reality in film is incomparably the more significant for people of today, since it provides the equipment-free aspect of reality they are*

*entitled to demand from a work of art, and does so precisely on the basis of the most intensive interpenetration of reality with equipment.*

## XV

*The technological reproducibility of the artwork changes the relation of the masses to art. The extremely backward attitude toward a Picasso painting changes into a highly progressive reaction to a Chaplin film.* The progressive attitude is characterized by an immediate, intimate fusion of pleasure—pleasure in seeing and experiencing— with an attitude of expert appraisal. Such a fusion is an important social index. As is clearly seen in the case of painting, the more reduced the social impact of an art form, the more widely criticism and enjoyment of it diverge in the public. The conventional is uncritically enjoyed, while the truly new is criticized with aversion. Not so in the cinema. The decisive reason for this is that nowhere more than in the cinema are the reactions of individuals, which together make up the massive reaction of the audience, determined by the imminent concentration of reactions into a mass. No sooner are these reactions manifest than they regulate one another. Again, the comparison with painting is fruitful. A painting has always exerted a claim to be viewed primarily by a single person or by a few. The simultaneous viewing of paintings by a large audience, as happens in the nineteenth century, is an early symptom of the crisis in painting, a crisis triggered not only by photography but, in a relatively independent way, by the artwork's claim to the attention of the masses.

Painting, by its nature, cannot provide an object of simultaneous collective reception, as architecture has always been able to do, as the epic poem could do at one time, and as film is able to do today. And although direct conclusions about the social role of painting cannot be drawn from this fact alone, it does have a strongly adverse effect whenever painting is led by special circumstances, as if against its nature, to confront the masses directly. In the churches and monasteries of the Middle Ages, and at the princely courts up to about the end of the eighteenth century, the collective reception of paintings took place not simultaneously but in a manifoldly graduated and hierarchically mediated way. If that has changed, the change testifies to the special conflict in which painting has become enmeshed by the technological reproducibility of the image. And while efforts have been made to present paintings to the masses in galleries and salons, this mode of reception gives the masses no means of organizing and regulating their response. Thus, the same public which reacts progressively to a slapstick comedy inevitably displays a backward attitude toward Surrealism.

## XVI

*The most important social function of film is to establish equilibrium between human beings and the apparatus.* Film achieves this goal not only in terms of man's presentation of himself to the camera but also in terms of his representation of his environment by means of this apparatus. On the one hand, film furthers insight into the

necessities governing our lives by its use of close-ups, by its accentuation of hidden details in familiar objects, and by its exploration of commonplace milieux through the ingenious guidance of the camera; on the other hand, it manages to assure us of a vast and unsuspected field of action [*Spielraum*].

Our bars and city streets, our offices and furnished rooms, our railroad stations and our factories seemed to close relentlessly around us. Then came film and exploded this prison-world with the dynamite of the split second, so that now we can set off calmly on journeys of adventure among its far-flung debris. With the close-up, space expands; with slow motion, movement is extended. And just as enlargement not merely clarifies what we see indistinctly "in any case," but brings to light entirely new structures of matter, slow motion not only reveals familiar aspects of movements, but discloses quite unknown aspects within them—aspects "which do not appear as the retarding of natural movements but have a curious gliding, floating character of their own."[13] Clearly, it is another nature which speaks to the camera as compared to the eye. "Other" above all in the sense that a space informed by human consciousness gives way to a space informed by the unconscious. Whereas it is a commonplace that, for example, we have some idea what is involved in the act of walking (if only in general terms), we have no idea at all what happens during the split second when a person actually takes a step. We are familiar with the movement of picking up a cigarette lighter or a spoon, but know almost nothing of what really goes on between hand and metal, and still less how this varies with different moods. This is where the camera comes into play, with all its resources for swooping and rising, disrupting and isolating, stretching or compressing a sequence, enlarging or reducing an object. It is through the camera that we first discover the optical unconscious, just as we discover the instinctual unconscious through psychoanalysis.

Moreover, these two types of unconscious are intimately linked. For in most cases the diverse aspects of reality captured by the film camera lie outside only the *normal* spectrum of sense impressions. Many of the deformations and stereotypes, transformations and catastrophes which can assail the optical world in films afflict the actual world in psychoses, hallucinations, and dreams. Thanks to the camera, therefore, the individual perceptions of the psychotic or the dreamer can be appropriated by collective perception. The ancient truth expressed by Heraclitus, that those who are awake have a world in common while each sleeper has a world of his own, has been invalidated by film—and less by depicting the dream world itself than by creating figures of collective dream, such as the globe-encircling Mickey Mouse.

*If one considers the dangerous tensions which technology and its consequences have engendered in the masses at large—tendencies which at critical stages take on a psychotic character—one also has to recognize that this same technologization [Technisierung] has created the possibility of psychic immunization against such mass psychoses. It does so by means of certain films in which the forced development of sadistic fantasies or masochistic delusions can prevent their natural and dangerous maturation in the masses.* Collective laughter is one such preemptive and healing outbreak of mass psychosis. The countless grotesque events consumed in films are a graphic indication of the dangers threatening mankind from the repressions implicit in civilization. American slapstick comedies and Disney films trigger a therapeutic release

of unconscious energies.[14] Their forerunner was the figure of the eccentric. He was the first to inhabit the new fields of action opened up by film—the first occupant of the newly built house. This is the context in which Chaplin takes on historical significance.

## XVII

It has always been one of the primary tasks of art to create a demand whose hour of full satisfaction has not yet come.[15] The history of every art form has critical periods in which the particular form strains after effects which can be easily achieved only with a changed technical standard—that is to say, in a new art form. The excesses and crudities of art which thus result, particularly in periods of so-called decadence, actually emerge from the core of its richest historical energies. In recent years, Dadaism has amused itself with such barbarisms. Only now is its impulse recognizable: *Dadaism attempted to produce with the means of painting (or literature) the effects which the public today seeks in film.*

Every fundamentally new, pioneering creation of demand will overshoot its target. Dadaism did so to the extent that it sacrificed the market values so characteristic of film in favor of more significant aspirations—of which, to be sure, it was unaware in the form described here. The Dadaists attached much less importance to the commercial usefulness of their artworks than to the uselessness of those works as objects of contemplative immersion. They sought to achieve this uselessness not least by thorough degradation of their material. Their poems are "word-salad" containing obscene expressions and every imaginable kind of linguistic refuse. The same is true of their paintings, on which they mounted buttons or train tickets. What they achieved by such means was a ruthless annihilation of the aura in every object they produced, which they branded as a reproduction through the very means of its production. Before a painting by Arp or a poem by August Stramm, it is impossible to take time for concentration and evaluation, as one can before a painting by Derain or a poem by Rilke. Contemplative immersion—which, as the bourgeoisie degenerated, became a breeding ground for asocial behavior—is here opposed by distraction [*Ablenkung*] as a variant of social behavior. Dadaist manifestations actually guaranteed a quite vehement distraction by making artworks the center of scandal. One requirement was paramount: to outrage the public.

From an alluring visual composition or an enchanting fabric of sound, the Dadaists turned the artwork into a missile. It jolted the viewer, taking on a tactile [*taktisch*] quality. It thereby fostered the demand for film, since the distracting element in film is also primarily tactile, being based on successive changes of scene and focus which have a percussive effect on the spectator.[16] *Film has freed the physical shock effect—which Dadaism had kept wrapped, as it were, inside the moral shock effect—from this wrapping.*

## XVIII

The masses are a matrix from which all customary behavior toward works of art is today emerging newborn. Quantity has been transformed into quality: *the greatly*

*increased mass of participants has produced a different kind of participation.* The fact that this new mode of participation first appeared in a disreputable form should not mislead the observer. The masses are criticized for seeking distraction [*Zerstreuung*] in the work of art, whereas the art lover supposedly approaches it with concentration. In the case of the masses, the artwork is seen as a means of entertainment; in the case of the art lover, it is considered an object of devotion.—This calls for closer examination. Distraction and concentration form an antithesis, which may be formulated as follows. A person who concentrates before a work of art is absorbed by it; he enters into the work, just as, according to legend, a Chinese painter entered his completed painting while beholding it. By contrast, the distracted masses absorb the work of art into themselves. Their waves lap around it; they encompass it with their tide. This is most obvious with regard to buildings. Architecture has always offered the prototype of an artwork that is received in a state of distraction and through the collective. The laws of architecture's reception are highly instructive.

Buildings have accompanied human existence since primeval times. Many art forms have come into being and passed away. Tragedy begins with the Greeks, is extinguished along with them, and is revived centuries later. The epic, which originates in the early days of peoples, dies out in Europe at the end of the Renaissance. Panel painting is a creation of the Middle Ages, and nothing guarantees its uninterrupted existence. But the human need for shelter is permanent. Architecture has never had fallow periods. Its history is longer than that of any other art, and its effect ought to be recognized in any attempt to account for the relationship of the masses to the work of art. Buildings are received in a twofold manner: by use and by perception. Or, better: tactilely and optically. Such reception cannot be understood in terms of the concentrated attention of a traveler before a famous building. On the tactile side, there is no counterpart to what contemplation is on the optical side. Tactile reception comes about not so much by way of attention as by way of habit. The latter largely determines even the optical reception of architecture, which spontaneously takes the form of casual noticing, rather than attentive observation. Under certain circumstances, this form of reception shaped by architecture acquires canonical value. *For the tasks which face the human apparatus of perception at historical turning points cannot be performed solely by optical means—that is, by way of contemplation. They are mastered gradually—taking their cue from tactile reception—through habit.*

Even the distracted person can form habits. What is more, the ability to master certain tasks in a state of distraction first proves that their performance has become habitual. The sort of distraction that is provided by art represents a covert measure of the extent to which it has become possible to perform new tasks of apperception. Since, moreover, individuals are tempted to evade such tasks, art will tackle the most difficult and most important tasks wherever it is able to mobilize the masses. It does so currently in film. *Reception in distraction—the sort of reception which is increasingly noticeable in all areas of art and is a symptom of profound changes in apperception—finds in film its true training ground.* Film, by virtue of its shock effects, is predisposed to this form of reception. In this respect, too, it proves to be the most important subject matter, at present, for the theory of perception which the Greeks called aesthetics.

## *XIX*

The increasing proletarianization of modern man and the increasing formation of masses are two sides of the same process. Fascism attempts to organize the newly proletarianized masses while leaving intact the property relations which they strive to abolish. It sees its salvation in granting expression to the masses—but on no account granting them rights.[17] The masses have a *right* to changed property relations; fascism seeks to give them *expression* in keeping these relations unchanged. *The logical outcome of fascism is an aestheticizing of political life*. With D'Annunzio, decadence made its entry into political life; with Marinetti, Futurism; and with Hitler, the Bohemian tradition of Schwabing.

*All efforts to aestheticize politics culminate in one point. That one point is war*. War, and only war, makes it possible to set a goal for mass movements on the grandest scale while preserving traditional property relations. That is how the situation presents itself in political terms. In technological terms it can be formulated as follows: only war makes it possible to mobilize all of today's technological resources while maintaining property relations. It goes without saying that the fascist glorification of war does not make use of *these* arguments. Nevertheless, a glance at such glorification is instructive. In Marinetti's manifesto for the colonial war in Ethiopia, we read:

> For twenty-seven years, we Futurists have rebelled against the idea that war is anti-aesthetic. . . . We therefore state: . . . War is beautiful because—thanks to its gas masks, its terrifying megaphones, its flame throwers, and light tanks—it establishes man's dominion over the subjugated machine. War is beautiful because it inaugurates the dreamed-of metallization of the human body. War is beautiful because it enriches a flowering meadow with the fiery orchids of machine-guns. War is beautiful because it combines gunfire, barrages, cease-fires, scents, and the fragrance of putrefaction into a symphony. War is beautiful because it creates new architectures, like those of armored tanks, geometric squadrons of aircraft, spirals of smoke from burning villages, and much more. . . . Poets and artists of Futurism, . . . remember these principles of an aesthetic of war, that they may illuminate . . . your struggles for a new poetry and a new sculpture![18]

This manifesto has the merit of clarity. The question it poses deserves to be taken up by the dialectician. To him, the aesthetic of modern warfare appears as follows: if the natural use of productive forces is impeded by the property system, then the increase in technological means, in speed, in sources of energy will press toward an unnatural use. This is found in war, and the destruction caused by war furnishes proof that society was not mature enough to make technology its organ, that technology was not sufficiently developed to master the elemental forces of society. The most horrifying features of imperialist war are determined by the discrepancy between the enormous means of production and their inadequate use in the process of production (in other words, by unemployment and the lack of markets). *Imperialist war is an uprising on the part of technology, which demands repayment in "human material" for the natural material society has denied it*. Instead of deploying power stations across the land, society deploys manpower in the form of armies. Instead of promoting air traffic, it promotes traffic in shells. And in gas warfare it has found a new means of abolishing the aura.

"Fiat ars—pereat mundus," says fascism, expecting from war, as Marinetti admits, the artistic gratification of a sense perception altered by technology. This is evidently the consummation of *l'art pour l'art*. Humankind, which once, in Homer, was an object of contemplation for the Olympian gods, has now become one for itself. Its self-alienation has reached the point where it can experience its own annihilation as a supreme aesthetic pleasure. *Such is the aestheticizing of politics, as practiced by fascism. Communism replies by politicizing art.*

Written late December 1935–beginning of February 1936; unpublished in this form in Benjamin's lifetime. *Gesammelte Schriften*, VII, 350–384 (1989). Translated by Edmund Jephcott and Harry Zohn. Notes are Benjamin's.

## NOTES

1. Abel Gance, "Le Temps de l'image est venu!" (It Is Time for the Image!), in Léon Pierre-Quint, Germaine Dulac, Lionel Landry, and Abel Gance, *L'Art cinématographique*, vol. 2 (Paris, 1927), pp. 94–96.

2. In film, the technological reproducibility of the product is not an externally imposed condition of its mass dissemination, as it is, say, in literature or painting. *The technological reproducibility of films is based directly on the technology of their production. This not only makes possible the mass dissemination of films in the most direct way, but actually enforces it.* It does so because the process of producing a film is so costly that an individual who could afford to buy a painting, for example, could not afford to buy a [master print of a] film. It was calculated in 1927 that, in order to make a profit, a major film needed to reach an audience of nine million. Of course, the advent of sound film [in that year] initially caused a movement in the opposite direction: its audience was restricted by language boundaries. And that coincided with the emphasis placed on national interests by fascism. But it is less important to note this setback (which in any case was mitigated by dubbing) than to observe its connection with fascism. The simultaneity of the two phenomena results from the economic crisis. The same disorders which led, in the world at large, to an attempt to maintain existing property relations by brute force induced film capital, under the threat of crisis, to speed up the development of sound film. Its introduction brought temporary relief, not only because sound film attracted the masses back into the cinema but also because it consolidated new capital from the electricity industry with that of film. Thus, considered from the outside, sound film promoted national interests; but seen from the inside, it helped internationalize film production even more than before.

3. This polarity cannot come into its own in the aesthetics of Idealism, which conceives of beauty as something fundamentally undivided (and thus excludes anything polarized). Nonetheless, in Hegel this polarity announces itself as clearly as possible within the limits of Idealism. We quote from his *Vorlesungen zur Philosophie der Geschichte* [Lectures on the Philosophy of History]: "Images were known of old. In those early days piety required them for worship, but it could do without *beautiful* images. Such images might even be disturbing. In every beautiful image, there is also something external—although, insofar as the image is beautiful, its spirit still speaks to the human being. But religious worship, being no more than a spiritless torpor of the soul, is directed at a *thing*. . . . Fine art arose . . . in the church . . . , though art has now gone beyond the ecclesiastical principle." Likewise, the following passage from the *Vorlesungen über die Ästhetik* [Lectures on Aesthetics] indicates that Hegel sensed a problem here: "We are beyond the stage of venerating works of art as divine and as objects deserving our worship. Today the impression they produce is of a more reflective kind, and the emotions they arouse require a more stringent test."

4. The aim of revolutions is to accelerate this adaptation. Revolutions are innervations of the collective—or, more precisely, efforts at innervation on the part of the new, historically unique collective which has its organs in the new technology. This second technology is a system in which the mastering of elementary social forces is a precondition for playing [*das Spiel*] with natural forces. Just as a child who has learned to grasp stretches out its hand for the moon as it would for a ball, so humanity, in its efforts at innervation, sets its sights as much on currently utopian goals as on goals within reach. For in revolutions, it is not only the second technology which asserts its claims vis-à-vis society. Because this technology aims at liberating human beings from drudgery, the individual suddenly sees his scope for play, his field of action [*Spielraum*], immeasurably expanded. He does not yet know his way around this space. But already he registers his demands on it. For the more the collective makes the second technology its own, the more keenly individuals belonging to the collective feel how little they have received of what was due them under the dominion of the first technology. In other words, it is the individual liberated by the liquidation of the first technology who stakes his claim. No sooner has the second technology secured its initial revolutionary gains than vital questions affecting the individual—questions of love and death which had been buried by the first technology—once again press for solutions. Fourier's work is the first historical evidence of this demand.

5. Abel Gance, "Le Temps de l'image est venu!" in *L'Art cinématographique*, vol. 2, p. 101.

6. Séverin-Mars, cited ibid., p. 100.

7. Franz Werfel, "Ein Sommernachtstraum: Ein Film von Shakespeare und Reinhardt," *Neues Wiener Journal*, cited in *Lu*, November 15, 1935.

8. Luigi Pirandello, *Il turno* (The Turn), cited by Léon Pierre-Quint, "Signification du cinéma," in *L'Art cinématographique*, vol. 2, pp. 14–15.

9. Rudolf Arnheim, *Film als Kunst* (Berlin, 1932), pp. 176–177. [see p. 279 in this volume] In this context, certain apparently incidental details of film directing which diverge from practices on the stage take on added interest. For example, the attempt to let the actor perform without makeup, as in Dreyer's *Jeanne d'Arc*. Dreyer spent months seeking the forty actors who constitute the Inquisitors' tribunal. Searching for these actors was like hunting for rare props. Dreyer made every effort to avoid resemblances of age, build, and physiognomy in the actors. (See Maurice Schultz, "Le Maquillage" [Makeup], in *L'Art cinématographique*, vol. 6 [Paris, 1929], pp. 65–66.) If the actor thus becomes a prop, the prop, in its turn, not infrequently functions as actor. At any rate, it is not unusual for films to allocate a role to a prop. Rather than selecting examples at random from the infinite number available, let us take just one especially revealing case. A clock that is running will always be a disturbance on the stage, where it cannot be permitted its role of measuring time. Even in a naturalistic play, real-life time would conflict with theatrical time. In view of this, it is most revealing that film—where appropriate—can readily make use of time as measured by a clock. This feature, more than many others, makes it clear that—circumstances permitting—each and every prop in a film may perform decisive functions. From here it is but a step to Pudovkin's principle, which states that "to connect the performance of an actor with an object, and to build that performance around the object, . . . is always one of the most powerful methods of cinematic construction" (V. I. Pudovkin, *Film Regie und Filmmanuskript* [Film Direction and the Film Script] (Berlin, 1928), p. 126). Film is thus the first artistic medium which is able to show how matter plays havoc with human beings [*wie die Materie dem Menschen mitspielt*]. It follows that films can be an excellent means of materialist exposition.

10. The significance of beautiful semblance [*schöner Schein*] is rooted in the age of auratic perception that is now coming to an end. The aesthetic theory of that era was most fully articulated by Hegel, for whom beauty is "the appearance [*Erscheinung*] of spirit in its

immediate . . . sensuous form, created by the spirit as the form adequate to itself" (Hegel, *Werke*, vol. 10, part 2 [Berlin, 1837], p. 121). [ . . . ]

11. The change noted here in the mode of exhibition—a change brought about by reproduction technology—is also noticeable in politics. *The crisis of democracies can be understood as a crisis in the conditions governing the public presentation of politicians.* Democracies exhibit the politician directly, in person, before elected representatives. The parliament is his public. But innovations in recording equipment now enable the speaker to be heard by an unlimited number of people while he is speaking, and to be seen by an unlimited number shortly afterward. This means that priority is given to presenting the politician before the recording equipment. Parliaments are becoming depopulated at the same time as theaters. Radio and film are changing not only the function of the professional actor but, equally, the function of those who, like the politician, present themselves before these media. The direction of this change is the same for the film actor and the politician, regardless of their different tasks. It tends toward the exhibition of controllable, transferable skills under certain social conditions, just as sports first called for such exhibition under certain natural conditions. This results in a new form of selection—selection before an apparatus—from which the champion, the star, and the dictator emerge as victors.

12. It should be noted in passing that proletarian class consciousness, which is the most enlightened form of class consciousness, fundamentally transforms the structure of the proletarian masses. The class-conscious proletariat forms a compact mass only from the outside, in the minds of its oppressors. At the moment when it takes up its struggle for liberation, this apparently compact mass has actually already begun to loosen. It ceases to be governed by mere reactions; it makes the transition to action. The loosening of the proletarian masses is the work of solidarity. In the solidarity of the proletarian class struggle, the dead, undialectical opposition between individual and mass is abolished; for the comrade, it does not exist. Decisive as the masses are for the revolutionary leader, therefore, his great achievement lies not in drawing the masses after him, but in constantly incorporating himself into the masses, in order to be, for them, always one among hundreds of thousands. But the same class struggle which loosens the compact mass of the proletariat compresses that of the petty bourgeoisie. The mass as an impenetrable, compact entity, which Le Bon and others have made the subject of their "mass psychology," is that of the petty bourgeoisie. The petty bourgeoisie is not a class; it is in fact only a mass. And the greater the pressure acting on it between the two antagonistic classes of the bourgeoisie and the proletariat, the more compact it becomes. In *this* mass the emotional element described in mass psychology is indeed a determining factor. But for that very reason this compact mass forms the antithesis of the proletarian cadre, which obeys a collective *ratio*. In the petty-bourgeois mass, the reactive moment described in mass psychology is indeed a determining factor. But precisely for that reason this compact mass with its unmediated reactions forms the antithesis of the proletarian cadre, whose actions are mediated by a task, however momentary. Demonstrations by the compact mass thus always have a panicked quality—whether they give vent to war fever, hatred of Jews, or the instinct for self-preservation. Once the distinction between the compact (that is, petty-bourgeois) mass and the class-conscious, proletarian mass has been clearly made, its operational significance is also clear. This distinction is nowhere more graphically illustrated than in the not uncommon cases when some outrage originally performed by the compact mass becomes, as a result of a revolutionary situation and perhaps within the space of seconds, the revolutionary action of a class. The special feature of such truly historic events is that a reaction by a compact mass sets off an internal upheaval which loosens its composition, enabling it to become aware of itself as an association of class-conscious cadres. Such concrete events contain in very abbreviated form what communist tacticians call "winning over the petty bourgeoisie." These tacticians have a further interest in clarifying this process. The ambiguous concept of the masses, and the indiscriminate references to their mood which are commonplace in the German revolutionary

press, have undoubtedly fostered illusions which have had disastrous consequences for the German proletariat. Fascism, by contrast, has made excellent use of these laws—whether it understood them or not. It realizes that the more compact the masses it mobilizes, the better the chance that the counterrevolutionary instincts of the petty bourgeoisie will determine their reactions. The proletariat, on the other hand, is preparing for a society in which neither the objective nor the subjective conditions for the formation of masses will exist any longer.

13. Rudolf Arnheim, *Film als Kunst*, p. 138.

14. Of course, a comprehensive analysis of these films should not overlook their double meaning. It should start from the ambiguity of situations which have both a comic and a horrifying effect. As the reactions of children show, comedy and horror are closely related. In the face of certain situations, why shouldn't we be allowed to ask which reaction is the more human? Some recent Mickey Mouse films offer situations in which such a question seems justified. (Their gloomy and sinister fire-magic, made technically possible by color film, highlights a feature which up to now has been present only covertly, and shows how easily fascism takes over "revolutionary" innovations in this field too.) What is revealed in recent Disney films was latent in some of the earlier ones: the cozy acceptance of bestiality and violence as inevitable concomitants of existence. This renews an old tradition which is far from reassuring—the tradition inaugurated by the dancing hooligans to be found in depictions of medieval pogroms, of whom the "riff-raff" in Grimm's fairy tale of that title are a pale, indistinct rear-guard.

15. "The artwork," writes André Breton, "has value only insofar as it is alive to reverberations of the future." And indeed every highly developed art form stands at the intersection of three lines of development. First, technology is working toward a particular form of art. Before film appeared, there were little books of photos that could be made to flit past the viewer under the pressure of the thumb, presenting a boxing match or a tennis match; then there were coin-operated peepboxes in bazaars, with image sequences kept in motion by the turning of a handle. Second, traditional art forms, at certain stages in their development, strain laboriously for effects which later are effortlessly achieved by new art forms. Before film became established, Dadaist performances sought to stir in their audiences reactions which Chaplin then elicited more naturally. Third, apparently insignificant social changes often foster a change in reception which benefits only the new art form. Before film had started to create its public, images (which were no longer motionless) were received by an assembled audience in the Kaiserpanorama. Here the audience faced a screen into which stereoscopes were fitted, one for each spectator. In front of these stereoscopes single images automatically appeared, remained briefly in view, and then gave way to others. Edison still had to work with similar means when he presented the first film strip—before the movie screen and projection were known; a small audience gazed into an apparatus in which a sequence of images was shown. Incidentally, the institution of the Kaiserpanorama very clearly manifests a dialectic of development. Shortly before film turned the viewing of images into a collective activity, image viewing by the individual, through the stereoscopes of these soon outmoded establishments, was briefly intensified, as it had been once before in the isolated contemplation of the divine image by the priest in the cella.

16. Let us compare the screen [*Leinwand*] on which a film unfolds with the canvas [*Leinwand*] of a painting. The image on the film screen changes, whereas the image on the canvas does not. The painting invites the viewer to contemplation; before it, he can give himself up to his train of associations. Before a film image, he cannot do so. No sooner has he seen it than it has already changed. It cannot be fixed on. The train of associations in the person contemplating it is immediately interrupted by new images. This constitutes the shock effect of film, which, like all shock effects, seeks to induce heightened attention. *Film is the art form corresponding to the pronounced threat to life in which people live today.*

It corresponds to profound changes in the apparatus of apperception—changes that are experienced on the scale of private existence by each passerby in big-city traffic, and on the scale of world history by each fighter against the present social order.

17. A technological factor is important here, especially with regard to the newsreel, whose significance for propaganda purposes can hardly be overstated. *Mass reproduction is especially favored by the reproduction of the masses.* In great ceremonial processions, giant rallies and mass sporting events, and in war, all of which are now fed into the camera, the masses come face to face with themselves. This process, whose significance need not be emphasized, is closely bound up with the development of reproduction and recording technologies. In general, mass movements are more clearly apprehended by the camera than by the eye. A bird's-eye view best captures assemblies of hundreds of thousands. And even when this perspective is no less accessible to the human eye than to the camera, the image formed by the eye cannot be enlarged in the same way as a photograph. This is to say that mass movements, and above all war, are a form of human behavior especially suited to the camera.

18. Cited in *La Stampa Torino*.

# JEAN EPSTEIN

## *Photogénie* and the Imponderable

Born in Warsaw, Poland, but educated in France and Switzerland, Jean Epstein (1897–1953) was a major force within the avant-garde film movement of France during the 1920s and 1930s where he was heavily influenced by French filmmaker and theorist Louis Delluc. In addition to being a prolific film critic and scholar who published numerous essays and books, such as *Bonjour Cinéma* (1921) and *The Cinema Seen from Etna* (1936), Epstein made several important experimental films, including the *Coeur fidèle* (1923) and *The Fall of the House of Usher* (1928). The latter film was considered a prime example of impressionist cinema and a classic illustration of his theories on the power of slow-motion cinematography. Epstein also made several documentaries, beginning with *Pasteur* (1922). Both his writing and film practices illustrated his thought that cinema was less about genre and subject matter than about its unmatched ability to capture the energy and complexity of the modern world.

The relative novelty of the cinema in the 1920s and 1930s accounts for much of Epstein's fascination with the film image, particularly the concept of *photogénie*. In the heyday of avant-garde and experimental films such as *The Passion of Joan of Arc* (1928), the capacity of film technology to create different temporal speeds, to capture life close up, and to see objects from dramatically different angles suggested not only a new art of the image but also indicated a way of seeing that surpassed the physiology of human sight. Even by 1935, when classical film styles were relatively common and advanced, Epstein remains convinced of the centrality and power of *photogénie*, particularly for synchronous sound and, as he predicts in this essay, color cinema (a claim made precisely the year that the first Technicolor narrative feature film, *Becky Sharp*, appeared).

Originally published in 1935, "*Photogénie* and the Imponderable" develops Epstein's focus on and fascination with the concept of *photogénie*, defining and distinguishing what he

considered a cinematic power unavailable to any other art. While some writers emphasize editing or narrative structures as the quintessence of film, Epstein focuses on the unique power of the film image in its ability to capture an almost ineffable visual insight distilled from, but unavailable to, common vision. Epstein asserts that there is a "clairvoyance of cinematography" that represents the world in a continuous mobility that both transforms and reveals the world in a new way. Epstein's notion of *photogénie* resonates with other early efforts to define cinematic specificity, and this essay has inspired different incarnations of his argument throughout the twentieth century. André Bazin's claims for filmic depth of field as the singular achievement of the movie image (p. 309) can be placed in a tradition that begins with Epstein, and Roland Barthes's influential arguments about the "punctum" of the photographic image—its distinctive and untranslatable heart—clearly belong to this same tradition.

## READING CUES & KEY CONCEPTS

■ Explain what Epstein means when he claims one of the distinctive powers of film is that it can "extend the variability of intimate psychological time . . . to external reality."

■ Based on Epstein's ideas laid out in this essay, select one image from a film as an example of *photogénie*. Describe how the film image both transforms and reveals reality.

■ What is Epstein suggesting about the cinema when he employs metaphors of monstrosity, disease, and the superhuman to describe what the cinema reveals as no other art form does?

■ **Key Concepts:** Clairvoyance of Cinema; Magnification of the Screen; *Photogénie*; Psychological Time; Spirit of Appearances

# *Photogénie* and the Imponderable

From now on, cinematography, like any other means of thinking, allows us to emerge victorious over that secret reality in which all appearances have their still invisible roots.

Years ago, certain signs indicated this to us. It happened so simply. To begin with, every wheel which revolved on the screen stopped turning, went first in reverse and then forward, in jolts, now quickly, now slowly. Calculations explained it. But if cinematic reproduction so grossly altered the nature of movement, transforming it into stops and countermovements, wasn't it necessary to think that many other recorded movements also were rendered with a specific kind of inaccuracy which was perhaps less apparent and more profound?

Everyone knows at least one anecdote about actors who cried at seeing themselves on the screen for the first time; they thought they were someone else. Whether an actor or not, each of us is confounded when gazing at himself as seen by the camera lens. The first feeling is always the horror of perceiving and acknowledging a stranger in oneself. And for those who have lived and experienced much together,

cinematography doesn't offer the face and voice of the one which the other had supposedly known. It leaves us uneasy. If no one person resembles himself on the screen, have we the right to believe that nothing resembles itself and that cinematography, as long as one doesn't put up obstructions, can itself create a new aspect of the world?

Each image of the filmstock carries within it an instant of a universe whose spirit we reconstruct progressively in the continuity of projection. What are the particular characteristics of the world which cinematography allows us to represent? What is the system of reference within which events are inscribed on film?

Even though the image intercepted by the screen is not yet stereoscopic, we are familiar enough with the descriptive convention of depth of field to be able to admit that the three spatial dimensions of reality are restored in the universe created by the screen. But the specific quality of this new projected world is to make another perspective of matter evident, that of time. The fourth dimension, which once seemed mysterious, becomes a notion as banal as that of the other three coordinates through the techniques of slow motion and fast motion. Time is the fourth dimension of a universe of space-time. Cinematography currently is the only instrument that records an event according to a system of four reference points. In that, it is proving superior to man, who seems constitutionally unsuited to capture a continuous event in four dimensions all by himself.

Man's physiological inability to master the notion of space-time and to escape this atemporal section of the world, which we call the present and of which we are almost exclusively conscious, is the cause of most "accidents of matter and knowing," most of which would be avoided if we could directly seize the world as the flow that it is. If someone is clairvoyant, his gift is: to conceive of time and space simultaneously.

Such also is the clairvoyance of cinematography which represents that world in its overall, continuous mobility. Faithful to the etymology of its name, it discovers movement where our eye sees nothing but stasis. Already no longer satisfied with reproducing the trajectory of shots, it is recreating that of sound, it is going to capture that of volumes and colors; and it's likely other evolutions will be revealed to us. All those authors who are currently multiplying the moving camera shots in their films do so not out of some affectation of style. They are instinctively obeying a primary law of their art and, even if they don't believe it, are gradually educating our spirit. Even now, fixed, disparate appearances no longer mean as much to the basic premises of even our everyday philosophy.

Nothing before cinematography had even allowed us to extend the variability of intimate psychological time, however limited, to external reality, to modify experimentally the temporal coordinate of the perspective of phenomena, or to guess that one would thus come to know other prodigious forms of the universe. Slow motion and fast motion reveal a world where the kingdoms of nature know no boundaries. Everything is alive. Crystals become larger, growing one on top of another, smoothly uniting out of something like sympathy. Symmetries constitute their customs and traditions. Are they really so different from flowers or the cells of the noblest tissues? And the plant which bends its stalk and turns its leaves toward the light; isn't what opens and closes its corolla, what inclines its stamen to the pistil, in fast motion, precisely the same quality of life in the horse and rider

which, in slow motion, soar over the obstacle, pressing close to one another? And all that decays turns into rebirth.

These experiments contradict and throw into confusion the sense of order which we have established at great cost in our conception of the universe. Yet it is hardly news that any classification has something of the arbitrary about it and that we abandon frameworks which seem overly artificial. The generalized sense of our own psychological time, which still varies very little, turns out to be an illusion that we have created in order to think more easily. The gaze which cinematography lets us cast over nature, where such time is neither unique nor constant, is perhaps more fecund than the one we cast out of egocentric habit. A simple modification of recording in reverse, and cinematography lets us reassemble the normal course of time and gives us a glimpse of this world which the popularizers of relativity theories have only sketchily imagined. The representation of an event "recorded" in reverse and projected forward, reveals a space-time in which the effect replaces the cause; in which everything which should be attracted is repelled; in which the downward acceleration of a weight becomes an upward deceleration of lightness, centrifugal rather than centripetal; in which all vectors are reversed. This universe, however, is hardly incomprehensible, and even speech can be understood with practice. Thus do we dream of the mysterious resurrection of retinal images, constructing a dream which seems to end on the ringing of the sleeper's awakening, just as it leaves him. And we ask ourselves who understands the real meaning of time's flowing? Not without some anxiety, man finds himself before that chaos which he has covered up, denied, forgotten, or thought was tamed. Cinematography apprises him of a monster.

An amazing animism is restored to the world. We know now, once we've seen it, that we are surrounded by inhuman living things. If there are incalculable numbers of these lower life forms, there are some which transcend our own. Here again, by developing the range of our senses and by playing with the perspective of time, cinematography renders perceptible through sight and sound individual beings we thought invisible and inaudible and divulges the reality of certain abstractions.

Three times have I seen and heard on the screen two generations of a family who had wanted to commemorate, in microcosm, the gentle pride of their grandfather in all kinds of tiny dynastic occasions, almost month by month, over a twenty-year-period. Thinking I was resigned out of politeness to an hour of boredom, I was surprised to see and hear an imposing phantom and a strange voice gradually take shape. It reminded me of that phantom voice Poe once heard, which was the voice not of any living creature but of a multitude of living things and which, varying in rhythm from syllable to syllable, whispered into his ear the beloved intonations of so many lost friends. From oldest ancestor to youngest child, all the resemblances and differences delineated a single character. The family seemed to me like an individual whose dissimilar members never disrupted the sense of unity and, on the contrary, proved necessary to its equilibrium. In the hall, as the chattering of so many faces subsided and fell silent, an idle conversation found an unusual resonance in me, for its murmur was exactly in unison with the voices issuing at that moment from the loudspeaker; this chorus was the voice of the family. Not a single person in the assembled group seemed to me free, neither in what they had been, nor in what they were, nor in what they would be. And what issued from the mouth of one or another

was the family, which answered me with its singular voice, according to its singular character, with its set way of thinking and which carried on across many past, present, and future bodies.

Once cinematography will have reached the century mark of its existence, now that we have the means of carrying out experiments and preserving filmstock, it will have been able to capture the startling and instructive appearances of this familial monster. Many other concepts await their personification through cinematography; among the closest are heredity, the affectations of the mind, diseases. In the silent period, M. Bruneau composed a short film of nothing but close-ups of people laughing; you couldn't view it without astonishment. One would have had to never experience a hospital clinic for typhus or tetanus in order to believe the aphorism: "There are no illnesses, there are only ill people." An epidemic lays its hands on individuals of all ages, conditions, temperaments, and morals; and it impresses on each the same attitude, the same facial mask, the same mental state. A pathogenic agent creates a tightly knit family, its family; all conform to a single personality, which is its alone.

If the search for these superhuman individuals has yet to be attempted, it's because our intelligence is specifically analytical, ill-suited to extract from the world views which are other than fragmentary, limited in time and localized in space. The slices of the universe we examine under the microscope cannot lead us to suspect the immense series constituted by other forms of existence which are practically ubiquitous and infinite. One of the fundamental characteristics of cinematography is to make up for this deficiency to a degree, to prepare certain syntheses for us, to reconstruct a form of continuity whose extent and elasticity in space-time is beyond the bounds of our physiology.

In beginning to explore the world, the eye and ear of cinematography are already demonstrating that movement is rigorously universal. Evoked on the screen, the first instances of this immeasurable mass of chaotic and secret, synthetic forms of existence, much superior to ours in power and duration, have approached the heart of the visible and audible, have revealed the spirit's appearances as well as the spirit of appearances, have reduced the differences between spirit and matter to the limits of our senses, which also arbitrarily separate hot from cold, shadow from light, future from past. But when an apparatus emerges which sharpens one sense or another, the boundary which we assume separates life from death changes, and we discover that it doesn't exist.

However, the analytical power of camera lenses and microphones is also something to be considered; and, following the natural inclination of our thinking and our least effort, we have already employed it to advantage, especially in studies of mechanics. We have applied it less to psychology. Yet a machine that would confess souls has always been an ideal of man, and today we know tests are capable of baring the most secret thoughts. I haven't read much about the parallel recording of voice and facial expression in slow motion, with the exception of this: an American judge, who found himself confronted by two women who each claimed to be the mother of a lost little girl, had the initial reactions of the child filmed as she was placed in front of first one claimant and then the other; and he didn't settle the case until after viewing and re-viewing the film.

In this search for sincerity, high-speed recording can sometimes, in the presence of an excellent actor as subject, lead to errors; but the most detailed

laboratory tests carry the same risk and provide the trained, intelligent simulator with even more opportunities. Just as the mind hasn't the time to retain, the eye has neither the time nor the field of vision to see everything in an expression: the premonition, the emergence, the evolution, the struggle among the intercurrent feelings which are eventually composed into an observable outcome, all that is spread out spontaneously by slow motion. And the magnification of the screen lets us examine it as in a magnifying glass. There the most alluring falsehoods lose their force while the truth bursts forth on first sight, strikes the spectator with the unexpectedness of the evident, and arouses an aesthetic emotion, a sense of infallible wonderment and pleasure. This feeling happens to each of us as we experience the unexpected in front of certain newsreel images in which real gestures become surprising.

Mirrors are unfaithful witnesses without insight (they invert the asymmetrical features which play such a great role in expression). Who has not wished to consult an observer such as cinematography daily on the subject of himself, in order to confirm his own sincerity, his own force of conviction?

# DZIGA VERTOV

## Film Directors: A Revolution

Born Denis Kaufman (1896–1954), Dziga Vertov adopted a pseudonym to evoke a spinning top. Vertov was a filmmaker and theoretician who not only wrote important proclamations and manifestos on the political power of film during the celebrated 1920s of Soviet cinema but also made one of the most important experimental documentaries in film history, *The Man with a Movie Camera* (1929). Working with multiple newsreel teams, he formed Kino-Eye, a group, dedicated to bringing Marxist principles to the movies, that included his brother and cameraman, Mikhail Kaufman, and his wife and editor, Yelizaveta Svilova. (Another brother, Boris Kaufman, became a noted cinematographer in France and Hollywood.) Writing in the wake of the Russian Revolution and at the end of the silent era of cinema, Vertov committed completely to the revolutionary capacity of the cinema to create collective activity and to offer people a new way to see the world as a place of change. By the 1930s, however, as Stalin's Soviet Union gravitated toward art forms promoting "socialist realism," Vertov's aesthetic program based in avant-garde notions of film form was being accused of an artistic elitism that alienated the general population.

Vertov's writings align historically and intellectually with the Constructivism and Futurism movements. Like these avant-garde aesthetics, his arguments emphasize the modern energies of machines, cities, and speed. For him and others, the movies became the best emblem and vehicle for art's new and modern potential, most notably through the power of editing or montage. Accordingly, he coined the term "kino-eye" (translated in the selection as "cinema-eye"), for "the documentary cinematic decoding of both the visible world and that which is invisible to the naked eye," an essentially cinematic way

of envisioning a new world. Situated in the dynamic crosscurrents of the 1920s, Vertov's positions argue vociferously against the dominant mimetic and narrative trends of Hollywood cinema and for a more dynamic interaction between films and audiences. As an indication of his always forward thinking, Vertov recognizes even in 1929, just after the introduction of synchronized sound, that sound could offer another important dimension to the dialectic powers of the cinema.

"Film Directors: A Revolution" (1923) is one of Vertov's more renowned essays, describing film's potential to revolutionize the world. Specifically, Vertov argues how movies (and later radio), by eschewing artificial narratives and stories, not only document reality but also dramatize how individuals and social groups can productively construct their reality. Decades later, these iconoclastic positions have resonated most demonstrably with the different new wave cinemas of the 1960s, particularly with the films of Jean-Luc Godard, who produced films such as *La Chinoise* (1967) as part of his "Dziga Vertov Group," and the poetic and political films of Chris Marker.

## READING CUES & KEY CONCEPTS

■ Why do you think Vertov feels that the montage constructions of "cinema-eye" surpass the vision of the human eye? Offer an example that supports his ideas from a particular film.

■ Note the unusual writing style and organization of Vertov's essay. Consider how his writing style complements the themes and arguments in the essay.

■ Vertov suggests three stages of film editing and argues for the crucial importance of the "interval" in the process. Describe those stages, and think of how this interval can act as an expedient "itinerary" for the eyes of the viewer.

■ **Key Concepts:** Futurists; Cinema-Eye; Montage; Visual "Intervals"

# Film Directors: A Revolution

. . . . . . . . . . . . . .

## 1

Looking at the pictures that have come to us from the West and from America, and bearing in mind the information we have about the work and experiments abroad and at home, I arrive at this conclusion: The death sentence passed by film-directors in 1919 on every film without exception is effective to this very day.

The most thorough observation reveals not a single picture, not a single experiment directed, as they should be, towards the *emancipation of the film-camera*, which remains wretchedly enslaved, subordinated to the imperfect, undiscerning human eye.

We are not protesting at the *undermining* of literature and the theatre by the cinema, and we fully sympathize with the use of the cinema for all branches of science, but we define these functions of the cinema as sidelines diverging from the main line.

*The basic and most important thing is: CINEMA-PERCEPTION OF THE WORLD.*

The starting-point is: *use of the film-camera as a cinema-eye, more perfect than the human eye for fathoming the chaos of those visual phenomena which evoke spatial dimension.*

The cinema-eye lives and moves in time and space, apprehends and fixes impressions in quite a different way from that of the human eye. The position of our bodies at the moment of observation, the number of features perceived by us in one or another visual phenomenon in one second of time is not at all binding on the film-camera, which, the more perfect it is, the more and the better it perceives things.

We cannot make our eyes better than they are already made, but we can perfect the film-camera without limit.

Up to today the film-cameraman has many a time suffered rebukes about a running horse which on the screen moved unnaturally slowly (rapid turning of the film-camera handle), or, conversely, about a tractor which ploughed a field too quickly (slow turning of the film-camera handle) and so on.

These are accidents, of course, but we are preparing a system, a contrived system of cases like these, a system of *apparent* irregularities which probe into and organise phenomena.

Up to today we *have coerced the film-camera and made it copy the work of our own eyes.* And the better the copying, the more highly was the shot considered.

From today we are liberating the camera and making it work in the opposite direction, furthest away from copying.

All the weaknesses of the human eye are external. We affirm the *cinema-eye, that gropes in the chaos of movements for a resultant force for its own movement, we affirm the cinema-eye with its dimension of time and space, growing in its own strength and its own resources to reach self-affirmation.*

## 2

. . . I force the spectator to see in the way most advantageous for me to show this or that visual phenomenon. The eye is subordinated to the will of the film-camera and directed by it onto those consecutive moments of action, which in the briefest and clearest way lead the cinema-phrase to the heights or depths of resolution.

For example: a shot of boxing, not from the point of view of a spectator present at the match, but a shot of the consecutive movements (methods) of the boxers. Or: a shot of a group of dancers—but not from the viewpoint of a spectator sitting in a hall with a ballet on stage in front of him.

It is known that a spectator at a ballet watches haphazardly sometimes the general group of dancers, sometimes separate dancers at random, and sometimes somebody's feet: *a series of incoherent impressions, different for each single spectator.*

We must not present the cinema audience with this. The system of consecutive movements demands shots of the dancers or boxers as an exposition of the tricks presented one after the other, with the *forced* transference of the spectator's eyes onto those successive details which must be seen.

*The film-camera drags the eyes of the audience* from hands to feet, from feet to eyes, and so on in the best order possible, and organises details into a regular montage-study.

## 3

You can be walking along the street in Chicago today, in 1923, but I can make you bow to the late comrade Volodarsky, who in 1918 is walking along a street in Petrograd, and he will return your bow.

Another example: the coffins of national heroes are lowered into their tombs (taken in Astrakhan in 1918), the tombs are filled in (Kronstadt, 1921), a gun salute (Petrograd, 1920), eternal remembrance, hats are removed (Moscow 1922)—such things can be fitted together even from thankless material which was not specially filmed (see *Kino-Pravda* No. 13). A further example of this is the montage of the greetings of the crowd and the montage of the salute of the vehicles for comrade Lenin (*Kino-Pravda* No. 14), taken in different places, at different times.

. . . I am the cinema-eye. I am a constructor.

I have set you down, you who have today been created by me, in a most amazing room, which did not exist up to this moment, also created by me.

In this room are 12 walls filmed by me in various parts of the world.

Putting together the shots of the walls and other details I was able to arrange them in an order which pleases you, and which will correctly construct by intervals the cinema-phrase, which is in fact a room . . . . . . . . . . . . . . . . . . . . . . . . . . . . . . . . . . . . . . . .
. . . . . . . . . . . . . . . . . . . . . . . . . . . . . . . . . . . . . . . . . . . . . . . . . . . . . . . . . . . . . . . . . . . . . . . . . . . . . . .

I am the cinema-eye. I create a man more perfect than Adam was created, I create thousands of different people from various preliminary sketches and plans.

I am the cinema-eye.

I take from one person the strongest and deftest hands, from another I take the strongest and swiftest legs, from a third the most beautiful and expressive head and I create a new, perfect man in a montage . . .

## 4

. . . I am the cinema-eye. I am a mechanical eye.

I, a machine, can show you the world as only I can see it.

From today I liberate myself for ever from human immobility. *I am in perpetual motion*, I approach and move away from objects, I creep up to them, I climb onto them, I move alongside the muzzle of a running horse, I tear into the crowd at full speed, I run before the fleeing soldiers, I tip over onto my back, I ascend with aeroplanes, I fall and rise together with falling and rising bodies.

Here am I, the camera, rushing about guided by a resultant force, manoeuvring in the chaos of motions, fixing motion from motion in the most complex combinations.

Freed from the obligation of 16–17 frames a second, freed from the limits of time and space, *I can contrast any points in the universe*, wherever I might fix them.

My way leads to the creation of a fresh perception of the world. And this is how I can decipher anew a world unknown to you.

## 5

... Once again let us settle one thing: the eye and the ear.

The ear does not spy and the eye does not eavesdrop.

*A division of functions:*

*The radio-ear—the montaged "I hear!"*

*The cinema-eye—the montaged "I see!"*

*This is for you, citizens, for a start, instead of music, painting, theatre, cinema and* other castrated effusions.

Amid the chaos of motions rushing past, rushing away, rushing forward and collid-ing together—into life there comes simply *the eye.*

The day of visual impressions has passed. How can a day's impressions be con-structed into an effective whole in a visual study?

If everything that the eye saw were to be photographed onto a film there would naturally be confusion. If it were artistically assembled, what was photographed would be clearer. If the encumbering rubbish were thrown out, it would be still bet-ter. We shall obtain an organised manual of impressions of the *ordinary eye.*

The mechanical eye—the film-camera, refusing to use the human eye as a crib, repelled and attracted by motions, gropes about in the chaos of visual events for the path for its own motion or oscillation, and experiments by stretching time, breaking up its motions, or vice versa, absorbing time into itself, swallowing up the years, thereby schematizing prolonged processes which are inaccessible to the normal eye ...

... To the aid of the machine-age comes ... the *cineaste-pilot,* who not only con-trols the motions of the camera but who *trusts* in it during spatial experimentation, and ... the *cineaste-engineer,* who controls the cameras at a distance.

The result of this sort of combined action of the liberated and perfected camera, and of the strategic brain of man directing, observing and taking stock of things, is a notice-ably fresher, and therefore interesting, presentation of even the most ordinary things ...

... How many people are there thirsting for spectacular shows that wear out their trousers in the theatres?

They flee from the daily round, they flee from the prose of life. And yet the theatre is almost always just a wretched counterfeit of that very same life plus a stupid con-glomeration of the affectations of ballet, musical squeaks, lighting effects, decora-tions (from the daubing-type to the constructive-type) and sometimes the excellent work of a literary master, perverted by all the rubbish. Certain masters of the theatres are destroying the theatres from the inside, breaking the old forms and declaring new slogans for work in the theatre; brought in to help this are bio-mechanics (a good exercise in itself), the cinema (glory and honour to it), writers (not bad in themselves), constructions (there are good ones), motor-cars (how can one not respect a motor-car?), and gun-fire (a dangerous and impressive trick in the front rows), but in general not a single feature stands out in it.

Theatre, and nothing more.

Not only not a synthesis, but not even a regular miscellany.

And it cannot be otherwise.

We, the film-makers, are determined opponents of premature synthesis ("to synthesis as the zenith of achievement!"), and realise it is pointless to mix up fragments of achievement: the poor infants immediately perish through overcrowding and disorder. And in general—*the arena is small.*

Please let's get into life.

*This is where we work—we, the masters of vision—organisers of visible life, armed with the ever-present cinema-eye.*

*This is where the masters of words and sounds work, the most skillful montage-makers of audible life. And I venture to slip in with them the ubiquitous mechanical ear and mouth-piece—the radio-telephone.*

What does this amount to?

It means *the newsreel film and the radio newsreel.* I intend to stage a parade of film-makers in Red Square on the occasion of the *Futurists'* issuing of the first edition of the montaged radio-newsreel.

Not the "Pathe" newsreel-films nor Gaumont (a newspaper-type "newsreel") and not even *Kino-Pravda* (a political "newsreel"), but a genuine cinema newsreel— *a swift review of VISUAL events deciphered by the film-camera, pieces of REAL energy* (I distinguish this from theatrical energy), *brought together at intervals to form an accumulatory whole by means of highly skilled montage.*

This structure for the cinema allows any theme to be developed, whether comic, tragic, contrived or anything else.

The whole trick lies in this or the juxtapositioning of visual features, the whole trick lies in the intervals.

The unusual flexibility of the montage-construction permits any political, economic, or other motifs be brought into the cinema-study. And that is why

*FROM TODAY neither psychological nor detective dramas are needed in the cinema*

*FROM TODAY theatrical productions taken onto film are not needed*

*FROM TODAY neither Dostoevsky nor Nat Pinkerton need be scripted*

*Everything can be included in the new concept of the newsreel film.*

*These two things now make a decisive entry into the muddle of life:*

1. *the cinema-eye, which disputes the visual presentation of the world by human eye, and presents its "I see!"*

2. *the cineaste-montageur, who organises moments of life-construct now seen in cinema-eye fashion for the first time.*

[TRANSLATED BY RICHARD SHERWOOD]

# SERGEI EISENSTEIN

......................................................................................

# The Dramaturgy of Film Form
# (The Dialectical Approach to Film Form)

Sergei Mikhailovich Eisenstein (1898–1948) is one of the most significant figures in film theory and in Soviet cinema of the 1920s. He is often seen as the foremost among the rare group of theorists-practitioners in cinema best known for formulating the theory and practice of dialectical montage—an editing style that highlights the collision or conflict

between and within successive shots. After his education in engineering was interrupted by the 1917 Russian Revolution, Eisenstein served in the Red Army as a technician, and in the following years became a set designer and then director at the avant-garde Moscow Proletkult Theater. The theater participated in the revolutionary cause by promoting culture and artistic self-expression among workers and it would remain an important influence on Eisenstein. Eisenstein believed the duty of an artist was to contribute to the creation of a new society by raising the consciousness of the masses, and he embraced the film medium as the most efficient tool in achieving this goal. Eisenstein left an invaluable legacy of theoretical writings advocating a formalist theory of cinema and made influential films such as *Strike* (1924), *October* (1927), and *Alexander Nevsky* (1938). His most famous film and a seminal achievement in film montage, *Battleship Potemkin* (1925), is one of the most compelling illustrations of film as an effective means of persuasion.

For Eisenstein and his montage theory colleagues, Lev Kuleshov (p. 135), Dziga Vertov (p. 257), V. I. Pudovkin, and Alexander Dovzhenko, art is not a reproduction of reality. Rather, the basis of art is in its formal elements, which serve as the building blocks of an artist's construction process. At the center of this construction is the principle of the dialectic, a conflict between individual elements that creates meaning larger than, and different from, the sum of these elements. Eisenstein believed that cinematic meaning is not inherent in the image itself (as it is in the later realist theory of André Bazin [p. 309]) but is constructed by the process of montage. Eisenstein drew from an eclectic combination of theories, like Pavlovian psychology and Marx's dialectic, as well as art practices, like Japanese kabuki theater and Chinese ideograms, to formulate his theories of "the montage of attractions" and "intellectual montage." These principles of montage, which Eisenstein integrated into his own films, emerged in the era of silent film and were most effective in the realm of images. Like many theorists who worked in the silent film era, Eisenstein found the prevalent practices of synchronized sound incompatible with his approach to film, though he incorporated sound and music into his antirealist theory and practice.

Written in 1929, Eisenstein's seminal essay, "The Dramaturgy of Film Form," is crucial to understanding his theory and his cinematic goals. The form of the essay itself is an unusual and rapid collage of ideas that defies linear logic and appears to be an imitation of his editing technique. In it, Eisenstein asserts that conflict is the fundamental principle of every work of art. He demonstrates how essential the concept of the dialectic is to cinematic form, and through numerous and detailed filmic examples shows how such montage can be created. Each shot, for Eisenstein, possesses potential energy that displays itself in visual terms. This energy materializes and creates a conflict when the two shots collide, and it is this specific interaction of shots that produces meaning. Eisenstein's principles of montage, one of the cornerstones of film theory, has had a profound influence on the filmmaking world, well beyond any specific time period or genre. Many filmmakers, including Alfred Hitchcock, Francis Ford Coppola, and Brian De Palma, owe much of their style to Eisenstein's groundbreaking work and pay homage to him either through direct reference or pastiche.

## READING CUES & KEY CONCEPTS

■ Eisenstein asserts that "the shot is not a montage element—the shot is a montage cell (a molecule)." What does he mean by this, and what is the difference between the two definitions?

■ For Eisenstein, montage is more than a method used to link separate shots; it should be used to manipulate the response or emotions of the audience. What role, according to what you have read, does the audience have in the creation of the film's meaning?

■ Think about your own experiences with film viewing; can you use them to explain Eisenstein's claim that an individual shot "has in itself no reality at all"?

■ **Key Concepts:** Montage; Dialectical Materialism; Conflict; Collision

# The Dramaturgy of Film Form
# (The Dialectical Approach to Film Form)

. . . . . . . . . . . . . .

According to Marx and Engels the system of the dialectic is only the conscious reproduction of the dialectical course (essence) of the external events of the world. (Razumovsky, *The Theory of Historical Materialism*, Moscow, 1928)

*Thus:*
the projection of the dialectical system of objects into the brain
—*into abstract creation*—
—*into thought*—
produces dialectical modes of thought—dialectical materialism—

PHILOSOPHY.

*Similarly:*
the projection of the same system of objects—in concrete creation—in form—produces

ART.

The basis of this philosophy is the *dynamic* conception of objects: being as a constant evolution from the interaction between two contradictory opposites.
Synthesis that *evolves* from the opposition between thesis and antithesis.
It is equally of basic importance for the correct conception of art and all art forms.
In the realm of art this dialectical principle of the dynamic is embodied in

CONFLICT

as the essential basic principle of the existence of every work of art and every form.

FOR ART IS ALWAYS CONFLICT:

1. because of its social mission,
2. because of its nature,
3. because of its methodology.

1. *Because of its social mission, since:* it is the task of art to reveal the contradictions of being. To forge the correct intellectual concept, to form the right view by stirring up contradictions in the observer's mind and through the dynamic clash of opposing passions.

2. *Because of its nature, since:* because of its nature it consists in the conflict between natural being and creative tendentiousness. Between organic inertia and purposeful initiative.

The hypertrophy of purposeful initiative—of the principle of rational logic—leaves art frozen in mathematical technicism. (Landscape becomes topography, a painting of St. Sebastian becomes an anatomical chart.)

Hypertrophy of organic naturalness—of organic logic—dissolves art into form-lessness.

(Malevich becomes Kaulbach,
Archipenko a waxworks show.)
Because:
    the limit of organic form
    (the passive principle of being) is

<div align="center">NATURE</div>

    the limit of rational form
    (the active principle of production) is

<div align="center">INDUSTRY</div>

and:
    at the intersection of nature
    and industry stands

<div align="center">ART.</div>

    1. The logic of organic form

<div align="center">versus</div>

    2. the logic of rational form produces in collision the dialectic of the art form.

*The interaction between the two produces and determines the dynamic.* (Not just in the sense of space-time, but also in the field of pure thought. I similarly regard the evolution of new concepts and attitudes in the conflict between normal conceptions and particular representations as a dynamic—a dynamisation of the inertia of perception—a dynamisation of the "traditional view" into a new one.)

*The basis of distance determines the intensity of the tension:* (viz., for instance, in music the concept of intervals. In it there can be cases where the gap is so wide that it can lead to a break, to a disintegration of the homogeneous concept of art. The "inaudibility" of certain intervals.)

*The spatial form of this dynamic is the expression of the phases in its tension—rhythm.* This applies to every art form and, all the more so, to every form of its expression. Thus human expression is a conflict between conditioned and uncon-ditioned reflex.

(I do not agree on this point with Klages who
1. considers human expression not dynamically as process but statically as result and
2. attributes everything that moves to the field of the "soul" and, by contrast, only that which restrains to "reason," in the idealistic concept of "reason" and "soul" which here corresponds indirectly with the ideas of conditioned and unconditioned reflex.)

The same is equally true for every field, in so far as it can be understood as art. Thus, for instance, logical thought, viewed as art, also produces the same dynamic mechanism: "The intellectual lives of Plato or Dante . . . were largely guided and sustained by their delight in the sheer beauty of the *rhythmic relation* between law and instance, species and individual, or cause and effect."

This also applies in other fields, e.g. in language, where the strength, vitality and dynamism derive from the irregularity of the particular in relation to the rule governing the system as a whole.

In contrast to this we can see the sterility of expression in artificial, totally regulated languages like Esperanto. It is from this same principle that the whole charm of poetry derives: its rhythm emerges as conflict between the metric measure adopted and the distribution of sounds that ambushes that measure.

The concept of even a formally static phenomenon as a dynamic function dialectically symbolises the wise words of Goethe that

"Architecture is frozen music."

We shall employ this concept further. And, just as in homogeneous thought (a monistic attitude), both the whole and the minutest detail must be permeated by a *single principle*, so, together with the conflict of *social conditionality* and the conflict of *reality*, that same principle of conflict serves as the foundation stone for the *methodology* of art. As the basic principle of the rhythm that is to be created and of the derivation of the art form.

3. *Because of its methodology:* shot and montage are the basic elements of film.

## MONTAGE

Soviet film has stipulated this as the nerve of film.

To determine the essence of montage is to solve the problem of film as such.

The old film-makers, including the theoretically quite outmoded Lev Kuleshov, regarded montage as a means of producing something by describing it, adding individual shots to one another like building blocks.

Movement within these shots and the resulting length of the pieces were thus to be regarded as rhythm.

A fundamentally false notion! It would mean defining an object exclusively in terms of its external course. Regarding the mechanical process of sticking the pieces together as a principle. We cannot characterise this kind of relationship between lengths as rhythm.

It would give rise to a metre that was as opposed to rhythm as much as the mechanical-metric Mensendick system is opposed to the organic rhythmic Bode school in the case of bodily expression.

According to this definition (which Pudovkin also shares as a theorist) montage is the means of *unrolling* an idea through single shots (the "epic" principle).

*But in my view montage is not an idea composed of successive shots stuck together but an idea that* DERIVES *from the collision between two shots that are independent of one another* (the "dramatic" principle). ("Epic" and "dramatic" in relation to the methodology of form and not content or plot!!) As in Japanese hieroglyphics in which two independent ideographic characters ("shots") are juxtaposed and *explode* into a concept. THUS:

| | | |
|---|---|---|
| Eye + Water | = | Crying |
| Door + Ear | = | Eavesdropping |
| Child + Mouth | = | Screaming |
| Mouth + Dog | = | Barking |
| Mouth + Bird | = | Singing |
| Knife + Heart | = | Anxiety, etc.* |

Sophistry? Not at all! Because we are trying here to derive the whole essence, the stylistic principle and the character of film from its technical (-optical) foundations.

We know that the phenomenon of movement in film resides in the fact that still pictures of a moving body blend into movement when they are shown in quick succession one after the other.

The vulgar description of what happens—as a *blending*—has also led to the vulgar notion of montage mentioned above.

Let us describe the course of the said phenomenon more precisely, just as it really is, and draw our conclusions accordingly.

Is that correct? In pictorial-phraseological terms, yes.

But not in mechanical terms.

For in fact each sequential element is arrayed, not *next* to the one it follows, but on *top* of it. *For:* the idea (sensation) of movement arises in the process of superimposing on the retained impression of the object's first position the object's newly visible second position.

That is how, on the other hand, the phenomenon of spatial depth as the optical superimposition of two planes in stereoscopy arises. The superimposition of two dimensions of the same mass gives rise to a completely new higher dimension.

In this instance, in the case of stereoscopy, the superimposition of two non-identical two-dimensionalities gives rise to stereoscopic three-dimensionality. In another field: concrete word (denotation) set against concrete word produces abstract concept.

As in Japanese (see above), in which *material* ideogram set against *material* ideogram produces *transcendental result* (concept).

The incongruity in contour between the first picture that has been imprinted on the mind and the subsequently perceived second picture—the conflict between the two—gives birth to the sensation of movement, the idea that movement has taken place.

The degree of incongruity determines the intensity of impression, determines the tension that, in combination with what follows, will become the real element of authentic rhythm.

Here we have, in the temporal sense, what we see emerging spatially on the graphic or painted surface.

What does the dynamic effect of a picture consist of?

The eye follows the direction of an element. It retains a visual impression which then collides with the impression derived from following the direction of a second

---

* Abel Rémusat, "Recherches sur l'origine de la formation de l'écriture chinoise" [Research on the Origin of the Formation of Chinese Script], *Académie des inscriptions et belles-lettres*, Paris: Memoires, vol. 8(ii), Paris, 1827, pp. 1–33.

element. The conflict between these directions creates the dynamic effect in the apprehension of the whole.

I.  It may be purely linear: Fernand Léger, Suprematism.

II.  It may be "anecdotal." The secret of the fabulous mobility of the figures of Daumier and Lautrec consists in the fact that various parts of the bodies of their figures are depicted in spatial situations (positions) that vary temporally. See, for instance, Lautrec's "Miss Cissy Loftus":

> A logical development of position A for the foot leads to the elaboration of a corresponding position A for the body. But from the knee up the body is already represented in position A+a. The cinematic effect of the still picture is already visible here: from hips to shoulders we already have A+a+a. The figure seems alive and kicking!

III.  Primitive Italian Futurism lies somewhere between I and II: the man with six legs in six positions. (Between I and II because II achieves its effects by retaining natural unity and anatomical cohesion, whereas I achieves this through purely elementary elements, while III, although undermining nature, is not yet pushed as far as abstraction.)

IV.  It can be of an ideographic kind. Like the pregnant characterisation of a Sharaku (eighteenth-century Japan). The secret of his extremely clever power of expression lies in the anatomical *spatial disproportion* of the parts. (You might term I above *temporal disproportion*.) Julius Kurth expresses himself thus in *Sharaku* (he is describing a portrait of an actor, comparing it to a mask):

> Whereas the anatomical proportions of the carved wooden mask are almost correct, the proportions of the face in the print are quite impossible. The distance between the eyes is so great as to make a mockery of common sense. The nose, in comparison with the eyes at least, is twice as long as a normal nose could possibly be, the chin is on the whole out of all proportion to the mouth: the relationships between the eyebrows, the mouth, the details in general are quite unthinkable. We can observe the same thing in all Sharaku's large heads. It is just not possible that the great master was unaware that these proportions were wrong. He quite deliberately repudiated naturalism and, *while each detail taken separately is constructed on the principles of concentrated naturalism, their general compositional juxtaposition is subjugated to a purely semantic purpose.*

The spatial calculation of the corresponding size of one detail in relation to another and the collision between that and the dimension determined for it by the artist produces the characterisation: the resolution of the representation.

Finally, colour. A colour shade conveys a particular rhythm of vibration to our vision. (This is not perceived visually, but purely physiologically, because colours are distinguished from one another by the frequency of their light vibrations.) The nearest shade has a different frequency of vibration.

The counterpoint (conflict) between the two—the retained and the still emerging—frequency produces the dynamic of our perceptions and of the interplay of colour.

From here we have only to make one step from visual vibration to acoustic vibration and we find ourselves in the field of music. We move from the realm of the spatial-pictorial to the realm of the temporal-pictorial.

Here the same law rules. Because for music counterpoint is not just a form of composition but the basic rationale for the possibility of sound perception and differentiation. One might also say that in all the cases cited here the same *principle of comparison* operates: it makes possible for us discovery and observation in every field. With the moving image (film) we have, as it were, the synthesis of these two counterpoints: the spatial counterpoint of the image and the temporal counterpoint of music. Characterised in film through what we might describe as:

### VISUAL COUNTERPOINT

This concept, when applied to film, allows us to designate various approaches to the problem, to a kind of film grammar. Similarly with a syntax of film expressions in which the visual counterpoint can determine a completely new system of forms of expression. (Experiments in this direction will be illustrated by extracts from my films.) In all this:

The *basic presupposition* is:

*The shot is not a montage element—the shot is a montage cell (a molecule).*

This formulation explodes the dualistic division in the analysis:

of: title and shot

and: shot and montage.

Instead it is viewed dialectically as three different *phases in the formation of a homogeneous expressive task*. With homogeneous characteristics that determine the homogeneity of their structural laws.

*The relationship between the three: conflict within a thesis* (an abstract idea):

1. is *formulated* in the dialectic of the *title,*

2. is *formed* spatially in the *conflict within* the shot—and

3. *explodes* with the growing intensity of the *conflict montage between the shots.*

Once again this is quite analogous to human psychological expression. This is a conflict of motives. Conceivable, likewise, in three phases:

1. Purely verbal utterance. Without intonation: spoken expression.

2. Gesticulative (mimic-intentional) expression. Projection of conflict on to the entire expressive body-system of man. ("Gesture" and "sound gesture"—intonation.)

3. Projection of conflict into the spatial. With the growing intensity (of motives) the zigzag of mimic expression is catapulted into the surrounding space according to the same distorting formula. A zigzag of expression deriving from the spatial disposition of man in space.

Herein lies the basis for a quite new conception of the problems of film form. We cite as examples of conflict:

1. Graphic conflict.

2. Conflict between planes.

3. Conflict between volumes.

4. Spatial conflict.

5. Conflict in lighting.

6. Conflict in tempo, etc., etc.

(NB Here they are characterised by their principal feature, by their *dominant*. It is obvious that they occur mainly as complexes, grouped together. That applies to both the shot and to montage.)

For montage transition it is sufficient to imagine any example as being divided into two independent primary pieces

This is the graphic case. It applies also to all other cases. The extent to which the conflict concept extends in the treatment of film form is illustrated by the following further examples:

7. Conflict between matter and shot (achieved by *spatial distortion* using camera angle).

8. Conflict between matter and its spatiality (achieved by *optical distortion* using the lens).

9. Conflict between an event and its temporality (achieved by slowing down and speeding up [*Multiplikator*]) and lastly:

10. Conflict between the entire *optical* complex and a quite different sphere.

That is how the conflict between optical and acoustic experience produces:

SOUND FILM
which is realisable as
AUDIO-VISUAL COUNTERPOINT.

The formulation and observation of the phenomenon of film in the form of conflict provides the first opportunity to devise a homogeneous system of *visual dramaturgy* for every special and particular case of the problem of film.

To create a *dramaturgy of visual film form* that is determined in the same way as the existing *dramaturgy of film material* is determined. . . .

Montage as conflict illustrated in two frames from sequential shots in the Odessa steps sequence of Eisenstein's *Battleship Potemkin* (1925).

The same standpoint—viewed as an outcome for film composition—produces the following stylistic forms and possibilities and this could constitute a

FILM SYNTAX
A TENTATIVE FILM SYNTAX.

*We shall list here:*
A series of compositional possibilities that develop dialectically from the thesis that the concept of filmic movement (time lapse) derives from the superimposition of—the counterpoint between—two different stills.

I. *Each moving piece of montage in its own right.* Each photographed piece. The technical determination of the phenomenon of movement. *Not yet composition* (a man running, a gun firing, water splashing).

II. *Artificially produced representation of movement.* The basic optical sign is used for arbitrary composition:

*A. Logical*
Example 1. *Ten Days That Shook the World (October).*
Montage: repetition of a machine-gun firing by cross-cutting the relevant details of the firing.
*Combination a):*
Brightly lit machine-gun. Dark one.
Different shot. Double burst:
Graphic burst and light burst.
*Combination b):*
Machine-gun.
Close-up of the machine-gunner.
Effect almost of double exposure with rattling montage effect.
Length of the pieces—two frames.

Example 2. *Potemkin* (1925).
Representation of a spontaneous action, *Potemkin.* Woman with pince-nez. Followed immediately—without a transition—by the same woman with shattered pince-nez and bleeding eye. Sensation of a shot hitting the eye.

*B. Alogical*
Example 3. *Potemkin.*
This device used for symbolic pictorial expression. *Potemkin.* The marble lion leaps up, surrounded by the thunder of *Potemkin*'s guns firing in protest against the bloodbath on the Odessa Steps.
Cut together from three immobile marble lions at Alupka Castle (Crimea). One sleeping. One waking. One rising. The effect was achieved because the length of the middle piece was correctly calculated. Superimposition on the first piece produced the first jump. Time for the second position to sink in. Superimposition of the third position on the second—the second jump. Finally the lion is standing.

Example 4. *Ten Days.*
The firing in Example 1 is symbolically produced from elements that do not belong to the actual firing. To illustrate General Kornilov's attempted monarchist *putsch* it

occurred to me that his militarist *tendency* could be shown in the cutting (montage), but creating the montage material itself out of religious details. Because Kornilov had betrayed his tsarist tendency in the form of a curious "crusade" of Mohammedans (!) (his "Wild Division" from the Caucasus) and Christians (all the others) against the . . . Bolsheviks. To this end a Baroque Christ with beams streaming (exploding) from its halo was briefly intercut with a self-contained egg-shaped Uzume mask. The temporal conflict between the self-contained egg shape and the graphic star produced the effect of a simultaneous explosion (a bomb, a shot).

Example 5. *Ten Days.*
A similar combination of a Chinese sacred statue and a madonna with a halo. (NB As we see, this already provides the opportunity for tendentious (ideological) expression.)

Another example of more primitive effect from the same place: in the simple cross-cutting between church towers leaning in opposite directions.

So far the examples have shown *primitive-psychological* cases—using *only* the optical superimposition of movement.

III. The case of emotional combinations not merely of the visible elements of the pieces but principally of the chains of psychological association. *Associational montage* (1923–4). As a means of sharpening (heightening) a situation emotionally.

In Case I we had the following: two pieces A and B following one another are materially identical. According to the position of the material in the shot they are, however, not identical:

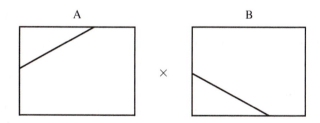

These two combined produced dynamisation in space—the impression of spatial dynamic:

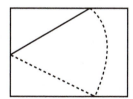

The degree of difference between positions A and B determines the tension of the movement. But let us take a new case:

Shot A and shot B are, in terms of material, *not identical*. The associations of the two shots are identical: associatively identical. By analogy this *dynamisation of the material* produces, not in the spatial but in the *psychological, i.e. the emotional, field:*

EMOTIONAL DYNAMISATION.

Example 1. *The Strike* (1923–4).
The shooting down of the workers is cut in such a way that the massacre is intercut with the slaughter of a cow. (Difference in material. But the slaughter is employed as an appropriate association.) This produces a powerful emotional intensification of the scene.

NB In this case the homogeneity of gesture plays a very great role in generally achieving the effect (the homogeneity of the dynamic gesture: movement within the shot—or of the static gesture: the graphic attitude of the shot). Here is an excerpt from the first version of this scene in the montage list (1923):

1. The head of a bull.

2. The butcher's knife strikes a downward blow.

3. Five hundred workers fall down a hill.

4. Fifty men get up. Hands.

5. A soldier's face. He aims.

6. Shots.

7. The bull standing. It twitches and falls.

8. Close-up. Convulsions of the hind legs. A hoof kicks into the blood.

9. Rifles.

10. Semi-close-up. People get up. Wounded.

11. Imploring hands raised towards the camera.

12. Butcher with blood-stained rope approaches the camera.

13. Hands.

14. The butcher approaches, etc.

This principle was subsequently also used by Pudovkin in *The End of St. Petersburg* (1927) when he intercut shots of stock exchange and battlefield. And, in *The Mother* (1926), the ice breaking and the workers' demonstration.

This method may decay pathologically if the essential viewpoint—the emotional dynamisation of the material—gets lost. Then it ossifies into lifeless literary symbolism and stylistic mannerism. We may cite the following as an example:

Example 2: *Ten Days.*
The mellifluous peace overtures of the Mensheviks at the Second Congress of the Soviets (during the storming of the Winter Palace) are intercut with harp-playing hands. A purely literary parallelism that does nothing to enliven the material.

Similarly in Otsep's *The Living Corpse*, with the intercutting (in imitation of *Ten Days*) of church cupolas or lyrical landscapes into the speeches of the prosecution and the defence counsels in the court. The same mistake as that above.

On the other hand, the predominance of purely dynamic effects may have a positive result:

Example 3: *Ten Days*.
The pathos of the adherence of the cycle battalion to the Second Congress of the Soviets is dynamised by the fact that, when their delegates enter, abstractly spinning cycle wheels (association with the battalion) were intercut. These resolved the pathetic content of the event as such into a perceptible dynamic. The same principle—the emergence of a concept, of a sensation from the juxtaposition of two disparate events—led on to:

IV. *The emancipation of closed action from its conditioning by time and space.* The first attempts at this were made in the *Ten Days* film.

Example 1. (*Ten Days*)
A trench packed with soldiers seems to be crushed by the weight of an enormous cannonball descending on the whole thing. Thesis brought to expression. In material terms the effect is achieved through the apparently chance intercutting between an independently existing trench and a metal object with a similarly military character. In reality they have absolutely no spatial relationship with one another.

Example 2: *Ten Days*.
Similarly in the scene of Kornilov's *putsch* attempt, which puts an end to Kerensky's Bonapartist plans. In this sequence one of Kornilov's tanks, emerging from the trench, shatters the plaster figure of Napoleon that stands on Kerensky's desk in the palace of Petrograd and has purely symbolic meaning.

This method of making whole sequences in this way is now mainly being employed by Dovzhenko: *The Arsenal* (1929). Also by Esfir Shub on her Tolstoy film (1928). In addition to this method of dissolving the accepted forms of handling film material I should like to cite another example, which has, however, not been realised in practice.

In 1924–5 I was very concerned with the idea of the filmic representation of real (actual) man. At that time the prevailing trend was that living man could only be shown in film in *long* dramatic scenes. And that cutting (montage) would destroy the idea of real man.

Abram Room established the record in this respect in *The Bay of Death* by using eighty metre-long uncut dramatic scenes. I felt (and feel) that such a concept is utterly unfilmic.

For what really is, in linguistic terms, a precise characterisation of man?
His raven-black hair . . .
The waves in his hair . . .
His flashing, bright blue eyes . . .
His steely muscles . . .
Even when it is not so exaggeratedly phrased, every description, every verbal representation of a man (see above!) becomes an accumulation of waterfalls, lightning conductors, landscapes, birds, etc.

Why then should cinema in its forms follow theatre and painting rather than the methodology of language, which gives rise, through the combination of concrete descriptions and concrete objects, to quite new concepts and ideas? It is much closer

to film than, for instance, painting, where form derives from *abstract* elements (line, colour). In film, by contrast, it is precisely the material *concreteness* of the shot as an element that is the most difficult aspect of the process of formation. Why not then lean rather more towards the system of language, where the same mechanism exists in the use of words and word complexes?

Why is it, on the other hand, that montage cannot be avoided even in the orthodox feature film?

The differentiation in montage pieces is determined by the fact that each piece has in itself no reality at all. But each piece is itself in a position to evoke a certain association. The accumulation of associations then achieves the same effect as that provoked in the audience by purely physiological means by a theatrical play that is unfolding in reality.

E.g. Murder on stage has a purely physiological effect. Perceived in a *single* montage sequence it acts like an item of *information*, a title. It only begins to work *emotionally* when it is presented in montage fragments. In montage pieces, each of which provokes a certain association, the sum of which amounts to a composite complex of emotional feeling. In traditional terms:

1. A hand raises a knife.

2. The eyes of the victim open wide.

3. His hands clutch the table.

4. The knife jerks.

5. The eyes close.

6. Blood spurts out.

7. A mouth shrieks.

8. Drops fall on to a shoe . . .

and all that kitsch! In any event each *individual piece* is already almost *abstract* in relation to the *action as a whole*. The more differentiated they are, the more abstract they become, aiming only at provoking a certain association. Now the following thought arises quite logically: could one not achieve the same effect more productively if one did not adhere so slavishly to plot but materialised the notion of *murder* in a free accumulation of associative material? Because the most important thing is to convey the representation of murder, the feeling of murder as such. Plot is only one of the means without which we still do not know how to communicate something to the audience. At any rate an attempt of this sort would produce the most interesting variety of forms. Let someone try it! Since 1923–4, when this thought occurred to me, I have unfortunately not had the time to carry out this experiment. Now I have turned to quite different problems.

But, *revenons à nos moutons*, which will bring us closer to these tasks. Whereas, with 1, 2 and 3 above, the suspense was calculated to achieve purely physiological

effects, from the purely optical to the emotional, we must also mention here the case in which the same conflict tension serves to achieve new concepts, new points of view, in other words, serves purely intellectual ends.

Example 1: *Ten Days.*
Kerensky's rise to (untrammelled) power and dictatorship after July 1917. Comic effect is achieved by *intercutting titles denoting ever higher rank* ("Dictator," "Generalissimo," "Minister of the Navy and the Army," etc.) with five or six sequences of the staircase in the Winter Palace with Kerensky ascending the *same* flight each time.

Here the conflict between the kitsch of the ascending staircase and Kerensky treading the same ground produces an intellectual resultant: the satirical degradation of these titles in relation to Kerensky's nonentity.

Here we have a counterpoint between a verbally expressed, conventional idea and a pictorial representation of an individual who is unequal to that idea.

The incongruity between these two produces a purely *intellectual* resolution at the expense of this individual. Intellectual dynamisation.

Example 2: *Ten Days.*
Kornilov's march on Petrograd took place under the slogan "In the Name of God and the Fatherland." Here we have an attempt to use the representation for anti-religious ends. A number of images of the divine were shown in succession. From a magnificent Baroque Christ to an Eskimo idol.

Here a conflict arises between the concept "God" and its symbolisation. Whereas idea and image are completely synonymous in the first Baroque image, they grow further apart with each subsequent image. We retain the description "God" and show idols that in no way correspond with our own image of this concept. From this we are to draw anti-religious conclusions as to what the divine as such really is.

Similarly, there is here an attempt to draw a purely intellectual conclusion as a resultant of the conflict between a preconception and its *gradual tendentious discrediting by degrees* through pure illustration.

The gradual succession continues in a process of comparing each new image with its common designation and *unleashes a process that, in terms of its form, is identical to a process of logical deduction.* Everything here is already intellectually conceived, not just in terms of the resolution but also of the method of expressing ideas.

The conventional *descriptive* form of the film becomes a kind of reasoning (as a formal possibility).

Whereas the conventional film directs and develops the *emotions*, here we have a hint of the possibility of likewise developing and directing the entire *thought process.*

These two attempts were received in a very hostile fashion by the majority of the critics. Because they were understood in purely political terms. I willingly concede that it is precisely *this form that is best suited to express ideologically critical theses.* But it is a pity that the critics completely overlooked the filmic opportunities that could be derived from it. In both these attempts we find the first, still embryonic attempts to construct a really quite new form of filmic expression.

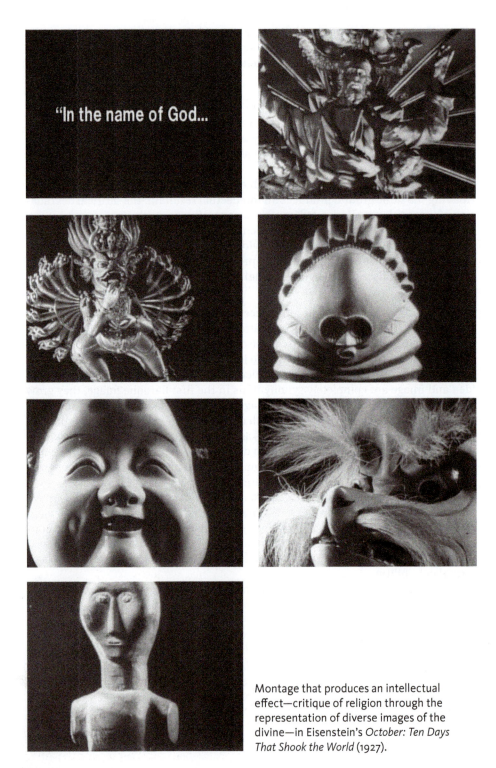

Montage that produces an intellectual effect—critique of religion through the representation of diverse images of the divine—in Eisenstein's *October: Ten Days That Shook the World* (1927).

A purely intellectual film which, freed from traditional limitations, will achieve direct forms for thoughts, systems and concepts without any transitions or paraphrases. And which can therefore become a

SYNTHESIS OF ART AND SCIENCE.

That will become the really new watchword for our epoch in the field of art. And really justify Lenin's statement that "of all the arts . . . cinema is the most important."

One of my next films, which is intended to embody the Marxist world-view, will be devoted to an experiment in this direction.

# RUDOLF ARNHEIM

## Film and Reality

FROM *Film as Art*

Rudolf Arnheim (1904–2007) was born in Berlin, where he studied Gestalt psychology, before leaving Germany in 1933 when Hitler came to power. Arnheim emigrated to the United States in 1940, became a naturalized citizen in 1946, and was a member of the faculty of Sarah Lawrence College for almost three decades. Music, art history, philosophy, and psychology were among the many fields that he studied, and they inform his interdisciplinary understanding of film. In addition to publishing *Film* and the reissue *Film as Art* in 1933, he also published *Art and Visual Perception* (1954) and his study *Picasso's Guernica* (1962). All of Arnheim's work explores the movement and connections between different aesthetic disciplines. This is evident in "Film and Reality," as he carefully maps fundamental differences between older visual arts, such as painting, photography, and theater, to support his central argument that film is the newest art, with specific and unique powers.

Even though the cinema was more than thirty years old at the writing of this essay, debates continued into the 1930s as to whether film could be justifiably defended as an art form rather than simply dismissed as entertainment or merely a mechanical reproduction of the world. These debates about film as art in the early 1930s merged with debates about the impact of the arrival of synchronized sound in the movie industry after 1927. For many filmmakers and film critics the arrival of sound cinema threatened the artistic power of silent cinema, which they felt had greater visual freedom and fewer demands to adhere to commonplace notions of realism. Arnheim himself felt the silent masterpieces of the 1920s, such as Eisenstein's *Battleship Potemkin* (1925) or avant-garde films like *Ballet mécanique* (1924), were able to transform reality by transforming human perception and that creative works of this kind represented the essence of cinema.

In "Film and Reality," Arnheim argues against the common claims that the power of film lies in its ability fully and transparently to represent reality. Rather, for Arnheim, the power of film lies in the ability to promote and engage the "delimitations," or restrictions, of the camera, screen, and frame to create a perspective and not simply present the world

as it is. Arnheim states that cinematic restrictions, such as the absence of color, the limitations of framing, and lack of imagistic depth of field, provide creative potential to manipulate and change normal human perceptions of time and space. It is interesting to compare Arnheim's theory here with Walter Benjamin's thoughts in "The Work of Art in the Age of Its Technological Reproducibility" (p. 229) written only a few years later. For both theorists, cinema's mechanical or technological reproductions offered new ways to engage the world—in terms of the politics of film reception for Benjamin and in terms of a new formal psychology of perception for Arnheim. Indeed, more recent film theory including Gilles Deleuze's elaborate investigation of cinema's unique engagements with time (p. 185) can be seen as the legacy of Arnheim's work.

## READING CUES & KEY CONCEPTS

▣ What does Arnheim mean by the "absence of the space-time continuum" in film art? Think of a specific film sequence that illustrates how that absence can become the source of a film's "creativity."

▣ To what extent have changes in the technology of filmmaking after 1933 challenged Arnheim's argument? Consider how he might have assimilated those changes into his argument.

▣ Reflect on Arnheim's notion that film is midway between photography and the theatrical stage. How does this formulation help to explain his theory of film?

▣ **Key Concepts:** Constancy of Size; Constancy of Shape; Mechanical Reproduction; Partial Illusion; The "Pictureness" of Film; Space-Time Continuum; Two- and Three-Dimensional Impressions

# Film and Reality

. . . . . . . . . . . . . .

Film resembles painting, music, literature, and the dance in this respect—it is a medium that may, but need not, be used to produce artistic results. Colored picture post cards, for instance, are not art and are not intended to be. Neither are a military march, a true confessions story, or a strip tease. And the movies are not necessarily film art.

There are still many educated people who stoutly deny the possibility that film might be art. They say, in effect: "Film cannot be art, for it does nothing but reproduce reality mechanically." Those who defend this point of view are reasoning from the analogy of painting. In painting, the way from reality to the picture lies via the artist's eye and nervous system, his hand and, finally, the brush that puts strokes on canvas. The process is not mechanical as that of photography, in which the light rays reflected from the object are collected by a system of lenses and are then directed onto a sensitive plate where they produce chemical changes. Does this state of affairs justify our denying photography and film a place in the temple of the Muses?

It is worth while to refute thoroughly and systematically the charge that photography and film are only mechanical reproductions and that they therefore have

no connection with art—for this is an excellent method of getting to understand the nature of film art.

With this end in view, the basic elements of the film medium will be examined separately and compared with the corresponding characteristics of what we perceive "in reality." It will be seen how fundamentally different the two kinds of image are; and that it is just these differences that provide film with its artistic resources. We shall thus come at the same time to understand the working principles of film art.

## The Projection of Solids upon a Plane Surface

Let us consider the visual reality of some definite object such as a cube. If this cube is standing on a table in front of me, its position determines whether I can realize its shape properly. If I see, for example, merely the four sides of a square, I have no means of knowing that a cube is before me, I see only a square surface. The human eye, and equally the photographic lens, acts from a particular position and from there can take in only such portions of the field of vision as are not hidden by things in front. As the cube is now placed, five of its faces are screened by the sixth, and therefore this last only is visible. But since this face might equally well conceal something quite different—since it might be the base of a pyramid or one side of a sheet of paper, for instance—our view of the cube has not been selected characteristically.

We have, therefore, already established one important principle: If I wish to photograph a cube, it is not enough for me to bring the object within range of my camera. It is rather a question of my position relative to the object, or of where I place it. The aspect chosen above gives very little information as to the shape of the cube. One, however, that reveals three surfaces of the cube and their relation to one another, shows enough to make it fairly unmistakable what the object is supposed to be. Since our field of vision is full of solid objects, but our eye (like the camera) sees this field from only one station point at any given moment, and since the eye can perceive the rays of light that are reflected from the object only by projecting them onto a plane surface—the retina—the reproduction of even a perfectly simple object is not a mechanical process but can be set about well or badly.

The second aspect gives a much truer picture of the cube than the first. The reason for this is that the second shows more than the first—three faces instead of only one. As a rule, however, truth does not depend on quantity. If it were merely a matter of finding which aspect shows the greatest amount of surface, the best point of view could be arrived at by purely mechanical calculation. There is no formula to help one choose the most characteristic aspect: it is a question of feeling. Whether a particular person is "more himself" in profile than full face, whether the palm or the outside of the hand is more expressive, whether a particular mountain is better taken from the north or the west cannot be ascertained mathematically—they are matters of delicate sensibility.

Thus, as a preliminary, people who contemptuously refer to the camera as an automatic recording machine must be made to realize that even in the simplest photographic reproduction of a perfectly simple object, a feeling for its nature is required which is quite beyond any mechanical operation. We shall see later, by the way, that in artistic photography and film, those aspects that best show the characteristics of

a particular object are not by any means always chosen; others are often selected deliberately for the sake of achieving specific effects.

## *Reduction of Depth*

How do our eyes succeed in giving us three-dimensional impressions even though the flat retinae can receive only two-dimensional images? Depth perception relies mainly on the distance between the two eyes, which makes for two slightly different images. The fusion of these two pictures into one image gives the three-dimensional impression. As is well known, the same principle is used in the stereoscope, for which two photographs are taken at once, about the same distance apart as the human eyes. This process cannot be used for film without recourse to awkward devices, such as colored spectacles, when more than one person is to watch the projection. For a single spectator it would be easy to make a stereoscopic film. It would only mean taking two simultaneous shots of the same incident a couple of inches apart and then showing one of them to each eye. For display to a larger number of spectators, however, the problem of stereoscopic film has not yet been solved satisfactorily—and hence the sense of depth in film pictures is extraordinarily small. The movement of people or objects from front to back makes a certain depth evident—but it is only necessary to glance into a stereoscope, which makes everything stand out most realistically, to recognize how flat the film picture is. This is another example of the fundamental difference between visual reality and film.

The effect of film is neither absolutely two-dimensional nor absolutely three-dimensional, but something between. Film pictures are at once plane and solid. In Ruttmann's film *Berlin* there is a scene of two subway trains passing each other in opposite directions. The shot is taken looking down from above onto the two trains. Anyone watching this scene realizes, first of all, that one train is coming toward him and the other going away from him (three-dimensional image). He will then also see that one is moving from the lower margin of the screen toward the upper and the other from the upper toward the lower (plane image). This second impression results from the projection of the three-dimensional movement onto the screen surface, which, of course, gives different directions of motion.

The obliteration of the three-dimensional impression has as a second result a stronger accentuation of perspective overlapping. In real life or in a stereoscope, overlapping is accepted as due merely to the accidental arrangement of objects, but very marked cuts result from superimpositions in a plane image. If a man is holding up a newspaper so that one corner comes across his face, this corner seems almost to have been cut out of his face, so sharp are the edges. Moreover, when the three-dimensional impression is lost, other phenomena, known to psychologists as the constancies of size and shape, disappear. Physically, the image thrown onto the retina of the eye by any object in the field of vision diminishes in proportion to the square of the distance. If an object a yard distant is moved away another yard, the area of the image on the retina is diminished to one-quarter of that of the first image. Every photographic plate reacts similarly. Hence in a photograph of someone sitting with his feet stretched out far in front of him the subject comes out with enormous feet and much too small a head. Curiously enough, however, we do not in real life get impressions to accord with the images on the retina. If a man is standing three feet away and another equally tall six feet away, the area of the image of the second does not

appear to be only a quarter of that of the first. Nor if a man stretches out his hand toward one does it look disproportionately large. One sees the two men as equal in size and the hand as normal. This phenomenon is known as the constancy of size. It is impossible for most people—excepting those accustomed to drawing and painting, that is, artificially trained—to see according to the image on the retina. This fact, incidentally, is one of the reasons the average person has trouble copying things "correctly." Now an essential for the functioning of the constancy of size is a clear three-dimensional impression; it works excellently in a stereoscope with an ordinary photograph, but hardly at all in a film picture. Thus, in a film picture, if one man is twice as far from the camera as another, the one in front looks very considerably the taller and broader.

It is the same with the constancy of shape. The retinal image of a table top is like the photograph of it; the front edge, being nearer to the spectator, appears much wider than the back; the rectangular surface becomes a trapezoid in the image. As far as the average person is concerned, however, this again does not hold good in practice: he *sees* the surface as rectangular and draws it that way too. Thus the perspective changes taking place in any object that extends in depth are not observed but are compensated unconsciously. That is what is meant by the constancy of form. In a film picture it is hardly operative at all—a table top, especially if it is near the camera, looks very wide in front and very narrow at the back.

These phenomena, as a matter of fact, are due not only to the reduction of three-dimensionality but also to the unreality of the film picture altogether—an unreality due just as much to the absence of color, the delimitation of the screen, and so forth. The result of all this is that sizes and shapes do not appear on the screen in their true proportions but distorted in perspective.

[ · · · ]

## Delimitation of the Image and Distance from the Object

Our visual field is limited. Sight is strongest at the center of the retina, clearness of vision decreases toward the edges, and, finally, there is a definite boundary to the range of vision due to the structure of the organ. Thus, if the eyes are fixed upon a particular point, we survey a limited expanse. This fact is, however, of little practical importance. Most people are quite unconscious of it, for the reason that our eyes and heads are mobile and we continually exercise this power, so that the limitation of our range of vision never obtrudes itself. For this reason, if for no other, it is utterly false for certain theorists, and some practitioners, of the motion picture to assert that the circumscribed picture on the screen is an image of our circumscribed view in real life. That is poor psychology. The limitations of a film picture and the limitations of sight cannot be compared because in the actual range of human vision the limitation simply does not exist. The field of vision is in practice unlimited and infinite. A whole room may be taken as a continuous field of vision, although our eyes cannot survey this room from a single position, for while we are looking at anything our gaze is not fixed but moving. Because our head and eyes move we visualize the entire room as an unbroken whole.

It is otherwise with the film or photograph. For the purpose of this argument we are considering a single shot taken with a fixed camera. We shall discuss traveling and panorama shots later. (Even these aids in no sense replace the natural range

of vision nor are they intended to do so.) The limitations of the picture are felt immediately. The pictured space is visible to a certain extent, but then comes the edge which cuts off what lies beyond. It is a mistake to deplore this restriction as a drawback. I shall show later that on the contrary it is just such restrictions which give film its right to be called an art.

This restriction [ . . . ] explains why it is often very difficult to reproduce intelligibly in a photograph the spatial orientation of the scene depicted. If, for example, the slope of a mountain is photographed from below, or a flight of steps from above, the finished picture surprisingly will often give no impression of height or depth. To represent an ascent or descent by purely visual means is difficult unless the level ground can somehow be shown as a frame of reference. Similarly there must be standards of comparison to show the size of anything. To show the height of trees or of a building, for instance, human figures may be introduced beside them. A man in real life looks all round him when he is walking; and even supposing he is going up a mountain path with his eyes fixed on the ground at his feet, he still has a sense of the general lie of the surrounding country in his mind. This perception comes to him chiefly because his muscles and his sense of balance tell him at every instant exactly in what relation his body stands to the horizontal. Hence he can continually assess correctly the visual impression of the slanting surface. In contrast to such a man is one who is looking at a photograph or screen picture. He must depend upon what his eyes tell him without any assistance from the rest of his body. Moreover, he has only that part of the visual situation which is included within the confines of the picture to help him get his bearings.

The range of the picture is related to the distance of the camera from the object. The smaller the section of real life to be brought into the picture, the nearer the camera must be to the object, and the larger the object in question comes out in the picture— and vice versa. If a whole group of people is to be photographed, the camera must be placed several yards away. If only a single hand is to be shown, the camera must be very close, otherwise other objects besides the hand will appear in the picture. By this means the hand comes out enormously large and extends over the whole screen. Thus the camera, like a man who can move freely, is able to look at an object from close to or from a distance—a self-evident truth that must be mentioned inasmuch as from it is derived an important artistic device. (Variations of range and size can also be obtained by lenses of different focal lengths. The effects are similar but involve no change of the distance from the object and, therefore, no change of perspective.)

How large an object appears on the screen depends partly on the distance at which the camera was placed from it, but partly also on how much the picture is enlarged when the finished film is projected. The degree of enlargement depends on the lens of the projection machine and on the size of the theater. A film may be shown in whatever size is preferred—as small as the pictures in a child's magic lantern or gigantic as in a movie palace. There is, however, an optimum relationship between the size of the picture and its distance from the spectators. In a motion-picture theater the spectator sits relatively far away from the screen. Hence the projection must be large. But those watching pictures in a living room are quite close to the screen and therefore the projection may be much smaller. Nevertheless, the range of sizes used in practice is wider than is altogether desirable. In large theaters the projection

is larger than in small ones. The spectators in the front rows naturally see a much larger picture than those in the back rows. It is, however, by no means a matter of indifference how large the picture appears to the spectator. The photography is designed for projection of a particular relative size. Thus in a large projection, or when the spectator is near the picture, movements appear more rapid than in a small one, since in the former case a larger area has to be covered than in the latter. A movement which seems hurried and confused in a large picture may be perfectly right and normal in a smaller one. The relative size of the projection, moreover, determines how clearly the details in the picture are visible to the spectator; and there is obviously a great difference between seeing a man so clearly that one can count the dots on his tie, and being able to recognize him only vaguely—more especially since, as has been pointed out, the size in which the object is to appear is used by the film director to obtain a definite artistic effect. Thus by the spectator's sitting too near or too far away a most disagreeable and obvious misrepresentation of what the artist intended may arise. Up to the present it is impossible to show a film to a large audience so that each member of it sees the picture in its right dimensions. After all, spectators must, as far as possible, be placed one behind the other; because when the rows of seats extend too far sideways, those sitting at the ends will see the picture distorted—and that is even worse.

## Absence of the Space-Time Continuum

In real life every experience or chain of experiences is enacted for every observer in an uninterrupted spatial and temporal sequence. I may, for example, see two people talking together in a room. I am standing fifteen feet away from them. I can alter the distance between us; but this alteration is not made abruptly. I cannot suddenly be only five feet away; I must move through the intervening space. I can leave the room; but I cannot suddenly be in the street. In order to reach the street I must go out of the room, through the door, down the stairs. And similarly with time. I cannot suddenly see what these two people will be doing ten minutes later. These ten minutes must first pass in their entirety. There are no jerks in time or space in real life. Time and space are continuous.

Not so in film. The period of time that is being photographed may be interrupted at any point. One scene may be immediately followed by another that takes place at a totally different time. And the continuity of space may be broken in the same manner. A moment ago I may have been standing a hundred yards away from a house. Suddenly I am close in front of it. I may have been in Sydney a few moments ago. Immediately afterward I can be in Boston. I have only to join the two strips together. To be sure, in practice this freedom is usually restricted in that the subject of the film is an account of some action, and a certain logical unity of time and space must be observed into which the various scenes are fitted. For time especially there are definite rules which must be obeyed.

Within any one film sequence, scenes follow each other in their order of time—unless some digression is introduced as, for example, in recounting earlier adventures, dreams, or memories. Within such a flashback, again, time passes naturally, but the action occurs outside the framework of the main story and need not even

stand in any precise time relationship ("before" or "after") to it. Within individual scenes the succession of separate events implies a corresponding sequence of time. If, for example, a "long shot" of a man raising a revolver and firing it is shown, the raising and firing cannot be shown again afterward as a close-up. To do so would be to make a sequence of events that were in fact simultaneous.

That things are happening simultaneously is of course most simply indicated by showing the events in one and the same picture. If I see someone writing at a table in the foreground and someone else in the back playing the piano, the situation is self-explanatory as far as time is concerned. This method is, nevertheless, often avoided for artistic reasons and the situation composed of separate shots.

If two sequences of the action are to be understood as occurring at the same time they may simply be shown one after the other, in which case, however, it must be obvious from the content that simultaneity is intended. The most primitive way of giving this information in a silent film is by printed titles. ("While Elise was hovering between life and death, Edward was boarding the liner at San Francisco.") Or something of this sort: A horse race has been announced to begin at 3:40. The scene is a room full of people who are interested in the race. Someone pulls out a watch and shows the hands pointing to 3:40. Next scene—the racecourse with the horses starting. Events occurring simultaneously may also be shown by cutting up the various scenes and alternating the sections so that the progress of the different events is shown by turns.

Within the individual scenes the time continuum must never be disturbed. Not only must things that occur simultaneously not be shown one after the other, but no time must be omitted. If a man is going from the door to the window, the action must be shown in its entirety; the middle part, for example, must not be suppressed and the spectator left to see the man starting from the door and then with a jerk arriving at the window. This gives the feeling of a violent break in the action, unless something else is inserted so that the intervening time is otherwise occupied. Time may be dropped in the course of a scene only to produce a deliberately comic effect—as, for instance, when Charlie Chaplin enters a pawnbroker's shop and emerges instantly without his overcoat. Since to show complete incidents would frequently be dull and inartistic, because superfluous, the course of the action is sometimes interrupted by parts of scenes taking place simultaneously somewhere else. In this way it can be arranged to show only those moments of each event which are necessary for the action without patching together things that are incoherent in time. Apart from this, each scene in a good film must be so well planned in the scenario that everything necessary, and only what is necessary, takes place within the shortest space of time.

Although the time continuum within any individual scene must remain uninterrupted, the time relationship between scenes that occur at different places is undefined in principle so that it may be impossible to tell whether the second scene takes place before, during, or after the first. This is very clearly shown in many educational films where there is no connection in time but only in subject. As, for example: ". . . not only rabbits but also lions may be tamed." First picture—performing rabbits. Within this scene the continuity of time must be observed. Second picture—lion taming. Here too the continuity of time must not be broken. These two scenes, however, have no sort of time connection. The lion taming may go on before, during, or after the performance with the rabbits. In other words, the time connection is of no

consequence and therefore does not exist. Similar situations arise occasionally in narrative films.

If sequences are meant to follow each other in time, the content of the film must make this relationship clear, precisely as in the case of simultaneity; because the fact that two sequences follow each other on the screen does not indicate in itself that they should be understood as following each other in time.

[ · · · ]

Film—the animated image—comes midway between the theater and the still picture. It presents space, and it does it not as on the stage with the help of real space, but, as in an ordinary photograph, with a flat surface. In spite of this, the impression of space is for various reasons not so weak as in a still photograph. A certain illusion of depth holds the spectator. Again, in contrast with the photograph, time passes during the showing of a film as it does on the stage. This passage of time can be utilized to portray an actual event, but is, nevertheless, not so rigid that it cannot be interrupted by breaks in time without the spectator feeling that these breaks do violence to it. The truth is that the film retains something of the nature of a flat, two-dimensional picture. Pictures may be displayed for as long or short a time as one pleases, and they can be shown next to one another even if they depict totally different periods in time.

Thus film, like the theater, provides a partial illusion. Up to a certain degree it gives the impression of real life. This component is all the stronger since in contrast to the theater the film can actually portray real—that is, not simulated—life in real surroundings. On the other hand, it partakes strongly of the nature of a picture in a way that the stage never can. By the absence of colors, of three-dimensional depth, by being sharply limited by the margins on the screen, and so forth, film is most satisfactorily denuded of its realism. It is always at one and the same time a flat picture post card and the scene of a living action.

[ · · · ]

## Absence of the Nonvisual World of the Senses

Our eyes are not a mechanism functioning independently of the rest of the body. They work in constant coöperation with the other sense organs. Hence surprising phenomena result if the eyes are asked to convey ideas unaided by the other senses. Thus, for example, it is well known that a feeling of giddiness is produced by watching a film that has been taken with the camera traveling very rapidly. This giddiness is caused by the eyes participating in a different world from that indicated by the kinesthetic reactions of the body, which is at rest. The eyes act as if the body as a whole were moving; whereas the other senses, including that of equilibrium, report that it is at rest.

Our sense of equilibrium when we are watching a film is dependent on what the eyes report and does not as in real life receive kinesthetic stimulation. Hence certain parallels which are sometimes drawn between the functioning of the human eye and the camera—for instance, the comparison between the mobility of the eyes and that of the camera—are false. If I turn my eyes or my head, the field of vision is altered. Perhaps a moment ago I was looking at the door; now I am looking at the

bookcase; then at the dining-room table, then at the window. This panorama, however, does not pass before my eyes and give the impression that the various objects are moving. Instead I realize that the room is stationary as usual, but that the direction of my gaze is changing, and that that is why I see other parts of the motionless room. This is not the case in film. If the camera was rotated while the picture was being shot, the bookcase, table, window, and door will proceed across the screen when the picture is projected; it is they which are moving. For since the camera is not a part of the spectator's body like his head and his eyes, he cannot tell that it has been turned. He can see the objects on the screen being displaced and at first is led to assume that they are in motion. In Jacques Feyder's *Les Nouveaux Messieurs*, for example, there is a scene in which the camera passes rapidly along a long wall covered with posters. The result is that the wall seems to move past the camera. If the scene that has been photographed is very simple to understand, if it is easy to get one's bearings in it, the spectator corrects this impression more or less rapidly. If, for instance, the camera is first directed toward a man's legs and if it then pans slowly up toward his head, the spectator knows very well that the man did not float feet first past a stationary camera. Film directors, however, often turn or shift the camera for taking pictures that are not so easy to grasp, and then a sensation of drifting supervenes which may be unintentional and may easily make the audience feel dizzy. This difference between the movements of the eyes and those of the camera is increased because the film picture has, as was said above, a fixed limit whereas the field of vision of our eyes is practically unbounded. Fresh objects are continually appearing within the frame of the picture and then disappearing again, but for the eyes there is an unbroken space-continuum through which the gaze wanders at will.

Thus there is relativity of movement in film. Since there are no bodily sensations to indicate whether the camera was at rest or in motion, and if in motion at what speed or in what direction, the camera's position is, for want of other evidence, presumed to be fixed. Hence if something moves in the picture this motion is at first seen as a movement of the thing itself and not as the result of a movement of the camera gliding past a stationary object. In the extreme case this leads to the direction of motion being reversed. If, for example, a moving car is filmed from a second one which is overtaking the first, the finished picture will show a car apparently traveling backward. It is, however, possible to make clear which movement is relative and which absolute by the nature and behavior of the objects shown in the picture. If it is obvious from the picture that the camera was standing on a moving car, that is, if parts of this car are seen in the picture, and, contrary to the landscape, they stay in the same place in the picture, the car will be perceived as moving and the surrounding landscape as stationary.

There is also a relativization of spatial coördinates—above, below, and so forth. To this are partly due the phenomena we described above in the section on the "Delimitation of the Image." A photograph of a slanting surface may not give an appearance of slope because there is no sensation of gravity to help the spectator realize "up and down." It is impossible to feel whether the camera was standing straight or was placed at an angle. Therefore, as long as there is nothing to indicate the contrary, the projection plane is perceived as vertical. If the camera is held over a bed to show from above the head of a man lying in it, the impression may easily be given that the man is sitting upright and that the pillow is perpendicular. The screen is vertical, although since the camera was turned downward it actually

represents a horizontal surface. This effect can be avoided only by showing enough of the surroundings in the picture to give the spectator his bearings.

As regards the other senses: No one who went unprejudiced to watch a silent film missed the noises which would have been heard if the same events had been taking place in real life. No one missed the sound of walking feet, nor the rustling of leaves, nor the ticking of a clock. The lack of such sounds (speech, of course, is also one of them) was hardly ever apparent, although they would have been missed with a desperate shock in real life. People took the silence of the movies for granted because they never quite lost the feeling that what they saw was after all only pictures. This feeling alone, however, would not be sufficient to prevent the lack of sound being felt as an unpleasant violation of the illusion. That this did not happen is again connected with what was explained above: that in order to get a full impression it is not necessary for it to be complete in the naturalistic sense. All kinds of things may be left out which would be present in real life, so long as what is shown contains the essentials. Only after one has known talkies is the lack of sound conspicuous in a silent film. But that proves nothing and is not an argument against the potentialities of silent film, even since the introduction of sound.

It is much the same with the sense of smell. There may be people who if they see a Roman Catholic service on the screen imagine that they can smell incense; but no one will miss the stimulus. Sensations of smell, equilibrium, or touch are, of course, never conveyed in a film through direct stimuli, but are suggested indirectly through sight. Thence arises the important rule that it is improper to make films of occurrences whose central features cannot be expressed visually. Of course a revolver shot might occur as the central point of a silent film; a clever director could afford to dispense with the actual noise of the shot. It is enough for the spectator to see the revolver being fired and possibly to see the wounded man fall. In Josef von Sternberg's *The Docks of New York* a shot is very cleverly made visible by the sudden rising of a flock of scared birds.

# SIEGFRIED KRACAUER

## Basic Concepts; Inherent Affinities

FROM *Theory of Film*

Siegfried Kracauer (1889–1966), author of the provocative study of German Expressionist cinema, *From Caligari to Hitler* (1947), a number of significant essays gathered in the English-language collection *The Mass Ornament* (1995) and *Theory of Film* (1960), a treatise on cinematic realism, is one of the most prominent figures in classical film theory. Working for the liberal German newspaper *Frankfurter Zeitung* during the progressive and unstable Weimar period, Kracauer helped pioneer the cultural criticism of everyday life in modern mass society that was also practiced by such prominent friends as Walter Benjamin and Theodor W. Adorno. With the rise of National Socialism, Kracauer fled to Paris and later, along with his wife, Benjamin, and other German Jewish intellectuals, to the French port city of

Marseille. While awaiting passage to the United States in 1941, Kracauer began work on what he planned as a comprehensive study of film aesthetics. *Theory of Film* was finally published in 1960 in a political, intellectual, and cinematic culture radically different from the one in which it was conceived. Kracauer's writing straddled the pre- and postwar periods as well as two continents, illuminating the preoccupations of film theorists in both moments and locations, while registering the catastrophic rupture that was World War II and the Holocaust.

Kracauer was one of the first cultural theorists to emphasize the value of the study of everyday life. Kracauer felt that the aesthetic mirroring of the fragmentation and alienation of modern life provided the masses with a way of objectifying, and thus enduring it—an argument very similar to Benjamin's in "The Work of Art in the Age of Its Technological Reproducibility" (p. 229). Kracauer's *Theory of Film* concentrates primarily on the photographic nature of film. The text is structured as a systematic account of the aesthetic specificities of the film medium, beginning with Kracauer's enduring, if somewhat misleading, opposition between realistic and "formative" (formal) tendencies in film history, represented by the styles of Lumière and Méliès respectively. Kracauer believes that it is film's mission "to record and reveal physical reality." Because of the medium's indexical properties—light registers the image of the object, and its movement, on film's emulsion, leaving a trace, or index—photographic realism is based on more than resemblance; it implies a material connection to the object at a moment in time.

Kracauer's aesthetic view contrasts markedly with Sergei Eisenstein's will to impose meaning through film technique (p. 262). His ideas are also at odds with the semiotic theories developed at the end of the 1960s that understood film as a sign system dominated by narrative structure. Yet his focus on physical or "camera-reality," dismissed by some contemporary critics as "naïve realism," is viewed as more complex and ambivalent in recent evaluations of Kracauer's work by Miriam Hansen (p. 325) and others. *Theory of Film* can be read as a postwar text of anxiety and doubt—film's ability to capture the contingent is rendered valuable in the wake of mass destruction. André Bazin (p. 309), with whom Kracauer is often grouped as a proponent of film's realist mission, elevated film's ontology for similar reasons if with different, less materialist, emphasis.

## READING CUES & KEY CONCEPTS

▓ Kracauer asserts that "films come into their own when they record and reveal physical reality." What possible aspects of film does this definition leave out?

▓ According to Kracauer, how do film and photography differ from other art forms in terms of the artist's role?

▓ What, for Kracauer, is "the cinematic approach" to filmmaking? Consider the examples that Kracauer gives to support his theory, and think of some of your own.

▓ What are the "realistic tendencies" and "formative tendencies" in film history? If there were realistic and formative tendencies in classical film theory, where would Kracauer fit? Where would Eisenstein fit?

▓ **Key Concepts:** Material Aesthetics; Realistic Tendency; Formative Tendency; Contingency; Indexicality

# Basic Concepts

. . . . . . . . . . . . . . .

L ike the embryo in the womb, photographic film developed from distinctly
separate components. Its birth came about from a combination of instanta-
neous photography, as used by Muybridge and Marey, with the older devices of
the magic lantern and the phenakistoscope.[1] Added to this later were the con-
tributions of other nonphotographic elements, such as editing and sound. Nev-
ertheless photography, especially instantaneous photography, has a legitimate
claim to top priority among these elements, for it undeniably is and remains the
decisive factor in establishing film content. The nature of photography survives
in that of film.

Originally, film was expected to bring the evolution of photography to an end—
satisfying at last the age-old desire to picture things moving. This desire already
accounted for major developments within the photographic medium itself. As far
back as 1839, when the first daguerreotypes and talbotypes appeared, admiration
mingled with disappointment about their deserted streets and blurred landscapes.[2]
And in the 'fifties, long before the innovation of the hand camera, successful
attempts were made to photograph subjects in motion.[3] The very impulses which
thus led from time exposure to snapshot engendered dreams of a further extension
of photography in the same direction—dreams, that is, of film. About 1860, Cook and
Bonnelli, who had developed a device called a photobioscope, predicted a "complete
revolution of photographic art. . . . We will see . . . landscapes," they announced, "in
which the trees bow to the whims of the wind, the leaves ripple and glitter in the rays
of the sun."[4]

Along with the familiar photographic leitmotif of the leaves, such kindred sub-
jects as undulating waves, moving clouds, and changing facial expressions ranked
high in early prophecies. All of them conveyed the longing for an instrument which
would capture the slightest incidents of the world about us—scenes that often would
involve crowds, whose incalculable movements resemble, somehow, those of waves
or leaves. In a memorable statement published before the emergence of instanta-
neous photography, Sir John Herschel not only predicted the basic features of the
film camera but assigned to it a task which it has never since disowned: "the vivid
and lifelike reproduction and handing down to the latest posterity of any transac-
tion in real life—a battle, a debate, a public solemnity, a pugilistic conflict."[5] Ducos
du Hauron and other forerunners also looked forward to what we have come to label
newsreels and documentaries—films devoted to the rendering of real-life events.[6]
This insistence on recording went hand in hand with the expectation that motion
pictures could acquaint us with normally imperceptible or otherwise induplica-
ble movements—flashlike transformations of matter, the slow growth of plants,
etc.[7] All in all, it was taken for granted that film would continue along the lines of
photography.[8]

To summarize: the preceding statements about photography also hold true of
the cinematic medium; but they do not apply to it mechanically or go far enough to
exhaust its potentialities. Elaborations and extensions are needed.

[ · · · ]

## *The Two Main Tendencies*

If film grows out of photography, the realistic and formative tendencies must be operative in it also. Is it by sheer accident that the two tendencies manifested themselves side by side immediately after the rise of the medium? As if to encompass the whole range of cinematic endeavors at the outset, each went the limit in exhausting its own possibilities. Their prototypes were Lumière, a strict realist, and Méliès, who gave free rein to his artistic imagination. The films they made embody, so to speak, thesis and antithesis in a Hegelian sense.[9]

### LUMIÈRE AND MÉLIÈS

Lumière's films contained a true innovation, as compared with the repertoire of the zootropes or Edison's peep boxes:[10] they pictured everyday life after the manner of photographs.[11] Some of his early pictures, such as *Baby's Breakfast* (*Le Déjeuner de bébé*) or *The Card Players* (*La Partie d'écarté*), testify to the amateur photographers's delight in family idyls and genre scenes.[12] And there was *Teasing the Gardener* (*L'Arroseur arrosé*), which enjoyed immense popularity because it elicited from the flow of everyday life a proper story with a funny climax to boot. A gardener is watering flowers and, as he unsuspectingly proceeds, an impish boy steps on the hose, releasing it at the very moment when his perplexed victim examines the dried-up nozzle. Water squirts out and hits the gardener smack in the face. The denouement is true to style, with the gardener chasing and spanking the boy. This film, the germ cell and archetype of all film comedies to come, represented an imaginative attempt on the part of Lumière to develop photography into a means of story telling.[13] Yet the story was just a real-life incident. And it was precisely its photographic veracity which made Maxim Gorki undergo a shock-like experience. "You think," he wrote about *Teasing the Gardener*, "the spray is going to hit you too, and instinctively shrink back."[14]

On the whole, Lumière seems to have realized that story telling was none of his business; it involved problems with which he apparently did not care to cope. Whatever story-telling films he, or his company, made—some more comedies in the vein of his first one, tiny historical scenes, etc.—are not characteristic of his production.[15] The bulk of his films recorded the world about us for no other purpose than to present it. This is in any case what Mesguich, one of Lumière's "ace" cameramen, felt to be their message. At a time when the talkies were already in full swing he epitomized the work of the master as follows: "As I see it, the Lumière Brothers had established the true domain of the cinema in the right manner. The novel, the theater, suffice for the study of the human heart. The cinema is the dynamism of life, of nature and its manifestations, of the crowd and its eddies. All that asserts itself through movement depends on it. Its lens opens on the world."[16]

Lumière's lens did open on the world in this sense. Take his immortal first reels *Lunch Hour at the Lumière Factory* (*Sortie des usines Lumière*), *Arrival of a Train* (*L'Arrivée d'un train*), *La Place des Cordeliers a Lyon*:[17] their themes were public places, with throngs of people moving in diverse directions. The crowded streets captured by the stereographic photographs of the late 'fifties thus reappeared on the primitive screen. It was life at its least controllable and most unconscious moments, a jumble of transient, forever dissolving patterns accessible only to the camera. The

much-imitated shot of the railway station, with its emphasis on the confusion of arrival and departure, effectively illustrated the fortuity of these patterns; and their fragmentary character was exemplified by the clouds of smoke which leisurely drifted upward. Significantly, Lumière used the motif of smoke on several occasions. And he seemed anxious to avoid any personal interference with the given data. Detached records, his shots resembled the imaginary shot of the grandmother which Proust contrasts with the memory image of her.

Contemporaries praised these films for the very qualities which the prophets and forerunners had singled out in their visions of the medium. It was inevitable that, in the comments on Lumière, "the ripple of leaves stirred by the wind" should be referred to enthusiastically. The Paris journalist Henri de Parville, who used the image of the trembling leaves, also identified Lumière's over-all theme as "nature caught in the act."[18] Others pointed to the benefits which science would derive from Lumière's invention.[19] In America his camera-realism defeated Edison's kinetoscope with its staged subjects.[20]

Lumière's hold on the masses was ephemeral. In 1897, not more than two years after he had begun to make films, his popularity subsided. The sensation had worn off; the heyday was over. Lack of interest caused Lumière to reduce his production.[21]

Georges Méliès took over where Lumière left off, renewing and intensifying the medium's waning appeal. This is not to say that he did not occasionally follow the latter's example. In his beginnings he too treated the audience to sightseeing tours; or he dramatized, in the fashion of the period, realistically staged topical events.[22] But his main contribution to the cinema lay in substituting staged illusion for unstaged reality, and contrived plots for everyday incidents.[23]

The two pioneers were aware of the radical differences in their approach. Lumière told Méliès that he considered film nothing more than a "scientific curiosity,"[24] thereby implying that his cinematograph could not possibly serve artistic purposes. In 1897, Méliès on his part published a prospectus which took issue with Lumière: "Messrs. Méliès and Reulos specialize mainly in fantastic or artistic scenes, reproductions of theatrical scenes, etc. . . . thus creating a special genre which differs entirely from the customary views supplied by the cinematograph—street scenes or scenes of everyday life."[25]

Méliès's tremendous success would seem to indicate that he catered to demands left unsatisfied by Lumière's photographic realism. Lumière appealed to the sense of observation, the curiosity about "nature caught in the act"; Méliès ignored the workings of nature out of the artist's delight in sheer fantasy. The train in *Arrival of a Train* is the real thing, whereas its counterpart in Méliès's *An Impossible Voyage* (*Voyage à travers l'impossible*) is a toy train as unreal as the scenery through which it is moving. Instead of picturing the random movements of phenomena, Méliès freely interlinked imagined events according to the requirements of his charming fairy-tale plots. Had not media very close to film offered similar gratifications? The artist-photographers preferred what they considered aesthetically attractive compositions to searching explorations of nature. And immediately before the arrival of the motion picture camera, magic lantern performances indulged in the projection of religious themes, Walter Scott novels, and Shakespearean dramas.[26]

Yet even though Méliès did not take advantage of the camera's ability to record and reveal the physical world, he increasingly created his illusions with the aid of techniques peculiar to the medium. Some he found by accident. When taking shots of the Paris Place de l'Opéra, he had to discontinue the shooting because the celluloid strip did not move as it should; the surprising result was a film in which, for no reason at all, a bus abruptly transformed itself into a hearse.[27] True, Lumière also was not disinclined to have a sequence of events unfold in reverse, but Méliès was the first to exploit cinematic devices systematically. Drawing on both photography and the stage, he innovated many techniques which were to play an enormous role in the future—among them the use of masks, multiple exposure, superimposition as a means of summoning ghosts, the lap-dissolve, etc.[28] And through his ingenuity in using these techniques he added a touch of cinema to his playful narratives and magic tricks. Stage traps ceased to be indispensable; sleights-of-hand yielded to incredible metamorphoses which film alone was able to accomplish. Illusion produced in this climate depended on another kind of craftsmanship than the magician's. It was cinematic illusion, and as such went far beyond theatrical make-believe. Méliès's *The Haunted Castle* (*Le Manoir du diable*) "is conceivable only in the cinema and due to the cinema," says Henri Langlois, one of the best connoisseurs of the primitive era.[29]

Notwithstanding his film sense, however, Méliès still remained the theater director he had been. He used photography in a pre-photographic spirit—for the reproduction of a papier-mâché universe inspired by stage traditions. In one of his greatest films, *A Trip to the Moon* (*Le Voyage dans la lune*), the moon harbors a grimacing man in the moon and the stars are bull's-eyes studded with the pretty faces of music hall girls. By the same token, his actors bowed to the audience, as if they performed on the stage. Much as his films differed from the theater on a technical plane, they failed to transcend its scope by incorporating genuinely cinematic subjects. This also explains why Méliès, for all his inventiveness, never thought of moving his camera;[30] the stationary camera perpetuated the spectator's relation to the stage. His ideal spectator was the traditional theatergoer, child or adult. There seems to be some truth in the observation that, as people grow older, they instinctively withdraw to the positions from which they set out to struggle and conquer. In his later years Méliès more and more turned from theatrical film to filmed theater, producing *féeries* which recalled the Paris Châtelet pageants.[31]

### THE REALISTIC TENDENCY

In following the realistic tendency, films go beyond photography in two respects. First, they picture movement itself, not only one or another of its phases. But what kinds of movements do they picture? In the primitive era when the camera was fixed to the ground, it was natural for film makers to concentrate on moving material phenomena; life on the screen was life only if it manifested itself through external, or "objective," motion. As cinematic techniques developed, films increasingly drew on camera mobility and editing devices to deliver their messages. Although their strength still lay in the rendering of movements inaccessible to other media, these movements were no longer necessarily objective. In the technically mature film "subjective" movements—movements, that is, which the spectator is invited to execute—constantly compete with objective ones. The spectator may have to identify himself with a tilting, panning, or traveling camera which insists on bringing

motionless as well as moving objects to his attention.[32] Or an appropriate arrangement of shots may rush the audience through vast expanses of time and/or space so as to make it witness, almost simultaneously, events in different periods and places.

Nevertheless the emphasis is now as before on objective movement; the medium seems to be partial to it. As René Clair puts it: "If there is an aesthetics of the cinema . . . it can be summarized in one word: 'movement.' The external movement of the objects perceived by the eye, to which we are today adding the inner movement of the action."[33] The fact that he assigns a dominant role to external movement reflects, on a theoretical plane, a marked feature of his own earlier films—the ballet-like evolutions of their characters.

Second, films may seize upon physical reality with all its manifold movements by means of an intermediary procedure which would seem to be less indispensable in photography—staging. In order to narrate an intrigue, the film maker is often obliged to stage not only the action but the surroundings as well. Now this recourse to staging is most certainly legitimate if the staged world is made to appear as a faithful reproduction of the real one. The important thing is that studio-built settings convey the impression of actuality, so that the spectator feels he is watching events which might have occurred in real life and have been photographed on the spot.[34]

Falling prey to an interesting misconception, Emile Vuillermoz champions, for the sake of "realism," settings which represent reality as seen by a perceptive painter. To his mind they are more real than real-life shots because they impart the essence of what such shots are showing. Yet from the cinematic point of view these allegedly realistic settings are no less stagy than would be, say, a cubist or abstract composition. Instead of staging the given raw material itself, they offer, so to speak, the gist of it. In other words, they suppress the very camera-reality which film aims at incorporating. For this reason, the sensitive moviegoer will feel disturbed by them.[35] (The problems posed by films of fantasy which, as such, show little concern for physical reality will be considered later on.)

Strangely enough, it is entirely possible that a staged real-life event evokes a stronger illusion of reality on the screen than would the original event if it had been captured directly by the camera. The late Ernö Metzner who devised the settings for the studio-made mining disaster in Pabst's *Kameradschaft*—an episode with the ring of stark authenticity—insisted that candid shots of a real mining disaster would hardly have produced the same convincing effect.[36]

One may ask, on the other hand, whether reality can be staged so accurately that the camera-eye will not detect any difference between the original and the copy. Blaise Cendrars touches on this issue in a neat hypothetical experiment. He imagines two film scenes which are completely identical except for the fact that one has been shot on the Mont Blanc (the highest mountain of Europe) while the other was staged in the studio. His contention is that the former has a quality not found in the latter. There are on the mountain, says he, certain "emanations, luminous or otherwise, which have worked on the film and given it a soul."[37] Presumably large parts of our environment, natural or man-made, resist duplication.

## THE FORMATIVE TENDENCY

The film maker's formative faculties are offered opportunities far exceeding those offered the photographer. The reason is that film extends into dimensions which

photography does not cover. These differ from each other according to area and composition. With respect to areas, film makers have never confined themselves to exploring only physical reality in front of the camera but, from the outset, persistently tried to penetrate the realms of history and fantasy. Remember Méliès. Even the realistic-minded Lumière yielded to the popular demand for historical scenes. As for composition, the two most general types are the story film and the non-story film. The latter can be broken down into the experimental film and the film of fact, which on its part comprises, partially or totally, such subgenres as the film on art, the newsreel, and the documentary proper.

It is easy to see that some of these dimensions are more likely than others to prompt the film maker to express his formative aspirations at the expense of the realistic tendency. As for areas, consider that of fantasy: movie directors have at all times rendered dreams or visions with the aid of settings which are anything but realistic. Thus in *Red Shoes* Moira Shearer dances, in a somnambulistic trance, through fantastic worlds avowedly intended to project her unconscious mind—agglomerates of landscape-like forms, near-abstract shapes, and luscious color schemes which have all the traits of stage imagery. Disengaged creativity thus drifts away from the basic concerns of the medium. Several dimensions of composition favor the same preferences. Most experimental films are not even designed to focus on physical existence; and practically all films following the lines of a theatrical story evolve narratives whose significance overshadows that of the raw material of nature used for their implementation. For the rest, the film maker's formative endeavors may also impinge on his realistic loyalties in dimensions which, because of their emphasis on physical reality, do not normally invite such encroachments; there are enough documentaries with real-life shots which merely serve to illustrate some self-contained oral commentary.

## CLASHES BETWEEN THE TWO TENDENCIES

Films which combine two or more dimensions are very frequent; for instance, many a movie featuring an everyday-life incident includes a dream sequence or a documentary passage. Some such combinations may lead to overt clashes between the realistic and formative tendencies. This happens whenever a film maker bent on creating an imaginary universe from freely staged material also feels under an obligation to draw on camera-reality. In his *Hamlet* Laurence Olivier has the cast move about in a studio-built, conspicuously stagy Elsinore, whose labyrinthine architecture seems calculated to reflect Hamlet's unfathomable being. Shut off from our real-life environment, this bizarre structure would spread over the whole of the film were it not for a small, otherwise insignificant scene in which the real ocean outside that dream orbit is shown. But no sooner does the photographed ocean appear than the spectator experiences something like a shock. He cannot help recognizing that this little scene is an outright intrusion; that it abruptly introduces an element incompatible with the rest of the imagery. How he then reacts to it depends upon his sensibilities. Those indifferent to the peculiarities of the medium, and therefore unquestioningly accepting the staged Elsinore, are likely to resent the unexpected emergence of crude nature as a letdown, while those more sensitive to the properties of film will in a flash realize the make-believe character of the castle's mythical

splendor. Another case in point is Renato Castellani's *Romeo and Juliet*. This attempt to stage Shakespeare in natural surroundings obviously rests upon the belief that camera-reality and the poetic reality of Shakespeare verse can be made to fuse into each other. Yet the dialogue as well as the intrigue establish a universe so remote from the chance world of real Verona streets and ramparts that all the scenes in which the two disparate worlds are seen merging tend to affect one as an unnatural alliance between conflicting forces.

Actually collisions of this kind are by no means the rule. Rather, there is ample evidence to suggest that the two tendencies which sway the medium may be interrelated in various other ways. Since some of these relationships between realistic and formative efforts can be assumed to be aesthetically more gratifying than the rest, the next step is to try to define them.

## The Cinematic Approach

It follows from what has been said in the preceding chapter that films may claim aesthetic validity if they build from their basic properties; like photographs, that is, they must record and reveal physical reality. I have already dealt with the possible counterargument that media peculiarities are in general too elusive to serve as a criterion; for obvious reasons it does not apply to the cinematic medium either. Yet another objection suggests itself. One might argue that too exclusive an emphasis on the medium's primary relation to physical reality tends to put film in a strait jacket. This objection finds support in the many existing films which are completely unconcerned about the representation of nature. There is the abstract experimental film. There is an unending succession of "photoplays" or theatrical films which do not picture real-life material for its own sake but use it to build up action after the manner of the stage. And there are the many films of fantasy which neglect the external world in freely composed dreams or visions. The old German expressionist films went far in this direction; one of their champions, the German art critic Herman G. Scheffauer, even eulogizes expressionism on the screen for its remoteness from photographic life.[38]

Why, then, should these genres be called less "cinematic" than films concentrating on physical existence? The answer is of course that it is the latter alone which afford insight and enjoyment otherwise unattainable. True, in view of all the genres which do not cultivate outer reality and yet are here to stay, this answer sounds somewhat dogmatic. But perhaps it will be found more justifiable in the light of the following two considerations.

First, favorable response to a genre need not depend upon its adequacy to the medium from which it issues. As a matter of fact, many a genre has a hold on the audience because it caters to widespread social and cultural demands; it is and remains popular for reasons which do not involve questions of aesthetic legitimacy. Thus the photoplay has succeeded in perpetuating itself even though most responsible critics are agreed that it goes against the grain of film. Yet the public which feels attracted, for instance, by the screen version of *Death of a Salesman*, likes this version for the very virtues which made the Broadway play a hit and does not in the least care whether or not it has any specifically cinematic merits.

Second, let us for the sake of argument assume that my definition of aesthetic validity is actually one-sided; that it results from a bias for one particular, if

important, type of cinematic activities and hence is unlikely to take into account, say, the possibility of hybrid genres or the influence of the medium's nonphotographic components. But this does not necessarily speak against the propriety of that definition. In a strategic interest it is often more advisable to loosen up initial one-sidedness—provided it is well founded—than to start from all too catholic premises and then try to make them specific. The latter alternative runs the risk of blurring differences between the media because it rarely leads far enough away from the generalities postulated at the outset; its danger is that it tends to entail a confusion of the arts. When Eisenstein, the theoretician, began to stress the similarities between the cinema and the traditional art media, identifying film as their ultimate fulfillment, Eisenstein, the artist, increasingly trespassed the boundaries that separate film from elaborate theatrical spectacles: think of his *Alexander Nevsky* and the operatic aspects of his *Ivan the Terrible*.[39]

In strict analogy to the term "photographic approach" the film maker's approach is called "cinematic" if it acknowledges the basic aesthetic principle. It is evident that the cinematic approach materializes in all films which follow the realistic tendency. This implies that even films almost devoid of creative aspirations, such as newsreels, scientific or educational films, artless documentaries, etc., are tenable propositions from an aesthetic point of view—presumably more so than films which for all their artistry pay little attention to the given outer world. But as with photographic reportage, newsreels and the like meet only the minimum requirement.

What is of the essence in film no less than photography is the intervention of the film maker's formative energies in all the dimensions which the medium has come to cover. He may feature his impressions of this or that segment of physical existence in documentary fashion, transfer hallucinations and mental images to the screen, indulge in the rendering of rhythmical patterns, narrate a human-interest story, etc. All these creative efforts are in keeping with the cinematic approach as long as they benefit, in some way or other, the medium's substantive concern with our visible world. As in photography, everything depends on the "right" balance between the realistic tendency and the formative tendency; and the two tendencies are well balanced if the latter does not try to overwhelm the former but eventually follows its lead.

## The Issue of Art

When calling the cinema an art medium, people usually think of films which resemble the traditional works of art in that they are free creations rather than explorations of nature. These films organize the raw material to which they resort into some self-sufficient composition instead of accepting it as an element in its own right. In other words, their underlying formative impulses are so strong that they defeat the cinematic approach with its concern for camera-reality. Among the film types customarily considered art are, for instance, the above-mentioned German expressionist films of the years after World War I; conceived in a painterly spirit, they seem to implement the formula of Hermann Warm, one of the designers of *The Cabinet of Dr. Caligari* settings, who claimed that "films must be drawings brought to life."[40] Here also belongs many an experimental film; all in all, films of this type are not only intended as autonomous wholes but frequently ignore physical reality

or exploit it for purposes alien to photographic veracity. By the same token, there is an inclination to classify as works of art feature films which combine forceful artistic composition with devotion to significant subjects and values. This would apply to a number of adaptations of great stage plays and other literary works.

Yet such a usage of the term "art" in the traditional sense is misleading. It lends support to the belief that artistic qualities must be attributed precisely to films which neglect the medium's recording obligations in an attempt to rival achievements in the fields of the fine arts, the theater, or literature. In consequence, this usage tends to obscure the aesthetic value of films which are really true to the medium. If the term "art" is reserved for productions like *Hamlet* or *Death of a Salesman*, one will find it difficult indeed to appreciate properly the large amount of creativity that goes into many a documentary capturing material phenomena for their own sake. Take Ivens's *Rain* or Flaherty's *Nanook*, documentaries saturated with formative intentions: like any selective photographer, their creators have all the traits of the imaginative reader and curious explorer; and their readings and discoveries result from full absorption in the given material and significant choices. Add to this that some of the crafts needed in the cinematic process—especially editing—represent tasks with which the photographer is not confronted. And they too lay claim to the film maker's creative powers.

This leads straight to a terminological dilemma. Due to its fixed meaning, the concept of art does not, and cannot, cover truly "cinematic" films—films, that is, which incorporate aspects of physical reality with a view to making us experience them. And yet it is they, not the films reminiscent of traditional art works, which are valid aesthetically. If film is an art at all, it certainly should not be confused with the established arts.[41] There may be some justification in loosely applying this fragile concept to such films as *Nanook*, or *Paisan*, or *Potemkin* which are deeply steeped in camera-life. But in defining them as art, it must always be kept in mind that even the most creative film maker is much less independent of nature in the raw than the painter or poet; that his creativity manifests itself in letting nature in and penetrating it.

# Inherent Affinities

If photography survives in film, film must share the same affinities. Accordingly, four of the five affinities which seem to be characteristic of film should be identical with those of photography. Nevertheless they call for renewed discussion because of their extended scope and their specifically cinematic implications. The last affinity to be examined—for the "flow of life"—is peculiar to film alone, since photography cannot picture life in motion.

## *The Unstaged*

As has been pointed out, everything reproducible in terms of the camera may be represented on the screen—which means that, for instance, the "canning" of a theatrical performance is in principle unobjectionable. Yet I have stressed that films

conform to the cinematic approach only if they acknowledge the realistic tendency by concentrating on actual physical existence—"the beauty of moving wind in the trees," as D. W. Griffith expressed it in a 1947 interview in which he voiced his bitterness at contemporary Hollywood and its unawareness of that beauty.[1] In other words, film, notwithstanding its ability to reproduce, indiscriminately, all kinds of visible data, gravitates toward unstaged reality. And this in turn has given rise to two interrelated propositions regarding staging: First, staging is aesthetically legitimate to the extent that it evokes the illusion of actuality. Second, by the same token anything stagy is uncinematic if it passes over the basic properties of the medium.

There would be nothing to be added were it not for the last proposition about staginess. Although the general statement that the artificiality of stagy settings or compositions runs counter to the medium's declared preference for nature in the raw is certainly to the point, it nevertheless requires qualification. Experience shows that the uncinematic effect of staginess is mitigated in at least two cases.

For one thing, take all the films which, from *The Cabinet of Dr. Caligari* to the Japanese *Gate of Hell*, are palpably patterned on paintings: it is true that they ignore unadulterated reality, reality not yet subjected to painterly treatment, but at the same time they meet Hermann Warm's request that films should be "drawings brought to life." Now their compliance with his request is of consequence cinematically. One will remember that in the preceding chapter movement as contrasted with motionlessness has been identified as a subject of cinematic interest. Films bringing "drawings . . . to life" may be considered an annex to this group; if they do not contrast motion with a state of rest, yet they picture the birth of motion out of that state. In fact, we experience the sensation of nascent movement whenever seemingly painted figures and objects take on life in spite of their inherent immobility. The experience is all the more stirring since they cannot help preserving the character of drawings. As the protagonists of *Caligari*—Dr. Caligari himself and the medium Cesare—move through expressionist settings, they continue to fuse with the motionless shadows and bizarre designs about them.[2] And some scenes of *Gate of Hell* are nothing but scrolls set moving as if by a magic wand. What attracts us in these films is the miracle of movement as such. It adds a touch of cinema to them.

As for the other case, a similar effect may be produced with the aid of specifically cinematic techniques and devices. This is in keeping with what has been said about the relationships between the basic and technical properties of film in the second chapter. According to the rule advanced there, even a film with stagy settings—to mention only this one aspect of staginess—may acquire a cinematic quality provided its technical execution testifies to a sense of the medium; whereby it is understood, though, that such a film is under all circumstances less cinematic than a film devoted to camera-reality. In Olivier's *Hamlet* the camera is continually on the move, thus making the spectator almost forget that the interiors through which it travels and pans are intended to externalize the mood of the play rather than impart that of anything external; or to be more precise, he must divide his attention between two conflicting worlds which are supposed to merge into a whole but actually do not blend well: the cinematic world suggested by camera movement and the deliberately unreal world established by the stage designer. In the same way Fritz Lang manages to imbue the flood episode of his *Metropolis*, a film of unsurpassable staginess in many respects, with a semblance of cinematic life. The fleeing

crowds in that episode are staged veraciously and rendered through a combination of long shots and close shots which provide exactly the kind of random impressions we would receive were we to witness this spectacle in reality. Yet the cinematic impact of the crowd images somewhat suffers from the fact that the scene is laid in architectural surroundings which could not be more stylized.

## *The Fortuitous*

The fortuitous being a characteristic of camera-reality, film no less than photography is attracted by it. Hence the major role assigned to it in a truly cinematic genre, the American silent film comedy. To be sure, the minor triumphs of Buster Keaton or Chaplin's Tramp over destructive natural forces, hostile objects, and human brutes were sometimes due to feats of acrobatic skill. Yet unlike most circus productions, film comedy did not highlight the performer's proficiency in braving death and surmounting impossible difficulties; rather, it minimized his accomplishments in a constant effort to present successful rescues as the outcome of sheer chance. Accidents superseded destiny; unpredictable circumstances now foreshadowed doom, now jelled into propitious constellations for no visible reason. Take Harold Lloyd on the skyscraper: what protected him from falling to death was not his prowess but a random combination of external and completely incoherent events which, without being intended to come to his help, dovetailed so perfectly that he could not have fallen even had he wanted to. Accidents were the very soul of slapstick.[3]

The affinity of film for haphazard contingencies is most strikingly demonstrated by its unwavering susceptibility to the "street"—a term designed to cover not only the street, particularly the city street, in the literal sense, but also its various extensions, such as railway stations, dance and assembly halls, bars, hotel lobbies, airports, etc. If the medium's descent from, and kinship with, photography needed additional confirmation, this very specific preference, common to both of them, would supply it. Within the present context the street, which has already been characterized as a center of fleeting impressions, is of interest as a region where the accidental prevails over the providential, and happenings in the nature of unexpected incidents are all but the rule. Startling as it may sound, since the days of Lumière there have been only few cinematic films that would not include glimpses of a street, not to mention the many films in which some street figures among the protagonists.

It was D. W. Griffith who initiated this tradition. For prototypes of cinematically significant imagery one will always have to revert to him. He featured the street as an area dominated by chance in a manner reminiscent of Lumière's shots of crowded public places. In one of his early films, which bears the suggestive title *The Musketeers of Pig Alley*, much of the action is laid in dingy houses, a New York East Side street teeming with nondescript passers-by, a low dive, and a small yard between cheap tenement houses where teenagers forever loiter about. More important, the action itself, which revolves around a thievery and ends on a pursuit, grows out of these locales. They offer opportunities to the criminal gang to which the thief is committed; and they provide the adventitious encounters and promiscuous gatherings which are an essential element of the intrigue. All this is resumed on a broader scale in the "modern story" of Griffith's *Intolerance*. There the street takes on an additional function reserved for it: it turns into the scene of bloody clashes between striking

workers and soldiers sent out against them. (The sights of the crowds of fleeing workers and the corpses left behind foreshadow the Russian films of the Revolution.)

Yet if the street episodes of the "modern story" involve the depiction of mass violence, they do by no means exhaust themselves in it. Eisenstein praises them for something less glaring—the way in which they impress upon the spectator the fortuitous appearances and occurrences inseparable from the street as such. In 1944, all that he remembered of these episodes was an ephemeral passer-by. After having described him, Eisenstein continues: "As he passes he interrupts the most pathetic moment in the conversation of the suffering boy and girl. I can remember next to nothing of the couple, but this passer-by who is visible in the shot only for a flashing glimpse stands alive before me now—and I haven't seen the film for twenty years! Occasionally," he adds, "these unforgettable figures actually walked into Griffith's films almost directly from the street: a bit-player developed in Griffith's hands to stardom; the passer-by who may never again have been filmed."[4]

## Endlessness

Like photography, film tends to cover all material phenomena virtually within reach of the camera. To express the same otherwise, it is as if the medium were animated by the chimerical desire to establish the continuum of physical existence.

### 24 CONSECUTIVE HOURS

This desire is drastically illustrated by a film idea of Fernand Léger's. Léger dreamed of a monster film which would have to record painstakingly the life of a man and a woman during twenty-four consecutive hours: their work, their silence, their intimacy. Nothing should be omitted; nor should they ever be aware of the presence of the camera. "I think," he observed, "this would be so terrible a thing that people would run away horrified, calling for help as if caught in a world catastrophe."[5] Léger is right. Such a film would not just portray a sample of everyday life but, in portraying it, dissolve the familiar contours of that life and expose what our conventional notions of it conceal from view—its widely ramified roots in crude existence. We might well shrink, panic-stricken, from these alien patterns which would denote our ties with nature and claim recognition as part of the world we live in and are.

**[ · · · ]**

## The Indeterminate

### PSYCHOPHYSICAL CORRESPONDENCES

As an extension of photography, film shares the latter's concern for nature in the raw. Though natural objects are relatively unstructured and, hence, indeterminate as to meaning, there are varying degrees of indeterminacy. Notwithstanding their relative lack of structure, a somber landscape and a laughing face seem to have a definite significance in any given culture; and the same holds true of certain colors and light effects. Yet even these more outspoken phenomena are still essentially

indefinable, as can be inferred from the readiness with which they change their apparently fixed meaning within changing contexts. To take an example from the screen, in *Alexander Nevsky* the Teutonic knights are clothed in white hoods; the white usually suggestive of innocence here is made to signify scheming ruthlessness. In the same way, dependent on the context, the somber landscape may connote defiant intrepidity and the laughing face hysterical fear.

Natural objects, then, are surrounded with a fringe of meanings liable to touch off various moods, emotions, runs of inarticulate thoughts; in other words, they have a theoretically unlimited number of psychological and mental correspondences. Some such correspondences may have a real foundation in the traces which the life of the mind often leaves in material phenomena; human faces are molded by inner experiences, and the patina of old houses is a residue of what has happened in them. This points to a two-way process. It is not only the given objects which function as stimuli; psychological events also form nuclei, and of course they on their part have physical correspondences. Under the influence of the shock he suffers when dipping a madeleine into his tea, Proust's narrator is, body and soul, transported back to places, scenes, and the core of names many of which amount to overpowering images of things external. The generic term "psychophysical correspondences" covers all these more or less fluid interrelations between the physical world and the psychological dimension in the broadest sense of the word—a dimension which borders on that physical universe and is still intimately connected with it.

For reasons discussed in earlier pages, screen images tend to reflect the indeterminacy of natural objects. However selective, a film shot does not come into its own unless it incorporates raw material with its multiple meanings or what Lucien Sève calls the "anonymous state of reality." Incidentally, Sève, a brilliant young French critic, is quite aware of this characteristic of the cinematic shot. He judiciously remarks that the shot "delimits without defining" and that it has the quality, "unique among the arts, of offering not much more explanations than reality" itself.[6]

But this raises a vitally important problem of editing.

## A BASIC EDITING PRINCIPLE

Any film maker evolving a narrative is faced with the task of simultaneously living up to two obligations which seem to be difficult to reconcile.

On the one hand, he will have to advance the action by assigning to each shot a meaning relevant to the plot. That this reduction of meanings falls to editing was demonstrated by Kuleshov in the experiment he conducted together with Pudovkin. In order to prove the impact of editing on the significance of shots, he inserted one and the same shot of Mosjukhin's otherwise noncommittal face in different story contexts; the result was that the actor's face appeared to express grief on a sad occasion and smiling satisfaction in a pleasant environment.[7] In terms of the Kuleshov experiment, the film maker must therefore insert Mosjukhin's face in such a way that it assumes the significance required by the story at this particular place. (Some story types depend for implementation to a larger extent than others on the removal of all meanings which do not "belong.")

On the other hand, the film maker will wish to exhibit and penetrate physical reality for its own sake. And this calls for shots not yet stripped of their

multiple meanings, shots still able to release their psychological correspondences. Accordingly, he must see to it that Mosjukhin's face retains, somehow, its virgin indeterminacy.

But how can one meet this last requirement within the framework of an exacting narrative? Jean Epstein once protested his weakness for the standardized pistol scene in American films of the mid-'twenties—the pistol would be slowly removed from a half-open drawer and would then be enlarged to fill the screen, an enormous menace vaguely foreshadowing the crucial moment: "I loved this pistol. It appeared as a symbol of a thousand possibilities. The desires and disappointments it represented; the mass of combinations to which it offered a clue."[8] What distinguishes this pistol scene is obviously the way it is edited. The shots comprising it are so juxtaposed that at least one of them—that of the pistol—preserves a certain independence of the intrigue. And Epstein revels in it because it does not just point forward to something that will subsequently happen but stands out as an image iridescent with multiple meanings. Nevertheless this shot may well benefit the action. It is possible, then, to integrate shots of indistinct meaningfulness into a narrative.

**[ · · · ]**

Notwithstanding their latent or ultimately even manifest bearing on the narrative to which they belong, all these shots are more or less free-hovering images of material reality. And as such they also allude to contexts unrelated to the events which they are called upon to establish. Their cinematic quality lies precisely in their allusiveness, which enables them to yield all their psychological correspondences. Hence the infatuation of sensitive film makers or critics with pictorial material of a purely allusive character. "The frown of a tower," says Herman G. Scheffauer, "the scowl of a sinister alley, . . . the hypnotic draught of a straight road vanishing to a point—these exert their influences and express their natures; their essences flow over the scene and blend with the action. A symphony arises between the organic and the inorganic worlds and the lens peers behind inscrutable veils."[9]

This leads to the formulation of a basic editing principle: any film narrative should be edited in such a manner that it does not simply confine itself to implementing the intrigue but also turns away from it toward the objects represented so that they may appear in their suggestive indeterminacy.

## The "Flow of Life"

It follows from what has just been said that cinematic films evoke a reality more inclusive than the one they actually picture. They point beyond the physical world to the extent that the shots or combinations of shots from which they are built carry multiple meanings. Due to the continuous influx of the psychophysical correspondences thus aroused, they suggest a reality which may fittingly be called "life." This term as used here denotes a kind of life which is still intimately connected, as if by an umbilical cord, with the material phenomena from which its emotional and intellectual contents emerge. Now films tend to capture physical existence in its endlessness. Accordingly, one may also say that they have an affinity, evidently denied to photography, for the continuum of life or the "flow of life," which of course is identical with open-ended life. The concept "flow of life," then, covers the stream of

material situations and happenings with all that they intimate in terms of emotions, values, thoughts. The implication is that the flow of life is predominantly a material rather than a mental continuum, even though, by definition, it extends into the mental dimension. (It might tentatively be said that films favor life in the form of everyday life—an assumption which finds some support in the medium's primordial concern for actuality.)

## ONCE AGAIN THE STREET

Eisenstein has been quoted as saying that the "unforgettable figures" in Griffith's films occasionally walked into them "almost directly from the street." Within the same context Eisenstein also remarks that "Griffith's inimitable bit-characters . . . seem to have run straight from life onto the screen."[10] Inadvertently he thus equates life with the street. The street in the extended sense of the word is not only the arena of fleeting impressions and chance encounters but a place where the flow of life is bound to assert itself. Again one will have to think mainly of the city street with its ever-moving anonymous crowds. The kaleidoscopic sights mingle with unidentified shapes and fragmentary visual complexes and cancel each other out, thereby preventing the onlooker from following up any of the innumerable suggestions they offer. What appears to him are not so much sharp-contoured individuals engaged in this or that definable pursuit as loose throngs of sketchy, completely indeterminate figures. Each has a story, yet the story is not given. Instead, an incessant flow of possibilities and near-intangible meanings appears. This flow casts its spell over the *flâneur* or even creates him. The *flâneur* is intoxicated with life in the street—life eternally dissolving the patterns which it is about to form.[11]

The medium's affinity for the flow of life would be enough to explain the attraction which the street has ever since exerted on the screen. Perhaps the first deliberately to feature the street as the scene of life was Karl Grune in a half-expressionist, half-realistic film which significantly bears the title *The Street* (*Die Strasse*). Its hero is a middle-aged *petit bourgeois* possessed with the desire to escape from the care of his lifeless wife and the prison of a home where intimacy has become deadening routine. The Street calls him. There life surges high and adventures are waiting for him. He looks out of the window and sees—not the street itself but a hallucinated street. "Shots of rushing cars, fireworks, and crowds form, along with shots taken from a roller coaster, a confusing whole made still more confusing by the use of multiple exposures and the insertion of transparent close-ups of a circus clown, a woman, and an organ-grinder."[12] One evening he walks out into the real street— studio-built, for that matter—and gets more than his fill of sensations, what with card sharpers, prostitutes, and a murder to boot. Life, an agitated sea, threatens to drown him. There is no end of films in this vein. If it is not a street proper they picture, it is one of its extensions, such as a bar, a railway station, or the like. Also, life may change its character; it need not be wild and anarchical as with Grune. In Delluc's *Fievre* or Cavalcanti's *En Rade* a mood of *fin-de-siècle* disenchantment and nostalgic longing for faraway countries lingers in crowded sailor hangouts. And in Vittorio De Sica's *The Bicycle Thief* and *Umberto D.* the omnipresent streets breathe a tristesse which is palpably the outcome of unfortunate social conditions. But whatever its dominant characteristics, street life in all these films is not fully

determined by them. It remains an unfixable flow which carries fearful uncertainties and alluring excitements.

## STAGE INTERLUDES

Stage episodes not only occur in numerous regular feature films, such as *The Birth of a Nation* or *La Grande Illusion*, but form the backbone of most run-of-the-mill musicals. Chaplin as the Tramp has occasionally been fond of disrupting theatrical performances; and E. A. Dupont in his *Variety* has effectively contrasted dependable on-stage perfection with unpredictable off-stage passion.

Stage interludes within otherwise realistic films assume a cinematic function to the extent that they throw into relief the flow of life from which they detach themselves. Paradoxical as it may seem, the stagy, normally against the grain of the medium, assumes a positive aesthetic function if it is made to enhance the unstaged. Accordingly, the more stylized a cut-in theatrical production number, the better does it lend itself to serving as a foil to camera-reality. Many a film affording glimpses of opera scenes actually exaggerates their artificiality so as to sensitize us, by way of contrast, to the flow of haphazard events surging around that opera isle. In Germaine Dulac's *The Smiling Madame Beudet*, a French *avant-garde* film of 1922, the superimposed images of singers in the roles of Faust and Mephistopheles are visibly intended to ridicule operas for their glamorous aloofness from the boredom of small-town streets, unloved people, and vain daydreams—all those corrosive influences which compose and decompose Madame Beudet's drab existence. Perhaps the best opera satire ever made is that incomparable stage sequence in René Clair's *Le Million* in which two corpulent singers deliver a love duet, while behind them two young lovers, hidden from the theater audience by the sets, are so profoundly enamored of each other that they seem unaware of being in a place where they do not belong. They are strangers there; and their genuineness as real-life characters is highlighted by the constant parallels which the camera draws between them and the performers whose every move is carefully planned.

Yet this is not all. Clair manages to confer upon the loving couple and their world the very magic which the stage is supposed to radiate. When looking at the fat singers from the angle of the man in the pit, we see them in a setting which, however enchanting, is unaffected by their voices and incapable of stirring any illusions. It remains what it is—painted canvas. But no sooner are the lovers brought into focus than this very scenery undergoes a miraculous change, even though the close shots used in presenting it infallibly reveal it to be sheer pretense. A piece of pasteboard drifting past sham blossoms becomes a frail white cloud; the scraps of paper released from the flies turn into fragrant rose petals. Thus stage illusion is debunked and at the same time called upon to convey the glow and glory of unadulterated life.

Despite its unique attractiveness for film, the visible world as it surrounds us here and now is only one of the areas which film makers have explored since the archaic days of the medium. Films or film sequences invading other areas, especially the realms of history and fantasy, are quite common. They raise aesthetic problems of interest.

## NOTES

### Basic Concepts

1. Sadoul, *L'Invention du cinéma*, pp. 8, 49ff., 63–81 (about Marey). This book is a "must" for anyone interested in the complex developments that led up to Lumière. For Muybridge, see also Newhall, "Photography and the Development of Kinetic Visualization," *Journal of the Warburg and Courtauld Institutes*, 1944, vol. 7, pp, 42–3. T. Ra., "Motion Pictures," *Encyclopedia Britannica*, 1932, vol. 15, pp. 854–6, offers a short survey of the period.

2. Newhall, op. cit. p. 40.

3. Ibid. p. 40.

4. Sadoul, *L'Invention du cinéma*, p. 38.

5. Herschel, "Instantaneous Photography," *Photographic News*, 1860, vol. 4, no. 88:13. I am indebted to Mr. Beaumont Newhall for his reference to this quote.

6. Sadoul, *L'Invention du cinéma*, pp. 36–7, 86, 241–2.

7. It was Ducos du Hauron who, as far back as 1864, predicted these developments; see Sadoul, ibid. p. 37.

8. Mr. Georges Sadoul, *L'Invention du cinéma*, p. 298, sagaciously observes that the names given the archaic film cameras offer clues to the then prevailing aspirations. Such names as vitascope, vitagraph, bioscope, and biograph were undoubtedly intended to convey the camera's affinity for "life," while terms like kinetoscope, kinetograph, and cinematograph testified to the concern with movement.

9. Caveing, "Dialectique du concept du cinéma," *Revue internationale de filmologie* (part I: July–Aug. 1947, no. 1; part II: Oct. 1948, nos. 3–4) applies, in a somewhat highhanded manner, the principles of Hegel's dialectics to the evolution of the cinema. The first dialectic stage, he has it, consists of Lumière's reproduction of reality and its antithesis—complete illusionism, as exemplified by Méliès (see especially part I, pp. 74–8). Similarly, Morin, *Le Cinéma ou l'homme imaginaire*, p. 58, conceives of Méliès's "absolute unreality" as the antithesis, in a Hegelian sense, of Lumière's "absolute realism." See also Sadoul, *Histoire d'un art*, p. 31.

10. Sadoul, *L'Invention du cinéma*, pp. 21–2, 241, 246.

11. Langlois, "Notes sur l'histoire du cinéma," *La Revue du cinéma*, July 1948, vol. III, no. 15:3.

12. Sadoul, op. cit. p. 247.

13. Ibid. pp. 249, 252, 300; and Sadoul, *Histoire d'un art*, p. 21.

14. Gorki, "You Don't Believe Your Eyes," *World Film News*, March 1938, p. 16.

15. Bessy and Duca, *Louis Lumière, inventeur*, p. 88. Sadoul, op. cit. pp. 23–4.

16. Quoted by Sadoul, *L'Invention du cinéma*, p. 208. See also, ibid. p. 253.

17. Sadoul, ibid. pp. 242–4, 248. Vardac, *Stage to Screen*, pp. 166–7. Vardac emphasizes that an ever-increasing concern with realism prompted the nineteenth-century stage to make elaborate use of special devices. For instance, Steele MacKaye, a theatrical producer who died shortly before the arrival of the vitascope, invented a "curtain of light" so as to produce such effects as the fade-in, the fade-out, and the dissolve (p. 143).

18. Sadoul, op. cit. p. 246.

19. Bessy and Duca, *Louis Lumière, inventeur*, pp. 49–50. Sadoul, *Histoire d'un art*, p. 23.

20. Sadoul, *L'Invention du cinéma*, pp. 222–4, 227.

21. Sadoul, ibid. p. 332, and Sadoul, *Histoire d'un art*, p. 24.

22. Sadoul, *L'Invention du cinéma*, pp. 322, 328.

23. Ibid. p. 332. Langlois, "Notes sur l'histoire du cinéma," *La Revue du cinéma*, July 1948, vol. III, no. 15:10.

24. Quoted by Bardèche and Brasillach, *The History of Motion Pictures*, p. 10.

25. Sadoul, *L'Invention du cinéma*, p. 332.

26. Ibid. pp. 102, 201; esp. 205.

27. Ibid. pp. 324–6.

28. For Méliès's technical innovations, see Sadoul, *Les Pionniers du cinéma*, pp. 52–70.

29. Langlois, "Notes sur l'histoire du cinéma," *La Revue du cinéma*, July 1948, vol. III, no. 15:5.

30. Sadoul, op. cit. pp. 154, 166.

31. Sadoul, *L'Invention du cinéma*, pp. 330–31.

32. Cf. Meyerhoff, *Tonfilm und Wirklichkeit*, pp. 13, 22.

33. Clair, *Réflexion faite*, p. 96; he made this statement in 1924.

34. Ibid. p. 150.

35. Vuillermoz, "Réalisme et expressionisme," *Cinéma* (Les cahiers du mois, 16/17), 1925, pp. 78–9.

36. See Kracauer, *From Caligari to Hitler*, p. 240.

37. Berge, "Interview de Blaise Cendrars sur le cinéma," *Cinéma* (Les cahiers du mois, 16/17), 1925, p. 141. For the problems involved in the staging of actuality, see also Mauriac, *L'Amour du cinéma*, p. 36, and Obraszow, "Film und Theater," in *Von der Filmidee zum Drehbuch*, p. 54.

38. Scheffauer, "The Vivifying of Space," *The Freeman*, Nov. 24 and Dec. 1, 1920.

39. Eisenstein, *Film Form*, pp. 181–2.

40. See Kracauer, *From Caligari to Hitler*, p. 68.

41. Arnold Hauser belongs among the few who have seen this. In his *The Philosophy of Art History*, p. 363, he says: "The film is the only art that takes over considerable pieces of reality unaltered; it interprets them, of course, but the interpretation remains a photographic one." His insight notwithstanding, however, Hauser seems to be unaware of the implications of this basic fact.

### Inherent Affinities

1. Stern, "D. W. Griffith and the Movies," *The American Mercury*, March 1944, vol. LXVIII, no. 303:318–19.

2. See Kracauer, *From Caligari to Hitler*, pp. 69–70.

3. Cf. Kracauer, "Silent Film Comedy," *Sight and Sound*, Aug.–Sept. 1951, vol. 21, no. 1:31.

4. Eisenstein, *Film Form*, p. 199.

5. Léger, "A propos du cinéma," in L'Herbier, ed., *Intelligence du cinématographe*, p. 340.

6. Sève, "Cinéma et méthode," *Revue internationale de filmologie*, July–Aug. 1947, vol. I, no. 1:45; see also 30–31.

7. Pudovkin, *Film Technique and Film Acting*, part I, p. 140.

8. Epstein, *Le Cinématographe vu de l'Etna*, p. 13.

9. Scheffauer, "The Vivifying of Space," *The Freeman*, Nov. 24 and Dec. 1, 1920. See also Clair, *Réflexion faite*, p. 106. Rotha, *The Film Till Now*, p. 365, characterizes Feyder's *Therese Raquin* as a film in which content grows out of images indulging in "subtle indirect suggestion."

10. Eisenstein, *Film Form*, p. 199.

11. Benjamin, "Ueber einige Motive bei Baudelaire," *Zeitschrift fuer Sozialforschung* 1939, vol. VIII, nos. 1–2:60 n., 67, 88.

12. See Kracauer, *From Caligari to Hitler*, p. 121.

# ANDRÉ BAZIN

. . . . . . . . . . . . . . . . . . . . . . . . . . . . . . . . . . . . . . . . . . . . . . . . . . . . . . . . . . . . . . . . . . . . .

## The Ontology of the Photographic Image; The Evolution of the Language of Cinema

FROM *What Is Cinema?*

Born in Angers, France, and educated as a teacher, André Bazin (1918–1958) is seen as the most important realist film theorist; his ideas vitalized public discourse about film and were decisive in establishing film as an intellectual discipline. Bazin became intrigued by the power of cinema during World War II, setting up ciné-clubs where he screened banned films in defiance of the Nazi authorities during the German occupation of Paris. He started his career as a film critic with the Catholic intellectual journal *L'Esprit* and associated himself with a wide array of film magazines such as *L'Écran français, La Revue du cinéma,* and *Critique.* In 1951 he established, with Jacques Doniol-Valcroze and Joseph-Marie Lo Duca, *Cahiers du cinéma,* which quickly became one of the most influential film journals. *Cahiers* had a pivotal influence in the development of auteur theory, uncovering the distinctive style of directors such as Alfred Hitchcock, Howard Hawks, and Douglas Sirk. Under Bazin's mentorship, *Cahiers* brought together a generation of young critics seeking a new cinema such as François Truffaut, Jean-Luc Godard, Eric Rohmer, and Claude Chabrol, who went on to direct their own films and create the influential French New Wave.

Although realist aesthetic traditions predate cinema, questions about realism in film took on new urgency in the late 1940s because of the potential of cinema to help rebuild national identity by revealing to audiences the complex dynamics of everyday life. For example, the filmmakers of Italian neorealism used realist aesthetics to address the most pressing postwar concerns about freedom, democracy, and anti-fascism. Inspired by this historical moment, Bazin believed that film had a unique obligation toward reality and should document, rather than interpret, the world. He asserted that because a movie camera is defined by a process of mechanical photographic reproduction without human intervention, its inherent realism is the very essence of the film medium. Bazin found the styles of Sergei Eisenstein and German Expressionist films such as *The Cabinet of Dr. Caligari* (1920), which manipulated lighting and mise-en-scène, restrictive and in violation of the "continuum of reality." Instead, Bazin admired filmmakers such as Jean Renoir, Vittorio de Sica, Robert Bresson, and Orson Welles, who used a less interventionist, or a more "neutral," style—deploying the long take and depth of field that Bazin believed captured the development of an event in its reality.

A selection of Bazin's essays on cinema were posthumously published in 1958 in two volumes provocatively titled, *What Is Cinema?* This basic question is what philosophy calls an ontological question, a question of being. In the 1945 essay "The Ontology of the Photographic Image," Bazin argues that photography responds to a human desire to "embalm" reality and that cinema goes even further in preserving the passage of time. In the magisterial "The Evolution of the Language of Cinema," the final form of several articles published

between 1950 and 1955, Bazin compares two different filmmaking styles: that of filmmakers of "the image," who dissect the space/time continuum, and that of filmmakers of "reality," who respect the spatiotemporal integrity of the world in front of the camera. He offers an account of film history by tracing the progression of a realist tradition in cinema, beginning with the Lumières, continuing with Robert Flaherty and F. W. Murnau, and reaching a kind of fulfillment with Italian neorealism. While Bazin keeps his essay grounded in specific filmic examples, his language elevates cinema to a rite endowed with its own untouchable reality and almost spiritual potential, and to a political medium equipped to fulfill a democratic and egalitarian promise. Bazin's meditative humanism would later come into conflict with the basic premises of semiotics and structuralism, which assume the fundamentally constructed nature of reality. Nevertheless, due to its thorough and devoted approach to film as a serious object of study, and for its unique exploration of the essence of cinema, Bazin's theory of realism retains a crucial place in film studies.

## READING CUES & KEY CONCEPTS

■ Bazin famously uses the metaphor of a mummy to discuss the realist impulse in art. Consider some of the other metaphors Bazin uses and their implications.

■ Bazin distinguishes between filmmakers of "reality" who "relate to the plastics of the image," and filmmakers of "the image" who relate to "the resources of montage." How does this distinction take into account the fact that film, as a whole and by its very definition, is always a succession of images or, as Bazin puts it, "the ordering of images in time"?

■ Explain Bazin's claim that montage in the films of Eisenstein or Kuleshov did not "show us the event; it alluded to it."

■ According to Bazin, what does the introduction of sound contribute to the tradition of realism in cinema?

■ **Key Concepts:** Ontology; Realism; Plasticity of the Image; Depth of Field; Long Take

# The Ontology of the Photographic Image

. . . . . . . . . . . . . .

If the plastic arts were put under psychoanalysis, the practice of embalming the dead might turn out to be a fundamental factor in their creation. The process might reveal that at the origin of painting and sculpture there lies a mummy complex. The religion of ancient Egypt, aimed against death, saw survival as depending on the continued existence of the corporeal body. Thus, by providing a defense against the passage of time it satisfied a basic psychological need in man, for death is but the victory of time. To preserve, artificially, his bodily appearance is to snatch it from the flow of time, to stow it away neatly, so to speak, in the hold of life. It was natural, therefore, to keep up appearances in the face of the reality of death by preserving flesh and bone. The first Egyptian statue, then, was a mummy, tanned and

petrified in sodium. But pyramids and labyrinthine corridors offered no certain guarantee against ultimate pillage.

Other forms of insurance were therefore sought. So, near the sarcophagus, alongside the corn that was to feed the dead, the Egyptians placed terra cotta statuettes, as substitute mummies which might replace the bodies if these were destroyed. It is this religious use, then, that lays bare the primordial function of statuary, namely, the preservation of life by a representation of life. Another manifestation of the same kind of thing is the arrow-pierced clay bear to be found in prehistoric caves, a magic identity-substitute for the living animal, that will ensure a successful hunt. The evolution, side by side, of art and civilization has relieved the plastic arts of their magic role. Louis XIV did not have himself embalmed. He was content to survive in his portrait by Le Brun. Civilization cannot, however, entirely cast out the bogy of time. It can only sublimate our concern with it to the level of rational thinking. No one believes any longer in the ontological identity of model and image, but all are agreed that the image helps us to remember the subject and to preserve him from a second spiritual death. Today the making of images no longer shares an anthropocentric, utilitarian purpose. It is no longer a question of survival after death, but of a larger concept, the creation of an ideal world in the likeness of the real, with its own temporal destiny. "How vain a thing is painting" if underneath our fond admiration for its works we do not discern man's primitive need to have the last word in the argument with death by means of the form that endures. If the history of the plastic arts is less a matter of their aesthetic than of their psychology then it will be seen to be essentially the story of resemblance, or, if you will, of realism.

Seen in this sociological perspective photography and cinema would provide a natural explanation for the great spiritual and technical crisis that overtook modern painting around the middle of the last century. André Malraux has described the cinema as the furthermost evolution to date of plastic realism, the beginnings of which were first manifest at the Renaissance and which found its completest expression in baroque painting.

It is true that painting, the world over, has struck a varied balance between the symbolic and realism. However, in the fifteenth century Western painting began to turn from its age-old concern with spiritual realities expressed in the form proper to it, towards an effort to combine this spiritual expression with as complete an imitation as possible of the outside world.

The decisive moment undoubtedly came with the discovery of the first scientific and already, in a sense, mechanical system of reproduction, namely, perspective: the camera obscura of Da Vinci foreshadowed the camera of Niepce. The artist was now in a position to create the illusion of three-dimensional space within which things appeared to exist as our eyes in reality see them.

Thenceforth painting was torn between two ambitions: one, primarily aesthetic, namely the expression of spiritual reality wherein the symbol transcended its model; the other, purely psychological, namely the duplication of the world outside. The satisfaction of this appetite for illusion merely served to increase it till, bit by bit, it consumed the plastic arts. However, since perspective had only solved the problem of form and not of movement, realism was forced to continue the search for some way of giving dramatic expression to the moment, a kind of psychic fourth dimension that could suggest life in the tortured immobility of baroque art.[1]

The great artists, of course, have always been able to combine the two tendencies. They have allotted to each its proper place in the hierarchy of things, holding reality at their command and molding it at will into the fabric of their art. Nevertheless, the fact remains that we are faced with two essentially different phenomena and these any objective critic must view separately if he is to understand the evolution of the pictorial. The need for illusion has not ceased to trouble the heart of painting since the sixteenth century. It is a purely mental need, of itself nonaesthetic, the origins of which must be sought in the proclivity of the mind towards magic. However, it is a need the pull of which has been strong enough to have seriously upset the equilibrium of the plastic arts.

The quarrel over realism in art stems from a misunderstanding, from a confusion between the aesthetic and the psychological; between true realism, the need that is to give significant expression to the world both concretely and its essence, and the pseudorealism of a deception aimed at fooling the eye (or for that matter the mind); a pseudorealism content in other words with illusory appearances.[2] That is why medieval art never passed through this crisis; simultaneously vividly realistic and highly spiritual, it knew nothing of the drama that came to light as a consequence of technical developments. Perspective was the original sin of Western painting.

It was redeemed from sin by Niepce and Lumière. In achieving the aims of baroque art, photography has freed the plastic arts from their obsession with likeness. Painting was forced, as it turned out, to offer us illusion and this illusion was reckoned sufficient unto art. Photography and the cinema on the other hand are discoveries that satisfy, once and for all and in its very essence, our obsession with realism.

No matter how skillful the painter, his work was always in fee to an inescapable subjectivity. The fact that a human hand intervened cast a shadow of doubt over the image. Again, the essential factor in the transition from the baroque to photography is not the perfecting of a physical process (photography will long remain the inferior of painting in the reproduction of color); rather does it lie in a psychological fact, to wit, in completely satisfying our appetite for illusion by a mechanical reproduction in the making of which man plays no part. The solution is not to be found in the result achieved but in the way of achieving it.[3]

This is why the conflict between style and likeness is a relatively modern phenomenon of which there is no trace before the invention of the sensitized plate. Clearly the fascinating objectivity of Chardin is in no sense that of the photographer. The nineteenth century saw the real beginnings of the crisis of realism of which Picasso is now the mythical central figure and which put to the test at one and the same time the conditions determining the formal existence of the plastic arts and their sociological roots. Freed from the "resemblance complex," the modern painter abandons it to the masses who, henceforth, identify resemblance on the one hand with photography and on the other with the kind of painting which is related to photography.

Originality in photography as distinct from originality in painting lies in the essentially objective character of photography. [Bazin here makes a point of the fact that the lens, the basis of photography, is in French called the "objectif," a nuance that is lost in English.—Tr.] For the first time, between the originating object and its reproduction there intervenes only the instrumentality of a nonliving agent. For

the first time an image of the world is formed automatically, without the creative intervention of man. The personality of the photographer enters into the proceedings only in his selection of the object to be photographed and by way of the purpose he has in mind. Although the final result may reflect something of his personality, this does not play the same role as is played by that of the painter. All the arts are based on the presence of man, only photography derives an advantage from his absence. Photography affects us like a phenomenon in nature, like a flower or a snowflake whose vegetable or earthly origins are an inseparable part of their beauty.

This production by automatic means has radically affected our psychology of the image. The objective nature of photography confers on it a quality of credibility absent from all other picture-making. In spite of any objections our critical spirit may offer, we are forced to accept as real the existence of the object reproduced, actually *re*-presented, set before us, that is to say, in time and space. Photography enjoys a certain advantage in virtue of this transference of reality from the thing to its reproduction.[4]

A very faithful drawing may actually tell us more about the model but despite the promptings of our critical intelligence it will never have the irrational power of the photograph to bear away our faith.

Besides, painting is, after all, an inferior way of making likenesses, an *ersatz* of the processes of reproduction. Only a photographic lens can give us the kind of image of the object that is capable of satisfying the deep need man has to substitute for it something more than a mere approximation, a kind of decal or transfer. The photographic image is the object itself, the object freed from the conditions of time and space that govern it. No matter how fuzzy, distorted, or discolored, no matter how lacking in documentary value the image may be, it shares, by virtue of the very process of its becoming, the being of the model of which it is the reproduction; it *is* the model.

Hence the charm of family albums. Those grey or sepia shadows, phantomlike and almost undecipherable, are no longer traditional family portraits but rather the disturbing presence of lives halted at a set moment in their duration, freed from their destiny; not, however, by the prestige of art but by the power of an impassive mechanical process: for photography does not create eternity, as art does, it embalms time, rescuing it simply from its proper corruption.

Viewed in this perspective, the cinema is objectivity in time. The film is no longer content to preserve the object, enshrouded as it were in an instant, as the bodies of insects are preserved intact, out of the distant past, in amber. The film delivers baroque art from its convulsive catalepsy. Now, for the first time, the image of things is likewise the image of their duration, change mummified as it were. Those categories of *resemblance* which determine the species *photographic* image likewise, then, determine the character of its aesthetic as distinct from that of painting.[5]

The aesthetic qualities of photography are to be sought in its power to lay bare the realities. It is not for me to separate off, in the complex fabric of the objective world, here a reflection on a damp sidewalk, there the gesture of a child. Only the impassive lens, stripping its object of all those ways of seeing it, those piled-up preconceptions, that spiritual dust and grime with which my eyes have covered it, is able to present it in all its virginal purity to my attention and consequently to my love. By the power of photography, the natural image of a world that we neither know nor can know, nature at last does more than imitate art: she imitates the artist.

Photography can even surpass art in creative power. The aesthetic world of the painter is of a different kind from that of the world about him. Its boundaries enclose a substantially and essentially different microcosm. The photograph as such and the object in itself share a common being, after the fashion of a fingerprint. Wherefore, photography actually contributes something to the order of natural creation instead of providing a substitute for it. The surrealists had an inkling of this when they looked to the photographic plate to provide them with their monstrosities and for this reason: the surrealist does not consider his aesthetic purpose and the mechanical effect of the image on our imaginations as things apart. For him, the logical distinction between what is imaginary and what is real tends to disappear. Every image is to be seen as an object and every object as an image. Hence photography ranks high in the order of surrealist creativity because it produces an image that is a reality of nature, namely, an hallucination that is also a fact. The fact that surrealist painting combines tricks of visual deception with meticulous attention to detail substantiates this.

So, photography is clearly the most important event in the history of plastic arts. Simultaneously a liberation and a fulfillment, it has freed Western painting, once and for all, from its obsession with realism and allowed it to recover its aesthetic autonomy. Impressionist realism, offering science as an alibi, is at the opposite extreme from eye-deceiving trickery. Only when form ceases to have any imitative value can it be swallowed up in color. So, when form, in the person of Cézanne, once more regains possession of the canvas there is no longer any question of the illusions of the geometry of perspective. The painting, being confronted in the mechanically produced image with a competitor able to reach out beyond baroque resemblance to the very identity of the model, was compelled into the category of object. Henceforth Pascal's condemnation of painting is itself rendered vain since the photograph allows us on the one hand to admire in reproduction something that our eyes alone could not have taught us to love, and on the other, to admire the painting as a thing in itself whose relation to something in nature has ceased to be the justification for its existence.

On the other hand, of course, cinema is also a language.

# The Evolution of the Language of Cinema

. . . . . . . . . . . . . .

By 1928 the silent film had reached its artistic peak. The despair of its elite as they witnessed the dismantling of this ideal city, while it may not have been justified, is at least understandable. As they followed their chosen aesthetic path it seemed to them that the cinema had developed into an art most perfectly accommodated to the "exquisite embarrassment" of silence and that the realism that sound would bring could only mean a surrender to chaos.

In point of fact, now that sound has given proof that it came not to destroy but to fulfill the Old Testament of the cinema, we may most properly ask if the technical revolution created by the sound track was in any sense an aesthetic revolution. In other words, did the years from 1928 to 1930 actually witness the birth of a new cinema? Certainly, as regards editing, history does not actually show as wide a breach as might

be expected between the silent and the sound film. On the contrary there is discernible evidence of a close relationship between certain directors of 1925 and 1935 and especially of the I940's through the 1950's. Compare for example Erich von Stroheim and Jean Renoir or Orson Welles, or again Carl Theodore Dreyer and Robert Bresson. These more or less clear-cut affinities demonstrate first of all that the gap separating the 1920's and the 1930's can be bridged, and secondly that certain cinematic values actually carry over from the silent to the sound film and, above all, that it is less a matter of setting silence over against sound than of contrasting certain families of styles, certain basically different concepts of cinematographic expression.

Aware as I am that the limitations imposed on this study restrict me to a simplified and to that extent enfeebled presentation of my argument, and holding it to be less an objective statement than a working hypothesis, I will distinguish, in the cinema between 1920 and 1940, between two broad and opposing trends: those directors who put their faith in the image and those who put their faith in reality. By "image" I here mean, very broadly speaking, everything that the representation on the screen adds to the object there represented. This is a complex inheritance but it can be reduced essentially to two categories: those that relate to the plastics of the image and those that relate to the resources of montage, which, after all, is simply the ordering of images in time.

Under the heading "plastics" must be included the style of the sets, of the make-up, and, up to a point, even of the performance, to which we naturally add the lighting and, finally, the framing of the shot which gives us its composition. As regards montage, derived initially as we all know from the masterpieces of Griffith, we have the statement of Malraux in his *Psychologie du cinéma* that it was montage that gave birth to film as an art, setting it apart from mere animated photography, in short, creating a language.

The use of montage can be "invisible" and this was generally the case in the pre-war classics of the American screen. Scenes were broken down just for one purpose, namely, to analyze an episode according to the material or dramatic logic of the scene. It is this logic which conceals the fact of the analysis, the mind of the spectator quite naturally accepting the viewpoints of the director which are justified by the geography of the action or the shifting emphasis of dramatic interest.

But the neutral quality of this "invisible" editing fails to make use of the full potential of montage. On the other hand these potentialities are clearly evident from the three processes generally known as parallel montage, accelerated montage, montage by attraction. In creating parallel montage, Griffith succeeded in conveying a sense of the simultaneity of two actions taking place at a geographical distance by means of alternating shots from each. In *La Roue* Abel Gance created the illusion of the steadily increasing speed of a locomotive without actually using any images of speed (indeed the wheel could have been turning on one spot) simply by a multiplicity of shots of ever-decreasing length.

Finally there is "montage by attraction," the creation of S. M. Eisenstein, and not so easily described as the others, but which may be roughly defined as the reenforcing of the meaning of one image by association with another image not necessarily part of the same episode—for example the fireworks display in *The General Line* following the image of the bull. In this extreme form, montage by attraction was rarely used even by its creator but one may consider as very near to it in principle the

more commonly used ellipsis, comparison, or metaphor, examples of which are the throwing of stockings onto a chair at the foot of a bed, or the milk overflowing in H. G. Clouzot's *Quai des orfèvres*. There are of course a variety of possible combinations of these three processes.

Whatever these may be, one can say that they share that trait in common which constitutes the very definition of montage, namely, the creation of a sense or meaning not objectively contained in the images themselves but derived exclusively from their juxtaposition. The well-known experiment of Kuleshov with the shot of Mozhukhin in which a smile was seen to change its significance according to the image that preceded it, sums up perfectly the properties of montage.

Montage as used by Kuleshov, Eisenstein, or Gance did not show us the event; it alluded to it. Undoubtedly they derived at least the greater part of the constituent elements from the reality they were describing but the final significance of the film was found to reside in the ordering of these elements much more than in their objective content. The substance of the narrative, whatever the realism of the individual image, is born essentially from these relationships—Mozhukhin plus dead child equal pity—that is to say an abstract result, none of the concrete elements of which are to be found in the premises; maidens plus appletrees in bloom equal hope. The combinations are infinite. But the only thing they have in common is the fact that they suggest an idea by means of a metaphor or by an association of ideas. Thus between the scenario properly so-called, the ultimate object of the recital, and the image pure and simple, there is a relay station, a sort of aesthetic "transformer." The meaning is not in the image, it is in the shadow of the image projected by montage onto the field of consciousness of the spectator.

Let us sum up. Through the contents of the image and the resources of montage, the cinema has at its disposal a whole arsenal of means whereby to impose its interpretation of an event on the spectator. By the end of the silent film we can consider this arsenal to have been full. On the one side the Soviet cinema carried to its ultimate consequences the theory and practice of montage while the German school did every kind of violence to the plastics of the image by way of sets and lighting. Other cinemas count too besides the Russian and German, but whether in France or Sweden or the United States, it does not appear that the language of cinema was at a loss for ways of saying what it wanted to say.

If the art of cinema consists in everything that plastics and montage can add to a given reality, the silent film was an art on its own. Sound could only play at best a subordinate and supplementary role: a counterpoint to the visual image. But this possible enhancement—at best only a minor one—is likely not to weigh much in comparison with the additional bargain-rate reality introduced at the same time by sound.

Thus far we have put forward the view that expressionism of montage and image constitute the essence of cinema. And it is precisely on this generally accepted notion that directors from silent days, such as Erich von Stroheim, F. W. Murnau, and Robert Flaherty, have by implication cast a doubt. In their films, montage plays no part, unless it be the negative one of inevitable elimination where reality superabounds. The camera cannot see everything at once but it makes sure not to lose any part of what it chooses to see. What matters to Flaherty, confronted with Nanook hunting the seal, is the relation between Nanook and the animal; the actual length of the waiting period. Montage could suggest the time involved. Flaherty however confines himself to

showing the actual waiting period; the length of the hunt is the very substance of the image, its true object. Thus in the film this episode requires one setup. Will anyone deny that it is thereby much more moving than a montage by attraction?

Murnau is interested not so much in time as in the reality of dramatic space. Montage plays no more of a decisive part in *Nosferatu* than in *Sunrise*. One might be inclined to think that the plastics of his image are expressionistic. But this would be a superficial view. The composition of his image is in no sense pictorial. It adds nothing to the reality, it does not deform it, it forces it to reveal its structural depth, to bring out the preexisting relations which become constitutive of the drama. For example, in *Tabu*, the arrival of a ship from left screen gives an immediate sense of destiny at work so that Murnau has no need to cheat in any way on the uncompromising realism of a film whose settings are completely natural.

But it is most of all Stroheim who rejects photographic expressionism and the tricks of montage. In his films reality lays itself bare like a suspect confessing under the relentless examination of the commissioner of police. He has one simple rule for direction. Take a close look at the world, keep on doing so, and in the end it will lay bare for you all its cruelty and its ugliness. One could easily imagine as a matter of fact a film by Stroheim composed of a single shot as long-lasting and as close-up as you like. These three directors do not exhaust the possibilities. We would undoubtedly find scattered among the works of others elements of nonexpressionistic cinema in which montage plays no part—even including Griffith.

But these examples suffice to reveal, at the very heart of the silent film, a cinematographic art the very opposite of that which has been identified as *"cinéma par excellence,"* a language the semantic and syntactical unit of which is in no sense the Shot; in which the image is evaluated not according to what it adds to reality but what it reveals of it. In the latter art the silence of the screen was a drawback, that is to say, it deprived reality of one of its elements. *Greed*, like Dreyer's *Jeanne d'Arc*, is already virtually a talking film. The moment that you cease to maintain that montage and the plastic composition of the image are the very essence of the language of cinema, sound is no longer the aesthetic crevasse dividing two radically different aspects of the seventh art. The cinema that is believed to have died of the soundtrack is in no sense *"the* cinema." The real dividing line is elsewhere. It was operative in the past and continues to be through thirty-five years of the history of the language of the film.

Having challenged the aesthetic unity of the silent film and divided it off into two opposing tendencies, now let us take a look at the history of the last twenty years.

From 1930 to 1940 there seems to have grown up in the world, originating largely in the United States, a common form of cinematic language. It was the triumph in Hollywood, during that time, of five or six major kinds of film that gave it its overwhelming superiority: (1) American comedy (*Mr. Smith Goes to Washington*, 1936); (2) The burlesque film (The Marx Brothers); (3) The dance and vaudeville film (Fred Astaire and Ginger Rogers and the Ziegfield Follies); (4) The crime and gangster film (*Scarface, I Am a Fugitive from a Chain Gang, The Informer*); (5) Psychological and social dramas (*Back Street, Jezebel*); (6) Horror or fantasy films (*Dr. Jekyll and Mr. Hyde, The Invisible Man, Frankenstein*); (7) The western (*Stagecoach*, 1939). During

that time the French cinema undoubtedly ranked next. Its superiority was gradually manifested by way of a trend towards what might be roughly called stark somber realism, or poetic realism, in which four names stand out: Jacques Feyder, Jean Renoir, Marcel Carné, and Julien Duvivier. My intention not being to draw up a list of prizewinners, there is little use in dwelling on the Soviet, British, German, or Italian films for which these years were less significant than the ten that were to follow. In any case, American and French production sufficiently clearly indicate that the sound film, prior to World War II, had reached a well-balanced stage of maturity.

First as to content. Major varieties with clearly defined rules capable of pleasing a worldwide public, as well as a cultured elite, provided it was not inherently hostile to the cinema.

Secondly as to form: well-defined styles of photography and editing perfectly adapted to their subject matter; a complete harmony of image and sound. In seeing again today such films as *Jezebel* by William Wyler, *Stagecoach* by John Ford, or *Le Jour se lève* by Marcel Carné, one has the feeling that in them an art has found its perfect balance, its ideal form of expression, and reciprocally one admires them for dramatic and moral themes to which the cinema, while it may not have created them, has given a grandeur, an artistic effectiveness, that they would not otherwise have had. In short, here are all the characteristics of the ripeness of a classical art.

I am quite aware that one can justifiably argue that the originality of the postwar cinema as compared with that of 1938 derives from the growth of certain national schools, in particular the dazzling display of the Italian cinema and of a native English cinema freed from the influence of Hollywood. From this one might conclude that the really important phenomenon of the years 1940–1950 is the introduction of new blood, of hitherto unexplored themes. That is to say, the real revolution took place more on the level of subject matter than of style. Is not neorealism primarily a kind of humanism and only secondarily a style of film-making? Then as to the style itself, is it not essentially a form of self-effacement before reality?

Our intention is certainly not to preach the glory of form over content. Art for art's sake is just as heretical in cinema as elsewhere, probably more so. On the other hand, a new subject matter demands new form, and as good a way as any towards understanding what a film is trying to say to us is to know how it is saying it.

Thus by 1938 or 1939 the talking film, particularly in France and in the United States, had reached a level of classical perfection as a result, on the one hand, of the maturing of different kinds of drama developed in part over the past ten years and in part inherited from the silent film, and, on the other, of the stabilization of technical progress. The 1930's were the years, at once, of sound and of panchromatic film. Undoubtedly studio equipment had continued to improve but only in matters of detail, none of them opening up new, radical possibilities for direction. The only changes in this situation since 1940 have been in photography, thanks to the increased sensitivity of the film stock. Panchromatic stock turned visual values upside down, ultrasensitive emulsions have made a modification in their structure possible. Free to shoot in the studio with a much smaller aperture, the operator could, when necessary, eliminate the soft-focus background once considered essential. Still there are a number of examples of the prior use of deep focus, for example in the work of Jean Renoir. This had always been possible on exteriors, and given a measure of skill, even in the studios. Anyone could do it who really wanted

to. So that it is less a question basically of a technical problem, the solution of which has admittedly been made easier, than of a search after a style—a point to which we will come back. In short, with panchromatic stock in common use, with an understanding of the potentials of the microphone, and with the crane as standard studio equipment, one can really say that since 1930 all the technical requirements for the art of cinema have been available.

Since the determining technical factors were practically eliminated, we must look elsewhere for the signs and principles of the evolution of film language, that is to say by challenging the subject matter and as a consequence the styles necessary for its expression.

By 1939 the cinema had arrived at what geographers call the equilibrium-profile of a river. By this is meant that ideal mathematical curve which results from the requisite amount of erosion. Having reached this equilibrium-profile, the river flows effortlessly from its source to its mouth without further deepening of its bed. But if any geological movement occurs which raises the erosion level and modifies the height of the source, the water sets to work again, seeps into the surrounding land, goes deeper, burrowing and digging. Sometimes when it is a chalk bed, a new pattern is dug across the plain, almost invisible but found to be complex and winding, if one follows the flow of the water.

## *The Evolution of Editing since the Advent of Sound*

In 1938 there was an almost universal standard pattern of editing. If, somewhat conventionally, we call the kind of silent films based on the plastics of the image and the artifices of montage, "expressionist" or "symbolistic," we can describe the new form of storytelling "analytic" and "dramatic." Let us suppose, by way of reviewing one of the elements of the experiment of Kuleshov, that we have a table covered with food and a hungry tramp. One can imagine that in 1936 it would have been edited as follows:

1. Full shot of the actor and the table.

2. Camera moves forward into a close-up of a face expressing a mixture of amazement and longing.

3. Series of close-ups of food.

4. Back to full shot of person who starts slowly towards the camera.

5. Camera pulls slowly back to a three-quarter shot of the actor seizing a chicken wing.

Whatever variants one could think of for this scene, they would all have certain points in common:

1. The verisimilitude of space in which the position of the actor is always determined, even when a close-up eliminates the decor.

2. The purpose and the effects of the cutting are exclusively dramatic or psychological.

In other words, if the scene were played on a stage and seen from a seat in the orchestra, it would have the same meaning, the episode would continue to exist

objectively. The changes of point of view provided by the camera would add nothing. They would present the reality a little more forcefully, first by allowing a better view and then by putting the emphasis where it belongs.

It is true that the stage director like the film director has at his disposal a margin within which he is free to vary the interpretation of the action but it is only a margin and allows for no modification of the inner logic of the event. Now, by way of contrast, let us take the montage of the stone lions in *The End of St. Petersburg*. By skillful juxtaposition a group of sculptured lions are made to look like a single lion getting to its feet, a symbol of the aroused masses. This clever device would be unthinkable in any film after 1932. As late as 1935 Fritz Lang, in *Fury*, followed a series of shots of women scandalmongering with shots of clucking chickens in a farmyard. This relic of associative montage came as a shock even at the time, and today seems entirely out of keeping with the rest of the film. However decisive the art of Marcel Carné, for example, in our estimate of the respective values of *Quai des Brumes* or of *Le Jour se lève* his editing remains on the level of the reality he is analyzing. There is only one proper way of looking at it. That is why we are witnessing the almost complete disappearance of optical effects such as superimpositions, and even, especially in the United States, of the close-up, the too violent impact of which would make the audience conscious of the cutting. In the typical American comedy the director returns as often as he can to a shot of the characters from the knees up, which is said to be best suited to catch the spontaneous attention of the viewer—the natural point of balance of his mental adjustment.

Actually this use of montage originated with the silent movies. This is more or less the part it plays in Griffith's films, for example in *Broken Blossoms*, because with *Intolerance* he had already introduced that synthetic concept of montage which the Soviet cinema was to carry to its ultimate conclusion and which is to be found again, although less exclusively, at the end of the silent era. It is understandable, as a matter of fact, that the sound image, far less flexible than the visual image, would carry montage in the direction of realism, increasingly eliminating both plastic expressionism and the symbolic relation between images.

Thus around 1938 films were edited, almost without exception, according to the same principle. The story was unfolded in a series of set-ups numbering as a rule about 600. The characteristic procedure was by shot-reverse-shot, that is to say, in a dialogue scene, the camera followed the order of the text, alternating the character shown with each speech.

It was this fashion of editing, so admirably suitable for the best films made between 1930 and 1939, that was challenged by the shot in depth introduced by Orson Welles and William Wyler. The influence of *Citizen Kane* cannot be overestimated. Thanks to the depth of field, whole scenes are covered in one take, the camera remaining motionless. Dramatic effects for which we had formerly relied on montage were created out of the movements of the actors within a fixed framework. Of course Welles did not invent the in-depth shot any more than Griffith invented the close-up. All the pioneers used it and for a very good reason. Soft focus only appeared with montage. It was not only a technical must consequent upon the use of images in juxtaposition, it was a logical consequence of montage, its plastic equivalent. If at a given moment in the action the director, as in the scene imagined above, goes to a

close-up of a bowl of fruit, it follows naturally that he also isolates it in space through the focusing of the lens. The soft focus of the background confirms therefore the effect of montage, that is to say, while it is of the essence of the storytelling, it is only an accessory of the style of the photography. Jean Renoir had already clearly understood this, as we see from a statement of his made in 1938 just after he had made *La Bête humaine* and *La Grande illusion* and just prior to *La Règle du jeu*: "The more I learn about my trade the more I incline to direction in depth relative to the screen. The better it works, the less I use the kind of set-up that shows two actors facing the camera, like two well-behaved subjects posing for a still portrait." The truth of the matter is, that if you are looking for the precursor of Orson Welles, it is not Louis Lumière or Zecca, but rather Jean Renoir. In his films, the search after composition in depth is, in effect, a partial replacement of montage by frequent panning shots and entrances. It is based on a respect for the continuity of dramatic space and, of course, of its duration.

To anybody with eyes in his head, it is quite evident that the one-shot sequences used by Welles in *The Magnificent Ambersons* are in no sense the purely passive recording of an action shot within the same framing. On the contrary, his refusal to break up the action, to analyze the dramatic field in time, is a positive action the results of which are far superior to anything that could be achieved by the classical "cut."

All you need to do is compare two frames shot in depth, one from 1910, the other from a film by Wyler or Welles, to understand just by looking at the image, even apart from the context of the film, how different their functions are. The framing in the 1910 film is intended, to all intents and purposes, as a substitute for the missing fourth wall of the theatrical stage, or at least in exterior shots, for the best vantage point to view the action, whereas in the second case the setting, the lighting, and the camera angles give an entirely different reading. Between them, director and cameraman have converted the screen into a dramatic checkerboard, planned down to the last detail. The clearest if not the most original examples of this are to be found in *The Little Foxes* where the *mise-en-scène* takes on the severity of a working drawing. (Welles' pictures are more difficult to analyze because of his baroque excesses.) Objects and characters are related in such a fashion that it is impossible for the spectator to miss the significance of the scene. To get the same results by way of montage would have necessitated a detailed succession of shots.

What we are saying then is that the sequence of shots "in depth" of the contemporary director does not exclude the use of montage—how could he, without reverting to a primitive babbling?—he makes it an integral part of his "plastic." The storytelling of Welles or Wyler is no less explicit than John Ford's but theirs has the advantage over his that it does not sacrifice the specific effects that can be derived from unity of image in space and time. Whether an episode is analyzed bit by bit or presented in its physical entirety cannot surely remain a matter of indifference, at least in a work with some pretensions to style. It would obviously be absurd to deny that montage has added considerably to the progress of film language, but this has happened at the cost of other values, no less definitely cinematic.

This is why depth of field is not just a stock in trade of the cameraman like the use of a series of filters or of such-and-such a style of lighting, it is a capital gain in the field of direction—a dialectical step forward in the history of film language.

Nor is it just a formal step forward. Well used, shooting in depth is not just a more economical, a simpler, and at the same time a more subtle way of getting the most out of a scene. In addition to affecting the structure of film language, it also affects the relationships of the minds of the spectators to the image, and in consequence it influences the interpretation of the spectacle.

It would lie outside the scope of this article to analyze the psychological modalities of these relations, as also their aesthetic consequences, but it might be enough here to note, in general terms:

1. That depth of focus brings the spectator into a relation with the image closer to that which he enjoys with reality. Therefore it is correct to say that, independently of the contents of the image, its structure is more realistic;

2. That it implies, consequently, both a more active mental attitude on the part of the spectator and a more positive contribution on his part to the action in progress. While analytical montage only calls for him to follow his guide, to let his attention follow along smoothly with that of the director who will choose what he should see, here he is called upon to exercise at least a minimum of personal choice. It is from his attention and his will that the meaning of the image in part derives.

3. From the two preceding propositions, which belong to the realm of psychology, there follows a third which may be described as metaphysical. In analyzing reality, montage presupposes of its very nature the unity of meaning of the dramatic event. Some other form of analysis is undoubtedly possible but then it would be another film. In short, montage by its very nature rules out ambiguity of expression. Kuleshov's experiment proves this *per absurdum* in giving on each occasion a precise meaning to the expression on a face, the ambiguity of which alone makes the three successively exclusive expressions possible.

On the other hand, depth of focus reintroduced ambiguity into the structure of the image if not of necessity—Wyler's films are never ambiguous—at least as a possibility. Hence it is no exaggeration to say that *Citizen Kane* is unthinkable shot in any other way but in depth. The uncertainty in which we find ourselves as to the spiritual key or the interpretation we should put on the film is built into the very design of the image.

It is not that Welles denies himself any recourse whatsoever to the expressionistic procedures of montage, but just that their use from time to time in between one-shot sequences in depth gives them a new meaning. Formerly montage was the very stuff of cinema, the texture of the scenario. In *Citizen Kane* a series of superimpositions is contrasted with a scene presented in a single take, constituting another and deliberately abstract mode of storytelling. Accelerated montage played tricks with time and space while that of Welles, on the other hand, is not trying to deceive us; it offers us a contrast, condensing time, and hence is the equivalent for example of the French imperfect or the English frequentative tense. Like accelerated montage and montage of attractions these superimpositions, which the talking film had not used for ten years, rediscovered a possible use related to temporal realism in a film without montage.

If we have dwelt at some length on Orson Welles it is because the date of his appearance in the filmic firmament (1941) marks more or less the beginning of a new

period and also because his case is the most spectacular and, by virtue of his very excesses, the most significant.

Yet *Citizen Kane* is part of a general movement, of a vast stirring of the geological bed of cinema, confirming that everywhere up to a point there had been a revolution in the language of the screen.

I could show the same to be true, although by different methods, of the Italian cinema. In Roberto Rossellini's *Paisà* and *Allemania Anno Zero* and Vittorio de Sica's *Ladri de Biciclette*, Italian neorealism contrasts with previous forms of film realism in its stripping away of all expressionism and in particular in the total absence of the effects of montage. As in the films of Welles and in spite of conflicts of style, neorealism tends to give back to the cinema a sense of the ambiguity of reality. The preoccupation of Rossellini when dealing with the face of the child in *Allemania Anno Zero* is the exact opposite of that of Kuleshov with the close-up of Mozhukhin. Rossellini is concerned to preserve its mystery. We should not be misled by the fact that the evolution of neorealism is not manifest, as in the United States, in any form of revolution in editing. They are both aiming at the same results by different methods. The means used by Rossellini and de Sica are less spectacular but they are no less determined to do away with montage and to transfer to the screen the *continuum* of reality. The dream of Zavattini is just to make a ninety-minute film of the life of a man to whom nothing ever happens. The most "aesthetic" of the neorealists, Luchino Visconti, gives just as clear a picture as Welles of the basic aim of his directorial art in *La Terra Trema*, a film almost entirely composed of one-shot sequences, thus clearly showing his concern to cover the entire action in interminable deep-focus panning shots.

However we cannot pass in review all the films that have shared in this revolution in film language since 1940. Now is the moment to attempt a synthesis of our reflections on the subject.

It seems to us that the decade from 1940 to 1950 marks a decisive step forward in the development of the language of the film. If we have appeared since 1930 to have lost sight of the trend of the silent film as illustrated particularly by Stroheim, F. W. Murnau, Robert Flaherty, and Dreyer, it is for a purpose. It is not that this trend seems to us to have been halted by the talking film. On the contrary, we believe that it represented the richest vein of the so-called silent film and, precisely because it was not aesthetically tied to montage, but was indeed the only tendency that looked to the realism of sound as a natural development. On the other hand it is a fact that the talking film between 1930 and 1940 owes it virtually nothing save for the glorious and retrospectively prophetic exception of Jean Renoir. He alone in his searchings as a director prior to *La Règle du jeu* forced himself to look back beyond the resources provided by montage and so uncovered the secret of a film form that would permit everything to be said without chopping the world up into little fragments, that would reveal the hidden meanings in people and things without disturbing the unity natural to them.

It is not a question of thereby belittling the films of 1930 to 1940, a criticism that would not stand up in the face of the number of masterpieces, it is simply an attempt to establish the notion of a dialectic progress, the highest expression of which was found in the films of the 1940's. Undoubtedly, the talkie sounded the knell of a certain aesthetic of the language of film, but only wherever it had turned its back on

its vocation in the service of realism. The sound film nevertheless did preserve the essentials of montage, namely discontinuous description and the dramatic analysis of action. What it turned its back on was metaphor and symbol in exchange for the illusion of objective presentation. The expressionism of montage has virtually disappeared but the relative realism of the kind of cutting that flourished around 1937 implied a congenital limitation which escaped us so long as it was perfectly suited to its subject matter. Thus American comedy reached its peak within the framework of a form of editing in which the realism of the time played no part. Dependent on logic for its effects, like vaudeville and plays on words, entirely conventional in its moral and sociological content, American comedy had everything to gain, in strict line-by-line progression, from the rhythmic resources of classical editing.

Undoubtedly it is primarily with the Stroheim-Murnau trend—almost totally eclipsed from 1930 to 1940—that the cinema has more or less consciously linked up once more over the last ten years. But it has no intention of limiting itself simply to keeping this trend alive. It draws from it the secret of the regeneration of realism in storytelling and thus of becoming capable once more of bringing together real time, in which things exist, along with the duration of the action, for which classical editing had insidiously substituted mental and abstract time. On the other hand, so far from wiping out once and for all the conquests of montage, this reborn realism gives them a body of reference and a meaning. It is only an increased realism of the image that can support the abstraction of montage. The stylistic repertory of a director such as Hitchcock, for example, ranged from the power inherent in the basic document as such, to superimpositions, to large close-ups. But the close-ups of Hitchcock are not the same as those of C. B. de Mille in *The Cheat* [1915]. They are just one type of figure, among others, of his style. In other words, in the silent days, montage evoked what the director wanted to say; in the editing of 1938, it described it. Today we can say that at last the director writes in film. The image—its plastic composition and the way it is set in time, because it is founded on a much higher degree of realism—has at its disposal more means of manipulating reality and of modifying it from within. The film-maker is no longer the competitor of the painter and the playwright, he is, at last, the equal of the novelist.

## NOTES

### The Ontology of the Photographic Image

1. It would be interesting from this point of view to study, in the illustrated magazines of 1890–1910, the rivalry between photographic reporting and the use of drawings. The latter, in particular, satisfied the baroque need for the dramatic. A feeling for the photographic document developed only gradually.

2. Perhaps the Communists, before they attach too much importance to expressionist realism, should stop talking about it in a way more suitable to the eighteenth century, before there were such things as photography or cinema. Maybe it does not really matter if Russian painting is second-rate provided Russia gives us first-rate cinema. Eisenstein is her Tintoretto.

3. There is room, nevertheless, for a study of the psychology of the lesser plastic arts, the molding of death masks for example, which likewise involves a certain automatic process. One might consider photography in this sense as a molding, the taking of an impression, by the manipulation of light.

4. Here one should really examine the psychology of relics and souvenirs which likewise enjoy the advantages of a transfer of reality stemming from the "mummy-complex." Let us merely note in passing that the Holy Shroud of Turin combines the features alike of relic and photograph.

5. I use the term *category* here in the sense attached to it by M. Gouhier in his book on the theater in which he distinguishes between the dramatic and the aestheic categories. Just as dramatic tension has no artistic value, the perfection of a reproduction is not to be identified with beauty. It constitutes rather the prime matter, so to speak, on which the artistic fact is recorded.

# MIRIAM HANSEN

# The Mass Production of the Senses: Classical Cinema as Vernacular Modernism

Miriam Hansen (1949–2011), Ferdinand Schevill Distinguished Service Professor in the Humanities at the University of Chicago, has achieved prominence in contemporary film studies for her work on theories of modernity and mass culture and their relation to American film history. Hansen's work rethinks classical film theory as well as the "classical" cinema of studio-era Hollywood. Hansen interprets the work of Theodor W. Adorno and Walter Benjamin in a number of extremely influential articles and reevaluates the career of their contemporary, Siegfried Kracauer, in her introduction to a definitive English edition of his *Theory of Film*. She is best known for her award-winning study, *Babel and Babylon: Spectatorship in American Silent Film* (1991). In it, she defines cinema's role in shaping changing historical experience, particularly for immigrants and women, for whom it represented a new and potentially liberating access to modernizing, public culture.

In "The Mass Production of the Senses" (1999), Hansen questions whether classical cinema is as stable and homogenous as the field of cinema studies has thus far constructed it to be. She urges us to think of classical Hollywood cinema as a type of "vernacular modernism," a term that she introduces to define cinema as a mass cultural form with which audiences all over the world became "fluent," in contrast with the mostly European high modernism that emerged in the same period (for example, Cubism, the writings of James Joyce and Virginia Woolf, atonal music). She argues that the social and sensorial changes brought about by modernity are reflected both in recognized forms of artistic modernism and in the vernacular modernism of the movies. She asserts that what we've come to call "classical" cinema really has as much to do with the bodily experiences of modern life, such as disorientation, shock, and laughter, as it does with "classical" principles of order and balance. Cinematic mainstays from slapstick to special effects speak to these thrills, connecting the beginning of cinema, with its raucous audiences and presentational style, to the postmodern period dominated by special effects and action films inspired by amusement park rides. Hansen's theory challenges the most influential conceptualizations of classical Hollywood style in film studies. Her notion of vernacular

modernism has also been extended to include the silent and early sound-era cinemas of Shanghai, Japan, and India, helping to rethink cinema's role in globalization.

## READING CUES & KEY CONCEPTS

▣ Hansen compares Hollywood and Soviet cinema in her essay. What are some of the implications of considering both in terms of modernist aesthetics?

▣ Draw out the aesthetic judgments and historical frameworks that underlie the accounts of "classical cinema" that Hansen enumerates in her essay.

▣ What does "reflexiveness" mean in this essay?

▣ According to what you read in Hansen's essay, how does the idea of vernacular modernism contribute to a different understanding of the dominance of Hollywood cinema worldwide?

▣ **Key Concepts:** Modernism; Postmodernism; Modernity; Cognitive Psychology; Discourse; Diegesis; Continuity; Reflexiveness; Hegemony; Americanism; Public Sphere

# The Mass Production of the Senses: Classical Cinema as Vernacular Modernism

. . . . . . . . . . . . . .

In this chapter, I wish to reassess the juncture of cinema and modernism, and I will do so by moving from the example of early Soviet cinema to a seemingly less likely case, that of the classical Hollywood film. My inquiry is inspired by two complementary sets of questions: one pertaining to what cinema studies can contribute to our understanding of modernism and modernity; the other aimed at whether and how the perspective of modernist aesthetics may help us elucidate and reframe the history and theory of cinema. The juncture of cinema and modernism has been explored in a number of ways, ranging from research on early cinema's interrelations with the industrial–technological modernity of the late nineteenth century, through an emphasis on the international art cinemas of the interwar and new wave periods, to speculations on the cinema's implication in the distinction between the modern and the postmodern. My focus here will be more squarely on mid-twentieth-century modernity, roughly from the 1920s through the 1950s—the modernity of mass production, mass consumption, and mass annihilation—and the contemporaneity of a particular kind of cinema, mainstream Hollywood, with what has variously been labelled "high" or "hegemonic modernism."

Whether or not one agrees with the postmodernist challenge to modernism and modernity at large, it did open up a space for understanding modernism as a much wider, more diverse phenomenon, eluding any single-logic genealogy that runs, say, from Cubism to Abstract Expressionism, from Eliot, Pound, Joyce, and Kafka to Beckett and Robbe-Grillet, from Schönberg to Stockhausen. For more than a decade now scholars have been dislodging that genealogy and delineating alternative forms

of modernism both in the West and in other parts of the world—modernisms that vary according to their social and geopolitical locations, often configured along the axis of post/coloniality, and according to the specific subcultural and indigenous traditions to which they responded. In addition to opening up the modernist canon, these studies assume a notion of modernism that is "more than a repertory of artistic styles," more than sets of ideas pursued by groups of artists and intellectuals.[1] Rather, modernism encompasses a whole range of cultural and artistic practices that register, respond to, and reflect upon processes of modernization and the experience of modernity, including a paradigmatic transformation of the conditions under which art is produced, transmitted, and consumed. In other words, just as modernist aesthetics are not reducible to the category of style, they tend to blur the boundaries of the institution of art in its traditional, eighteenth-century and nineteenth-century incarnations that turn on the ideal of aesthetic autonomy and the distinction of "high" versus "low," of autonomous art versus popular and mass culture.[2]

Focusing on the nexus between modernism and modernity, then, also implies a wider notion of the aesthetic, one that situates artistic practices within a larger history and economy of sensory perception which Walter Benjamin for one saw as the decisive battleground for the meaning and fate of modernity.[3] While the spread of urban–industrial technology, the large-scale disembedding of social (and gender) relations, and the shift to mass consumption entailed processes of real destruction and loss, there also emerged new modes of organizing vision and sensory perception, a new relationship with "things," different forms of mimetic experience and expression, of affectivity, temporality, and reflexivity, a changing fabric of everyday life, sociability, and leisure. From this perspective, I take the study of modernist aesthetics to encompass cultural practices that both articulated and mediated the experience of modernity, such as the mass-produced and mass-consumed phenomena of fashion, design, advertising, architecture, and urban environment, of photography, radio, and cinema. I am referring to this kind of modernism as "vernacular" (and avoiding the ideologically overdetermined term "popular") because the term vernacular combines the dimension of the quotidian, of everyday usage, with connotations of discourse, idiom, and dialect, with circulation, promiscuity, and translatability. It is in the sense of the latter, finally, that this chapter will also address the vexed issue of Americanism, the question as to why and how an aesthetic idiom developed in one country could achieve transnational and global currency, and how this account might add to and modify our understanding of classical cinema.

I begin with an example that takes us back to one standard paradigm of twentieth-century modernism: Soviet cinema and the context of Soviet avant-garde aesthetics. At the 1996 festival of silent film in Pordenone, the featured program was a selection of early Soviet films, made in the period 1918–24, that is, before the great era of montage cinema, before the canonical works of Eisenstein, Pudovkin, Vertov, Dovzhenko. The question that guided the viewing of these films was, of course, how Russian cinema got from the Old to the New within a rather short span of time; how the sophisticated *mise en scène* cinema of the Czarist era, epitomized by the work of Yevgenij Bauer, was displaced by Soviet montage aesthetics. Many of the films shown confirmed what film historians, following Kuleshov, had vaguely assumed before: that this transformation was mediated, to a significant degree, by the impact

of Hollywood. American films began to dominate Russian screens as early as 1915 and by 1916 had become the main foreign import. Films made during the years following 1917, even as they staged revolutionary plots for "agit" purposes, may display interesting thematic continuities with Czarist cinema (in particular, a strong critique of patriarchy) and still contain amazing compositions in depth. Increasingly, however, the *mise en scène* is broken down according to classical American principles of continuity editing, spatio-temporal coherence, and narrative causality. A famous case in point is Kuleshov's 1918 directorial debut, *Engineer Prite's Project*, a film that employed Hollywood-style continuity guidelines in a polemical break with the slow pace of Russian "quality pictures."[4] But the "American accent" in Soviet film—faster cutting rate, closer framing, and breakdown of diegetic space—was more pervasive and can be found as well, in varying degrees of consistency, in the work of other directors (Vladimir Gardin, Ceslav Sabinskij, Ivan Perestiani). Hyperbolically speaking, one might say that Russian cinema became Soviet cinema by going through a process of Americanization.

To be sure, Soviet montage aesthetics did not emerge full-blown from the encounter with Hollywood-style continuity editing; it is unthinkable without the new avant-garde movements in art and theater, without Constructivism, Suprematism, Productivism, Futurism—unthinkable without a politics of radical transformation. Nor was continuity editing perceived as neutral, as simply the most "efficient" way of telling a story. It was part and parcel of the complex of "Americanism" (or, as Kuleshov referred to it, "Americanitis") which catalysed debates on modernity and modernist movements in Russia as it did in other countries. As elsewhere, the enthusiasm for things American, tempered by a critique of capitalism, took on a variety of meanings, forms, and functions. Discussing the impact of American on Soviet cinema, Yuri Tsivian distinguishes between two kinds of Americanism: stylistic borrowings of the classical kind described above ("American montage," "American foreground"); and a fascination with the "lower genres," with adventure serials, detective thrillers, and slapstick comedies which, Tsivian argues, were actually more influential during the transitional years. If the former kind of Americanism aspired to formal standards of narrative efficiency, coherence, and motivation, the latter was concerned with external appearance, the sensual, material surface of American films: their use of exterior locations, focus on action and thrills, physical stunts and attractions; their tempo, directness, and flatness; their eccentricity and excess of situations over plot.[5]

Tsivian analyses the Americanism of the "lower" genres as an intellectual fashion or taste. Discerning "something of a slumming mentality" in Eisenstein's [ . . . ] fascination with "serial queen" melodramas, he situates the preference of Soviet filmmakers for "cinematic pulp fiction" (Victor Shklovsky) in the context of the leftist avant-garde's attack on high art, cultural pretensions, and Western ideals of naturalism.[6] What interests me in this account is less the intellectual and artistic intertext than the connection it suggests *across* the distinction, between the two faces of American cinema: the classical norm, as an emergent form that was to dominate domestic as well as foreign markets for decades to come, and the seemingly nonclassical, or less classical, undercurrent of genres that thrive on something other than or, at the very least, oblique to the classical norm. What also interests me in the dynamics of Americanism and Soviet film is the way it urges us to reconsider the relationship between classical cinema and modernism, a relationship that within

cinema studies has habitually been thought of as an opposition, as one of fundamentally incompatible registers.

The opposition between classicism and modernism has a venerable history in literature, art, and philosophy, with classicism linked to the model of tradition, and modernism to the rhetoric of a break with precisely that tradition.[7] In that general sense, there would be no problem with importing this opposition into the field of cinema and film history, with classical cinema falling on the side of tradition, and alternative film practices on the side of modernism. If, however, we consider the cinema as part of the historical formation of modernity, as a larger set of cultural and aesthetic, technological, economic, social, and political transformations, the opposition of classical cinema and modernism, the latter understood as a discourse articulating and responding to modernity, becomes a more complicated issue.

I am using "classical cinema" here as a technical term that has played a crucial part in the formation of cinema studies as an academic discipline. The term came to serve as a foundational concept in the analysis of the dominant form of narrative cinema, epitomized by Hollywood during the studio era; in that endeavor, "classical cinema" referred to roughly the same thing whether you were doing semiotics, psychoanalytic film theory, neo-formalist poetics, or revisionist film history. This is not to say that it *meant* the same thing, and just a brief glimpse at its key moments will illustrate the transvaluations and disjunctures of the term.

Not coincidentally, the reference to Hollywood products as "classical" has a French pedigree. As early as 1926, Jean Renoir uses the phrase "cinematic classicism" (in this case referring to Chaplin and Lubitsch).[8] A more specific usage of the term occurs in Robert Brasillach and Maurice Bardèche's *Histoire du cinéma*, in particular the second edition of 1943, revised with a collaborationist bent, in which the authors refer to the style evolved in American sound film of 1933–9 as the "classicism of the 'talkie.'"[9] After the Occupation, critics, notably André Bazin, began to speak of Hollywood filmmaking as "a classical art." By the 1950s, Bazin would celebrate John Ford's *Stagecoach* (1939) as "the ideal example of the maturity of a style brought to classic perfection," comparing the film to "a wheel, so perfectly made that it remains in equilibrium on its axis in any position."[10] This classical quality of American film, to quote Bazin's well-known statement, is a result not of individual talent but of "the genius of the system, the richness of its ever-vigorous tradition, and its fertility when it comes into contact with new elements."[11]

The first major transvaluation of the concept of classical cinema came with post-1968 film theory, in the all-round critique of ideology directed against the very system celebrated by Bazin. In this critique, formulated along Althusserian and Lacanian lines and from Marxist and later feminist positions, classical Hollywood cinema was analysed as a mode of representation that masks the process and fact of production, turns discourse into diegesis, history into story and myth; as an apparatus that sutures the subject in an illusory coherence and identity; and as a system of stylistic strategies that weld pleasure and meaning to reproduce dominant social and sexual hierarchies. The notion of "classical cinema" elaborated in the pages of *Cahiers du Cinéma, Cinéthique, Screen, Camera Obscura,* and elsewhere was less indebted to a neoclassicist ideal (as it still was for Bazin and Rohmer) than to the writings of Roland Barthes, in particular *S/Z* (1970), which attached the label of a "classic," "readerly," ostensibly transparent text to the nineteenth-century realist novel.[12]

Another turn in the conception of "classical cinema" entails the rejection of any evaluative usage of the term, whether celebratory or critical, in favor of a more descriptive, presumably value-free and scientifically valid, account. This project has found its most comprehensive realization to date in David Bordwell, Janet Staiger, and Kristin Thompson's monumental and impressive study, *The classical Hollywood cinema: film style and mode of production to 1960* (1985). The authors conceive of classical cinema as an integral, coherent system, a system that interrelates a specific mode of production (based on Fordist principles of industrial organization) and a set of interdependent stylistic norms that were elaborated by 1917 and remained more or less in place until about 1960. The underlying notion of classical film style, rooted in neo-formalist poetics and cognitive psychology, overlaps in part with the account of the classical paradigm in 1970s' film theory, particularly with regard to principles of narrative dominance, linear and unobtrusive narration centering on the psychology and agency of individual characters, and continuity editing. But where psychoanalytic-semiotic theorists pinpoint unconscious mechanisms of identification and the ideological effects of "realism," Bordwell and Thompson stress thorough motivation and coherence of causality, space, and time; clarity and redundancy in guiding the viewer's mental operations; formal patterns of repetition and variation, rhyming, balance, and symmetry; and overall compositional unity and closure.[13] In Bordwell's formulation, "the principles which Hollywood claims as its own rely on notions of decorum, proportion, formal harmony, respect for tradition, mimesis, self-effacing craftsmanship, and cool control of the perceiver's response—canons which critics in any medium usually call 'classical.'"[14]

Such a definition is not just generally "classical" but more specifically recalls neoclassicist standards, from seventeenth-century neo-Aristotelian theories of drama to eighteenth-century ideals in music, architecture, and aesthetic theory. (I do not wish to equate eighteenth-century aesthetics at large with the neoclassicist tradition, nor with an ahistorical reduction to neo-formalist principles: the eighteenth century was at least as much concerned with affect and effect, with theatricality and sensation, passion and sentiment, as with the balance of form and function.) As in literary and aesthetic antecedents that invoke classical antiquity as a model—recall Stendhal's definition of classicism as a style that "gives the greatest possible pleasure to an audience's ancestors"[15]—the temporal dynamics of the term classical as applied to the cinema is retrospective; the emphasis is on tradition and continuity rather than newness as difference, disruption, and change.

I can see a certain revisionist pleasure in asserting the power and persistence of classical standards in the face of a popular image of Hollywood as anything but decorous, harmonious, traditional, and cool. But how does this help us account for the appeal of films as diverse as *Lonesome, Liberty, Freaks, Gold Diggers of 1933, Stella Dallas, Fallen Angel, Kiss Me Deadly, Bigger Than Life, Rock-a-Bye Baby* (add your own examples)? And even if we succeeded in showing these films to be constructed on classical principles—which I am sure can be done—what have we demonstrated? To repeat Rick Altman's question in an essay that challenges Bordwell, Thompson, and Staiger's model: "How classical was classical narrative?"[16] Attempts to answer that rhetorical question have focused on what is left out, marginalized, or repressed in the totalizing account of classical cinema—in particular, the strong

substratum of theatrical melodrama, with its uses of spectacle and coincidence, but also genres such as comedy, horror, and pornography which involve the viewer's body and sensory-affective responses in ways that may not exactly conform to classical ideals. What is also minimized is the role of genre in general, specifically the affective-aesthetic division of labor among genres in structuring the consumption of Hollywood films. An even lesser role is granted to stars and stardom, which cannot be reduced to the narrative function of character and, like genre but even more so, involve the spheres of distribution, exhibition practices, and reception. *The classical Hollywood cinema* explicitly and, it should be said, with self-imposed consistency brackets the history of reception and film culture, along with the cinema's interrelations with American culture at large.

It is not my intention to contest the achievement of Bordwell, Staiger, and Thompson's work: the book does illuminate crucial aspects of how Hollywood cinema works and goes a long way toward accounting for the stability and persistence of this particular cultural form. My interest is rather in two questions that the book does *not* address, or addresses only to close off. One question pertains to the historicity of classical cinema, in particular its contemporaneity with twentieth-century modernisms and modern culture; the other question is to what extent and how the concept can be used to account for Hollywood's worldwide hegemony. To begin with, I am interested in the anachronism involved in asserting the priority of stylistic principles modelled on seventeenth-century and eighteenth-century neo-classicism when we are dealing with a cultural formation that was, after all, perceived as the incarnation of *the modern*, an aesthetic medium up-to-date with Fordist–Taylorist methods of industrial production and mass consumption, with drastic changes in social, sexual, and gender relations, in the material fabric of everyday life, in the organization of sensory perception and experience. For contemporaries, Hollywood at its presumably most classical figured as the very symbol of contemporaneity, the present, modern times: "this our period," as Gertrude Stein famously put it, "was undoubtedly the period of the cinema and series production."[17] And it held that appeal not only for avant-garde artists and intellectuals in the USA and the modernizing capitals of the world (Berlin, Paris, Moscow, Shanghai, Tokyo, São Paulo, Sydney, Bombay), but also for emerging mass publics both at home and abroad. Whatever the economic and ideological conditions of its hegemony—and I wish by no means to discount them—classical Hollywood cinema could be imagined as a cultural practice on a par with the experience of modernity, as an industrially produced, mass-based, vernacular modernism.

In cinema studies, the juncture of the classical and the modern has, for the most part, been written as a bifurcated history. The critique of classical cinema in 1970s' film theory took over a structuralist legacy of binarisms, such as Barthes's opposition between the "readerly" and "writerly," which translated into the binary conception of film practice as either "classical/idealist," that is, ideological, or "modernist/materialist," that is, self-reflexive and progressive. This is particularly the case for the theory and practice of "counter cinema" that David Rodowick has dubbed "political modernism"—from Jean-Luc Godard and Peter Gidal through Noel Burch, Peter Wollen, Stephen Heath, Laura Mulvey, and others—which owes much to the revival or belated reception of the 1920s' and 1930s' leftist avant-garde, notably Brecht.[18] Moreover, the polarization of classical cinema and modernism seemed sufficiently

warranted by skepticism *vis-à-vis* Hollywood's self-promotion as "international modern," considering how much the celebration of American cinema's contemporaneity, youth, vitality, and directness was part of the industry's own mythology, deployed to legitimate cut-throat business practices and the relentless expansion of economic power worldwide.

While Bordwell and Thompson's neo-formalist approach is to some extent indebted to the political–modernist tradition, *The classical Hollywood cinema* recasts the binarism of classicism and modernism in two ways. At the level of industrial organization, the modernity of Hollywood's mode of production (Fordism) is subsumed under the goal of maintaining the stability of the system as a whole; thus major technological and economic changes (such as the transition to sound) are discussed in terms of a search for "functional equivalents" by which the institution ensures the overall continuity of the paradigm.[19] In a similar vein, any stylistic deviations of the modernist kind *within* classical cinema—whether imports from European avant-garde and art films, native *films noir,* or work of idiosyncratic auteurs such as Welles, Hitchcock, and Preminger—are cited as proof of the system's amazing appropriative flexibility: "So powerful is the classical paradigm that it regulates what may violate it."[20]

[ · · · ]

One might argue that it would be more appropriate to consider classical Hollywood cinema within the framework of "American national cinema." Such a reframing would allow us, among other things, to include independent film practices outside and against the pull of Hollywood (such as "race films," regional, subcultural, and avant-garde film practices). While this strategy is important especially for teaching American cinema, the issue of Hollywood's role in defining and negotiating American nationality strikes me as more complicated. If we wish to "provincialize Hollywood," to vary on Dipesh Chakrabarty's injunction to "provincialize" European accounts of modernity,[21] it is not enough to consider American cinema on a par with any other national cinema—inasmuch as that very category in many cases describes defensive formations shaped in competition with and resistance to Hollywood products. In other words, the issue of classicality is bound up with the question of what constituted the hegemony of American movies worldwide, what assured them the historic impact they had, for better or for worse, within a wide range of different local contexts and diverse national cinemas.

The question of what constitutes Hollywood's power on a global scale returns us to the phenomenon of Americanism discussed earlier in connection with Soviet film. I am concerned with Americanism here less as a question of exceptionalism, consensus ideology, or crude economic power—though none of these aspects can be ignored—than as a question of cultural circulation and hegemony. Victoria de Grazia has argued that Americanism still awaits analysis, beyond the polarized labels of, respectively, cultural imperialism and a worldwide spreading of the American Dream, as "the historical process by which the American experience was transformed into a universal model of business society based on advanced technology and promising formal equality and unlimited mass consumption."[22] However ideological these promises may, or may not, turn out to be, de Grazia observes that,

unlike earlier imperial practices of colonial dumping, American cultural exports "were designed to go as far as the market would take them, starting at home." In other words, "cultural exports shared the basic features of American mass culture, intending by that term not only the cultural artifacts and associated forms, but also the civic values and social relations of the first capitalist mass society."[23]

Regarding classical cinema, one could take this argument to suggest that the hegemonic mechanisms by which Hollywood succeeded in amalgamating a diversity of competing traditions, discourses, and interests on the *domestic* level may have accounted for at least some of the generalized appeal and robustness of Hollywood products *abroad* (a success in which the diasporic, relatively cosmopolitan profile of the Hollywood community no doubt played a part as well). In other words, by forging a mass market out of an ethnically and culturally heterogeneous society (if often at the expense of racial others), American classical cinema had developed an idiom, or idioms, that travelled more easily than its national-popular rivals. I do not wish to resuscitate the myth of film as a new "universal language," whose early promoters included D.W. Griffith and Carl Laemmle (founder of the Universal Film Company), nor do I mean to gloss over the business practices by which the American film industry secured the dominance of its products on foreign markets, in particular through control of distribution and exhibition venues.[24] But I do think that, whether we like it or not, American movies of the classical period offered something like the first global vernacular. If this vernacular had a transnational and translatable resonance it was not just because of its optimal mobilization of biologically hardwired structures and universal narrative templates but, more important, because it played a key role in mediating competing cultural discourses on modernity and modernization, because it articulated, multiplied, and globalized a particular historical experience.

If classical Hollywood cinema succeeded as an international modernist idiom on a mass basis, it did so not because of its presumably universal narrative form but because it meant different things to different people and publics, both at home and abroad. We must not forget that these films, along with other mass cultural exports, were consumed in locally quite specific, and unequally developed, contexts and conditions of *reception*; that they not only had a levelling impact on indigenous cultures but also challenged prevailing social and sexual arrangements and advanced new possibilities of social identity and cultural styles; and that the films were also changed in that process. Many films were literally changed, both for particular export markets (for example, the conversion of American happy endings into tragic endings for Russian release) and by censorship, marketing, and programming practices in the countries in which they were distributed, not to mention practices of dubbing and subtitling. As systematic as the effort to conquer foreign markets undoubtedly was, the actual reception of Hollywood films was likely a much more haphazard and eclectic process, depending on a variety of factors. How were the films programmed in the context of local film cultures, in particular conventions of exhibition and reception? Which genres were preferred in which places (for instance, slapstick in European and African countries, musical and historical costume dramas in India), and how were American genres dissolved and assimilated into different generic traditions, different concepts of genre? And how did American imports figure within the public horizon of reception which might have included

both indigenous products and films from other foreign countries? To write the international history of classical American cinema, therefore, is a matter of tracing not just its mechanisms of standardization and hegemony but the diversity of ways in which this cinema was translated and reconfigured in local and translocal contexts of reception.

This means that Americanism, notwithstanding Antonio Gramsci (as well as recent critiques of Gramsci and left Fordism), cannot simply be reduced to a regime of mechanized production, an ideological veneer for discipline, abstraction, reification, new hierarchies, and routes of power. Nor can it be reduced to the machine aesthetics of intellectual and high modernism. We cannot understand the appeal of Americanism unless we take seriously the promises of mass consumption, and the dreams of a mass culture often in excess of and conflict with the regime of production that spawned that mass culture ("Americanization from below").[25] In other words, we have to understand the material, sensory conditions under which American mass culture, including Hollywood, was received and could have functioned as a powerful matrix for modernity's liberatory impulses—its moments of abundance, play, and radical possibility, its glimpses of collectivity and gender equality (the latter signalled by its opponents' excoriation of Americanism as a "new matriarchy").[26]

The juncture of classical cinema and modernity reminds us, finally, that the cinema was not only part and symptom of the crisis and upheaval at which modernity was experienced and perceived; it was also, most importantly, the single most inclusive, cultural horizon in which the traumatic effects of modernity were reflected, rejected or disavowed, transmuted or negotiated. That the cinema was capable of a reflexive relation with modernity and modernization was registered by contemporaries early on, and I read Benjamin's and Siegfried Kracauer's writings of the 1920s and 1930s as, among other things, an effort to theorize this relation as a new mode of reflexivity.[27] Neither simply a medium for realistic representation (in the sense of Marxist notions of reflection or *Widerspiegelung*), nor particularly concerned with formalist self-reflexivity, commercial cinema appeared to realize Johann Gottlieb Fichte's troping of reflection as "seeing with an added eye" in an almost literal sense, and it did so not just on the level of individual, philosophical cognition but on a mass scale.[28] I am also drawing on more recent sociological debates on "reflexive modernization" (Ulrich Beck, Anthony Giddens, Scott Lash), a concept deployed to distinguish the risk-conscious phase of current post- or second modernity from a presumably more single-minded, orthodox, and simple, first modernity. However, I would argue (though I cannot do so in detail here) that modernization inevitably provokes the need for reflexivity and that if sociologists considered the cinema in aesthetic and sensorial terms rather than as just another media of information and communication they would find ample evidence, in American and other cinemas of the interwar period, of an at once modernist and vernacular reflexivity.[29]

This dimension of reflexivity is key to the claim that the cinema not only represented a specifically modern type of public sphere, the public here understood as a "social horizon of experience," but that this new mass public could have functioned as a discursive form in which individual experience could be articulated and find recognition by subjects and others, including strangers. Kracauer, in his more utopian moments, understood the cinema as an alternative public sphere—alternative both

to bourgeois institutions of art, education, and culture and to the traditional arenas of politics—an imaginative horizon in which, however compromised by its capitalist foundations, something like an actual democratization of culture seemed to be taking shape; in his words, the possibility of a "self-representation of the masses subject to the process of mechanization."[30] The cinema suggested this possibility not only because it attracted, and made visible to itself and society, an emerging, heterogeneous mass public ignored and despised by dominant culture; the new medium also offered an alternative because it engaged the contradictions of modernity at the level of the senses, the level at which the impact of modern technology on human experience was most palpable and irreversible. In other words, the cinema not only traded in the mass production of the senses but also provided an aesthetic horizon for the experience of industrial mass society.

While Kracauer's observations were based on movie-going in Weimar Germany, he attributed this sensory reflexivity more often than not to American film, in particular slapstick comedy, with its well-choreographed orgies of demolition and clashes between people and things. The logic he discerned in slapstick films pointed up a disjuncture within Fordist mass culture, the possibility of an anarchic supplement generated on the same principles:

> One has to hand this to the Americans: with slapstick films they have created a form that offers a counterweight to their reality. If in that reality they subject the world to an often unbearable discipline, the film in turn dismantles this self-imposed order quite forcefully.[31]

The reflexive potential of slapstick comedy can be (and has been) argued on a number of counts, at the levels of plot, performance, and *mise en scène*, and as depending on the particular inflection of the genre: in addition to articulating, and playing games with, the violence of technological regimes, mechanization, and clock time, slapstick films also specialized in deflating the terror of consumption, of a new culture of status and distinction.[32] Likewise, the genre was a vital site for engaging the conflicts and pressures of a multi-ethnic society (think of the many Jewish performers who thematized the discrepancies between diasporic identity and upward mobility, from Larry Semon and Max Davidson to George Sydney). And, not least, slapstick comedy allowed for a playful and physical expression of anxieties over changed gender roles and new forms of sexuality and intimacy.

But what about other genres? And what about popular narrative films that conform more closely to classical norms? Once we begin looking at Hollywood films as both a provincial response to modernization and a vernacular for different, diverse, yet also comparable experiences, we may find that genres such as the musical, horror, or melodrama may offer just as much reflexive potential as slapstick comedy, with appeals specific to those genres and specific resonances in different contexts of reception. This is to suggest that reflexivity can take different forms and different affective directions—both in individual films and directorial œuvres and in the aesthetic division of labor among Hollywood genres—and that reflexivity does not always have to be critical or unequivocal; on the contrary, the reflexive dimension of these films may consist precisely in the ways in which they allow their viewers to confront the constitutive ambivalence of modernity.

The reflexive dimension of Hollywood films in relation to modernity may take cognitive, discursive, and narrativized forms, but it is crucially anchored in sensory experience and sensational affect—in processes of mimetic identification that are more often than not partial and excessive in relation to narrative comprehension. Benjamin, writing about the elimination of distance in the new perceptual regimes of advertising and cinema, sees in the giant billboards that present things in new proportions and colors a backdrop for a "sentimentality . . . restored to health and liberated in American style," just as in the cinema "people whom nothing moves or touches any longer learn to cry again."[33] The reason slapstick comedy hit home and flourished worldwide was not critical reason but that the films propelled their viewers' bodies into laughter. And adventure serials succeeded because they conveyed a new immediacy, energy, and sexual economy, not only in Soviet Russia and not only among avant-garde intellectuals. Again and again, writings on the American cinema of the interwar period stress the new physicality, the exterior surface or "outer skin" of things (Antonin Artaud), the material presence of the quotidian; as Louis Aragon put it, "really common objects, everything that celebrates life, not some artificial convention that excludes corned beef and tins of polish."[34] I take such statements to suggest that the reflexive, modernist dimension of American cinema does not necessarily require that we demonstrate a cognitive, compensatory, or therapeutic function in relation to the experience of modernity but that, in a very basic sense, even the most ordinary commercial films were involved in producing a new sensory culture.

Hollywood did not just circulate images and sounds; it produced and globalized a new sensorium; it constituted, or tried to constitute, new subjectivities and subjects. The mass appeal of these films resided as much in their ability to engage viewers at the narrative–cognitive level, or in their providing models of identification for being modern, as it did in the register of what Benjamin troped as the "optical unconscious."[35] It was not just *what* these films showed, what they brought into optical consciousness, as it were, but the way they opened up hitherto unperceived modes of sensory perception and experience, their ability to suggest a different organization of the daily world. Whether this took the shape of dreams or of nightmares, it marked an aesthetic mode that was decidedly not "classical"—at least not if we literalize that term and reduce it to neo-classicist formal and stylistic principles. Yet, if we understand the "classical" in American cinema as a metaphor of a global sensory vernacular, rather than a universal narrative idiom, then it might be possible to imagine the two Americanisms operating in the development of Soviet cinema, the modernist fascination with the "low," sensational, attractionist genres, and the classicist ideal of formal and narrative efficiency, as vectors of the same phenomenon, each contributing to the hegemony of Hollywood film. This may well be a fantasy: the fantasy of a cinema that could help its viewers negotiate the tension between reification and the aesthetic strongly understood, the possibilities, anxieties, and costs of an expanded sensory and experiential horizon—the fantasy, in other words, of a mass-mediated public sphere capable of responding to modernity and its failed promises. Now that postmodern media culture is busy recycling the ruins of both classical cinema and modernity, we may be in a better position to see the residues of a dreamworld of mass culture that is no longer ours—and yet to some extent still is.

## NOTES

[NB Notes have been shortened for this edition. —Ed.]

1. Lawrence Rainey and Robert von Hallberg, "Editorial/Introduction," *Modernism/Modernity* 1, 1 (1994): 1.

2. Peter Bürger, following Adorno, asserts that the very category of "style" is rendered problematic by the advanced commodification of art in the twentieth century and he considers the refusal to develop a coherent style (as in Dada and Surrealism) as a salient feature of avant-gardist, as distinct from modernist, aesthetics; see Bürger, *Theory of the avant-garde*, translated by Michael Shaw (Minneapolis, MN, University of Minnesota Press, 1984), especially ch. 2.1, "The historicity of aesthetic categories."

3. In his famous essay, "The work of art in the age of mechanical reproduction" (second version, 1935), Benjamin wrote of "the theory [*die Lehre*] of perception that the Greeks called aesthetics" [*Gesammelte Schriften*, vol. VII, eds R. Tiedemann and H. Schweppenhäuser (Frankfurt am Main, Suhrkamp, 1989), p. 381], and he conceived of the politics of this essay very much as an effort to confront the aesthetic tradition narrowly understood, in particular the persistence of aestheticism in contemporary literature and art, with the changes wrought upon the human sensorium by industrial and military technology. See Susan Buck-Morss, "Aesthetics and anaesthetics: Walter Benjamin's artwork essay reconsidered," *October* 62 (Fall 1992), pp. 3–41; also, see Hansen, "Benjamin and cinema: not a one-way street," *Critical Inquiry* 25, 2 (Winter 1999), pp. 306–43.

4. Yuri Tsivian, "Between the Old and the New: Soviet film culture in 1918–1924," *Griffithiana* 55/56 (1996), 15–63; 39; Tsivian, "Cutting and framing in Bauer's and Kuleshov's films," *Kintop: Jahrbuch zur Erforschung des frühen Films*, 1 (1992), pp. 103–13; Kristin Thompson and David Bordwell, *Film history: an introduction* (New York, McGraw-Hill, 1994), p. 130.

5. Tsivian, "Between the Old and the New," pp. 39–45.

6. Tsivian, "Between the Old and the New," p. 43. A related recruiting of "low" popular culture for the programmatic attack on the institution of art can be found in Western European avant-garde movements, in particular Dadaism and Surrealism.

7. Robert B. Pippin, *Modernism as a philosophical problem* (London, Basil Blackwell, 1991), p. 4.

8. See Thomas Elsaesser, "What makes Hollywood run?," *American Film*, 10, 7 (May 1985), pp. 52–5, 68.

9. Robert Brasillach and Maurice Bardèche, *Histoire du cinéma*, 2nd edn (Paris, Denoël, 1943), p. 369, quoted in David Bordwell, *On the history of film style* (Cambridge, MA, Harvard University press, 1997), p. 47.

10. André Bazin, "The evolution of the western," *What Is cinema?*, selected and edited by Hugh Gray (Berkeley, CA, University of California Press, 1971), vol. II, p. 149.

11. André Bazin, "La Politique des auteurs," in ed. Peter Graham, *The New Wave* (New York, Doubleday, 1968), pp. 143, 154.

12. See Judith Mayne, "*S/Z* and film theory," *Jump Cut* 12/13 (December 1976), pp. 41–5. A notable exception to this tendency is Raymond Bellour who stresses the formal and stylistic principles at work in classical cinema (patterns of repetition–resolution, rhyming, symmetry, redundancy, interlacing of micro and macro structures) by which classical films produce their conscious and unconscious meanings and effects. See Bellour, *L'analyse du film* (Paris, Éditions Albatros, 1979), which includes the texts translated as "Segmenting/analyzing" and "The obvious and the code," in Rosen, *Narrative, apparatus, ideology*, pp. 66–92, 93–101.

13. In *The classical Hollywood cinema* (New York, Columbia University Press, 1985), p. 19, "realism" is equated with verisimilitude and as such figures as one of four types of narrative motivation (compositional, realistic, intertextual, artistic). While this qualification seems appropriate *vis-à-vis* the diversity of Hollywood genres (think of the musical, for

instance), it does not make the issue of cinematic "realism" go away, whether as rhetorical claim, ideological fiction, or aesthetic possibility.

14. David Bordwell, Janet Staiger, and Kristin Thompson, *The classical Hollywood cinema*, pp. 3–4.

15. Bordwell *et al., Classical Hollywood cinema*, pp. 367–8.

16. Altman, "Dickens, Griffith, and film theory today," in Gaines, ed., *Classical Hollywood narrative*, p. 14.

17. Gertrude Stein, "Portraits and Repetition," in *Lectures in America* (New York, Random House, 1935), p. 177. For a critical account of the industrial, political, and cultural dimensions of Fordism, see Terry Smith, *Making the modern: industry, art, and design in America* (Chicago, IL, University of Chicago Press, 1993).

18. D. N. Rodowick, *The crisis of political modernism: criticism and ideology in contemporary film theory* (Urbana and Chicago, IL, University of Illinois Press, 1988).

19. Bordwell *et al., The classical Hollywood cinema*, p. 304.

20. Bordwell *et al., The classical Hollywood cinema*, p. 81. Such statements bear an uncanny similarity to Max Horkheimer and Theodor W. Adorno's analysis, in *Dialectic of Enlightenment* (1944/47), of the "Culture industry" as an all-absorbing totality though obviously without the despair and pessimism that prompted that analysis.

21. Dipesh Chakrabarty, "Postcoloniality and the artifice of history: who speaks for 'Indian' pasts?" *Representations*, 37 (Winter 1992), pp. 1–26; 20.

22. Victoria de Grazia, "Americanism for export," *Wedge*, 7–8 (Winter–Spring 1985), pp. 74–81; 73. Also, see de Grazia, "Mass culture and sovereignty: the American challenge to European cinemas, 1920–1960," *Journal of Modern History*, 61, 1 (March 1989), pp. 53–87.

23. De Grazia, "Americanism for export," p. 77.

24. On the role of foreign markets for the American film industry, see Kristin Thompson, *Exporting entertainment* (London, British Film Institute, 1985); Ian Jarvie, *Hollywood's overseas campaign: the North Atlantic movie trade, 1920–1950* (Cambridge and New York, Cambridge University Press, 1992); David W. Ellwood and Rob Kroes (eds), *Hollywood in Europe: experiences of a cultural hegemony* (Amsterdam, VU University Press, 1994); Ruth Vasey, *The world according to Hollywood, 1918–1939* (Madison, WI, University of Wisconsin Press, 1997). On the celebration of film as a new "universal language" during the period 1910–19, see M. Hansen, *Babel and Babylon: spectatorship in American silent film* (Cambridge, MA, Harvard University Press, 1991), pp. 76–81, 183–7.

25. The phrase "Americanization from below" is used by Kaspar Maase in his study of West German youth culture of the 1950s, *BRAVO Amerika: Erkundungen zur Jugendkultur der Bundesrepublik in den fünfziger Jahren* (Hamburg, Junius, 1992), p. 19.

26. On the different economy of gender relations connoted by American culture in Weimar Germany, see Nolan, *Visions of modernity*, pp. 120–27.

27. Hansen, "Benjamin and cinema," and "America, Paris, the Alps: Kracauer (and Benjamin) on cinema and modernity," in Charney and Schwartz, eds, *Cinema and the invention of modern life*, pp. 362–402.

28. Quoted in Ulrich Beck, Anthony Giddens, and Scott Lash, *Reflexive modernization: politics, tradition and aesthetics in the modern social order* (Stanford, CA, Stanford University Press, 1994), p. 175.

29. See Beck, Giddens, and Lash, *Reflexive modernization*; also see Giddens, *Modernity and self-identity* (Stanford, CA, Stanford University Press, 1991).

30. S. Kracauer, "Berliner Nebeneinander: Kara-Iki—Scala-Ball im Savoy—Menschen im Hotel," *Frankfurter Zeitung*, 17 February 1933; also, see "Cult of Distraction" (1926) and

other essays in Kracauer, *The mass ornament: Weimar essays*, translated, edited, and introduction by Thomas Y. Levin (Cambridge, MA, Harvard University Press, 1995).

31. Kracauer, *Frankfurter Zeitung*, 29 January 1926.

32. See, for instance, Eileen Bowser, "Subverting the conventions: slapstick as genre," in Bowser, ed., *The slapstick symposium*, May 1985, The Museum of Modern Art, New York (Brussels, Fédération Internationale des Archives du Film, 1988), pp. 13–17; Crafton, "Pie and Chase"; Charles Musser, "Work, ideology and Chaplin's tramp," *Radical History*, 41 (April 1988), pp. 37–66.

33. Benjamin, "One-way street" (1928), translated by Edmund Jephcott, in *Selected writings*, eds Marcus Bullock and Michael W. Jennings (Cambridge, MA, Harvard University Press, 1996), p. 476 (translation modified).

34. Antonin Artaud, "The shell and the clergyman: film scenario," *Transition*, 29–30 (June 1930), p. 65, quoted in Siegfried Kracauer, *Theory of film* (1960; Princeton, NJ, Princeton University Press, 1997), p. 189; Louis Aragon, "On decor" (1918) in Richard Abel, ed., *French film theory and criticism: a history/anthology, 1907–1939*, 2 vols (Princeton, NJ, Princeton University Press, 1988), vol 1, p. 165.

35. Benjamin develops the notion of an "optical unconscious" in "A short history of photography" (1931), translated by Stanley Mitchell, *Screen*, 13 (Spring 1972), pp. 7–8, and in his famous essay, "The work of art in the age of mechanical reproduction" (1936), *Illuminations*, ed. Hannah Arendt, translated by Harry Zohn (New York, Schocken, 1969), pp. 235–7.

# PART 4
# AUTEURISM: DIRECTORS, STARS, AND BEYOND

*A dead body floats facedown in a swimming pool. A voiceover narrates: "Yes, this is Sunset Blvd., Los Angeles, California. It's about 5 o'clock in the morning. That's the homicide squad, complete with detectives and newspaper men." The voice quickly identifies the dead body of screenwriter Joe Gillis as his own.*
Opening scene from Billy Wilder's *Sunset Boulevard* (1950)

The history of cinema features an abundance of films whose stories are about stars, directors, and writers. *Sunset Boulevard* (1950) is the dark and melancholic tale of faded silent-film actress Norma Desmond (Gloria Swanson), a former movie director who is now Desmond's protective butler (played by a famous director from the 1920s, Erich von Stroheim), and struggling L.A. screenwriter Joe Gillis (William Holden). This story of interlocking desperations begins famously with the death of the writer who is also the narrator of the film, and each of the characters represents a need for celebrity, power, and, most important, a means of expressing himself or herself that has been lost or never gained. It is not surprising that *Sunset Boulevard* is only one of many films that focus on one or more

of the key players in the making of a movie, since film audiences, like film theorists, have always sought out a creative source for the magic and beauty of the movies. The study of this singular creative source, or vision, is known as auteurism, a French term (now anglicized) that indicates cinematic authorship.

Auteurism usually locates the creative vision informing a film in directors (and occasionally in stars, producers, writers, or other primary figures in a film's production). What this implies is that a single figure, such as the director, is largely responsible for the themes, style, and meaning of a film and that, more often than not, a viewer can trace a consistent evolution of style and themes across a specific director's body of work. The agency of the auteur usually aligns the directive power of an individual with the creative vision of a film and, as such, the roots of auteurism are derived from a Romantic expressivity that claims that the meaning of a film, poem, or other text can be traced back to the imagination, intentions, or simply dispositions of the author/auteur.

ROLAND BARTHES discusses the "author" in broad terms that can be extended to the film auteur in his 1968 essay, "The Death of the Author," raising wide-ranging questions and concerns about privileging an individual source of a text. Although Barthes's essay is not about film, it is a watershed work (along with Michel Foucault's 1969 "What Is an Author?") that undermines the biographical agency of the author/auteur and redirects that agency to a system of language and textuality. According to Barthes, the relation of expressive author to text has been reversed in modern works (including films) so that we now should look at the way the author/auteur is configured in the work as a textual "enunciation," a set of meanings determined by the material discourse of the text, rather than see the work as an expression of the author. Indeed Barthes's argument should remind us that the movies are a collaborative art whose meanings do not necessarily lead back to a single voice or vision, and that considering directors or actors as the source of a film's meaning is only one of many ways to approach and understand a film. A good deal of the pathos in *Sunset Boulevard* is that the principal individuals all long for creative agency but can only manage relationships that are alternately self-absorbed, predatory, and protective. That the film begins with the death of the screenwriter who narrates the story and ends with the revelation that his death comes at the hands of one of the main characters might be seen as a grisly embodiment of the fundamental assumptions of auteurism and Barthes's critique of its ghostly persistence.

As the term implies, auteurism has decidedly literary roots but a specific (and notably French) history in film theory. Perhaps the most celebrated early declaration of the connection between the filmmaker as auteur and more traditional creative artists is ALEXANDRE ASTRUC's 1948 essay "The Birth of a New Avant-Garde: La Caméra-Stylo." In it, Astruc makes the now-famous claim that filmmakers can begin to use the camera like a pen due to the freedom and creative mobility that the new lightweight 16mm cameras offer, and thereby express ideas and views just as novelists, essayists, and philosophers could with the written language. In the late 1940s, the historic turn toward a more personal and expressive cinema had other underpinnings, such as the appearance of the philosophical schools of existentialism and the Paramount Decision of 1948, which undercut the Hollywood studio system and led to more independent film production. In this climate, there appeared a growing number of ciné-clubs that might feature a large number of films by the same director. This immersion in films by the same filmmaker provided

the impetus for the academic study of auteurs. Various art cinemas emerged, and films by auteurs such as Ingmar Bergman and Federico Fellini redefined the industry of movie-making according to a liberal humanist model based in the creativity of the individual artist. Especially central to the development of auteur theory, the French New Wave produced a multitude of young writer-directors who more or less aligned themselves with François Truffaut's seminal 1954 essay "A Certain Tendency of the French Cinema" and its scathing attack on mere *metteurs-en-scène*, that is, directors with technical competence but none of the creative vision of auteurs.

A leading proponent of auteur theory in the United States, ANDREW SARRIS adapted the auteurist arguments articulated by the French New Wave and specifically the essays in the influential *Cahiers du cinéma* in his book *The American Cinema*. In his well-known essay, "Notes on the Auteur Theory in 1962," Sarris argues that auteurs are powerful agents whose films reveal a consistent technical competence, a recognizable style, and "interior meanings," an approach that "humanizes" the moviemaking industry as an art form, like Romantic poetry for its poets, and so provides a means of evaluating and critically differentiating films. Somewhat ironically, Sarris's pantheon of great directors includes in the two highest categories of creative filmmakers Buster Keaton, Cecil B. DeMille, and Erich von Stroheim, all of whom appear in *Sunset Boulevard* (the first two directors as themselves and von Stroheim as the butler). However, Billy Wilder, the director of *Sunset Boulevard*, is placed in the middling "Less Than Meets the Eye" category. While it may be said that Wilder's films do not possess a visible evolution or consistent "interior meanings," it is still clear that the measurement of auteurist success and value is a less-than-objective endeavor, a point that Sarris stresses in the revealing follow-up essay "The Auteur Theory Revisited," included here. Sarris even "upgrades" Wilder's status in his later work, *You Ain't Heard Nothing Yet!*

Other approaches to auteurism have taken on the challenges posed by Barthes's dismissal or reconfiguration of the author/auteur as a textual enunciation, and the seemingly impressionistic evaluation of auteurs by Sarris and others. Through his discussion of Howard Hawks and John Ford in "The Auteur Theory," PETER WOLLEN shifts the emphasis away from the actual filmmaker to the viewer or critic's "operation of decipherment." He sees the potential in this shift to reveal "authors where none had been seen before," often by identifying structural patterns and variants on them in films. For Wollen, film is unmistakably a collaborative art that involves a great deal of "noise" from other participants such as producers, actors, and writers; these contributions become "catalysts" that are processed, consciously or unconsciously, through the auteur's mind.

Although TANIA MODLESKI and JUDITH MAYNE share a feminist concern with how women engage auteurism as viewers and filmmakers, they have different approaches to the question. Modleski uses the films of perhaps the most widely recognized film auteur, Alfred Hitchcock, not only to explore consistent themes in those films, but also to discuss how viewers, particularly female viewers, engage Hitchcock's disquieting vision of women. Specifically, she uses the voyeuristic, violent, and presumably misogynistic structures of Hitchcock films to explore female subjectivity and locate the "gaps" and "blindspots" in the "man-centered vision" that once dominated much contemporary film theory. For Modleski, Hitchcock the auteur hardly dominates the female spectator

(or male spectator); in fact, he creates complex films that require viewers to reflect, identify, and think in ways that challenge the vision of even a masterful filmmaker like himself.

Addressing the glaring omission of women in auteurist canons, Mayne critically assesses feminist film theory's revival of Dorothy Arzner, virtually the only woman to direct movies during the heyday of the Hollywood studio system. Her essay touches a variety of larger issues such as the distinctions between women as literary authors and women as cinematic authors, the challenges of describing female expression in mainstream cinema as other than simply oppositional or disruptive, and the way that focusing on gender difference can erase other differences, such as those of sexual orientation or race. In the process, Mayne raises the vexing issue of essentialism, one example being the tendency to automatically attribute a filmmaker's artistic or representational expression to his or her biological or cultural "essence." Mayne engages both textual and psychoanalytic theories to locate a lesbian signature not only in Dorothy Arzner's deployment of female communities in her films but also in extratextual features such as her promotional and industrial images, and how they transfer to her films. For feminist perspectives on auteurism like these, *Sunset Boulevard* offers few clear entryways, though the film itself can be seen as a bitter indictment of a patriarchal film industry and a tribute to the authorial ambition of the female star. More subtly and interestingly, Wilder's range of films exhibits an especially rich gender dynamic, manifested in his writing for female stars like Greta Garbo in *Ninotchka* (1939) and his development of narratives and themes that challenge heteronormativity in films like *Some Like It Hot* (1959).

While the film director is by far the individual most likely to be designated as a film's author, other figures and forces occasionally assume that authorial position, including stars, producers, and even studios. RICHARD DYER's landmark study of film stars redirects some of the traditional issues about auteurism toward actors and stars specifically, indicating how the films of stars like Garbo more likely cohere around the star's presence and persona than the signature style of a director. Stars have occasionally achieved a singular control over a film from its planning to its shooting to its distribution.

In his essay "The Commerce of Auteurism," TIMOTHY CORRIGAN takes a different tack and focuses on a force that he feels increasingly defines auteurism—the commercial issues in the film industry. Corrigan investigates the global resurrection of the author/auteur in recent decades, arguing that contemporary auteurs strategically fashion ideas and images of themselves as a way to shape how audiences view their films. As filmmaking and the movie industries evolve today, so do the meanings and potential of auteurism—it is no longer simply about the expression of art-film directors or canons of Hollywood filmmakers. Who or what controls the meaning and perspective of a film and how it is shaped changes historically, and the source of creativity is constantly repositioning itself industrially and culturally. The auteur-star Norma Desmond in *Sunset Boulevard* who famously declares "I am big. It's the pictures that got small," refuses to adjust to those changes as she clings to her lost status. Her tragic character speaks profoundly and prophetically to the need to see beyond the singular auteur as the creative center of a film and to the various fluctuating industrial and institutional contexts that define and redefine that creative center.

# ROLAND BARTHES

## The Death of the Author

One of the leading French intellectual figures of the second half of the twentieth century, Roland Barthes (1915–1980) helped define both structuralism and poststructuralism and made indelible contributions to literary theory, semiotics, and visual and cultural studies. Barthes's father died when Barthes was an infant, and he moved with his mother to Paris as a child. He lived with her most of his life and paid tribute to her in his moving reflection on photography, *Camera Lucida* (1980), which would be his last work. Classically educated, including at the Sorbonne, Barthes suffered from tuberculosis that interrupted his studies. He taught at secondary schools in the 1930s and 1940s, and held appointments at the Centre National de la Recherche Scientifique in the 1950s, the École Pratique des Hautes Études in the 1960s and 1970s, and at the Collège de France for four years until his untimely death in a street accident.

Barthes challenged the literary establishment with his embrace of new ideas, applying linguistics and structural anthropology to the study of literary form. He extended his critical commentary to such "signs" of everyday life as magazine photography, toys, tour guides, red wine, and wrestling in his influential contribution to semiology, *Mythologies* (1955), a collection of short newspaper commentaries. Throughout his career, Barthes remained interested in visual texts; several of his essays on film and photography appeared in English in *Image/Music/Text* (1977), translated by British film theorist Stephen Heath. A prolific writer and true public intellectual, Barthes was at the center of the turn to "theory" (incorporating deconstruction, poststructuralism, psychoanalysis, and postmodernism) in France and in the American academy after the late 1960s. In his dozens of publications, Barthes maintained a distinct critical stance, along with a beautiful, often quite subjective, writing style.

Among numerous paradigm-shifting publications, "The Death of the Author" (1968) is perhaps Barthes's best known. Written after a conservative scholar attacked Barthes's approach to the revered French author Racine, the essay signaled a rift with the old that catalyzed the political and cultural turmoil of May 1968 in France. For Barthes, the author can no longer be considered the guarantor of meaning, a God-like figure to whom the critic owes deference. Instead, Barthes insists on the open-endedness of interpretation, describing the text as a "tissue of quotations" that the reader "disentangles." His position was consistent with contemporary politics and philosophies of language, and it also championed contemporary formal experimentation in writing and filmmaking. Barthes's questioning of authorial intention and of the traditional view of art as expression contradicted the *politique des auteurs* or "auteur theory" developed by French film critics in the 1950s. Yet his insistence on the productive role of criticism, the "birth of the reader" that he proposes is made possible by the death of the author, profoundly influenced such film theorists as Peter Wollen (p. 361). In addition, Barthes's notion that a text is experienced in the present and thus not in terms of a past, and therefore given, meaning is worthy of consideration in approaching such contemporary phenomena as "director's cuts" and DVD commentaries.

## READING CUES & KEY CONCEPTS

■ How does Barthes establish the "prestige of the individual" in a historical and literary tradition?

■ Why does Barthes capitalize the term "Author"? Reflect on the connection he makes between theology and literary criticism.

■ Does Barthes's account of the traditional author/text relationship as that of "a father to his child" resonate with ways films are linked to their directors?

■ **Key Concepts:** Text; Subject; Performative; Writing; Scriptor; Reader

# The Death of the Author

. . . . . . . . . . . . . .

In his story *Sarrasine* Balzac, describing a castrato disguised as a woman, writes the following sentence: "*This was woman herself, with her sudden fears, her irrational whims, her instinctive worries, her impetuous boldness, her fussings, and her delicious sensibility.*" Who is speaking thus? Is it the hero of the story bent on remaining ignorant of the castrato hidden beneath the woman? Is it Balzac the individual, furnished by his personal experience with a philosophy of Woman? Is it Balzac the author professing "literary" ideas on femininity? Is it universal wisdom? Romantic psychology? We shall never know, for the good reason that writing is the destruction of every voice, of every point of origin. Writing is that neutral, composite, oblique space where our subject slips away, the negative where all identity is lost, starting with the very identity of the body writing.

No doubt it has always been that way. As soon as a fact is *narrated* no longer with a view to acting directly on reality but intransitively, that is to say, finally outside of any function other than that of the very practice of the symbol itself, this disconnection occurs, the voice loses its origin, the author enters into his own death, writing begins. The sense of this phenomenon, however, has varied; in ethnographic societies the responsibility for a narrative is never assumed by a person but by a mediator, shaman or relator whose "performance"—the mastery of the narrative code—may possibly be admired but never his "genius." The author is a modern figure, a product of our society insofar as, emerging from the Middle Ages with English empiricism, French rationalism and the personal faith of the Reformation, it discovered the prestige of the individual, of, as it is more nobly put, the "human person." It is thus logical that in literature it should be this positivism, the epitome and culmination of capitalist ideology, which has attached the greatest importance to the "person" of the author. The *author* still reigns in histories of literature, biographies of writers, interviews, magazines, as in the very consciousness of men of letters anxious to unite their person and their work through diaries and memoirs. The image of literature to be found in ordinary culture is tyrannically centred on the author, his person, his life, his tastes, his passions, while criticism still consists for the most part in saying that Baudelaire's work is the failure of Baudelaire the man, Van Gogh's his madness, Tchaikovsky's his

vice. The *explanation* of a work is always sought in the man or woman who produced it, as if it were always in the end, through the more or less transparent allegory of the fiction, the voice of a single person, the *author* "confiding" in us.

Though the sway of the Author remains powerful (the new criticism has often done no more than consolidate it), it goes without saying that certain writers have long since attempted to loosen it. In France, Mallarmé was doubtless the first to see and to foresee in its full extent the necessity to substitute language itself for the person who until then had been supposed to be its owner. For him, for us too, it is language which speaks, not the author; to write is, through a prerequisite impersonality (not at all to be confused with the castrating objectivity of the realist novelist), to reach that point where only language acts, "performs," and not "me." Mallarmé's entire poetics consists in suppressing the author in the interests of writing (which is, as will be seen, to restore the place of the reader). Valéry, encumbered by a psychology of the Ego, considerably diluted Mallarmé's theory but, his taste for classicism leading him to turn to the lessons of rhetoric, he never stopped calling into question and deriding the Author; he stressed the linguistic and, as it were, "hazardous" nature of his activity, and throughout his prose works he militated in favour of the essentially verbal condition of literature, in the face of which all recourse to the writer's interiority seemed to him pure superstition. Proust himself, despite the apparently psychological character of what are called his *analyses*, was visibly concerned with the task of inexorably blurring, by an extreme subtilization, the relation between the writer and his characters; by making of the narrator not he who has seen and felt nor even he who is writing, but he who is *going to write* (the young man in the novel—but, in fact, how old is he and who is he?—wants to write but cannot; the novel ends when writing at last becomes possible), Proust gave modern writing its epic. By a radical reversal, instead of putting his life into his novel, as is so often maintained, he made of his very life a work for which his own book was the model; so that it is clear to us that Charlus does not imitate Montesquiou but that Montesquiou—in his anecdotal, historical reality—is no more than a secondary fragment, derived from Charlus. Lastly, to go no further than this prehistory of modernity, Surrealism, though unable to accord language a supreme place (language being system and the aim of the movement being, romantically, a direct subversion of codes—itself moreover illusory: a code cannot be destroyed, only "played off"), contributed to the desacrilization of the image of the Author by ceaselessly recommending the abrupt disappointment of expectations of meaning (the famous surrealist "jolt"), by entrusting the hand with the task of writing as quickly as possible what the head itself is unaware of (automatic writing), by accepting the principle and the experience of several people writing together. Leaving aside literature itself (such distinctions really becoming invalid), linguistics has recently provided the destruction of the Author with a valuable analytical tool by showing that the whole of the enunciation is an empty process, functioning perfectly without there being any need for it to be filled with the person of the interlocutors. Linguistically, the author is never more than the instance of writing, just as *I* is nothing other than the instance of saying *I*: language knows a "subject," not a "person," and this subject, empty outside of the very enunciation which defines it, suffices to make language "hold together," suffices, that is to say, to exhaust it.

The removal of the Author (one could talk here with Brecht of a veritable "distancing," the Author diminishing like a figurine at the far end of the literary stage) is not merely an historical fact or an act of writing; it utterly transforms the modern text (or—which is the same thing—the text is henceforth made and read in such a way that at all its levels the author is absent). The temporality is different. The Author, when believed in, is always conceived of as the past of his own book: book and author stand automatically on a single line divided into a *before* and an *after*. The Author is thought to *nourish* the book, which is to say that he exists before it, thinks, suffers, lives for it, is in the same relation of antecedence to his work as a father to his child. In complete contrast, the modern scriptor is born simultaneously with the text, is in no way equipped with a being preceding or exceeding the writing, is not the subject with the book as predicate; there is no other time than that of the enunciation and every text is eternally written *here and now*. The fact is (or, it follows) that *writing* can no longer designate an operation of recording, notation, representation, "depiction" (as the Classics would say); rather, it designates exactly what linguists, referring to Oxford philosophy, call a performative, a rare verbal form (exclusively given in the first person and in the present tense) in which the enunciation has no other content (contains no other proposition) than the act by which it is uttered—something like the *I declare* of kings or the *I sing* of very ancient poets. Having buried the Author, the modern scriptor can thus no longer believe, as according to the pathetic view of his predecessors, that this hand is too slow for his thought or passion and that consequently, making a law of necessity, he must emphasize this delay and indefinitely "polish" his form. For him, on the contrary, the hand, cut off from any voice, borne by a pure gesture of inscription (and not of expression), traces a field without origin—or which, at least, has no other origin than language itself, language which ceaselessly calls into question all origins.

We know now that a text is not a line of words releasing a single "theological" meaning (the "message" of the Author-God) but a multi-dimensional space in which a variety of writings, none of them original, blend and clash. The text is a tissue of quotations drawn from the innumerable centres of culture. Similar to Bouvard and Pécuchet, those eternal copyists, at once sublime and comic and whose profound ridiculousness indicates precisely the truth of writing, the writer can only imitate a gesture that is always anterior, never original. His only power is to mix writings, to counter the ones with the others, in such a way as never to rest on any one of them. Did he wish to *express himself*, he ought at least to know that the inner "thing" he thinks to "translate" is itself only a ready-formed dictionary, its words only explainable through other words, and so on indefinitely; something experienced in exemplary fashion by the young Thomas de Quincey, he who was so good at Greek that in order to translate absolutely modern ideas and images into that dead language, he had, so Baudelaire tells us (in *Paradis Artificiels*), "created for himself an unfailing dictionary, vastly more extensive and complex than those resulting from the ordinary patience of purely literary themes." Succeeding the Author, the scriptor no longer bears within him passions, humours, feelings, impressions, but rather this immense dictionary from which he draws a writing that can know no halt: life never does more than imitate the book, and the book itself is only a tissue of signs, an imitation that is lost, infinitely deferred.

Once the Author is removed, the claim to decipher a text becomes quite futile. To give a text an Author is to impose a limit on that text, to furnish it with a final signified, to close the writing. Such a conception suits criticism very well, the latter then allotting itself the important task of discovering the Author (or its hypostases: society, history, psyché, liberty) beneath the work: when the Author has been found, the text is "explained"—victory to the critic. Hence there is no surprise in the fact that, historically, the reign of the Author has also been that of the Critic, nor again in the fact that criticism (be it new) is today undermined along with the Author. In the multiplicity of writing, everything is to be *disentangled*, nothing *deciphered*; the structure can be followed, "run" (like the thread of a stocking) at every point and at every level, but there is nothing beneath: the space of writing is to be ranged over, not pierced; writing ceaselessly posits meaning ceaselessly to evaporate it, carrying out a systematic exemption of meaning. In precisely this way literature (it would be better from now on to say *writing*), by refusing to assign a "secret," an ultimate meaning, to the text (and to the world as text), liberates what may be called an anti-theological activity, an activity that is truly revolutionary since to refuse to fix meaning is, in the end, to refuse God and his hypostases—reason, science, law.

Let us come back to the Balzac sentence. No one, no "person," says it: its source, its voice, is not the true place of the writing, which is reading. Another—very precise—example will help to make this clear: recent research (J.-P. Vernant[1]) has demonstrated the constitutively ambiguous nature of Greek tragedy, its texts being woven from words with double meanings that each character understands unilaterally (this perpetual misunderstanding is exactly the "tragic"); there is, however, someone who understands each word in its duplicity and who, in addition, hears the very deafness of the characters speaking in front of him—this someone being precisely the reader (or here, the listener). Thus is revealed the total existence of writing: a text is made of multiple writings, drawn from many cultures and entering into mutual relations of dialogue, parody, contestation, but there is one place where this multiplicity is focused and that place is the reader, not, as was hitherto said, the author. The reader is the space on which all the quotations that make up a writing are inscribed without any of them being lost; a text's unity lies not in its origin but in its destination. Yet this destination cannot any longer be personal: the reader is without history, biography, psychology; he is simply that *someone* who holds together in a single field all the traces by which the written text is constituted. Which is why it is derisory to condemn the new writing in the name of a humanism hypocritically turned champion of the reader's rights. Classic criticism has never paid any attention to the reader; for it, the writer is the only person in literature. We are now beginning to let ourselves be fooled no longer by the arrogant antiphrastical recriminations of good society in favour of the very thing it sets aside, ignores, smothers, or destroys; we know that to give writing its future, it is necessary to overthrow the myth: the birth of the reader must be at the cost of the death of the Author.

## NOTES

1. [Cf. Jean-Pierre Vernant (with Pierre Vidal-Naquet), *Mythe et tragédie en Grèce ancienne,* Paris 1972, esp. pp. 19–40, 99–131.]

# ALEXANDRE ASTRUC

## The Birth of a New Avant-Garde: La Caméra-Stylo

Alexandre Astruc (b. 1923) was educated in Paris where he worked as a literary and film critic after 1945. From 1969 to 1972 he was a television reporter for Radio Luxembourg, and through the course of his career he received several prestigious awards from the French government. Astruc wrote successful novels, including *Les Vacances* (1945), a book on philosopher Jean-Paul Sartre, and essays for influential journals such as *Combat* and *L'Écran français*. He also directed numerous films, including *Aller et Retour* (1948), *The Crimson Curtain* (1953), *End of Desire* (1958), and *The Fall of the House of Usher* (1981) for television. He is perhaps best known, however, for his critical writing, specifically "The Birth of a New Avant-Garde: La Caméra-Stylo," whose brash call for a new cinema reflects much of the revolutionary spirit of postwar French intellectual and artistic life.

The introduction of lightweight 16mm camera equipment featuring reflex viewing systems (like the Arriflex camera system from Germany and the Éclair Cameflex from France) made Astruc's vision of a "caméra-stylo"—that is, a camera with the mobility and flexibility of a pen—more than an intellectual metaphor. Somewhat coincidentally, the Paramount Decision of 1948 in the United States effectively began the breakup of the Hollywood studio system. This decision, coupled with global cinema's general sense of malaise about the adequacy of classical cinema to represent the new realities of the world and the individuals in it after the catastrophes of World War II, opened the door for a growing culture of independent cinema that would encourage the more personal and creative perspectives Astruc foresaw. The yearning for new directions or a "new avant-garde" can be seen in the Italian neorealist cinema that appeared in 1945 with Roberto Rossellini's *Rome, Open City* and, shortly after, with the gradual emergence of the French New Wave (for which Astruc's essay might be considered the first proclamation) and their backlash against the French so-called Tradition of Quality.

The publication of Astruc's essay in 1948 in *L'Écran français* made visible the wide-ranging implications of his positions on filmmaking and film criticism, where filmmakers turned to more personal topics and criticism began to hail directors with individual styles. To some extent, the essay looks back to Sergei Eisenstein's arguments about the dialectical language of film montage (p. 262) in its claims for a specific cinematic language that could articulate any subject or topic. Its impact on postwar filmmaking was, however, more significant. Within Astruc's circle, critics-turned-filmmakers such as Jean-Luc Godard, François Truffaut, and Alain Resnais, as well as others like Agnès Varda, began in the 1950s to articulate the need for more creative movies based on an appreciation of the filmmaker as auteur or author (p. 342), that primary figure behind a "caméra-stylo." As this group evolved into the French New Wave and its influence expanded through the 1960s and 1970s, these notions of a personal auteurist cinema and the creative construction of a language of cinema first made popular by Astruc's essay would become the

centerpieces of much film criticism and theory. Even today, the heritage of Astruc's essay remains extensive, anticipating the growing flexibilities and freedoms of digital cinema and the persistent critical importance of cinematic authors from Jane Campion to Quentin Tarantino.

## READING CUES & KEY CONCEPTS

■ Examine the literary analogy that is the basis for Astruc's argument: the "caméra-stylo" offers the freedom associated with that of a novelist or poet. In terms of both film production and film viewing, what seems accurate about this claim? What might complicate or even invalidate it? What does it suggest about adaptation studies?

■ Consider how Astruc's position is compatible or incompatible with other models for understanding movies, such as those that see film as a realistic or mimetic medium, or those concerned with a politics of film.

■ Astruc's vision is of a "cinema expressing ideas," making film "such a precise language that it will soon be possible to write ideas directly on film." What does he mean by this? Consider his film examples of this "new future for the cinema." Do they support these claims? Can you identify other, more recent, films that are primarily about "writing ideas"?

■ **Key Concepts:** Avant-Garde; Cinematic Expression of Thought; Film Language; Surrealism; Caméra-Stylo

# The Birth of a New Avant-Garde: La Caméra-Stylo

. . . . . . . . . . . . . .

*What interests me in the cinema is abstraction.*

Orson Welles

One cannot help noticing that something is happening in the cinema at the moment. Our sensibilities have been in danger of getting blunted by those everyday films which, year in year out, show their tired and conventional faces to the world.

The cinema of today is getting a new face. How can one tell? Simply by using one's eyes. Only a film critic could fail to notice the striking facial transformation which is taking place before our very eyes. In which films can this new beauty be found? Precisely those which have been ignored by the critics. It is not just a coincidence that Renoir's *La Règle du Jeu*, Welles's films, and Bresson's *Les Dames du Bois de Boulogne*, all films which establish the foundations of a new future for the cinema, have escaped the attention of critics, who in any case were not capable of spotting them.

But it is significant that the films which fail to obtain the blessing of the critics are precisely those which myself and several of my friends all agree about. We see in

them, if you like, something of the prophetic. That's why I am talking about *avant-garde*. There is always an *avant-garde* when something new takes place. . . .

To come to the point: the cinema is quite simply becoming a means of expression, just as all the other arts have been before it, and in particular painting and the novel. After having been successively a fairground attraction, an amusement analogous to boulevard theatre, or a means of preserving the images of an era, it is gradually becoming a language. By language, I mean a form in which and by which an artist can express his thoughts, however abstract they may be, or translate his obsessions exactly as he does in the contemporary essay or novel. That is why I would like to call this new age of cinema the age of *caméra-stylo* (camera-pen). This metaphor has a very precise sense. By it I mean that the cinema will gradually break free from the tyranny of what is visual, from the image for its own sake, from the immediate and concrete demands of the narrative, to become a means of writing just as flexible and subtle as written language. This art, although blessed with an enormous potential, is an easy prey to prejudice; it cannot go on for ever ploughing the same field of realism and social fantasy which has been bequeathed to it by the popular novel. It can tackle any subject, any genre. The most philosophical meditations on human production, psychology, metaphysics, ideas, and passions lie well within its province. I will even go so far as to say that contemporary ideas and philosophies of life are such that only the cinema can do justice to them. Maurice Nadeau wrote in an article in the newspaper *Combat*: "If Descartes lived today, he would write novels." With all due respect to Nadeau, a Descartes of today would already have shut himself up in his bedroom with a 16mm camera and some film, and would be writing his philosophy on film: for his *Discours de la Methods* would today be of such a kind that only the cinema could express it satisfactorily.

It must be understood that up to now the cinema has been nothing more than a show. This is due to the basic fact that all films are projected in an auditorium. But with the development of 16mm and television, the day is not far off when everyone will possess a projector, will go to the local bookstore and hire films written on any subject, of any form, from literary criticism and novels to mathematics, history, and general science. From that moment on, it will no longer be possible to speak of *the* cinema. There will be *several* cinemas just as today there are several literatures, for the cinema, like literature, is not so much a particular art as a language which can express any sphere of thought.

This idea of the cinema expressing ideas is not perhaps a new one. Feyder has said: "I could make a film with Montesquieu's *L'Esprit des Lois*." But Feyder was thinking of illustrating it "with pictures" just as Eisenstein had thought of illustrating Marx's *Capital* in book fashion. What I am trying to say is that the cinema is now moving towards a form which is making it such a precise language that it will soon be possible to write ideas directly on film without even having to resort to those heavy associations of images that were the delight of the silent cinema. In other words, in order to suggest the passing of time, there is no need to show falling leaves and then apple trees in blossom; and in order to suggest that a hero wants to make love there are surely other ways of going about it than showing a saucepan of milk boiling over on to the stove, as Douzot does in *Quai des Orfèvres*.

The fundamental problem of the cinema is how to express thought. The creation of this language has preoccupied all the theoreticians and writers in the history of the cinema, from Eisenstein down to the scriptwriters and adaptors of the sound cinema. But neither the silent cinema, because it was the slave of a static conception of the image, nor the classical sound cinema, as it has existed right up to now, has been able to solve this problem satisfactorily. The silent cinema thought it could get out of it through editing and the juxtaposition of images. Remember Eisenstein's famous statement: "Editing is for me the means of giving movement (i.e. an idea) to two static images." And when sound came, he was content to adapt theatrical devices.

One of the fundamental phenomena of the last few years has been the growing realisation of the dynamic, i.e. significant, character of the cinematic image. Every film, because its primary function is to move, i.e. to take place in time, is a theorem. It is a series of images which, from one end to the other, have an inexorable logic (or better even, a dialectic) of their own. We have come to realise that the meaning which the silent cinema tried to give birth to through symbolic association exists within the image itself, in the development of the narrative, in every gesture of the characters, in every line of dialogue, in those camera movements which relate objects to objects and characters to objects. All thought, like all feeling, is a relationship between one human being and another human being or certain objects which form part of his universe. It is by clarifying these relationships, by making a tangible allusion, that the cinema can really make itself the vehicle of thought. From today onwards, it will be possible for the cinema to produce works which are equivalent, in their profundity and meaning, to the novels of Faulkner and Malraux, to the essays of Sartre and Camus. Moreover we already have a significant example: Malraux's *L'Espoir*, the film which he directed from his own novel, in which, perhaps for the first time ever, film language is the exact equivalent of literary language.

Let us now have a look at the way people make concessions to the supposed (but fallacious) requirements of the cinema. Scriptwriters who adapt Balzac or Dostoievsky excuse the idiotic transformations they impose on the works from which they construct their scenarios by pleading that the cinema is incapable of rendering every psychological or metaphysical overtone. In their hands, Balzac becomes a collection of engravings in which fashion has the most important place, and Dostoievsky suddenly begins to resemble the novels of Joseph Kessel, with Russian-style drinking-bouts in night-clubs and troika races in the snow. Well, the only cause of these compressions is laziness and lack of imagination. The cinema of today is capable of expressing any kind of reality. What interests us is the creation of this new language. We have no desire to rehash those poetic documentaries and surrealist films of twenty-five years ago every time we manage to escape the demands of a commercial industry. Let's face it: between the pure cinema of the 1920s and filmed theatre, there is plenty of room for a different and individual kind of film-making.

This of course implies that the scriptwriter directs his own scripts; or rather, that the scriptwriter ceases to exist, for in this kind of film-making the distinction between author and director loses all meaning. Direction is no longer a means of illustrating or presenting a scene, but a true act of writing. The film-maker/author writes with his camera as a writer writes with his pen. In an art in which a length of film and sound-track is put in motion and proceeds, by means of a certain form and

a certain story (there can even be no story at all—it matters little), to evolve a philosophy of life, how can one possibly distinguish between the man who conceives the work and the man who writes it? Could one imagine a Faulkner novel written by someone other than Faulkner? And would *Citizen Kane* be satisfactory in any other form than that given to it by Orson Welles?

Let me say once again that I realise the term *avant-garde* savours of the surrealist and so-called abstract films of the 1920s. But that *avant-garde* is already old hat. It was trying to create a specific domain for the cinema; we on the contrary are seeking to broaden it and make it the most extensive and clearest language there is. Problems such as the translation into cinematic terms of verbal tenses and logical relationships interest us much more than the creation of the exclusively visual and static art dreamt of by the surrealists. In any case, they were doing no more than make cinematic adaptations of their experiments in painting and poetry.

So there we are. This has nothing to do with a school, or even a movement. Perhaps it could simply be called a tendency: a new awareness, a desire to transform the cinema and hasten the advent of an exciting future. Of course, no tendency can be so called unless it has something concrete to show for itself. The films will come, they will see the light of day—make no mistake about it. The economic and material difficulties of the cinema create the strange paradox whereby one can talk about something which does not yet exist; for although we know what we want, we do not know whether, when, and how we will be able to do it. But the cinema cannot but develop. It is an art that cannot live by looking back over the past and chewing over the nostalgic memories of an age gone by. Already it is looking to the future, for the future, in the cinema as elsewhere, is the only thing that matters.

# ANDREW SARRIS

## The Auteur Theory Revisited

Andrew Sarris (b. 1928) is one of America's most influential film commentators, a role he has enjoyed for the past four decades. Co-founder of the National Society of Film Critics, Sarris teaches at Columbia University and was, until 2009, film critic for the *New York Observer*. He is perhaps best known for coining and popularizing the term "auteur theory" as critic for the *Village Voice* during the 1950s and 1960s.

"Auteur theory" was Sarris's term for *la politique des auteurs*, the critical program developed by the critics of the French film journal *Cahiers du cinéma* that looked for a director's distinctive mark across his or her body of work. Sarris put this theory into practice in his book *The American Cinema, Directors and Directions 1929–1968* (1968), ranking studio-era Hollywood directors according to his own subjective criteria; what he called his "pantheon" included such directors as Orson Welles and John Ford. Among the critics of Sarris's positions were the *New Yorker*'s Pauline Kael and the novelist and screenwriter Gore Vidal. They argued that auteur theory diminished the contribution of other key creative personnel, including the screenwriter, in favor of a cult of the director.

In this 1977 essay, "The Auteur Theory Revisited," Sarris gives a rich picture of the critical controversies surrounding auteurism, clarifying the position he had originally laid out in "Notes on the Auteur Theory in 1962." In the earlier essay, he enumerates three criteria of value in assessing a director's oeuvre: technical competence, distinguishable personality, and the somewhat elusive "interior meaning" derived from "the tension between the director's personality and his material." Here, he historicizes the contribution of the *Cahiers* critics, singling out their attention to film's visual language and their refusal to distinguish film art from the commercial output of Hollywood. While he readily admits that auteurism is a tool for critics, not filmmakers, his own emphasis on the director's role helped pave the way for the rise of the new American cinema. Auteurism continues to shape both critical and commonsense approaches to both Hollywood and international directors.

## READING CUES & KEY CONCEPTS

▨ How does the anecdotal style of the essay give contemporary readers insight into film culture of the 1970s?

▨ Sarris reconsiders his earlier focus on the "romantic agony of the artist." What does he propose instead, and what methods of criticism does he recommend?

▨ Consider Sarris's comments at the beginning of the essay on the resurgence of auteurist approaches in 1977 in light of discourses on auteurism in the early twenty-first century.

▨ **Key Concepts:** Auteurism; Cult of the Director; Mise-en-Scène; Interior Meaning

# The Auteur Theory Revisited

. . . . . . . . . . . . . .

One would think that after so many years of furious controversy there would be no need for another article on the auteur theory. Yet all sorts of scholarly books and articles continue to disseminate an astounding amount of misinformation on the origin and evolution of auteurism. What to do? Having been officially credited or blamed for bringing the words *auteur, auteurism,* and *auteurist* into the English language, I seem to be stuck with these tar-baby terms for the rest of my life. My own previous writings on the subject have been compiled in *The Primal Screen,* a little-read volume that came out in 1973. "Notes on the Auteur Theory in 1962" first appeared in *Film Culture,* "Notes on the Auteur Theory in 1970" followed in *Film Comment,* and so now in 1977 a pattern of periodicity seems to justify my current endeavor. Also, auteurism seems to have become a scapegoat for just about every cultural affliction associated with the cinema.

For example, Gore Vidal (in the April *American Film*) associates auteurism with the deification of directors over writers in the moviemaking process. Speaking of Renoir's "great heist" of *The Southerner,* Vidal explains: "Renoir was a man who had great trouble speaking English, much less writing it, and the script was written by

William Faulkner. According to Zachary Scott, who acted in it, Faulkner really liked the script and would have been pleased to have had the credit. But Renoir so muddled the business that the credit finally read: 'Screenplay by Jean Renoir.'"

Unfortunately, Vidal neglects to mention that *The Southerner* was adapted from a novel entitled *Hold Autumn in Your Hand* by George Sessions Perry, the forgotten man in the anti-Renoir, pro-Faulkner anecdote. Who was George Sessions Perry? I have no idea, and neither, apparently, does Vidal. He is (or was) a veteran of the vast army of virtually anonymous authors who have supplied so many of the stories on the screen. Vidal's anecdote implies that Faulkner thought up the story of *The Southerner* all by himself, and Renoir then stole the script and "muddled" it, whatever that means. The anecdote loses something if Faulkner is revealed as the middleman in the screenwriting process. Until Vidal is prepared to research how much Faulkner's script owes to Perry's novel, the indictment of Renoir as a plagiarist must be thrown out for lack of evidence. Besides, Renoir's reputation does not rest excessively on *The Southerner* any more than Faulkner's reputation rests on his screenplays, credited or uncredited.

Both Renoir and Faulkner must be evaluated in terms of the total context of their careers. This is one of the basic assumptions of auteurism, one that we have always taken for granted in literature, music, and the fine arts, but one that came very late to cinema because of the lack of archival facilities. Hence, film history existed long before there were qualified historians to appraise it. It might be said that the early auteurists discovered so many lost and forgotten treasures in the cinemathèques that a theory of history was thrust upon them. They then suggested thematic and stylistic hypotheses which they sought to establish with the proof of a pattern of achievement. But movies were still alive and kicking, and individual careers were still evolving. Some auteurists had placed their bets on Hawks and Hitchcock, others on Renoir and Rossellini. Violent debates ensued between the partisans of Mizoguchi and Kurosawa, Dreyer and Bergman, Antonioni and Fellini, Walsh and Losey. No auteurist completely agreed with any other.

"The auteur theory itself," I wrote back in 1962, "is a pattern theory in constant flux." Despite all my disclaimers, qualifications, and reservations, however, a composite image of the auteurist emerged in anti-auteurist writings. Auteurists were invariably male (at least according to Pauline Kael). They never bathed because it took time away from their viewing of old movies. They shared a preposterous passion for Jerry Lewis. They preferred trash to art. They encouraged the younger generation not to read books.

Vidal himself seeks to establish a dialectical confrontation between the word and the image: "Movies are stories; only writers can tell stories. So the wrong people are making the movies." It might be argued by the defenders of directors that movies are stories told primarily through pictures, or, at least, movies *should* be stories told primarily through pictures. Vidal has an answer for that, too: "We do need the cameraman, the editor. But above all we need the script."

Vidal's position is not particularly audacious for Hollywood. One can imagine the ghosts of the old Hollywood moguls nodding in agreement with Vidal's summary dismissal of directors. All you need to make a good movie is a good story. Everybody on the Bel Air circuit knows *that*. A few years ago *Esquire* published a screenplay entitled *Two-Lane Blacktop* with a come-on across the cover to the effect that this

was going to be the best movie of the year. When the critics and public failed to concur with *Esquire*'s prediction, the magazine sheepishly shifted the blame to director Monte Hellman, accusing him of being an auteur. Actually, *Two-Lane Blacktop* was not a bad movie. Choking on the exhaust fumes of the more vulgar and more violent *Easy Rider*, it never caught on at the box office with its subtly modernist malaise, and a brilliant performance by Warren Oates was wasted. This is one of the problems in resolving arguments between auteurists and anti-auteurists: The two sides can never agree entirely on what is good and what is bad. In opposition to the horror stories of Gore Vidal and Rex Reed, there is even a small cult for the movie version of *Myra Breckenridge*.

If one were to examine the pertinent texts of the fifties, the sixties, or the seventies, one would be hard put to find a single generalization in auteurist criticism sweeping enough to justify the simplistic attacks made against it. For one thing, auteurism did not evolve in a vacuum. In the beginning, particularly, its preoccupation with visual structure and personal style was largely a reaction against the sloganized vocabulary of social significance and socialist realism. The open-minded and open-hearted French attitude toward myth and genre enabled a new generation of American critics to rediscover and reclaim the American cinema. Suddenly there was credit to parcel out for Hollywood's long-despised out-put, whereas before the auteurists there was only blame. After years on the front lines, my own attitude to the auteurist controversy may have been summed up in the defiant words sung by the late Edith Piaf: "*Non, non, je ne regrette rien.*"

Still, if I had to do it all over again, I would reformulate the auteur theory with a greater emphasis on the tantalizing mystery of style than on the romantic agony of the artists. Why, I wondered back in the mid-fifties, had so many Hollywood movies endured as classics despite the generalized contempt of the highbrows? The auteur theory turned out to be a very workable hypothesis for this task of historical reevaluation. But I was never all that interested in the clinical "personalities" of directors, and I have never considered the interview as one of the indispensable weapons in my critical arsenal.

The interview is an autonomous art form like any other, and it follows that directors who give good interviews do not necessarily make good movies, and directors who give bad interviews do not necessarily make bad movies. I am, if anything, anti-interview in that I believe that a director's formal utterances (his films) tell us more about his artistic personality than do his informal utterances (his conversations).

That is why I was far more strongly influenced by the cinemathèque-oriented critics on *Cahiers du Cinéma* before 1960 than the tape-recorder interviewers on *Cahiers du Cinéma* after 1960. It is not a question simply of Truffaut, Godard, Chabrol, Rohmer, Rivette, Valcroze, and others validating their pre-1960 critiques with their post-1960 filmmaking. I doubt that Gore Vidal has any notion of what Truffaut was writing about back in 1954 when Truffaut first articulated *la politique des auteurs* as an attack on the tradition of quality in the French cinema. Godard's translated criticism has merely mystified even his most determined American admirers. Having published twelve editions of *Cahiers du Cinéma in English* between 1965 and 1967, I can testify that many of my French-speaking acquaintances in America were frequently unable to decipher the cryptic pronouncements of *Cahiers*.

Indeed, few people seem to be aware that my original article on the auteur theory was largely an examination of André Bazin's critique of *la politique des auteurs*. Vidal lumps together all French film critics into one monolithic auteurist block as if *Cahier*ism was a national vice. Yet *Cahiers* never sold more than fifteen thousand copies of any monthly issue, and its opinions were violently opposed by other specialized French film publications, most notably and most persistently by *Positif,* which made a point of preferring Huston to Hitchcock, and Fellini to Rossellini. For every Bazin in French film criticism there were a dozen French Bosley Crowthers and Siegfried Kracauers. One did not have to be an auteurist or a *Cahier*ist to adore Jerry Lewis. He happened to be a very catholic French taste. In fact, the most prominent of the Lewis lovers were on the staff of *Positif.*

Similarly, the auteurists of the fifties and sixties did not introduce the cult of the director. Dwight MacDonald and John Grierson were writing very knowledgeably about Hollywood directors back in the early thirties. The great majority of film histories around the world have been organized in terms of the collected works of individual directors. If, as Vidal implies, all that auteurism represents is an emphasis on directors, this so-called theory should be banished for its banality.

A great deal of confusion has been caused by the assumption that auteurism was inseparably linked with the personal tastes of individual critics. Since I was one of the first two American auteurists (along with the late Eugene Archer), I must bear a large part of the blame for this confusion. Let me state at this point, albeit belatedly, that auteurism and Sarrisism are not identical. Both, I hope, have been evolving over the past quarter of a century on a widening front of scholarly activity. Along the way, certain tendencies have clustered around auteurism to form a basis for discussion. Among these tendencies have been the antimontage writings of André Bazin, the many French meditations on mise-en-scène, Lawrence Alloway's celebrations of pop art, and Peter Wollen's valiant efforts to reconcile auteurism with semiotics. Some of these formulations conflicted with others to such an extent that alleged auteurists were often at one another's throats. I have written extensively on many of these internal conflicts, and I have no desire to rehash them now. What I propose instead is a report on the theoretical fallout from the polemical explosions of the past. An attempt will be made to add historical perspective to auteurism, and to emerge with a usable residue of critical theory for 1977.

Bazin's most striking contribution to film aesthetics was the restoration of interest in the integrity of the visual field. If he did not actually demolish the montage theories of Eisenstein, Pudovkin, Kuleshov, and Vertov, he did succeed in reducing these theories from imperatives to options. Bazin's writings were never systematic enough or comprehensive enough to establish new imperatives, and there is little indication that he ever wished to establish a new orthodoxy to replace the old. But he did change the way many critics looked at motion pictures. No longer was the ambiguity of the individual image disdained for the dialectical conflict between successive images. Examining both the deep focus shots in *Citizen Kane* and the slow pans in *Open City*, Bazin managed to link these two otherwise dissimilar films in the very ingenious concept of optical realism.

When Bazin's writings first began to filter across the Atlantic in the mid-fifties, the American cinema was in the midst of a formal crisis with wide screens. Most American reviewers either ignored the width altogether or dealt with it in isolation

from the script. Wide-screen color canvases like *East of Eden* and *Rebel without a Cause* were reviewed in America as if they were small-screen, black-and-white Philco Television Playhouse productions like *Marty*. I recall Claude Chabrol's attack on my review of *East of Eden* as "*ennuyeux*." He was right to the extent that my critique did not do justice to the film's emotional sweep encompassed in tilted, distended compositions.

American movies are often discriminated against in America because the ear takes precedence over the eye. By contrast, the French were able to provide a detailed visual analysis of American movies precisely because they were undistracted by the dialogue. To an American ear *Rebel without a Cause* is still gravely flawed by its undigested clinical dialogue. But one would have to be blind to fail to realize that Ray has transcended the tedious social worker rhetoric of the film with a succession of striking initiatory ceremonies all filmed with profound splendor. And it is to our everlasting disgrace that the French understood James Dean on a mythic level long before we did. Similarly, they understood how deeply Alfred Hitchcock's *Vertigo* had influenced Alain Resnais and Alain Robbe-Grillet's *Last Year at Marienbad*. While the New York critics were honoring Stanley Kramer's *The Defiant Ones*, the *Cahiers* critics were cheering Orson Welles's *Touch of Evil*. Obviously, their eyes were quicker than our ears.

Although in the long run they could not have the last word on the American cinema, they gave many of us the first glimpse of this elusive entity. American film criticism has not been the same since. There was a time when movies were judged almost entirely in terms of an absolute fidelity to social reality. Good intentions alone were too often considered the paving stones to heaven. By establishing the notion of individual creation in even the Hollywood cinema, the French shifted the critical emphasis away from the nature of content to the director's attitude toward content.

This attitude was expressed through a somewhat mystical process called mise-en-scène, defined perhaps most eloquently by French critic-director Alexandre Astruc:

> But Mizoguchi knows well that, after all, it is not very important for his film to turn out well; he is more concerned with knowing whether the strongest bonds between himself and his characters are those of tenderness or contempt. He is like the viewer who sees the reflection of pleasure on the features of the one he watches, even though he also knows quite well that it is not this reflection alone which he is seeking but perhaps quite simply the tedious confirmation of something he has always known but cannot refrain from verifying. So I consider mise-en-scène as a means of transforming the world into a spectacle given primarily to oneself—yet what artist does not know instinctively that what is seen is less important than the way of seeing, or of a certain way of needing to see or be seen.

As I wrote some years ago, I would suggest a definition of mise-en-scène that includes all the means available to a director to express his attitude toward his subject. This takes in cutting, camera movement, pacing, the direction of players and their placement in the decor, the angle and distance of the camera, and even the content of the shot. Mise-en-scène as an attitude tends to accept the cinema as it is and enjoy it for what it is—a sensuous conglomeration of all the other arts.

Bazin, Astruc, and Roger Leehardt caused a ferment in film aesthetics by demystifying so-called "pure" cinema. There was no such entity, they insisted. We could now discuss hitherto verboten subjects such as adaptations without placing surgical masks over our faces. What were once considered germs from the other arts were now treated as vitamins. Hence, whereas Agee worried that Olivier's film treatment of *Henry V* was not truly cinematic, Bazin applauded Olivier for honoring cinema by honoring theater.

The French critics tended to brush aside the distinctions between cinema as a medium and cinema as an art form. "The cinema is everything," Godard declared. And he meant it. Every scrap of film was grist for his sensibility. The cinema was no longer a holy temple to which only certain sanctified works were admitted. Cinema was to be found on every movie screen in the world, and Hollywood movies were no less cinematic than anything else. There was still room for disagreement in this new critical climate, but the disputes were couched in terms more relative than absolute.

About the time that auteurism was swimming across the English Channel to London's moviemanes and across the Atlantic to New York's film cultists, pop art exploded all across the cultural landscape, and nothing has seemed the same since. The two movements converged uneasily in the sixties in such multifaceted artifacts as Richard Lester's *A Hard Day's Night* with the Beatles, John Boorman's *Having a Wild Weekend* with the Dave Clark Five, Jean-Luc Godard's *One Plus One* with the Rolling Stones, the experimental kinetics of Frank Zappa, and the personal appearances on film of Bob Dylan.

Lawrence Alloway, who had coined the term "pop art," proposed "a criticism of movies as a pop art which can have a critical currency beyond that of footnotes and preposterous learning." Alloway thereby came into conflict with the scholarly tendencies of auteurism. The terms in which he defined the cinema—whether as "the index of a Baudelairean art of modern life" with "modernity" defined by Baudelaire as "that which is ephemeral, fugitive, contingent upon the occasion" or as "the art synthesis proposed by Wagner, the total work to which all arts contribute"—were terms that pertained more to sociological criticism than to auteurist criticism. For the hard-core auteurists, the hitherto despised Hollywood movies could be judged as high art. For Alloway, high art had been supplanted by pop art, and new forms of judgment were required. Alloway's stress on the topicality and expendability of movies as consumer products was not without a certain ironic condescension toward the medium. By contrast, most auteurists tended to view movies as sacred relics of a spiritual medium. Their tone was reverent and, hence, vulnerable. Their only excuse (and mine) was that they thought that they were writing only for other believers.

No one to my knowledge has ever commented on the Kierkegaard quotation from *Either/Or* with which I introduced my 1962 auteur article:

> I call these sketches shadowgraphs, partly by the designation to remind you at once that they derive from the darker side of life, partly because like other shadowgraphs they are not directly visible. When I take a shadowgraph in my hand, it makes no impression on me, and gives me no clear conception of it. Only when I hold it up opposite the wall, and now look not directly at it, but at that which appears on the wall, am I able to see it. So also with the picture which

does not become perceptible until I see through the external. This external is perhaps quite unobtrusive but not until I look through it do I discover that inner picture which I desire to show you, an inner picture too delicately drawn to be outwardly visible, woven as it is of the tenderest moods of the soul.

Kierkegaard's "inner picture" eventually found its way into my essay as "interior meaning," a term that gave me a great deal of trouble at the time, but one that has since come to define what all serious film criticism seeks to discover. Auteurism has less to do with the way movies are made than with the way they are elucidated and evaluated. It is more a critical instrument than a creative inspiration. Peter Wollen has suggested the hypothetical nature of the enterprise, and I will go along with that. The cinema is a deep, dark mystery that we auteurists are attempting to solve. It is a labyrinth with a treacherous resemblance to reality. I suppose that the difference between auteurists and structuralists is the difference between knowing all the questions before finding the answers, and knowing all the answers before formulating the questions.

At this late date I am prepared to concede that auteurism is and always has been more a tendency than a theory, more a mystique than a methodology, more an editorial policy than an aesthetic procedure. Contrary to anti-auteurist legends, auteurist critics around the world are an unruly lot. For the most part, they do not describe themselves as auteurists. They are content to describe the stylistic and thematic epiphanies of their favorite auteurs.

# PETER WOLLEN

# The Auteur Theory

FROM *Signs and Meaning in the Cinema*

Born in London in 1938, Peter Wollen is a film theorist, filmmaker, screenwriter, political journalist, and Professor Emeritus in the Department of Film, Television and New Media at the University of California, Los Angeles. He is a key contributor to such influential journals as *New Left Review, Screen,* and *Framework,* and the author of several scholarly works, of which the best known is his seminal work in film and structuralist theory, *Signs and Meaning in the Cinema* (1969), in which the selection included here first appeared. Wollen also has an interesting and rich career as a filmmaker, which he began as a co-writer of Michelangelo Antonioni's *The Passenger* (1975). His directorial debut, *Penthesilea: Queen of the Amazons* (1974) is the first of six films co-written and co-directed with fellow film theorist, Laura Mulvey (p. 713), to whom he was married. Their films, a combination of radical political thought and avant-garde form, present a challenge to conventional film technique. In 1977, Wollen and Mulvey collaborated on *The Riddles of the Sphinx,* a fusion of feminism and formal experimentation, which is often seen as one of the most theoretically rigorous films to emerge out of the 1970s. In 1998, Wollen curated an exhibition, "Addressing the

Century: 100 Years of Art and Fashion," at the Hayward Gallery in London and published a new and expanded edition of *Signs and Meaning in the Cinema*.

François Truffaut's 1954 essay in *Cahiers du cinéma* that attacked the French Tradition of Quality and lauded the Hollywood studio system and the auteurism of such Hollywood directors as Nicholas Ray, Orson Welles, and Alfred Hitchcock catalyzed the growth of auteur theory during the 1950s. However, it also incited fierce arguments over artistic authority. With the emergence of structuralist and semiotic theory in the 1960s, which emphasized meaning as a product of larger cultural forces and social construction, the position that film was an expression of the creative will of individual auteurs was soon displaced. Wollen takes a structuralist approach to auteurism, maintaining the idea of the author, but perceiving it as a critical construct rather than an individual creator. Countering the arguments of Andrew Sarris, the primary American spokesperson for auteurism, for whom the director was the main criterion of value and originator of meaning (p. 354), Wollen insists that the purpose of auteur analysis is to reveal a structure within the work that shapes it and gives it a certain pattern.

Wollen's "The Auteur Theory" is one of the most significant contributions to the debates in auteur theory. Emerging out of the influences of structuralism and the Left in London in the late 1960s, it can be seen as a reaction to, and a revision of, the auteur theory that came to dominate film criticism in the 1950s and 1960s. Wollen distinguishes between the films of "metteurs-en-scène" and the films of "auteurs." For him, the films of metteurs-en-scène are mere cinematic translations from script to screen, and value remains on the level of form or performance, whereas the films of auteurs have a "semantic dimension" that can be revealed by the structural analysis of the patterns and shifting relations in a body of work. Wollen's position represents a transitional moment in film criticism between auteur theory and structuralism and poststructuralism, both of which see the author as a socially constructed site. This moment is perhaps most emblematically represented by Roland Barthes (p. 345) who famously announces "the death of the author," defining the concept as being merely a discursive instance in the process of reading or watching.

## READING CUES & KEY CONCEPTS

■ Wollen's auteur theory fuses the individualism of auteurism and the impersonal science of structuralism. Consider how he reconciles these two seemingly contradictory paradigms.

■ Wollen says that auteur theory has survived, despite its diffuse nature, because it is "indispensable" for a film critic. To what extent is a consideration of the author a necessary part of film analysis?

■ Wollen asserts that "the film is not a communication, but an artifact which is unconsciously structured in a certain way." Given this position, what is the usefulness of maintaining the concept of the auteur?

■ **Key Concepts:** Auteur Theory; Metteur-en-Scène; Structural Analysis; Semantics; Antinomies; Corpus; Decipherment

# The Auteur Theory

. . . . . . . . . . . . . .

The *politique des auteurs*—the auteur theory, as Andrew Sarris calls it—was developed by the loosely knit group of critics who wrote for *Cahiers du Cinéma* and made it the leading film magazine in the world. It sprang from the conviction that the American cinema was worth studying in depth, that masterpieces were made not only by a small upper crust of directors, the cultured gilt on the commercial gingerbread, but by a whole range of authors, whose work had previously been dismissed and consigned to oblivion. There were special conditions in Paris which made this conviction possible. Firstly, there was the fact that American films were banned from France under the Vichy government and the German Occupation. Consequently, when they reappeared after the Liberation they came with a force—and an emotional impact—which was necessarily missing in the Anglo-Saxon countries themselves. And, secondly, there was a thriving ciné-club movement, due in part to the close connections there had always been in France between the cinema and the intelligentsia: witness the example of Jean Cocteau or André Malraux. Connected with this ciné-club movement was the magnificent Paris *Cinémathèque*, the work of Henri Langlois, a great auteur, as Jean-Luc Godard described him. The policy of the *Cinémathèque* was to show the maximum number of films, to plough back the production of the past in order to produce the culture in which the cinema of the future could thrive. It gave French *cinéphiles* an unmatched perception of the historical dimensions of Hollywood and the careers of individual directors.

The auteur theory grew up rather haphazardly; it was never elaborated in programmatic terms, in a manifesto or collective statement. As a result, it could be interpreted and applied on rather broad lines; different critics developed somewhat different methods within a loose framework of common attitudes. This looseness and diffuseness of the theory has allowed flagrant misunderstandings to take root, particularly among critics in Britain and the United States. Ignorance has been compounded by a vein of hostility to foreign ideas and a taste for travesty and caricature. However, the fruitfulness of the auteur approach has been such that it has made headway even on the most unfavourable terrain. For instance, a recent straw poll of British critics, conducted in conjunction with a Don Siegel Retrospective at the National Film Theatre, revealed that, among American directors most admired, a group consisting of Budd Boetticher, Samuel Fuller and Howard Hawks ran immediately behind Ford, Hitchcock and Welles, who topped the poll, but ahead of Billy Wilder, Josef Von Sternberg and Preston Sturges.

Of course, some individual directors have always been recognised as outstanding: Charles Chaplin, John Ford, Orson Welles. The auteur theory does not limit itself to acclaiming the director as the main author of a film. It implies an operation of decipherment; it reveals authors where none had been seen before. For years, the model of an author in the cinema was that of the European director, with open artistic aspirations and full control over his films. This model still lingers on; it lies behind the existential distinction between art films and popular films. Directors who built their reputations in Europe were dismissed after they crossed the Atlantic, reduced to anonymity. American Hitchcock was contrasted unfavourably with English Hitchcock, American Renoir with French Renoir, American Fritz Lang

with German Fritz Lang. The auteur theory has led to the revaluation of the second, Hollywood careers of these and other European directors; without it, masterpieces such as *Scarlet Street* or *Vertigo* would never have been perceived. Conversely, the auteur theory has been sceptical when offered an American director whose salvation has been exile to Europe. It is difficult now to argue that *Brute Force* has ever been excelled by Jules Dassin or that Joseph Losey's recent work is markedly superior to, say, *The Prowler*.

In time, owing to the diffuseness of the original theory, two main schools of auteur critics grew up: those who insisted on revealing a core of meanings, of thematic motifs, and those who stressed style and *mise en scène*. There is an important distinction here, which I shall return to later. The work of the auteur has a semantic dimension, it is not purely formal; the work of the *metteur en scène*, on the other hand, does not go beyond the realm of performance, of transposing into the special complex of cinematic codes and channels a pre-existing text: a scenario, a book or a play. As we shall see, the meaning of the films of an auteur is constructed *a posteriori*; the meaning—semantic, rather than stylistic or expressive—of the films of a *metteur en scène* exists a *priori*. In concrete cases, of course, this distinction is not always clear-cut. There is controversy over whether some directors should be seen as auteurs or *metteurs en scène*. For example, though it is possible to make intuitive ascriptions, there have been no really persuasive accounts as yet of Raoul Walsh or William Wyler as auteurs, to take two very different directors. Opinions might differ about Don Siegel or George Cukor. Because of the difficulty of fixing the distinction in these concrete cases, it has often become blurred; indeed, some French critics have tended to value the *metteur en scène* above the auteur. MacMahonism sprang up, with its cult of Walsh, Lang, Losey and Preminger, its fascination with violence and its notorious text: "Charlton Heston is an axiom of the cinema." What André Bazin called "aesthetic cults of personality" began to be formed. Minor directors were acclaimed before they had, in any real sense, been identified and defined.

Yet the auteur theory has survived despite all the hallucinating critical extravaganzas which it has fathered. It has survived because it is indispensable. Geoffrey Nowell-Smith has summed up the auteur theory as it is normally presented today:

> One essential corollary of the theory as it has been developed is the discovery that the defining characteristics of an author's work are not necessarily those which are most readily apparent. The purpose of criticism thus becomes to uncover behind the superficial contrasts of subject and treatment a hard core of basic and often recondite motifs. The pattern formed by these motifs . . . is what gives an author's work its particular structure, both defining it internally and distinguishing one body of work from another.

It is this "structural approach," as Nowell-Smith calls it, which is indispensable for the critic.

The test case for the auteur theory is provided by the work of Howard Hawks. Why Hawks, rather than, say, Frank Borzage or King Vidor? Firstly, Hawks is a director who has worked for years within the Hollywood system. His first film, *Road to Glory*, was made in 1926. Yet throughout his long career he has only once received general critical acclaim, for his wartime film, *Sergeant York*, which closer inspection

reveals to be eccentric and atypical of the main *corpus* of Hawks's films. Secondly, Hawks has worked in almost every genre. He has made westerns (*Rio Bravo*), gangsters (*Scarface*), war films (*Air Force*), thrillers (*The Big Sleep*), science fiction (*The Thing from Another World*), musicals (*Gentlemen Prefer Blondes*), comedies (*Bringing up Baby*), even a Biblical epic (*Land of the Pharaohs*). Yet all of these films (except perhaps *Land of the Pharaohs*, which he himself was not happy about) exhibit the same thematic preoccupations, the same recurring motifs and incidents, the same visual style and tempo. In the same way that Roland Barthes constructed a species of *homo racinianus*, the critic can construct a *homo hawksianus*, the protagonist of Hawksian values in the problematic Hawksian world.

Hawks achieved this by reducing the genres to two basic types: the adventure drama and the crazy comedy. These two types express inverse views of the world, the positive and negative poles of the Hawksian vision. Hawks stands opposed, on the one hand, to John Ford and, on the other hand, to Budd Boetticher. All these directors are concerned with the problem of heroism. For the hero, as an individual, death is an absolute limit which cannot be transcended: it renders the life which preceded it meaningless, absurd. How then can there be any meaningful individual action during life? How can individual action have any value—be heroic—if it cannot have transcendent value, because of the absolutely devaluing limit of death? John Ford finds the answer to this question by placing and situating the individual within society and within history, specifically within American history. Ford finds transcendent values in the historic vocation of America as a nation, to bring civilisation to a savage land, the garden to the wilderness. At the same time, Ford also sees these values themselves as problematic; he begins to question the movement of American history itself. Boetticher, on the contrary, insists on a radical individualism. "I am not interested in making films about mass feelings. I am for the individual." He looks for values in the encounter with death itself: the underlying metaphor is always that of the bull-fighter in the arena. The hero enters a group of companions, but there is no possibility of group solidarity. Boetticher's hero acts by dissolving groups and collectivities of any kind into their constituent individuals, so that he confronts each person face-to-face; the films develop, in Andrew Sarris's words, into "floating poker games, where every character takes turns at bluffing about his hand until the final showdown." Hawks, unlike Boetticher, seeks transcendent values beyond the individual, in solidarity with others. But, unlike Ford, he does not give his heroes any historical dimension, any destiny in time.

For Hawks the highest human emotion is the camaraderie of the exclusive, self-sufficient, all-male group. Hawks's heroes are cattlemen, marlin-fishermen, racing-drivers, pilots, big-game hunters, habituated to danger and living apart from society, actually cut off from it physically by dense forest, sea, snow or desert. Their aerodromes are fog-bound; the radio has cracked up; the next mail-coach or packet-boat does not leave for a week. The *élite* group strictly preserves its exclusivity. It is necessary to pass a test of ability and courage to win admittance. The group's only internal tensions come when one member lets the others down (the drunk deputy in *Rio Bravo*, the panicky pilot in *Only Angels Have Wings*) and must redeem himself by some act of exceptional bravery, or occasionally when too much "individualism" threatens to disrupt the close-knit circle (the rivalry between drivers in *Red Line 7000*, the fighter pilot among the bomber crew in *Air Force*). The group's security

is the first commandment: "You get a stunt team in acrobatics in the air—if one of them is no good, then they're all in trouble. If someone loses his nerve catching animals, then the whole bunch can be in trouble." The group members are bound together by rituals (in *Hatari!* blood is exchanged by transfusion) and express themselves univocally in communal sing-songs. There is a famous example of this in *Rio Bravo.* In *Dawn Patrol* the camaraderie of the pilots stretches even across the enemy lines: a captured German ace is immediately drafted into the group and joins in the sing-song; in *Hatari!* hunters of different nationality and in different places join together in a song over an intercom radio system.

Hawks's heroes pride themselves on their professionalism. They ask: "How good is he? He'd better be good." They expect no praise for doing their job well. Indeed, none is given except: "The boys did all right." When they die, they leave behind them only the most meagre personal belongings, perhaps a handful of medals. Hawks himself has summed up this desolate and barren view of life:

> It's just a calm acceptance of a fact. In *Only Angels Have Wings*, after Joe dies, Cary Grant says: "He just wasn't good enough." Well, that's the only thing that keeps people going. They just have to say: "Joe wasn't good enough, and I'm better than Joe, so I go ahead and do it." And they find out they're not any better than Joe, but then it's too late, you see.

In Ford films, death is celebrated by funeral services, an impromptu prayer, a few staves of "Shall we gather at the river?"—it is inserted into an ongoing system of ritual institutions, along with the wedding, the dance, the parade. But for Hawks it is enough that the routine of the group's life goes on, a routine whose only relieving features are "danger" (*Hatari!*) and "fun." Danger gives existence pungency: "Every time you get real action, then you have danger. And the question, 'Are you living or not living?' is probably the biggest drama we have." This nihilism, in which "living" means no more than being in danger of losing your life—a danger entered into quite gratuitously—is augmented by the Hawksian concept of having "fun." The word "fun" crops up constantly in Hawks's interviews and scripts. It masks his despair.

When one of Hawks's *élite* is asked, usually by a woman, why he risks his life, he replies: "No reason I can think of makes any sense. I guess we're just crazy." Or Feathers, sardonically, to Colorado in *Rio Bravo*: "You haven't even the excuse I have. We're all fools." By "crazy" Hawks does not mean psychopathic: none of his characters are like Turkey in Peckinpah's *The Deadly Companions* or Billy the Kid in Penn's *The Left-Handed Gun*. Nor is there the sense of the absurdity of life which we sometimes find in Boetticher's films: death, as we have seen, is for Hawks simply a routine occurrence, not a *grotesquerie*, as in *The Tall T* ("Pretty soon that well's going to be chock-a-block") or *The Rise and Fall of Legs Diamond*. For Hawks "craziness" implies difference, a sense of apartness from the ordinary, everyday, social world. At the same time, Hawks sees the ordinary world as being "crazy" in a much more fundamental sense, because devoid of any meaning or values. "I mean crazy reactions—I don't think they're crazy, I think they're normal—but according to bad habits we've fallen into they seemed crazy." Which is the normal, which the abnormal? Hawks recognises, inchoately, that to most people his heroes, far from embodying rational values, are only a dwindling band of eccentrics. Hawks's "kind of men" have no place in the world.

The Hawksian heroes, who exclude others from their own *élite* group, are themselves excluded from society, exiled to the African bush or to the Arctic. Outsiders, other people in general, are perceived by the group as an undifferentiated crowd. Their role is to gape at the deeds of the heroes whom, at the same time, they hate. The crowd assembles to watch the showdown in *Rio Bravo*, to see the cars spin off the track in *The Crowd Roars*. The gulf between the outsider and the heroes transcends enmities among the *élite*: witness *Dawn Patrol* or Nelse in *El Dorado*. Most dehumanised of all is the crowd in *Land of the Pharaohs*, employed in building the Pyramids. Originally the film was to have been about Chinese labourers building a "magnificent airfield" for the American army, but the victory of the Chinese Revolution forced Hawks to change his plans. ("Then I thought of the building of the Pyramids; I thought it was the same kind of story.") But the presence of the crowd, of external society, is a constant covert threat to the Hawksian *élite*, who retaliate by having "fun." In the crazy comedies ordinary citizens are turned into comic butts, lampooned and tormented: the most obvious target is the insurance salesman in *His Girl Friday*. Often Hawks's revenge becomes grim and macabre. In *Sergeant York* it is "fun" to shoot Germans "like turkeys"; in *Air Force* it is "fun" to blow up the Japanese fleet. In *Rio Bravo* the geligniting of the badmen "was very funny." It is at these moments that the *élite* turns against the world outside and takes the opportunity to be brutal and destructive.

Besides the covert pressure of the crowd outside, there is also an overt force which threatens: woman. Man is woman's "prey." Women are admitted to the male group only after much disquiet and a long ritual courtship, phased round the offering, lighting and exchange of cigarettes, during which they prove themselves worthy of entry. Often they perform minor feats of valour, even then though they are never really full members. A typical dialogue sums up their position:

> *Woman:* You love him, don't you?
> *Man* (embarrassed): Yes ... I guess so. ...
> *Woman:* How can I love him like you?
> *Man:* Just stick around.

The undercurrent of homosexuality in Hawks's films is never crystallised, though in *The Big Sky*, for example, it runs very close to the surface. And he himself described *A Girl in Every Port* as "really a love story between two men." For Hawks men are equals, within the group at least, whereas there is a clear identification between women and the animal world, most explicit in *Bringing Up Baby*, *Gentlemen Prefer Blondes* and *Hatari!* Man must strive to maintain his mastery. It is also worth noting that, in Hawks's adventure dramas and even in many of his comedies, there is no married life. Often the heroes were married, or at least intimately committed, to a woman at some time in the distant past but have suffered an unspecified trauma, with the result that they have been suspicious of women ever since. Their attitude is "Once bitten, twice shy." This is in contrast to the films of Ford, which almost always include domestic scenes. Woman is not a threat to Ford's heroes; she falls into her allotted social place as wife and mother, bringing up the children, cooking, sewing, a life of service, drudgery and subordination. She is repaid for this by being sentimentalised. Boetticher, on the other hand, has no obvious place for women at all; they are phantoms, who provoke action, are pretexts for male modes of conduct,

but have no authentic significance in themselves. "In herself, the woman has not the slightest importance."

Hawks sees the all-male community as an ultimate; obviously it is very retrograde. His Spartan heroes are, in fact, cruelly stunted. Hawks would be a lesser director if he was unaffected by this, if his adventure dramas were the sum total of his work. His real claim as an author lies in the presence, together with the dramas, of their inverse, the crazy comedies. They are the agonised exposure of the underlying tensions of the heroic dramas. There are two principal themes, zones of tension. The first is the theme of regression: of regression to childhood, infantilism, as in *Monkey Business*, or regression to savagery: witness the repeated scene of the adult about to be scalped by painted children, in *Monkey Business* and in *The Ransom of Red Chief*. With brilliant insight, Robin Wood has shown how *Scarface* should be categorised among the comedies rather than the dramas: Camonte is perceived as savage, childlike, subhuman. The second principal comedy theme is that of sex-reversal and role-reversal. *I Was a Male War Bride* is the most extreme example. Many of Hawks's comedies are centred round domineering women and timid, pliable men: *Bringing Up Baby* and *Man's Favourite Sport*, for example. There are often scenes of male sexual humiliation, such as the trousers being pulled off the hapless private eye in *Gentlemen Prefer Blondes*. In the same film, the Olympic Team of athletes are reduced to passive objects in an extraordinary Jane Russell song number; big-game hunting is lampooned, like fishing in *Man's Favourite Sport*; the theme of infantilism

***Gentlemen Prefer Blondes*** **(1953)** Men's Olympic team reduced to passive objects.

***Bringing Up Baby*** **(1938)**   Reversed gender roles in Howard Hawks's comedies.

***Hatari!*** **(1962)**   Identification between woman and the animal world.

crops up again: "The child was the most mature one on board the ship, and I think he was a lot of fun."

Whereas the dramas show the mastery of man over nature, over woman, over the animal and childish; the comedies show his humiliation, his regression. The heroes become victims; society, instead of being excluded and despised, breaks in with irruptions of monstrous farce. It could well be argued that Hawks's outlook, the alternative world which he constructs in the cinema, the Hawksian heterocosm, is not one imbued with particular intellectual subtlety or sophistication. This does not detract from its force. Hawks first attracted attention because he was regarded naïvely as an action director. Later, the thematic content which I have outlined was detected and revealed. Beyond the stylemes, semantemes were found to exist; the films were anchored in an objective stratum of meaning, a plerematic stratum, as the Danish linguist Hjelmslev would put it. Thus the stylistic expressiveness of Hawks's films was shown to be not purely contingent, but grounded in significance.

Something further needs to be said about the theoretical basis of the kind of schematic exposition of Hawks's work which I have outlined. The "structural approach" which underlies it, the definition of a core of repeated motifs, has evident affinities with methods which have been developed for the study of folklore and mythology. In the work of Olrik and others, it was noted that in different folk-tales the same motifs reappeared time and time again. It became possible to build up a lexicon of these motifs. Eventually Propp showed how a whole cycle of Russian fairy-tales could be analysed into variations of a very limited set of basic motifs (or moves, as he called them). Underlying the different, individual tales was an archi-tale, of which they were all variants. One important point needs to be made about this type of structural analysis. There is a danger, as Lévi-Strauss has pointed out, that by simply noting and mapping resemblances, all the texts which are studied (whether Russian fairy-tales or American movies) will be reduced to one, abstract and impoverished. There must be a moment of synthesis as well as a moment of analysis: otherwise, the method is formalist, rather than truly structuralist. Structuralist criticism cannot rest at the perception of resemblances or repetitions (redundancies, in fact), but must also comprehend a system of differences and oppositions. In this way, texts can be studied not only in their universality (what they all have in common) but also in their singularity (what differentiates them from each other). This means of course that the test of a structural analysis lies not in the orthodox canon of a director's work, where resemblances are clustered, but in films which at first sight may seem eccentricities.

In the films of Howard Hawks a systematic series of oppositions can be seen very near the surface, in the contrast between the adventure dramas and the crazy comedies. If we take the adventure dramas alone it would seem that Hawks's work is flaccid, lacking in dynamism; it is only when we consider the crazy comedies that it becomes rich, begins to ferment: alongside every dramatic hero we are aware of a phantom, stripped of mastery, humiliated, inverted. With other directors, the system of oppositions is much more complex: instead of there being two broad strata of films there are a whole series of shifting variations. In these cases, we need to analyse the roles of the protagonists themselves, rather than simply the worlds in which they operate. The protagonists of fairy-tales or myths, as Lévi-Strauss has

pointed out, can be dissolved into bundles of differential elements, pairs of opposites. Thus the difference between the prince and the goose-girl can be reduced to two antinomic pairs: one natural, male versus female, and the other cultural, high versus low. We can proceed with the same kind of operation in the study of films, though, as we shall see, we shall find them more complex than fairy-tales.

It is instructive, for example, to consider three films of John Ford and compare their heroes: Wyatt Earp in *My Darling Clementine*, Ethan Edwards in *The Searchers* and Tom Doniphon in *The Man Who Shot Liberty Valance*. They all act within the recognisable Ford world, governed by a set of oppositions, but their *loci* within that world are very different. The relevant pairs of opposites overlap; different pairs are foregrounded in different movies. The most relevant are garden versus wilderness, ploughshare versus sabre, settler versus nomad, European versus Indian, civilised versus savage, book versus gun, married versus unmarried, East versus West. These antinomies can often be broken down further. The East, for instance, can be defined either as Boston or Washington and, in *The Last Hurrah*, Boston itself is broken down into the antipodes of Irish immigrants versus Plymouth Club, themselves bundles of such differential elements as Celtic versus Anglo-Saxon, poor versus rich, Catholic versus Protestant, Democrat versus Republican, and so on. At first sight, it might seem that the oppositions listed above overlap to the extent that they become practically synonymous, but this is by no means the case. As we shall see, part of the development of Ford's career has been the shift from an identity between civilised versus savage and European versus Indian to their separation and final reversal, so that in *Cheyenne Autumn* it is the Europeans who are savage, the victims who are heroes.

The master antinomy in Ford's films is that between the wilderness and the garden. As Henry Nash Smith has demonstrated, in his magisterial book *Virgin Land*, the contrast between the image of America as a desert and as a garden is one which has dominated American thought and literature, recurring in countless novels, tracts, political speeches and magazine stories. In Ford's films it is crystallised in a number of striking images. *The Man Who Shot Liberty Valance*, for instance, contains the image of the cactus rose, which encapsulates the antinomy between desert and garden which pervades the whole film. Compare with this the famous scene in *My Darling Clementine*, after Wyatt Earp has gone to the barber (who civilises the unkempt), where the scent of honeysuckle is twice remarked upon: an artificial perfume, cultural rather than natural. This moment marks the turning-point in Wyatt Earp's transition from wandering cowboy, nomadic, savage, bent on personal revenge, unmarried, to married man, settled, civilised, the sheriff who administers the law.

Earp, in *My Darling Clementine*, is structurally the most simple of the three protagonists I have mentioned: his progress is an uncomplicated passage from nature to culture, from the wilderness left in the past to the garden anticipated in the future. Ethan Edwards, in *The Searchers*, is more complex. He must be defined not in terms of past versus future or wilderness versus garden compounded in himself, but in relation to two other protagonists: Scar, the Indian chief, and the family of homesteaders. Ethan Edwards, unlike Earp, remains a nomad throughout the film. At the start, he rides in from the desert to enter the log-house; at the end, with perfect symmetry, he leaves the house again to return to the desert, to vagrancy.

In many respects, he is similar to Scar; he is a wanderer, a savage, outside the law: he scalps his enemy. But, like the homesteaders, of course, he is a European, the mortal foe of the Indian. Thus Edwards is ambiguous; the antinomies invade the personality of the protagonist himself. The oppositions tear Edwards in two; he is a tragic hero. His companion, Martin Pawley, however, is able to resolve the duality; for him, the period of nomadism is only an episode, which has meaning as the restitution of the family, a necessary link between his old home and his new home.

Ethan Edwards's wandering is, like that of many other Ford protagonists, a quest, a search. A number of Ford films are built round the theme of the quest for the Promised Land, an American re-enactment of the Biblical exodus, the journey through the desert to the land of milk and honey, the New Jerusalem. This theme is built on the combination of the two pairs: wilderness versus garden and nomad versus settler; the first pair precedes the second in time. Thus, in *Wagonmaster*, the Mormons cross the desert in search of their future home; in *How Green Was My Valley* and *The Informer*, the protagonists want to cross the Atlantic to a future home in the United States. But, during Ford's career, the situation of home is reversed in time. In *Cheyenne Autumn* the Indians journey in search of the home they once had in the past; in *The Quiet Man*, the American Sean Thornton returns to his ancestral home in Ireland. Ethan Edwards's journey is a kind of parody of this theme: his object is not constructive, to found a home, but destructive, to find and scalp Scar. Nevertheless, the weight of the film remains orientated to the future: Scar has burned down the home of the settlers, but it is replaced and we are confident that the homesteader's wife, Mrs. Jorgensen, is right when she says: "Some day this country's going to be a fine place to live." The wilderness will, in the end, be turned into a garden.

*The Man Who Shot Liberty Valance* has many similarities with *The Searchers*. We may note three: the wilderness becomes a garden—this is made quite explicit, for Senator Stoddart has wrung from Washington the funds necessary to build a dam which will irrigate the desert and bring real roses, not cactus roses; Tom Doniphon shoots Liberty Valance as Ethan Edwards scalped Scar; a log-home is burned to the ground. But the differences are equally clear: the log-home is burned after the death of Liberty Valance; it is destroyed by Doniphon himself; it is his own home. The burning marks the realisation that he will never enter the Promised Land, that to him it means nothing; that he has doomed himself to be a creature of the past, insignificant in the world of the future. By shooting Liberty Valance he has destroyed the only world in which he himself can exist, the world of the gun rather than the book; it is as though Ethan Edwards had perceived that by scalping Scar, he was in reality committing suicide. It might be mentioned too that, in *The Man Who Shot Liberty Valance*, the woman who loves Doniphon marries Senator Stoddart. Doniphon when he destroys his log-house (his last words before doing so are "Home, sweet home!") also destroys the possibility of marriage.

The themes of *The Man Who Shot Liberty Valance* can be expressed in another way. Ransom Stoddart represents rational-legal authority, Tom Doniphon represents charismatic authority. Doniphon abandons his charisma and cedes it, under what amount to false pretences, to Stoddart. In this way charismatic and rational-legal authority are combined in the person of Stoddart and stability thus assured.

In *The Searchers* this transfer does not take place; the two kinds of authority remain separated. In *My Darling Clementine* they are combined naturally in Wyatt Earp, without any transfer being necessary. In many of Ford's late films—*The Quiet Man, Cheyenne Autumn, Donovan's Reef*—the accent is placed on traditional authority. The island of Ailakaowa, in *Donovan's Reef,* a kind of Valhalla for the homeless heroes of *The Man Who Shot Liberty Valance*, is actually a monarchy, though complete with the Boston girl, wooden church and saloon, made familiar by *My Darling Clementine*. In fact, the character of Chihuahua, Doc Holliday's girl in *My Darling Clementine*, is split into two: Miss Lafleur and Lelani, the native princess. One represents the saloon entertainer, the other the non-American in opposition to the respectable Bostonians, Amelia Sarah Dedham and Clementine Carter. In a broad sense, this is a part of a general movement which can be detected in Ford's work to equate the Irish, Indians and Polynesians as traditional communities, set in the past, counter-posed to the march forward to the American future, as it has turned out in reality, but assimilating the values of the American future as it was once dreamed.

It would be possible, I have no doubt, to elaborate on Ford's career, as defined by pairs of contrasts and similarities, in very great detail, though—as always with film criticism—the impossibility of quotation is a severe handicap. My own view is that Ford's work is much richer than that of Hawks and that this is revealed by a structural analysis; it is the richness of the shifting relations between antinomies in Ford's work that makes him a great artist, beyond being simply an undoubted auteur. Moreover, the auteur theory enables us to reveal a whole complex of meaning in films such as *Donovan's Reef,* which a recent filmography sums up as just "a couple of Navy men who have retired to a South Sea island [and] now spend most of their time raising hell." Similarly, it throws a completely new light on a film like *Wings of Eagles*, which revolves, like *The Searchers*, round the vagrancy versus home antinomy, with the difference that when the hero does come home, after flying round the world, he trips over a child's toy, falls down the stairs and is completely paralysed so that he cannot move at all, not even his toes. This is the macabre *reductio ad absurdum* of the settled.

Perhaps it would be true to say that it is the lesser auteurs who can be defined, as Nowell-Smith put it, by a core of basic motifs which remain constant, without variation. The great directors must be defined in terms of shifting relations, in their singularity as well as their uniformity. Renoir once remarked that a director spends his whole life making one film; this film, which it is the task of the critic to construct, consists not only of the typical features of its variants, which are merely its redundancies, but of the principle of variation which governs it, that is its esoteric structure, which can only manifest itself or "seep to the surface," in Lévi-Strauss's phrase, "through the repetition process." Thus Renoir's "film" is in reality a "kind of permutation group, the two variants placed at the far ends being in a symmetrical, though inverted, relationship to each other." In practice, we will not find perfect symmetry, though as we have seen, in the case of Ford, some antinomies are completely reversed. Instead, there will be a kind of torsion within the permutation group, within the matrix, a kind of exploration of certain possibilities, in which some antinomies are foregrounded, discarded or even inverted, whereas others remain stable and constant. The important thing to stress, however, is that it is only

the analysis of the whole *corpus* which permits the moment of synthesis when the critic returns to the individual film.

Of course, the director does not have full control over his work; this explains why the auteur theory involves a kind of decipherment, decryptment. A great many features of films analysed have to be dismissed as indecipherable because of "noise" from the producer, the cameraman or even the actors. This concept of "noise" needs further elaboration. It is often said that a film is the result of a multiplicity of factors, the sum total of a number of different contributions. The contribution of the director—the "directorial factor," as it were—is only one of these, though perhaps the one which carries the most weight. I do not need to emphasise that this view is quite the contrary of the auteur theory and has nothing in common with it at all. What the auteur theory does is to take a group of films—the work of one director— and analyse their structure. Everything irrelevant to this, everything non-pertinent, is considered logically secondary, contingent, to be discarded. Of course, it is possible to approach films by studying some other feature; by an effort of critical ascesis we could see films, as Von Sternberg sometimes urged, as abstract light-show or as histrionic feasts. Sometimes these separate texts—those of the cameraman or the actors—may force themselves into prominence so that the film becomes an indecipherable palimpsest. This does not mean, of course, that it ceases to exist or to sway us or please us or intrigue us; it simply means that it is inaccessible to criticism. We can merely record our momentary and subjective impressions.

[ · · · ]

What the auteur theory demonstrates is that the director is not simply in command of a performance of a pre-existing text; he is not, or need not be, only a *metteur en scène*. Don Siegel was recently asked on television what he took from Hemingway's short story for his film, *The Killers*; Siegel replied that "the only thing taken from it was the catalyst that a man has been killed by somebody and he did not try to run away." The word Siegel chose—"catalyst"—could not be bettered. Incidents and episodes in the original screenplay or novel can act as catalysts; they are the agents which are introduced into the mind (conscious or unconscious) of the auteur and react there with the motifs and themes characteristic of his work. The director does not subordinate himself to another author; his source is only a pretext, which provides catalysts, scenes which fuse with his own preoccupations to produce a radically new work. Thus the manifest process of performance, the treatment of a subject, conceals the latent production of a quite new text, the production of the director as an auteur.

Of course, it is possible to value performances as such, to agree with André Bazin that Olivier's *Henry V* was a great film, a great rendering, transposition into the cinema, of Shakespeare's original play. The great *metteurs en scène* should not be discounted simply because they are not auteurs: Vincente Minnelli, perhaps, or Stanley Donen. And, further than that, the same kind of process can take place that occurred in painting: the director can deliberately concentrate entirely on the stylistic and expressive dimensions of the cinema. He can say, as Josef Von Sternberg did about *Morocco*, that he purposely chose a fatuous story so that people would not be distracted from the play of light and shade in the photography. Some of Busby Berkeley's extraordinary sequences are equally detached from any

kind of dependence on the screenplay: indeed, more often than not, some other director was entrusted with the job of putting the actors through the plot and dialogue. Moreover, there is no doubt that the greatest films will be not simply auteur films but marvellous expressively and stylistically as well: *Lola Montès, Shinheike Monogatari, La Règle du Jeu, La Signora di Tutti, Sansho Dayu, Le Carrosse d'Or.*

The auteur theory leaves us, as every theory does, with possibilities and questions. We need to develop much further a theory of performance, of the stylistic, of graded rather than coded modes of communication. We need to investigate and define, to construct critically the work of enormous numbers of directors who up to now have only been incompletely comprehended. We need to begin the task of comparing author with author. There are any number of specific problems which stand out: Donen's relationship to Kelly and Arthur Freed, Boetticher's films outside the Ranown cycle, Welles's relationship to Toland (and—perhaps more important—Wyler's), Sirk's films outside the Ross Hunter cycle, the exact identity of Walsh or Wellman, the decipherment of Anthony Mann. Moreover there is no reason why the auteur theory should not be applied to the English cinema, which is still utterly amorphous, unclassified, unperceived. We need not two or three books on Hitchcock and Ford, but many, many more. We need comparisons with authors in the other arts: Ford with Fenimore Cooper, for example, or Hawks with Faulkner. The task which the critics of *Cahiers du Cinéma* embarked on is still far from completed.

# TANIA MODLESKI

. . . . . . . . . . . . . . . . . . . . . . . . . . . . . . . . . . . . . . . . . . . . . . . . . . . . . . . . .

# Hitchcock, Feminism, and the Patriarchal Unconscious

FROM *The Women Who Knew Too Much*

One of the foremost figures in feminist film theory, Tania Modleski received her doctoral degree from Stanford University and is currently Florence R. Scott Professor of English at the University of Southern California. Drawing from psychoanalysis, feminist theory, cultural criticism, and popular culture, she has published numerous articles in significant film journals, such as *Camera Obscura, Screen,* and *Film Quarterly,* and authored such books as *Loving with a Vengeance* (1982) and *Feminism without Women* (1991). She is perhaps best known for her 1988 study of Hitchcock's cinematic representation of women, *The Women Who Knew Too Much.* Modleski's work offers an important intervention into the debates in feminist film theory and theories of the cinematic apparatus and spectatorship by moving beyond the critique of the representation of women in film and popular culture into the underlying assumptions of theory itself.

Questioning the very premises on which auteur and feminist theory were built, Modleski's study of Hitchcock significantly shifted the ground of debate on female spectatorship and the pleasures of mainstream cinema, offered a new perspective on

Hitchcock as an auteur, and presented a forceful critique of some of the major tenets of contemporary film theory. She questions the commonly held belief in auteur theory that directors are the masters of their discourse and demonstrates that Hitchcock's cinematic discourse, and in particular his representation of women, is not as unified and unambiguous as auteur theory has suggested. Yet, she does not believe that this ambivalence erases Hitchcock's authorship, as structuralism would have it, but rather it is evidence of the contradictory, and often unintended and unconscious, structure of an auteur's work. Modleski's position is comparable to Peter Wollen's challenges to classical auteur theory (p. 361), as she subverts directorial authority and traces the ambivalence within an auteur's body of work without undermining it completely. Even more radical are Modleski's challenges to what she calls "the founding document of psychoanalytic feminist film theory," Laura Mulvey's "Visual Pleasure and Narrative Cinema" (p. 713), which uses Hitchcock's work as a prime example to assert that classical Hollywood narrative inevitably molds female characters into passive objects of male voyeuristic desire and in turn defines female spectatorship and identification as masochistic.

In the introduction to *The Women Who Knew Too Much* included here, Modleski discusses the centrality of Hitchcock's films in feminist film criticism, both for feminists who argue that classical narrative cinema constructs the female figure as a passive object, and for those who argue that Hitchcock's women present a threat precisely because they are *not* passive. Modleski intervenes on both sides of the debate by showing the fundamental ambivalence of Hitchcock's films, the conflicting "ways in which masculine identity is bound up with feminine identity." She complicates the straightforward notion of identity and identification by engaging the problem of the "double desire" of the female spectator (passive and active, homosexual and heterosexual), a concept introduced by Teresa de Lauretis (p. 573), as well as men's fascination and identification with the feminine. Male and female socialization patterns, she argues, are thus invoked in Hitchcock only "to reveal the difficulties inherent in these processes." Modleski's work is crucial to both auteur theory and feminist film theory, reinvigorating the discussions on the dynamics of mainstream cinema and anticipating such works as Carol J. Clover's 1992 study of horror cinema, *Men, Women, and Chain Saws* (p. 511).

## READING CUES & KEY CONCEPTS

- Consider what Modleski means by her argument that "not only is it possible to argue that feminist consciousness is the mirror of patriarchal consciousness, but one might argue as well that the patriarchal *unconscious* lies in femininity." What are the implications of such a statement?

- Many feminists argue that feminist film criticism and women's cinema should focus on creating an alternative, specifically feminine vision, rather than merely deconstruct a dominant, patriarchal vision. What are the advantages or disadvantages of Modleski's project, which is focused on the latter—a critique of a male director's vision?

- After reading Modleski's critique, do you think Hitchcock's status as auteur is still justified? Why or why not?

- **Key Concepts:** Masochism; Female Spectatorship; Identification; Ambivalence

# Hitchcock, Feminism, and the Patriarchal Unconscious

· · · · · · · · · · · · · ·

## Hitchcock and Feminist Film Theory

In providing for a number of his films to be withheld from circulation for rerelease many years later, Alfred Hitchcock has ensured that his popularity with a fickle filmgoing public remains as strong as ever. With this ploy, by which he has managed to continue wielding an unprecedented power over a mass audience, Hitchcock betrays a resemblance to one of his favorite character types—the person who exerts an influence from beyond the grave. That this person is often a woman—Rebecca in the film of the same name, Carlotta and Madeleine in *Vertigo*, Mrs. Bates in *Psycho*—is not without interest or relevance to [my] thesis. Hitchcock's great need (exhibited throughout his life as well as in his death) to insist on and exert authorial control may be related to the fact that his films are always in danger of being subverted by females whose power is both fascinating and seemingly limitless.

Such ghostly manipulations on Hitchcock's part would be ineffective, however, were it not for the fact that the films themselves possess an extraordinary hold on the public's imagination. Of course, some critics have been inclined to dismiss the films' appeal by attributing it simply to the mass audience's desire for sensational violence—usually directed against women—and "cheap, erotic" thrills, to quote "Mrs. Bates." While these critics find themselves increasingly in the minority, it is nevertheless somewhat surprising to reflect on the extent to which *feminists* have found themselves compelled, intrigued, infuriated, and inspired by Hitchcock's works.

In fact, the films of Hitchcock have been central to the formulation of feminist film theory and to the practice of feminist film criticism. Laura Mulvey's essay, "Visual Pleasure and Narrative Cinema," which may be considered the founding document of psychoanalytic feminist film theory, focuses on Hitchcock's films in order to show how women in classic Hollywood cinema are inevitably made into passive objects of male voyeuristic and sadistic impulses; how they exist simply to fulfill the desires and express the anxieties of the men in the audience; and how, by implication, women filmgoers can only have a masochistic relation to this cinema.[1] Since the publication of Mulvey's essay in 1975, a number of feminist articles on Hitchcock films have tended to corroborate her insights.

Believing that the representation of women in film is more complicated than Mulvey's article allows, I published an article in 1982 on Hitchcock's first American film, *Rebecca*, which was based on the best selling "female Gothic" novel by Daphne du Maurier.[2] There I argued that some films do allow for the (limited) expression of a specifically female desire and that such films, instead of following the male oedipal journey, which film theorists like Raymond Bellour see as the trajectory of *all* Hollywood narrative, trace a female oedipal trajectory, and in the process reveal some of the difficulties for women in becoming socialized in patriarchy.[3] Subsequently, Teresa de Lauretis in *Alice Doesn't* referred to that essay and to Hitchcock's films *Rebecca* and *Vertigo* to develop a theory of the female spectator. According to de Lauretis, identification on the part of women at the cinema is much more complicated than feminist theory has understood: far from being simply masochistic, the female spectator

is always caught up in a double desire, identifying at one and the same time not only with the passive (female) object, but with the active (usually male) subject.[4]

Mulvey herself has had occasion to rethink some of her essay's main points and has done so in part through a reading of Hitchcock's *Notorious* that qualifies the condemnation of narrative found in "Visual Pleasure."[5] Other feminists have returned, almost obsessively, to Hitchcock in order to take up other issues, fight other battles. In an extremely interesting essay on *The Birds*, for example, Susan Lurie analyzes a segment that has also been analyzed by Raymond Bellour: the ride out and back across Bodega Bay. Lurie is concerned to dispute the Lacanian theory relied on so heavily by Bellour and Mulvey—particularly in the latter's argument that woman's body signifies lack and hence connotes castration for the male. In Lurie's view, women like Melanie Daniels in *The Birds* are threatening not because they automatically connote castration, but because they *don't*, and so the project of narrative cinema is precisely to "castrate" the woman whose strength and perceived wholeness arouses dread in the male.[6] Thus, if de Lauretis is primarily interested in complicating Mulvey's implied notion of femininity, Lurie is chiefly concerned with questioning certain aspects of Mulvey's theory of masculinity and masculine development. And both develop their arguments through important readings of Hitchcock's films.

Recently, Robin Wood, a male critic who has been a proponent of Hitchcock's films for many years, has become interested in these issues.[7] In the 1960s, Wood's book—the first in English on Hitchcock—set out to address the question, "Why should we take Hitchcock seriously?" In the 1980s, Wood declares, the question must be, "Can Hitchcock be saved for feminism?"—though his very language, implying the necessity of rescuing a favorite auteur from feminist obloquy, suggests that the question is fundamentally a rhetorical one. And indeed, although Wood claims in his essay not to be interested in locating "an uncontaminated feminist discourse in the films," he proceeds to minimize the misogyny in them and to analyze both *Rear Window* and *Vertigo* as exposés of the twisted logic of patriarchy, relatively untroubled by ambivalence or contradiction.

It may be symptomatic that in contrast to the female critics I have mentioned, the stated goal of the one male critic concerned with feminism is to reestablish the authority of the artist—to "save" Hitchcock. For Wood, political "progressiveness" has come to replace moral complexity as the criterion by which to judge Hitchcock's art, but the point remains the same—to justify the ways of the auteur to the filmgoing public. The feminist critics I have mentioned, by contrast, use Hitchcock's works as a means to elucidate issues and problems relevant to women in patriarchy. In so doing these critics implicitly challenge and decenter directorial authority by considering Hitchcock's work as the expression of cultural attitudes and practices existing to some extent outside the artist's control. My own work is in the irreverent spirit of this kind of feminist criticism and is, if anything, more explicitly "deconstructionist" than this criticism has generally tended to be. Thus, one of my main theses is that time and again in Hitchcock films, the strong fascination and identification with femininity revealed in them subverts the claims to mastery and authority not only of the male characters but of the director himself.

This is not to say that I am entirely unsympathetic to Wood's position. Indeed, this critic's work seems to me an important corrective to studies which see in Hitchcock only the darkest misogynistic vision. But what I want to argue is *neither* that Hitchcock

is utterly misogynistic *nor* that he is largely sympathetic to women and their plight in patriarchy, but that his work is characterized by a thoroughgoing ambivalence about femininity—which explains why it has been possible for critics to argue with some plausibility on either side of the issue. It also, of course, explains why the issue can never be resolved and why, when one is reading criticism defending or attacking Hitchcock's treatment of women, one continually experiences a feeling of "yes, but. . . ." [My] book aims to account, often through psychoanalytic explanations, for the ambivalence in the work of Hitchcock. In the process, it continually demonstrates that despite the often considerable violence with which women are treated in Hitchcock's films, they remain resistant to patriarchal assimilation.

In order to explain the ambivalence in these films, I will be especially concerned with showing the ways in which masculine identity is bound up with feminine identity—both at the level of society as well as on the individual, psychological level. In this respect, the book will confirm that what Fredric Jameson says about ruling class literature is also true of patriarchal cultural production. According to Jameson in *The Political Unconscious*, consciousness on the part of the oppressed classes, expressed, "initially, in the unarticulated form of rage, helplessness, victimization, oppression by a common enemy," generates a "mirror image of class solidarity among the ruling groups. . . . This suggests . . . that the *truth* of ruling-class consciousness . . . is to be found in working-class consciousness."[8] Similarly, in Hitchcock, the "truth" of patriarchal consciousness lies in feminist consciousness and depends precisely on the depiction of victimized women found so often in his films. The paradox is such, then, that male solidarity (between characters, director, spectators, as the case may be) entails giving expression to women's feelings of "rage, helplessness, victimization, oppression." This point is of the greatest consequence for a theory of the female spectator. Insofar as Hitchcock films repeatedly reveal the way women are oppressed in patriarchy, they allow the female spectator to feel an anger that is very different from the masochistic response imputed to her by some feminist critics.

Not only is it possible to argue that feminist consciousness is the mirror of patriarchal consciousness, but one might argue as well that the patriarchal *un*conscious lies in femininity (which is not, however, to equate femininity with the unconscious). Psychoanalysis has shown that the process by which the male child comes to set the mother at a distance is of very uncertain outcome, which helps to explain why it is continually necessary for man to face the threat woman poses and to work to subdue that threat both in life and in art. The dynamics of identification and identity, I will argue, are fraught with difficulties and paradoxes that are continually reflected and explored in Hitchcock films.[9] To take an example suggestive of Jameson's mirror metaphor, when Scottie Ferguson in *Vertigo* begins investigating the mysterious Madeleine Elster, the first point of view shot shows him as a mirror image of the woman, and the rest of the film traces the vicissitudes of Scottie's attempts to reassert a masculinity lost when he failed in his performance of the law.

By focusing on the problematics of identity and identification, then, this study aims to insert itself in the debates circulating around Hitchcock's films and to examine some of the key theoretical issues developed in the various critiques. On the one hand, I seek to engage the problem of the female spectator, especially in the analysis of those films told from the woman's point of view (i.e., *Blackmail*, *Rebecca*, and *Notorious*). But even some of those films which seem exclusively to adopt the male point of view, like

*Murder!*, *Rear Window*, or *Vertigo*, may be said either to have woman as the ultimate point of identification or to place the spectator—regardless of gender—in a classically "feminine" position. On the other hand, then, my intent is to problematize *male* spectatorship and masculine identity in general. The analysis will reveal that the question which continually—if sometimes implicitly—rages around Hitchcock's work as to whether he is sympathetic towards women or misogynistic is fundamentally unanswerable because he is both.[10] Indeed, as we shall see, the misogyny and the sympathy actually entail one another—just as Norman Bates's close relationship with his mother provokes his lethal aggression towards other women.

## The Female Spectator

As the figure of Norman Bates suggests, what both male and female spectators are likely to see in the mirror of Hitchcock's films are images of ambiguous sexuality that threaten to destabilize the gender identity of protagonists and viewers alike. Although in *Psycho* the mother/son relationship is paramount, I will argue that in films from *Rebecca* on it is more often the mother/daughter relationship that evokes this threat to identity and constitutes the main "problem" of the films. In *Vertigo*, for example, Madeleine is the (great grand)daughter of Carlotta Valdez who seems to possess the heroine so thoroughly that the latter loses her individuality. *Rebecca's* heroine experiences a similar difficulty in relation to the powerful Rebecca, first wife of the heroine's husband. Marnie's main "problem"—as far as patriarchy is concerned—is an excessive attachment to her mother that prevents her from achieving a "normal," properly "feminine," sexual relationship with a man. In other films, the mother figure is actually a mother-in-law, but one who so closely resembles the heroine, it is impossible to escape the suspicion that the mother/daughter relationship is actually what is being evoked. In *Notorious*, both Alicia and her mother-in-law have blonde hair and foreign accents; and in *The Birds*, there is an uncanny resemblance between Melanie Daniels and Mitch's mother, Lydia. In all these films, moreover, Hitchcock manipulates point of view in such a way that the spectator him/herself is made to share the strong sense of identification with the (m)other.

As feminists have recently stressed, the mother/daughter relationship is one of the chief factors contributing to the bisexuality of women—a notion that several critics have argued is crucial to any theory of the female spectator seeking to rescue women from "silence, marginality, and absence." Very soon after the publication of Mulvey's essay, feminist critics began to approach this idea of female bisexuality in order to begin to explain women's experience of film. A consideration of this experience, they felt, was lacking in Mulvey's work, which thereby seemed to collaborate unwittingly in patriarchy's plot to render women invisible. In a much quoted discussion among film critics and filmmakers Michelle Citron, Julia Lesage, Judith Mayne, B. Ruby Rich, and Anna Marie Taylor that appeared in *New German Critique* in 1978, one of the major topics was the bisexuality of the female spectator. In the course of the discussion, the participants, attempting to counter what might be called the "compulsory heterosexuality" of mainstream film, concluded that more attention needs to be paid to women's erotic attraction to other women—to, for example, Marlene Dietrich not only as a fetishized object of male desire, which is how Mulvey had seen her, but as a female star with an "underground reputation" among lesbians as "a kind of subcultural icon."[11] Several of

the participants stressed that female eroticism is obviously going to differ from male eroticism; the experience of the female spectator is bound to be more complex than a simple passive identification with the female object of desire or a straightforward role reversal—a facile assumption of the transvestite's garb. Julia Lesage insisted, "Although women's sexuality has been shaped under a dominant patriarchal culture, clearly women do not respond to women in film and the erotic element in quite the same way that men do, given that patriarchal film has the structure of a male fantasy" (p. 89). In other words, there must be other options for the female spectator than the two pithily described by B. Ruby Rich: "to identify either with Marilyn Monroe or with the man behind me hitting the back of my seat with his knees" (p. 87).

Several of the women in this discussion were strenuously anti-Freudian, claiming that Freud's framework cannot account for the position of female spectators. Recent Freudian and neo-Freudian accounts of women's psychic development in patriarchy and applications of these accounts to issues in feminist film theory have, however, suggested otherwise. Thus Gertrud Koch, addressing the question of "why women go to men's movies," refers to Freud's theory of female bisexuality, which is rooted in woman's preoedipal attachment to her mother. This attachment, it will be remembered, came as a momentous discovery to Freud and resulted in his having to revise significantly his theories of childhood sexuality and to recognize the fundamental asymmetry in male and female development.[12] The female's attachment to the mother, Freud came to understand, often goes "unresolved" throughout woman's life and coexists with her later heterosexual relationships. Hence, Teresa de Lauretis's notion of a "double desire" on the part of the female spectator—a desire that is *both* passive and active, homosexual and heterosexual. Koch speculates that men's need to prohibit and punish female voyeurism is attributable to their concern about women's pleasure in looking at other women: "Man's fear of permitting female voyeurism stems not only from fear of women looking at other men and drawing (to him perhaps unfavorable) comparisons but is also connected to a fear that women's bisexuality could make them competitors for the male preserve."[13]

In her book, *Women and Film: Both Sides of the Camera*, feminist film critic E. Ann Kaplan draws on the neo-Freudian work of Julia Kristeva to make a similar point about men's repression of the "nonsymbolic" (preoedipal) aspects of motherhood. According to Kristeva/Kaplan, patriarchy must repress these nonsymbolic aspects of motherhood because of the "homosexual components" involved in the mother/daughter relationship.[14] Elsewhere, Kaplan analyzes *Stella Dallas*, a film about an intense mother/daughter relationship, in order to argue that the process of repression is enacted in classical cinema and that the female spectator herself comes to desire this repression and to endorse the heterosexual contract that seals the film at its end.[15] Another analysis of *Stella Dallas* by Linda Williams argues against this view and persuasively postulates a contradictory "double desire" on the part of the female spectator: on the one hand, we identify with the working class Stella and share her joy at having successfully sacrificed herself in giving away her daughter to the upper-class father and boyfriend and, on the other hand, because of the way point of view has been handled in the film, we are made to experience the full poignancy and *undesirability* of the loss of the close affective relationship with the daughter.[16] In other words, we could say that the spectator simultaneously experiences the symbolic *and* the nonsymbolic aspects of motherhood, despite patriarchy's attempts to repress and deny the latter.

In stressing the contradictory nature of female spectatorship, Williams's essay can be seen as a critique not only of the position that, given the structure of classic narrative film as male fantasy, the female spectator is forced to adopt the heterosexual view, but also of the opposite position, most forcefully articulated by Mary Ann Doane, which sees the preoedipal relationship with the mother as the source of insurmountable difficulties for the female spectator. Doane draws on the work of Christian Metz and his theories of spectatorship based on male fetishism and disavowal, in order to disqualify female voyeurism. According to Doane, a woman's putative inability to achieve a distance from the *textual* body is related to her inability to separate decisively from the *maternal* body. Because women lack a penis, they lack the possibility of losing the "first stake of representation," the mother, and thus of symbolizing their difference from her (a "problem" that is at the heart of *Rebecca*): "this closeness to the body, this excess, prevents the woman from assuming a position similar to the man's in relation to signifying systems. For she is haunted by the loss of a loss, the lack of that lack so essential for the realization of the ideals of semiotic systems."[17] There are, I believe, several ways for feminists to challenge such a nihilistic position. One might, for example, point out the tortuous logic of these claims, as Hélène Cixous has done ("She lacks lack? Curious to put it in so contradictory, so extremely paradoxical a manner: she lacks lack. To say she lacks lack is also, after all, to say she doesn't miss lack . . . since she doesn't miss the lack of lack.").[18] Or, one might say with Linda Williams and B. Ruby Rich that the female spectator does indeed experience a "distance" from the image as an inevitable result of her being an exile "living the tension of two different cultures."[19] Or, one might, as I do, question the very "ideals" of the "semiotic systems" invoked by Doane—and, in particular, the ideal of "distance," or what in Brechtian theory is called "distanciation."

According to Doane, woman's closeness to the (maternal) body means that she "overidentifies with the image": "The association of tears and 'wet wasted afternoons' (in Molly Haskell's words) with genres specified as feminine (the soap opera, the 'woman's picture') points very precisely to this type of overidentification, this abolition of a distance, in short this inability to fetishize."[20] Now, as I have mentioned, many of Hitchcock's films actually thematize the "problem" of "overidentification"—the daughter's "overidentification" with the mother and, in at least one film (*Rear Window*), the woman's "overidentification" with the "textual body." Given Hitchcock's preoccupation with female bisexuality and given his famed ability to draw us into close identifications with his characters—so many of them women—his work would seem to provide the perfect testing ground for theories of female spectatorship.

But the question immediately arises as to why a male director—and one so frequently accused of unmitigated misogyny—would be attracted to such subjects. I want to suggest that woman's bisexual nature, rooted in preoedipality, and her consequent alleged tendency to overidentify with other women and with texts, is less a problem for *women*, as Doane would have it, than it is for patriarchy. And this is so not only for the reason suggested by Gertrud Koch (that female bisexuality would make women into competitors for "the male preserve"), but far more fundamentally because it reminds man of his *own* bisexuality (and thus his resemblance to Norman Bates), a bisexuality that threatens to subvert his "proper" identity, which depends upon his ability to distance woman and make her his property. In my readings of

Hitchcock, I will demonstrate how men's fascination and identification with the feminine continually undermine their efforts to achieve masculine strength and autonomy and is a primary cause of the violence towards women that abounds in Hitchcock's films. These readings are meant to implicate certain Marxist/psychoanalytical film theories as well, since by uncritically endorsing "distanciation" and detachment (however "passionate" this detachment is said to be) as the "proper"—i.e., politically correct—mode of spectatorship, they to some extent participate in the repression of the feminine typical of the "semiotic system" known as classic narrative cinema.[21]

## Men at the Movies

The psychiatrist, the voice of institutional authority who "explains" Norman Bates to us at the end of the film, pronounces matricide to be an unbearable crime—"most unbearable to the son who commits it." In my opinion, though, the crime is "most unbearable" to the victim who suffers it, and despite the fact that a major emphasis of my book is on masculine subjectivity in crisis, its ultimate goals are a deeper understanding of women's victimization—of the sources of matrophobia and misogyny—and the development of female subjectivity, which is continually denied women by male critics, theorists, and artists (as well as by their female sympathizers).

<center>[ · · · ]</center>

It is part of my project to explore the dialectic of identification and dread in the male spectator's response to femininity—the movement between the two poles Alice Jardine has said characterize contemporary culture: "hysteria" (confusion of sexual boundaries) and "paranoia" (their reinforcement).[22] The paranoia may be seen as a consequence of the hysteria—but, as Jardine elsewhere observes, it is fundamentally a reaction against women who know not only too much, but anything at all: "Man's response in both private and public to a woman who *knows* (anything) has most consistently been one of paranoia."[23] "I know a secret about you, Uncle Charlie," says Charlie the niece to her uncle in *Shadow of a Doubt*, thereby arousing his murderous rage. Charlie is a typical Hitchcock female, both because her close relationship to her mother arouses in her a longing for a different kind of life than the one her father offers them and because she seems to possess special, incriminating knowledge about men. Charlie's attitude is representative of the two types of resistance to patriarchy I have been discussing here—that which seeks to know men's "secrets" (patriarchy's "blind spots, gaps, and repressed areas") and that which knows the kinds of pleasure unique to women's relationship with other women. This book is devoted to understanding how female spectators may be drawn into this special relationship and how men may react to women who are suspected of possessing such valuable secret knowledge.

## A Frankly Inventive Approach

All of this is to suggest that Hitchcock films as I read them are anything but exemplary of Hollywood cinema. Rather, if the films do indeed invoke typical patterns of male and female socialization, as Raymond Bellour has repeatedly argued, they

do so only to reveal the difficulties inherent in these processes—and to implicate the spectator in these difficulties as well. Interestingly, even Mulvey's essay, which uses Hitchcock films as the main evidence in her case against Hollywood cinema, actually ends up claiming that *Vertigo* is critical of the kinds of visual pleasure typically offered by mainstream cinema, a visual pleasure that is rooted in the scopic regime of the male psychic economy. In her reading of the film, Mulvey thus unwittingly undercuts her own indictment of narrative cinema as possessing no redeeming value for feminism.

Of course, Mulvey is not the first commentator to discover in Hitchcock films self-reflexive critiques of voyeurism and visual pleasure—a whole tradition of criticism celebrates the director's ability to manipulate spectators so as to make us uncomfortably aware of the perverse pleasures of cinema going. But for all the claims of traditional critics to have had their eyes opened to the moral ambiguities inherent in film viewing, most remain incredibly blind to the relation of voyeurism to questions of sexual difference. For example, male critics frequently point to *Psycho* as a film which punishes audiences for their illicit voyeuristic desires, but they ignore the fact that within the film not only are women objects of the male gaze, they are also recipients of most of the punishment. It is left to feminist criticism to point out that after Marion Crane is killed in the shower, the camera focuses on her sightless eye; that when Mother is finally revealed, it is Marion's sister who is forced to confront the horrible vision; that while she screams out in fright, the swinging lightbulb is reflected in the eye sockets of the female corpse; and that, finally, at the end of the film, "Mother" is agonizingly aware of being stared at and tries desperately to demonstrate her harmlessness to her unseen observers by refusing to swat a fly. In acknowledging such sexual asymmetry in desire and its punishment (where men possess the desire and women receive the punishment), we are forced to relinquish the more facile notions about Hitchcock's self-reflexivity and his critiques of voyeurism—at the very least we would need to invoke the notions discussed earlier of male masochism and its denial or displacement.

An analysis of voyeurism and sexual difference is only one of the ways a specifically feminist approach can provide a much needed perspective on Hitchcock's films. Indeed, there are many questions that I think begin to look very different when seen by a woman. What, for example, happens to the frequently noted theme of the "transference of guilt" when we insist against the grain of an entire history of Hitchcock criticism that a certain heroine is innocent because she was defending herself against rape? In patriarchy woman's sexual "guilt" is unique to her and is not "transferable" to men. Or, to take another example, how do the theatrical motifs so common in Hitchcock films change their meaning when considered in the light of Western culture's association of femininity with theater and spectacle? Or, again, how may we begin to rethink Hitchcock's "Catholicism" when we view it in the context of Julia Kristeva's work on religion and matrophobia—matrophobia being so strong an element in Hitchcock that it is acknowledged by even the most traditional of nonfeminist critics? While not the primary focus of this work, such concerns which have been central to Hitchcock studies will be given a new inflection in my readings. I am, however, by no means claiming to advance comprehensive, definitive interpretations of the films. Less ambitiously, I think of my book as a sustained meditation on a few of the issues that have been of paramount interest to feminist film theory.

In his recent work, *The World, the Text, and the Critic*, Edward Said has beautifully described the critic as one who "is responsible to a degree for articulating those voices dominated, displaced, or silenced by the textuality of texts. Texts are a system of forces institutionalized by the reigning culture at some human cost to its various components. . . . The critic's attitude . . . should . . . be frankly inventive, in the traditional sense of *inventio* so fruitfully employed by Vico, which means finding and exposing things that otherwise may be hidden beneath piety, heedlessness, or routine."[24] Feminism, too, has by now its pieties and routines. Insofar as it all too readily accepts the ideals of male semiotic systems, feminism also needs to be challenged by a "frankly inventive" approach, an approach that, if it seems alien at first, is so only because it is situated in the realm of the uncanny—speaking with a voice that inhabits us all, but that for some of us has been made strange through fear and repression.

If it did not sound more frivolous than I intend to be, then, I would say that part of my intention is to defend that much maligned woman, Mrs. Bates, whose *male* child suffers such a severe case of "overidentification" with her that he is driven to matricide and to the rape/murder of various young women. At the end of the film, "Mrs. Bates" (who has the last word) speaks through her son's body to protest her innocence and place the blame for the crimes against women on her son. I think she speaks the truth. As I will argue, the sons are indeed the guilty ones, and, moreover, it is my belief that the crime of matricide is destined to occur over and over again (on the psychic plane) until woman's voice allows itself to be heard—in women and men alike.

## NOTES

1. Laura Mulvey, "Visual Pleasure and Narrative Cinema," *Screen* 16, no. 3 (1975): 6–18.

2. Tania Modleski, "Never to be Thirty-Six Years Old: *Rebecca* as Female Oedipal Drama," *Wide Angle* 5, no. 1 (1982): 34–41.

3. The most explicit statement of this may be found in an interview with Bellour conducted by Janet Bergstrom, "Alternation, Segmentation, Hypnosis: Interview with Raymond Bellour," *Camera Obscura*, nos. 3–4 (1979): 93.

4. Teresa de Lauretis, *Alice Doesn't: Feminism, Semiotics, Cinema* (Bloomington: Indiana University Press, 1984), p. 153.

5. In an unpublished paper delivered at the conference "New Narrative Cinema," Simon Fraser University, September 1983.

6. Susan Lurie, "The Construction of the Castrated Woman in Psychoanalysis and Cinema," *Discourse*, no. 4 (Winter 1981–82): 52–74.

7. Robin Wood, "Fear of Spying," *American Film* (November 1982): 28–35.

8. Fredric Jameson, *The Political Unconscious: Narrative as a Socially Symbolic Act* (Ithaca: Cornell University Press, 1981), pp. 289–90.

9. For one account of this process see Mary Ann Doane, "Misrecognition and Identity," *Ciné-Tracts* 3, no. 3 (Fall 1980), pp. 25–32.

10. In *From Reverence to Rape: The Treatment of Women in the Movies* (New York: Penguin, 1974), Molly Haskell notes the "complex interplay of misogyny and sympathy in Hitchcock" (p. 32).

11. Michelle Citron, Julia Lesage, Judith Mayne, B. Ruby Rich, and Anna Maria Taylor, "Women and Film: A Discussion of Feminist Aesthetics," *New German Critique* 13 (Winter 1978): 87. Hereafter cited in the text.

12. Freud discussed differences between female and male sexual development in "Female Sexuality," *The Standard Edition of the Complete Psychological Works of Sigmund Freud*, trans. James Strachey (London: Hogarth, 1974), Vol. 21, and "Femininity," *New Introductory Lectures on Psychoanalysis*, trans. James Strachey (New York: Norton, 1965), pp. 99–119.

13. Gertrud Koch, "Why Women Go to Men's Films," *Feminist Aesthetics*, ed. Gisela Ecker (Boston: Beacon, 1985), p. 110.

14. E. Ann Kaplan, *Women and Film: Both Sides of the Camera* (New York and London: Methuen, 1983), p. 6.

15. E. Ann Kaplan, "The Case of the Missing Mother: Maternal Issues in Vidor's *Stella Dallas*," *Heresies* 16 (1983): 81–85.

16. Linda Williams, "Something Else Besides a Mother: *Stella Dallas* and the Maternal Melodrama," *Cinema Journal* 24, no. 1 (Fall 1984): 2–27. [Reprinted in this volume, p. 725.—Ed.]

17. Mary Ann Doane, "Film and the Masquerade: Theorising the Female Spectator," *Screen* 23, nos. 3–4 (September–October 1982): 79.

18. Hélène Cixous, "Castration or Decapitation?" trans. Annette Kuhn, *Signs* 7, no. 1 (Autumn 1981): 48.

19. Citron et. al., "Women and Film," p. 87. Quoted in Williams, "Something Else," pp. 19–20.

20. Doane, "Film and the Masquerade," p. 80.

21. The term "passionate detachment" is Mulvey's, but it has been picked up by Annette Kuhn, who uses it as the title for the opening chapter of her book *Women's Pictures: Feminism and Cinema* (London: Routledge & Kegan Paul, 1982), pp. 3–18.

22. Alice Jardine, *Gynesis: Configurations of Woman and Modernity* (Ithaca: Cornell University Press, 1985), p. 48.

23. Jardine, *Gynesis*, p. 98.

24. Edward Said, *The World, the Text, and the Critic* (Cambridge: Harvard University Press, 1983), p. 53.

# JUDITH MAYNE

## Lesbian Looks: Dorothy Arzner and Female Authorship

A central figure in contemporary academic film studies, Judith Mayne (see head note on p. 88) has consistently brought questions of gender and sexuality to bear on film theory and historiography. Originally presented at *How Do I Look?* one of the first conferences on queer film and video, and included in the conference book of that title, this essay also appeared (in a slightly different form) as a chapter in Mayne's book *The Woman at the Keyhole* (1990).

In her reconsideration of Dorothy Arzner (1897–1979), virtually the only woman director active in studio-era Hollywood, Mayne both continues and interrogates the important work of early 1970s feminist critics Pam Cook and Claire Johnston on Arzner. Interested in more than the project of retrieving women directors from historical obscurity, Cook and Johnston offered a complex reading of the textual marks of female authorship across Arzner's oeuvre. However, Mayne questions why they nevertheless ignored the *visual* representations

of Arzner, which suggested, according to the gender conventions of her time, that she was a lesbian. For Mayne, this omission of Arzner's lesbianism in feminist film theory is significant. In "Lesbian Looks," she creatively employs feminist film theory's understanding of the tension between spectacle and narrative in cinema's construction of gender to analyze how Arzner's authorial image might resonate in the narratives of her films.

Mayne's work on Arzner resulted in *Directed by Dorothy Arzner* (1994), a monograph in which she merges a sophisticated understanding of the construction of Arzner's authorial persona with extensive historical research. Her reinterpretation of Dorothy Arzner has encouraged critical approaches to the work of such gay male directors in Hollywood as George Cukor and James Whale that go beyond the search for gay subtexts and engage questions of historiography and epistemology. Mayne's work, together with the work of other film scholars on directors whose identities are exceptions to the historical dominance of heterosexual white men in the director's chair, suggests that declarations of the "death of the author" may be premature. The study of authorship in cinema has insights to yield not only about film texts, but also about the intersections of identity and the social contexts in which films are produced and consumed.

## READING CUES & KEY CONCEPTS

■ What arguments does Mayne make for the function of irony in Dorothy Arzner's work?

■ In what ways can Mayne's emphasis on "spectacle" be extended to readings that subvert Hollywood narrative in other ways?

■ Given the example of Mayne's work, how can lesbian/gay/bisexual/transgender (LGBT) criticism draw upon feminist criticism?

■ **Key Concepts:** Female Authorship; Fetishism; Irony; Lesbian Reading; Signature

# Lesbian Looks: Dorothy Arzner and Female Authorship

· · · · · · · · · · · · ·

Some cinematic images have proven to be irresistibly seductive as far as lesbian readings are concerned: Greta Garbo kissing her lady-in-waiting in *Queen Christina* (1933), Marlene Dietrich in drag kissing a female member of her audience in *Morocco* (1930), Katharine Hepburn in male attire being seduced by a woman in *Sylvia Scarlett* (1935)—all these images have been cited and reproduced so frequently in the context of gay and lesbian culture that they have almost acquired lives of their own. By lives of their own, I am referring not only to their visibility but also to how lesbian readings of them require a convenient forgetfulness or bracketing of what happens to these images, plot and narrative-wise, in the films in which they appear, where heterosexual symmetry is usually restored with a vengeance. Depending upon your point of view, lesbian readings of isolated scenes are successful

appropriations and subversions of Hollywood plots, or naive fetishizations of the image. Put another way, there is a striking division between the spectacular lesbian uses to which single, isolated images may be applied and the narratives of classical Hollywood films, which seem to deaden any such possibilities.

Feminist film theory, as it has developed in the last fifteen years, has scorned the subversive potential of such appropriations. Although the narrative of feminist film theory does not exactly follow the plot of a classical Hollywood film, the writings of feminist film theorists have affirmed, in a rather amazingly mimetic fashion, that the Hollywood apparatus is absolute, the codes and conventions of Hollywood narrative only flexible enough to make the conquest of the woman and the affirmation of the heterosexual contract that much more inevitable. In countering "spectacular" lesbian uses with "narratives"—those of Hollywood or of feminist film theory—I am, of course, evoking what has become the standard feminist account of the classical Hollywood cinema, where the spectacle of the male gaze and its female object and the narrative of agency and resolution make for a perfect symmetrical fit, with heterosexual authority affirmed.

Although much may be said about the relation between feminism, Hollywood plots, and lesbian images, my purpose here is to explore another cinematic image with unmistakable lesbian contours, one which has attained—at least in feminist film theory and criticism—the kind of visibility more commonly and typically associated with the female star. Dorothy Arzner was one of the few women to have been a successful director in Hollywood, with a career that extended from the late 1920s to the early 1940s. Arzner was one of the early "rediscoveries" of feminist film theory in the 1970s, and that rediscovery remains the most significant and influential attempt to theorize female authorship in the cinema. As one of the very few women directors who were successful in Hollywood, particularly during the studio years, Arzner has served as an important example of a woman director working within the Hollywood system who managed, in however limited ways, to make films that disturb the conventions of Hollywood narrative.

A division characterizes the way Arzner has been represented in feminist film studies, a division analogous to the tension between the lesbian reading of Dietrich, Garbo, and Hepburn and the textual workings of the films that, if they do not deny the validity of such a reading, at least problematize it. For there is, on the one hand, a textual Arzner, one whose films—as the by-now classic feminist account developed by Claire Johnston would have it—focus on female desire as an ironic inflection of the patriarchal norms of the cinema. On the other hand, there is a very visible Arzner, an image that speaks a kind of desire and suggests a kind of reading that is quite notably absent in discussions of Arzner's films.

Noting that structural coherence in Arzner's films comes from the discourse of the woman, Claire Johnston—whose reading of Arzner has defined the terms of subsequent discussions of her work—relies on the notion of defamiliarization, derived from the Russian formalists' *priem ostrananie*, the device of making strange, to assess the effects of the woman's discourse on patriarchal meaning: "the work of the woman's discourse renders the narrative strange, subverting and dislocating it at the level of meaning."[1] In this context Johnston discusses what has become the single most famous scene from Arzner's films, the scene in which Judy (Maureen O'Hara), who has played ballet stooge to the vaudeville performer Bubbles (Lucille Ball) in *Dance, Girl,*

*Dance* (1940), confronts her audience and tells them how *she* sees *them*. This is, John-
ston argues, the only real break between dominant discourse and the discourse of the
woman in Arzner's work. The moment in *Dance, Girl, Dance* when Judy faces her audi-
ence is a privileged moment in feminist film theory and criticism, foregrounding as it
does the sexual hierarchy of the gaze, with female agency defined as the return of the
male look, problematizing the objectification of woman.[2] The celebrity accorded this
particular scene in Arzner's film needs to be seen in the context of feminist film theory
in the mid-1970s. Confronted with the persuasive psychoanalytically-based theoreti-
cal model according to which women either did not or could not exist on screen, the
discovery of Arzner, and especially of Judy's "return of the gaze," offered some glim-
mer of historical hope as to the possibility of a female intervention in the cinema. To
be sure, the scope of the intervention is limited, for as Johnston herself stresses, Judy's
radical act is quickly recuperated within the film when the audience gets up to cheer
her on and she and Bubbles begin to fight on stage to the delight of the audience.

Other readings of Arzner's films develop, in different ways, the ambivalence of
the female intervention evoked in Johnston's analysis. In responses to Arzner's work,
one can read reflections of larger assumptions concerning the Hollywood cinema as
an apparatus. At one extreme is Andrew Britton's assessment of Arzner (in his study
of Katharine Hepburn) as the unproblematized *auteur* of *Christopher Strong* (1933),
the film in which Hepburn appears as an aviatrix who falls in love with an older,
married man. That *Christopher Strong* functions as a "critique of the effect of patri-
archal heterosexual relations on relations between women" suggests that the classi-
cal cinema lends itself quite readily to a critique of patriarchy, whether as the effect
of the woman director or the female star.[3] At the opposite extreme, Jacquelyn Suter's
analysis of *Christopher Strong* proceeds from the assumption that whatever "female
discourse" there is in the film is subsumed and neutralized by the patriarchal dis-
course on monogamy.[4] If the classical cinema described by Britton seems remark-
ably open to effects of subversion and criticism, the classical cinema described by
Suter is just as remarkably closed to any meanings but patriarchal ones; one is left to
assume that female authorship, as far as Hollywood cinema is concerned, is either
an unproblematic affirmation of agency or virtually an impossibility. That Britton is
the only openly gay critic among those I've mentioned thus far suggests, of course,
a familiar desire to assert the possibility of lesbian authorship, to identify the con-
ventions of Hollywood cinema as less absolutely consonant with heterosexual and
patriarchal desire than other critics have suggested.

Interestingly, however, the appearance of Arzner within the context of lesbian
and gay studies is quite literally that—a persona, an image quite obviously readable
in lesbian terms. In Vito Russo's *The Celluloid Closet*, a striking photograph of Arzner
and her good friend Joan Crawford appears in the text, along with a brief mention by
another director concerning Arzner's lesbianism and her closeted status, but none of
her films are cited: even by the measure of implicit gay content, Arzner's films seem
to offer little.[5] This photograph is adapted in the images included in Tee Corinne's
*Women Who Loved Women*, and Corinne's description of Arzner emphasizes again
an isolated image that is readable in lesbian terms only when placed within Corinne's
narrative sequence: "Quiet closeted women," she writes, "like film director Dorothy
Arzner worked in Hollywood near flamboyant and equally closeted bisexuals like
Garbo and Dietrich."[6]

The textual practice that has been central to a feminist theory of female authorship disappears when Arzner is discussed in the context of lesbian and gay culture, suggesting a tension between Arzner as a lesbian image and Arzner as a female signature to a text. This tension is addressed explicitly in the introduction to the *Jump Cut* special section on lesbians and film that appeared in 1981. The editors of the special section note that Arzner's "style of dress and attention to independent women characters in her films has prompted the search for a lesbian subtext in her work—despite the careful absence of any statements by Arzner herself that could encourage such an undertaking."[7] It is curious that Arzner's dress is not readable as such a "statement"; and the term *subtext* seems curiously anachronistic at a time in film criticism when so much attention was being paid to the apparently insignificant detail through which an entire film could be read deconstructively or at least against the grain. Yet the awkwardness of the term suggests the difficulty of not only reconciling but also accounting for any connection between Arzner's image and her films. Despite the supposed absence of lesbian "subtexts" in Arzner's films, Arzner looms large as an object of visual fascination in the *Jump Cut* text.

It is not only in gay and lesbian studies, however, that Arzner's persona acquires a signifying function seemingly at odds with her film practice. Even though what I've said thus far suggests a gap between feminist readings of Arzner's films and lesbian and gay readings of her image, Arzner has proven to be a compelling image for feminist film theory and criticism. Although Arzner favored a look and a style that quite clearly connotes lesbian identity, discussions of her work always seem to stop short of any concrete recognition that sexual preference might have something to do with how her films function, particularly concerning the "discourse of the woman" and female communities, or that the contours of female authorship in her films might be defined in lesbian terms. This marginalization is all the more striking, given how remarkably *visible* Arzner has been as an image in feminist film theory. That Arzner's image and appearance would find a responsive audience in gay and lesbian culture makes obvious sense. But in a field like feminist film theory, which has resolutely bracketed any discussion of lesbianism or of the female homoerotic, such visibility seems curious indeed, and in need of a reading. With the possible exception of Maya Deren, Arzner is more frequently represented visually than any other woman director central to contemporary feminist discussions of film. And unlike Deren, who appeared extensively in her own films, Arzner does not have the reputation of being a particularly self-promoting, visible, or *out* (in several senses of the term) woman director.

Not only has Arzner been consistently present as an image in feminist film studies, but two tropes are obsessively present in images of her as well—tropes that have been equally obsessive points of departure and return in feminist film theory. She is portrayed against the backdrop of the large-scale apparatus of the Hollywood cinema, or she is shown with other women, usually actresses, most of whom are emphatically "feminine," creating a striking contrast indeed. Both of these tropes appear in the photograph on the cover of the British Film Institute (BFI) collection edited by Claire Johnston, *The Work of Dorothy Arzner: Towards a Feminist Cinema.* On the front, we see Arzner in profile, slouching directorially in a perch next to a very large camera; seated next to her is a man. They both look toward what initially appears to be the unidentified field of vision. When the cover is laid out flat, however,

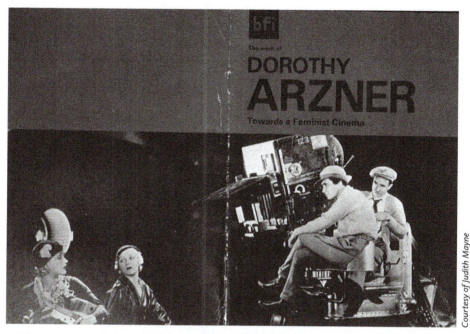

Director Dorothy Arzner on the set of *Working Girls* (1930), an image Mayne suggests deserves a second look from feminist critics.

we see that the photograph "continues" on the back: two young women, one holding packages, look at each other, their positions reflecting symmetrically those of Arzner and her male companion.

It is difficult to read precisely the tenor of the scene (from *Working Girls* [1930]) between the two women: some hostility perhaps, or desperation. The camera occupies the center of the photograph, as a large, looming—and predictably phallic—presence. The look on the man's face strongly suggests the clichés of the male gaze that have been central to feminist film theory: from his perspective the two women exist as objects of voyeuristic pleasure. Arzner's look has quite another function, however, one that has received very little critical attention, and that is to decenter the man's look and eroticize the exchange of looks between the two women.[8] Although virtually none of the feminist critics who analyze Arzner's work have discussed her lesbianism or her lesbian persona, a curious syndrome is suggested by this use of "accompanying illustrations." The photograph on the cover of the pamphlet edited by Claire Johnston teases out another scene of cinematic desire, complete with the devices of delay, framing, and even a version of shot/countershot more properly associated with the articulation of heterosexual desire in the classical narrative cinema.

Conversely, the representation of Arzner with the camera and with more "feminine" women can be read in relation to one of the most striking preoccupations of feminist film theory, that of the preferred notion of sexual difference, which has consistently displaced marginal desires from the center stage of heterosexual symmetry.

Whether blending into a background of the cumbersome and quite literal cinematic apparatus or gazing longingly at another woman, whether assuming the phallic machinery of the classical cinema or the position of spectatorial desire, Arzner's image oscillates between a heterosexual contract assumed by feminist theorists to be absolute, on the one hand, and another scene, another configuration of desire, on the other. Arzner's persona has acquired a rather amazing flexibility as well, if not always with the same teasing play of front and back cover evident in the BFI pamphlet. One of the early, "classic" anthologies of feminist film theory and criticism (Karyn Kay and Gerald Peary's *Women and the Cinema: A Critical Anthology*, New York: E. P Dutton, 1977), for instance, features Arzner on its cover along with three other women, all of them well-known actresses, in a rectangle of shifting opposing poles: the good girl (Bardot in wedding dress)/bad girl (Jane Fonda as prostitute in *Klute*) dichotomy characteristic of an "images of women" approach to film analysis and a classically feminine (Bardot and Fonda) demeanor as opposed to a more androgynous one (Arzner and Dietrich). In a recent collection of essays on feminist film theory, not one of the several reprinted essays on Arzner discusses erotic connections between women. Yet on the cover of the book is a photograph of Arzner and Rosalind Russell exchanging a meaningful look with more than a hint of lesbian desire.

One begins to suspect that the simultaneous evocation and dispelling of an erotic bond between women in Arzner's work is a structuring absence in feminist film theory. Arzner's lesbianism may not be theorized in relation to her films, but her remarkable visibility in feminist film criticism suggests that feminists replicate the very fetishism they have identified as being "criticized" in Arzner's films. To be sure, any parallel between a classical, male-centered trajectory like fetishism and the dynamics of feminist theory can only be made tentatively.[9] But there is nonetheless a striking fit between Octave Mannoni's formula for disavowal ("I know very well, but all the same . . ."), adapted by Christian Metz to analyze cinematic fetishism, and the consistent and simultaneous evocation and disavowal of Arzner's lesbian persona.[10] The evidence of lesbianism notwithstanding, feminist critics would speak, rather, through a heterosexual master code, where any and all combinations of "masculinity," from the male gaze to Arzner's clothing, and "femininity," from conventional objectification of the female body to the female objects of Arzner's gaze, result in a narrative and visual structure indistinguishable from the dominant Hollywood model. To be sure, Arzner's work is praised for its "critique" of the Hollywood system, but the critique is so limited that it only affirms the dominance of the object in question.

Some feminist work on Arzner does acknowledge her supposed "mannish" appearance, and one of the preferred phrases for avoiding any mention of lesbianism—"female bonding"—is fairly common in writing on Arzner. However, the two separate but interconnected questions I am raising here—whether there is any fit to be made between the persona and the films, and why feminist film theorists are so drawn to the dykey image yet so reluctant to utter the word *lesbian*—have not been widely addressed. To my knowledge, the only feminist critic to suggest that Arzner's films cite the persona, and are therefore informed by lesbian desire, is Sarah Halprin. Halprin suggests, fairly generously, that the reason for the omission of any discussion of Arzner's obvious lesbian looks in relation to her films is, in part, the suspicion of any kind of biographical information in analysis of female authorship; and she suggests

that a reading of marginal characters in Arzner's films, who resemble Arzner herself, might offer, as she puts it, a "whole new way of relating" to Arzner's work.[11] As with the term *subtext* mentioned earlier, in relation to the *Jump Cut* essay, there is an acknowledgment here that the wish to read Arzner's films through Arzner's appearance may resurrect a traditional form of auteurism, a form of biographical criticism that would seem to be hopelessly naive in an era of poststructuralist suspicion of any equations between the maker and the text. But the Arzner persona as it circulates in feminist film studies does not seem to me to be a simple case of the "real woman" versus the "text," since those illustrations of Arzner have themselves become so thoroughly a part of the web of both feminist film theory and Arzner's work. More strikingly, the "illustrations" of Arzner in the company of a female star echo uncannily in the stills from her films that illustrate the discussions of textual practice—like Billie Burke and Rosalind Russell in *Craig's Wife* (1936) (with Russell now assuming the more Arzneresque position), or Madame Basilova and Judy in *Dance, Girl, Dance*.

Take Madame Basilova, for example. What has been read, in *Dance, Girl, Dance*, as the woman's return of a male gaze she does not possess might be read differently as one part of a process of the exchange of looks between women that begins within the female dance troupe managed by Basilova. Judy's famous scolding of the audience is identified primarily as a communication, not between a female performer and a male audience (the audience is not, in any case, exclusively male) but between the performer and the female member of the audience (secretary to Steven Adams, the man who will eventually become Judy's love interest) who stands up to applaud her.[12] And the catfight that erupts between Judy and Bubbles on stage seems to me less a recuperative move—transforming the potential threat of Judy's confrontation into an even more tantalizing spectacle—than the claiming by the two women of the stage as an extension of their conflicted friendship, not an alienated site of performance. The stage is, in other words, *both* the site of the objectification of the female body *and* the site for the theatricalizing of female friendship.

This "both/and"—the stage (and by metaphoric implication, the cinema itself) simultaneously serving as an arena of patriarchal exploitation and of female self-representation—contrasts with the more limited view of Arzner's films in Johnston's work, where more of a "neither/nor" logic is operative—neither patriarchal discourse nor the "discourse of the woman" allows women a vantage point from which to speak, represent, or imagine themselves. Reading Arzner's films in terms of the "both/and" suggests an irony more far-reaching than that described by Johnston. Johnston's reading of Arzner is suggestive of Shoshana Felman's definition of irony as "dragging authority as such into a scene which it cannot master, of which it is not aware and which, for that very reason, is the scene of its own self-destruction. . . ."[13] But the irony in *Dance, Girl, Dance* does not just demonstrate how the patriarchal discourse of the cinema excludes women, but rather how the cinema functions in two radically different ways, both of which are "true," as it were, and totally incompatible. I am borrowing here from Donna Haraway's definition of irony: "Irony is about contradictions that do not resolve into larger wholes, even dialectically, about the tension of holding incompatible things together because both or all are necessary and true."[14] This insistence on two equally compelling and incompatible truths constitutes a form of irony far more complex than Johnston's analysis of defamiliarization.

Johnston's notion of Arzner's irony assumes a patriarchal form of representation that may have its gaps and its weak links, but which remains dominant in every sense of the word. For Johnston, Arzner's irony can only be the irony of negativity puncturing holes in patriarchal assumptions. Such a view of irony has less to do, I would argue, with the limitations of Arzner's career (for example, as a woman director working within the inevitable limitations of the Hollywood system) than with the limitations of the film theory from which it grows. If the cinema is understood as a one-dimensional system of male subjects and female objects, then it is not difficult to understand how the irony in Arzner's films is limited, or at least would be *read* as limited. Although rigid hierarchies of sexual difference are indeed characteristic of dominant cinema, they are not absolute, and Arzner's films represent other kinds of cinematic pleasure and desire.

An assessment of Arzner's importance within the framework of female authorship needs to account not only for how Arzner problematizes the pleasures of the cinematic institution as we understand it—for example, in terms of voyeurism and fetishism reenacted through the power of the male gaze and the objectification of the female body—but also for how, in her films, those pleasures are identified in ways that are not reducible to the theoretical clichés of the omnipotence of the male gaze. The irony of *Dance, Girl, Dance* emerges from the conflicting demands of performance and self-expression, which are linked, in turn, to heterosexual romance and female friendship. Female friendship acquires a resistant function in the way that it exerts a pressure against the supposed "natural" laws of heterosexual romance. Relations between women and communities of women have a privileged status in Arzner's films. To be sure, Arzner's films offer plots—particularly insofar as resolutions are concerned—compatible with the romantic expectations of the classical Hollywood cinema: communities of women may be important, but boy-still-meets-girl. Yet there is also an erotic charge identified within those communities. If heterosexual initiation is central to Arzner's films, it is precisely in its function as rite of passage (rather than natural destiny) that a marginal presence is felt.

Consider, for instance, *Christopher Strong*. Katharine Hepburn first appears in the film as a prize-winning object in a scavenger hunt, for she can claim that she is over twenty-one and has never had a love affair. Christopher Strong, the man with whom she will eventually become involved, is the male version of this prize-winning object, for he has been married for more than five years and has always been faithful to his wife. As Cynthia Darrington, Hepburn dresses in decidedly unfeminine clothing and walks with a swagger that is masculine, or athletic, depending upon your point of view. Hepburn's jodhpurs and boots may well be, as Beverle Houston puts it, "that upper-class costume for a woman performing men's activities,"[15] but this is also clothing that strongly denotes lesbian identity and (to stress again Sarah Halprin's point) that is evocative of the way Arzner herself, and other lesbians of the time, dressed. Cynthia's "virginity" becomes a euphemistic catch-all for a variety of margins in which she is situated, both as a woman devoted to her career and as a woman without a sexual identity. The process the film traces is, precisely, that of the acquisition of heterosexual identity.

I am not arguing that *Christopher Strong*, like the dream that says one thing but ostensibly "really" means its mirror opposite, can be decoded as a coherent

"lesbian film" or that the real subject of the film is the tension between gay and straight identities. The critical attitude toward heterosexuality takes the form of inflections—bits and pieces of tone and gesture and emphasis—that result in the conventions of heterosexual behavior becoming loosened up, shaken free of some of their identifications with the patriarchal status quo. Most important perhaps, the acquisition of heterosexuality becomes the downfall of Cynthia Darrington.

[ · · · ]

As should be obvious by now, I am arguing that it is precisely in its ironic inflection of heterosexual norms, whether by the mirroring gesture that suggests a reflection of Arzner herself or by the definition of the female community as resistant to, rather than complicitous with, heterosexual relations, that Arzner's signature is written on her films.

These two components central to female authorship in Arzner's work—female communities and the mirroring of Arzner herself—are not identical. One, stressing the importance of female communities and friendship among women, may function as a pressure exerted against the rituals of heterosexual initiation but is not necessarily opposed to them. This foregrounding of relationships among women problematizes the fit between female friendship and heterosexual romance, but the fit is still there; that is, the compatibility with the conventions of the classical Hollywood cinema is still possible. The representation of lesbian codes, mirrored in Arzner's and other lesbians' dress, constitutes the second strategy, which is more marginal and not integrated into narrative flow. These are the images that lend themselves to lesbian appropriation. Moreover, these two authorial inscriptions—the emphasis on female communities, the citations of marginal lesbian gestures—are not situated on a "continuum," that model of continuity from female friendship to explicit lesbianism so favored in much contemporary lesbian-feminist writing.[16] Rather, these two strategies exist in tension with each other, constituting yet another level of irony in Arzner's work. Female communities are compatible with the classical Hollywood narrative while they problematize it. The lesbian gesture occupies no such position of compatibility; it does not mesh easily with narrative continuity in Arzner's films.

Thus, in *Dance, Girl, Dance*, Arzner accentuates not only the woman's desire as embodied in Judy and her relationships with other women, but also secondary female figures, who never really become central but who do not evaporate into the margins, either—such as the secretary (who leads the applause during Judy's "return of the gaze" number) and Basilova. That these figures do not simply "disappear" suggests even more strongly their impossible relationship to the Hollywood plot, a relationship that *is* possible insofar as Judy is concerned. Now, Basilova *does* disappear in *Dance, Girl, Dance*, but in one of the most absurdly staged death scenes imaginable. In *Craig's Wife*, however, there is a more immediate relationship between marginality and female communities, although significantly the marginality has less of a lesbian inflection, both in dress and gesture. Julia Lesage has noted that in *Craig's Wife* Arzner rereads George Kelly's play, the source of the film, so that the secondary women characters are treated much more fully than in the play.[17] *Craig's Wife*—preoccupied with heterosexual demise rather than initiation—shows us Harriet (Rosalind Russell), a woman so obsessively concerned with her house that

nothing else is of interest to her: At the conclusion of the film, virtually everyone has cleared out of Harriet's house, and Harriet seems pathetically neurotic and alone. The widow next door (Billie Burke) brings Harriet some roses. In Kelly's play, Harriet has become a mirror image of her neighbor, for both are portrayed as women alone, to be pitied. But in Arzner's film, the neighbor represents Harriet's last chance for connection with another human being. Thus the figure who, in Kelly's play, is a pale reflection of Harriet becomes in the film the suggestion of another identity and of the possibility of a female community. The resolution of Arzner's version of *Craig's Wife* has little to do with the loss of a husband and more to do with situating Harriet Craig's fantasy come horribly true alongside the possibility of connection with another woman. And, although Billie Burke is hardly evocative of lesbianism (like Basilova is in *Dance, Girl, Dance*), she and Rosalind Russell offer a play of contrasts visually similar to those visible in photographs of Arzner with more "feminine" women. The other woman portrayed by Billie Burke is, quite literally, a marginal figure in the original play who, through Arzner's reading, becomes a reflection on marginality itself.[18]

The female signature in Arzner's work is marked by that irony of equally compelling and incompatible discourses to which I have referred, and the lesbian inflection articulates the division between female communities that can function, although problematically, within a heterosexual universe, and the eruptions of lesbian marginality that do not. This lesbian irony taps differing and competing views of lesbianism within contemporary feminist and lesbian theory—as the most intense form of female and feminist bonding and as distinctly opposed to and other than heterosexuality (whether practiced by women or men). In Arzner's own time, these competing definitions would be read as the conflict between a desexualized nineteenth-century ideal of romantic friendship among women and the "mannish lesbian" (exemplified by Radclyffe Hall), defined by herself and her critics as a sexual being.[19] Arzner's continued "visibility" suggests not only that the tension is far from being resolved, but also that debates about lesbian identity inform, even (and especially!) in unconscious ways, the thinking of feminists who do not identify as lesbians.

I am suggesting, of course, that lesbian irony constitutes one of the pleasures in Arzner's films and that irony is a desirable aim in women's cinema. Irony can, however, misfire.[20] [ . . . ] In *Dance, Girl, Dance*, for instance, racial stereotypes emerge at three key moments in the narrative of the film. [ . . . ] In each of these instances, the racial stereotype affirms the distinction between white subject and black object just when the distinction between male subject and female object is being put into question. Though there is nothing in *Dance, Girl, Dance* that approximates a sustained discourse on race, these brief allusions to racial stereotypes are eruptions that cannot be dismissed or disregarded as mere background or as unconscious reflections of a dominant cinematic practice that was racist. The marks of authorship in *Dance, Girl, Dance* include these extremely problematic racist clichés as well as the ironic inflection of the heterosexual contract.

**[ · · · ]**

Dorothy Arzner has come to represent both a textual practice (consciously) and an image (less consciously) in feminist film theory. The textual practice has been described as if there were no determinations—such as those in *Dance, Girl, Dance*

having to do with race—besides those of gender. In other words, Arzner's reception foregrounds the extent to which feminist film theory has disavowed the significance of race, particularly when racist codes contradict or complicate the disruption of gender hierarchies. The relationship between the textual practice and the image suggests an area of fascination, if not love, that dare not speak its (her) name. The preferred term *sexual difference* in feminist film theory slides from the tension between masculinity and femininity into a crude determinism whereby there is no representation without heterosexuality. Lesbianism raises some crucial questions concerning identification and desire in the cinema, questions with particular relevance to female cinematic authorship. Cinema offers simultaneous affirmation and dissolution of the binary oppositions upon which our most fundamental notions of self and other are based. In feminist film theory, one of the most basic working assumptions has been that in the classical cinema, at least, there is an unproblematic fit between the hierarchies of masculinity and femininity on the one hand, and activity and passivity on the other. If disrupting and disturbing that fit is a major task for filmmakers and theorists, then lesbianism would seem to have a strategically important function. For one of the "problems" that lesbianism poses, insofar as representation is concerned, is precisely the fit between the paradigms of sex and agency, the alignment of masculinity with activity and femininity with passivity.

It is undoubtedly one of those legendary "no coincidences" that one discourse in which the "problem" of lesbianism is thus posed most acutely is psychoanalysis. For reasons both historical and theoretical, the most persuasive, as well as controversial, accounts of cinematic identification and desire have been influenced by psychoanalysis. Laura Mulvey's classic account of sexual hierarchy in narrative cinema established the by-now familiar refrain that the ideal spectator of the classical cinema—whatever his or her biological sex or cultural gender—is male. Many critics have challenged or extended the implications of Mulvey's account, most frequently arguing that for women (and sometimes for men as well), cinematic identification occurs at the very least across gender lines, whether in transvestite or bisexual terms.[21] However complex such accounts, they tend to leave unexamined another basic assumption common both to Mulvey's account and to contemporary psychoanalytic accounts of identification, and that is that cinematic identification not only functions to affirm heterosexual norms, but also finds its most basic condition of possibility in the heterosexual division of the universe. Although feminist film theory and criticism have devoted remarkably extensive attention to the function of the male gaze in film, the accompanying heterosexual scenario has not received much attention, except for the occasional nod to what seems to be more the realm of the obvious than the explorable or questionable.

An impressive body of feminist writing has been devoted to the exploration of how—following Luce Irigaray—heterosexuality functions as a ruse, a decoy relation to mask male homosocial and homosexual bonds. "Reigning everywhere, although prohibited in practice," Irigaray writes, "hom(m)osexuality is played out through the bodies of women, matter, or sign, and heterosexuality has been up to now just an alibi for the smooth workings of man's relations with himself."[22] Comparatively little attention has been paid to how heterosexual economies work to assure that any exchange between women remains firmly ensconced within that "hom(m)osexual" economy. To be sure, male and female homosexualities occupy quite different positions, and

given the logic of the masculine "same" that dominates the patriarchal order, female homosexuality cannot be ascribed functions that are similar to male homosexuality. However, the two homosexualities share the potential to disrupt, in however different ways, the reign of the "hom(m)osexual." Irigaray speaks of the "fault, the infraction, the misconduct, and the challenge that female homosexuality entails." For lesbianism threatens to upset the alignment between masculinity and activity, and femininity and passivity. Hence, writes Irigaray, "[t]he problem can be minimized if female homosexuality is regarded merely as an imitation of male behavior."[23]

[ · · · ]

Expanding on Irigaray, Teresa de Lauretis writes: "Lesbian representation, or rather, its condition of possibility, depends on separating out the two contrary undertows that constitute the paradox of sexual (in)difference, on isolating but maintaining the two senses of homosexuality and hommosexuality."[24] The lesbian irony in Arzner's signature suggests that division to which de Lauretis refers, a division between a representation of female communities and an inscription of marginality. That irony stands in (ironic) contrast to feminist film theory's division of Arzner into a textual hommo-sexual (in print) and a visible homosexual (in pictures).

Given Arzner's career in Hollywood, and the realist plots central to her films, her influence would seem to be most apparent among those filmmakers who have appropriated the forms of Hollywood cinema to feminist or even lesbian ends—for example, Susan Seidelman (*Desperately Seeking Susan*, 1985) and Donna Deitch (*Desert Hearts*, 1985). A more striking connection, however, exists with those contemporary women filmmakers whose films extend the possibilities of lesbian irony, while revising the components of the classical cinema and inventing new cinematic forms simultaneously. Despite the rigid distinction between dominant and alternative film that has remained a foregone conclusion in feminist film theory, the articulation of lesbian authorship in Arzner's work finds a contemporary echo in films that may be more "obviously" lesbian than *Dance, Girl, Dance* or *Craig's Wife*, but whose authorial strategies have been either unreadable or misread in the terms of feminist film theory. Films like Chantal Akerman's *Je tu il elle* (1974), Ulrike Ottinger's *Ticket of No Return* [*Portrait of a Woman Drinker*] (1979), or Midi Onodera's *Ten Cents a Dance* (1985) are remarkable explorations of the desire to see and to be seen, to detach and to fuse, to narrate one's own desire and to exceed or otherwise complicate the very terms of that narration.

Less optimistically, the disturbing fit between sexual and racial codes of performance, between different modes of irony, finds a contemporary echo in those women's films in which lesbian desire and race collide. The results may not be so clearly racist as in *Dance, Girl, Dance*, but they raise equally important questions for feminist readings based on the implicit assumption that all women are white and heterosexual. In several films that have become classics of feminist film theory—Sally Potter's *Thriller* (1977) and *The Gold Diggers* (1983), and Laura Mulvey's and Peter Wollen's *Riddles of the Sphinx* (1977)—an attraction between two women is central in visual and narrative terms, and in each case the attraction occurs between a white woman and a black woman. Now, these films do not evoke lesbianism and race in identical ways, and my point is not to conclude with a blanket condemnation of them. Rather I want to suggest that the disturbing

questions they raise beyond the staples of feminist theory, like mothering, female friendship, and reading against the grain (whether of psychoanalysis or of opera), have not been discussed. The tensions and contradictions so dear to contemporary feminist theory stop at the point that an investigation of sexual difference would require exploration of the other sexual difference, or that an examination of female identity as the negative of man would require consideration of white privilege.

Lesbian authorship in Arzner's work constantly assumes the irony of incompatible truths. This irony is not, however, necessarily contestatory or free of the rigid dualisms of white patriarchal film practice. Although I think feminist film theory might do well to explore its own investment in the pleasures of irony, Arzner's case is crucial for a history of lesbian desire and film practice. My own desire, in exploring the way in which Arzner and her films have been read in feminist film theory, has been to make a connection between the lesbian image and the narrative text, while resisting the lure of a seamless narrative, in which the spectacular lesbianism of the photographs of Arzner would fit comfortably and unproblematically with her films, in which spectacle and narrative would be as idealistically joined for feminism and lesbianism as they presumably are in patriarchal film practice.

## NOTES

1. Claire Johnston, "Dorothy Arzner: Critical Strategies," in *The Work of Dorothy Arzner: Towards a Feminist Cinema*, ed. Claire Johnston (London: British Film Institute, 1975), 6.

2. Lucy Fischer reads *Dance, Girl, Dance* in terms of this "resistance to fetishism." See *Shot/Countershot* (Princeton: Princeton University Press, 1989), 148–54.

3. Andrew Britton, *Katharine Hepburn: The Thirties and After* (Newcastle upon Tyne: Tyneside Cinema, 1984), 74.

4. Jacquelyn Suter, "Feminine Discourse in *Christopher Strong*," *Camera Obscura*, no. 3–4 (Summer 1979), 135–50.

5. Vito Russo, *The Celluloid Closet: Homosexuality in the Movies* (New York: Harper and Row, 1981), 50.

6. Tee Corinne, *Women Who Loved Women* (Pearlchild, 1984), 7.

7. Edith Becker, Michelle Citron, Julia Lesage, and B. Ruby Rich, "Special Section: Lesbians and Film: Introduction," *Jump Cut*, no. 24–25 (March 1981), 18.

8. Jackie Stacey discusses female sexual attraction as a principle of identification in *All About Eve* (1950) and *Desperately Seeking Susan*; see "Desperately Seeking Difference," *Screen* 28, no. 1 (Winter 1987), 48–61.

9. For an excellent discussion of the very possibility of a feminist fetishism, see Jane Marcus, "The asylums of Antaeus. Women, war and madness: Is there a feminist fetishism?" In *The Difference Within: Feminism and Critical Theory*, ed. Elizabeth Meese and Alice Parker (Amsterdam and Philadelphia: John Benjamins Publishing Co., 1989), 49–83. Marcus examines how feminists in the suffrage movement oscillated "between denial and recognition of rape as the common denominator of female experience" (76). Naomi Schor has examined the possibility of female fetishism in the writings of George Sand; see "Female Fetishism: The Case of George Sand," in *The Female Body in Western Culture*, ed. Susan Suleiman (Cambridge, Mass.: Harvard University Press, 1986), 363–72.

10. See Christian Metz, *The Imaginary Signifier*, trans. Ben Brewster (Bloomington: Indiana University Press, 1982), 69–80. A chapter in Octave Mannoni's *Clefs pour l'imaginaire ou l'autre scène* (Paris: Editions du Seuil, 1969) is entitled "Je sais bien, mais quand même . . ." ("I know very well, but all the same . . .").

11. Sarah Halprin, "Writing in the Margins (review of E. Ann Kaplan, *Women and Film: Both Sides of the Camera*)," *Jump Cut*, no. 29 (February 1984), 32.

12. Barbara Koenig Quart stresses the relationship between Judy and the secretary in her reading of the scene. See *Women Directors: The Emergence of a New Cinema* (New York and Westport, Conn.: Praeger, 1988), 25.

13. Shoshana Felman, "To Open the Question," *Yale French Studies*, no. 55–56 (1980), 8.

14. Donna Haraway, "A Manifesto for Cyborgs: Science, Technology, and Socialist Feminism in the 1980s," *Socialist Review*, no. 80 (1985), 65.

15. Beverle Houston, "Missing In Action: Notes on Dorothy Arzner," *Wide Angle* 6, no. 3 (1984), 27.

16. The phrase *lesbian continuum* comes from Adrienne Rich, "Compulsory Heterosexuality and Lesbian Existence," *Signs* 5, no. 4 (Summer 1980), 631–60.

17. Julia Lesage, "The Hegemonic Female Fantasy in *An Unmarried Woman* and *Craig's Wife*," *Film Reader*, no. 5 (1982), 91.

18. Melissa Sue Kort also discusses Arzner's reading of the Kelly play, noting that the "shift from play to film changes Harriet from villain to victim." See her discussion of the film in "'Spectacular Spinelessness,'" in *Men by Women*, ed. Janet Todd (1982), vol. 2 of *Women and Literature* (New York and London: Holmes and Meier), 196–200.

19. See Esther Newton, "The Mythic Mannish Lesbian: Radclyffe Hall and the New Woman," *Signs* 9, no. 4 (Summer 1984), 557–75. See also Lillian Faderman, *Surpassing the Love of Men: Romantic Friendship and Love between Women from the Renaissance to the Present* (New York: William Morrow and Co., 1981), esp. parts II and III.

20. Nancy K. Miller makes this observation about irony: "To the extent that the ethos (character, disposition) of feminism historically has refused the doubleness of 'saying one thing while it tries to do another' (the mark of classical femininity, one might argue), it may be that an ironic feminist discourse finds itself at odds both with itself (its identity to itself) and with the expectations its audience has of its position. If that is true, then irony, in the final analysis, may be a figure of limited effectiveness. On the other hand, since nonironic, single, sincere hortatory feminism is becoming ineffectual, it may be worth the risk of trying out this kind of duplicity on the road." See "Changing the Subject: Authorship, Writing, and the Reader," in *Feminist Studies/Critical Studies*, ed. Teresa de Lauretis (Bloomington: Indiana University Press, 1986), 119 n. 18.

21. See David Rodowick, "The Difficulty of Difference," *Wide Angle* 5, no. 1 (1982), 4–15; Teresa de Lauretis, *Alice Doesn't: Feminism, Semiotics, Cinema* (Bloomington: Indiana University Press, 1984), ch. 5; Miriam Hansen, "Pleasure, Ambivalence, Identification: Valentino and Female Spectatorship," *Cinema Journal* 25, no. 4 (Summer 1986), 6–32; Gaylyn Studlar, *In the Realm of Pleasure: Von Sternberg, Dietrich, and the Masochistic Aesthetic* (Urbana: University of Illinois Press, 1988). Mulvey herself has contributed to the discussion; see "Afterthoughts on 'Visual Pleasure and Narrative Cinema' inspired by King Vidor's *Duel in the Sun* (1946)," in *Visual and Other Pleasures* (Bloomington: Indiana University Press, 1989), 29–38.

22. Luce Irigaray, "Women on the Market," *This Sex Which Is Not One*, trans. Catherine Porter with Carolyn Burke (Ithaca, N.Y.: Cornell University Press, 1985), 172.

23. Luce Irigaray, "Commodities among Themselves," *This Sex Which Is Not One*.

24. Teresa de Lauretis, "Sexual Indifference and Lesbian Representation," *Theatre Journal* 40, no. 2 (May 1988), 159.

# RICHARD DYER

. . . . . . . . . . . . . . . . . . . . . . . . . . . . . . . . . . . . . . . . . . . . . . . . . . . . . . . . . . . . . . . . .

# From *Stars*

Author of ten books to date, Richard Dyer (b. 1945) is one of the leading figures in English-language cinema studies. His work deeply influenced the study of the cultural meaning and function of stars and entertainment genres like the musical (see p. 465); he virtually established gay and lesbian film studies and remains one of the most effective and prolific critics writing within that burgeoning field. He is also known for his 1997 study *White* (p. 822), which approaches representations of race in cinema and culture through the position that is too often the unmarked, presumptive norm. After receiving his Ph.D. from the Centre for Contemporary Cultural Studies at the University of Birmingham, Dyer taught for many years at the University of Warwick before taking up his current position at Kings College London.

As the opening of Dyer's book claims in plainspoken prose: stars are the most pervasive, yet least studied, aspect of cinema. Originally published in 1979, *Stars* addressed that lack, combining sociology and semiology with popular discourses on film in its systematic approach to the basic questions of why, what, and how stars signify. Dyer's work broke with the textual and psychoanalytic emphases of much British film theory of the period, anticipating the wider turn to cultural contexts in film studies in the 1980s and 1990s. In particular, Dyer's study helps us evaluate the complexity of the popular response to film. Attention to stars challenges the notion of the director as "author" of a text by attributing the source of some of its meaning to other key personnel. However, it shares with auteur theory the conviction that only a body of work, not a single film, reveals the social meaning of a particular persona, whether that of a star or another kind of film "author."

In the excerpts included here, Dyer introduces the idea of stars as "types" and outlines methods for evaluating the significant contribution of a star to the meaning and cultural status of texts. Using classical Hollywood stars like James Dean and Marilyn Monroe as examples, Dyer considers how these figures bring audience's prior associations to each of their film roles as well as how a star's films, along with publicity, promotion, and even scholarly studies, help construct the star image over time. Dyer examines how stars reinforce and also redefine social constructs and mediate contradictions between the extraordinary and the ordinary, male and female roles, or visibility (whether as protagonist or spectacle) and invisibility. Countless scholars have followed Dyer's example, looking at stars from other periods, media, and national cinemas. As celebrity culture seems to grow in interest and variety with the proliferation of new media forms, his groundbreaking work is all the more valuable. Fully considering this contribution challenges the notion of the director as "author" of a film as well as approaches that see a film in isolation from other films or from its reception contexts, including its fans.

## READING CUES & KEY CONCEPTS

▪ Consider Dyer's notion that different stars represent different "social types." Based on his examples, can you think of contemporary stars that represent the alternative or subversive type?

▪ Think about Dyer's methodology for "reading" a particular star. Apply his criteria of promotion, publicity, films, and criticism and commentary to your own "reading" of a contemporary star.

▪ Consider the concept of "star as author" in Dyer's account. Think of a contemporary example that would help explain this concept.

▪ **Key Concepts:** Ideology; Semiotics; Star-Image; Fans; Camp; Polysemy

# From *Stars*

## *Introduction*

Although stars form the basis of probably the larger part of everyday discussion of films, and although the majority of film books produced are fan material of one kind or another, very little in the way of sustained work has been done in the area. No work, that is, that elaborates some kind of theory of the phenomenon and uses this theory to inform empirical investigation of it.

Within film studies, reasons for studying the stars have largely come from two rather different concerns that may broadly be characterised as the sociological and the semiotic. The former centres on the stars as a remarkable, and probably influential or symptomatic, social phenomenon, as well as being an aspect of film's "industrial" nature. In this perspective, films are only of significance in so far as they have stars in them. The semiotic concern reverses this. Here, stars are only of significance because they are in films and therefore are part of the way films signify. [ . . . ] One of my assumptions has been that this distinction, while useful in helping one to handle an otherwise unmanageably large topic, is essentially one of convenience, and that both concerns are mutually interdependent. Thus, on the one hand the sociological concern can only make headway when informed by a proper engagement with the semiotics of stars, that is, their specific signification as realised in media texts (including films, but also newspaper stories, television programmes, advertisements, etc.). This is because, sociologically speaking, stars do not exist outside of such texts; therefore it is these that have to be studied; and they can only be studied with due regard to the specificities of what they are, namely, significations. Equally, on the other hand, the semiotic concern has to be informed by the sociological, partly because stars are, like all significations, also and always social facts, but also because it is only on the basis of a proper theorisation of one's object of study that one is able to pose questions of it. Semiotic analysis has to make assumptions about how texts work before proceeding to analyse them; once it is granted that all texts are social facts, then it follows that these textual assumptions must be grounded in sociological ones. You need to know

of thing a text is in society in order to know what kind of questions you
mately pose of it, what kind of knowledge you can reasonably expect it to

[ · · · ]

## ars as Types

Despite the extravagant lifestyle of the stars, elements such as the rags-to-riches
motif and romance as an enactment of the problems of heterosexual monogamy
suggest that what is important about the stars, especially in their particularity, is
their typicality or representativeness. Stars, in other words, relate to the social types
of a society.

### THE NOTION OF SOCIAL TYPE

The notion of a type—or rather a social type—has been developed by O. E. Klapp.
Here we are concerned with what social types are.

In *Heroes, Villains and Fools,* Klapp defines a social type as "a collective norm of
role behaviour formed and used by the group: an idealized concept of how people
are expected to be or to act" (p. 11). It is a shared, recognisable, easily grasped image
of how people are in society (with collective approval or disapproval built into it).
On the basis of this Klapp proceeds to provide a typology of the prevalent social
types in America, and he frequently provides stars' names to illustrate the different
examples. Thus under "heroes of social acceptability," he lists Will Rogers, Sophie
Tucker and Perry Como, and under "snobs" he lists Grace Kelly, Elizabeth Taylor,
Ingrid Bergman, Zsa Zsa Gabor, Katharine Hepburn, Garbo and Davis. (A star may
of course be listed under several different, even contradictory, categories reflecting
both the ambiguity of their image and the differences in audience attitudes—thus
Monroe for instance is used as an example of "love queen" and "simpleton," while
Liberace is a "charmer," a "dude," a "deformed fool" and a "prude.") The star both
fulfils/incarnates the type and, by virtue of her/his idiosyncrasies, individuates it.
(Critics committed to individualism as a philosophy or tenet of common sense tend
to speak of the star's individuation of a type as "transcendence.")

[ · · · ]

### ALTERNATIVE OR SUBVERSIVE TYPES

Most types discussed by Klapp, and indeed most stars discussed as social types, are
seen as representing dominant values in society, by affirming what those values are
in the "hero" types (including those values that are relatively appropriate to men
and women) and by denouncing other values in the villain and fool types. Klapp
argues, however, that there may also be other types that express discontent with
or rejection of dominant values. These types will also be grounded in a normative
world-view, but as an alternative to the dominant one.

[ · · · ]

## The Rebel

The type that springs most readily to mind in this context is "the rebel." I[n] [ar]ticle "The Rebel Hero," a brief survey of this type, Sheila Whitaker lists John G[arfield,] Montgomery Clift, Marlon Brando, James Dean, Albert Finney, Paul Newman[, Steve] McQueen and Jane Fonda as representative of the rebel hero. She stresses d[iffer]ent relations of rebellion—the immigrant (Garfield), the rebel against his own c[lass] (Clift), generation gap rebels (Brando, Dean), the anti-hero (Newman, McQuee[n,] Finney) and the politically conscious rebel (Fonda). The question with these stars is to what extent do they really embody oppositional views (and in what terms)? We can break this question into two parts. First, are they informed by concepts of anomie or alienation? (I do not mean to imply that they or those responsible for their image were students of sociology; but sociological concepts like anomie and alienation can be seen as theoretical abstractions of widely known beliefs and understandings—the common sense and political practice of society throw up the theoretical constructs of sociology which enable us to see that sense and that practice with greater clarity.) Are they grounded in material categories or in a generalised *Angst*? The answer does not seem to be clear cut. Immigration and youth are material categories, and one can see Finney and Fonda as embodying working-class and women's situations respectively. However, not all the rebels Whitaker lists can be seen in similar terms, nor is it clear that the rebellion of those who can is actually cast in terms of that material situation. Are Garfield's films *about* the oppression of immigrants? Is Finney in *Saturday Night and Sunday Morning* a rebel against the middle class? Brando, Dean and Fonda do expressly articulate the situation of youth and women, and could be said to be "alienated" rebels to that degree.

Second, do these stars, in expressing rebellion, heavily promote it or recuperate it? In answering this question, we would do as well to remember that in terms of "effect" we do not really know whether Garfield *et al.* made people more rebellious or not. What we can examine is the degree to which the image points to the legitimacy of rebellion or its inadequacy. In general, I would suggest it does the latter, because of the characteristics of the *type* to which the stars belong and because of the film *narratives* in which they are placed. *The type itself* is problematic because firstly, most of the heroes are either actually anomic or largely so, so that in the case of those who are not, the alienated/materialist elements are liable to be subsumed under anomie. (Garfield, Finney and Fonda are not rebelling as immigrant, worker and woman respectively, but because they don't "fit" even among immigrants, workers and women.) Secondly, the heavy emphasis on youth in the type carries with it the notion of the "passing phase," the "inevitable," "natural" rebellion (often shored up with garbled notions of the Oedipus complex). Youth is the ideal material term on which to displace social discontent, since young people always get older (and "grow up"). Thus the rebellion of Garfield, Finney or Fonda can be seen as symptomatic of their youth rather than anything else. This process of displacement reflects that analysed in *Resistance through Rituals*,[1] whereby press reaction to youth movements of the 50s and 60s is shown to have consistently avoided recognising these movements as class-specific. Thirdly, the type is very little connected to the basic structures of society. Class really only has relevance in the case of Finney. Most of the heroes are male in very traditional ways (often enforced by generic associations from the Western and the thriller), though I would agree with Jack Babuscio that Clift and Dean, who were both gay, did something to launch a non-macho image of

a man.[2] Fourthly, inarticulacy (a symptom of anomie) is the defining characteristic of the type, and it inhibits him/her from any analysis of the situation. (Fonda is, of course, the exception to the last two points. It may be that I am wrong to follow Whitaker's inclusion of her alongside Garfield *et al.* It may be that the cinematic rebel type is defined by being male and inarticulate, and that Fonda is a different type altogether. At the same time, many of the other points that can be made about the "rebelliousness" of the rebel type do seem applicable to her attempt to embody radical attitudes.) The *narratives* of the films in which these stars appeared tend to recuperate rather than promote the rebellion they embody. This is partly due to the way in which they tend to develop the problem of the hero as an individual, quasi-psychological problem. The fault is liable to be located in him/her and not in the society in which s/he lives (e.g. *The Wild One, Klute*). When there is some suggestion that the problem lies outside the hero, then this problem is often defined as the failure of some persons in her/his world to live up to traditional concepts and dominant values. James Dean's two "youth" films, *Rebel without a Cause* and *East of Eden*, seem to me to indicate that the character played by Dean has problems that are not only his psychological hang-up but in the family situation in which he lives. This does not mean, however, that the films are critical of the family as an institution, but rather of the failure of the parents of the Dean character to fulfil adequately their familial roles. In *Rebel* he has too weak a father, in *Eden* too charismatic a mother. In other words, the rebellion against family is recuperated because it is against an inadequate family rather than the family as a social institution.

## The Independent Woman

Perhaps one of the reasons for the almost implacable recuperation of the rebel type is that s/he is too obviously oppositional to social values. A more covert example is the independent woman type (or series of types) embodied by Davis, Katharine Hepburn, Barbara Stanwyck, Rosalind Russell, Joan Crawford and others during the 30s and 40s. Do these stars represent a more complete alternative or opposition to dominant values?

In *From Reverence to Rape*, Molly Haskell suggests a distinction within these stars between the superfemale and the superwoman. (The same star may be both types at different points in her career.) The superfemale is

> a woman who, while exceedingly "feminine" and flirtatious, is too ambitious and intelligent for the docile role society has decreed she play. . . . She remains within traditional society, but having no worthwhile project for her creative energies, turns them onto the only available material—the people around her—with demonic results. (p. 214)

The chief example of this category is Bette Davis, particularly in *Of Human Bondage, Jezebel, The Little Foxes, Dangerous, Dark Victory* and *Mr. Skeffington*. The superwoman is

> a woman who, like the superfemale, has a high degree of intelligence or imagination, but instead of exploiting her femininity, adopts male characteristics in order to enjoy male prerogatives, or merely to survive. (ibid.)

The chief examples here are Joan Crawford as Vienna (in *Johnny Guitar*) and Katharine Hepburn.

This is a suggestive distinction, although it could do with some working-up to be made more directly usable. Is it just a question of the difference between roles within and without the domestic arena? Are there characteristic narrative patterns that structure the representation of the two types? What is the relationship between the star as a total image and the specific character constructed in given films? Are the types carried by physical features, iconography of dress and gesture, modes of performance? These are genuine questions, not disguised attacks on Haskell's distinction. Answering them would be a way of clarifying the distinction and how it operates.

There is a second order of problems with the distinction, and that is how the superfemale or the superwoman actually embodies a radical alternative/opposition to prevalent female types. The "superfemale" seems inevitably to be shown as demonic in her actions, and it is hard to distinguish her too firmly from other "strong," "magnetic" types such as the "bitch" (Davis), the *femme fatale* and the intellectual/aristocratic type (Hepburn), all of which strongly discount the value of female strength and intelligence. At most, the superfemale type seems capable of articulating the damage done when a person of great capacities is confined to a demeaning or over-restricted world.

The superwoman on the other hand raises a more complex set of problems. What exactly is going on when a female character "adopts male characteristics"? There are perhaps two ways of understanding this.

On the one hand, one can recognise that "characteristics" of personality are not gender-specific (there is nothing innately male about aggressiveness or innately female about gentleness), but that, for whatever historical-cultural reasons, certain characteristics are associated with one gender rather than the other and that, as a consequence, individual women and men have a great deal invested (in terms of their identities as women and men) in preserving the association between such-and-such a characteristic and one gender or the other. This means that attempts to alter this, to cross gender barriers, to adopt the characteristics associated with the opposite sex, is a matter of negotiation, of working out a way of doing this which both frees people from the constructions of gender-roles and yet does not utterly damage their self-identities. This seems to be the kind of process that Haskell especially admires in Katharine Hepburn. In her relationship with Spencer Tracy, "Tracy can be humiliated and still rebound without (too much) loss of ego. Hepburn occasionally can defer to him and still not lose her identity" (p. 230). More generally, Hepburn's superwoman

> is able to achieve her ends in a man's world, to insist on her intelligence, to insist on using it, and yet be able to "dwindle," like Millamant in *The Way of the World*, "into marriage," but only after an equal bargain has been struck of conditions mutually agreed on. (p. 230)

As Claire Johnston has pointed out, the emphasis in Haskell on "reconciliation between men and women . . . flexibility of role playing, 'love' and camaraderie" ignores "the question of the nuclear family [that] has been central to the feminist critique of patriarchal culture" ("Feminist Politics and Film History," p. 121), and treats the problem simply as people deciding to relate better to each other rather than analysing what prevents this and where the roles come from. However, perhaps as a

model of how relationships between the sexes might be conducted (a practical ideal rather than a romantic one), as a "utopian" expression (telling us where we want to get to, rather than how to get there), the negotiated adoption of "male characteristics" celebrated by Haskell could be acceptable as an alternative/oppositional statement. As she develops it, however, there are I think two further problems. One is that the women seem to have to do all the running, make all the moves (including most of the concessions); it might be worth examining one of the Tracy/Hepburn films to see how far Tracy is prepared to adopt "female characteristics." The second is that there is a strain of anti-gayness in her writing, which suggests that the ideal relationship between women and men is also the ideal human relationship—in other words, Haskell is heterosexually normative (or heterosexist).

On the other hand, some feminist theory suggests that in a patriarchal culture there is no such thing as "the female," only the non-male.[3] That is to say that films are unable to conceive of, or to cope with, anything that is female, which means in effect that the only way a woman can be accepted as a person (except as a demeaned, and still ultimately threatening, sexual object) is for her to become "non-male": that is, without gender. Although Haskell herself does not work within these terms, some of her accounts of the superwoman stars do support it. Thus the relationship between Joan Blondell and James Cagney in *Blonde Crazy* is based on "the unspoken understanding that a woman is every bit the 'gentleman'—or nongentleman—as a man is and can match him in wits and guts and maybe even surpass him" (p. 130). And she quotes a very revealing piece of dialogue from the Rosalind Russell film *Take a Letter, Darling*, in which Robert Benchley, her boss, complains that her competitors—all men—don't understand her:

"They don't know the difference between a woman and a . . ."
"A what?" Russell asks.
"I don't know," Benchley replies, "there's no name for you."

The Hawks women whom Haskell admires are accepted into the male group, as soon as they cease to be womanly—Jean Arthur in *Only Angels Have Wings* is a striking case in point. What seems to me to be happening in the narrative of these films is that there is a contempt for female characteristics yet an obligation to have woman characters. This problem is resolved in the person of the woman who becomes a man (almost). What one thinks about this procedure depends upon one's politics, and in particular whether one does despise female characteristics or whether one sees them as, certainly, oppressed and not, potentially anyway, gender-specific, yet still none the less representing real strengths and values that form the basis and power of the women's movement.

The "independence" of the stars under consideration here is expressed both in the characters they play and in what was reported about them in magazines (e.g. Davis's fight with Warner Bros. over her contract, Hepburn's intellectual background, Crawford's struggle to the top from a background of poverty). Do the narratives of the films they appear in legitimate and promote this image, or undermine it?

The endings of the films usually involve a "climb-down" on the part of the star. As Elizabeth Dalton observes, in a survey of Warner Bros. films about working women: "A woman could be resourceful, intelligent, even cynical, for 59 minutes but in the last two, she would realise that it was love and marriage that she really

wanted" ("Women at Work: Warners in the Thirties," p. 17). This dénouement may also involve punishment and humiliation for the star—not only at the hands of the male character(s), but at the hands of the film itself. In *His Girl Friday*, when Rosalind Russell corners the sheriff who wants to avoid her questions, she is filmed in a way that makes her look comic, not resourceful. *Mildred Pierce* blames Mildred/Crawford for the death of her youngest daughter; despite the fact that the latter is in the care of her father at the time, the film manages to put the blame onto Mildred/Crawford for her independence. Though there are exceptions to the rule, the narratives do not appear to legitimise independence.

Haskell, however, has argued that, in a sense, these endings do not matter. What we remember is the independence not the climb-down or the humiliation:

> We see the June bride played by Bette Davis surrender her independence at the altar; the actress played by Margaret Sullavan in *The Moon's Our Home* submit to the straitjacket in which Henry Fonda enfolds and symbolically subjugates her; Katharine Hepburn's Alice Adams achieve her highest ambitions in the arms of Fred MacMurray; Rosalind Russell as an advertising executive in *Take a Letter, Darling* find happiness in the same arms; Joan Crawford as the head of a trucking firm in *They All Kissed the Bride* go weak at the knees at the sight of labor leader played by Melvyn Douglas. And yet we remember Bette Davis not as the blushing bride but as the aggressive reporter and sometime-bitch; Margaret Sullavan leading Fonda on a wild-goose chase through the backwoods of Vermont; Katharine Hepburn standing on the "secretarial stairway" to independence; Rosalind Russell giving MacMurray the eye as her prospective secretary; and Joan Crawford looking about as wobbly as the Statue of Liberty. (*From Reverence to Rape*, pp. 3–4)

Of course, we cannot know what "we"—the audience in general—remember, but I think one could argue that in terms of emphasis, weighting within the film, performance, *mise en scène*, etc. the independence elements are stronger, more vivid, than the climb-down resolutions. Two observations support this. One, unlike the rebels, the narratives do not seem invariably to point to inadequacies in the psychology of either the independent woman stars or the people of their immediate environment to explain, and explain away, their independence. Two, because we are dealing with stars, and not just fictional characters, the specific details of what happens in the plot of the film may matter less than the "personality" that the film as a whole reveals—the star phenomenon emphasises the kind of person the star is rather than the specific circumstances of particular roles.

Marjorie Rosen in *Popcorn Venus* argues that the narratives of the independent woman films always show the star's independence and intelligence in the service of men. It is men who define the social goals and norms; it is to get a man, or for love of a man, that the star acts as she does: "It's unfortunate that Hollywood could not visualize a woman of mental acumen unless she was fixing up a mess her man/boss had made, covering a scoop to prove herself to a man, or deftly forging a life of dishonesty" (p. 147). It's hard to say how true this really is. Many of the films are about the star's independence *threatening* her relationship with the man she loves, but the pattern suggested by Rosen may also operate, thus effectively denying the

woman's independence any autonomy. *Now, Voyager* might be a case in point—the narrative details Davis's liberation from the dowdy spinster role imposed on her, yet it is a man, a psychiatrist (Claude Rains), who "gives" her the "means" to be free, and a man (Paul Henreid) who provides her with her ultimate project in life, namely, his daughter. While this element is certainly there, it does not, in my opinion, totally undermine the progressive elements in the film. It is just one of the contradictions of the film, and I suspect this narrative aspect, when it is there, often largely acts as a contradiction rather than an utter denial of "independence."

As Molly Haskell herself has pointed out, the independent women stars are often signalled as being exceptional or extraordinary women. Dietrich, Hepburn, Rosalind Russell, Davis, all have strong upper-class, intellectual or, in the case of Dietrich, exotic associations which make them "exceptions to the rule, the aristo-crats of their sex" (*From Reverence to Rape*, p. 160). Haskell argues this "weakens their political value." I am not myself so sure of this. All stars are in one way or another exceptional, just as they are all ordinary. The un-extraordinary "girl next door" types like June Allyson, Doris Day and Betty Grable are no less characteristic of the star phenomenon than are extraordinary types like Hepburn *et al.* It's worth remembering too that other independent women stars—Barbara Stanwyck, Ann Sheridan, Claire Trevor—do not carry upper-class or intellectual associations.

Many of the stars in the independent woman category were characterised by sex-ual ambiguity in their appearance and presentation. This can be an aspect of their physical attributes—the broad shoulders of Joan Crawford and Greta Garbo, Katha-rine Hepburn's height, the "tough" face of Barbara Stanwyck, Bette Davis's strutting walk—which, in the case of Crawford, could also be exaggerated by the way she was dressed. It can also be a play on costume, sequences of cross-dressing such as:

> Dietrich in white tie and tails, Garbo as the lesbian Queen Christina (although with "cover" romance), Eleanor Powell in top hat and tails for her tap numbers, and Katharine Hepburn as the Peter Pan–like Sylvia Scarlett; all introduced tantalizing notes of sexual ambiguity that became permanent accretions to their screen identities. (Haskell, p. 132)

This could of course be seen as another instance of cinema being unable to cope with the female and so presenting splendid women as men. However, recent discussion of the cinema in relation to homosexuality has suggested a different emphasis. Janet Meyers and Caroline Sheldon see these stars as an oblique expression of lesbianism:

> The qualities they projected of being inscrutable to the men in the films and aloof, passionate, direct, could not be missed. They are all strong, tough and yet genuinely tender. In short, though rarely permitted to hint it, they are lesbians. (Janet Meyers, "Dyke Goes to the Movies," p. 37)

Sheldon suggests in "Lesbians and Film: Some Thoughts" that if we understand lesbi-anism, not necessarily in purely sexual terms, but in terms of "woman-identification," then these stars are lesbian. They are "women who define themselves in their own terms . . . playing parts in which they are comparatively independent of domestic expectations and of men." Meyers and Sheldon are working within a lesbian feminist political perspective that will not be acceptable to many (including many feminists),

but their emphasis is a useful corrective to Haskell's heterosexist assumptions. Both recognise that lesbianism (in the erotic sense) may be used in film for the titillation of heterosexual men, but the sense of aloofness, "otherness," and non-domesticity combined with sometimes quite overtly erotic relationships with women could be seen as subversive of the heterosexual male's pleasure at being titillated.

Jack Babuscio and I have suggested a different emphasis to this, whereby the cross-dressing and play on sexual roles can be seen as a way of heightening the fact that the sex roles are *only* roles and not innate or instinctual personal features. This may be seen as part of the phenomenon of camp in the cinema:

> Camp, by focusing on the outward appearances of role, implies that roles and, in particular, sex roles are superficial—a matter of style. . . . Finding stars camp is not to mock them. . . . It is more a way of poking fun at the whole cosmology of restrictive sex roles and sexual identifications which our society uses to oppress its women and repress its men—including those on screen. (Jack Babuscio, "Camp and the Gay Sensibility," pp. 44, 46)[4]

In this respect then, independent-woman type stars make explicit the life-as-theatre metaphor which underpins the star phenomenon. This can be seen especially in the work of Bette Davis. Davis is one of the most "mannered" of the independent women—or any other—stars, yet this effectively foregrounds manners as a social code. With most stars, their particular manner is seen as a spontaneous emanation of the personality; but Davis is hard to treat in the same way since her manner is so obviously "put on." In certain films—*Jezebel, The Little Foxes, Dark Victory, Now, Voyager, All About Eve*—this sense of the artifice of social performance meshes with notions of social expectations and requirements, of women and/or of class.

## Stars as Specific Images

Stars embody social types, but star images are always more complex and specific than types. Types are, as it were, the ground on which a particular star's image is constructed. This image is found across a range of media texts. I want to discuss the nature of the different categories into which these texts fall, and then to consider [ . . . ] how these texts construct a specific star image.

A star image is made out of media texts that can be grouped together as *promotion, publicity, films,* and *criticism* and *commentaries.*

### PROMOTION

This refers to texts which were produced as part of the deliberate creation/manufacture of a particular image or image-context for a particular star. It includes (i) material concerned directly with the star in question—studio announcements, press hand-outs (including potted biographies), fan club publications (which were largely controlled by the studios), pin-ups, fashion pictures, ads in which stars endorse a given merchandise, public appearances (e.g. at premieres, as recorded on film or

in the press); and (ii) material promoting the star in a particular film—hoardings, magazine ads, trailers, etc. Thomas B. Harris has described this in some detail in "The Building of Popular Images."

Promotion is probably the most straightforward of all the texts which construct a star image, in that it is the most deliberate, direct, intentioned and self-conscious (which is not to say that it is by any means entirely any of those things).

Promotion can get things wrong. Early promotion may not push the aspects of the performer which were subsequently to make them a star (e.g. both Davis and Monroe were promoted as routine pin-up starlets to begin with). However, this is more the exception than the rule, and either way promotion can be taken as an indicator of the studio's (or its promotion department's), agent's or star's conception of a given star image.

On occasion, promotion of a film may be deliberately untrue to the film itself, in the interests of promoting the star's image (e.g. Marlon Brando's attempts to escape the "Stanley Kowalski" image of *A Streetcar Named Desire* by playing Napoleon in *Désirée* and Mark Antony in *Julius Caesar* did not deter the promoters of those films from billing his roles in Kowalski-esque terms—see the discussion by Hollis Alpert in his *The Dreams and the Dreamers*, "Marlon Brando and the Ghost of Stanley Kowalski").

## PUBLICITY

This is theoretically distinct from promotion in that it is not, or does not appear to be, *deliberate* image-making. It is "what the press finds out," "what the star lets slip in an interview," and is found in the press and magazines (not only the strictly film ones), radio and television interviews, and the gossip columns. In practice, much of this too was controlled by the studios or the star's agent, but it did not appear to be, and in certain cases (e.g. Ingrid Bergman's "illegitimate" child by Roberto Rossellini) it clearly was not. The only cases where one can be fairly certain of genuine publicity are the scandals: Fatty Arbuckle's rape case, Ingrid Bergman's child, the murder of Lana Turner's gigolo boyfriend, Robert Mitchum's dope charge, Judy Garland's drunken breakdowns, Elizabeth Taylor's "breaking up" of Debbie Reynolds's marriage with Eddie Fisher. Scandals can harm a career (Arbuckle permanently, Bergman temporarily) or alternatively give it a new lease of life (Turner, Mitchum, Taylor). An unnamed publicity man is quoted by Hollis Alpert to suggest a link between scandal and success and glamour:

> The stars are losing their glamour. It's next to impossible to get Burt Lancaster into columns these days. He's too serious. The public prefers its stars to behave a little crazy. Look what that dope party did for Bob Mitchum! Look how Deborah Kerr's divorce troubles sent her price way up! Who wants to form a fan club for a businessman? (*The Dreams and the Dreamers*, p. 39)

The importance of publicity is that, in its apparent or actual escape from the image that Hollywood is trying to promote, it seems more "authentic." It is thus often taken to give a privileged access to the real person of the star. It is also the place where one can read tensions between the star-as-person and her/his image,

tensions which at another level become themselves crucial to the image (e.g. Marilyn Monroe's attempts to be considered something other than a dumb blonde sex object, Robert Redford's "loner" shunning of the attention his star status attracts).

## FILMS

Inevitably, the films have a distinct and privileged place in a star's image. It is after all *film* stars that we are considering—their celebrity is defined by the fact of their appearing in films. However, the star is also a phenomenon of cinema (which as a business could make money from stars in additional ways to having them make films, e.g. in advertising, the fan industry, personal appearances) and of general social meanings, and there are instances of stars whose films may actually be less important than other aspects of their career. Brigitte Bardot is a case in point, and Zsa Zsa Gabor is a film star whose films only a dedicated buff could name. The deaths of Montgomery Clift, James Dean, Marilyn Monroe and Judy Garland (and the premature retirement of Greta Garbo) may be as significant as the films they made, while Lana Turner's later films were largely a mere illustration of her life. It may be as pin-ups that Betty Grable and Rita Hayworth are really important, and as recording stars that Frank Sinatra and Bing Crosby really matter. While in general films are the most important of the texts, one should bear these points in mind when, as here, the focus is the star's total image rather than the role of that image in the films.

Particularly important is the notion of the *vehicle*. Films were often built around star images. Stories might be written expressly to feature a given star, or books might be bought for production with a star in mind. Sometimes alterations to the story might be effected in order to preserve the star's image. This is what is implied by the term "star vehicle" (a term actually used by Hollywood itself).

The vehicle might provide a character of the type associated with the star (e.g. Monroe's "dumb blonde" roles, Garbo's melancholic romantic roles); a situation, setting or generic context associated with the star (e.g. Garbo in relationships with married men, Wayne in Westerns; as Colin McArthur has noted of stars of gangster films, they "seem to gather within themselves the qualities of the genre . . . so that the violence, suffering and *Angst* of the films is restated in their faces, physical presence, movement and speech" (*Underworld USA*, p. 24)); or opportunities for the star to do her/his thing (most obviously in the case of musical stars—e.g. a wistful solo number for Judy Garland, an extended ballet sequence for Gene Kelly—but also, for instance, opportunities to display Monroe's body and wiggle walk, scenes of action in Wayne's films). Vehicles are important as much for what conventions they set up as for how they develop them, for their ingredients as for their realisation. In certain respects, a set of star vehicles is rather like a film genre such as the Western, the musical or the gangster film. As with genres proper, one can discern across a star's vehicles continuities of iconography (e.g. how they are dressed, made-up and coiffed, performance mannerisms, the settings with which they are associated), visual style (e.g. how they are lit, photographed, placed within the frame) and structure (e.g. their role in the plot, their function in the film's symbolic pattern). Of course, not all films made by a star are vehicles, but looking at their films in terms of vehicles draws attention to those films that do not "fit," that constitute inflections, exceptions to, subversions of the vehicle pattern and the star image. (For further consideration of genre in film,

see Edward Buscombe, "The Idea of Genre in the American Cinema"; the section on "Genre Criticism" in Bill Nichols, *Movies and Methods*; and Steve Neale, *Genre*.)

One needs also to consider the star's *filmic presentation*, the specific ways in which the star appears, performs and is used in individual films.

## CRITICISM AND COMMENTARIES

This refers to what was said or written about the star in terms of appreciation or interpretation by critics and writers. It covers contemporary and subsequent writings (including obituaries and other material written after a star's death or retirement), and is found in film reviews, books on films and indeed in almost any kind of writing dealing, fictitiously or otherwise, with the contemporary scene. To this can be added film, radio and television profiles of stars. These always appear after the initial promotion and film-making of a star, although they may act back on subsequent promotion and film activity (e.g. the response of critics to Davis in *Of Human Bondage* legitimated her demand for "strong" roles; the intellectuals' "discovery" of Monroe is discernible in the increasingly self-reflexive nature of her last films). We need to distinguish between criticism and commentaries that did that, and those that have been elaborated after the star's active involvement in film-making. The latter may suggest an interpretation of the star at odds with the star's contemporary image (e.g. today's cult of Humphrey Bogart and Monroe—do we see more worldly wisdom in him, more tragic consciousness in her?).

Criticism and commentaries are oddly situated in the star's image. They are media products, part of the cinematic machine, yet it is commonly held that they are to be placed on the side of the audience—the consumers of media texts—rather than that of the industry—the producers of media texts. Critics and commentators are often taken to express rather than to construct the response to a star, and indeed on occasion they may well be expressing a widely held, preexisting sentiment or view about a star. More frequently, however, they contribute to the shaping of "public opinion" about a star (and the relationship of what the media call "public opinion" to the opinion of the public must always remain problematic). Despite this, critics and commentators do not operate in the same space as those who construct the image in promotion and films. This gap between on the one hand promotional and filmic construction of the star image (which is further complicated by the highly ambivalent way publicity relates to promotion and films) and on the other the role of criticism and commentaries in that construction is a real one, and accounts for both the complexity, contradictoriness and "polysemy" of the star image and also for the capacity of critical opinion to contribute to shifts in careers such as those of Davis and Monroe noted above.

[ · · · ]

## *A Note on Authorship*

Authorship has long been an issue in film studies, in terms of who is to be considered the author of a film. Film poses this question with peculiar insistence because of its industrial production, involving hundreds of personnel and a very high degree of division of labour. (See Ivan Butler's *The Making of a Feature Film* for

a breakdown of this.) In the process of examining this, however, the very notion of authorship has been radically revised.

[ · · · ]

The major problem that all concepts of authorship present us with—in, be it said, all the arts—is the relationship between the semiotic or aesthetic text and the author. Traditionally this has been thought of as "expression": the text expresses the ideas, feelings and/or "personality" of the author. It has long been recognised, however, that such a formulation is inadequate, if only on the simple empirical grounds that authors are often not much like their texts. Various solutions to this have been posed, including the notions of the text as an expression of the author's unconscious and of her/his "artistic personality" (as something distinct from her/his personality in the rest of life). In film studies, this led to the habit of writing not of the films of Howard Hawks but of those of "Howard Hawks" (first suggested by Peter Wollen in the revised edition of his *Signs and Meaning in the Cinema*).

The problem, however, with any version of the expression theory is that it supposes a transparency between an author and her/his text. Yet it is a feature of all human expression that it "escapes" those who use it, precisely because expression is only possible through languages and codes that are more general, because shared, than an individual person or even group. This does not mean, though, that one can jettison individual persons from consideration of authorship altogether. Rather, we have to think of it in terms of people working on and in those languages and codes, and in so far as questions of personality are still in order, it is in the characteristic way of working with the codes that we can identify a film as "Hawks" or "Dietrich." Films then cannot be assumed to carry or embody authorial personality, but none the less people do work on films and make determinant decisions about them, and this is a legitimate area of enquiry.

## STARS AS AUTHORS

The study of stars as themselves authors belongs essentially to the study of the Hollywood production situation. It is certainly possible to establish, as "auteur theory" enjoins us, continuities, contradictions and transformations either in the totality of a star's image or in discrete elements such as dress or performance style, roles, publicity, iconography. However, the relationship between these and the star always has to be established by examination of what sources there are concerning the actual making of the image and films. That is to say, a star, in films, publicity and promotion, is a semiotic construction and the fact that that construction exhibits continuities does not prove that the star as person is responsible for them. S/he may be, but also may not be.

[ · · · ]

In considering this, we must first distinguish between on the one hand authorship of the star image and/or performance, and on the other hand authorship of films.

In the case of images and/or performance, there may be stars who totally controlled this (Fred Astaire, Joan Crawford), or only contributed to it (Marlene Dietrich, Robert Mitchum), as part of a collective team (John Wayne) or just one

disparate voice among many (Marilyn Monroe, Marlon Brando); alternatively there will be others who were almost totally the product of the studio/Hollywood machine (Lana Turner). (The names in brackets are guesses only and require further research to confirm or disprove.) The fact that the person of the star coincides with a text (the star image, the character, the performance) in the construction of which s/he was only a collaborator or even a mere vehicle should warn us not to elide the star-as-person with the star-as-text and assume that the former is the author of the latter. Although I find it hard to conceive of a star having no power in the decisions made about her/his image or performance, just how much power s/he had and how s/he exercised it has to be determined by looking at specific cases.

In the case of stars as authors of the films they starred in, we must begin by excepting those cases where stars directed (or scripted) themselves in films: for instance, Charlie Chaplin, Buster Keaton, Mae West (scripts), Ida Lupino, Jerry Lewis, John Wayne, Clint Eastwood. In these cases, we have to make a theoretical distinction between their role as star and their other role in the production. The number of cases in which the totality of a film can be laid at the door of the star must be very few indeed. (Candidates include Greta Garbo and *Queen Christina*, Ellen Burstyn and *Alice Doesn't Live Here Any More*, and most persuasively Barbra Streisand and *A Star Is Born*.) However, the star as one of the "voices" in a film (always remembering any voice can only be returned to its author as the point of decision-making in production, not that of unmediated expressivity) is surely very common. This "voice" is not necessarily confined to matters of performance, dress, etc., but may affect almost any aspect of the film, depending upon how the star exercised her/his power.

## NOTES

1. In Tony Jefferson *et al.* (eds.), *Resistance through Rituals*, originally published as *Working Papers in Cultural Studies*, 7/8.

2. See Jack Babuscio, "Screen Gays" in *Gay News* nos. 79 (Dean) and 104 (Clift).

3. The *locus classicus* of the view that "culture is male" is Simone de Beauvoir: *Le Deuxième Sexe*. For a discussion of more recent, psychoanalytically oriented theorisations, see Elizabeth Cowie, "Woman as Sign."

4. See also Richard Dyer, "It's Being So Camp as Keeps Us Going," pp. 11–13.

## BIBLIOGRAPHY

Affron, Charles, *Star Acting*, E. P. Dutton, New York, 1977.

Alpert, Hollis, *The Dreams and the Dreamers*, Macmillan, New York, 1962.

Babuscio, Jack, "Screen Gays," *Gay News*, nos. 73 ("Camp Women"), 75 ("Images of Masculinity"), 92 ("Sissies"), 93 ("Tomboys").

———, "Camp and the Gay Sensibility," in Dyer, Richard (ed.), *Gays and Film*, British Film Institute, London, 1977.

Buscombe, Edward, "The Idea of Genre in the American Cinema," *Screen*, vol. 11, no. 2, pp. 33–45.

Cowie, Elizabeth, "Woman as Sign," *m/f*, no. 1, pp. 49–63.

Dyer, Richard, "It's Being So Camp As Keeps Us Going," *Body Politic* (Toronto), no. 36, September 1977, pp. 11–13.

———, "The Way We Were," *Movie*, no. 22, pp. 30–3.

Finn, Tom, "Joe, Where Are You?" (Marlene Dietrich), *The Velvet Light Trap*, no. 6, Autumn 1972, pp. 9–14.

Harris, Thomas B., "The Building of Popular Images: Grace Kelly and Marilyn Monroe," *Studies in Public Communications* 1, 1957, pp. 45–8.

Haskell, Molly, *From Reverence to Rape*, Holt, Rinehart and Winston, New York, 1974; Penguin, London, 1974.

Johnston, Claire (ed.), *Notes on Women's Cinema*, Society for Education in Film and Television, London, 1973.

———, "Feminist Politics and Film History," *Screen*, vol. 16, no. 3, Autumn 1975, pp. 115–124.

Klapp, Orrin E., *Heroes, Villains and Fools*, Prentice-Hall, Englewood Cliffs, NJ, 1962.

McArthur, Colin, "The Real Presence," *Sight and Sound*, vol. 36, no. 3, Summer 1967, pp. 141–3.

Meyers, Janet, "Dyke Goes to the Movies," *Dyke* (New York), Spring 1976.

Mulvey, Laura, "Visual Pleasure and Narrative Cinema," *Screen*, vol. 16, no. 3, Autumn 1975, pp. 6–18.

Rosen, Marjorie, *Popcorn Venus*, Coward, McCann and Geoghegan, New York, 1973.

Sheldon, Caroline, "Lesbians and Film: Some Thoughts," in Dyer, Richard (ed.), *Gays and Film*, British Film Institute, London, 1977, pp. 5–26.

Solomon, Stanley, *The Film Idea*, Harcourt Brace Jovanovich, New York, 1972.

Walker, Alexander, *The Celluloid Sacrifice*, Michael Joseph, London, 1966; reprinted (new title, *Sex in the Movies*), Penguin, London, 1968.

———, *Stardom, the Hollywood Phenomenon*, Michael Joseph, London, 1970; Penguin, London, 1974.

Whitaker, Sheila, "The Rebel Hero," *Hollywood and the Great Stars Monthly*, no. 8, pp. 10–13.

Wollen, Peter, *Signs and Meaning in the Cinema*, Secker and Warburg, London, 1969; reprinted with new conclusion, 1973.

Wood, Robin, *Personal Views*, Gordon Fraser, London, 1976.

# TIMOTHY CORRIGAN

## The Commerce of Auteurism

FROM *A Cinema without Walls*

Co-editor of this anthology, Timothy Corrigan (b. 1951) is a leading figure in cinema studies and its pedagogy in the United States. He is Professor of Cinema Studies, English, and History of Art at the University of Pennsylvania, where he also served as the first director of the Cinema Studies program offering a major and graduate certificate. Trained in English Romanticism, he taught for twenty-four years at Temple University and published his first book on cinema, *New German Film: The Displaced Image*, in 1983. He has since written numerous books and articles on postwar American and international

cinema, adaptation, auteurism, and the essay film. Corrigan is also co-author of *The Film Experience* (2nd ed., 2009), and the author of the widely used, translated, and reprinted *A Short Guide to Writing about Film* (7th ed., 2010).

Corrigan was among the first to diagnose and analyze the extent to which contemporary film culture uses the name of the director to brand and sell its product. Writing after the spectacular failure of Michael Cimino's grandiose *Heaven's Gate* (1980), Corrigan sees the filmmakers of the New Hollywood era as social agents who helped—and sometimes failed—to organize audience and commercial expectations after the stable financial climate of the studio system could no longer do so. Corrigan punctures the illusions about the auteur as Romantic genius (Andrew Sarris, p. 354), or even as modernist "structuring principle of enunciation" (Peter Wollen, p. 361), as well as the idea that directors' names and reputations are the cultural property of a select few cognoscenti. Instead, he proposes the concept of the commercial auteur, a figure whose celebrity extends beyond individual films, marking them, the studio, the audience, and even the illusion of expressivity itself with its aura.

In "The Commerce of Auteurism," first published in 1991 and later revised, Corrigan draws on current examples of international auteurs and American directors in a prescient analysis of the authorial strategies that proliferated in the crowded marketplace of the final decade of the twentieth century and beyond. In the age of "mini-majors" (studio divisions that market independent and foreign films), new financial and technological challenges to the industry, and the increase in ancillary markets, information portals, and film festivals, every new filmmaker is a potential auteur trotted out for interviews and endorsements. Today's directors, whether directly manipulative of the discourse of authorship (M. Night Shyamalan, Quentin Tarantino) or more self-reflexive examples of what Corrigan names "auteurs of commerce" (Steven Soderbergh, Todd Haynes), must interact tactically with the market. Corrigan's analysis grounds the auteur's position and predicament in a close reading of interviews with the "godfather" of contemporary auteur brands, Francis Ford Coppola. His examination of Coppola's career reveals a self-constructed narrative of persecuted artist and visionary entrepreneur. This example leads Corrigan to suggest that rather than the "death of the author" (Roland Barthes, p. 345), we may have come upon the days of the death of the text, a time when it is no longer possible to evaluate a particular film outside the "commerce of auterism."

## READING CUES & KEY CONCEPTS

▪ Corrigan claims that the concept of auteurism is historically adaptable; trace the key moments he describes, from the postwar period to New Hollywood to the present.

▪ According to Corrigan, how does the use of the concept of the auteur to market a film help stabilize the number and variety of possible interpretations?

▪ Consider the concept of agency in Corrigan's essay. What does it offer considerations of authorship?

▪ How does Coppola add to his own image as a celebrity-auteur, according to Corrigan?

▪ **Key Concepts:** Expressivity; Commercial Auteur; Auteur of Commerce; Social Agent

# The Commerce of Auteurism

. . . . . . . . . . . . . .

*As soon as you become that big, you get absorbed.*

Francis Coppola

A foundation of postwar film criticism, auteurism has never been a consistent or stable way of talking about films and filmmakers. When auteurs and auteuristic codes for understanding movies spread from France to the United States and elsewhere in the sixties and seventies, these models were hardly the pure reincarnations (as critics sometimes urged us to believe) of literary notions of the author as the sole creator of the film or of Sartrean demands for "authenticity" in personal expression.[1] Rather, from its inception, auteurism has been bound up with changes in industrial desires, technological opportunities, and marketing strategies. In the United States, for instance, the industrial utility of auteurism from the late 1960s to the early 1970s had much to do with the waning of the American studio system and the subsequent need to find new ways to mark a movie other than with a studio's signature. One might also recognize the crucial contribution to auteurism made by the new social formation of movie audiences in the early sixties: the massive "teen-aging" of audiences in Europe and America. In the late sixties the global encounter with traditional forms of authority on campuses and on the streets opened doors in academia to nontraditional disciplines like film studies, and this in turn helped to create a crucial forum and platform for a new international art cinema identified with auteurs like Ingmar Bergman, Luis Buñuel, Michelangelo Antonioni, and Jean-Luc Godard, as well as American auteurs like Arthur Penn and Robert Altman.

The historical adaptability of auteurism, back through the works of early filmmakers like von Stroheim and Eisenstein and forward through the present generation of Spielberg and Cimino, identifies mainly the desire and demand of an industry to generate an artistic (and specifically Romantic) aura during a period when the industry as such needed to distinguish itself from other, less elevated, forms of mass media (most notably, television). Auteurism offered not just new audiences, retrieved from the modernist art communities, but new cultural sanctions to old audiences, alienated and awash in an indistinguishable spate of media images. Since the 1970s especially, the auteurist marketing of movies whose titles often proclaim the filmmaker's name, such as *Bernardo Bertolucci's 1900* (1976), *David Lean's Ryan's Daughter* (1970), or *Michael Cimino's Heaven's Gate* (1980), aim to guarantee a relationship between audience and movie whereby an intentional and authorial agency governs, as a kind of brand-name vision whose contextual meanings are already determined, the way a movie is seen and received.

## I. The Multiple Children of Truffaut: From Author to Agent

One of the chief mystifications or omissions within early theories and practices of auteurism has been a valorization of one or another idea of expression, mostly disconnected from its marketing and commercial implications.[2] Despite their large differences, theories and practices of auteurism from Astruc and Peter Wollen to Foucault and Stephen Heath, from John Ford to Jean-Luc Godard share basic

assumptions about the auteur as the structuring principle of enunciation, an orga-
nizing expression of one sort or another. Whether one locates that auteurial pres-
ence as a source for stylistic or other textual consistencies and variations or as a
figurative authority supplanting a lost or "dead" source (as Barthes would say) in
the form of a textual enunciation, the place of the auteur within a textual causality
describes a way of organizing spectatorial positions in a transcendent or trans-
subjective fashion (142–148).[3] To view a film as the product of an auteur means to
read or to respond to it as an expressive organization that precedes and forecloses
the historical fragmentations and subjective distortions that can take over the re-
ception of even the most classically coded movie. The often strained attempts to
make consistent or evolutionary the British and American movies of Hitchcock or
the German and Hollywood films of Fritz Lang are governed by some sense of a
historically trans-subjective and transcendent category which authorizes certain
readings or understandings of those movies. In David Bordwell's analysis of au-
teurism as an interpretative cue, the film director "becomes the real-world parallel
to the narrational presence 'who' communicates (what is the filmmaker saying?)
and 'who' expresses (what is the author's personal vision?)" (211).

Formalist and cognitive critiques of auteurism, such as Bordwell's, can van-
quish most of the myths of expressivity in the cinema in favor of more formal and
heuristic uses for the auteur. Yet, these too do not fully attend to the survival—
and, in fact, increasing importance—of the auteur as a *commercial* strategy for
organizing audience reception, as a critical concept bound to distribution and
marketing aims that identify and address the potential cult status of an auteur.
Today, even these modernist corrections, discussions, or deconstructions of the
romantic roots of auteurism need to be taken another step towards recontextual-
izing them within industrial and commercial trajectories. Illustrating this need to
investigate how "the author is constructed by and for commerce," John Caughie
has noted that this question has been overlooked since Brecht's 1931 account of
*The Threepenny Opera* trial in which Brecht "brilliantly exposes the contradiction
in cinema between the commercial need to maintain the ideology of the creative
artist and the simultaneous need to redefine ownership in terms of capital, rather
than creative investment" (2).[4]

This attention to a commerce of auteurism is especially critical in keeping
pace with the auteur as a practice and interpetative category during the last fif-
teen years, the period when the play of commerce has increasingly assimilated
the action of enunciation and expression. Certainly such a revaluation of auteur-
ism as more than enunciatory expression or a heuristic category could and should
take place across any of its historical variations and to a certain extent has already
been implicit in the social and historical emphasis of a "politique des auteurs." Yet
the international imperatives of postmodern culture have made it clear that com-
merce is now much more than just a contending discourse: if, in conjunction with
the so-called international art cinema of the sixties and seventies, the auteur had
been absorbed as a phantom presence within a text, he or she has rematerialized
in the eighties and nineties as a commercial performance of *the business of being
an auteur*. To follow this move in contemporary culture, the practices of auteur-
ism now must be re-theorized in terms of the wider material strategies of social
agency. Here the auteur can be described according to the conditions of a cultural

and commercial *intersubjectivity*, a social interaction distinct from an intentional causality or textual transcendence.

Models of agency are useful here precisely because they are models of inter-subjectivity which aim to undermine the metaphysics and the authority of expression and intention, the cornerstones of a stable subjectivity. They delineate a model of action in which both expression and reception are conditioned and monitored by reflective postures towards their material conditions. Charles Taylor, for instance, has argued a model of human agency which foregrounds "second order desires" where the "reflective self-evaluation" of "the self-interpreting subject" has as its object "the having of certain first-order desires" (43, 28, 15). Similarly Anthony Giddens suggests a materialist model of expression as self-reflexive action: the motivation of expressive action, the rationalization of that action, and the reflective monitoring of action concomitantly interact to map the structure of expression as a reflective social discourse which necessarily calls attention to the material terms of its communication. In both cases, agency becomes a mode of enunciation which describes an active and monitored engagement with its own conditions as the subjective expresses itself through the socially symbolic. In the cinema, auteurism as agency thus becomes a place for encountering not so much a transcending meaning (of first-order desires) but the different conditions through which expressive meaning is made by an auteur and reconstructed by an audience, conditions which involve historical and cultural motivations and rationalizations. Here, the strange array of contemporary auteurs from Francis Coppola to Quentin Tarantino may strategically embrace the more promising possibilities of the auteur as a commercial presence, since the commercial status of that presence now necessarily becomes part of an agency that culturally and socially monitors identification and critical reception.

## II. The Auteur as Celebrity

The practice of the auteur as a particular brand of social agency appears most clearly and ironically in the contemporary status of the auteur as star.[5] This idea of the auteur-star vaguely harks back to the earlier avatars of auteurism who were placed in certain aesthetic and intellectual pantheons: from Orson Welles to Robert Bresson, the celebrity of the auteur was the product of a certain textual distinction. As generally consistent as that tradition of the textual auteur is, more recent versions of the auteurist positions have swerved away from its textual center. In line with the marketing transformation of the international art cinema into the cult of personality that defined the film artist of the seventies, auteurs have become increasingly situated along an extra-textual path in which their commercial status as auteurs is their chief function as auteurs: the auteur-star is meaningful primarily as a promotion or recovery of a movie or group of movies, frequently regardless of the filmic text itself. Like *Michael Cimino's Heaven's Gate*, auteurist movies are often made before they get made; and, like Coppola's *Tucker* (1989), a director's promoted biography can preempt most textual receptions of a movie. In a twist on the tradition of certain movies being vehicles for certain stars, the auteur-star can potentially carry and redeem any sort of textual material, often to the extent of making us forget that material through the marvel of its agency. In this sense, promotional technology and

production feats become the new "camera-stylo," serving a new auteurism in which the making of a movie (like *Fitzcarraldo* [1982]) or its unmaking (like *Twilight Zone* [1983]) foreground an agency that forecloses the text itself. As Godard has parodied it so incisively in recent films like *King Lear* (1989), in today's commerce we want to know what our authors and auteurs look like or how they act; it is the text which may now be dead.

Placed before, after, and outside a film text and in effect usurping the work of that text and its reception, today's auteurs are agents who, whether they wish it or not, are always on the verge of being self-consumed by their status as stars. By this I am not suggesting merely some brand of egotism or self-marketing posture but that the binary distinctions that once formulated most models of auteurist expression against textual organization have collapsed into what Dana Polan has called, in a larger context, the postmodern "evacuation of sense" ("Brief Encounters," 167–187). The oppositional calculus of expression to text, psychology to meaning, or authority to interpretation no longer sustains the contemporary auteur film. Instead, institutional and commercial agencies define auteurism almost exclusively as publicity and advertisement, that is, as both a provocative and empty display of material that intercepts those more traditional oppositions. Meaghan Morris has noted (in language similar to Richard Dyer's description of stars), that today "the primary modes of film and *auteur* packaging are advertising, review snippeting, trailers, magazine profiles—always already in appropriation as the precondition, and not the postproduction of meaning" (122–123). To respond to a movie as primarily or merely a Spielberg film is, after all, often the pleasure of refusing an evaluative relation to it. An auteur film today seems to aspire more and more to a critical tautology, capable of being understood and consumed without being seen. Like an Andy Warhol movie, it can communicate a great deal for a large number of audiences who know the maker's reputation but have never seen the films themselves. This, not surprisingly, is what so exasperates neo-romantic Marxist critics of postmodernism who cling longingly to the High-Modernist conception of the filmmaker as expressive artist, to a time before "art becomes one more branch of commodity production" and "the artist loses all social status and faces the options of becoming a *poete maudit* or a journalist" (Jameson, "Reification," 136).

Of the several tacks within the commerce of the auteur-star, the two that are most pertinent here are: the commercial auteur and the auteur of commerce. Although the first category could theoretically include a vast range of stars as directors and directors as stars (Sylvester Stallone, Madonna, Clint Eastwood, and so forth) more purportedly respectable names in this group would include Spielberg, George Lucas, Brian De Palma, David Lean and, with different agendas, John Sayles, Woody Allen, Truffaut of the later years, Lina Wertmuller, the Bertolucci of the latest Academy Awards, and the Spike Lee of Air Jordans. My argument so far would assimilate most of these names since what defines this group is recognition, either foisted upon them or chosen by them, that the celebrity of their agency produces and promotes texts that invariably exceed the movie itself, both before and after its release.

The second category is, I believe, the more intriguing variation on the first, for there a filmmaker attempts to monitor or rework the institutional manipulations of the auteurist position within the commerce of the contemporary movie industry.

If normally the auteurist text promotes and recuperates a movie, these filmmakers now run the commerce of the auteurist and autonomous self up against its textual expression in a way that shatters the coherency of both authorial expression and stardom. Motivations, desires, and historical developments—which are frequently dramatized in critical readings of films as at least semi-autobiographical—now become destabilized and usually with a purpose: did, one asks, the same Fassbinder who made *The Marriage of Maria Braun* (1978) give us *Querelle* (1982)? While a more traditional auteurist position could describe these changes in perspective and expression according to some coherent notion of evolution, an evaluation of many contemporary filmmakers must admit fissures and discrepancies that consciously employ the public image of the auteur in order to then confront and fragment its expressive coherency.[6]

As a specific example of the contemporary auteur's construction and promotion of a self, I will concentrate on one "semi-textual" strategy often taken for granted in the relation between a filmmaker, the films, and an audience: the interview, which is one of the few, documentable extra-textual spaces where the auteur, in addressing cults of fans and critical viewers, engages and disperses his or her own organizing agency as auteur. Here, the standard directorial interview might be described according to the action of promotion and explanation: it is the writing and explaining of a film through the promotion of a certain intentional self; it is frequently the commercial dramatization of self as the motivating agent of textuality. But it is this image of the auteur that the contemporary auteur necessarily troubles, confuses, or subverts through the agency of commerce.

## III. The Economics of Self-Sacrifice: Coppola

Certainly Francis Coppola is one of the more celebrated and bewildering examples of auteurism as it has evolved through the seventies and eighties. In an essay on the evolution of Coppola's career, Richard Macksey has astutely made the connection between Orson Welles and the more recent child prodigy of Hollywood, the first anticipating and the second following the heyday of auteurism as Romantic expression and independent (if not transgressive) vision. Yet, as Macksey observes, distinctions between the two filmmakers are even more compelling. On the one hand, "Welles has been a presiding model of Romantic genius, the myth of the explosive, comprehensive talent challenging corporate power and ultimately becoming the victim of its own genius." On the other hand, there is Coppola's marketing of that myth:

> If he has inherited something of the Romantic artist's impatience with the system, his powers of persuasion and need to take risks have led him toward the boardroom rather than the garret, back toward the old putative center of power in Hollywood (and the financial centers off-camera) rather than toward exile and "independent filmmaking." His perilous if uncanny power to enlist bankers probably depends upon his temperamental inability to fold in a poker game; movie-making and risk-taking are synonymous for him. (2, 3)

As a Romantic entrepreneur, Coppola becomes a self-exiled and stridently independent auteur who claims in one sentence "I need to be a solo guy" and then for *Tucker* humbly surrenders the film to George Lucas's "marketing sense of what people want"

(Lindsey, 23–27). Straddling the margins of European art cinema and the center of commercial Hollywood, he is one of the original directors of the contemporary blockbuster (*The Godfather* [1972]) and the one whose experimental goals seem most threatened by the financial and commercial exigencies of his blockbuster successes. Jon Lewis explains that as "far back as 1968, four years before *The Godfather* made him the best-known director in America, Coppola predicted that this generation of film school-educated *auteurs* would someday trigger significant change in the movie business"; yet, with the needed special emphasis on finances in Coppola's version of this paradox, the dazzling box-office success of expensive auteurist movies like *The Godfather*, *Jaws*, and *Star Wars*—the very sort of movies Coppola had once believed would foster a new American auteur industry—led to an industrywide focus on blockbuster box offices revenues. The success of auteur films in the 1970s did not, as Coppola hoped it would, give auteur directors increased access to film financing. Instead, directors became increasingly dependent on studio financing to produce and distribute such "big" films (21, 22). Indeed, this ambivalent double-image as the auteur-star of goliathan productions and the auteur-creator victimized by the forces of those productions defines Coppola's central place within the commerce of auteurism, characterizing him, in Andrew Sarris's off-hand portrait, as a "modern dissonant auteur" ("O Hollywood!" 51).

Coppola's career has followed an almost allegorical path. It begins confidently as a commercial talent (*Finian's Rainbow* [1968] and *The Rain People* [1969]), transforms itself through the commerce of auteurism (*The Godfather* and *The Conversation* [1974]), suffers the contradictions of that position (*Apocalypse Now* [1979] and *One from the Heart* [1982]), and settles uncomfortably into the aims of the commercial auteur (*Tucker*). Jeffrey Chown has described these commercial pressures and contradictions, beginning with Coppola's first appearance as the auteur-creator of *The Godfather*: "it is curious that the film that put Coppola on the celebrity map, that gave him the magic adjective 'bankable,' is also extremely problematic in terms of authorship. . . . Coppola coordinated diverse creative agents in this production, he was clearly the catalyst for the film's success, but, in a career view, his creative control and originality are far less than in other films that bear his directorial signature" (59). Even Coppola's most artsy and individual film, *The Conversation*, demonstrates major industrial complications within auteurism, at least as it is applied to the control of the filmmaker. Walter Murch, who engineered the brilliant soundtrack and much of the editing of that movie, can claim, for many critics, the most important part in that film. With *Apocalypse Now*, moreover, this most celebrated of contemporary American auteurs surrenders the choice of three different endings to a battery of advisors and miles of computer printouts which surveyed the expectations and desires of different audiences (including President Carter). In the most industrial and textual sense then, Coppola has become the willing victim of his successful name: as Chown observes of the critical slaughter that greeted *One from the Heart*, *The Outsiders* (1983), and *Rumble Fish* (1983): "The name Francis Ford Coppola connotes spectacles, Hollywood entertainment combined with artistic sensibility, Italian weddings, and napalm in the morning. Coppola the individual seems stifled by those expectations" (175). As with his capitulations to Army censors for *Gardens of Stone* (1987), self-destruction seems part of his "creative compromises" with the contemporary terms of auteurism.

His commercial compromises with the agency of auteurism mean, more exactly, a kind of sacrificing of that self as a spending and expending. In 1975, Coppola summed up his perspective on auteurism this way:

> The *auteur* theory is fine, but to exercise it you have to qualify, and the only way you can qualify is by having *earned* the right to have control, by having turned out a series of really incredibly good films. Some men have it and some men don't. I don't feel that one or two beautiful films entitle anyone to that much control. A lot of very promising directors have been destroyed by it. It's a big dilemma, of course, because, unfortunately, the authority these days is almost always shared with people who have no business being producers and studio executives. With one or two exceptions, there's no one running the studios who's qualified, either, so you have a vacuum, and the director has to fill it. (Murray, 68)

Coppola's emphasis here on the word "earned" is especially significant since for him the expressionistic privileges of auteurism are directly related to financial actualities of investment and risk: an auteur earns his status by spending himself, and both gestures involve the aggrandizement, demeaning, and "expending" of oneself through a primary identification with the agency and exchange of money. Thus the compliment of a self that is constructed as a financial agency is degradation of that self as *merely* a financial product. For Coppola, "the artist's worst fear is that he'll be exposed as a sham" (Murray, 65), namely, that an audience's financial investment in his agency will be revealed as only commerical advertisement.

This image of self curiously mirrors the obsessive geniuses found in Coppola's liturgical and operatic narratives. From the two *Godfathers* through *Apocalypse Now* and *Tucker*, his visionary characters invariably pursue grandiose spectacles which reflect their desires but which either literally or metaphorically then serve to destroy them. While these spectacles frequently echo their nineteenth-century origins (lavish visuals and operatic soundtracks), the more exact terms of their agency as cinematic characters are the contemporary spectacles of industrial technology as a financial investment (for war, for corporate industry, for the business of the family). *The Conversation* is the most appropriate example: driven by the passions of the protagonist Harry, it is a conversation through technology that leads to the absolute collapse of a sacrosanct individuality. Coppola's description of Harry, the devout and tortured Catholic, could indeed describe Coppola himself as auteur: "he's a man who has dedicated his existence to a certain kind of activity, to technology, and who in a part of his life experiences regrets and realizes that the weapon he uses for others in a certain fashion is destroying the man himself. . . . [T]he single reason for which he is destroyed is perhaps that he has started to question all that" (Belloni, 51). If Hollywood's commercial industry is the financial agency which makes and unmakes Coppola the auteur, Coppola remains driven to invest and lose that self in ever grander forms of its technological spectacle. Perhaps the most extraordinary and thus indicative examples of this tendency are Coppola's technological dream projects: a giant domed theater in the Rocky Mountains or an imagined film *Megalopolis* where four elaborate video-films would draw on Goethe's *Elective Affinities* to tell the story of Japanese–U.S. relations.[7]

Not coincidentally, I think, an interview with Coppola becomes a media performance focused on the technology and the business that define and threaten him. Worried about the casual nonchalance of his meeting with this auteur, for instance, one interviewer notes Coppola's immediate identification with the technology of the performance, "I needn't have worried. The minute I switched on my tape recorder, Coppola came to life. This was *work*. First, he corrected the position of the machine, then he fiddled with the volume and tone controls till he had them set to his satisfaction. Finally, he allowed me to question him" (Murray, 54). More generally, Coppola frequently constructs himself in an interview as an entrepreneur orchestrating the forces of technology or as a character lost in the improvisations of Hollywood business. In the same interview, he describes his expectations and frustrations about the Academy Awards, his struggles with Paramount executives to have Marlon Brando cast for *The Godfather*, and then acknowledges that this most famous vehicle for his agency as an auteur had less to do with his control of the film than with submission of self and the loss of energy: "A lot of the energy that went into the film went into simply trying to convince the people who held the power to let me do the film my way" (59).

Ultimately, of course, it is this expenditure of energy as the loss of self that is the contradictory measure of Coppola as auteur. Evaluating the ratio of his position as artist against his possible decision to actually assume the full agency of a studio (which he would do with phoenix-like Zoetrope Studios), he casts himself according to the finances of running a large piece of technology:

> If I were running a studio, it might take me 100 B.T.U.s worth of energy to bend something a quarter inch; if I stay independent and use my own resources, those 100 B.T.U.s could bend something a foot. . . . But look: The average executive of a movie studio may make $150,000 a year, and have a corresponding power, over his company. As a film artist I make much, much more than that and, consequently, have that much more power over my company. . . . Perhaps the wisest thing to do is to use all my energies to make a film that grosses some stupendous amount, then go out and buy a major company and change it from the top. (Murray, 68)

Appropriately, for this elaborate characterization of himself at the turning point in his commercial career, Coppola begins this 1975 interview by claiming "this is my last interview" (54). Within this glossy, high-tech conversation with *Playboy*, he must naturally be given up from the start.

Attempting to synthesize his relation to his movies in the manner of the Big Picture, Coppola's interviews often make him into the film itself. He becomes the presiding genius of the film of himself; however, this genius is represented not in expression or productive control but in expenditure and loss: loss of control, loss of money, loss of vision, and loss of self. His renowned posture as a risk-taker thus becomes a bombastic effacement of any distinguishing differences between his intentions and the films. In 1982, Jonathan Cott asks Coppola about the publicity gained from adopting this posture of loss during the production of *One from the Heart*. His response resembles the hysteric in trouble with his language and the trouble with the distinction between self and the agency for that self:

> The real answer, from my point of view, is that I just say what the facts are; in this case, that I'm working on a film, I'm told that the money's gone, and that if I want

to go ahead, I'll have to risk something of my own. And by that point, I'm so far into it that I say okay. . . . And then that tends to be the story that the people who write about me want to go for. If they ask me, "If the picture's a flop, will the company go out of business?" and if I say yes, it's because that seems to be the case. But it's not the idea that I want to push out into the public. In fact, I regret that I'm treated more as a charlatan or a con man than as a professional person, and to be honest, my feelings are hurt. I feel that I'm not reckless or crazy. It's just that I'm primarily interested in making films more than amassing money, which is just a tool. If someone suddenly gave me a billion dollars, for instance, I'd only invest it in my work. I will say yes to anything that seems reasonable to me, and sometimes I get in a little deep because I want to participate so much. (24)

A key moment in this interview, as with others with him, is the appeal for sympathy, not the distance of authority. It elicits a kind of social and psychological identification between Coppola and an imagined interlocutor, like that between a spectator and an actor-victim in an epic movie. For Coppola, the auteur communicates from one heart to another, and, for him specifically, the self-portrayal of the auteur as what has been persecuted and dismissed by the operatic conglomerates who have made him a powerless vehicle become the terms for a sympathetic identification: "I've done so much for them, and yet they resent even putting me in a position where I don't have to go to one of them with my hat in my hand and have them tell me what movies I can or cannot make" (76). At other times, with astonishing dexterity, he rhetorically moves between an image of himself as the powerful agent of a financial and technological machine and an image of the completely insignificant individuality that inhabits that agency:

You know what I think? I think people are afraid of me, basically. They're afraid if I ever got like too much power, I'd change their lives, and they're right! . . . I'm only a minor representative of the times. I may be a schmuck, but you can be sure that some other people somewhere are going to start doing the same kind of stuff, and the world is going to change. . . . As for myself, I'm not worried. What the hell! If I don't do it with this film, I'll go and invent some little gadget that will make billions! (Cott, 76)

The sympathetic enlistment of an audience now becomes the path for locating multiple subjectivities ("other people somewhere") within an agency that disallows the authority or stability of any single organizing perspective. In this action, Coppola puts into play the central problem of contemporary auteurism as an interpretive category: while it remains a more powerful figure and agency than ever, it is invariably forced to disperse its authority in terms of its commercial agency.

In the end, Coppola remains the most utopian figure within commercial auteurism, for whom the spectacle of self-destruction becomes a way back to self-expression. For him, the destruction of the authority of the auteur can mean the resurrection of a world of private auteurs, an intimate yet goliathan network of electronic communication. Speculating on the future of new technologies which regenerate themselves through money made and money spent on them, he proclaims a home video exchange which somehow retains the aura of auteurist agency, the expressive "I" becoming a third person plural:

Everybody will use it, everybody will make films, everybody will make dreams. That's what I think is gonna happen. You'll ship 'em over to your friend, and he'll ship one back. . . . I think that, very shortly, there's going to be a whole new approach to things, and the designers and the architects and philosphers and artists are going to be the ones to help lead the society. (Cott, 76)

## IV. The Age and Aging of Auteurs

There are many kinds of auteurs in contemporary culture. And there are many strategies through which a moviemaker can employ the agency of auteurism and by which audiences can use it as a way of understanding films. Both European and Asian filmmakers, for instance, have complicated this category for many years, and one only has to look to German or Chilean/French filmmakers such as Alexander Kluge or Raoul Ruiz to get a sense of the range of such revisions of auteurist practices. In the United States, the "displaced Hollywood auteur," more so than ever before, raises questions that need to be addressed. From Peter Weir and Wim Wenders to Stephen Frears, this group of global filmmakers who move in and out of Hollywood suggests contradictions and alternative descriptions to the history and coherence of auteurism.

In "The Unauthorized Auteur Today," Dudley Andrew has added another dimension to auteurism that needs to be taken into account. Following Gilles Deleuze's suggestion about the relation between an auteur's signature and a temporal "duration," Andrew argues that my primarily spatial relation of the commerce of auteurism, as it plays across public and private space, underestimates the temporal dimension of the auteur. The signature, Andrew posits, "embeds within it—as a hypertext—a genuine fourth dimension, the temporal process that brought the text into being in the first place. . . . The auteur marks the presence of temporality and creativity in the text, including the creativity of emergent thought contributed by the spectator" (83). Coppola's history as a filmmaker thus resonates through any individual film as a complex presence, and his recent release of *Apocalypse Now Redux* (2001) becomes an unusually visible and dramatic example of how the temporality of auteurism anticipates new films and remakes old ones. Appearing simultaneously with Peter Cowie's *Hearts of Darkness: A Filmmaker's Apocalypse* and a decade after Eleanor Coppola's documentary *Hearts of Darkness* (1991), new films and new documents reclaim a signature film as, now, a director's cut, remaking and revising the name of Coppola as a temporal extension.[8]

In whatever shape and in whatever agency, auteurs are far from dead. In fact, they may be more alive than at any other point in film history. This particular interpretive category has of course never addressed audiences in simple or singular ways. Yet, within the commerce of contemporary culture, auteurism has become, as both a production and interpretive position, something quite different from what it once may have been. Since the early 1970s, the commercial conditioning of this figure has evacuated it of much of its expressive power and textual coherency; simultaneously this commercial conditioning has called renewed attention to the layered pressures of auteurism as an agency which establishes different modes of identification with its audiences. However vast some of their differences as filmmakers may be, they each, it seems to me, willingly or not have had to give up their authority as authors and begin to communicate as simply figures within the commerce of that image. For viewers,

this should mean the pleasure of engaging and adopting one more text that surrounds a movie without the pretenses of its traditional authorities and mystifications.

## NOTES

1. See Jim Hillier's introduction to *Cahiers du Cinéma*, 1–17.

2. A collection of the major documents and debates about auteurism can be found in *Theories of Authorship: A Reader*, ed. John Caughie. See also Robert Sklar, *Movie-Made America: A Cultural History of American Movies*, 292–94.

3. See Peter Wollen, *Signs and Meaning in the Cinema*, Michel Foucault, "What Is an Author?" in *Language, Counter-Memory, Practice*, 113–38; Stephen Heath, "Comment on 'The Idea of Authorship,'" 86–91.

4. See Brecht's *Le Proces de quat'sous: experience sociologique*, 148–221 and Ben Brewster, "Brecht and the Film Industry," 16–33.

5. Revealing in its directness is Joseph Gelmis, *The Film Director as Superstar*. "Over half the movie tickets sold today," he notes, "are bought by moviegoers between the ages of sixteen and twenty-five. They know what a director is, what he does and what he's done" (xvii). A much more sophisticated analysis of that tendency is Sheila Johnston's "A Star Is Born."

6. In *Narration in the Fiction Film* David Bordwell recognizes this fragmentation of the auteur but sees it as a mere variation on the traditional auteur-narrator: "The popularity of R. W. Fassbinder in recent years may owe something to his ability to change narrational personae from film to film so that there is a 'realist' Fassbinder, a 'literary' Fassbinder, a 'pastiche' Fassbinder, and so on" (210). Obviously I believe that mobilizing these different agencies within an auteurist category has larger implications.

7. Not surprisingly, the ambivalent identification of the artistic self within the commerce of auteurism and its promise of the great spectacle of self becomes fraught with all the liturgical guilt of sin and self-sacrifice: "I am more interested in technology than I am in content. This, in some circles, is the same as admitting that one is a child molester and likes it. The truth is that I am interested in a content I can't get at. I yearn to be able to move into a world where story and content is available to me; where my ideas connect into a pattern that could be identified as a story. But I truly cannot get there" (Coppola, 3D).

8. Indeed, this temporal dimension of auteurism calls attention to other temporal figurings of auteurs within a commercial and historical agency. A common characteristic of new auteurs like Quentin Tarantino, for example, is the "immediacy" of the career (for Tarantino, made and hailed between 1992 and 1994 with *Reservoir Dogs* and *Pulp Fiction*). Other contemporary auteurs choose different temporal signatures: for example, they may be "historically remade" (as one might argue about Samuel Fuller), or become "proleptic" auteurs whose reputations have been established in advance of their films (like Michael Cimino even before his first film, *The Deerhunter* [1978] was released).

## WORKS CITED

Andrew, Dudley. "The Unauthorized Auteur Today." In *Film Theory Goes to the Movies*, ed. Collins, Collins, and Radner (New York: Routledge, 1993).

Barthes, Roland. *Image-Music-Text* (New York: Hill and Wang, 1977).

Belloni, Gabria and Lorenzo Codelli. "Conversation avec Francis Ford Coppola," *Positif* 161 (1974): 50–55.

Bordwell, David. *Narration in the Fiction Film* (Madison: University of Wisconsin Press, 1985).

Brecht, Bertolt. *Le Proces de quat'sous: experience sociologique*, 148–221 (Paris: Editions de l'Arche, 1970).

Brewster, Ben. "Brecht and the Film Industry," *Screen* 16 (Winter 1976–77): 16–33.

Caughie, John, ed. *Theories of Authorship: A Reader* (London: Routledge, 1981).

Chown, Jeffrey. *Hollywood Auteur: Francis Coppola* (New York: UMI Research Press, 1981).

Coppola, Francis. "The Director on Content," *Washington Post*, August 29, 1982: 30.

Cott, Jonathan. "Francis Coppola," *Rolling Stone*, March 18, 1982: 20–24. 76.

Cowie, Peter. *The Apocalypse Now Book* (New York: DeCapo, 2001).

Foucault, Michel, "What Is an Author?" in *Language, Counter-Memory, Practice*, ed. Donald F. Bouchard, trans. Donald F. Bouchard and Sherry Simon (Ithaca, N.Y.: Cornell University Press, 1977).

Giddens, Anthony. *Central Problems in Social Theory: Action, Structure, and Contrast in Social Analysis* (Berkeley: University of California Press, 1983).

Gelmis, Joseph. *The Film Director as Superstar* (Garden City, N.Y.: Doubleday, 1970).

Heath, Stephen. "Comment on 'The Idea of Authorship,'" *Screen* 14:3 (Autumn 1973), 86–91.

Hillier, Jim, ed. *Cahiers du Cinéma: The 1950s* (Cambridge, Mass.: Harvard University Press, 1985).

Jameson, Fredric. "Reification and Utopia in Mass Culture," *Social Text* 1 (1979): 130–48.

Johnston, Sheila. "A Star Is Born: Fassbinder and the New German Cinema," *New German Critique* 24–25 (Fall/Winter 1981–1982): 57–72.

Lewis, Jon. *Whom God Wishes to Destroy* (Durham, N.C.: Duke University Press, 1993).

Lindsey, Robert. "Francis Ford Coppola: Promises to Keep," *New York Times Magazine*, July 24, 1998, sec. 6: 23–27.

Macksey, Richard. "'The Glitter of the Infernal Stream': The Splendors and Miseries of Francis Coppola," *Bennington Review* (1983).

Morris, Meaghan. "Tooth and Claw: Tales of Survival and *Crocodile Dundee*." In *Universal Abandon: The Politics of Postmodernism*, ed. Andrew Ross (Minneapolis: University of Minnesota Press, 1988), 105–127.

Murray, William. "*Playboy* Interview: Francis Ford Coppola," *Playboy* 22 (July 1975): 53–68, 184–185.

Polan, Dana. "Brief Encounters: Mass Culture and the Evacuation of Sense," in *Studies in Entertainment: Critical Approaches to Mass Culture*, ed. Tania Modleski (Bloomington: Indiana University Press, 1986), 167–187.

Sarris, Andrew. "O Hollywood!, Oh Mores!" *Village Voice*, March 5, 1985: 5.

Sklar, Robert. *Movie-Made America: A Cultural History of American Movies* (New York: Vintage, 1975).

Wollen, Peter. *Signs and Meaning in the Cinema* (Bloomington: Indiana University Press, 1972).

# JEROME CHRISTENSEN

## Studio Authorship, Corporate Art

Co-founder and director of the Film and Media Studies Program and Center for Digital Media Research and Development at John Hopkins University, Jerome Christensen (b. 1948) is currently Professor of English at the University of California, Irvine, where he teaches both literature and film. He is author of numerous books on eighteenth- and nineteenth-

century literature, including *Romanticism at the End of History* (2000) and *Lord Byron's Strength: Romantic Writing and Commercial Society* (1992).

With his expertise in English Romanticism and his attention to the commercial and historical cross-currents affecting writers of that period, Christensen provides a persuasive argument for why the Romantic heritage of auteurism can and should be rediscovered in the larger commercial structures of the film industry. Specifically, he provocatively redirects the focus of auteurism away from individual artistic intentions towards the corporate intentions of a studio. In this way, Christensen's idea lines up with larger trends in contemporary film theory in two ways. First, it reflects the dramatic rethinking and reconceptualization of auteurism that occurred in the wake of Roland Barthes's (p. 345) and Michel Foucault's questionings of the biographical and Romantic assumptions of what authorship means and how it needs to be reconsidered in larger institutional and social terms as an "author-construction." Second, it expands the precise historical studies—such as those by David Bordwell (p. 558), Janet Staiger, and Tom Gunning (p. 69)—that direct attention toward the contextual forces that shape the production and reception of films rather than focus on the film itself.

Originally published in 2006, Christensen's argument in "Studio Authorship, Corporate Art" stretches across twentieth-century Hollywood filmmaking. He grounds his argument for the studio author in the tradition of 1930s grand movie factories like MGM and Paramount and continues in that trajectory using the examples of Universal Pictures and United Artists in the 1950s. His argument also has important implications for how studio identities altered after 1960 when the traditional studio system eroded and was reconstructed by conglomerate and transnational corporations that took control of moviemaking. Indeed, one example of corporate authorship in the film industry can be found in the heyday of Miramax and the defining leadership of Bob and Harvey Weinstein in the 1990s when they released such films as Quentin Tarantino's *Reservoir Dogs* (1992) and *Trainspotting* (1996).

## READING CUES & KEY CONCEPTS

■ How does Christensen understand the notion of authorial intention? How can a corporate body have intentions?

■ What kind of evidence does Christensen suggest demonstrates a studio's "hypothetical intention" for a movie? Managerial memos, financial records, promotional materials?

■ What does Christensen mean by his suggestion that studio executives are corporate "actors"? How does he feel that role creates the signature for a film?

■ **Key Concepts:** Author Construction; Corporate Intention; Functionalist Model of Film History; Hypothetical Intentionalism; Institutional History; Studio Authorship

# Studio Authorship, Corporate Art

. . . . . . . . . . . . . .

In its 1932 profile of Metro-Goldwyn-Mayer, *Fortune* departs from analysis of the studio's history, structure, and personality to herald the advent of corporate art:

MGM is neither one man nor a collection of men. It is a corporation. Whenever a motion picture becomes a work of art it is unquestionably due to men. But the moving pictures have been born and bred not of men but of corporations. Corporations have set up the easels, bought the pigments, arranged the views, and hired the potential artists. Until the artists emerge, at least, the corporation is bigger than the sum of its parts. Somehow, although our poets have not yet defined it for us, a corporation lives a life and finds a fate outside the lives and fates of its human constituents.[1]

In other words, the condition for the emergence of cinematic works of art is not individual genius, not technology, not even money, but the corporate organization of the studio. *Fortune* does not promise that Hollywood motion pictures will transport like art or that they will endure like art, but, it affirms, if any do they will count as examples of *corporate* art.

*Fortune*'s corporate art thesis has attracted few adherents in film studies. Richard Maltby's generalization in 1998 still holds true: "There has . . . been a fairly clear division between a practice of textual analysis that has either avoided historical contextualization or engaged in it only minimally, and economic film history that has largely avoided confronting the movies as formal objects."[2] The predominant theoretical approach to American film history descends from David Bordwell, Janet Staiger, and Kristen Thompson's landmark 1987 book *The Classical Hollywood Cinema*, which comprehends Hollywood films as industrial commodities. According to *The Classical Hollywood Cinema*, by the mid-1920s feature filmmaking had evolved from the individualistic enterprise of the early silent era into an industrial system organized on quasi-Fordist principles of mass production. Supervised by an inelastic hierarchy of managers, propelled by a rhythm of technological innovation and standardization, characterized by a coherent set of "ideological signifying practices," and driven to maximize profit, the motion picture industry produced, distributed, and exhibited marginally differentiated commodities for mass consumption.[3] *The Classical Hollywood Cinema* does combine extraordinary attention to film form with its equally impressive analysis of the industrial system. Those perspectives, however, work together because "group style" finally matters insofar as it contributes to the construction of a classical narrative, which, in the last instance, has as its function making a profit.[4] Whatever the distinctions between the mode of production in Detroit and Hollywood, it was the mode of production that mattered. Responsive to the market and changing practices, Hollywood product may have been elegantly varied, but individual films had no more meaning than the stylish tailfin on a Chevrolet or the newest hue of a Frigidaire.

Because meaning is incidental to the mode of production, questions of authorship are just not relevant. Form follows function, not intention. What an owner, manager, or worker wants to do or thinks he or she is doing has little bearing on what is finally done. In defending *The Classical Hollywood Cinema*'s functionalism, Dirk Eitzen seconds the view that in Hollywood "there is a clear discrepancy between the motivations for innovation and the actual causes of change. It was the consequences of inventions that determined their 'success,' and consequences, though they were deliberately sought, could very rarely be fully anticipated."[5] Thus although there were competing innovations by Hollywood practitioners, it was the system, not the individual inventors or even their managers, which determined

their success: "The innovations that won out were always those that fit best into the established 'modes' of practice and production" (p. 77). For the functionalist any supposed motive, whether individual or corporate, is a secondary effect of the dynamism of an industrial system that is fundamentally a technology for efficient self-reproduction through profit-maximization.

As applied by followers of *The Classical Hollywood Cinema*, the functionalist model normalizes the complex and peculiar business of making motion pictures by amalgamating the Hollywood studios into an industry, "a group of firms producing products that are close substitutes for each other."[6] Those firms may compete strenuously; or, as in the film industry, they might collectively agree to restrain competition in order to maintain a certain level of prices and restrict entry into the industry. Unlike a corporation, an industry is not a person, which is to say that although it may be incidentally personified (as "Hollywood" regularly is in the pages of *The Classical Hollywood Cinema*) and assigned "wants" or "needs," an industry can actually "want" or "decide" only when firms with shared interests formally establish an association or council, appoint representatives, agree on objectives, collaborate on policies, and hire spokesmen. Journalists at *Variety* in the 1930s could learn what the motion picture industry "thought" by consulting individuals charged to speak on its behalf, such as Will Hays, or by surveying an aggregate, such as the studio heads or the members of the Academy of the Motion Picture Arts and Sciences. They could learn nothing about what the industry wanted, needed, or planned by watching motion pictures. An industry perspective does have the considerable benefit of isolating the common denominators that permit cooperation on technical standards, establishment of conventions of representation, recognition of spheres of influence, and the traffic of personnel among the studios. But looking at Hollywood as a generic industry has the considerable disadvantage of erasing the strategies of individual studios, each of which—oligopolistic agreements notwithstanding—had a distinctive corporate intention that informed the meanings its films communicated to their various audiences. The phrase "MGM wanted" or "Warner Bros. decided" is not shorthand for an aggregate of individual opinions; it is the apt recognition of a corporate "person" capable of strategic intentions and tactical maneuvers, a person who has an achieved social reality and is the bearer of constitutional rights. When Jolson sang, Warner Bros. performed. When the Lion roars, MGM speaks.

When corporate theory is invoked in the landmark multi-volume *History of the American Cinema*, it involves a repudiation of the agency of persons—individuals and corporations—in favor of systemic inexorability. Donald Crafton speaks for the consensus when he asserts, "Symptomatic of the newer academic treatment of sound is the rejection of history told as the exploits of business geniuses or of individual stars, like Jolson. We now see these movers and shakers as cogs in the larger system."[7] In the volume devoted to the Hollywood of the 1930s, Tino Balio identifies two phases in the understanding of the motion picture industry as a corporate enterprise: outmoded accounts of Hollywood as under the virtual control of the Wall Street financiers who owned the studios, and "revisionist" accounts that "rest more or less on contemporary critiques of finance capitalism that focus on corporate hegemony. Robert Sklar," Balio says, "summarized the new thinking when he said that it is not so important 'who owns the movie companies but who manages

them.'" Like Bordwell, Staiger, and Thompson, Balio cites as his authority on the "new thinking" Alfred D. Chandler's *Visible Hand*, which

> defined the modern business enterprise as having two specific characteristics: "It contains many distinct operating units and is managed by a hierarchy of salaried executives." Motion-picture firms took on the first characteristic during the teens and the twenties when they integrated both horizontally and vertically. As they grew in size, these firms became managerial, which is to say, they rationalized and organized operations into autonomous departments each headed by a professional manager.[8]

<p align="center">[ · · · ]</p>

The work of a new generation of institutional historians has restored contingency to the account of the corporate revolution. William G. Roy has distilled the terms of the "major underlying debate" among contemporary historians and theorists of the modern corporation: those who insist that "the economy operates according to an economic logic based on efficiency" are opposed by those who are convinced that it "operates according to a social logic based on institutional arrangements, including power."[9] Roy's own case histories of the tissue of decisions made by financiers, entrepreneurs, stockbrokers, and legislators at the turn of the twentieth century seek to explain why, for example, James Duke's American Tobacco Company and not the National Tobacco Works rose to dominance in the cigarette industry. The efficiency of the business organization was rarely decisive in such contests. The success of particular corporations in specific industries was contingent on both the mix and mastery of the actors (entrepreneurs, financiers, legislators, judges) involved and the material and political opportunities available for exploitation. By committing to the efficiency thesis, ignoring both corporate intentions and the realization of those intentions in articulate artifacts, overvaluing technological determination, and undervaluing the studios' strategic exercise of behavioral, structural, and symbolic power, functionalist film scholars typically construct a history of unintended but preordained consequences and tell a story that could have gone no other way. To get the story right, we need to learn how corporate enterprises determined what they wanted, to reconstruct what corporate actors did to get what they needed in order to acquire what they wanted, and to pay close attention to the way in which corporate representations helped achieve corporate objectives.

For anyone interested in what motion pictures mean—what arguments they make, what actions they perform—it is as important to know that *The Gold Diggers of 1933* (1933) is a Warner Bros. film as it is that Mervyn LeRoy and Busby Berkeley directed it. What was distinctive about Berkeley's choreography was adequately imitated in MGM's *Dancing Lady*, which was rushed into production in the summer of 1933 to capitalize on the popularity of Warners' *42nd Street* and which, under David O. Selznick's supervision, did its best to mimic Berkeley's spectacular dance numbers. Yet the commitment to studio identity trumps copycatting for dollars. It would have never occurred to MGM (and therefore to Selznick) to mount a musical that features the commutative chorus rather than an inimitable star. In *Gold Diggers* the leading characters—Polly (Ruby Keeler), who sometimes impersonates Carol; Carol (Joan Blondell), who sometimes impersonates Polly; Trixie (Aline MacMahon), and the aptly named Fay Fortune (Ginger Rogers)—emerge from the chorus as a group

still bound by friendship and rivalry. In *Dancing Lady*, Janie Barlow, a burlesque dancer avid for "art," gets her start on Broadway as a member of the chorus, but that's merely a plot point on the royal road of Janie's destiny; there is no evidence that she knows anyone else's name or could be mistaken for any of the other dancers. And when Janie emerges as featured performer, she does it alone and is justified by a star quality that has nothing to do with her singing or dancing ability and everything to do with the fact that she is played by Joan Crawford. MGM showed little respect for directors: when Berkeley went to Metro he lost his style and when LeRoy signed on for more money than any other director in the history of the studio he lost all the dynamism that the raggedy, fast-paced environment of Warners had supplied him. MGM did not worry about directors, but it did worry about stars. It faces down the threat of star insurgency in *Singin' in the Rain* (1952) where one star who aspires to dictate to the studio is destroyed (and all stars both in the film and on the lot warned) by the demonstration *on the screen* of how the studio can exploit its formidable apparatus to synthesize the intra- and extra-diegetic and make a new star right before the eyes of the audience *in* the film and the audience *of* the film. That *Morocco* (1930) was made by Paramount may appear to be a fact of less significance than that Josef Von Sternberg directed and that Marlene Dietrich and Gary Cooper starred in the film—but it seems that way only because *Morocco was* made by Paramount. As a later Paramount motion picture, *Sunset Boulevard* (1950), would argue, in Hollywood only at Paramount were the directors and their stars more important than the studio—a hierarchy that was Paramount's brand identity.

[ · · · ]

To show that certain films are in accord with documented or inferred studio interests would be insufficient evidence to validate the thesis of studio authorship, for that test would ultimately appeal to the judgment of the market. To make the case that Hollywood motion pictures mean and that the studio makes that meaning in order to define its interests and to shape its future depends on the persuasiveness of the prior claim that a corporation can intend. And that depends on what one means by intention. To begin to specify the character of corporate intention, it will be useful to lay out an argument advanced by Noel Carroll on behalf of a theory of interpretation that he calls "moderated actual intentionalism." Carroll initially developed his theory in opposition to Beardsley and Wimsatt's postwar statement of "the intentional fallacy," which Carroll broadly renders as the view that "the realm of art and literature . . . is or should be sufficiently different from other domains of human intercourse so that the difference mandates a different form of interpretation, one in which authorial intent is irrelevant."[10] In his subsequent elaboration of the theory Carroll presupposes agreement that texts, which he also calls "artworks," can only be understood as meaningful and, therefore, subject to interpretation if they have been intended by an author. Carroll's presupposition enfolds my argument to a point: no interpretation without meaning; no meaning without intention; no intention without an author. Carroll does not approve of all intentionalists, however. He repudiates "the most extreme form" of intentionalism, which, he says, "maintains that the meaning of an artwork is fully determined by the actual intentions of the artist (or artists) who created it"—a view that leads to what he refers to as "'Humpty–Dumpty–ism': the idea that an author could make a work mean anything simply because he wills it so." In the name of moderation

and the service of common sense, Carroll insists that an author's statement of intention must be supported by the language of the text.

Carroll's chief objective, however, is to contest adherents of "hypothetical intentionalism," who claim that "the correct interpretation or meaning of an artwork is constrained not by the actual intentions of authors (compatible with what they wrote), but by the best hypotheses available about what they intended." The hypothetical intentionalist, Carroll reports, goes so far as to reject the actual writer as a privileged informant in favor of information that would have been publicly available to an ideal reader of the text.

[ · · · ]

Despite its serious flaws as a defense of "moderated actual intentionalism," Carroll's strict constructionist critique of the hypothesists is serviceable just so far as it applies to literary and other ordinary texts that *do* have an actual individual author, someone with whom we could imagine conversing. Hollywood motion pictures do not. Any claimant of that status can be effectively contested; at the end of the day, the distributive justice of the credit roll is the only authority that matters.[11] Consequently, most interpretive debates within film studies, whether or not they are explicitly informed by intentionalist commitments, have to do with a "theoretical entity" called an "author-construction." Positions on the authorship of studio films tend to cluster antithetically: at one pole are auteurist accounts which stipulate that some actual individual's contribution, whether director, screenwriter, or producer, qualifies her to be credited as auteur despite her limited participation and control; at the other extreme are materialist accounts that render some mode or means of production, some apparatus, or set of industrial conditions as the functional equivalent of the author. There is, however, a third, more comprehensive alternative: a person who is not actual but who, by warrantable assertion, nonetheless qualifies for the status of the intending author: the corporate studio itself.

By "the corporate studio itself," I include those Hollywood production companies that were incorporated (such as Samuel Goldwyn, Inc. and MGM until the end of the 1930s), those that were the production subsidiaries of larger corporations which included distribution and exhibition companies (Twentieth Century–Fox Film Corporation, RKO Radio Pictures, Inc., Paramount Pictures, Inc.), the one that straddled that distinction (Warner Bros.), and production companies that shared the structure, practices, and objectives of the major studios (Universal Pictures, Selznick International, United Artists after 1950). Organizational commitment to the "concept of the corporation" as "a social institution organizing human efforts to a common end" is decisive in determining studio authorship, not strict adherence to any particular organizational form.[12]

[ · · · ]

Hypothetical intentionalism is not parasitic on actual intentionalism any more than corporations are parasitic on actual humans. To state the studio authorship thesis in its full extension: no interpretation without meaning, no meaning without intention, no intention without an author, *no author without a person, and no person with greater right to or capacity for authorship than a corporate person.* Unlike the conversational model, which requires the interpreter to acquire her meanings from

what humans say about texts, the studio authorship thesis funds a theory of how persons make texts as well as how persons should interpret them.

[ · · · ]

In the preface to the second edition of *Managing for Results* (1986), Drucker credited his 1964 book with being the "first to address itself to what is now called 'business strategy,'"[13] By 1971, however, Kenneth R. Andrews could say that "business strategy," which defines the "choices of product or service and market of an individual business" had become distinguished from "corporate strategy," which applies to "the whole enterprise." Working with that distinction, Andrews revises Barnard's notion of the "common purpose" in light of the objectives of strategic management in the contemporary corporation. As Andrews defines it, "corporate strategy is the pattern of decisions in a company that determines and reveals its objectives, purposes, or goals, and defines the range of business the company is to pursue, the kind of economic and human organization it is or intends to be and the nature of the economic and non-economic contribution it intends to make to its shareholders, employees, customers, and communities."[14] Intention here emerges as a manager deduces from "decisions observed, what the pattern is and what the company's goals and policies are" (Andrews, 1987: 18). Corporate strategy cannot be referred to any empirical individual such as, say, the writer of a mission statement ("What exactly did you mean by saying our mission was 'the general welfare?'") or the innovator of a product line ("Does this mean that all our shorts have to be baggy?") or the CEO ("What was the *real* reason we merged with AOL, Mr. Levin?"). Because the "essence of the definition of strategy . . . is *pattern*. . . . It is the unity, coherence, and internal consistency of a company's strategic decisions that position the company in its environment and give the firm its identity, its power to mobilize its strength, and its likelihood of success in the marketplace" (Andrews, 1987: 15). Corporate employees become effective executives insofar as they are able to discern a pattern and, discounting the professed intentions of the actual agent of any particular decision, make a decision consistent with the operant intention.

Andrews' corporate executive is an *actor* who interprets a set of decisions as establishing the character of the organization, which he impersonates in order to make a decision that will accomplish corporate objectives and do so as if the corporation, not he, were the author of that strategy. Impersonation is the norm for successful performance in the corporation as, Barry King argues, it is in the theater and motion pictures:

> The actor's intention to portray a specific character in a specific way may seem at first sight, and the case of a leading actor is often so represented, to correspond to authorship conceived as the creative principle of the fixed, delimited text. But the process of character representation through impersonation entails that the actor should strive to obliterate his or her sense of identity in order to become a signifier for the intentionality inscribed in character. Such obliteration returns the project of intentionality to the level of the narrative itself which is usually "authored" reductively in terms of the director's or playwright's "vision," rather than as a meaning emergent from a collective act of representation. The full participation of the actor in the narrative as character thereby depends upon the suppression of the literary conception of the author.[15]

If we substitute "corporation" for "character" and "strategy" for "narrative," we are on firm ground making our conversion. It's when we get to the reduction that things get sticky. There is no question that such reduction occurs in all kinds of corporations: Ken Lay becomes the man with the vision for Enron, Gerald Levin for Time-Warner. Both men were gifted actors who had seized the opportunity to impersonate corporate intention; both cultivated a *reputation* for vision that reduced them to personifications of the company they led: the CEO as star. Eventually that status as personification became an alibi for each man when the strategy pursued by his company ended in disaster.

The template for that corporate device was the career of Irving Thalberg, whose pre-eminence at MGM was owed both to the unparalleled success of the motion pictures the studio produced under his supervision and to his decision *not* to take credit for any of the motion pictures that he produced. That willed anonymity was read by *Fortune* (as it had already been read by Hollywood) as Thalberg's preternaturally effective impersonation of the corporate intention in his work as vice-president of production even as he raised MGM to pre-eminence by attributing authorship to the studio. Of course, *Fortune*'s project was to pull the veil aside and bare the device by which Thalberg lost himself in the part of the studio; but as always at MGM, baring the device does not mean demystification, for although Thalberg is pressed into service as the personification of the studio that is the personification of Hollywood, in certifying Thalberg as the genius he has been called, *Fortune* renders him as the personification of the essential mystification that Hollywood, that corporate art, is and, not incidentally, the magazine makes Thalberg the first star executive in Hollywood and, arguably, in corporate America. *Fortune* never exactly called Thalberg a "star"—it took F. Scott Fitzgerald to do that—but the star-making machinery that would be applied to Alfred P. Sloan of General Motors, Joseph P. Kennedy of the US Maritime Commission, and Benito Mussolini of Italy was fabricated in its first profile of a Hollywood studio.

Neither the corporation nor the executive, MGM or Thalberg, is the actual author of the motion pictures that played in Loew's theaters. *There is no actual author.* And because there is none, the corporate intention cannot possibly be recovered from notebooks or minutes. In objecting to the "fictional" aspect of the implied author in Levinson's model, Carroll complains, "It is difficult to see how this theoretical construct could really explain the features of a text, since this theoretical construct could not have causally influenced the text in any way" (Carroll, 2001: 206). Yet that does not make sense for corporations. Whatever one's point of view on the merits of or limits to corporate personhood, no one has seriously doubted that the theoretical construct called the corporate person has causally influenced work of all kinds. At a more local level, consider a scene in which a writer, balked in the course of composition, asks herself, "what does all this mean?" She may look through her notes and drafts but not to search out a note that says, "I intend this." She is trying to discern a pattern in the decisions that she has made during the process of composition. The "I" that is the subject of her question can only be hypothesized; and if the hypothesis causally influences the making of the artwork, it is because the writer has been able successfully to impersonate the shaping intention of the work.

Let's look at an actual person, R. S. Crane—a theorist from the postwar era of corporate hegemony and an adversary of Beardsley and Wimsatt on the intentionalism

front. Crane begins one of his essays with a short reflection on the process of his own writing, which, despite ample preparation, does not proceed with ease unless he is directed by a "synthesizing idea." Crane's account of how this works is worth quotation:

> As a conception my idea may be tight or loose, complex or simple; I call it a shaping cause for the very good reason that, once such a principle has come to me for a particular essay, it generates consequences and problems in the detailed working out of my subject which I cannot well escape so long as I remain committed to writing the essay as I see it ought to be written. It exerts, that is, a kind of impersonal and objective power, which is at once compulsive and suggestive, over everything I attempt to do, until in the end I come out with a composition which, if my execution has been adequate, is quite distinct, as an ordered whole, from anything I myself completely intended or foresaw when I began to write, so that afterwards I sometimes wonder, even when I applaud, how I could ever have come to say what I have said.[16]

We can certainly see the lineaments, if not the visage, of hypothetical intentionalism in this bit of self-illumination. It does some violence to Crane to translate his 1953 account of a person's commitment to an "impersonal and objective power" to a generalization about the corporate studio, but it is the right violence to do. For Crane's "conception" of an impersonal, generative principle or "shaping cause" is what Drucker had in mind when, in 1946, he annunciated pax corporate America by promoting the "concept of the corporation" as "the dynamic element" of American society, the "symbol through which the facts are organized in a social pattern." Drucker might have anticipated that thoughtful people in the 1950s would have "intuitions" like Crane's in a society whose "representative institution" is the corporation, "which sets the standard for the way of life and the mode of living of our citizens; which leads, molds and directs; which determines our perspective on our own society" (Drucker, *Concept*: 6–8). Crane departs from the model of studio authorship by relying on a hit or miss intuition caused by an impersonal power. The impersonal person of the corporation is so organized that conceptions and decisions can be routinely generated by managerial technique.[17] When intuition hits it causes Crane to commit himself to an inescapable compulsion, but making movies cannot wait on intuition. The motion picture studio is so organized that to make movies filmmakers must impersonate a studio intention often unarticulated by any executive at the studio and then (here it goes the theater one better) *act* as if they are lost in the part. The motion picture studio is so organized that it remains the representative corporation in a society where the corporation is the representative institution, for in pursuing its own individual objectives the Hollywood studio equips its customers as no other business does with the tools to thrive if not in an actual corporation then in a society that inescapably labors under the concept of the corporation.

The tasks that follow from the studio authorship thesis are threefold: (1) to discern the pattern of studio productions that define its identity, represent its objectives, and that endeavor to achieve those objectives; (2) to account for how the corporate intention was realized in individual motion pictures within the organizational hierarchy; and (3) to contribute to the debate regarding "The New Hollywood," especially regarding

the effects of changes in the entertainment industry since the breakup of the studio system in the 1950s and 1960s on the social character, the system of representation, and the strategic aspirations of Hollywood studios.[18] We should look at movies, study the companies that made them, and ask whether the concept of the studio developed in the classical era and "the concept of the corporation" formulated by Drucker and others in the postwar era are still compatible and, if so, whether they are still pertinent in the globalized digital economy of the twenty-first century. A useful hypothesis might be that insofar as corporations increasingly understand their objectives in terms of a marketing paradigm and as long as that marketing paradigm depends on a traffic in identities (which make persons who become actors by becoming customers), the concept of the studio will remain vital to the success of corporate art.

## NOTES

1. *Fortune* (6 December J932); in *The American Film Industry*, ed. Tino Balio (Madison: University of Wisconsin Press, 1976), p. 263.

2. Richard Maltby, "'Nobody Knows Everything': Post-Classical Historiographies and Consolidated Entertainment," in Steve Neale and Murray Smith (eds.), *Contemporary Hollywood Cinema* (London: Routledge, 1998), pp. 25–6.

3. David Bordwell, Janet Staiger, and Kristin Thompson, *The Classical Hollywood Cinema: Film Style and Mode of Production to 1960* (New York: Columbia University Press, 1985).

4. Elizabeth Cowie, "Storytelling: Classical Hollywood Cinema and Classical Narrative," *Contemporary Hollywood Cinema*, p. 180.

5. Dirk Eitzen, "Evolution, Functionalism, and the Study of the American Cinema," *Velvet Light Trap*, no. 28 (Fall 1991), p. 76.

6. M. E. Porter, *Competitive Strategy* (New York: Free Press, 1980), p. 5. Quoted in Arnold Windeler, "Project Networks and Changing Industry Practices—Collaborative Content Production in the German Television Industry," *Organization Studies* (November 2001), n.p.

7. Donald Crafton, *The Talkie: American Cinema's Transition to Sound, 1926–1931*; Vol. 4 of *History of the American Cinema* (Berkeley: University of California Press, 1997), p. 5.

8. Tino Balio, *The Grand Design: Hollywood as a Modern Business Enterprise, 1930–1939*; vol. 5 of *History of the American Cinema* (Berkeley: University of California Press, 1993), pp. 25–6.

9. William Roy, *Socializing Capital: The Rise of the Large Industrial Corporation in America* (Princeton, NJ: Princeton University Press, 1997), p. 6. See also Charles Perrow, *Organizing America: Wealth, Power, and the Origins of Corporate Capitalism* (Princeton: Princeton University Press, 2002).

10. Noel Carroll, "Art, Intention, and Conversation," *Beyond Aesthetics: Philosophical Essays* (Cambridge: Cambridge University Press, 2001), pp. 157–8. Tellingly, Carroll gets "The Intentional Fallacy" wrong. A better, though still inadequate, statement of the purpose of the essay would be that "the realm of poetry is or should be segregated from personal expression so that the poem can be objectively evaluated."

11. Carroll invokes as evidence for his argument a moment at the end of the motion picture *Stand By Me* (1986), where it is difficult to tell whether a computer has been turned off accidentally or deliberately. Starkly different interpretations of the conclusion follow from each option. Carroll suspects that "most viewers would be loath to commend the producers of *Stand By Me* if it turned out they just didn't know what they were doing. But if we discovered, perhaps by asking them, that they did make the relevant scene with the exorcism interpretation in mind, the modest actual intentionalist would be happy . . ."

(Carroll, 2001: 210). Carroll does not clarify who the "producers of *Stand By Me*" are, those who are given screen credit as producers, according to Hollywood convention, or those who actually had a hand in the artistic production of the film. And if he would prefer the latter, would he be happy with a few producers, say, the director and maybe the screenwriter, or might he not feel compelled to poll all the producers, of the film: the assistant director responsible for monitoring activity on the set or all prop men who might have had occasion to touch the computer? If there is problem enough in identifying the actual producers of the film, deciding on a protocol to adjudicate different claims for responsibility would be seriously complicated. Would the producers be asked in a group or separately? Could we really expect any producer to confess to an accident? Would unanimous agreement be necessary or only agreement by a majority? Carroll's example actually shows that whatever one thinks of the merit of moderate actual intentionalism as an interpretive protocol for novels and poems, it cannot be applied to motion pictures with anything approaching the confidence his theory requires.

12. Peter F. Drucker, *Concept of the Corporation* (New York: John Day, 1946), p. 12.

13. Peter F. Drucker, *Managing for Results* (1964; rpt., New York: Harper and Row, 1986), vii.

14. Kenneth R. Andrews, *The Concept of Corporate Strategy* (1971; 3rd edn., Homewood, IL: Irwin, 1987), p. 13.

15. Barry King, "Articulating Stardom," *Screen* 26, no. 5 (September–October, 1985), p. 31.

16. R. S. Crane, "Towards a More Adequate Criticism of Poetic Structure," in *The Languages of Criticism and the Structure of Poetry* (Toronto: Toronto University Press, 1953), pp. 141–2.

17. With space, the illustration drawn from Crane could be complemented by a more self-conscious example of corporate theory from 1953: Dowling Productions' remarkable *Donovan's Brain*. That picture radically departs from its source, Robert Siodmak's novel, and earlier adaptations to explore with unprecedented incisiveness the thematics of the corporate takeover, represented as a scientist's ability to communicate with and be directed by the brain of a rapacious corporate executive, which has been extracted from the dying man's body. *Donovan's Brain* anticipates less the polyvalent *Invasion of the Body Snatchers*, directed by Don Siegel in 1956 for Walter Wanger Productions than the aggressively anti-corporate allegory of *The Invasion of the Body Snatchers* of 1978, directed by Philip Kaufman in spite of United Artists and its parent, the Transamerica Corporation.

18. For examples, see the numerous superb essays on the New Hollywood collected in Steve Neale and Murray Smith (eds.), *Contemporary Hollywood Cinema* (London: Routledge, 1998) and Jon Lewis (ed.), *The New American Cinema* (Durham: Duke University Press, 1998).

# PART 5
# GENRE: CLASSIFYING STORIES

*Ghost Dog, aware of his approaching death, stands face to face with his "retainer,"
Louie. Already embodying the unlikely and seemingly incompatible generic elements of
Japanese samurai and American gangster movies, in this scene, Ghost Dog invokes yet
another genre. Willingly submitting himself to death by his master in this quasi
stand-off scenario, he rearticulates a famous Western, saying: "This is high noon."*
Final Scene from Jim Jarmusch's *Ghost Dog: The Way of the Samurai* (1998)

One of the most fundamental insights in film theory is that the film experience extends well beyond the act of watching a film. It begins in advance, with, among other things, recollections of our previous film experiences, including our likes and dislikes, which then determine what kind of film we are going to watch and, to some extent, how we receive it. We often choose what to watch based on what we know of a particular film genre (meaning "type" or "class")—a set of conventions and formulas developed and repeated through film history. Furthermore, the way we understand a film has a great deal to do with the expectations it creates as a genre film. *Ghost Dog: The Way of the Samurai* (1998) by Jim Jarmusch is a film about an African American mafia hit man who has taken the spiritual and philosophical posture of a samurai. The film is a curious bricolage of samurai, gangster, Hong Kong action, and western movies; a collision of different, seemingly incompatible genres that mirrors the film's narrative about the clash of different cultures in a modern U.S. city. *Ghost Dog* draws from the image banks of both popular and high culture, from diverse historical and cultural contexts, and it clearly references and rearticulates

various classic genre films, such as *Seven Samurai* (1954), *High Noon* (1952), and *The Godfather* (1972). The film's meaning and humor depend considerably on the viewer's preexisting knowledge of the conventions of these film genres, as does its deconstruction of generic norms and myths. For example, the mafia portrayed in *Ghost Dog* is completely debauched and degenerate, contrasting strongly with the largely romantic and luxurious gangster world shown in films such as *The Godfather* and *The Untouchables* (1987). The godfathers in *Ghost Dog* are aged, bankrupt, and lonely. Behind with their rent, they watch television cartoons in a nearly catatonic state.

The concept of genre not only structures the experience of film audiences, but grouping and classifying films by style and story also serves producers and critics. The generic questions that underpin our choice, and understanding, of a film are precisely the same questions that producers need to take into account when anticipating the response to their product. Therefore, genre can forecast and imply a certain economic predictability or risk. Likewise, attention to those same issues provides film critics with practical tools for analyzing a film in terms of how it conforms to, negotiates, or subverts particular generic formulas, as well as how these generic formulas function in a broader cultural context as myths or cultural rituals. Genre is thus a conceptual thread that ties together and makes continuous seemingly different concerns: the frameworks of textual interpretation and critical analysis, the interests of the industry, and the desires and expectations of audiences.

Genre is an ancient approach to classifying diverse artistic texts that was revived by eighteenth-century European classicism; much later, cinema offered a unique staging ground for broader discussions of genre in relation to mass entertainment and media culture. However, it is important to note that genre's inherent critical disposition—viewing works of art as instances of types—conflicts with the aesthetic notion that works of art are authentic and unique personal expressions. Not surprisingly then, by the time cinema arrived in the 1890s, genres were discredited due to their association with mass-market publishing. This illuminates the disconnect between the significance of genre terminology in the film industry and the lack of early critical and scholarly attention to film genre.

Genre terms were used increasingly during the early years of film production to identify and differentiate films, and as Hollywood's size and influence grew throughout the 1920s, generic categories took on even bigger importance. As studios struggled to recover from the conversion to sound and soaring production costs throughout the decade, the pressure for a standardized product was extreme, and generic conventions became a commercial necessity. However, it wasn't until after World War II (under the influence of *Cahiers du cinéma* and its editors' reappraisal of Hollywood cinema) that mainstream film critics began to take genre films and genre criticism more seriously. Indeed, the emergence of genre criticism in the late 1960s and early 1970s can be understood as a corrective or outright rejection of auteurism. Genre criticism refuses the Romantic conception of the artist as unique and exclusive, and assumes a more inclusive method where issues of text and aesthetics intersect with those of industry, history and society, culture and audiences.

Equally important to note are the pitfalls, doubts, and questions that have plagued genre theory throughout film history. While some genres represent established categories of studio production (like the western and the musical), others (such as film noir) were retroactive designations constructed by critics—so do genres simply exist or are they *post facto* constructions of analysts? Are they based on story content or subject

matter (war films), artistic status (art films), mood or style (film noir), or perhaps sexual or racial affiliation (queer cinema, black cinema)? Given the variety of contexts and uses for generic labels and their crosscultural circulation, are such labels obsolete and hopelessly provisional? *Ghost Dog* is certainly a prime example of such problems in genre classification—"urban gangster film," "samurai film," "Jim Jarmusch film," or "postmodern film" are all equally valid descriptions of it. While it references and co-opts specific genre films and their generic elements, it neither belongs wholly to one of those genres, nor is it a simple mix of them. Rather, it reassembles its various generic elements into a unique expression—*Ghost Dog* refuses narrow definitions of genre and subverts prescriptive notions of what each genre should do.

In spite of its complications, genre has been a key concept in the development of film theory. It has been employed persistently in film theory and criticism with significant implications and has proved to be an important conceptual tool for thinking about cinema on a range of practical and theoretical levels. The selections in Part 5 explore the theoretical developments in genre theory, using the concept of genre to address simultaneously the dynamics of the text and the activities of the industry, audiences, and critics. Taken together, the essays reveal the problematic and provisional nature of generic labels as well as their centrality in understanding how cinematic meaning is constructed and received.

We begin with ARISTOTLE's *Poetics*, the classic text of genre studies whose methodology and generic terms have served as a foundation for many subsequent studies in both literature and film. In particular, Aristotle's definition of tragedy touches on several aspects of genre that became important to genre criticism in film: such as the kinds of events portrayed, the social rank and ethical quality of the characters, narrative structure, and audience effects. Offering a useful method in identifying the qualities and limits of each genre, Aristotle's model provides a cornerstone of genre analysis in film and has proved remarkably influential and durable. Yet Aristotle's model deals with "types," which run the risk of static taxonomy and essentialism, one of the pitfalls of genre theory when applied to cinema. It relies on the ahistorical premise that genre is already "out there" and has essential qualities that can be revealed through proper analysis, masking the productive role of scholars in the definition of generic categories. More important, in the context of cinema, such a model abstracts genre from industrial and cultural uses of the term, and it does not take into account the complex and continuous evolution of cinematic forms.

Given the problems of defining genre using a set of theoretical principles, most critical writing employs new methods that acknowledge the historical contingency of genre as well as its function in a larger social context, even when deploying Aristotle's categories. One such method in genre criticism draws analogies between genre and myth, arguing that genre, like myth, serves a ritual purpose and has an organic relation to social consciousness. In his 1981 book *Hollywood Genres*, THOMAS SCHATZ, informed by Lévi-Strauss's structuralist reading of myth, defines genres around a set of binary oppositions and argues that their narrative patterns work to resolve specific cultural tensions, if only temporarily. Schatz divides Hollywood genres into those that attempt to reestablish social order (western, crime, detective) and those that attempt to establish social integration (musical, comedy, melodrama). He maintains that the resolution of conflict is the genre film's function as "cultural ritual," although this process happens differently for different genres.

Similarly, RICHARD DYER, in "Entertainment and Utopia," is interested in the idea of genre as cultural myth, focusing on the musical, which was traditionally dismissed as "mere entertainment" rather than seen as a genre performing a culturally significant role. Dyer takes very seriously the idea of entertainment *as* entertainment, and he examines how the everyday problems of scarcity, bleakness, and lack of community are addressed through the abundance of energy and the utopian sensibility offered by the style, gestures, song, and dance of the musical. The utopian world in musicals, he maintains, is not conveyed through representational codes but rather through the level of sensibility, "the feelings it embodies." It is this utopian sensibility that accounts for the success of the musical, even though the solutions offered by musicals to the real needs of a society are created by the same society and therefore do not succeed.

While Schatz and Dyer propose a ritual significance in Hollywood genres, the editors of the film journals *Cahiers du cinéma* and *Screen* argued that Hollywood film imposed dominant ideological meanings on audiences, and they saw genre as an ideological tool, rather than a social ritual. JEAN-LOUIS COMOLLI and JEAN NARBONI, the editors of *Cahiers* in the late 1960s and 1970s, draw on the theories of Karl Marx and Louis Althusser to define Hollywood film as a commodity functioning according to the laws of the market, and as a part of the ideological superstructure determined by the capitalist system. They argue that cinema, rather than reproducing reality, reproduces only the world of the dominant ideology. They classify films based on whether they expose cinema's alleged "depiction of reality," and from this point of view, genre is critiqued as being a subset of the broader ideological structure of classical Hollywood narrative, since it binds the viewer to the institution of cinema as a whole.

Against this view of film genres as a mere symptom of mass production, theorists began to see genre as a result of a complex encounter between the audience's ritual values and the industry's ideological commitments, recognizing that the way audiences use genre to understand a film's internal and external codes is not a fixed process but a continuously changing and fluid one. For RICK ALTMAN, the key to the success of genre lies not in its reflection of an audience ideal, nor in its reflection of the dominant ideology of the Hollywood industry, but rather in its ability to carry out both functions simultaneously. Rejecting genre purists (Aristotle), semioticians in search of elements of film language, and myth critics (Schatz), Altman proposes a language-oriented model that is more sensitive to the historical conditions in which genres circulate and are consumed.

"A Semantic/Syntactic/Pragmatic Approach to Genre" is a follow-up to Altman's 1984 article "A Semantic/Syntactic Approach to Film Genre." In the original essay Altman developed an approach that was both "semantic" in its concern with visual iconography and narrative content, and "syntactic" in its focus on the structure into which narrative elements are inserted. Altman asserted that films can mix the semantics of one genre with the syntax of another, and that they can dissolve syntactic bonds while leaving semantic patterns in place. In his later essay included here, he expands this semantic/syntactic approach to account for broader historical patterns of generic change and what he calls the "multi-discursive" aspect of genre, the fact that it serves diverse audiences differently and represents a site of struggle among multiple users. The "pragmatic" part of his triadic approach thus addresses the "use factor" that subjects the semantic and syntactic factors to further analysis based on the uses to which they are put. *Ghost Dog* is an excellent example of this; the film questions the conventions of gangster genre syntax (the mafia has no influence on the

community, and the industrial city they live in seems to be in a complete state of decay), and it uses a unique mix of genres to forge a new syntax out of familiar semantic material. Moreover, *Ghost Dog*'s weaving of clashing genre elements into a new syntax constructs a broader discourse about the hybrid nature of the multicultural urban environment portrayed in the film and of Ghost Dog himself. This hybridity is a perpetual source of conflict, a conflict that rests on the assumption that labels have fixed, rather than fluid and arbitrarily assigned meaning. The pragmatic approach recognizes such fluidity.

This mapping of generic form against broader social conditions and historical tensions is a crucial aspect of *Ghost Dog* and also a crucial aspect of genre theory, most of which situates the study of genre within the broader intertextual context of cinema, seeing genre as a complex discursive system involving not just films themselves but also other cultural phenomena. THOMAS ELSAESSER's "Tales of Sound and Fury: Observations on the Family Melodrama" is one of the definitive texts on the subject of melodrama. He traces the evolution of the melodramatic form in several European countries and links this to the rise of the bourgeoisie as a class and to its need for self-representation in a secular world. Reminding us of the historical contingency of generic forms, his study of such Hollywood directors as Douglas Sirk demonstrates how the melodramatic imagination was adapted to reveal (more than resolve) the inadequacies of mainstream American culture in the 1950s.

For other critics, this expanded approach means posing the question of film genre not only in terms of aesthetic or industrial processes, but also as a broader process of cognition that involves the spectator. This active power of the audience is a crucial aspect of many recent critiques that are interested in genre analysis not in and of itself but insofar as it offers larger insights into the dynamics of social hierarchies and patterns of identification. CAROL J. CLOVER's feminist investigation of the horror genre, *Men, Women, and Chain Saws*, uses the study of genre to raise larger questions about the cinematic apparatus and cinematic identification. The goal of her analysis of the relationship in horror film between viewers (largely young males) to what she terms the "female victim-heroes" is not so much to define the characteristics of the genre but rather to show how the complexity of this relationship subverts and revises our understanding of the presumably stable and fixed paradigm of spectatorship and identification. In *Ghost Dog*, Ghost Dog befriends a Haitian ice cream man. Although they develop a deep bond and communicate easily with each other, the film subtitles their conversations, putting the spectator in the position of an outsider in relation to their friendship—a position that otherwise belongs to the main character in the film. Among other things, this shows that the process of "reading" and decoding meaning (inherent in the question of film genre) goes much deeper than using the same language; rather, it is part of a much broader question about cultural cognition and social processes of identification.

*Ghost Dog* is only one example of a film composed of diverse generic elements reassembled in ways that reject singular generic understanding. As such, it points both to the fact that genre is still a significant conceptual and theoretical category, and to the reality that it cannot be seen as a one-dimensional entity. In a manner similar to other contemporary films (*Moulin Rouge!* [2001], *Chicago* [2002], *Slumdog Millionaire* [2008]), the film not only subverts generic boundaries but also blatantly quotes, recirculates, and reassembles already familiar generic texts. *Ghost Dog*'s literary references—*Frankenstein, Hagakure: The Book of the Samurai*, and Du Bois's *The Souls of Black Folk*—are in dialogue with each other;

the animated cartoons that the film draws from, like *Betty Boop*, *Felix the Cat*, and *Itchy and Scratchy*, converse with its cinematic references, *The Godfather* and *Seven Samurai*. Even the music in *Ghost Dog* melds Asian influences, reggae, jazz, hip hop, and urban sounds. This coexistence of generic elements from popular culture with various generic texts of different historical periods and cultural contexts shows how individual generic features, rather than being the property of specific genres, circulate fluidly through popular culture. In this way, *Ghost Dog*, as well as most contemporary genre theory, establishes genre not only as a necessary mechanism of film comprehension, but also as a mechanism through which cinema functions by deriving from and assimilating a range of cultural expressions.

# ARISTOTLE

## The Origins of Tragedy, Comedy and Epic

### FROM *Poetics*

Aristotle (384–322 B.C.E.) is often considered the first writer to attempt a systematic classification of genre. Born in the northern Greek city of Stagira, he was raised as a member of the aristocracy and moved to Athens where he studied in Plato's Academy. After distinguishing himself as an educator and a scholar of biology, botany, physics, psychology, politics, and numerous other subjects, Aristotle was invited by King Philip of Macedonia around 343 B.C.E. to tutor his heir, the future Alexander the Great. He later began his own school in Athens at the Lyceum, where he taught rhetoric, poetics, and metaphysics, and lived out his last years on the island of Euboea.

Alongside the work of his mentor Plato, Aristotle's writings (of which perhaps only one-fifth have survived) have become foundational documents in Western philosophy, literary criticism, and narrative arts such as drama and film. Although he apparently never completed a full account of two of the three genres he identifies in the *Poetics*—comedy and epic poetry—he does provide a systematic analysis of tragedy that theoretically acts as a model for any genre. Based in a method of categorizing and differentiating kinds of representation, this early treatise is a cornerstone for all future studies of genre.

To understand the roots of many film genre theories, it is crucial to understand Aristotle's *Poetics* and the critical paradigm it establishes for understanding dramatic tragedy. Using dramas such as Sophocles' *Oedipus Rex* as primary examples, Aristotle articulates the six distinctive characteristics that he believes all successful tragedies share: plot, character, thought, diction, music, and spectacle. Furthermore, for Aristotle, tragedy can be divided into four subgenres: the complex tragedy, the tragedy of suffering, the tragedy of character, and the tragedy of spectacle. Aristotle's rational and programmatic perspective suggestively anticipates the classical Hollywood studio system whose industrial formula of generic standardization and differentiation provided the foundation for Hollywood genres. Aristotle's description of plot as the representation of a single action

in which there is a specific kind of construction that involves specific kinds of incidents (e.g., "terrifying and pitiable") enacted by specific kinds of characters not only foreshadows the classical Hollywood narrative with its unified action, reversals, and concluding resolutions but also the generic variations on that narrative.

Aristotle's scientific approach to genre anticipates neoformalist approaches to film and film genre, as well as theories of film practice that aim at defining the specificity of film forms and distinctive characteristics of different film genres. Contemporary scholars such as David Bordwell and Kristin Thompson are prolific proponents of a formalist approach based in Aristotle's principles. Many modern genre studies often suggest an Aristotelian ambition for objectivity.

## READING CUES & KEY CONCEPTS

■ Consider Aristotle's description of the six categories for tragic form. To what extent are they applicable to discussions of classical film narrative?

■ Aristotle's method and process work carefully to categorize and differentiate the key features of the dramatic tragedy. How would a similar method describe a film genre such as comedy, westerns, or musicals?

■ As productive as a scientific approach to genre can be, what does it seem to omit or minimize that you would argue is central to a theory of film genre?

■ **Key Concepts:** Representation; Plot as the Construction of Action; Tragic Recognition; Tragic Reversal; Tragic Spectacle

# The Origins of Tragedy, Comedy and Epic

## *The Origins of Poetry*

Two causes seem to have generated the art of poetry as a whole, and these are natural ones.

(i) Representation is natural to human beings from childhood. They differ from the other animals in this: man tends most towards representation and learns his first lessons through representation.

Also (ii) everyone delights in representations. An indication of this is what happens in fact: we delight in looking at the most proficient images of things which in themselves we see with pain, e.g. the shapes of the most despised wild animals and of corpses. The cause of this is that learning is most pleasant, not only for philosophers but for others likewise (but they share in it to a small extent). For this reason they delight in seeing images, because it comes about that they learn as they observe, and infer what each thing is, e.g. that this person [represents] that one. For if one has not seen the thing [that is represented] before, [its image] will not produce pleasure as a representation, but because of its accomplishment, colour, or some other such cause.

[ · · · ]

## *The Definition of Tragedy*

Tragedy is a representation of a serious, complete action which has magnitude, in embellished speech, with each of its elements [used] separately in the [various] parts [of the play]; [represented] by people acting and not by narration; accomplishing by means of pity and terror the catharsis of such emotions.

By "embellished speech," I mean that which has rhythm and melody, i.e. song; by "with its elements separately," I mean that some [parts of it] are accomplished only by means of spoken verses, and others again by means of song.

### THE DEDUCTION OF THE QUALITATIVE PARTS OF TRAGEDY FROM ITS NATURE

Since people acting produce the representation, first (i) the ornament of spectacle will necessarily be a part of tragedy; and then (ii) song and (iii) diction, for these are the media in which they produce the representation. By "diction" I mean the construction of the [spoken] verses itself; by "song" I mean that of which the potential is entirely obvious.

Since [tragedy] is a representation of an action, and is enacted by people acting, these people are necessarily of a certain sort according to their character and their reasoning. For it is because of these that we say that actions are of a certain sort, and it is according to people's actions that they all succeed or fail. So (iv) the plot is the representation of the action; by "plot" here, I mean the construction of the incidents. By (v) the "characters," I mean that according to which we say that the people in action are of a certain sort. By (vi) "reasoning," I mean the way in which they use speech to demonstrate something or indeed to make some general statement.

So tragedy as a whole necessarily has six parts, according to which tragedy is of a certain sort. These are plot, characters, diction, reasoning, spectacle and song. The media in which [the poets] make the representation comprise two parts [i.e. diction and song], the manner in which they make the representation, one [i.e. spectacle], and the objects which they represent, three [i.e. plot, character and reasoning]; there are no others except these. Not a few of them, one might say, use these elements; for [drama] as a whole has instances of spectacle, character, plot, diction, song and reasoning likewise.

### PLOT IS THE MOST IMPORTANT PART OF TRAGEDY

But the most important of these is the structure of the incidents. For (i) tragedy is a representation not of human beings but of action and life. Happiness and unhappiness lie in action, and the end [of life] is a sort of action, not a quality; people are of a certain sort according to their characters, but happy or the opposite according to their actions. So [the actors] do not act in order to represent the characters, but they include the characters for the sake of their actions. Consequently the incidents, i.e. the plot, are the end of tragedy, and the end is most important of all.

(ii) Again, without action a tragedy cannot exist, but without characters it may. For the tragedies of most recent [poets] lack character, and in general there are many such poets. E.g. too among the painters, how Zeuxis relates to Polygnotus—Polygnotus is a good character-painter, but Zeuxis' painting contains no character at all.

(iii) Again, if [a poet] puts in sequence speeches full of character, well-composed in diction and reasoning, he will not achieve what was [agreed to be] the function of tragedy; a tragedy that employs these less adequately, but has a plot (i.e. structure of incidents), will achieve it much more.

(iv) In addition, the most important things with which a tragedy enthralls [us] are parts of plot—reversals and recognitions.

(v) A further indication is that people who try their hand at composing can be proficient in the diction and characters before they are able to structure the incidents; e.g. too almost all the early poets.

## THE NATURE AND IMPORTANCE OF TRAGEDY'S OTHER PARTS

So plot is the origin and as it were the soul of tragedy, and the characters are secondary. It is very similar in the case of painting too: if someone daubed [a surface] with the finest pigments indiscriminately, he would not give the same enjoyment as if he had sketched an image in black and white. Tragedy is a representation of an action, and for the sake of the action above all [a representation] of the people who are acting.

Reasoning comes third, i.e. being able to say what is possible and appropriate, which is its function in the case of the speeches of civic life and rhetoric. The old [poets] made people speak like citizens, but the recent ones make them speak like rhetoricians. Character is that which reveals decision, of whatever sort; this is why those speeches in which the speaker decides or avoids nothing at all do not have character. Reasoning, on the other hand, is that with which people demonstrate that something is or is not, or make some universal statement.

Diction is fourth. By "diction" I mean, as we said earlier, communication by means of language, which has the same potential in the case of both verse and [prose] speeches.

Of the remaining [parts], song is the most important of the embellishments. Spectacle is something enthralling, but is very artless and least particular to the art of poetic composition. The potential of tragedy exists even without a performance and actors; besides, the designer's art is more essential for the accomplishment of spectacular [effects] than is the poets'.

## *The Nature of Plot*

Now that these definitions have been given, let us next discuss what sort of structure of the incidents there should be, since this is the first and most important [part] of tragedy.

### PLOT SHOULD REPRESENT A SINGLE COMPLETE ACTION OF THE PROPER MAGNITUDE

We have laid down that tragedy is the representation of a complete i.e. whole action which has some magnitude (for there can be a whole with no magnitude). A whole is that which has a beginning, a middle and a conclusion. A beginning is that which itself does not of necessity follow something else, but after which there naturally is,

or comes into being, something else. A conclusion, conversely, is that which itself naturally follows something else, either of necessity or for the most part, but has nothing else after it. A middle is that which itself naturally follows something else, and has something else after it. Well-constructed plots, then, should neither begin from a random point nor conclude at a random point, but should use the elements we have mentioned [i.e. beginning, middle and conclusion.]

Further, to be fine both an animal and every thing which is constructed from some [parts] should not only have these [parts] in order, but also possess a magnitude that is not random. For fineness lies in magnitude and order. For this reason a fine animal can be neither very small, for observation becomes confused when it approaches an imperceptible instant of time; nor [can it be] very large, for observation cannot happen at the same time, but its unity and wholeness vanish from the observers' view, e.g. if there were an animal a thousand miles long. Consequently, just as in the case of bodies and of animals these should have magnitude, but [only] a magnitude that is easily seen as a whole, so too in the case of plots these should have length, but [only] a length that is easily memorable.

As for the limit on their length, one limit relates to performances and the perception [of them], not to the art [itself]. If the performance of a hundred tragedies were required [at one tragic competition], they would be performed "against the clock," as the saying goes! But as for the limit according to the nature of the thing [itself], the larger the plot is, the finer it is because of its magnitude, so long as the whole is still clear. To give a simple definition, in whatever magnitude a change from misfortune to good fortune, or from good fortune to misfortune, can come about by a sequence of events in accordance with probability or necessity—this is an adequate definition of its magnitude.

### THE UNITY OF PLOT DOES NOT COME FROM REPRESENTING A SINGLE PERSON

A plot is not unified, as some suppose, if it concerns one single person. An indefinitely large number of things happens to one person, in some of which there is no unity. So too the actions of one person are many, but do not turn into a single action. For this reason, it seems, all those poets who composed a *Heracleid*, a *Theseid* or similar poems are in error. They suppose that, because Heracles was a single person, his story too must be a single story. But, just as Homer is superior in other respects, it seems that he saw this clearly as well (whether by art or by nature). In composing the *Odyssey*, he did not put into his poem everything that happened to Odysseus, e.g. that he was wounded on Parnassus and pretended to be insane during recruitment; whether one of these things happened did not make it necessary or probable that the other would happen. But he constructed the *Odyssey* around a single action of the kind we are discussing, and the *Iliad* similarly.

Therefore, just as in the other representational arts a single representation is of a single [thing], so too the plot, since it is a representation of an action, ought to represent a single action, and a whole one at that; and its parts (the incidents) ought to be so constructed that, when some part is transposed or removed, the whole is disrupted and disturbed. Something which, whether it is present or not present, explains nothing [else], is no part of the whole.

## POETRY SHOULD REPRESENT UNIVERSALS, NOT PARTICULARS

It is also obvious from what we have said that it is the function of a poet to relate not things that have happened, but things that may happen, i.e. that are possible in accordance with probability or necessity. For the historian and the poet do not differ according to whether they write in verse or without verse—the writings of Herodotus could be put into verse, but they would be no less a sort of history in verse than they are without verses. But the difference is that the former relates things that have happened, the latter things that may happen. For this reason poetry is a more philosophical and more serious thing than history; poetry tends to speak of universals, history of particulars. A universal is the sort of thing that a certain kind of person may well say or do in accordance with probability or necessity—this is what poetry aims at, although it assigns names [to the people]. A particular is what Alcibiades did or what he suffered.

In the case of comedy this has already become clear. When [comic poets] have composed a plot according to probability, only then do they supply the names at random; they do not, like the composers of lampoons, compose [poems] about particular individuals. In the case of tragedy [the poets] keep to actual names. The reason is that what is possible is believable; we do not believe that what has never happened is possible, but things which have happened are obviously possible—they would not have happened, if they were impossible. Nonetheless even among tragedies some have only one or two well-known names, and the rest made up; and some have not one, e.g. Agathon's *Antheus*. In this [drama] the incidents and the names alike are made up, and it is no less delightful. Consequently one must not seek to keep entirely to the traditional stories which tragedies are about. In fact it is ridiculous to seek to do so, since even the well-known [incidents] are known only to a few people, but even so everyone enjoys them.

So it is clear from these arguments that a poet must be a composer of plots rather than of verses, insofar as he is a poet according to representation, and represents actions. So even if it turns out that he is representing things that happened, he is no less a poet; for there is nothing to prevent some of the things that have happened from being the sort of things that may happen according to probability, i.e. that are possible, which is why he can make a poetic composition about them.

## *The Kinds of Plot*

### THE EPISODIC PLOT

Among simple plots and actions, episodic [tragedies] are the worst. By "episodic" I mean a plot in which there is neither probability nor necessity that the episodes follow one another. Such [tragedies] are composed by inferior poets because of themselves, but by good ones because of the actors. For in composing competition-pieces, they extend the plot beyond its potential and are often compelled to distort the sequence.

### PLOTS THAT AROUSE AMAZEMENT

The representation is not only of a complete action but also of terrifying and pitiable [incidents]. These arise to a very great or a considerable extent when they happen contrary to expectation but because of one another. For they will be more amazing in this way than if [they happened] on their own, i.e. at random, since the most amazing

even among random events are those which appear to have happened as it were on purpose, e.g. the way the statue of Mitys at Argos killed the man who was the cause of Mitys' death, by falling on him as he looked at it. Such things do not seem to happen at random. Consequently plots of this kind are necessarily finer.

## SIMPLE AND COMPLEX PLOTS

Among plots, some are simple and some are complex; for the actions, of which plots are representations, are evidently of these kinds. By "simple," I mean an action which is, as we have defined it, continuous in its course and single, where the transformation comes about without reversal or recognition. By "complex," I mean an action as a result of which the transformation is accompanied by a recognition, a reversal or both. These should arise from the actual structure of the plot, so it happens that they arise either by necessity or by probability as a result of the preceding events. It makes a great difference whether these [events] happen because of those or [only] after those.

## *The Parts of Plot*

### REVERSAL

A reversal is a change of the actions to their opposite, as we said, and that, as we are arguing, in accordance with probability or necessity. E.g. in the *Oedipus*, the man who comes to bring delight to Oedipus, and to rid him of his terror about his mother, does the opposite by revealing who Oedipus is; and in the *Lynceus*, Lynceus is being led to his death, and Danaus follows to kill him, but it comes about as a result of the preceding actions that Danaus is killed and Lynceus is rescued.

### RECOGNITION

A recognition, as the word itself indicates, is a change from ignorance to knowledge, and so to either friendship or enmity, among people defined in relation to good fortune or misfortune. A recognition is finest when it happens at the same time as a reversal, as does the one in the *Oedipus*. There are indeed other [kinds of] recognition. For it can happen in the manner stated regarding inanimate objects and random events; and one can recognise whether someone has done something or not done it. But the sort that most belongs to the plot, i.e. most belongs to the action, is that which we have mentioned: for such a recognition and reversal will contain pity or terror (tragedy is considered to be a representation of actions of this sort), and in addition misfortune and good fortune will come about in the case of such events.

Since recognition is a recognition of people, some recognitions are by one person only of the other, when the identity of one of them is clear; but sometimes there must be a recognition of both persons. E.g. Iphigeneia is recognised by Orestes as a result of her sending the letter, but it requires another recognition for him [to be recognised] by Iphigeneia.

### SUFFERING

These, then, reversal and recognition, are two parts of plot. A third is suffering. Of these, we have discussed reversal and recognition. Suffering is a destructive or painful action, e.g. deaths in full view, agonies, woundings etc.

### *The Quantitative Parts of Tragedy*

Regarding the parts of tragedy, we stated earlier which ones should be used as elements. The quantitative parts, i.e. the separate parts into which it is divided, are as follows: (i) prologue, (ii) episode, (iii) exit and (iv) choral [part], with this divided into (a) processional and (b) stationary [song]—these are shared by all [dramas], and [songs sung] from the stage, i.e. dirges—these are particular [to some].

(i) A prologue is a whole part of a tragedy that is before the processional [song] of the chorus.

(ii) An episode is a whole part of a tragedy that is between whole choral songs.

(iii) An exit is a whole part of a tragedy after which there is no song of the chorus.

(iv) Of the choral [part], (a) a processional is the first whole utterance of the chorus; (b) a stationary song is a song of the chorus without anapaestic or trochaic verse; and (c) a dirge is a lament shared by the chorus and [those] on stage.

Regarding the parts of tragedy, we stated earlier which ones should be used [as elements]; the quantitative ones, i.e the separate parts into which it is divided, are these.

# THOMAS SCHATZ

· · · · · · · · · · · · · · · · · · · · · · · · · · · · · · · · · · · · · · · · · · · · · · · · · · · · ·

## Film Genre and the Genre Film

FROM *Hollywood Genres*

Thomas Schatz (b. 1948) is the Philip G. Warner Regents Professor of Communication at the University of Texas and author of numerous books on Hollywood film, including *Hollywood Genres: Formulas, Filmmaking, and the Studio System* (1981), *The Genius of the System: Hollywood Filmmaking in the Studio Era* (1988), and *Boom and Bust: American Cinema in the 1940s* (1997). As these titles suggest, Schatz is as much a historian of the film industry and the studio system as he is of specific films and how they are constructed. For Schatz, film genres act as the meeting point between the studio and individual films where what André Bazin called the "genius of the system" produces distinguished individual films according to generic paradigms. His work appeared in the first decades of serious academic study of film in the United States, making him a pioneer in developing a systematic and sophisticated approach to what were, for many, simply entertainment formulas.

Schatz's approach to film genre was certainly influenced by the cultural, academic, and industrial shifts in cinema leading up to the 1980s. While the then-current trend in auteur theory valorized filmmakers as the creative source of films, Schatz was drawn to the broader and less personal creative powers of the Hollywood studio system. In terms of the film industry, the late 1960s and 1970s witnessed the proliferation of a variety of new films that recalled older genres, like westerns and gangster films, but remade for the New Hollywood audience—two well-known examples being *The Wild Bunch* (1969) and *Bonnie and Clyde* (1967). In addition, film scholars of the time were increasingly turning

to semiology as a way to explore the "language system" of film and to help explain the changing communicative relationship between specific films and particular cultures and communities.

Against the backdrop of these changes, Schatz enumerated his theory of film genre in *Hollywood Genres*, from which "Film Genre and the Genre Film" is excerpted. Schatz connects westerns across the decades, from John Ford's *Stagecoach* (1939) to *The Searchers* (1956) and his generically reflexive *The Man Who Shot Liberty Valance* (1962), to modern generic variations such as George Roy Hill's *Butch Cassidy and the Sundance Kid* (1969), Sam Peckinpah's *The Wild Bunch* (1969), and even Martin Scorsese's urban remake of *The Searchers*, *Taxi Driver* (1976). In doing so, Schatz encourages a structural and grammatical understanding of how stories and characters are constructed through genres. His perspective also emphasizes the changing "unspoken agreements" between a genre film and its audience, whereby audiences expect movies to provide certain generic formulas and conventions. While Schatz's argument is an important contribution to contemporary debates about genre and the language of film, it also acts as a distinctive bridge between traditional studies of genres based on notions of ritual and iconography and contemporary studies of genre and ideology, particularly in its attention to ritualistic and communal meanings of film genres. Indeed, many subsequent theories of genre, including those of Carol J. Clover (p. 511) and Rick Altman (p. 487), expand on, refine, and argue with what Schatz suggests about a grammar of genre and the ideologies of the social bonds it fosters.

## READING CUES & KEY CONCEPTS

▪ Schatz focuses exclusively on the Hollywood system in his investigation of the "grammar of genres" and "social communities." Consider whether or not his formulas can be successfully adapted to an analysis of genres from other cultures or to Hollywood genres transplanted to other film cultures (such as the westerns of Australian cinema).

▪ Although Schatz's essay provides a way to identify and map changes in genre, he does not attempt to explain "distressed genres" that lose their historical vitality over time or new genres that arise without a long history behind them. Consider how one might explain the disappearance of a genre's communal significance. What are some examples?

▪ **Key Concepts:** Deep Structure; Generic Communities; Iconography; Genres of Determinate and Indeterminate Space; Rites of Order; Rites of Integration

# Film Genre and the Genre Film

. . . . . . . . . . . . . .

A genre film, like virtually any story, can be examined in terms of its fundamental narrative components: plot, setting, and character. These components have a privileged status for the popular audience, due to their existence within a familiar formula that addresses and reaffirms the audience's values and attitudes. Thus the genre film's narrative components assume a preordained thematic significance

that is quite different from non-generic narratives. Each genre film incorporates a specific cultural context—what Warshow termed its "field of reference"—in the guise of a familiar *social community*. This generic context is more than the physical setting, which some genre critics have argued defines the genre as such. The American frontier or the urban underworld is more than a physical locale which identifies the Western or the gangster film; it is a cultural milieu where inherent thematic conflicts are animated, intensified, and resolved by familiar characters and patterns of action. Although all drama establishes a community that is disturbed by conflict, in the genre film both the community and the conflict have been conventionalized. Ultimately, our familiarity with any genre seems to depend less on recognizing a specific setting than on recognizing certain dramatic conflicts that we associate with specific patterns of action and character relationships. There are some genres, in fact, like the musical and the screwball comedy, that we identify primarily through conventions of action and attitude, and whose settings vary widely from one film to the next.

From this observation emerges a preliminary working hypothesis: the determining, identifying feature of a film genre is its cultural context, its community of interrelated character types whose attitudes, values, and actions flesh out dramatic conflicts inherent within that community. The generic community is less a specific place (although it may be, as with the Western and gangster genres) than a network of characters, actions, values, and attitudes. Each genre's status as a distinct cultural community is enhanced by Hollywood's studio production system, in that each generic context is orchestrated by specialized groups of directors, writers, producers, performers, sets, studio lots, and even studios themselves. (Consider Warner Brothers' heavy production of gangster films in the early '30s and MGM's musicals in the late '40s.)

A genre, then, represents a *range of expression* for filmmakers and a *range of experience* for viewers. Both filmmakers and viewers are sensitive to a genre's range of expression because of previous experiences with the genre that have coalesced into a system of value-laden narrative conventions. It is this system of conventions—familiar characters performing familiar actions which celebrate familiar values—that represents the genre's narrative context, its meaningful cultural community.

## Iconography: Imagery and Meaning

The various generic communities—from the Old West to the urban underworld to outer space—provide both a visual arena in which the drama unfolds and also an intrinsically significant realm in which specific actions and values are celebrated. In addressing the inherent meaning or intrinsic significance of objects and characters within any generic community, we are considering that genre's *iconography*. Iconography involves the process of *narrative and visual coding* that results from the repetition of a popular film story. A white hat in a Western or a top hat in a musical, for instance, is significant because it has come to serve a specific symbolic function within the narrative system.

This coding process occurs in all movies, since the nature of filmic storytelling is to assign meaning to "bare images" as the story develops. In the final sequence of *Citizen Kane*, for example, the symbolic reverberations of the burning sled and

the "No Trespassing" sign result from the cumulative effects of the film's narrative process. These effects in *Kane* accumulate within that single film, though, and had no significance prior to our viewing of that film.

A *generic icon*, in contrast, assumes significance not only through its usage within individual genre films but also as that usage relates to the generic system itself. The Westerner's white horse and hat identify a character before he speaks or acts because of our previous experiences with men who wear white hats and ride white horses. The more interesting and engaging genre films, of course, do more than merely deliver the codes intact—as did many of those "B" Westerns of the '30s that almost literally "all look alike"—but instead manipulate the codes to enhance their thematic effect.

[ · · · ]

A genre's iconography involves not only the visual coding of the narrative, but indicates *thematic value* as well (white civilization good versus black anarchy evil, with black-and-white as thematically ambiguous). We distinguish between characters who wear white and characters who wear black in Westerns, or those who sing and dance and those who do not in musicals, and these distinctions reflect the thematic conflicts inherent within these communities. Because visual coding involves narrative and social values, it also extends to certain nonvisual aspects of genre filmmaking. Such elements as dialogue, music, and even casting may become key components of a genre's iconography.

Think, for example, of the appropriateness of the casting in the film just described or think of the way certain movie stars are generally associated with specific genres. Katharine Hepburn, Fred Astaire, Joan Crawford, and Humphrey Bogart have become significant components of a genre's meaning-making system. When we think of Bogart as the typical hardboiled detective or of Astaire as the ultimate, spontaneous, self-assured music man, we are thinking not of the particular human being or of any single screen role but rather of a screen *persona*—i.e., an attitudinal posture that effectively transcends its role in any individual film.

A genre's iconography reflects the value system that defines its particular cultural community and informs the objects, events, and character types composing it. Each genre's implicit system of values and beliefs—its *ideology* or world view—determines its cast of characters, its problems (dramatic conflicts), and the solutions to those problems. In fact, we might define film genres, particularly at the earlier stages of their development, as social problem-solving operations: They repeatedly confront the ideological conflicts (opposing value systems) within a certain cultural community, suggesting various solutions through the actions of the main characters. Thus, each genre's problem-solving function affects its distinct formal and conceptual identity.

## *Character and Setting: Communities in Conflict*

In discussing the grammar (or system of conventions) of any Hollywood film genre, it is important to note that the *material economy*, which motivated the studios to refine story formulas, translates into *narrative economy* for filmmakers and viewers. Each genre incorporates a sort of narrative shorthand whereby significant dramatic

conflicts can intensify and then be resolved through established patterns of action and by familiar character types. These dramatic conflicts are themselves the identifying feature of any genre; they represent the transformation of some social, historical, or even geographical (as in the Western) aspect of American culture into one locus of events and characters.

Although the dramatic conflicts are basic to the generic "community," we cannot identify that community solely by its physical setting. If film genres were identified by setting alone, then we would have to deal with an "urban" genre that includes such disparate forms as gangster films, backstage musicals, and detective films. Because the setting provides an *arena* for conflicts, which are themselves determined by the actions and attitudes of the *participants*, we must look to the generic character types and the conflicts they generate in identifying any genre. And we might consider a generic community and its characters in relation to the system of values which both define the problem and eventually are appealed to in solving it.

What emerges as a social problem (or dramatic conflict) in one genre is not necessarily a problem in another. Law and order is a problem in the gangster and detective genres, but not in the musical. Conversely, courtship and marriage are problems in the musical but not in the gangster and detective genres. Individualism is celebrated in the detective genre (through the hero's occupation and world view) and in the gangster film (through the hero's career and eventual death), while the principal characters in the musical compromise their individuality in their eventual romantic embrace and thus demonstrate their willingness to be integrated into the social community. In each of these genres, the characters' identities and narrative roles (or "functions") are determined by their relationship with the community and its value structure. As such, the generic character is psychologically static—he or she is the physical embodiment of an attitude, a style, a world view, of a predetermined and essentially unchanging cultural posture. Cowboy or Indian, gangster or cop, guy or doll, the generic character is identified by his or her function and status within the community.

The static vision of the generic hero—indeed of the entire constellation of familiar character types—helps to define the community and to animate its cultural conflicts. For example, the Western hero, regardless of his social or legal standing, is necessarily an agent of civilization in the savage frontier. He represents both the social order and the threatening savagery that typify the Western milieu. Thus he animates the inherent dynamic qualities of the community, providing a dramatic vehicle through which the audience can confront generic conflicts.

This approach also enables us to distinguish between such seemingly similar "urban crime" formulas as the gangster and detective genres. Usually, both genres are set in a contemporary urban milieu and address conflicts principally between social order and anarchy and between individual morality and the common good. But because of the characteristic attitudes and values of the genre's principal characters, these conflicts assume a different status in each genre and are resolved accordingly. The detective, like the Westerner, represents the man-in-the-middle, mediating the forces of order and anarchy, yet somehow remaining separate from each. He has opted to construct his own value system and behavioral code, which happens (often, almost accidentally) to coincide with the forces of social order. But the detective's predictable return to his office retreat at film's end and his refusal to assimilate the values and lifestyle of the very society he serves ultimately reaffirm

his—and the genre's—ambiguous social stance. The gangster film, conversely, displays little thematic ambiguity. The gangster has aligned himself with the forces of crime and social disorder, so both his societal role and his conflict with the community welfare demand his eventual destruction.

All film genres treat some form of threat—violent or otherwise—to the social order. However, it is the attitudes of the principal characters and the resolutions precipitated by their actions which finally distinguish the various genres from one another. Nevertheless, there is a vital distinction between kinds of generic settings and conflicts. Certain genres (Western, detective, gangster, war, et al.) have conflicts that, indigenous to the environment, reflect the physical and ideological struggle for its control. These conflicts are animated and resolved either by an individual male hero or by a collective (war, science fiction, cavalry, certain recent Westerns). Other genres have conflicts that are not indigenous to the locale but are the result of the conflict between the values, attitudes, and actions of its principal characters and the "civilized" setting they inhabit. Conflicts in these genres (musical, screwball comedy, family melodrama) generally are animated by a "doubled" hero—usually a romantic couple whose courtship is complicated and eventually ideologically resolved. A musical's setting may be a South Pacific island or the backstage of a Broadway theater, but we relate to the film immediately by its treatment of certain sexual and occupational conflicts and also by our familiarity with the type of characters played by its "stars."

Thus, it is *not* the musical numbers themselves which identify these films as musicals. Many Westerns and gangster films, for example, contain musical numbers and still aren't confused with musicals (Westerns like *Dodge City* and *Rio Bravo*, for instance, or gangster films like *The Roaring Twenties* and *The Rise and Fall of Legs Diamond*). The frontier saloon and the gangster's speakeasy may be conventional locales within their respective communities, but their entertainment function clearly is peripheral to the central issue. However, in "musical Westerns" like *Annie Get Your Gun, The Harvey Girls*, and *Oklahoma!*, the nature and resolution of the dramatic conflicts as well as the characterization clearly are expressed via the musical formula. In *The Harvey Girls*, for instance, the narrative centers around the exploits of several dozen women—including Judy Garland and Cyd Charisse, which should provide us with a generic cue—who migrate West to work in a restaurant. Certain Western conventions are nodded to initially: the girls are told aboard the train headed West that "You're bringing civilization. . . . You girls are bringing order to the West"; later, there is a comic brawl between these "Harvey Girls" and the local saloon girls. But the Western genre's fundamental traits (the individual male hero responding to the threat of savagery and physical violence within an ideologically unstable milieu) are not basic to the film. Once the characters and conflicts are established, the setting might as well be Paris or New York City or even Oz.

As I hope these examples indicate, the various Hollywood genres manipulate character and social setting quite differently in developing dramatic conflicts. We might consider a broad distinction between genres of *determinate space* and those of *indeterminate space*, between genres of an ideologically contested setting and an ideologically stable setting. In a genre of determinate space (Western, gangster, detective, et al.), we have a symbolic arena of action. It represents a cultural realm in which fundamental values are in a state of sustained conflict. In these genres, then,

the contest itself and its necessary arena are "determinate"—a specific social conflict is violently enacted within a familiar locale according to a prescribed system of rules and behavioral codes.

The iconographic arena in determinate genres is entered by an individual or collective hero, at the outset, who acts upon it, and finally leaves. This entrance-exit motif recurs most in genres characterized by an individual hero: for example, the Westerner enters a frontier community, eliminates (or perhaps causes) a threat to its survival, and eventually rides "into the sunset"; the detective takes the case, investigates it, and returns to his office; the gangster, introduced to urban crime, rises to power, and finally is killed or jailed. In these genres, the individual hero incorporates a rigid, essentially static attitude in dealing with his very dynamic, contested world.

In contrast, genres of indeterminate space generally involve a doubled (and thus dynamic) hero in the guise of a romantic couple who inhabit a "civilized" setting, as in the musical, screwball comedy, and social melodrama. The physical and ideological "contest" which determines the arena of action in the Western, gangster, and detective genres is not an issue here. Instead, genres of indeterminate space incorporate a civilized, ideologically stable milieu, which depends less upon a heavily coded place than on a highly conventionalized value system. Here conflicts derive not from a struggle over control of the environment, but rather from the struggle of the principal characters to bring their own views in line either with one another's or, more often, in line with that of the larger community.

Unlike genres of determinate space, these genres rely upon a progression from romantic antagonism to eventual embrace. The kiss or embrace signals the integration of the couple into the larger cultural community. In addition, these genres use iconographic conventions to establish a social setting—the proscenium or theater stage with its familiar performers in some musicals, for example, or the repressive small-town community and the family home in the melodrama. But because the generic conflicts arise from attitudinal (generally male-female) oppositions rather than from a physical conflict, the coding in these films tends to be less visual and more ideological and abstract. This may account for the sparse attention they have received from genre analysts, despite their widespread popularity.

Ultimately, genres of indeterminate, civilized space (musical, screwball comedy, social melodrama) and genres of determinate, contested space (Western, gangster, detective) might be distinguished according to their differing ritual functions. The former tend to celebrate the values of *social integration*, whereas the latter uphold the values of *social order*. The former tend to cast an attitudinally unstable couple or family unit into some representative microcosm of American society, so that their emotional and/or romantic "coupling" reflects their integration into a stable environment. The latter tend to cast an individual, violent, attitudinally static male into a familiar, predetermined milieu to examine the opposing forces vying for control. In making this distinction, though, we should not lose sight of these genres' shared social function. In addressing basic cultural conflicts and celebrating the values and attitudes whereby these conflicts might be resolved, all film genres represent the filmmakers' and audience's cooperative efforts to "tame" those beasts, both actual and imaginary, which threaten the stability of our everyday lives.

## *Plot Structure: From Conflict to Resolution*

As a popular film audience, our shared needs and expectations draw us into the movie theater. If we are drawn there by a genre film, we are familiar with the ritual. In its animation and resolution of basic cultural conflicts, the genre film celebrates our collective sensibilities, providing an array of ideological strategies for negotiating social conflicts. The conflicts themselves are significant (and dramatic) enough to ensure our repeated attendance. The films within a genre, representing variations on a cultural theme, will employ different means of reaching narrative resolution, but that closure is generally as familiar as the community and its characters. (Think of the general discomfort felt upon realizing, even quite early in seeing a genre film, that Cagney's heroic gangster would "get his" or that Tracy and Hepburn would cease their delightful hostilities and embrace in time for the closing credits.)

Actually, the most significant feature of any generic narrative may be its resolution—that is, its efforts to solve, even if only temporarily, the conflicts that have disturbed the community welfare. The Western, for example, despite its historical and geographical distance from most viewers, confronts real and immediate social conflicts: individual versus community, town versus wilderness, order versus anarchy, and so on. If there is anything escapist about these narratives, it is their repeated assertion that these conflicts can be solved, that seemingly timeless cultural oppositions can be resolved favorably for the larger community.

In a Hollywood Western, as in virtually any Hollywood genre film, plot development is effectively displaced by setting and character: once we recognize the familiar cultural arena and the players, we can be fairly certain how the game will be played and how it will end. Because the characters, conflicts, and resolution of the non-generic narrative are unfamiliar and unpredictable, we negotiate them less by previous filmic experiences than by previous "real-world" (personal and social) experiences. Clearly, both generic and non-generic narratives must rely to some degree upon real-world and also upon previous narrative-filmic experiences in order to make sense. In the genre film, however, the predictability of conflict and resolution tends to turn our attention away from the linear, cause-and-effect plot, redirecting it to the conflict itself and the opposed value systems it represents. Instead of a linear chain of events, which are organized by the changing perceptions of an individual protagonist, the genre film's plot traces the intensification of some cultural opposition which is eventually resolved in a predictable fashion.

Thus, we might describe the plot structure of a genre film in the following way:

*establishment* (via various narrative and iconographic cues) of the generic community with its inherent dramatic conflicts;

*animation* of those conflicts through the actions and attitudes of the genre's constellation of characters;

*intensification* of the conflict by means of conventional situations and dramatic confrontations until the conflict reaches crisis proportions;

*resolution* of the crisis in a fashion which eliminates the physical and/or ideological threat and thereby celebrates the (temporarily) well-ordered community.

In this plot structure, linear development is subordinate to and qualified by the *oppositional* narrative strategy. Opposing value systems are either mediated by an individual or a collective, which eliminates one of the opposing systems. Or else these oppositions are actually embodied by a doubled hero whose (usually romantic) coupling signals their synthesis. In either instance, resolution occurs, even if only temporarily, in a way that strokes the collective sensibilities of the mass audience. It is in this context that the genre film's function as cultural ritual is most evident.

In their formulaic narrative process, genre films celebrate the most fundamental ideological precepts—they examine and affirm "Americanism" with all its rampant conflicts, contradictions, and ambiguities. Not only do genre films establish a sense of continuity between our cultural past and present (or between present and future, as with science fiction), but they also attempt to eliminate the distinctions between them. As social ritual, genre films function to stop time, to portray our culture in a stable and invariable ideological position. This attitude is embodied in the generic hero—and in the Hollywood star system itself—and is ritualized in the resolution precipitated by the hero's actions. Whether it is a historical Western or a futuristic fantasy, the genre film celebrates certain inviolate cultural attributes.

Ultimately, the sustained success of any genre depends upon at least two factors: the thematic appeal and significance of the conflicts it repeatedly addresses and its flexibility in adjusting to the audience's and filmmakers' changing attitudes toward those conflicts. These can be seen, for example, in the Western hero's status as both rugged individualist and also as agent of a civilization that continually resists his individualism. The degree to which that opposition has evolved over the past seventy-five years has accommodated changes in our cultural sensibilities. Or consider science fiction, a literary and cinematic genre that realized widespread popularity in the late '40s and early '50s. This genre articulated the conflicts and anxieties that accompanied the development of atomic power and the prospect of interplanetary travel. Because science fiction deals with so specialized a cultural conflict—essentially with the limits and value of human knowledge and scientific experimentation—it is considerably less flexible, but no less topical, than the Western. Nevertheless, each genre has a static nucleus that manifests its thematic oppositions or recurring cultural conflicts. And each genre has, through the years, dynamically evolved as shown by the ways its individual films manipulate those oppositions. If we see genre as a problem-solving strategy, then, the static nucleus could be conceived as the problem and the variety of solutions (narrative resolutions) as its dynamic surface structure.

In this sense, a genre's basic cultural oppositions or inherent dramatic conflicts represent its most basic determining feature. Also the sustained popularity of any genre indicates the essentially unresolvable, irreconcilable nature of those oppositions. Resolution involves a point of dramatic closure in which a compromise or temporary solution to the conflict is projected into a sort of cultural and historical timelessness. The threatening external force in contested space is violently destroyed and eliminated as an ideological threat; in uncontested space the vital lover's spontaneity and lack of social inhibition are bridled by a domesticating counterpart in the name of romantic love. In each, philosophical or ideological conflicts are "translated" into emotional terms—either violent or sexual, or both—and are resolved accordingly. In the former, the emotive resolution is externalized, in

the latter it is internalized. Still, the resolution does not function to *solve* the basic cultural conflict. The conflict is simply recast into an emotional context where it can be expeditiously, if not always logically, resolved.

**[ · · · ]**

## *Generic Evolution: Patterns of Increasing Self-Consciousness*

We have already noted that genre filmmakers are in a rather curious bind: they must continually vary and reinvent the generic formula. At the same time they must exploit those qualities that made the genre popular in the first place. As Robert Warshow puts it: "Variation is absolutely necessary to keep the type from becoming sterile; we do not want to see the same movie over and over again, only the same form"[1] (Warshow, 1962, p. 147). His point is well taken: the genre's "deeper" concern for certain basic cultural issues may remain intact, but to remain vital its films must keep up with the audience's changing conception of these issues and with its growing familiarity with the genre. But how does a genre evolve, and does its evolution follow any consistent or predictable pattern? If certain formal and thematic traits distinguish a genre throughout its development, what changes as the form evolves?

First, a genre's evolution involves both internal (formal) and external (cultural, thematic) factors. The subject matter of any film story is derived from certain "real-world" characters, conflicts, settings, and so on. But once the story is repeated and refined into a formula, its basis in experience gradually gives way to its own internal narrative logic. Thus, the earliest Westerns (many of which actually depicted then-current events) obviously were based on social and historical reality, But as the genre developed, it gradually took on its own reality. Even the most naive viewer seems to understand this. It comes as no surprise to learn that Western heroes didn't wear white hats and fringed buckskin, that gunfights on Main Street were an exceedingly rare occurrence, or that the towns and dress codes and other trappings of movie Westerns were far different from those of the authentic American West. In this sense, we recognize and accept the distinctive grammar—the system of storytelling conventions—that has evolved through the repeated telling of Western tales.

Simultaneously, however, we also realize that these real-world factors, basic to the genre's dramatic conflicts, are themselves changing. Consider how the changing image of Native Americans ("Injuns") has been influenced by our culture's changing view of Manifest Destiny, the settling of the West, and the treatment of peoples whose cultures were overwhelmed by the encroachment of civilization. Or consider how the atom bomb and space travel affected the development of the science fiction genre after World War II; consider the impact of organized crime on the gangster and detective genres in the 1950s. Perhaps the effects of these external social factors are best seen case by case. A genre's formal internal evolution, however, especially when considered in terms of our growing familiarity with it over time, does seem to follow a rather consistent pattern of schematic development.

**[ · · · ]**

Leo Braudy describes the process of generic evolution: "Genre films essentially ask the audience, 'Do you still want to believe this?' Popularity is the audience

answering, 'Yes.' Change in genre occurs when the audience says, 'That's too infantile a form of what we believe. Show us something more complicated' "[2] (Braudy, 1976, p. 179). This rather casual observation involves a number of insights, especially in its allusion to the "conversation" between filmmakers and audience and in its reference to audience "belief." The genre film reaffirms what the audience believes both on individual and on communal levels. Audience demand for variation does not indicate a change in belief, but rather that the belief should be reexamined, grow more complicated formally and thematically, and display, moreover, stylistic embellishment.

Thus, the end of a genre's classic stage can be viewed as that point at which the genre's straightforward message has "saturated" the audience. With its growing awareness of the formal and thematic structures, the genre evolves into what Focillon termed the age of refinement. As a genre's classic conventions are refined and eventually parodied and subverted, its transparency gradually gives way to *opacity*: we no longer look *through* the form (or perhaps "into the mirror") to glimpse an idealized self-image, rather we look *at the form itself* to examine and appreciate its structure and its cultural appeal.

A genre's progression from transparency to opacity—from straightforward storytelling to self-conscious formalism—involves its concerted effort to explain itself, to address and evaluate its very status as a popular form. A brief consideration of any Hollywood genre would support this view, particularly those with extended life spans like the musical or the Western. By the early 1950s, for example, both of these genres had begun to exhibit clear signs of formal self-consciousness. In such self-reflexive musicals as *The Barkleys of Broadway* (1949), *An American in Paris* (1951), *Singin' in the Rain* (1952), *The Band Wagon* (1953), and *It's Always Fair Weather* (1955), the narrative conflict confronts the nature and value of musical comedy as a form of popular entertainment. In accord with the genre's conventions, these conflicts are couched in a male-female opposition, but the boy-gets-girl resolution is now complicated by a tension between serious art and mere entertainment. These movies interweave motifs involving successful courtship and the success of The Show, and that success is threatened and resolved in a fashion which provides an "apology" for the musical as popular art.

In *The Barkleys of Broadway*, for instance, Ginger Rogers abandons musical comedy for "legitimate theater" but eventually returns both to the stage musical and to her former partner-spouse (Fred Astaire). Gene Kelly in *An American in Paris* must decide between a career as a painter, supported by spinster-dowager Nina Foch, and a "natural" life of dance and music with young Leslie Caron. In these and the other films, the generic conventions, which earlier were components of the genre's unspoken ideology, have now become the central thematic elements of the narrative. No longer does the genre simply celebrate the values of music, dance, and popular entertainment, it actually "critiques" and "deconstructs" them in the process (Feuer, 1978).[3]

The Western genre, which was entering its classic age in the late 1930s (*Stagecoach, Union Pacific, Dodge City, Destry Rides Again, Frontier Marshal*, all 1939), exhibits by the 1950s a similar formal and thematic self-scrutiny. Such films as *Red River* (1948), *I Shot Jesse James* (1949), *The Gunfighter* (1950), *Winchester 73* (1950), *High Noon* (1952), and *The Naked Spur* (1953) indicate that the genre had begun to question its own conventions, especially regarding the social role and psychological

make-up of the hero. Consider, for example, the substantial changes in the screen persona of John Wayne or of Jimmy Stewart during this period. In such baroque Westerns as *Red River* and *The Searchers* (starring Wayne) and *Winchester 73*, *The Naked Spur*, *The Man from Laramie*, and *Two Rode Together* (Stewart), Wayne's stoic machismo and Stewart's "aw-shucks" naiveté are effectively inverted to reveal genuinely psychotic, antisocial figures.

Naturally, we do not expect a classic Westerner like Wayne's Ringo Kid in *Stagecoach* to exhibit the psychological complexity or the "antiheroic" traits of later Western figures. Our regard for a film like *Stagecoach* has to do with its clear, straightforward articulation of the Western myth. A later film like *Red River*, which incorporates a younger figure (Montgomery Clift) to offset and qualify the classic Westerner's heroic posture, serves to refine and to call into question the genre's basic values. These values are subverted, or perhaps even rejected altogether, in later films like *The Searchers*, *The Wild Bunch*, and even in a comic parody like *Butch Cassidy and the Sundance Kid*. In these films, the "code of the West" with its implicit conflicts and ideology provides the dramatic focus, but our regard for that code changes as do the actions and attitudes of the principal characters.

The Western and the musical seem to represent genres in which the evolutionary "cycle" seems more or less complete. However, not all genres complete that cycle or necessarily follow such a progression. For example, in the gangster genre, various external pressures (primarily the threat of government censorship and religious boycott) disrupted the genre's internal evolution. And in the war genre, the prosocial aspects of supporting a war effort directly ruled out any subversion or even the serious questioning of the hero's attitudes. War films that did question values were made after the war and generally are considered as a subgenre. There are also genres currently in midcycle, like the "disaster" or the "occult" genres popularized during the 1970s. The disaster genre, whose classic stage was launched with *The Poseidon Adventure* and *Airport*, has evolved so rapidly that a parody of the genre, *The Big Bus* (1976), appeared within only a few years of the form's standardization. Interestingly, the audience didn't seem to know what to make of *The Big Bus*, and the film died at the box office. Apparently the genre hadn't sufficiently saturated the audience to the point where a parody could be appreciated.

Thus, it would seem that, throughout a genre's evolution from transparent social reaffirmation to opaque self-reflexivity, there is a gradual shift in narrative emphasis from social value to formal aesthetic value. Because continued variation tends to sensitize us to a genre's social message, our interests, and those of the filmmakers, gradually expand from the message itself to its articulation, from the tale to the visual and narrative artistry of its telling. It is no coincidence, then, that so many directors, who worked with a genre later in its development, are considered *auteurs*. We tend to regard early genre filmmakers as storytellers or craftsmen and later ones as artists. Naturally there are exceptions—Ford's early Westerns, Busby Berkeley's '30s musicals, all of Hitchcock's thrillers—but these involve directors whose narrative artistry and understanding of the genre's thematic complexity were apparent throughout their careers.

Generally speaking, it seems that those features most often associated with narrative artistry—ambiguity, thematic complexity, irony, formal self-consciousness—rarely are evident in films produced earlier in a genre's development. They tend to

work themselves into the formula itself as it evolves. We are dealing here with the inherent artistry of the formula itself as it grows and develops. A newborn genre's status as social ritual generally resists any ironic, ambiguous, or overly complex treatment of its narrative message. But as filmmakers and audiences grow more familiar with the message as it is varied and refined, the variations themselves begin to exhibit qualities associated with narrative art.

This does not mean that early genre films have no aesthetic value or later ones no social value. There is, rather, a shift in emphasis from one cultural function (social, ritualistic) to another (formal, aesthetic). And both are evident in all genre films. A genre's initial and sustained popularity may be due primarily to its social function, but a degree of aesthetic appeal is also apparent in even the earliest, or the most transparently, prosocial genre films. Each genre seems to manifest a distinct visual and compositional identity: the prospect of infinite space and limitless horizons in the Western, documentary urban realism in the gangster film, the "American Expressionism" of *film noir* and the hardboiled detective film, the musical's celebration of life through motion and song, and so on.

This aesthetic potential may have been tapped by filmmakers—writers, producers, performers, cameramen, editors, as well as directors—who quite simply made good movies. They manipulated any number of narrative and cinematic qualities that imbued their films with an artistry that may or may not have been common for the genre at that stage of its development. Whether considering artistically exceptional films early in a genre's evolution or the more self-reflexive films produced during its later stages, it is difficult not to appreciate the formal and ideological flexibility of Hollywood's genres. These story formulas have articulated and continually reexamined basic social issues, weaving a cultural tapestry whose initial design became ever more detailed and ornate, ever more beautiful.

## NOTES

1. Robert Warshow, *The Immediate Experience* (Garden City, N.Y.: Doubleday and Co., Inc., 1962), p. 147.

2. Leo Braudy, *The World in a Frame* (Garden City, N.Y.: Anchor Press/Doubleday, 1976), p. 179.

3. For a more detailed treatment of the evolution of the musical genre, see Jane Feuer, *The Hollywood Musical: The Aesthetics of Spectator Involvement in an Entertainment Form* (Iowa City: University of Iowa, 1978), unpublished doctoral dissertation.

# RICHARD DYER

# Entertainment and Utopia

Richard Dyer, Professor of Film Studies at King's College London, brought his graduate training in cultural studies and his work as a gay rights activist to the emerging discipline of film studies in the 1970s, significantly influencing the field's openness to questions of how cultural forms express identity, social power, and the possibility of change. As the

title of one of his many books, *Only Entertainment* (1992), suggests, he has consistently taken the concept of entertainment *as* entertainment seriously, asserting that despite connotations of escapism and mindlessness, entertainment matters in our social world because it expresses a utopian impulse.

Prior to Dyer's work on musicals, studies tended to focus on genres such as westerns and gangster films that were thought to transcend "mere entertainment," evoking the tragic fates of their male protagonists. As he does in his related work on film stars (p. 401) and race in film (p. 822), Dyer draws on a semiotic framework, explaining that different kinds of signs work differently to convey meaning. Dialogue and character present themes and conflicts according to established narrative patterns or codes, but music and dance, color and gesture rely on "non-representational" signs; that is, they convey meanings through emotions that cannot be translated into fixed messages. Dyer thus argues for a much more thorough and precise attention to the sound of music and the style of dance in films.

Dyer's essay, "Entertainment and Utopia," originally published in *Movie* in 1977, spells out in clear terms with concrete examples that the Hollywood musical is less concerned with what utopia *looks* like (although certain movies attempt to depict ideal societies) than with what utopia *feels* like, and this is conveyed primarily through musical numbers that obey rules different from those of ordinary life. Dyer draws on the argument that a society's myths attempt to imaginatively resolve contradictions that prevail on the level of lived social reality. In contemporary society, entertainment genres take over this mythical function. Dyer identifies everyday problems of scarcity, dreariness, and fragmentation that the musical genre addresses through abundance, energy, and community. He draws from three classic Hollywood musicals (and two contrasting genres) to show how different types of musicals attempt to resolve contradictions in different ways, whether through the opposition between narrative and musical numbers in the backstage musical (such as *Dream Girls* [2006]) or the overall sense of utopia that colors the world of musicals that integrate numbers and narrative more seamlessly (such as *Moulin Rouge!* [2001]). However, Dyer does acknowledge that the solutions that entertainment genres provide to social inequities are ultimately those offered by that self-same society. However, he argues that drawing attention to a society's deficiency is "ideologically speaking, playing with fire." The success of such recent musicals as *Chicago* (2002), as well as the central role the pop soundtrack plays in movies of many different genres, recalls the appeal of the classics Dyer discusses and inspires the recognition that although they are only entertainment, they have a great deal to say about the society that produced and enjoyed them.

## READING CUES & KEY CONCEPTS

◼ Consider Dyer's idea that musicals reflect "what utopia feels like." What does he mean by this? Think about how this concept could be applied to a musical whose setting is dark, or whose resolution is sad.

◼ What does the distinction between representational and non-representational codes add to our approach to a genre like the musical? How might it apply to the horror film?

▓ Dyer argues that the musical genre attempts to address specific social deficiencies by offering imaginary solutions. Consider how this argument applies to another genre.

▓ **Key Concepts:** Utopianism; Codes; Non-Representational Signs; Contradiction; Integrated Musical

# Entertainment and Utopia

· · · · · · · · · · · · · ·

This article is about musicals as entertainment. I don't necessarily want to disagree with those who would claim that musicals are also "something else" (e.g., "Art") or argue that entertainment itself is only a product of "something more important" (e.g., political/economic manipulation, psychological forces), but I want to put the emphasis here on entertainment as entertainment. Musicals were predominantly conceived of, by producers and audiences alike, as "pure entertainment"—the *idea* of entertainment was a prime determinant on them. Yet because entertainment is a commonsense, "obvious" idea, what is really meant and implied by this never gets discussed.

Musicals are one of a whole string of forms—music hall, variety, TV spectaculars, pantomime, cabaret, etc.—that are usually summed up by the term "show biz." The idea of entertainment I want to examine here is most centrally embodied by these forms, although I believe that it can also be seen at work, *mutatis mutandis*, in other forms and I suggest below, informally, how this might be so. However, it is probably true to say that "show biz" is the most thoroughly entertainment-oriented of all types of performance, and that notions of myth, art, instruction, dream and ritual may be equally important, even at the conscious level with regard to, say, Westerns, the news, soap opera, or rock music.

It is important, I think, to stress the cultural and historical specificity of entertainment. The kinds of performance produced by professional entertainment are different in audience, performers and above all intention from the kinds of performance produced in tribal, feudal or socialist societies. It is not possible here to provide the detailed historical and anthropological argument to back this up, but I hope the differences will suggest themselves when I say that entertainment is a type of performance produced for profit, performed before a generalised audience (the "public") by a trained, paid group who do nothing else but produce performances which have the sole (conscious) aim of providing pleasure.

Because entertainment is produced by professional entertainers, it is also largely defined by them. That is to say, although entertainment is part of the coinage of everyday thought, nonetheless how it is defined, what it is assumed to be, is basically decided by those people responsible (paid) for providing it in concrete form. Professional entertainment is the dominant agency for defining what entertainment is. This does not mean, however, that it *simply* reproduces and expresses patriarchal capitalism. There is the usual struggle between capital (the backers) and labour (the performers) over the control of the product, and professional entertainment is unusual in that: (1) it is in the business of producing forms, not things, and

(2) the work force (the performers themselves) is in a better position to determine the form of its product than are, say, secretaries or car workers. The fact that professional entertainment has been by and large conservative in this century should not blind us to the implicit struggle within it, and looking beyond class to divisions of sex and race, we should note the important role of structurally subordinate groups in society—women, blacks, gays—in the development and definition of entertainment. In other words, show business's relationship to the demands of patriarchal capitalism is a complex one. Just as it does not simply "give the people what they want" (since it actually defines those wants), so, as a relatively autonomous mode of cultural production, it does not simply reproduce unproblematically patriarchal capitalist ideology. Indeed, it is precisely on seeming to achieve both these often opposed functions simultaneously that its survival largely depends.

Two of the taken-for-granted descriptions of entertainment, as "escape" and as "wish-fulfilment," point to its central thrust, namely, utopianism. Entertainment offers the image of "something better" to escape into, or something we want deeply that our day-to-day lives don't provide. Alternatives, hopes, wishes—these are the stuff of utopia, the sense that things could be better, that something other than what is can be imagined and maybe realised.

Entertainment does not, however, present models of utopian worlds, as in the classic utopias of Sir Thomas More, William Morris, *et al.* Rather the utopianism is contained in the feelings it embodies. It presents, head-on as it were, what utopia would feel like rather than how it would be organised. It thus works at the level of sensibility, by which I mean an effective code that is characteristic of, and largely specific to, a given mode of cultural production.

This code uses both representational and, importantly, non-representational signs. There is a tendency to concentrate on the former, and clearly it would be wrong to overlook them—stars are nicer than we are, characters more straightforward than people we know, situations more soluble than those we encounter. All this we recognise through representational signs. But we also recognise qualities in non-representational signs—colour, texture, movement, rhythm, melody, camerawork—although we are much less used to talking about them. The nature of non-representational signs is not however so different from that of representational. Both are, in C. S. Peirce's terminology, largely iconic; but whereas the relationship between signifier and signified in a representational icon is one of resemblance between their appearance, their look, the relationship in the case of the non-representational icon is one of resemblance at the level of basic structuration.

This concept has been developed (among other places) in the work of Suzanne K. Langer, particularly in relation to music. We feel music (arguably more than any other performance medium), yet it has the least obvious reference to "reality"—the intensity of our response to music can only be accounted for by the way music, abstract, formal though it is, still embodies feeling. Langer puts it thus in *Feeling and Form*:

> The tonal structures we call "music" bear a close logical similarity to the forms of human feeling—forms of growth and of attenuation, flowing and slowing, conflict and resolution, speed, arrest, terrific excitement, calm or subtle activation or dreamy lapses—not joy and sorrow perhaps, but the poignancy of both—the

greatness and brevity and eternal passing of everything vitally felt. Such is the pattern, or logical form, of sentience; and the pattern of music is that same form worked out in pure measures, sound and silence. Music is a tonal analogue of emotive life.

Such formal analogy, or congruence of logical structures, is the prime requisite for the relation between a symbol and whatever it is to mean. The symbol and the object symbolized must have some common logical form.

Langer realises that recognition of a common logical form between a performance sign and what it signifies is not always easy or natural: "The congruence of two given perceptible forms is not always evident upon simple inspection. The common *logical* form they both exhibit may become apparent only when you know the principle whereby to relate them." This implies that responding to a performance is not spontaneous—you have to learn what emotion is embodied before you can respond to it. A problem with this as Langer develops it is the implication that the emotion itself is not coded, is simply "human feeling." I would be inclined, however, to see almost as much coding in the emotions as in the signs for them. Thus, just as writers such as E. H. Gombrich and Umberto Eco stress that different modes of representation (in history and culture) correspond to different modes of perception, so it is important to grasp that modes of experiential art and entertainment correspond to different culturally and historically determined sensibilities.

This becomes clear when one examines how entertainment forms come to have the emotional signification they do: that is, by acquiring their signification in relation to the complex of meanings in the social-cultural situation in which they are produced. Take the extremely complex history of tap dance—in black culture, tap dance has had an improvisatory, self-expressive function similar to that in jazz; in minstrelsy, it took on an aspect of jolly mindlessness, inane good humour, in accord with minstrelsy's image of the Negro; in vaudeville, elements of mechanical skill, tap dance as a feat, were stressed as part of vaudeville's celebration of the machine and the brilliant performer. Clearly there are connections between these different significations, and there are residues of all of them in tap as used in films, television and contemporary theatre shows. This has little to do however with the intrinsic meanings of hard, short, percussive, syncopated sounds arranged in patterns and produced by the movement of feet, and everything to do with the significance such sounds acquire from their place within the network of signs in a given culture at a given point of time. Nevertheless, the signification is essentially apprehended through the coded non-representational form (although the representational elements usually present in a performance sign—a dancer is always "a person dancing"—may help to anchor the necessarily more fluid signification of the non-representational elements; for example, a black man, a white man in blackface, a troupe, or a white woman tap-dancing may suggest different ways of reading the taps, because each relates to a slightly different moment in the evolution of the non-representational form, tap dance).

I have laboured this point at greater length than may seem warranted partly with polemic intent. Firstly, it seems to me that the reading of non-representational signs in the cinema is particularly undeveloped. On the one hand, the *mise-en-scène* approach (at least as classically developed in *Movie*) tends to treat the non-representational as a function of the representational, simply a way of bringing out, emphasising, aspects

| | *Energy:* Capacity to act vigorously; human power, activity, potential. | *Abundance:* Conquest of scarcity; having enough to spare without sense of poverty of others; enjoyment of sensuous material reality. |
|---|---|---|
| Show Biz Forms | Dance—tap, Latin American, American Theatre Ballet; also "oomph," "pow," "bezazz"—qualities of performance. | Spectacle; Ziegfeld, Busby Berkeley, MGM. |
| Sources of Show Biz Forms | Tap—black and white folk culture; American Theatre Ballet—modern dance plus folk dance plus classical ballet. | Court displays; high art influences on Ziegfeld, Cedric Gibbons (MGM)—and haute couture. |
| *Gold Diggers of 1933* | "Pettin' in the Park" (tap, roller skates; quick tempo at which events are strung together). | "Pettin' . . . " (leisure park) "We're in the Money" (showgirls dressed in coins) "Shadow Waltz" (lavish sets; tactile, non-functional, wasteful clothing; violins as icon of high culture—expense). |
| *Funny Face* | "Think Pink" "Clap Yo' Hands" (tap) "Let's Kiss and Make Up" (tap and Astaire's longevity) Cellar dance. | "Think Pink" (use of materials and fabrics) "Bonjour Paris" "On How to Be Lovely" (creation of fashion image). |
| *On the Town* | "New York, New York" "On the Town" "Prehistoric Man" "Come Up to My Place." | "New York, New York" (cf. "Bonjour Paris") "Miss Turnstiles" (woman as commodity-fantasy). |
| Westerns | Chases, fights, bar-room brawls; pounding music (sixties onward). | Land—boundlessness and/or fertility. |
| TV News | Speed of series of sharp, short items; the "latest" news; hand-held camera. | Technology of news-gathering—satellites, etc.; doings of rich; spectacles of pageantry and destruction. |

| *Intensity:* Experiencing of emotion directly, fully, unambiguously, "authentically," without holding back. | *Transparency:* A quality of relationships—between represented characters (e.g., true love), between performer and audience ("sincerity"). | *Community:* Togetherness, sense of belonging, network of phatic relationships (i.e., those in which communication is for its own sake rather than for its message). |
|---|---|---|
| "Incandescent" star performers (Garland, Bassey, Streisand); torch singing. | "Sincere" stars (Crosby, Gracie Fields); love and romance. | The singalong chorus numbers. |
| Star phenomenon in wider society; the blues. | Star phenomenon in wider society: 18th-century sentimental novel. | Pub entertainment *and* parlour balladry; choral traditions in folk and church. |
| "Forgotten Man" "I've Got to Sing a Torch Song" (blues inflections) | "Shadow Waltz" (Keeler and Powell as couple in eye-to-eye contact). | Showgirls (wise-cracking interaction, mutual support—e.g., sharing clothes). |
| "How Long Has This Been Going On?" | "Funny Face" "He Loves and She Loves" " 'S Wonderful" | (?) Cellar dance. |
| "A Day in New York" ballet; climactic chase. | "You're Awful" (insult turned into declaration of love) "Come up to My Place" (direct invitation) | "You Can Count on Me" |
| Confrontation on street; suspense. | Cowboy as "man" straight, straightforward, morally unambiguous, puts actions where his words are. | Townships; cowboy camaraderie. |
| Emphasis on violence, dramatic incident; selection of visuals with eye to climactic moments. | (?) "Man of the people" manner of some newscasters, celebrities and politicians; (?) Simplification of events to allow easy comprehension. | The world rendered as global village; assumptions of consensus. |

of plot, character, situation, without signification in their own right. On the the other hand, semiotics has been concerned with the codification of the representational. Secondly, I feel that film analysis remains notoriously non-historical, except in rather lumbering, simplistic ways. My adaptation of Langer seeks to emphasise not the connection between signs and historical events, personages or forces, but rather the history of signs themselves as they are produced in culture and history. Nowhere here has it been possible to reproduce the detail of any sign's history (and I admit to speculation in some instances), but most of the assertions are based on more thorough research, and even where they are not, they should be.

The categories of entertainment's utopian sensibility are sketched in the accompanying table [see pp. 470–471] together with examples of them. The three films used will be discussed below; the examples from Westerns and television news are just to suggest how the categories may have wider application; the sources referred to are the cultural, historical situation of the code's production.

The categories are, I hope, clear enough, but a little more needs to be said about "intensity." It is hard to find a word that quite gets what I mean. What I have in mind is the capacity of entertainment to present either complex or unpleasant feelings (e.g., involvement in personal or political events, jealousy, loss of love, defeat) in a way that makes them seem uncomplicated, direct and vivid, not "qualified" or "ambiguous" as day-to-day life makes them, and without those intimations of self-deception and pretence. (Both intensity and transparency can be related to wider themes in the culture, as "authenticity" and "sincerity" respectively; see Lionel Trilling's *Sincerity and Authenticity*.)

The obvious problem raised by this breakdown of the utopian sensibility is where these categories come from. One answer, at a very broad level, might be that they are a continuation of the utopian tradition in Western thought. George Kateb, in his survey of utopian thought, *Utopia and Its Enemies*, describes what he takes to be the dominant motifs in this tradition, and they do broadly overlap with those outlined above. Thus:

> . . . when a man [sic] thinks of perfection . . . he thinks of a world permanently without strife, poverty, constraint, stultifying labour, irrational authority, sensual deprivation . . . peace, abundance, leisure, equality, consonance of men and their environment.

We may agree that notions in this broad conceptual area are common throughout Western thought, giving it, and its history, its characteristic dynamic, its sense of moving beyond what is to what ought to be or what we want to be. However, the very broadness, and looseness, of this common ground does not get us very far—we need to examine the specificity of entertainment's utopia.

One way of doing so is to see the categories of the sensibility as temporary answers to the inadequacies of the society which is being escaped from through entertainment. This is proposed by Hans Magnus Enzensberger in his article, "Constituents of a Theory of the Media" (in *Sociology of Mass Communication*, edited by Dennis McQuail). Enzensberger takes issue with the traditional left-wing use of concepts of "manipulation" and "false needs" in relation to the mass media:

The electronic media do not owe their irresistible power to any sleight-of-hand but to the elemental power of deep social needs which come though even in the present depraved form of these media. . . .

Consumption as spectacle contains the promise that want will disappear. The deceptive, brutal and obscene features of this festival derive from the fact that there can be no question of a real fulfilment of its promise. But so long as scarcity holds sway, use-value remains a decisive category which can only be abolished by trickery. Yet trickery on such a scale is only conceivable if it is based on mass need. This need—it is a utopian one—is there. It is the desire for a new ecology, for a breaking-down of environmental barriers, for an aesthetic which is not limited to the sphere of the "artistic." These desires are not—or are not primarily—internalized rules of the games as played by the capitalist system. They have physiological roots and can no longer be suppressed. Consumption as spectacle is—in parody form—the anticipation of a utopian situation.

This does, I think, express well the complexity of the situation. However Enzensberger's appeal to "elemental" and "physiological" demands, although we do not need to be too frightened by them, is lacking in both historical and anthropological perspectives. I would rather suggest, a little over-schematically, that the categories of the utopian sensibility are related to specific inadequacies in society as follows:

| *Social Tension/Inadequacy/Absence* | *Utopian Solution* |
|---|---|
| Scarcity (actual poverty in the society; poverty observable in the surrounding societies, e.g., Third World); unequal distribution of wealth | Abundance (elimination of poverty for self and others; equal distribution of wealth) |
| Exhaustion (work as a grind, alienated labour, pressures of urban life) | Energy (work and play synonymous), city dominated (*On the Town*) or pastoral return (*The Sound of Music*) |
| Dreariness (monotony, predictability, instrumentality of the daily round) | Intensity (excitement, drama, affectivity of living) |
| Manipulation (advertising, bourgeois democracy, sex roles) | Transparency (open, spontaneous, honest communications and relationships) |
| Fragmentation (job mobility, rehousing and development, high-rise flats, legislation against collective action) | Community (all together in one place, communal interests, collective activity) |

The advantage of this analysis is that it does offer some explanation of why entertainment *works*. It is not just left-overs from history, it is not *just* what show business, or "they," force on the rest of us, it is not simply the expression of eternal needs—it responds to real needs *created by society*. The weakness of the analysis (and this holds true for Enzensberger too) is in the give-away absences from the left-hand column—no mention of class, race or patriarchy. That is, while entertainment is responding to needs that are real, at the same time it is also defining and delimiting what constitutes the legitimate needs of people in this society.

I am not trying to recoup here the false needs argument—we are talking about real needs created by real inadequacies, but they are not the only needs and inadequacies of the society. Yet entertainment, by so orienting itself to them, effectively denies the legitimacy of other needs and inadequacies, and especially of class, patriarchal and sexual struggles. (Though once again we have to admit the complexity and contradictions of the situation—that, for instance, entertainment is not the only agency which defines legitimate needs, and that the actual role of women, gay men and blacks in the creation of show business leaves its mark in such central oppositional icons as, respectively, the strong woman type, e.g., Ethel Merman, Judy Garland, Elsie Tanner, camp humour and sensuous taste in dress and decor, and almost all aspects of dance and music. Class, it will be noted, is still nowhere.)

Class, race and sexual caste are denied validity as problems by the dominant (bourgeois, white, male) ideology of society. We should not expect show business to be markedly different. However, there is one further turn of the screw, and that is that, with the exception perhaps of community (the most directly working class in source), the ideals of entertainment imply wants that capitalism itself promises to meet. Thus abundance becomes consumerism, energy and intensity personal freedom and individualism, and transparency freedom of speech. In other (Marcuse's) words, it is a partially "one-dimensional" situation. The categories of the sensibility point to gaps or inadequacies in capitalism, but only those gaps or inadequacies that capitalism proposes itself to deal with. At our worse sense of it, entertainment provides alternatives *to* capitalism which will be provided *by* capitalism.

However, this one-dimensionality is seldom so hermetic, because of the deeply contradictory nature of entertainment forms. In variety, the essential contradiction is between comedy and music turns; in musicals, it is between the narrative and the numbers. Both these contradictions can be rendered as one between the heavily representational and verisimilitudinous (pointing to the way the world is, drawing on the audience's concrete experience of the world) and the heavily non-representational and "unreal" (pointing to how things could be better). In musicals, contradiction is also to be found at two other levels—within numbers, between the representational and the non-representational, and within the non-representational, owing to the differing sources of production inscribed in the signs.

To be effective, the utopian sensibility has to take off from the real experiences of the audience. Yet to do this, to draw attention to the gap between what is and what could be, is, ideologically speaking, playing with fire. What musicals have to do, then

(not through any conspiratorial intent, but because it is always easier to take the line of least resistance, i.e., to fit in with prevailing norms), is to work through these contradictions at all levels in such a way as to "manage" them, to make them seem to disappear. They don't always succeed.

I have chosen three musicals which seem to me to illustrate the three broad tendencies of musicals—those that keep narrative and number clearly separated (most typically, the backstage musical); those that retain the division between narrative as problems and numbers as escape, but try to "integrate" the numbers by a whole set of papering-over-the-cracks devices (e.g., the well-known "cue for a song"); and musicals which try to dissolve the distinction between narrative and numbers, thus implying that the world of the narrative is also (already) utopian.

The clear separation of numbers and narrative in *Gold Diggers of 1933* is broadly in line with a "realist" aesthetic: the numbers occur in the film in the same way as they occur in life, that is, on stages and in cabarets. This "realism" is of course reinforced by the social-realist orientation of the narrative, settings and characterisation, with their emphasis on the Depression, poverty, the quest for capital, "gold-digging" (and prostitution). However, the numbers are not wholly contained by this realist aesthetic—the way in which they are opened out, in scale and in cinematic treatment (overhead shots, etc.), represents a quite marked shift from the real to the non-real, and from the largely representational to the largely non-representational (sometimes to the point of almost complete abstraction). The thrust of the narrative is towards seeing the show as a "solution" to the personal, Depression-induced problems of the characters; yet the non-realist presentation of the numbers makes it very hard to take this solution seriously. It is "just" escape, "merely" utopian.

If the numbers embody (capitalist) palliatives to the problems of the narrative—chiefly, abundance (spectacle) in place of poverty, and (non-efficacious) energy (chorines in self-enclosed patterns) in place of dispiritedness—then the actual mode of presentation undercuts this by denying it the validity of "realism."

However, if one then looks at the contradiction between the representational and non-representational within the numbers, this becomes less clear-cut. Here much of the representational level reprises the lessons of the narrative—above all, that women's only capital is their bodies as objects. The abundant scale of the numbers is an abundance of piles of women; the sensuous materialism is the texture of femaleness; the energy of the dancing (when it occurs) is the energy of the choreographic imagination, to which the dancers are subservient. Thus, while the non-representational certainly suggests an alternative to the narrative, the representational merely reinforces the narrative (women as sexual coinage, women—and men—as expressions of the male producer).

Finally, if one then looks at the non-representational alone, contradictions once again become apparent—e.g., spectacle as materialism and metaphysics (that is, on the one hand, the sets, costumes, etc. are tactile, sensuous, physically exhilarating, but on the other hand, are associated with fairy-land, magic, the by-definition immaterial), dance as human creative energy and sub-human mindlessness.

In *Funny Face*, the central contradiction is between art and entertainment, and this is further worked through in the antagonism between the central couple, Audrey Hepburn (art) and Fred Astaire (entertainment). The numbers are escapes from the problems, and discomforts, of the contradiction—either by asserting the unanswerably more pleasurable qualities of entertainment (e.g., "Clap Yo' Hands" following the dirge-like Juliette Greco–type song in the "empathicalist," i.e., existentialist, *soirée*), or in the transparency of love in the Hepburn–Astaire numbers.

But it is not always that neat. In the empathicalist cellar club, Hepburn escapes Astaire in a number with some of the other beats in the club. This reverses the escape direction of the rest of the film (i.e., it is an escape from entertainment/Astaire into art). Yet within the number, the contradiction repeats itself. Before Hepburn joins the group, they are dancing in a style deriving from Modern Dance, angular, oppositional shapes redolent in musical convention of neurosis and pretentiousness (*cf.* Danny Kaye's number, "Choreography," in *White Christmas*). As the number proceeds, however, more show biz elements are introduced—use of syncopated clapping, forming in a vaudeville line-up, and American Theatre Ballet shapes. Here an "art" form is taken over and infused with the values of entertainment. This is a contradiction between the representational (the dreary night club) and the non-representational (the oomph of music and movement) but also, within the non-representational, between different dance forms. The contradiction between art and entertainment is thus repeated at each level.

In the love numbers, too, contradictions appear, partly by the continuation in them of troubling representational elements. In *Funny Face*, photographs of Hepburn as seen by Astaire, the fashion photographer, are projected on the wall as background to his wooing her and her giving in. Again, their final dance of reconciliation to "'S Wonderful" takes place on the grounds of a chateau, beneath the trees, with doves fluttering around them. Earlier, this setting was used as the finish for their fashion photography sequence. In other words, in both cases, she is reconciled to him only by capitulating to his definition of her. In itself, there is nothing contradictory in this—it is what Ginger Rogers always had to do. But here the mode of reconciliation is transparency and yet we can see the strings of the number being pulled. Thus the representational elements, which bespeak manipulation of romance, contradict the non-representational, which bespeaks its transparency.

The two tendencies just discussed are far more common than the third, which has to suggest that utopia is implicit in the world of the narrative as well as in the world of the numbers.

The commonest procedure for doing this is removal of the whole film in time and space—to turn-of-the-century America (*Meet Me in St. Louis, Hello Dolly!*), Europe (*The Merry Widow, Gigi, Song of Norway*), cockney London (*My Fair Lady, Oliver!, Scrooge*), black communities (*Hallelujah!, Cabin in the Sky, Porgy and Bess*), etc.—to places, that is, where it can be believed (by white urban Americans) that song and dance are "in the air," built into the peasant/black culture and blood, or part of a more free-and-easy stage in American development. In these films, the introduction of any real narrative concerns is usually considerably delayed and comes

chiefly as a temporary threat to utopia—thus reversing the other two patterns, where the narrative predominates and numbers function as temporary escapes from it. Not much happens, plot-wise, in *Meet Me in St. Louis* until we have had "Meet Me in St. Louis," "The Boy Next Door," "The Trolley Song" and "Skip to My Lou"—only then does father come along with his proposal to dismantle this utopia by his job mobility.

Most of the contradictions developed in these films are over-ridingly bought off by the nostalgia or primitivism which provides them with the point of departure. Far from pointing forwards, they point back, to a golden age—a reversal of utopianism that is only marginally offset by the narrative motive of recovery of utopia. What makes *On the Town* interesting is that its utopia is a well-known modern city. The film starts as an escape—from the confines of Navy life into the freedom of New York, and also from the weariness of work, embodied in the docker's refrain, "I feel like I'm not out of bed yet," into the energy of leisure, as the sailors leap into the city for their day off. This energy runs through the whole film, *including the narrative*. In most musicals, the narrative represents things as they are, to be escaped from. But most of the narrative of *On the Town* is about the transformation of New York into utopia. The sailors release the *social* frustrations of the women—a tired taxi driver just coming off shift, a hard-up dancer reduced to belly-dancing to pay for ballet lessons, a woman with a sexual appetite that is deemed improper—not so much through love and sex as through energy. This sense of the sailors as a transforming energy is heightened by the sense of pressure on the narrative movement suggested by the device of a time-check flashed on the screen intermittently.

This gives a historical dimension to a musical, that is, it shows people making utopia rather than just showing them from time to time finding themselves in it. But the people are men—it is still men making history, not men and women together. (And the Lucy Schmeeler role is unforgivably male chauvinist.) In this context, the "Prehistoric Man" number is particularly interesting. It centres on Ann Miller, and she leads the others in the take-over of the museum. For a moment, then, a woman "makes history." But the whole number is riddled with contradictions, which revolve round the very problem of having an image of a women acting historically. If we take the number and her part in it to pieces, we can see that it plays on an opposition between self-willed and mindless modes of being; and this play is between representational (R) and non-representational (NR) at all aesthetic levels.

| *Self-willed* | *Mindless* |
| --- | --- |
| Miller as star (R) | Miller's image ("magnificent animal") (R) |
| Miller character—decision-maker in narrative (R) | Number set in anthropology museum—associations with primitivism (R) |
| Tap as self-expressive form (NR) | Tap as mindless repetitions (NR) |
| Improvisatory routine (R/NR) | |

The idea of a historical utopianism in narrativity derives from the work of Ernest Bloch. According to Fredric Jameson in *Marxism and Form,* Bloch "has essentially two different languages or terminological systems at his disposition to describe the formal nature of Utopian fulfilment: the movement of the world in time towards the future's ultimate moment, and the more spatial notion of that adequation of object to subject which must characterise that moment's content. . . . [these] correspond to dramatic and lyrical modes of the presentation of not-yet-being."

Musicals (and variety) represent an extraordinary mix of these two modes— the historicity of narrative and the lyricism of numbers. They have not often taken advantage of it, but the point is that they could, and that this possibility is always latent in them. They are a form we still need to look at if films are, in Brecht's words on the theatre, to "organise the enjoyment of changing reality."

# JEAN-LOUIS COMOLLI AND JEAN NARBONI

## Cinema/Ideology/Criticism

Jean-Louis Comolli (b. 1941) and Jean Narboni (b. 1937) are French film writers, editors, and directors. They were senior members of the collective that edited one of the most important film journals, *Cahiers du cinéma*, in its crucial period after 1968 when the journal was committed to deconstructing mainstream cinema by developing a radical theory of film practice. Narboni has appeared as an actor in several films; published widely on cinema, including coordinating publications for *Cahiers*; and taught at La Fémis, the French national film school. Comolli, who currently teaches film theory at the University of Paris VIII, has directed around twenty films and published numerous works on film theory, documentary, and jazz. But they are perhaps best known for their editorials in *Cahiers*, including their influential call for politically oriented criticism, "Cinema/Ideology/Criticism," which appeared originally in 1969 and became central to film debates in the late 1960s and 1970s.

The worldwide events of May 1968—the political uprising in France, the Soviet crushing of the Hungarian uprising, the outbreak of political violence in Northern Ireland, protests against the Vietnam War—echoed profoundly through the world of culture and politics, causing upheaval within left-wing politics that resulted in radical thinking about the function of culture and cultural work. In terms of film theory, the spirit of the 1960s proliferated in many left-leaning journals (*Positif, Cinétique, Cahiers du cinéma, Screen, Framework*) whose aim was to examine cinema as a realm of political struggle. In their strictly political approach to film, Comolli and Narboni relied particularly on Louis Althusser's concept of "ideology," that is, the imaginary expression of the relationship of individuals to the real conditions of their existence as a feature of the social order that structures one's experience. In their Marxist view, Western-produced film is explicitly a commercial product and therefore implicitly a part of an ideology that is determined by the capitalist system. Comolli and Narboni condemn previous theories of cinema that emphasized its realism (André Bazin, p. 309) and argue that reality recorded by a camera is merely an expression of the prevailing ideology. They feel that therefore a filmmaker's primary task is to expose cinema's alleged depiction of reality and disrupt the connection between cinema and its ideological function.

The main objective of Comolli and Narboni's "Cinema/Ideology/Criticism" was to establish a system of categories by which critics could distinguish between films whose form and content both carry and endorse the dominant ideology, and those which attempt to subvert it through both content and formal strategies that breach the conventions of "realist" cinema. Their system of classification begins with the distinction between "live" (documentary) and fiction film, and they further break down these two categories according to form and content. Among the four categories of fiction film, Comolli and Narboni clearly express their aesthetic preference for progressive cinema and formal experimentation in the name of ideological subversion—a preference that excluded most Hollywood cinema. However, their most interesting point is their fifth category ("e"), which represents the films that seem to belong within the dominant ideology but end up turning that ideology back on itself, "causing it to swerve and get off course." This category allows the critic agency in the production of meaning and opens up possibilities for ideological analysis of Hollywood genre cinema. Comolli and Narboni's approach remained influential in textual analysis of individual films as well as in the articulation of film theory. The obligation to analyze cinema ideologically was the main motivating force behind the development of psychoanalytic and feminist film theory in the 1970s, and Comolli and Narboni's classification system contributed to the establishment of the "progressive" text as a distinction in film.

## READING CUES & KEY CONCEPTS

■ Comolli and Narboni's classification system is predicated on a clear definition of their key terms. Consider their definition of "film" and compare it to your definition of "film." How do the two differ? What do they include that you do not, and vice versa?

■ What do Comolli and Narboni mean when they assert that "every film is political"?

■ Consider their fifth category of film and how it appears to include and acknowledge the possibility of "progressiveness" in Hollywood film. How do you interpret this category? Can you think of a Hollywood movie you've seen recently which would fit into this category, and if so, in what way?

■ **Key Concepts:** Dominant Ideology; Political Cinema; Signifier/Signified

# Cinema/Ideology/Criticism

· · · · · · · · · · · · · ·

Scientific criticism has an obligation to define its field and methods. This implies awareness of its own historical and social situation, a rigorous analysis of the proposed field of study, the conditions which make the work necessary and those which make it possible, and the special function it intends to fulfil.

It is essential that we at *Cahiers du Cinéma* should now undertake just such a global analysis of our position and aims. Not that we are starting entirely from zero. Fragments of such an analysis have been coming out of material we have published recently (articles, editorials, debates, answers to readers" letters) but in an imprecise form and as if by accident. They are an indication that our readers, just as much as we ourselves, feel the need for a clear theoretical base to which to relate our critical

practice and its field, taking the two to be indivisible. "Programmes" and "revolutionary" plans and declarations tend to become an end in themselves. This is a trap we intend to avoid. Our objective is not to reflect upon what we "want" (would like) to do, but upon what we *are* doing and what we *can* do, and this is impossible without an analysis of the present situation.

## I. Where?

(a) First, our situation. *Cahiers* is a group of people working together; one of the results of our work appearing as a magazine.[1] A magazine, that is to say, a particular product, involving a particular amount of work (on the part of those who write it, those who produce it and, indeed, those who read it). We do not close our eyes to the fact that a product of this nature is situated fairly and squarely inside the economic system of capitalist publishing (modes of production, spheres of circulation, etc). In any case it is difficult to see how it could be otherwise today, unless one is led astray by Utopian ideas of working "parallel" to the system. The first step in the latter approach is always the paradoxical one of setting up a false front, a "neo-system" alongside the system from which one is attempting to escape, in the fond belief that it will be able to negate the system. In fact all it can do is reject it (idealist purism) and consequently it is very soon jeopardized by the enemy upon which it modelled itself.[2] This "parallelism" works from one direction only. It touches only one side of the wound, whereas we believe that both sides have to be worked upon. And the danger of the parallels meeting all too speedily in infinity seems to us sufficient to argue that we had better stay in the finite and allow them to remain apart.

This assumed, the question is: what is our attitude to our situation? In France the majority of films, like the majority of books and magazines, are produced and distributed by the capitalist economic system and within the dominant ideology. Indeed, strictly speaking all are, whatever expedient they adopt to try and get around it. This being so, the question we have to ask is: which films, books and magazines allow the ideology a free, unhampered passage, transmit it with crystal clarity, serve as its chosen language? And which attempt to make it turn back and reflect itself, intercept it, make it visible by revealing its mechanisms, by blocking them?

(b) For the situation in which we are *acting* is the field of cinema (*Cahiers* is a film magazine),[3] and the precise object of our study is the history of a film: how it is produced, manufactured, distributed,[4] understood.

What is the film today? This is the relevant question; not, as it possibly once was: what is the cinema? We shall not be able to ask that again until a body of knowledge, of theory, has been evolved (a process to which we certainly intend to contribute) to inform what is at present an empty term, with a concept. For a film magazine the question is also: what work is to be done in the field constituted by films? And for *Cahiers* in particular: what is our specific function in this field? What is to distinguish us from other "film magazines"?

## II. The Films

What is a film? On the one hand it is a particular product, manufactured within a given system of economic relations, and involving labour (which appears to the

capitalist as money) to produce—a condition to which even "independent" film-makers and the "new cinema" are subject—assembling a certain number of workers for this purpose (even the director, whether he is Moullet or Oury, is in the last analysis only a film worker). It becomes transformed into a commodity, possessing exchange value, which is realized by the sale of tickets and contracts, and governed by the laws of the market. On the other hand, as a result of being a material product of the system, it is also an ideological product of the system, which in France means capitalism.[5]

No film-maker can, by his own individual efforts, change the economic relations governing the manufacture and distribution of his films. (It cannot be pointed out too often that even film-makers who set out to be "revolutionary" on the level of message and form cannot effect any swift or radical change in the economic system—deform it, yes, deflect it, but not negate it or seriously upset its structure. Godard's recent statement to the effect that he wants to stop working in the "system" takes no account of the fact that any other system is bound to be a reflection of the one he wishes to avoid. The money no longer comes from the Champs-Elysées but from London, Rome or New York. The film may not be marketed by the distribution monopolies but it is shot on film stock from another monopoly—Kodak.) Because every film is part of the economic system it is also a part of the ideological system, for "cinema" and "art" are branches of ideology. None can escape: somewhere, like pieces in a jigsaw, all have their own allotted place. The system is blind to its own nature, but in spite of that, indeed because of that, when all the pieces are fitted together they give a very clear picture. But this does not mean that every film-maker plays a similar role. Reactions differ.

It is the job of criticism to see where they differ, and slowly, patiently, not expecting any magical transformations to take place at the wave of a slogan, to help change the ideology which conditions them.

A few points, which we shall return to in greater detail later: *every film is political*, inasmuch as it is determined by the ideology which produces it (or within which it is produced, which stems from the same thing). The cinema is all the more thoroughly and completely determined because unlike other arts or ideological systems its very manufacture mobilizes powerful economic forces in a way that the production of literature (which becomes the commodity "books," does not—though once we reach the level of distribution, publicity and sale, the two are in rather the same position).

Clearly, the cinema "reproduces" reality: this is what a camera and film stock are for—so says the ideology. But the tools and techniques of film-making are a part of "reality" themselves, and furthermore "reality" is nothing but an expression of the prevailing ideology. Seen in this light, the classic theory of cinema that the camera is an impartial instrument which grasps, or rather is impregnated by, the world in its "concrete reality" is an eminently reactionary one. What the camera in fact registers is the vague, unformulated, untheorized, unthought-out world of the dominant ideology. Cinema is one of the languages through which the world communicates itself to itself. They constitute its ideology for they reproduce the world as it is experienced when filtered through the ideology. (As Althusser defines it, more precisely: "Ideologies are perceived-accepted-suffered cultural objects, which work fundamentally on men by a process they do not understand. What men express in their ideologies is not their true relation to their conditions of existence, but how they react to their conditions of

existence; which presupposes a real relationship and an imaginary relationship.") So, when we set out to make a film, from the very first shot, we are encumbered by the necessity of reproducing things not as they really are but as they appear when refracted through the ideology. This includes every stage in the process of production: subjects, "styles," forms, meanings, narrative traditions; all underline the general ideological discourse. The film is ideology presenting itself to itself, talking to itself, learning about itself. Once we realize that it is the nature of the system to turn the cinema into an instrument of ideology, we can see that the film-maker's first task is to show up the cinema's so-called "depiction of reality." If he can do so there is a chance that we will be able to disrupt or possibly even sever the connection between the cinema and its ideological function.

The vital distinction between films today is whether they do this or whether they do not.

(a) The first and largest category comprises those films which are imbued through and through with the dominant ideology in pure and unadulterated form, and give no indication that their makers were even aware of the fact. We are not just talking about so-called "commercial" films. The *majority* of films in all categories are the unconscious instruments of the ideology which produces them. Whether the film is "commercial" or "ambitious," "modern" or "traditional," whether it is the type that gets shown in art houses, or in smart cinemas, whether it belongs to the "old" cinema or the "young" cinema, it is most likely to be a re-hash of the same old ideology. For all films are commodities and therefore objects of trade, even those whose discourse is explicitly political—which is why a rigorous definition of what constitutes "political" cinema is called for at this moment when it is being widely promoted. This merging of ideology and film is reflected in the first instance by the fact that audience demand and economic response have also been reduced to one and the same thing. In direct continuity with political practice, ideological practice reformulates the social need and backs it up with a discourse. This is not a hypothesis, but a scientifically-established fact. The ideology is talking to itself; it has all the answers ready before it asks the questions. Certainly there is such a thing as public demand, but "what the public wants" means "what the dominant ideology wants." The notion of a public and its tastes was created by the ideology to justify and perpetuate itself. And this public can only express itself via the thought-patterns of the ideology. The whole thing is a closed circuit, endlessly repeating the same illusion.

The situation is the same at the level of artistic form: These films totally accept the established system of depicting reality: "bourgeois realism" and the whole conservative box of tricks: blind faith in "life," "humanism," "common sense" etc. A blissful ignorance that there might be something wrong with this whole concept of "depiction" appears to have reigned at every stage in their production, so much so, that to us it appears a more accurate gauge of pictures in the "commercial" category than box-office returns. Nothing in these films jars against the ideology, or the audience's mystification by it. They are very reassuring for audiences for there is no difference between the ideology they meet every day and the ideology on the screen. It would be a useful complementary task for film critics to look into the way the ideological system and its products merge at all levels: to study the phenomenon whereby a film being shown to an audience becomes a monologue, in which the ideology talks to itself, by examining the success of films by, for instance, Melville, Oury and Lelouch.

(b) A second category is that of films which attack their ideological assimilation on two fronts. Firstly, by direct political action, on the level of the "signified," i.e. they deal with a directly political subject. "Deal with" is here intended in an active sense: they do not just discuss an issue, reiterate it, paraphrase it, but use it to attack the ideology (this presupposes a theoretical activity which is the direct opposite of the ideological one). This act only becomes politically effective if it is linked with a breaking down of the traditional way of depicting reality. On the level of form, *Unreconciled*, *The Edge* and *Earth in Revolt* all challenge the concept of "depiction" and mark a break with the tradition embodying it.

We would stress that only action on both fronts, "signified" and "signifiers"[6] has any hope of operating against the prevailing ideology. Economic/political and formal action have to be indissolubly wedded.

(c) There is another category in which the same double action operates, but "against the grain." The content is not explicitly political, but in some way becomes so through the criticism practised on it through its form.[7] To this category belong *Méditerranée*, *The Bellboy*, *Persona*. . . . For *Cahiers* these films (b and c) constitute the essential in the cinema, and should be the chief subject of the magazine.

(d) Fourth case: those films, increasingly numerous today, which have an explicitly political content (*Z* is not the best example as its presentation of politics is unremittingly ideological from first to last; a better example would be *Le Temps de Vivre*) but which do not effectively criticize the ideological system in which they are embedded because they unquestioningly adopt its language and its imagery.

This makes it important for critics to examine the effectiveness of the political criticism intended by these films. Do they express, reinforce, strengthen the very thing they set out to denounce? Are they caught in the system they wish to break down . . . ? (see a)

(e) Five: films which seem at first sight to belong firmly within the ideology and to be completely under its sway, but which turn out to be so only in an ambiguous manner. For though they start from a nonprogressive standpoint, ranging from the frankly reactionary through the conciliatory to the mildly critical, they have been worked upon, and work, in such a real way that there is a noticeable gap, a dislocation, between the starting point and the finished product. We disregard here the inconsistent—and unimportant—sector of films in which the director makes a *conscious* use of the prevailing ideology, but leaves it absolutely straight. The films we are talking about throw up obstacles in the way of the ideology, causing it to swerve and get off course. The cinematic framework lets us see it, but also shows it up and denounces it. Looking at the framework one can see two moments in it: one holding it back within certain limits, one transgressing them. An internal criticism is taking place which cracks the film apart at the seams. If one reads the film obliquely, looking for symptoms; if one looks beyond its apparent formal coherence, one can see that it is riddled with cracks: it is splitting under an internal tension which is simply not there in an ideologically innocuous film. The ideology thus becomes subordinate to the text. It no longer has an independent existence: It is *presented* by the film. This is the case in many Hollywood films for example, which while being completely integrated in the system and the ideology end up by partially dismantling the system from within. We must find out what makes it possible for a film-maker to corrode the ideology by restating it in the terms of his film: if he sees his film simply as a blow in favour of liberalism, it will be recuperated instantly by the ideology; if on the other

hand, he conceives and realizes it on the deeper level of imagery, there is a chance that it will turn out to be more disruptive. Not, of course, that he will be able to break the ideology itself, but simply its reflection in his film. (The films of Ford, Dreyer, Rossellini, for example.)

Our position with regard to this category of films is: that we have absolutely no intention of joining the current witch-hunt against them. They are the mythology of their own myths. They criticize themselves, even if no such intention is written into the script, and it is irrelevant and impertinent to do so for them. All we want to do is to show the process in action.

(f) Films of the "live cinema" (*cinéma direct*) variety, group one (the larger of the two groups). These are films arising out of political (or, it would probably be more exact to say: social) events or reflections, but which make no clear differentiation between themselves and the nonpolitical cinema because they do not challenge the cinema's traditional, ideologically-conditioned method of "depiction." For instance a miner's strike will be filmed in the same style as *Les Grandes Familles*. The makers of these films suffer under the primary and fundamental illusion that if they once break off the ideological filter of narrative traditions (dramaturgy, construction, domination of the component parts by a central idea, emphasis on formal beauty) reality will then yield itself up in its true form. The fact is that by doing so they only break off one filter, and not the most important one at that. For reality holds within itself no hidden kernel of self-understanding, of theory, of truth, like a stone inside a fruit. We have to manufacture those. (Marxism is very clear on this point, in its distinction between "real" and "perceived" objects.) Cf *Chiefs* (Leacock and a good number of the May films).

This is why supporters of *cinéma direct* resort to the same idealist terminology to express its role and justify its successes as others use about products of the greatest artifice: "accuracy," "a sense of lived experience," "flashes of intense truth," "moments caught live," "abolition of all sense that we are watching a film" and finally: fascination. It is that magical notion of "seeing is understanding": ideology goes on display to prevent itself from being shown up for what it really is, contemplates itself but does not criticize itself.

(g) The other kind of "live cinema." Here the director is not satisfied with the idea of the camera "seeing through appearances," but attacks the basic problem of depiction by giving an active role to the concrete stuff of his film. It then becomes productive of meaning and is not just a passive receptacle for meaning produced outside it (in the ideology): *La Règne du Jour, La Rentrée des Usines Wonder*.

## III. *Critical Function*

Such, then, is the field of our critical activity: these films, within the ideology, and their different relations to it. From this precisely defined field spring four functions: (1) in the case of the films in category (a): show what they are blind to; how they are totally determined, moulded, by the ideology; (2) in the case of those in categories (b), (c) and (g), read them on two levels, showing how the films operate critically on the level of signified and signifiers; (3) in the case of those of types (d) and (f), show how the signified (political subject matter) is always weakened, rendered harmless, by the absence of technical/theoretical work on the signifiers; (4) in the case of those

in group (e) point out the gap produced between film and ideology by the way the films work, and show how they work.

There can be no room in our critical practice either for speculation (commentary, interpretation, de-coding even) or for specious raving (of the film-columnist variety). It must be a rigidly factual analysis of what governs the production of a film (economic circumstances, ideology, demand and response) and the meanings and forms appearing in it, which are equally tangible.

The tradition of frivolous and evanescent writing on the cinema is as tenacious as it is prolific, and film analysis today is still massively predetermined by idealistic presuppositions. It wanders farther abroad today, but its method is still basically empirical. It has been through a necessary stage of going back to the material elements of a film, its signifying structures, its formal organization. The first steps here were undeniably taken by André Bazin, despite the contradictions that can be picked out in his articles. Then followed the approach based on structural linguistics (in which there are two basic traps, which we fell into—phenomenological positivism and mechanistic materialism). As surely as criticism had to go through this stage, it has to go beyond. To us, the only possible line of advance seems to be to use the theoretical writing of the Russian film-makers of the twenties (Eisenstein above all) to elaborate and apply a critical theory of the cinema, a specific method of apprehending rigorously defined objects, in direct reference to the method of dialectical materialism.

It is hardly necessary to point out that we know that the "policy" of a magazine cannot—indeed, should not—be corrected by magic overnight. We have to do it patiently, month by month, being careful in our own field to avoid the general error of putting faith in spontaneous change, or attempting to rush in a "revolution" without the preparation to support it. To start proclaiming at this stage that the truth has been revealed to us would be like talking about "miracles" or "conversion." All we should do is to state what work is already in progress and publish articles which relate to it, either explicitly or implicitly.

We should indicate briefly how the various elements in the magazine fit into this perspective. The essential part of the work obviously takes place in the theoretical articles and the criticisms. There is coming to be less and less of a difference between the two, because it is not our concern to add up the merits and defects of current films in the interests of topicality, nor, as one humorous article put it "to crack up the product." The interviews, on the other hand, and also the "diary" columns and the list of films, with the dossiers and supplementary material for possible discussion later, are often stronger on information than theory. It is up to the reader to decide whether these pieces take up any critical stance, and if so, what.

[Translated by Susan Bennett]

## NOTES

1. Others include distribution, screening and discussion of films in the provinces and the suburbs, sessions of theoretical work (see "Montage" no. 210).

2. Or tolerated, and jeopardized by this very toleration. Is there any need to stress that it is the tried tactic of covertly repressive systems not to harass the protesting fringe? They go out of

their way to take no notice of them, with the double effect of making one half of the opposition careful not to try their patience too far and the other half complacent in the knowledge that their activities are unobserved.

3. We do not intend to suggest by this that we want to erect a corporatist fence round our own field, and neglect the infinitely larger field where so much is obviously at stake politically. Simply, we are concentrating on that precise point of the spectrum of social activity in this article, in response to precise operational needs.

4. A more and more pressing problem. It would be inviting confusion to allow it to be tackled in bits and pieces and obviously we have to make a unified attempt to pose it theoretically later on. For the moment we leave it aside.

5. Capitalist ideology. This term expresses our meaning perfectly, but as we are going to use it without further definition in this article, we should point out that we are not under any illusion that it has some kind of "abstract essence." We know that it is historically and socially determined, and that it has multiple forms at any given place and time, and varies from historical period to historical period. Like the whole category of "militant" cinema, which is totally vague and undefined at present. We must (a) rigorously define the function attributed to it, its aims, its side effects (information, arousal, critical reflection, provocation "which always has *some* effect" . . .); (b) define the exact political line governing the making and screening of these films—"revolutionary" is too much of a blanket term to serve any useful purpose here; and (c) state whether the supporters of militant cinema are in fact proposing a line of action in which the cinema would become the poor relation, in the illusion that the less the cinematic aspect is worked on, the greater the strength and clarity of the "militant" effect will be. This would be a way of avoiding the contradictions of "parallel" cinema and getting embroiled in the problem of deciding whether "underground" films should be included in the category, on the pretext that their relationship to drugs and sex, their preoccupation with form, might possibly establish new relationships between film and audience.

6. We are not shutting our eyes to the fact that it is an oversimplification (employed here because operationally easier) to make such a sharp distinction between the two terms. This is particularly so in the case of the cinema, where the signified is more often than not a product of the permutations of the signifiers, and the sign has dominance over the meaning.

7. This is not a magical doorway out of the system of "depiction" (which is particularly dominant in the cinema) but rather a rigorous, detailed, large-scale work on this system— what conditions make it possible, what mechanisms render it innocuous. The method is to draw attention to the system, so that it can be seen for what it is, to make it serve one's own ends, condemn itself out of its own mouth. Tactics employed may include "turning cinematic syntax upside-down" but it cannot be just that. Any old film nowadays can upset the normal chronological order in the interests of looking vaguely "modern." But *The Exterminating Angel* and *The Diary of Anna Magdalena Bach* (though we would not wish to set them up as a model) are rigorously chronological without ceasing to be subversive in the way we have been describing, whereas in many a film the mixed-up time sequence simply covers up a basically naturalistic conception. In the same way, perceptual confusion (avowed intent to act on the unconscious mind, changes in the texture of the film, etc) are not sufficient in themselves to get beyond the traditional way of depicting "reality." To realize this, one has only to remember the unsuccessful attempts there have been of the "lettriste" or "zacum" type to give back its infinity to language by using nonsense words or new kinds of onomatopoeia. In the one and the other case only the most superficial level of language is touched. They create a new code, which operates on the level of the impossible, and has to be rejected on any other, and is therefore not in a position to transgress the normal.

# RICK ALTMAN

## A Semantic/Syntactic/Pragmatic Approach to Genre

FROM *Film/Genre*

Rick Altman (b. 1945) is Professor of Cinema and Comparative Literature at the University of Iowa, a leading cinema studies program in the United States. Altman is an authority on genre theory and film sound, and his award-winning books include *The American Film Musical* (1987), *Film/Genre* (1999), and *Silent Film Sound* (2004). His 2008 work, *A Theory of Narrative*, extends well beyond cinema while keeping it central to his ambitious reworking of approaches to narrative.

Altman draws on his research on the musical, and deploys vocabulary and modes of inquiry from linguistics and philosophy, to ask fundamental questions about genre as a category of filmmaking, film analysis, and audience comprehension. In his influential 1984 essay "A Semantic/Syntactic Approach to Film Genre" (the precursor to the selection included here), Altman claimed that while the term "genre" was essential to film studies, the field lacked a common vocabulary that could address the weaknesses and synthesize the strengths of different approaches. In linguistics, "semantics" refers to meaning and "syntax" refers to the rules governing sentence construction. Altman follows Lévi-Strauss and Barthes in applying these terms to higher-level systems of communication, in this case, genre. For example, semantic approaches tend to define genre descriptively and inclusively: What is a western? A film set in the West. In contrast, syntactic approaches attempt to identify the relationship between elements addressed in the genre. For example, a classic western like *My Darling Clementine* (1944) depicts a test with the law on the American frontier. Altman advocates combining these two approaches in a way that also addresses two other fundamental tensions in the way genre had previously been understood: the question of historical change, and the conflict between claims that genre primarily serves a ritual function for audiences' needs and wishes, and those that see genre as an ideological mechanism of the status quo. By describing fundamental contradictions within the literature on genre, and offering a new methodology for approaching its study, Altman's essay advanced the field of genre theory.

In the conclusion to his later book *Film/Genre* (1999), "A Semantic/Syntactic/Pragmatic Approach to Genre," Altman expands upon, and critiques, the ideas and terms in his 1984 essay. He begins where the earlier essay leaves off, recognizing that different audiences find different elements of genre meaningful, and that responses also vary over time. To account for "multiple users and branching uses," Altman concludes that we also need a pragmatic approach to genre. Pragmatics attends to how language is actually used. Just as the infinite number of sounds or word combinations only becomes meaningful in practice, genre cannot be approached as a stable category that preexists audiences but must be understood interactively. Altman acknowledges that his revised theory gives more weight to variations in the

*reception* of genre films. But he differs from Stuart Hall (p. 77) in stressing that such variations give rise in turn to variations in the *production* of films, in an overall process of change. His reconfigured understanding of genre is very useful in the current media landscape, in which media texts provide multiple entry points for fans and genres rapidly combine and mutate. For example, big-budget adaptations of comic books can be understood on multiple levels as action films, family entertainment, special effects spectacle, and parody.

## READING CUES & KEY CONCEPTS

■ Detail how Altman characterizes the limitations of his previous model of genre.

■ How does Altman define "generic users"?

■ Consider Altman's discussion of "nomads who become settlers." What does he mean by this? Apply his discussion to an emerging genre.

■ **Key Concepts:** Semantics; Syntactics; Pragmatics; Commutation Test; User Groups

# A Semantic/Syntactic/Pragmatic Approach to Genre

. . . . . . . . . . . . . .

> *Far from postulating a uniquely internal, formal progression, I would propose that the relationship between the semantic and the syntactic constitutes the very site of negotiation between Hollywood and its audience, and thus between ritual and ideological uses of genre. . . . Most genres go through a period of accommodation during which the public's desires are fitted to Hollywood's priorities (and vice-versa). . . .*
>
> *Whenever a lasting fit is obtained . . . it is because a common ground has been found, a region where the audience's ritual values coincide with Hollywood's ideological ones. . . . The successful genre owes its success . . . to its ability to carry out both functions simultaneously. It is this sleight of hand, this strategic overdetermination, that most clearly characterizes American film production during the studio years.*
>
> Rick Altman, "A Semantic/Syntactic Approach to Film Genre"
> (1984, pp. 13–15)

Some years ago I published an article proposing "A Semantic/Syntactic Approach to Film Genre." That article has enjoyed a certain success. As often happens with attempts to reduce complex phenomena to a simple formula, however, I remained haunted by certain aspects of my neat and manageable semantic/syntactic approach. "Just where, for example, do we locate the exact border between the semantic and the syntactic?" (1984, p. 15), I asked towards the end of the article. I might also have given voice to some more obvious and even more difficult questions: Of all the possible semantic and syntactic elements in a given film, how do we know to which ones we should attend? Don't different spectators notice different elements? Doesn't that change anything? I would have undoubtedly had ready answers at the time, but I now recognize that many of those answers would have been fundamentally

circular in nature. The genre tells us what to notice, I would have said, and some spectators know the genre better than others.

Thus defended, the semantic/syntactic approach may serve analytical purposes admirably, offering a satisfying descriptive vocabulary useful for interpreting individual texts and relating them to existing generic groupings. When it comes to a broader theoretical and historical understanding, however, such a defense definitely falls short. Even though the article made a valiant and perhaps at times successful effort to account for genre history, it ignored the threat that divergent perceptions represent not only for the overall semantic/syntactic theory, but even for its descriptive adequacy. Assuming stable recognition of semantic and syntactic factors across an unstable population, I underemphasized the fact that genres look different to different audiences, and that disparate viewers may perceive quite disparate semantic and syntactic elements in the same film. This blindness in turn kept me from fully investigating the possibility that genres might serve diverse groups diversely.

Because I was seeking a clear, supple, relevant terminology that could be shared by all spectators, my perspective was ironically limited *by the very nature of my project*. In search of the transparent and the objective, I couldn't possibly see that every terminology is to some extent tied to a particular use. Just as Todorov's project is compromised by his willingness to base a theory on someone else's definition and delimitation of swans, and Wittgenstein's entire enterprise is undermined by a decision to predicate his theory on the unexamined category of games, so I found my work compromised by the unspoken assumption that terminology can be neutral. So pleased was I to have figured out why the same texts are regularly treated by ritual and ideological critics in radically opposed ways that I failed to recognize in this opposition the key to the whole problem. While the article acknowledged a genre's ability simultaneously to satisfy differing needs, which I attributed to two collective singulars (the "audience" and "Hollywood"), I never awakened to the fact that genres may have multiple conflicting audiences, that Hollywood itself harbors many divergent interests, and that these multiple genre practitioners use genres and generic terminology in differing and potentially contradictory ways.

I continue to believe that genres embody precisely those moments/situations/structures that are capable of simultaneously benefiting multiple users. But this ability to satisfy several groups at the same time complicates the issue significantly. When we look at established genres all we can see is the coincidence, alignment and reinforcement so characteristic of successful genres. This is why it has been important to look at patterns of generic change—genre origins, genre redefinition and genre repurposing—along with the more traditional topics of generic stability and structure.

My attempt to forge an objective terminology suffered from a failure to recognize the discursive nature of genres. I take some solace in reporting that I had good company in this particular doghouse. From Aristotle to Wittgenstein and from Frye to Fowler (but with the notable exception of recent forays by Rosmarin and Beebee), most genre theories have been less than fully sensitive to generic discursivity. As I have suggested in the present book, genres now appear to me not just discursive but, because they are mechanisms for co-ordinating diverse users, multi-discursive. Instead of utilizing a single master language, as most previous genre theoreticians would have it, a genre may appropriately be considered multi-coded. Each genre is simultaneously defined by multiple codes, corresponding to the multiple groups who, by helping to define the genre, may be said to "speak" the genre. When the

diverse groups using the genre are considered together, genres appear as regulatory schemes facilitating the integration of diverse factions into a single social fabric.

## A Semantic/Syntactic/Pragmatic Approach

Though semantic/syntactic terminology may be useful in describing the effects of generic discursivity, it is not by itself sufficient to expose or explain them. That is why I have found it necessary to build the semantic/syntactic/pragmatic approach presented in this book. At this point, a few words about the notion of pragmatics are in order. A simple linguistic analogy will help explain this concept. Human sound-producing capacity is theoretically infinite in nature, yet individual languages recognize as meaningful only a small percentage of the sound variations actually produced by speakers. Linguists and other language users distinguish between meaningful and meaningless sound variation by way of a simple procedure called the commutation test. This test involves hypothetically substituting one sound for another and noting whether the change of sounds makes a difference in meaning; if the meaning changes, then the difference between the two sounds is recognized as significant and meaningful. This process depends on the assumption that language is split into separate levels: only by interrogating the level of meaning can we identify significance at the level of sound variation.

Following Jurij Lotman (1977), I have suggested that this pattern can be extended beyond language to an understanding of texts (1981). Beyond the levels of phonemes and morphemes, one can discern further levels dependent on the use to which language is put in a particular text or group of texts. Applying the commutation test to a poem or a film, we can discover which linguistic units take on meaning at a textual level. In one sense, this logic is flawless; the same structures that make it possible for language to communicate meaning are redeployed to create meaning at a higher level. Just as the level of meaningful words is necessary to ground the commutation that identifies which sounds are significant, so a textual level is necessary to ground linguistic meaning. To put it more simply, you can't decide which sounds are significant without knowing which of all possible sound combinations have meaning as words; similarly, you can't know which sound groupings have meaning as words without knowing how those sound clusters are used in practice. Use grounds linguistic meaning just as linguistic meaning grounds sound significance. Attention to that use is what linguists call *pragmatic* analysis.

The logic and the simplicity of this claim, along with the apparent fixity of language, kept me from recognizing one fundamental fact about this process, however. Far from being permanently grounded at a high level by some universally accepted practice, this system involves an infinite regression where each level, instead of being permanently guaranteed by the next, is only temporarily buttressed by a level that is itself only temporarily grounded by a level that is itself . . . and so on. Rather than breeding stability and security, this system thrives on borrowed time and deferral. The long history and social usefulness of individual languages may give them a high degree of apparent stability, yet even they are never as stable and secure as our dictionaries imply. The farther we go from phonemes and morphemes toward textual uses and generic uses, the more problematic and unstable the system.

Though I may have paid too little attention to the exponentially increasing "use indeterminacy" factor as we move from left to right along the noise/phoneme/

morpheme/text/genre chain, I still maintain that textual and generic signification are created in a manner similar to linguistic meaning, by use of the same principles at a higher level. We know which sounds have phonemic value by testing (through commutation) their use in specific words or expressions; we know in turn which phoneme clusters count as meaningful words by testing through commutation their use in specific texts. We know which specific textual patterns count as meaningful only by virtue of their deployment in broader cultural institutions like genres. The meaning of each level is assured only through its use at a higher level.

It is precisely this "use factor" that pragmatics addresses. Whether we are discussing literature or cinema (or any other meaning-making system), the base language(s) surpass their own structure and meaning as they are integrated into textual uses. This is the level that semantic/syntactic terminology serves so well. In order to understand which semantic and syntactic factors actually make meaning, however, it is necessary to subject them to a further analysis based on the uses to which they are put. Though the process appears entirely linear, with each level determined and defined by the next, that linearity is actually no more than a convenient fiction, for even the simplest language or text may have multiple users and branching uses.

If the whole story were told, at every level of analysis we would have to recognize that the next level up is not limited to a single use pattern against which the lower level can be commuted. Unsure which use pattern to take seriously, we would have to commute every potentially significant unit multiple times, in relation to each of the different higher-level uses with which it is associated. Leading to massive undecidability, this situation would destroy our ability to separate meaningful sounds from noise, words from jabberwocky, and textual structures from random patterns. Linguistic clarity would be sacrificed, along with shared cultural expectations. So undesirable is this situation that virtually all cultures have devised ways to reduce linguistic usage dispersion (and thus the effects of use indeterminacy) in order to guarantee continued clear communication. If every meaning depends on an indeterminate number of conflicting users, then no stable communication can take place; so society artificially restricts the range of acceptable uses, thus controlling the potential dispersion and infinite regression of the meaning-making series. If every meaning had to be deferred, then communication would literally be impossible; society far prefers to restrict communication (which is thus always slight miscommunication) rather than risk full freedom, which might destroy communication altogether.

Linguistic variation is relatively easy to restrain. At the level of texts and institutions, however, usage dispersion is virtually impossible to contain. This is why an understanding of broad-based representational practices like literature and cinema requires a separate pragmatics. Because semantic and syntactic elements are used in so many different ways, pragmatic analysis of genres cannot depend solely on commutation as its major analytical technique. Instead of looking primarily down the chain of meaning toward texts, morphemes and phonemes, pragmatic analysis must constantly attend to the competition among multiple users that characterizes genres. As such, pragmatic analysis necessarily abandons the linearity of the linguistic model on which it was originally based. Always assuming multiple users of various sorts—not only various spectator groups, but producers, distributors, exhibitors, cultural agencies, and many others as well—pragmatics recognizes that some familiar patterns, such as genres, owe their very existence to that multiplicity.

## Reception, Opposition, Poaching

The relationship between pragmatics and reception study deserves special attention. For a long time, traditional approaches to genre study assumed that genres (a) pre-exist spectators and (b) guide audience reception. Reception study denies the latter claim but accepts the former. Because the semantic/syntactic/pragmatic approach instead treats genres as a site of struggle and co-operation among multiple users, it must deny both claims. Whereas reception study limits its attention to various individuals' or groups' processing of a text or genre, pragmatic analysis treats reading as a more complex process involving not only hegemonic complicity across user groups but also a feedback system connecting user groups. Instead of a one-way text-to-reader configuration, pragmatics thus assumes a constant (if sometimes extremely slow) cross-fertilization process whereby the interests of one group may appear in the actions of another. Thus film production and genre formation cannot be systematically and simple-mindedly located upstream from film viewing, as most reception studies would have it. Instead of raising reception to an all-powerful final position in the production/distribution/exhibition/consumption/interpretation process (as several recent theorists have done), pragmatics recognizes reception study as an appropriate way to acknowledge the activities of specific user groups, but only in order subsequently to embed reception in a broader process-oriented and interactive analysis of competing user groups.

Like reception study, a semantic/syntactic/pragmatic approach refuses determinacy to textual structures taken alone, but in addition it acknowledges the difficulty of extracting those textual structures from the institutions and social habits that frame them and lend them the appearance of making meaning on their own. While pragmatic analysis sometimes destabilizes meaning by showing just how dependent it is on particular uses of a text or genre, at other times it succeeds in revealing the meaning-grounding institutions that make meaning seem to arise directly out of semantics and syntax. Just as it is no longer acceptable to base all genre theory on the special cases of the musical and the Western, it is unacceptable to base our understanding of textual determinacy on the case of marginal reception. Yet, as I have argued, marginal reception does have a special position in the theory of genres, like that of nations, because new structures regularly grow out of spectator positions once characterized as downright eccentric.

Just as it is essential to understand the breadth of a semantic/syntactic/pragmatic approach as compared to reception study, it is important to distinguish between the systemic approach of pragmatics and the more limited (though helpful) notions offered by Stuart Hall and Michel de Certeau. Because Hall and de Certeau have —concentrated heavily—especially in their most influential work—on the act of reading itself, they have often failed to address the broader problems covered by pragmatic analysis. In his article "Encoding/Decoding" (1980), Hall has described readers as either accepting, negotiating or opposing an intended reading. For de Certeau, "readers are travellers; they move across lands belonging to someone else, like nomads poaching their way across fields they did not write, despoiling the wealth of Egypt to enjoy it themselves" (1984, p. 174). The "poaching nomad" metaphor proves strikingly revelatory of Hall's and de Certeau's fundamental conservatism. According to de Certeau's account, there once was a great nation named

Egypt, now despoiled by a tribe of nomads. Nothing before, nothing after. But how did Egypt get to be a great nation and what happened to the nomads? De Certeau's "snapshot" historiography occludes discussion of these questions.

Instead of describing the overall process of reading and its relationship to institutions, both Hall and de Certeau are content to enlarge a single moment of that process. How did intended readings become identifiable as such? How did some people achieve the right to encode meanings, while others are reduced to decoding? As Hall and his followers model the situation, even the most oppositional reading is still just an act of decoding, ultimately dependent on a prior act of encoding. While the connections between encoding and decoding are carefully traced, no clear path leads from decoding to subsequent encodings, from opposing to intending, from the margins of a current society to the centre of a reconfigured society. Similarly, de Certeau assumes that the map has already been drawn by others, and that no nomadic activity can ever alter it. Not even squatters, who might claim their rights and thus settle the land, readers are treated as poachers on land owned by someone else, who established claim to the land in some mythic past. But just what did happen to Joseph, Moses and their tribe of nomads?

Over the past two decades, reception study has become a growth industry. Surprisingly, however, reception-oriented theorists have failed to draw the radical conclusions of their insights. Stressing localized reception (in time as well as space) of texts produced by someone outside the reception sphere, critics have never taken seriously the ability of audiences to generate their own texts and thus to become intenders, mappers and owners in their own right. Only when we voluntarily restrict our vision to a narrow slice of history do the players appear to be Egypt and the nomads. When we take a wider view, we easily recognize that civilizations have a more complex relation to poachers and nomads. In fact, every civilization was, in an important sense, produced by the settling of nomads. But once they have settled and drawn a new map, every former band of nomads is nothing more than another Egypt now subject to the poaching of a new band of nomads. With each cycle, the nomadic poachers become property owners, and thus authors, map-makers and intenders, thereby establishing the capital that attracts still others' poaching activity.

Tales of marauding tribes on the southern reaches of the Nile may seem entirely unrelated to film genre, yet the systems operate similarly. In order to create new film cycles, producers must attach new adjectives to existing substantival genres. In so doing, producers are precisely "poaching" on established genre territory. Yet this unauthorized, product-differentiating activity often settles into a new genre immediately subject to further nomadic raiding. Cycles and genres, nomads and civilizations, raids and institutions, poachers and owners—all are part of the ongoing remapping process that alternately energizes and fixes human perception. When cycles settle into genres, their fixity makes them perfect targets for raids by new cycles. When their wandering in the wilderness is done, nomads spawn civilizations only to be robbed and plundered by yet other wandering tribes. After their raid on existing film vocabulary, feminist film critics formed a series of successful institutions that for now protect their acquisitions but must eventually succumb to yet other raiders. Successful poachers eventually retire with their spoils to a New World where they are in turn despoiled by a new generation of poachers. Those who poached on *drama* by adding to it a nomadic *melo-* need not be surprised when a new group of nomads kidnaps the resultant *melodrama* and mates it with a wandering *family*.

Writing at a point in history when it was essential to free critics from the tyranny of textual analysis, Hall and de Certeau rightly accord to readers a degree of freedom and activity previously unavailable. To the extent that they restrict their analysis to a single category of users (readers), however, they are unable to capture the pragmatic complexity of literary and filmic systems. In their work, and that of many other critics and theoreticians writing over the last two decades, one senses a residue of the preceding text-based era. Today we have good cause to understand texts as one part of a far broader cultural enterprise. Only by shifting attention from reception practices alone to the broader—and conflicting—usage patterns of all users can we escape the residual tyranny of the text-king.

## Planning and Using Cities and Texts

When production and reception are thought of as primarily mental activities, they are not always easy to imagine. Material examples offer a more satisfying way of figuring the challenge and the promise of a semantic/syntactic/pragmatic approach. City planning offers particularly clear benefits in this regard. Take the example of Brasilia, recently recounted to me by Brazilian film scholar Ismail Xavier. As designed in the 50s by city-planner Lúcio Costa and architect Oscar Niemeyer, Brazil's new inland capital was to consist of multi-class units each with all necessary services. It soon became clear, however, that this utopian vision would not succeed, since government functionaries seeking lodging close to their centrally located offices quickly drove lower-class residents out of convenient locations. That is, the carefully developed Costa/Niemeyer plan, with a clearly identified syntactic arrangement of semantic elements, was opposed by a group of poachers. Thus far, the circumstances bear out Hall's and de Certeau's approaches.

Where the pragmatic side of semantic/syntactic/pragmatic analysis shows its mettle, however, is in its geographical and chronological expansion of use analysis. It is not enough to concentrate on the functionaries' reading of this city plan. What benefits accrued to other groups through this process? Why did the lower classes move? Did they find benefits in their new location (such as reduced cost, increased space, or intensified communication within their own group)? What interest beyond easy access to the workplace did the new inhabitants have (for example, the prestige of centrality in a city lacking more traditional markers of success, such as differentiated buildings)? The original plan clearly served the well-known leftist utopian notions of the planners; what social, economic and government purposes are served by the functionaries' poaching? The original plan represented an ideal, indeed a *genre*, of city planning characteristic of many projects around the world, before and since. The subsequent re-ghettoization just as clearly introduced a revised set of relationships among the city's users, corresponding to a different genre built on partial satisfaction of the needs of multiple user groups.

The above "geographical" expansion of pragmatic analysis to other contemporary user groups must be complemented by a "chronological" expansion to past and future city-planning projects. Costa and Niemeyer were clearly designing not just as individuals with an imagination, but also in response to the experience of previous populations in previous spaces. That is, they themselves are the site not of a single user priority but of several contradictory priorities representing practitioners

of previous city plans. Their own plan is thus "their own plan" only to the extent that such an expression can imply co-ordination of several use desires evinced by others. Moving down the flow of time, how did Costa and Niemeyer use the experience of Brasilia in their subsequent planning? How did this experiment affect others' plans? While each architect's attempt to resolve the problems addressed by Costa and Niemeyer might be thought of as a particular individual's design, it must be recognized that subsequent planners are simply the interpreters of user desires made evident by Brasilia and other related designs. To the extent that an individual planner balances those needs in a way already made familiar by other planners, a particular genre is reinforced and renewed. As opposed to the analysis of individual texts and their reception, understanding of genres requires this geographical and chronological expansion.

Just as city planners once thought that people would automatically inhabit their city as designed, so genre theorists once believed that readers and viewers would automatically follow the lead of textual producers. In fact, there was once a time when both expectations were to a great extent correct—not because use-as-planned is built into cities or texts, but because the economic and social support structures surrounding cities and texts silently and effectively exhorted populations and audiences to play their expected role. As long as audiences and critics alike regularly took the practice of use-as-directed to imply use-as-planned, we needed to be reminded of the difference between the two. Fifteen years ago, it was important to have Roger Odin, in his initial foray into the realm of semio-pragmatics, point out that "images never tell us how to read them" (1983, p. 68).

However, we no longer need to be reminded that different audiences can make different meanings out of the same text. Instead, what we need is an approach that

- addresses the fact that every text has multiple users;

- considers why different users develop different readings;

- theorizes the relationship among those users; and

- actively considers the effect of multiple conflicting uses on the production, labeling, and display of films and genres alike.

In constructing a semantic/syntactic/pragmatic approach to genre, I have attempted to address these very goals. This has led me to propose that what we call *genre* is in fact something quite different from what has always been supposed.

Instead of a word or a category capable of clear and stable definition (the goal of previous genre theorists), genre has here been presented as a multivalent term multiply and variously valorized by diverse user groups. Successful genres of course carry with them an air of user agreement about the nature both of genres in general and of this genre in particular, thus implying that genres are the unproblematic product of user sharing. In fact, the moments of clear and stable sharing typically adduced as generic models represent special cases within a broader general situation of user competition. While genres may make meaning by regulating and co-ordinating disparate users, they always do so in an arena where users with divergent interests compete to carry out their own programs.

As a final point, which has ramifications far too broad to have entered fully into my argument, I would simply point out that what I have just claimed about genre is true of every communicative structure in every language ever devised. Though the social utility of language has forced cultures to downplay this point, every word, every meaningful gesture, every film image makes meaning only through a process of multiple commutation engendered by the multiple usefulness of the sign in question. In spite of Saussure's claim to be presenting a *Course in GENERAL Linguistics*, our theories of language have always been theories of the exception, of the socially stabilized special case. A truly general theory would have to pass—as I have here—through analysis of contradictory usage, constant repurposing and systematic miscommunication, thus surpassing the specially determinate situation we call language.

The positions presented and defended here offer an avenue to a renewed general theory of meaning, one that fully recognizes the importance of competition and miscomprehension to any theory of communication and comprehension. Presented here solely with relation to film genre, semantic/syntactic/pragmatic analysis may be applied to any set of texts, because it is truly based on a general theory of meaning.

## BIBLIOGRAPHY

De Certeau, Michel. *The Practice of Everyday Life.* Berkeley: Univ. of California Press, 1984.

Hall, Stuart. "Encoding, Decoding." *Culture, Media, Language.* Eds. Stuart Hall, Dorothy Hobson, Andrew Lowe, Paul Willis. London: Hutchinson, 1980.

Lotman, Jurij. *The Structure of the Artistic Text.* Trans. Ronald Vroon. Ann Arbor: Michigan Slavic Materials, 1977.

Odin, Roger. "Pour une semio-pragmatique du cinema." *Iris* 1.1 (1983): 67–82.

# THOMAS ELSAESSER

......................................................................

# Tales of Sound and Fury:
# Observations on the Family Melodrama

German-born Thomas Elsaesser (b. 1943) is Research Professor in the Department of Media and Culture at the University of Amsterdam, where he established the film and television studies program and edits the book series *Film Culture in Transition.* He is widely considered one of the founders of the contemporary discipline of film studies, in which he has been an active and authoritative scholar for three decades. During his lengthy tenure at University of East Anglia, and subsequently in the Netherlands, he wrote or edited more than twenty-five books (published in both English and German, and translated into several other languages) and dozens of articles. His key works in German cinema studies include *New German Cinema* (1989, 2nd ed. 1994), *Fassbinder's Germany* (1996), and *Weimar Cinema and After* (2000). He has also published widely on Hollywood cinema and

film theory and helped set the parameters of emerging areas in the discipline, including early cinema and television and new media studies.

As editor of the magazine *Monogram* in the early 1970s, Elsaesser pioneered a vibrant, politically engaged film criticism in the United Kingdom that paralleled the criticism thriving in France during the heyday of the journal *Cahiers du cinéma*. When the films of Douglas Sirk, a European intellectual turned self-conscious Hollywood stylist, were featured at the Edinburgh Film Festival, Elsaesser contributed to an understanding of Sirk as an auteur critical of the American postwar status quo. The symptomatic reading of a "progressive text" (see Jean-Louis Comolli and Jean Narboni, p. 478), through which the critic locates moments of formal tension that reveal a film's discomfort with the socially conservative message Hollywood genre films are assumed to convey, became an influential critical practice.

Elsaesser's "Tales of Sound and Fury," originally published in *Monogram* in 1972, places the "family melodramas" of Sirk, Nicholas Ray, and Vincente Minnelli in a critical lineage of the melodramatic mode as it traverses media, national traditions, and historical crisis points. Introducing rich formal detail, Elsaesser looks at typical melodramatic patterns of continuity and discontinuity within postwar Technicolor dramas of families and communities in crisis, the big-budget kin of television soap operas and nighttime serial dramas. Contrasting the characters' psychological blockages and inarticulateness with the expressiveness of the mise-en-scène (music, décor, fashion, gesture, vocal qualities), Elsaesser identifies the malaise within prosperity as well as the utopian desire that consumer culture can convey. His attention to detail is all the more remarkable given the difficulty of access to film prints in the period before videocassettes and DVDs; this essay is the product of devoted cinema-going and is likely to send readers looking for the many films he mentions. Critics like Laura Mulvey (p. 713) and Linda Williams (p. 725) and filmmakers like Todd Haynes have built upon Elsaesser's attention to melodrama as a fundamental cinematic mode, one that is neither inherently conservative nor necessarily able to lay bare the conflicts that energize it. Feminist critics have questioned the auteurist approach of male critics who privilege Sirk's style as a form of irony, arguing that they are thereby distancing themselves, and the director, from the supposedly trivial, "feminine," subject matter of his films. Nevertheless, feminist critics credit Elsaesser's groundbreaking article for bringing film studies' attention to a genre that has remained central to the field.

## READING CUES & KEY CONCEPTS

▪ Consider the ways Elsaesser characterizes melodrama as a genre through settings, themes, and motifs. How does he connect formal detail to meaning?

▪ Locate examples of the historical origins of film melodrama in Elsaesser's essay. How does he relate the family melodrama to the historical period in which it flourished—Eisenhower-era America?

▪ Locate a place in the essay in which both genre and auteurist criticism come into play. Is there tension between these different ways of looking at films?

▪ **Key Concepts:** Domestic Melodrama; Ideology; Discontinuity; Irony

# Tales of Sound and Fury: Observations on the Family Melodrama

· · · · · · · · · · · · · ·

A sked about the colour in *Written on the Wind*, Douglas Sirk replied: "Almost throughout the picture I used deep-focus lenses which have the effect of giving a harshness to the objects and a kind of enamelled, hard surface to the colours. I wanted this to bring out the inner violence, the energy of the characters, which is all inside them and can't break through." It would be difficult to think of a better way of describing what this particular movie and indeed most of the best family melodramas of the 1950s and early 60s are about. Or for that matter, how closely, in this film, style and technique is related to theme.

My notes want to pursue an elusive subject in two directions: to indicate the development of what one might call the melodramatic imagination across different artistic forms and in different epochs; secondly, Sirk's remark tempts one to look for some structural and stylistic constants in one medium during one particular period (the Hollywood family melodrama between roughly 1940 and 1963) and to speculate on the cultural and psychological context which this form of melodrama so manifestly reflected and helped to articulate. Nonetheless this is not a historical study in any strict sense, nor a *catalogue raisonné* of names and titles, for reasons that have something to do with my general method as well as with the obvious limitations imposed on film research by unavailability. As a consequence, I lean rather heavily on half a dozen films, and notably *Written on the Wind*, to develop my points. This said, it is difficult to see how references to twenty more movies would make the argument any truer. For better or worse, what I want to say should at this stage be taken to be provocative rather than proven.

## *How to Make Stones Weep*

Bearing in mind that (whatever one's scruples about an exact definition) everybody has some idea of what is meant by "melodramatic," any discussion of the melodrama as a specific cinematic mode of expression has to start from its antecedents—the novel and certain types of "entertainment" drama—from which script-writers and directors have borrowed their models. The first thing one notices is that the media and literary forms which have habitually embodied melodramatic situations have changed considerably in the course of history and, further, they differ from country to country: in England, it has mainly been the novel and the literary gothic where melodramatic motifs persistently crop up;[1] in France, it is the costume drama and historical novel; in Germany "high" drama and the ballad, as well as more popular forms like *Moritat* (street-songs); finally, in Italy, the opera rather than the novel reached the highest degree of sophistication in the handling of melodramatic situations.

**[ · · · ]**

There seems a radical ambiguity attached to the melodrama, which holds even more for the film melodrama. Depending on whether the emphasis fell on the odyssey of suffering or the happy ending, on the place and context of rupture (moral conversion of the villain, unexpected appearance of a benevolent Capucine monk

throwing off his pimp's disguise), that is to say, depending on what dramatic mileage was got out of the heroine's perils before the ending (and one only has to think of Sade's *Justine* to see what could be done with the theme of innocence unprotected), melodrama would appear to function either subversively or as escapism—categories which are always relative to the given historical and social context.[2]

In the cinema, Griffith is a good example. Using identical dramatic devices and cinematic techniques, he could, with *Intolerance, Way Down East* or *Broken Blossoms* create, if not exactly subversive, at any rate socially committed melodramas, whereas *Birth of a Nation* or *Orphans of the Storm* are classic examples of how melodramatic effects can successfully shift explicit political themes onto a personalised plane. In both cases, Griffith tailored ideological conflicts into emotionally loaded family situations.

The persistence of the melodrama might indicate the ways in which popular culture has not only taken note of social crises and the fact that the losers are not always those who deserve it most, but has also resolutely refused to understand social change in other than private contexts and emotional terms. In this, there is obviously a healthy distrust of intellectualisation and abstract social theory—insisting that other structures of experience (those of suffering, for instance) are more in keeping with reality. But it has also meant ignorance of the properly social and political dimensions of these changes and their causality, and consequently it has encouraged increasingly escapist forms of mass-entertainment.

[ · · · ]

To sum up: these [nineteenth-century] writers understood the melodrama as a form which carried its own values and already embodied its own significant content; it served as the literary equivalent of a particular, historically and socially conditioned *mode of experience*. Even if the situations and sentiments defied all categories of verisimilitude and were totally unlike anything in real life, the structure had a truth and a life of its own, which an artist could make part of his material. This meant that those who consciously adopted melodramatic techniques of presentation did not necessarily do so out of incompetence nor always from a cynical distance, but, by turning a body of techniques into a stylistic principle that carried the distinct overtones of spiritual crisis, they could put the finger on the texture of their social and human material while still being free to shape this material. For there is little doubt that the whole conception of life in nineteenth-century Europe and England, and especially the spiritual problems of the age, were often viewed in categories we would today call melodramatic—one can see this in painting, architecture, the ornamentation of gadgets and furniture, the domestic and public *mise en scene* of events and occasions, the oratory in parliament, the Tractarian rhetoric from the pulpit as well as the more private manifestations of religious sentiment. Similarly, the timeless themes that Dostoyevsky brings up again and again in his novels—guilt, redemption, justice, innocence, freedom—are made specific and historically real not least because he was a great writer of melodramatic scenes and confrontations, and they more than anything else define that powerful irrational logic in the motivation and moral outlook of, say, Raskolnikov, Ivan Karamazov or Kirilov. Finally, how different Kafka's novels would be, if they did not contain those melodramatic family situations, pushed to the point where they reveal a dimension at once comic and tragically absurd—perhaps the existential undertow of all genuine melodrama.

## *Putting Melos into Drama*

In its dictionary sense, melodrama is a dramatic narrative in which musical accompaniment marks the emotional effects. This is still perhaps the most useful definition, because it allows melodramatic elements to be seen as constituents of a system of punctuation, giving expressive colour and chromatic contrast to the story-line, by orchestrating the emotional ups and downs of the intrigue. The advantage of this approach is that it formulates the problems of melodrama as problems of style and articulation.

Music in melodrama, for example, as a device among others to dramatise a given narrative, is subjective, programmatic. But because it is also a form of punctuation in the above sense, it is both functional (that is, of structural significance) and thematic (that is, belonging to the expressive content) because used to formulate certain moods—sorrow, violence, dread, suspense, happiness. The syntactic function of music has, as is well-known, survived into the sound film, and the experiments conducted by Hanns Eisler and T. W. Adorno are highly instructive in this respect.[3] A practical demonstration of the problem can be found in the account which Lillian Ross gives of how Gottfried Reinhardt and Dore Schary re-edited John Huston's *Red Badge of Courage* to give the narrative a smoother dramatic shape, by a musical build-up to the climaxes in a linear order, which is exactly what Huston had wanted to avoid when he shot it.[4]

Because it had to rely on piano accompaniment for punctuation, all silent film drama—from *True Heart Susie*, to *Foolish Wives* or *The Lodger*—is "melodramatic." It meant that directors had to develop an extremely subtle and yet precise formal language (of lighting, staging decor, acting, close-up, montage and camera movement), because they were deliberately looking for ways to compensate for the expressiveness, range of inflection and tonality, rhythmic emphasis and tension normally present in the spoken word. Having had to replace that part of language which is sound, directors like Murnau, Renoir, Hitchcock, Mizoguchi, Hawks, Lang, Sternberg achieved in their films a high degree (well recognised at the time) of plasticity in the modulation of optical planes and spatial masses which Panofsky rightly identified as a "dynamisation of space."

Among less gifted directors this sensitivity in the deployment of expressive means was partly lost with the advent of direct sound, since it seemed no longer necessary in a strictly technical sense—pictures "worked" on audiences through their dialogue, and the semantic force of language overshadowed the more sophisticated pictorial effects and architectural values. This perhaps helps to explain why some major technical innovations, such as colour, widescreen and deep-focus lenses, crane and dolly, in fact encouraged a new form of sophisticated melodrama. Directors (quite a sizeable proportion of whom came during the 30s from Germany, and others were clearly indebted to German expressionism and Max Reinhardt's methods of theatrical *mise en scene*) began showing a similar degree of visual culture as the masters of silent film-drama: Ophuls, Lubitsch, Sirk, Preminger, Welles, Losey, Ray, Minnelli, Cukor.

Considered as an expressive code, melodrama might therefore be described as a particular form of dramatic *mise en scene*, characterised by a dynamic use of spatial and musical categories, as opposed to intellectual or literary ones. Dramatic

situations are given an orchestration which will allow for complex aesthetic patterns: indeed, orchestration is fundamental to the American cinema as a whole (being essentially a dramatic cinema, spectacular, and based on a broad appeal) because it has drawn the aesthetic consequences of having the spoken word more as an additional "melodic" dimension than as an autonomous semantic discourse. Sound, whether musical or verbal, acts first of all to give the illusion of depth to the moving image, and by helping to create the third dimension of the spectacle, dialogue becomes a scenic element, along with more directly visual means of the *mise en scene*. Anyone who has ever had the bad luck of watching a Hollywood movie dubbed into French or German will know how important diction is to the emotional resonance and dramatic continuity. Dubbing makes the best picture seem visually flat and dramatically out of sync: it destroys the flow on which the coherence of the illusionist spectacle is built.

That the plasticity of the human voice is quite consciously employed by directors for what are often thematic ends is known: Hawks trained Lauren Bacall's voice so that she could be given "male" lines in *To Have and Have Not*, an effect which Sternberg anticipated when he took great care to cultivate Marlene Dietrich's diction, and it is hard to miss the psychoanalytic significance of Robert Stack's voice in *Written on the Wind*, sounding as if every word had to be painfully pumped up from the bottom of one of his oil-wells.

If it is true that speech in the American cinema loses some of its semantic importance in favour of its material aspects as sound, then conversely, lighting, composition, decor increase their semantic and syntactic contribution to the aesthetic effect. They become functional and integral elements in the construction of meaning. This is the justification for giving critical importance to the *mise en scene* over intellectual content or story-value. It is also the reason why the domestic melodrama in colour and widescreen, as it appeared in the 40s and 50s is perhaps the most highly elaborated, complex mode of cinematic signification that the American cinema has ever produced, because of the restricted scope for external action determined by the subject, and because everything, as Sirk said, happens "inside." To the "sublimation" of the action picture and the Busby Berkeley/Lloyd Bacon musical into domestic and family melodrama corresponded a sublimation of dramatic conflict into decor, colour, gesture and composition of frame, which in the best melodramas is perfectly thematised in terms of the characters' emotional and psychological predicaments.

For example, when in ordinary language we call something melodramatic, what we often mean is an exaggerated rise-and-fall pattern in human actions and emotional responses, a from-the-sublime-to-the-ridiculous movement, a foreshortening of lived time in favour of intensity—all of which produces a graph of much greater fluctuation, a quicker swing from one extreme to the other than is considered natural, realistic or in conformity with literary standards of verisimilitude: in the novel we like to sip our pleasures, rather than gulp them. But if we look at, say, Minnelli, who has adapted some of his best melodramas (*The Cobweb, Some Came Running, Home From the Hill, Two Weeks in Another Town, The Four Horsemen of the Apocalypse*) from generally extremely long, circumstantially detailed popular novels (by James Jones, Irving Shaw *et al*), it is easy to see how in the process of having to reduce seven to nine hours' reading matter to ninety-odd minutes, such a more

violent "melodramatic" graph almost inevitably produces itself, short of the narrative becoming incoherent. Whereas in novels, especially when they are staple pulp fare, size connotes solid emotional involvement for the reader, the specific values of the cinema lie in its concentrated visual metaphors and dramatic acceleration rather than in the fictional techniques of dilation. The commercial necessity of compression (being also a formal one) is taken by Minnelli into the films themselves and developed as a theme—that of a pervasive psychological pressure on the characters. An acute sense of claustrophobia in decor and locale translates itself into a restless, and yet suppressed energy surfacing sporadically in the actions and the behaviour of the protagonists—which is part of the subject of a film like *Two Weeks in Another Town*, with hysteria bubbling all the time just below the surface. The feeling that there is always more to tell than can be said leads to very consciously elliptical narratives, proceeding often by visually condensing the characters' motivation into sequences of images which do not seem to advance the plot. The shot of the Trevi fountain at the end of a complex scene where Kirk Douglas is making up his mind in *Two Weeks* is such a metaphoric condensation, and so is the silent sequence, consisting entirely of what might appear to be merely impressionistic dissolves, in the *Four Horsemen*, when Glenn Ford and Ingrid Thulin go for a ride to Versailles, but which in fact tells and foretells the whole trajectory of their relationship.

Sirk, too, often constructs his films in this way: the restlessness of *Written on the Wind* is not unconnected with the fact that he almost always cuts on movement. His visual metaphors ought to have a chapter to themselves: a yellow sports-car drawing up the gravelled driveway to stop in front of a pair of shining white Doric columns outside the Hadley mansion is not only a powerful piece of American iconography, especially when taken in a plunging high-angle shot, but the contrary associations of imperial splendour and vulgar materials (polished chrome-plate and stucco plaster) create a tension of correspondences and dissimilarities in the same image, which perfectly crystallises the decadent affluence and melancholic energy that give the film its uncanny fascination. Sirk has a peculiarly vivid eye for the contrasting emotional qualities of textures and materials, and he combines them or makes them clash to very striking effect, especially when they occur in a non-dramatic sequence: again in *Written on the Wind*, after the funeral of Hadley Sr., a black servant is seen taking an oleander wreath off the front gate. A black silk ribbon gets unstuck and is blown by the wind along the concrete path. The camera follows the movement, dissolves and dollies in on a window, where Lauren Bacall, in an oleander-green dress is just about to disappear behind the curtains. The scene has no plot significance whatsoever. But the colour parallels black/black, green/green, white concrete/white lace curtains provide an extremely strong emotional resonance in which the contrast of soft silk blown along the hard concrete is registered the more forcefully as a disquieting visual association. The desolation of the scene transfers itself onto the Bacall character, and the traditional fatalistic association of the wind reminds us of the futility implied in the movie's title.

These effects, of course, require a highly self-conscious stylist, but they are by no means rare in Hollywood. The fact that commercial necessities, political censorship and the various morality codes restricted directors in what they could tackle as a subject has entailed a different awareness of what constituted a worthwhile subject, a change in orientation from which sophisticated melodrama benefited perhaps

most. Not only did they provide a defined thematic parameter, but they encouraged a conscious use of style as meaning, which is a mark of what I would consider to be the very condition of a modernist sensibility working in popular culture. To take another example from Minnelli: his existential theme of a character trying to construct the world in the image of an inner self, only to discover that this world has become uninhabitable because it is both frighteningly suffocating and intolerably lonely (*The Long, Long Trailer* and *The Cobweb*) is transformed and given social significance when joined to the stock melodrama motif of the woman who, having failed to make it in the big city, comes back to the small-town home in the hope of finding her true place at last, but who is made miserable by mean-mindedness and bigotry and then suffocated by the sheer weight of her none-too-glorious, still ruefully remembered past (*Hilda Crane, Beyond the Forest, All I Desire*).[5] In Minnelli, it becomes an opportunity to explore in concrete circumstances the more philosophical questions of freedom and determinism, especially as they touch the aesthetic problem of how to depict a character who is not constantly externalising himself into action, without thereby trapping him in an environment of ready-made symbolism (for example, the discussion of decor and decoration in *The Cobweb*).

Similarly, when Robert Stack shows Lauren Bacall her hotel suite in *Written on the Wind*, where everything from flowers and pictures on the wall to underwear, nail polish and handbag is provided, Sirk not only characterises a rich man wanting to take over the woman he fancies body and soul, or the oppressive nature of an unwanted gift. He is also making a direct comment on the Hollywood stylistic technique that "creates" a character out of the elements of the decor, and that prefers actors who can provide as blank a facial surface and as little of a personality as possible.

Everyone who has thought at all about the Hollywood aesthetic wants to formulate one of its peculiar qualities: that of direct emotional involvement, whether one calls it "giving resonance to dramatic situations" or "fleshing out the cliché" or whether, more abstractly, one talks in terms of identification patterns, empathy and catharsis. Since the American cinema, determined as it is by an ideology of the spectacle and the spectacular, is essentially dramatic (as opposed to lyrical; concerned with mood or the inner self) and not conceptual (dealing with ideas and the structures of cognition and perception), the creation or re-enactment of situations which the spectator can identify with and recognise (whether this recognition is on the conscious or unconscious level is another matter) depends to a large extent on the aptness of the iconography (the "visualisation") and on the quality (complexity, subtlety, ambiguity) of the orchestration for what are trans-individual, popular mythological (and therefore generally considered culturally "lowbrow") experiences and plot-structures. In other words, this type of cinema depends on the ways "melos" is given to "drama" by means of lighting, montage, visual rhythm, decor, style of acting, music—that is, on the ways the *mise en scene* translates character into action (not unlike the pre–Henry James novel) and action into gesture and dynamic space (comparable to nineteenth-century opera and ballet).

[ · · · ]

In the domestic melodrama: the social pressures are such, the frame of respectability so sharply defined that the range of "strong" actions is limited. The tellingly impotent gesture, the social gaffe, the hysterical outburst replaces any more directly

liberating or self-annihilating action, and the cathartic violence of a shoot-out or a chase becomes an inner violence, often one which the characters turn against themselves. The dramatic configuration, the pattern of the plot makes them, regardless of attempts to break free, constantly look inwards, at each other and themselves. The characters are, so to speak, each others' sole referent, there is no world outside to be acted on, no reality that could be defined or assumed unambiguously. In Sirk, of course, they are locked into a universe of real and metaphoric mirrors, but quite generally, what is typical of this form of melodrama is that the characters' behaviour is often pathetically at variance with the real objectives they want to achieve. A sequence of substitute actions creates a kind of vicious circle in which the close nexus of cause and effect is somehow broken and—in an often overtly Freudian sense—displaced. James Dean in *East of Eden* thinks up a method of cold storage for lettuce, grows beans to sell to the Army, falls in love with Julie Harris, not to make a pile of money and live happily with a beautiful wife, but in order to win the love of his father and oust his brother—neither of which he achieves. Although very much on the surface of Kazan's film, this is a conjunction of puritan capitalist ethic and psychoanalysis which is sufficiently pertinent to the American melodrama to remain exemplary.

The melodramas of Ray, Sirk *or* Minnelli do not deal with this displacement-by-substitution directly, but by what one might call an intensified symbolisation of everyday actions, the heightening of the ordinary gesture and a use of setting and decor so as to reflect the characters' fetishist fixations. Violent feelings are given vent on "overdetermined" objects (James Dean kicking his father's portrait as he storms out of the house in *Rebel Without a Cause*), and aggressiveness is worked out by proxy. In such films, the plots have a quite noticeable propensity to form a circular pattern, which in Ray involves an almost geometrical variation of triangle into circle and vice versa,[6] whereas Sirk (*nomen est omen*) often suggests in his circles the possibility of a tangent detaching itself—the full-circle construction of *Written on the Wind* with its linear coda of the Hudson-Bacall relationship at the end, or even more visually apparent, the circular race around the pylons in *Tarnished Angels* broken when Dorothy Malone's plane in the last image soars past the fatal pylon into an unlimited sky.

[ · · · ]

## *Where Freud Left His Marx in the American Home*

There can be little doubt that the post-war popularity of the family melodrama in Hollywood is partly connected with the fact that in those years America discovered Freud. This is not the place to analyse the reasons why the United States should have become the country in which his theories found their most enthusiastic reception anywhere, or why they became such a decisive influence on American culture, but the connections of Freud with melodrama are as complex as they are undeniable. An interesting fact, for example, is that Hollywood tackled Freudian themes in a particularly "romantic" or gothic guise, through a cycle of movies inaugurated possibly by Hitchcock's first big American success, *Rebecca*. Relating his Victorianism to the Crawford-Stanwyck-Davis type "women's picture," which for obvious reasons became a major studio concern during the war years and found its apotheosis in

such movies as John Cromwell's *Since You Went Away* (to the front, that is), Hitchcock infused his film, and several others, with an oblique intimation of female frigidity producing strange fantasies of persecution, rape and death—masochistic reveries and nightmares, which cast the husband into the role of the sadistic murderer. This projection of sexual anxiety and its mechanisms of displacement and transfer is translated into a whole string of movies often involving hypnosis and playing on the ambiguity and suspense of whether the wife is merely imagining it or whether her husband really does have murderous designs on her: Hitchcock's *Notorious* and *Suspicion*, Minnelli's *Undercurrent*, Cukor's *Gaslight*, Sirk's *Sleep My Love*, Tourneur's *Experiment Perilous*, Lang's *Secret Beyond the Door*, all belong in this category, as does Preminger's *Whirlpool*, and in a wider sense Renoir's *Woman on the Beach*. What strikes one about this list is not only the high number of European émigrés entrusted with such projects, but that virtually all of the major directors of family melodramas (except Ray) had in the 1950s a (usually not entirely successful) stab at the explicitly Freudian Gothic melodrama in the 1940s.[7]

More challenging, and difficult to prove, is the speculation that certain stylistic and structural features of the sophisticated melodrama may involve principles of symbolisation and coding which Freud conceptualised in his analysis of dreams and later also applied in his *Psychopathology of Everyday Life*. I am thinking not only of the prevalence of what Freud called "Symptomhandlungen" (symptomatic acts) or "Fehl-Leistungen" (translated as "parapraxes"), that is, slips of the tongue or other projections of inner states into interpretable overt behaviour. This is a way of symbolising the double meaning of actions or signalling contradictory attitudes common to the American cinema in virtually every genre. However, there is a certain refinement in the melodrama—it becomes part of the composition of the frame, more subliminally and unobtrusively transmitted to the spectator. When Minnelli's characters find themselves in an emotionally precarious or contradictory situation, it often affects the "balance" of the visual composition—wine glasses, a piece of china or a trayful of drinks emphasise the fragility of their situation—e.g. Judy Garland over breakfast in *The Clock*, Richard Widmark in *The Cobweb* explaining himself to Gloria Grahame, or Gregory Peck trying to make his girlfriend see why he married someone else in *Designing Woman*. When Robert Stack in *Written on the Wind*, standing by the window he has just opened to get some fresh air into an extremely heavy family atmosphere, hears of Lauren Bacall expecting a baby, his misery becomes eloquent by the way he squeezes himself into the frame of the half-open window, every word his wife says to him bringing torment to his lacerated soul and racked body.

Along similar lines, I have in mind the kind of "condensation" of motivation into metaphoric images or sequences of images mentioned earlier, the relation that exists in Freudian dream-work between manifest dream material and latent dream content. Just as in dreams certain gestures and incidents mean something by their structure and sequence, rather than by what they literally represent, the melodrama often works, as I have tried to show, by a displaced emphasis, by substitute acts, by parallel situations and metaphoric connections. In dreams one tends to "use" as dream material incidents and circumstances from one's waking experience during the previous day, in order to "code" them, while nevertheless keeping a kind of emotional logic going, and even condensing their images into what, during the dream at least, seems an inevitable sequence. Melodramas often use middle-class American

society, its iconography and the family experience in just this way as their manifest "material," but "displace" it into quite different patterns, juxtaposing stereotyped situations in strange configurations, provoking clashes and ruptures which not only open up new associations but also redistribute the emotional energies which suspense and tensions have accumulated in disturbingly different directions. American movies, for example, often manipulate very shrewdly situations of extreme embarrassment (a blocking of emotional energy) and acts or gestures of violence (direct or indirect release) in order to create patterns of aesthetic significance which only a musical vocabulary might be able to describe accurately, and for which a psychologist or anthropologist might offer some explanation.

One of the principles involved is that of continuity and discontinuity (what Sirk has called the "rhythm of the plot"). A typical situation in American melodramas has the plot build up to an evidently catastrophic collision of counter-running sentiments, but a string of delays gets the greatest possible effect from the clash when it does come. In Minnelli's *The Bad and the Beautiful* Lana Turner plays an alcoholic actress who has been "rescued" by producer Kirk Douglas giving her a new start in the movies. After the premiere, flushed with success, self-confident for the first time in years, and in happy anticipation of celebrating with Douglas, with whom she has fallen in love, she drives to his home armed with a bottle of champagne. However, we already know that Douglas isn't emotionally interested in her ("I need an actress, not a wife" he later tells her) and is spending the evening with a "broad" in his bedroom. Lana Turner, suspecting nothing, is met by Douglas at the foot of the stairs, and she, at first too engrossed in herself to notice how cool he is, collapses when the other woman suddenly appears at the top of the stairs in Douglas' dressing gown. Her nervous breakdown in the car is conveyed by headlights flashing against her windscreen like a barrage of footlights and arc-lamps.

This letting-the-emotions-rise and then bringing them suddenly down with a thump is an extreme example of dramatic discontinuity, and a similar, vertiginous drop in the emotional temperature punctuates a good many melodramas—almost invariably played out against the vertical axis of a staircase.[8] In one of the most paroxysmal montage sequences that the American cinema has known, Sirk has Dorothy Malone in *Written on the Wind* dance on her own, like some doomed goddess from a Dionysian mystery, while her father is collapsing on the stairs and dying from a heart-attack. Again, in *Imitation of Life*, John Gavin gets the brush-off from Lana Turner as they are going down the stairs, and in *All I Desire* Barbara Stanwyck has to disappoint her daughter about not taking her to New York to become an actress, after the girl has been rushing downstairs to tell her father the good news. Ray's use of the staircase for similar emotional effects is well-known and most spectacular in *Bigger than Life*, but to give an example from another director, Henry King, I'd like to quote a scene from *Margie*, a film following rather closely Minnelli's *Meet Me in St. Louis*, where the heroine, Jeanne Crain, about to be taken to the graduation ball by a blind date (whom we know to be her father) since her poetry-loving bespectacled steady has caught a cold, comes tearing down from her bedroom when she hears that the French master, on whom she has a crush, has dropped in. She virtually rips the bouquet of flowers out of his hands and is overwhelmed by joy. With some embarrassment, he has to explain that he is taking somebody else to the ball, that he only came to return her papers, and Margie,

mortified, humiliated and cringing with shame, has just enough time to get back upstairs before she dissolves in tears.

While this may not sound terribly profound on paper, the visual orchestration of such a scene can produce some rather strong emotional effects and the strategy of building up to a climax so as to throttle it the more abruptly is a form of dramatic reversal by which Hollywood directors consistently criticised the streak of incurably naive moral and emotional idealism in the American psyche, first by showing it to be often indistinguishable from the grossest kind of illusion and self-delusion, and then by forcing a confrontation when it is most wounding and contradictory. The emotional extremes are played off in such a way that they reveal an inherent dialectic, and the undeniable psychic energy contained in this seemingly so vulnerable sentimentality is utilised to furnish its own antidote, to bring home the discontinuities in the structures of emotional experience which give a kind of realism and toughness rare if not unthinkable in the European cinema.

What makes these discontinuities in the melodrama so effective is that they occur, as it were, under pressure. Although the kinetics of the American cinema are generally directed towards creating pressure and manipulating it (as suspense, for example), the melodrama presents in some ways a special case. In the Western or the thriller, suspense is generated by the linear organisation of the plot and the action, together with the kind of "pressure" which the spectator brings to the film by way of anticipation and *apriori* expectations of what he hopes to see; melodrama, however, has to accommodate the latter type of pressure, as already indicated, in what amounts to a relatively "closed" world.

This is emphasised by the function of the decor and the symbolisation of objects: the setting of the family melodrama almost by definition is the middle-class home, filled with objects, which in a film like Philip Dunne's *Hilda Crane*, typical of the genre in this respect, surround the heroine in a hierarchy of apparent order that becomes increasingly suffocating. From father's armchair in the living room and mother's knitting, to the upstairs bedroom, where after five years' absence dolls and teddies are still neatly arranged on the bedspread, home not only overwhelms Hilda with images of parental oppression and a repressed past (which indirectly provoke her explosive outbursts that sustain the action), it also brings out the characteristic attempt of the bourgeois household to make time stand still, immobilise life and fix forever domestic property relations as the model of social life and a bulwark against the more disturbing sides in human nature. The theme has a particular poignancy in the many films about the victimisation and enforced passivity of women—women waiting at home, standing by the window, caught in a world of objects into which they are expected to invest their feelings. *Since You Went Away* has a telling sequence when Claudette Colbert, having just taken her husband to the troop-train at the station, returns home to clear up after the morning's rush. Everything she looks at or touches—dressing-gown, pipe, wedding-picture, breakfast cup, slippers, shaving brush, the dog—reminds her of her husband, until she cannot bear the strain and falls on her bed sobbing. The banality of the objects combined with the repressed anxieties and emotions force a contrast that makes the scene almost epitomise the relation of decor to character in melodrama: the more the setting fills with objects to which the plot gives symbolic significance, the more the characters are enclosed in seemingly ineluctable situations. Pressure is generated

by things crowding in on them and life becomes increasingly complicated because cluttered with obstacles and objects that invade their personalities, take them over, stand for them, become more real than the human relations or emotions they were intended to symbolise.

It is again an instance of Hollywood stylistic devices supporting the themes, or commenting on each other. Melodrama is fixed by the claustrophobic atmosphere of the bourgeois home and/or the small-town setting, its emotional pattern is that of panic and latent hysteria, reinforced stylistically by a complex handling of space in interiors (Sirk, Ray and Losey particularly excel in this) to the point where the world seems totally predetermined by "meaning" and pervaded by interpretable signs. This marks another recurrent feature, already touched on, that of desire focusing on the unobtainable object. The mechanisms of displacement and transfer, in an enclosed field of pressure, open a highly dynamic, yet discontinuous cycle of non-fulfilment, where discontinuity creates a universe of powerfully emotional, but obliquely related fixations. In melodrama, violence, the strong action, the dynamic movement, the full articulation and the fleshed-out emotions—so characteristic of the American cinema—become the very signs of the characters' alienation, and thus serve to formulate a devastating critique of the ideology that supports it.

$$[ \cdots ]$$

One of the characteristic features of melodramas in general is that they concentrate on the point of view of the victim: what makes the films mentioned above exceptional is the way they manage to present *all* the characters convincingly as victims. The critique—the questions of "evil," of responsibility—is firmly placed on a social and existential level, away from the arbitrary and finally obtuse logic of private motives and individualised psychology. This is why the melodrama, at its most accomplished, seems capable of reproducing more directly than other genres the patterns of domination and exploitation existing in a given society, especially the relation between psychology, morality and class-consciousness, by emphasising so clearly an emotional dynamic whose social correlative is a network of external forces directed oppressively inward, and with which the characters themselves unwittingly collude to become their agents. In Minnelli, Sirk, Ray, Cukor and others, alienation is recognised as a basic condition, fate is secularised into the prison of social conformity and psychological neurosis, and the linear trajectory of self-fulfilment so potent in American ideology is twisted into the downward spiral of a self-destructive urge seemingly possessing a whole social class.

This typical masochism of the melodrama, with its incessant acts of inner violation, its mechanisms of frustration and over-compensation, is perhaps brought most into the open through characters who have a drink problem (cf. *Written on the Wind, Hilda Crane, Days of Wine and Roses*). Although alcoholism is too common an emblem in films and too typical of middle-class America to deserve a close thematic analysis, drink does become interesting in movies where its dynamic significance is developed and its qualities as a visual metaphor recognised: wherever characters are seen swallowing and gulping their drinks as if they were swallowing their humiliations along with their pride, vitality and the life-force have become palpably destructive, and a phoney libido has turned into real anxiety. *Written on the Wind*

is perhaps the movie that most consistently builds on the metaphoric possibilities of alcohol (liquidity, potency, the phallic shape of bottles). Not only is its theme an emotional drought that no amount of alcohol, oil pumped by the derricks, or petrol in fast cars and planes can mitigate, it also has Robert Stack compensate for his sexual impotence and childhood guilt feelings by hugging a bottle of raw corn every time he feels suicidal, which he proceeds to smash in disgust against the paternal mansion. In one scene Stack is making unmistakable gestures with an empty Martini bottle in the direction of his wife, and an unconsummated relationship is visually under-scored when two brimful glasses remain untouched on the table, as Dorothy Malone does her best to seduce an unresponsive Rock Hudson at the family party, having previously poured her whisky into the flower vase of her rival, Lauren Bacall.

**[ · · · ]**

The point is that this inadequacy has itself a name, relevant to the melodrama as a form: (dramatic) irony and (tragic) pathos, which both in tragedy and melodrama is the response to the recognition of different levels of awareness. Irony privileges the spectator vis-à-vis the protagonists, for he registers the difference from a supe-rior position. Pathos results from non-communication or silence made eloquent— people talking at cross-purposes (Robert Stack and Lauren Bacall when she tells him she's pregnant in *Written on the Wind*), a mother watching her daughter's wed-ding from afar (Barbara Stanwyck in *Stella Dallas*) or a woman returning unnoticed to her family, watching them through the window (again Barbara Stanwyck in *All I Desire*)—where highly emotional situations are underplayed to present an ironic discontinuity of feeling or a qualitative difference in intensity, usually visualised in terms of spatial distance and separation.

Such archetypal melodramatic situations activate very strongly an audience's participation, for there is a desire to make up for the emotional deficiency, to impart the different awareness, which in other genres is systematically frustrated to produce suspense: the primitive desire to warn the heroine of the perils looming visibly over her in the shape of the villain's shadow. But in the more sophisticated melodramas this pathos is most acutely produced through a "liberal" *mise en scene* which balances different points of view, so that the spectator is in a position of seeing and evaluating contrasting attitudes within a given thematic framework—a framework which is the result of the total configuration and therefore inaccessible to the protagonists them-selves. The spectator, say in Otto Preminger's *Daisy Kenyon* or a Nicholas Ray movie is made aware of the slightest qualitative imbalance in a relationship and also sensi-tised to the tragic implications which a radical misunderstanding or a misconception of motives might have, even when this is not played out in terms of a tragic ending.

If pathos is the result of a skilfully displaced emotional emphasis, it is frequently used in melodramas to explore psychological and sexual repression, usually in con-junction with the theme of inferiority; inadequacy of response in the American cin-ema often has an explicitly sexual code: male impotence and female frigidity—a subject which allows for thematisation in various directions: not only to indicate the kinds of psychological anxiety and social pressures which generally make peo-ple sexually unresponsive, but as metaphors of un-freedom or a quasi-metaphysical "overreaching" (as in Ray's *Bigger than Life*). In Sirk, where the theme has an exem-plary status, it is treated as a problem of "decadence"—where intention, awareness,

yearning, outstrip performance—sexual, social, moral. From the Willi Birgel character in *Zu Neuen Ufern* onwards, Sirk's most impressive characters are never up to the demands which their lives make on them, though some are sufficiently sensitive, alive and intelligent to feel and know about this inadequacy of gesture and response. It gives their pathos a tragic ring, because they take on suffering and moral anguish knowingly, as the just price for having glimpsed a better world and having failed to live it. A tragic self-awareness is called upon to compensate for lost spontaneity and energy, and in films like *All I Desire* or *There's Always Tomorrow*, where as so often, the fundamental irony is in the titles themselves, this theme which has haunted the European imagination at least since Nietzsche, is absorbed into an American small-town atmosphere, often revolving around the questions of dignity and responsibility, how to yield when confronted with true talent and true vitality—in short, those qualities that dignity is called upon to make up for.

In the Hollywood melodrama characters made for operettas play out the tragedies of mankind which is how they experience the contradictions of American civilisation. Small wonder they are constantly baffled and amazed, as Lana Turner is in *Imitation of Life*, about what is going on around them and within them. The discrepancy of seeming and being, of intention and result, registers as a perplexing frustration, and an ever-increasing gap opens between the emotions and the reality they seek to reach. What strikes one as the true pathos is the very mediocrity of the human beings involved, putting such high demands upon themselves trying to live up to an exalted vision of man, but instead living out the impossible contradictions that have turned the American dream into its proverbial nightmare. It makes the best American melodramas of the 50s not only critical social documents but genuine tragedies, despite, or rather because of the "happy ending": they record some of the agonies that have accompanied the demise of the "affirmative culture." Spawned by liberal idealism, they advocate with open, conscious irony that the remedy is more of the same. But even without the national calamities that were to visit the US in the 1960s, this irony, too, belongs to a different age.

## NOTES

This essay was originally published in *Monogram* no. 4, 1972, pp. 2–15. [*This version has been abbreviated for this volume.—Ed.*]

1. A. Filon, *The English Stage* (London, 1897). Filon also offers an interesting definition of melodrama: "When dealing with Irving. I asked the question, so often discussed, whether we go to the theatre to see a representation of life, or to forget life and seek relief from it. Melodrama solves this question and shows that both theories are right, by giving satisfaction to both desires, in that it offers the extreme of realism in scenery and language together with the most uncommon sentiments and events."

2. About the ideological function of nineteenth-century Victorian melodrama, see M. W. Disher: "Even in gaffs and saloons, melodrama so strongly insisted on the sure reward to be bestowed in this life upon the law-abiding that sociologists now see in this a Machiavellian plot to keep democracy servile to Church and State. ( . . . ) There is no parting the two strains, moral and political, in the imagination of the nineteenth-century masses. They are hopelessly entangled. Democracy shaped its own entertainments at a time when the vogue of Virtue Triumphant was at its height and they took their pattern from it. ( . . . ) Here are Virtue Triumphant's attendant errors: confusion between sacred and profane, between worldly and spiritual advancement, between self-interest and self-sacrifice. . . ." (*Blood and Thunder*, London, 1949, pp. 13–14.) However, it ought to be remembered that there are

melodramatic traditions outside the puritan-democratic world view: Catholic countries, such as Spain, Mexico (cf. Bunuel's Mexican films) have a very strong line in melodramas, based on the themes of atonement and redemption. Japanese melodramas have been "high-brow" since the Monogatari stories of the sixteenth century, and in Mizoguchi's films (*The Life of Oharu, Shin Heike Monogatari*) they reach a transcendence and stylistic sublimation rivalled only by the very best Hollywood melodramas.

3. Hanns Eisler, *Composing for the Films* (London: Dobson, 1951).

4. Lillian Ross, *Picture* (Harmondsworth: Penguin, 1958).

5. The impact of *Madame Bovary* via Willa Cather on the American cinema and the popular imagination would deserve a closer look.

6. See articles in *Brighton Film Review* nos. 19, 20.

7. The most successful examples of this genre are no doubt Alfred Hitchcock's *Rebecca* and *Suspicion*. Sirk's *Sleep My Love*, Fritz Lang's *Secret Behind the Door* or *House by the River* would also qualify. *A Woman's Secret* (1949) includes Ray in this category as well, while the Ida Lupino character in Ray's *On Dangerous Ground* (1952)—blind, living with a homicidal brother—while not a gothic melodrama is reminiscent of a "masochistic" strain in the Hollywood 1940s women's picture.

8. As a principle of *mise en scene* the dramatic use of staircases recalls the famous *Jessnertreppe* of German theatre. The thematic conjunction of family and height/depth symbolism is described by Max Tessier: "The hero or heroine are tossed about in a social equivalent of a scenic railway, with rigorously compartmentalised classes. Their ambition is to get out, once and for all, of a milieu that is morally depraved and physically distressing, in order to gain access to the Nirvana of the grand bourgeoisie. . . . No family, no melodrama! For there to be melodrama, there first must be a lapse, sin, a social transgression, and what milieu is more ideally suited for the development of such a gangrene than the familial cell, tied as it is to a hierarchical conception of society?" (*Cinéma 71*, no. 161, p. 46—my translation).

# CAROL J. CLOVER

# Her Body, Himself

FROM *Men, Women, and Chain Saws*

A medievalist and film scholar, Carol J. Clover (b. 1940) is the Emerita Professor of Rhetoric, Scandinavian, and Film Studies at the University of California, Berkeley, where she has taught diverse courses on gender, legal and narrative procedure, film history and theory, film and law, and film genre. Trained as a medievalist at Berkeley and Uppsala University, she taught at Harvard University before returning to Berkeley. She has written extensively in the field of medieval languages and literatures, especially on the history and culture of early Northern Europe, and in 1996 she was elected to the American Academy of Arts and Sciences for her work on the Middle Ages. Following a period of work-study at the Swedish Film Institute, she also began teaching and writing in the field of film and is best known in film studies for her influential study of the slasher film, *Men, Women, and Chain Saws: Gender in the Modern Horror Film* (1992), which won best book awards in both the United States and the United Kingdom. She has since published on the courtroom drama.

Clover draws an intriguing connection between popular cinema and medieval culture, seeing both as performances characterized by formulaic narratives, invisibly authored and audience-driven. It is precisely these characteristics that guide her feminist investigation of the appeal of the horror genre in *Men, Women, and Chain Saws*. Clover's work is an important departure from more traditional studies of genre film that explore and define narrative and syntactic elements of genre. Avoiding genre definitions and formal analysis of genre, Clover is interested in how a particular genre (in this case horror) raises larger questions about the cinematic apparatus and cinematic experience. Clover's book is thus neither about horror per se nor about horror audiences, but rather about the relationship of viewers of horror films (largely young males) to what she terms the genre's "female victim-heroes." Clover is mainly concerned with what this relationship can reveal about the process of cinematic identification and spectatorship and about the politics of criticism and theory in general. Her analysis not only addresses some of the fundamental questions about how this relationship can alter the meaning of the horror genre, but it also displaces the presumably fixed paradigm of spectatorship and identification. With precedents such as Linda Williams's "When the Woman Looks" and Tania Modleski's *The Women Who Knew Too Much* (p. 375), Clover presents a solid critique of Laura Mulvey's description of male-centered identification processes (p. 713), arguing that though the slasher film is often labeled a male-driven and male-centered genre, it in fact works to align the spectator with the female victim-hero.

"Her Body, Himself," the first chapter of *Men, Women, and Chain Saws*, is a reading of gender identification in slasher films that seems to proceed quite traditionally through several syntactic elements of this genre. However, it also offers a very unorthodox analysis of the significance of what Clover famously calls the "Final Girl," the female character who survives the serial killer and usually ends the threat he presents. Gender and gender identification in slasher films, Clover demonstrates, are anything but pure and stable categories, not least because identification oscillates between the oppressor and the victim, between active and passive. The process is further complicated, she maintains, because both the "Other" (the killer or monster) and the "Final Girl" are decidedly androgynous and resist the notion of sexual difference as a set of clear opposites. Clover effectively shows how the slasher film genre presents us with constructions of gender identity that question and transcend the conventional categories and dominant paradigms of the cinematic apparatus. Her analysis has had a vast influence in film theory, and the figure of the "Final Girl" has inspired a wide range of artists.

## READING CUES & KEY CONCEPTS

▪ According to Clover, how does the character of the "Final Girl" function differently for male and female audiences?

▪ The "Final Girl" formula of the slasher genre is often seen as a feminist development. What is Clover's interpretation of this view?

▪ Discussing identification in slasher films, Clover says that "what filmmakers seem to know better than film critics is that gender is less a wall than a permeable membrane." What does she mean?

▪ **Key Concepts:** Slasher Film; Female Victim-Hero/"Final Girl"; Gender Identification

# Her Body, Himself

· · · · · · · · · · · · · ·

At the bottom of the horror heap lies the slasher (or splatter or shocker or stalker) film: the immensely generative story of a psychokiller who slashes to death a string of mostly female victims, one by one, until he is subdued or killed, usually by the one girl who has survived.[1] Drenched in taboo and encroaching vigorously on the pornographic, the slasher film lies by and large beyond the purview of the re-spectable (middle-aged, middle-class) audience. It has also lain by and large beyond the purview of respectable criticism. Staples of drive-ins and exploitation houses, where they "rub shoulders with sex pictures and macho action flicks," these are films that are "never even written up."[2] Even commentaries that celebrate "trash" disavow the slasher, usually passing it over in silence or bemoaning it as a degenerate aberration.[3] Film magazine articles on the genre rarely get past technique, special effects, and profits. Newspapers relegate reviews of slashers to the syndicated "Joe Bob Briggs, Drive-in Movie Critic of Grapevine, Texas," whose lowbrow, campy tone ("We're talking two breasts, four quarts of blood, five dead bodies. . . . Joe Bob says check it out") establishes what is deemed the necessary distance between the read-ership and the movie.[4] There are of course the exceptional cases: critics or social observers who have seen at least some of the films and tried to come to grips with their ethics or aesthetics or both. Just how troubled is their task can be seen from its divergent results. For one critic, *The Texas Chain Saw Massacre* is "the *Gone With the Wind* of meat movies."[5] For another it is a "vile little piece of sick crap . . . noth-ing but a hysterically paced, slapdash, imbecile concoction of cannibalism, voodoo, astrology, sundry hippie-esque cults, and unrelenting sadistic violence as extreme and hideous as a complete lack of imagination can possibly make it."[6] Writes a third, "[Director Tobe] Hooper's cinematic intelligence becomes more apparent in every viewing, as one gets over the initial traumatizing impact and learns to respect the pervasive felicities of camera placement and movement."[7] The Museum of Modern Art bought the film the same year that at least one country, Sweden, banned it.

Robin Wood's tack is less aesthetic than ethnographic. "However one may shrink from systematic exposure to them [slasher films], however one may deplore the social phenomena and ideological mutations they reflect, their popularity . . . suggests that even if they were uniformly execrable they shouldn't be ignored."[8] We may go a step further and suggest that the qualities that locate the slasher film outside the usual aesthetic system—that indeed render it, along with pornography and low horror in general, the film category "most likely to be betrayed by artistic treatment and lav-ish production values"[9]—are the very qualities that make it such a transparent source for (sub)cultural attitudes toward sex and gender in particular. Unmediated by other-worldly fantasy, cover plot, bestial transformations, or civilized routine, slasher films present us in startlingly direct terms with a world in which male and female are at des-perate odds but in which, at the same time, masculinity and femininity are more states of mind than body. The premise of this chapter, then, is that the slasher film, not de-spite but exactly because of its crudity and compulsive repetitiveness, gives us a clearer picture of current sexual attitudes, at least among the segment of the population that forms its erstwhile audience, than do the legitimate products of the better studios.

If popularity alone measures the fitness of a form for study, and if profits and sequels are the measure of popularity, then the slasher qualifies. *Halloween* cost $320,000 to make and within six years had grossed more than $75,000,000; even a highly produced film like *The Shining* has repaid its costs tenfold. *Alien* (a science-fiction/slasher hybrid) and *The Hills Have Eyes* are at Part Two. *The Texas Chain Saw Massacre* and *Psycho* are currently at Part Three. A *Nightmare on Elm Street* and *Halloween* have reached Part Five, and *Friday the Thirteenth* Part Eight. These are better taken as remakes than sequels; although the later part purports to take up where the earlier part left off, in most cases it simply duplicates with only slight variation the plot and circumstances—the formula—of its predecessor. Nor do different titles indicate different plots; *Friday the Thirteenth* is set at summer camp and *Halloween* in town, but the story is much the same, compulsively repeated in those thirteen films and in dozens like them under different names. The popularity of the slasher began to tail off in the mid-eighties, and by the end of the decade the form was largely drained.

But for some twelve years the slasher was the "exploitation" form of choice for junior horror fans. Although girls too went to slasher movies, usually in the company of boyfriends but sometimes in same-sex groups (my impression is that the *Nightmare on Elm Street* series in particular attracted girls in groups), the majority audience, perhaps even more than the audience for horror in general, was largely young and largely male—conspicuously groups of boys who cheer the killer on as he assaults his victims, then reverse their sympathies to cheer the survivor on as she assaults the killer. Young males are also, I shall suggest, the slasher film's implied audience, the object of its address. The question, then, has to do with that particular audience's stake in that particular nightmare; with what in the story is crucial enough to warrant the price of admission, and what the implications are for the current discussion of women and film.

## The Slasher Film

The appointed ancestor of the slasher film is Hitchcock's *Psycho* (1960). Its elements are familiar: the killer is the psychotic product of a sick family, but still recognizably human; the victim is a beautiful, sexually active woman; the location is not-home, at a Terrible Place; the weapon is something other than a gun; the attack is registered from the victim's point of view and comes with shocking suddenness. None of these features is original, but the unprecedented success of Hitchcock's particular formulation, above all the sexualization of both motive and action, prompted a flood of imitations and variations. In 1974, however, a film emerged that revised the *Psycho* template to such a degree and in such a way as to make a new phase: *The Texas Chain Saw Massacre* (Tobe Hooper).[10] Together with *Halloween* (John Carpenter, 1978), it engendered a new spate of variations and imitations.

The plot of *Chain Saw* is simple enough. Five young people are driving through Texas in a van; they stop off at an abandoned house and are serially murdered by the psychotic sons of a degenerate local family; the sole survivor is a woman. The horror, of course, lies in the elaboration. Early in the film the group picks up a hitchhiker, but when he starts a fire and slashes Franklin's arm (having already slit open his own hand), they kick him out. The abandoned house they subsequently visit, once the home of Sally and Franklin's grandparents, turns out to be right next door to the house of the hitchhiker and his family: his brother, Leatherface; their father; an

aged and only marginally alive grandfather; and their dead grandmother and her dog, whose mummified corpses are ceremonially included in the family gatherings. Three generations of slaughterhouse workers, once proud of their craft but now displaced by machines, have taken up killing and cannibalism as a way of life. Their house is grotesquely decorated with human and animal remains—bones, feathers, hair, skins. The young people drift apart in their exploration of the abandoned house and grounds and are picked off one by one by Leatherface and Hitchhiker. Last is Sally. The others are attacked and killed with dispatch, but Sally must fight for her life, enduring all manner of horrors through the night. At dawn she manages to escape to the highway, where she scrambles into a pickup and is saved.

Likewise the nutshell plot of *Halloween*: a psychotic killer (Michael) stalks a small town on Halloween and kills a string of teenage friends, one after another; only Laurie survives. The twist here is that Michael has escaped from the asylum in which he has been incarcerated since the age of six, when he killed his sister minutes after she and her boyfriend parted following an illicit interlude in her parents' bed. That murder, in flashback, opens the film. It is related entirely in the killer's first person (I-camera), and only after the fact is the identity of the perpetrator revealed. Fifteen years later, Michael escapes his prison and returns to kill Laurie, whom he construes as another version of his sister (a sequel clarifies that she is in fact his *younger* sister, adopted by another family at the time of the earlier tragedy). But before Michael gets to Laurie, he picks off her high school friends: Annie, in a car on her way to her boyfriend's; Bob, going to the kitchen for a beer after sex with Lynda; Lynda, talking on the phone with Laurie and waiting for Bob to come back with the beer. At last only Laurie remains. When she hears Lynda squeal and then go silent on the phone, she leaves her own babysitting house to go to Lynda's. Here she discovers the three bodies and flees, the killer in pursuit. The remainder of the film is devoted to the back-and-forth struggle between Laurie and Michael. Again and again he bears down on her, and again and again she either eludes him (by running, hiding, breaking through windows to escape, locking herself in) or strikes back (once with a knitting needle, once with a hanger). In the end, Dr. Loomis (Michael's psychiatrist in the asylum) rushes in and shoots the killer (though not so fatally as to prevent his return in the sequels).[11]

Before we turn to an inventory of generic components, let us add a third, later example: *The Texas Chain Saw Massacre II*, from 1986. The slaughterhouse family (now cutely named the Sawyers) is the same, though older and, owing to their unprecedented success in the sausage business, richer.[12] When Mr. Sawyer begins to suspect from her broadcasts that a disk jockey named Stretch knows more than she should about one of their recent crimes, he dispatches his sons Leatherface and Chop Top to the radio station late at night. There they seize the technician and corner Stretch. At the crucial moment, however, power fails Leatherface's chain saw. As Stretch cowers before him, he presses the now-still blade up along her thigh and against her crotch, where he holds it unsteadily as he jerks and shudders in what we understand to be orgasm. After that the sons leave. The intrepid Stretch tracks them to their underground lair outside of town. Tumbling down the Texas equivalent of a rabbit hole, Stretch finds herself in the subterranean chambers of the Sawyer operation. Here, amid all the slaughterhouse paraphernalia and within walls that drip with blood, the Sawyers live and work. Like the decrepit mansion of Part One, the residential parts of the establishment are quaintly decorated with human and animal remains. After

a long ordeal at the hands of the Sawyers, Stretch manages to scramble up through a culvert and beyond that up onto a nearby pinnacle, where she finds a chain saw and wards off her final assailant. The Texas Ranger, who had followed her to the Sawyers with the intention of saving her and busting the case, evidently perishes in a grenade explosion underground, leaving Stretch the sole survivor.

The spiritual debt of all the post-1974 slasher films to *Psycho* is clear, and it is a rare example that does not pay a visual tribute, however brief, to the ancestor—if not in a shower stabbing, then in a purling drain or the shadow of a knife-wielding hand. No less clear, however, is the fact that the post-1974 examples have, in the usual way of folklore, contemporized not only Hitchcock's terms but also, over time, their own. We have, in short, a cinematic formula with a twenty-six-year history, of which the first phase, from 1960 to 1974, is dominated by a film clearly rooted in the sensibility of the 1950s, while the second phase, bracketed by the two *Texas Chain Saw* films from 1974 and 1986, responds to the values of the late sixties and early seventies. That the formula in its most recent guise may be in decline is suggested by the campy, self-parodying quality of *Texas Chain Saw II*, as well as the emergence, in legitimate theater, of the slasher satire *Buckets of Blood*. Between 1974 and 1986, however, the formula evolved and flourished in ways of some interest to observers of popular culture, above all those concerned with the representation of women in film.

[ · · · ]

## The Body

On the face of it, the relation between the sexes in slasher films could hardly be clearer. The killer is with few exceptions recognizably human and distinctly male; his fury is unmistakably sexual in both roots and expression; his victims are mostly women, often sexually free and always young and beautiful. Just how essential this victim is to horror is suggested by her historical durability. If the killer has over time been variously figured as shark, fog, gorilla, birds, and slime, the victim is eternally and prototypically the damsel. Cinema hardly invented the pattern. It has simply given visual expression to the abiding proposition that, in Poe's famous formulation, the death of a beautiful woman is the "most poetical topic in the world."[13] As horror director Dario Argento puts it, "I like women, especially beautiful ones. If they have a good face and figure, I would much prefer to watch them being murdered than an ugly girl or man."[14] Brian De Palma elaborates: "Women in peril work better in the suspense genre. It all goes back to the *Perils of Pauline*. . . . If you have a haunted house and you have a woman walking around with a candelabrum, you fear more for her than you would for a husky man."[15] Or Hitchcock, during the filming of *The Birds*: "I always believe in following the advice of the playwright Sardou. He said, 'Torture the women!' The trouble today is that we don't torture women enough."[16] What the directors do not say, but show, is that "Pauline" is at her very most effective in a state of undress, borne down upon by a blatantly phallic murderer, even gurgling orgasmically as she dies. The case could be made that the slasher films available at a given neighborhood video rental outlet recommend themselves to censorship under the Dworkin-MacKinnon guidelines at least as readily as do the hard-core films the next section over, at which that legislation aimed; for if some of the victims are men,

the argument goes, most are women, and the women are brutalized in ways that come too close to real life for comfort. But what this line of reasoning does not take into account is the figure of the Final Girl. Because slashers lie for all practical purposes beyond the purview of legitimate criticism, and to the extent that they have been reviewed at all have been reviewed on an individual basis, the phenomenon of the female victim-hero has scarcely been acknowledged.[17]

It is, of course, "on the face of it" that most of the public discussion of film takes place—from the Dworkin-MacKinnon legislation to Siskel and Ebert's reviews to our own talks with friends on leaving the movie house. Underlying that discussion is the assumption that the sexes are what they seem; that screen males represent the Male and screen females the Female; that this identification along gender lines authorizes impulses toward violence in males and encourages impulses toward victimization in females. In part because of the massive authority cinema by nature accords the image, even academic film criticism has been slow—slower than literary criticism—to get beyond appearances. Film may not appropriate the mind's eye, but it certainly encroaches on it; the gender characteristics of a screen figure are a visible and audible given for the duration of the film. To the extent that the possibility of cross-gender identification has been entertained, it has been that of the female with the male. Thus some critics have wondered whether the female viewer, faced with the screen image of a masochistic/narcissistic female, might not rather elect to "betray her sex and identify with the masculine point of view." The reverse question—whether men might not also, on occasion, elect to betray their sex and identify with screen females—has scarcely been asked, presumably on the assumption that men's interests are well served by the traditional patterns of cinematic representation. For there is the matter of the "male gaze." As E. Ann Kaplan sums it up, "within the film text itself, men gaze at women, who become objects of the gaze; the spectator, in turn, is made to identify with this male gaze, and to objectify the woman on the screen; and the camera's original 'gaze' comes into play in the very act of filming."[18] But if it is so that all of us, male and female alike, are by these processes "made to" identify with men and "against" women, how are we then to explain the appeal to a largely male audience of a film genre that features a female victim-hero? The slasher film brings us squarely up against fundamental questions of film analysis: where does the literal end and the figurative begin? how do the two levels interact and what is the significance of the interaction? and to which, in arriving at a political judgment (as we are inclined to do in the case of low horror and pornography in particular), do we assign priority?

A figurative or functional analysis of the slasher begins with the processes of point of view and identification. The male viewer seeking a male character, even a vicious one, with whom to identify in a sustained way has little to hang onto in the standard example. On the good side, the only viable candidates are the boyfriends or schoolmates of the girls. They are for the most part marginal, undeveloped characters. More to the point, they tend to die early in the film. If the traditional horror plot gave the male spectator a last-minute hero with whom to identify, thereby "indulging his vanity as protector of the helpless female,"[19] the slasher eliminates or attenuates that role beyond any such function; indeed, would-be rescuers are not infrequently blown away for their trouble, leaving the girl to fight her own fight. Policemen, fathers, and sheriffs appear only long enough to demonstrate risible incomprehension

and incompetence. On the bad side, there is the killer. The killer is often unseen or barely glimpsed, during the first part of the film, and what we do see, when we finally get a good look, hardly invites immediate or conscious empathy. He is commonly masked, fat, deformed, or dressed as a woman. Or "he" *is* a woman: woe to the viewer of *Friday the Thirteenth I* who identifies with the male killer only to discover, in the film's final sequences, that he was not a man at all but a middle-aged mother. In either case, the killer is himself eventually killed or otherwise evacuated from the narrative. No male character of any stature lives to tell the tale.

The one character of stature who does live to tell the tale is in fact the Final Girl. She is introduced at the beginning and is the only character to be developed in any psychological detail. We understand immediately from the attention paid it that hers is the main story line. She is intelligent, watchful, levelheaded; the first character to sense something amiss and the only one to deduce from the accumulating evidence the pattern and extent of the threat; the only one, in other words, whose perspective approaches our own privileged understanding of the situation. We register her horror as she stumbles on the corpses of her friends. Her momentary paralysis in the face of death duplicates those moments of the universal nightmare experience—in which she is the undisputed "I"—on which horror frankly trades. When she downs the killer, we are triumphant. She is by any measure the slasher film's hero. This is not to say that our attachment to her is exclusive and unremitting, only that it adds up, and that in the closing sequence (which can be quite prolonged) it is very close to absolute.

An analysis of the camerawork bears this out. Much is made of the use of the I-camera to represent the killer's point of view. In these passages—they are usually few and brief, but striking—we see through his eyes and (on the soundtrack) hear his breathing and heartbeat. His and our vision is partly obscured by the bushes or window blinds in the foreground. By such means we are forced, the logic goes, to identify with the killer. In fact, however, the relation between camera point of view and the processes of viewer identification is poorly understood; the fact that Steven Spielberg can stage an attack in *Jaws* from the shark's point of view (underwater, rushing upward toward the swimmer's flailing legs) or Hitchcock an attack in *The Birds* from the bird-eye perspective (from the sky, as they gather to swoop down on the streets of Bodega) would seem to suggest either that the viewer's identificatory powers are unbelievably elastic or that point-of-view shots can sometimes be pro forma.[20] It has also been suggested that the hand-held or similarly unanchored first-person camera works as much to destabilize as to stabilize identification. Let us accept this equation: point of view = identification. We are linked, in this way, with the killer in the early part of the film, usually before we have seen him directly and before we have come to know the Final Girl in any detail. Our closeness to him wanes as our closeness to the Final Girl waxes—a shift underwritten by story line as well as camera position. By the end, point of view is hers: we are in the closet with her, watching with her eyes the knife blade pierce the door; in the room with her as the killer breaks through the window and grabs at her; in the car with her as the killer stabs through the convertible top, and so on. And with her, we become if not the killer of the killer then the agent of his expulsion from the narrative vision. If, during the film's course, we shifted our sympathies back and forth and dealt them out to other characters along the way, we belong in the end to the Final Girl; there is no alternative. When Stretch eviscerates Chop Top at the end of *Texas Chain Saw II*, she is literally the only character left alive, on either side.

Audience response ratifies this design. Observers unanimously stress the readiness of the "live" audience to switch sympathies in midstream, siding now with the killer and now, and finally, with the Final Girl. As Schoell, whose book on shocker films wrestles with its own monster, "the feminists," puts it:

> Social critics make much of the fact that male audience members cheer on the misogynous misfits in these movies as they rape, plunder, and murder their screaming, writhing female victims. Since these same critics walk out of the moviehouse in disgust long before the movie is over, they don't realize that these same men cheer on (with renewed enthusiasm, in fact) the heroines, who are often as strong, sexy, and independent as the [earlier] victims, as they blow away the killer with a shotgun or get him between the eyes with a machete. All of these men are said to be identifying with the maniac, but they enjoy *his* death throes the most of all, and applaud the heroine with admiration.[21]

What filmmakers seem to know better than film critics is that gender is less a wall than a permeable membrane.[22]

No one who has read "Red Riding Hood" to a small boy or attended a viewing of, say, *Deliverance* (an all-male story that women find as gripping as men do)—or, more recently, *Alien* and *Aliens*, with whose space-age female Rambo, herself a Final Girl, male viewers seem to engage with ease—can doubt the phenomenon of cross-gender identification.[23] This fluidity of engaged perspective is in keeping with the universal claims of the psychoanalytic model: the threat function and the victim function coexist in the same unconscious, regardless of anatomical sex. But why, if viewers can identify across gender lines and if the root experience of horror is sex blind, are the screen sexes not interchangeable? Why not more and better female killers, and why (in light of the maleness of the majority audience) not Pauls as well as Paulines? The fact that horror film so stubbornly figures the killer as male and the principal as female would seem to suggest that representation itself is at issue—that the sensation of bodily fright derives not exclusively from repressed content, as Freud insisted, but also from the bodily manifestations of that content.

Nor is the gender of the principals as straightforward as it first seems. The killer's phallic purpose, as he thrusts his drill or knife into the trembling bodies of young women, is unmistakable. At the same time, however, his masculinity is severely qualified: he ranges from the virginal or sexually inert to the transvestite or transsexual, and is spiritually divided ("the mother half of his mind") or even equipped with vulva and vagina. Although the killer of *God Told Me To* is represented and taken as a male in the film text, he is revealed, by the doctor who delivered him, to have been sexually ambiguous from birth: "I truly could not tell whether that child was male or female; it was as if the sexual gender had not been determined . . . as if it were being developed."[24] In this respect, slasher killers have much in common with the monsters of classic horror—monsters who, in Linda Williams's formulation, represent not just "an eruption of the normally repressed animal sexual energy of the civilized male" but also the "power and potency of a *non-phallic* sexuality." To the extent that the monster is constructed as feminine, the horror film thus expresses female desire only to show how monstrous it is.[25] The intention is manifest in *Aliens*, in which the Final Girl, Ripley, is pitted in the climactic scene against the most terrifying "alien" of all: an egg-laying Mother.

Decidedly "intrauterine" in quality is the Terrible Place, dark and often damp, in which the killer lives or lurks and whence he stages his most terrifying attacks. "It often happens," Freud wrote, "that neurotic men declare that they feel there is something uncanny about the female genital organs. This *unheimlich* place, however, is an entrance to the former *Heim* [home] of all human beings, to the place where each of us lived once upon a time and in the beginning. . . . In this case too then, the *unheimlich* is what once was *heimisch*, familiar; the prefix '*un*' [un-] is the token of repression."[26] It is the exceptional film that does not mark as significant the moment that the killer leaps out of the dark recesses of a corridor or cavern at the trespassing victim, usually the Final Girl. Long after the other particulars have faded, the viewer will remember the images of Amy assaulted from the dark halls of a morgue (*He Knows You're Alone*), or Melanie trapped in the attic as the savage birds close in (*The Birds*). In such scenes of convergence the Other is at its bisexual mightiest, the victim at her tiniest, and the component of sadomasochism at its most blatant.

The gender of the Final Girl is likewise compromised from the outset by her masculine interests, her inevitable sexual reluctance, her apartness from other girls, sometimes her name. At the level of the cinematic apparatus, her unfemininity is signaled clearly by her exercise of the "active investigating gaze" normally reserved for males and punished in females when they assume it themselves; tentatively at first and then aggressively, the Final Girl looks *for* the killer, even tracking him to his forest hut or his underground labyrinth, and then *at* him, therewith bringing him, often for the first time, into our vision as well. When, in the final scene, she stops screaming, faces the killer, and reaches for the knife (sledge hammer, scalpel, gun, machete, hanger, knitting needle, chain saw), she addresses the monster on his own terms. To the critics' objection that *Halloween* in effect punished female sexuality, director John Carpenter responded: "They [the critics] completely missed the boat there, I think. Because if you turn it around, the one girl who is the most sexually uptight just keeps stabbing this guy with a long knife. She's the most sexually frustrated. She's the one that killed him. Not because she's a virgin, but because all that repressed energy starts coming out. She uses all those phallic symbols on the guy. . . . She and the killer have a certain link: sexual repression."[27] For all its perversity, Carpenter's remark does underscore the sense of affinity, even recognition, that attends the final encounter. But the "certain link" that puts killer and Final Girl on terms, at least briefly, is more than "sexual repression." It is also a shared masculinity, materialized in "all those phallic symbols"—and it is also a shared femininity, materialized in what comes next (and what Carpenter, perhaps significantly, fails to mention): the castration, literal or symbolic, of the killer at her hands. The Final Girl has not just manned herself; she specifically unmans an oppressor whose masculinity was in question to begin with.[28] By the time the drama has played itself out, darkness yields to light (typically as day breaks) and the close quarters of the barn (closet, elevator, attic, basement) give way to the open expanse of the yard (field, road, lake-scape, cliff). With the Final Girl's appropriation of "all those phallic symbols" comes the dispelling of the "uterine" threat as well. Consider again the paradigmatic ending of *Texas Chain Saw II*. From the underground labyrinth, murky and bloody, in which she faced saw, knife, and hammer, Stretch escapes through a culvert into the open air. She clambers up the jutting rock and with a chain saw takes her stand. When her last assailant comes at her, she slashes open his lower abdomen—the sexual

symbolism is all too clear—and flings him off the cliff. Again, the final scene shows her in extreme long shot, standing on the ledge of a pinnacle, drenched in sunlight, buzzing chain saw held overhead.

The tale would indeed seem to be one of sex and parents. The patently erotic threat is easily seen as the materialized projection of the viewer's own incestuous fears and desires. It is this disabling cathexis to one's parents that must be killed and rekilled in the service of sexual autonomy. When the Final Girl stands at last in the light of day with the knife in her hand, she has delivered herself into the adult world. Carpenter's equation of the Final Girl with the killer has more than a grain of truth. The killers of *Psycho*, *The Eyes of Laura Mars*, *Friday the Thirteenth II–VI*, and *Cruising*, among others, are explicitly figured as sons in the psychosexual grip of their mothers (or fathers, in the case of *Cruising*). The difference is between past and present and between failure and success. The Final Girl enacts in the present, and successfully, the parenticidal struggle that the killer himself enacted unsuccessfully in his own past—a past that constitutes the film's backstory. She is what the killer once was; he is what she could become should she fail in her battle for sexual selfhood. "You got the choice, boy," says the tyrannical father of Leatherface in *Texas Chain Saw II*, "sex or the saw; you never know about sex, but the saw—the saw is the family."

The tale is no less one of maleness. If the experience of childhood can be—is perhaps ideally—enacted in female form, the breaking away requires the assumption of the phallus. The helpless child is gendered feminine; the autonomous adult or subject is gendered masculine; the passage from childhood to adulthood entails a shift from feminine to masculine. It is the male killer's tragedy that his incipient femininity is not reversed but completed (castration) and the Final Girl's victory that her incipient masculinity is not thwarted but realized (phallicization). When De Palma says that female frailty is a predicate of the suspense genre, he proposes, in effect, that the lack of the phallus, for Lacan the privileged signifier of the symbolic order, is itself simply horrifying, at least in the mind of the male observer. Where pornography (the argument goes) resolves that lack through a process of fetishization that allows a breast or leg or whole body to stand in for the missing member, the slasher film resolves it either through eliminating the woman (earlier victims) or reconstituting her as masculine (Final Girl). The moment at which the Final Girl is effectively phallicized is the moment that the plot halts and horror ceases. Day breaks, and the community returns to its normal order.

Casting psychoanalytic verities in female form has a venerable cinematic history. Ingmar Bergman, for one, has made a career of it. One immediate practical advantage, by now presumably unconscious on the part of makers as well as viewers, has to do with a preestablished cinematic "language" for capturing the moves and moods of the female body and face. The cinematic gaze, we are told, is male, and just as that gaze "knows" how to fetishize the female form in pornography (in a way that it does not "know" how to fetishize the male form),[29] so it "knows," in horror, how to track a woman ascending a staircase in a scary house and how to study her face from an angle above as she first hears the killer's footfall. A set of conventions we now take for granted simply "sees" males and females differently.

To this cinematic habit may be added the broader range of emotional expression traditionally allowed women. Angry displays of force may belong to the male, but crying, cowering, screaming, fainting, trembling, begging for mercy belong to

the female. Abject terror, in short, is gendered feminine, and the more concerned a given film is with that condition—and it is the essence of modern horror—the more likely the femaleness of the victim.[30] It is no accident that male victims in slasher films are killed swiftly or offscreen, and that prolonged struggles, in which the victim has time to contemplate her imminent destruction, inevitably figure females. Only when one encounters the rare expression of abject terror on the part of a male (as in *I Spit on Your Grave*) does one apprehend the full extent of the cinematic double standard in such matters.[31]

It is also the case that gender displacement can provide a kind of identificatory buffer, an emotional remove that permits the majority audience to explore taboo subjects in the relative safety of vicariousness. Just as Bergman came to realize that he could explore castration anxiety more freely via depictions of hurt female bodies (witness the genital mutilation of Karin in *Cries and Whispers*), so the makers of slasher films seem to know that sadomasochistic incest fantasies sit more easily with the male viewer when the visible player is female. It is one thing for that viewer to hear the psychiatrist intone at the end of *Psycho* that Norman as a boy (in the backstory) was abnormally attached to his mother; it would be quite another to see that attachment dramatized in the present, to experience in nightmare form the elaboration of Norman's (the viewer's own) fears and desires. If the former is playable in male form, the latter, it seems, is not.

The Final Girl is, on reflection, a congenial double for the adolescent male. She is feminine enough to act out in a gratifying way, a way unapproved for adult males, the terrors and masochistic pleasures of the underlying fantasy, but not so feminine as to disturb the structures of male competence and sexuality. The question then arises whether the Final Girls of slasher films—Stretch, Stevie, Marti, Will, Terry, Laurie, and Ripley—are not boyish for the same reason that female "victims" in Victorian flagellation literature—"Georgy," "Willy"—are boyish: because they are transformed males. The transformation, Steven Marcus writes, "is itself both a defense against and a disavowal of the fantasy it is simultaneously expressing—namely, that a *boy* is being beaten—that is, loved—by another man."[32] What is represented as male-on-female violence, in short, is figuratively speaking male-on-male sex. For Marcus, the literary picture of flagellation, in which *girls* are beaten, is utterly belied by the descriptions (in *My Secret Life*) of real-life episodes in which the persons being beaten are not girls at all but "gentlemen" dressed in women's clothes ("He had a woman's dress on tucked up to his waist, showing his naked rump and thighs. . . . On his head was a woman's cap tied carefully round his face to hide whiskers") and whipped by prostitutes. Reality, Marcus writes, "puts the literature of flagellation out of the running . . . by showing how that literature is a completely distorted and idealized version of what actually happens."[33] Applied to the slasher film, this logic reads the femaleness of the Final Girl (at least up to the point of her transformation) and indeed of the woman victims in general as only apparent, the artifact of heterosexual deflection. It may be through the female body that the body of the audience is sensationalized, but the sensation is an entirely male affair.[34]

At least one director, Hitchcock, explicitly located thrill in the equation victim = audience. So we judge from his marginal jottings in the shooting instructions for the shower scene in *Psycho*: "The slashing. An impression of a knife slashing, as if tearing at the very screen, ripping the film."[35] Not just the body of Marion is to be

ruptured, but also the body on the other side of the film and screen: our witnessing body. As Marion is to Norman, the audience of *Psycho* is to Hitchcock; as the audiences of horror film in general are to the directors of those films, female is to male. Hitchcock's "torture the women" then means, simply, torture the audience. De Palma's remarks about female frailty ("Women in peril work better in the suspense genre. . . . you fear more for her than you would for a husky man") likewise contemplate a male-on-"female" relationship between director and viewer. Cinefantastic horror, in short, succeeds in incorporating its spectators as "feminine" and then violating that body—which recoils, shudders, cries out collectively—in ways otherwise imaginable, for males, only in nightmare. The equation is nowhere more plainly put than in David Cronenberg's *Videodrome*. Here the threat is a mind-destroying video signal; the victims, television viewers. Despite the (male) hero's efforts to defend his mental and physical integrity, a deep, vagina-like gash appears on his lower abdomen. Says the media conspirator as he thrusts a videocassette into the victim's gaping wound, "You must open yourself completely to this."

If the slasher film is "on the face of it" a genre with at least a strong female presence, it is in these figurative readings a thoroughly male exercise, one that finally has very little to do with femaleness and very much to do with phallocentrism. Figuratively seen, the Final Girl is a male surrogate in things oedipal, a homoerotic stand-in, the audience incorporate; to the extent she means "girl" at all, it is only for purposes of signifying male lack, and even that meaning is nullified in the final scenes. Our initial question—how to square a female victim-hero with a largely male audience—is not so much answered as it is obviated in these readings. The Final Girl is (apparently) female not despite the maleness of the audience, but precisely because of it. The discourse is wholly masculine, and females figure in it only insofar as they "read" some aspect of male experience. To applaud the Final Girl as a feminist development, as some reviews of *Aliens* have done with Ripley, is, in light of her figurative meaning, a particularly grotesque expression of wishful thinking.[36] She is simply an agreed-upon fiction and the male viewer's use of her as a vehicle for his own sadomasochistic fantasies an act of perhaps timeless dishonesty.

<div align="center">[ · · · ]</div>

It may be just this theatricalization of gender that makes possible the willingness of the male viewer to submit himself to a brand of spectator experience that Hitchcock designated as "feminine" in 1960 and that has become only more so since then. In classic horror, the "feminization" of the audience is intermittent and ceases early. Our relationship with Marion's body in *Psycho* halts abruptly at the moment of its greatest intensity (slashing, ripping, tearing). The considerable remainder of the film distributes our bruised sympathies among several lesser figures, male and female, in such a way and at such length as to ameliorate the Marion experience and leave us, in the end, more or less recuperated in our presumed masculinity. Like Marion, the Final Girl is the designated victim, the audience incorporate, the slashing, ripping, and tearing of whose body will cause us to flinch and scream out in our seats. But unlike Marion, she does not die. If *Psycho*, like other classic horror films, solves the femininity problem by obliterating the female and replacing her with representatives of the masculine order (mostly but not inevitably males), the modern slasher solves it by regendering the woman. We are, as an audience, in the end

"masculinized" by and through the very figure by and through whom we were earlier "feminized." The same body does for both, and that body is female.

The last point is the crucial one: the same *female* body does for both. The Final Girl (1) undergoes agonizing trials, and (2) virtually or actually destroys the antagonist and saves herself. By the lights of folk tradition, she is not a heroine, for whom phase 1 consists in being saved by someone else, but a hero, who rises to the occasion and defeats the adversary with his own wit and hands. Part 1 of the story sits well on the female; it is the heart of heroine stories in general (Red Riding Hood, Pauline), and in some figurative sense, in ways I have elaborated in some detail, it is gendered feminine even when played by a male. Odysseus's position, trapped in the cave of the Cyclops, is not after all so different from Pauline's lashed to the tracks or Sally's tied to a chair in the dining room of the slaughterhouse family. The decisive moment, as far as the fixing of gender is concerned, lies in what happens next: those who save themselves are male, and those who are saved by others are female. No matter how "feminine" his experience in phase 1, the traditional hero, if he rises against his adversary and saves himself in phase 2, will be male.

What is remarkable about the slasher film is how close it comes to reversing the priorities. Presumably for the various functional or figurative reasons I have considered in this chapter, phase 1 wants a female: on that point all slashers from *Psycho* on are agreed. Abject fear is still gendered feminine, and the taboo anxieties in which slashers trade are still explored more easily via Pauline than Paul. The slippage comes in phase 2. As if in mute deference to a cultural imperative, slasher films from the seventies bring in a last-minute male, even when he is rendered supernumerary by the Final Girl's sturdy defense. By 1980, however, the male rescuer is either dismissably marginal or dispensed with altogether; not a few films have him rush to the rescue only to be hacked to bits, leaving the Final Girl to save herself after all. At the moment that the Final Girl becomes her own savior, she becomes a hero; and the moment that she becomes a hero is the moment that the male viewer gives up the last pretense of male identification. Abject terror may still be gendered feminine, but the willingness of one immensely popular current genre to re-represent the hero as an anatomical female would seem to suggest that at least one of the traditional marks of heroism, triumphant self-rescue, is no longer strictly gendered masculine.

So too the cinematic apparatus. The classic split between "spectacle and narrative," which "supposes the man's role as the active one of forwarding the story, making things happen," is at least unsettled in the slasher film.[37] When the Final Girl (in films like *Hell Night* and *Texas Chain Saw Massacre II*) assumes the "active investigating gaze," she exactly reverses the look, making a spectacle of the killer and a spectator of herself. Again, it is through the killer's eyes (I-camera) that we saw the Final Girl at the beginning of the film, and through the Final Girl's eyes that we see the killer, often for the first time with any clarity, sometime around the middle of the film and toward the end increasingly. The gaze becomes, at least for a while, female. More to the point, the female exercise of scopic control results not in her annihilation, in the manner of classic cinema, but in her triumph; indeed, her triumph *depends* on her assumption of the gaze.[38]

It is no surprise, in light of these developments, that the Final Girl should show signs of boyishness. Her symbolic phallicization, in the last scenes, may or may not

proceed at root from the horror of lack on the part of audience and maker. But it certainly proceeds from the need to bring her in line with the epic laws of Western narrative tradition—the very unanimity of which bears witness to the historical importance, in popular culture, of the literal representation of heroism in male form—and it proceeds no less from the need to render the reallocated gaze intelligible to an audience conditioned by the dominant cinematic apparatus.

It is worth noting that the higher genres of horror have traditionally resisted such developments. The idea of a female who outsmarts, much less outfights—or outgazes—her assailant is unthinkable in the films of De Palma and Hitchcock.[39] Although the slasher film's victims may be sexual teases, they are not in addition simpleminded, scheming, physically incompetent, and morally deficient in the manner of these filmmakers' female victims. And however revolting their special effects and sexualized their violence, few slasher murders approach the level of voluptuous sadism that attends the destruction of women in De Palma's films. For reasons on which we can only speculate, femininity is more conventionally elaborated and inexorably punished, and in an emphatically masculine environment, in the higher forms—the forms that *are* written up, and not by Joe Bob Briggs.

That the slasher film speaks deeply and obsessively to male anxieties and desires seems clear—if nothing else from the maleness of the majority audience. And yet these are texts in which the categories masculine and feminine, traditionally embodied in male and female, are collapsed into one and the same character—a character who is anatomically female and one whose point of view the spectator is unambiguously invited, by the usual set of literary-structural and cinematic conventions, to share. The willingness and even eagerness (so we judge from these films' enormous popularity) of the male viewer to throw in his emotional lot, if only temporarily, with not only a woman but a woman in fear and pain, at least in the first instance, would seem to suggest that he has a vicarious stake in that fear and pain. If it is also the case that the act of horror spectatorship is itself registered as a "feminine" experience—that the shock effects induce in the viewer bodily sensations answering the fear and pain of the screen victim—the charge of masochism is underlined. This is not to say that the male viewer does not also have a stake in the sadistic side; narrative structure, cinematic procedures, and audience response all indicate that he shifts back and forth with ease. It is only to suggest that in the Final Girl sequence his empathy with what the films define as the female posture is fully engaged, and further, because this sequence is inevitably the central one in any given film, that the viewing experience hinges on the emotional assumption of the feminine posture. Kaja Silverman takes it a step further: "I will hazard the generalization that it is always the victim—the figure who occupies the passive position—who is really the focus of attention, and whose subjugation the subject (whether male or female) experiences as a pleasurable repetition of his/her own story," she writes. "Indeed, I would go so far as to say that the fascination of the sadistic point of view is merely that it provides the best vantage point from which to watch the masochistic story unfold."[40]

The slasher is hardly the first genre in the literary and visual arts to invite identification with the female; one cannot help wondering more generally whether the historical maintenance of images of women in fear and pain does not have more to do

with male vicarism than is commonly acknowledged. What distinguishes the slasher, however, is the absence or untenability of alternative perspectives and hence the exposed quality of the invitation. As a survey of the tradition shows, this has not always been the case. The stages of the Final Girl's evolution—her piecemeal absorption of functions previously represented in males—can be located in the years following 1978. The fact that the typical patrons of these films are the sons of marriages contracted in the sixties or even early seventies leads me to speculate that the dire claims of that era—that the women's movement, the entry of women into the workplace, and the rise of divorce and woman-headed families would yield massive gender confusion in the next generation—were not entirely wrong. We preferred, in the eighties, to speak of the cult of androgyny, but the point is roughly the same. The fact that we have in the killer a feminine male and in the main character a masculine female—parent and everyteen, respectively—would seem, especially in the latter case, to suggest a loosening of the categories, or at least of the category of the feminine.[41] It is not that these films show us gender and sex in free variation; it is that they fix on the irregular combinations, of which the combination masculine female repeatedly prevails over the combination feminine male. The fact that masculine males (boyfriends, fathers, would-be rescuers) are regularly dismissed through ridicule or death or both would seem to suggest that it is not masculinity per se that is being privileged, but masculinity in conjunction with a female body—indeed, as the term victim-hero contemplates, masculinity in conjunction with femininity. For if "masculine" describes the Final Girl some of the time, and in some of her more theatrical moments, it does not do justice to the sense of her character as a whole. She alternates between registers from the outset; before her final struggle she endures the deepest, throes of "femininity"; and even during the final struggle she is now weak and now strong, now flees the killer and now charges him, now stabs and is stabbed, now cries out in fear and now shouts in anger. She is a physical female and a characterological androgyne: like her name, not masculine but either/or, both, ambiguous.[42]

Robin Wood speaks of the sense that horror, for him the by-product of cultural crisis and disintegration, is "currently the most important of all American [film] genres and perhaps even the most progressive, even in its overt nihilism."[43] Likewise Vale and Juno say of the "incredibly strange films," mostly low-budget horror, that their volume surveys, "They often present unpopular—even radical—views addressing the social, political, racial, or sexual inequities, hypocrisy in religion or government."[44] And Tania Modleski rests her case against the Frankfurt School–derived critique of mass culture on the evidence of the slasher, which does *not* propose a spurious harmony; does *not* promote the "specious good" (but indeed often exposes and attacks it); does *not* ply the mechanisms of identification, narrative continuity, and closure to provide the sort of narrative pleasure constitutive of the dominant ideology.[45] One is deeply reluctant to make progressive claims for a body of cinema as spectacularly nasty toward women as the slasher film is, but the fact is that the slasher does, in its own perverse way and for better or worse, constitute a visible adjustment in the terms of gender representations. That it is an adjustment largely on the male side, appearing at the furthest possible remove from the quarters of theory and showing signs of trickling upward, is of no small interest in the study of popular culture.[46]

## NOTES

1. A longer version of this essay was published under the title "Her Body, Himself: Gender in the Slasher Film" in *Representations* 20 (1987).

2. Dickstein, "The Aesthetics of Fright," p. 34.

3. "Will Rogers said he never met a man he didn't like, and I can truly say the same about the cinema," Harvey R. Greenberg writes in his paean to horror, *The Movies on Your Mind*. His claim does not, however, extend to the "plethora of execrable imitations [of *Psycho*] that debased cinema" (p. 137).

4. "Joe Bob Briggs" was evidently invented as a solution to the *Dallas Times Herald*'s problem of "how to cover trashy movies." See Calvin Trillin's "American Chronicles: The Life and Times of Joe Bob Briggs, So Far," *New Yorker*, 22 December 1986, pp. 73–88.

5. Lew Brighton, "Saturn in Retrograde," p. 27.

6. Stephen Koch, "Fashions in Pornography," pp. 108–9.

7. Wood, "Return of the Repressed," p. 30.

8. Robin Wood, "Beauty Bests the Beast," p. 63.

9. Dickstein, "The Aesthetics of Fright," p. 34.

10. For an account of the ways the "family horror" aspect of the *Psycho* formula has evolved over the decades, see Patricia Erens, "The Stepfather."

11. Dika outlines the narrative sequence of the standard "stalker" film as follows. Past Event: The young community is guilty of a wrongful action; the killer sees an injury, fault, or death; the killer kills the guilty members of the young community. Present Event: an event commemorates the past action; the killer's destructive force is reactivated; the killer re-identifies the guilty parties; a member from the old community warns the young community; the young community pays no heed; the killer stalks members of the young community; the killer kills members of the young community; the heroine sees the extent of the murders; the heroine sees the killer; the heroine does battle with the killer; the heroine kills or subdues the killer; the heroine survives; but the heroine is not free. See her *Games of Terror*, esp. p. 136.

12. The evolution of the human-sausage theme is typical of the back-and-forth borrowing in low horror. *Texas Chain Saw Massacre I* hints at it; *Motel Hell* turns it into an industry ("Farmer Vincent's Smoked Meats: This is It!" proclaims a local billboard); and *Texas Chain Saw Massacre II* expands it to a statewide chili-tasting contest.

13. Edgar Allan Poe, "The Philosophy of Composition," p. 55.

14. Argento as quoted in Schoell, *Stay Out of the Shower*, p. 54.

15. De Palma as quoted in ibid., p. 41.

16. Hitchcock as quoted in Spoto, *The Dark Side of Genius*, p. 483.

17. Cf. Dika's *Games of Terror*, which, although not particularly concerned with the female heroes of slasher films, does recognize their centrality and does suggest a reason for their emergence at this historical moment.

18. Silvia Bovenschen, "Is There a Feminine Aesthetic?" p. 114; E. Ann Kaplan, *Women and Film*, p. 15.

19. Wood, "Beauty Bests the Beast," p. 64.

20. The locus classicus in this connection is the view-from-the-coffin shot in Carl Th. Dreyer's *Vampyr*, in which the I-camera sees through the eyes of a dead man. See Nash, "*Vampyr* and the Fantastic," esp. pp. 32–33.

21. Schoell, *Stay Out of the Shower*, p. 55. Two points in this paragraph deserve emending. One is the suggestion that rape is common in these films; it is in fact virtually absent, by

definition. The other is the characterization of the Final Girl as "sexy." She may be attractive (though typically less so than her friends), but she is with few exceptions sexually inactive.

22. Likewise age and social group. Wood is struck by the willingness of the teenage audience to identify "against" itself, with the forces of the enemy of youth. "Watching it [*Texas Chain Saw Massacre I*] recently with a large, half-stoned youth audience, who cheered and applauded every one of Leatherface's outrages against their representatives on the screen, was a terrifying experience" ("Return of the Repressed," p. 32).

23. "I really appreciate the way audiences respond," Gail Anne Hurd, producer of *Aliens*, is reported to have said. "They buy it. We don't get people, even rednecks, leaving the theater saying 'That was stupid. No woman would do that.' You don't have to be a liberal ERA supporter to root for Ripley"; as reported in the *San Franciso Examiner Datebook*, 10 August 1986, p. 19. *Time* magazine (28 July 1986) suggests that Ripley's maternal impulses (she squares off against the worst aliens of all in her quest to save a little girl) give the audience "a much stronger rooting interest in Ripley, and that gives the picture resonances unusual in a popcorn epic." The drift has gained steam since then (and since the original writing of this essay).

24. Further: "When she [the mother] referred to the infant as a male, I just went along with it. Wonder how that child turned out—male, female, or something else entirely?" The birth is understood to be parthenogenetic, and the bisexual child, literally equipped with both sets of genitals, is figured as the reborn Christ.

25. Linda Williams, "When the Woman Looks," p. 90. Williams's emphasis on the phallic leads her to dismiss slasher killers as a "non-specific male killing force" and hence a degeneration in the tradition. "In these films the recognition and affinity between woman and monster of classic horror film gives way to pure identity: she *is* the monster, her mutilated body the only visible horror" (p. 96). This analysis does not do justice to the obvious bisexuality (or at least modified masculinity) of slasher killers, nor does it take into account the new strength of the female victim. The slasher film may not, in balance, be more subversive than traditional horror, but it is certainly not less so.

26. Sigmund Freud, "The 'Uncanny,'" p. 245.

27. John Carpenter interviewed by Todd McCarthy, "Trick or Treat."

28. See Williams, "When the Woman Looks" for a fuller speculation on castration as the link between woman and killer.

29. So traditional film and heterosexual pornography, in any case. Gay male pornography, however, films some male bodies in much the same way that heterosexual pornography films female bodies, and even mainstream cinema has begun to linger over male torsos and buns in ways that halt the narrative flow (such halting being, for Laura Mulvey, the hallmark of the fetishizing gaze). See Mulvey, "Visual Pleasure and Narrative Cinema," esp. pp. 11–14.

30. Tudor's *Monsters and Mad Scientists* charts and speculates on the reasons for the increasing centrality of victimization in horror cinema.

31. See chapter 3 ("Getting Even") [of *Men, Women, and Chain Saws*] for a comparison of the visual treatment of the (male) rape in *Deliverance* with the (female) rapes in such films as Hitchcock's *Frenzy*, Wes Craven's *Last House on the Left*, and Ingmar Bergman's *The Virgin Spring*.

32. Steven Marcus, *The Other Victorians*, pp. 260–61.

33. Ibid., pp. 125–27.

34. It could be argued that *The Burning*, a summer-camp slasher movie in which the function of Final Girl is filled not by a female character but by a nerdish male one (who finally finds it in himself to stop cringing and running and fight back, with the result that it is he, not the "normal" boys, who brings the monster down), reveals the essential maleness of the story (and hence supports a reading of the Final Girl as boy in drag). The question remains why the function is so frequently and conspicuously played by a female.

35. As quoted by Spoto, *The Dark Side of Genius*, p. 431.

36. This would seem to be the point of the final sequence of Brian De Palma's *Blow-Out*, in which we see the boyfriend of the victim-hero stab the killer to death but later hear the television announce that the woman herself vanquished the killer. The frame plot of the film has to do with the making of a slasher film ("Co-Ed Frenzy"), and it seems clear that De Palma means his ending to stand as a comment on the Final Girl formula of the genre. De Palma's (and indirectly Hitchcock's) insistence that only men can kill men, or protect women from men, deserves a separate essay.

37. Mulvey, "Visual Pleasure and Narrative Cinema," p. 12.

38. Of the "woman's film" (in particular *The Two Mrs. Carrolls*), Mary Ann Doane has written: "The woman's exercise of an active investigating gaze can only be simultaneous with her own victimization. The place of her specularization is transformed into the locus of a process of seeing designed to unveil an aggression against itself" (*The Desire to Desire*, p. 136). It must be this expectation of punishment that the slasher plays with and then upends.

39. In fact, as Modleski has shown (*The Women Who Knew Too Much*), Hitchcock's relation to women is an ambivalent one. No one has attempted such an analysis of De Palma.

40. Kaja Silverman, "Masochism and Subjectivity," p. 5. Needless to say, this is not the explanation for the girl-hero offered by the industry. *Time* magazine on *Aliens*: "As Director Cameron says, the endless 'remulching' of the masculine hero by the 'male-dominated industry' is, if nothing else, commercially shortsighted. 'They choose to ignore that 50% of the audience is female. And I've been told that it has been proved demographically that 80% of the time it's women who decide which film to see' " (28 July 1986). It is of course not Cameron who established the female hero of the series but Ridley Scott (in *Alien*), and it is fair to assume, from his careful manipulation of the formula, that Scott got her from the slasher film, where she has flourished for some time with audiences that are heavily male. (Nor is Cameron's claim that even mainstream audiences are 50% female borne out by any audience study I know of.) Cameron's analysis is thus both self-serving and beside the point.

41. Dika proposes a political-allegorical reading of the Final Girl: "Female (a rarity in the American genre film) and 'castrated,' she is a symbol for an enfeebled United States, but one that, when roused, is still strong" (*Games of Terror*, p. 138).

42. If this analysis is correct, we may expect horror films of the future to feature Final Boys as well as Final Girls (Pauls as well as Paulines). Two figures may be incipient examples: Jesse, the pretty boy in *A Nightmare on Elm Street II*, and Ashley, the character who dies last in *The Evil Dead* (1983). Neither quite plays the role, but their names, and in the case of Jesse the characterization, seem to play on the traditions.

43. Wood, "Return of the Repressed," p. 28. For the opposite view, based on classic horror in both literary and cinematic manifestations, see Franco Moretti, "The Dialectic of Fear."

44. Vale and Juno, *Incredibly Strange Films*, p. 5.

45. Tania Modleski, "The Terror of Pleasure," pp. 155–66.

46. The upward trickle has become something of a flood since this essay was first published in 1987.

## WORKS CITED

Bovenschen, Silvia. "Is There a Feminine Aesthetic?" *New German Critique* 10 (1977): 444–69.

Brighton, Lew. "Saturn in Retrograde; or, The Texas Jump Cut." *The Film Journal* 7 (1975): 24–27.

Dickstein, Morris. "The Aesthetics of Fright." In *Planks of Reason*, edited by Barry Keith Grant. Metuchen, N.J.: Scarecrow Press, 1984.

Dika, Vera. *Games of Terror: Halloween, Friday the 13th, and the Films of the Stalker Cycle.* Rutherford, N.J.: Fairleigh Dickinson University Press, 1990.

———. "Misrecognition and Identity." *Ciné-Tracts* 11 (1980): 25–32.

Erens, Patricia. "The Stepfather." *Film Quarterly* 41 (1987–1988): 48–54.

Freud, Sigmund. "The 'Uncanny'" (1919). *The Standard Edition of the Complete Psychological Works of Sigmund Freud.* Translated by James Strachey. London: Hogarth Press, 1986. 17: 219–52.

Greenberg, Harvey. *The Movies on Your Mind.* New York: Dutton, 1975.

Kaminsky, Stuart M. *American Film Genres: Approaches to a Critical Theory of Popular Film.* New York: Dell 1977.

Kaplan, E. Ann. *Women and Film: Both Sides of the Camera.* London: Methuen, 1983.

Koch, Stephen. "Fashions in Pornography: Murder as Cinematic Chic." *Harper's,* November 1967.

McCarthy, Todd. "Trick or Treat." *Film Comment* 16 (1980): 17–24.

McCarty, John. *Splatter Movies.* New York: St. Martin's, 1981.

Marcus, Stephen. *The Other Victorians: A Study of Sexuality and Pornography in Mid-Nineteenth-Century England.* New York: Basic Books, 1964.

Modleski, Tania. *The Women Who Knew Too Much: Hitchcock and Feminist Theory.* New York: Methuen, 1988.

———. "The Terror of Pleasure: The Contemporary Horror Film and Postmodern Theory." In *Studies in Entertainment: Critical Approaches to Mass Culture.* Bloomington: Indiana University Press, 1986.

Moretti, Franco. "The Dialectic of Fear." *New Left Review* 136 (1982): 67–85.

Mulvey, Laura. "Visual Pleasure and Narrative Cinema." *Screen* 16 (1985): 6–18.

Nash, Mark. "*Vampyr* and the Fantastic." *Screen* 17 (1976): 29–67.

Poe, Edgar Allan. "The Philosophy of Composition." In *Great Short Works of Edgar Allan Poe,* edited by G. R. Thompson. New York: Literary Classics of the Univted States, 1970.

Rothman, William. *Hitchcock: the Murderous Gaze.* Cambridge: Harvard University Press, 1984.

Schoell, William. *Stay Out of the Shower: Twenty-five Years of Shocker Films Beginning with Psycho.* New York: Dembner, 1985.

Silverman, Kaja. "Masochism and Subjectivity." *Framwork* 12 (1980): 2–9.

Spoto, Donald. *The Dark Side of Genius: The Life of Alfred Hitchcock.* New York: Ballantine, 1983.

Tudor, Andrew. *Monsters and Mad Scientists: A Cultural History of the Horror Movie.* Oxford: Blackwell, 1989.

Vale, V., and Andrea Juno, eds. *Incredibly Strange Films. Re/Search* 10 (1988).

Williams, Linda. "When the Woman Looks." In *Re-Vision: Essays in Feminist Film Criticism,* edited by Mary Ann Doane, Patricia Mellencamp, and Linda Williams. Frederick, Md.: University Publications of America, 1984.

Wood, Robin. "Beauty Bests the Beast." *American Film* 8 (1983): 63–65.

———. "Return of the Repressed." *Film Comment* 14 (1978): 25–32.

# PART 6
# NARRATIVE: TELLING STORIES

*Our play is made up of separate stories, laid in different periods of history, each with its own set of characters. Each story shows how hatred and intolerance, through all the ages, have battled against love and charity. Therefore, you will find our play turning from one of the four stories to another, as the common theme unfolds in each.*

Opening text from D. W. Griffith's *Intolerance* (1916)

In spite, or because, of its place in early film history, D. W. Griffith's *Intolerance* (1916) identifies many of the prominent traditions that play a part in the formation of film narrative. Coming one year after his famous (and infamous) *The Birth of a Nation* (1915), Griffith's second ambitious and epic film recalls the dramatic expansions in narrative form that *The Birth of a Nation* helped to define as the classical narrative system, while obliquely addressing the justified outrage and "intolerance" that greeted the racism of that earlier film. United loosely through the theme of intolerance and entwined by crosscutting among them, the four narrative tales include the destruction of Babylon, the crucifixion of Christ, the sixteenth-century St. Bartholomew's Day massacre, and a modern tale of social injustice threatening a wrongly accused man. These separate narratives daringly

layer and intersect across the ages and, in extending the normal bounds of narrative cinema, remind us of the many creative possibilities beyond that classical system.

In the opening prologue, *Intolerance* overlaps two traditional narrative forms when it describes itself as a theatrical "play" and then introduces the first of its four stories with the image of a book that opens like a novel to start the film's narrative. Shortly after these first intertitles and images, *Intolerance* introduces a third literary antecedent, the emblematic figure of a woman "endlessly rocking" a cradle, which is an image taken from a Walt Whitman quotation. A play, a novel, and a poem thus become the three cornerstones of film's engagement with narrative literary forms and its attempt to remake them through the new powers of cinematic narrative even in this early stage of film history.

Film theory has consistently focused on narrative for numerous practical reasons, the foremost one being that narrative films have, since Griffith's day, been the primary practice in the artistic, commercial, and economic history of the cinema. Certainly experimental and documentary movies have represented important alternatives to narrative throughout film history, but narrative film immediately established itself as the most efficient way to produce a continuous supply of new films (from old and new stories) and draw in new and returning audiences. Not only do narrative plots and stories provide the underpinning for most films, but for much of the twentieth century, a so-called classical narrative structure also dominated the way films are constructed.

According to this classical narrative pattern, stories are organized into plots as a linear chronology that develops through a cause-and-effect logic, propelled forward by the actions and agency of one or more primary characters. Classical film narrative also tends to favor plots that move toward a clear sense of closure, since a clear ending emphasizes the unity of the narrative and provides the audience with pleasure and satisfaction. While much of film theory has been devoted to investigating the variations and implications of this classical narrative model (in terms of the worldviews it constructs), other theoretical inquiries have focused on alternatives to that model. *Intolerance* is such a fascinating and important example of film narrative because at a watershed moment in movie history it both acknowledges its relationship to classical stories and, in its four-part multiplication of those stories as a single narrative, tests the limits of classical narrative.

As Griffith's film indicates, much of narrative film practice and theory involves recognizing and distinguishing how film narratives have been adapted from literary narratives. Providing a useful foundation in narrative theory, TZVETAN TODOROV in his 1969 essay, "Structural Analysis of Narrative," aims to describe a "poetics" (recalling Aristotle's generic poetics, p. 446) that maps the structural formulas shared by a wide variety of narratives (including films). A structural study of the four stories that comprise *Intolerance*, for instance, would conceivably describe the parallel structures of calm, crisis, and resolution that they share. Complicating the notion of structural similarity among narratives, ROBERT STAM's "Beyond Fidelity" is a sophisticated contemporary investigation of age-old questions about adaptation in which he overturns conventional prejudices about literature's seniority to claim a more creative and crosscultural interaction between literary and cinematic narratives.

Throughout film history, classical narrative has been tested at numerous times and in numerous ways, most prominently by post–World War II new wave cinemas that often refashioned and undermined traditional narrative structures rather than simply

rejecting them in favor of more experimental organizations. In "The Art Cinema as a Mode of Film Practice," David Bordwell attempts a historical variation on Todorov's "narratology" by analyzing the distinguishing features of "art cinema" narratives, such as the wandering characters and dreamy logic found in the films of Michelangelo Antonioni and Ingmar Bergman. For Bordwell, these art films violate and detour around the classical narrative model through a particular narrative self-consciousness or personal expressivity (associated with the auteur/director of the film) that combines with elliptical plot developments and a presiding ambiguity of action that especially troubles their narrative closure.

Perhaps more profound and significant than discussions of art film narratives, pronounced challenges to the way we think about film narrative come from feminist and critical race studies. In "Desire in Narrative," Teresa de Lauretis explores and critiques the fundamental concept in classical narratives that the action is oriented around, and driven by, male perspective and agency, while female characters tend to be passive non-actors who function merely as the goal of the male quest for self-realization. For de Lauretis, engaging with and disrupting such narratives is crucial. Manthia Diawara confronts the tradition of Hollywood narrative in his essay "Black American Cinema: The New Realism." He takes Hollywood to task not only for its distorting representations of African American characters, but also for its failure to recognize the distinctive shapes of African American narratives. Spanning film history from D. W. Griffith to modern African American filmmakers like Julie Dash and Spike Lee, Diawara convincingly argues that unique narrative rhythms and compositions, such as circular rather than linear narrative patterns, can reflect the specific culture and history of black filmmakers.

Another productive challenge to theories of both classical and alternative film narratives arises from narrative investigations in television studies and new media theory. As Jane Feuer points out in "Narrative Form in American Network Television," both the way we watch stories and how stories are constructed on television differ considerably from our relationship with film narratives. Most notably, the concepts of linearity and narrative resolution are typically inadequate for descriptions of television serials and many other television genres. With the proliferation of narratives across computer screens and Internet sites, Henry Jenkins's "Searching for the Origami Unicorn" brings narrative theory into the age of new media. As part of his book on the "convergence" of new and old media technologies, Jenkins tracks the film *The Matrix* across its convoluted narrative structure as characters move in and out of different realities. He takes it a step further, mapping the movie's centrifugal spread across a range of other forms and venues, from Web sites to public performances in Tokyo, that demonstrate how far and wide narrative activity today spreads via an increasingly "participatory culture" constantly exchanging a "collective intelligence."

Narrative has long been a chief focus for film theory, extending from Griffith's dramatic experiments with narrative form in *Intolerance* through to contemporary fascination with how new technologies and media alter and complicate narrative forms. Film narratives describe moments in history, myths of nationhood, class struggles, tales of crime and punishment, religious beliefs, and the dynamics of gender roles. The needs that narrative fulfills and the fascination that it elicits have not waned since the movies began, and it is no wonder that film theory has so regularly pursued its structures, meanings, and changing cultural and historical significance.

# TZVETAN TODOROV

# Structural Analysis of Narrative

Bulgarian-born French philosopher Tzvetan Todorov (b. 1939) is a prominent and prolific literary and cultural theorist and historian. His translations helped introduce the work of the Russian Formalists to postwar French intellectual circles in the 1960s and 1970s; their linguistic theories, together with Claude Lévi-Strauss's *Structural Anthropology* (1958), helped shape the structuralist movement. Todorov's 1970 study of the fantastic in literature is one of the clearest examples of his investment and role in this movement, but over his long career, Todorov has employed many other approaches to a wide range of topics. He is the author of more than twenty books, many of them translated into English, including *The Poetics of Prose* (1971), *Conquest of America* (1984), and *Facing the Extreme: Moral Life in the Concentration Camps* (1991).

Building on the structural linguistics of Ferdinand de Saussure, structuralist critics studied the underlying laws of cultural phenomena like myth and narrative in a scientific fashion, breaking with older ways of viewing literature as the expression of creative individuals. The structural analysis of narrative, or narratology, proved eminently applicable to popular films, whose generic formulae show the basic elements of plot in strong relief. Todorov's contributions, alongside those of Roland Barthes (p. 345) and narratologist Vladimir Propp (who analyzed Russian folktales to isolate their recurring narrative mores and personae) influenced studies of the repetitive structures of film genres.

Lucid and polemical, "Structural Analysis of Narrative" makes the argument for a theoretical approach to literature through systematic attention to what individual works have in common. Todorov demonstrates with a sample analysis of the tales collected in Boccaccio's *Decameron* (1353), showing them to be variations on elemental plot rules. He breaks down narrative form into agents or characters and basic actions (such as "violation" or "punishment") which he compares to linguistic structures. He concludes that stories begin in a state of equilibrium that is disrupted and end when a new equilibrium is established. But just as the outrageous erotic details of the *Decameron* that Todorov recounts are not fully served by the tales' reduction to the quasi-algebraic formulae Todorov provides in this essay, so too are individual films greatly reduced when abstracted to common patterns. Subsequent work on film narrative addressed both underlying structure and textual detail.

## READING CUES & KEY CONCEPTS

■ How does Todorov define the structural approach to narrative, in contrast with other methods?

■ What is the relation between the abstract and the example in the method Todorov outlines?

■ Consider Todorov's definition of the minimal plot as the "shift from one equilibrium to another." Is this applicable to a film genre like the western?

■ **Key Concepts:** Structuralism; Specificity; Poetics; Narratology; Plot; Agent; Action

# Structural Analysis of Narrative

· · · · · · · · · · · · ·

The theme I propose to deal with is so vast that the few pages which follow will inevitably take the form of a resumé. My title, moreover, contains the word "structural," a word more misleading than enlightening today. To avoid misunderstandings as much as possible, I shall proceed in the following fashion. First, I shall give an abstract description of what I conceive to be the structural approach to literature. This approach will then be illustrated by a concrete problem, that of narrative, and more specifically, that of plot. The examples will all be taken from the *Decameron* of Boccaccio. Finally, I shall attempt to make several general conclusions about the nature of narrative and the principles of its analysis.

First of all, one can contrast two possible attitudes toward literature: a theoretical attitude and a descriptive attitude. The nature of structural analysis will be essentially theoretical and non-descriptive; in other words, the aim of such a study will never be the description of a concrete work. The work will be considered as the manifestation of an abstract structure, merely one of its possible realizations; an understanding of that structure will be the real goal of structural analysis. Thus, the term "structure" has, in this case, a logical rather than spatial significance.

Another opposition will enable us to focus more sharply on the critical position which concerns us. If we contrast the internal approach to a literary work with the external one, structural analysis would represent an internal approach. This opposition is well known to literary critics, and Wellek and Warren have used it as the basis for their *Theory of Literature*. It is necessary, however, to recall it here, because, in labeling all structural analysis "theoretical," I clearly come close to what is generally termed an "external" approach (in imprecise usage, "theoretical" and "external," on the one hand, and "descriptive" and "internal," on the other, are synonyms). For example, when Marxists or psychoanalysts deal with a work of literature, they are not interested in a knowledge of the work itself, but in the understanding of an abstract structure, social or psychic, which manifests itself through that work. This attitude is therefore both theoretical and external. On the other hand, a New Critic (imaginary) whose approach is obviously internal, will have no goal other than an understanding of the work itself; the result of his efforts will be a paraphrase of the work, which is supposed to reveal the meaning better than the work itself.

Structural analysis differs from both of these attitudes. Here we can be satisfied neither by a pure description of the work nor by its interpretation in terms that are psychological or sociological or, indeed, philosophical. In other words, structural analysis coincides (in its basic tenets) with theory, with poetics of literature. Its object is the literary discourse rather than works of literature, literature that is virtual rather than real. Such analysis seeks no longer to articulate a paraphrase, a rational resumé of the concrete work, but to propose a theory of the structure and operation of the literary discourse, to present a spectrum of literary possibilities, in such a manner that the existing works of literature appear as particular instances that have been realized.

It must immediately be added that, in practice, structural analysis will also refer to real works: the best stepping-stone toward theory is that of precise, empirical

knowledge. But such analysis will discover in each work what it has in common with others (study of genres, of periods, for example), or even with all other works (theory of literature); it would be unable to state the individual specificity of each work. In practice, it is always a question of going continually back and forth, from abstract literary properties to individual works and vice versa. Poetics and description are in fact two complementary activities.

On the other hand, to affirm the internal nature of this approach does not mean a denial of the relation between literature and other homogeneous series, such as philosophy or social life. It is rather a question of establishing a hierarchy: literature must be understood in its specificity, as literature, before we seek to determine its relation with anything else.

It is easily seen that such a conception of literary analysis owes much to the modern notion of science. It can be said that structural analysis of literature is a kind of propaedeutic for a future science of literature. This term "science," used with regard to literature, usually raises a multitude of protests. It will therefore perhaps be fitting to try to answer some of those protests right now.

Let us first of all reread that page from Henry James's famous essay on "The Art of Fiction," which already contains several criticisms: "Nothing, for instance, is more possible than that he [the novelist] be of a turn of mind for which this odd, literal opposition of description and dialogue, incident and description, has little meaning and light. People often talk of these things as if they had a kind of internecine distinctness, instead of melting into each other at every breath, and being intimately associated parts of one general effort of expression. I cannot imagine composition existing in a series of blocks, nor conceive, in any novel worth discussing at all, of a passage of description that is not in its intention narrative, a passage of dialogue that is not in its intention descriptive, a touch of truth of any sort that does not partake of the nature of incident, or an incident that derives its interest from any other source than the general and only source of the success of a work of art— that of being illustrative. A novel is a living thing, all one and continuous, like any other organism, and in proportion as it lives will it be found, I think, that in each of the parts there is something of each of the other parts. The critic who over the close texture of a finished work shall pretend to trace a geography of items will mark some frontiers as artificial, I fear, as any that have been known to history."

In this excerpt, the critic who uses such terms as "description," "narration," "dialogue," is accused by Henry James of committing two sins. First, there will never be found, in a real text, a pure dialogue, a pure description, and so on. Secondly, the very use of these terms is unnecessary, even harmful, since the novel is "a living thing, all one and continuous."

The first objection loses all its weight as soon as we put ourselves in the perspective of structural analysis; although it does aim at an understanding of concepts like "description" or "action," there is no need to find them in a pure state. It seems rather natural that abstract concepts cannot be analyzed directly, at the level of empirical reality. In physics, for example, we speak of a property such as temperature although we are unable to isolate it by itself and are forced to observe it in bodies possessing many other qualities also, like resistance and volume. Temperature is a theoretical concept, and it does not need to exist in a pure state; such is also true for description.

The second objection is still more curious. Let us consider the already dubious comparison between a work and a living thing. We all know that any part of our body will contain blood, nerves, muscles—all at the same time; we nonetheless do not require the biologist to abandon these misleading abstractions, designated by the words: blood, nerves, muscles. The fact that we find them together does not prevent us from distinguishing them. If the first argument of James had a positive aspect (it indicated that our objective should be composed of abstract categories and not concrete works), the second represents an absolute refusal to recognize the existence of abstract categories, of whatever is not visible.

There is another very popular argument against the introduction of scientific principles in literary analysis. We are told in this instance that science must be objective, whereas the interpretation of literature is always subjective. In my opinion this crude opposition is untenable. The critic's work can have varying degrees of subjectivity; everything depends on the perspective he has chosen. This degree will be much lower if he tries to ascertain the properties of the work rather than seeking its significance for a given period or milieu. The degree of subjectivity will vary, moreover, when he is examining different strata of the same work. There will be very few discussions concerning the metrical or phonic scheme of a poem; slightly more concerning the nature of its images; still more with regard to the more complex semantic patterns.

On the other hand there is no social science (or science whatsoever) which is totally free of subjectivity. The very choice of one group of theoretical concepts instead of another presupposes a subjective decision; but if we do not make this choice, we achieve nothing at all. The economist, the anthropologist, and the linguist must be subjective also; the only difference is that they are aware of it and they try to limit this subjectivity, to make allowance for it within the theory. One can hardly attempt to repudiate the subjectivity of the social sciences at a time when even the natural sciences are affected by it.

It is now time to stop these theoretical speculations and to give an example of the structural approach to literature. This example will serve as illustration rather than proof: the theories which I have just exposed will not be necessarily contested if there are some imperfections in the concrete analysis based on them.

The abstract literary concept I would like to discuss is that of plot. Of course, that does not mean that literature, for me, is reduced to plot alone. I do think, however, that plot is a notion that critics undervalue and, hence, often disregard. The ordinary reader, however, reads a book above all as the narration of a plot; but this naive reader is uninterested in theoretical problems. My aim is to suggest a certain number of useful categories for examining and describing plots. These categories can thus implement the meager vocabulary at our command with regard to the analysis of narrative; it consists of such terms as action, character, recognition.

The literary examples that I shall use are taken from the *Decameron* of Boccaccio. I do not intend, however, to give an analysis of the *Decameron*: these stories will be used only to display an abstract literary structure, that is, plot. I shall begin by stating the plots of several of the tales.

A monk introduces a young girl into his cell and makes love to her. The abbot detects this misbehavior and plans to punish him severely. But the monk learns of the abbot's discovery and lays a trap for him by leaving his cell. The abbot goes in and succumbs to the charms of the girl, while the monk tries his turn at watching.

At the end when the abbot intends to punish him, the monk points out that he has just committed the same sin. Result: the monk is not punished (I,4).

Isabetta, a young nun, is with her lover in her cell. Upon discovering this, the other nuns become jealous and go to wake up the abbess and have Isabetta punished. But the abbess was in bed with an abbot; because she has to come out quickly, she puts the under-shorts of the abbot on her head instead of her coif. Isabetta is led into the church; as the abbess begins to lecture her, Isabetta notices the garment on her head. She brings this evidence to everyone's attention and thus escapes punishment (IX,2).

Peronnella receives her lover while her husband, a poor mason, is absent. But one day he comes home early. Peronnella hides the lover in a cask; when the husband comes in, she tells him that somebody wanted to buy the cask and that this somebody is now in the process of examining it. The husband believes her and is delighted with the sale. The lover pays and leaves with the cask (VII,2).

A married woman meets her lover every night in the family's country house, where she is usually alone. But one night the husband returns from town; the lover has not come yet; he arrives a little later and knocks at the door. The wife asserts that this is a ghost who comes to annoy her every night and must be exorcised. The husband pronounces the formula which the wife has improvised; the lover figures out the situation and leaves, pleased with the ingenuity of his mistress (VII,1).

It is easy to recognize that these four plots (and there are many others like them in the *Decameron*) have something in common. In order to express that, I shall use a schematic formulation which retains only the common elements of these plots. The sign → will indicate a relation of entailment between two actions.

X violates a law → Y must punish X → X tries to avoid being punished →

$$\rightarrow \begin{cases} \text{Y violates a law} \\ \\ \text{Y believes that X is not violating the law} \end{cases} \rightarrow \text{Y does not punish X}$$

This schematic representation requires several explanations.

1. We first notice that the minimal schema of the plot can be shown naturally by a clause. Between the categories of language and those of narrative there is a profound analogy which must be explored.

2. Analysis of this narrative clause leads us to discover the existence of two entities which correspond to the "parts of speech." a) The agents, designated here by X and Y, correspond to proper nouns. They serve as subject or object of the clause; moreover, they permit identification of their reference without its being described. b) The predicate, which is always a verb here: violate, punish, avoid. The verbs have a semantic characteristic in common: they denote an action which modifies the preceding situation. c) An analysis of other stories would have shown us a third part of narrative speech, which corresponds to quality and does not alter the situation in which it appears: the adjective. Thus in I,8: at the beginning of the action Ermino is stingy, whereas Guillaume is generous. Guillaume finds a way to ridicule Ermino's stinginess, and since then Ermino is "the most generous and pleasant of gentlemen." The qualities of the two characters are examples of adjectives.

3. Actions (violate, punish) can have a positive or a negative form; thus, we shall also need the category of status, negation being one possible status.

4. The category of modality is also relevant here. When we say "X must punish Y," we denote thereby an action which has not yet taken place (in the imaginary universe of the story) but which is nonetheless present in a virtual state. André Jolles suggested that entire genres could be characterized by their mood; legends would be the genre of the imperative, to the extent that they offer us an example to follow; the fairy tale is, as is often said, the genre of the optative, of the fulfilled wish.

5. When we write "Y believes that X is not violating the law," we have an example of a verb ("believe") which differs from the others. It is not a question of a different action here but of a different perception of the same action. We could therefore speak of a kind of "point of view" which refers not only to the relation between reader and narrator, but also to the characters.

6. There are also relations between the clauses; in our example this is always a causal relation; but a more extensive study would distinguish at least between entailment and presupposition (for example, the relation introducing modal punishment). Analysis of other stories shows that there are also purely temporal relations (succession) and purely spatial ones (parallelism).

7. An organized succession of clauses forms a new syntagmatic pattern, sequence. Sequence is perceived by the reader as a finished story; it is the minimal narrative in a completed form. This impression of completion is caused by a modified repetition of the initial clause; the first and the last clause will be identical but they will either have a different mood or status, for instance, or they will be seen from different points of view. In our example it is punishment which is repeated: first changed in modality, then denied. In a sequence of temporal relations, repetition can be total.

8. We might also ask: is there a way back? How does one get from the abstract, schematic representation to the individual tale? Here, there are three answers:

   a) The same kind of organization can be studied at a more concrete level: each clause of our sequence could be rewritten as an entire sequence itself. We would not thereby change the nature of the analysis, but rather the level of generality.

   b) It is also possible to study the concrete actions that incorporate our abstract pattern. For instance, we may point out the different laws that become violated in the stories of the *Decameron* or the different punishments that are meted out. That would be a thematic study.

   c) Finally, we can examine the verbal medium which composes our abstract patterns. The same action can be expressed by means of dialogue or description, figurative or literal discourse; moreover, each action can be seen from a different point of view. Here we are dealing with a rhetorical study.

These three directions correspond to the three major categories of narrative analysis: study of narrative syntax, study of theme, study of rhetoric.

At this point we may ask: what is the purpose of all this? Has this analysis taught us anything about the stories in question? But that would be a bad question. Our goal is not a knowledge of the *Decameron* (although such analysis will also serve that purpose), but rather an understanding of literature or, in this specific instance, of plot. The categories of plot mentioned here will permit a more extensive and precise description of other plots. The object of our study must be narrative mood, or point of view, or sequence, and not this or that story in and for itself.

From such categories we can move forward and inquire about the possibility of a typology of plots. For the moment it is difficult to offer a valid hypothesis; therefore I must be content to summarize the results of my research on the *Decameron*.

The minimal complete plot can be seen as the shift from one equilibrium to another. This term "equilibrium," which I am borrowing from genetic psychology, means the existence of a stable but not static relation between the members of a society; it is a social law, a rule of the game, a particular system of exchange. The two moments of equilibrium, similar and different, are separated by a period of imbalance, which is composed of a process of degeneration and a process of improvement.

All of the stories of the *Decameron* can be entered into this very broad schema. From that point, however, we can make a distinction between two kinds of stories. The first can be labeled "avoided punishment"; the four stories I mentioned at the beginning are examples of it. Here we follow a complete cycle: we begin with a state of equilibrium which is broken by a violation of the law. Punishment would have restored the initial balance; the fact that punishment is avoided establishes a new equilibrium.

The other type of story is illustrated by the tale about Ermino (I,8), which we may label "conversion." This story begins in the middle of a complete cycle, with a state of imbalance created by a flaw in one of the characters. The story is basically the description of an improvement process—until the flaw is no longer there.

The categories which help us to describe these types tell us much about the universe of a book. With Boccaccio, the two equilibriums symbolize (for the most part) culture and nature, the social and the individual; the story usually consists in illustrating the superiority of the second term over the first.

We could also seek even greater generalizations. It is possible to contrast a specific plot typology with a game typology and to see them as two variants of a common structure. So little has been done in this direction that we do not even know what kinds of questions to ask.[1]

I would like to return now to the beginning argument and to look at the initial question again: what is the object of structural analysis of literature (or, if you wish, of poetics)? At first glance, it is literature or, as Jakobson would have said, literariness. But let us look more closely. In our discussion of literary phenomena, we have had to introduce a certain number of notions and to create an image of literature; this image constitutes the constant preoccupation of all research on poetics. "Science is concerned not with things but with the system of signs it can substitute for things," wrote Ortega y Gasset. The virtualities which make up the object of poetics (as of all other sciences), these abstract qualities of literature exist only in the discourse of poetics itself. From this perspective, literature becomes only a mediator, a language, which poetics uses for dealing with itself.

We must not, however, conclude that literature is secondary for poetics or that it is not, in a certain sense, the object of poetics. Science is characterized precisely

by this ambiguity concerning its object, an ambiguity that need not be resolved, but rather used as the basis for analysis. Poetics, like literature, consists of an uninterrupted movement back and forth between the two poles: the first is auto-reference, preoccupation with itself; the second is what we usually call its object.

There is a practical conclusion to be drawn from these speculations. In poetics as elsewhere, discussions of methodology are not a minor area of the larger field, a kind of accidental by-product: they are rather its very center, its principal goal. As Freud said, "The important thing in a scientific work is not the nature of the facts with which it is concerned, but the rigor, the exactness of the method which is prior to the establishment of these facts, and the research of a synthesis as large as possible."

[TRANSLATED BY ARNOLD WEINSTEIN]

## NOTES

1. A few bibliographical suggestions: I deal more at length with the same problems in the chapter "Poétique" of the collective work *Qu'est-ce que le structuralisme?* (Paris, Editions du Seuil, 1968); and in my book *Grammaire du Décaméron*, to be published by Mouton, The Hague. Several studies using a similar perspective have been published in the periodical *Communications* (Paris, Editions du Seuil), Nos. 4, 8, 11 (articles of Barthes, Bremond, Genette, *etc.*).

# ROBERT STAM

· · · · · · · · · · · · · · · · · · · · · · · · · · · · · · · · · · · · · · · · · · · · · · · · · · · · · · · · · · · · · · · · · · · · · · · · · · · · · · · · · · · · · · · · · · · · · · · · · · · · · · · · · · · · · · · · · · · · · · · · · · · · · ·

# Beyond Fidelity: The Dialogics of Adaptation

Currently Professor of Cinema Studies at New York University, Robert Stam (b. 1941) is perhaps best known for his work on the relationship between literature and film. With a keen interest in French, Brazilian, and other postwar national cinemas, and in contemporary cultural theory, particularly postcolonialism and multiculturalism, he has also been a prominent voice in debates about the politics of transnational representation. His work in film studies includes many books, among them *Literature through Film: Realism, Magic, and the Art of Adaptation* (2005), *Literature and Film: A Guide to the Theory and Practice of Adaptation* (2005), and the prize-winning *Unthinking Eurocentrism: Multiculturalism and the Media* (with Ella Shohat, 1994, see p. 800).

Stam's writing appears in a contemporary climate that has embraced many of the broader perspectives suggested by cultural studies and poststructuralism. Specifically, film studies has increasingly taken into consideration questions about cultural differences as well as the dialogic interaction of many practices such as painting, literature, new technologies, and politics. One of the more significant results stemming from this expanded view of film studies is a renewed look at the complexities of film adaptations and how the movement between literary and film narratives (a staple of film history since 1895) identifies numerous critical issues about what's distinctive about film practices and what they share with other practices. Not surprisingly perhaps, these more theoretical shifts in how adaptation and film narratives interact parallel many of the recent narrative experiments

in contemporary films. From Spike Jonze's twisting meditation on adaptations, fidelity, and narratives in *Adaptation* (2002) to Alejandro González Iñárritu's interlocking and over-lapping of different stories in *Amores Perros* (2000), contemporary film narratives have reminded viewers of the richness of storytelling and how culturally inflected film narratives invariably are.

In its call for a fresh and more objective look at film adaptation, "Beyond Fidelity" (2000) implicitly recognizes the continuing centrality and inventiveness of literary adaptations, while representing many of the new debates that have continued to shape adaptation studies. Stam points out that literature has traditionally enjoyed a privileged place because its history precedes film and also because movie narratives are typically associated with popular culture rather than high culture. Consequently, discussions about film adaptations of novels and literary narratives have commonly taken on a moralistic tone, as indicated by the debate about whether or not a film narrative has been "faithful" to a novel.

Arguing carefully against such traditional prejudices, Stam offers a rich theoretical reworking of how different narrative "texts" can interact and relate to one another beyond the restrictions of fidelity. In short, he posits that literature and film each tell their stories according to their own textual possibilities and limitations, and the transmutations that occur between them should not be framed as failings, but rather as triumphs. To some extent, Stam's essay has both stimulated and responded to a new wave of critical interest in adaptation studies and how it impacts narrative theory, film reception, and gender studies. Stam's concerns with the textual and cultural dialogues of narrative open out to the larger cultural interactions and exchanges described by scholars such as John Berger (p. 114), Stuart Hall (p. 77), and Hamid Naficy (p. 977).

## READING CUES & KEY CONCEPTS

▪ Consider Stam's argument against fidelity in discussions of adaptation. How does he complicate and question its premises?

▪ How does Stam use Gerard Genette's five types of transtextuality to fortify his argument? Identify an example of each of the five types of transtextuality in film history.

▪ What is the distinction that Stam makes in his essay between "transformation" and "transmutation"?

▪ **Key Concepts:** Dialogics; Fidelity; Iconophobia; Logophilia; Medium Specificity; Transtextuality; Intertextuality; Transmutation; Focalization

# Beyond Fidelity: The Dialogics of Adaptation

The language of criticism dealing with the film adaptation of novels has often been profoundly moralistic, awash in terms such as *infidelity, betrayal, deformation, violation, vulgarization,* and *desecration,* each accusation carrying its

specific charge of outraged negativity. *Infidelity* resonates with overtones of Victorian prudishness; *betrayal* evokes ethical perfidy; *deformation* implies aesthetic disgust; *violation* calls to mind sexual violence; *vulgarization* conjures up class degradation; and *desecration* intimates a kind of religious sacrilege toward the "sacred word." In this chapter I would like to move beyond a moralistic approach to propose specific strategies for the analysis of adaptations. Rather than develop a full-blown narratological theory of novel and film, my agenda is modest and practical. But first I need to deal with the issue of "fidelity."

## *The Chimera of Fidelity*

Let me begin by acknowledging that the notion of the fidelity of an adaptation to its source novel does contain its grain of truth. When we say an adaptation has been "unfaithful" to the original, the term gives expression to the disappointment we feel when a film adaptation fails to capture what we see as the fundamental narrative, thematic, and aesthetic features of its literary source. The notion of fidelity gains its persuasive force from our sense that some adaptations are indeed better than others and that some adaptations fail to "realize" or substantiate that which we most appreciated in the source novels. Words such as *infidelity* and *betrayal* in this sense translate our feeling, when we have loved a book, that an adaptation has not been worthy of that love. We read a novel through our introjected desires, hopes, and utopias, and as we read we fashion our own imaginary mise-en-scène of the novel on the private stages of our minds. When we are confronted with someone else's phantasy, as Christian Metz pointed out long ago, we feel the loss of our own phantasmatic relation to the novel, with the result that the adaptation itself becomes a kind of "bad object."[1] To paraphrase the Georges Perec lines borrowed by Godard in *Masculin Féminin*, "We left the theatre sad. It was not the adaptation of which we had dreamed. . . . It wasn't the film we would have liked to make. Or, more secretly, that we would have liked to live."[2]

But the partial persuasiveness of "fidelity" should not lead us to endorse it as an exclusive methodological principle. The notion of fidelity is highly problematic for a number of reasons. First, it is questionable whether strict fidelity is even possible. A counter-view would insist that an adaptation is automatically different and original due to the change of medium. Here we can take as our own Fritz Lang's response (in *Contempt*) to the producer Prokosch's accusation of infidelity to the script: "Yes, Jerry, in the script it's written, in a film it's images and sounds . . . a motion picture it's called." The words of a novel, as countless commentators have pointed out, have a virtual, symbolic meaning; we as readers, or as directors, have to fill in their paradigmatic indeterminances. A novelist's portrayal of a character as "beautiful" induces us to imagine the person's features in our minds. Flaubert never even tells us the exact color of Emma Bovary's eyes, but we color them nonetheless. A film, by contrast, must choose a specific performer. Instead of a virtual, verbally constructed Madame Bovary open to our imaginative reconstruction, we are faced with a specific actress, encumbered with nationality and accent, a Jennifer Jones or an Isabelle Huppert.

This "automatic difference" between film and novel becomes evident even in fairly straightforward adaptations of specific novelistic passages. Take, for example,

the passage from Steinbeck's *The Grapes of Wrath* in which Ma Joad contemplates her memorabilia just before leaving her Oklahoma home for California:

> She sat down and opened the box. Inside were letters, clippings, photographs, a pair of earrings, a little gold signet ring, and a watch chain braided of hair and tipped with gold swivels. She touched the letters with her fingers, touched them lightly, and she smoothed a newspaper clipping on which there was an account of Tom's trial. (*The Grapes of Wrath*, London: Penguin, 1976, p. 118)

In this case a realist director (John Ford) adapted a realist novel just a few months after the novel's publication, attempting a "faithful" rendition of the specific passage. In the film we see Ma Joad sit down, open the box, and look at letters, clippings, photographs, and so forth. But even here the "cinematization" generates an inevitable supplement. Where Steinbeck wrote "photographs," Ford had to choose specific photographs. The mention of "earrings" in the novel does not dictate Ford's choice of having Ma Joad try them on. The newspaper account of Tom's trial requires the choice of a specific newspaper, specific headlines, specific illustrations, and specific fonts, none of which is spelled out in the original. But beyond such details of mise-en-scène, the very processes of filming—the fact that the shots have to be composed, lit, and edited in a certain way—generates an automatic difference. Nothing in the novel prepares us for the idea that Ma Joad will look at the memorabilia by the light of a fire or that the fire's reflection will flicker over her face. Nothing dictates the point-of-view cutting that alternates close shots of Ma Joad's face with what she is looking at, the contemplative rhythm of shot and reverse shot, or the interplay of on-screen and off-screen space, all of which is arguably in the spirit of the novel but not literally in the written text. Nor does the Steinbeck passage mention music, yet the Ford version features a melancholy accordion version of a song ("Red River Valley"). And even if the text had mentioned "Red River Valley," that would still be quite different from our actually hearing it performed. And even if the passage had mentioned both the music and the firelight and the light's flickering over Ma Joad's face, that would still not be anything like our seeing her face (or Jane Darwell's) and hearing the music at the same time.

The shift from a single-track, uniquely verbal medium such as the novel, which "has only words to play with," to a multitrack medium such as film, which can play not only with words (written and spoken), but also with theatrical performance, music, sound effects, and moving photographic images, explains the unlikelihood—and I would suggest even the undesirability—of literal fidelity. Because novels do not usually feature soundtracks, for example, should the filmmaker deprive him or herself of music as an expressive resource?[3] But quite apart from this change in signifying materials, other contingencies also render fidelity in adaptation virtually impossible. The demand for fidelity ignores the actual processes of making films—for example, the differences in cost and in modes of production. A novel is usually produced by a single individual; the film is almost always a collaborative project, mobilizing at minimum a crew of four or five people and at maximum a cast and crew and support staff of hundreds. Although novels are relatively unaffected by questions of budget, films are deeply immersed in material and financial contingencies. Therefore, grand panoramic novels such as *War and Peace* might be difficult to film on a low budget, whereas interiorized novellas such as *Notes from Underground* seem more manageable. With a novel, questions of material infrastructure enter only at the point of

distribution, whereas in the cinema they enter at the phase of production of the text itself. Although a novel can be written on napkins in prison, a film assumes a complex material infrastructure—camera, film stock, laboratories—simply in order to exist. Although it costs almost nothing for a novelist to write "The Marquis left Versailles palace at 5:00 P.M. on a cold and wintry day in January 1763," the filmmaker requires substantial funding in order to stage a simulacral Paris (or to shoot on location), to dress the actors in period costume, and so forth.

The notion of "fidelity" is essentialist in relation to both media involved. First, it assumes that a novel "contains" an extractable "essence," a kind of "heart of the artichoke" hidden "underneath" the surface details of style. Hidden within *War and Peace*, it is assumed, there is an originary core, a kernel of meaning or nucleus of events that can be "delivered" by an adapation. But in fact there is no such transferable core: a single novelistic text comprises a series of verbal signals that can generate a plethora of possible readings, including even readings of the narrative itself. The literary text is not a closed, but an open structure (or, better, structuration, as the later Barthes would have it) to be reworked by a boundless context. The text feeds on and is fed into an infinitely permutating intertext, which is seen through ever-shifting grids of interpretation.

This process is further complicated by the passage of time and by change of place. The verbal signals are not always communicated in the same way in a changed context. References obvious to eighteenth-century readers of *Robinson Crusoe* are not necessarily obvious to twentieth-century readers. References clear to English readers of the novel are not necessarily clear to French readers. At the same time, certain features of Defoe's hero, such as his misogyny and latent homoeroticism, might be *more* visible to present-day than to eighteenth-century readers precisely because contemporary critical discourses have made feminist and homosexual readings available. The greater the lapse in time, the less reverence toward the source text and the more likely the reinterpretation through the values of the present. Thus Jack Gold's adaptation of *Robinson Crusoe, Man Friday,* "sees" the Defoe novel through the contemporary values of the counter-culture—spontaneity, sexual freedom, antiracism.

The question of fidelity ignores the wider question: Fidelity to what? Is the filmmaker to be faithful to the plot in its every detail? That might mean a thirty-hour version of *War and Peace.* Virtually all filmmakers condense the events of the novels being adapted, if only to conform to the norms of conventional theatrical release. Should one be faithful to the physical descriptions of characters? Perhaps so, but what if the actor who happens to fit the description of Nabokov's Humbert also happens to be a mediocre actor? Or is one to be faithful to the author's intentions? But what might they be, and how are they to be inferred? Authors often mask their intentions for personal or psychoanalytic reasons or for external or censorious ones. An author's expressed intentions are not necessarily relevant, since literary critics warn us away from the "intentional fallacy," urging us to "trust the tale not the teller." The author, Proust taught us, is not necessarily a purposeful, self-present individual, but rather "un autre moi." Authors are sometimes not even aware of their own deepest intentions. How, then, can filmmakers be faithful to them? And to what authorial instance is one to be faithful? To the biographical author? To the textual implied author? To the narrator? Or is the adapter-filmmaker to be true to the style of a work? To its narrative point of view? Or to its artistic devices?[4]

Much of the discussion of film adaptation quietly reinscribes the axiomatic superiority of literary art to film, an assumption derived from a number of super-imposed prejudices: *seniority*, the assumption that older arts are necessarily better arts; *iconophobia*, the culturally rooted prejudice (traceable to the Judaic-Muslim-Protestant prohibitions on "graven images" and to the Platonic and Neoplatonic depreciation of the world of phenomenal appearance) that visual arts are necessarily inferior to the verbal arts; and *logophilia*, the converse valorization, characteristic of the "religions of the book," of the "sacred word" of holy texts.

Structuralist and poststructuralist theoretical developments, meanwhile, indirectly undermine some of these prejudices in ways that have implications for our discussion of adaptation. The structuralist semiotics of the 1960s and 1970s treated all signifying practices as productive of "texts" worthy of the same close attention as literary texts. The Bakhtinian "translinguistic" conception of the author as the orchestrator of preexisting discourses, meanwhile, along with Foucault's downgrading of the author in favor of a pervasive anonymity of discourse, opened the way to a "discursive" and nonoriginary approach to all arts. With poststructuralism the figure of the author, rather like the Robin Williams character in *Deconstructing Harry*, loses focus and firmness. Derridean deconstruction, meanwhile, by dismantling the hierarchy of "original" and "copy," suggests that both are caught up in the infinite play of dissemination. A film adaptation seen as a "copy," by analogy, would not necessarily be inferior to the novel as the "original." And if authors are fissured, fragmented, multidiscursive, hardly "present" even to themselves, how can an adaptation communicate the "self-presence" of authorial intention? In the same vein, Roland Barthes's provocative leveling of the hierarchy between literary criticism and literature tends, by analogy, to rescue the film adaptation as a form of criticism or "reading" of the novel, one not necessarily subordinate to the source novel.

## From Essence to Specificity

A variation on the theme of fidelity suggests that an adaptation should be faithful not so much to the source text, but rather to the essence of the medium of expression. This "medium-specificity" approach assumes that every medium is inherently "good at" certain things and "bad at" others.[5] A cinematic essence is posited as favoring certain aesthetic possibilities and foreclosing others, as if a specific aesthetic were inscribed on the celluloid itself. Here is film critic Pauline Kael (in *Deeper into Movies*) on the subject of the "natural" propensities of the film medium:

> Movies are good at action; they're not good at reflective thought or conceptual thinking. They're good at immediate stimulus, but they're not a good means of involving people in the other arts or in learning about a subject. The film techniques themselves seem to stand in the way of the development of curiosity.

Kael seems to be saying that films cannot be intelligent or reflective—and this is from someone who claims to be a "fan" of the movies. Despite her self-proclaimed populism, Kael shares with certain literary elitists the assumption that the cinema inevitably lacks the depth and dignity of literature. But apart from her factitious hierarchizing of the arts, Kael makes suspect generalizations about the cinema. Are films good at portraying only action and not subjective states? What about surrealism and

expressionism, not to mention music and video or the work of Alfred Hitchcock? Should film not be "theatrical"? Should all the films inspired by Brecht in their dramaturgy or by Stanislavsky in their acting be dismissed as "uncinematic"? Notions of filmic and literary essence, in this sense, impose an oppressive straitjacket on an open-ended and "non-finalized" set of practices.

A more satisfying formulation would emphasize not ontological essence, but rather diacritical specificity. Each medium has its own specificity deriving from its respective materials of expression. The novel has a single material of expression, the written word, whereas the film has at least five tracks: moving photographic image, phonetic sound, music, noises, and written materials. In this sense, the cinema has not lesser, but rather greater resources for expression than the novel, and this is independent of what actual filmmakers have done with these resources. (I am arguing not superiority of talent, but only complexity of resources. Indeed, one could credit literary fictioners with doing a lot with little, whereas filmmakers could be censured for doing so little with so much.) In a suggestive passage, Nabokov's Humbert Humbert laments the prodding deliberateness of prose fiction, with its subordination to linear consecution, its congenital incapacity to seize the moment in its multifaceted simultaneity. Gleefully reporting his wife Charlotte's providential death by car crash, he deplores having to put "the impact of an instantaneous vision into a sequence of words." The "physical accumulation on the page," he complains, "impairs the actual flash, the sharp unity of impression" (*Lolita* [New York: Berkley Medallion, 1977], p. 91). By contrast, the same crash as staged by Kubrick's *Lolita* offers precisely this simultaneity of impression: we see the crash as we hear it, along with the commentative music that conveys a specific attitude toward the events presented. Yet I am in no way arguing the superiority of the Kubrick rendition. Nabokov, paradoxically, conveys more sense of discontinuity (for example, between the tragic theme of untimely death on the one hand and Humbert's flip, cynical, self-regarding style of presentation on the other) than does Kubrick, despite the discontinuous multiplicity of the film tracks.

Although Humbert Humbert lusts after the cinema's "fantastic simultaneousness," he might also envy its potential for nonsimultaneity, its capacity for mingling apparently contradictory times and temporalities. Each of the filmic tracks can potentially develop an autonomous temporality entering into complex relations with the other tracks. Film's multitrack nature makes it possible to stage contradiction between music and image—for example, Kubrick's underscoring of the opening shot of nuclear bombers, in *Dr. Strangelove*, with the instrumental version of "Try a Little Tenderness." A quoted piece of music, with its own rhythm and continuity, can "accompany" an image track characterized by a different rhythm and continuity. Thus the cinema offers possibilities of disunity and disjunction not immediately available to the novel. The possible contradictions between tracks become an aesthetic resource, opening the way to a multitemporal, polyrhythmic cinema.

The novelistic character also potentially undergoes a kind of fissure or fragmentation within the film adaptation. Although the novelistic character is a verbal-artifact, constructed quite literally out of words, the cinematic character is a uncanny amalgam of photogenie, body movement, acting style, and grain of voice, all amplified and molded by lighting, mise-en-scène, and music. And although novels have only character, film adaptations have both character (actantial function) and performer,

allowing for possibilities of interplay and contradiction denied a purely verbal medium. In the cinema a single actor can play many roles: Peter Sellers played three roles in *Dr. Strangelove*, Eddie Murphy five roles in *The Nutty Professor*. Conversely, multiple performers can play a single role: different actors portrayed the four incarnations of Christ in Rocha's *Age of the Earth*, and two actresses (Angela Molina and Carole Bouquet) played Conchita in Buñuel's adaptation of *The Woman and the Puppet* (*That Obscure Object of Desire*).

In the cinema the performer also brings along a kind of baggage, a thespian intertext formed by the totality of antecedent roles. Thus Lawrence Olivier brings with him the intertextual memory of his Shakespeare performances, just as Madonna brings the memory of the various personae of her music videos. By casting Jack Palance as the hated film producer Prokosch in *Contempt*, the auteurist Godard brilliantly exploited the sinister memory of Palance's previous roles as a barbarian (in *The Barbarians*, 1959), and as Atilla the Hun (in *Sign of the Pagans*, 1959). This producer, the casting seems to be telling us, is both a gangster and a barbarian, a suggestion confirmed by the brutish behavior of the character. The director can also have the performer play against the intertext, thus exploiting a realm of tension not available to the novel. To appreciate the force of this difference, we need only contemplate the consequences of other casting choices. What would have happened if Fritz Lang had played the Prokosch role in *Contempt* or if Marlon Brando—or Pee Wee Herman—had played Humbert Humbert in *Lolita*?

Along with character and performer, the cinema offers still another entity denied the novel: the dubber (postsynchroniser), allowing for further permutations of character and voice. In India playback singers, who dub the moving lips of the stars on the image track, become famous in their own right. This third instance enables filmmakers to make thematic points about characters. Thus Glauber Rocha, in his *Deus e Diabo na Terra do Sol* (*Black God, White Devil*, 1964), has actor Othos Bastos dub the voices of both the "black God" and the "white devil," thus insinuating a deeper subterranean unity linking these apparently antagonistic characters.

Both novel and film have consistently cannibalized other genres and media. The novel began by orchestrating a polyphonic diversity of materials—courtly fictions, travel literature, allegory, and jestbooks—into a new narrative form, repeatedly plundering or annexing neighboring arts, creating novel hybrids such as poetic novels, dramatic novels, cinematic novels, and journalistic novels. But the cinema carries this cannibalization to its paroxysm. As a rich, sensorially composite language characterized by what Metz calls "codic heterogeneity," the cinema becomes a receptacle open to all kinds of literary and pictorial symbolism, to all types of collective representation, to all ideologies, to all aesthetics, and to the infinite play of influences within cinema, within the other arts, and within culture generally.

The cinema is both a synesthetic and a synthetic art, synesthetic in its capacity to engage various senses (sight and hearing) and synthetic in its anthropophagic capacity to absorb and synthesize antecedent arts. A composite language by virtue of its diverse matters of expression—sequential photography, music, phonetic sound, and noise—the cinema "inherits" all the art forms associated with these matters of expression. Cinema has available to it the visuals of photography and painting, the movement of dance, the decor of architecture, and the performance of theater. Both the novel and the fiction film are summas by their very nature. Their essence

is to have no essence, to be open to all cultural forms. Cinema can literally include painting, poetry, and music, or it can metaphorically evoke them by imitating their procedures; it can show a Picasso painting or emulate cubist techniques or visual dislocation, cite a Bach cantata, or create montage equivalents of fugue and counterpoint. Godard's *Passion* not only includes music (Ravel, Mozart, Ferre, Beethoven, and Fauré), but is conceived musically, and not only includes animated tableaux based on celebrated paintings (Rembrandt's *Night Watch*, Goya's *The Third of May*, and Delacroix's *Turkish Bathers*), but also expresses a painterly concern with light and color. The famous definitions of cinema in terms of other arts—"painting in motion" (Canudo), "sculpture in motion" (Vachel Lindsay), "music of light" (Abel Gance), and "architecture in movement" (Elie Fauré)—merely call attention to the synthetic multiplicity of signifiers available to the cinema.

## *Translations and Transformations*

If "fidelity" is an inadequate trope, we must then ask, What tropes might be more appropriate? One trope, I would suggest, is "translation." The trope of adaptation as translation suggests a principled effort of intersemiotic transposition, with the inevitable losses and gains typical of any translation.[6] The trope of translation undergirds the textual mechanisms of Godard's *Le Mepris* (*Contempt*, 1963), itself an adaptation of the Moravia novel *Il Disprezzo*, a novel whose partial subject is the issue of the adaptation of Homer's *The Odyssey* for film. The film deals with various kinds of translations, literal and figurative. The translation is literal both in its implicit reference to the translation of *The Odyssey* from classical Greek into contemporary European vernaculars and in its literal inclusion of a translator (not present in the novel)—the interpreter Francesca (Georgia Moll)—who mediates linguistically between the monolingual American producer Prokosch and his more polyglot European interlocutors. (When Italian laws concerning obligatory postsynchronization led Italian dubbers to eliminate the role of Francesca, Godard disassociated himself from the Italian version of the film.) Francesca's hurried translations of Fritz Lang's poetic quotations prove that, in art as in language, "traduire, c'est trahir." Her translations invariably miss a nuance, smooth over an aggression, or exclude an ambiguity. But the film also concerns less literal translations: the generic "translation" of Homer's epic poetry into contemporary novelistic prose and the intersemiotic "translation" of Moravia's novel into Godard's photographic images and sounds. In this sense, *Contempt* can be seen as a meditation on the richly ambiguous nature of all translation and adaptation. At the same time, the film suggests, art renews itself through creative mistranslation.

In fact, adaptation theory has available a whole constellation of tropes—translation, reading, dialogization, cannibalization, transmutation, transfiguration, and signifying—each of which sheds light on a different dimension of adaptation. For example, the trope of adaptation as a "reading" of the source novel—a reading that is inevitably partial, personal, and conjectural—suggests that just as any text can generate an infinity of readings, so any novel can generate any number of adaptations. Why should we assume that one director—for example, John Huston—has said everything that needs to be said about *Moby-Dick*? (If one has nothing new to say about a novel, Orson Welles once suggested, why adapt it at all?) A single novel can thus generate any number of critical readings and creative misreadings. Indeed,

many novels have been adapted repeatedly. *Madame Bovary* has been adapted at least nine times, in countries as diverse as France, Portugal, the United States, India, and Argentina. Each adaptation sheds a new cultural light on the novel; the Hindi version, entitled *Maya* (Illusion) not only envisions Bovary through the grid of Hindu philosophy ("the veil of illusion"), but also links Emma's romanticism, quite logically, to the conventions of the Bombay musical.

[ · · · ]

## Adaptation as Intertextual Dialogism

Adaptations, then, can take an activist stance toward their source novels, inserting them into a much broader intertextual dialogism. An adaptation, in this sense, is less an attempted resuscitation of an originary word than a turn in an ongoing dialogical process. The concept of intertextual dialogism suggests that every text forms an intersection of textual surfaces. All texts are tissues of anonymous formulae, variations on those formulae, conscious and unconscious quotations, and conflations and inversions of other texts. In the broadest sense, intertextual dialogism refers to the infinite and open-ended possibilities generated by all the discursive practices of a culture, the entire matrix of communicative utterances within which the artistic text is situated, which reach the text not only through recognizable influences, but also through a subtle process of dissemination.

Intertextuality, then, helps us transcend the aporias of "fidelity." But intertextuality can be conceived in a shallow or a deep manner. Bakhtin spoke of the "deep generating series" of literature—that is, the complex and multidimensional dialogism, rooted in social life and history, comprising both primary (oral) and secondary (literary) genres—which engendered literature as a cultural phenomenon. Bakhtin attacked the limitation of the literary scholar-critic's interest exclusively in the "literary series," arguing for a more diffuse dissemination of ideas as interanimating all the "series," literary and nonliterary, as they are generated by what he called the "powerful deep currents of culture." Literature, and by extension the cinema, must be understood within what Bakhtin called the "differentiated unity of the epoch's entire culture" (Bakhtin, "Response to a Question from *Novy Mir*," in *Speech Genres and Other Late Essays* [ed. Carl Emerson and Michael Holquist, Austin: University of Texas Press, 1986], p. 3).

Building on Bakhtin and Julia Kristeva, in *Palimpsests* (1982) Gérard Genette offers other analytic concepts useful for our discussion of adaptation. Genette proposed a more inclusive term, *transtextuality*, to refer to "all that which puts one text in relation, whether manifest or secret, with other texts." Genette posited five types of transtextual relations, some of which bear relevance to adaptation. He defined the first type, "intertextuality" as the "effective co-presence of two texts" in the form of quotation, plagiarism, and allusion. Adaptation, in this sense, participates in a double intertextuality, one literary and the other cinematic.

"Paratextuality," Genette's second type of transtextuality, refers to the relation, within the totality of a literary work, between the text proper and its "paratext"—titles, prefaces, postfaces, epigraphs, dedications, illustrations, and even book jackets and signed autographs—in short, all the accessory messages and commentaries that come to surround the text and at times become virtually indistinguishable

from it. In the case of film, the paratext might include widely quoted prefatory remarks by a director at a film's first screening, reported remarks by a director about a film, or widely reported information about the budget of a film.

"Metatextuality," Genette's third type of transtextuality, consists of the critical relation between one text and another, whether the commented text is explicitly cited or only silently evoked. In this sense, *The Other Francisco* can be seen as a metatextual critique of the Suárez y Romero novel. "Architextuality," Genette's fourth category, refers to the generic taxonomies suggested or refused by the titles or infratitles of a text. Architextuality has to do with an artist's willingness or reluctance to character-ize a text generically in its title. Because most adaptations of novels simply carry over the title of the original, if only to take advantage of a preexisting market, this term would seem irrelevant to our discussion. Yet in some cases a changed title signals the transformations operative in the adaptation. Giral's title *The Other Francisco* alerts us to Giral's radical transfiguration of the politics and aesthetics of the source novel. The title *Clueless* disguises the Jane Austen source (*Emma*) while signaling the film's milieu: rich, upper-middle-class adolescents. The title of *Man Friday*, an adaptation of *The Adventures of Robinson Crusoe*, signals a change in voice and perspective from those of the colonizer Crusoe to those of the colonized Friday, now no longer the "boy" of colonialist discourse, but a "man."

"Hypertextuality," Genette's fifth type of transtextuality, is perhaps the most suggestive of Genette's categories. It refers to the relation between one text, which Genette calls "hypertext," to an anterior text, or "hypotext," which the former trans-forms, modifies, elaborates, or extends. In literature the hypotexts of *The Aeneid* include *The Odyssey* and *The Iliad*, whereas the hypotexts of Joyce's *Ulysses* include *The Odyssey* and *Hamlet*. Both *The Aeneid* and *Ulysses* are hypertextual elaborations of a single hypotext, *The Odyssey*. Filmic adaptations, in this sense, are hypertexts derived from preexisting hypotexts that have been transformed by operations of selection, amplifi-cation, concretization, and actualization. The diverse filmic adaptations of *Madame Bovary* (by Renoir and Minnelli) or of *La Femme et le Pantin* (by Duvivier, von Stern-berg, and Buñuel) can be seen as variant hypertextual "readings" triggered by the same hypotext. Indeed, the diverse prior adaptations can form a larger, cumulative hypotext that is available to the filmmaker who comes relatively "late" in the series.

Film adaptations, then, are caught up in the ongoing whirl of intertextual ref-erence and transformation, of texts generating other texts in an endless process of recycling, transformation, and transmutation, with no clear point of origin. Let us take as an example *The Adventures of Robinson Crusoe*, one of the seminal source novels of a specific European tradition, the realistic mimetic novel supposedly based on "real life" and written in such a way as to generate a strong impression of factual reality. Yet this "realistic" novel is itself rooted in various intertexts: the Bible, the literature of religious meditation, the journalistic texts about Crusoe's prototype, Alexander Selkirk, and sensationalist travel literature, to mention just a few. Defoe's 1719 novel, rooted in this complex and variegated intertext, also generated its own textual "afterlife" or "post-text." In France the exemplars of this post-text were called Robinsonades. Already in 1805, less than a century after the publication of the Defoe novel, a German encyclopedia (*Bibliothek der Robinsone*) offered a comprehensive guide to all the works inspired by *Robinson Crusoe*. Nor did this novelistic post-text end in the nineteenth century, as both Michel Tournier's *Vendredi, ou l'Ile de la*

*Pacifique* and Derek Walcott's *Pantomime*, in both of which *Crusoe* is reread through an anticolonialist grid, clearly attest.

The *Crusoe* post-text also has ramifications in the world of film, where a long pageant of adaptations has rung in changes on the themes of the original. *Miss Crusoe* (1919) performs a variation in gender, which is interesting because the novel, against the grain of the "desert island" genre, scarcely mentions women at all. *Little Robinson Crusoe* (1924), carrying out the logic of *Crusoe*-as-children's-book, changes the age of the protagonist, with Jackie Coogan coming to the island on wings to be worshiped by the naive natives. *Mr. Robinson Crusoe* (1932) keeps Crusoe but supplies him with a feminine companion, perhaps inevitably called not Friday, but Saturday. *Swiss Family Robinson* (1940) permutates the number and social status of the characters, changing the solitary Crusoe to an entire family. The Laurel and Hardy film *Robinson Crusoeland* (1950) performs a shift in genre, from colonial adventure story to slapstick comedy. Similarly, *Robinson Crusoe on Mars* (1964) turns the novel into science fiction: the "pioneer" on earth becomes a pioneer in space. In *Lieutenant Robinson Crusoe* (1965) there are transformations both professional and zoological, as Defoe's protagonist becomes the sailor played by Dick van Dyke, and Crusoe's parrot is replaced by a chimpanzee.

[ · · · ]

## *The Grammar of Transformation*

To sum up what has been argued thus far, one way to look at adaptation is to see it as a matter of a source novel hypotext's being transformed by a complex series of operations: selection, amplification, concretization, actualization, critique, extrapolation, analogization, popularization, and reculturalization. The source novel, in this sense, can be seen as a situated utterance produced in one medium and in one historical context, then transformed into another equally situated utterance that is produced in a different context and in a different medium. The source text forms a dense informational network, a series of verbal cues that the adapting film text can then take up, amplify, ignore, subvert, or transform. The film adaptation of a novel performs these transformations according to the protocols of a distinct medium, absorbing and altering the genres and intertexts available through the grids of ambient discourses and ideologies, and as mediated by a series of filters: studio style, ideological fashion, political constraints, auteurist predilections, charismatic stars, economic advantage or disadvantage, and evolving technology. The film hypertext, in this sense, is transformational almost in the Chomskian sense of a "generative grammar" of adaptation, with the difference that these cross-media operations are infinitely more unpredictable and multifarious than they would be were it a matter of "natural language."

Central to the transformational grammar of adaptation are permutations in locale, time, and language. The Renoir and the Chabrol adaptations of *Madame Bovary* feature continuity between the language and locale of the source novel and the language and locale of the film adaptations. The Minnelli adaptation, by contrast, features discontinuity; studio lots "stand in" for France, and the actors speak English, with occasional use of French words and intermittent use of French accents. The filmmaker adapting a novel written in another country and in another language is

confronted with a series of options: Should the director find performers from the country in question? Should he have actors from the "home" country speak with an accent? Or should the adapter "Americanize" the source novel? The bored provincial protagonist of Woody Allen's *Purple Rose of Cairo* (played by Mia Farrow), deluded by artistic fictions, can on some levels be seen as an American Bovary. The director must also confront questions of temporality and epoch. Is the film adaptation a costume drama that respects the historical time frame of the original, or does it "update" the novel? The history of the theater features innumerable updatings of Shakespeare, for example, yet the practice is less common in film. Of the recent spate of Jane Austen films, only *Clueless* updated the original, but without referencing the novel explicitly.

**[ · · · ]**

The question of intertext also brings up the question of parody. Although some adaptations, such as the Richardson and Osborne *Tom Jones*, pick up on the parodic cues of their source novels, others ignore them. Both the Chabrol and the Renoir adaptations of *Madame Bovary*, for example, do surprisingly little with a recurrent feature of the source novel, its rendering of Emma's interior consciousness, in *le style indirect libre*, through parodic exaggerations of the stylistic vices of such writers as Chateaubriand and Sir Walter Scott. Minnelli emphasizes Emma's early reading of romantic novels, but has James Mason's voiceover condemn her "illusions" and "dreams" in a univocal fashion that has little to do with Gustave ("Madame-Bovary-c'est-moi") Flaubert's "complicitous critique" of his heroine. Kubrick's version of *Lolita*, similarly, does almost nothing with the densely parodic prose of the Nabokov source novel or, for that matter, with all the self-flauntingly cinematic and self-referential ideas proposed in Nabokov's screenplay, partly as a function of Kubrick's instrumental view (at the time) of prose style as what the artist uses to fascinate the beholder and thus to convey feelings and thoughts.[7]

## *Transmutations of Plot and Character*

Much of the literature on adaptation has concentrated on specifically textual operations having to do with plot events and characters. Often we find a kind of condensation of characters. The many Okie families of *The Grapes of Wrath* are foreshortened into the Joads of the John Ford version. The bevy of female lovers of Jules and Jim in the Henri Pierre Roche novel are condensed into Catherine (Jeanne Moreau) in the Truffaut adaptation. Film adaptations have a kind of "Sophie's choice" about which characters in the novel will live or die. But although adaptations tend to sacrifice "extra" characters from novels, occasionally the opposite process takes place, as in the case of *El Otro Francisco*. The Minnelli version of *Madame Bovary* adds the character of Flaubert himself, who is being tried for obscenity in the courts of France. Godard adds the character of the translator Francesca in *Contempt*, precisely in order to highlight the polyglot ambiance of international coproductions in the 1960s, as well as to make a more metaphorical point about adaptation as a process of translation.

Characters can also be subtly changed. The white judge in Thomas Wolfe's *Bonfire of the Vanities* became the black judge played by Morgan Freeman in the Brian de Palma adaptation, presumably as a way of sidestepping and warding off the accusations of racism leveled against the novel. Film adaptations often ignore key passages in the

source books. None of the *Madame Bovary* adapters, to my knowledge, chose to stage the opening passage in which a group of pupils "nous étions a l'étude, quand le Proviseur entra, suivi d'un nouveau. . . ." And most of the adaptations downplay Charles's first wife in order to concentrate on the relationship between Emma and Charles.

Film adaptations usually make temporal changes as well. Therefore, two months in the Alberto Moravia source novel become just two days in the Godard adaptation (*Contempt*), part of a Brechtian "theatricalization" of the source novel. On the other hand, events in the source novel can be amplified, as when, in the case of *Tom Jones*, a few sentences regarding Squire Western's love of hunting became in the film the pretext for a spectacular fox hunt staged in an attempt to make the film more "cinematic" but also in order to strengthen the satire of the landed gentry. Film adaptations can also add events—for example, in the form of Peter Sellers's inspired improvisations in the Kubrick *Lolita*. These additions can have any number of motivations: to take advantage of a brilliant actor, to suggest contemporary relevance, or to "correct" the novel for aesthetic reasons. In the case of Godard's *Masculin Féminin*, supposedly an adaptation of a Guy de Maupassant story, very little was retained from the source novel. Godard kept only a few of the characters' names and almost nothing else, to the point that those who sold the rights concluded that those rights had not even been used.

There is also the complex question of point of view. Does the film adaptation maintain the point of view and the focalization (Genette) of the novel? Who tells the story in the novel vis-à-vis the film? Who focalizes the story—that is, who sees within the story? Genette distinguishes between the instance that tells (the narrator), the instance that sees and experiences (the character), and the instance that knows (the filter). In Godard's *Contempt* there is a clear shift in point of view or, to change the metaphor, to a change in voice, a "transvocalization." Although the novel is narrated as a reminiscence in the first person by screenwriter Ricardo Molteni (Paul in the film), the film is neither narrated in the first person, nor is it a reminiscence, nor is it told from any particular point of view except that, perhaps, of the cinema itself. What was therapeutic first-person rumination in the novel—"I decided to write these memoirs in hopes of finding [Camille] again"—becomes a kind of no-person point of view in the film. The unreliable narrator of the novel—we slowly realize that he is highly disturbed, paranoid, almost hallucinatory—gives way to the impersonal narration of the film, all as part of a drift toward a Brechtian depersonalization and depsychologizing. The emphasis shifts from one character's mind to the relations between five characters belonging to the same film milieu.

This is not the place to attempt to perform an ambitious extrapolation of Genette's categories concerning novelistic discourse to filmic discourse. Suffice it to say that such categories as "variable focalization" and "multiple focalization" are very suggestive for film analysis. The former evokes the tag-team approach to point of view that characterizes Hitchcock's films, moving between major characters such as Mitch and Melanie in *The Birds* but also moving to minor characters such as the boy who whistles at Melanie in the opening shots, the man who observes her from the dock at Bodega Bay, or even the birds who oversee her departure in the shot/reverse shot structure of the final sequence. "Multiple focalization" evokes not only the multiple perspectives of a film such as *Rashomon* or *Citizen Kane*, but also the multiple focalizations of a dispersed narrative such as that of Altman's *Nashville*.

Film adaptations of novels often change novelistic events for (perhaps uncon-scious) ideological reasons. In the case of the Minnelli *Madame Bovary*, Charles Bovary is made to refuse to operate on Hippolyte (whereas in the novel he bungles the operation), presumably out of respect for Hollywood pieties concerning the pater familias figure. Film adaptations of novels thus become entangled in questions of ideology. Does the film "push" the novel to the left or the right in terms of sexual, racial, and class politics? Spielberg's *The Color Purple* plays down the lesbianism of the Alice Walker novel. And by having Shug reconcile with her censorious preacher father, the adaptation "repatriarchalizes" a feminist novel. The John Ford version of *The Grapes of Wrath* shies away from the socialist drift of the Steinbeck novel. But the drift is not always rightward. *Man Friday* pushes *Robinson Crusoe* to the antiracist, anticolonialist, antireligious left. The narrative sequencing can also be rearranged, with clear ideological overtones. The circular structure of the Kubrick *Lolita* clearly draws attention away from Humbert Humbert's nympholepsy and toward the murderous rivalry between Humbert and Quilty in ways that lead one to suspect that this was a sop to the censors. In the John Ford *Grapes of Wrath*, as has often been pointed out, the sequencing of the three camps—the Hooverville, the New Deal "Wheatpatch," and the Keane Ranch—is altered so as to transform what was a spiraling descent into oppression into an ascent into New Deal benevolence and good order.[8]

Just as interesting as what in the source novel is eliminated or bypassed is why certain materials are ignored. The intercalary, essayistic chapters of *The Grapes of Wrath* were largely eliminated from the John Ford adaptation, presumably because they were seen as "uncinematic" but also because those chapters happen to be the places in which John Steinbeck's (then) socialist opinions were most in evidence. The philo-sophical meditations that dot Melville's *Moby-Dick* were largely ignored in the John Huston adaptation, again because of their "uncinematic" nature but also perhaps because film producers assumed that the mass audience would not be "up to" such lofty and allusive materials. The adaptations of reflexive novels such as *Tom Jones* or *Lolita*, in the same vein, tend to downplay the literary-critical excursuses that mark the source novels. Although reflexive in certain respects, the Osborne and Richardson *Tom Jones* does not try to recreate the film equivalents of Fielding's essays in literary criticism—for example, by proffering film criticism—presumably because tampering too much with the filmic illusion would spoil the "sport" of the fiction.

Here we enter the fraught area of comparative stylistics. To what extent are the source novel and the film adaptation innovative in aesthetic terms, and if they are innovative, are they innovative in the same way? *Madame Bovary* was extremely in-novative at its time for its decentered approach to narrative, its subversion of norms of character, its mobile approach to point of view, and its systemic frustration of the reader's expectations. To what extent do the various film versions provide an equiv-alent sense of such innovations? To what extent do they go beyond the novel to innovate in cinematic terms? The answers to these questions become crucial when we realize that *Madame Bovary*, although written prior to the advent of the cinema, can reasonably be called protocinematic. Eisenstein famously cited the "agricultural fair" chapter in the Flaubert novel as a brilliant precinematic example of montage. The concept of the "cinematic novel" has, admittedly, often been abused, bandied about so imprecisely as to mean anything from a book that has sharply imagined

physical action to a book that uses certain techniques reminiscent of film. Despite this danger, it is nonetheless fruitful, I think, to see a novel such as *Madame Bovary* as protocinematic. Flaubert was an author at a crucial transitional moment within the history of the novel, one distinct from both the sober documentary realism of Defoe and the playful reflexivity of a Cervantes or a Fielding. I am referring to the moment when a kind of mobilized regard crystallized the altered perceptions associated with modernity—an altered gaze associated both with impressionism in painting, where the artist is attentive to what intervenes between the object and the eye, and with modernism in the novel, where point of view and filters of consciousness become paramount organizing principles—instantiating a subjectification and a relativization of the stabilities of the classical realist model.

Flaubert's *Madame Bovary* might be called both proleptically modernist and protocinematic in a number of senses: in its film script–like notation of precise gestures (see, for example, the account of Charles Bovary's first arrival at Emma's family farm); in its artful modulation, à la Hitchcock, of point of view, whereby we experience flickering moments of identification not only with major characters such as Emma and Charles, but also with minor characters and even with unnamed characters who never again appear in the text; in its precise articulation, reminiscent of camera "setups," of character vantage points within voyeuristic structures (for example, the two gossips who observe Emma from their attic post or the "curieux" of the final pages who peeks at Charles from behind a bush); in its kinetic, destabilized portraiture of characters as a kind of flowing composition in time; in its verbal recreation of the "feel" of seeing, especially encumbered seeing (Emma's squinting, her intermittent loss of focus, her attempts to discern objects in the distance); in its "impressionist" attention to the vapors and gases jostling one another in the atmosphere, as well as to the dynamic agency of light in modifying appearances, as seen in the use of such light-active words as *blanchissaient, vernissait,* and *veloutant*; in the corporeal empathy with which it identifies the reader with the very body of the heroine (for example, the account of Emma's milky orgasm with Rodolphe); in the kinesthetic quality of Flaubert's prose, its manner of mobilizing the reader's gaze (for example, the accounts of the passing world as seen from the moving *hirondelle*); and in the ironic manipulation of "focal length"—for instance, in the abrupt move from the long view of the cab containing the fornicating Leon and Emma to the close view of "the torn-up note," followed by the extremely long view that turns Emma into a generic "femme" descending from a vehicle.

Compared with the novel, the film adaptations of *Madame Bovary* are much less innovative, and much more concerned with adapting the text to a mainstream audience. In other words, the phenomenon of "mainstreaming" is not limited to ideological issues; there also exists the phenomenon of aesthetic mainstreaming. Despite its surface modernity and its technological razzle-dazzle, dominant cinema has maintained, on the whole, a premodernist aesthetic corresponding to that of the nineteenth-century mimetic novel. In its dominant mode it became a receptacle for the mimetic aspirations abandoned by the most advanced practitioners of the other arts. Film inherited the illusionistic ideals that impressionism had relinquished in painting, that Jarry had attacked in the theater, and that Proust, Joyce, and Woolf had undermined in the novel. Aesthetic censorship, in this sense, might be in some ways more severe and deeply rooted than political self-censorship. Adaptation, in this

sense, seems to encounter the most difficulty with modernist novels such as Joyce's *Ulysses*, Nabokov's *Lolita*, or Duras's *L'Amant*. When Jean-Jacques Annaud turns Marguerite Duras's modernist, feminist novel *L'Amant* into a linear, masculinist, mainstream film, we are not entirely wrong to regret that the director has misrecognized the most salient traits of Durasian *écriture*. When a modernist, discontinuous novel is made relatively continuous through the dumb inertia of convention; when a filmic adaptation is thought to need a sympathetic male protagonist in order to be palatable for a mass audience (whence Minnelli's idealized Charles Bovary); when the hero cannot die or the villain must be punished; when a digressive, disruptive style must be linearized into a classical three-act structure with exposition, conflict, and climax; when morality must be reconfigured to suit preestablished Manichean schemas; when a difficult, reflexive novel must be made transparent and redundant; when the spectator must be led by the hand—in such cases, I would suggest, we find a kind of ideologically driven failure of nerve to deal with the aesthetic implications of novelistic modernism.

By adopting the approach to adaptation I have been suggesting, we in no way abandon our rights or responsibilities to make judgments about the value of specific film adaptations. We can—and, in my view, we should—continue to function as critics; but our statements about films based on novels or other sources need to be less moralistic, less panicked, less implicated in unacknowledged hierarchies, more rooted in contextual and intertextual history. Above all, we need to be less concerned with inchoate notions of "fidelity" and to give more attention to dialogical responses—to readings, critiques, interpretations, and rewritings of prior material. If we can do all these things, we will produce a criticism that not only takes into account, but also welcomes, the differences among the media.

## NOTES

1. See Christian Metz, *The Imaginary Signifier* (Bloomington: Indiana University Press, 1977), p. 12.

2. Georges Pérec, *Les Choses* (Paris: L. N. Julliard, 1965), p. 80 (translation mine).

3. One of the side effects of reading a novel after having seen its cinematic adaptation, for me at least, is that I tend to "hear" the music track as I read.

4. Julio Bressane, in his film adaptation of the Machado de Assis novel *Memorias Postumas de Bras Cubas*, professed a lack of interest in the novel's plot while rigorously attempting to find film equivalents of its devices. The literary device of the posthumous narrator, for example, is "translated" by a filmmaker's sound boom's banging up against a skeleton.

5. For a critique of medium-specificity arguments, see Noel Carroll, *Theorizing the Moving Image* (Cambridge: Cambridge University Press, 1996).

6. For a systematic, even technical, exploration of adaptation as translation, see Patrick Cattrysse, *Pour une Théorie de l'Adaptation Filmique: Le Film Noir Américain* (Paris: Peter Lang, 1995).

7. One regrets that the later, more reflexive, Kubrick of *Clockwork Orange* and *Dr. Strangelove* did not return to the Nabokov text and process it through a more stylistically self-conscious grid.

8. See Warren French, *Filmguide to* The Grapes of Wrath (Bloomington: Indiana University Press, 1973).

# DAVID BORDWELL

## The Art Cinema as a Mode of Film Practice

FROM *Poetics of Cinema*

Internationally renowned, and one of the most prolific and also most accessible film scholars in America, David Bordwell (b. 1947) has made major contributions in narrative theory, the history of film style, cognitive film theory, and the study of national cinemas. He received his doctoral degree in Speech and Communication Arts at the University of Iowa in 1974, and is Jacques Ledoux Professor of Film Studies, Emeritus, in the Department of Communication Arts at the University of Wisconsin-Madison. His numerous books, among them *The Classical Hollywood Cinema* (with Janet Staiger and Kristin Thompson, 1985), *Narration in the Fiction Film* (1985), and more recently, *The Way Hollywood Tells It: Story and Style in Modern Movies* (2006) and *Poetics of Cinema* (2007), have made a considerable imprint on film studies, inaugurating a neoformalist approach to the study of filmic texts and providing an alternative to classical film theory. He and his wife, Kristin Thompson, are widely respected for their authoritative film studies textbooks, and Bordwell also maintains a prominent blog on international film and film studies.

Bordwell is often considered the founder of cognitive film theory, a theory grounded in empirical research on perception and story comprehension to explain how we make sense of movies. Bordwell's "historical poetics of cinema" is a formal study of cinema that is clearly positioned as an alternative to the theories that dominated film studies in the 1970s and 1980s, which Bordwell and Noël Carroll dubbed "Grand Theory"—somewhat more acrimoniously known as "SLAB" (Saussurean semiotics, Lacanian psychoanalysis, Althusserian Marxism, Barthesian textual analysis). Avoiding what he sees as the generalizations of mainstream theory, Bordwell seeks to explain the formal principles behind how films are constructed and how particular effects are achieved. In addition, Bordwell explores the empirical circumstances that give rise to or change these principles.

One of his most widely anthologized articles, "The Art Cinema as a Mode of Film Practice" was originally published in *Film Criticism* in 1979, and then as an expanded version in *Narration and the Fiction Film* in 1985. Included here is the original version with Bordwell's 2007 afterword, as it appears in *Poetics of Cinema*, a book that brings together twenty-five years of his work. Bordwell applies the principles of thematics, narrative form, and stylistics to art cinema, discovering that its range of techniques and effects is different from the principles of classical narration. He argues that art cinema is a distinct branch of film practice, with historical significance and a specific set of formal conventions and viewing modes. Unlike classical cinema where narrative form motivates cinematic representation and a psychologically defined cause-effect structure is developed through goal-oriented characters, art cinema is based on a loosened and ambiguous cause-effect linkage of events, where characters lack clear desires and goals and the author is foregrounded as a formal component in the film's structure. For Bordwell, the art-cinema mode of narration is one of the most significant general modes of film practice

and one of the few alternatives to the historically dominant classical Hollywood narrative. He is careful to point out, however, that the lines between the two are not always clear, as these two modes continuously inform and influence each other.

In the afterword, Bordwell moves beyond the formal characteristics of the art-cinema mode of narration to address the significance of institutions that have played a key role in cultivating, sustaining, and institutionalizing art cinema. Film schools and the festival circuit (which is the world's alternative to Hollywood's distribution system), for example, made visible and established many national cinemas and movements (such as the Iranian New Wave, or Chinese and Japanese cinema) that share formal concerns with European art cinema.

## READING CUES & KEY CONCEPTS

■ One of the characteristics of art-cinema narration, according to Bordwell, is that it is "less concerned with action than reaction." What does he mean by this? Can you think of examples from classical Hollywood films that use a similar technique?

■ According to Bordwell, art cinema "defines itself as a realistic cinema," and he establishes realism as one of the main features that motivates the narrative. How is this realism in art cinema different from "verisimilitude" that motivates classical cinema narration?

■ While Bordwell charts a clear difference between classical and art-cinema modes of narration, he acknowledges that the two influence and learn from each other. Given these crossovers, especially in contemporary cinema, can we still draw clear lines between these two modes?

■ **Key Concepts:** Art Cinema; Ambiguity; Narration; Authorial Expressivity; Realism

# The Art Cinema as a Mode of Film Practice

. . . . . . . . . . . . . .

*L*a Strada (1954), 8 1/2 (1963), *Wild Strawberries* (1957), *The Seventh Seal* (1957), *Persona* (1966), *Ashes and Diamonds* (1958), *Jules et Jim* (1962), *Knife in the Water* (1962), *Vivre sa vie* (1962), *Muriel* (1963): Whatever else one can say about these films, cultural fiat gives them a role altogether different from *Rio Bravo* (1959) on the one hand and *Mothlight* (1963) on the other. They are "art films," and, ignoring the tang of snobbishness about the phrase, we can say that these and many other films constitute a distinct branch of the cinematic institution. My purpose in this essay is to argue that we can usefully consider the "art cinema" as a distinct mode of film practice, possessing a definite historical existence, a set of formal conventions, and implicit viewing procedures. Given the compass of this paper, I can only suggest some lines of work, but I hope to show that constructing the category of the art cinema is both feasible and illuminating.

It may seem perverse to propose that films produced in such variable cultural contexts might share fundamentally similar features. Yet I think there are good reasons for believing this, reasons which come from the films' place in history. In

the long run, the art cinema descends from the early *film d'art* and such silent national cinema schools as German Expressionism and Neue Sachlichkeit and French Impressionism.[1] (A thorough account of its sources would have to include literary modernism, from Proust and James to Faulkner and Camus.) More specifically, the art cinema as a distinct mode appears after World War II when the dominance of the Hollywood cinema was beginning to wane. In the United States, the courts' divorcement decrees created a shortage of films for exhibition. Production firms needed overseas markets and exhibitors needed to compete with television. In Europe, the end of the war reestablished international commerce and facilitated film export and coproductions. Thomas Guback has shown how, after 1954, films began to be made for international audiences.[2] American firms sponsored foreign production, and foreign films helped American exhibitors fill screen time. The later Neorealist films may be considered the first postwar instances of the international art cinema, and subsequent examples would include most works of the New Wave, Fellini, Resnais, Bergman, De Sica, Kurosawa, Pasolini, et al. While the art cinema is of little economic importance in the United States today, it evidently continues, as such international productions as *The Serpent's Egg* (1977) and *Stroszek* (1977) show.

Identifying a mode of production/consumption does not exhaustively characterize the art cinema, since the cinema also consists of formal traits and viewing conventions. To say this, however, is to invite the criticism that the creators of such film are too inherently different to be lumped together. Yet I shall try to show that whereas stylistic devices and thematic motifs may differ from director to director, the overall *functions* of style and theme remain remarkably constant in the art cinema as a whole. The narrative and stylistic principles of the films constitute a logically coherent mode of cinematic discourse.

## Realism, Authorship, Ambiguity

The classical narrative cinema—paradigmatically, studio feature filmmaking in Hollywood since 1920—rests upon particular assumptions about narrative structure, cinematic style, and spectatorial activity. While detailing those assumptions is a task far from complete,[3] we can say that in the classical cinema, narrative form motivates cinematic representation. Specifically, cause-effect logic and narrative parallelism generate a narrative which projects its action through psychologically defined, goal oriented characters. Narrative time and space are constructed to represent the cause-effect chain. To this end, cinematic representation has recourse to fixed figures of cutting (e.g., 180 continuity, crosscutting, "montage sequences"), mise-en-scène (e.g., three-point lighting, perspective sets), cinematography (e.g., a particular range of camera distances and lens lengths), and sound (e.g., modulation, voice-over narration). More important than these devices themselves are their functions in advancing the narrative. The viewer makes sense of the classical film through criteria of verisimilitude (is *x* plausible?), of generic appropriateness (is *x* characteristic of this sort of film?) and of compositional unity (does *x* advance the story?). Given this background set, we can start to mark off some salient features of the art cinema.

First, the art cinema defines itself explicitly against the classical narrative mode, and especially against the cause-effect linkage of events. These linkages become

looser, more tenuous in the art film. In *L'Avventura* (1960), Anna is lost and never found; in *À bout de souffle* (aka *Breathless*, 1960), the reasons for Patricia's betrayal of Michel remain unknown; in *Bicycle Thieves* (1948), the future of Antonio and his son is not revealed. It will not do, however, to characterize the art film solely by its loosening of causal relations. We must ask what motivates that loosening, what particular modes of unity follow from these motivations, what reading strategies the film demands, and what contradictions exist in this order of cinematic discourse.

The art cinema motivates its narratives by two principles; realism and authorial expressivity. On the one hand, the art cinema defines itself as a realistic cinema. It will show us real locations (Neorealism, the New Wave) and real problems (contemporary "alienation," "lack of communication," etc.). Part of this reality is sexual; the aesthetics and commerce of the art cinema often depend upon an eroticism that violates the production code of pre-1950 Hollywood. *A Stranger Knocks* (1959) and *And God Created Woman* (1956) are no more typical of this than, say, *Jules et Jim* and *Persona* (whereas one can see *Le Mépris*, 1963, as consciously working upon the very problem of erotic spectacle in the art cinema). Most important, the art cinema uses "realistic"—that is, psychologically complex—characters.

The art cinema is classical in its reliance upon psychological causation; characters and their effects on one another remain central. But whereas the characters of the classical narrative have clear-cut traits and objectives, the characters of the art cinema lack defined desires and goals. Characters may act for inconsistent reasons (Marcello in *La Dolce Vita*, 1960) or may question themselves about their goals (Borg in *Wild Strawberries* and the Knight in *The Seventh Seal*). Choices are vague or nonexistent. Hence a certain drifting episodic quality to the art film's narrative. Characters may wander out and never reappear; events may lead to nothing. The Hollywood protagonist speeds directly toward the target; lacking a goal, the art-film character slides passively from one situation to another.

The protagonist's itinerary is not completely random; it has a rough shape: a trip (*La Strada*; *Wild Strawberries*; *The Silence*, 1963), an idyll (*Jules et Jim*; *Elvira Madigan*, 1967; *Pierrot le fou*, 1965), a search (*L'Avventura*; *Blow-Up*, 1966; *High and Low*, 1963), even the making of a film (*8 1/2*; *Le Mépris*; *The Clowns*, 1971; *Fellini Roma*, 1972; *Day for Night*, 1973; *The Last Movie*, 1971). Especially apt for the broken teleology of the art film is the biography of the individual, in which events become pared down toward a picaresque successivity (*La Dolce Vita*; Ray's *Apu* trilogy, 1955–1959; *Alfie*, 1966). If the classical protagonist struggles, the drifting protagonist traces an itinerary, an encyclopedic survey of the film's world. Certain occupations (stockbroking in *L'Eclisse*, 1962; journalism in *La Dolce Vita* and *The Passenger*, 1975; prostitution in *Vivre sa vie* and *Nights of Cabiria*, 1957) favor a survey form of narrative. Thus the art film's thematic of *la condition humaine*, its attempt to pronounce judgments on "modern life" as a whole, proceeds from its formal needs: had the characters a goal, life would no longer seem so meaningless.

What is essential to any such organizational scheme is that it be sufficiently loose in its causation as to permit characters to express and explain their psychological states. Slow to act, these characters tell all. The art cinema is less concerned with action than reaction; it is a cinema of psychological effects in search of their causes. The dissection of feeling is often represented explicitly as therapy and cure (e.g., *Through a Glass Darkly*, *Persona*), but even when it is not, the forward

flow of causation is braked and characters pause to seek the aetiology of their feelings. Characters often tell one another stories: autobiographical events (especially from childhood), fantasies, and dreams. (A recurring line: "I had a strange dream last night.") The hero becomes a supersensitive individual, one of those people on whom nothing is lost. During the film's survey of its world, the hero often shudders on the edge of breakdown. There recurs the realization of the anguish of ordinary living, the discovery of unrelieved misery: compare the heroines of *Europa 51* (1952), *L'Avventura, Deserto rosso* (1964), and *Une femme mariée* (1964), In some circumstances the characters must attribute their feelings to social situations (as in *Ikiru* [1952], *I Live in Fear* [1955], and *Shame*). In *Europa 51*, a communist tells Irene that individuals are not at fault: "If you must blame something, blame our postwar society." Yet there is seldom analysis at the level of groups or institutions; in the art cinema, social forces become significant insofar as they impinge upon the psychologically sensitive individual.

A conception of realism also affects the film's spatial and temporal construction, but the art cinema's realism here encompasses a spectrum of possibilities. The options range from documenting factuality (e.g., *Il Posto*, 1961) to intense psychological subjectivity (*Hiroshima mon amour*, 1959). (When the two impulses meet in the same film, the familiar "illusion–reality" dichotomy of the art cinema results.) Thus room is left for two reading strategies. Violations of classical conceptions of time and space are justified as the intrusion of an unpredictable and contingent daily reality or as the subjective reality of complex characters. Plot manipulations of story order (especially flashbacks) remain anchored to character subjectivity as in *8 1/2* and *Hiroshima mon amour*. Manipulations of duration are justified realistically (e.g., the *temps morts* of early New Wave films) or psychologically (the jump cuts of *À bout de souffle* signaling a jittery lifestyle). By the same token, spatial representation will be motivated as documentary realism (e.g., location shooting, available light), as character revelation, or in extreme cases as character subjectivity. André Bazin may be considered the first major critic of the art cinema, not only because he praised a loose, accidental narrative structure that resembled life but also because he pin-pointed privileged stylistic devices for representing a realistic continuum of space and time (deep-focus, deep space, the moving camera, and the long take). In brief, a commitment to both objective and subjective verisimilitude distinguished the art cinema from the classical narrative mode.[4]

Yet at the same time, the art cinema foregrounds the *author* as a structure in the film's system. Not that the author is represented as a biographical individual (although some art films, e.g., Fellini's, Truffaut's, and Pasolini's, solicit confessional readings), but rather the author becomes a formal component, the overriding intelligence organizing the film for our comprehension. Over this hovers a notion that the art-film director has a creative freedom denied to her/his Hollywood counterpart.[5] Within this frame of reference, the author is the textual force "who" communicates (what is the film *saying*?) and "who" expresses (what is the artist's *personal vision*?). Lacking identifiable stars and familiar genres, the art cinema uses a concept of authorship to unify the text.

Several conventions operate here. The competent viewer watches the film expecting not order in the narrative but stylistic signatures in the narration: technical touches (Truffaut's freeze frames, Antonioni's pans) and obsessive motifs (Buñuel's

anticlericalism, Fellini's shows, Bergman's character names). The film also offers itself as a chapter in an *oeuvre*. This strategy becomes especially apparent in the convention of the multi-film work (the *Apu* trilogy, Bergman's two trilogies, Rohmer's "Moral Tales," and Truffaut's Doinel series). The initiated catch citations: references to previous films by the director or to works by others (e.g., the New Wave homages).

A small industry is devoted to informing viewers of such authorial marks. International film festivals, reviews and essays in the press, published scripts, film series, career retrospectives, and film education all introduce viewers to authorial codes. What is essential is that the art film be read as the work of an expressive individual. It is no accident, then, that the *politique des auteurs* arose in the wake of the art cinema, that *Cahiers du cinéma* admired Bergman and Antonioni as much as Hawks and Minnelli, that Robin Wood could esteem both Preminger and Satyajit Ray. As a critical enterprise, *auteur* analysis of the 1950s and 1960s consisted of applying art-cinema reading strategies to the classical Hollywood cinema.[6]

How does the author come forward in the film? Recent work in *Screen* has shown how narrational marks can betray the authorial code in the classical text, chiefly through gaps in motivation.[7] In the art-cinema text, the authorial code manifests itself as recurrent violations of the classical norm. Deviations from the classical canon—an unusual angle, a stressed bit of cutting, a prohibited camera movement, an unrealistic shift in lighting or setting—in short, any breakdown of the motivation of cinematic space and time by cause-effect logic—can be read as "authorial commentary." The credits for the film, as in *Persona* or *Blow-Up*, can announce the power of the author to control what we see. Across the entire film, we must recognize and engage with the shaping narrative intelligence. For example, in what Norman Holland calls the "puzzling film,"[8] the art cinema foregrounds the narrational act by posing enigmas. In the classic detective tale, however, the puzzle is one of *story*: who did it? How? Why? In the art cinema, the puzzle is one of *plot*: who is telling this story? How is this story being told? Why is this story being told this way? Another example of such marking of narration is the device of the flashforward—the plot's representation of a future story action. The flashforward is unthinkable in the classical narrative cinema, which seeks to retard the ending and efface the mode of narration. But in the art cinema, the flashforward functions perfectly to stress authorial presence: we must notice how the narrator teases us with knowledge that no character can have. Far from being isolated or idiosyncratic, such instances typify the tendency of the art film to throw its weight onto plot, not story; we play a game with the narrator.

Realism and authorial expressivity, then, will be the means whereby the art film unifies itself. Yet these means now seem contradictory. Verisimilitude, objective or subjective, is inconsistent with an intrusive author. The surest signs of authorial intelligibility—the flashforward, the doubled scene in *Persona*, the color filters at the start of *Le Mépris*—are the least capable of realistic justification. Contrariwise, to push the realism of psychological uncertainty to its limit is to invite a haphazard text in which the author's shaping hand would not be visible. In short, a realist aesthetic and an expressionist aesthetic are hard to merge.

The art cinema seeks to solve the problem in a sophisticated way: by the device of *ambiguity*. The art film is nonclassical in that it foregrounds deviations from the classical norm—there are certain gaps and problems. But these very deviations

are *placed*, resituated as realism (in life things happen this way) or authorial commentary (the ambiguity is symbolic). Thus the art film solicits a particular reading procedure: whenever confronted with a problem in causation, temporality, or spatiality, we first seek realistic motivation. (Is a character's mental state causing the uncertainty? Is life just leaving loose ends?) If we're thwarted, we next seek authorial motivation. (What is being "said" here? What significance justifies the violation of the norm?) Ideally, the film hesitates, suggesting character subjectivity, life's untidiness, and author's vision. Whatever is excessive in one category must belong to another. Uncertainties persist but are understood as such, as *obvious* uncertainties, so to speak. Put crudely, the slogan of art cinema might be "When in doubt, read for maximum ambiguity."

The drama of these tendencies can play across an entire film, as *Giulietta degli spiriti* and *Deserto rosso* illustrate. Fellini's film shows how the foregrounding of authorial narration can collapse before the attempt to represent character subjectivity. In the hallucinations of Giulietta, the film surrenders to expressionism. *Deserto rosso* keeps the elements in better balance. Putting aside the island fantasy, we can read any scene's color scheme in two registers simultaneously: as psychological verisimilitude (Giuliana sees her life as a desert) or as authorial commentary (Antonioni-as-narrator says that this industrial landscape is a desert).

If the organizational scheme of the art film creates the occasion for maximizing ambiguity, how to conclude the film? The solution is the open-ended narrative. Given the film's episodic structure and the minimization of character goals, the story will often lack a clear-cut resolution. Not only is Anna never found, but the ending of *L'Avventura* refuses to specify the fate of the couple. At the close of *Les 400 coups* (1959), the freeze frame becomes the very figure of narrative irresolution, as does the car halted before the two roads at the end of *Knife in the Water*. At its limit, the art cinema creates an *8 1/2* or a *Persona*, a film which, lacking a causally adequate ending, seems to conclude several distinct times. A banal remark of the 1960s, that such films make you leave the theater thinking, is not far from the mark: the ambiguity, the play of thematic interpretation, must not be halted at the film's close. Furthermore, the pensive ending acknowledges the author as a peculiarly humble intelligence; she or he knows that life is more complex than art can ever be, and the only way to respect this complexity is to leave causes dangling, questions unanswered. With the open and arbitrary ending, the art film reasserts that ambiguity is the dominant principle of intelligibility, that we are to watch less for the tale than the telling, that life lacks the neatness of art and this art knows it.

## The Art Cinema in History

The foregoing sketch of one mode of cinema needs more detailed examination, but in conclusion it may be enough to suggest some avenues for future work.

We cannot construct the art cinema in isolation from other cinematic practices. The art cinema has neighbors on each side, adjacent modes which define it. One such mode is the classical narrative cinema (historically, the dominant mode). There also exists a modernist cinema—that set of formal properties and viewing protocols that presents, above all, the radical split of narrative structure from cinematic style, so that the film constantly strains between the coherence of the fiction

and the perceptual disjunctions of cinematic representation. It is worth mentioning that the modernist cinema is not ambiguous in the sense that the art cinema is; perceptual play, not thematic ambivalence, is the chief viewing strategy. The modernist cinema seems to me manifested (under various circumstances) in films like *October* (1928), *La Passion de Jeanne d'Arc* (1928), *Lancelot du Lac* (1974), *Play Time* (1967), and *An Autumn Afternoon* (1963). The art cinema can then be located in relation to such adjacent modes.

We must examine the complex historical relation of the art cinema to the classical narrative cinema. The art film requires the classical background set because deviations from the norm must be registered as such to be placed as realism or authorial expression. Thus the art film acknowledges the classical cinema in many ways, ranging from Antonioni's use of the detective story to explicit citations in New Wave films. Conversely, the art cinema has had an impact on the classical cinema. Just as the Hollywood silent cinema borrowed avant-garde devices but assimilated them to narrative ends, so recent American filmmaking has appropriated art-film devices. Yet such devices are bent to causally motivated functions—the jump cut for violence or comedy, the sound bridge for continuity or shock effect, the elimination of the dissolve, and the freeze frame for finality. (Compare the narrative irresolution of the freeze frame in *Les 400 coups* with its powerful closure in *Butch Cassidy and the Sundance Kid*, 1969.) More interestingly, we have seen an art cinema emerge in Hollywood. The open endings of *2001* (1968) and *Five Easy Pieces* (1970) and the psychological ambiguity of *The Conversation* (1974), *Klute* (1971), and *Three Women* (1977) testify to the assimilation of the conventions of the art film. (Simplifying brusquely, we might consider *The Godfather I* [1972] as a classical narrative film and *The Godfather II* [1974] as more of an art film.) Yet if Hollywood is adopting traits of the art cinema, that process must be seen as not simple copying but complex transformation. In particular, American film genres intervene to warp art-cinema conventions in new directions (as the work of Altman and Coppola shows).[9]

It is also possible to see that certain classical filmmakers have had something of the art cinema about them. Sirk, Ford, and Lang all come to mind here, but the preeminent instance is Alfred Hitchcock. Hitchcock has created a textual persona that is in every way equal to that of the art-cinema's author; of all classical films, I would argue, Hitchcock's foreground the narrational process most strikingly. A film like *Psycho* demonstrates how the classical text, with its psychological causality, its protagonist/antagonist struggle, its detective story, and its continuous time and homogenous space, can under pressure exhibit the very negation of the classical system: psychology as inadequate explanation (the psychiatrist's account); character as only a position, an empty space (the protagonist is successively three characters, the antagonist is initially two, then two-as-one); and crucially stressed shifts in point-of-view which raise the art-film problem of narrational attitude. It may be that the attraction of Hitchcock's cinema for both mass audience and English literature professor lies in its successful merger of classical narrative and art-film narration.

Seen from the other side, the art cinema represents the domestication of modernist filmmaking. The art cinema softened modernism's attack on narrative causality by creating mediating structures—"reality," character subjectivity, authorial vision—that allowed a fresh coherence of meaning. Works of Rossellini, Eisenstein, Renoir, Dreyer, and Ozu have proven assimilable to art cinema in its turn, an important point

of departure. By the 1960s, the art cinema enabled certain filmmakers to define new possibilities. In *Gertrud* (1964), Dreyer created a perceptual surface so attenuated that all ambiguity drains away, leaving a narrative vacuum.[10] In *L'Année dernière à Marienbad* (1961), Resnais dissolved causality altogether and used the very conventions of art cinema to shatter the premise of character subjectivity. In *Nicht versöhnt* (1965), Straub and Huillet took the flashback structure and *temps morts* of the art cinema and orchestrated empty intervals into a system irreducible to character psychology or authorial commentary. Nagisha Oshima turned the fantasy-structures and the narrational marks of the New Wave to political-analytical ends in *The Ceremony* (1971) and *Death by Hanging* (1968). Most apparently, Godard, one of the figureheads of the 1960s art cinema, had by 1968 begun to question it. (*Deux ou trois choses que je sais d'elle* [1967] can be seen as a critique of *Deserto rosso*, or even of *Une femme mariée*.) Godard also reintroduced the issue of montage, a process which enabled *Tout va bien* (1972) and subsequent works to use Brechtian principles to analyze art-film assumptions about the unity of ideology. If, as some claim, a historical-materialist order of cinema is now appearing, the art cinema must be seen as its necessary background, and its adversary.

## *Afterword*

The preceding was published in 1979 and reprinted here without revision. Like many early statements in a research tradition, it has a peremptory tenor: This is this, that is that, no fine gradations allowed. To revise it would go beyond mere updating; I'd want to query its overconfident generalizations. Some of my claims (like the faith in an emerging "historical-materialist" cinema) and terms (like "the narrator") no longer convince me. Many of the generalizations still seem to me on the right track, but they would need much more nuancing and refinement, and the result would be very different, and much longer.

Actually, some of the refinements have snuck into other things I've written. Never expecting to reprint the piece, I cannibalized it twice. I used it to counterpoint a study of classical Hollywood narrative (*The Classical Hollywood Cinema*, pp. 370–377), and I expanded it in a discussion of modes of narration (*Narration in the Fiction Film*, pp. 205–233). These are more informative, but several readers have told me that they prefer the cleaner outlines of the original, and it has found its way into anthologies and course packets, so I bring it back one last time. As you might expect, though, I can't refrain from making a few new remarks, if only to flag some points that could be usefully rethought. Kristin Thompson and I have tried to offer a more systematic and comprehensive discussion of some of these issues in our survey text, *Film History: An Introduction*.[11]

Since I wrote the piece, some scholars have examined the art cinema as an institution in world film commerce. A great many fiscal mechanisms support production, distribution, and exhibition on the European scene.[12] The varied mix of funding sources (private capital, national subsidy, and European Union programs) has brought forth resourceful media players such as Marin Karmitz of Paris, who started by owning theater screens and has become both a producer and distributor of major films from Europe, Asia, and the Middle East. Somewhat surprisingly, American investment and distribution have also helped sustain art cinema, from

small companies supporting the 1950s efforts to current interest on the part of Sony and others in financing Asian projects.[13]

In any producing country, films assume many diverse shapes. There are always genre pictures, particularly melodramas and comedies showcasing popular local talent. (The farce featuring TV performers seems a cross-cultural constant.) Local output also usually includes a few prestige items, often adapted from national literary classics or based on memorable historical episodes. But Europe also promoted a conception of creativity that was rare elsewhere: the auteur film. The idea of a director expressing his (only rarely her) vision of life on film remains crucial to the art cinema. The head of New Danish Screen, a funding scheme from the nation's film institute, says, "We secure a place to develop a director's personal style without the pressure of commercial success criteria."[14] Yet personal style can have cultural and financial implications. The idea of authorship can accommodate policies that demand that local films reflect national culture (who was more French than François Truffaut, more Bavarian than Rainer Werner Fassbinder?), while also providing a marketable identity to films made with low budgets and relatively unknown stars. A sector of world film commerce still depends on the auteur premise. Acknowledging a powerful creator as the source of the film's formal and thematic complexity yields something marketable internationally, a brand name that can carry over from project to project. Pedro Almodóvar, Lars von Trier, Michael Haneke, Roman Polanski, and a few others are still guarantees of saleable cinema. Individualized branding is even more important as creators become international directors, as Lone Sherfig moves from Denmark to Scotland to make *Wilbur Wants to Kill Himself* (2002) or the German Tom Tykwer allies with Miramax to make *Heaven* (2002). And, of course, the concept of authorship spread outside Europe rather quickly, with Kurosawa Akira and Satyajit Ray becoming celebrated as individual creators in the 1950s and 1960s.

Two institutions that I didn't mention have become ever more important in the cultivation of art movies. The first, and less studied, is the film school. The USSR founded a national film school in 1919, and European countries followed after World War II. Film schools have multiplied since the 1960s, either in universities or under the auspices of national film institutes. Apart from ensuring a flow of trained professionals into the industry, film schools carry in their curricula and course assignments certain presumptions about what constitutes aesthetically worthwhile cinema. Judging from my limited experience, European film academies were in the 1990s still quite oriented to the idea of individual expression—though my sense is that students who were interested in TV production, where most of the jobs were, were less committed to auteur premises. It would be a big project, but someone should study the policies, the taste structures, and the craft practices of non-U.S. film schools, and analyze the films that result.

A second sort of institution is receiving more study just now. The filmmakers and movements that defined the postwar art cinema earned much of their fame on the festival circuit, from *Rashomon* (winner at Venice in 1951) through *If* (winner at Cannes in 1969). When my essay was published in 1979, there were at most 75 principal film festivals; today there are about 250, with hundreds more serving local, regional, and specialist audiences. The development of low-budget independent cinemas, the ease with which films can be submitted on video, and the huge

variety of festival themes (e.g., animation, science fiction, gay and lesbian, and film scores) have made the scene overwhelming. There is even a trade magazine for festival planners.[15] Each year hundreds of programmers are chasing the world's top three or four dozen films. Everyone wants red carpet events, with major stars and directors turning up for the press. If a festival isn't allowed by the international association to award prizes, the organizers can still fly in three or four critics from the Fédération Internationale de la Presse Cinématographique (FIPRESCI) and establish a jury for a FIPRESCI prize. Festivals enhance tourism and give even the smallest city a moment in the limelight. As packaging events, they build an accumulating excitement around films that many attendees wouldn't bother to see in regular theatrical runs.

At the same time, festivals are the world's alternative to Hollywood's theatrical distribution system. A decentralized, informal network of programmers, gatekeepers, and tastemakers brings to notice films of daring and ambition.[16] Festivals are the major clearinghouse for art cinema, with prizes validating the year's top achievements. To win at one of the big three—Berlin, Cannes, and Venice—or to be purchased at Cannes, Toronto, or Sundance lifts a film above the thousands of other titles demanding attention. The payoff goes beyond cinephilia: Taiwan and Iran have used victories on the festival circuit to improve their cultural image.[17] Hong Kong cinema would not have gained its prestige in the West without the energetic proselytizing of festival programmers and loyal journalists.[18]

Not all movies screened at festivals are art films, but festivals sustain the formal and stylistic conventions that my essay tried to isolate. Those conventions emerged earliest, I still believe, in Western and Eastern European cinema, but the essay did slight other cinematic traditions. For example, filmmakers in developing countries like Turkey and Egypt were sensitive to developing art cinema trends, but I simply didn't know enough about them. Nor did I know enough about South American film to do justice to it. Italian neorealism had a strong influence there in the 1950s, and a few filmmakers, notably Leopoldo Torre Nilsson in Argentina, quickly picked up on Bergman and Antonioni. Brazil's Cinema Nôvo and other trends criticized art cinema traditions in ways roughly comparable to the politicized modernist cinema of Europe.

Asia may have lagged somewhat, with the exception of Japan. Although lacking exact counterparts to the standard-bearers of European art movies, Japan had an experimental tradition in mainstream production, and there were many more convention-busting directors at work than the essay suggests (such as Suzuki Seijun and Wakamatsu Kojiro). As the 1980s unfolded, however, the other cinemas of Asia were drawing heavily on the models I review here. Directors of the Fifth Generation in China, the Hong Kong New Wave, and above all the New Taiwanese Cinema were salient examples. Chen Kaige's neorealistic *Yellow Earth* (1984) and his more stylized efforts like *The Big Parade* (1986) and *King of the Children* (1987); Edward Yang's *That Day, on the Beach* (1983) and *The Terrorizers* (1986); Ann Hui's *The Secret* (1979); and Patrick Tam's *Love Massacre* (1981) and *Nomad* (1982)—these and many other works attest to the emergence of a transnational Chinese art cinema. Wong Kar-wai's *Days of Being Wild* (1991) brought Hong Kong art cinema to maturity, and his time-bending lyricism, from *Ashes of Time* (1994) to *2046* (2004), has been indebted to Western literary and cinematic models.[19] In Taiwan, the earliest New Cinema films belong to an autobiographical redrafting of neorealism, but several directors moved beyond it. Edward Yang was strongly influenced by European cineastes, notably Antonioni,

and his masterpiece *A Brighter Summer Day* (1991) married local realism (the film is based on a notorious murder) and self-conscious artifice. Hou Hsiao-hsien was no cinephile, working instead in Taiwan's local industry, but after making triumphant contributions to New Cinema realism, he widened his ambitions. He experimented with decentered historical narrative (*City of Sadness*, 1989; *The Puppetmaster*, 1993), reflexive construction (*Good Men, Good Women*, 1995; *Three Times*, 2005), extreme technical restraint (*Flowers of Shanghai*, 1998), and self-conscious invocations of film history (the Ozu homage *Café Lumière*, 2004).[20]

The 1990s also saw the emergence of a new generation of Japanese directors, including Kore-eda Hirokazu (*Maborosi*, 1995), Suwa Nobuhiro (*M/Other*, 1999), Aoyama Shinji (*Eureka*, 2000), and Kitano Takeshi, who shifted between poetic genre films and more abstract efforts like *Dolls* (2002). At the same period, South Korean directors Hong Sang-soo (*The Power of Kangwon Province*, 1998), Lee Chang-dong (*Peppermint Candy*, 2000), Kim Ki-duk (*The Isle*, 2000), and Park Chan-wook (*Sympathy for Mr. Vengeance*, 2002) began winning festival acclaim. Mainland China has reinstituted art cinema as an export commodity, with films such as Tian Zhuangshuang's *Springtime in a Small Town* (2002) and Jia Zhang-ke's *The World* (2004).

Many of these newer traditions, it seems, replay at an accelerated pace the trajectory of European art cinema. An indigenous realist movement, somewhat comparable to Italian neorealism, becomes more conscious of the conventions involved in realism, and develops more abstract experiments in form. The emergence of Iranian cinema is a remarkable instance. Budgets are bare-bones by Western standards, and by using nonactors and locations, filmmakers have presented post-Shah Iranian culture to a world that knew little of it. The humanistic strain of neorealism finds echoes in films like *The Key* (1987), *The White Balloon* (1995), *The Apple* (1998), *The Child and the Soldier* (2000), and *Blackboards* (2000). At the same time, and often within the same films, we find sophisticated games with cinematic technique. *The Mirror* (1997) starts with a little girl's frustration with trying to cross a busy intersection, then shifts its story action almost wholly to the soundtrack when she barricades herself behind her household gate and refuses to meet the camera. Mohsen Makhmalbaf's *Moment of Innocence* (1996) shows him staging a film based on a crime he committed in his youth, and the result is a dizzying *mise en abyme* reminiscent of *8 1/2*. The country seems immersed in cinephilia. When a laborer and film fan pretends to be director Makhmalbaf, Abbas Kiarostami covers his trial and stages a meeting between him and Makhmalbaf. He calls the result *Close Up* (1990). But then the impostor justifies himself by making his own film, called *Close-Up Long-Shot* (1996). Kiarostami himself—superb screenwriter, director of exemplary documentaries and fiction films, and experimenter with portable video and Warholian recording (*Ten*, 2002; *Five Dedicated to Ozu*, 2003)—stands as an emblem of a culture in love with cinematic artifice but also compelled to bear witness to the lives of ordinary people. Who in the West would have predicted that a great cinema, at once humanist and formalist, would have come from Iran?

Not that the period proved unproductive elsewhere. Russia and Eastern Europe contributed to the tradition of philosophically weighty works with Andrei Tarkovsky's *The Mirror* (1975) and *Nostalghia* (1983) and Krzysztof Kieślowski's coproductions, notably the *Three Colors* trilogy (1993–1994). Aleksandr Sokurov created mournful, quasi-mystical works (*The Second Circle*, 1990; *Whispering Pages*, 1993) that paralleled

the elegiac music pouring out of late Soviet and post-Soviet composers like Artymov and Kancheli. In Hungary, Béla Tarr (*Satanstango*, 1994) and György Fehér (*Passion*, 1998) created harsh, palpably grimy tales of rural life. France continued to support Philippe Garrel, Claire Denis, and others of ambitious bent, whereas Belgium sustained the regional realism of the Dardenne brothers, Jean-Pierre and Luc. Denmark provided Europe's newest Cinema of Quality, with well-carpentered scripts, thoughtful themes, and versatile actors, as well as, thanks to the Dogme 95 impulse, some films pushing against the ethos of professionalism with rawer works. A film, said Lars von Trier, should be "like a pebble in your shoe."[21] Yet quite outside the dominion of Dogme lay Christoffer Boe, whose *Reconstruction* (2003) owes a good deal to Alain Resnais' polished time jumping.

American filmmakers have been assimilating art-film conventions for a long time, as my essay suggests, but the process has been given a new force by the rise of the independent film sector. Steven Soderbergh can remake an Andrey Tarkovsky film (*Solaris*, 1972 and 2002), Paul Thomas Anderson can borrow sound devices from Jacques Tati (*Punch-Drunk Love*, 2002), and Hal Hartley can absorb ideas from Jean-Luc Godard and Robert Bresson.[22] The burst of experimentation on display in films like *Memento* (2000), *Adaptation* (2002), and *Primer* (2004) probably owes as much to the European heritage as it does to U.S. traditions of film noir and fantasy. In many respects, the U.S. indie cinema blends European art-cinema principles with premises of classical Hollywood storytelling.[23] Ahmad, the protagonist of Ramin Bahrani's *Man Push Cart* (2005), has as firm a set of purposes as any Hollywood hero, but the first half-hour of the film conceals them from us. Instead, the scenes concentrate on his daily grind as he sells coffee and pastries from a wheeled stall. We get to know him by the way he lugs his propane tank, fills the coffee roaster, unpacks doughnuts and Danishes, and hauls his massive cart through midtown traffic. Suspending our awareness of the protagonist's goals forces us to focus on minutiae of the story world.

Several books would be needed to do justice to this worldwide activity,[24] so I'll close by pointing out two areas that have intrigued me from the standpoint of a poetics. First is a new stylistic trend that coalesced as I was writing my essay. As if in rebuke to the 1960s reliance on montage and camera movement, several directors cultivated an approach based on the static, fairly distant long take. In Europe, this took the shape of what I've called the *planimetric image*. The shot is framed perpendicular to a back wall or ground, with figures caught in frontal or profile positions, as in police mug shots. We can find this emerging in the 1960s, with the new reliance on long lenses, but it became a feature of much European staging of the 1970s and 1980s, and it was picked up in other national cinemas.[25] This device presents the scene as a more abstract configuration, perhaps distancing us from its emotional tenor, and it can support those psychologically imbued *temps morts* that are crucial to the realistic impulse of the mode. This visual schema can also display some of the arresting boldness of an advertising layout, as in the *cinéma du look* trend of 1980s France. The planimetric image became quite common in world cinema and constitutes one of the art cinema's permanent contributions to cinema's pictorial repertoire. As a substitute for orthodox shot/reverse-shot cutting, it became a staple of deadpan humor in both art films like Kitano Takeshi's and cult hits like *Napoleon Dynamite* (2004).

[ · · · ]

A second aspect touched on in this essay became a concern of my book *Narration in the Fiction Film*. The art cinema engages us not only by asking us to construct the *fabula* action but also by teasing us to make sense of the ongoing narration. So how is this slippery narration patterned across the length of the whole film? Taking as my example Resnais' *La Guerre est finie* (1966), I argued that many art films create a "game of form." The film initially trains the viewer in its distinctive storytelling tactics, but as the film proceeds, those tactics mutate in unforeseeable ways. In *La Guerre est finie*, the key device—the hypothetical sequence, showing several alternative actions the protagonist might take in the future—is announced quite early. At first it seems difficult and disruptive, but through repetition it becomes stabilized. Then, however, the narration renders the hypothetical sequences more indeterminate, introducing uncertainty by mixing in flashbacks and abrupt transitions to new scenes. The final section of the film is the most transparent, as the story action comes to the fore, but there are still variations that make the premises of presentation somewhat unpredictable. The finale leaves open both the consequences of story causality and the rules governing the narration itself.[26]

**[ · · · ]**

Such formal play constitutes one norm within art cinema narration. It's as apparent in the disjunctive editing and misleading camera positions as in works from 40 years before. The study of this tradition from the standpoint of poetics continues to bring new possibilities to light.

## NOTES

1. More radical avant-garde movements, such as Soviet montage filmmaking, surrealism, and *cinéma pur*, seem to have been relatively without effect upon the art cinema's style. I suspect that those experimental styles that did not fundamentally challenge narrative coherence were the most assimilable to the postwar art cinema.

2. See Thomas Guback, *The International Motion Picture Industry* (Bloomington: Indiana University Press, 1969), passim.

3. See, for example, Philip Rosen, "Difference and Displacement in *Seventh Heaven*," *Screen* 18, no. 2 (Summer 1977): 89–104.

4. This point is taken up in Christian Metz, "The Modern Cinema and Narrativity," in his *Film Language*, trans. Michael Taylor (New York: Oxford University Press, 1974), 185–227.

5. Arthur Knight compares the Hollywood film to a commodity and the foreign film to an artwork: "Art is not manufactured by committees. Art comes from an individual who has something that he must express. . . . This is the reason why we hear so often that foreign films are 'more artistic' than our own. There is in them the urgency of individual expression, an independence of vision, the coherence of a single-minded statement." Quoted in Michael F. Mayer, *Foreign Films on American Screens* (New York: Arco, 1965), vii.

6. "The strategy was to talk about Hawks, Preminger, etc. as artists like Buñuel and Resnais" (Jim Hillier, "The Return to *Movie*," *Movie*, no. 20 [Spring 1975]: 17). I do not mean to imply that auteur criticism did not at times distinguish between the classical narrative and the art cinema. A book like V. F. Perkins' *Film as Film* (Baltimore: Penguin, 1978) insists not only upon authorial presence but also upon the causal motivation and the stylistic economy characteristic of the classical cinema. Thus, Perkins finds the labored directorial touches of Antonioni and Bergman insufficiently motivated by story action. Nevertheless, Perkins'

interpretation of the jeep sequence in *Carmen Jones* in terms of characters' confinement and liberation (80–82) is a good example of how Hollywood cutting and camera placement can be invested with symbolic traces of the author.

7. See, for instance, Mark Nash, "*Vampyr* and the Fantastic," *Screen* 17, no. 3 (Autumn, 1976): 29–67; and Paul Willemen, "The Fugitive Subject," in *Raoul Walsh*, ed. Phil Hardy (London: Edinburgh Film Festival, 1974), 63–89.

8. Norman Holland, "The Puzzling Movies: Three Analyses and a Guess at Their Appeal," *Journal of Social Issues* 20, no. 1 (January 1964): 71–96.

9. See Steve Neal, "New Hollywood Cinema," *Screen* 17, no. 2 (Summer 1976): 117–33; and Paul Willemen, "Notes on Subjectivity: On Reading Edward Branigan's 'Subjectivity Under Siege,'" *Screen* 19, no. 1 (Spring 1978): 59–64. See also Robin Wood, "Smart-Ass and Cutie Pie: Notes Toward an Evaluation of Altman," *Movie*, no. 21 (Autumn 1975): 1–17.

10. See David Bordwell, *The Films of Carl Theodor Dreyer* (Berkeley: University of California Press, 1981).

11. Kristin Thompson and David Bordwell, *Film History: An Introduction*, 2nd ed. (New York: McGraw-Hill, 2003). On art-cinema traditions, see chs. 4–6, 8, 16–20, 23, 25–26, and 28.

12. Steve Neale made an early contribution to this line of thinking with "Art Cinema as Institution," *Screen* 22, no. 1 (1981): 11–39. For an overview of state support of the European cinema, see Anne Jäckel, *European Film Industries* (London: British Film Institute, 2003).

13. See Tino Balio, *United Artists: The Company that Changed the Film Industry* (Madison: University of Wisconsin Press, 1987), chs. 7 and 9; and Peter Lev, *The Euro-American Cinema* (Austin: University of Texas Press, 1993).

14. Vinca Wiedemann, quoted in Jacob Wendt Jensen, "Northern Lights," *Screen International*, May 5, 2006, 16.

15. See *Film Festival Today* magazine and its website, http://www.filmfestivaltoday.com.

16. On film festivals' role in international film culture, see Thompson and Bordwell, *Film History*, 716–18. A more extensive account is provided in Thomas Elsaesser, "Film Festival Networks: The New Topographies of Cinema in Europe," in his *European Cinema: Face to Face With Hollywood* (Amsterdam: Amsterdam University Press, 2005), 82–107.

17. The Tehran-based magazine *Film International* has kept track of festival entries and awards. See for example the charts in Mohammad Atebbai, "Iranian Films and the International Scene in 1997," *Film International*, no. 19 (1998): 17–20; and Mohammad Atebbai, "Iranian Films in the International Scene in 1998," *Film International*, no. 23 (1999): 10–14.

18. See my *Planet Hong Kong: Popular Cinema and the Art of Entertainment* (Cambridge, Mass.: Harvard University Press, 2000), 87–89.

19. For a thorough account of Wong's debts to prestigious literature and film, see Stephen Teo, *Wong Kar-wai* (London: British Film Institute, 2005). I discuss Wong's experimental impulses in my *Planet Hong Kong*, 266–89.

20. On Hou's context and development, see Emilie Yueh-yu Yeh and Darrell Davis, *Taiwan Film Directors: A Treasure Island* (New York: Columbia University Press, 2005), chs. 1, 2, and 4. Hou's stylistics and industrial context are considered in chapter 5 of my *Figures Traced in Light* (Berkeley: University of California Press, 2005).

21. Quoted in Stig Bjorkman, "Preface," in Lars von Trier, *Breaking the Waves* (London: Faber and Faber, 1996), 8. For detailed discussions of Dogme and von Trier, see Mette Hjort and Scott Mackenzie, eds., *Purity and Provocation: Dogme 95* (London: British Film Institute, 2003); and Mette Hjort, *Small Nation, Global Cinema: The New Danish Cinema* (Minneapolis: University of Minnesota Press, 2005). I discuss modern Danish film as an accessible art cinema in my "A Strong Sense of Narrative Desire: A Decade of Danish Film," *Film* (Copenhagen), no. 34 (Spring 2004): 24–27, http://www.dfi.dk.

22. I discuss Hartley's adaptation of some European staging principles in "Up Close and Impersonal: Hal Hartley and the Persistence of Tradition" (June 2005), http://www.16-9 .dk/2005-06/side11-inenlish.htm, or by a link from my website http://www.davidbordwell .net. It was first published as "Nah dran und unpersönlich: Hal Hartley und die Beharrlichkeit der Tradition," in *Die Spur durch den Spiegel: Der Film in der Kultur der Moderne*, ed. Malte Hagener, Johann Schmidt, and Michael Wedel (Berlin: Bertz Verlag, 2004), 410–21.

23. See Geoff King, *American Independent Cinema* (Bloomington: Indiana University Press, 2005). See also David Bordwell, Janet Staiger, and Kristin Thompson, *The Classical Hollywood Cinema: Film Style and Mode of Production to 1960* (New York: Columbia University Press, 1985), 372–77; and J. J. Murphy, *Me and You and Memento and Fargo* (New York: Continuum, 2007).

24. See András Bálint Kovács' comprehensive study, *Modern European Art Cinema From the 1950s to the 1970s,* Cinema and Modernity Series (Chicago: University of Chicago Press, 2007). See also John Orr, *Cinema and Modernity* (London: Polity, 1994).

25. On the planimetric image, see my *On the History of Film Style*, 261–64; my *Figures Traced in Light*, 167–68, 173–76, 232–33; and my essay "Modelle der Rauminszenierung im zeitgenössishen europäischen Kino" in *Zeit, Schnitt, Raum*, ed. Andreas Rost (Munich: Verlag der Autoren, 1997), 17–42.

26. See David Bordwell, *Narration in the Fiction Film* (Madison: University of Wisconsin Press, 1985), 213–28.

# TERESA DE LAURETIS

## Desire in Narrative

FROM *Alice Doesn't*

Distinguished Professor Emerita of the History of Consciousness at the University of California, Santa Cruz, Teresa de Lauretis (b. 1938) made an indelible contribution to contemporary film theory with *Alice Doesn't* (1984), the book from which this selection is drawn, and her subsequent *Technologies of Gender* (1987). Born and educated in Italy, de Lauretis came to cinema studies through literature and semiotics, and her inquiries into avant-garde practice, narrative film, and poststructuralist and psychoanalytic theory are always informed by her feminist approach. Based for a number of years at the University of Wisconsin-Milwaukee, de Lauretis participated in a series of crucial cinema conferences there in the 1970s, one of which resulted in the influential publication *The Cinematic Apparatus* (1980), co-edited by de Lauretis and Stephen Heath. In the 1990s, de Lauretis emerged as an important figure in lesbian and queer theory, and her most recent books are sustained engagements with psychoanalytic theory.

In her work, de Lauretis carefully distinguishes between "Woman" and "women": the first is the myth or representation constructed through literary, visual, and other cultural practices; the second is the female-gendered person, the "social subject" who may internalize the myth and struggle with it, but whose practices, habits, and desires

can in turn change the representation. De Lauretis situates the influence of "Woman" on women within the complex interaction of narrativity and imaging in spectatorship. She insists that the processes through which we engage with stories as they unfold cannot be disentangled from the processes of identifying with visual representations and their cultural encoding. Hence female spectators are "hooked" by both story and image.

"Desire in Narrative" is a commanding rereading of narratology and psychoanalytic theory. Making creative use of the mythical figures of Medusa and the Sphinx, de Lauretis reveals how such theories put male desire—exemplified by the figure of Oedipus—at the center of narrative's unfolding. Thus "Woman" is positioned as passive, the "princess" who is won at the end of the story. De Lauretis's tour de force of narrative theory, with its gendered divisions between active hero and passive heroine, culminates in the essay's key contribution to feminist theories of spectatorship by revisiting Laura Mulvey's claims in "Visual Pleasure and Narrative Cinema" (p. 713). Responding to Mulvey's compelling formulation of male as active bearer of the look and female as "to-be-looked-at," de Lauretis proposes that narrative produces "a surplus of pleasure" rather than a lack thereof for the female subject. Drawing from Sigmund Freud's writings (p. 708), *Vertigo* (1958), and Tania Modleski's work on Hitchcock (p. 375), de Lauretis suggests that the female subject identifies with both what she calls "the active figure of narrative movement" and "the figure of narrative closure," and not simply with the latter. However, de Lauretis stresses that this pleasure will continue to be produced for "cinema and society's profit," unless these narrative and spectatorial patterns can be disrupted by new kinds of filmmaking. Instead of giving up on storytelling in favor of abstraction or documentary truth-telling, de Lauretis recommends that women's cinema embrace narrative despite its history of operating from Oedipus's point of view. Rhetorically powerful, de Lauretis's contribution is a reminder of how intertwined Freudian psychoanalysis is in stories and storytelling and how great an influence it has had on feminist literary theory, art history, and film studies. As women's filmmaking and art practice turned away from a rigorous antinarrative, "anti-pleasure" position in the 1980s, de Lauretis's work became all the more relevant, shedding light on gender, genre, and so-called postfeminist culture's emphasis on women's (consumerist) pleasure.

## READING CUES & KEY CONCEPTS

■ What is de Lauretis's critique of structuralism? How does taking desire into account alter the structuralist account of narrative's "universality"?

■ De Lauretis emphasizes that Laura Mulvey's theory of the male gaze in cinema depends as much on how it is played out in narrative as it does on visual codes. Consider how de Lauretis uses this insight to challenge the assumption that the female spectator is shut out of this system of pleasure.

■ What does de Lauretis mean by the phrase "narrative and Oedipal with a vengeance"? Consider why she retains this psychoanalytic concept despite her critique.

■ **Key Concepts:** Narrativity; Oedipus; Identification; Desire; Female Spectatorship

# Desire in Narrative

· · · · · · · · · · · · ·

## *The Question of Desire*

"Sadism demands a story," writes Laura Mulvey in the essay already cited on several occasions. The proposition, with its insidious suggestion of reversibility, is vaguely threatening. (Is a story, are all stories, to be claimed by sadism?) The full statement reads: "Sadism demands a story, depends on making something happen, forcing a change in another person, a battle of will and strength, victory/defeat, all occurring in a linear time with a beginning and an end."[1] This sounds like a common definition of narrative, yet is offered as a description of sadism. Are we to infer that sadism is the causal agent, the deep structure, the generative force of narrative? Or at least coextensive with it? We would prefer to think the proposition is biased or at best particular, pertinent to some narrative genres like the thriller (after all, she is speaking of Hitchcock's films), but surely not applicable to all narratives, not universally valid. For, as Roland Barthes once stated, narrative is universal, is present in every society, age, and culture:

> Carried by articulated language, spoken or written, fixed or moving images, gestures, and the ordered mixture of all these substances; narrative is present in myth, legend, fable, tale, novella, epic, history, tragedy, drama, comedy, mime, painting (think of Carpaccio's *Saint Ursula*), stained glass windows, cinema, comics, news item, conversation. . . . Caring nothing for the division between good and bad literature, narrative is international, transhistorical, transcultural: it is simply there, like life itself.[2]

Barthes's famous essay served as introduction to the 1966 issue of *Communications*, devoted to the structural analysis of narrative, a seminal work in what has become known as narratology and undoubtedly a cornerstone in narrative theory. The volume and the work of its contributors owed much to a variety of sources, from structural linguistics to Russian Formalism and Prague School poetics, as did all semiological research in its early stages; but its coming to existence at that particular time must be traced directly to the publication, in 1958, of Lévi-Strauss's *Anthropologie structurale* and the English translation of Propp's *Morphology of the Folktale*.[3] The early structural studies were concerned with the logic of narrative possibilities, of actions and their patterned arrangement, be it the logic of a diachronic unfolding of the actions performed by the characters (Propp's "functions" and "*dramatis personae*"); or the logic of a paradigmatic distribution of semantic macrounits (Lévi-Strauss's "mythemes") and the relations among them; or, in Barthes's own, more finely articulated model, the logic of a vertical ("hierarchical") integration of narrative instances and levels of description.

Not surprisingly, none of these models would support or even admit of a connection between sadism and narrative that may presuppose the agency of desire. Or more exactly, none would admit of a *structural* connection between sadism and narrative; that is to say, one by which the agency of desire might be seen somehow at work in that logic, that "higher order of relation," that "passion of meaning" which narrative, Barthes says, excites in us. The structural models would consider sadism

or desire as types of thematic investment, to be located on the level of content, and thus preempt the possibility of an integral relationship, a mutual structural implication of narrative with desire and *a fortiori* sadism. Curiously, however, Barthes ends his essay with this statement: "It may be significant that it is at the same moment (around the age of three) that the little human 'invents' at once sentence, narrative, and the Oedipus" (p. 124). He will of course pursue the relation between narrative and Oedipal structuration, as it is mediated by language, in later works from *S/Z* to *The Pleasure of the Text*. But in so doing—this too may be significant—Barthes drifts further and further away from his own semiological model, and, far from seeking to establish an analytic structural framework, his writing will become increasingly fragmented and fragmentary, personal, a subject's discourse. Nevertheless, once suggested, the connection between narrative and the Oedipus, desire and narrative, not only appears to be incontestable but, divesting itself from Barthes's singular critical *iter*, urges a reconsideration of narrative structure—or better, narrativity.

Since the early structural analyses, semiotics has developed a dynamic, processual view of signification as a work(ing) of the codes, a production of meaning which involves a subject in a social field. The object of narrative theory, redefined accordingly, is not therefore narrative but narrativity; not so much the structure of narrative (its component units and their relations) as its work and effects. Today narrative theory is no longer or not primarily intent on establishing a logic, a grammar, or a formal rhetoric of narrative; what it seeks to understand is the nature of the structuring and destructuring, even destructive, processes at work in textual and semiotic production. It was again Barthes who, in his notion of the text, sketched out a new direction and a useful critical approach to the question of narrativity: "The work can be held in the hand, the text is held in language, only exists in the movement of a discourse . . . or again, *the Text is experienced only in an activity of production*" (p. 157).

To ask in what ways and by what means desire works along with narrativity, within the movement of its discourse, requires attention to two distinct but interrelated lines of inquiry. First, the reexamination of the relations of narrative to genres, on the one hand, and to epistemological frameworks on the other; thus, the understanding of the various conditions of presence of narrative in forms of representation that go from myth and folktale to drama, fiction, cinema, and further, historical narration, the case history, up to what Turner calls "social dramas." Narrative has been the focus of much recent critical debate. A comparison of the 1980 special issue of *Critical Inquiry* on narrative, for example, with the 1966 *Communications* mentioned earlier indicates a shift in emphasis. The "transhistorical," narratological view of narrative structures seems to have given way to an attempt to historicize the notion of narrative by relating it to the subject and to its implication in, or dependence on the social order, the law of meaning; or to the transformative effects produced in processes of reading and practices of writing. More often than not, however, those efforts all but reaffirm an integrative and ultimately traditional view of narrativity. Paradoxically, in spite of the methodological shift away from the notion of structure and toward a notion of process, they end up dehistoricizing the subject and thus universalizing the narrative process as such. The problem, I believe, is that many of the current formulations of narrative process fail to see that subjectivity is engaged in the cogs of narrative and indeed constituted in the

relation of narrative, meaning, and desire; so that the very work of narrativity is the engagement of the subject in certain positionalities of meaning and desire. Or else they fail to locate the relation of narrative and desire where it takes place, where that relation is materially inscribed—in a field of textual practices. Thus, finally, they fail to envisage a materially, historically, and experientially constituted subject, a subject engendered, we might say, precisely by the process of its engagement in the narrative genres.

Second, then, the relation of narrative and desire must be sought within the specificity of a textual practice, where it is materially inscribed. This is especially obvious when one considers narrativity in cinema, where the issue of material specificity (not simply of "techniques") is unavoidable and in fact has long been a central question of film theory—whence the value, the relevance of cinema for any general theory of narrative. But within film theory, too, a certain shifting of emphasis has occurred with regard to narrative. While narrative film has always been the primary area of reference for critical and theoretical discourses on cinema, narrative structuration has received on the whole much less attention than have the technical, economic, ideological, or aesthetic aspects of filmmaking and film viewing.[4] Moreover, the issue of narrative has served as a bone of contention, as well as a rigid criterion of discrimination, between dominant, mainstream cinema and avant-garde or independent practices. The distinction is not unlike that often made between mainstream fiction and metafiction or antinarrative; except that in cinema that distinction is articulated and defined in political terms.

Because of the material specificity of cinema—its near-total and unmediated dependence on the socioeconomic and the technological—film theory and film practice stand in a close-knit relationship, bound by strict ties of historical proximity. Thus it is not by pure coincidence that the return to narrative on the part of theory, its increasing concern with narrativity, corresponds to a return of narrative in alternative and avant-garde film practices. That does not mean that the emergence of narrative would mark an apolitical or reactionary turn. On the contrary, as Claire Johnston first noted back in 1974, narrative is a major issue in women's cinema; a feminist strategy should combine, rather than oppose, the notions of film as a political tool and film as entertainment. The political, analytical work of women's cinema is to bring home the fact that "cinema involves the production of signs," and "the sign is always a product"; that what the camera grasps is not reality as such but "the 'natural' [naturalized] world of the dominant ideology. . . . The 'truth' of our oppression cannot be 'captured' on celluloid with the 'innocence' of the camera: it has to be constructed, manufactured." Thus, she insisted, the project of feminist film criticism was to build up a systematic body of knowledge about film and to develop the means to interrogate male bourgeois cinema; but that knowledge must then feed back into filmmaking practices, where what is at stake is "the working through," the question, of desire. "In order to counter our objectification in the cinema, our collective fantasies must be released: women's cinema must embody the working through of desire: such an objective demands the use of the entertainment film."[5] Very much out of this same concern, in a recent essay on sexual identity in melodrama, Laura Mulvey addresses the question of pleasure for the female spectator and turns to consider the positionalities of identification available to her in narrative cinema, which are "triggered by the logic of narrative grammar."[6]

For feminist theory in particular, the interest in narrativity amounts to a *theoretical return* to narrative and the posing of questions that have been either preempted or displaced by semiotic studies. That return amounts, as is often the case with any radical critique, to a rereading of the sacred texts against the passionate urging of a different question, a different practice, and a different desire. For if Metz's work on *la grande syntagmatique* left little room for a consideration of the working of desire in narrative structuration, Barthes's discourse on the pleasure of the text, at once erotic and epistemological, also develops from his prior hunch that a connection exists between language, narrative, and the Oedipus. Pleasure and meaning move along the triple track he first outlined, and the tracking is from the point of view of Oedipus, so to speak, its movement is that of a masculine desire.

> The pleasure of the text is ... an Oedipal pleasure (to denude, to know, to learn the origin and the end), if it is true that every narrative (every unveiling of the truth) is a staging of the (absent, hidden, or hypostatized) father—which would explain the solidarity of narrative forms, of family structures, and of prohibitions of nudity.[7]

The analogy that Robert Scholes proposes between narrative and sexual intercourse again affirms, in the manner of a *reductio ad absurdum*, what seems to be the inherent maleness of all narrative movement:

> The archetype of all fiction is the sexual act. In saying this I do not mean merely to remind the reader of the connection between all art and the erotic in human nature. Nor do I intend simply to suggest an analogy between fiction and sex. For what connects fiction—and music—with sex is the fundamental orgastic rhythm of tumescence and detumescence, of tension and resolution, of intensification to the point of climax and consummation. In the sophisticated forms of fiction, as in the sophisticated practice of sex, much of the art consists of delaying climax within the framework of desire in order to prolong the pleasurable act itself. When we look at fiction with respect to its form alone, we see a pattern of events designed to move toward climax and resolution, balanced by a counter-pattern of events designed to delay this very climax and resolution.[8]

Lightly gliding over a further parallelism linking the content of the fictional work with the "possible procreative content" and the "necessary emotional content" of the sexual act, Scholes proceeds to look closely at what he calls "the meaning of the fictional act." The analogy still holds. In both cases, fiction and sex, the act "is a reciprocal relationship. It takes two." Unless the writer writes or the reader reads "for his own amusement," pursuing solitary pleasures ("but these are acts of mental masturbation," observes the critic, determined to run his metaphor into the ground), "in the full fictional act [they] share a relationship of mutual dependency. The meaning of the fictional act itself is something like love." And in the end, "when writer and reader make a 'marriage of true minds,' the act of fiction is perfect and complete."

Those of us who know no art of delaying climax or, reading, feel no incipient tumescence, may well be barred from the pleasure of this "full fictional act"; nor may we profit from the rhythm method by which it is attained. But knowing, as one does,

how rare a thing a marriage of true minds can be, and then how rarely it lasts beyond the first few chapters; and knowing, furthermore, how the story usually goes, one might be brought to wonder: is Mulvey perhaps not wrong, after all, in seeing a connection between sadism and narrative? And the suggestion that the connection is one of mutual implication already appears much less far-fetched, and all the more outrageous. In the following pages I shall seek to explore further the nature of that connection which, I suspect, is constitutive of narrative and of the very work of narrativity.

Suppose we were to ask the question: what became of the Sphinx after the encounter with Oedipus on his way to Thebes? Or, how did Medusa feel seeing herself in Perseus' mirror just before being slain? To be sure, an answer could be found by perusing a good textbook of classical mythology; but the point is, no one knows off-hand and, what is more, it seldom occurs to anyone to ask. Our culture, history, and science do not provide an answer; but neither do the modern mythologies, the fictions of our social imagination, the stories and the images produced by what may be called the psychotechnologies of our everyday life. Medusa and the Sphinx, like the other ancient monsters, have survived inscribed in hero narratives, in someone else's story, not their own; so they are figures or markers of positions—places and topoi—through which the hero and his story move to their destination and to accomplish meaning.

Classical mythology of course was populated with monsters, beings awesome to behold, whose power to capture vision, to lure the gaze, is conveyed in the very etymon of the word "monster." But only a few have survived past the dark ages into Renaissance epos, and beyond the age of reason into the imaginary of modernism; and perhaps not by chance the few that have survived are narratively inscribed within stories of heroes and semantically associated with boundary. What these monsters stand for, to us, is the symbolic transposition of the place where they stand, the literary topos being literally, in this case, a topographical projection; the *limen*, frontier between the desert and the city, threshold to the inner recesses of the cave or maze, metaphorizes the symbolic boundary between nature and culture, the limit and the test imposed on man.

The ancient monsters had a sex, as did the gods, in a mythology whose painstakingly rich articulation of sexual difference was to be boiled down to the stark Platonic opposition man/non-man. And again in the modern mythologies, the gender of monsters, unlike the sex of angels, is a carefully worked out representation. The Minotaur, for example, imprisoned at the center of the labyrinth in Crete, exacts his toll in human lives indiscriminately (seven girls, seven boys) as would a natural plague; more beast than man, he represents the bestial, animal side of man that must be sought out and conquered. The issue of Pasifae's unnatural union with a bull, he is described as "half bull and half man" but referred to as "the Cretan Bull" or even, with unwitting irony, by the patronymic "Minos' bull."[9] In *Fellini's Satyricon* he is represented with a man's body and the head of a bull. Medusa and the Sphinx, on the contrary, are more human than animal, and definitely female: the latter has the body of a winged lion but a woman's head; Medusa is female and beautiful, although she too is connected with bestiality (she was Poseidon's lover and pregnant with his offspring when Perseus killed her, and from her body, as her

head was severed, sprang forth the winged horse Pegasus). Medusa's power to cast the spell which in many cultures is actually called "the evil eye," is directly represented in her horribly "staring eyes," which are a constant feature of her figurative and literary representations; while the serpents in their hair or "girdles" are a variable attribute of all three Gorgons, together with other monstrous features such as wings, "a lolling tongue," or "grinning heads."[10]

Medusa's power, her evil look, is more explicit than the Sphinx's but both achieve analogous long-term effects: they not only kill or devour, but blind as well. The legends of Perseus and Oedipus, in which they are inscribed, make it clear that their threat is to man's vision, and their power consists in their enigma and "to-be-looked-at-ness" (in Mulvey's word), their luring of man's gaze into the "dark continent," as Freud put it, the enigma of femininity. They are obstacles man encounters on the path of life, on his way to manhood, wisdom, and power; they must be slain or defeated so that he can go forward to fulfill his destiny—and his story. Thus we don't know, his story doesn't tell, what became of the Sphinx after the encounter with Oedipus, though some may claim to have caught a glimpse of her again in the smile of Mona Lisa, and others, like mythologist H. J. Rose, simply state that she "killed herself in disgust," after Oedipus solved her riddle—and married Jocasta.[11] Medusa, of course, was slain, though she too is still laughing, according to Hélène Cixous.[12] The questions we might ask are obvious. Why did the Sphinx kill herself (like Jocasta), and why the disgust? Why did Medusa not wake up to her own slaying, or did she perhaps *have* to be asleep? Let us ask our questions, then—if we can.

In an essay entitled "Rereading Femininity" Shoshana Felman points out how Freud's own interrogation of the "riddle" of femininity, his very asking of the question "woman" ("What does a woman want?"), paradoxically excludes women from the question, bars them from asking it themselves. She quotes Freud's words:

> Throughout history people have knocked their heads against the riddle of the nature of femininity. . . . Nor will *you* have escaped worrying over this problem—those of you who are men; to those of you who are women this will not apply—you are yourselves the problem.

And she comments:

> A question, Freud thus implies, is always a question of desire; it springs out of a desire which is also the desire for a question. Women, however, are considered merely as the *objects* of desire, and as the *objects* of the question. To the extent that women "*are* the question," they cannot *enunciate* the question; they cannot be the speaking *subjects* of the knowledge or the science which the question seeks.[13]

What Freud's question really asks, therefore, is "what is femininity—for men?" In this sense it is a question of desire: it is prompted by men's desire for woman, and by men's desire to know. Let me now elaborate this point a little further. Freud's is a question addressed to men, both in the sense that the question is not asked of women ("to those of you who are women, this will not apply") and that its answer is *for* men, reverts to men. The similarity between this "riddle" and the riddle of the Sphinx is striking, for in the latter, also, the term of address is man. Oedipus is addressed, he solves the riddle, and his answer, the very meaning or content of the riddle, is—man,

universal man, Oedipus therefore. However, the apparent syntactical parallelism of the two expressions, "the riddle of the Sphinx" and "the riddle of femininity," disguises one important difference, the source of enunciation: *who* asks the question? While Oedipus is he who answers the riddle posed by the Sphinx, Freud stands in both places at once, for he first formulates—defines—the question and then answers it. And we shall see that his question, what is femininity, acts precisely as the impulse, the desire that will generate a narrative, the story of femininity, or how a (female) child with a bisexual disposition becomes a little girl and then a woman.

What must be stressed in this respect, however obvious it may seem, is that Freud's evocation of the myth of Oedipus is mediated by the text of Sophocles. The Oedipus of psychoanalysis is the *Oedipus Rex*, where the myth is already textually inscribed, cast in dramatic literary form, and thus sharply focused on the hero as mover of the narrative, the center and term of reference of consciousness and desire. And indeed in the drama it is Oedipus who asks the question and presses for an answer that will come back to him with a vengeance, as it were. "Not Creon, you are your own worst enemy," foretells Tiresias. As for the Sphinx, she is long gone and little more than a legend in the world of the tragedy, the plague-ridden city of Thebes. She only served to test Oedipus and qualify him as hero. Having fulfilled her narrative function (the function of the Donor, in Propp's terms), her question is now subsumed in his; her power, his; her fateful gift of knowledge, soon to be his. Oedipus's question then, like Freud's, generates a narrative, turns into a quest. Thus not only is a question, as Felman says, always a question of desire; a story too is always a question of desire.

But whose desire is it that speaks, and whom does that desire address? The received interpretations of the Oedipus story, Freud's among others, leave no doubt. The desire is Oedipus's, and though its object may be woman (or Truth or knowledge or power), its term of reference and address is man: man as social being and mythical subject, founder of the social order, and source of mimetic violence; hence the institution of the incest prohibition, its maintenance in Sophocles' Oedipus as in Hamlet's revenge of his father, its costs and benefits, again, for man. However, we need not limit our understanding of the inscription of desire in narrative to the Oedipus story proper, which is in fact paradigmatic of all narratives. According to Greimas, for instance, the semantic structure of all narrative is the movement of an actant-subject toward an actant-object. In this light, it is not accidental that the central Bororo myth in Lévi-Strauss's study of over eight hundred North and South American myths is an autochthonous variant of the Greek myth of Oedipus; or that the circus act of the lion tamer, analyzed by Paul Bouissac, is semiotically constructed along a narrative and clearly Oedipal trajectory.

[ · · · ]

## Oedipus Interruptus

To succeed, for a film, is to fulfill its contract, to please its audiences or at least induce them to buy the ticket, the popcorn, the magazines, and the various paraphernalia of movie promotion. But for a film to work, to be effective, it *has* to please. All films must offer their spectators some kind of pleasure, something of interest, be it a technical, artistic, critical interest, or the kind of pleasure that goes by the names

of entertainment and escape; preferably both. These kinds of pleasure and interest, film theory has proposed, are closely related to the question of desire (desire to know, desire to see), and thus depend on a personal response, an engagement of the spectator's subjectivity, and the possibility of identification.

The fact that films, as the saying goes, speak to each one and to all, that they address spectators both individually and as members of a social group, a given culture, age, or country, implies that certain patterns or possibilities of identification for each and all spectators must be built into the film. This is undoubtedly one of the functions of genres, and their historical development throughout the century attests to the need for cinema to sustain and provide new modes of spectator identification in keeping with social changes. Because films address spectators as social subjects, then, the modalities of identification bear directly on the process of spectatorship, that is to say, the ways in which the subjectivity of the spectator is engaged in the process of viewing, understanding (making sense of), or even *seeing* the film.

If women spectators are to buy their tickets and their popcorn, the work of cinema may be said to require women's consent; and we may well suspect that narrative cinema in particular must be aimed, like desire, toward seducing women into femininity. What manner of seduction operates in cinema to procure that consent, to engage the female subject's identification in the narrative movement, and so fulfill the cinematic contract? What manner of seduction operates in cinema to solicit the complicity of women spectators in a desire whose terms are those of the Oedipus? In the following pages I will be concerned with female spectatorship, and in particular the kinds of identification available to women spectators and the nature of the process by which female subjectivity is engaged in narrative cinema; thus I will reconsider the terms or positionalities of desire as constituted in cinema by the relations of image and narrative.

The cinematic apparatus, in the totality of its operations and effects, produces not merely images but imaging. It binds affect and meaning to images by establishing terms of identification, orienting the movement of desire, and positioning the spectator in relation to them.

> The film poses an image, not immediate or neutral, but posed, framed and centered. Perspective-system images bind the spectator in place, the suturing central position that is the sense of the image, that sets its scene (in place, the spectator *completes* the image as its subject). Film too, but it also moves in all sorts of ways and directions, flows with energies, is potentially a veritable festival of affects. Placed, that movement is all the value of film in its development and exploitation: reproduction of life and the engagement of the spectator in the process of that reproduction as articulation of coherence. What moves in film, finally, is the spectator, immobile in front of the screen. Film is the regulation of that movement, the individual as subject held in a shifting and placing of desire, energy, contradiction, in a perpetual retotalization of the imaginary (the set scene of image and subject).[14]

What Heath has called the "passage" of the spectator-subject through the film (the movement of the spectator taken up as subject, performing the film) is modulated on the movement of the film, its "regulation" of the flow of images, its "placing"

of desire. The process of regulation, in the classical economy of film, is narrativiza-tion; and narrative, the "welding together" of space and spectator, is the form of that economy (p. 43). "Narrativization is then the term of film's entertaining: process and process contained, subject bound in that process and its directions of meaning. . . . The spectator is *moved*, and *related* as subject in the process and images of that movement" (p. 62). The formulation is forceful and convincing, though not unam-biguous. While anyone who has watched movies and reflected on the experience of spectatorship would agree that, indeed, to watch is to be moved and, at the same time, held in a coherence of meaning and vision; yet that very experience is what must make us question whether—or better, how—women spectators are "related as subject" in the film's images and movement.

In the narrative film the spectator's movement or passage is subject to an ori-entation, a direction—a teleology, we might say, recalling Freud's word—that is the movement of narrative. Film narrative too, if Lotman's typology be credited, is a process by which the text-images distributed across the film (be they images of people, objects, or of movement itself) are finally regrouped in the two zones of sexual difference, from which they take their culturally preconstructed meaning: mythical subject and obstacle, maleness and femaleness. In cinema the process is accomplished in specific ways. The codes whereby cinema articulates and inscribes both the narrative movement and the subject's passage in the film, the codes which constitute the specificity of cinema as a semiotic practice, have been discussed else-where. But for the purposes of the present inquiry one crucial point may be usefully emphasized: the centrality of the system of the look in cinematic representation.

The look of the camera (at the profilmic), the look of the spectator (at the film projected on the screen), and the intradiegetic look of each character within the film (at other characters, objects, etc.) intersect, join, and relay one another in a complex system which structures vision and meaning and defines what Alberti would call the "visible things" of cinema. Cinema "turns" on this series of looks, writes Heath, and that series in turn provides the framework "for a pattern of multiply relaying identifications"; within this framework occur both "subject-identification" and "subject-process."[15] "It is the place of the look that defines cinema," specifies Mulvey, and governs its representation of woman. The possibility of shifting, varying, and exposing the look is employed both to set out and to contain the tension between a pure solicitation of the scopic drive and the demands of the diegesis; in other words, to integrate voyeurism into the conventions of storytelling, and thus combine visual and narrative pleasure. The following passage refers to two particular films, but could easily be read as paradigmatic of the narrative film in general:

> The film opens with the woman as object of the combined gaze of spectator and all the male protagonists in the film. She is isolated, glamorous, on display, sex-ualised. But as the narrative progresses she falls in love with the main male protagonist and becomes his property, losing her outward glamorous charac-teristics, her generalised sexuality, her show-girl connotations; her eroticism is subjected to the male star alone.[16]

If the female position in narrative is fixed by the mythical mechanism in a certain portion of the plot-space, which the hero crosses or crosses to, a quite similar effect

is produced in narrative cinema by the apparatus of looks converging on the female figure. The woman is framed by the look of the camera as icon, or object of the gaze: an image made to be looked at by the spectator, whose look is relayed by the look of the male character(s). The latter not only controls the events and narrative action but is "the bearer" of the look of the spectator. The male protagonist is thus "a figure in a landscape," she adds, "free to command the stage . . . of spatial illusion in which he articulates the look and creates the action" (p. 13). The metaphors could not be more appropriate.

In that landscape, stage, or portion of plot-space, the female character may be all along, throughout the film, representing and literally marking out the place (to) which the hero will cross. There she simply awaits his return like Darling Clementine; as she indeed does in countless Westerns, war, and adventure movies, providing the "love interest," which in the jargon of movie reviewers has come to denote, first, the singular function of the female character, and then, the character itself.[17] Or she may resist confinement in that symbolic space by disturbing it, perverting it, making trouble, seeking to exceed the boundary—visually as well as narratively—as in film noir. Or again, when the film narrative centers on a female protagonist, in melodrama, in the "woman's film," etc., the narrative is patterned on a journey, whether inward or outward, whose possible outcomes are those outlined by Freud's mythical story of femininity. In the best of cases, that is, in the "happy" ending, the protagonist will reach the place (the space) where a modern Oedipus will find her and fulfill the promise of his (off-screen) journey. Not only, then, is the female position that of a given portion of the plot-space; more precisely, in cinema, it figures the (achieved) movement of the narrative toward that space. It represents narrative closure.

In this sense, Heath has suggested, narrative is a process of restoration that depends finally on the image of woman, generalized into what he calls the *narrative image*, a function of exchange within the terms of the film's contract. In *Touch of Evil*, specifically, "the narrative must serve to restore the woman as good object (the narrative image depends on this); which obliges it to envisage her as bad object (the other side of the restoration that it seeks to accomplish)." Of narrative cinema in general he writes:

> Narrative contains a film's multiple articulations as a single articulation, its images as a single image (the "narrative image," which is a film's presence, how it can be talked about, what it can be sold and bought on, itself represented as—in the production stills displayed outside a cinema, for example).[18]

If narrative is governed by an Oedipal logic, it is because it is situated within the system of exchange instituted by the incest prohibition, where woman functions as both a sign (representation) and a value (object) for that exchange. And if we remark Lea Melandri's observation that the woman as Mother (matter and matrix, body and womb) is the primary measure of value, "an equivalent more universal than money," then indeed we can see why the narrative image on which the film, any film, can be represented, sold, and bought is finally the woman.[19] What the promotion stills and posters outside the cinema display, to lure the passers-by, is not just an *image of woman* but the image of her narrative position, the *narrative image* of woman—a felicitous phrase suggestive of the join of image and story, the interlocking of visual and narrative registers effected by the cinematic apparatus of the look. In cinema

as well, then, woman properly represents the fulfillment of the narrative promise (made, as we know, to the little boy), and that representation works to support the male status of the mythical subject. The female position, produced as the end result of narrativization, is the figure of narrative closure, the narrative image in which the film, as Heath says, "comes together."

With regard to women spectators, therefore, the notion of a passage or movement of the spectator through the narrative film seems strangely at odds with the theories of narrative presented so far. Or rather, it would seem so if we assumed—as is often done—that spectators naturally identify with one or the other group of text-images, one or the other textual zone, female or male, according to their gender. If we assumed a single, undivided identification of each spectator with either the male or the female figure, the passage through the film would simply instate or reconfirm male spectators in the position of the mythical subject, the human being; but it would only allow female spectators the position of the mythical obstacle, monster or landscape. How can the female spectator be entertained as subject of the very movement that places her as its object, that makes her the figure of its own closure?

Clearly, at least for women spectators, we cannot assume identification to be single or simple. For one thing, identification is itself a movement, a subject-process, a relation: the identification (of oneself) with something other (than oneself). In psychoanalytic terms, it is succinctly defined as the "psychological process whereby *the subject* assimilates an aspect, property or attribute of the other and *is transformed*, wholly or partially, after the model the other provides. It is by means of a series of identifications that the personality is constituted and specified."[20] This last point is crucial, and the resemblance of this formulation to the description of the apparatus of the look in cinema cannot escape us. The importance of the concept of identification, Laplanche and Pontalis insist, derives from its central role in the formation of subjectivity; identification is "not simply one psychical mechanism among others, but the operation itself whereby the human subject is constituted" (p. 206). To identify, in short, is to be actively involved as subject in a process, a series of relations; a process that, it must be stressed, is materially supported by the specific practices— textual, discursive, behavioral—in which each relation is inscribed. Cinematic identification, in particular, is inscribed across the two registers articulated by the system of the look, the narrative and the visual (sound becoming a necessary third register in those films which intentionally use sound as an anti-narrative or de-narrativizing element).

Secondly, no one can really *see* oneself as an inert object or a sightless body; neither can one see oneself *altogether* as other. One has an ego, after all, even when one is a woman (as Virginia Woolf might say), and by definition the ego must be active or at least fantasize itself in an active manner.[21] Whence, Freud is led to postulate, the phallic phase in females: the striving of little girls to be masculine is due to the active aim of the libido, which then succumbs to the momentous process of repression when femininity "sets in." But, he adds, that masculine phase, with its libidinal activity, never totally lets up and frequently makes itself felt throughout a woman's life, in what he calls "regressions to the fixations of the pre-Oedipus phases." One can of course remark that the term "regression" is a vector in the field of (Freud's) narrative discourse. It is governed by the same mythical mechanism that underlies his story of femininity, and oriented by the teleology of (its)

narrative movement: progression is toward Oedipus, toward the Oedipal stage (which in his view marks the onset of womanhood, the initiation to femininity); regression is away from Oedipus, retarding or even impeding the female's sexual development, as Freud would have it, or as I see it, impeding the fulfillment of the male's desire, as well as narrative closure.

The point, however, is made—and it is relevant to the present discussion—that "femininity" and "masculinity" are never fully attained or fully relinquished: "in the course of some women's lives there is a repeated alternation between periods in which femininity or masculinity gain the upper hand."[22] The two terms, femininity and masculinity, do not refer so much to qualities or states of being inherent in a person, as to positions which she occupies in relation to desire. They are terms of identification. And the alternation between them, Freud seems to suggest, is a specific character of female subjectivity. Following through this view in relation to cinematic identification, could we say that identification in women spectators alternates between the two terms put in play by the apparatus: the look of the camera and the image on the screen, the subject and the object of the gaze? The word alternation conveys the sense of an either/or, either one or the other at any given time (which is presumably what Freud had in mind), not the two together. The problem with the notion of an alternation between image and gaze is that they are not commensurable terms: the gaze is a figure, not an image. We see the image; we do not see the gaze. To cite again an often-cited phrase, one can "look at her looking," but one cannot look at oneself looking. The analogy that links identification-with-the-look to masculinity and identification-with-the-image to femininity breaks down precisely when we think of a spectator alternating between the two. Neither can be abandoned for the other, even for a moment; no image can be identified, or identified with, apart from the look that inscribes it as image, and vice versa. If the female subject were indeed related to the film in this manner, its division would be irreparable, unsuturable; no identification or meaning would be possible. This difficulty has led film theorists, following Lacan and forgetting Freud, practically to disregard the problem of sexual differentiation *in the spectators* and to define cinematic identification as masculine, that is to say, as an identification with the gaze, which both historically and theoretically is the representation of the phallus and the figure of the male's desire.[23]

That Freud conceived of femininity and masculinity primarily in narrative rather than visual terms (although with an emphasis on sight—in the traumatic apprehension of castration as punishment—quite in keeping with his dramatic model) may help us to reconsider the problem of female identification. Femininity and masculinity, in his story, are positions occupied by the subject in relation to desire, corresponding respectively to the passive and the active aims of the libido.[24] They are positionalities within a movement that carries both the male child and the female child toward one and the same destination: Oedipus and the Oedipal stage. That movement, I have argued, is the movement of narrative discourse, which specifies and even produces the masculine position as that of mythical subject, and the feminine position as mythical obstacle or, simply, the space in which that movement occurs. Transferring this notion by analogy to cinema, we could say that the female spectator identifies with both the subject and the space of the narrative movement, with the figure of movement and the figure of its closure, the

narrative image. Both are figural identifications, and both are possible at once; more, they are concurrently borne and mutually implicated by the process of narrativity. This manner of identification would uphold both positionalities of desire, both active and passive aims: desire for the other, and desire to be desired by the other. This, I think, is in fact the operation by which narrative and cinema solicit the spectators' consent and seduce women into femininity: by a double identification, a surplus of pleasure produced by the spectators themselves for cinema and for society's profit.

In other words, if women spectators are "related as subject" in the film's images and movement, as Heath puts it, it is insofar as they are engaged in a twofold process of identification, sustaining two distinct sets of identifying relations. The first set is well known in film theory: the masculine, active, identification with the gaze (the looks of the camera and of the male characters) and the passive, feminine identification with the image (body, landscape). The second set, which has received much less attention, is implicit in the first as its effect and specification, for it is produced by the apparatus which is the very condition of vision (that is to say, the condition under which what is visible acquires meaning). It consists of the double identification with the figure of narrative movement, the mythical subject, and with the figure of narrative closure, the narrative image. Were it not for the possibility of this second, figural identification, the woman spectator would be stranded between two incommensurable entities, the gaze and the image. Identification, that is, would be either impossible, split beyond any act of suture, or entirely masculine. The figural narrative identification, on the contrary, is double; both figures can and in fact must be identified with at once, for they are inherent in narrativity itself. It is this narrative identification that assures "the hold of the image," the anchoring of the subject in the flow of the film's movement.

<p style="text-align:center">[ · · · ]</p>

Let me be more precise, at the cost of some repetition. If the heroine of [Hitchcock's] *Rebecca* is made to kill off the mother, it is not only because the rules of the drama demand narrative closure; it is also because, like them, cinema works for Oedipus. The heroine therefore has to move on, like Freud's little girl, and take her place where Oedipus will find her awaiting *him*. What if, once he reached his destination, he found that Alice didn't live there anymore? He would promptly set out to find another, to find true woman or at least her truthful image. [ . . . ] The image into which Scottie "remakes" Judy for himself (literally makes her up) in *Vertigo* must be the truthful image of Madeleine. With his uncommonly keen sense of cinematic convention, Hitchcock encapsulates this search for the true image—a search on the part of the hero, but equally a search on the part of the film itself—in a visual parable. When Scottie's one-time fiancée and now "good friend" Midge wants to offer herself as object of his desire, she paints a portrait of herself dressed as Carlotta Valdes, the presumed ancestor in the museum portrait who is the object of Madeleine's desire and identification. Scottie evidently rejects the offer; Midge has failed to understand that what attracts Scottie is not the simple *image* of woman (were it so, he would be in love with Carlotta) but her narrative image, in this case the desire for the (dead) Mother which Madeleine represents and mediates for him. Whence Hitchcock's comment: "I was intrigued by the hero's attempts to re-create the image of a dead woman through another one who's alive. . . . To put it plainly, the man wants to go to bed with a woman who's dead; he is indulging in a form of necrophilia."[25] Ostensibly,

Hitchcock is referring here to the second part of the film and Scottie's efforts to remake Judy as Madeleine. But the film's construction *en abyme* supports, I think, this reading of the portrait sequence.

In the second part (the third reel) of *Vertigo*, after Madeleine's "death," Scottie essays to remake Judy in her image, to make her up, quite literally, to look like Madeleine. Ironically, it is exactly at the moment when he has achieved the transformation, and thus the identity of the two images (and just after a very long kiss sequence, ending in a fade, signals the moment of sexual consummation), that he discovered the hoax by which Judy had impersonated Madeleine; which renders both their images equally "untrue." But Judy has agreed to impersonate Madeleine *the second time* out of her love for Scottie; her desire is thus revealed at the same time as the hoax, concurrent and complicit with it. It is the same with Midge's portrait, only this time what is false is not merely the image (the portrait of Carlotta with Midge's face), but indeed the narrative image of the woman, for Judy-Madeleine turns out to be alive and real—and *thus* untrue. Unlike *Rebecca*, the different images and desires put in play by *Vertigo* are relayed through the male protagonist. Madeleine's desire for (and identification with) the dead Mother, mirroring Scottie's own desire, is impossible; the Mother is dead, and so does Madeleine die. Judy's and Midge's desires for Scottie are duplicitous. The film closes, appropriately, on the narrative image of Judy dead on the rooftop and Scottie looking.[26] Hitchcock says:

> I put myself in the place of a child whose mother is telling him a story. When there's a pause in her narration, the child always says, "What comes next, Mommy?" Well, I felt that the second part of the novel was written as if nothing came next, whereas in my formula, the little boy, *knowing* that Madeleine and Judy are the same person, would then ask, "And Stewart doesn't know it, does he? What will he do when he finds out about it?" [pp. 184–85]

This is the question the film addresses, as do so many other films and as Freud's exploration of the psyche does. No story perhaps can be written "as if nothing came next." But the question of desire is always cast in these terms: "what will he do when he finds out?" the little boy asks of the man, or vice versa.

Such is the work of cinema as we know it: to represent the vicissitudes of his journey, fraught with false images (his blindness) but unerringly questing after the one true vision that will confirm the truth of his desire. So that even in the genre Molly Haskell aptly dubbed "the woman's film," which is supposed to represent a woman's fantasy or, like *Rebecca*, actually sets in play the terms of female desire, dominant cinema works for Oedipus.[27] If it stoops to the "old-fashioned psychological story," the tear-jerker from the "school of feminine literature," as Hitchcock lamented of his script for *Rebecca*, it is to conquer women's consent and so fulfill its social contract, the promise made to the little man.[28] Alas, it is still for him that women must be seduced into femininity and be remade again and again as woman. Thus when a film accidentally or unwisely puts in play the terms of a divided or double desire (that of the person Judy-Madeleine who desires both Scottie and the Mother), it must display that desire as impossible or duplicitous (Madeleine's and Judy's, respectively, in *Vertigo*), finally contradictory (Judy-Madeleine is split into Judy/Madeleine *for* Scottie); and then proceed to resolve the contradiction much in

the same way as myths and the mythologists do: by either the massive destruction or the territorialization of women.

This sounds harsh, I realize, but it is not hopeless. Women are resisting destruction and are learning the tricks of making and reading maps as well as films. And what I see now possible for women's cinema is to respond to the plea for "a new language of desire" expressed in Mulvey's 1975 essay. I see it possible even without the stoic, brutal prescription of self-discipline, the destruction of visual pleasure, that seemed inevitable at the time. But if the project of feminist cinema—to construct the terms of reference of another measure of desire and the conditions of visibility for a different social subject—seems now more possible and indeed to a certain extent already actual, it is largely due to the work produced in response to that self-discipline and to the knowledge generated from the practice of feminism and film.

[ · · · ]

It may well be, however, that the story has to be told differently. Take Oedipus, for instance. Suppose: Oedipus does not solve the riddle. The Sphinx devours him for his arrogance; he didn't *have* to go to Thebes by that particular crossroads. Or, *he* kills himself in disgust. Or, he finally understands Tiresias' accusation ("You are the rotting canker in the state") to mean that patriarchy itself, which Oedipus represents as he represents the state, is the plague that wastes Thebes—and *then* he blinds himself; after which, possibly, Artemis would grant that he become a woman, and here the story of Oedipus could end happily.[29] Or, it could start over and be exactly like Freud's story of femininity, and this version could end with a freeze-frame of him as a patient of Charcot at the Salpêtrière. Or . . . . But in any case if Oedipus does not solve the riddle, then the riddle is no longer a riddle; it remains an enigma, structurally insoluble because undecidable, like those of the Oracles and the Sybils. And men will have to imagine other ways to deal with the fact that they, men, are born of women. For this is the ultimate purpose of the myth, according to Lévi-Strauss: to resolve that glaring contradiction and affirm, by the agency of narrative, the autochthonous origin of man.[30] Or perhaps they will have to accept it *as* a contradiction, by which in any case they will continue to be born. And in this remake of the story the Sphinx does not kill herself in self-hatred (women do that enough as it is); but continues to enunciate the enigma of sexual difference, of life and death, and the question of desire. Why, asks Ursula LeGuin in her essay-fiction "It Was a Dark and Stormy Night: Why Are We Huddling about the Campfire?" why do we tell one another stories? Probably, she answers, just in order to exist, or to sustain desire even as we die from it.[31] The Sphinx, which according to the *Los Angeles Times* of March 2, 1982, is dying of cancer, as Freud was when he wrote the never-delivered lecture on femininity, is the enunciator of the question of desire as precisely enigma, contradiction, difference not reducible to sameness by the signification of the phallus or to a body existing outside discourse; an enigma which is structurally undecidable but daily articulated in the different practices of living. And this could be the end of my Oedipus story, but I had rather end it with a hopeful footnote.[32]

[ · · · ]

I am not advocating the replacement or the appropriation or, even less, the emasculation of Oedipus. What I have been arguing for, instead, is an interruption of the triple track by which narrative, meaning, and pleasure are constructed from his point of view. The most exciting work in cinema and in feminism today is not anti-narrative or anti-Oedipal; quite the opposite. It is narrative and Oedipal with a vengeance, for it seeks to stress the duplicity of that scenario and the specific contradiction of the female subject in it, the contradiction by which historical women must work with and against Oedipus.

> Long afterward, Oedipus, old and blinded, walked the roads. He smelled a familiar smell. It was the Sphinx. Oedipus said, "I want to ask one question. Why didn't I recognize my mother?" "You gave the wrong answer," said the Sphinx. "But that was what made everything possible," said Oedipus. "No," she said. "When I asked, What walks on four legs in the morning, two at noon, and three in the evening, you answered, Man. You didn't say anything about woman." "When you say Man," said Oedipus, "you include women too. Every-one knows that." She said, "That's what you think."[33]

## NOTES

1. Laura Mulvey, "Visual Pleasure and Narrative Cinema," *Screen* 16, no. 3 (Autumn 1975): 14.

2. Roland Barthes, "Introduction to the Structural Analysis of Narratives" in *Image-Music-Text*, trans. Stephen Heath (New York: Hill and Wang. 1977), p. 79. All further references to this volume will be cited in the text.

3. Contributors to the volume included Claude Bremond, A.-J. Greimas, and Tzvetan Todorov (on whose work Barthes draws heavily for his model): plus Umberto Eco and Christian Metz, whose paper "La grande syntagmatique du film narratif" virtually opened up the area of structural-semiotic analysis of cinema.

4. Metz's work on narrative structuration in classical cinema—*Film Language: A Semiotics of the Cinema*, trans. Michael Taylor (New York: Oxford University Press, 1974), and *Language and Cinema* (The Hague and Paris: Mouton, 1974)—had a great impact on the development of film theory (see, for example, Stephen Heath, "The Work of Christian Metz" in *Screen Reader 2* [London: SEFT, 1981], pp. 138–61); but was soon overshadowed by Metz's own subsequent work, *The Imaginary Signifier*, trans. Ben Brewster et al. (Bloomington: Indiana University Press, 1981), which shifted attention in the direction of psychoanalysis and questions of spectatorship.

5. Claire Johnston, "Women's Cinema as Counter-Cinema," in Claire Johnston, ed., *Notes on Women's Cinema* (London: SEFT, 1974), pp. 28 and 31.

6. "In *Visual Pleasure* my argument was axed around a desire to identify a pleasure that was specific to cinema, that is the eroticism and cultural conventions surrounding the look. Now, on the contrary, I would rather emphasise the way that popular cinema inherited traditions of story telling that are common to other forms of folk and mass culture, with attendant fascinations other than those of the look." Laura Mulvey, "Afterthoughts on 'Visual Pleasure and Narrative Cinema' inspired by *Duel in the Sun* (King Vidor, 1946)," *Framework*, no. 15/16/17 (1981), p. 13.

7. Roland Barthes, *The Pleasure of the Text*, trans. Richard Miller (New York: Hill and Wang, 1975), p. 10.

8. Robert Scholes, *Fabulation and Metafiction* (Urbana: University of Illinois Press, 1979), p. 26. The following quotes are from p. 27.

9.  H. J. Rose, *The Handbook of Greek Mythology* (New York: Dutton, 1959), p. 183. On the representation of difference in ancient Greek society, and the shift it underwent in the transition from literary-mythic to philosophical discourse between the fifth and the fourth centuries B.C., see Page du Bois, *Centaurs and Amazons: Women and the Pre-History of the Great Chain of Being* (Ann Arbor: The University of Michigan Press, 1982).

10.  Rose, p. 30.

11.  Ibid, p. 188.

12.  Hélène Cixous, "The Laugh of the Medusa," trans. Keith Cohen and Paula Cohen, in *New French Feminisms*, ed. Elaine Marks and Isabelle de Courtivron (Amherst: The University of Massachusetts Press, 1980), pp. 245–64. All further references to this work will be cited in the text.

13.  Shoshana Felman, "Rereading Femininity," *Yale French Studies*, no. 62 (1981), pp. 19 and 21. The text she quotes from is Freud, "Femininity," in *New Introductory Lectures on Psychoanalysis*, trans. James Strachey (New York: Norton, 1965), p. 112. In his biography of Freud, Ernest Jones states: "There is little doubt that Freud found the psychology of women more enigmatic than that of men. He said once to Marie Bonaparte: 'The great question that has never been answered and which I have not yet been able to answer, despite my thirty years of research into the feminine soul, is "What does a woman want?" ' " (*Sigmund Freud: Life and Work*, vol. 2, London, 1955, p. 468).

14.  Stephen Heath, *Questions of Cinema* (Bloomington: Indiana University Press, 1981), p. 53.

15.  Ibid., pp. 119–20. "The shift between the first and second looks sets up the spectator's identification with the camera (rigorously constructed, placing heavy constraints, for example, on camera movement). The look at the film is an involvement in identifying relations of the spectator to the photographic image (the particular terms of position required by the fact of the photograph itself), to the human figure presented in image (the enticement and the necessity of a human presence 'on the screen'), to the narrative which gives the sense of the flow of photographic images (the guide-line for the spectator through the film, the ground that must be adopted for its intelligible reception). Finally, the looks of the characters allow for the establishment of the various 'point of view' identifications (the spectator looking with a character, from near to the position of his or her look, or as a character, the image marked in some way as 'subjective')" (p. 120).

16.  Mulvey, "Visual Pleasure and Narrative Cinema," p. 13. In this connection should be mentioned the notion of a "fourth look" advanced by Willemen: a form of direct address to the viewer, an "articulation of images and looks which brings into play the position and activity of the viewer. . . . When the scopic drive is brought into focus, then the viewer also runs the risk of becoming the object of the look, of being overlooked in the act of looking. The fourth look is the *possibility* of that look and is always present in the wings, so to speak." (Paul Willemen, "Letter to John," *Screen* 21, no. 2 [Summer 1980]: 56.) I will return to this notion later on.

17.  See Claire Johnston, "Women's Cinema as Counter-Cinema," p. 27; and Pam Cook and Claire Johnston, "The Place of Women in the Cinema of Raoul Walsh," in *Raoul Walsh*, ed. Phil Hardy (Edinburgh: Edinburgh Film Festival, 1974).

18.  Heath, *Questions of Cinema*, p. 121. The reference to *Touch of Evil* is on p. 140.

19.  Lea Melandri, *L'infamia originaria* (Milan: Edizioni L'Erba Voglio, 1977).

20.  J. Laplanche and J.–B. Pontalis, *The Language of Psycho-Analysis*, trans. Donald Nicholson-Smith (New York: Norton, 1973), p. 205; my emphasis.

21.  This point is also made by Mulvey, "Afterthoughts . . . inspired by *Duel in the Sun*" (see note 6 above), who, on the basis of Freud's view of femininity, proposes that female spectators have access to the (film's) fantasy of action "through the metaphor of masculinity"; the

character of Pearl (Jennifer Jones), by dramatizing the oscillation of female desire between "passive" femininity and "regressive masculinity," encapsulates the position of the female spectator "as she temporarily accepts 'masculinization' in memory of her 'active' phase." However, Mulvey concludes, as Pearl's story illustrates, masculine identification for the female spectator is always "at cross purposes with itself, restless in its transvestite clothes" (p. 15). Although my discussion will develop in rather different ways, I fully share her concern to displace the active-passive, gaze-image dichotomy in the theory of spectatorship and to rethink the possibilities of *narrative* identification as a subject-effect in women spectators, an effect that is persistently denied by the prevailing notion of women's narcissistic over-identification with the image. See Mary Ann Doane, "Film and the Masquerade: Theorising the Female Spectator," *Screen* 23, no. 3–4 (September/October 1982): 74–87.

22. Freud, "Femininity," p. 131. It may be worth repeating, however, that Freud's view of the female's Oedipus situation underwent considerable transformation. In "The Dissolution of the Oedipus Complex" (1924) he held that "the girl's Oedipus complex is much simpler than that of the small bearer of the penis . . . it seldom goes beyond the taking of her mother's place and the adopting of a feminine attitude towards her father." In two subsequent papers, "Some Psychical Consequences of the Anatomical Distinction Between the Sexes" (1925) and "Female Sexuality" (1931), this situation became progressively more complex as Freud began to stress and to articulate the nature of the female's pre-Oedipal attachment to the mother. His last paper on "Femininity" (1933) was further informed by analytical accounts of adult female patients provided by women analysts.

23. See Jacqueline Rose, "The Cinematic Apparatus: Problems in Current Theory" in *The Cinematic Apparatus*, ed. Teresa de Lauretis and Stephen Heath (London: Macmillan and New York: St. Martin's Press, 1980), pp. 172–86. See also Heath, "Difference," *Screen* 19, no. 3 (Autumn 1978): 50–112.

24. This is particularly clear in Freud's analysis of the beating fantasy in males and females. See "A Child is Being Beaten," op. cit.

25. François Truffaut, *Hitchcock* (New York: Simon & Schuster, 1967), pp. 184, 186. All further references to this work will be cited in the text. The lead roles in *Vertigo* (1958) are James Stewart (Scottie), Kim Novak (Madeleine and Judy), and Barbara Bel Geddes (Midge).

26. Actually, we do not *see* Judy's body on the rooftop, but rather we imagine it, seeing Scottie's look. More precisely, the film imagines it for us by calling up the visual memory of Madeleine's body on the rooftop in an earlier shot from the same camera position now occupied by Scottie. This is one example, among many that could be brought, of the working of narrativity in the filmic text to construct a memory, a vision, and a subject position for the spectator. It is an especially clear example of the distinction made earlier between image and figure. While Scottie is the image we spectators look at, and Judy is not in the image at all, what we see (envision and understand) is the object of his look; what we are seeing is not the woman but her narrative image. Scottie is the figure of narrative movement, his look and his desire define what is visible or can be seen; Judy/Madeleine is the figure of narrative closure, on whom look and desire and meaning converge and come to rest. Thus it is only by considering the narrative and figural dimension embedded in vision, in our reading of an image, that the notion of "woman as image" can be understood in its complexity.

27. This is admirably demonstrated by Linda Williams in her extended review of *Personal Best*, Robert Towne's very popular film about two women pentathletes who are both friends and lovers, and competitors in the 1980 Olympics. While asserting a new ethic of support and cooperation among athletes who are female, the film denies or at least forcefully undercuts the significance of their lesbian relation and thus banishes one woman from its narrative conclusion in favor of reasserting the correct, adult heterosexuality of the other. Williams concludes: "This allows the film to recuperate their (unnamed) sensual pleasure into its

own regime of voyeurism. Ultimately, the many nude scenes and crotch-shots can be enjoyed much the way the lesbian turn-ons of traditional heterosexual pornography are enjoyed—as so much titillation before the penis makes its grand entrance." Linda Williams, *"Personal Best:* Women in Love," *Jump Cut,* no. 27 (July 1982), p. 12.

28. Despite the film's success and its winning an Oscar, Hitchcock himself does not like *Rebecca.* Asked by Truffaut whether he is satisfied with his first Hollywood film, the director answers: "Well, it's not a Hitchcock picture; it's a novelette, really. The story is old-fashioned; there was a whole school of feminine literature at the period, and though I'm not against it, the fact is that the story is lacking in humor. . . . [The film] has stood up quite well over the years. I don't know why." (*Hitchcock*, pp. 91–93).

29. Marie Balmary's reading of the Oedipus myth in *Psychoanalysing Psychoanalysis: Freud and the Hidden Fault of the Father*, trans. Ned Lukacher (Baltimore and London: The Johns Hopkins University Press, 1982) stresses the role of the father in the son's destiny as a function of identification. Balmary's reading is against Freud's own, and indeed takes place in the context of her reevaluation of the theory of the Oedipus complex in light of Freud's biography: as Oedipus was doomed to repeat unwittingly, by his crimes of incest and patricide, the faults of Laius (sexual violation of another's son and intended murder of his own), so did Freud repress the knowledge of his father's sexual incontinence (Jakob Freud's relationships with Rebecca, his mysterious second wife, and then with Sigmund's mother, his third wife). According to Balmary, it was Sigmund's repression of Jakob's "fault" that caused Freud to repudiate his first seduction theory, namely, that hysteria was the result of sexual overtures or actual seduction by the patient's father; and to discount the massive clinical evidence he had collected in the ten years prior to Jakob's death (1896) in favor of a seduction-fantasy theory based on the sudden "discovery" in 1897 that the Oedipus complex was a universal psychic structure. That latter, "idealist" model, she argues, was but a projection of Freud's own psychic reality, his symbolic identification with the father; and that has been the price to psychoanalytic theory of his complicity with the Law. Regrettably Balmary's analysis, contained within a Lacanian framework, draws no larger critical implications than those of a vaguely anti-Oedipal ethics.

30. See Lévi-Strauss, *Structural Anthropology*, pp. 212 and 226; "The myth has to do with the inability, for a culture which holds the belief that mankind is autochthonous . . . to find a satisfactory transition between this theory and the knowledge that human beings are actually born from the union of man and woman. Although the problem obviously cannot be solved, the Oedipus myth provides a kind of logical tool which relates the original problem—born from one or born from two?—to the derivative problem: born from different or born from same?" (p. 212) And "since the purpose of myth is to provide a logical model capable of overcoming a contradiction (an impossible achievement if, as it happens, the contradiction is real), a theoretically infinite number of slates will be generated, each one slightly different from the others. Thus, myth grows spiral-wise *until the intellectual impulse which has produced it is exhausted*" (p. 226; my emphasis).

31. Ursula K. Le Guin, "It Was a Dark and Stormy Night; or, Why Are We Huddling about the Campfire?" *Critical Inquiry* 7, no. 1 (Autumn 1980): 191–99.

32. The fact that at this moment in history, it is women, feminists, who speak from the place of the Sphinx, and who look at Perseus while Medusa is being slain, may not be inconsistent with the structural-Hegelian paradigm. But then, that would mean that the moral order of meaning and the rule of law of patriarchy are no longer those in relation to which woman is being constituted as subject. It would mean, in short, that our moment in history does mark the beginning of what Kristeva has called "the passage of patriarchal society." I said, a hopeful footnote.

33. Muriel Rukeyser, "Myth," in *The Collected Poems* (New York: McGraw-Hill, 1978), p. 498.

# MANTHIA DIAWARA

. . . . . . . . . . . . . . . . . . . . . . . . . . . . . . . . . . . . . . . . . . . . . . . . . . . . . .

# Black American Cinema: The New Realism

Manthia Diawara (b. 1953), presently chair of the Africana Studies Department at New York University, is one of the most important intellectuals engaged in black cultural studies, a project begun in the early 1980s in England by such figures as Stuart Hall (p. 77) and Paul Gilroy. A native of Mali, Diawara left for France upon finishing high school, then came to the United States. He received his Ph.D. in comparative literature and film from Indiana University, and his dissertation on the politics and aesthetics of African cinema provided the basis for *African Cinema,* published in 1985. Since then, Diawara has published widely on the topic of film and literature of the black diaspora. In 1993 he edited the volume *Black American Cinema,* and he is the author of *In Search of Africa* (1998), and *We Won't Budge: An African Exile in the World* (2003). He collaborated with Ngũgĩ wa Thiong'o in making the documentary *Sembene Ousmane: The Making of African Cinema* (1994), and also directed the documentaries *Rouch in Reverse* (1995), a critique of European visual anthropology through the work of Jean Rouch, a distinguished ethnographic filmmaker, and *Who's Afraid of N'gugi?* (2006) about the prominent Kenyan author.

In film studies, the growing discourse of black film has been broadened considerably by Diawara's groundbreaking work, particularly his rethinking of the questions of black spectatorship in relation to traditional Hollywood paradigms. If the work of Laura Mulvey questioned the universal paradigm of spectatorship and showed that it is gendered, Diawara further complicated the culturally inflected nature of spectatorship, showing that spectatorship is also shaped by class, race, and national identity, among other cultural identities. Diawara's positions are associated with the work of so-called strategic essentialists (among them Arthur Jafa, Greg Tate, and Tricia Rose) who are concerned with redefining reductive, narrow notions of cultural purity and monolithic conceptions of black culture. Focusing on the material conditions of black people in the Americas, Diawara also explores the ways in which African diasporic cultural production questions the simple notions of modernity and postmodernity.

Diawara's edited volume *Black American Cinema* was the first major collection of criticism on the topic (see also Toni Cade Bambara, p. 871) It explores the relationship between black American filmmakers and those from the diaspora, as well as the nature of black film aesthetics and the representation of a black imaginary, demonstrating the complexity and richness of the black contribution to American film at a moment (the early 1990s), when films by African American directors were achieving a new commercial viability. The first essay in the collection, Diawara's "Black American Cinema: The New Realism" describes the wide range of narrative and aesthetic modes used by a new generation of black filmmakers (such as Julie Dash, John Singleton, and Spike Lee) to represent black realities. Diawara argues that films that are broadly combined under the label the "New Black Realism," while seemingly adopting the conventions of verisimilitude of the classical Hollywood narrative, in fact employ different modes of narration to achieve their reality effect for black spectators. He identifies two narrative paradigms of black cinema: space-based

narration, which foregrounds the creation of spaces on the screen "for Black voices, Black history, and Black culture" that were previously nonexistent in mainstream Hollywood cinema; and time-based narration, where the linear progress of time is linked to the growth of the black characters on the screen, making "times exist for the purpose of defining their needs and their desires." Diawara shows that as the filmmakers grapple with both the complexity of the reality they want to represent and with mainstream representations of that reality on the screen, they have to invent new forms of realist aesthetics.

## READING CUES & KEY CONCEPTS

▨ According to Diawara, what is the relationship between black independent cinema and mainstream cinema?

▨ How is Diawara's notion of the New Black Realism different from other realist modes, such as classical Hollywood or Italian neorealism?

▨ Consider Diawara's description of realist aesthetic modes in representing black reality: "The new realism films imitate the existent reality of urban life in America." How is (or isn't) the very notion of filmic "realism" problematized in Diawara's formulation?

▨ **Key Concepts: New Black Realism; Space-Based Narrative; Time-Based Narrative; Race Films; Black Independent Cinema; Blaxploitation Films**

# Black American Cinema: The New Realism

. . . . . . . . . . . . . .

The release of D. W. Griffith's *The Birth of a Nation* in 1915 defined for the first time the side that Hollywood was to take in the war to represent Black people in America. In *The Birth of a Nation*, D. W. Griffith, later a founding member of United Artists, created and fixed an image of Blackness that was necessary for racist America's fight against Black people. *The Birth of a Nation* constitutes the grammar book for Hollywood's representation of Black manhood and womanhood, its obsession with miscegenation, and its fixing of Black people within certain spaces, such as kitchens, and into certain supporting roles, such as criminals, on the screen. White people must occupy the center, leaving Black people with only one choice—to exist in relation to Whiteness. *The Birth of a Nation* is the master text that suppressed the real contours of Black history and culture on movie screens, screens monopolized by the major motion picture companies of America.

Griffith's film also put Black people and White liberals on the defensive, inaugurating a plethora of historical and critical writings against *The Birth of a Nation*, and overdetermining a new genre, produced exclusively for Black audiences, called race films. More insidiously, however, the racial conflict depicted in *The Birth of a Nation* became Hollywood's only way of talking about Black people. In other words, whenever Black people appeared on Hollywood screens, from *The Birth of a Nation* to *Guess Who's Coming to Dinner?* to *The Color Purple*, they are represented as a problem, a thorn in America's heel. Hollywood's Blacks exist

primarily for White spectators whose comfort and understanding the films must seek, whether they thematize exotic images dancing and singing on the screen, or images constructed to narrate a racial drama, or images of pimps and muggers. With *The Birth of a Nation* came the ban on Blacks participating in bourgeois humanism on Hollywood screens. In other words, there are no simple stories about Black people loving each other, hating each other, or enjoying their private possessions without reference to the White world, because the spaces of those stories are occupied by newer forms of race relation stories which have been overdetermined by Griffith's master text.

The relations between Black independent cinema and the Hollywood cinema just described above parallel those between Blackness and Americanness; the dichotomy between the so-called marked cultures and unmarked cultures; but also the relations between "high art" and "low art." The complexity of these relations is such that every independent filmmaker's dream is to make films for Hollywood where she/he will have access to the resources of the studios and the movie theaters. On the other hand, the independents often use an aesthetic and moral high ground to repudiate mainstream cinema, which is dismissed as populist, racist, sexist, and reactionary. Furthermore, a look at the relations between Oscar Micheaux and the Hollywood "race films," Melvin Van Peebles and the Blaxploitation films, Charles Burnett (*Killer of Sheep*), Haile Gerima (*Bush Mama*), and Spike Lee and the rethematization of urban life in such films as *City of Hope, Grand Canyon, Boyz N the Hood*, and *Straight Out of Brooklyn* reveals that mainstream cinema constantly feeds on independent cinema and appropriates its themes and narrative forms.

Some of the most prominent Black film historians and critics, such as Albert Johnson, Donald Bogle, and Thomas Cripps, emphasize mainly mainstream cinema when discussing Black films. With the exception of a few breakthrough films, such as those by Micheaux, Van Peebles, and Lee, these historians are primarily concerned with the issues of integration and race relations in mainstream films, Black actors and actresses on the big screen, and the construction of stereotypes in Hollywood films. They rarely pay attention to independent cinema, which includes far more Black directors than Hollywood, and in which aesthetics, political concerns such as authorship and spectatorship, and the politics of representation with respect to Black cinema are more prevalent. Critics and historians such as Clyde Taylor, Toni Cade Bambara, Phyllis Klotman, and Gladstone Yearwood are the first to focus on Black independent cinema as a subject of study. More recently, the *Black Film Review* has assumed the preeminent role in Black film history and criticism.

Hollywood's block-booking system prevents independently produced films from reaching movie theaters and large audiences. This may be one reason why film historians and critics neglect independent cinema: some film magazines, such as *Cineaste*, adopt a policy of accepting only reviews of films that have been distributed and seen by their readers. It is also possible to argue that Black independent cinema has remained marginal until now because its language, not unlike the language of most independent films, is metafilmic, often nationalistic, and not "pleasurable" to consumers accustomed to mainstream Hollywood products. Black independent cinema, like most independent film practices, approaches film as a research tool.

The filmmakers investigate the possibilities of representing alternative Black images on the screen; bringing to the foreground issues central to Black communities in America; criticizing sexism and homophobia in the Black community; and deploying Afrafemcentric discourses that empower Black women. The narratives of such films are not always linear; the characters represent a tapestry of voices from W. E. B. DuBois, Frantz Fanon, Toni Morrison, Malcolm X, Martin Luther King, Jr., Karl Marx, Angela Davis, Alice Walker, and Zora Neale Hurston. Even what passes as documentary in Black independent films, like *The Bombing of Osage Avenue* (Louis Massiah), is an artistic reconstruction of archival footage and "real" events.

What is, therefore, the Black independent cinema, and what constitutes its influence on mainstream cinema? The French appropriately refer to independent cinema as *cinema d'art et essai*. In France, the government sponsors such a cinema by imposing a distribution tax on commercial films. The *cinema d'art et essai* is less concerned about recouping its cost of production and making a profit; its main emphasis is toward artistic development, documenting an area of research, and delineating a certain philosophy of the world. In the late 1950s, a group of French youth, who were dissatisfied with commercial films and wanted to make their own films, mobilized private and personal funds along with government funds to produce low-budget films. The result is well known today as the French New Wave, considered by some as one of the pivotal moments in film history.

As an alternative to commercial cinema, which emphasized the well-made story, acting, and the personality of the actor, the New Wave put in the foreground the director, whom it raised to the same artistic level as the author of a painting, a novel, or a poem; the New Wave also demystified the notion of the well-made story by experimenting with different ways of telling the same story, and by deconstructing the notion of actor and acting. Jean-Luc Godard's *Breathless* (1959), for example, is famous for its reinsertion of the "jump-cut" as a valid narrative device. The jump-cut, which was avoided in Hollywood films in order not to disrupt the spectator with "unnecessary" repetitions, has today become a powerful narrative device used by directors such as Spike Lee, who redefines it and uses it to describe the repetition and the sameness in racial and sexual stereotyping. In *Do the Right Thing* (1988) Lee uses the same angle to repeat several shots of Blacks, Italians, Jews, and Koreans repeating racial stereotypes, unlike Godard, who uses the same image twice from the same angle. Lee practices the same device in *She's Gotta Have It* (1985) to construct sexual stereotypes among young Black males.

This example of the New Wave reveals that independent filmmakers come to their vocation for at least two reasons: one political, and the other artistic. Politically, they are dissatisfied with commercial cinema's lack of courage to address certain issues. They feel that they have to make their own films if they want to see those issues on the screen. Artistically, they want to explore new ways of telling stories; they want to experiment with the camera, the most powerful invention of modern times, and engage the infinite possibilities of storytelling. There are other examples of alternative or independent cinemas that occupy important places in the history of film. The Italian Neorealism, the Brazilian Cinema Novo, and the Argentinian Third Cinema have all created alternative narrative techniques that were at first unknown to commercial cinemas, but are claimed today as part of traditional narrative practices.

Similarly, the closing of Hollywood's mind to Black history and culture, which do not revolve around White people, is the reason why most Black filmmakers since Oscar Micheaux have turned first to the independent sector. Since Oscar Micheaux, Black independents have pioneered creating alternative images of Blacks on the screen, constructing new narrative forms derived from Black literature and folklore, and denouncing racism, sexism and homophobia in American culture.

This is not, however, to romanticize the independent practice. Micheaux made his films by selling personal property and borrowing money from friends. Still today, independent filmmaking causes many people to become poor. It takes more than six years for some filmmakers to gather the money for one film. Charles Burnett's *To Sleep with Anger* and Julie Dash's *Daughters of the Dust* came only after arduous years of fund-raising. Haile Gerima has been trying to raise funds for *Nunu* for several years now. We have not yet seen second features by talented directors such as Billy Woodberry (*Bless Their Little Hearts*), Larry Clark (*Passing Through*), Alile Sharon Larkin (*A Different Image*), and Warrington Hudlin (*Street Corner Stories*). Spike Lee sums up the harsh reality of independent production as follows:

> When I went to film school, I knew I did not want to have my films shown only during Black History Month in February or at libraries. I wanted them to have a wide distribution. And I did not want to spend four or five years trying to piece-meal together the money for my films. I did my first film, *She's Gotta Have It*, independently for $175,000. We had a grant from the New York State Council on the Arts and were raising money the whole time we were shooting. We shot the film in twelve days. The next stage was to get it out of the lab. Then, the most critical part was when I had to hole up in my little apartment to get it cut. I took about two months to do that. I had no money coming in, so I had to hold off the debtors because I knew if I had enough time to at least get it in good enough shape to show, we could have some investor screenings, and that's what happened. We got it blown up to 35mm for a film festival. What you have to do is to try to get a distributor. You enter as many film festivals as you can.[1]

Black independent cinema is any Black-produced film outside the constraints of the major studios. The filmmakers' independence from Hollywood enables them to put on the screen Black lives and concerns that derive from the complexity of Black communities. Independent films provide alternative ways of knowing Black people that differ from the fixed stereotypes of Blacks in Hollywood. The ideal spectators of the films are those interested in Black people's perspectives on American culture. White people and Whiteness are marginalized in the films, while central positions are relegated to Black people, Black communities, and diasporic experiences. For example, the aesthetics of uplifting the race in a film like *The Scar of Shame* (1928, The Colored Players) concern particularly Black spectators, whom the filmmakers' stated mission is to entertain and educate. The film posits Black upper-class culture as that which should be emulated by lower-class Blacks in order to humanize themselves. Unlike Hollywood films of that time, which identified with the ideal White male, the camera in *The Scar of Shame* identifies with the position of the Black bourgeoisie. The film is precious today as a document of Black bourgeois ways of being in the 1920s and 1930s. Crucially, it constitutes, with Oscar Micheaux's films, a genre

of Black independent cinema which puts Black people and their culture at the center as subjects of narrative development; in these films, Black people are neither marginalized as a problem, nor singled out as villainous stereotypes such as Hollywood constructs in its films.

Contemporary independent films continue the same effort of inquiring into Black subjectivities, the heterogeneity of Black lives, the Black family, class and gender relations, and diasporic aesthetics. Recently, independent Black women filmmakers such as Kathleen Collins (*Losing Ground*), Alile Sharon Larkin (*A Different Image*), Ayoka Chenzira (*Zajota: the Boogie Spirit*), Julie Dash (*Daughters of the Dust*), and Zeinabu Davis (*A Powerful Thang*) have explored such themes as Black womanhood and spirituality, diaspora art and music, and Afrocentric aesthetics. Black manhood, the urban landscape, unemployment and the Black family are thematized in films like *Sweet Sweetback's Baadasssss Song* (Van Peebles), *Killer of Sheep* (Burnett), *Bless Their Little Hearts* (Woodberry), *Serving Two Masters* (Tim Lewis), *Street Corner Stories* (Warrington Hudlin), *Chameleon Street* (Wendell Harris), and *Ashes and Embers* (Haile Gerima). The themes of sexuality and homophobia are depicted in *Tongues Untied* (Marlon Riggs), *Storme: Lady of the Jewel Box* (Michelle Parkerson), *She's Gotta Have It* (Spike Lee), *Ganja and Hess* (Bill Gunn), *Splash* (Thomas Harris), and *She Don't Fade* (Cheryl Dunye). The major Black documentary artists, such as William Greaves, Louis Massiah, Camille Billops, and [St. Claire] Bourne, have also enriched the documentary genre by focusing their cameras on Black people in order to reconstruct history, celebrating Black writers and activists, and giving voice to people who are overlooked by television news and mainstream documentaries.

## Two Paradigms of Black Cinema Aesthetics

Jane Gaines defines Oscar Micheaux's editing style as follows: "Perhaps to elude any attempt to essentialize it, we could treat this style as more of an ingenious solution to the impossible demands of the conventions of classical Hollywood style, shortcuts produced by the exigencies of economics, certainly, but also modifications produced by an independent who had nothing at stake in strict adherence to Hollywood grammar." Gaines goes on to posit that Micheaux's "freewheeling cinematic grammar" constitutes both a misreading and an improvement upon Hollywood logic. Clearly, Micheaux's "imperfect" cinema (to borrow a term from Julio Garcia Espinoza), which misreads and improves upon Hollywood logic, is a powerful metaphor for the way in which African-Americans survived and continue to survive within a hostile economic and racist system, and used the elements of that survival as raw material to humanize and improve upon American modernism. Micheaux's "loose editing," like the improvisation of jazz, surprises and delights the spectator with forbidden images of America that Hollywood's America conceals from its space. In so far as the classical Hollywood narrative proceeds by concealment of space, Micheaux's "imperfect" narrative constitutes an excess which reveals the cheat cuts, the other America artificially disguised by the Hollywood logic. It is in this sense that Gaines writes of improvement of film language by Micheaux. Another contributor to the volume, Ron Green, compares Micheaux's film style to Black English, and to jazz. His cinema is one of the first to endow African-Americans with cinematic voice and subjectivity through his uncovering of new spaces at the threshold of dominant cinema.

The first step in interpreting a Black film aesthetic must therefore be directed towards an analysis of the composition of the new shots discovered by Micheaux, and their potential effects on spectators. In [*Black American Cinema*], Micheaux's films are discussed in an in-depth manner for the first time by Jane Gaines and Ron Green. Micheaux's legacy as an independent filmmaker not only includes his entrepreneurial style in raising money and making films outside the studios. He also turned his cameras towards Black people and the Black experience in a manner that did not interest Hollywood directors of race films. Crucially, Micheaux's camera positioned Black spectators on the same side as the Black middle-class ideology, acquiring for his films an aesthetic that was primarily specific to the ways of life of that class.

Similarly, in the 1970s, Melvin Van Peebles and Bill Gunn positioned spectators with respect to different imaginaries derived from the Black experience in America. In *Sweet Sweetback's Baadasssss Song*, Van Peebles thematizes Black nationalism by casting the Black community as an internal colony, and Sweetback, a pimp, as the hero of decolonization. Toni Cade Bambara refers to *Sweet Sweetback* as "a case of Stagolee meets Fanon or Watermelon Man plays Bigger Thomas." *Sweet Sweetback* is about policing and surveillance of Black communities, and the existentialist struggle of the film's main character, a Black man. As Bambara notices, Bigger Thomas is not the only literary reference in the film; it also draws on the theme of the running Black man in *Invisible Man*, which is collapsed into a transformed Hollywood stereotype of the Black stud. As such, *Sweet Sweetback* is famous as the paradigmatic text for the 1970s Blaxploitation films. The theme of the Black man running from the law or from Black-on-Black crime, which links Van Peebles to such Black American writers as Richard Wright, Ralph Ellison, and Chester Himes, is also echoed in 1990s films like *Juice*, *Straight Out of Brooklyn*, and *Boyz N the Hood*, not to mention *New Jack City*, a film directed by Van Peebles's son, Mario Van Peebles.

*Sweet Sweetback*'s aesthetic draws on the logic of Black nationalism as the basis of value judgment, and defines itself by positioning the spectator to identify with the Black male hero of the film. Bambara rightly criticizes the centrality of Black manhood at the expense of women in *Sweet Sweetback*, but recognizes nationalist narratives as enabling strategies for survival, empowerment, and self-determination. As Sweetback is helped to escape from the police by one Black person after another, the nationalist discourse of the film transforms the ghetto, where Black people are objects, into the community, where they affirm their subjecthood. To put it in Bambara's words, "Occupying the same geographical terrain are the *ghetto*, where we are penned up in concentration-camp horror, and the *community*, where we enact daily rituals of group validation in a liberated zone."

In *Ganja and Hess*, Bill Gunn aestheticizes the Black imaginary by placing the spectator on the same side as the Black church. The spectator draws pleasure from the film through the confrontation between the ideology of the Black church and vampirism, addiction to drugs and sex, and materialism. *Ganja and Hess* is perhaps the most beautifully shot Black film, and the most daring with respect to pushing different passions to their limits. The Black artist, Meda (played by Bill Gunn himself), is a nihilist who advocates total silence because, as a Black person, his art is always already overdetermined by race in America. The love scenes in the film are commingled with vampiristic gestures that are attractive and repulsive at the same time. At the Cannes Film Festival in 1973, Gunn's daring camera angles during

one of the loves scenes brought spectators to joy, applauding and screaming "Bravo! Bravo!" in the middle of the film. *Ganja and Hess* also pushes the classical narrative to the threshold by framing a frontal nude image of a Black man coming out of a swimming pool and running toward a window where a woman, Ganja (Marlene Clarke), smilingly awaits him.

What is radical about both *Ganja and Hess* and *Sweet Sweetback* is their formal positioning of Black characters and Black cultures at the center of the screen, creating a sense of defamiliarization of the classical film language. The two films also inaugurate for Black cinema two narrative tracks with regard to time and space. While *Ganja and Hess* is cyclical, going back and forth between pre-Christian time and the time after Christ, *Sweet Sweetback* is a linear recording of the progress of Black liberation struggle.

With regard to Black aesthetics, it is possible to put in the same category as *Ganja and Hess* such films as *A Powerful Thang* (Davis), *Daughters of the Dust* (Dash), *Losing Ground* (Collins), *Killer of Sheep* and *To Sleep with Anger* (Burnett), *Tongues Untied* (Riggs), and *She's Gotta Have It* (Lee). These films are concerned with the specificity of identity, the empowerment of Black people through mise-en-scène, and the rewriting of American history. Their narratives contain rhythmic and repetitious shots, going back and forth between the past and the present. Their themes involve Black folklore, religion, and the oral traditions which link Black Americans to the African diaspora. The narrative style is symbolic.

*Sweet Sweetback*, on the other hand, defines its aesthetics through recourse to the realistic style in film. The story line develops within the logic of continuity editing, and the characters look ordinary. The film presents itself as a mirror on a Black community under siege. The real effect is reinforced throughout the film by events which are motivated by racial and gendered causes. The sound track and the costumes link the film to a specific epoch in the Civil Rights Movement. Unlike the first category of films, which uses the symbolic style and concerns itself with the past, *Sweet Sweetback* makes the movement toward the future present by confronting its characters with obstacles ahead of them. Other films in this category include *Cooley High* (Michael Schultz), *House Party* (Reginald Hudlin), *Chameleon Street* (Harris), *Passing Through* (Clark), *Do the Right Thing* (Lee), *Straight Out of Brooklyn* (Rich), *Juice* (Ernest Dickerson), and *Boyz N the Hood* (Singleton). These lists are neither exhaustive nor fixed. The realist category has more in common with the classical Hollywood narrative, with its quest for the formation of the family and individual freedom, and its teleological trajectory (beginning, middle, and end). The symbolic narratives have more in common with Black expressive forms like jazz, and with novels by such writers as Toni Cade Bambara, Alice Walker, and Toni Morrison, which stop time to render audible and visible Black voices and characters that have been suppressed by centuries of Eurocentrism.

The comparison of the narrative styles deployed by *Sweet Sweetback* and *Ganja and Hess*[2] is useful in order to link the action-oriented *Sweet Sweetback* to modernism, and the reflexive style of *Ganja and Hess* to postmodernism. *Sweet Sweetback* defines its Afro-modernism through a performative critique of the exclusion of Blacks from reaping the fruits of American modernity and liberal democracy. *Ganja and Hess* is a postmodern text which weaves together a time of pre-Christian Africa, a time of Christ's Second Coming in the Black church, and a time of liberated Black

women. Crucially, therefore, the repetition of history as played out on the grid of the Black diaspora is important to the definition of Gunn's film language. Through the repetition of these Black times in the film, Bill Gunn defines a Black aesthetic that puts in the same space African spirituality, European vampire stories, the Black church, addiction to drugs, and liberated feminist desires.

## The New Black Films

It is easy to see the symbolic, reflexive, and expressive styles in films such as *Killer of Sheep* and *Daughters of the Dust,* and the active, materially grounded, and linear styles in *Boyz N the Hood*. But before looking more closely at these films, it is important to put into some perspective the ways in which Black films posit their specificity by challenging the construction of time and space in Hollywood films. It is only in this sense that arguments can begin about whether they displace, debunk, or reinforce the formulaic verisimilitude of Hollywood.

The way in which a filmmaker selects a location and organizes that location in front of the camera is generally referred to in film studies as mise-en-scène. Spatial narration in classical cinema makes sense through a hierarchical disposition of objects on the screen. Thus space is related to power and powerlessness, in so far as those who occupy the center of the screen are usually more powerful than those situated in the background or completely absent from the screen. I have described here Black people's relation to spatially situated images in Hollywood cinema. When Black people are absent from the screen, they read it as a symbol of their absence from the America constructed by Hollywood. When they are present on the screen, they are less powerful and less virtuous than the White man who usually occupies the center. Hollywood films have regularly tried to resolve this American dilemma, either through token or symbolic representation of Blacks where they are absent—for instance, the mad Black scientist in *Terminator 2*; or through a substitution of less virtuous Blacks by positive images of Blacks—for instance, *Grand Canyon* or *The Cosby Show*. But it seems to me that neither symbolic representation nor positive images sufficiently address the specificity of Black ways of life, and how they might enter in relation to other Americans on the Hollywood screen. Symbolic representation and positive images serve the function of plotting Black people in White space and White power, keeping the real contours of the Black community outside Hollywood.

The construction of time is similarly problematic in the classical narrative. White men drive time from the East to the West, conquering wilderness and removing obstacles out of time's way. Thus the "once upon a time" which begins every story in Hollywood also posits an initial obstacle in front of a White person who has to remove it in order for the story to continue, and for the conquest ideology of Whiteness to prevail. The concept of beginning, middle, and end, in itself, is universal to storytelling. The difference here is that Hollywood is only interested in White people's stories (White times), and Black people enter these times mostly as obstacles to their progress, or as supporting casts for the main White characters. "Once upon a time" is a traditional storytelling device which the storyteller uses to evoke the origin of a people, their ways of life, and the role of the individual in the society. The notion of *rite de passage* is a useful concept for describing the individual's separation from or incorporation into a social time. The classical narrative in cinema adheres to

this basic ideological formula in order to tell White people's stories in Hollywood. It seems that White times in Hollywood have no effect on Black people and their communities: whether they play the role of a negative or positive stereotype, Black people neither grow nor change in the Hollywood stories. Because there is a dearth of Black people's stories in Hollywood that do not revolve around White times, television series such as *Roots*, and films such as *Do the Right Thing*, which situate spectators from the perspective of a Black "once upon a time," are taken out of proportion, celebrated by Blacks as authentic histories, and debunked by Whites as controversial.

To return again to the comparison between *Sweet Sweetback* and *Ganja and Hess*, it is easy to see how important time and space are to defining the cinematic styles they each extol. The preponderance of space in films such as *Ganja and Hess* reveals the hierarchies of power among the characters, but it also reveals the preoccupation of this style of Black cinema with the creation of space on the screen for Black voices, Black history and Black culture. As I will show later with a discussion of space in *Daughters of the Dust*, Black films use spatial narration as a way of revealing and linking Black spaces that have been separated and suppressed by White times, and as a means of validating Black culture. In other words, spatial narration is a filmmaking of cultural restoration, a way for Black filmmakers to reconstruct Black history, and to posit specific ways of being Black Americans in the United States.

The emphasis on time, on the other hand, reveals the Black American as he/she engenders him/herself amid the material conditions of everyday life in the American society. In films like *Sweet Sweetback* and *Boyz N the Hood*, where a linear narrative time dominates, the characters are depicted in continuous activities, unlike the space-based narratives, where the past constantly interrupts the present, and repetitions and cyclicality define narration. Crucially, whereas the space-oriented narratives can be said to center Black characters on the screen, and therefore empower them, the Black-time narratives link the progress of time to Black characters, and make time exist for the purpose of defining their needs and their desires. Whereas the space-based narratives are expressive and celebratory of Black culture, the time-based narratives are existentialist performances of Black people against policing, racism, and genocide. I would like now to turn to *Daughters of the Dust* and *Boyz N the Hood* to illustrate the point.

## Space and Identity: Black Expressive Style *in* Daughters of the Dust

> *I am the first and the last*
> *I am the honored one and the scorned one*
> *I am the whore and the holy one*
> *I am the wife and the virgin*
> *I am the barren one and many are my daughters. . . .*
> *I am the silence that you cannot understand. . . .*
> *I am the utterance of my name.*
>
> *Daughters of the Dust*

I have argued that the Hollywood classical narrative often articulates time and space through recourse to a discriminating gaze toward American Blacks. When the story is driven by time and action, it is usually White time. I'll say more about this in

my discussion below of *Boyz N the Hood*. Similarly, when spatial considerations dominate the production of the story, the purpose is usually to empower White men. Common sense reveals that characters that are more often on the screen, or occupy the center of the frame, command more narrative authority than those that are in the background, on the sides, or completely absent from the frame. By presence, here, I have in mind first of all the literal presence of White characters in most of the shots that constitute the typical Hollywood film, which helps to define these characters as heroes of the story. There is also the symbolic presence through which narrative authority for the organization of space is attributed to certain characters in the story. These devices of spatial narration are effective in linking characters with spaces, and in revealing space occupancy as a form of empowerment. For example, through the character played by Robert Duval in *Apocalypse Now*, Francis Ford Coppola parodies the power associated with White male actors such as John Wayne as they are framed at the center of the screen.

There is preponderance of spatial narration in Julie Dash's *Daughters of the Dust*. Black women and men occupy every frame of the film, linking Black identity to a place called Ibo Landing in the Sea Islands of South Carolina, and, more importantly, empowering Black women and their ways of life. On a surface and literal level, the wide appeal of the film for Black women depends on the positioning of the women characters as bigger than life in the middle of the screen, which mirrors the beautiful landscape of Ibo Landing. Black women see themselves on the screen, richly adorned, with different hues of Blackness and Black hair styles, and flaunting their culture. In *Daughters of the Dust*, the screen belongs to Black women. At a deeper level, where space and time are combined into a narrative, Julie Dash emphasizes spatial narration as a conduit to Black self-expressivity, a storytelling device which interrogates identity, memory, and Black ways of life. *Daughters of the Dust* stops time at 1902, when the story was set, and uses the canvas of Ibo Landing in the Sea Islands to glance backward to slavery, the Middle Passage, African religions, Christianity, Islam, the print media, photography, moving pictures, and African-American folkways, as elements with which Black people must come to terms in order to glance forward as citizens of the United States. In other words, the film asks us to know ourselves first, know where we came from, before knowing where we are going. To put it in yet another way, Ibo Landing is a symbolic space in which African-Americans can articulate their relation to Africa, the Middle Passage, and the survival of Black people and their ways of life in America. Crucially, the themes of survival, the memories of African religions and ways of life which enter into conflict with Christianity and European ways of life, and the film's proposal of syncretism as a way out, are narrativized from Black women's points of view.

**[ · · · ]**

I have discussed so far the ways in which *Daughters of the Dust* uses African belief systems as the center which enables Black women and men to articulate their identities on the space of Ibo Landing. Grandma Nana, particularly, posits the ancestor worship system as a text which holds together the world of Ibo Landing and provides answers to practical daily problems. A crucial question remains: whether the belief in ancestors can coexist with other belief systems, such as Christianity and Islam, on and off the island? At first, religious systems seem to be opposed in *Daughters of*

*the Dust.* Bilal, who is Muslim, is opposed to the Baptists, who think that their God is better. Viola and Haagar use Christianity to elevate themselves above Grandma Nana. They see ancestor worship as an idolatry which is confined to Ibo Landing. They look to the North as a sign of enlightenment and Christian salvation.

Clearly, Julie Dash represents all these belief systems on the space of Ibo Landing not to show the fixity of different religions, and their essentialist nature, but to propose all of them as part of what makes Black people in America complex. Toward the end of the film Grandma Nana brings together the different belief systems, when she ties together the Bible and a sacred object from her own religion, and asks every one to kiss the hybridized Bible before departing from the island. This syncretic move is her way of mixing up the religions in Ibo Landing, and activating their combined power to protect those who are moving North. Earlier in the film she commands Eli to "celebrate our ways" when he goes North. The syncretic move is therefore also a survival tactic for the African ways of life up North.

Arguably, another reason for deploying ancestor worship (and casting Grandma Nana at the center in the film) is to reveal its usable power in holding the Black family together. Placing women at the center of the frame is also Julie Dash's way of creating space for Black people in modernity, as is her redefinition of Black images in their relation to such modern tools as still photography, newspapers, and moving pictures. Julie Dash's spatial narrative style inextricably combines the identities of her characters with the landscape of Ibo Landing. Her mise-en-scène of Grandma Nana, Haagar, Yellow Mary, and Eula in the center of the frame makes the space theirs, and their possession of the space makes them bigger than life. They become so associated with the space of Ibo Landing, through close-ups of various sorts, that it becomes difficult to imagine Ibo Landing now without the faces of these Black women. Analogically speaking, it is like imagining America in Western films without the faces of John Wayne, Kirk Douglas, and Gary Cooper.

The spatial narrative style of *Daughters of the Dust* enables Julie Dash to claim America as the land of Black people, to plot Africanism in American ways of life, and to make intelligible African voices that were rendered inarticulate. To return to the thematization of religion in the film, Julie Dash has made manifest an Africanism that was repressed for centuries, but that refused to die. As Grandma Nana states, "those African ancestors sneak up on you when you least suspect them." With her revival of ancestor worship as a narrative grid, as a point of reference for different themes in the film, Julie Dash has ignited the fire of love and caring among Black people. The path between the ancestors and the womb constitutes a Black structure of feeling, a caring handed down from generation to generation, which commands us to care for our children. In an article entitled "Nihilism and Black America," Cornel West proposes "a politics of conversion" as a way out of the carelessness of Black-on-Black crime, and as a protection against "market-driven corporate enterprises, and white supremacism." For West,

> The genius of our black foremothers and forefathers was to create powerful buffers to ward off the nihilistic threat, to equip black folk with cultural armor to beat back the demons of hopelessness, meaninglessness, and lovelessness. . . . These traditions consist primarily of black religious and civic institutions that sustained familial and communal networks of support.[3]

Perhaps Julie Dash's theory of ancestor worship should be among those institutions that constitute Black structures of feeling; as Grandma Nana puts it, let the ancestors guide us and protect us.

## *Black Times, Black Stories:* Boyz N the Hood

*Either they don't know, or don't show, or don't care about what's going on in the 'Hood.*

*Boyz N the Hood*

To return now to *Boyz N the Hood*, I would like to illustrate its emphasis on time and movement as a way of defining an alternative Black film language different from the spatial and expressive language of *Daughters of the Dust*. Like *Daughters of the Dust*, *Boyz N the Hood* begins with a well-defined date. But unlike *Daughters of the Dust*, which is set in 1902 and looks into the past as a way of unfolding its story, *Boyz N the Hood* starts in 1984, and continues for more than seven years into the future. *Daughters of the Dust* is about Black peoples' reconstitution of the memories of the past; it is a film about identity, and the celebration of Black ways of life. *Boyz N the Hood*, on the other hand, is a rite of passage film, a film about the Black man's journey in America. The story line is linear in *Boyz N the Hood*, whereas *Daughters of the Dust* unfolds in a circular manner.

In films like *Boyz N the Hood*, *Juice*, *Straight Out of Brooklyn*, and *Deep Cover*, the narrative time coincides with the development of the lives of the characters in the films. Many of these films begin with the childhood of the main characters, who then enter into adulthood, and face many obstacles in their lives. These films produce an effect of realism by creating an overlap between the rite of passage into manhood and the narrative time of the story. The notion of rite of passage, which defines the individual's relation to time in terms of separation from or incorporation into society, helps us to understand the use of narrative time in a film like *Boyz N the Hood*. The beginning, middle, and end of *Boyz N the Hood* constitute episodes that mark the young protagonist's incorporation into the many levels of society. In fact, the structure of the film is common to African-American folktales, as well as to the classical cinema. It is as follows: A boy has to go on a journey in order to avert an imminent danger. He travels to the home of a relative or friend (uncle, aunt, father, mother, wise man, and so on) who teaches him, or helps him to overcome the obstacle. At the end, he removes the danger, and his nation (or community, or family) gets stronger with him. This skeletal structure is common to texts as diverse as *The Epic of Sunjata* (D. T. Niane), the *Aeneid* (Virgil), and *The Narrative of the Life of Frederick Douglass* (Douglass), as well as to the Hollywood Western genre, the martial art films, and the Rocky films with Sylvester Stallone. The literal journey in time and space overlaps with the symbolic journey of the rite of passage. Typically, this type of storytelling addresses moments of crisis, and the need to build a better society.

The moment of crisis is symbolized in *Boyz N the Hood* by the opening statistical information, which states that "One out of every twenty-one Black American males will be murdered in their lifetime. Most will die at the hands of another Black male." Thus, *Boyz N the Hood* is a cautionary tale about the passage into manhood, and about the development of a politics of caring for the lives of Black males. More specifically, it is about Tre Styles (Cuba Gooding Jr.), the main character, and his relation to the

obstacles that he encounters on his way to manhood. Crucially, the major distractive forces in the film are the police, gang life, and the lack of supervision for the youth. To shield Tre from these obstacles, his mother sends him to live with his father, whose teaching will guide him through the many rites of passage toward manhood.[4]

The film is divided into three episodes, and each episode ends with rituals of separation and transition. In the first episode the ritual ends with Tre leaving his mother (first symbol of weaning) and friends behind. The story of this episode implies that most of the friends he leaves behind will not make it. On the way to his father's house, Tre's mother says, "I don't want you to end up dead, or in jail, or drunk standing in front of one of these liquor stores." The second episode ends with Doughboy's (Ice Cube) arrest by the police, who take him to the juvenile detention camp. The third episode ends with the death of Ricky Baker, Doughboy, and many other Black males. At the end of each episode, Tre moves to a higher understanding of life.

[ · · · ]

Signs (Stop, One Way, Wrong Way, LAPD, Liquor Store, POLICE LINE DO NOT CROSS, and so on) play an important role in limiting the movement of people in South Central Los Angeles. Showing the airplane flying over the roofs not only indicates where we are in LA, but also suggests the freedom associated with flying away from such an enclosed space. Black American literature often draws on the theme of flying to construct desire for liberated spaces: Bigger Thomas of *Native Son* (Richard Wright) sees flying as a way out of the ghetto of South Side Chicago; Milkman of *Song of Solomon* (Morrison) reenacts the myth of flying Americans in order to free himself from an unwanted situation.

The signs become control tools for the police, in the way that they limit individual freedom of movement in the "hood." They also define the hood as a ghetto by using surveillance from above and outside to take agency away from people in the community. In fact, *Boyz N the Hood* is about the dispute over agency and control of the community that pits the protagonist and his allies against gang members and the police. The drawings of helicopters, police cars, and wanted men show how the police surveillance has penetrated the imaginary even of schoolchildren in the hood. Later on in the film, helicopter noise, police sirens, and police brutality are revealed to be as menacing and distracting to people in the hood as drugs and gang violence.

The dispute over the control of the hood is also a dispute over images. The police need to convince themselves and the media that every Black person is a potential gang member, armed and dangerous, in order to continue the policing of the hood in a terroristic and militaristic manner. For the Black policeman in the film, the life of a Black person is not worth much: "one less nigger out in the street and we won't have to worry about him." It is by making the gang members and other people in the hood accept this stereotype of themselves that the community is transformed into a ghetto, a place where Black life is not worth much. It seems to me that *Boyz N the Hood* blames the rise of crime and the people's feeling of being trapped in the hood on a conspiracy among the gang members, the police, the liquor stores, and Reagan. Indeed, the film raises questions of human rights violation when gang warfare and police brutality collude to prevent people from moving around freely, sleeping, or studying.

On the other hand, Tre's struggle to gain agency also coincides with his passage to manhood, and the development of a politics of caring for the community. *Boyz N the Hood*, in this respect, is one of the most didactic Black films. The other

contenders are *Deep Cover*, and perhaps some rap videos which espouse a politics of identification with lawbreakers against the police.[5] The didacticism of *Boyz N the Hood* emanates from the film's attempt to teach Tre not to accept the police's and the media's stereotype of him and other young Black males as worthless; and to teach him to care for his community and reclaim it from both the gangs and the police. Didactic film language abounds in the film. We see it when the camera lingers on the liquor stores and homeless people, as Tre and his mother drive to his father's house. The mother, in one of the first instances of teaching Tre in the film, states that she loves him and that is why she is taking him out of this environment. Earlier in the same episode, we also saw the Reagan posters interpreted in a didactic manner, so as to blame him for the decay of the urban community. The posters are situated in the same environment as the murder scene.

However, Tre's father, more than the didactic camera and editing styles, is the central figure of judgment in the film. He calls the Black policeman "brother" in order to teach him, in the presence of Tre, how to care about other Black people; he delivers lessons on sex education, Black-on-Black crimes, the dumping of drugs in the Black community, gentrification, and the importance of Black-owned businesses in the Black community. He earns the nickname of preacher, and Tre's friends describe him as a sort of "Malcolm/Farrakhan" figure. Crucially, his teachings help Tre to develop a politics of caring, to stay in school, and more importantly, to stay alive. It is revealing in this sense that a didactic and slow-paced film like *Boyz N the Hood* can be entertaining and pleasurable at the same time.

## The New Black Realism

Realism as a cinematic style is often claimed to describe films like *Boyz N the Hood*, *Juice*, and *Straight Out of Brooklyn*. When I taught *Boyz N the Hood*, my students talked about it in terms of realism: "What happened in the film happens every day in America." "It is like it really is in South Central LA." "It describes policing in a realistic manner." "The characters on the screen look like the young people in the movie theater." "It captures gang life like it is." "It shows Black males as an endangered species." "I liked its depiction of liquor stores in the Black community." "I identified with Ice Cube's character because I know guys like that back home."

Clearly, there is something in the narrative of films like *Boyz N the Hood* and *Straight Out of Brooklyn* that links them, to put it in Aristotelian terms, to existent reality in Black communities. In my class, some students argued that these films use hip hop culture, which is the new Black youth culture and the most important youth culture in America today. Thus, the characters look *real* because they dress in the style of hip hop, talk the lingo of hip hop, practice its world view toward the police and women, and are played by rap stars such as Ice Cube. Furthermore, the films thematize an advocacy for Black males, whom they describe as endangered species, in the same way that rap groups such as Public Enemy sing in defense of Black males.

It seems to me, therefore, that the films are about Black males' initiation into manhood, the obstacles encountered that often result in death and separation, and the successful transition of some into manhood and responsibility toward the community. In *Juice*, for example, of the four young boys who perform the ritual of growing

up, two die, one is seriously injured by a gun shot, and only one seems to have been successfully incorporated into society. Removing obstacles out of Black males' way is also the central theme of *Chameleon Street, Straight Out of Brooklyn, Deep Cover* and *Boyz N the Hood.*

In *Deep Cover*, the ritual of manhood involves the main character's exposure of a genocide plotted by drug dealers in Latin America and the highest officials in the US government against the Black community. The real "deep cover" in *Deep Cover* is the recipe for caring for the community against genocidal forces like White supremacists, drugs, and Black-on-Black crime. The removal of obstacles out of the main character's way leads to the discovery of the politics of caring to the Black community. In this film, as in many new Black realism films, to be a man is to be responsible for the Black community, and to protect it against the aforementioned dangers. John (Larry Fishburne), a cop working undercover as a drug dealer, enters in an intriguing relationship with a Black detective (Clarence Williams), who plays the born-again policeman. The religious policeman keeps reminding John of his responsibility to the community, and John laughs at him. Toward the end of the film, when the character played by Clarence Williams gets shot, John is united with him by the force of caring, and realizes that he must fight both the drug dealers and the police to protect his own.

A key difference between the new Black realism films and the Blaxploitation series of the 1970s lies in character development through rites of passage in the new films. Unlike the static characters of the Blaxploitation series, the characters of the new realism films change with the enfolding of the story line. As characters move obstacles out of their way, they grow into men, and develop a politics of caring for the community. The new realism films imitate the existent reality of urban life in America. Just as in real life the youth are pulled between hip hop life style, gang life, and education, we see in the films neighborhoods that are pulled between gang members, rappers, and education-prone kids. For the black youth, the passage into manhood is also a dangerous enterprise which leads to death both in reality and in film.

## NOTES

1. Janice Mosier Richolson, "He's Gotta Have It: An Interview with Spike Lee," in *Cineaste*, Vol. 28, No. 4, (1992), p. 14.

2. For more on the aesthetics of *Sweet Sweetback* and *Ganja and Hess*, see the important book, *Black Cinema Aesthetics: Issues in Independent Black Filmmaking*, edited by Gladstone L. Yearwood, Athens: Ohio University Center for Afro-American Studies, 1982; Tommy L. Lott, "A No-Theory Theory of Contemporary Black Cinema," in *Black American Literature Forum* 25/2 (1991); and Manthia Diawara and Phyllis Klotman, "*Ganja and Hess:* Vampires, Sex, and Addictions," in *Black American Literature Forum* 25/2 (1991).

3. Cornel West, "Nihilism in Black America," in *Dissent* (Spring 1991), 223.

4. Clearly, there is a put-down of Black women in the rhetoric used to send Tre to his father's house. For an excellent critique of female-bashing in the film see Jacqui Jones, "The Ghetto Aesthetic," in *Wide Angle*, Volume 13, Nos. 3 & 4 (1991), 32–43.

5. See Regina Austin, " 'The Black Community,' Its Lawbreakers and a Politics of Identification," in *Southern California Law Review* (May 1992), for a thorough discussion of Black peoples' identification with the community and its lawbreakers.

# JANE FEUER

## Narrative Form in American Network Television

Jane Feuer (b. 1951) is Professor of English at the University of Pittsburgh and an influential theorist of television, genre, and popular culture. She is the author of *The Hollywood Musical* (1983) and *Seeing through the Eighties: Television and Reaganism* (1995) as well as a contributor to the online journal *Flow*. Her work on television, like that of other cultural studies scholars, presents a significant break with mass communications research that approaches the medium empirically.

Attention to television significantly complicates many of film studies' assumptions about audiovisual texts and their social uses. Feuer usefully brings the insights of film theory to her work on television, illuminating the similarities and, above all, the differences between the two. Succinctly and persuasively, Feuer argues that television deploys different narrative qualities than film, which has a more direct debt to the novelistic: television values open-endedness over closure, character over causality, "menu-driven" rather than linear plots. These narrative differences are accompanied by different modes of spectatorship; the television viewer is envisioned as a family member in the home, not as an abstract spectator-subject. Accordingly, television draws on a myth of presence, directly addressing the viewer and demanding interactivity, rather than effacing the signs of the apparatus as classical cinema is assumed to do.

In her 1986 essay "Narrative Form in American Network Television," Feuer distinguishes between two genres that exemplify these narrative qualities: the episodic series and the continuing serial drama. Using classic "quality" 1970s sitcoms like *All in the Family* and *The Mary Tyler Moore Show* and 1980s serial dramas like *Dynasty* as examples, Feuer shows how these forms go about their social and ideological projects differently. Episodic series like sitcoms perpetually reintegrate the family, Feuer argues; serials dramatize the family's continual disintegration. Feuer suggests that viewers tune in to such shows each week to experience these tentative resolutions; in this way, she shows how narrative—the tale itself—is always connected with "narrativity," or the telling of the tale. The historical value of Feuer's piece is enhanced as she considers U.S. network television as it begins to transition to an increased emphasis on serialization, a trend that has continued in the "post-network" era. Plots not only carry over from episode to episode but narrative elements spill over into other media like the Internet (see Henry Jenkins, p. 619). Feuer's argument is helpful in assessing these developments in the medium that has remained the dominant narrative engine within U.S. society for more than half a century.

## READING CUES & KEY CONCEPTS

■ Feuer claims that "television as an apparatus differs in almost every significant respect from cinema." Enumerate some of these differences, and consider their implications.

■ How does Feuer connect the dominant mode of viewing television to the psychology of the viewer? How does it differ from film spectatorship? What conclusions might be drawn about interacting with computers?

■ How and why is television a "familialized" technology? How do understandings of the family play out in the form as well as the content of television genres?

■ **Key Concepts:** Aesthetics of Presence; Episodic Series; Continuing Serial Drama

# Narrative Form in American Network Television

· · · · · · · · · · · · ·

Theories of television narrative have attempted to situate the television "appa-ratus" both in its continuity with earlier narrative forms and in its difference from them. Much British television theory appears to accept the premise that

> like cinema, television is an apparatus used for the production-reproduction of the novelistic; it serves to address the problem of the definition of forms of indi-vidual meaning within the limits of existing social representations and their determining social relations, the provision and maintenance of terms of social intelligibility for the individual.[1]

Certainly, in a broad historical sense, one cannot take exception to this claim. How-ever, to follow out this line of reasoning is to stress television's similarity to the novel and cinema, rather than its differences from other narrative forms. In what follows, I will stress theories of difference over those of continuity, since I believe that television[2] as an apparatus differs in almost every significant respect from cinema. Television is not very well described by models of narrative analysis based on linearity and resolu-tion. Nor is its metapsychology that of the cinema. According to Rick Altman,

> Whereas the level of audience attention to a given Hollywood film scene may be roughly dependent on the importance of that scene for resolving the plot's di-lemmas, attention to a given *Dallas* scene depends instead on the topic and characters present. In recognition of this difference, we might say that classical Hollywood narrative is in large part *goal-driven*, while attention to American television narrative is heavily *menu-driven*.[3]

If the historical subject for the novel and cinema has been the isolated individual "reader/spectator," then the subject interpellated by television has been always al-ready familial.

## *Television Narrative Structure*

Most theories of cinematic narrative have stressed a linear, causal model derived from the work of Roland Barthes and others. That this is the dominant model for conceptualizing cinematic narrative is illustrated by a definition of "narrative"

given in a popular film introductory text as "a chain of events in cause/effect relation-ship occuring in time."[4] Following Barthes, the narrative structure of the classical Hollywood text is seen as proceeding through a chain of narrative "enigmas" toward closure. Although much criticism has been leveled at such a totalizing theory of cin-ematic narrative (not the least because it describes masculine genres better than feminine genres) I believe that it is even less applicable to the operation of television. The television apparatus works against logical notions of causality and closure. According to John Ellis, television narrative operates through the segment, i.e. a relatively self-contained scene that is discontinuous with other segments. Ellis goes on to argue that "movement from one segment to the next is a matter of succession rather than consequence." Thus, for Ellis, all television narrative is *serial* rather than linear, in the sense that "the series implies the form of the dilemma rather than that of resolution and closure."[5] In this sense, neither of the two forms of television nar-rative that I will discuss—the episodic series and the continuing serial—correspond to the dominant model of popular cinematic narrative. However, their methods of non-correspondence differ.

## METAPSYCHOLOGY

The dominant model of the "cinematic apparatus" based on the work of Metz, Baudry and others does not account very well for television. Television may be seen to possess a different "imaginary" from cinema, to articulate a different position for its subject, and to demand ways of looking which do not correspond to mirror-identification and voyeurism as they have been described for the cinema. In another context, I have argued that so-called magazine format non-fiction television sets up an idealized quasi-nuclear family whose unity is seen as an attribute of the medium itself.[6] This representational strategy has its completion in the mode of address of the apparatus—"from our family to yours." (These are the actual words used in the Christmas mes-sage sent to "my family" by the local news "team" in my market.) That is to say that the "implied spectator" for television is not the isolated, immobilized pre-Oedipal individual described by Metz and Baudry in their metapsychology of the cinema, but rather a post-Oedipal, fully socialized family member. Thus we need to revise a model of specularity derived from the cinema by providing for television a new destination to Metz's quest in *The Imaginary Signifier* for an analogue to the Lacanian mirror.[7] For television, we would have to dispute or at least reformulate Metz's claim that the spectator's own body is never reflected in the mirror. To be perversely literal-minded (in keeping with the spirit of much metapsychological speculation of this ilk), the television screen *does* reflect the body of the family, if we turn the images off. This is perhaps a metaphorical way of arguing that the rep-resentational content of television proposes a reflection, however distorted, of the body of the familialized viewing subject. We are not dealing with the same degree of signification-by-absence that can be deduced from an examination of the "basic cinematographic apparatus" if only because, as I have argued at length elsewhere, television disseminates an ideology of presence that has its basis in the presumed "live" status of the apparatus.[8]

By extension, the unevenly developed dialectic of voyeurism and exhibition-ism that Metz theorizes for the cinema does not operate with the same force for

television. Far from wanting to disguise its discourse as story, television seems to want to foreground its discursive status. As Robert Stam has written regarding television news, "if illusionistic fictions disguise their discourse as history, television news, in certain respects, wraps up its history as discourse."[9] This calls into question a model of spectatorship based upon voyeurism. Television's foremost illusion is that it is an *interactive medium*, not that we are peering into a self-enclosed diegetic space. This generalized stance of the apparatus as a whole, due in part to the property of "flow," tends to carry over to the more cinematic narrative modes of the episodic series and the continuing serial, if only because these "diegetic" fictions are continually interrupted (especially on American television) by more discursive structures in the form of voice-over announcements, commercials, and promotional "spots." The "diegesis" in television can never be sustained in the imaginary of the cinema either at a narrative level or at the level of modes of reception. As Raymond Williams has explained, the historically determined mode of reception for television in the West depends upon a social use of technology "which served an at once mobile and home-centered way of living: a form of *mobile privatization*."[10] This is in sharp contrast to the psychoanalytical view of the historical conditions of reception for theatrical cinema which might be described as "immobilized public consumption." In this regard, it is important to take into account studies which demonstrate the viewer's "talking back" to television—a process now literalized on certain cable systems by interactive cable capability, but also an implied feature of network television. The very concept "diegesis" is unthinkable on television. One rather astonishing example of television's tendency to "break" the cinematic diegesis (that I have observed recently) is a pattern of interrupting the ten o'clock drama with "promos" for the eleven o'clock local news in which the news anchors, in direct address, attempt to draw parallels between the presumed diegetic fiction and a "real" happening that will be "covered" in the forthcoming news broadcast. For example, a "news report" on college students' ritualistic viewing of *Dynasty* was announced during the commercial break preceding the last segment of *Dynasty* and then broadcast during the news report directly following *Dynasty*. Similarly, following a "trauma drama" on teen suicide, the eleven o'clock news announced and subsequently presented "expert" psychological advice on how to recognize suicidal tendencies in "your" children. The example appears all the more bizarre if considered in terms of screen theory, when one recognizes that the identical "expert advice" had already been given within the diegesis of the made-for-TV film in the form of a public address to a self-help group given by the mother of one of the dead children. Yet it does not appear bizarre to the viewing subject thus addressed precisely because such disregard for the diegetic is a *conventional* television practice, not an exceptional one. Television as an ideological apparatus strives to break down any barriers between the fictional diegesis, the advertising diegesis, and the diegesis of the viewing family, finding it advantageous to assume all three are one and the same.

## FAMILIALIZED TECHNOLOGY

In order to deal with differences within American network television's representational mode, a good place to begin would be in the different strategies for dealing with "the family," both at the level of narration and that of mode of reception.

Although both the episodic series and the continuing serial are serial forms con-stituted by the media's economically derived need for perpetual self-reduplication, they differ in their narrative strategies. The self-replication of the episodic series depends upon a continual re-integration of the family; that of the continuing serial depends upon a continual disintegration of the family.

In almost Lévi-Straussian terms, the dominant binary opposition informing television's representational practices is that of inside the family/outside the fam-ily. Both the episodic series and the continuing serial have as their "irresolvable" cultural contradiction the need to explain factors which in reality are "outside" in terms of the "inside." For television, both the economic and the socio-political cannot be thought except in terms of "inside the family"—an impossible dilemma, if indeed such dilemmas cannot be resolved inside the family. The social may not be equivalent to the familiar, but for ideological reasons, television's narrative representations would have it so. Here we must part company with Lévi-Strauss, in order to note that the inability to resolve the inside/outside contradiction is not a universal attribute of the human mind but rather an ideological construct derived from the social formation as a whole and buttressed by the specific role of the television apparatus as a mechanism for reproducing ideology. Thus the television "apparatus" is historically determined.

Recent revisionist broadcast historians have emphasized the extent to which a *social* conception of broadcast technology influenced the development of that tech-nology in the direction of Williams's "mobile privatization." According to these historians, the technology by no means determined its innovation as an apparatus for private consumption within the family. In its experimental period, television's ini-tial location was in the public theater, and it was primarily its association with radio that led to television's innovation as a home-based advertising media in America.[11] Radio itself had been instrumental in the growth of consumerism, the process of changing the American home into a unit for consumption rather than production. In this changing ideology of the home, the radio receiver played a significant role in conferring status.[12] Whereas the radio industry had initially sought in the family a market for its receiving equipment (as had the BBC in its formative years), the American radio manufacturers from their first attempts to innovate television in the 1930s already had in mind a model for selling families to advertisers. This socio-economic relationship between the apparatus and the familial viewing subject has its counter-part in television's textual strategies.

## THE EPISODIC SERIES

As an example of the mode of representation of the episodic series, I will discuss its simplest and least cinematic genre—the situation comedy. In the early 1970s two conceptions of the sitcom family competed for dominance on American network TV. The Norman Lear sitcoms (*All in the Family, Maude, The Jeffersons*) dealt with nu-clear families beset from the outside by a variety of socially-derived problems. This ideological conflict which each week would spring from a new source or "enigma" would split the family apart, usually dividing neatly along progressive v. reactionary lines. Typically, *All in the Family* would provide two axes along which "secondary identifications" could be made—the reactionary father v. the liberal children—thus

making the Lear sitcom epitomize a "liberal" narrative strategy, based on balance and a "choice" of objects for identification. By the end of each episode, the specific "enigma of the week" would be resolved, with the underlying social problem (usually involving racial or feminist issues) retained as an "absent cause" for the ensuing series episode. The Lear family, however much they were divided along political lines, would each week be reintegrated in order that a new enigma could be introduced. The Lear sitcom thus politicized the basic sitcom structure of a return to equilibrium and a new dilemma which would proceed in an endless circle until the series was canceled.

The alternate 1970s paradigm, the family of co-workers, was a product of MTM Enterprises' sitcom factory. Here the dilemmas tended to be interpersonal or "lifestyle" issues which made a better transition than the Lear programs into the apolitical late 1970s (e.g. *Taxi, Cheers*). If the Lear sitcom implied that solutions within the family were but a means of temporary weekly closure, the MTM sitcom stressed the unity of the family above all other values. The substitution of the work family for the nuclear family actually aided in this task, since its all-encompassing nature provided no avenues of escape. It also provided a "mirror" family that was at once more realistic and more Utopian—realistic in that the nuclear family was no longer the dominant form outside the texts; Utopian in that love and work merged in an essentially harmonious universe that represented a throwback to a less corporate age—a residual ideology. A typical situation on *The Mary Tyler Moore Show* would involve a threat to the unity of the family that would be resolved when the recalcitrant family member realized that family unity represents a higher goal than personal ambition. For example, for each of the main characters, an episode featured the dilemma of taking a new job that would mean withdrawal from the work-family; in each case the character is unable at the last moment to "leave home" and the episode ends in a group celebration of the reintegration of the family. When a major character actually did depart, she would be replaced by a new family member, thus keeping the work/family balance stable.

The dominant view of the episodic series sitcom as essentially static and conservative is argued in David Grote's *The End of Comedy*.[13] Following Northrop Frye's conception of the comic mode, Grote's argument is based on a distinction between the comic mode of the television sitcom and Grote's idiosyncratic view of the 2,000 years of dramatic comedy preceding it. According to Grote, the enduring form of "new comedy" was anarchic in that it continually retold the story of a regeneration of the social order through the rebellion of a young couple against the authority of the father. The sitcom, by contrast, resists not only the change of the traditional comic plot but *all* change of any kind. According to Grote, the sitcom carries its repetition compulsion to such an extreme that it has all but rejected the concept of plot as a process of change from an old equilibrium to a new. His description of the process by which narrative development is avoided supports the view that television series narrative is essentially circular. The sitcom, he says, never reaches a new equilibrium but only returns to that point of stasis from which the episode began. From this static narrative economy, Grote deduces that the moral lesson of the sitcom is that all problems can be solved within the family. Changes of mind and solutions to problems all happen to outsiders who must be expelled by the end of each episode. Thus the reintegration of the sitcom family is bought at the cost of narrative and ideological stasis.

Grote's view of the sitcom's handling of the inside/outside the family contradiction might be that one side of the binary opposition (the outside) is, through the narrative mechanism of the sitcom plot, erased. We are left with a pure interiority and a monolithically conservative view of social relations. We can then contrast this to the developmental mode of the continuing serial in which both situations and characters change and grow organically, thus setting up another neat binary opposition between a reactionary form (the sitcom) and a progressive form (the continuing serial). That this is an attractive interpretation is proven by the popularity of this view in both journalistic and academic circles.

However, much is omitted in this easy explanation, most significantly any theory of how the sitcom is *read* by its audience. Grote is unable to explain how an audience that for 2,000 years was able to accept a progressive form of comedy could—in about twenty years—get "hooked" on such a static, anti-progressive form and then, in the space of about five years, become subjects for an entirely new developmental form of narrative art—the continuing serial drama. Such a rapid public acceptance of an overarching diachronic transformation of the narrative apparatus of American network television is the historical "fact" that an undialectical view such as Grote's is unable to explain. Instead of viewing changes in narrative forms as breaks in essentially synchronic structures, I believe we must view the transformation from the episodic series to the continuing serial both dialectically and historically.

In order to do this, we have to question a monolithically static view of the episodic series at the same time that we qualify the developmental interpretation of serial form. For if the episodic series sitcom was static at the level of situation, it was not so at the level of character (throughout the 1970s). Narrative analysis, however, has taught us to look for change in a rather Proppian fashion as the syntagmatic changes in narrative functions. This kind of change will not be found in the "pure" episodic series. For example, after seven years, Mary Richards was still encountering the same situations she had in the first season. But Mary had changed in terms of the traits attached to her character, that is, paradigmatically. If we examine the credit sequences for the first, second, and ensuing seasons, this change is apparent in that the initial enigma shifts from the future conditional to the future indicative tense (you might just make it after all/ you're gonna make it after all). After this, the question "how will you make it on your own?" is dropped altogether; presumably it is no longer in question.

Another factor that the concentration on plot functions overlooks is that the static nature of the family-integration plot is not without its progressive aspects. The fact that Mary's situation could not develop very much should not be seen in an entirely negative light. For it meant that Mary could never leave the Utopian work/ family in order to settle down into bourgeois domesticity. After the pilot episode, there was never any question of Mary attaching herself to a particular man. In many respects, the family of co-workers represented a progressive alternative—in its integration of the public and domestic spheres, in its emphasis on reciprocity within independence, and its valuing of the collective experience of the ensemble. For the spectator, especially the "new woman" audience for which this program had a special meaning, the family in the mirror was a Utopian one that deserved to remain together. Here we must question Grote's tendency to read Frye in the most strongly developmental way possible. Although Frye says that "the theme of the

comic is the integration of society, which usually takes the form of incorporating a central character into it," he does not say that movement toward a *more* Utopian society is inevitable in comedy.[14] And there is a sense in which the reintegration of the family each week *does* represent "development."

## THE CONTINUING SERIAL

Given the sitcom's potential for diachronic development in the direction of character growth and change, we should view the greater diachronic development of the American sitcom in the 1980s as part of the general movement on American television toward the continuing serial form, not as an abrupt break with the static series format. A number of developments within television programming during the mid-1970s provided the transition to the continuing serial. First, as I have already mentioned, sitcoms began to move toward a more developmental model, so that by the early 1980s it was possible for a sitcom such as *Cheers* to modify even the basic situation (i.e. Diane's and Sam's enmity). Secondly, in two crucial programs—*Mary Hartman* and *Soap*, comedy and melodrama were combined in a continuing serial format. Thirdly, continuing daytime serials became very popular; and peak-time melodramas emerged with *Dallas*. At the same time, certain peak-time melodramatic series types (the "cop show" and the medical drama) began to take on the continuing serial format. Thus we have to explain and correlate a double transformation—from the comic to the melodramatic and from the series to the serial.

*Mary Hartman* and *Soap* both illustrate that when the sitcom moved in the direction of the continuing serial, it also took on a more melodramatic flavor. One possible explanation for this is that comedy tends to stress integration and closure, whereas melodrama has always stressed disintegration and an "unsatisfying" or ambiguous sense of closure. But the self-replication of the continuing serial cannot depend upon integration. In order to keep the various plot lines going, disintegration must be the method of self-replication. In the continuing serial, as exemplified by the daytime soap opera, the inside/outside the family contradiction has always been expressed in terms of the disintegration of the family. This is not to imply that circumstances outside the familial have any greater force. As Tania Modleski has stated, the main fantasy of the soap opera remains that of a fully self-sufficient family.[15] The difference is that whereas in the MTM sitcom that family is constantly regenerated in a Utopian fashion, in the continuing melodramatic serial the integrated family is a goal whose achievement would mean the end of the hermeneutic chain. We cannot say that the movement toward the continuing serial *caused* a change toward melodrama, or vice versa. Rather, it seems logical that the two should have been articulated together.[16] Since I have discussed the dynamics of the continuing serial elsewhere,[17] I would like to proceed directly to the implications of the transition to the continuing serial as form-in-dominance. For different reasons a number of analysts have wanted to describe this change as "progressive." However, all (including myself) have tended to confuse a *narrative* sense of "progress" with a political sense of the term. For the industry and the popular press that perpetuates its views, serials are progressive in that they affirm bourgeois notions of character development and growth. We can reject this explanation at two levels—first, it is arguable that a static conception of character is a more damning description of bourgeois social relations. Secondly, it is

not correct to say that characters *change* in continuing serials. Quite the contrary—they perpetuate the narrative by continuing to make the same mistakes. Rather, due to the multiple plot structure, characters' *positions* shift in relation to other characters. To quote Rick Altman, "*Dallas* is organized not according to a novelistic hermeneutic, but around an intricate menu of topics which for some viewers are experienced by character and for others by theme."[18] The diachronic development of continuing serials depends more upon the shifting status of the various couples and families. At any given synchronic moment, families that were once integrated are now disintegrated, and vice-versa. Integration into a happy family remains the ultimate goal, but it cannot endure for any given couple. The various sets of couples achieve in fulcrum fashion a balance between harmony and disharmony, but no one couple can remain in a state of integration (or of disintegration).

My discussion of the sitcom makes clear that "misreadings" are eminently possible; indeed the "liberal" structure of the Lear sitcom ensured differential readings of Archie's racism. However, I would still maintain that the emphasis upon reintegration of the family does not allow much space for a critique of the nuclear family structure itself. (However, one might read the substitution of the Utopian work family as constituting a form of critique.)

For the continuing serial, the very need to "rupture" the family in order for the plot to continue can be viewed as a "dangerous" strategy in the sense that it allows for a reading of the disintegration as a critique of the family itself. Specifically, it threatens to explode the strategy of containment common to both the series and serial by which all conflicts are expressed in terms of the family. In the sitcom, the threatening forces are re-expelled each week. The continuing serial, by contrast, maintains its "outside" within the family structure. The outside forces which threaten the sitcom family become the inside forces which threaten the internal disintegration of the continuing serial family. In allowing the family to be perennially torn apart, there is always the danger that "the outside" will explode upon the inside. We cannot, however, guarantee that this will lead to *politically* progressive readings of continuing serials. Rather than set up an opposition between the episodic series and the continuing serial along reactionary/radical lines, I would prefer to view them as two different responses to television's dual ideological compulsions: the need to repeat and the need to contain.

## NOTES

1. Stephen Heath and Gillian Skirrow, "Television: a world in action," *Screen* 18, summer 1977.
2. I refer to American commercial television and to some British programming.
3. "Television/Sound," paper delivered at the Society for Cinema Studies Conference, Madison, Wisconsin, March 1984.
4. David Bordwell and Kristin Thompson, *Film Art: An Introduction* (Reading, Mass: Addison-Wesley, 1979).
5. John Ellis, *Visible Fictions* (London: Routledge and Kegan Paul, 1982), pp. 145–60.
6. "The concept of live TV: ontology as ideology," in E. Ann Kaplan, ed., *Regarding Television* (Fredrick, Maryland: University Publications of America, 1983), pp. 12–22.
7. Christian Metz, *The Imaginary Signifier* (Bloomington: Indiana University Press, 1975), pp. 1–88.
8. Kaplan, *op. cit.*

9. "Television news and its spectator," in Kaplan, ed., *op. cit.*, p. 38.

10. *Television: Technology and Cultural Form* (New York: Schocken Books, 1975), p. 26.

11. Jeanne Allen, "The social matrix of television: invention in the U.S.," in Kaplan, *op. cit.*

12. Willian Boddy, "The rhetoric and the economic roots of the American broadcast industry," *Cine-Tracts* 2, spring, 1979.

13. Hamden, Connecticut: The Shoestring Press, 1983.

14. *Anatomy of Criticism* (Princeton, New Jersey: Princeton University Press, 1957), p. 43.

15. *Loving with a Vengeance* (New York and London: Methuen, 1984).

16. We also need to conceptualize the historical and cultural factors influencing the shift in narrative paradigms beyond the obvious observation that the "mood" of the country had "swung" from liberal to conservative.

17. "Melodrama, serial form and television today," *Screen* 25 Jan./Feb. 1984, pp. 4–18.

18. See note 3.

# HENRY JENKINS

. . . . . . . . . . . . . . . . . . . . . . . . . . . . . . . . . . . . . . . . . . . . . . . . . . . . . . . . . .

# Searching for the Origami Unicorn: *The Matrix* and Transmedia Storytelling

FROM *Convergence Culture*

Currently Professor of Communication, Journalism, and Cinematic Arts at the University of Southern California, Henry Jenkins (b. 1958) is the founder and former director of MIT's Comparative Media Studies Program and the author or editor of ten books, including *Convergence Culture: Where Old and New Media Collide* (2006), *Textual Poachers: Television Fans and Participatory Culture* (1992), and *Fans, Bloggers and Gamers: Media Consumers in a Digital Age* (2006), as well as a prominent blogger on related issues. Unlike traditional film theory, Jenkins's research and writing are not simply concerned with film canons, film auteurs, and film history; he consistently explores how film, television, the Internet, and other new-media technologies have spread through popular culture.

To a large extent, the historical context for this essay from Jenkins's *Convergence Culture* is the center of its argument. Just as the primary subject of *The Matrix* (1999), the film Jenkins uses in his essay, describes a network of different realities at once digitized, illusory, and mythical, today's media culture has rapidly expanded the worlds we inhabit through the images we watch. The concept of passively watching movies in the dark has been vastly reconfigured by the fact that we have so many new and interactive channels for viewing media—laptop DVD players, the Internet, smartphones, iPod screens, YouTube videos, Facebook pages, blogs, and Twitter networks. These interactive technologies allow viewers to move past passive viewing and to shape, embody, and determine their experience in many different ways. One well-known and early example of these changes is *The Blair Witch Project* (1999). This popular low-budget film used a particularly active and

widespread Internet marketing campaign to transform a relatively simple horror movie into a version of collaborative transmedia storytelling in which participants energized the film as an event, with a constant flow of information and rumors about the film.

Throughout the book in which this essay appears, Jenkins's three-tiered focus is the contemporary interaction of media convergence, participatory culture, and collective intelligence. In "Searching for the Origami Unicorn," *The Matrix* becomes "emblematic of the cult movie in convergence culture" as the complexity of its narrative requires viewers as narrative participants to search for information online, or play certain video games in order to fully understand the narrative gaps or puzzles. This version of "synergistic storytelling" demonstrates a necessary "collaborative authorship" or collective "world building" in which viewers are fans who complicate a narrative by exploring its range of possibilities rather than passively following a single path with a determined beginning, middle, and end. Reflecting his subject matter, Jenkins tells multiple stories in sidebars to the original version of this essay. Jenkins's position complicates reception and spectatorship theories, as well as concepts of postmodernism, and his work is complemented by Lisa Nakamura's reading of the *Matrix* trilogy (p. 1041).

## READING CUES & KEY CONCEPTS

◼ While Jenkins states that fans play a large role in what he calls "synergistic storytelling," he also points out that transnational financial franchises play a major role in encouraging and developing these kinds of new narratives. Consider how he addresses this issue in his essay.

◼ Some critics are suggesting the collapse of storytelling, but Jenkins believes that we are witnessing the evolution and emergence of new story structures, "which create complexity by expanding the range of narrative possibility rather than pursuing a single path with a beginning, middle, and end." Consider how Jenkins's notion of "collaborative authorship" affects the final meaning of contemporary narratives or how we understand what they signify. Are there other recent movies that build the difficulty of discovering a meaning into their narrative?

◼ **Key Concepts:** Additive Comprehension; Collaborative Authorship; Convergent Media; Cultural Attractor; Cultural Activator; Transmedia Storytelling

# Searching for the Origami Unicorn: *The Matrix* and Transmedia Storytelling

. . . . . . . . . . . . . .

In Peter Bagge's irreverent "Get It?," one of some twenty-five comic stories commissioned for *The Matrix* homepage, three buddies are exiting a theater where they have just seen the Wachowski brothers' opus for the first time. For two of them, *The Matrix* (1999) has been a transforming experience:

"Wow! That was Awesome!"
"*The Matrix* was the best movie I've seen in ages!"

The third is perplexed. From the looks on the faces of the prune-faced older couple walking in front of them, his confusion is not unique. "I didn't understand a word of it!"

"You mean you were sitting there scratching your head through the whole thing?"

When they retire to a local bar, one buddy persists in trying to explain *The Matrix*, patiently clarifying its concepts of manufactured reality, machine-controlled worlds, and "jacking in," while the other, being more pessimistic, grumbles, "I don't think you'll ever understand it." As their hapless pal walks away, the other two turn out to be cybernetic "agents," who concede that it's a good thing most humans don't get this movie, since "the fewer humanoids who comprehend what's really going on, the fewer we will have to destroy."[1]

Noted for his sharp social satire in *Hate* comics (1990–1998) and, more recently, *Reason* magazine, Bagge contrasts between those who "get" *The Matrix* and those who do not. Something about the film leaves some filmgoers feeling inadequate and others empowered. Bagge wrote this strip immediately after the release of the first *Matrix* movie. As we will see, things get only more complicated from there.

No film franchise has ever made such demands on its consumers. The original movie, *The Matrix*, took us into a world where the line between reality and illusion constantly blurred, and where the bodies of humans are stored as an energy source to fuel machines while their minds inhabit a world of digital hallucinations. Neo, the hacker protagonist-turned-messiah, gets pulled into the Zion resistance movement, working to overturn the "agents" who are shaping reality to serve their own ambiguous ends. The prerelease advertising for the first film tantalized consumers with the question, "What is the Matrix?" sending them to the Web in search of answers. Its sequel, *The Matrix Reloaded* (2003), opens without a recap and assumes we have almost complete mastery over its complex mythology and ever-expanding cast of secondary characters. It ends abruptly with a promise that all will make sense when we see the third installment, *The Matrix Revolutions* (2003). To truly appreciate what we are watching, we have to do our homework.

The filmmakers plant clues that won't make sense until we play the computer game. They draw on the back story revealed through a series of animated shorts, which need to be downloaded off the Web or watched off a separate DVD. Fans raced, dazed and confused, from the theaters to plug into Internet discussion lists, where every detail would be dissected and every possible interpretation debated.

When previous generations wondered whether they "got" a movie, it was usually a European art movie, an independent film, or perhaps an obscure late-night cult flick. But *The Matrix Reloaded* broke all box office records for R-rated films, earning a mind-boggling $134 million in revenues in its first four days of release. The video game sold more than a million copies in its first week on the market. Before the movie was even released, 80 percent of the American film-going public identified *The Matrix Reloaded* as a "must see" title.[2]

*The Matrix* is entertainment for the age of media convergence, integrating multiple texts to create a narrative so large that it cannot be contained within a single medium. The Wachowski brothers played the transmedia game very well, putting out the original film first to stimulate interest, offering up a few Web comics to sustain the hard-core fan's hunger for more information, launching the anime in

anticipation of the second film, releasing the computer game alongside it to surf the publicity, bringing the whole cycle to a conclusion with *The Matrix Revolutions*, and then turning the whole mythology over to the players of the massively multiplayer online game. Each step along the way built on what has come before, while offering new points of entry.

*The Matrix* is also entertainment for the era of collective intelligence. Pierre Lévy speculates about what kind of aesthetic works would respond to the demands of his knowledge cultures. First, he suggests that the "distinction between authors and readers, producers and spectators, creators and interpreters will blend" to form a "circuit" (not quite a matrix) of expression, with each participant working to "sustain the activity" of the others. The artwork will be what Lévy calls a "cultural attractor," drawing together and creating common ground between diverse communities; we might also describe it as a cultural activator, setting into motion their decipherment, speculation, and elaboration. The challenge, he says, is to create works with enough depth that they can justify such large-scale efforts: "Our primary goal should be to prevent closure from occurring too quickly."[3] *The Matrix* clearly functions both as a cultural attractor and a cultural activator. The most committed consumers track down data spread across multiple media, scanning each and every text for insights into the world. Keanu Reeves explained to *TV Guide* readers: "What audiences make of *Revolutions* will depend on the amount of energy they put into it. The script is full of cul-de-sacs and secret passageways."[4] Viewers get even more out of the experience if they compare notes and share resources than if they try to go it alone.

In this chapter, I am going to describe *The Matrix* phenomenon as transmedia storytelling. A transmedia story unfolds across multiple media platforms, with each new text making a distinctive and valuable contribution to the whole. In the ideal form of transmedia storytelling, each medium does what it does best—so that a story might be introduced in a film, expanded through television, novels, and comics; its world might be explored through game play or experienced as an amusement park attraction. Each franchise entry needs to be self-contained so you don't need to have seen the film to enjoy the game, and vice versa. Any given product is a point of entry into the franchise as a whole. Reading across the media sustains a depth of experience that motivates more consumption. Redundancy burns up fan interest and causes franchises to fail. Offering new levels of insight and experience refreshes the franchise and sustains consumer loyalty. The economic logic of a horizontally integrated entertainment industry—that is, one where a single company may have roots across all of the different media sectors—dictates the flow of content across media. Different media attract different market niches. Films and television probably have the most diverse audiences; comics and games the narrowest. A good transmedia franchise works to attract multiple constituencies by pitching the content somewhat differently in the different media. If there is, however, enough to sustain those different constituencies—and if each work offers fresh experiences—then you can count on a crossover market that will expand the potential gross.

Popular artists—working in the cracks of the media industry—have realized that they can surf this new economic imperative to produce more ambitious and challenging works. At the same time, these artists are building a more collaborative relationship with their consumers: working together, audience members can process more story information than previously imagined. To achieve their goals, these

storytellers are developing a more collaborative model of authorship, co-creating content with artists with different visions and experiences at a time when few artists are equally at home in all media.

Okay, so the franchise is innovative, but is *The Matrix* any good? Many film critics trashed the later sequels because they were not sufficiently self-contained and thus bordered on incoherent. Many games critics trashed the games because they were too dependent on the film content and did not offer sufficiently new experiences to players. Many fans expressed disappointment because their own theories about the world of *The Matrix* were more rich and nuanced than anything they ever saw on the screen. I would argue, however, that we do not yet have very good aesthetic criteria for evaluating works that play themselves out across multiple media. There have been far too few fully transmedia stories for media makers to act with any certainty about what would constitute the best uses of this new mode of storytelling, or for critics and consumers to know how to talk meaningfully about what works or doesn't work within such franchises. So let's agree for a moment that *The Matrix* was a flawed experiment, an interesting failure, but that its flaws did not detract from the significance of what it tried to accomplish.

Relatively few, if any, franchises achieve the full aesthetic potential of transmedia storytelling—yet. Media makers are still finding their way and are more than willing to let someone else take the risks. Yet, at the heart of the entertainment industry, there are young and emerging leaders (such as Danny Bilson and Neil Young at Electronic Arts or Chris Pike at Sony Interactive) who are trying to push their companies to explore this new model for entertainment franchises. Some of them are still regrouping from their first bleeding-edge experiments in this space (Dawson's Desktop, 1998)—some of which had modest success (*The Blair Witch Project*, 1999), some of which they now saw as spectacular failures (*Majestic*, 2001). Some of them are already having closed-door meetings to try to figure out the best way to ensure more productive collaborations across media sectors. Some are working on hot new ideas masked by nondisclosure agreements. All of them were watching closely in 2003, which *Newsweek* had called "The Year of *The Matrix*," to see how audiences were going to respond to the Wachowski brothers' ambitious plans.[5] And, like Peter Bagge, they were looking at the faces of people as they exit the theaters, demanding to know if they "got" it.

## *What Is the Matrix?*

Umberto Eco asks what, beyond being loved, transforms a film such as *Casablanca* (1942) into a cult artifact. First, he argues, the work must come to us as a "completely furnished world so that its fans can quote characters and episodes as if they were aspects of the private sectarian world."[6] Second, the work must be encyclopedic, containing a rich array of information that can be drilled, practiced, and mastered by devoted consumers.

The film need not be well made, but it must provide resources consumers can use in constructing their own fantasies: "In order to transform a work into a cult object one must be able to break, dislocate, unhinge it so that one can remember only parts of it, irrespective of their original relationship to the whole."[7] And the cult film need not be coherent: the more different directions it pushes, the more different

communities it can sustain and the more different experiences it can provide, the better. We experience the cult movie, he suggests, not as having "one central idea but many," as "a disconnected series of images, of peaks, of visual icebergs."[8]

The cult film is made to be quoted, Eco contends, because it is made from quotes, archetypes, allusions, and references drawn from a range of previous works. Such material creates "a sort of intense emotion accompanied by the vague feeling of a déjà vu."[9] For Eco, *Casablanca* is the perfect cult movie because it is so unself-conscious in its borrowings: "Nobody would have been able to achieve such a cosmic result intentionally."[10] And for that reason, Eco is suspicious of cult movies by design. In the age of postmodernism, Eco suggests, no film can be experienced with fresh eyes; all are read against other movies. In such a world, "cult has become the normal way of enjoying movies."[11]

If *Casablanca* exemplifies the classical cult movie, one might see *The Matrix* as emblematic of the cult movie in convergence culture. Here's science fiction writer Bruce Sterling trying to explain its fascination:

> First and foremost, the film's got pop appeal elements. All kinds of elements: suicidal attacks by elite special forces, crashing helicopters, oodles of martial arts, a chaste yet passionate story of predestined love, bug-eyed monsters of the absolute first water, fetish clothes, captivity and torture and daring rescue, plus really weird, cool submarines. . . . There's Christian exegesis, a Redeemer myth, a death and rebirth, a hero in self-discovery, *The Odyssey*, Jean Baudrillard (lots of Baudrillard, the best part of the film), science fiction ontological riffs of the Philip K. Dick school, Nebuchadnezzar, the Buddha, Taoism, martial-arts mysticism, oracular prophecy, spoon-bending telekinesis, Houdini stage-show magic, Joseph Campbell, and Godelian mathematical metaphysics.[12]

And that's just in the first film!

The film's endless borrowings also spark audience response. Layers upon layers of references catalyze and sustain our epistemophilia; these gaps and excesses provide openings for the many different knowledge communities that spring up around these cult movies to display their expertise, dig deep into their libraries, and bring their minds to bear on a text that promises a bottomless pit of secrets. Some of the allusions—say, the recurring references to "through the looking glass," the White Rabbit, and the Red Queen, or the use of mythological names for the characters (Morpheus, Persephone, Trinity)—pop off the screen upon first viewing. Others—say, the fact that at one point, Neo pulls a copy of Baudrillard's *Simulacra and Simulation* (1981/1995) from his shelf—become clear only after you talk about the film with friends. Some—like the fact that Cypher, the traitor, is referred to at one point as "Mr. Reagan" and asks for an alternative life where he is an actor who gains political power—are clear only when you put together information from multiple sources. Still others—such as the license plates on the cars (such as DA203 or IS5416), which reference specific and context-appropriate Bible verses (Daniel 2:3 or Isaiah 54:16)—may require you to move through the film frame by frame on your DVD player.

The deeper you drill down, the more secrets emerge, all of which can seem at any moment to be *the key* to the film. For example, Neo's apartment number is 101, which is the room number of the torture chamber in George Orwell's *1984* (1949). Once you've

picked up this number, then you discover that 101 is also the floor number for the Merovingians' nightclub and the number of the highway where the characters clash in *The Matrix Reloaded*, and from there, one can't help but believe that all of the other various numbers in the film may also carry hidden meanings or connect significant characters and locations together. The billboards in the backgrounds of shots contain cheat codes that can be used to unlock levels in the *Enter the Matrix* (2003) game.

The sheer abundance of allusions makes it nearly impossible for any given consumer to master the franchise totally. In this context, the Wachowski brothers have positioned themselves as oracles—hidden from view most of the time, surfacing only to offer cryptic comments, refusing direct answers, and speaking with a single voice. Here, for example, are some characteristic passages from one of their few online chat sessions:

> *Question*: "There are quite a few hidden messages in the movie that I notice the more I watch it. Can you tell me about how many there are?"
> *Wachowski brothers*: "There are more than you'll ever know."[13]

> *Question*: "Have you ever been told that *The Matrix* has Gnostic overtones?"
> *Wachowski brothers*: "Do you consider that to be a good thing?"

> *Question*: "Do you appreciate people dissecting your movie? Do you find it a bit of an honor or does it annoy you a little, especially when the person may have it all wrong?
> *Wachowski brothers*: "There's not necessarily ever an 'all wrong.' Because it's about what a person gets out of the movie, what an individual gets out of the movie."

The Wachowskis were more than happy to take credit for whatever meanings the fans located, all the while implying there was more, much more, to be found if the community put its collective mind to work. They answered questions with questions, clues with clues. Each clue was mobilized, as quickly as it materialized, to support a range of different interpretations.

So what is *The Matrix*? As one fan demonstrates, the question can be answered in so many different ways:

- Is it a "love story"? (Keanu Reeves said that in an interview.)

- Is it a "titanic struggle between intuition and controlling intellect"? (Hugo Weaving = Agent Smith said that in an interview about *The Matrix Reloaded*.)

- Is it a story about religious salvation? (*The Matrix Reloaded* was banned in Egypt, because it is "too religious.")

- Is it a story about "Believing in something" or about "Not believing in something"?

- Is it a story about "artificial humanity" or "artificial spirituality"?

- Is it a story with elements from Christianity? Buddhism? Greek mythology? Gnosticism? Hinduism? Freemasonry? The secret society Priory of Zion (Prieure du Notre Dame du Sion) (and its connection to the use of chessboard imagery at the castle Rennes-le-Chateau)?

- Is Neo a reincarnated Buddha? Or a new Jesus Christ (Neo Anderson = new son of man)?

- Is it a science-fiction movie? A fantasy movie?

- Is it a story about secret societies keeping society under control?

- Is it a story about men's history or men's future?

- Is it just a visually enhanced futuristic Kung-Fu movie? A modern Japanime?[14]

Even with all of the film releases out on DVD, and thus subject to being scrutinized indefinitely, the most dedicated fans were still trying to figure out *The Matrix* and the more casual viewers, not accustomed to putting this kind of work into an action film, had concluded that the parts just didn't add up.

## *"Synergistic Storytelling"*

*The Matrix* is a bit like *Casablanca* to the nth degree, with one important difference: *Casablanca* is a single movie; *The Matrix* is three movies and more. There is, for example, *The Animatrix* (2003), a ninety-minute program of short animated films, set in the world of *The Matrix* and created by some of the leading animators from Japan, South Korea, and the United States, including Peter Chung (*Aeon Flux*, 1995), Yoshiaki Kawajiri (*Wicked City*, 1987), Koji Morimoto (*Robot Carnival*, 1987), and Shinichiro Watanabe (*Cowboy Bebop*, 1998). *The Matrix* is also a series of comics from cult writers and artists, such as Bill Sienkiewicz (*Elektra: Assassin*, 1986–87), Neil Gaiman (*The Sandman*, 1989–96), Dave Gibbons (*Watchmen*, 1986–87), Paul Chadwick (*Concrete*, 1987–98), Peter Bagge (*Hate*, 1990–98), David Lapham (*Stray Bullets*, 1995–), and Geof Darrow (*Hard Boiled*, 1990–92). *The Matrix* is also two games—*Enter the Matrix*, produced by David Perry's Shiny Entertainment, and a massively multiplayer game set in the world of *The Matrix*, scripted in part by Paul Chadwick.

The Wachowskis wanted to wind the story of *The Matrix* across all of these media and have it all add up to one compelling whole. Producer Joel Silver describes a trip the filmmakers took to Japan to talk about creating an animated television series: "I remember on the plane ride back, Larry sat down with a yellow pad and kinda mapped out this scheme we would do where we would have this movie, and these video games and these animated stories, and they would all interact together."[15] David Perry described the game as, in effect, another *Matrix* movie. The actors reportedly were uncertain which scenes were being filmed for the game and which for the movie.[16] The consumer who has played the game or watched the shorts will get a different experience of the movies than one who has simply had the theatrical film experience. The whole is worth more than the sum of the parts.

We may better understand how this new mode of transmedia storytelling operates by looking more closely at some of the interconnections between the various *Matrix* texts. For example, in the animated short, *Final Flight of the Osiris* (2003), the protagonist, Jue, gives her life trying to get a message into the hands of the Nebuchadnezzar crew. The letter contains information about the machines boring their way down to Zion. In the final moments of the anime, Jue drops the letter into a mailbox. At the opening of *Enter the Matrix*, the player's first mission is to retrieve the letter

from the post office and get it into the hands of our heroes. And the opening scenes of *The Matrix Reloaded* show the characters discussing the "last transmissions of the Osiris." For people who see only the movie, the sources of the information remain unclear, but someone who has a transmedia experience will have played an active role in delivering the letter and may have traced its trajectory across three different media.

Similarly, the character of The Kid is introduced in another of the animated shorts, *The Kid's Story* (2003), about a high school student who discovers on his own the truth about the Matrix as Neo and his friends try to rescue him from the agents. In *The Matrix Reloaded*, they reencounter The Kid on the outskirts of Zion, where he begs to join their crew: "It's fate. I mean you're the reason I'm here, Neo," but Neo defers, saying, "I told you, kid, you found me, I didn't find you. . . . You saved yourself." The exchange is staged as if everybody in the audience would know what the two are talking about and feels more like a scene involving an already established character than their first on-screen introduction. The Kid's efforts to defend Zion became one of the core emotional hooks in the climactic battle in *Revolutions*.

In *The Matrix: Reloaded*, Niobe appears unexpectedly in the freeway chase just in time to rescue Morpheus and Trinity, but for people who play the game, getting Niobe to the rendezvous point is a key mission. Again, near the end of *The Matrix Reloaded*, Niobe and her crew are dispatched to blow up the power plant, but apart from the sense that the plan must have worked to enable what we see on screen to unfold, the actual details of her operation is not represented, so that it can be played out in more depth in the game. We reencounter Niobe at the start of *The Matrix Revolutions* where she was left off at the climax of *Enter the Matrix*.

By the standards of classical Hollywood storytelling, these gaps (such as the failure to introduce The Kid or to explain where Niobe came from) or excesses (such as the reference to "the last transmission of the Osiris") confuse the spectator.[17] The old Hollywood system depended on redundancy to ensure that viewers could follow the plot at all times, even if they were distracted or went out to the lobby for a popcorn refill during a crucial scene. The new Hollywood demands that we keep our eyes on the road at all times, and that we do research before we arrive at the theater.

This is probably where *The Matrix* fell out of favor with the film critics, who were used to reviewing the film and not the surrounding apparatus. Few of them consumed the games or comics or animated shorts, and, as a consequence, few absorbed the essential information they contained. As Fiona Morrow from the *London Independent* explained, "You can call me old-fashioned—what matters to me is the film and only the film. I don't want to have to 'enhance' the cinematic experience by overloading on souped-up flimflam."[18] Those who realized there was relevant information in those other sources were suspicious of the economic motives behind what *Salon*'s Ivan Askwith called "synergistic storytelling": "Even if the new movies, game, and animated shorts live up to the high standards set by the first film, there's still an uneasy feeling that Warner Bros. is taking advantage of *The Matrix*'s cult following to cash in while it can." *The San Jose Mercury*'s Mike Antonucci saw it all as "smart marketing" more than "smart storytelling."[19]

So let's be clear: there are strong economic motives behind transmedia storytelling. Media convergence makes the flow of content across multiple media platforms inevitable. In the era of digital effects and high-resolution game graphics, the game world can now look almost exactly like the film world—because they are reusing

many of the same digital assets. Everything about the structure of the modern entertainment industry was designed with this single idea in mind—the construction and enhancement of entertainment franchises. As we saw in the previous chapter, there is a strong interest in integrating entertainment and marketing, to create strong emotional attachments and use them to make additional sales. Mike Saksa, the senior vice president for marketing at Warner Bros., couldn't be more explicit on this point: "This [*The Matrix*] truly is Warner Bros.'s synergy. All divisions will benefit from the property. . . . We don't know what the upside is, we just know it's going to be very high."[20]

The enormous "upside" is not just economic, however. *The Matrix* franchise was shaped by a whole new vision of synergy. Franchising a popular film, comic book, or television series is nothing new. Witness the endless stream of plastic figurines available in McDonald's Happy Meals. Cross-promotion is everywhere. But much of it, like the Happy Meal toys, are pretty lame and easily forgotten. Current licensing arrangements ensure that most of these products are peripheral to what drew us to the original story in the first place. Under licensing, the central media company—most often the film producers—sells the rights to manufacture products using its assets to an often unaffiliated third party; the license limits what can be done with the characters or concepts to protect the original property. Soon, licensing will give way to what industry insiders are calling "co-creation." In co-creation, the companies collaborate from the beginning to create content they know plays well in each of their sectors, allowing each medium to generate new experiences for the consumer and expand points of entry into the franchise.

The current licensing system typically generates works that are redundant (allowing no new character background or plot development), watered down (asking the new media to slavishly duplicate experiences better achieved through the old), or riddled with sloppy contradictions (failing to respect the core consistency audiences expect within a franchise). These failures account for why sequels and franchises have a bad reputation. Franchise products are governed too much by economic logic and not enough by artistic vision. Hollywood acts as if it only has to provide more of the same, printing a *Star Trek* (1966) logo on so many widgets. In reality, audiences want the new work to offer new insights and new experiences. If media companies reward that demand, viewers will feel greater mastery and investment; deny it, and they stomp off in disgust.

In 2003, I attended a gathering of top creatives from Hollywood and the games industry, hosted by Electronic Arts; they were discussing how co-creation might work. Danny Bilson, the vice president of intellectual property development at Electronic Arts, organized the summit on what he calls "multiplatform entertainment."[21] As someone who has worked in film (*The Rocketeer*, 1991), television (*The Sentinel*, 1996; *Viper*, 1994), and comics (*The Flash*, 1990), as well as in games, Bilson understands the challenges of creating content in each medium and of coordinating between them. He wants to develop games that do not just move Hollywood brands into a new media space, but also contribute to a larger storytelling system. For this to work, he argues, the story needs to be conceived in transmedia terms from the start:

> We create movies and games together, organically, from the ground up, with the
> same creative force driving them. Ideally that creative force involves movie writ
> ers and directors who are also gamers. In any art form, you have to like it to do well

with it; in fact, you have to be a fan of it to do well at it. Take that talent and build multiplatform entertainment. The movie and game are designed together, the game deepens and expands the fiction but does not simply repeat material from the film. It should be organic to what made the film experience compelling.

Going forward, people are going to want to go deeper into stuff they care about rather than sampling a lot of stuff. If there's something I love, I want it to be bigger than just those two hours in the movie theater or a one hour a week experience on TV. I want a deepening of the universe. . . . I want to participate in it. I've just been introduced to the world in the film and I want to get there, explore it. You need that connection to the world to make participation exciting.

Bilson wants to use his position as the man who supervises all creative properties for the world's leading game publisher to create multiplatform entertainment. His first step is the development of *GoldenEye: Rogue Agent* (2004), a James Bond game where one gets to play the part of classic Bond villains like Dr. No or Goldfinger, restaging confronting 007 within digital re-creations of the original movie sets. Everything in the game is consistent with what viewers know from the Bond movies, but the events are seen from an alternative moral perspective.

This level of integration and coordination is difficult to achieve even though the economic logic of the large media conglomerates encourages them to think in terms of synergies and franchises. So far, the most successful transmedia franchises have emerged when a single creator or creative unit maintains control. Hollywood might well study the ways that Lucasfilm has managed and cultivated its *Indiana Jones* (1981) and *Star Wars* (1977) franchises. When *Indiana Jones* went to television, for example, it exploited the medium's potential for extended storytelling and character development: *The Young Indiana Jones Chronicles* (1992) showed the character take shape against the backdrop of various historical events and exotic environments. When *Star Wars* moved into print, its novels expanded the timeline to show events not contained in the film trilogies, or recast the stories around secondary characters, as did the *Tales from the Mos Eisley Cantina* (1995) series, which fleshes out those curious-looking aliens in the background of the original movie.[22] When *Star Wars* went to games, those games didn't just enact film events; they showed what life would be like for a Jedi trainee or a bounty hunter. Increasingly, elements are dropped into the films to create openings that will only be fully exploited through other media.

While the technological infrastructure is ready, the economic prospects sweet, and the audience primed, the media industries haven't done a very good job of collaborating to produce compelling transmedia experiences. Even within the media conglomerates, units compete aggressively rather than collaborate. Many believe that much greater coordination across the media sectors is needed to produce transmedia content. Electronic Arts (EA) explored this model in developing its *Lord of the Rings* titles. EA designers worked on location with Peter Jackson's production unit in New Zealand. As Neil Young, the man in charge of the *Lord of the Rings* franchise for EA, explained,

I wanted to adapt Peter's work for our medium in the same way that he has adapted Tolkien's work for his. Rather than being some derivative piece of merchandise along the same continuum with the poster, the pen, the mug, or the

key chain, maybe we could turn that pyramid up the side of its head, leverage those pieces which have come before, and become the pinnacle of the property instead of the basement. Whether you are making the mug, whether you are making the key chain, or whether you are making the game, pretty much everyone has access to the same assets. For me, when I took over *Lord of the Rings*, that seemed untenable if you want to build something that captured Peter's unique vision, and Howard Shore's music, and the actors, and the look of this world, and. . . you needed much more direct access. Instead of working exclusively through the consumer products group, we built a partnership directly with the New Line Production company, 3 Foot 6 Productions that functioned as a clearing house for the things we needed.[23]

This system allowed them to import thousands of "assets" from the film production into the game, ensuring an unprecedented degree of fidelity to the details of Tolkien's world. At the same time, working closely with Jackson and the other filmmakers gave Young greater latitude to explore other dimensions of that world that would not appear on screen.

David Perry has described his relationship with the Wachowski brothers in very similar terms: "The Wachowskis get games. They were standing on the set making sure we got what we needed to make this a quality game. They know what gamers are looking for. With the power they have in Hollywood, they were able to make sure we got everything we needed to make this game what it is."[24] Perry's team logged four months of motion capture work with Jada Pinkett Smith, the actress who played Niobe, and other members of the *Matrix* cast. All the movements and gestures were created by actual performers working on the set and were seen as extensions of their characterizations. The team used alpha-mapping to create a digital version of the actress's face and still preserve her own facial expressions. The game incorporated many of the special effects that had made *The Matrix* so distinctive when the film was first released, allowing players to duplicate some of the stunts that Woo-ping Yuen (the noted Hong Kong fight choreographer) had created through his wire work or to move through "bullet time," the film's eye-popping slow-motion technique.

## Collaborative Authorship

Media conglomeration provided a context for the Wachowski brothers' aesthetic experiment—they wanted to play with a new kind of storytelling and use Warner Bros.'s blockbuster promotion to open it to the largest possible public. If all they wanted was synergy, they could have hired hack collaborators who could crank out the games, comics, and cartoons. This has certainly occurred in other cases that have sought to imitate the *Matrix* model. More recent films, ranging from *Charlie's Angels* to *The Riddick Chronicles*, from *Star Wars* to *Spider-Man*, have developed cartoons, for example, which were intended to bridge between sequels or foreshadow plot developments. Of these, only the *Star Wars* shorts worked with a distinguished animator—in that case, Genndy Tartakovsky (*Samurai Jack*).[25] By contrast, the Wachowskis sought animators and comic-book writers who already had cult followings and were known for their distinctive visual styles and authorial voices. They worked with people they admired, not people they felt would follow orders.

As Yoshiaki Kawajiri, the animator of *Program*, explained, "It was very attractive to me because the only limitation was that I had to play within the world of the *Matrix*; other than that I've been able to work with complete freedom."[26]

The Wachowski brothers, for example, saw co-creation as a vehicle for expanding their potential global market, bringing in collaborators whose very presence evoked distinct forms of popular culture from other parts of the world. Geof Darrow, who did the conceptual drawings for the ships and technology, trained under Moebius, the Eurocomics master noted for images that blur the line between the organic and the mechanical. The filmmakers hired the distinguished Hong Kong fight choreographer, Woo-ping Yuen, who was noted for having helped to reinvent Jackie Chan's screen persona, developing a distinctive female style for Michelle Yeoh, and bringing Asian-style fighting to global cinema via *Crouching Tiger, Hidden Dragon* (2000).[27] The films were shot in Australia and the directors drew on local talent, such as Baz Luhrmann's longtime costume designer Kym Barrett. The cast was emphatically multiracial, making use of African American, Hispanic, South Asian, southern European, and aboriginal performers to create a Zion that is predominantly non-white.

Perhaps most importantly, the Wachowski brothers sought out Japanese and other Asian animators as collaborators on *The Animatrix*. They cite strong influences from manga (Japanese comics) and anime, with Morpheus's red leather chair a homage to *Akira* (1988) and Trinity's jumpsuit coming straight from *Ghost in the Shell* (1995). Arguably, their entire interest in transmedia storytelling can be traced back to this fascination with what anthropologist Mimi Ito has described as Japan's "media mix" culture. On the one hand, the media mix strategy disperses content across broadcast media, portable technologies such as game boys or cell phones, collectibles, and location-based entertainment centers from amusement parks to game arcades. On the other, these franchises depend on hypersociability, that is, they encourage various forms of participation and social interactions between consumers.[28] This media mix strategy has made its way to American shores through series like *Pokémon* (1998) and *Yu-Gi-Oh!* (1998), but operates in even more sophisticated forms in more obscure Japanese franchises. In bringing in Japanese animators closely associated with this media mix strategy, the Wachowski brothers found collaborators who understood what they were trying to accomplish.

The Wachowski brothers didn't simply license or subcontract and hope for the best. The brothers personally wrote and directed content for the game, drafted scenarios for some of the animated shorts, and co-wrote a few of the comics. For fans, their personal engagement made these other *Matrix* texts a central part of the "canon." There was nothing fringe about these other media. The filmmakers risked alienating filmgoers by making these elements so central to the unfolding narrative. At the same time, few filmmakers have been so overtly fascinated with the process of collaborative authorship. *The Matrix* Web site provides detailed interviews with every major technical worker, educating fans about their specific contributions. The DVDs, shipped with hours of "the making of" documentaries, again focused on the full range of creative and technical work.

We can see collaborative authorship at work by looking more closely at the three comics stories created by Paul Chadwick, "Déjà Vu," "Let It All Fall Down," and "The Miller's Tale."[29] Chadwick's comics were ultimately so embraced by the Wachowski brothers that Chadwick was asked to help develop plots and dialogue for the online

*Matrix* game. Chadwick might at first glance seem an odd choice to work on a major movie franchise. He is a cult comics creator best known for *Concrete* and for his strong commitment to environmentalist politics. Working on the very edges of the superhero genre, Chadwick uses Concrete, a massive stone husk that houses the mind of a former political speech writer, to ask questions about the current social and economic order. In *Think Like a Mountain* (1996), Concrete joins forces with the Earth First! movement that is spiking trees and waging war on the lumber industry to protect an old-growth forest.[30] Chadwick's political commitments are expressed not only through the stories but also through his visual style: he creates full-page spreads that integrate his protagonists into their environments, showing the small creatures that exist all around us, hidden from view but impacted by the choices we make.

Chadwick uses his contributions to *The Matrix* to extend the film's critique of the urban landscape and to foreground the ecological devastation that resulted from the war between the machines and the humans. In "The Miller's Tale," his protagonist, a member of the Zion underground, tries to reclaim the land so that he can harvest wheat and make bread. Risking his life, he travels across the blackened landscape in search of seeds with which he can plant new crops; he grinds the grain to make loaves to feed the resistance movement. Chadwick's miller is ultimately killed, but the comic ends with a beautiful full-page image of the plant life growing over the ruins we recognize from their appearance in several of *The Matrix* movies. Of all of the comics' artists, Chadwick shows the greatest interest in Zion and its cultural rituals, helping us to understand the kinds of spirituality that emerges from an underground people.[31]

While he builds on elements found in the films, Chadwick finds his own emphasis within the material and explores points of intersection with his own work. The other animators and comic artists more or less do the same, further expanding the range of potential meanings and intertextual connections within the franchise.

## The Art of World-Making

The Wachowski brothers built a playground where other artists could experiment and fans could explore. For this to work, the brothers had to envision the world of *The Matrix* with sufficient consistency that each installment is recognizably part of the whole and with enough flexibility that it can be rendered in all of these different styles of representation—from the photorealistic computer animation of *Final Flight of the Osiris* to the blocky graphics of the first *Matrix* Web game. Across those various manifestations of the franchise, there are dozens of recurring motifs, such as the falling green *kanji*, Morpheus's bald head and mirror-shade glasses, the insectlike ships, Neo's hand gestures, or Trinity's acrobatics.[32] No given work will reproduce every element, but each must use enough that we recognize at a glance that these works belong to the same fictional realm. Consider one of the posters created for *The Matrix* Web page: an agent dressed in black is approaching a bullet-shattered phone booth, his gun in hand, while in the foreground the telephone dangles off its hook. Which of these elements is exclusive to *The Matrix*? Yet, anyone familiar with the franchise can construct the narrative sequence from which this image must have been taken.

More and more, storytelling has become the art of world building, as artists create compelling environments that cannot be fully explored or exhausted within a

single work or even a single medium. The world is bigger than the film, bigger even than the franchise—since fan speculations and elaborations also expand the world in a variety of directions. As an experienced screenwriter told me, "When I first started, you would pitch a story because without a good story, you didn't really have a film. Later, once sequels started to take off, you pitched a character because a good character could support multiple stories. And now, you pitch a world because a world can support multiple characters and multiple stories across multiple media." Different franchises follow their own logic: some, such as the *X-Men* (2000) movies, develop the world in their first installment and then allow the sequels to unfold different stories set within that world; others, such as the *Alien* (1979) films or George Romero's *Living Dead* (1968) cycle, introduce new aspects of the world with each new installment, so that more energy gets put into mapping the world than inhabiting it.

World-making follows its own market logic, at a time when filmmakers are as much in the business of creating licensed goods as they are in telling stories. Each truly interesting element can potentially yield its own product lines, as George Lucas discovered when he created more and more toys based on the secondary characters in his movies. One of them, Boba Fett, took on a life of its own, in part through children's play.[33] Boba Fett eventually became the protagonist of his own novels and games and played a much larger role in the later films. Adding too much information, however, carries its own risks: fans had long debated whether Boba Fett could actually be a woman underneath the helmet, since we never actually got to see the character's face or hear its voice. But as Lucas fleshed out the character, he also closed down those possibilities, preempting important lines of fan speculation even as he added information that might sustain new fantasies.

As the art of world-making becomes more advanced, art direction takes on a more central role in the conception of franchises. A director such as Tim Burton developed a reputation less as a storyteller (his films often are ramshackle constructions) than as a cultural geographer, cramming every shot with evocative details. The plot and the performances in *Planet of the Apes* (2001), for example, disappointed more or less everyone, yet every shot rewards close attention as details add to our understanding of the society the apes have created; a hard-core fan studies how they dress, how they designed their buildings, what artifacts they use, how they move, what their music sounds like, and so forth. Such a work becomes more rewarding when we watch it on DVD, stopping and starting to absorb the background. Some fans trace these tendencies back to *Blade Runner* (1982), where urbanologist Syd Mead was asked to construct the future metropolis on the recognizable foundations of existing Los Angeles. These visions could only be fully appreciated by reading through the coffee-table books that accompany the release of such films and provide commentary on costume design and art direction decisions.

New-media theorist Janet Murray has written of the "encyclopedic capacity" of digital media, which she thinks will lead to new narrative forms as audiences seek information beyond the limits of the individual story.[34] She compares this process of world-making in games or cinema to Faulkner, whose novels and short stories added together to flesh out the life and times of a fictional county in Mississippi. To make these worlds seem even more real, she argues, storytellers and readers begin to create "contextualizing devices—color-coded paths, time lines, family trees, maps, clocks, calendars, and so on."[35] Such devices "enable the viewer to grasp the

dense psychological and cultural spaces [represented by modern stories] without becoming disoriented."[36] The animated films, the game, and the comics function in a similar way for *The Matrix*, adding information and fleshing out parts of the world so that the whole becomes more convincing and more comprehensible.

Mahiro Maeda's "The Second Renaissance" (2003), for example, is a richly detailed, rapid-paced chronicle that takes us from the present moment to the era of machine rule that opens the first *Matrix* movie. The animated short is framed as a documentary produced by a machine intelligence to explain the events leading to their triumph over the humans. "The Second Renaissance" provides the timeline for *The Matrix* universe, giving a context for events such as the trial of B116ER, the first machine to kill a human, the Million Machine March, and the "darkening of the skies" that are mentioned in other *Matrix* texts. As Maeda explains,

> In Part One, we see humans treat robots as objects, while in Part Two the relationship between human being and robot switches, as humans are studied by the machines. I enjoyed examining how the two sides changed. . . . I wanted to show the broadness of the society, and how the robots were such a part of the background of life that they were treated as mere objects by human beings. . . . In exploring the history of *The Matrix*, I wanted to show the audience how badly the robots were being treated. The images we see of the robots being abused are buried in the Archives. There are many examples of mankind's cruelty in the past.[37]

To shape our response to the images of human authorities crushing the machines, Maeda tapped the image bank of twentieth-century civil unrest, showing the machines throwing themselves under the treads of tanks in a reference to Tiananmen Square or depicting bulldozers rolling over mass graves of crashed robots in a nod toward Auschwitz.

"The Second Renaissance" provides much of the historical background viewers need as they watch Neo return to 01, the machine city, to plead with its inhabitants for assistance in overthrowing the agents. Without learning about the many times the machines had pursued diplomatic relations with the humans and been rejected, it is hard to understand why his approach yielded such transforming results. Similarly, the images showing the humans' efforts to block off the Earth from solar rays resurfaces when we see Neo's craft go above the cloud level and into the blue skies that humans have not seen for generations. "Second Renaissance" introduces many of the weapons deployed during the final assault on Zion, including the massive "mecha" suits the humans wear as they fight off the invaders.

At the same time, "The Second Renaissance" builds upon "Bits and Pieces of Information," one of *The Matrix* comics drawn by Geof Darrow from a script by the Wachowski brothers.[38] The comic introduced the pivotal figure of B116ER, the robot who kills his masters when he is about to be junked and whose trial first asserted the concept of machine rights within human culture. Much like "The Second Renaissance," "Bits and Pieces of Information" draws on the existing iconography of human-rights struggles, quoting directly from the Dred Scott decision and naming the robot after Bigger Thomas, the protagonist of Richard Wright's *Native Son* (1940). If the first feature film started with a simple opposition between man and machines, the Wachowski brothers used these intertexts to create a much more emotionally

nuanced and morally complicated story. In the end, man and machines can still find common interests despite centuries of conflict and oppression.

Most film critics are taught to think in terms of very traditional story structures. More and more, they are talking about a collapse of storytelling. We should be suspicious of such claims, since it is hard to imagine that the public has actually lost interest in stories. Stories are basic to all human cultures, the primary means by which we structure, share, and make sense of our common experiences. Rather, we are seeing the emergence of new story structures, which create complexity by expanding the range of narrative possibility rather than pursuing a single path with a beginning, middle, and end. *Entertainment Weekly* proclaimed 1999, the year that *The Matrix, Fight Club, The Blair Witch Project, Being John Malkovich, Run Lola Run, Go, American Beauty,* and *The Sixth Sense* hit the market, as "the year that changed the movies." Filmgoers educated on nonlinear media like video games were expecting a different kind of entertainment experience.[39] If you look at such works by old criteria, these movies may seem more fragmented, but the fragments exist so that consumers can make the connections on their own time and in their own ways. Murray notes, for example, that such works are apt to attract three very different kinds of consumers: "the actively engaged real-time viewers who must find suspense and satisfaction in each single episode and the more reflective long-term audience who look for coherent patterns in the story as a whole . . . [and] the navigational viewer who takes pleasure in following the connections between different parts of the story and in discovering multiple arrangements of the same material."[40]

For all of its innovative and experimental qualities, transmedia storytelling is not entirely new. Take, for example, the story of Jesus as told in the Middle Ages. Unless you were literate, Jesus was not rooted in a book but was something you encountered at multiple levels in your culture. Each representation (a stained-glass window, a tapestry, a psalm, a sermon, a live performance) assumed that you already knew the character and his story from someplace else. More recently, writers such as J. R. R. Tolkien sought to create new fictions that self-consciously imitated the organization of folklore or mythology, creating an interlocking set of stories that together flesh out the world of Middle Earth. Following a similar logic, Maeda explicitly compares "The Second Renaissance" to Homeric epics: "I wanted to make this film as beautiful as a story from ancient Greek myth, and explore what it means to be human, as well as not human, and how the ideas are related to one another. In Greek myths there are moments where the best side of human nature is explored, and others where the protagonists are shown as very cruel. I wanted to bring the same atmosphere to these episodes."[41]

When the Greeks heard stories about Odysseus, they didn't need to be told who he was, where he came from, or what his mission was. Homer was able to create an oral epic by building on "bits and pieces of information" from preexisting myths, counting on a knowledgeable audience to ride over any potential points of confusion. This is why high school students today struggle with *The Odyssey*, because they don't have the same frame of reference as the original audience. Where a native listener might hear a description of a character's helmet and recognize him as the hero of a particular city-state and, from there, know something of his character and importance, the contemporary high school student runs into a brick wall, with some of the information that once made these characters seem so real buried in some arcane

tome. Their parents may confront a similar barrier to fully engaging with the film franchises so valued by their children—walking into an *X-Men* movie with no background in comics might leave you confused about some of the minor characters who have much deeper significance to long-term comics readers. Often, characters in transmedia stories do not need to be introduced so much as reintroduced, because they are known from other sources. Just as Homer's audience identified with different characters depending on their city-state, today's children enter the movie with preexisting identifications because they have played with the action figures or game avatars.

The idea that contemporary Hollywood draws on ancient myth structures has become common wisdom among the current generation of filmmakers. Joseph Campbell, the author of *The Hero with a Thousand Faces* (1949), praised *Star Wars* for embodying what he has described as the "monomyth," a conceptual structure abstracted from a cross-cultural analysis of the world's great religions.[42] Today, many screenwriting guides speak about the "hero's journey," popularizing ideas from Campbell, and game designers have similarly been advised to sequence the tasks their protagonists must perform into a similar physical and spiritual ordeal.[43] Audience familiarity with this basic plot structure allows script writers to skip over transitional or expository sequences, throwing us directly into the heart of the action.

Similarly, if protagonists and antagonists are broad archetypes rather than individualistic, novelistic, and rounded characters, they are immediately recognizable. We can see *The Matrix* as borrowing these archetypes both from popular entertainment genres (the hacker protagonist, the underground resistance movement, the mysterious men in black) as well as from mythological sources (Morpheus, Persephone, The Oracle). This reliance on stock characters is especially important in the case of games where players frequently skip through the instruction books and past early cut scenes, allowing little time for exposition before grabbing the controller and trying to navigate the world. Film critics often compared the characters in *The Matrix* films to video game characters. Roger Ebert, for example, suggests that he measured his concern for Neo in *Revolutions* less in terms of affection for the character and "more like the score in a video game."[44] *Slate*'s David Edelstein suggests that a spectacular opening stunt by Trinity in *The Matrix Reloaded* "has the disposable feel of a video game. You can imagine the program resetting itself, and then all of those little zeros and ones reassembling to play again."[45] In both cases, the writers use the video game analogy to imply a disinterest in the characters, yet, for gamers, the experience is one of immediacy: the character becomes a vehicle for their direct experience of the game world. By tapping video game iconography, *The Matrix* movies create a more intense, more immediate engagement for viewers who come into the theater knowing who these characters are and what they can do. As the film continues, we flesh out the stick figures, adding more back story and motivation, and we continue to search for additional insights across other media as we exit the theater.

When I suggest parallels between *The Odyssey* and *The Matrix*, I anticipate a certain degree of skepticism. I do not claim that these modern works have the same depth of incrusted meanings. These new "mythologies," if we can call them that, are emerging in the context of an increasingly fragmented and multicultural society. While *The Matrix* films have been the subject of several books linking them to core

philosophical debates, and while many fans see these films as enacting religious myths, articulating spirituality is not their primary function, the perspective they take is not likely to be read literally by their audience, and their expressed beliefs are not necessarily central to our everyday lives. Homer wrote within a culture of relative consensus and stability, whereas *The Matrix* emerges from a time of rapid change and cultural diversity. Its goals are not so much to preserve cultural traditions as to put together the pieces of the culture in innovative ways. *The Matrix* is a work very much of the moment, speaking to contemporary anxieties about technology and bureaucracy, feeding on current notions of multi-culturalism and tapping recent models of resistance. The story may reference a range of different belief systems, such as the Judeo-Christian Messiah myth, to speak about these present-day concerns with some visionary force. At the same time, by evoking these earlier narratives, *The Matrix* invites us to read more deeply in the Western tradition and bring what we find there to bear on contemporary media.[46]

Consider, for example, this reading of the tribal celebration in *The Matrix Reloaded* through the lens of biblical interpretation:

> The feet [stamping] on the ground means that Zion is on Earth. Plain and simple. This parallels the Architect scene, and gets to the main thesis. We are cast out of the "perfection" of Heaven and living in the Real World. Symbolically, the Matrix is Heaven. Cypher makes this point in the first movie. The Real World is hard, dirty, and uncomfortable. The Matrix is, well, paradise. This point is made again in the first movie by Agent Smith, who calls the Matrix "the perfect human world" [paraphrased]. Recall that the Architect scene happens in utterly clean, utterly white perfection. The Biblical reference is clear enough. Neo, Trinity, Morpheus, and the rest of Zion have rejected God's Garden of Eden where all their needs are taken care of in favor of a hard, scrabbling existence where at least they have free will.[47]

So, even if you see classical myths as more valuable than their contemporary counterpart, works such as *The Matrix* draw consumers back to those older works, giving them new currency.

Film critic Roger Ebert ridicules this attempt to insert traditional myth into a pop science fiction/kung fu epic:

> These speeches provide not meaning, but the effect of meaning: it sure sounds like those guys are saying some profound things. This will not prevent fanboys from analyzing the philosophy of *The Matrix Reloaded* in endless web postings. Part of the fun is becoming an expert in the deep meaning of shallow pop mythology; there is something refreshingly ironic about becoming an authority on the transient extrusions of mass culture, and Morpheus (Laurence Fishburne) now joins Obi-Wan Kenobi as the Plato of our age.[48]

This criticism looks different if you accept that value arises here from the process of looking for meaning (and the elaboration of the story by the audience) and not purely from the intentionality of the Wachowski brothers. What the Wachowski brothers did was trigger a search for meaning; they did not determine where the audience would go to find their answers.

## *Additive Comprehension*

If creators do not ultimately control what we take from their transmedia stories, this does not prevent them from trying to shape our interpretations. Neil Young talks about "additive comprehension." He cites the example of the director's cut of *Blade Runner*, where adding a small segment showing Deckard discovering an origami unicorn invited viewers to question whether Deckard might be a replicant: "That changes your whole perception of the film, your perception of the ending. . . . The challenge for us, especially with *The Lord of the Rings*, is how do we deliver the origami unicorn, how do we deliver that one piece of information that makes you look at the films differently." Young explained how that moment inspired his team: "In the case of *The Lord of the Rings: Return of the King* the added comprehension is the fact that Gandalf is the architect of this plan and has been the architect of this plan for some time. . . . Our hope is that you would play the game and that would motivate you to watch the films with this new piece of knowledge which would shift your perception of what has happened in the previous films." Here, Young points toward a possibility suggested by the books but not directly referenced in the films themselves.

Like his colleague Danny Bilson, Young sees transmedia storytelling as the terrain he wants to explore with his future work. His first experiment, *Majestic*, created a transmedia experience from scratch with bits of information coming at the player via faxes, cell-phone calls, e-mail, and Web sites. With *The Lord of the Rings* games, he worked within the constraints of a well-established world and a major movie franchise. Next, he is turning his attention toward creating new properties that can be built from the ground up as cross-media collaborations. His thinking races far ahead: "I want to understand the kinds of story comprehension which are unique to transmedia storytelling. I've got my world, I've got my arcs, some of those arcs can be expressed in the video game space, some of them can be expressed in the film space, the television space, the literary space, and you are getting to the true transmedia storytelling."

With *Enter the Matrix*, the "origami unicorn" takes several forms, most notably refocusing of the narrative around Niobe and Ghost. As the game's designer, David Perry, explains, every element of the game went toward helping us understand who these people are: "If you play as Ghost, who's a Zen Buddhist Apache assassin, you'll automatically ride shotgun in the driving levels, which allow you to fire out the window at agents hunting you down. Niobe is known in Zion as being one of the fastest, craziest drivers in the *Matrix* universe, so when you play the game as her, you'll get to drive through a complex *Matrix* world filled with real traffic and pedestrians, while a computer-controlled Ghost takes out the enemies."[49] Cut scenes (those moments in the game which are prerecorded and not subject to player intervention) give us more insight into the romantic triangle among Niobe, Morpheus, and Locke, which helps to explain, in part, Locke's hostility to Morpheus throughout the film. Having played through the game, you can read the longing and tension within their on-screen relationship. As for Ghost, he remains a background figure in the movie, having only a handful of spoken lines, but his screen appearances reward those who have made the effort to play the game. Some film critics complained about the degree to which Niobe's character displaces Morpheus from the center of *The Matrix Revolutions*, as if a minor

character were upstaging a well-established protagonist. Yet, how we felt about Niobe would depend on whether we had played *Enter the Matrix*. Someone who had played the games would have spent, perhaps, a hundred hours controlling Niobe's character, compared to less than four hours watching Morpheus; struggling to keep the character alive and to complete the missions would have resulted in an intense bond that would not be experienced by viewers who saw her on screen only for a handful of scenes.

Perhaps the most spectacular example of "additive comprehension" occurred after the film trilogy had been completed. With little fanfare or warning, on May 26, 2005, Morpheus, Neo's mentor, was killed off in *The Matrix Online*, while trying to reclaim Neo's body that had been carried away by the machines at the end of *Revolutions*. As Chadwick explained, "They wanted to start with something significant and meaningful and shocking and this was it."[50] A major turning point in the franchise occurred not on screen for a mass audience but in game for a niche public. Even many of those playing the game would not have witnessed the death directly but would have learned about it through rumors from other players or from some other secondary source. Morpheus's death was then used to motivate a variety of player missions within the game world.

EA's Young worried that the Wachowski brothers may have narrowed their audience by making too many demands on them:

> The more layers you put on something, the smaller the market. You are requiring people to intentionally invest more time in what it is you are trying to tell them and that's one of the challenges of transmedia storytelling. . . . If we are going to take a world and express it through multiple media at the same time, you might need to express it sequentially. You may need to lead people into a deep love of the story. Maybe it starts with a game and then a film and then television. You are building a relationship with the world rather than trying to put it all out there at once.

Young may well be right. The Wachowski brothers were so uncompromising in their expectations that consumers would follow the franchise that much of the emotional payoff of *Revolutions* is accessible only to people who have played the game. The film's attempts to close down its plot holes disappointed many hardcore fans. Their interest in *The Matrix* peaked in the middle that tantalized them with possibilities. For the casual consumer, *The Matrix* asked too much. For the hard-core fan, it provided too little. Could any film have matched the fan community's escalating expectations and expanding interpretations and still have remained accessible to a mass audience? There has to be a breaking point beyond which franchises cannot be stretched, subplots can't be added, secondary characters can't be identified, and references can't be fully realized. We just don't know where it is yet.

Film critic Richard Corliss raised these concerns when he asked his readers, "Is Joe Popcorn supposed to carry a *Matrix* concordance in his head?"[51] The answer is no, but "Joe Popcorn" can pool his knowledge with other fans and build a collective concordance on the Internet.[52] Across a range of fan sites and discussion lists, the fans were gathering information, tracing allusions, charting chains of commands, constructing timelines, assembling reference guides, transcribing dialogue, extending the story through their own fan fiction, and speculating like crazy about what it all

meant. The depth and breadth of *The Matrix* universe made it impossible for any one consumer to "get it" but the emergence of knowledge cultures made it possible for the community as a whole to dig deeper into this bottomless text.

Such works also pose new expectations on critics—and this may be part of what Corliss was reacting against. In writing this chapter, I have had to tap into the collective intelligence of the fan community. Many of the insights I've offered here emerged from my reading of fan critics and the conversations on discussion lists. While I possess some expertise of my own as a longtime science fiction and comics fan (knowing for example the ways that Paul Chadwick's previous work in comics connects to his participation in *The Matrix* franchise), this merely makes me one more member of this knowledge community—someone who knows some things but has to rely on others to access additional information. I may have analytic tools for examining a range of different media but much of what I suggest here about the links between the game and the films, for example, emerged not from my own game playing but from the conversations about the game online. In the process of writing this chapter, then, I became a participant rather than an expert, and there is much about this franchise which I still do not know. In the future, my ideas may feed back into the conversation, but I also will need to tap the public discussion in search of fresh information and insights. Criticism may have once been a meeting of two minds—the critic and the author—but now there are multiple authors and multiple critics.

Inhabiting such a world turns out to be child's play—literally. Transmedia storytelling is perhaps at its most elaborate, so far, in children's media franchises like *Pokémon* or *Yu-Gi-Oh!* As education professors David Buckingham and Julian Sefton-Green explain, "*Pokémon* is something you do, not just something you read or watch or consume."[53] There are several hundred different *Pokémon*, each with multiple evolutionary forms and a complex set of rivalries and attachments. There is no one text where one can go to get the information about these various species; rather, the child assembles what they know about the *Pokémon* from various media with the result that each child knows something his or her friends do not and thus has a chance to share this expertise with others. Buckingham and Sefton-Green explain: "Children may watch the television cartoon, for example, as a way of gathering knowledge that they can later utilize in playing the computer game or in trading cards, and vice versa. . . . The texts of *Pokémon* are not designed merely to be consumed in the passive sense of the word. . . . In order to be part of the *Pokémon* culture, and to learn what you need to know, you must actively seek out new information and new products and, crucially, engage with others in doing so."[54]

We might see such play with the possibilities of *Pokémon* or *Yu-Gi-Oh!* as part of the process by which young children learn to inhabit the new kinds of social and cultural structures Lévy describes.[55] Children are being prepared to contribute to a more sophisticated knowledge culture. So far, our schools are still focused on generating autonomous learners; to seek information from others is still classified as cheating. Yet, in our adult lives, we are depending more and more on others to provide information we cannot process ourselves. Our workplaces have become more collaborative; our political process has become more decentered; we are living more and more within knowledge cultures based on collective intelligence. Our schools are not teaching what it means to live and work in such knowledge communities, but popular culture may be doing so. In *The Internet Galaxy* (2001), cybertheorist

Manuel Castells claims that while the public has shown limited interest in hypertexts, they have developed a hypertextual relationship to existing media content: "Our minds—not our machines—process culture. . . . If our minds have the material capability to access the whole realm of cultural expressions—select them, recombine them—we do have a hypertext: the hypertext is inside us."[56] Younger consumers have become informational hunters and gatherers, taking pleasure in tracking down character backgrounds and plot points and making connections between different texts within the same franchise. And so it is predictable that they are going to be expecting these same kinds of experiences from works that appeal to teens and young adults, resulting in something like *The Matrix*.

Soon, we may be seeing these same hypertextual or transmedia principles applied to the quality dramas that appeal to more mature consumers—shows such as *The West Wing* (1999) or *The Sopranos* (1999), for example, would seem to lend themselves readily to such expectations, and soap operas have long depended on elaborate character relationships and serialized plotlines that could easily expand beyond television and into other media. One can certainly imagine mysteries that ask readers to search for clues across a range of different media or historical fictions that depend on the additive comprehension enabled by multiple texts to make the past come alive for their readers. This transmedia impulse is at the heart of what I am calling convergence culture. More experimental artists, such as Peter Greenaway or Matthew Barney, are already experimenting with how they might incorporate transmedia principles into their work. One can also imagine that kids who grew up in this media-mix culture would produce new kinds of media as transmedia storytelling becomes more intuitive. *The Matrix* may be the next step in that process of cultural evolution—a bridge to a new kind of culture and a new kind of society. In a hunting culture, kids play with bows and arrows. In an information society, they play with information.

Now some readers may be shaking their heads in total skepticism. Such approaches work best with younger consumers, they argue, because they have more time on their hands. They demand way too much effort for "Joe Popcorn," for the harried mom or the working stiff who has just snuggled onto the couch after a hard day at the office. As we have seen, media conglomeration creates an economic incentive to move in this direction, but Hollywood can only go so far down that direction if audiences are not ready to shift their mode of consumption. Right now, many older consumers are left confused or uninvolved with such entertainments, though some are also learning to adapt. Not every story will go in this direction—though more and more stories are traveling across media and offering a depth of experience that would have been unanticipated in previous decades. The key point is that going in deep has to remain an option—something readers choose to do—and not the only way to derive pleasure from media franchises. A growing number of consumers may be choosing their popular culture because of the opportunities it offers them to explore complex worlds and compare notes with others. More and more consumers are enjoying participating in online knowledge cultures and discovering what it is like to expand one's comprehension by tapping the combined expertise of these grassroots communities. Yet, sometimes, we simply want to watch. And as long as that remains the case, many franchises may remain big and dumb and noisy. But don't be too surprised if around the edges there are clues that something else is also going on or that the media companies will offer us the chance to buy into new kinds of experiences with those characters and those worlds.

## NOTES

1. Peter Bagge, "Get It?" http://whatisthematrix.warnerbros.com, reproduced in Andy and Larry Wachowski (eds.), *The Matrix Comics* (New York: Burlyman Entertainment, 2003).

2. On the commercial success of the films, see "The Matrix Reloaded," *Entertainment Weekly,* May 10, 2001.

3. Pierre Lévy, *Collective Intelligence: Mankind's Emerging World in Cyberspace* (Cambridge, Mass.: Perseus Books, 1997).

4. Franz Lidz, "Rage against the Machines," *TV Guide,* October 25, 2003, http://www.reevesdrive.com/newsarchive/2003/tvg102503.htm.

5. Devin Gordon, "The Matrix Makers," *Newsweek,* January 6, 2003, accessed at http://msnbc.msn.com/id/3067730.

6. Umberto Eco, "*Casablanca*: Cult Movies and Intertextual Collage," in *Travels in Hyperreality* (New York: Harcourt Brace, 1986), p. 198.

7. Ibid.

8. Ibid.

9. Ibid., p. 200.

10. Ibid.

11. Ibid., p. 210.

12. Bruce Sterling, "Every Other Movie Is the Blue Pill," in Karen Haber (ed.), *Exploring the Matrix: Visions of the Cyber Present* (New York: St. Martin's Press, 2003), pp. 23–24.

13. This and subsequent quotations are taken from Matrix Virtual Theater, Wachowski Brothers Transcript, November 6, 1999, as seen at http://www.warnervideo.com/matrixevents/wachowski.html.

14. "Matrix Explained: What Is the Matrix?" http://www.matrix-explained.com/about_matrix.htm.

15. Joel Silver, as quoted in "Scrolls to Screen: A Brief History of Anime," *The Animatrix* DVD.

16. Ivan Askwith, "A *Matrix* in Every Medium," *Salon,* May 12, 2003, accessed at http://archive.salon.com/tech/feature/2003/05/12/matrix_universe/index_np.html.

17. For a useful discussion, see Kristin Thompson, *Storytelling in the New Hollywood: Understanding Classical Narrative Technique* (Cambridge, Mass.: Harvard University Press, 1999).

18. Fiona Morrow, "Matrix: The 'trix of the Trade," *London Independent,* March 28, 2003.

19. Mike Antonucci, "Matrix Story Spans Sequel Films, Video Game, Anime DVD," *San Jose Mercury,* May 5, 2003.

20. Jennifer Netherby, "The Neo-Classical Period at Warner: *Matrix* Marketing Mania for Films, DVDs, Anime, Videogame," *Looksmart,* January 31, 2003.

21. Danny Bilson, interview with author, May 2003. All subsequent quotations from Bilson come from that interview.

22. See Will Brooker, *Using the Force: Creativity, Community, and Star Wars Fans* (New York: Continuum, 2002).

23. Neil Young, interview with the author, May 2003. All subsequent quotations from Young come from this interview.

24. John Gaudiosi, "*The Matrix* Video Game Serves as a Parallel Story to Two Sequels on Screen," *Daily Yomiuri,* April 29, 2003.

25. "Three Minute Epics: A Look at *Star Wars: Clone Wars*," February 20, 2003, www.starwars.com/feature/20040220.

26. Interview, Yoshiaki Kawajiri, http://www.intothematrix.com/rl_cmp/rl_interview_ kawajiri.html.

27. For a useful overview, see Walter Jon Williams, "Yuen Woo-Ping and the Art of Flying," in Karen Haber (ed.), *Exploring the Matrix: Visions of the Cyber Present* (New York: St. Martin's Press, 2003), pp. 122–125.

28. Mizuko Ito, "Technologies of the Childhood Imagination: *Yugioh*, Media Mixes and Everyday Cultural Production," in Joe Karaganis and Natalie Jeremijenko (eds.), *Network/ Netplay: Structures of Participation in Digital Culture* (Durham, N.C.: Duke University Press, 2005).

29. Paul Chadwick, "The Miller's Tale," "Déjà vu," and "Let It All Fall Down," http:// whatisthematrix.warnerbros.com/rl_cmp/rl_middles3_paultframe.html. "The Miller's Tale" is reproduced in Andy and Larry Wachowski (eds.), *The Matrix Comics* (New York: Burlyman Entertainment, 2003).

30. Paul Chadwick, *Concrete: Think Like a Mountain* (Milwaukie, Or.: Dark Horse Comics, 1997).

31. This shared vision may be why Chadwick was asked to develop the plotlines for the Matrix multiplayer online game. For more on Chadwick's involvement, see "The Matrix Online: Interview with Paul Chadwick," Gamespot, http://www.gamespot.com/pc/rpg/ matrixonlinetentatvetitle/preview_6108016.html.

32. For a useful discussion of the continuities and discontinuities in a media franchise, see William Uricchio and Roberta E. Pearson, "I'm Not Fooled by That Cheap Disguise," in Roberta E. Pearson and William Uricchio (eds.), *The Many Lives of the Batman: Critical Approaches to a Superhero and His Media* (New York: Routledge, 1991).

33. The audience's role in fleshing out Boba Fett is a recurring reference in Will Brooker, *Using the Force: Creativity, Community and Star Wars Fans* (New York: Continuum, 2002).

34. Janet Murray, *Hamlet on the Holodeck: The Future of Narrative in Cyberspace* (Cambridge, Mass.: MIT Press, 1999), pp. 253–258.

35. Ibid.

36. Ibid.

37. "Mahiro Maeda," interview, at http://www.intothematrix.com/rl_cmp/rl_interview_ maeda2.html.

38. Geof Darrow, "Bits and Pieces of Information," accessed at http://whatisthematrix .warnerbros.com, reproduced in Andy and Larry Wachowski (eds.), *The Matrix Comics* (New York: Burlyman Entertainment, 2003).

39. Jeff Gordinier, "1999: The Year That Changed the Movies," *Entertainment Weekly,* October 10 2004, http://www.ew.com/ew/report/0.6115.271806_7_0_ .00.html.

40. Murray, *Hamlet,* p. 257.

41. Maeda, interview.

42. Betty Sue Flowers (ed.), *Joseph Campbell's The Power of Myth with Bill Moyers* (New York: Doubleday, 1988).

43. See, for example, M. M. Goldstein, "The Hero's Journey in Seven Sequences: A Screenplay Structure," NE Films, September 1998, http://www.newenglandfilm.com/news/archives/ 98september/sevensteps.htm; Troy Dunniway, "Using the Hero's Journey in Games," Gamasutra.com, http://www.gamasutra.com/features/2000127/dunniway_pfv.htm.

44. Roger Ebert, "The Matrix Revolutions," *Chicago Sun Times,* November 5, 2003.

45. David Edelstein, "Neo Con," *Slate,* May 14, 2003, http://slate.msn.com/id/2082928.

46. Fans are not the only people seeking for meaning through *The Matrix.* See, for example, William Irwin (ed.), *The Matrix and Philosophy: Welcome to the Desert of the Real* (Chicago: Open Court, 2002).

47. Brian Takle, "The Matrix Explained," May 20, 2003, http://webpages.charter.net/btakle/matrix_reloaded.html.

48. Ebert, "Matrix Revolutions."

49. John Gaudiosi, " '*Matrix*' Vid Game Captures Film Feel," *Hollywood Reporter*, February 6, 2003, accessed at http://www.thelastfreecity.com/docs/7965.html.

50. Stephen Totilo, "Matrix Saga Continues On Line—Without Morpheus," MTV.Com, May 26, 2005, http://www.mtv.com/games/video_games/news/story.jhtml?id=1502973.

51. Richard Corliss, "Popular Metaphysics," *Time*, April 19, 1999.

52. See, for example, Suz, "The Matrix Concordance," at http://members.lycos.co.uk/needanexit/concor.html.

53. David Buckingham and Julian Sefton-Green, "Structure, Agency, and Pedagogy in Children's Media Culture," in Joseph Tobin (ed.), *Pikachu's Global Adventure: The Rise and Fall of Pokémon* (Durham, N.C.: Duke University Press, 2004), p. 12.

54. Ibid., p.22.

55. Marsha Kinder identified similar trends as early as 1991, arguing that children's media could be read as a site of experimentation for these corporate strategies and as the place where new consumers are educated into the demands of what I am calling convergence culture. Cartoon series such as *Teenage Mutant Ninja Turtles* and games such as *Super Mario Bros.* were teaching kids to follow characters across media platforms, to adjust fluidly to a changing media environment, and to combine passive and interactive modes of engagement. Marsha Kinder, *Playing with Power in Movies, Television and Video Games: From Muppet Babies to Teenage Mutant Ninja Turtles* (Berkeley: University of California Press, 1991).

56. Manuel Castells, *The Internet Galaxy: Reflections on the Internet, Business, and Society* (Oxford: Oxford University Press, 2001), pp. 202–203.

# PART 7

# ALTERNATIVE MODES: EXPERIMENTAL AND DOCUMENTARY FILM

*A dream sequence, a flashback to the incident at the Sabra and Shatila refugee camps of Israel's First Lebanon War of 1982, recurs over and over. Against a sky filled with dark yellow flares, three nude men leave the water and slowly approach the shore. A trailing shot of their silhouettes shows them dressing and retrieving their guns and approaching the city of Beirut. Shot in slow motion, the sequence quickly shifts from a yellow day to a dark gray night, marking a representational and temporal disruption in the sequence. The dream ends on a close-up of Ari's blank face, the image of an uncomprehending soldier haunted by a very real history.*

Scene from Ari Folman's *Waltz with Bashir* (2008)

A film about the Israeli invasion of Lebanon in 1982, *Waltz with Bashir* employs a contemporary variation of the process known as rotoscoping, a technique that superimposes animation on live-action footage. This autobiographical investigation begins with the filmmaker's nightmare of being chased by twenty-six dogs and then proceeds through a series of interviews with friends and veterans that return him to his experience of the war as an Israeli soldier and to the scenes of his traumatic memories. In the closing sequence, the animation shifts unexpectedly to actual newsreel footage that documents the historical slaughter of Palestinian refugees by Christian militia. What is so dramatic (but less and

less unusual in contemporary cinema) is the overlap and shift here between a documentary film tradition aimed at recording the facts of life (the newsreel footage) and an experimental one associated with exploring its creative aspects (the use of animation); this conjunction highlights the great conceptual differences as well as the common ground between the two modes.

To conflate experimental and documentary films is generally and historically a mistake. Both practices do, however, have a differential relationship with narrative films, and the two sets of theoretical debates surrounding these practices also occasionally overlap, just as films from Dziga Vertov's *The Man with a Movie Camera* (1929) to *Waltz with Bashir* merge and blur tactics from both traditions. Film theory has described and championed these differences from narrative cinema in sometimes similar and sometimes dissimilar ways. In the first two decades of the twentieth century, all films represented a radical break with the traditional arts and modes of representation as well as a remarkable new way to represent reality in all its fullness. As narrative cinema became the dominant, mainstream film form by the 1920s, documentary films and experimental films began to assert themselves. Documentary films distinguished their aims, in the words of filmmaker John Grierson, as "the creative treatment of actuality"; experimental films aligned themselves with the European avant-garde's motto "to make it new" so as to unsettle conventional perceptions of the world. For film theorists, these alternative practices immediately offer a forum in which to investigate two central questions that the new energies and possibilities of documentary and experimental film are especially primed to raise: How can reality be represented in more authentic and complex ways? How can film forms investigate visual and audio perception in more creative and diverse ways?

In answering these questions, theories of documentary and experimental cinema develop and differentiate themselves around three evolving issues or concerns. For both practices, theorists have attempted to identify the forms, organizational patterns, technological strategies, and institutions specific to documentary or experimental films, including their distinctive points of view and the particular power and use of certain new technologies, such as the lightweight magnetic sound equipment introduced in the late 1950s and early 1960s. In addition, film theory often argues how experimental and documentary films engage viewers in unique ways that confront and expand how they see the world. Also implicit or explicit in many theoretical positions are the ways in which both practices serve or mimic disciplinary models other than those associated with novels and short stories. Poetry and painting, anthropology and ethnography, politics, semiotics and linguistics, as well as psychology and psychoanalysis are commonly thought of as the frameworks that elucidate the subjects and strategies of these films.

Historically, both traditions have had numerous defenders and spokespeople that extend back through centuries of art and literary criticism. CHARLES BAUDELAIRE's essay "The Salon of 1859: The Modern Public and Photography" represents one of these precinematic positions, notably appearing only a few decades before the arrival of the cinema in the 1890s. Baudelaire polemically identifies the threat of the photographic image and its documentary impulse to painting's more imaginative experiments. Written in the midst of the 1920s French avant-garde movement and at the high point of silent cinema, GERMAINE DULAC's "The Avant-Garde Cinema" can be seen as a determined response to Baudelaire's position. Dulac forcefully articulates that cinema's powers as an

art reside not in mere representation of the real but in its ability to use light and movement to reveal the inner life of objects, people, and their experiences. Conversely, appearing a decade later, JOHN GRIERSON's "First Principles of Documentary" hails the documentary as a different kind of new filmmaking aimed at penetrating the surface of an exterior world to reveal the truth of real people and events, as exemplified by Robert Flaherty's *Nanook of the North* (1922) and *Man of Aran* (1934).

Filmmaker STAN BRAKHAGE and documentary scholar BILL NICHOLS follow, and expand upon, Dulac's and Grierson's respective positions on the experimental film and documentary. Brakhage makes an even stronger case than Dulac in his essay "In Consideration of Aesthetics" for the abstract art of experimental film. He argues that the aesthetic experience it creates through light and movement is all the more powerful because of its distance from the world of daily experience. In "Performing Documentary," Nichols expands considerably on Grierson's call for a documentary film practice by cataloguing a variety of documentary modes that developed through the twentieth century, including expository, observational, interactive, and reflexive. The most recent variation he discusses is the "performative" documentary, where there is a productive tension between reality and its subjective presentation on film. While *Waltz with Bashir* might be too dependent on live action and dramatic events to qualify as an experimental film, the foregrounding of an individual perspective and its animated "performance" does appear to fit Nichols's definitions of both reflexive and performative documentaries, both of which draw on experimental strategies.

In more recent film theory, both the practices of, and discourses about, documentary and experimental cinema have frequently crossed over into each other's territories and blurred each other's boundaries in ways that follow the larger convergences of media culture. In doing so they may offer the kind of theoretical hybrids that seem most suited to films like *Waltz with Bashir*. The DOGME 95 group, one of the most provocative film movements to appear in the 1990s, returns to some fundamental documentary and *cinéma vérité* assumptions about cinematic authenticity and argues, in the "Manifesto" and "Vow of Chastity," that many of the distinctive precepts of documentary filmmaking (as nongeneric and impersonal, for instance) should also be part of narrative fiction films. Taking a very different tack, TRINH T. MINH-HA's "Documentary Is/Not a Name" is a polemic against documentary traditions that aspire to some kind of direct or unmediated access to reality and truth; instead the representation of reality, Trinh argues, invariably involves the production of specific points of view and meanings, often associated with questionable assumptions about evidence and expertise.

While narrative cinema remains the dominant film mode today, documentary and experimental films have, especially in recent decades, reasserted their claim to a central place in both practice and theory. Because of the possibilities of new digital technologies, increased theatrical distribution, and the incorporation of nonnarrative strategies within narrative films, films like *Waltz with Bashir*, *Waking Life* (2001), and *The Beaches of Agnes* (2008) that combine documentary and experimental strategies have found a wider audience and greater appeal with the general moviegoing public. The proliferation of these films also brings into sharp focus the contemporary fascination with the fundamental questions of documentary and experimental film theory and makes clear that film theory of any kind requires careful attention to these forms of filmmaking.

# CHARLES BAUDELAIRE

# The Salon of 1859: The Modern Public and Photography

Nineteenth-century French poet, critic, and translator Charles Baudelaire (1821–1867) is most renowned for his fin-de-siècle collection of poetry *Les fleurs du mal* (*Flowers of Evil*), first published two years before the review of the Salon of 1859 included here. Influenced by the work of Edgar Allan Poe and representative of Baudelaire's contempt for middle-class values, his poems—often about eroticism, drugs, and death—were condemned as obscene by the Public Safety section of the Ministry of the Interior and banned in France until 1949. Baudelaire was part of a tumultuous period of cultural change, and some literary historians consider him the first poet to make a radical break with traditional verse forms as well as conventional subjects. Baudelaire's writings were on the cutting and experimental edge of nineteenth-century literature and, despite his early death, he has had a long-lasting influence on twentieth-century avant-garde movements.

The various "salons" of the mid-nineteenth century, that is, annual art exhibitions in the Louvre, often became the battleground for arguing what was considered conventional and dull art versus what was thought of as innovative and distinctive. Out of these confrontations came the revolutionary Impressionist work of Edouard Manet and others. These artists would lead the way toward the even more experimental images of the Post-Impressionists later in the century, which would in turn give rise to modernist artists such as Picasso, whose cubist fracturing of the image would align with the cinematic avant-gardes of the 1920s. The historical and cultural context of the salons and their debates suggests some of the irony of Baudelaire's condemnation of photography: he felt this newest of the visual arts offered only a blunt realism that blocked the imaginative freedom of experimental and innovative art. Like many of the artists and writers of this period, Baudelaire demanded that art show "modern life," specifically the changing world of the nineteenth century, and he saw the increasing popularity of photography as an obstacle to modern vision.

In this selection from his essay "The Salon of 1859," originally published between June 10 and July 20 of 1859, Baudelaire derides the triviality that he felt had invaded even the titles of paintings. His main target, however, is the photographic reproduction of reality that emerged with the appearance of photographs in the 1830s and gathered steam by midcentury, when it seemed to overshadow the traditions of classical beauty and creativity. In his aim to reconcile truly modern art and what he considers the merely mechanical forms of modernization, Baudelaire lashes out at the public masses whose fascination with fads makes them incapable of true perception and slave to "blind and imbecile infatuation." Although Baudelaire's comments address photography and not film, both the historical timing and subject matter anticipate central debates that would emerge in later film theory about technological reproduction as an artistic means and about the cultural status of photography and film as "merely" mass entertainment. Examples of these later debates are represented throughout this anthology, including selections by John Berger

(p. 114), Walter Benjamin (p. 229), Tom Gunning (p. 69), Henry Jenkins (p. 619), and Fredric Jameson (p. 1031).

## READING CUES & KEY CONCEPTS

■ Consider Baudelaire's distinction between beauty and truth or poetry and progress. What are his assumptions about the differences? How is photography implicated in the loss of the latter in the service of the former?

■ Examine what is so dangerous for Baudelaire about the way the "public" masses desire to see the world.

■ Why, for Baudelaire, does photographic realism disallow artistic experimentation?

■ **Key Concepts:** The Sphere of the Intangible; Impact of Wonder versus Thrill of Surprise; The Photographic Industry

# The Salon of 1859: The Modern Public and Photography

. . . . . . . . . . . . . .

In this country, the natural painter, like the natural poet, is almost a monster. Our exclusive taste for the true (so noble a taste when limited to its proper purposes) oppresses and smothers the taste for the beautiful. Where only the beautiful should be looked for—shall we say in a beautiful painting, and anyone can easily guess the sort I have in mind—our people look only for the true. They are not artistic, naturally artistic; philosophers, perhaps, or moralists, engineers, lovers of instructive anecdotes, anything you like, but never spontaneously artistic. They feel, or rather judge, successively, analytically. Other more favoured peoples feel things quickly, at once, synthetically.

I was referring just now to the artists who seek to astonish the public. The desire to astonish or be astonished is perfectly legitimate. "It is a happiness to wonder": but also "It is a happiness to dream." If you insist on my giving you the title of artist or art-lover, the whole question is by what means you intend to create or to feel this impact of wonder? Because beauty always contains an element of wonder, it would be absurd to assume that what is wonderful is always beautiful. Now the French public, which, in the manner of mean little souls, is singularly incapable of feeling the joy of dreaming or of admiration, wants to have the thrill of surprise by means that are alien to art, and its obedient artists bow to the public's taste; they aim to draw its attention, its surprise, stupefy it, by unworthy stratagems, because they know the public is incapable of deriving ecstasy from the natural means of true art.

In these deplorable times, a new industry has developed, which has helped in no small way to confirm fools in their faith, and to ruin what vestige of the divine might still have remained in the French mind. Naturally, this idolatrous multitude was calling for an ideal worthy of itself and in keeping with its own nature. In the domain of painting and statuary, the present-day credo of the worldly wise, especially in France (and I do not believe that anyone whosoever would dare to maintain the

contrary), is this: "I believe in nature, and I believe only in nature." (There are good reasons for that.) "I believe that art is, and can only be, the exact reproduction of nature." (One timid and dissenting sect wants naturally unpleasing objects, a chamber pot, for example, or a skeleton, to be excluded.) "Thus if an industrial process could give us a result identical to nature, that would be absolute art." An avenging God has heard the prayers of this multitude; Daguerre[1] was his messiah. And then they said to themselves: "Since photography provides us with every desirable guarantee of exactitude" (they believe that, poor madmen!) "art is photography." From that moment onwards, our loathsome society rushed, like Narcissus, to contemplate its trivial image on the metallic plate. A form of lunacy, an extraordinary fanaticism, took hold of these new sun-worshippers. Strange abominations manifested themselves. By bringing together and posing a pack of rascals, male and female, dressed up like carnival-time butchers and washerwomen, and in persuading these "heroes" to "hold" their improvised grimaces for as long as the photographic process required, people really believed they could represent the tragic and the charming scenes of ancient history. Some democratic writer must have seen in that a cheap means of spreading the dislike of history and painting amongst the masses, thus committing a double sacrilege, and insulting, at one and the same time, the divine art of painting and the sublime art of the actor. It was not long before thousands of pairs of greedy eyes were glued to the peepholes of the stereoscope, as though they were the skylights of the infinite. The love of obscenity, which is as vigorous a growth in the heart of natural man as self-love, could not let slip such a glorious opportunity for its own satisfaction. And pray do not let it be said that children, coming home from school, were the only people to take pleasure in such tomfooleries; it was the rage of society. I once heard a smart woman, a society woman, not of my society, say to her friends, who were discreetly trying to hide such pictures from her, thus taking it upon themselves to have some modesty on her behalf: "Let me see; nothing shocks me." That is what she said, I swear it, I heard it with my own ears; but who will believe me? "You can see that they are great ladies,"[2] says Alexandre Dumas. "There are greater ones still!" echoes Cazotte.

As the photographic industry became the refuge of all failed painters with too little talent, or too lazy to complete their studies, this universal craze not only assumed the air of blind and imbecile infatuation, but took on the aspect of revenge. I do not believe, or at least I cannot bring myself to believe, that any such stupid conspiracy, in which, as in every other, wicked men and dupes are to be found, could ever achieve a total victory; but I am convinced that the badly applied advances of photography, like all purely material progress for that matter, have greatly contributed to the impoverishment of French artistic genius, rare enough in all conscience. Modern fatuity may roar to its heart's content, eruct all the borborygmi of its pot-bellied person, vomit all the indigestible sophistries stuffed down its greedy gullet by recent philosophy; it is simple common-sense that, when industry erupts into the sphere of art, it becomes the latter's mortal enemy, and in the resulting confusion of functions none is well carried out. Poetry and progress are two ambitious men that hate each other, with an instinctive hatred, and when they meet along a pathway one or other must give way. If photography is allowed to deputize for art in some of art's activities, it will not be long before it has supplanted or corrupted art altogether, thanks to the stupidity of the masses, its natural ally. Photography must, therefore, return to its true duty, which is that of handmaid of the arts and sciences,

but their very humble handmaid, like printing and shorthand, which have neither created nor supplemented literature. Let photography quickly enrich the traveller's album, and restore to his eyes the precision his memory may lack; let it adorn the library of the naturalist, magnify microscopic insects, even strengthen, with a few facts, the hypotheses of the astronomer; let it, in short, be the secretary and record-keeper of whomsoever needs absolute material accuracy for professional reasons. So far so good. Let it save crumbling ruins from oblivion, books, engravings, and manuscripts, the prey of time, all those precious things, vowed to dissolution, which crave a place in the archives of our memories; in all these things, photography will deserve our thanks and applause. But if once it be allowed to impinge on the sphere of the intangible and the imaginary, on anything that has value solely because man adds something to if from his soul, then woe betide us!

I know perfectly well I shall be told: "The disease you have just described is a disease of boneheads. What man worthy of the name of artist, and what true art-lover has ever confused art and industry?" I know that, but let me, in my turn, ask them if they believe in the contagion of good and evil, in the pressure of society on the individual, and the involuntary, inevitable obedience of the individual to society. It is an indisputable and irresistible law that the artist acts upon the public, that the public reacts on the artist; besides, the facts, those damning witnesses, are easy to study; we can measure the full extent of the disaster. More and more, as each day goes by, art is losing in self-respect, is prostrating itself before external reality, and the painter is becoming more and more inclined to paint, not what he dreams, but what he sees. And yet *it is a happiness to dream*, and it used to be an honour to express what one dreamed; but can one believe that the painter still knows that happiness?

Will the honest observer declare that the invasion of photography and the great industrial madness of today are wholly innocent of this deplorable result? Can it legitimately be supposed that a people whose eyes get used to accepting the results of a material science as products of the beautiful will not, within a given time, have singularly diminished its capacity for judging and feeling those things that are most ethereal and immaterial?

## NOTES

1. Louis Daguerre (1789–1851), inventor, with Nicéphor Nièpce, of photography.
2. The quotations come from Dumas's *La Tour de Nesle* (1832) and Nerval's essay on Cazotte. (Pléiade)

# GERMAINE DULAC

## The Avant-Garde Cinema

Filmmaker and writer Germaine Dulac (1882–1942) was a leading figure in French experimental filmmaking of the silent era and an important precursor of later women directors in both the industry and the avant-garde sector. She was a writer and editor for the French feminist journal *La Française* who formed her own production company

and directed her first film in 1915. *The Smiling Madame Beudet* (1922), a narrative film that uses innovative techniques such as optical devices to depict the inner life of a housewife trapped in a marriage to a boorish businessman, is widely considered her masterpiece. In 1927, Dulac directed the first surrealist film, *The Seashell and the Clergyman*, from a scenario by poet Antonin Artaud. The film's dream logic and controversial reception have shrouded this historic collaboration in misunderstanding. The coming of sound and the industrialization of filmmaking put an end to Dulac's independent career, as it did for many women directors. During the 1930s Dulac supervised newsreel production for the film company Pathé.

Together with such figures as Jean Epstein (p. 252) and Louis Delluc, Dulac is identified with the French Impressionist film movement and the film magazines and ciné-clubs that made for such a vibrant film culture in France in the 1920s. She wrote and lectured widely on film aesthetics, advocating cinema's affinities with music, in which she had been trained, over literature. Avant-garde film cultures and experimentation in the arts thrived throughout Europe during this period, and Dulac preserves this vibrant history and experimental spirit in her writing and teaching.

In "The Avant-Garde Cinema," which was written shortly after the coming of sound in 1932, Dulac gives an accessible introduction to the history of cinema up until that moment from the perspective of the avant-garde film. Drawing on the military origin and definition of the term "avant-garde"—advance guard, in the lead—Dulac stresses that avant-garde film is essential to the evolution of the medium and that its contributions are necessary to the film industry as well as to film art. Like many later historians, she calls the medium's embrace of a narrative logic "arbitrary" and advocates for exploration of the image, of movement and rhythm, and of the "imponderable"—whether through slow-motion scientific films or attempts to convey the logic of dreams. Dulac's essay acknowledges conventional notions of artistic impression and expression, and the predictable antagonism of audiences and mainstream filmmaking to the avant-garde. However, she also expresses a realistic attitude that remains instructive for experimental endeavors today, acknowledging that even the avant-garde film is dependent on capital for production and distribution. Films like those by her peers Abel Gance and Soviet director Sergei Eisenstein show the incorporation of avant-garde techniques into narrative filmmaking, and a similar symbiosis persists in the work of such contemporary commercial auteurs as David Fincher and Michel Gondry.

## READING CUES & KEY CONCEPTS

■ Dulac revisits the opposition between Méliès and Lumière in her history of the avant-garde. How does she locate the avant-garde impulse at the very origins of cinema?

■ Consider what Dulac classifies as "purely visual elements" of filmmaking in her essay. How does cinema distinguish itself from previous art forms?

■ How does Dulac rethink the relationship between experimentation in film and the film industry? Does this mutually dependent relationship exist today?

■ **Key Concepts:** Avant-Garde; Pure Cinema; Impressionism; Expressionism

# The Avant-Garde Cinema

. . . . . . . . . . . . .

## *The Works of the Cinematic Avant-Garde: Their Destiny before the Public and Film Industry*

We can use the term "avant-garde" for any film whose technique, employed with a view to a renewed expressiveness of image and sound, breaks with established traditions to search out, in the strictly visual and auditory realm, new emotional chords. The avant-garde film does not appeal to the mere pleasure of the crowd. It is at once too egoistic and too altruistic. Egoistic, because it is the personal manifestation of a pure thought; altruistic, because it is isolated from every concern other than progress. The sincere avant-garde film has this fundamental quality of containing, behind a sometimes inaccessible surface, the seeds of the discoveries which are capable of advancing film toward the cinematic form of the future. The avant-garde is born of both the criticism of the present and the foreknowledge of the future.

The cinema is an art and an industry. Considered as art, it must jealously defend its purity of expression and never betray that purity in order to convince. But it is also an industry. To make a film and distribute it require money, a lot of money. The photographic film which receives the image is expensive, its processing costly. By itself, every visual or audio element used corresponds to a figure, a fixed expense. The electricity required for a beautiful lighting effect can only be had for money, and for another example, there is the lens. The list would be a long one, were I to go on.

The film industry produces commercial films, films made with a concern for reaching the public at large, and it produces mercantile films as well. By mercantile films should be understood those which make every concession to pursue a simple economic goal, and by commercial films those which, taking the greatest possible advantage of cinematic expression and technique, sometimes produce interesting works while still working toward a reasonable profit. That is where the union of industry and art occurs.

From the commercial cinema emerges the total work, the balanced film for which the industry and the avant-garde, separated in their two camps, both work.

In general, the industry does not attach itself zealously to the contribution of art; the avant-garde, with its opposite impulse, considers nothing else. Whence the antagonism.

**[ · · · ]**

The avant-garde and the commercial cinema, that is, the art and the industry of film, form an inseparable whole.

But the avant-garde, which is essential to the evolution of film, has most of the public and all of the producers against it.

The various avant-garde schools have attempted:

1. To free the cinema from the hold of the existing arts;

2. To bring it back to the considerations essential to it: movement, rhythm, life.

## HISTORIC EVOLUTION

Since Louis Lumière's mechanical discovery, cinema has always excited research by film-makers, on the level of the spirit, parallel to that of the inventors. Wasn't Méliès, in his day, an avant-garde filmmaker, substituting the spirit of cinema for the spirit of photography?[1]

**[ · · · ]**

It is rather upsetting to consider the simple mentality with which the public received the first cinematic presentations. First of all, for the public, the cinema was a photographic means of reproducing the mechanical movement of life. They were happy with the sight of a train arriving in a station, without dreaming that, therein, lay hidden a new contribution offering a means of expression to the sensibility and the intelligence.

The capture of life-movement envisaged as simple photographic reproduction became, before every other effort, an outlet for literature. Animated photographs were assembled around a composed, fictive action; the life angle was abandoned and only the literature angle kept in view. And so the cinema entered into the cerebral domain of narrative movement. A theatrical work is movement. The novel is also movement, because there is an interlocking and succession of situations, ideas, feelings, which interact with one another. The human being is movement, because he moves, he acts. From deduction to deduction, from confusion to confusion, rather than study in themselves, for their intrinsic value, the ideas of movement, of the image and its rhythm, they turned the cinema into a photographed stage show. They took it as an easy means of multiplying the episodes and settings of a drama, of reinforcing and varying the theatrical or novelistic situations of the story with the help of endless cuts, using an alternation of artificial sets and natural backdrops.

The years passed, improving the means of execution and affirming the film sense, the direction the filmmakers had taken. The narrative cinema evolved, completely arbitrary and novelistic. The plot was wrapped in realistic forms and the emotions reduced to proportions which were strictly true and human.

The logic of an event, the precision of a frame, the correctness of a pose constituted the basic structural parts of the new cinematic technique. Moreover, along with composition, expressive pacing intervened in the organization of the images and gave birth to rhythm, although, in spite of the visual sense which was beginning to dawn, the story "for the story" won out.

The shots no longer succeeded one another independently, tied together by nothing more than a title, but came to depend on each other with a moving and rhythmical psychological logic.

Before long, they thought of photographing the unexpressed, the invisible, the imponderable, the human soul, the visual "suggestive" emerging from the precision of photography. Above the facts, a line of feelings was sketched out, harmonic, dominating people and things.

From this the psychological film logically emerged. It seemed childish to put a character in a given situation without evoking the realm of his interior life, and so they added to his movements the perception of his thoughts, his feeling, his sensations. With the addition to the bare facts of the drama of the description of the multiple and contradictory impressions in the course of an action—the facts no longer existing in themselves, but becoming the consequence of a moral state—a duality imperceptibly

entered, a duality which, to remain in equilibrium, adapted itself to the cadence of a rhythm, to the dynamism and pace of the images.

And the avant-garde activity began. The public and most of the film industrialists had accepted realism; confronted with the developed and isolated play of emotional and perceptual elements, they rebelled. The cinema must, according to their theories, belong exclusively and dryly to the drama created by the situations and the facts, and not to the drama provoked by the conflicts of minds and hearts. They fought against impressionism and expressionism without realizing that all the research undertaken by the innovators of the day was enlarging the domain of pure action, of emotion set free by "psychological projections and analysis of atmosphere."[2]

Abel Gance's *La Roue* marks a great step forward. In this film, psychology, gestures, drama became dependent on a cadence. The characters were no longer the only important factors in the work, but rather the objects as well, the machines, and the length of the shots, their composition, their opposition, their framing, their harmony. Rails, locomotives, boilers, wheels, pressure gauge, smoke, and tunnels act through the images along with the characters; a new drama burst forth made up of raw emotions and of lines of development. The conception of the art of movement, and of systematically paced images came into its own, as well as the expression of *things* magnificently accomplishing the visual poem made up of human life-instincts, playing with matter and the imponderable. A symphonic poem, where emotion bursts forth not in facts, not in actions, but in visual sonorities. Imperceptibly, narrative storytelling, the actor's performance lost some of their isolated value, in favor of a general orchestration made up of planes, rhythms, frames, angles, light, proportions, contrasts, harmony of images.

"To strip the cinema of all those elements which did not properly belong to it, to find its true essence in the understanding of movement and visual values: this was the new esthetic that appeared in the light of a new dawn."[3]

## THE DEFINITIVE RISE OF THE AVANT-GARDE

It was about 1924 when the undertakings and experiments of a few courageous directors split off from commercial production to become what is called avant-garde production. The divorce between these two forms of production became necessary because the public could not accept certain innovative scenes in the films of the day, passionately involved as they were in the convolutions of the plot. These passages, moreover, were officially suppressed, if they crept into the finished work, either by the producers or by the theatre-owners, who were anxious to spare the audience the shock or the displeasure brought on by a new technique of expressive images.

And so there were, from then on, avant-garde production and distribution. Minimal production; limited distribution. Production which was minimal because the experiments did not find, in order to multiply, the capital which is continually necessary to any stable cinematic effort. And the avant-garde, detached from motives of profit, marched boldly on toward the conquest of the new modes of expression which it felt would serve to expand cinematic thought, with nothing to fall back on, materially or morally, but with faith. It studied the expansion it wanted, analysing the possibilities, determined to make the expression of every being, of every object, moving. It scorned neither the infinitely large nor the infinitely small. Within pure cinematic means, beyond literature

and theatre, it sought emotion and feeling in movement, volumes and forms, playing with transparencies, opacities and rhythms. It was the era of pure cinema which, rejecting all other action, wanted to cling only to that which emerged directly from the image, "in the attempt to give a strictly personal expression of the universe."[4]

Pure cinema did not reject sensitivity or drama, but it tried to attain them through purely visual elements. It went in search of emotion beyond the limits of the human, to everything that exists in nature, to the invisible, the imponderable, to abstract movement. It was this school which set forth in various forms, both ironic[5] and sensitive,[6] the expression of movement and rhythm, liberating these from the novelistic situation, in order to allow the idea, the criticism or the dramatic action, to burst forth suggestively. The proofs to be given were:

1. That the expression of a movement depends on its rhythm;

2. That the rhythm in itself and the development of a movement constitute the two perceptual and emotional elements which are the bases of the dramaturgy of the screen;

3. That the cinematic work must reject every esthetic principle which does not properly belong to it and seek out its own esthetic in the contributions of the visual;

4. That the cinematic action must be *life*.

5. That the cinematic action must not be limited to the human person, but must extend beyond it into the realm of nature and dream.

The essential givens of pure cinema might be found in certain scientific writings, those which discuss, for example, the formation of crystals, the trajectory of a bullet, the bursting of a bubble (a pure rhythm, and what a moving one! wonderful syntheses), the evolution of microbes, the expressiveness and lives of insects.

Was not cinema potentially capable of grasping with its lenses the infinitely large and the infinitely small? This school of the ungraspable turned its attention to other dramas than those played by actors. More than anything else, it was attacked because it scorned the story to latch onto suggestive impression and expression and because it enveloped the viewer in a network, not of events to follow, but of sensations to experience and to feel. Today we find the influence of this school expressed very clearly in the actions of certain beautiful films which are accessible to every taste, such as *The General Line [Old and New]* (transformation of cream into butter and the movement of the mechanical churn) and Dovzhenko's *Earth* (the rain fertilizing the soil and running over the flowers and fruit). Alongside of the pure cinema school, certain visual composers set out to treat nature itself in new rhythms, transforming abstract reveries into concrete and living realities. With them, the cinema expanded its stock of rhythmic truths.[7]

All these contributions of the avant-garde were instinctively absorbed by the commercial cinema, slowly, and without a revolution. While the pure cinema remained deliberately abstract, other audacious works inspired by it applied its techniques to more direct feelings, in general using that technique toward ends which met with less resistance.

[ · · · ]

## CONCLUSION

To sum up, the avant-garde has been the abstract exploration and realization of pure thought and technique, later applied to more clearly human films. It has not only established the foundations of the dramaturgy of the screen, but researched and cultivated all the possibilities of expression locked in the lens of a movie camera.

Its influence is undeniable. It has, so to speak, sharpened the eye of the public, the sensitivity of the creators, and broken new ground in enlarging cinematic thought in its totality.

The avant-garde, let us repeat, is a living ferment; it contains the seeds of the conceptions of future generations, which is to say, progress.

The cinematic avant-garde is necessary to the art, and to the industry.

[Translated by Robert Lamberton]

## NOTES

1. In the case of Méliès, the French play on words, *esprit* = spirit *and* wit, is important, though impossible to translate.—Tr.

2. *Das Kabinett des Dr. Caligari, Coeur Fidèle, La Souriante Madame Beudet, El Dorado.*—Surprising though it may be, it was enlightened producers who made such undertakings possible at this period.

3. Germaine Dulac, *Les Esthétiques et Les Entraves*, Librairie Félix Alcan, 1927.

4. Jean Tédesco.

5. Fernand Léger's *Ballet Mécanique*, Hans Richter's series of films, René Clair's *Entr' acte*.

6. Viking Eggeling's absolute films, Ruttmann's *Opus I-IV*, Henri Chomette's *Reflets du Lumière et de Vitesse, Cinq Minutes de Cinéma Pur*, Deslaw's *La Marche des Machines*, René Clair's *Essais en Couleurs* and *La Tour*, Joris Ivens's *Le Pont*, Germaine Dulac's *Arabesques, Disque 927*, and *Thèmes et Variations*.

7. Jean Grémillon's *Tour au Large*, Dimitri Kirsanoff's *Brumes d'Automne*, Joris Ivens's *Regen*, Marcel Carné's *Nogent, Eldorado du Dimanche*, Jean Vigo's film of social criticism *A propos de Nice*, Victor Blum's mountain film *Wasser*, Ruttmann's *Melodie der Welt*, Caballeros's *Essence de Verveine*.

# JOHN GRIERSON

## First Principles of Documentary

Considered the father of British and Canadian documentary film, John Grierson (1898–1972) was a filmmaker, critic, and producer. In 1933, Grierson began work for the General Post Office Film Unit, which became the primary institutional framework for documentary cinema in England. He later established the Film Centre, an advisory and coordinating body for documentary movies. In the late 1930s he worked in Canada, coordinating the

production of films for the National Film Board of Canada (NFB), before returning to England to make propaganda films during World War II. Although his only directing credit is for *Drifters* (1929), a film about North Sea herring fishermen, Grierson was the central force in the advancement of documentary cinema in the 1930s and 1940s through his commitment to film education, political engagement with current events and realities, and the formation of institutional infrastructures for the production and distribution of documentary films. He coined the term "documentary" in his review of *Moana* (1926) by Robert Flaherty (another important figure in early documentary cinema). His well-known definition of documentary as the "creative treatment of actuality" became the motto of a wave of young documentary filmmakers that he nurtured throughout the 1930s.

The late 1920s and the 1930s are largely thought of as the watershed years for documentary cinema. While commercial narrative films, primarily from Hollywood, continued to dominate the cultural landscape, alternative subjects and styles took on greater importance as political turbulence rattled nations around the world and film became recognized as a major educational force. Along with the avant-garde and experimental films of the 1920s, documentary films such as Flaherty's *Man of Aran* (1934), Dziga Vertov's *The Man with a Movie Camera* (1929), and Walter Ruttmann's *Berlin, Symphony of a Great City* (1927), offered new and important ways of seeing society and promulgating values beyond those of entertainment. As World War II approached, documentary cinema often became associated with propaganda films, such as Leni Riefenstahl's notorious *Triumph of the Will* (1935), a depiction of Hitler's appearance at a Nazi rally, but this new direction only underlined Grierson's insistence that documentary truth is always a malleable truth.

The selection included here, "First Principles of Documentary," is the 1935 revision and expansion of his 1926 essay of the same title. In it, Grierson argues some now commonly accepted fundamentals of the form: the documentary is an opening of the screen to the real world; it should feature non-actors and have an emphasis on the raw material of life. At the same time, Grierson complicates the naïve notion that documentaries can or should offer a purely objective and unmediated view of the world. Instead, he persuasively claims the best documentaries penetrate the "surface values" of a subject as a way to "reveal" life rather than simply describe it. Certainly these arguments should be evaluated alongside those of other film theorists of the period, such as Walter Benjamin (p. 229), Siegfried Kracauer (p. 289), and Rudolf Arnheim (p. 279), but it's also worth considering how Grierson looks forward to the many contemporary models of documentary cinema that, as the work of Bill Nichols (p. 672) demonstrates, see documentary reality as a function of different kinds of creativity.

## READING CUES & KEY CONCEPTS

■ Despite his admiration of the films of Robert Flaherty, Grierson warns against his penchant for "neo-Rousseauism." What does he mean by this, and what are the dangers he sees? What are the alternatives for documentary filmmakers?

■ Summarize Grierson's distinction between journalism and documentary films. Why is this distinction important to his definition of documentaries?

■ What is the place of the individual subject in Grierson's first principles of documentary?

■ **Key Concepts:** Imagism; Documentary Description versus Drama; Romantic Documentary versus Realist Documentary; Symphonic Form

# First Principles of Documentary

. . . . . . . . . . . . . .

Documentary is a clumsy description, but let it stand. The French who first used the term only meant travelogue. It gave them a solid high-sounding excuse for the shimmying (and otherwise discursive) exoticisms of the Vieux Colombier. Meanwhile documentary has gone on its way. From shimmying exoticisms it has gone on to include dramatic films like *Moana, Earth,* and *Turksib.* And in time it will include other kinds as different in form and intention from *Moana,* as *Moana* was from *Voyage au Congo.*

So far we have regarded all films made from natural material as coming within the category. The use of natural material has been regarded as the vital distinction. Where the camera shot on the spot (whether it shot newsreel items or magazine items or discursive "interests" or dramatised "interests" or educational films or scientific films proper or *Changs* or *Rangos*) in that fact was documentary. This array of species is, of course, quite unmanageable in criticism, and we shall have to do something about it. They all represent different qualities of observation, different intentions in observation, and, of course, very different powers and ambitions at the stage of organizing material. I propose, therefore, after a brief word on the lower categories, to use the documentary description exclusively of the higher.

The peacetime newsreel is just a speedy snip-snap of some utterly unimportant ceremony. Its skill is in the speed with which the babblings of a politican (gazing sternly into the camera) are transferred to fifty million relatively unwilling ears in a couple of days or so. The magazine items (one a week) have adopted the original "Tit-Bits" manner of observation. The skill they represent is a purely journalistic skill. They describe novelties novelly. With their money-making eye (their almost only eye) glued like the newsreels to vast and speedy audiences, they avoid on the one hand the consideration of solid material, and escape, on the other, the solid consideration of any material. Within these limits they are often brilliantly done. But ten in a row would bore the average human to death. Their reaching out for the flippant or popular touch is so completely far-reaching that it dislocates something. Possibly taste; possibly common sense. You may take your choice at those little theatres where you are invited to gad around the world in fifty minutes. It takes only that long—in these days of great invention—to see almost everything.

"Interests" proper improve mightily with every week, though heaven knows why. The market (particularly the British market) is stacked against them. With two-feature programmes the rule, there is neither space for the short *and* the Disney *and* the magazine, nor money left to pay for the short. But by good grace, some of the renters throw in the short with the feature. This considerable branch of cinematic illumination tends, therefore, to be the gift that goes with the pound of tea; and like all gestures of the grocery mind it is not very liable to cost much. Whence my wonder at improving qualities. Consider, however, the very frequent beauty and very great skill of exposition in such

Ufa shorts as *Turbulent Timber*, in the sports shorts from Metro-Goldwyn-Mayer, in the *Secrets of Nature* shorts from Bruce Woolfe, and the Fitzpatrick travel talks. Together they have brought the popular lecture to a pitch undreamed of, and even impossible in the days of magic lanterns. In this little we progress.

These films, of course, would not like to be called lecture films, but this, for all their disguises, is what they are. They do not dramatize, they do not even dramatize an episode: they describe, and even expose, but in any aesthetic sense, only rarely reveal. Herein is their formal limit, and it is unlikely that they will make any considerable contribution to the fuller art of documentary. How indeed can they? Their silent form is cut to the commentary, and shots are arranged arbitrarily to point the gags or conclusions. This is not a matter of complaint, for the lecture film must have increasing value in entertainment, education and propaganda. But it is as well to establish the formal limits of the species.

This indeed is a particularly important limit to record, for beyond the newsmen and the magazine men and the lecturers (comic or interesting or exciting or only rhetorical) one begins to wander into the world of documentary proper, into the only world in which documentary can hope to achieve the ordinary virtues of an art. Here we pass from the plain (or fancy) descriptions of natural material, to arrangements, rearrangements, and creative shapings of it.

First principles. (1) We believe that the cinema's capacity for getting around, for observing and selecting from life itself, can be exploited in a new and vital art form. The studio films largely ignore this possibility of opening up the screen on the real world. They photograph acted stories against artificial backgrounds. Documentary would photograph the living scene and the living story. (2) We believe that the original (or native) actor, and the original (or native) scene, are better guides to a screen interpretation of the modern world. They give cinema a greater fund of material. They give it power over a million and one images. They give it power of interpretation over more complex and astonishing happenings in the real world than the studio mind can conjure up or the studio mechanician recreate. (3) We believe that the materials and the stories thus taken from the raw can be finer (more real in the philosophic sense) than the acted article. Spontaneous gesture has a special value on the screen. Cinema has a sensational capacity for enhancing the movement which tradition has formed or time worn smooth. Its arbitrary rectangle specially reveals movement; it gives it maximum pattern in space and time. Add to this that documentary can achieve an intimacy of knowledge and effect impossible to the shim-sham mechanics of the studio, and the lily-fingered interpretations of the metropolitan actor.

I do not mean in this minor manifesto of beliefs to suggest that the studios cannot in their own manner produce works of art to astonish the world. There is nothing (except the Woolworth intentions of the people who run them) to prevent the studios going really high in the manner of theatre or the manner of fairy tale. My separate claim for documentary is simply that in its use of the living article, there is *also* an opportunity to perform creative work. I mean, too, that the choice of the documentary medium is as gravely distinct a choice as the choice of poetry instead of fiction. Dealing with different material, it is, or should be, dealing with it to different aesthetic issues from those of the studio. I make this distinction to the point of asserting that the young director cannot, in nature, go documentary and go studio both.

In an earlier reference to Flaherty, I have indicated how one great exponent walked away from the studio: how he came to grips with the essential story of the Eskimos, then with the Samoans, then latterly with the people of the Aran Islands: and at what point the documentary director in him diverged from the studio intention of Hollywood. The main point of the story was this. Hollywood wanted to impose a ready-made dramatic shape on the raw material. It wanted Flaherty, in complete injustice to the living drama on the spot, to build his Samoans into a rubber-stamp drama of sharks and bathing belles. It failed in the case of *Moana*; it succeeded (through Van Dyke) in the case of *White Shadows of the South Seas*, and (through Murnau) in the case of *Tabu*. In the last examples it was at the expense of Flaherty, who severed his association with both.

With Flaherty it became an absolute principle that the story must be taken from the location, and that it should be (what he considers) the essential story of the location. His drama, therefore, is a drama of days and nights, of the round of the year's seasons, of the fundamental fights which give his people sustenance, or make their community life possible, or build up the dignity of the tribe.

Such an interpretation of subject-matter reflects, of course, Flaherty's particular philosophy of things. A succeeding documentary exponent is in no way obliged to chase off to the ends of the earth in search of old-time simplicity, and the ancient dignities of man against the sky. Indeed, if I may for the moment represent the opposition, I hope the Neo-Rousseauism implicit in Flaherty's work dies with his own exceptional self. Theory of naturals apart, it represents an escapism, a wan and distant eye, which tends in lesser hands to sentimentalism. However it be shot through with vigour of Lawrentian poetry, it must always fail to develop a form adequate to the more immediate material of the modern world. For it is not only the fool that has his eyes on the ends of the earth. It is sometimes the poet: sometimes even the great poet, as Cabell in his *Beyond Life* will brightly inform you. This, however, is the very poet who on every classic theory of society from Plato to Trotsky should be removed bodily from the Republic. Loving every Time but his own, and every Life but his own, he avoids coming to grips with the creative job in so far as it concerns society. In the business of ordering most present chaos, he does not use his powers.

Question of theory and practice apart, Flaherty illustrates better than anyone the first principles of documentary. (1) It must master its material on the spot, and come in intimacy to ordering it. Flaherty digs himself in for a year, or two maybe. He lives with his people till the story is told "out of himself." (2) It must follow him in his distinction between description and drama. I think we shall find that there are other forms of drama or, more accurately, other forms of film, than the one he chooses; but it is important to make the primary distinction between a method which describes only the surface values of a subject, and the method which more explosively reveals the reality of it. You photograph the natural life, but you also, by your juxtaposition of detail, create an interpretation of it.

This final creative intention established, several methods are possible. You may, like Flaherty, go for a story form, passing in the ancient manner from the individual to the environment, to the environment transcended or not transcended, to the consequent honours of heroism. Or you may not be so interested in the individual. You may think that the individual life is no longer capable of cross-sectioning reality. You may believe that its particular belly-aches are of no consequence in a world which

complex and impersonal forces command, and conclude that the individual as a self-sufficient dramatic figure is outmoded. When Flaherty tells you that it is a devilish noble thing to fight for food in a wilderness, you may, with some justice, observe that you are more concerned with the problem of people fighting for food in the midst of plenty. When he draws your attention to the fact that Nanook's spear is grave in its upheld angle, and finely rigid in its down-pointing bravery, you may, with some justice, observe that no spear, held however bravely by the individual, will master the crazy walrus of international finance. Indeed you may feel that in individualism is a yahoo tradition largely responsible for our present anarchy, and deny at once both the hero of decent heroics (Flaherty) and the hero of indecent ones (studio). In this case, you will feel that you want your drama in terms of some cross-section of reality which will reveal the essentially co-operative or mass nature of society: leaving the individual to find his honours in the swoop of creative social forces. In other words, you are liable to abandon the story form, and seek, like the modern exponent of poetry and painting and prose, a matter and method more satisfactory to the mind and spirit of the time.

*Berlin* or the Symphony of a City initiated the more modern fashion of finding documentary material on one's doorstep: in events which have no novelty of the unknown, or romance of noble savage on exotic landscape, to recommend them. It represented, slimly, the return from romance to reality.

*Berlin* was variously reported as made by Ruttmann, or begun by Ruttmann and finished by Freund: certainly it was begun by Ruttmann. In smooth and finely tempo'd visuals, a train swung through suburban mornings into Berlin. Wheels, rails, details of engines, telegraph wires, landscapes and other simple images flowed along in procession, with similar abstracts passing occasionally in and out of the general movement. There followed a sequence of such movements which, in their total effect, created very imposingly the story of a Berlin day. The day began with a processional of workers, the factories got under way, the streets filled: the city's forenoon became a hurly-burly of tangled pedestrians and street cars. There was respite for food: a various respite with contrast of rich and poor. The city started work again, and a shower of rain in the afternoon became a considerable event. The city stopped work and, in further more hectic processional of pubs and cabarets and dancing legs and illuminated sky-signs, finished its day.

In so far as the film was principally concerned with movements and the building of separate images into movements, Ruttmann was justified in calling it a symphony. It meant a break away from the story borrowed from literature, and from the play borrowed from the stage. In *Berlin* cinema swung along according to its own more natural powers: creating dramatic effect from the tempo'd accumulation of its single observations. Cavalcanti's *Rien que les Heures* and Léger's *Ballet Mécanique* came before *Berlin*, each with a similar attempt to combine images in an emotionally satisfactory sequence of movements. They were too scrappy and had not mastered the art of cutting sufficiently well to create the sense of "march" necessary to the genre. The symphony of Berlin City was both larger in its movements and larger in its vision.

There was one criticism of *Berlin* which, out of appreciation for a fine film and a new and arresting form, the critics failed to make; and time has not justified the omission. For all its ado of workmen and factories and swirl and swing of a great city, Berlin created nothing. Or rather if it created something, it was that shower of rain in the afternoon. The people of the city got up splendidly, they tumbled through their

five million hoops impressively, they turned in; and no other issue of God or man emerged than that sudden besmattering spilling of wet on people and pavements.

I urge the criticism because *Berlin* still excites the mind of the young, and the symphony form is still their most popular persuasion. In fifty scenarios presented by the tyros, forty-five are symphonies of Edinburgh or of Ecclefechan or of Paris or of Prague. Day breaks—the people come to work—the factories start—the street cars rattle—lunch hour and the streets again—sport if it is Saturday afternoon—certainly evening and the local dance hall. And so, nothing having happened and nothing positively said about anything, to bed; though Edinburgh is the capital of a country and Ecclefechan, by some power inside itself, was the birthplace of Carlyle, in some ways one of the greatest exponents of this documentary idea.

The little daily doings, however finely symphonized, are not enough. One must pile up beyond doing or process to creation itself, before one hits the higher reaches of art. In this distinction, creation indicates not the making of things but the making of virtues.

And there's the rub for tyros. Critical appreciation of movement they can build easily from their power to observe, and power to observe they can build from their own good taste, but the real job only begins as they apply ends to their observation and their movements. The artist need not posit the ends—for that is the work of the critic—but the ends must be there, informing his description and giving finality (beyond space and time) to the slice of life he has chosen. For that larger effect there must be power of poetry or of prophecy. Failing either or both in the highest degree, there must be at least the sociological sense implicit in poetry and prophecy.

The best of the tyros know this. They believe that beauty will come in good time to inhabit the statement which is honest and lucid and deeply felt and which fulfils the best ends of citizenship. They are sensible enough to conceive of art as the by-product of a job of work done. The opposite effort to capture the by-product first (the self-conscious pursuit of beauty, the pursuit of art for art's sake to the exclusion of jobs of work and other pedestrian beginnings), was always a reflection of selfish wealth, selfish leisure and aesthetic decadence.

This sense of social responsibility makes our realist documentary a troubled and difficult art, and particularly in a time like ours. The job of romantic documentary is easy in comparison: easy in the sense that the noble savage is already a figure of romance and the seasons of the year have already been articulated in poetry. Their essential virtues have been declared and can more easily be declared again, and no one will deny them. But realist documentary, with its streets and cities and slums and markets and exchanges and factories, has given itself the job of making poetry where no poet has gone before it, and where no ends, sufficient for the purposes of art, are easily observed. It requires not only taste but also inspiration, which is to say a very laborious, deep-seeing, deep-sympathizing creative effort indeed.

The symphonists have found a way of building such matters of common reality into very pleasant sequences. By uses of tempo and rhythm, and by the large-scale integration of single effects, they capture the eye and impress the mind in the same way as a tattoo or a military parade might do. But by their concentration on mass and movement, they tend to avoid the larger creative job. What more attractive (for a man of visual taste) than to swing wheels and pistons about in ding-dong description of a machine, when he has little to say about the man who tends it, and still less to say

about the tin-pan product it spills? And what more comfortable if, in one's heart, there is avoidance of the issue of underpaid labour and meaningless production? For this reason I hold the symphony tradition of cinema for a danger and *Berlin* for the most dangerous of all film models to follow.

Unfortunately, the fashion is with such avoidance as *Berlin* represents. The highbrows bless the symphony for its good looks and, being sheltered rich little souls for the most part, absolve it gladly from further intention. Other factors combine to obscure one's judgment regarding it. The post-1918 generation, in which all cinema intelligence resides, is apt to veil a particularly violent sense of disillusionment, and a very natural first reaction of impotence, in any smart manner of avoidance which comes to hand. The pursuit of fine form which this genre certainly represents is the safest of asylums.

The objection remains, however. The rebellion from the who-gets-who tradition of commercial cinema to the tradition of pure form in cinema is no great shakes as a rebellion. Dadaism, expressionism, symphonies, are all in the same category. They present new beauties and new shapes; they fail to present new persuasions.

The imagist or more definitely poetic approach might have taken our consideration of documentary a step further, but no great imagist film has arrived to give character to the advance. By imagism I mean the telling of story or illumination of theme by images, as poetry is story or theme told by images: I mean the addition of poetic reference to the "mass" and "march" of the symphonic form.

*Drifters* was one simple contribution in that direction, but only a simple one. Its subject belonged in part to Flaherty's world, for it had something of the noble savage and certainly a great deal of the elements of nature to play with. It did, however, use steam and smoke and did, in a sense, marshal the effects of a modern industry. Looking back on the film now, I would not stress the tempo effects which it built (for both *Berlin* and *Potemkin* came before it), nor even the rhythmic effects (though I believe they outdid the technical example of *Potemkin* in that direction). What seemed possible of development in the film was the integration of imagery with the movement. The ship at sea, the men casting, the men hauling, were not only seen as functionaries doing something. They were seen as functionaries in half a hundred different ways, and each tended to add something to the illumination as well as the description of them. In other words the shots were massed together, not only for description and tempo but for commentary on it. One felt impressed by the tough continuing upstanding labour involved, and the feeling shaped the images, determined the background and supplied the extra details which gave colour to the whole. I do not urge the example of *Drifters*, but in theory at least the example is there. If the high bravery of upstanding labour came through the film, as I hope it did, it was made not by the story itself, but by the imagery attendant on it. I put the point, not in praise of the method but in simple analysis of the method.

The symphonic form is concerned with the orchestration of movement. It sees the screen in terms of flow and does not permit the flow to be broken. Episodes and events, if they are included in the action, are integrated in the flow. The symphonic form also tends to organize the flow in terms of different movements, e.g. movement for dawn, movement for men coming to work, movement for factories in full swing, etc., etc. This is a first distinction.

See the symphonic form as something equivalent to the poetic form of, say, Carl Sandburg in *Skyscraper, Chicago, The Windy City* and *Slabs of the Sunburnt West*. The object is presented as an integration of many activities. It lives by the many human associations and by the moods of the various action sequences which surround it. Sandburg says so with variations of tempo in his description, variations of the mood in which each descriptive facet is presented. We do not ask personal stories of such poetry, for the picture is complete and satisfactory. We need not ask it of documentary. This is a second distinction regarding symphonic form.

These distinctions granted, it is possible for the symphonic form to vary considerably. Basil Wright, for example, is almost exclusively interested in movement, and will build up movement in a fury of design and nuances of design; and for those whose eye is sufficiently trained and sufficiently fine will convey emotion in a thousand variations on a theme so simple as the portage of bananas (*Cargo from Jamaica*). Some have attempted to relate this movement to the pyrotechnics of pure form, but there never was any such animal. (1) The quality of Wright's sense of movement and of his patterns is distinctively his own and recognizably delicate. As with good painters, there is character in his line and attitude in his composition. (2) There is an over-tone in his work which—sometimes after seeming monotony— makes his description uniquely memorable. (3) His patterns invariably weave— not seeming to do so—a positive attitude to the material, which may conceivably relate to (2). The patterns of *Cargo from Jamaica* were more scathing comment on labour at twopence a hundred bunches (or whatever it is) than mere sociological stricture. His movements—(*a*) easily down; (*b*) horizontal; (*c*) arduously 45° up; (*d*) down again—conceal, or perhaps construct, a comment. Flaherty once maintained that the east-west contour of Canada was itself a drama. It was precisely a sequence of down, horizontal, 45° up, and down again.

I use Basil Wright as an example of "movement in itself"—though movement is never in itself—principally to distinguish those others who add either tension elements or poetic elements or atmospheric elements. I have held myself in the past an exponent of the tension category with certain pretension to the others. Here is a simple example of tension from *Granton Trawler*. The trawler is working its gear in a storm. The tension elements are built up with emphasis on the drag of the water, the heavy lurching of the ship, the fevered flashing of the birds, the fevered flashing of faces between waves, lurches and spray. The trawl is hauled aboard with strain of men and tackle and water. It is opened in a release which comprises equally the release of men, birds and fish. There is no pause in the flow of movement, but something of an effort as between two opposing forces, has been recorded. In a more ambitious and deeper description the tension might have included elements more intimately and more heavily descriptive of the clanging weight of the tackle, the strain on the ship, the operation of the gear under water and along the ground, the scuttering myriads of birds laying off in the gale. The fine fury of ship and heavy weather could have been brought through to touch the vitals of the men and the ship. In the hauling, the simple fact of a wave breaking over the men, subsiding and leaving them hanging on as though nothing had happened, would have brought the sequence to an appropriate peak. The release could have attached to itself images of, say, birds wheeling high, taking off from the ship, and of contemplative, i.e. more intimate, reaction on the faces of the men. The drama would have gone deeper by the greater insight into the energies and reactions involved.

Carry this analysis into a consideration of the first part of *Deserter*, which piles up from a sequence of deadly quiet to the strain and fury—and aftermath—of the strike, or of the strike sequence itself, which piles up from deadly quiet to the strain and fury—and aftermath—of the police attack, and you have indication of how the symphonic shape, still faithful to its own peculiar methods, comes to grip with dramatic issue.

The poetic approach is best represented by *Romance Sentimentale* and the last sequence of *Ekstase*. Here there is description without tension, but the moving description is lit up by attendant images. In *Ekstase* the notion of life renewed is conveyed by a rhythmic sequence of labour, but there are also essential images of a woman and child, a young man standing high over the scene, skyscapes and water. The description of the various moods of *Romance Sentimentale* is conveyed entirely by images: in one sequence of domestic interior, in another sequence of misty morning, placid water and dim sunlight. The creation of mood, an essential to the symphonic form, may be done in terms of tempo alone, but it is better done if poetic images colour it. In a description of night at sea, there are elements enough aboard a ship to build up a quiet and effective rhythm, but a deeper effect might come by reference to what is happening under water or by reference to the strange spectacle of the birds which, sometimes in ghostly flocks, move silently in and out of the ship's lights.

A sequence in a film by Rotha indicates the distinction between the three different treatments. He describes the loading of a steel furnace and builds a superb rhythm into the shovelling movements of the men. By creating behind them a sense of fire, by playing on the momentary shrinking from fire which comes into these shovelling movements, he would have brought in the elements of tension. He might have proceeded from this to an almost terrifying picture of what steel work involves. On the other hand, by overlaying the rhythm with, say, such posturing or contemplative symbolic figures, as Eisenstein brought into his *Thunder Over Mexico* material, he would have added the elements of poetic image. The distinction is between (*a*) a musical or non-literary method; (*b*) a dramatic method with clashing forces; and (*c*) a poetic, contemplative, and altogether literary method. These three methods may all appear in one film, but their proportion depends naturally on the character of the director—and his private hopes of salvation.

I do not suggest that one form is higher than the other. There are pleasures peculiar to the exercise of movement which in a sense are tougher—more classical—than the pleasures of poetic description, however attractive and however blessed by tradition these may be. The introduction of tension gives accent to a film, but only too easily gives popular appeal because of its primitive engagement with physical issues and struggles and fights. People like a fight, even when it is only a symphonic one, but it is not clear that a war with the elements is a braver subject than the opening of a flower or, for that matter, the opening of a cable. It refers us back to hunting instincts and fighting instincts, but these do not necessarily represent the more civilized fields of appreciation.

It is commonly believed that moral grandeur in art can only be achieved, Greek or Shakespearian fashion, after a general laying out of the protagonists, and that no head is unbowed which is not bloody. This notion is a philosophic vulgarity. Of recent years it has been given the further blessing of Kant in his distinction between

the aesthetic of pattern and the aesthetic of achievement, and beauty has been considered somewhat inferior to the sublime. The Kantian confusion comes from the fact that he personally had an active moral sense, but no active aesthetic one. He would not otherwise have drawn the distinction. So far as common taste is concerned, one has to see that we do not mix up the fulfilment of primitive desires and the vain dignities which attach to that fulfilment, with the dignities which attach to man as an imaginative being. The dramatic application of the symphonic form is not, *ipso facto*, the deepest or most important. Consideration of forms neither dramatic nor symphonic, but dialectic, will reveal this more plainly.

# STAN BRAKHAGE

## In Consideration of Aesthetics

American avant-garde filmmaker Stan Brakhage (1933–2003) is one of the most important and prolific figures in experimental film and arguably one of the great artists of the twentieth century. Born in Kansas City, Missouri, he briefly attended Dartmouth College before dropping out to pursue filmmaking. After completing his first film, *Interim* (1952), at the age of nineteen, he moved to San Francisco to attend the San Francisco School of Art but dropped out again to move to New York City in 1954. There, he met a number of notable artists, including Maya Deren, Jonas Mekas, Joseph Cornell, and John Cage (with whom he also collaborated).

Expressing a radical reconception of cinema and focusing on the expressive qualities of the medium itself, Brakhage's early films were often met with derision, but they soon began to receive recognition in exhibitions and in film publications such as *Film Culture*. Brakhage remained extremely productive throughout his life. He made nearly four hundred films; among his best-known film works are *Dog Star Man* (1962–1964), *The Act of Seeing with One's Own Eyes* (1971), and *The Dante Quartet* (1987). He also wrote a number of books on the art of film and its intersections with poetry, music, dance, and painting. Brakhage's passion for cinema extended well beyond his own practice; not only did he advocate for, preserve, and make available the work of other avant-garde filmmakers, he championed and encouraged many young filmmakers as a longtime professor at the University of Colorado. The Academy of Motion Picture Arts and Sciences Film Archive is currently working to preserve and restore his entire film output.

The central achievement of Brakhage's experimental cinema is its radical split from not only commercial narrative cinema but also from European avant-garde cinema. While Maya Deren (p. 144) still accepted the inherent realism of the photographic image, Brakhage's experimental work split radically from that idea. He felt strongly that the projected image should be transformed from its photographic realism (which he calls "a contemporary mechanical myth") into a highly personal expression of an individual's emotions, ideas, and visions. In his book *Metaphors on Vision* (1963), he calls for a new kind of cinema that intends to film not the world itself, but the act of seeing the world, previously unimagined and undefined by conventions of representation. Brakhage forces viewers to move away from

the habitual ways of processing movie images that focus on content and narrative and instead refocus their attention toward less obvious pictorial and sensory qualities, such as light, movement, and texture. Often eschewing photography altogether and focusing directly on the bare act of perception, Brakhage's films are decidedly nonrepresentational and champion techniques that defamiliarize the image, such as superimposition, odd angles, filters, rapid handheld camera movements, as well as scratching and drawing directly on the surface of the film strip.

Brakhage's essay "In Consideration of Aesthetics," written in 1996, is an expression of his lifelong desire to define cinema by unique qualities that would make cinema equal, structurally and aesthetically, to other art forms such as poetry, painting, dance, and music. Searching for the aesthetic possibilities of film that "promote mental reflection rather than reflective recollection," Brakhage defines the medium as "Light Moving in Time" (after the title of William Wees's book). For Brakhage, experimenting with light is the central perceptual strategy for restoring what he calls "pure vision." The infinite varieties and manifestations of light and its materialization into objects are the basis of perception/cognition and thus the basis of cinema as a visual medium. Rebelling against the language-based theories of film that had to ignore the avant-garde and experimental film movements to maintain their coherence, Brakhage conceives of cinema as a fundamentally visual experience grounded in subjective feelings that are inseparable from our ability to think.

## READING CUES & KEY CONCEPTS

▪ As he considers an appropriate definition of film, Brakhage dismisses such common designations as "electric shadows" or "writing in movement." Why?

▪ In his descriptions of art forms such as painting or music, Brakhage focuses entirely on their aesthetic, rather than representational, qualities. Why is this strict separation between form and content important for his concept of cinema? Do you think aesthetic and representational aspects of film are mutually exclusive?

▪ What is the relationship, according to Brakhage, between aesthetic qualities of the film medium and mental reflection?

▪ **Key Concepts:** Cognition; Recognition; Aesthetic Experience; Light Moving in Time

# In Consideration of Aesthetics

. . . . . . . . . . . . . .

*Before a work of art people who feel little or no emotion for pure form find themselves at a loss. They are deaf men at a concert. They know that they are in the presence of something great, but they lack the power of apprehending it. They know that they ought to feel for it a tremendous emotion, but it happens that the particular kind of emotion it can raise is one that they can feel hardly or not at all. And so they read into the forms of the works those facts and ideas for which they are capable of feeling emotion, and feel for them the emotions that they can feel—the ordinary emotions of life. When confronted by a picture,*

*instinctively they refer its forms back to the world from which they came. They treat created form as though it were imitated form, a picture as though it were a photograph. Instead of going out on the stream of art into a new world of aesthetic experience, they turn a sharp corner and come straight home to the world of human interests. For them the significance of the work of art depends on what they bring to it; no new thing is added to their lives, only the old material is stirred. A good work of visual art carries a person who is capable of appreciating it out of life into ecstasy: to use art as a means to the emotion of life is to use a telescope for reading the news. You will notice that people who cannot feel pure aesthetic emotions remember pictures by their subjects; whereas people who can, as often as not, have no idea what the subject of a picture is. They have never noticed the representative element, and so when they discuss pictures they talk about the shapes and forms and the relations and quantities of colors. Often they can tell by the quality of a single line whether or not a man is a good artist. They are concerned only with lines and colors, their relations and quantities and qualities; but only from these will they win an emotion more profound and far more sublime than any that can be given by the description of facts and ideas.*

Clive Bell, from his book *Art* (Capricorn Books, 1958)

The artist bending to the necessities of his/her creative process ought, for aesthetics' sake, eschew the strengths of the given medium.

Every craft is best qualified to achieve a particular affect. Music most ordinarily presents human inward noises—the heart-at-beat, the nerves strumming-in-ear, the breath and all attendant throat-flute, glottal mucus slippage . . . the seepage of blood's pitch in veins, or breath's tone-cross-tongue and reverberations 'gainst dome of mouth, the inner snare-drum/trombone of yawn jaw's cartilage, the castanets of teeth, nasal wind hiss and moan, so forth (all noise approximate to the hairs of ear and inner ear's solitude). Painting presents perhaps a window, a cupboard of gathered flattened objects which one might (but cannot) touch, perhaps a likeness of ancestral ghost, a *sign* of what might have been, might be. Sculpture presents the very (coldly) touchable thing as object itself—a stand-in which might be mistaken on sight as such, for animal being (Pygmalion). Architecture, then, that which surrounds the living being and all such objectification as it has gathered—presents a womb, as it were, as well as tomb of the mind's mathematics . . . externalizing numbers into space, numb thought's otherwise endless flights of fancy. And Poetry?—the very exteriorization of thought process, both halves of the brain (the right, rhythmed, musically wired, and the compartment left) at *one* in ordering the chamber-music-muscularity of throat apparatus, tongue, teeth, to exquisite grunts of meat-thought-staccatos. Dance, similarly, best organizes the exterior body to mimic its innards, most usually prompted by Music's rhythm-mimesis of same.

And Drama?—Drama, that least evolutionary of *all* the Arts, deserves our special study. Drama is, as everyone knows, that form of Human expression which most times presents our everyday-and-nightmare-night's imagined outer world (the "mirror held up to nature," as it were, is, and ever shall be). The right of ritual is its actuality as immediate event—that, perhaps, is why it cannot evolve—also that it most depends upon topically gathered audience, entertainment ambiance, to exist.

Once Music centers itself in other-than-rhythm-*number*, to the extent of imagined spatial, and centers as subtly as to accommodate articulately the pulse of sounded textures (vibratory wave-lengths in juxtaposition as *space*, an *invented* space, i.e., neither seen *nor* sensorially heard), once a grid-of-habit has suggested an extra-intellectual experiencing of it (of a spiritual inventory, so to speak) it, then thoroughly composed, can engender an aesthetic experience, i.e., a conceptual equivalent of sense input. To be blunt, once sounds are no longer speech-in-audio-hyperbole and/or the rhythmic tutor of dance, nor the occasion of any other social usage, Music can so tickle the brain as to engender a feeling of rightness (and of no other meaning whatso-ever) sufficient to be that "legal" variability of Known (tone-row, metronome/whatever) which constitutes delightful synaptic surprise to the mind. By "legal" I mean that those "aberrations" of new musical order must conform to the known as surely as the surpris-ing variations of glass in rippling water conform to the known glass under water (to borrow an Ezra Pound metaphor): variables, each rip and twist of glass-form *must* seem inevitable in the beseeming infinity of torqued rippling.

Now, I think it is clear that while Music maintains audible corollary of nerves-as-roots in the physiology of the artist, the aesthetic of organized sound is, most natu-rally, an inspiration dedicated to such freedom-of-expression as prompts thought's sense of rightness . . . i.e., sense of finite variation with*in* the humanly comprehen-sible (" . . . the outside limits of being human" as poet Charles Olson put it). Music, which very *easily* tickles music into dance, and/or extends the tonal range of language into song, does *rather* tend (at center of its historical evolution) to eschew these vir-tues (or to subsume them into) a presentation of pitched spatial and rhythm temporal comprehensions (for aesthetic experiencing).

And, if it be true that "All arts aspire to Music," need I write more? . . .

Paint's styles of surface fret (the hand-writ of the painter) or invented depth (ever more and more elaborate in varieties of historical—i.e., emblematic—trickery) or symbolic color, assignment of form (as representational signifier . . . the very sig-nature of the artist up-front, a warning 'gainst "window shopping"), all such, and many other artist tactics, counteract Painting's easiest illusion meanings. Sculptors ever more and more adamantly, and again and against, center their Art in the revela-tion of stone, wood, metal . . . (when Michaelangelo's "Pieta" began to be worshipped he carved "Made by Michaelangelo" across the breast band of the Virgin).

"Architecture is frozen music," says Goethe—i.e., what he honors of it is art.

Poetry is enabled to make new grounds for interpretive sense precisely because at scratch it eschews any such usage as currently common sense of the language, opts rather for right brain's neuron song . . . rummaging the left hemisphere for only that language which will suffice rhythmically/texturally in orchestral support of the song schema.

Dance stances, creates the great defiance of gravity illusion: and when that petri-fies into tutus so forth, Isadora Duncan takes her prime inspiration from Greek friezes.

Only the theatre of Gertrude Stein's "closet drama" (in the tradition of Strindberg, Wedekind, Buchner, Yeats) can *perhaps evolve* Drama itself out of the soup of Polis, "the soaps," the soap-box.

Which brings us to consideration of Motion Pictures—ninety-nine and forty-four one hundredths per cent Theatrical, not essentially different from the fast-changing sets of Max Rheinhardt and Co., essentially still an experience akin to watching a

stage-play thru a variety of opera-glasses controlled by the director-editor of the movie being passively watched.

When I was young, we used to make a distinction between stagy "escape" entertainment (most often called Photo-plays) and the possibilities of a moving picture Art (which we called Films).

The Chinese have a beautiful glyph for their movie-designation: "Electric Shadows." But it hasn't seemed to help them make anything of lasting visual value in their whole known filmic history.

The French term "cinematographer" means "writer of movement" and, indeed, most of their motion-picture making (past George Méliès) stays stuck to Literature, theatrical or otherwise.

The most aesthetically hopeful definition of Film I've found is Bill Wees' "Light Moving in Time"—as is the title of his book on the subject (published by University of California Press, Berkeley).

Note that it is *not* ordinarily any semblance of moving light which we witness watching movies. Rather we see silhouettes flickering various characters of motion within transparent back sets or foreground blockages, all back-lit by a rectangle of projected illumination. Light, steadily contained in its flattened box of screen is most usually interfered with, smudged and dyed, by photographic spectrum and shadows representative of nameable forms. The staggered (frame-by-frame) movement of these forms is only a *very* subtly visible (twenty-four frames per second) metronome reference to clockwork, thus obliquely to mechanical Time.

Why, then, do I find "Light Moving in Time" to be the best definition of Film? Because I am primarily interested in the aesthetic possibilities of the medium, and these are those which promote mental reflection (rather than reflective recollection).

The brain IS light (wave/particle) in electric (synaptic) movement: the movements (electrical investments) are as infinite as the possible neural connections, but its lightning-like activity is specifically paced (by the ABC's of its waves and the outside limits of its variable seizures) and thus Timed, finite!

Each brain's main job is reference (thus re-presentational) but its life unto itself is that of Timed Light. Its electric moves react to input: thus the senses impose wavery particulars upon the contained free-play of illumination. Its physiology (and that of the whole nervous system) composes, the very shapes of cells being something of a fret pattern to contain this all-sensory storm of sparks, to impose, for example, visual form.

Visual Forms, reinforced by similarity of eye input (into content), interplay with the prime cognition that "All that is is light" (Dun Scotus Erigena). This interplay is the balance/counter-balance of any brain's genetic cultural individual "dance," and this, therefore, stance-dance would seem to be the only fully meaningful (i.e., meansless-usage) entertainment available of cognition (as distinct from re-cognition).

Film ought aesthetically to exist flickering electric and free of photographic animation, free of the mechanical trickery of, the outright fakery of the illusion of movie pictures. All interferences with The Light (all shaped tones and formal silhouettes) ought to be an illumination of source-as-light (or at least be subservient, as symbol, say, representatives of Time, to Light's life . . . as is, to be sure, the almost equal space of Black in the projection of every split second of lighted frame). The light, then, would be seen to move because of the light-signifying shapes and tones in their signatory continuities (especially if these were tones in visual chromatic

harmony, and shapes in evolutionary form at one with illumination). This anyway, is the aspiration of artists whose Art aspires to Music, and "Art is art-as-art. And everything else is everything else" (Barnett Newman, painter, sculptor).

# BILL NICHOLS

## Performing Documentary

FROM *Blurred Boundaries*

A film historian and theoretician of documentary cinema, Bill Nichols (b. 1942) is Professor of Cinema and Director of the Graduate Program of Cinema Studies at San Francisco State University. Former President of the Society of Cinema Studies, Nichols has been in the vanguard of the resurgence of theoretical studies of documentary since 1980. He is the author of many volumes, including *Blurred Boundaries: Questions of Meaning in Contemporary Culture* (1994), *Introduction to Documentary* (2001), *Representing Reality: Issues and Concepts in Documentary* (1991), and *Newsreel: Documentary Filmmaking on the American Left* (1980). He is also the editor of two anthologies of film theory, volumes 1 and 2 of *Movies and Methods* (1976 and 1985).

The wave of recent critical and scholarly interest in documentary film has been fueled in part by the rapid growth and global spread of documentary practices in the last three decades. During the 1930s, film criticism became attuned to distinctions that helped define documentaries as an objective and unmediated representation of reality and often as representations of critical social and natural phenomena. In the 1960s and 1970s, theoretical debates about documentaries followed the spread of cinéma vérité (in France) and direct cinema (in North America). During the last quarter of the twentieth century, documentaries proliferated to a degree never before seen through the new technological opportunities of cable television and DVD production and distribution, and through an unprecedented popularity and presence in theatrical venues and art houses. While television offered opportunities for innovative documentaries, like Ken Burns's eleven-hour documentary series *The Civil War* (1984), theatrically released documentaries—from the mockumentary spoof *This Is Spinal Tap* (1984) to Michael Moore's politically provocative *Fahrenheit 9/11* (2004)—made clear that documentaries were more commercially and culturally viable than ever before. At the same time, the heritage of documentary cinema as a straightforward record of reality gave way to new, often demanding experimentations and the expanding globalization of documentaries represented by such films as *Born into Brothels: Calcutta's Red Light Kids* (2004) and Nichols's own first example, Pratibha Parmar's *Sari Red* (1988).

"Performing Documentary," a chapter in his book *Blurred Boundaries*, extends and develops Nichols's earlier attempt at categorizing different documentary modes as they evolve through the twentieth century. His original schema indicated four different ways in which these films engage reality: expository, observational, interactive, and reflexive.

In this essay, Nichols adds a fifth mode, the performative, which is a documentary practice that shifts from focusing on the referential as a dominant feature to emphasize instead a subjective "performance" of that act of reference. Informing Nichols's argument are many investigations of the relationship between film and reality, from the writings of Lev Kuleshov (p. 135) and John Grierson (p. 657) to Fatimah Tobing Rony's postcolonial look at ethnographic cinema (p. 840). Although an interest in representing reality remains contemporary culture has, for Nichols, made reality a far more shifting and subjective terrain.

## READING CUES & KEY CONCEPTS

◼ Many recent documentaries are about "performance": for instance the performance of music in rockumentaries like *Stop Making Sense* (1984) or the performance of a political or social role in *Primary* (1960). How is a performative documentary different from a documentary about performance?

◼ In its emphasis on subjective encounters, a performative documentary risks the kind of solipsism that reality television often embodies. Consider how Nichols counters this risk with his notion of "magnitude."

◼ **Key Concepts:** Expository Documentary; Observational Documentary; Interactive Documentary; Reflexive Documentary; Performative Documentary; Social Subjectivity; Questions of Magnitude; Discourse of Sobriety

# Performing Documentary

. . . . . . . . . . . . . .

## *Orientations*

Consider these two scenes. They are the first sequences from two recent works and they indicate some of the ways in which the boundaries of documentary and experimental, personal and political, essay and report have blurred considerably.

The first is from *Sari Red* (Pratibha Parmar, U.K., 1988). Throughout the sequence hard-to-identify, pulsating, perhaps spiritual music plays. The frame shows nothing but the easy shimmer of blue-green water; the shot lasts at least fifteen seconds. A little girl dashes down an alleyway; she is arrested in a freeze frame. Laundry flutters from a clothesline. Two Asian women walk down a crowded urban street; behind them, a policewoman moves from left to right. The voice-over of a polished, female voice intones, "It was not an unusual day for November, bright, chilly." The voice tells us that three women were walking home after classes as we see a small group of young Asian women walk along the street. Two women, whom we see only from shoulders to waist, work on dressing in saris. The music continues. One of the women, now on a rooftop, pivots, the sari fabric swirling in the air like a veil. The image of water is superimposed; the two substances—fabric, fluid—play across the frame. A woman's hands knead dough in close-up. Two more Asian women work together in a backyard. A woman stands, dressed in a blue sari, until the film cuts to the close-up of a blue coffin handle. Chanting voices fade in: "Paki wog; Paki wog. . . ." As the scene cuts to a long shot of an

apartment building with laundry fluttering from balconies, the same female voice-over continues:

> Invisible wings carrying words of hatred.
> This was not the first time. They had heard it before.
> The voices of hatred, the laughter of hyenas
> Taking pleasure in our pain.

The second scene is the pre-credit sequence from *Sights Unseen* (Jonathan Robinson, India/United States, 1990).[1] It begins with a quote from Jean Genet's *A Thief's Journal:* Traveling and border crossings are passage less into another country than "to the interior of an image." A slow-motion, close-up shot of an Indian woman fills the frame as she slowly turns to the right, away from the camera. Indian music accompanies the image as a male voice-over commences, "In his hotel room, the tourist dreams of the native quarter." In a dark, unidentifiable space, flames leap up from a small wood fire. The voice continues, "In the native quarter, he becomes nostalgic for the vacuousness of the hotel room." The Indian woman reappears. The camera tracks in slow motion to the right as she turns to the left, facing a European man who approaches her. The voice: "He has come for an entertainment which at every step risks becoming too intrusive, too threatening." The man brushes by her, but they do not embrace. Instead they gaze at each other, perhaps unsure of each other's reality. "He is the product of a culture that looks restlessly outside itself for its dream material." A radio beeping signal, similar to that used with the RKO logo, begins as the film cuts to the color image of a slowly revolving globe. Over the globe the film's title appears.

These two scenes suggest something of the texture and tone of what may well be a distinct mode of documentary representation: performative documentary. This essay attempts to explore the distinctive qualities and issues that come associated with this highly suggestive, clearly fabricated, referential but not necessarily reflexive form of documentary filmmaking.

## A New Mode in Town

Things change. The four modes of documentary production that presented themselves as an exhaustive survey of the field no longer suffice.[2] The final mode, *reflexive* documentary, might be expected to return us to a modified version of the first, expository, mode, but this has not proven the case. Instead the reflexive mode as first conceived seems to harbor within it an alternative mode, a mode that does not draw our attention to the formal qualities or political context of the film directly so much as deflect our attention from the referential quality of documentary altogether. Films suggesting this alternative mode, which may be called performative documentary, include: *Sari Red* and *Khush* (Pratibha Parmar, U.K., 1988, 1991), *History and Memory* (Rea Tajiri, United States, 1991), *Unfinished Diary* (Marilu Mallet, Canada, 1983), *Our Marilyn* (Brenda Longfellow, Canada, 1988), *Sight Unseen* (Jonathan Robinson, India/United States, 1990), *Films Are Dreams* (Sylvia Sensiper, Tibet/United States, 1989), *I'm British But . . .* (Gurinder Chadha, U.K., 1989), *Unbidden Voices* (Prajna Parasher and Deb Ellis, U.S., 1989), *A Song of Ceylon* (Laleen Jayamanne, Sri Lanka, 1985), *Territories* (Isaac Julien, Sankofa Film and Video Collective, U.K., 1984), *Looking for Langston* (Isaac Julien, U.K., 1991), *Tongues Untied* (Marlon Riggs, U.S., 1989), *Forest of Bliss* (Robert Gardner, India/United States, 1985),

*The Body Beautiful* (Ngozi Onwurah, U.K., 1991), and *Naked Spaces: Living Is Round* (Trinh T. Minh-ha, West Africa/United States, 1985).

What such films have in common is a deflection of documentary from what has been its most commonsensical purpose—the development of strategies for persuasive argumentation about the historical world. If we place documentary within the framework proposed by Roman Jacobson's six aspects of any communication (expressive, referential, poetic, rhetorical, phatic, and metacommunicative), performative documentary marks a shift in emphasis from the referential as the dominant feature. This windowlike quality of addressing the historical world around us yields to a variable mix of the expressive, poetic, and rhetorical aspects as new dominants. (Ever since *Night Mail* [Basil Wright and Harry Watt, Great Britain, 1936] and *Turksib* [Victor Turin, Soviet Union, 1929] documentary has exhibited these qualities; what is distinctive here is their function as an organizing *dominant* for the text.)[3] This shift blurs yet more dramatically the already imperfect boundary between documentary and fiction. It also makes the viewer rather than the historical world a primary referent. (These films address us, not with commands or imperatives necessarily, but with a sense of emphatic engagement that overshadows their reference to the historical world.)

One implication of this shift is the possibility of giving figuration to a social subjectivity that joins the abstract to the concrete, the general to the particular, the individual to the collective, and the political to the personal, in a dialectical, transformative mode. One risk, exemplified by the oxymoron "reality television"—meaning those shows like *I Witness Video, Cops,* and *FBI: The Untold Story*—is the collapse of all questions of magnitude and social subjectivity into spectacle and a reactionary politics of law and order. This essay sets out to explore the consequences and implications of the performative mode of documentary representation in further detail.

A schematic summary of these five modes of documentary representation, suggesting how each attempts to provide redress for a deficiency in the previous mode while eventually presenting limitations of its own, would look like this (*see table*). Documentary arises, with Grierson and Dziga Vertov, in response to fiction.

| *Mode* | *—Deficiency* |
|---|---|

**Hollywood fiction**
—absence of "reality"
  **Expository documentary** (1930s): directly address the real
    —overly didactic
    **Observational doc.** (1960s): eschew commentary, observe things as they happen
     —lack of history, context
     **Interactive doc.** (1960s–'70s): interview, retrieve history
      —excessive faith in witnesses, naive history
      **Reflexive doc.** (1980s): question documentary form, defamiliarize the other modes
       —too abstract, lose sight of actual issues
       **Performative doc.** (1980s–'90s): stress subjective aspects of a classically objective discourse
        —possible limitations: loss of referential emphasis may relegate such films to the avant-garde; "excessive" use of style

In relation to performative documentary, the first four modes can be more readily seen to share a common emphasis on the referent. Performative documentaries may make use of these other four modes by inflecting them differently. (None of these modes expels previous modes; instead they overlap and interact. The terms are partly heuristic and actual films usually mix different modes although one mode will normally be dominant.) Expository qualities may speak less about the historical world than serve to evoke or poetically engage this world. Questions of authority may diminish in favor of questions of tone, style, and voice. *Reassemblage*, for example, effects such a shift through its poetic cadences of image, music, text. *Tongues Untied* opens with the mesmerizing call of "brother to brother, brother to brother," accompanied by images of black men at play and in relation to one another, followed by graphic video footage of police brutality against young black men at Howard Beach, and concluding with a slow, balletic dance by Marlon Riggs himself, in which he moves across a darkened, undefined space, his hands above his head, searching and protective, until he ends in the arms of another black man, Essex Hamphill.

Observational techniques no longer give the impression of "capturing" the referential realm itself, the historical world as it is, so much as lend stress to qualities of duration, texture, and experience, often liberated from intimate association with social actors giving virtual performances according to the expressive codes familiar to us from fiction. *Forest of Bliss*, *The Nuer*, and *Our Marilyn* share this characteristic, bringing to the fore a vivid sense of temporal duration and spatial location without establishing the dramaturgical propositions so common to classic observational works such as *Primary*, *High School*, or *Soldier Girls* (individuated characters, psychological complexity, and virtual performances).[4]

Interactive techniques, which traditionally incorporate the filmmaker within the historical world he or she films, now give greater emphasis to the affective dimensions of experience for the filmmaker, to the filmmaker's subjective position and emotional disposition. Diane Kitchen's *Before We Knew Nothing*, for example, gives remarkable priority to the experience of fieldwork itself for its practitioner; *Films Are Dreams* and *Before We Knew Nothing* insist on the mediations that come between field-worker and subject, in these cases, preexisting images, imaginary geographies, and projected desires.

Reflexive techniques, if employed, do not so much estrange us from the text's own procedures as draw our attention to the subjectivities and intensities that surround and bathe the scene as represented. Reflexiveness may draw attention to the performative quality of the film per se, heightening our awareness that it is the film which brings into being as if for the first time a world whose appearances and meanings we think we already know. *Khush*, for example, interposes a continuing motif of two women languorously embracing each other, a highly stylized and fictitious "event" that evokes the subjective dimension contained within the more traditional interviews that parallel it. Similarly, *I'm British But . . .* intercuts its interviews with shots of a Bangla music group standing on a rooftop performing a song that provides a reflexive commentary on the statements of the film's interviewees. (The interviewees begin by asserting their unhyphenated identity as Scots, Welsh, English, no longer a part of the older, less assimilated Pakistani community; the song reminds us of the colonial legacy and its racist continuation that cannot so readily be erased.) In a more formally complex and integrated way, *A Song of Ceylon* also remembers the colonial

legacy by placing a ceremony devoted to curing a case of possession within a frame-work that suggests possession may be a form of political resistance that has particular resonance for women.

## *The Referents R Us*

Performative documentary presents a distinct disturbance to ethnographic film. Such films have been classically bound together by a triadic conception of "the field": the academic institutions that support it, the geographic sites that host it, and the disciplinary forces that police it.[5] Further binding them together is a conception of realism and its apparent access to the historically real which performative documentaries devalue (but do not reject). Performative documentary suspends realist representation. Performative documentary puts the referential aspect of the message in brackets, under suspension. Realism finds itself deferred, dispersed, interrupted, and postponed. These films make the proposition that it is possible to know difference differently.[6] Realist epistemology comes into question and under siege. It is this suspension of representation as commonly practiced that authorizes Trinh to write, with breathtaking force, against that inevitable turn within the realist imperative when things are meant to add up, gather themselves to a conclusion, come to the point, or penetrate to the heart of the matter:

> Seeking to perforate meaning by forcing my entry or breaking it open to dissipate what is thought to be its secrets seems to me as crippled an act as verifying the sex of an unborn child by ripping open the mother's womb.[7]

The disturbance to ethnography is epistemological in magnitude. It is a disturbance as old as art itself but it operates in unexpected and disconcerting ways when located within the heart of the discourses of sobriety, among them documentary, and, among documentaries, ethnography more than most. What do we know and *how* do we know it? What counts as necessary and sufficient knowledge?

Such an epistemological shift poses questions of comprehension as well. To comprehend *Tongues Untied, Surname Viet Given Name Nam, A Song of Ceylon*, or *Territories* requires us to attend to the content of the form, in Hayden White's phrase. This may render them precariously close to incomprehensible within the institutional framework of documentary practice today and the discourses of sobriety it emulates. The sense of incomprehension is not literal—such films can be understood it seems—but categorical: they seem comprehensible more as fictions or formal experiments than as documentaries.

In short, performative documentary takes up the challenge proposed by Teresa de Lauretis but in a more dispersed perspective: de Lauretis argues that the principal challenge for a feminist aesthetics is to construct a feminist viewer position or subjectivity regardless of the actual gender or subjectivity of the viewer.[8] Performative documentary adopts a similar goal in relation to subjectivities that range from black or Pakistani British gay to that of the Spanish-speaking Chilean exile in francophone Montreal and the Afro-Caribbean children of the diaspora dislocated in contemporary Britain.

Performative documentary clearly embodies a paradox: it generates a distinct tension between performance and document, between the personal and the typical, the embodied and disembodied, between, in short, history and science. One draws attention

to itself, the other to what it represents. One is poetic and evocative, the other evidential and referential in emphasis. Performative documentary does not hide its signifieds in the guise of a referent it effortlessly pulls from its hat. These films stress their own tone and expressive qualities while also retaining a referential claim to the historical. They address the challenge of giving meaning to historical events through the evocations they provide for them. Performative documentary eschews the conventional plots adopted by most historians (tragedy, comedy, romance, and irony) and the conventional, realist notions of historicality they sustain as well.

Their structure more closely approximates that call for figurability made by Fredric Jameson in his discussion of *Dog Day Afternoon*. Figurability, like Raymond Williams's notion of "structures of feeling," is an emergent category, a possibility that takes form in a liminal moment prior to any empirical gesture toward verification: Figurability addresses "the need for social reality and everyday life to have developed to the point at which its underlying class structure becomes *representable* in tangible form. . . . [T]he relationship between class consciousness and figurability, in other words, demands something more basic than abstract knowledge, and implies a mode of experience that is more visceral and existential than the abstract certainties of economics and marxian social science: the latter merely continue to convince us of the informing presence, behind daily life, of the logic of capitalist production."[9] Jameson calls for a sense of class consciousness in "vivid and experiential ways" that moves us into the domain of culture where representation finds itself suspended among "personal fantasy, collective storytelling, narrative figurability."[10] (These are precisely the modes combined in Marlon Riggs's *Tongues Untied* and Pratibha Parmar's *Khush*, and, though strongly referential, such works are at a considerable remove from earlier efforts to represent the experiential such as *Paul Tomkawicz, Streetcar Man* [Roman Kroitor, 1954], or *Drifters* [John Grierson, 1929], where a far more classic realism holds sway.)

Performative documentaries embody, through their form, an existential situatedness that is a necessary precondition for the type of class consciousness described by Jameson.

But such films remain true to the paradox mentioned a moment ago; the referential aspect of the message that turns us toward the historical world is not abandoned. Such works then, though expressive, stylized, subjective, and evocative, also constitute a fiction (un)like any other. The indexical bond, which can also prove an indexical bind for the documentary form, remains operative but in a subordinated manner.

In *Sari Red*, for example, the central "incident," in which three Pakistani women are run down on the sidewalk by a van containing several white males, retains its historical status, as does the murder in *The Thin Blue Line*, but its meaning is up for grabs. (This struggle over interpretation within the domain of the factual and historical has never been more evident, or fateful, than in the successful defense of the four white police officers who brutally beat Rodney King on the streets of Los Angeles. The first jury's acceptance of the defense's interpretation makes vividly clear how crucial questions of viewer and frame, or context, are.)

*Sari Red* locates the incident, associatively, within a nexus of class, race, nation, and memory, and the film's poetic/expressive/conative work is less directed at proving what "really happened" than in reframing what has been remembered, contextualizing it within a situated response of memory and collective affirmation.

*Sari Red* seeks to promote a social subjectivity within the viewer that remains unattached to a logical explanation, a way of accounting for this brutal event that reduces the existential and visceral to the abstract and analytic. *Sari Red* departs from the search for a code, a master narrative, an explanatory principle within which to subsume the particular to the general. Instead it holds to the particular, the historicality of history, while rendering it within a framework that refuses to fetishize the mystery of the unrepeatable, the past and done, leaving it frozen in a timeless moment of mythology. This film, like other performative works, makes its target an ethics of viewer response more than a politics of group action or an analysis of the ideology of the subject. Its very form exemplifies such an ethic in its own responsiveness to what has been, and been done.

Unlike reflexive documentary, performative documentary uses referentiality less as a subject of interrogation than as a component of a message directed elsewhere. Performative work may have a defamiliarizing effect, in the spirit of the Russian formalists' notion of *ostranenie*, or of Brecht's concept of alienation, but less in terms of acknowledging the constructed nature of the referential message and more in prompting us to reconsider the underlying premises of documentary epistemology itself. Performative documentary attempts to reorient us—affectively, subjectively—toward the historical, poetic world it brings into being.

This shift parallels the notions in Charles Sanders Peirce's semiotics that give priority to the experiential quality of an individual's relation to signs.[11] What Peirce calls the "logical interpretant" might correspond to the tendency of performative documentary to dispose us to see our relation to the world anew, in less abstract, overly conceptualized categories. Peirce argued that the final effect of a sign is to dispose us toward action modified as a result of the experience of the sign, or, here, text. This is a level of engagement that serves to "make sense" of the world rather than to impose a pure logic. To defamiliarize a previous relation opens the possibility for a change of habit, a transformation of awareness, a "raised" consciousness in those visceral and existential terms that are part of figuration.

## *Evocation*

The shift of emphasis toward the poetic, expressive, and rhetorical also reconfigures questions of validation. The process of identifying a problem and proposing a solution no longer has operative force. Our assessment and engagement, then, is "less in terms of [the message's] clarity or its truth value with respect to its referent than in terms of its performative force—a purely pragmatic consideration."[12] Questions of pragmatics shift the dominant from the work's referential relation, its indexical binding to fragments of the historical world, to its relation to its viewers. *We* are what such films refer to.

Stress falls on the evocative quality of the text rather than on its representationalism. Realism, of course, is quite capable of drawing upon expressive qualities. Subjective camera movement, impressionistic montage, dramatic lighting, compelling music: such elements fit comfortably within a realist style but, in documentary, they are traditionally subordinated to a documentary logic, which is governed, in turn, by the protocols of the discourses of sobriety.[13] Expressive qualities color, inflect, flavor, but seldom determine the overall organization of the text or the viewer's overall response to it.

Performative documentary, on the other hand, frees these expressive elements from their subordination to a logic. Such documentaries can therefore be more iconic than indexical, being less heavily dependent on an indexical authentication of what is seen and heard. (*The Thin Blue Line* offers vivid examples, perhaps none more so than the slow-motion flight of the vanilla ice-cream malt that sails through the night air in some of the reenactments of the crime.) Performative films rely much less heavily on argument than suggestion; they do not explain or summarize so much as imply or intimate. In *Reassemblage*, for example, Trinh insists that she will not speak about but only "speak nearby." She is good to her word when we see, for example, an elderly man weaving in a village. No comment occurs to anchor this "ethnographic detail"; instead images of weaving are themselves woven into a montage that evokes a sense of rhythm and quality of life without attempting to penetrate, isolate, or conceptualize what we see. In films like *Reassemblage* or *A Song of Ceylon*, we observe social actors who do not coalesce into characters (that fusion of actor and role that gains stability and psychological depth over the course of the [realist] narrative). In others works like *Films Are Dreams* or *Tongues Untied*, social actors take on the narrative coherence of a character; they approximate once more those forms of virtual performance that are documentary's answer to professional acting. But in either case, the stress is on the referential turn toward, not a historical domain, expressively enriched, but an experiential domain, expressively substantiated. It is the difference between description and evocation.

Some time ago David MacDougall offered eloquent testimony to the capacity of ethnographic film to describe everyday life and lived experience in a way distinct from written texts. This quality seemed well worth cultivating to MacDougall since it made use of film to render the texture of experience with such compelling detail. As he put it, film can render

> . . . the appearance of a people and their surroundings, their technology and physical way of life; their ritual activities and what beliefs these signify; the quality of the interpersonal communication, and what it tells of their relationships; the psychology and personalities of individuals in the society; the relation of people to their environment—their knowledge of it, use of it, and movement within it; the means by which the culture is passed on from one generation to another; the rhythms of the society, and its sense of geography and time; the values of the people; their political and social organization; their contacts with other cultures; and the overall quality of their world view.[14]

For MacDougall, this evocative potential seemed linked to a potential shift in epistemology, or at least a radical reconceptualization of the terms and conditions of ethnographic film so that it would no longer be seen simply as a colorful adjunct to written ethnography but offer a distinct way of seeing, and knowing, of its own. But MacDougall does not insist on this rupture. There is the lingering sense that the texture of life contributes to an economy and logic that are still fundamentally referential and realist. MacDougall also evokes a generic oneness ("the overall quality of their world view") which leaves the position, affiliation, and affective dimension of the filmmaker's own engagement to the periphery. Performative documentary seeks to evoke not the quality of a people's worldview but the specific qualities that surround

particular people, discrete events, social subjectivities, and historically situated encounters between filmmakers and their subjects. The classic anthropological urge to typify on the basis of a cultural identity receives severe modification. (MacDougall's own films exhibit these performative qualities, to a greater extent than this quote, and may attempt to persuade traditional ethnographers to give greater attention to film but in a way that leaves traditional assumptions essentially intact.)

The break with the tradition of referentiality and realism that Dziga Vertov, Sergei Eisenstein, and Jean Rouch, among others, pioneered receives more forceful articulation in Stephen Tyler's call for a postmodern ethnography. (Unfortunately, Tyler's call addresses written ethnography; he seems unaware of how much his call has already been answered, but largely outside the domain of the ethnographic discipline itself.) Tyler writes, "[Evocation] defamiliarizes commonsense reality in a bracketed context of performance, evokes a fantasy whole abducted from fragments, and then returns participants to the world of commonsense transformed, renewed and sacralized."[15]

Since "sacralize" does not appear in the *Oxford English Dictionary*, I can only surmise that it is Tyler's attempt to convey the sense of spiritual renewal that evocation carries for him, more than the sense of altered consciousness and social transformation it holds for me. What does stand out in Tyler's call is the move away from empiricism, realism, and narrative; his is a call for a defamiliarizing mode of expression that embodies a sense of a world brought into being between text and viewer that is remarkably close to the pioneering theories of Sergei Eisenstein.[16]

## *Genealogy*

Performative documentary, like reflexive documentaries, does not propose a primary object of study beyond itself but instead gives priority to the affective dimensions struck up between ourselves and the text. It proposes a way of being-in-the-world as this world is itself brought into being through the very act of comprehension, "abducted from fragments," as Stephen Tyler puts it. Using the "dynamite of a tenth of a second" celebrated by Walter Benjamin, performative documentary burst the contemporary prison world (of what is and what is deemed appropriate, of realism and its documentary logic) so that we can go traveling within a new world of our own creation.

Films like *Tongues Untied* step beyond thick interpretation, beyond problems and their "solution," beyond explanation or spectacle. *Handsworth Song, History and Memory, Sari Red, Of Great Events and Ordinary People, Unbidden Voices* and *Sights Unseen* all find forms of historical horror that the text then surpasses by giving form to memory and social subjectivity, to remembrance and transformation. Such works offer figuration to alternative forms of social subjectivity and the human self—beyond the individual and his or her conscience, beyond the subject of Althusserian ideology, beyond the manifestations of an unconscious that reenacts its tales of a family romance. Such figuration possesses a dialectical quality. It moves between the particular, with its density and texture, and the general, with its power to name and conceptualize. It circulates between the body, with the knowledge resident within it, and history, where knowledge and power contend. Location, body, self:

these elements of a world we thought we knew turn strange and unfamiliar in the landscape of performative documentary.

Among the genealogical precursors to performative documentary are:

1. Early Soviet cinema, including the work of Dovzhenko, Eisenstein, and Vertov, which developed a remarkable array of techniques to defamiliarize everyday perception and yet retain a vivid sense of historical consciousness.

2. Those early expository documentaries that were as much poetic as argumentative, such as *Night Mail* (Basil Wright and Harry Watt, Great Britain, 1936), *Turksib* (Victor Turin, Soviet Union, 1929), *Song of Ceylon* (Basil Wright, Ceylon/Great Britain, 1934), *The Bridge* (Joris Ivens, The Netherlands, 1928), *Listen to Britain* (Humphrey Jennings, Great Britain, 1942), *Louisiana Story* (Robert Flaherty, United States, 1948), or *The River* (Pare Lorentz, United States, 1937). Such films gave the impression of discovering mystery and wonder in the world around us and resorted to poetic rhythm, montage, visual rhymes, and musical incantation to awaken such wonder in the viewer.

3. The avant-garde tradition that mediated between the "two materialisms" (of the cinematic apparatus itself and historical materialism), including the work of Godard, Jon Jost, and David Rimmer.[17]

4. The avant-garde tradition of autobiography that coincides in many aspects with the confessional quality of a number of performative documentaries, including Jonas Mekas, Kenneth Anger, Maya Deren, and, above all, Stan Brakhage.[18]

5. The ethnopoetics of Jean Rouch, who has consistently argued for, and embodied, a style of filmmaking that does not so much combine the subjective and objective poles of traditional ethnography as sublate them into a distinct form.[19]

6. The tradition of magical realism, specifically in the form discussed by Fredric Jameson, where it serves as an alternative to the postmodern nostalgia film. Magical realism, in this perspective, eschews the representation of the past by images and simulacra for a "different kind of past that has (along with active visions of the future) been a necessary component for groups of people in other situations in the projection of their praxis and the energizing of their collective project."[20]

7. Recent interactive and reflexive documentary (*Las Madres de la Plaza de Mayo*, *Cane Toads*, *Roses in December*, and *The Thin Blue Line*), where moments of performativity nest within the domain of a different dominant.[21] Performative documentary could be considered a reversal of priorities, or dominants, in this case, from a referential emphasis to a more expressive one.

8. Those recent works (*The Body Beautiful*, *Measures of Distance*, *History and Memory*, and so on) which combine elements of autobiography and the poetic in a documentary form to which a situated, embodied sense of political testimonial has been added. (What these films suggest is the significant degree to which certain avant-garde and documentary traditions have become blurred into a more singular enterprise, affording a perspective from which much of what we have called documentary might be reconsidered as experimental and much of what we have called experimental or avant-garde might be reconsidered as documentary.)

In addition to this cinematic genealogy, both a historiographic and a linguistic model provide suggestive affinities. Performative documentary moves toward those forms of historical explanation described by Hayden White as formist and contextualist but in a far more vividly dialectical fashion.[22]

Formist explanations favor the unique characteristic of situations and events; stress falls to "variety, color and vividness" (White, 14). The tendency is toward dispersal rather than integration, with lower regard for conceptual precision than other alternatives. "But such historians usually make up for the vacuity of their generalizations by the vividness of their reconstructions of particular agents, agencies, and acts represented in their narratives" (15). (And, I would add for performative documentary, the vividness of their evocation of the subjectivities that accompany these agents, agencies, and acts.)

Contextualist explanations also give low priority to generalization. They set events within a context but stop short of deriving laws, governing principles, or prevailing ideas as the mechanistic and organicist forms do. Contextualist historiography straddles the terrain between "the radically dispersive tendency of Formist and the abstractive tendencies of Organicism and Mechanism" (18). It settles for a relative integration of trends or general characteristics of a period or epoch. As White puts it, contextualism favors tacit rules for linking specific historical occurrences to a more inclusive domain: "these rules are not construed as equivalent to the universal laws of cause and effect postulated by the Organicist. Rather, they are construed as actual relationships that are presumed to have existed at specific times and places, the first, final, and material causes of which can never be known" (18).

Though sharing the preference for the local, the concrete, and the evocative, performative documentary also generally insists on the dialectical relationship between precisely this kind of richly and fully evoked specificity and overarching conceptual categories such as exile, racism, sexism, or homophobia. These latter are seldom named and never described or explained in any detail. They are tacitly evoked through juxtaposition and montage (Howard Beach footage in *Tongues Untied*, Chinese military occupation of Tibet in *Films Are Dreams*, police "riot control" in *Handsworth Songs*, for example), but the texts do not insist on specific linkages or explanations. This they leave, to a significant degree, to the viewer. (It is we who must discover that the specific instances we see share a family resemblance characterizable as racism, sexism, and so on.)

Performative texts thus avoid both the reductionism inherent to theory and the vacuous obsession with detail inherent to formism and contextualism. They are more properly, and fully, dialectical than a more abstract, theoretical account of dialectics could be. And as a dialectical representation, performative documentary addresses the fundamental question of social subjectivity, of those linkages between self and other that are affective as fully as they are conceptual.

A useful genealogical model here might be the ancient Greek use of the middle voice.[23] What seems most suggestive is the way in which the middle voice was originally positioned in relation to the active voice, with the passive voice serving a subordinate function. Middle voice addressed those situations in which an action took place within a subject or effected the nature of the subject, situations where the action envelopes the subject and the subject is immersed in the action. In active voice

a subject, already constituted anterior to an action, acts (she persuades her friend). In middle voice the subject and her subjectivity is itself constituted in the process of acting (she obeyed her friend: in Greek, "persuade" and "obey" are the same verb used in the active and middle voices respectively).

The middle voice cuts through the dilemma constructed by the ancient debate of whether we are fully developed mortals responsible for our actions or the passive objects of divine activity. Middle voice is something of a linguistic response to the sense we may have that we are "immersed in the action in such a way that, at least at times, 'doer' and 'done to' become inadequate categories, drawing a sharp line, legislating a boundary, where none is felt. . . . "[24]

Social subjectivity would link not only the doer and the done to, in self-constituting action, but the state of "doer/done to" experienced by one and that experienced by others. Social subjectivity, like the social imaginary that it transcends, is a category of collective consciousness. It exceeds or surpasses the monadic desire by a preconstituted subject underpinning the dynamics of self/other, us/them dichotomies. Social subjectivity evokes a discourse of visceral, existential affinity. Social subjectivity transforms desire into popular memory, political community, shared orientation, and utopian yearning for what has not yet come to be. Like Marlon Riggs's dance upon a darkened stage in *Tongues Untied*, or the latent, both homoerotic and political energy of the sleeping, hammock-held sailors of *Battleship Potemkin*, this form of subjectivity gives physical embodiment to the power of collective, self-transformative action.

## A Shift in Praxis: From Unity to Affinity

Performative documentary takes up those strategic locations called for by the shifting terms of identity politics and a postmodern disposition for cyborg affinities.[25] By relying on a dispersed, associative, contextualizing, but also social and dialectical mode of evocation, performative documentary is a particularly apt choice in a time when master narratives, like master plans, are in disrepute. They invoke an epistemology of the moment, of memory and place, more than of history and epoch. An altered emphasis, an alternative epistemology, but one that remains open, teleonomic and social. What Fredric Jameson describes as the "power and positive value of situation-specific thinking and speaking" could have been written with performative documentary itself in mind:

> . . . dialectical thinking and language—or a properly dialectical code as such—projects a synthesis of both, that is to say a thinking which is abstract and situation-specific all at once (or which, to use Marx's far more satisfactory formulation, is capable of "rising from the abstract to the concrete").[26]

But reality-transforming, affinity-building qualities remain at a premium. Without those aspects of performative documentary that evoke questions of magnitude, of a felt tension between representation and represented, evocation will collapse back into the solipsistic terms of a privatized consciousness. Social subjectivity will remain beyond the horizon of a text that affirms the personal vision and subjective experience of individual, poetic consciousness but little more. This question of magnitude as a domain of social subjectivity and

historical engagement is what distinguishes performative documentary from a large portion of the traditional film avant-garde with which it otherwise shares so much.

And yet the passage from a transcendental but individual consciousness to a dialectical and social one is further compounded by the absence of a specifically political frame within which performative documentary might be received. The formalists' claim that there is no "there" there becomes joined to the Marxists' lament that there is no Left left. This is not quite true, though. It would be more accurate to say that the Left has taken a dispersed, decentered form, and that its absence is only perceptible when what we seek is the traditional Left of vanguard parties, united front politics, and a correct line. Political affinities are already dispersed across a wide field of organizations and issues; they overlap and coalesce in unpredictable and unstable ways. There is great cause for optimism in this movement toward a new magnitude of political organization and process, to which performative documentary contributes significantly, but an aura of nostalgic loss and misrecognition may also loom. This is, after all, a time of multinational if not global capitalism, of a new world order of command and control, of interactive but hierarchically organized communications, of a "late" capitalism that continues to discover ways to transform and perpetuate itself.

As this economic lion, or perhaps paper tiger, grows larger and larger, more globally interconnected and less locally responsible, the contrast between its power and scope and the apparent power of identity politics, makeshift alliances, and cyborg affinities may seem dwarfed out of all proportion. This is a perception that performative documentary sets out to revise. By restoring a sense of the local, specific, and embodied as a vital locus for social subjectivity, performative documentary gives figuration to and evokes dimensions of the political unconscious that remain suspended between an immediate here and now and a utopian alternative.

When, in Lizzie Borden's *Born in Flames* (1983), Adelaide Norris asks Zella Wylie about the political efficacy of united-front politics, Wylie offers a hypothetical choice: Which would you rather see, one big, powerful lion or five hundred mice pounce through the door? Wylie opts for the mice: "Five hundred mice can do a lot of damage."[27] Performative documentary is on the side of the mice.

## NOTES

1. When a film shot in one country is by a filmmaker based in another country, I have listed the country where it was shot first.

2. I discuss these four modes in detail in *Representing Reality* (Bloomington: Indiana University Press, 1991).

3. "Dominant" is used in the Russian formalist sense as the formal organizing element of a work that orchestrates or regulates the function of all other elements. The dominant can range from a musical rhythm to a set of genre conventions. See Kristin Thompson, *Eisenstein's Ivan the Terrible: A Neoformalist Analysis* (Princeton: Princeton University Press, 1981), for an excellent discussion of this and other formalist concepts.

4. For a discussion of virtual performance see *Representing Reality*, 122.

5. Sarina Pearson presents this trichotomy in her thesis videotape, *The Field* (UC Santa Cruz, 1992).

6. Sarah Williams makes a call for this possibility in her critique of the anthropological criticism of the films of Trinh T. Minh-ha. Sarah Williams, "Suspending Anthropology's Inscription: Observing Trinh Minh-ha Observed," *Visual Anthropology Review* 7, no. 1 (Spring 1991): 7–14.

7. Trinh T. Minh-ha, *Woman/Native/Other* (Bloomington: Indiana University Press, 1989), 48–49.

8. Teresa de Lauretis, "Rethinking Women's Cinema," *Technologies of Gender* (Bloomington: Indiana University Press, 1987).

9. Fredric Jameson, "Class and Allegory in Contemporary Mass Culture: *Dog Day Afternoon* as a Political Film," in Bill Nichols, ed., *Movies and Methods*, II (Berkeley: University of California Press, 1985), 719.

10. Ibid.

11. The implications of Peirce's semiotics for feminism are treated in Teresa de Lauretis's "Semiotics and Experience," *Alice Doesn't* (Bloomington: Indiana University Press, 1984). I have extended her argument to fill a more inclusive frame.

12. Hayden White, "The Question of Narrative in Contemporary Historical Theory," *The Content of the Form* (Baltimore: Johns Hopkins University Press, 1987), 39.

13. I discuss "documentary logic," "narrative coherence," and the "discourses of sobriety" at greater length in *Representing Reality*, 118–25, and 3–4, 5 for discourses of sobriety.

14. David MacDougall, "Prospects for the Ethnographic Film," in Bill Nichols, ed., *Movies and Methods*, I (Berkeley: University of California Press, 1976), 146.

15. Stephen Tyler, "Post-Modern Ethnography: From Document of the Occult to Occult Document," in James Clifford and George E. Marcus, *Writing Culture: The Poetics and Politics of Ethnography* (Berkeley: University of California Press, 1986), 126.

16. A quite useful discussion of Eisenstein's thought in relation to how montage evokes a "fantasy whole abducted from fragments" is Jacques Aumont, *Montage Eisenstein* (Bloomington: Indiana University Press, 1987), especially chapter 4, "Montage in Question."

17. Jean-Luc Godard: *Vivre sa vie* (1962), *Numero Deux* (1975), *Six fois deux* (1976); David Rimmer: *Variations on a Cellophane Wrapper* (1970), *Real Italian Pizza* (1971); Jon Jost: *Speaking Directly: Some American Notes* (1974); Yvonne Rainer: *The Man Who Envied Women* (1985). The political significance of this work and the work cited in the next footnote (the autobiographical avant-garde) is nicely elaborated in David James, *Allegories of Cinema: American Film in the Sixties* (Princeton: Princeton University Press, 1989).

18. Jonas Mekas: *Diaries, Notes and Sketches* (1964–1969), *Reminiscences of a Journey to Lithuania* (1971); Kenneth Anger: *Fireworks* (1947), *Inauguration of the Pleasure Dome* (1954), *Scorpio Rising* (1962–63); Maya Deren: *Meshes of the Afternoon* (1943), *Ritual in Transfigured Time* (1946), *The Divine Horsemen* (1947, completed 1977); Stan Brakhage: *Desistfilm* (1953), *Window Water Baby Moving* (1963), *Scenes from under Childhood* (1969), *The Act of Seeing with one's own eyes* (1971).

19. Of particular importance are *Les maîtres fous* (1954), *Jaguar* (1954–67), *Moi, un noir* (1957), *Chronique d'un été* (1960). The most complete discussion of Rouch is Paul Stoller, *The Cinematic Griot* (Chicago: University of Chicago Press, 1992).

20. Fredric Jameson, "On Magic Realism in Film," *Signatures of the Visible* (New York: Routledge, 1990): 137. Jameson provides a valuable series of references on the use of the term in relation to Latin American literature and sets his own usage in this context, stressing, however, slightly different points, particularly the combination of a historical orientation, the use of color photography in a way distinct from what he terms postmodern "gloss" (139–44), and the reduction of narrative dynamics by means of an increased attention to violence (this is in relation to fiction films). He concludes this characterization: "All [these films] . . . enjoin a visual spell, an enthrallment to the image in its present of time . . ." (130) which

he distinguishes from the usual dynamics of the gaze and from any ontology of the real. He goes on to theorize that magical realism addresses those historical moments when disjunction, or the clash of modes of production, is central (138). There is, then, a historical root for the magical aspect of realism. "[T]he articulated superposition of whole layers of the past within the present (Indian or pre-Columbian realities, the colonial era, the wars of independence, caudillismo, the period of American domination . . .) is the formal precondition for the emergence of this new narrative style" (139). The close linkage of performative documentary with history and memory in relation to issues of race, class, and gender in a postcolonial world order gives resonance to this affiliation with magical realism.

21. The shift from these documentaries to performative ones is a matter of degree, and heuristics. (Some, like *Las Madres*, might readily be recruited to the ranks of the performative if we wish to stress the linkages to magical realism and to issues of historical disjunction, or struggle.) I have described these more expressive and poetic moments in terms of subjectivity and identification in *Representing Reality*, 155–60.

22. See White, *Metahistory* (Baltimore: Johns Hopkins University Press, 1973), especially pp. 13–21. Further references are cited as page numbers in the text.

23. My interest in this concept stems from informal discussion with Hayden White, who gave a talk on this subject and has an article on it in progress.

24. John Peradotto, *Man in the Middle Voice: Name and Narration in the* Odyssey (Princeton: Princeton University Press, 1990), 133. See also L. R. Palmer, *The Greek Language* (Atlantic Headlands, NJ, 1980), 292. Another key reference to the middle voice is Roland Barthes, "To Write: Intransitive Verb?" in Richard Macksey and Eugene Donato, eds., *The Language of Criticism and the Sciences of Man: The Structuralist Controversy* (Baltimore: Johns Hopkins University Press, 1970), 134–44. The potential relationship between middle voice and Freudian concepts such as sadomasochism would prove a fruitful avenue of exploration which is deferred here. A suggestive beginning, however, might be Mikkel Borch-Jacobsen, *The Freudian Subject* (Stanford: Stanford University Press, 1988); Borch-Jacobsen argues that identification and desire are far more closely entangled than usual, and their implication not evident, because Freud and we now lack the (middle) voice which might have best expressed this entanglement.

25. "Strategic location" is Edward Said's term for the "author's position in a text with regard to the Oriental [or other politically charged] material he writes about." *Orientalism* (New York: Vintage Books, 1978), 20.

26. Fredric Jameson, "The Existence of Italy," in *Signatures of the Visible* (New York: Routledge, 1990), 168.

27. Five hundred mice is not the perfect political recipe. The call for multiple affinities and mutuality overcomes severe limitations in the traditional united front politics of individual and subgroup subordination to a single, unified agenda. But the centripetal forces that constitute identity politics can also be exclusionary, and the bridging relationships between groups ephemeral and unstable.

   The different possibilities are suggestively and perhaps inadvertently conveyed in the closing moments of *Tongues Untied*. Riggs juxtaposes footage from a civil rights march in the 1960s, led by the Reverend Martin Luther King, Jr., with a gay rights parade in the 1980s. The purposefulness and intensity of the marchers is apparent in both, but a significant contrast occurs in the mix of races and sexes who march under the banner of civil rights and the all-black contingent that marches under the banner of black gay pride. The very terms on which black gay identity come to be constructed make the type of solidarity evident in the civil rights march extremely difficult. This is a problem facing identity politics generally, not only black, gay males. A useful starting point for a critical rethinking of identity politics is Judith Butler, *Gender Trouble: Feminism and the Subversion of Identity* (New York: Routledge, 1989).

# DOGME 95

# Manifesto;
# Vow of Chastity

Dogme 95 is an avant-garde filmmaking movement launched in 1995 by the Danish directors Lars von Trier and Thomas Vinterberg. Gathering strength throughout the second half of the 1990s, the movement started a Danish new wave, drew international attention, and influenced independent filmmakers around the world. Dogme 95 began, in a staged manner, in Paris in March 1995 at *Le Cinéma vers son deuxième siècle*, an international symposium held to celebrate cinema's first century. Invited to discuss the future of cinema, Lars von Trier, already widely known for his controversial films, read his manifesto from a red leaflet, showered the amused audience with pamphlets announcing the Dogme 95 movement, and abruptly departed. Dogme (Danish for dogma, or strict tenet) and their manifesto, signed by von Trier and Vinterberg on behalf of a collective of four filmmakers, renounced the current art of filmmaking and proposed rules that would change the face of cinema by freeing the artist from the constraints of big budgets and visual excess. The first of the Dogme films (Dogme #1), Vinterberg's 1998 controversial *Festen* (*The Celebration*) and von Trier's *The Idiots* (Dogme #2), also from 1998, were shot and edited on video before being transferred to 35 mm film. These films underscored the digital revolution that was underway, directly challenging cinematic practice in a way that had not happened since the 1960s.

Situating itself in relation to *cinéma vérité* and new wave movements of the 1960s (particularly the French New Wave), Dogme 95's "Manifesto" presents itself as a "rescue action" against "certain tendencies" of cinema (a deliberate reference to François Truffaut's 1954 "Une certaine tendance du cinéma français," the manifesto of the New Wave). The authors argue that the European new waves that invented the auteurist aesthetic failed because they adopted a bourgeois perception of art (i.e., the concept of film director as sole auteur) that was co-opted in the 1980s by the commercial industry. Dogme 95 calls for a return to authenticity and vows to overturn the cosmeticism of modern cinema, the predictability of plot, and the superficiality of action.

Aiming to purify filmmaking, the accompanying "Vow of Chastity" offers ten concrete rules to explain how a Dogme 95 film should be made. It demands location shooting without artificial props or sets as well as the use of handheld cameras without special lighting, prohibits nondiegetic sound and music, and insists that the film take place "here and now" with temporal and geographical realism. The document takes an anti-auteur stance and calls upon directors to refrain from personal taste to "force the truth out of characters and settings." The ten rules coax directors to unveil truth rather than to produce or fabricate it. Dogme 95 believes that the camera should capture *live* cinema rather than realistic cinema, reducing it to recording events whose progression relies on the characters. Interestingly, as strict and rigid as the "Vow of Chastity" sets out to be, its rules have been circumvented and broken, even in the very first Dogme film and in most of von Trier's films (such as *Breaking the Waves* [1996], *Dancer in the*

*Dark* [2000]). Films that are certified as Dogme films clearly do not adhere strictly to these rules but rather pursue the general spirit of the manifesto's anti-auteur and anti-illusionist stance.

Dogme 95 not only revived the Danish film industry (which has produced over 150 features since 1998), but it also quickly became an international movement with a global appeal, with sixty-five Dogme features certified to date. Its minimalist, low-budget aesthetic and its anticommercial and anti-auteurist stance suggest that anyone can obtain a Dogme certificate if his/her film is in accordance with the rules laid out in "Vow of Chastity." Coinciding with the arrival of consumer-level digital technology, and the do-it-yourself (DIY) rebellion in the 1990s fueled by such American independent filmmakers as Jim Jarmusch, Kevin Smith, and Quentin Tarantino, the movement became an art-house brand name and sparked international cinema that may not conform to all the "rules" but is based on the spirit of collaboration and authenticity that Dogme 95 champions.

## READING CUES & KEY CONCEPTS

■ Looking at Dogme 95 rules, consider how its concept of "realism" and authenticity is different from other realist movements you know, such as Italian neorealism.

■ Dogme 95 seems to be based on a productive tension: on the one hand, it imposes, through the "Vow of Chastity," strict and repressive principles, and on the other hand, it asks filmmakers to abandon control. What does this paradox suggest about the movement?

■ Consider how the language of both documents echoes earlier filmmaking manifestos such as Dziga Vertov's "Film Directors."

■ **Key Concepts:** Dogme 95; Avant-Garde; Illusionist Cinema

# Manifesto

. . . . . . . . . . . . . .

Dogme 95 is a collective of film directors founded in Copenhagen in spring 1995.

Dogme 95 has the expressed goal of countering "certain tendencies" in the cinema today.

**Dogme 95 is a rescue action!**

In 1960 enough was enough! The movie was dead and called for resurrection. The goal was correct but the means were not! The new wave proved to be a ripple that washed ashore and turned to muck.

Slogans of individualism and freedom created works for a while, but no changes. The wave was up for grabs, like the directors themselves. The wave was never stronger than the men behind it. The anti-bourgeois cinema itself became bourgeois,

because the foundations upon which its theories were based was the bourgeois perception of art. The auteur concept was bourgeois romanticism from the very start and thereby . . . false!

To Dogme 95 cinema is not individual!

Today a technological storm is raging, the result of which will be the ultimate democratisation of the cinema. For the first time, anyone can make movies. But the more accessible the medium becomes, the more important the avant-garde. It is no accident that the phrase "avant-garde" has military connotations. Discipline is the answer . . . we must put our films into uniform, because the individual film will be decadent by definition!

Dogme 95 counters the individual film by the principle of presenting an indisputable set of rules known as the Vow of Chastity.

# Vow of Chastity

. . . . . . . . . . . . . .

I swear to submit to the following set of rules drawn up and confirmed by Dogme 95:

1. Shooting must be done on location. Props and sets must not be brought in. (If a particular prop is necessary for the story, a location must be chosen where this prop is to be found.)

2. The sound must never be produced apart from the images or vice versa. (Music must not be used unless it occurs where the scene is being shot.)

3. The camera must be hand-held. Any movement or immobility attainable in the hand is permitted. (The film must not take place where the camera is standing; shooting must take place where the film takes place.)

4. The film must be in colour. Special lighting is not acceptable. (If there is too little light for exposure the scene must be cut or a single lamp be attached to the camera.)

5. Optical work and filters are forbidden.

6. The film must not contain superficial action. (Murders, weapons, etc. must not occur.)

7. Temporal and geographical alienation are forbidden. (That is to say that the film takes place here and now.)

8. Genre movies are not acceptable.

9. The film format must be Academy 35 mm.

10. The director must not be credited.

Furthermore I swear as a director to refrain from personal taste! I am no longer an artist. I swear to refrain from creating a "work," as I regard the instant as more important than the whole. My supreme goal is to force the truth out of my characters

and settings. I swear to do so by all the means available and at the cost of any good taste and any aesthetic considerations.

Thus I make my Vow of Chastity."

Copenhagen, Monday 13 March 1995

On behalf of **Dogme 95**
Lars von Trier
Thomas Vinterberg

# TRINH T. MINH-HA

. . . . . . . . . . . . . . . . . . . . . . . . . . . . . . . . . . . . . . . . . . . . . . . . . . . . . . . . . . . . . . . . . . . . . . . .

# Documentary Is/Not a Name

Filmmaker, writer, and composer, Trinh T. Minh-ha (b. 1953) is a leading figure in postcolonial feminist filmmaking and theory of the last several decades. Born in Vietnam and educated in the United States and France in comparative literature and ethnomusicology, Trinh is currently Professor of Women's Studies and Rhetoric (Film) at the University of California, Berkeley. She made her first film, *Reassemblage* (1982), when she was teaching in Dakar, Senegal. Subsequently, she made six feature films—on Africa, Japan, and China, among other cultures—including the documentary *Surname Viet Given Name Nam* (1989) and the digital fiction film *Night Passage* (2005). She works closely with her partner Jean-Paul Bourdier, with whom she produced the installation book *The Desert Is Watching*. Trinh has also published numerous books including poetry, theoretical texts, and two collections of scripts and interviews.

Reassemblage is a forty-minute self-reflexive documentary on African women and the documentary form itself, in particular the power imbedded in the relationship between looker and looked-at, anthropologist and culture of study. The film is taught in anthropology, film studies, postcolonial theory, and women's studies classes, and it exemplifies the powerful convergence of theory and practice that is present throughout Trinh's work. For example, Trinh makes her films "theoretical" by including passages of self-reflexive voiceover narration, and she makes her critical writings "artistic" by employing literary devices like irony and personification to make the reader think about who is speaking and who is spoken for. Trinh is also particularly concerned with how colonial history has infused and affected visual practices, as evidenced by the power imbalances in ethnography and by what she has called documentary's "totalizing quest of meaning."

In "Documentary Is/Not a Name," first published in 1990 after the release of *Surname Viet Given Name Nam*, Trinh questions the truth claims of the documentary form by drawing an analogy between the relationship of the name of something to the thing itself and the relationship of film to the reality it references. Trinh uses quotations from famous documentarians like John Grierson (p. 657) and Lindsay Anderson to raise the most fundamental questions of the genre: What is the status of evidence? Who is an expert?

Her review of the history of documentary leads her to the claim that "reality is more fabulous, more maddening, more strangely manipulative than fiction." This essay is an excellent example of Trinh's concerns with aesthetics, authority, and anthropology and, like all of Trinh's writing, irreducible as a rhetorical performance. Her essay foreshadows in many ways the hybrid fiction/documentary forms that rose to prominence in the last decades of the twentieth century; the rigorous and open documentary practice she advocates is a powerful corrective to the formulaic "reflexivity" of reality television.

## READING CUES & KEY CONCEPTS

■ Trinh opens her essay with the forceful claim that "there is no such thing as documentary." Track several ways in which she interprets and bolsters her claim as the essay unfolds.

■ How does Trinh reconceptualize the relationship between theory and practice in both the making and the interpreting of documentary?

■ Consider Trinh's analysis of the power of representing the other in relation to her claim that "reality" is not neutral.

■ How do the poetic aspects of Trinh's essay affect you as a reader in comprehending her argument? What does this use of language tell you about Trinh's relationship as a filmmaker to the concepts she discusses?

■ **Key Concepts:** Regimes of Truth; Reification; Referential; Reflexivity; Ethnographic Film

# Documentary Is/Not a Name

. . . . . . . . . . . . . .

*Nothing is poorer than a truth expressed as it was thought.*

Walter Benjamin

There is no such thing as *documentary*—whether the term designates a category of material, a genre, an approach, or a set of techniques. This assertion—as old and as fundamental as the antagonism between names and reality—needs incessantly to be restated, despite the very visible existence of a documentary tradition. In film, such a tradition, far from undergoing crisis today, is likely to fortify itself through its very recurrence of declines and rebirths. The narratives that attempt to unify/purify its practices by positing evolution and continuity from one period to the next are numerous indeed, relying heavily on traditional historicist concepts of periodization.

In a completely catalogued world, cinema is often reified into a corpus of traditions. On the one hand, truth is produced, induced, and extended according to the regime in power. On the other, truth lies in between all regimes of truth. To question the image of a historicist account of documentary as a continuous unfolding does not necessarily mean championing discontinuity; and to resist meaning does not necessarily lead to its mere denial. Truth, even when "caught on the run," does not yield itself either in names or in filmic frames; and meaning should be prevented from coming to closure at either what is said or what is shown. Truth and meaning: the two are likely to be

equated with one another. Yet, what is put forth as truth is often nothing more than *a* meaning. And what persists between the meaning of something and its truth is the interval, a break without which meaning would be fixed and truth congealed. This is perhaps why it is so difficult to talk about it, the interval. About the cinema. About. The words will not ring true. Not true; for what is one to do with films that set out to determine truth from falsity while the visibility of this truth lies precisely in the fact that it is false? How is one to cope with a "film theory" that can never theorize "about" film, but only *with* concepts that film raises in relation to concepts of other practices?

> *A man went to a Taoist temple and asked that his fortune be told. "First," said the priest, "you must donate incense money, otherwise the divination might not be as accurate as possible. Without such a donation, in fact, none of it will come true!"*
>
> <div align="right">Wit and Humor from Old Cathay</div>

Concepts are no less practical than images or sound. And, theory does have to be (de)constructed as it (de)constructs its object of study. While concepts of cinema are not readymades and do not preexist cinema, they are not theory *about* cinema either. The setting up of practice against theory, and vice-versa, is at best a tool for reciprocal challenge, but like all binary oppositions, it is caught in the net of a positivist thinking whose impetus is to supply answers at all costs, thereby limiting both theory and practice to a process of totalization. *I'm sorry, if we're going to use words we should be accurate in our use of them. It isn't a question of technique, it is a question of the material. If the material is actual, then it is documentary. If the material is invented, then it is not documentary . . . If you get so muddled up in your use of the term, stop using it. Just talk about films. Anyway, very often when we use these terms, they only give us an opportunity to avoid really discussing the film.*[1] In the general effort to analyze film and to produce "theory about film," there is an unavoidable tendency to reduce film theory to an area of specialization and of expertise, one that serves to constitute a *discipline*. There is also advocacy of an Enlightenment and bourgeois conception of language, which holds that the means of communication is the word, its object factual, its addressee a human subject (the linear, hierarchical order of things in a world of reification); whereas, language as the "medium" of communication in its most radical sense, "only communicates itself *in* itself."[2] The referential function of language is thus not negated, but freed from its false identification with the phenomenal world and from its assumed authority as a means of cognition about that world. Theory can be the very place where this negative knowledge about the reliability of theory's own operative principles is made accessible, and where theoretical categories, like all classificatory schemes, keep on being voided, rather than appropriated, reiterated, safeguarded.

Documentary is said to have come about as a need to inform the people (Dziga Vertov's *Kino-Pravda* or *Camera-Truth*), and subsequently to have affirmed itself as a reaction against the monopoly of the movie as entertainment came to have on the uses of film. Cinema was redefined as an ideal medium for social indoctrination and comment, the virtues of which lay in its capacity for "observing and selecting from life itself," for "opening up the screen on the real world," for photographing "the living scene and the living story," for giving cinema "power over a million and one images," as well as

for achieving "an intimacy of knowledge and effect impossible to the shimsham me-
chanics of the studio and the lily-fingered interpretation of the metropolitan actor."[3]
Asserting its independence from the studio and the star system, documentary has its
*raison d'être* in a strategic distinction. It puts the social function of film *on the market.*
It takes real people and real problems from the real world and *deals with* them. It *sets a
value* on intimate observation and *assesses its worth* according to how well it succeeds
in capturing reality on the run, "without material interference, without intermedi-
ary." Powerful living stories, infinite authentic situations. There are no retakes. The
stage is thus no more and no less than life itself. *With the documentary approach the
film gets back to its fundamentals. . . . By selection, elimination and coordination of nat-
ural elements, a film form evolves which is original and not bound by theatrical or liter-
ary tradition. . . . The documentary film is an original art form. It has come to grips with
facts—on its own original level. It covers the rational side of our lives, from the scientific
experiment to the poetic landscape-study, but never moves away from the factual.*[4]

The real world: so real that the Real becomes the one basic referent—pure, concrete,
fixed, visible, all-too-visible. The result is the advent of a whole aesthetic of objectivity
and the development of comprehensive technologies of truth capable of promoting
what is right and what is wrong in the world and, by extension, what is "honest" and
what is "manipulative" in documentary. This involves an extensive and relentless
pursuit of naturalism across all the elements of cinematic technology. Indispens-
able to this cinema of the authentic image and spoken word are, for example, the
directional microphone (localizing and restricting in its process of selecting sound
for purposes of decipherability) and the Nagra portable tape-recorder (unrivaled
for its maximally faithful ability to document). Lip-synchronous sound is validated
as the norm; it is a "must"—not so much in replicating reality (this much has been
acknowledged among the fact-makers) as in "showing real people in real locations at
real tasks." (Even non-sync sounds recorded in context are considered "less authen-
tic" because the technique of sound synchronization and its institutionalized use
have become "nature" within film culture.) Real time is thought to be more "truthful"
than filmic time, hence the long-take (that is, a take lasting the length of the 400-foot
roll of commercially available film stock) and minimal or no editing (change at the
cutting stage is "trickery," as if montage did not happen at the stages of conception
and shooting) are declared to be more appropriate if one is to avoid distortions in
structuring the material. The camera is the switch onto life. Accordingly, the close-up
is condemned for its partiality, while the wide angle is claimed as more objective
because it includes more in the frame; hence it can mirror the event-in-context more
faithfully. (The more, the larger, the truer—as if wider framing is less a framing than
tighter shots.) The light-weight, hand-held camera, with its independence from the
tripod—the fixed observation post—is extolled for its ability "to go unnoticed," since
it must be at once mobile and invisible, integrated into the milieu so as to change as
little as possible, but also able to put its intrusion to use to provoke people into utter-
ing the "truth" they would not otherwise unveil in ordinary situations.

*Thousands of bunglers have made the word [documentary] come to mean a deadly,
routine form of film-making, the kind an alienated consumer society might appear to
deserve—the art of talking a great deal during a film, with a commentary imposed from*

*the outside, in order to say nothing, and to show nothing.*[5] The perfectly objective social observer may no longer stand as the cherished model among documentary-makers today, but with every broadcast the viewer, Everyman, continues to be taught that he or she is first and foremost a Spectator. Either one is not responsible for what one sees (because only the event presented counts) or the only way one can have some influence on things is by sending in (monetary) donations. Thus, though the filmmaker's perception may readily be admitted as unavoidably personal, the objectiveness of the reality of what is seen and represented remains unchallenged. *[Cinéma-vérité:] it would be better to call it cinema-sincerity. . . . That is, that you ask the audience to have confidence in the evidence, to say to the audience, "This is what I saw. I didn't fake it, this is what happened . . . I look at what happened with my subjective eye and this is what I believe took place. . . . It's a question of honesty.*[6]

What is presented as evidence remains evidence, whether the observing eye qualifies itself as being subjective or objective. At the core of such a rationale dwells, untouched, the Cartesian division between subject and object that perpetuates a dualistic inside-versus-outside, mind-against-matter view of the world. Again, the emphasis is laid on the power of film to capture reality "out there" for us "in here." The moment of appropriation and of consumption is either simply ignored or carefully rendered invisible according to the rules of good and bad documentary. The art of talking-to-say-nothing goes hand-in-hand with the will to say, and to say only to confine something in a meaning. Truth has to be made vivid, interesting; it has to be "dramatized" if it is to convince the audience of the evidence, whose "confidence" in it allows truth to take shape. *Documentary—the presentation of actual facts in a way that makes them credible and telling to people at the time.*[7]

The real? Or the repetitive, artificial resurrection of the real, an operation whose overpowering success in substituting the visual and verbal signs of the real for the real itself ultimately helps challenge the real, thereby intensifying the uncertainties engendered by any clear-cut division between the two. In the scale of what is more and what is less real, subject matter is of prime importance ("It is very difficult if not impossible," says a film festival administrator, "to ask jurors of a panel in the documentary film category not to identify the quality of a film with the subject it treats"). The focus is undeniably on common experience, by which the "social" is defined: an experience that features, as a famed documentary-maker (Pierre Perrault) put it (paternalistically): "man, simple man, who has never expressed himself."[8]

The socially oriented filmmaker is thus the almighty voice-giver (here, in a vocalizing context that is all-male), whose position of authority in the production of meaning continues to go unchallenged, skillfully masked as it is by its righteous mission. The relationship between mediator and medium, or the mediating activity, is either ignored—that is, assumed to be transparent, as value-free and as insentient as an instrument of reproduction ought to be—or else, it is treated most conveniently: by humanizing the gathering of evidence so as to further the status quo ("Of course, like all human beings I am subjective, but nonetheless, I have confidence in the evidence!"). Good documentaries are those whose subject matter is "correct" and whose point of view the viewer agrees with. What is involved may be a question of honesty (vis-à-vis the material), but it is often also a question of (ideological) adherence, hence of legitimization.

Films made about the common people are, furthermore, naturally promoted as films made for the same people, and only for them. In the desire to service the needs of the un-expressed, there is, commonly enough, the urge to define them and their needs. More often than not, for example, when filmmakers find themselves in debates in which a film is criticized for its simplistic and reductive treatment of a subject, resulting in a maintenance of the very status quo it sets out to challenge, their tendency is to dismiss the criticism by arguing that the film is not made for "sophisticated viewers like ourselves, but for a general audience," thereby situating themselves above and apart from the *real* audience, those "out there," the simple-minded folks who need everything they see explained to them. Despite the shift of emphasis—from the world of the upwardly mobile and the very affluent that domi-nates the media to that of "their poor"—what is maintained intact is the age-old op-position between the creative, intelligent supplier and the mediocre, unenlightened consumer. The pretext for perpetuating such division is the belief that social rela-tions are determinate, hence endowed with objectivity. By *"impossibility of the social" I understand . . . the assertion of the ultimate impossibility of all "objectivity" . . . society presents itself, to a great degree, not as an objective, harmonic order, but as an ensem-ble of divergent forces which do not seem to obey any unified or unifying logic. How can this experience of the failure of objectivity be made compatible with the affirmation of an ultimate objectivity of the real?*[9] The silent common people—those who "have never expressed themselves" unless they are given the opportunity to voice their thoughts by the one who comes to redeem them—are constantly summoned to sig-nify the real world. They are the fundamental referent of the social, hence it suffices to point the camera at them, to show their (industrialized) poverty, or to contex-tualize and package their unfamiliar lifestyles for the ever-buying and donating general audience "back here," in order to enter the sanctified realm of the morally right, or the social. In other words, when the so-called "social" reigns, how these people (/we) come to visibility in the media, how meaning is given to their(/our) lives, how their(/our) truth is construed or how truth is laid down for them(/us) and despite them(/us), how representation relates to or *is* ideology, how media hegemony con-tinues its relentless course is simply not at issue.

> There isn't *any* cinéma-vérité. *It's necessarily a lie, from the moment the director intervenes—or it isn't cinema at all.*
>
> Georges Franju

When the social is hypostatized and enshrined as an ideal of transparency, when it itself becomes commodified in a form of sheer administration (better service, better control), the interval between the real and the image/d or between the real and the rational shrinks to the point of unreality. Thus, to address the question of production relations, as raised earlier, is endlessly to reopen the question: how is the real (or the social ideal of good representation) produced? Rather than catering to it, striving to capture and discover its truth as a concealed or lost object, it is therefore important also to keep asking: how is truth being ruled? *The penalty of realism is that it is about reality and has to bother forever not about being "beautiful" but about being right.*[10]

The fathers of documentary initially insisted that documentary is not News, but Art (a "new and vital art form," as Grierson once proclaimed): that its essence

is not information (as with "the hundreds of tweeddle-dum 'industrials' or worker-education films"); not reportage; not newsreels; but something close to "a creative treatment of actuality" (Grierson's renowned definition).

Documentary may be anti-aesthetic, as some still affirm in the line of the British forerunner, but it is claimed to be no less an art, albeit an art within the limits of factuality. When, in a world of reification, truth is widely equated with fact, any explicit use of the magic, poetic, or irrational qualities specific to the film medium itself would have to be excluded a priori as nonfactual. The question is not so much one of sorting out—illusory as this may be—what is inherently factual from what is not in a body of *preexisting* filmic techniques, as it is one of abiding by the laws of naturalism in film. In the reality of formula-films, only validated techniques are *right*, others are de facto wrong. All, however, depend on their degree of invisibility in producing meaning. Thus, shooting at any speed other than the standard 24-frames-per-second (the speed necessitated for lip-sync sound) is, for example, often condemned as a form of manipulation, implying thereby that manipulativeness has to be discreet—that is, acceptable only when not easily perceptible to the "real audience." Although the whole of filmmaking *is* a question of manipulation—whether "creative" or not—those endorsing the law unhesitatingly decree which technique is manipulative and which, supposedly, is not; and this judgment is made according to the degree of visibility of each. *A documentary film is shot with three cameras: 1) the camera in the technical sense; 2) the filmmaker's mind; and 3) the generic patterns of the documentary film, which are founded on the expectations of the audience that patronizes it. For this reason one cannot simply say that the documentary film portrays facts. It photographs isolated facts and assembles from them a coherent set of facts according to three divergent schemata. All remaining possible facts and factual contexts are excluded. The naive treatment of documentation therefore provides a unique opportunity to concoct fables. In and of itself, the documentary is no more realistic than the feature film.*[11]

Reality is more fabulous, more maddening, more strangely manipulative than fiction. To understand this is to recognize the naiveté of a development of cinematic technology that promotes increasingly unmediated access to reality. It is to see through the poverty of what Benjamin deplored as "a truth expressed as it was thought" and to understand why progressive fiction films are attracted by and constantly pay tribute to documentary techniques. These films put the "documentary effect" to advantage, playing on the viewer's expectations in order to "concoct fables." The documentary can easily thus become a "style": it no longer constitutes a mode of production or an attitude toward life, but proves to be only an element of aesthetics (or anti-aesthetics), which at best, and without acknowledging it, it tends to be in any case when, within its own factual limits, it reduces itself to a mere category, or a set of persuasive techniques. Many of these techniques have become so "natural" to the language of broadcast television that they "go unnoticed." These are, for example, the "personal testimony" technique (a star appears on screen to advertise his or her use of a certain product); the "plain folks" technique (a politician arranges to eat hot dogs in public); the "band wagon" technique (the use of which conveys the message that "everybody is doing it, why not you?");

or the "card stacking" technique (in which prearrangements for a "survey" show that a certain brand of product is more popular than any other to the inhabitants of a given area).[12]

*You must re-create reality because reality runs away; reality denies reality. You must first interpret it, or re-create it. . . . When I make a documentary, I try to give the realism an artificial aspect. . . . I find that the aesthetic of a document comes from the artificial aspect of the document . . . it has to be more beautiful than realism, and therefore it has to be composed . . . to give it another sense.*[13] A documentary aware of its own artifice is one that remains sensitive to the flow between fact and fiction. It does not work to conceal or exclude what is normalized as "non-factual," for it understands the mutual dependence of realism and "artificiality" in the process of filmmaking. It recognizes the necessity of composing (on) life in living it or making it. Documentary reduced to a mere vehicle of facts may be used to advocate a cause, but it does not constitute one in itself; hence the perpetuation of the bipartite system of division in the content-versus-form rationale. To compose is not always synonymous with ordering-so-as-to-persuade, and to give the filmed document another sense, another meaning, is not necessarily to distort it. If life's paradoxes and complexities are not to be suppressed, the question of degree and nuance is incessantly crucial. Meaning can therefore be political only when it does not let itself be easily stabilized, and when it does not rely on any single source of authority, but, rather, empties or decentralizes it. Thus, even when this source is referred to, it stands as one among many others, at once plural and utterly singular. In its demand to *mean* at any rate, the "documentary" often forgets how it comes about and how aesthetics and politics remain inseparable in its constitution. For, when not equated with mere techniques of beautifying, aesthetics allows one to experience life differently, or as some would say, to give it "another sense," remaining in tune with its drifts and shifts.

From its descriptions to its arrangements and rearrangements, reality on the move may be heightened or impoverished but is never neutral (that is, objective). *Documentary at its purest and most poetic is a form in which the elements that you use are the actual elements.*[14] The notion of "making strange" and of reflexivity remains but a mere distancing device so long as the division between "textual artifice" and "social attitude" exerts its power.[15] The "social" continues to go unchallenged, history keeps on being salvaged, while the sovereignty of the socio-historicizing subject is safely maintained. With the status quo of the making/consuming subject preserved, the aim is to correct "errors" (the false) and to construct an alternative view (offered as a this-is-the-true or mine-is-truer version of reality). It is, in other words, to replace one source of unacknowledged authority by another, but not to challenge the very constitution of authority. The new socio-historical text thus rules despotically as another master-centered text, since it unwittingly helps to perpetuate the Master's ideological stance.

When the textual and the political neither separate themselves from one another nor simply collapse into a single qualifier, the practice of representation can, similarly, neither be taken for granted nor merely dismissed as being ideologically reactionary. By putting representation under scrutiny, textual theory/practice has more likely

helped to upset rooted ideologies by bringing the mechanics of their inner workings to the fore. It makes possible the vital differentiation between authoritative criticism and uncompromising analyses and inquiries (including those of the analyzing/inquiring activity). Moreover, it contributes to a questioning of reformist "alternative" approaches that never quite depart from the lineage of white- and male-centered humanism. Despite their explicit socio-political commitment, in the end these approaches remain unthreatening, that is, "framed," and thus neither social nor political enough.

Reality runs away, reality denies reality. Filmmaking is after all a question of "framing" reality in its course. However, it can also be the very place where the referential function of the film image/sound is not simply negated, but reflected upon in its own operative principles and questioned in its authoritative identification with the phenomenal world. In attempts to suppress the mediation of the cinematic apparatus and the fact that language "communicates itself in itself," there always lurks a bourgeois conception of language. *Any revolutionary strategy must challenge the depiction of reality . . . so that a break between ideology and text is effected.*[16]

To deny the *reality* of film in claiming (to capture) *reality* is to stay "in ideology"— that is, to indulge in the (deliberate or not) confusion of filmic with phenomenal reality. By condemning self-reflexivity as pure formalism instead of challenging its diverse realizations, this ideology can "go on unnoticed," keeping its operations invisible and serving the goal of universal expansionism. Such aversion against reflexivity goes hand in hand with its widespread appropriation as a progressive, formalistic device in cinema, since both work to reduce its function to a harmlessly decorative one. (For example, it has become commonplace to hear such remarks as "a film is a film" or "this is a film about a film." Film-on-film statements are increasingly challenging to work with because they can easily fall prey to their own formulas and techniques.) Furthermore, reflexivity, at times equated with a personal perspective, is at other times endorsed as scientific rigor.

> *Two men were discussing the joint production of wine. One said to the other: "You shall supply the rice and I the water." The second asked: "If all the rice comes from me, how shall we apportion the finished product?" The first man replied: "I shall be absolutely fair about the whole thing. When the wine is finished, each gets back exactly what he puts in—I'll siphon off the liquid and you can keep the rest."*
>
> Wit and Humor from Old Cathay

One of the areas of documentary that remains most resistant to the reality of film-as-film is that known as anthropological filmmaking. Filmed ethnographic material, which for a long time was thought to "replicate natural perception," has renounced this authority only to purport to provide adequate "data" for the "sampling" of culture. The claim to objectivity may no longer stand in many anthropological circles, but its authority is likely to be replaced by the sacrosanct notion of the "scientific." Thus the recording and gathering of data and of people's testimonies are considered to be the limited aim of "ethnographic film." What makes a film anthropological and what makes it scientific, tautologically enough, is its "scholarly endeavor [to] respectively document and interpret according to anthropological standards."[17] Not merely ethnographic or documentary, as this definition specifies, but "scholarly" and anthropological, a fundamental scientific

obsession is present in every attempt to demarcate anthropology's territories. In order to be scientifically valid, a film needs the scientific intervention of the anthropologist, for it is only by adhering to the body of conventions set up by the community of anthropologists accredited by their "discipline" that the film can hope to qualify for the classification and be passed as a "scholarly endeavor."

One of the familiar arguments given by anthropologists to validate their prescriptively instrumental use of film and of people is to dismiss all works by filmmakers who are "not professional anthropologists" or "amateur ethnographers" under the pretext that they are not "anthropologically informed," hence they have "no theoretical significance from an anthropological point of view." To advance such a blatantly self-promoting rationale to institute "a deadly routine form of filmmaking" (to quote a sentence of Marcorelles once more) is also—through anthropology's primary task of "collecting data" for knowledge of mankind—to try to skirt what is known as the "salvage paradigm" and the issues implicated in the scientific deployment of Western world ownership.[18] The stronger anthropology's insecurity about its own project, the greater its eagerness to hold up a normative model, and the more seemingly serene its disposition to dwell in its own blinkered field.

In the sanctified terrain of anthropology, all of filmmaking is reduced to a question of method. It is demonstrated that the reason anthropological films go further than ethnographic films is because they do not, for example, just show activities being performed, but they also *explain* the "anthropological significance" of these activities (significance that, despite the disciplinary qualifier *anthropological*, is de facto identified with the meaning the natives give them themselves). Now, obviously, in the process of fixing meaning, not every explanation is valid. This is where the expert anthropologist plays his role and where methodologies need to be devised, legitimated, and enforced. For, if a non-professional explanation is dismissed here, it is not so much because it lacks insight or theoretical grounding, as because it escapes anthropological control. In the name of science, a distinction is made between reliable and unreliable information. Anthropological and non-anthropological explanations may share the same subject matter, but they differ in the way they produce meaning. The unreliable constructs are the ones that do not obey the rules of anthropological authority, which a concerned expert like Evans-Pritchard skillfully specifies as being nothing else but "a scientific habit of mind."[19] Science defined as the most appropriate approach to the object of investigation serves as a banner for every scientific attempt to promote the West's paternalistic role as subject of knowledge and its historicity of the Same. *The West agrees with us today that the way to Truth passes by numerous paths, other than Aristotelian Thomistic logic or Hegelian dialectic. But social and human sciences themselves must be decolonized.*[20]

In its scientific "quest to make meaning," anthropology constantly reactivates the power relations embedded in the Master's confident discourses on Himself and His Other, thereby aiding both the *centri*petal and *centri*fugal movement of their global spread. With the diverse challenges issued today to the very process of producing "scientific" interpretations of culture as well as to that of making anthropological knowledge possible, visually oriented members of its community have come up with an epistemological position in which the notion of reflexivity is typically reduced to a question of technique and method. Equated with a form of self-exposure common

in field work, it is discussed at times as *self-reflectivity* and at other times condemned as individualistic idealism sorely in need of being controlled if the individual maker is not to loom larger than the scientific community or the people observed. Thus, "being reflexive is virtually synonymous with being scientific."[21] The reasons justifying such a statement are many, but one that can be read through it and despite it is: as long as the maker abides by a series of "reflexive" techniques in filmmaking that are devised for the purpose of exposing the "context" of production and as long as the required techniques are method(olog)ically carried out, the maker can be assured that "reflexivity" is elevated to that status of scientific rigor. These reflexive techniques would include the insertion of a verbal or visual narrative about the anthropologist, the methodology adopted, and the condition of production—in other words, all the conventional means of validating an anthropological text through the disciplinary practice of head- and footnoting and the totalistic concept of pre-production presentation. Those who reject such a rationale do so out of a preoccupation with the "community of scientists," whose collective judgment they feel should be the only true form of reflection. For, an individual validation of a work can only be suspicious because it "ignores the historical development of science." In these constant attempts at enforcing anthropology as (a) discipline and at recentering dominant representation of culture (despite all the changes in methodologies), what seems to be oddly suppressed in the notion of reflexivity in filmmaking is its practice as processes to prevent meaning from ending with what is said and what is shown and—through inquiries into production relations—thereby to challenge representation itself even while emphasizing the reality of the experience of film as well as the important role that reality plays in the lives of the spectators.

> *Unless an image displaces itself from its natural state, it acquires no significance. Displacement causes resonance.*
>
> Shanta Gokhale [22]

As an aesthetic closure or an old relativizing gambit in the process nonetheless of absolutizing meaning, reflexivity proves critically in/significant when it merely serves to refine and to further the accumulation of knowledge. No going beyond, no elsewhere-within-here seems possible if the reflection on oneself is not at one and the same time the analysis of established forms of the social that define one's limits. Thus to drive the self into an abyss is neither a moralistic stricture against oneself nor a task of critique that humanizes the decoding self but never challenges the very notion of self and decoder. Left intact in its positionality and its fundamental urge to decree meaning, the self conceived both as key and as transparent mediator, is more often than not likely to turn responsibility into license. The license to *name*, as though meaning presented itself to be deciphered without any ideological mediation. As though specifying a context can only result in the finalizing of what is shown and said. As though naming can stop the process of naming: that very abyss of the relation of self to self.

The bringing of the self into play necessarily exceeds the concern for human errors, for it cannot but involve as well the problem inherent in representation and communication. Radically plural in its scope, reflexivity is thus not a mere question of *rect*ifying and *just*ifying (*subject*ivizing). What is set in motion in its praxis are the self-generating links between different forms of reflexivity. Thus, a subject who

points to him or herself as subject-in-process, a work that displays its own formal properties or its own constitution as work, is bound to upset one's sense of identity—the familiar distinction between the Same and the Other since the latter is no longer kept in a recognizable relation of dependence, derivation, or appropriation. The process of self-constitution is also that in which the self vacillates and loses its assurance. The paradox of such a process lies in its fundamental instability; an instability that brings forth the disorder inherent in every order. The "core" of representation is the reflexive interval. It is the place in which the play within the textual frame is a play on this very frame, hence on the borderlines of the textual and extra-textual, where a positioning within constantly incurs the risk of de-positioning, and where the work, never freed from historical and socio-political contexts nor entirely subjected to them, can only be itself by constantly risking being no-thing.

A work that reflects back on itself offers itself infinitely as nothing else but work . . . and void. Its gaze is at once an impulse that causes the work to fall apart (to return to the initial no-work-ness) and an ultimate gift to its constitution. A gift, by which the work is freed from the tyranny of meaning as well as from the omnipresence of a subject of meaning. To let go of the hold at the very moment when it is at its most effective is to allow the work to live, and to live on independently of the intended links, communicating itself in itself, like Benjamin's "the self is a text"—no more and no less "a project to be built."[23] *Orpheus' gaze . . . is the impulse of desire which shatters the song's destiny and concern, and in that inspired and unconcerned decision reaches the origin, consecrates the song.*[24]

Meaning can neither be imposed nor denied. Although every film is in itself a form of ordering and closing, each closure can defy its own closure, opening onto other closures, thereby emphasizing the interval between apertures and creating a space in which meaning remains fascinated by what escapes and exceeds it. The necessity to let go of the notion of intentionality that dominates the question of the "social" as well as that of creativity cannot therefore be confused with the ideal of nonintervention, an ideal in relation to which the filmmaker, trying to become as invisible as possible in the process of producing meaning, promotes empathic subjectivity at the expense of critical inquiry even when the intention is to show and to condemn oppression. *It is idealist mystification to believe that "truth" can be captured by the camera or that the conditions of a film's production (e.g., a film made collectively by women) can of itself reflect the conditions of its production. This is mere utopianism: new meaning has to be manufactured within the text of the film. . . . What the camera in fact grasps is the "natural" world of the dominant ideology.*[25]

In the quest for totalized meaning and for knowledge-for-knowledge's sake, the worst meaning is meaninglessness. A Caucasian missionary nun based in a remote village of Africa qualifies her task in these simple, confident terms: "We are here to help people give meaning to their lives." Ownership is monotonously circular in its give-and-take demands. It is a monolithic view of the world the irrationality of which expresses itself in the imperative of both giving and meaning, and the irreality of which manifests itself in the need to require that visual and verbal constructs yield meaning down to their last detail. *The West moistens everything with meaning, like an authoritarian religion which imposes baptism on entire people.*[26] Yet such illusion

is real; it has its own reality, one in which the subject of Knowledge, the subject of Vision, or the subject of Meaning continues to deploy established power relations, assuming Himself to be the basic reserve of reference in the totalizing quest for the referent, the true referent that lies out there in nature, in the dark, waiting patiently to be unveiled and deciphered correctly. To be redeemed. Perhaps then, an imagination that goes toward the texture of reality is one capable of working upon the illusion in question and the power it exerts. The production of one irreality upon the other and the play of non-sense (which is not mere meaninglessness) upon meaning may therefore help to relieve the basic referent of its occupation, for the present situation of critical inquiry seems much less one of attacking the illusion of reality as one of displacing and emptying out the establishment of totality.

## NOTES

1. Lindsay Anderson, as quoted in G. Roy Levin, *Documentary Explorations: Fifteen Interviews with Film-Makers*, Garden City, New York, Doubleday, 1971, p. 66.

2. Walter Benjamin, *One Way Street*, London, Verso, 1979, p. 109.

3. John Grierson, in Forsyth Hardy, ed., *Grierson On Documentary*, New York, Praeger, 1971, pp. 146–147.

4. Hans Richter, "Film as an Original Art Form," in R. Dyer MacCann, ed., *Film: A Montage of Theories*, New York, Dutton, 1966, p. 183.

5. Louis Morcorelles, *Living Cinema: New Directions in Contemporary Film-Making*, trans. I. Quigly, New York, Praeger, 1973, p. 37.

6. Jean Rouch, as quoted in *Documentary Explorations*, p. 135.

7. William Stott, *Documentary Expression and Thirties America*, New York, Oxford University Press, 1976, p. 73.

8. Quoted in *Living Cinema*, p. 26.

9. Ernesto Laclau, as quoted in "Building a New Left: An Interview with Ernest Laclau," *Strategies*, no. 1 (Fall 1988), p. 15.

10. Grierson, *Grierson on Documentary*, p. 249.

11. Alexander Kluge, as quoted in *Alexander Kluge, A Retrospective*, New York, The Goethe Institutes of North America, 1988, p. 4.

12. John Mercer, *An Introduction to Cinematography*, Champaign, Illinois, Stipes Publishing Co., 1968, p. 159.

13. Georges Franju, as quoted in *Documentary Explorations*, pp. 121, 128.

14. Lindsay Anderson, as quoted in *Ibid.*, p. 66.

15. This distinction motivates Dana Polan's argument in, "A Brechtian Cinema? Towards a Politics of Self-Reflexive Film," in B. Nichols, ed., *Movies and Methods*, vol. 2, Los Angeles, University of California Press, 1985, pp. 661–672.

16. Claire Johnston, "Women's Cinema as Counter-Cinema," in *Movies and Methods*, vol. 1, 1976, p. 215.

17. Henk Ketelaar, "Methodology in Anthropological Filmmaking. A Filmmaking Anthropologist's Poltergeist?" in N. Bogaart and Henk Ketelaar, eds., *Methodology in Anthropological Filmmaking*, Gottingen, Herodot, 1983, p. 182.

18. See James Clifford, "Of Other Peoples: Beyond the 'Salvage Paradigm,' " in Hal Foster, ed., *Discussions in Contemporary Culture*, Seattle, Washington, Bay Press, 1987, pp. 121–130.

19. E. E. Evans-Pritchard, *Theories of Primitive Religion*, Oxford, Clarendon Press, 1980.

20. E. Mveng, "Récents développements de la théologie africaine," *Bulletin of African Theology*, vol. 5, p. 9; as quoted in V. Y. Mudimbe, *The Invention of Africa: Gnosis, Philosophy and the Order of Knowledge*, Bloomington, Indiana University Press, 1988, p. 37.

21. Jay Ruby, "Exposing Yourself: Reflexivity, Anthropology and Film," *Semiotica*, no. 30 (1980), p. 165.

22. Shanta Gokhale, as quoted in Uma da Cunha, ed., *The New Generation, 1960–1980,* New Delhi, The Directorate of Film Festivals, 1981, p. 114.

23. Benjamin, *One Way Street*, p. 14.

24. Maurice Blanchot, in P. Adams Sitney, ed., *The Gaze of Orpheus and Other Literary Essays*, trans. L. Davis, Tarrytown, New York, Station Hill Press, 1981, p. 104.

25. Johnston, "Women's Cinema as Counter-Cinema," p. 214.

26. Roland Barthes, *Empire of Signs*, trans. Richard Howard, New York, Hill & Wang, 1982, p. 70.

# PART 8

# SEXUALITY AND GENDER IN CINEMA: FROM PSYCHOANALYSIS TO PERFORMATIVITY

*Orlando, the lovesick, elaborately dressed English ambassador to seventeenth-century Constantinople, falls into a swoon. When Orlando wakes, shedding a massive wig, she's become a woman. Stark naked, she stands and contemplates the transformation in the mirror. Cut to a close-up as actor Tilda Swinton turns her head, looking directly toward the camera. "Same person," she declares. "No difference at all. Just a different sex." The screen fades to black.*

Scene from Sally Potter's *Orlando* (1992)

When Sally Potter, a dancer, choreographer, and avant-garde feminist filmmaker, made her first "mainstream" film, an adaptation of Virginia Woolf's satirical novel *Orlando* (1928), she combined formal experimentation with the pleasurable spectacle of the costume drama, engaging with contemporary theoretical questions about the construction of gender and the historical affinity of women audiences with film genres that put female experience at their center. Orlando, born in 1600 to a noble family, is an aspiring poet who is graced with eternal youth in an encounter with Queen Elizabeth (Quentin Crisp). Audiences identify with this character as the narrative protagonist, but we also objectify his/her highly stylized appearance as the grammar of film spectacle has trained

us to do, asking: "Male or female?" and "What's the difference?" Thus the film raises a tangle of questions about the intersections of gender and sexuality with authorship, genre, and visual and narrative pleasure, challenging its audience to see with fresh eyes.

The study of gender and sexuality in cinema has many dimensions: the representation of gender difference and of desire and sexuality on screen; the gendered dynamics (both social and psychic) of viewing films; and the questions of production and address that gender inevitably influences, such as who makes films, and for whom? Underpinning this wide array of approaches is the profound connection between the movies and eroticism, as well as the vast sociological influence visual media wield over sex roles and patterns of behavior. These affinities have generated vigorous inquiry into the intersections of gender and sexuality and film, especially since the 1970s and the advent of contemporary film theory, which coincided with the second wave of the feminist movement.

Activist interest in women and media led scholars of the 1970s to research contributions women had made to film history and present screenings of films by such underrecognized women directors as Germaine Dulac (p. 651) and Dorothy Arzner (see Judith Mayne, p. 386), as well as to champion the films of contemporary directors like Potter. Scholarly readings of these films drew on the many sophisticated theories of representation coming to prominence at the time, including, paradoxically for many feminists, Freudian psychoanalysis. SIGMUND FREUD's 1927 essay "On Fetishism," a clinical account of sexual perversion, seems far removed from the study of film; moreover, it reinforces some of the most blatant biases of his age in its theory of fetishism as assuaging male castration anxiety. However, in this essay Freud astutely describes visual mechanisms for investing differences between the sexes with meanings and values that are derived from already existing cultural hierarchies; these mechanisms are echoed throughout mainstream film's "ways of seeing" women and men differently (see John Berger, p. 114). Thus we can read Freud's work not as saying that the male genital organ is inherently superior to, or morphologically all that different from, female genitalia, but rather that patriarchal culture allots the male anatomy a higher value because it seems to visibly distinguish men as the dominant gender. Freud asserts that fetishism as a sexual perversion denies gender difference in order to retain pleasure; certainly the wigs and costumes that Orlando wears to transcend temporal and gender barriers provide audiences with considerable pleasure in their blurring of boundaries. While Christian Metz (p. 17) used fetishism as an analogy to describe the disavowal or denial of difference that any spectator must achieve to "believe" in the cinematic illusion, LAURA MULVEY, in her enormously influential essay "Visual Pleasure and Narrative Cinema," uses fetishism in a manner that is closer to Freud's concern with sexuality and perceived gender difference. She argues that the visual dynamics at work in cinema favor a *male* spectator and that the codes of presentation of the female star as well as dominant narrative conventions of investigation and closure hide female difference even as it is flaunted. *Orlando* provides a good example of such narrative codes when, after the protagonist returns to England as a woman, she loses all property rights. Class privilege and physical beauty have carried Orlando across the centuries, but gender difference seems to stop narrative momentum in its tracks. Mulvey's essay, published in 1975 in the prominent film journal *Screen*, generated much of the vocabulary and terms of debate that followed in film theory, putting feminist questions at the center of the discipline. Carol J. Clover's innovative reading of the slasher film (p. 511) explores the missing element of

masochism in Mulvey's model. Teresa de Lauretis (p. 573) elaborates on how desire is engaged by narrative and Tania Modleski (p. 375) reconsiders Mulvey's characterization of Hitchcock's films as being particularly gratifying to male spectators.

LINDA WILLIAMS, in "'Something Else Besides a Mother,'" similarly explores a crucial omission in Mulvey's essay: the female spectator's experience of classical cinema. Since the early days of the medium, particular kinds of films, stars, and stories have been cultivated to appeal to female audiences. While it is certainly the case that not all women like melodramas, costume dramas, or romantic comedies, it has been convincingly argued that both the women's films of the 1930s and 1940s and today's "chick flicks" find wide appeal by touching on some of the most basic conflicts and contradictions of normative female experience (e.g., choosing between maternity and romance, career and family). These conflicts are rooted in psychic experiences of mothering and being mothered as well as in broader social experiences, which helps explain why psychoanalytic concepts (including accounts that move away from Freud's masculinist biases) continue to play a significant role in such criticism. Williams's wide-ranging reading of the dynamics of identification and separation between mothers and daughters in the woman's picture *Stella Dallas* (1937) will resonate with contemporary pop cultural texts from *The Gilmore Girls* (2000–2007) to *The Secret Life of Bees* (2008).

Gender does not just refer to women: the next two theorists featured in this section address the construction of masculinity in film. KOBENA MERCER, in "Dark and Lovely Too: Black Gay Men in Independent Film," addresses the intersection of race, gender, and sexuality, drawing on feminist film theory but looking at independent films by and about black gay men rather than at mainstream movies that have marginalized such perspectives. Too often, questions of gender are considered apart from those of race; yet these two dimensions of core identity are always experienced together, and desire and sexuality often cut across racial lines. The hierarchy of power in Mulvey's formula "woman as image, male as bearer of the look" is considerably complicated if race is taken into consideration and whiteness is rendered visible. As cultural critic bell hooks has argued, during slavery and its aftermath, black men looking at white women could provoke violent retaliation; for black women questions of invisibility might be as salient as those of (hyper) visibility in film. The focus of Mercer's essay is the work of Marlon Riggs and Isaac Julien, in which black men look at *each other* with desire. The dynamics of the gaze explore the historical experience of black men, an experience so underdocumented that the power of fantasy is required to bring it to the screen.

Mercer's essay was written at a time when the exploration of identity politics spurred great innovation in the arts; however, the mainstream films of the 1980s told a different story. This is the period when the blockbuster action film came to dominance in the worldwide box office, and the kind of masculinity such films privileged—the "hard body" typified by Sylvester Stallone—seemed designed to defend against identification with "the other." In "Dumb Movies for Dumb People," YVONNE TASKER studies blockbusters and their stars' images, concluding that the construction of masculinity is performative. In grammatical theory, a performative is a category of speech in which words *do*, rather than describe, something (examples include: "I promise," and "You are grounded"). Theories of gender performativity, most identified with the work of philosopher and queer theorist Judith Butler (*Gender Trouble*; 1998), argue that gender itself is enacted; it is not a preexisting core identity. Such a theory has obvious relevance to the movies, whether explicitly engaged in a film like *Orlando*, or offering a way to read anxieties about gender in comedies and action

movies. For Tasker, the parodic quality of Stallone and the buddy dynamics in the *Die Hard* franchise denaturalize masculinity without, she cautions, displacing its dominance.

Another important aspect of Mercer's and Tasker's essays is that they step back from textual critique or inquiry into the psychic interaction of the spectator and text to effect a broader cultural engagement characteristic of cultural studies as a methodology. Mercer's work addresses alternative images and the independent film sector, while Tasker looks at postmodernism and industrial and political shifts. The next two essays also engage a wider cultural field and the significance of struggles of power and knowledge around sexual definitions. Like Mercer, B. RUBY RICH looks at independent gay cinema in her manifesto-like essay, "New Queer Cinema." She asks how and why formally inventive feature films that challenged heterosexuality as social and narrative norm came to prominence in the 1990s, citing the historical affinity of queer artists and the avant-garde, shifts in technology and access, the political struggle against homophobia and AIDS, and the daring of queer theory.

LINDA WILLIAMS inquires into that vast but critically occluded segment of moving image production, pornography, in the introduction to *Porn Studies*, "Porn Studies: Proliferating Pornographies On/Scene." Williams follows up on her important study *Hard Core* and looks at the considerable transformations in this industry in the age of the Internet. Feminist film theory, though concerned with questions of desire (and even perversion, as evidenced by the use of the concepts of fetishism and voyeurism), directed much of its attention to Hollywood films of the classical period when sexually explicit or even suggestive material was banned by the Production Code Administration. The end of the studio era and changes in the regulation of movies' content helped create the modern pornography industry, though such material had circulated since the beginnings of the medium. While in the 1980s feminists debated pornography's relation to women's oppression on the one hand and freedom of expression on the other, Williams argues that today sexually explicit content has entered the mainstream of media and politics in ways that require new critical lenses and pedagogical engagement.

In pornography, just as in mainstream and alternative media, access to the means of production by women and underrepresented groups allows for different kinds of representations that can challenge assumptions about who controls the look, whose body is on display, and how power and pleasure are shaped by those relationships. Sally Potter follows Virginia Woolf's lead in imagining a hero/ine who is shaped by his/her times *and* capable of transcending them. Like Orlando, though film viewers are positioned by the gendered language and dynamics of desire deployed by the movies, they are also able to fantasize other possibilities.

# SIGMUND FREUD

## On Fetishism

Sigmund Freud (1856–1939) is the founder of psychoanalysis, both as a clinical method and as a theory of the unconscious. A secular Jew, he lived and practiced in Vienna, the center of a circle of devoted followers, until 1938, when he and his family fled the Nazis for London, where Freud died the next year. Freud's prolific writings, including *The Interpretation of Dreams* (1900), *The*

*Ego and the Id* (1923), *Civilization and Its Discontents* (1930), numerous case histories, and dozens of papers, are collected in English in James Strachey's twenty-four-volume *Standard Edition of the Complete Psychological Works of Sigmund Freud* (London: Hogarth Press, 1953–1974).

Freud's work had a profound influence on twentieth-century life and thought, shaping not only the clinical practice of psychology and psychiatry but also the humanities and social sciences. As part of the impulse to "return to Freud" in French postwar cultural theory associated with the work of psychoanalyst Jacques Lacan (1901–1981), among others, film theorists adopted psychoanalytic ideas about identification, desire, and the unconscious to understand how meaning is made at the movies and how spectators become engaged by its images, sounds, stories, and rituals. Freud was, and continues to be, a figure of some controversy: His theories of the sexual origins of the neuroses shocked Victorian society, and contemporary science rejects many components of his thought. Freud was challenged by contemporary women analysts to account more fully for female sexuality, and later his notion of the castration complex outraged some second-wave feminist commentators of the 1970s. Yet many other feminist theorists embraced psychoanalysis, in particular Lacan's work on "sexual difference," welcoming the centrality of sexuality and gender to its understanding of individual experience and knowledge. Freud wrote during a time of modernist experiment in the arts and during the first wave of feminism and gay rights. He was a man of his time in both his visionary ideas and his biases. However paradoxically, Freud and Lacan became central to feminist film theory in the 1970s and greatly influenced the course of the field for decades.

"On Fetishism," a short paper from 1927, exemplifies both sides of Freud. His masculinist bias is evident in his designation of the female genitalia as "inferior" and in such generalizations as "probably no male human being is spared the terrifying shock of threatened castration." Yet in his account of the ambivalent psychic position of fetishism, Freud details a reaction to the social demand for clearly differentiated gender and sexual positions that is quite flexible. He states that while the fetishist knows the anatomical difference between the sexes, he (and for Freud, all fetishists are male) believes something else—that the sexes are not so different after all. Fetishes, that is, libidinally charged representations, can assist in affirming this belief. The split between knowledge and belief Freud describes has been used by Christian Metz (p. 17) to describe spectatorial pleasure at the movies more generally (we know it isn't "real," but nonetheless "believe," and take pleasure, in the illusion). The psychoanalytic concept of castration central to this selection and to Laura Mulvey's "political use of psychoanalysis" (p. 713) need not refer to anatomy but rather can be taken to describe the gender imbalance in patriarchal society (in which value and capability are associated with masculinity). The fear of castration acknowledges that such a social advantage is vulnerable to change. While some readers might find this essay risible or even offensive, the generations of student readers who have stumbled over Mulvey's use of the term "castration" can benefit from Freud's original characterization of the fetishist's ingenuity.

## READING CUES & KEY CONCEPTS

■ Why, in Freud's account, is the fetishist's belief in the mother's phallus so important to preserve?

■ Why, in some respects, is the fetishist happy, according to Freud?

■ How does Freud explain, using the example of fetishism, the psyche's ability to hold two contradictory beliefs at the same time? Why is this significant for film viewing?

■ **Key Concepts:** Fetishism; Denial; Repression; Affect; Symptom; Physical Reality

# On Fetishism

. . . . . . . . . . . . . .

In the last few years I have had an opportunity of studying analytically a number of men whose object-choice was ruled by a fetish. One need not suppose that these persons had sought analysis on account of a fetish; the devotees of fetishes regard them as abnormalities, it is true, but only rarely as symptoms of illness; usually they are quite content with them or even extol the advantages they offer for erotic gratification. As a rule, therefore, the fetish made its appearance in analysis as a subsidiary finding.

For obvious reasons I cannot go into the details of these cases in a published paper; nor can I show how the selection of individual fetishes is in part conditioned by accidental circumstances. The case of a young man who had exalted a certain kind of "shine on the nose" into a fetishistic condition seemed most extraordinary. The very surprising explanation of this was that the patient had been first brought up in an English nursery and had later gone to Germany, where he almost completely forgot his mother-tongue. The fetish, which derived from his earliest childhood, had to be deciphered into English, not German; the *Glanz auf der Nase* [*shine on the nose*] was really "a *glance* at the nose"; the nose was thus the fetish, which, by the way, he endowed when he wished with the necessary special brilliance, which other people could not perceive.

In all the cases the meaning and purpose of the fetish turned out under analysis to be the same. It revealed itself so unequivocally and seemed to me so categorical that I should expect the same solution in all cases of fetishism. When I now disclose that the fetish is a penis-substitute I shall certainly arouse disappointment; so I hasten to add that it is not a substitute for any chance penis, but for a particular quite special penis that had been extremely important in early childhood but was afterwards lost. That is to say: it should normally have been given up, but the purpose of the fetish precisely is to preserve it from being lost. To put it plainly: the fetish is a substitute for the woman's (mother's) phallus which the little boy once believed in and does not wish to forego—we know why.[1]

What had happened, therefore, was that the boy had refused to take cognizance of the fact perceived by him that a woman has no penis. No, that cannot be true, for if a woman can be castrated then his own penis is in danger; and against that there rebels part of his narcissism which Nature has providentially attached to this particular organ. In later life grown men may experience a similar panic, perhaps when the cry goes up that throne and altar are in danger, and similar illogical consequences will also follow them. If I am not mistaken, Laforgue would say in this case that the boy "scotomizes" the perception of the woman's lack of a penis.[2] Now a new term is justified when it describes a new fact or brings it into

prominence. There is nothing of that kind here; the oldest word in our psychoana-lytical terminology, "repression," already refers to this pathological process. If we wish to differentiate between what happens to the *idea* as distinct from the *affect*, we can restrict "repression" to relate to the affect; the correct word for what hap-pens to the idea is then "denial." "Scotomization" seems to me particularly unsuit-able, for it suggests that the perception is promptly obliterated, so that the result is the same as when a visual impression falls on the blind spot on the retina. In the case we are discussing, on the contrary, we see that the perception has persisted and that a very energetic action has been exerted to keep up the denial of it. It is not true that the child emerges from his experience of seeing the female parts with an unchanged belief in the woman having a phallus. He retains this belief but he also gives it up; during the conflict between the deadweight of the unwel-come perception and the force of the opposite wish, a compromise is constructed such as is only possible in the realm of unconscious modes of thought—by the primary processes. In the world of psychical reality the woman still has a penis in spite of all, but this penis is no longer the same as it once was. Something else has taken its place, has been appointed its successor, so to speak, and now absorbs all the interest which formerly belonged to the penis. But this interest undergoes yet another very strong reinforcement, because the horror of castration sets up a sort of permanent memorial to itself by creating this substitute. Aversion from the real female genitals, which is never lacking in any fetishist, also remains as an indelible stigma of the repression that has taken place. One can now see what the fetish achieves and how it is enabled to persist. It remains a token of triumph over the threat of castration and a safeguard against it; it also saves the fetishist from being a homosexual by endowing women with the attribute which makes them acceptable as sexual objects. In later life the fetishist sees other advantages in his substitute for the genital. The significance of fetishes is not known to the world at large and therefore not prohibited; they are easily obtainable and sexual gratifica-tion by their means is thus very convenient. The fetishist has no trouble in getting what other men have to woo and exert themselves to obtain.

Probably no male human being is spared the terrifying shock of threatened cas-tration at the sight of the female genitals. We cannot explain why it is that some of them become homosexual in consequence of this experience, others ward it off by creating a fetish, and the great majority overcome it. It is possible that we do not yet know, among all the many factors operating, those which determine the more rare pathological results; we must be satisfied when we can explain what has happened, and may for the present leave on one side the task of explaining why something has *not* happened.

One would expect that the organs or objects selected as substitutes for the penis whose presence is missed in the woman would be such as act as symbols for the penis in other respects. This may happen occasionally but is certainly not the deter-mining factor. It seems rather that when the fetish comes to life, so to speak, some process has been suddenly interrupted—it reminds one of the abrupt halt made by memory in traumatic amnesias. In the case of the fetish, too, interest is held up at a certain point—what is possibly the last impression received before the uncanny traumatic one is preserved as a fetish. Thus the foot or shoe owes its attraction as a fetish, or part of it, to the circumstance that the inquisitive boy used to peer up

the woman's legs towards her genitals. Velvet and fur reproduce—as has long been suspected—the sight of the pubic hair which ought to have revealed the longed-for penis; the underlinen so often adopted as a fetish reproduces the scene of undressing, the last moment in which the woman could still be regarded as phallic. But I do not maintain that it is always possible to ascertain the determination of every fetish.

Investigations into fetishism are to be recommended to all who still doubt the existence of the castration complex or who can still believe that the horror of the female genitals has some other foundation: for instance, that it derives from a supposed memory of the trauma of birth.

For me there was another point of interest in the explanation of fetishism. Not long ago in quite a speculative way I formulated the proposition that the essential difference between neurosis and psychosis consists in this: that in neurosis the ego suppresses part of the id out of allegiance to reality, whereas in psychosis it lets itself be carried away by the id and detached from a part of reality.[3] But soon after this I had cause to regret that I had been so daring. In the analyses of two young men I learnt that each of them—one in his second and the other in his tenth year—had refused to acknowledge the death of his father—had "scotomized" it—and yet neither of them had developed a psychosis. A very important piece of reality had thus been denied by the ego, in the same way as the fetishist denies the unwelcome fact of the woman's castrated condition. I also began to suspect that similar occurrences are by no means rare in childhood, and thought I had made a mistake in my differentiation between neurosis and psychosis. It is true, there was one way out of the difficulty: it might be that my formula held good only when a higher degree of differentiation existed in the mental apparatus; reactions might be possible in a child which would cause severe injury in an adult.

But further research led to another solution of the contradiction. It turned out, that is, as follows: the two young men had no more "scotomized" the death of their fathers than a fetishist scotomizes the castration of women. It was only one current of their mental processes that had not acknowledged the father's death; there was another which was fully aware of the fact; the one which was consistent with reality stood alongside the one which accorded with a wish. One of these two cases of mine had derived an obsessional neurosis of some severity from this dissociation; in every situation in life he oscillated between two assumptions—on the one his father was still alive and hindered him from action, on the other his father was dead and he had the right to regard himself as his successor. In a psychosis the true idea which accorded with reality would have been *really* absent.

To return to my description of fetishism, I have to add that there are numerous and very weighty proofs of the double attitude of fetishists to the question of the castration of women. In very subtle cases the fetish itself has become the vehicle both of denying and of asseverating the fact of castration. This was exemplified in the case of a man whose fetish was a suspensory belt which can also be worn as bathing drawers; this piece of clothing covers the genitals and altogether conceals the difference between them. The analysis showed that it could mean that a woman is castrated, or that she is not castrated, and it even allows of a supposition that a man may be castrated, for all these possibilities could be equally well hidden beneath the belt; its forerunner in childhood had been the fig-leaf seen on a statue. Naturally, a

fetish of this kind constructed out of two opposing ideas is capable of great tenacity. Sometimes the double attitude shows itself in what the fetishist—either actually or in phantasy—does with the fetish. It is not the whole story to say that he worships it; very often he treats it in a way which is plainly equivalent to castrating it. This happens particularly when a strong father-identification has been developed, since the child ascribed the original castration of the woman to the father. Tender and hostile treatment of fetishes is mixed in unequal degrees—like the denial and the recognition of castration—in different cases, so that the one or the other is more evident. Here one gets a sort of glimpse of comprehension, as from a distance, of the behaviour of people who cut off women's plaits of hair; in them the impulse to execute the castration which they deny is what comes to the fore. The action contains within it two incompatible propositions: the woman has still got a penis and the father has castrated the woman. Another variety of this, which might be regarded as a race-psychological parallel to fetishism, is the Chinese custom of first mutilating a woman's foot and then revering it. The Chinese man seems to want to thank the woman for having submitted to castration.

The normal prototype of all fetishes is the penis of the man, just as the normal prototype of an organ felt to be inferior is the real little penis of the woman, the clitoris.

## NOTES

1. This interpretation was mentioned in 1910, without any reasons being given for it, in my study on Leonardo da Vinci (1910).

2. I correct myself here, however, by adding that I have the best reasons for knowing that Laforgue would not say this at all. It is clear from his own remarks that "scotomization" is a term deriving from a description of dementia praecox, not arising through the application of psychoanalytical conceptions to the psychoses, and cannot be applied to the processes of development and formation of neurosis. In the text I have been at pains to demonstrate this incompatibility. [Cf. Laforgue (1926).]

3. "Neurosis and Psychosis" (1924*a*) and "The Loss of Reality in Neurosis and Psychosis" (1924*c*).

# LAURA MULVEY

# Visual Pleasure and Narrative Cinema

Laura Mulvey (b. 1941), Professor of Film and Media Studies at Birkbeck College, University of London, is one of the most prominent, challenging, and incisive film scholars and practitioners, and her work has been enormously influential in the development of feminist film and media theory. Mulvey came to prominence as a feminist critic and film theorist in the early 1970s, writing for periodicals such as *Spare Rib* and *Seven Days*. Investigating

questions of spectatorship and its relationship to the male gaze, her critical work helped established feminist film theory as a significant field of study. She also put her theoretical views into practice as an avant-garde filmmaker, co-writing and directing (with her then-husband, Peter Wollen [p. 361]) six films that engage the discourses of feminist theory, psychoanalysis, and leftist politics, including *Penthesilea: Queen of the Amazons* (1974), *Riddles of the Sphinx* (1977), and *The Bad Sister* (1982). She returned to filmmaking in 1991 with *Disgraced Monuments*, which she co-directed with Mark Lewis. Her most recent book, *Death 24x a Second: Stillness and the Moving Image* (2006), explores the role of new media technologies in our experience of film.

Mulvey's feminist intervention into film theory signals a departure from the Marxist- and ideology-critique-dominated analysis of the 1960s and points to the emergence of new politics of gender, sexuality, race, and ethnicity. Much of the critical discussion in the 1970s revolved around feminist issues, exploring the mechanisms underlying patriarchal society to transform not only film but also the hierarchy of gendered social relations. Along similar lines, Mulvey's objective is not only theoretical but also consciously politi-cal, seeking to deconstruct the fundamental patriarchal conditions of "phallocentrism," a system that "depends on the image of the castrated woman to give order and meaning to its world."

Mulvey's famous and groundbreaking essay, "Visual Pleasure and Narrative Cinema," was first published in 1975 in the influential British film journal *Screen*. It inaugurated the intersection of film theory, psychoanalysis, and feminism and became one of the most widely discussed and widely anthologized essays in film theory. In it, Mulvey argues that the fundamentally patriarchal and imbalanced structure of classical Hollywood cinema inevitably privileges the male in terms of both narrative and spectatorship. Cinema, for Mulvey, constitutes a representational system through which a range of pleasures may be derived, particularly "scopophilic" pleasure, that is, the pleasure of looking. In narra-tive film, this takes the dominant form of men looking at women as erotic objects; men are ascribed the role of active spectator, the "bearer of the look," whereas women occupy the role of passive spectacle. Mulvey asserts that classical narrative systematizes these roles through camera techniques, reproducing a binary structure that mirrors gendered power relations in the social world. Mulvey calls for a new feminist avant-garde filmmak-ing that breaks down these cinematic codes and ruptures the pleasure offered by classi-cal narrative. This can be accomplished, she says, by freeing the look of the camera and transforming the scopophilic gaze of the audience into a detached and critical one—an approach Mulvey has attempted in her own films.

This essay was the subject of much interdisciplinary discussion among film theo-rists that continued into the 1980s. Mulvey has been criticized (see Tania Modleski, p. 375) for forcing the female spectator into a masculine mold, for denying the genuine female enjoyment of the classical cinema, and for failing to take into account spectato-rial positions that are not structured along normative lines (such as LGBT spectatorship). Mulvey addressed some of her essay's omissions in a follow-up article, "Afterthoughts on 'Visual Pleasure and Narrative Cinema'" (1981). Despite the controversy, Mulvey's article remains one of the most influential arguments in film theory, and her articulation of the male gaze in narrative cinema provides a foundation for all subsequent feminist film theory (see Teresa de Lauretis, p. 573; Carol J. Clover, p. 511; Fatimah Tobing Rony, p. 840).

## READING CUES & KEY CONCEPTS

■ How does Mulvey define "the gaze," and what are some of the key issues involved in her discussion of the gaze?

■ Mulvey's feminist project and her filmmaking are founded on the deconstruction of patriarchal structures. Can you think of any women's films that use a feminist strategy involving the construction, rather than deconstruction, of a language?

■ Consider the ways in which both oppositional culture and the symbolic order have changed since Mulvey's essay first appeared in 1975, and what implications these transformations may have for Mulvey's argument.

■ **Key Concepts:** Scopophilia; Fetishistic Scopophilia; Narcissism; Voyeurism; Male Gaze; "To-be-looked-at-ness"; Castration; Symbolic Order; Patriarchy

# Visual Pleasure and Narrative Cinema

. . . . . . . . . . . . . .

## I. Introduction

### A. A POLITICAL USE OF PSYCHOANALYSIS

This paper intends to use psychoanalysis to discover where and how the fascination of film is reinforced by pre-existing patterns of fascination already at work within the individual subject and the social formations that have moulded him. It takes as starting point the way film reflects, reveals and even plays on the straight, socially established interpretation of sexual difference which controls images, erotic ways of looking and spectacle. It is helpful to understand what the cinema has been, how its magic has worked in the past, while attempting a theory and a practice which will challenge this cinema of the past. Psychoanalytic theory is thus appropriated here as a political weapon, demonstrating the way the unconscious of patriarchal society has structured film form.

The paradox of phallocentrism in all its manifestations is that it depends on the image of the castrated woman to give order and meaning to its world. An idea of woman stands as lynch pin to the system: it is her lack that produces the phallus as a symbolic presence, it is her desire to make good the lack that the phallus signifies. Recent writing in *Screen* about psychoanalysis and the cinema has not sufficiently brought out the importance of the representation of the female form in a symbolic order in which, in the last resort, it speaks castration and nothing else. To summarise briefly: the function of woman in forming the patriarchal unconscious is two-fold, she first symbolises the castration threat by her real absence of a penis and second thereby raises her child into the symbolic. Once this has been achieved, her meaning in the process is at an end, it does not last into the world of law and language except as a memory which oscillates between memory of maternal plenitude and memory of lack. Both are posited on nature (or on anatomy in Freud's famous phrase). Woman's desire is subjected to her image as bearer of the bleeding wound, she can exist only in relation to castration and cannot transcend it. She turns her

child into the signifier of her own desire to possess a penis (the condition, she imagines, of entry into the symbolic). Either she must gracefully give way to the word, the Name of the Father and the Law, or else struggle to keep her child down with her in the half-light of the imaginary. Woman then stands in patriarchal culture as signifier for the male other, bound by a symbolic order in which man can live out his phantasies and obsessions through linguistic command by imposing them on the silent image of woman still tied to her place as bearer of meaning, not maker of meaning.

There is an obvious interest in this analysis for feminists, a beauty in its exact rendering of the frustration experienced under the phallocentric order. It gets us nearer to the roots of our oppression, it brings an articulation of the problem closer, it faces us with the ultimate challenge: how to fight the unconscious structured like a language (formed critically at the moment of arrival of language) while still caught within the language of the patriarchy. There is no way in which we can produce an alternative out of the blue, but we can begin to make a break by examining patriarchy with the tools it provides, of which psychoanalysis is not the only but an important one. We are still separated by a great gap from important issues for the female unconscious which are scarcely relevant to phallocentric theory: the sexing of the female infant and her relationship to the symbolic, the sexually mature woman as non-mother, maternity outside the signification of the phallus, the vagina. . . . But, at this point, psychoanalytic theory as it now stands can at least advance our understanding of the status quo, of the patriarchal order in which we are caught.

## B. DESTRUCTION OF PLEASURE AS A RADICAL WEAPON

As an advanced representation system, the cinema poses questions of the ways the unconscious (formed by the dominant order) structures ways of seeing and pleasure in looking. Cinema has changed over the last few decades. It is no longer the monolithic system based on large capital investment exemplified at its best by Hollywood in the 1930's, 1940's and 1950's. Technological advances (16mm, etc) have changed the economic conditions of cinematic production, which can now be artisanal as well as capitalist. Thus it has been possible for an alternative cinema to develop. However self-conscious and ironic Hollywood managed to be, it always restricted itself to a formal mise-en-scène reflecting the dominant ideological concept of the cinema. The alternative cinema provides a space for a cinema to be born which is radical in both a political and an aesthetic sense and challenges the basic assumptions of the mainstream film. This is not to reject the latter moralistically, but to highlight the ways in which its formal preoccupations reflect the psychical obsessions of the society which produced it, and, further, to stress that the alternative cinema must start specifically by reacting against these obsessions and assumptions. A politically and aesthetically avant-garde cinema is now possible, but it can still only exist as a counterpoint.

The magic of the Hollywood style at its best (and of all the cinema which fell within its sphere of influence) arose, not exclusively, but in one important aspect, from its skilled and satisfying manipulation of visual pleasure. Unchallenged, mainstream film coded the erotic into the language of the dominant patriarchal order. In

the highly developed Hollywood cinema it was only through these codes that the alienated subject, torn in his imaginary memory by a sense of loss, by the terror of potential lack in phantasy, came near to finding a glimpse of satisfaction: through its formal beauty and its play on his own formative obsessions. This article will discuss the interweaving of that erotic pleasure in film, its meaning, and in particular the central place of the image of woman. It is said that analysing pleasure, or beauty, destroys it. That is the intention of this article. The satisfaction and reinforcement of the ego that represent the high point of film history hitherto must be attacked. Not in favour of a reconstructed new pleasure, which cannot exist in the abstract, nor of intellectualised unpleasure, but to make way for a total negation of the ease and plenitude of the narrative fiction film. The alternative is the thrill that comes from leaving the past behind without rejecting it, transcending outworn or oppressive forms, or daring to break with normal pleasurable expectations in order to conceive a new language of desire.

## II. Pleasure in Looking/Fascination with the Human Form

A.  The cinema offers a number of possible pleasures. One is scopophilia. There are circumstances in which looking itself is a source of pleasure, just as, in the reverse formation, there is pleasure in being looked at. Originally, in his *Three Essays on Sexuality*, Freud isolated scopophilia as one of the component instincts of sexuality which exist as drives quite independently of the erotogenic zones. At this point he associated scopophilia with taking other people as objects, subjecting them to a controlling and curious gaze. His particular examples centre around the voyeuristic activities of children, their desire to see and make sure of the private and the forbidden (curiosity about other people's genital and bodily functions, about the presence or absence of the penis and, retrospectively, about the primal scene). In this analysis scopophilia is essentially active. (Later, in *Instincts and their Vicissitudes*, Freud developed his theory of scopophilia further, attaching it initially to pre-genital auto-eroticism, after which the pleasure of the look is transferred to others by analogy. There is a close working here of the relationship between the active instinct and its further development in a narcissistic form.) Although the instinct is modified by other factors, in particular the constitution of the ego, it continues to exist as the erotic basis for pleasure in looking at another person as object. At the extreme, it can become fixated into a perversion, producing obsessive voyeurs and Peeping Toms, whose only sexual satisfaction can come from watching, in an active controlling sense, an objectified other.

At first glance, the cinema would seem to be remote from the undercover world of the surreptitious observation of an unknowing and unwilling victim. What is seen of the screen is so manifestly shown. But the mass of mainstream film, and the conventions within which it has consciously evolved, portray a hermetically sealed world which unwinds magically, indifferent to the presence of the audience, producing for them a sense of separation and playing on their voyeuristic phantasy. Moreover, the extreme contrast between the darkness in the auditorium (which also isolates the spectators from one another) and the brilliance of the shifting patterns of light and shade on the screen helps to promote the illusion of voyeuristic separation. Although the film is really being shown, is there to be seen, conditions of

screening and narrative conventions give the spectator an illusion of looking in on a private world. Among other things, the position of the spectators in the cinema is blatantly one of repression of their exhibitionism and projection of the repressed desire on to the performer.

B. The cinema satisfies a primordial wish for pleasurable looking, but it also goes further, developing scopophilia in its narcissistic aspect. The conventions of mainstream film focus attention on the human form. Scale, space, stories are all anthropomorphic. Here, curiosity and the wish to look intermingle with a fascination with likeness and recognition: the human face, the human body, the relationship between the human form and its surroundings, the visible presence of the person in the world. Jacques Lacan has described how the moment when a child recognises its own image in the mirror is crucial for the constitution of the ego. Several aspects of this analysis are relevant here. The mirror phase occurs at a time when the child's physical ambitions outstrip his motor capacity, with the result that his recognition of himself is joyous in that he imagines his mirror image to be more complete, more perfect than he experiences his own body. Recognition is thus overlaid with mis-recognition: the image recognised is conceived as the reflected body of the self, but its misrecognition as superior projects this body outside itself as an ideal ego, the alienated subject, which, re-introjected as an ego ideal, gives rise to the future generation of identification with others. This mirror-moment predates language for the child.

Important for this article is the fact that it is an image that constitutes the matrix of the imaginary, of recognition/misrecognition and identification, and hence of the first articulation of the "I," of subjectivity. This is a moment when an older fascination with looking (at the mother's face, for an obvious example) collides with the initial inklings of self-awareness. Hence it is the birth of the long love affair/despair between image and self-image which has found such intensity of expression in film and such joyous recognition in the cinema audience. Quite apart from the extraneous similarities between screen and mirror (the framing of the human form in its surroundings, for instance), the cinema has structures of fascination strong enough to allow temporary loss of ego while simultaneously reinforcing the ego. The sense of forgetting the world as the ego has subsequently come to perceive it (I forgot who I am and where I was) is nostalgically reminiscent of that pre-subjective moment of image recognition. At the same time the cinema has distinguished itself in the production of ego ideals as expressed in particular in the star system, the stars centering both screen presence and screen story as they act out a complex process of likeness and difference (the glamorous impersonates the ordinary).

C. Sections II. A and B have set out two contradictory aspects of the pleasurable structures of looking in the conventional cinematic situation. The first, scopophilic, arises from pleasure in using another person as an object of sexual stimulation through sight. The second, developed through narcissism and the constitution of the ego, comes from identification with the image seen. Thus, in film terms, one implies a separation of the erotic identity of the subject from the object on the screen (active scopophilia), the other demands identification of the ego with the object on the screen through the spectator's fascination with and recognition of his like. The first is a function of the sexual instincts, the second of ego libido. This dichotomy

was crucial for Freud. Although he saw the two as interacting and overlaying each other, the tension between instinctual drives and self-preservation continues to be a dramatic polarisation in terms of pleasure. Both are formative structures, mechanisms not meaning. In themselves they have no signification, they have to be attached to an idealisation. Both pursue aims in indifference to perceptual reality, creating the imagised, eroticised concept of the world that forms the perception of the subject and makes a mockery of empirical objectivity.

During its history, the cinema seems to have evolved a particular illusion of reality in which this contradiction between libido and ego has found a beautifully complementary phantasy world. In *reality* the phantasy world of the screen is subject to the law which produces it. Sexual instincts and identification processes have a meaning within the symbolic order which articulates desire. Desire, born with language, allows the possibility of transcending the instinctual and the imaginary, but its point of reference continually returns to the traumatic moment of its birth: the castration complex. Hence the look, pleasurable in form, can be threatening in content, and it is woman as representation/image that crystallises this paradox.

## III. Woman as Image, Man as Bearer of the Look

A. In a world ordered by sexual imbalance, pleasure in looking has been split between active/male and passive/female. The determining male gaze projects its phantasy on to the female figure which is styled accordingly. In their traditional exhibitionist role women are simultaneously looked at and displayed, with their appearance coded for strong visual and erotic impact so that they can be said to connote *to-be-looked-at-ness*. Woman displayed as sexual object is the leit-motif of erotic spectacle: from pin-ups to strip-tease, from Ziegfeld to Busby Berkeley, she holds the look, plays to and signifies male desire. Mainstream film neatly combined spectacle and narrative. (Note, however, how the musical song-and-dance numbers break the flow of the diegesis.) The presence of woman is an indispensable element of spectacle in normal narrative film, yet her visual presence tends to work against the development of a story line, to freeze the flow of action in moments of erotic contemplation. This alien presence then has to be integrated into cohesion with the narrative. As Budd Boetticher has put it:

> "What counts is what the heroine provokes, or rather what she represents. She is the one, or rather the love or fear she inspires in the hero, or else the concern he feels for her, who makes him act the way he does. In herself the woman has not the slightest importance."

(A recent tendency in narrative film has been to dispense with this problem altogether: hence the development of what Molly Haskell has called the "buddy movie," in which the active homosexual eroticism of the central male figures can carry the story without distraction.) Traditionally, the woman displayed has functioned on two levels: as erotic object for the characters within the screen story, and as erotic object for the spectator within the auditorium, with a shifting tension between the looks on either side of the screen. For instance, the device of the show-girl allows the two looks to be unified technically without any apparent break in the diegesis. A woman performs within the narrative, the gaze of the spectator and that of the male

characters in the film are neatly combined without breaking narrative verisimilitude. For a moment the sexual impact of the performing woman takes the film into a no-man's-land outside its own time and space. Thus Marilyn Monroe's first appearance in *The River of No Return* and Lauren Bacall's songs in *To Have and Have Not*. Similarly, conventional close-ups of legs (Dietrich, for instance) or a face (Garbo) integrate into the narrative a different mode of eroticism. One part of a fragmented body destroys the Renaissance space, the illusion of depth demanded by the narrative, it gives flatness, the quality of a cut-out or icon rather than verisimilitude to the screen.

B.  An active/passive heterosexual division of labour has similarly controlled narrative structure. According to the principles of the ruling ideology and the psychical structures that back it up, the male figure cannot bear the burden of sexual objectification. Man is reluctant to gaze at his exhibitionist like. Hence the split between spectacle and narrative supports the man's role as the active one of forwarding the story, making things happen. The man controls the film phantasy and also emerges as the representative of power in a further sense: as the bearer of the look of the spectator, transferring it behind the screen to neutralise the extradiegetic tendencies represented by woman as spectacle. This is made possible through the processes set in motion by structuring the film around a main controlling figure with whom the spectator can identify. As the spectator identifies with the main male[1] protagonist, he projects his look on to that of his like, his screen surrogate, so that the power of the male protagonist as he controls events coincides with the active power of the erotic look, both giving a satisfying sense of omnipotence. A male movie star's glamorous characteristics are thus not those of the erotic object of the gaze, but those of the more perfect, more complete, more powerful ideal ego conceived in the original moment of recognition in front of the mirror. The character in the story can make things happen and control events better than the subject/spectator, just as the image in the mirror was more in control of motor coordination. In contrast to woman as icon, the active male figure (the ego ideal of the identification process) demands a three-dimensional space corresponding to that of the mirror-recognition in which the alienated subject internalised his own representation of this imaginary existence. He is a figure in a landscape. Here the function of film is to reproduce as accurately as possible the so-called natural conditions of human perception. Camera technology (as exemplified by deep focus in particular) and camera movements (determined by the action of the protagonist), combined with invisible editing (demanded by realism) all tend to blur the limits of screen space. The male protagonist is free to command the stage, a stage of spatial illusion in which he articulates the look and creates the action.

C.1 Sections III. A and B have set out a tension between a mode of representation of woman in film and conventions surrounding the diegesis. Each is associated with a look: that of the spectator in direct scopophilic contact with the female form displayed for his enjoyment (connoting male phantasy) and that of the spectator fascinated with the image of his like set in an illusion of natural space, and through him gaining control and possession of the woman within the diegesis. (This tension and the shift from one pole to the other can structure a single text. Thus both in *Only Angels Have Wings* and in *To Have and Have Not*, the film opens with the woman as

object of the combined gaze of spectator and all the male protagonists in the film. She is isolated, glamorous, on display, sexualised. But as the narrative progresses she falls in love with the main male protagonist and becomes his property, losing her outward glamorous characteristics, her generalised sexuality, her show-girl connotations; her eroticism is subjected to the male star alone. By means of identification with him, through participation in his power, the spectator can indirectly possess her too.)

But in psychoanalytic terms, the female figure poses a deeper problem. She also connotes something that the look continually circles around but disavows: her lack of a penis, implying a threat of castration and hence unpleasure. Ultimately, the meaning of woman is sexual difference, the absence of the penis as visually ascertainable, the material evidence on which is based the castration complex essential for the organisation of entrance to the symbolic order and the law of the father. Thus the woman as icon, displayed for the gaze and enjoyment of men, the active controllers of the look, always threatens to evoke the anxiety it originally signified. The male unconscious has two avenues of escape from this castration anxiety: preoccupation with the re-enactment of the original trauma (investigating the woman, demystifying her mystery), counterbalanced by the devaluation, punishment or saving of the guilty object (an avenue typified by the concerns of the *film noir*); or else complete disavowal of castration by the substitution of a fetish object or turning the represented figure itself into a fetish so that it becomes reassuring rather than dangerous (hence over-valuation, the cult of the female star). This second avenue, fetishistic scopophilia, builds up the physical beauty of the object, transforming it into something satisfying in itself. The first avenue, voyeurism, on the contrary, has associations with sadism: pleasure lies in ascertaining guilt (immediately associated with castration), asserting control and subjecting the guilty person through punishment or forgiveness. This sadistic side fits in well with narrative. Sadism demands a story, depends on making something happen, forcing a change in another person, a battle of will and strength, victory/defeat, all occuring in a linear time with a beginning and an end. Fetishistic scopophilia, on the other hand, can exist outside linear time as the erotic instinct is focussed on the look alone. These contradictions and ambiguities can be illustrated more simply by using works by Hitchcock and Sternberg, both of whom take the look almost as the content or subject matter of many of their films. Hitchcock is the more complex, as he uses both mechanisms. Sternberg's work, on the other hand, provides many pure examples of fetishistic scopophilia.

C.2 It is well known that Sternberg once said he would welcome his films being projected upside down so that story and character involvement would not interfere with the spectator's undiluted appreciation of the screen image. This statement is revealing but ingenuous. Ingenuous in that his films do demand that the figure of the woman (Dietrich, in the cycle of films with her, as the ultimate example) should be identifiable. But revealing in that it emphasises the fact that for him the pictorial space enclosed by the frame is paramount rather than narrative or identification processes. While Hitchcock goes into the investigative side of voyeurism, Sternberg produces the ultimate fetish, taking it to the point where the powerful look of the male protagonist (characteristic of traditional narrative film) is broken in favour of the image in direct erotic rapport with the spectator. The beauty of the woman as object and the screen space coalesce; she is no longer the bearer of guilt but a perfect

product, whose body, stylised and fragmented by close-ups, is the content of the film and the direct recipient of the spectator's look. Sternberg plays down the illusion of screen depth; his screen tends to be one-dimensional, as light and shade, lace, steam, foliage, net, streamers, etc, reduce the visual field. There is little or no mediation of the look through the eyes of the main male protagonist. On the contrary, shadowy presences like La Bessière in *Morocco* act as surrogates for the director, detached as they are from audience identification. Despite Sternberg's insistence that his stories are irrelevant, it is significant that they are concerned with situation, not suspense, and cyclical rather than linear time, while plot complications revolve around misunderstanding rather than conflict. The most important absence is that of the controlling male gaze within the screen scene. The high point of emotional drama in the most typical Dietrich films, her supreme moments of erotic meaning, take place in the absence of the man she loves in the fiction. There are other witnesses, other spectators watching her on the screen, their gaze is one with, not standing in for, that of the audience. At the end of *Morocco*, Tom Brown has already disappeared into the desert when Amy Jolly kicks off her gold sandals and walks after him. At the end of *Dishonoured*, Kranau is indifferent to the fate of Magda. In both cases, the erotic impact, sanctified by death, is displayed as a spectacle for the audience. The male hero misunderstands and, above all, does not see.

In Hitchcock, by contrast, the male hero does see precisely what the audience sees. However, in the films I shall discuss here, he takes fascination with an image through scopophilic eroticism as the subject of the film. Moreover, in these cases the hero portrays the contradictions and tensions experienced by the spectator. In *Vertigo* in particular, but also in *Marnie* and *Rear Window*, the look is central to the plot, oscillating between voyeurism and fetishistic fascination. As a twist, a further manipulation of the normal viewing process which in some sense reveals it, Hitchcock uses the process of identification normally associated with ideological correctness and the recognition of established morality and shows up its perverted side. Hitchcock has never concealed his interest in voyeurism, cinematic and non-cinematic. His heroes are exemplary of the symbolic order and the law—a policeman (*Vertigo*), a dominant male possessing money and power (*Marnie*)—but their erotic drives lead them into compromised situations. The power to subject another person to the will sadistically or to the gaze voyeuristically is turned on to the woman as the object of both. Power is backed by a certainty of legal right and the established guilt of the woman (evoking castration, psychoanalytically speaking). True perversion is barely concealed under a shallow mask of ideological correctness—the man is on the right side of the law, the woman on the wrong. Hitchcock's skilful use of identification processes and liberal use of subjective camera from the point of view of the male protagonist draw the spectators deeply into his position, making them share his uneasy gaze. The audience is absorbed into a voyeuristic situation within the screen scene and diegesis which parodies his own in the cinema. In his analysis of *Rear Window*, Douchet takes the film as a metaphor for the cinema. Jeffries is the audience, the events in the apartment block opposite correspond to the screen. As he watches, an erotic dimension is added to his look, a central image to the drama. His girlfriend Lisa had been of little sexual interest to him, more or less a drag, so long as she remained on the spectator side. When she crosses the barrier between his room and the block opposite, their relationship is re-born erotically. He does not

merely watch her through his lens, as a distant meaningful image, he also sees her as a guilty intruder exposed by a dangerous man threatening her with punishment, and thus finally saves her. Lisa's exhibitionism has already been established by her obsessive interest in dress and style, in being a passive image of visual perfection; Jeffries' voyeurism and activity have also been established through his work as a photo-journalist, a maker of stories and captor of images. However, his enforced inactivity, binding him to his seat as a spectator, puts him squarely in the phantasy position of the cinema audience.

In *Vertigo*, subjective camera predominates. Apart from one flash-back from Judy's point of view, the narrative is woven around what Scottie sees or fails to see. The audience follows the growth of his erotic obsession and subsequent despair precisely from his point of view. Scottie's voyeurism is blatant: he falls in love with a woman he follows and spies on without speaking to. Its sadistic side is equally blatant: he has chosen (and freely chosen, for he had been a successful lawyer) to be a policeman, with all the attendant possibilities of pursuit and investigation. As a result, he follows, watches and falls in love with a perfect image of female beauty and mystery. Once he actually confronts her, his erotic drive is to break her down and force her to tell by persistent cross-questioning. Then, in the second part of the film, he re-enacts his obsessive involvement with the image he loved to watch secretly. He reconstructs Judy as Madeleine, forces her to conform in every detail to the actual physical appearance of his fetish. Her exhibitionism, her masochism, make her an ideal passive counterpart to Scottie's active sadistic voyeurism. She knows her part is to perform, and only by playing it through and then replaying it can she keep Scottie's erotic interest. But in the repetition he does break her down and succeeds in exposing her guilt. His curiosity wins through and she is punished. In *Vertigo*, erotic involvement with the look is disorientating: the spectator's fascination is turned against him as the narrative carries him through and entwines him with the processes that he is himself exercising. The Hitchcock hero here is firmly placed within the symbolic order, in narrative terms. He has all the attributes of the partriachal super-ego. Hence the spectator, lulled into a false sense of security by the apparent legality of his surrogate, sees through his look and finds himself exposed as complicit, caught in the moral ambiguity of looking. Far from being simply an aside on the perversion of the police, *Vertigo* focuses on the implications of the active/looking, passive/looked-at split in terms of sexual difference and the power of the male symbolic encapsulated in the hero. Marnie, too, performs for Mark Rutland's gaze and masquerades as the perfect to-be-looked-at image. He, too, is on the side of the law until, drawn in by obsession with her guilt, her secret, he longs to see her in the act of committing a crime, make her confess and thus save her. So he, too, becomes complicit as he acts out the implications of his power. He controls money and words, he can have his cake and eat it.

## IV. Summary

The psychoanalytic background that has been discussed in this article is relevant to the pleasure and unpleasure offered by traditional narrative film. The scopophilic instinct (pleasure in looking at another person as an erotic object), and, in contradistinction, ego libido (forming identification processes) act as formations,

mechanisms, which this cinema has played on. The image of woman as (passive) raw material for the (active) gaze of man takes the argument a step further into the structure of representation, adding a further layer demanded by the ideology of the patriarchal order as it is worked out in its favourite cinematic form—illusionistic narrative film. The argument returns again to the psychoanalytic background in that woman as representation signifies castration, inducing voyeuristic or fetishistic mechanisms to circumvent her threat. None of these interacting layers is intrinsic to film, but it is only in the film form that they can reach a perfect and beautiful contradiction, thanks to the possibility in the cinema of shifting the emphasis of the look. It is the place of the look that defines cinema, the possibility of varying it and exposing it. This is what makes cinema quite different in its voyeuristic potential from, say, strip-tease, theatre, shows, etc. Going far beyond highlighting a woman's to-be-looked-at-ness, cinema builds the way she is to be looked at into the spectacle itself. Playing on the tension between film as controlling the dimension of time (editing, narrative) and film as controlling the dimension of space (changes in distance, editing), cinematic codes create a gaze, a world, and an object, thereby producing an illusion cut to the measure of desire. It is these cinematic codes and their relationship to formative external structures that must be broken down before mainstream film and the pleasure it provides can be challenged.

To begin with (as an ending), the voyeuristic-scopophilic look that is a crucial part of traditional filmic pleasure can itself be broken down. There are three different looks associated with cinema: that of the camera as it records the pro-filmic event, that of the audience as it watches the final product, and that of the characters at each other within the screen illusion. The conventions of narrative film deny the first two and subordinate them to the third, the conscious aim being always to eliminate intrusive camera presence and prevent a distancing awareness in the audience. Without these two absences (the material existence of the recording process, the critical reading of the spectator), fictional drama cannot achieve reality, obviousness and truth. Nevertheless, as this article has argued, the structure of looking in narrative fiction film contains a contradiction in its own premises: the female image as a castration threat constantly endangers the unity of the diegesis and bursts through the world of illusion as an intrusive, static, one-dimensional fetish. Thus the two looks materially present in time and space are obsessively subordinated to the neurotic needs of the male ego. The camera becomes the mechanism for producing an illusion of Renaissance space, flowing movements compatible with the human eye, an ideology of representation that revolves around the perception of the subject; the camera's look is disavowed in order to create a convincing world in which the spectator's surrogate can perform with verisimilitude. Simultaneously, the look of the audience is denied an intrinsic force: as soon as fetishistic representation of the female image threatens to break the spell of illusion, and the erotic image on the screen appears directly (without mediation) to the spectator, the fact of fetishisation, concealing as it does castration fear, freezes the look, fixates the spectator and prevents him from achieving any distance from the image in front of him.

This complex interaction of looks is specific to film. The first blow against the monolithic accumulation of traditional film conventions (already undertaken by radical film-makers) is to free the look of the camera into its materiality in time and space and the look of the audience into dialectics, passionate detachment. There is no doubt that this destroys the satisfaction, pleasure and privilege of the "invisible

guest," and highlights how film has depended on voyeuristic active/passive mechanisms. Women, whose image has continually been stolen and used for this end, cannot view the decline of the traditional film form with anything much more than sentimental regret.

## NOTES

1. There are films with a woman as main protagonist, of course. To analyse this phenomenon seriously here would take me too far afield. Pam Cook and Claire Johnston's study of *The Revolt of Mamie Stover* in Phil Hardy, ed: *Raoul Walsh*, Edinburgh 1974, shows in a striking case how the strength of this female protagonist is more apparent than real.

# LINDA WILLIAMS

# "Something Else Besides a Mother": *Stella Dallas* and the Maternal Melodrama

Professor of Film Studies and Rhetoric at the University of California, Berkeley, Linda Williams (b. 1946) is a leading scholar in cinema studies whose books *Hard Core: Power, Pleasure, and the Frenzy of the Visible* (second edition, 1999) and *Playing the Race Card: Melodramas of Black and White from Uncle Tom to O.J. Simpson* (2001) are landmark texts in the study of what she calls the "body genres" of pornography and melodrama, respectively (see also her essay on p. 774). Williams's key role in feminist film theory, as well as her role in making feminism key to film theory, is also illustrated in her edited and co-edited texts, including *Re-Vision* (1984), *Viewing Positions* (1994), *Re-Inventing Film Studies* (2000), and *Porn Studies* (2004), and *Screening Sex* (2008).

Feminist filmmaking, theory, and criticism thrived in the wake of Laura Mulvey's essay "Visual Pleasure and Narrative Cinema" (p. 713), with many, including Williams, asking the question that they felt Mulvey had omitted: What about the female spectator's pleasure? Like many, Williams searched for the answer to that question in melodrama, classical Hollywood films featuring female stars and directed at female audiences, also known as the "woman's picture." Mulvey herself looked to the appeal of the melodrama in her essay "Afterthoughts on 'Visual Pleasure and Narrative Cinema,'" and Mary Ann Doane published the groundbreaking *The Desire to Desire: The Woman's Film of the 1940s* in 1987, with a chapter on the maternal melodrama subgenre. Outside of film theory, prominent feminists like poet Adrienne Rich and filmmaker Michelle Citron were exploring the rich connections between mothers and daughters that are often distorted by patriarchal values.

Williams's 1984 essay "'Something Else Besides a Mother'" grounds the appeal of the woman's picture in cultural contradictions around women's roles and the psychic conflicts they generate. Williams writes partly in answer to prominent feminist film scholar E. Ann Kaplan's 1983 essay on the classic maternal melodrama *Stella Dallas* (1937), which was also a novel and radio soap opera. Kaplan's essay uses psychoanalytic theory to deplore how the institution of motherhood is venerated while the actual mother is effaced in the film. While

Williams also draws on psychoanalysis (albeit from a wider field of French and American feminist theorists) in her essay, she sees not female absence but rather ambivalence in these films' portrayal of mother/daughter conflicts and in viewers' passionate and contradictory responses to them. Williams's nuanced reading of *Stella Dallas* asserts that the female spectator recognizes the power of the maternal bond and is drawn toward the films' stories of sacrifice, but that she also defies the limited options they present. Her essay also lays the methodological groundwork for approaches to contemporary "chick flicks," which continue to explore conflicts between sexuality and mothering, use style as a signifier of self-worth, and are as ambivalent, intertextual, and intermedial as earlier women's genres.

## READING CUES & KEY CONCEPTS

■ Consider how Williams uses Nancy Chodorow's work to bring out themes in *Stella Dallas* that Freud's understanding of female psychology could not. Does this approach make the film's concerns more resonant?

■ How does Williams use visual evidence of conflicting points-of-view in *Stella Dallas* to corroborate her understanding of the contradictory nature of female spectatorship?

■ Compare *Stella Dallas* with a contemporary "woman's picture." Has the portrayal of mother/daughter relationships become less conflicted?

■ **Key Concepts:** Maternal Melodrama; Pre-Oedipal; Contradiction

# "Something Else Besides a Mother": *Stella Dallas* and the Maternal Melodrama

*Oh, God! I'll never forget that last scene, when her daughter is being married inside the big house with the high iron fence around it and she's standing out there—I can't even remember who it was, I saw it when I was still a girl, and I may not even be remembering it right. But I am remembering it—it made a tremendous impression on me—anyway, maybe it was Barbara Stanwyck. She's standing there and it's cold and raining and she's wearing a thin little coat and shivering, and the rain is coming down on her poor head and streaming down her face with the tears, and she stands there watching the lights and hearing the music and then she just drifts away. How they got us to consent to our own eradication! I didn't just feel pity for her; I felt that shock of recognition—you know, when you see what you sense is your own destiny up there on the screen or on the stage. You might say I've spent my whole life trying to arrange a different destiny!*[1]

These words of warning, horror, and fascination are spoken by Val, a character who is a mother herself, in Marilyn French's 1977 novel *The Women's Room*. They are especially interesting for their insight into the response of a woman viewer to the image of her "eradication." The scene in question is from the end of *Stella Dallas*,

King Vidor's 1937 remake of the 1925 film by Henry King. The scene depicts the resolution of the film: that moment when the good-hearted, ambitious, working-class floozy, Stella, sacrifices her only connection to her daughter in order to propel her into an upper-class world of surrogate family unity. Such are the mixed messages—of joy in pain, of pleasure in sacrifice—that typically resolve the melodramatic conflicts of "the woman's film."

It is not surprising, then, that Marilyn French's mother character, in attempting to resist such a sacrificial model of motherhood, should have so selective a memory of the conflict of emotions that conclude the film. Val only remembers the tears, the cold, the mother's pathetic alienation from her daughter's triumph inside the "big house with the high iron fence," the abject loneliness of the woman who cannot belong to that place and so "just drifts away." Val's own history, her own choices, have caused her to forget the perverse triumph of the scene: Stella's lingering for a last look even when a policeman urges her to move on; her joy as the bride and groom kiss; the swelling music as Stella does not simply "drift away" but marches triumphantly toward the camera and into a close-up that reveals a fiercely proud and happy mother clenching a handkerchief between her teeth.

It is as if the task of the narrative has been to find a "happy" ending that will exalt an abstract ideal of motherhood even while stripping the actual mother of the human connection on which that ideal is based. Herein lies the "shock of recognition" of which French's mother–spectator speaks.

The device of devaluing and debasing the actual figure of the mother while sanctifying the institution of motherhood is typical of "the woman's film" in general and the sub-genre of the maternal melodrama in particular.[2] In these films it is quite remarkable how frequently the self-sacrificing mother must make her sacrifice that of the connection to her children—either for her or their own good.

With respect to the mother–daughter aspect of this relation, Simone de Beauvoir noted long ago that because of the patriarchal devaluation of women in general, a mother frequently attempts to use her daughter to compensate for her own supposed inferiority by making "a superior creature out of one whom she regards as her double."[3] Clearly, the unparalleled closeness and similarity of mother to daughter sets up a situation of significant mirroring that is most apparent in these films. One effect of this mirroring is that although the mother gains a kind of vicarious superiority by association with a superior daughter, she inevitably begins to feel inadequate to so superior a being and thus, in the end, to feel inferior. Embroiled in a relationship that is so close, mother and daughter nevertheless seem destined to lose one another through this very closeness.

Much recent writing on women's literature and psychology has focused on the problematic of the mother–daughter relationship as a paradigm of a woman's ambivalent relationship to herself.[4] In *Of Woman Born* Adrienne Rich writes, "The loss of the daughter to the mother, mother to the daughter, is the essential female tragedy. We acknowledge Lear (father–daughter split), Hamlet (son and mother), and Oedipus (son and mother) as great embodiments of the human tragedy, but there is no presently enduring recognition of mother–daughter passion and rapture." No tragic, high culture equivalent perhaps. But Rich is not entirely correct when she goes on to say that "this cathexis between mother and daughter—essential, distorted, misused—is the great unwritten story."[5]

If this *tragic* story remains unwritten, it is because tragedy has always been assumed to be universal; speaking for and to a supposedly universal "mankind," it has not been able to speak for and to womankind. But melodrama is a form that does not pretend to speak universally. It is clearly addressed to a particular bourgeois class and often—in works as diverse as *Pamela, Uncle Tom's Cabin*, or the "woman's film"—to the particular gender of woman.

In *The Melodramatic Imagination* Peter Brooks argues that late eighteenth- and nineteenth-century melodrama arose to fill the vacuum of a post-revolutionary world where traditional imperatives of truth and ethics had been violently questioned and yet in which there was still a need for truth and ethics. The aesthetic and cultural form of melodrama thus attempts to assert the ethical imperatives of a class that has lost the transcendent myth of a divinely ordained hierarchical community of common goals and values.[6]

Because the universe had lost its basic religious and moral order and its tragically divided but powerful ruler protagonists, the aesthetic form of melodrama took on the burden of rewarding the virtue and punishing the vice of undivided and comparatively powerless characters. The melodramatic mode thus took on an intense quality of wish-fulfilment, acting out the narrative resolution of conflicts derived from the economic, social, and political spheres in the private, emotionally primal sphere of home and family. Martha Vicinus notes, for example, that in much nineteenth-century stage melodrama the home is the scene of this "reconciliation of the irreconcilable."[7] The domestic sphere where women and children predominate as protagonists whose only power derives from virtuous suffering thus emerges as an important source of specifically female wish-fulfilment. But if women audiences and readers have long identified with the virtuous sufferers of melodrama, the liberatory or oppressive meaning of such identification has not always been clear.

Much recent feminist film criticism has divided filmic narrative into male and female forms: "male" linear, action-packed narratives that encourage identification with predominantly male characters who "master" their environment; and "female" less linear narratives encouraging identification with passive, suffering heroines.[8] No doubt part of the enormous popularity of *Mildred Pierce* among feminist film critics lies with the fact that it illustrates the failure of the female subject (the film's misguided, long-suffering mother-hero who is overly infatuated with her daughter) to articulate her own point of view, even when her own voice-over introduces subjective flashbacks.[9] *Mildred Pierce* has been an important film for feminists precisely because its "male" film noir style offers such a blatant subversion of the mother's attempt to tell the story of her relationship to her daughter.

The failure of *Mildred Pierce* to offer either its female subject or its female viewer her own understanding of the film's narrative has made it a fascinating example of the way films can construct patriarchal subject-positions that subvert their ostensible subject matter. More to the point of the mother–daughter relation, however, is a film like *Stella Dallas*, which has recently begun to receive attention as a central work in the growing criticism of melodrama in general and maternal melodrama in particular.[10] Certainly the popularity of the original novel, of the 1925 (Henry King) and 1937 (King Vidor) film versions, and finally of the later long-running radio soap opera, suggests the special endurance of this mother–daughter love story across three decades of female audiences. But it is in its film versions in particular,

especially the King Vidor version starring Barbara Stanwyck, that we encounter an interesting test case for many recent theories of the cinematic presentation of female subjectivity and the female spectator.

Since so much of what has come to be called the classical narrative cinema concerns male subjects whose vision defines and circumscribes female objects, the mere existence in *Stella Dallas* of a female "look" as a central feature of the narrative is worthy of special scrutiny. Just what is different about the visual economy of such a film? What happens when a mother and daughter, who are so closely identified that the usual distinctions between subject and object do not apply, take one another as their primary objects of desire? What happens, in other words, when the look of desire articulates a rather different visual economy of mother–daughter possession and dispossession? What happens, finally, when the significant viewer of such a drama is also a woman?

**[ · · · ]**

## *"Something Else Besides a Mother"*

Stella's story begins with her attempts to attract the attention of the upper-class Stephen Dallas (John Boles), who has buried himself in the small town of Milhampton after a scandal in his family ruined his plans for marriage. Like any ambitious working-class girl with looks as her only resource, she attempts to improve herself by pursuing an upper-class man. To distinguish herself in his eyes, she calculatingly brings her brother lunch at the mill where Stephen is the boss, insincerely playing the role of motherly caretaker. The refinement that she brings to this role distinguishes her from her own drab, overworked, slavish mother (played by Marjorie Main, without her usual comic touch).

During their brief courtship, Stella and Stephen go to the movies. On the screen they see couples dancing in an elegant milieu followed by a happy-ending embrace. Stella is absorbed in the story and weeps at the end. Outside the theater she tells Stephen of her desire to "be like all the people in the movies doing everything well-bred and refined." She imagines his whole world to be like this glamorous scene. Her story will become, in a sense, the unsuccessful attempt to place herself in the scene of the movie without losing that original spectatorial pleasure of looking on from afar.

Once married to Stephen, Stella seems about to realize this dream. In the small town that once ignored her she can now go to the "River Club" and associate with the smart set. But motherhood intervenes, forcing her to cloister herself unhappily during the long months of pregnancy. Finally out of the hospital, she insists on a night at the country club with the smart set that has so far eluded her. (Actually many of them are a vulgar *nouveau-riche* lot of whom Stephen, upper-class snob that he is, heartily disapproves.) In her strenuous efforts to join in the fun of the wealthy, Stella makes a spectacle of herself in Stephen's eyes. He sees her for the first time as the working-class woman that she is and judges her harshly, reminding her that she once wanted to be something more than what she is. She, in turn, criticizes his stiffness and asks *him* to do some of the adapting for a change.

When Stephen asks Stella to come with him to New York City for a fresh start as the properly upper-class Mrs. Dallas, she refuses to leave the only world she knows.

Part of her reason must be that to leave this world would also be to leave the only identity she has ever achieved, to become nobody all over again. In the little mill town where Stephen had come to forget himself, Stella can find herself by measuring the distance traveled between her working-class girlhood and upper-class wifehood. It is as if she needs to be able to measure this distance in order to possess her new self from the vantage point of the young girl she once was with Stephen at the movies. Without the memory of this former self that the town provides, she loses the already precarious possession of her own identity.

As Stephen drifts away from her, Stella plunges into another aspect of her identity: motherhood. After her initial resistance, it is a role she finds surprisingly compelling. But she never resigns herself to being *only* a mother. In Stephen's absence she continues to seek an innocent but lively pleasure—in particular with the raucous Ed Munn. As her daughter Laurel grows up, we observe a series of scenes that compromise Stella in the eyes of Stephen (during those rare moments he comes home) and the more straight-laced members of the community. In each case Stella is merely guilty of seeking a little fun—whether by playing music and drinking with Ed or playing a practical joke with itching powder on a train. Each time we are assured of Stella's primary commitment to motherhood and of her many good qualities as a mother. (She even says to Ed Munn, in response to his crude proposal: "I don't think there's a man livin' who could get me going anymore.") But each time the repercussions of the incident are the isolation of mother and daughter from the upper-class world to which they aspire to belong but into which only Laurel fits. A particularly poignant moment is Laurel's birthday party where mother and daughter receive, one by one, the regrets of the guests. Thus the innocent daughter suffers for the "sins" of taste and class of the mother. The end result, however, is a greater bond between the two as each sadly but nobly puts on a good face for the other and marches into the dining room to celebrate the birthday alone.

In each of the incidents of Stella's transgression of proper behavior, there is a moment when we first see Stella's innocent point of view and then the point of view of the community or estranged husband that judges her a bad mother.[11] Their judgment rests on the fact that Stella insists on making her motherhood a pleasurable experience by sharing center stage with her daughter. The one thing she will not do, at least until the end, is retire to the background.

One basic conflict of the film thus comes to revolve around the *excessive presence* of Stella's body and dress. She increasingly flaunts an exaggeratedly feminine presence that the offended community prefers not to see. (Barbara Stanwyck's own excessive performance contributes to this effect. I can think of no other film star of the period so willing to exceed both the bounds of good taste and sex appeal in a single performance.) But the more ruffles, feathers, furs, and clanking jewelry that Stella dons, the more she emphasises her pathetic inadequacy.

Her strategy can only backfire in the eyes of an upper-class restraint that values a streamlined and sleek ideal of femininity. To these eyes Stella is a travesty, an overdone masquerade of what it means to be a woman. At the fancy hotel to which Stella and Laurel repair for their one fling at upper-class life together, a young college man exclaims at the sight of Stella, "That's not a woman, that's a Christmas tree!" Stella, however, could never understand such a backward economy, just as she cannot understand her upper-class husband's attempts to lessen the abrasive impact of

her presence by correcting her English and toning down her dress. She counters his efforts with the defiant claim, "I've always been known to have stacks of style!"

"Style" is the war paint she applies more thickly with each new assault on her legitimacy as a woman and a mother. One particularly affecting scene shows her sitting before the mirror of her dressing table as Laurel tells her of the "natural" elegance and beauty of Helen Morrison, the woman who has replaced Stella in Stephen's affections. Stella's only response is to apply more cold cream. When she accidentally gets cold cream on Laurel's photo of the ideal Mrs. Morrison, Laurel becomes upset and runs off to clean it. What is most moving in the scene is the emotional complicity of Laurel, who soon realizes the extent to which her description has hurt her mother, and silently turns to the task of applying more peroxide to Stella's hair. The scene ends with mother and daughter before the mirror tacitly relating to one another through the medium of the feminine mask—each putting on a good face for the other, just as they did at the birthday party.

"Stacks of style," layers of make-up, clothes, and jewelry—these are, of course, the typical accoutrements of the fetishized woman. Yet such fetishization seems out of place in a "woman's film" addressed to a predominantly female audience. More typically, the woman's film's preoccupation with a victimized and suffering womanhood has tended, as Mary Ann Doane has shown, to repress and hystericize women's bodies in a medical discourse of the afflicted or in the paranoia of the uncanny.[12]

We might ask, then, what effect a fetishized female image has in the context of a film "addressed" and "possessed by" women? Certainly this is one situation in which the woman's body does not seem likely to pose the threat of castration—since the significant viewers of (and within) the film are all female. In psychoanalytic terms, the fetish is that which disavows or compensates for the woman's lack of a penis. As we have seen above, for the male viewer the successful fetish deflects attention away from what is "really" lacking by calling attention to (over-valuing) other aspects of woman's difference. But at the same time it also inscribes the woman in a "masquerade of femininity"[13] that forever revolves around her "lack." Thus, at the extreme, the entire female body becomes a fetish substitute for the phallus she doesn't possess. The beautiful (successfully fetishized) woman thus represents an eternal essence of biologically determined femininity constructed from the point of view, so to speak, of the phallus.

In *Stella Dallas*, however, the fetishization of Stanwyck's Stella is unsuccessful; the masquerade of femininity is all too obvious; and the significant point of view on all this is female. For example, at the fancy hotel where Stella makes a "Christmas Tree" spectacle of herself she is as oblivious as ever to the shocking effect of her appearance. But Laurel experiences the shame of her friends' scorn. The scene in which Laurel experiences this shame is a grotesque parody of Stella's fondest dream of being like all the glamorous people in the movies. Stella has put all of her energy and resources into becoming this glamorous image. But incapacitated by a cold, as she once was by pregnancy, she must remain off-scene as Laurel makes a favorable impression. When she finally makes her grand entrance on the scene, Stella is spied by Laurel and her friends in a large mirror over a soda fountain. The mirror functions as the framed screen that reflects the parody of the image of glamour to which Stella once aspired. Unwilling to acknowledge their relation, Laurel runs out. Later, she insists that they leave. On the train home, Stella overhears Laurel's friends

joking about the vulgar Mrs. Dallas. It is then that she decides to send Laurel to live with Stephen and Mrs. Morrison and to give Laurel up for her own good. What is significant, however, is that Stella overhears the conversation at the same time Laurel does—they are in upper and lower berths of the train, each hoping that the other is asleep, each pretending to be asleep to the other. So Stella does not just experience her own humiliation; she sees for the first time the travesty she has become by sharing in her daughter's humiliation.

By seeing herself through her daughter's eyes, Stella also sees something more. For the first time Stella sees the reality of her social situation from the vantage point of her daughter's understanding, but increasingly upper-class, system of values: that she is a struggling, uneducated woman doing the best she can with the resources at her disposal. And it is *this* vision, through her daughter's sympathetic, mothering eyes—eyes that perceive, understand, and forgive the social graces Stella lacks—that determines her to perform the masquerade that will alienate Laurel forever by proving to her what the patriarchy has claimed to know all along: that it is not possible to combine womanly desire with motherly duty.

It is at this point that Stella claims, falsely, to want to be "something else besides a mother." The irony is not only that by now there is really nothing else she wants to be, but also that in pretending this to Laurel she must act out a painful parody of her fetishized self. She thus resurrects the persona of the "good-times" woman she used to want to be (but never entirely was) only to convince Laurel that she is an unworthy mother. In other words, she proves her very worthiness to be a mother (her desire for her daughter's material and social welfare) by acting out a patently false scenario of narcissistic self-absorption—she pretends to ignore Laurel while lounging about in a negligee, smoking a cigarette, listening to jazz, and reading a magazine called "Love."

In this scene the conventional image of the fetishized woman is given a peculiar, even parodic, twist. For where the conventional masquerade of femininity can be read as an attempt to cover up supposedly biological "lacks" with a compensatory excess of connotatively feminine gestures, clothes, and accoutrements, here fetishization functions as a blatantly pathetic disavowal of much more pressing social lacks—of money, education, and power. The spectacle Stella stages for Laurel's eyes thus displaces the real social and economic causes of her presumed inadequacy as a mother onto a pretended desire for fulfilment as a woman—to be "something else besides a mother."

At the beginning of the film Stella pretended a maternal concern she did not really possess (in bringing lunch to her brother in order to flirt with Stephen) in order to find a better home. Now she pretends a lack of the same concern in order to send Laurel to a better home. Both roles are patently false. And though neither allows us to view the "authentic" woman beneath the mask, the succession of roles ending in the final transcendent self-effacement of the window scene—in which Stella forsakes all her masks in order to become the anonymous spectator of her daughter's role as bride—permits a glimpse at the social and economic realities that have produced such roles. Stella's real offence, in the eyes of the community that so ruthlessly ostracises her, is to have attempted to play both roles at once.

Are we to conclude, then, that the film simply punishes her for these untimely resistances to her proper role? E. Ann Kaplan has argued that such is the case, and

that throughout the film Stella's point of view is undercut by those of the upper-class community—Stephen, or the snooty townspeople—who disapprove of her behavior. Kaplan notes, for example, that a scene may begin from Stella's point of view but shift, as in the case of an impromptu party with Ed Munn, to the more judgmental point of view of Stephen halfway through.[14]

I would counter, however, that these multiple, often conflicting, points of view—including Laurel's failure to see through her mother's act—prevent such a monolithic view of the female subject. Kaplan argues, for example, that the film punishes Stella for her resistances to a properly patriarchal view of motherhood by turning her first into a spectacle for a disapproving upper-class gaze and then finally into a mere spectator, locked outside the action in the final window scene that ends the film.[15]

Certainly this final scene functions to efface Stella even as it glorifies her sacrificial act of motherly love. Self-exiled from the world into which her daughter is marrying, Stella loses both her daughter and her (formerly fetishized) self to become an abstract (and absent) ideal of motherly sacrifice. Significantly, Stella appears in this scene for the first time stripped of the exaggerated marks of femininity—the excessive make-up, furs, feathers, clanking jewelry, and ruffled dresses—that have been the weapons of her defiant assertions that a woman *can* be "something else besides a mother."

It would be possible to stop here and take this ending as Hollywood's last word on the mother, as evidence of her ultimate unrepresentability in any but patriarchal terms. Certainly if we only remember Stella as she appears here at the end of the film, as Val in French's *The Women's Room* remembers her, then we see her only at the moment when she becomes representable in terms of a "phallic economy" that idealizes the woman as mother and in so doing, as Irigary argues, represses everything else about her. But although the final moment of the film "resolves" the contradiction of Stella's attempt to be a woman *and* a mother by eradicating both, the 108 minutes leading up to this moment present the heroic attempt to live out the contradiction.[16] It seems likely, then, that a female spectator would be inclined to view even this ending as she has the rest of the film: from a variety of different subject positions. In other words, the female spectator tends to identify with contradiction itself—with contradictions located at the heart of the socially constructed roles of daughter, wife *and* mother—rather than with the single person of the mother.

In this connection the role of Helen Morrison, the upper-class widowed mother whom Stephen will be free to marry with Stella out of the way, takes on special importance. Helen is everything Stella is not: genteel, discreet, self-effacing, and sympathetic with everyone's problems—including Stella's. She is, for example, the only person in the film to see through Stella's ruse of alienating Laurel. And it is she who, knowing Stella's finer instincts, leaves open the drapes that permit Stella's vision of Laurel's marriage inside her elegant home.

In writing about the narrative form of daytime soap operas, Tania Modleski has noted that the predominantly female viewers of soaps do not identify with a main controlling figure the way viewers of more classic forms of narrative identify. The very form of soap opera encourages identification with multiple points of view. At one moment, female viewers identify with a woman united with her lover, at the next with the sufferings of her rival. While the effect of identifying with a single controlling protagonist is to make the spectator feel empowered, the effect of multiple

identification in the diffused soap opera is to divest the spectator of power, but to increase empathy. "The subject/spectator of soaps, it could be said, is constituted as a sort of ideal mother: a person who possesses greater wisdom than all her children, whose sympathy is large enough to encompass the conflicting claims of her family (she identifies with them all), and who has no demands or claims of her own (she identifies with no character exclusively)."[17]

In *Stella Dallas* Helen is clearly the representative of this idealized, empathic but powerless mother. Ann Kaplan has argued that female spectators learn from Helen Morrison's example that such is the proper role of the mother; that Stella has up until now illicitly hogged the screen. By the time Stella has made her sacrifice and become the mere spectator of her daughter's apotheosis, her joy in her daughter's success assures us, in Kaplan's words, "of her satisfaction in being reduced to spectator. . . . While the cinema spectator feels a certain sadness in Stella's position, we also identify with Laurel and with her attainment of what we have all been socialized to desire; that is, romantic marriage into the upper class. We thus accede to the necessity for Stella's sacrifice."[18]

But do we? As Kaplan herself notes, the female spectator is identified with a variety of conflicting points of view as in the TV soap opera: Stella, Laurel, Helen and Stephen cannot resolve their conflicts without someone getting hurt. Laurel loses her mother and visibly suffers from this loss; Stella loses her daughter and her identity; Helen wins Stephen but powerlessly suffers for everyone including herself (when Stella had refused to divorce Stephen). Only Stephen is entirely free from suffering at the end, but this is precisely because he is characteristically oblivious to the sufferings of others. For the film's ending to be perceived as entirely without problem, we would have to identify with this least sensitive and, therefore, least sympathetic point of view.

Instead, we identify, like the ideal mother viewer of soaps, with *all* the conflicting points of view. Because Helen is herself such a mother, she becomes an important, but not an exclusive, focus of spectatorial identification. She becomes, for example, the significant witness of Stella's sacrifice. Her one action in the entire film is to leave open the curtains—an act that helps put Stella in the same passive and powerless position of spectating that Helen is in herself. But if this relegation to the position of spectator outside the action resolves the narrative, it is a resolution not satisfactory to any of its female protagonists.

Thus, where Kaplan sees the ending of *Stella Dallas* as satisfying patriarchal demands for the repression of the active and involved aspects of the mother's role, and as teaching female spectators to take their dubious pleasures from this empathic position outside the action, I would argue that the ending is too multiply identified, too dialectical in Julia Kristeva's sense of the struggle between maternal and paternal forms of language, to encourage such a response. Certainly the film has constructed concluding images of motherhood—first the high-toned Helen and finally a toned-down Stella—for the greater power and convenience of the father. But because the father's own spectatorial empathy is so lacking—Stephen is here much as he was with Stella at the movies, present but not identified himself—*we* cannot see it that way. We see instead the contradictions between what the patriarchal resolution of the film asks us to see—the mother "in her place" as spectator, abdicating her former position *in* the scene—and what we as empathic, identifying female spectators can't help but feel—the loss of mother to daughter and daughter to mother.

This double vision seems typical of the experience of most female spectators at the movies. One explanation for it is Nancy Chodorow's theory that female identity is formed through a process of double identification. The girl identifies with her primary love object—her mother—and then, without ever dropping the first identification, with her father. According to Chodorow, the woman's sense of self is based upon a continuity of relationship that ultimately prepares her for the empathic, identifying role of the mother. Unlike the male who must constantly differentiate himself from his original object of identification in order to take on a male identity, the woman's ability to identify with a variety of different subject positions makes her a very different kind of spectator.

[ · · · ]

We have seen in *Stella Dallas* how the mediation of the mother and daughter's look at one another radically alters the representation of them both. We have also seen that the viewer cannot choose a single "main controlling" point of identification but must alternate between a number of conflicting points of view, none of which can be satisfactorily reconciled. But the window scene at the end of the film would certainly seem to be the moment when all the above contradictions collapse into a single patriarchal vision of the mother as pure spectator (divested of her excessive bodily presence) and the daughter as the (now properly fetishized) object of vision. Although it is true that this ending, by separating mother and daughter, places each within a visual economy that defines them from the perspective of patriarchy, the female spectator's own look at each of them does not acquiesce in such a phallic visual economy of voyeurism and fetishism.

For in looking at Stella's own look at her daughter through a window that strongly resembles a movie screen,[19] the female spectator does not see and believe the same way Stella does. In this final scene, Stella is no different than the naïve spectator she was when, as a young woman, she went to the movies with Stephen. In order to justify her sacrifice, she must *believe* in the reality of the cinematic illusion she sees: bride and groom kneeling before the priest, proud father looking on. We, however, *know* the artifice and suffering behind it—Laurel's disappointment that her mother has not attended the wedding; Helen's manipulation of the scene that affords Stella her glimpse; Stella's own earlier manipulation of Laurel's view of her "bad" motherhood. So when we look at Stella looking at the glamorous and artificial "movie" of her daughter's life, we cannot, like Stella, naïvely believe in the reality of the happy ending, any more than we believe in the reality of the silent movements and hackneyed gestures of the glamorous movie Stella once saw.

Because the female spectator has seen the cost to both Laurel and Stella of the daughter's having entered the frame, of having become the properly fetishized image of womanhood, she cannot, like Stella, believe in happiness for either. She knows better because she has seen what each has had to give up to assume these final roles. But isn't it just such a balance of knowledge and belief (of the fetishist's contradictory phrase "I know very well but just the same . . .")[20] that has characterised the sophisticated juggling act of the ideal cinematic spectator?

The psychoanalytic model of cinematic pleasure has been based on the phenomenon of fetishistic disavowal: the contradictory gesture of *believing* in an illusion (the cinematic image, the female penis) and yet *knowing* that it is an illusion, an imaginary

signifier. This model sets up a situation in which the woman becomes a kind of failed fetishist: lacking a penis she lacks the biological foundation to engage in the sophisticated game of juggling presence and absence in cinematic representation; hence her presumed over-identification, her lack of the knowledge of illusion[21] and the resulting one, two, and three handkerchief movies. But the female spectator of *Stella Dallas* finds herself balancing a very different kind of knowledge and belief than the mere existence or non-existence of the female phallus. She *knows* that women can find no genuine form of representation under patriarchal structures of voyeuristic or fetishistic viewing, because she has seen Stella lose herself as a woman and as a mother. But at the same time she *believes* that women exist outside this phallic economy, because she has glimpsed moments of resistance in which two women have been able to represent themselves to themselves through the mediation of their own gazes.

This is a very different form of disavowal. It is both a *knowing* recognition of the limitations of woman's representation in patriarchal language and a contrary *belief* in the illusion of a pre-Oedipal space between women free of the mastery and control of the male look. The contradiction is as compelling for the woman as for the male fetishist, even more so because it is not based on the presence or absence of an anatomical organ, but on the dialectic of the woman's socially constructed position under patriarchy.

It is in a very different sense, then, that the psychoanalytic concepts of voyeurism and fetishism can inform a feminist theory of cinematic spectatorship—not as inscribing woman totally on the side of the passive object who is merely seen, as Mulvey and others have so influentially argued, but by examining the contradictions that animate women's very active and fragmented ways of seeing.

I would not go so far as to argue that these contradictions operate for the female viewer in every film about relations between women. But the point of focusing on a film that both addresses female audiences and contains important structures of viewing *between* women is to suggest that it does not take a radical and consciously feminist break with patriarchal ideology to represent the contradictory aspects of the woman's position under patriarchy. It does not even take the ironic distancing devices of, for example, the Sirkian melodrama to generate the kind of active, critical response that sees the work of ideology in the film. Laura Mulvey has written that the ironic endings of Sirkian melodrama are progressive in their defiance of unity and closure:

> It is as though the fact of having a female point of view dominating the narrative produces an excess which precludes satisfaction. If the melodrama offers a fantasy escape for the identifying women in the audience, the illusion is so strongly marked by recognisable, real and familiar traps that the escape is closer to a daydream than a fairy story. The few Hollywood films made with a female audience in mind evoke contradictions rather than reconciliation, with the alternative to mute surrender to society's overt pressure lying in defeat by its unconscious laws.[22]

Although Mulvey here speaks primarily of the ironic Sirkian melodrama, her description of the contradictions encountered by the female spectator apply in a slightly different way to the very un-ironic *Stella Dallas*. I would argue that *Stella Dallas* is a progressive film not because it defies both unity and closure, but because the definitive closure of its ending produces no parallel unity in its spectator. And

because the film has constructed its spectator in a female subject position locked into a primary identification with another female subject, it is possible for this spectator, like Val—the mother spectator from *The Women's Room* whose reaction to the film is quoted at the head of this article—to impose her own radical feminist reading on the film. Without such female subject positions inscribed within the text, the stereotypical self-sacrificing mother character would flatten into the mere maternal essences of so many motherly figures for melodrama.

*Stella Dallas* is a classic maternal melodrama played with a very straight face. Its ambivalences and contradictions are not cultivated with the intention of revealing the work of patriarchal ideology within it. But like any melodrama that offers a modicum of realism yet conforms to the "reconciliation of the irreconcilable" proper to the genre,[23] it must necessarily produce, when dealing with conflicts among women, what Val calls a "shock of recognition." This shock is not the pleasurable recognition of a verisimilitude that generates naïve belief, but the shock of seeing, as Val explains, "how they got us to consent to our own eradication." Val and other female spectators typically do *not* consent to such eradicating resolutions. They, and we, resist the only way we can by struggling with the contradictions inherent in these images of ourselves and our situation. It is a terrible underestimation of the female viewer to presume that she is wholly seduced by a naïve belief in these masochistic images, that she has allowed these images to put her in her place the way the films themselves put their women characters in their place.

It seems, then, that Adrienne Rich's eloquent plea for works that can embody the "essential female tragedy" of mother–daughter passion, rapture, and loss is misguided but only with respect to the mode of tragedy. I hope to have begun to show that this loss finds expression under patriarchy in the "distorted" and "misused" cathexes of the maternal melodrama. For unlike tragedy melodrama does not reconcile its audience to an inevitable suffering. Rather than raging against a fate that the audience has learned to accept, the female hero often accepts a fate that the audience at least partially questions.

The divided female spectator identifies with the woman whose very triumph is often in her own victimization, but she also criticizes the price of a transcendent "eradication" which the victim-hero must pay. Thus, although melodrama's impulse toward the just "happy ending" usually places the woman hero in a final position of subordination, the "lesson" for female audiences is certainly not to become similarly eradicated themselves. For all its masochism, for all its frequent devaluation of the individual person of the mother (as opposed to the abstract ideal of motherhood), the maternal melodrama presents a recognizable picture of woman's ambivalent position under patriarchy that has been an important source of realistic reflections of women's lives.

[ · · · ]

## NOTES

1. *The Women's Room* (New York: Summit Books, 1977), p. 227.
2. An interesting and comprehensive introduction to this sub-genre can be found in Christian Viviani's "Who is Without Sin? The Maternal Melodrama in American Film, 1930–1939."

    B. Ruby Rich and I have also briefly discussed the genre of these sacrificial maternal melodramas in our efforts to identify the context of Michelle Citron's avant-garde feminist

film, *Daughter Rite*. Citron's film is in many ways the flip side to the maternal melodrama, articulating the daughter's confused anger and love at the mother's sacrificial stance. "The Right of Re-Vision: Michelle Citron's *Daughter Rite*," *Film Quarterly* 35, no. 1, Fall 1981, pp. 17–22.

3. *The Second Sex*, trans. H. M. Parshley (New York: Bantam, 1961), pp. 488–9.

4. An excellent introduction to this rapidly growing area of study is Marianne Hirsch's review essay, "Mothers and Daughters," *Signs: Journal of Women in Culture and Society* 7, no. 1, 1981, pp. 200–22. See also Judith Kegan Gardiner, "On Female Identity and Writing by Women," *Critical Inquiry* 8, no. 2, Winter 1981, pp. 347–61.

5. *Of Woman Born* (New York: Bantam, 1977), pp. 240, 226.

6. *The Melodramatic Imagination: Balzac, Henry James, Melodrama and the Mode of Excess* (New Haven: Yale University Press, 1976).

7. Martha Vicinus, writing about the nineteenth-century melodrama, suggests that melodrama's "appropriate" endings offer "a temporary reconciliation of the irreconcilable." The concern is typically not with what is possible or actual but what is desirable. "Helpless and Unfriended: Nineteenth-Century Domestic Melodrama," *New Literary History*, 13, no. 1, Autumn 1981, p. 132. Peter Brooks emphasizes a similar quality of wish-fulfilment in melodrama, even arguing that psychoanalysis offers a systematic realization of the basic aesthetics of the genre: "If psychoanalysis has become the nearest modern equivalent of religion in that it is a vehicle for the cure of souls, melodrama is a way station toward this status, a first indication of how conflict, enactment, and cure must be conceived in a secularized world," p. 202.

8. Most prominent among these are Claire Johnston's "Women's Cinema as Counter Cinema" in *Notes on Women's Cinema*, (ed.) Claire Johnston, *Screen*, Pamphlet 2 (SEFT: 1972); and Laura Mulvey's "Visual Pleasure and Narrative Cinema," *Screen* 16, no. 3, Autumn 1975, pp. 6–18.

9. The list of feminist work on this film is impressive. It includes: Pam Cook, "Duplicity in *Mildred Pierce*," in *Women in Film Noir*, (ed.) E. Ann Kaplan (London: BFI, 1978), pp. 68–82; Molly Haskell, *From Reverence to Rape: The Treatment of Women in the Movies* (NY: Holt, Rinehart and Winston, 1973), pp. 175–80; Annette Kuhn, *Women's Pictures: Feminism and Cinema* (London: Routledge and Kegan Paul, 1982), pp. 28–35; Joyce Nelson, "*Mildred Pierce* Reconsidered," *Film Reader* 2, January 1977, pp. 65–70; and Janet Walker, "Feminist Critical Practice: Female Discourse in *Mildred Pierce*," *Film Reader* 5, 1982, pp. 164–71.

10. Molly Haskell only gave the film brief mention in her chapter on "The Woman's Film," *From Reverence to Rape: The Treatment of Women in the Movies* (NY: Holt, Rinehart and Winston, 1973), pp. 153–88. Since then the film has been discussed by Christian Viviani (see note 2); Charles Affron in *Cinema and Sentiment* (Chicago: University of Chicago Press, 1983), pp. 74–6; Ben Brewster, "A Scene at the Movies," *Screen* 23, no. 2, July–August 1982, pp. 4–5; and E. Ann Kaplan, "Theories of Melodrama: A Feminist Perspective," *Women and Performance: A Journal of Feminist Theory* 1, no. 1, Spring/Summer 1983, pp. 40–48. Kaplan also has a longer article on the film, "The Case of the Missing Mother: Maternal Issues in Vidor's *Stella Dallas*," *Heresies* 16, 1983, pp. 81–5. Laura Mulvey also mentions the film briefly in her "Afterthoughts on 'Visual Pleasure and Narrative Cinema' Inspired by *Duel in the Sun* (King Vidor, 1946)," *Framework* 15/16/17, Summer 1981, pp. 12–15—but only in the context of Vidor's much more male-oriented western. Thus, although *Stella Dallas* keeps coming up in the context of discussions of melodrama, sentiment, motherhood, and female spectatorship, it has not been given the full scrutiny it deserves, except by Kaplan, many of whose arguments I challenge in the present work.

11. Ann Kaplan emphasizes this "wrenching" of the filmic point of view away from Stella and toward the upper-class values and perspectives of Stephen and the townspeople. "The Case of the Missing Mother," p. 83.

12. Doane, "The Woman's Film: Possession and Address."

13. The term—originally used by Joan Rivière—is employed in Mary Ann Doane, "Film and the Masquerade: Theorising the Female Spectator," *Screen* 23, no. 34, September/October 1982, pp. 74–87.

14. Ann Kaplan, "The Case of the Missing Mother," p. 83.

15. Ibid.

16. Molly Haskell notes this tendency of women audiences to come away with a memory of heroic revolt, rather than the defeat with which so many films end, in her pioneering study *From Reverence to Rape: The Treatment of Women in the Movies* (New York: Holt, Rinehart and Winston, 1973), p. 31.

17. Modleski, "The Search for Tomorrow in Today's Soap Opera: Notes on a Feminine Narrative Form," *Film Quarterly* 33, no. 1, Fall 1979, p. 14. A longer version of this article can be found in Modleski's book *Loving with a Vengeance: Mass Produced Fantasies for Women* (Hamden, CT: Archon Books, 1982), pp. 85–109.

18. Kaplan, "Theories of Melodrama," p. 46.

19. Ben Brewster has cited the many cinematic references of the original novel as an indication of just how effective as an appeal to reality the cinematic illusion has become. "A Scene at the Movies," *Screen* 23, no. 2, July–August 1983, pp. 4–5.

20. Freud's theory is that the little boy believes in the maternal phallus even after he knows better because he has seen evidence that it does not exist has been characterized by Octave Mannoni as a contradictory statement that both asserts and denies the mother's castration. In this "Je sais bien mais quand même" (I know very well but just the same), the "just the same" is the fetish disavowal. Mannoni, *Clefs pour l'imaginaire* (Paris: Seuil, 1969), pp. 9–30. Christian Metz later applied this fetishistic structure to the institution of the cinema as the creator of believable fictions of perceptually real human beings who are nevertheless absent from the scene. Thus the cinema aims all of its technical prowess at the disavowal of the lack on which its "imaginary signifier" is based. *The Imaginary Signifier: Psychoanalysis and the Cinema*, trans. Celia Britton, Annwyl Williams, Ben Brewster, and Alfred Guzzetti (Bloomington Indiana: Indiana University Press, 1982), pp. 69–76.

21. Doane, "Film and the Masquerade," pp. 80–1.

22. Mulvey, "Notes on Sirk and Melodrama."

23. Vicinus, p. 132.

# KOBENA MERCER

## Dark and Lovely Too: Black Gay Men in Independent Film

Kobena Mercer (b. 1960) is a London-based writer on art and culture who has taught at the University of California, Santa Cruz, New York University, and Middlesex University. Mercer is the author of numerous essays, some of them collected in his book *Welcome to the Jungle: New Positions in Black Cultural Studies* (1994), and is the editor of *Exiles, Diasporas & Strangers* (2008), *Pop Art and Vernacular Cultures* (2007), *Discrepant Abstraction* (2006), and *Cosmopolitan Modernisms* (2005), volumes that explore the intersections

of contemporary art, cultural politics, and theories of representation. He has written definitive commentaries on the work of gay male visual artists of the African diaspora, including Nigerian-born British photographer Rotimi Fani-Kayode, and the subjects of the selection included here: American video artist Marlon Riggs, and British filmmker Isaac Julien, with whom Mercer has also collaborated.

In "Dark and Lovely Too," which first appeared in 1993 in the collection *Queer Looks*, Mercer begins by providing context for the independent works he writes about. Cultural production addressing race, gender, and sexuality burgeoned in the 1980s, made possible by arts funding initiatives (like Britain's black independent film workshops) and catalyzed by political organizing, the AIDS crisis, and theoretical writings on identity and difference. Such work took on the important task of self-representation in the face of histories of marginalization and stereotyping. However, Mercer cautions against the trap of what he calls "categorical identity politics," that is, determining a work of art's value based primarily on the social identity of its producer. Instead, Mercer detects varying strategies of realism and formalism in his analysis of Marlon Riggs's *Tongue Untied* (1990) and Isaac Julien's *Looking for Langston* (1988), analyzing their nuanced responses to racism in the lesbian and gay community as well as in the wider culture and to homophobia in the black community. Mercer draws on formal critique, psychoanalytic concepts of fetishism and fantasy, and theories of performativity and diasporan identity to demonstrate the interdependence between theory and practice in his essay—something that the works he analyzes also accomplish.

## READING CUES & KEY CONCEPTS

■ Mercer speaks of the "burden of representation" that falls upon the minority artist to say everything in the face of historical absence. How is this burden refused, according to him, in the artworks he describes?

■ How, according to Mercer, is the "'race, class, and gender' mantra" invoked to avoid grappling with the complexity within, and differences among, subjects and cultural productions? What does he suggest instead?

■ How does Mercer describe the specificities of black gay male identities in Britain and the United States as portrayed in the works he analyzes?

■ **Key Concepts:** Categorical Identity Politics; Diaspora; Performativity; Dialogic/ Monologic

# Dark and Lovely Too: Black Gay Men in Independent Film

· · · · · · · · · · · · · ·

We are in the midst of a wildly creative upsurge in black queer cultural politics. Through political activism and new forms of cultural practice, we have created a community that has inspired a new sense of collective identity among lesbians and gay men across the black diaspora.

The recent work in film and video by Isaac Julien and Marlon Riggs emerges from and contributes to the movement and direction of these new developments. I will begin by framing Riggs's *Tongues Untied* and Julien's *Looking for Langston* in the specific context of black lesbian and gay cultural politics, in order to open up a discussion on questions of difference and identity in the general context of contemporary struggles around race, gender, and sexuality. In this sense, what is important about black lesbian and gay cultural politics is not simply that we have created a new sense of community among ourselves—although the importance of that cannot be emphasized enough—but that our struggles make it possible to arrive at a new perspective on political identity and imagined community at large.

To invoke a couple of well-worn metaphors, we have been involved in a process of "making ourselves visible" and "finding a voice." Through activism and political organization, from large-scale international conferences to small-scale consciousness-raising groups, black lesbians and gay men have come out of the margins into the center of political visibility. One need only point to the numerous service organizations created in response to the AIDS crisis—or more specifically the crisis of indifference and neglect in the official public health policies of countries such as Britain and the United States—to recognize that our lives are at the center of contemporary politics. Such activity has created a base for collective empowerment. If I think about my own involvement in a small collective of gay men of African, Asian, and Caribbean descent which formed in London in the early eighties, what was so empowering was precisely the feeling of belonging which arose out of the transformation from "I" to "we."

It was through the process of coming together—communifying, as it were, that we transformed experiences previously lived as individual, privatized, and even pathologized problems into the basis for a sense of collective agency. This sense of agency enabled us to formulate an agenda around our experiences of racism in the white gay community and issues of homophobia in black communities. I think I can generalize here to the extent that the agenda of black lesbian and gay struggles over the past decade has been shaped and defined by this duality, by the necessity of working on at least two fronts at all times, and by the difficulty of constantly negotiating our relationship to the different communities to which we equally belong.

For this reason, rather than conceptualize our politics in terms of "double" or "triple" oppression, it should be seen as a hybridized form of political and cultural practice. By this I mean that precisely because of our lived experiences of discrimination in and exclusion from the white gay and lesbian community, and of discrimination in and exclusions from the black community, we locate ourselves in the spaces *between* different communities—at the intersections of power relations determined by race, class, gender, and sexuality. What follows from this is a recognition of the interdependence of different political communities, not completely closed off from each other or each hermetically sealed like a segregated bantustan but interlocking in contradictory relations over which we struggle. If you agree with this view, then it has important implications for the way we conceptualize the politics of identity.

We habitually think of identity in mutually exclusive terms, based on the either/or logic of binary oppositions. As black lesbians and gay men we are often asked, and sometimes ask ourselves: Which is more important to my identity, my blackness or

my sexuality? Once the question of identity is reduced to this either/or dichotomy, we can see how ridiculous and unhelpful it is; as black lesbians and gay men we cannot separate the different aspects of our identities precisely because we value both our blackness and our homosexuality. It is this contrast between both/and against either/or that is at stake in the problem of "identity politics"—in the pejorative sense of the term.

We are all familiar with the right-on rhetoric of "race, class, and gender," so often repeated like a mantra to signify one's acknowledgment of the diversity of social identities at play in contemporary politics. What is wrong with the "race, class, gender" mantra is that it encourages the reductive notion that there is a hierarchy of oppressions and thus a hierarchy of "doubly" or "triply" oppressed identities. What often occurs when different communities try to come together is a tendency to use our differences as a means of competition and closure in order to assert who is more oppressed than whom. In this way, difference becomes the basis of divisiveness, encouraging group closure in the competition for resources, rather than the recognition of the interdependence of our various communities. This is because identity is assumed to be an essential category, fixed once and for all by the community to which one belongs—a view which ignores the fact that we very rarely ever belong exclusively to one homogeneous and monolithic community and that, for most of us, everyday life is a matter of passing through, travelling between, and negotiating a plurality of different spaces. Black lesbians and gay men are not exempt from the worst aspects of such categorical identity politics. But precisely because of our hybrid legacy, drawing on the best aspects of our dual inheritance from both black struggles and lesbian and gay struggles of the sixties and seventies, we might arrive at a better appreciation of the politics of identity which begins with the recognition of difference and diversity.

Let me put it like this: the literary work of writers such as Audre Lorde, Joseph Beam, Essex Hemphill, Cheryl Clarke, and Assoto Saint—to name only a few—has been absolutely essential to the process of finding a voice and creating community. Through their stories we have transformed ourselves from objects of oppression into subjects and agents busy making history in our own right. Such narratives have been indispensible to the formation of our identity. As Stuart Hall has put it, "Identities are the names we give to the different ways we are positioned by, and position ourselves within, the narratives of the past."[1] But what we find in their work is not the expression of one singular, uniform, homogeneous, black lesbian or gay male identity that is at all times identical to itself. Rather we find stories that narrate our differences and the multiplicity of experiences lived by black lesbians and gay men. We find that black lesbians and gay men do not all speak in one voice. To me, this suggests the recognition of the possibility of unity-in-diversity, and implies a skeptical disposition towards categorical identity politics. Such work suggests that we give up the search for a purified ideal type or a positive role model of political correctness, because it teaches us to value our own multiple differences as the very stuff of which our queer diasporic identities are made.

Insofar as these issues inform the interventions that Isaac Julien and Marlon Riggs have made in independent film, it is important to situate their work in relation to the question of identity. Namely, that identities are not found in nature but historically constructed in culture—or to put it another way, *identity is not what*

*you are so much as what you do.* Black queer cultural politics has not expressed an essential identity that was always already there waiting to be discovered, but has actively invented a multitude of identities through a variety of activities and practices, whether organizing workshops and fund-raising parties, lobbying and mobilizing around official policies, writing poems, publishing magazines, taking photographs, or making films.

## Finding a Voice: Independent Cinema and Black Representation

*Tongues Untied* and *Looking for Langston* share a number of similarities: both are the "first" black independent productions to openly address black homosexuality, because prior to now such issues have been avoided or omitted from black independent cinema; both tell our stories of the experience of dual exclusion, being silenced and being hidden from history. And, taking all this into account, both have won similarly enthusiastic responses from various audiences around the world, and have received numerous awards and prizes.

At the same time, these two works could not be more different in style and approach. Whereas *Tongues* foregrounds autobiographical voices that speak from the lived experiences of black gay men in the here and now, and emphasizes the immediacy, direct address, and in-your-face realism associated with video, *Langston* speaks to black gay experience by tracking the enigmatic sexual identity of one of the most cherished icons of black cultural history, Langston Hughes, whose presence is evoked through music, poetry, and archival film to create a dreamlike space of poetic reverie, historically framed by images of the Harlem Renaissance of the 1920s. To put it crudely, the contrast in aesthetic strategies turns on the difference between a video which embodies the values of documentary realism and a film which self-consciously places itself in the art cinema tradition.

Rather than play one off against the other, I want to use these differences to underline my point about the plurality and diversity of identities among black gay men. From this perspective we can recognize the way in which both Julien and Riggs participate in a similar cultural and political project that concerns the struggle to find a voice in the language of cinema, which, up to now, has treated the black gay subject as merely an absence, or present only as an object of someone else's imagination. In this sense, Julien and Riggs deepen and extend the critical project of black independent cinema: to find a place from which to speak as a black subject in a discourse which has either erased and omitted the black subject, or represented the black subject only through the mechanism of the stereotype, fixed and frozen as an object of someone else's fears and fantasies. However, between them, the two works also challenge and disrupt certain assumptions within black independent cinema itself, and in this way their strategies bring to light an important paradox about race and representation which parallels the problem of identity in political discourse.

Both Julien and Riggs are independent practitioners, which is to say that the conditions of production in which they work are distinct from the conditions that obtain in the commercial film industry, in which production, distribution, and exhibition are monopolized by private corporations, mostly centered in Hollywood. Yet, as James Snead has pointed out, the term independent is something of a misnomer,

since such practitioners are highly dependent on the role of public sector institutions, not only in the funding of production, but in terms of the subsequent distribution and exhibition of films regarded as "noncommercial."[2]

Indeed, public funding is a key condition enabling both works. *Tongues* was financed by a range of grants from various foundations and institutions, including a Western States Regional Fellowship from the National Endowment for the Arts, and *Langston* was funded principally by the British Film Institute and Channel Four Television, both of which have an official mandate and responsibility to support work from and about social constituencies underrepresented in film and television.

Although such public sector institutions have shaped, influenced, and sometimes curtailed the renewal of black independent film in the 1980s, there are salient national differences in the conditions of independent practice. Whereas Julien's film is a Sankofa production and emerges from a context in which collective methods have flourished in the British workshop sector, which includes Black Audio Film Collective, Ceddo, Retake, and other groups, mostly in London,[3] Riggs directs his own independent production company, based in Oakland and works on an individual basis, as do most black practitioners in the United States—from Julie Dash and Haile Gerima to Charles Burnett and Michelle Parkerson—where the independent sector is more dispersed.

It is significant, however, that, at the point of exhibition, both *Tongues* and *Langston* have been shown twice on public television, on PBS in the United States and on Channel Four in Britain. This is significant, not simply in making the works accessible to a broader range of audiences, but in terms of the responsibility of public television—as opposed to commercial cinema—to represent the underrepresented. This can be seen as the locus of a particular problem in the politics of representation that all minority practitioners encounter, namely, that representation does not simply denote a practice of depiction but also has the connotation of a practice of delegation, in which the minority practitioner is often positioned in the role of a representative who speaks for the entire constituency from which he or she comes. Elsewhere, I have discussed this problematic as the "burden of representation" which black artists and filmmakers have had to negotiate once they gain access to the apparatus of representation.[4]

In a situation where the right to representation is rationed and regulated, so that minorities experience restricted access to the means of representation, there is often an assumption on the part of funding institutions and an expectation on the part of audiences that they should "speak for" their particular community. This is felt and lived as a real dilemma for artists and practitioners themselves, as Martina Attille, formerly of the Sankofa Collective, put it in relation to the making of *The Passion of Remembrance* in 1986:

> There was this sense of urgency to say it all, or at least to signal as much as we could in one film. Sometimes we can't afford to hold anything back for another time, another conversation or another film. That is the reality of our experience—sometimes we only get the one chance to make ourselves heard.[5]

What has emerged in the "new wave" of black independent film during the eighties, particularly in the British context, is the awareness of the impossibility of carrying this burden without being crushed by it. It is impossible for any one individual

to speak as a representative for an entire community without risking the violent reductionism which repeats the stereotypical view within the majority culture that minority communities are homogeneous, unitary, and monolithic because their members are all the same. It is impossible for any one black person to claim the right to speak for the diversity of identities and experiences within black society without the risk that such diversity will be simplified and reduced to what is seen as typical, a process which thereby reproduces and replicates the logic of the racist stereotype that all black people are, essentially, the same.

Julien and Riggs both recognize these pitfalls in racial representation, and what is remarkable is that through entirely different aesthetic strategies they enact a film practice which refuses to carry the burden of representation, instead opening it up to displace the assumptions and expectations contained within it. To examine how they do this I want to focus first on the articulation of multiple voices in *Tongues Untied* and then turn to the gaze and looking relations as articulated in *Looking for Langston*.

## *Dialogic Voicing in Documentary Realism*

One of the adjectives most frequently invoked in response to *Tongues Untied*, especially among black gay men, is "real": we value the film for its "realness." A cursory historical overview of black independent cinema would reveal the prevalence of a certain realist aesthetic, which must be understood as one of the privileged modes through which black filmmakers have sought to contest those versions of reality inscribed in the racist discourses of the dominant film culture. As a counterdiscourse, the imperative of such a realist aesthetic in black film, whether documentary or drama, is to "tell it like it is." What is at issue in the oppositional or critical role of black independent cinema is the ability to articulate a counterdiscourse based on an alternative version of reality inscribed in the voices and viewpoints of black social actors.

*Tongues* is congruent with the tradition of documentary realism in black film culture, as it foregrounds a range of autobiographical voices that dramatize the power of witness and testimony. Through the authority of their own experiences, black gay men come to voice as primary definers of reality. As Riggs has said in a recent interview:

> We live in a society in which truth is often defined by your reflection on the screen. . . . But you don't really live and you're not really somebody until you're somehow reflected there on the tube or in the theatre. . . . What films like *Tongues Untied* do, especially for people who have had no images of themselves out there to see, is give them a visible and visual representation of their lives.[6]

In this sense, the "realness" of the work concerns the desires and expectations of a black gay audience who decode it. But in terms of the aesthetic strategy in which it is encoded, such "realness" is an effect of the consistent use of direct address, whereby in place of the anonymous, impersonal, third-person narrator which tends to characterize the documentary genre, individuals tell their stories directly to the camera, creating the space for an interpersonal dialogue that is simultaneously confessional, affirmative, and confrontational. Its "realness" consists not simply

of the accuracy or veracity of its depiction of the experiences of African American gay men—through poetry, rap, drama, dance, and music—but through this dialogic mode of address which brings the spectator into a direct relationship with the stories and experiences that find their voices.

Of the four cinematic values associated with documentary realism—transparency, immediacy, authority, and authenticity—*Tongues* seems to emphasize the latter through Riggs's presence, as he tells his life story, which serves as a thread connecting the multiple components of the video: from the poems performed by Essex Hemphill, Steve Langley, and Allan Miller, and the scenes in which the homophobic voices of a black preacher, an activist, and various black entertainers conspire to silence, ridicule, and intimidate, to the eroticism of a tender embrace between two lovers, and scenes showing rallies and Gay Pride marches. The emphasis on authenticity, honesty, and truth-to-experience through personal disclosure is underlined by Riggs's visual presence at the beginning, where he appears nude: a gesture of exposure not only suggesting the vulnerability of revealing one's own life through one's story but also establishing the framework of personal disclosure that guides the work as a whole.

It is precisely the achievement of *Tongues Untied* that its realism foregrounds such authenticity without recourse to the master codes of the documentary genre, in which the function of the impersonal voice-of-God narrator seeks to resolve all questions raised, tie up all loose ends, and explain everything as the narrative inexorably moves towards the movement of closure. *Tongues* displaces this function entirely: there is no unifying voice-over, nor indeed any single voice privileged in a position of mastery, explanation, or resolution. In terms of his own presence, Riggs does not speak as a representative whose individual story is supposed to speak for every black gay man; rather, he speaks as one voice among others, each of which articulates different experiences and identities. He does not seek to typify some unitary and homogeneous essence called "the black, gay, male experience" by presenting his story as the only story or the whole story; rather, he speaks from the specificity of his own experience, which, because of the presence of other voices and stories, is not generalized or typified as such.

This kind of dialogic voicing assumes crucial importance for a number of reasons. First, by contrast, it highlights the degree to which black independent cinema has often inadvertently replicated the problem of exclusion by reproducing the monologic voicing of the master codes of documentary realism, in order to authorize its own counternarratives. Furthermore, because he does not privilege any one voice as the source of authority, Riggs highlights the degree to which those voices in black cinema that claim implicitly to be representative, and to speak for the entire black race, very often tend to be only the voices of black men, whose heroic and heterosexist accents often exclude the voices of black women and black gay men. In this sense, *Tongues* can be said to challenge the heterosexual presumption that so often characterizes the documentary realist aesthetic in black cinema.

To contextualize this issue, one might point to the dual role of Spike Lee as director and narrative character in *Do the Right Thing*, where he is positioned, along with the other main young black male protagonists, as the embodiment of the Bedford-Stuyvesant community itself, pitched into antagonism with white society across the battle lines of race and ethnicity. By making the implicit claim to speak

for the condition of young black men in the urban US (in terms of both the narrative structure and the marketing of the film), Lee seems to replicate the all-too-familiar stereotype of the "angry black man" consumed with rage about the politics of race and racism on the streets, to the exclusion of any other politics, such as his sexual politics between the sheets.

The second reason why the dialogic voicing of *Tongues* is important has to do with its awareness of the multidimensional character of the political. In this sense its "realness" has to do with the acknowledgment that real life is contradictory—"home is a place of truth, not peace," as Riggs comments at one point. In the autobiographical sequence, as he narrates his first kiss and being bussed to a nearly all-white school in the South, Riggs's narrative presence is framed by the concatenation of abusive epithets—"punk," "motherfuckin' coon," "homo," "nigger go home"—spat out at rhythmic intervals that underline the interplay of racism and homophobia, experienced at one and the same time. It is this awareness of a dialectic in the politics of race and sexuality that is maintained throughout the work by virtue of its dialogic strategy. *Tongues* does not seek to reduce, simplify, or resolve the lived experience of real antagonism but is constantly vigilant to the complex effects of contradiction—particularly as these enter into the interior space of our own relations with each other, our intimacy, and our aversion.

If the work refuses facile notions of "internalized oppression," it equally rejects the reductive tendency of the current discourse of endangered species in which black men are seen as victims and nothing but victims. Such questions concerning the contradictions through which black masculinity is lived are forcefully raised, but rather than provide the false security of easy answers, the strategy of direct address brings the viewer and audience into the dialogue as active participants who share an equal responsibility in the search for answers. By invoking a certain answerability on the part of the audience, what the film gives is not a neat resolution to the contradictions of the real, but a range of questions for the audience to take home.

If all this sounds terribly earnest, I should emphasize that the irreverent humor of *Tongues Untied* is absolutely crucial to the subversive force of its dialogic strategy. More to the point, the element of playfulness and parody, like the aesthetics of dialogic voicing, is thoroughly embedded in the oral tradition of African American cultural expression. As the Lavender Light quartet pleads in the tape, "Hey, boy, can you come out tonight?" *Tongues* shows that its tongue is firmly in cheek in this appropriation of black pop a cappella from the doo-wop tradition of the fifties. Like the freaky-deke ritual on the killing floor of the dance halls of the thirties, the Oaktown ensemble engaged in the electric slide and the beautifully stylized boys caught vogueing in New York City underline the affirmative role of black expressive culture—and the contributions black gays have made to the renewal of its expressive edge. As elements of black queer subcultural ritual, such dance forms enact a performative body politics, in which the black body is a site both of misery, oppression, and exploitation, as well as of resistance, transcendence, and ecstacy.

Moreover, considering the dialectic of appropriation as a constitutive feature of diasporan culture—in the case of vogueing, for instance, how black gays appropriate the poses of white female models in glossy fashion magazines to create a stylized dance form, are then appropriated in turn by white performers such as Malcolm

McLaren and Madonna—*Tongues Untied* performs a doubly critical role in its affirmation of black gay pleasures. On the one hand, by reinserting black gay subcultural style into the expressive context of the African American cultural tradition as a whole, it refutes the premise that gayness is a "white thing." On the other, by recontextualizing such styles in the lived experience of black gay men, it brings to light the extent to which our pleasures may be misappropriated by white audiences, who are nevertheless fascinated and perhaps even, in some sense, envious of them. Let's face it, who wouldn't want to be a member of the Institute of Snap!thology? "Don't mess with a snap diva!" If you want the politically correct party line, please stay at home and dial 1-900-Race-Class-Gender instead.

## Looking Relations: Allegories of Identity and Desire

In turning to Isaac Julien's *Looking for Langston*, I want to develop the theme of appropriation as a figure in diaspora culture. This is important, not simply because of the stylish way in which the film appropriates art cinema conventions, but more fundamentally because it is impossible to understand the formation of black British identities, gay or otherwise, without a recognition of the way in which different signs have been appropriated and rearticulated to construct new forms of political identity and imagined community in this specific context.

Here I would emphasize "imagined" in Benedict Anderson's term "imagined community,"[7] because without the notion of a collective historical imagination, how could we understand why a black British filmmaker whose parents migrated to London from St. Lucia would choose to make a film about a black American writer from Kansas City?

If one thinks about the naming of the black subject in postwar Britain, it becomes necessary to reiterate the theoretical view that subjectivity is indeed socially constructed in language. What we see are not simply different names used to designate the same community but the historical becoming of such a political community in and through a struggle over the signifiers of racial discourse. The displacement of the proper name—from "colored immigrants" in the 1950s, to "ethnic minorities" in the sixties, and to "black communities" in the seventies and eighties—vividly underlines the point that social identities are not just there in nature but are actively constructed in culture. Of course, this did not just happen in the realm of language alone, since a whole range of nondiscursive practices have constituted Black Britain as a domain of social and political antagonism. Nevertheless, it is crucial to acknowledge the material effects of symbolic and imaginary relations.

For over four hundred years in Western culture, the sign /black/ had nothing but negative connotations, to say the least. However, we have also seen that the signifying chain in which it was equated with negative values was not totally closed or fixed. In the US context during the 1960s, the term /black/ was disarticulated out of the negative chain of equivalence in racist discourse, and rearticulated into an alternative chain of equivalences as a sign of empowerment, indicated by the shift from Negro to Black. In Britain during the 1980s something similar happened, inspired and influenced by the black American example, as blackness was disarticulated out of one discursive system and rearticulated into another, where it became a sign of solidarity among Asian, African, and Caribbean peoples, and functioned as a term of

a politically chosen identity rather than a genetically ascribed one. The cultural politics of the black diaspora thus highlights a deconstructive process in which the central signifiers of racist ideology, based on the binary opposition of white/not-white, were rearticulated to produce a new set of connotations in one and the same sign.

It is an awareness of the multi-accentual character of the sign that informs the critical project of black British workshops, such as Sankofa and Black Audio Film Collective. And this awareness is not merely the result of an engagement with difficult poststructuralist theories, but something achieved through a practice of trial and error and open-ended experimentation inscribed in their productions, such as *Territories* (1984) and *Handsworth Songs* (1986). *Looking for Langston* continues the critique of racial representation signalled by those earlier works, but deepens and complicates it by extending it into the domain of fantasy. I would argue that the film is not a documentary search for the "truth" about Langston Hughes's ambiguous sexual identity so much as an investigation into the psychic reality of fantasy as that domain of subjectivity in which our desires and identifications are shaped. The film is as much a meditation on the psychic reality of the political unconscious—which concerns the imaginary and symbolic conduits of the diaspora, through which black Britons have sought to symbolize our political dreams and desires in part through identifications with black America and black Americans—as it is a poetic meditation on the psychic and social relations that circumscribe our lives as black gay men.

This double reading is suggested by the ambiguous sense of time and place evoked by the montage of music, poetry, and archival imagery across the film's monochrome texture and stylized art direction. Characters inhabit the fictional milieu of a twenties speakeasy, where tuxedoed couples dance and drink champagne, celebrating hedonistic pleasure in defiance of the hostile world outside. It is this outside that intrudes at the end of the film when thugs and police raid the club only to find that its denizens have disappeared, while eighties house music plays on the soundtrack almost like a music video. The multilayered texture evoked by the ambiguity of past and present, outside and inside, fact and fantasy, thus allows more than one reading about what the film is looking for. I want to focus on only two possibilities: an archeology of black modernism and an allegory of black gay male desire.

Langston Hughes is remembered as the key poet of the Harlem Renaissance and has come to be revered as a father figure of black literature, yet in the process of becoming such an icon, the complexity of his life and the complexity of the Harlem Renaissance itself has been subject to selective erasure and repression by the gatekeepers and custodians of "the colored museum." Hughes is remembered as a populist, public figure, but the enigma of his private life—his sexuality—is seen as something better left unaddressed in most biographies, an implicit gesture of denial which buries and represses the fact that the Harlem Renaissance was as gay as it was black, and that many of its key figures—Claude McKay, Alain Locke, Countee Cullen, Wallace Thurman, and Bruce Nugent—were known to be queer, one way or another. *Looking for Langston* engages with and enters into this area of enigma and ambiguity, not in order to arrive at an unequivocal answer embodied in factual evidence, but to explore the ways in which various facets of black cultural life are subject to psychic and social repression, from within as well as without.

As an archeological inquiry, the film excavates what has been hidden from history, not only the fluidity of sexual identities within the black cultural expression

of that period, but the intertwining of black culture and Euro-American modernism. Just as official histories of modernism tend to erase and selectively repress the work of black artists, official versions of the Harlem Renaissance narrative tend to avoid the sexual politics of the "jazz era." Yet the film suggests that it was precisely the imbrication of race and sexuality that underpinned the expressive and aesthetic values of the cultural practices of that time—from Picasso's *Demoiselles d'Avignon* to Josephine Baker, for instance. But *Looking for Langston* is not a history lesson: the point of archeology is not to research history for its own sake but to search for answers to contemporary dilemmas, in this case the need to historicize the hybrid domain of black British cultural production in the eighties and nineties.

The film looks for Langston, but what we find is Isaac. Not so much in an autobiographical sense, but in terms of a self-reflexive awareness of the multiple influences that inform his artistic choices and methods. The desire to unravel the hidden histories of the Harlem Renaissance serves as an emblem for an inventory of the diverse textual resources which have informed the renascence and renewal of black artistic and cultural practices in contemporary Britain. From this perspective, one might describe the film as a visual equivalent of a dialogue with the different cultural traditions from which Isaac Julien has invented his own artistic identity as a black gay auteur.

This view is suggested by the promiscuous intertextuality which the film sets in motion. Alongside visual quotations from Jean Cocteau, Kenneth Anger, and Jean Genet, the voices of James Baldwin, Bruce Nugent, Toni Morrison, and Amiri Baraka combine to emphasize the dialogic and hybridized character of the text. In this "stereophonic space," in Barthes's phrase, Julien acknowledges the importance of the Euro-American avant garde as much as the importance of black American literature as textual resources which black British artists have used in the process of finding their own voices. It is significant, therefore, that the film articulates theory and practice not in terms of didactic prescription but in terms of enacting a translation of cultural studies into cultural politics. This reflexive enactment of cultural theory is implicit in the role played by Stuart Hall in the film, who performs the voice-over narration, as his presence suggests that the intellectual practice associated with British cultural studies now informs Julien's filmic practice as a black gay auteur.

There is another aspect to this intertextuality that concerns what the film is looking for in the more literal sense. Its languid, dreamlike texture seduces the eye and its avowed homoeroticism solicits the gaze. Issues of voyeurism, fetishism, and scopophilic obsession arise across its sensual depiction of beautiful black male bodies. But the film does not simply indulge the pleasure in looking; it radically problematizes such pleasure by questioning the racial positions of the subject/object dichotomy associated with the dialectic of seeing and being seen.

Here the key motif is the direct look, whereby the black subject looks back (whether as auteur or character) and thus turns around the question of who has the right to look in order to ask the audience who or what *they* are looking for. This motif appeared in Julien's first film made with the Sankofa Collective, *Territories*, in the context of a confrontational, and somewhat didactic, inquiry into the objectification and fetishization of black culture as framed by the white gaze. In *Langston*, however, by virtue of the seductive and invitational direction of the textual strategy,

he achieves a more penetrating insight into the structures of racial and sexual fantasy, precisely by setting a trap for the gaze and by the provocative incitement of our wish to look.

It is significant that the ghost of Robert Mapplethorpe is present in this staging of the look. This occurs not so much in the scene in which a white male character leisurely leafs through *The Black Book*—while Essex Hemphill reads one of his poems pinpointing the reinscription of racism in white gay culture—but in terms of a set of aesthetic conventions, such as fragmentation and chiaroscuro lighting, which the film employs to punctuate its incitement of our pleasure in looking. In this way, Julien's strategy of promiscuous intertextuality appropriates a range of visual tropes associated with white artists like Mapplethorpe to lay bare the way in which race determines the flow of power relations through the gaze in complex and ambivalent ways.

Hence, in one key scene an exchange of looks takes place between the actor who may be interpreted as "Langston" (Ben Ellison) and his mythic object of desire, a black man named "Beauty" (Matthew Baidoo). This provokes a hostile, competitive glare from Beauty's white male partner (John Wilson), who makes a grand gesture of drinking more champagne. As he turns away to face the bar, Langston drifts into a daydream. In this sequence, Bruce Nugent's poem "Lillies and Jade" is read, over images that portray the Langston character searching for his lost object of desire in a field of poppies. At the end of his reverie, Langston imagines himself coupled with Beauty, their bodies entwined on a bed as if they have just made love. It is important to recognize that this coupling takes place in fantasy, because it underlines the loss of access to the object of desire as being the very source of fantasy itself. Moreover, it shows how race enters into the vocabulary of desire: as the object of both the black and the white man's gaze, Beauty acts as the signifier of desire as his desirability is enhanced precisely by the eroticized rivalry between their two looks.

It is here that the trope of visual fetishism found in Mapplethorpe's photographs makes a striking and subversive return, in close-up sequences set in the nightclub, intercut with Langston's daydream. From Langston's point of view, the camera lovingly lingers on the sensuous mouth of the actor portraying Beauty, with the rest of his face cast in shadow, like an iris shot in the silent movies. But, as in Mapplethorpe's images, the strong emphasis on chiaroscuro lighting invests the fetishized fragment, or body part, with a compelling erotogenic residue. The "thick lips" of the Negro are hypervalorized as the iconic emblem of Beauty's impossible desirability. In other words, Julien takes the risk of replicating the racial stereotype of the thick-lipped negro precisely to reposition the black subject as the desiring subject, not the alienated object, of the look. Like the image of the two men entwined on the bed, which recalls the homoerotic photographs of George Platt Lynes, yet also critiques them, it is only by intervening in and against the logic of fetishization in racial representation that Julien is able to open up the ambivalence of the psychic and social relations—of identification, object-choice, envy, and exclusion—inscribed in the brief relay of looks between the three men. Of each of these, I would draw attention to envy—wanting the object possessed by the Other—not only because it informs the kind of scopic obsession that Mapplethorpe works upon, suggesting that the white subject sees blackness as an enviable quality, but because as Julien recodes it, turning the fetish inside out, he points to the way that intraracial relations among

black men themselves also entail feelings of rivalry and envy at the very basis of our identifications with each other.

I have focussed on this particular moment because it strikes me that there are important formal similarities between Julien's strategy of working in and against the logic of racial fetishism and that of Nigerian-British gay photographer Rotimi Fani-Kayode, whose work is also inflected by a dialogic engagement with problems raised in Mapplethorpe. In contrast to the isolation effect in Mapplethorpe's work, whereby only one black male nude appears in the field of vision—a device that encourages a fantasy of mastery—in Kayode's work, such as *Technique of Ecstasy*, black men's bodies are coupled and contextualized to evoke an eroticism that seems to slip out of the implied power relations associated with the interracial subject/object dichotomy. Kayode creates an Afrocentric homoerotica precisely and perversely by appropriating conventions associated with the Eurocentric history of the fine art nude.

What Julien and Kayode share in common is not so much the fact that they are both black gay male artists, but that as artists they both use an intertextual strategy of appropriation and rearticulation in order to signify upon, and thus critique, the dominant regime of racial and sexual representation but without negating, denying, or disavowing the reality of the fantasies that give rise to such representations. Rather, by virtue of working in and against the master codes that regulate and govern the stereotypical, they begin to unravel what takes place at the borderlines between the psychic and the social, between fantasy and history.

In this brief discussion of *Looking for Langston* I have emphasized the formal dimension of its aesthetic strategy in order to draw attention to its enunciation of an allegory of desire, which is the source of its emotional resonance, not just for black gay men but for others in the audience as well. Although it is not the only available theory of desire, psychoanalysis suggests that desire is always about loss: our search for pleasure, the search for a significant other, is about the attempt to recover a state of fusion, wholeness, or nonseparation, which can never be fully retrieved. In so far as this lost object of desire can never really be found, the search for pleasure inevitably entails frustration, privation, and despair.

The achievement of *Looking for Langston* lies precisely in the way it shows how desire and despair run together, and thus how desire always entails rituals of mourning for what is lost and cannot be recovered. There is a sense of mourning, not just for Langston, buried in the past under the repressive weight of homophobic and ethnocentric narratives, but mourning for friends, lovers, and others lost to AIDS here and now, in the present. There is mourning, but not melancholia: as Langston himself says at the end of the film, "Why should I be blue? I've been blue all night through." Just like the multiple allusions of the term "blue," the textual strategy of the film as a whole creates an evocative "structure of feeling," in Raymond Williams's sense, that speaks not only to black gay men—although I can think of no other film which has laid bare our desire and despair in quite the way that it has— but to any desiring subject who has experienced the blues.

I want to conclude with a brief discussion of the issue of authorship, because the work of Marlon Riggs and Isaac Julien urges us to rethink questions of identity and agency that many thought were dead and buried with the poststructuralist argument concerning the "death of the author." That these are among the first cinematic

texts authored by black gay men means that it really *does* matter who is speaking. We can all live without the return of Romantic notions of creative genius, which always placed the author at the center of the text—resembling the godlike figure of the "universal intellectual" who thought he had an answer for everything—but we need to revise the notion that the author is simply an empty, abstract function of cultural discourse through whom various ideologies speak.

The welcomed development of postmodernism that accompanied the collapse of the grand narratives and the decentering of universal Man was that it revealed that the subject who had monopolized the microphone in public culture—by claiming to speak for humanity as a whole, while denying that right of representation to anyone who was not white, not male, not middle-class, and not Western—was nothing but a minority himself. If postmodernism simply means that the era of modernism is past, then hurrah! The pluralization and diversification of public space, where a variety of subjects find their voice and assert their right to speak, has only just begun. As black gay artists, "specific intellectuals" who speak from the specificity of their experience, Riggs and Julien, like other black lesbian and gay artists, have actively contributed to the cultural and political terrain of postmodernism.

Precisely because their work is so important, we should do more than merely celebrate. Above all, we should be deeply skeptical of a certain assumption embedded in categorical identity politics that would argue that these films are of aesthetic and political value *because* their authors are black gay men. Throughout this paper I have drawn attention to the formal strategies in *Tongues Untied* and *Looking for Langston* because I want to resist the conflation between artistic value and authorial identity that so often arises in debates on emerging artists. The problem here is not simply that bad works get celebrated alongside good ones but that constructive criticism is inhibited by the fear of being seen to be politically incorrect: if it is assumed that a black film is necessarily good because a black person made it, any criticism of the film is likely to be read as an attack on the very person who made it rather than on the film that was made.

Analogously, we are familiar with that rhetorical strategy of categorical identity politics in which a statement is prefaced by the adjectives that describe one's identity—for example, "As a black gay man, I feel angry about my place in the world." The statement may be entirely valid, but, because it is embedded in my identity, it preempts the possibility of critical dialogue, because your disagreement might be interpreted not as a comment on what I say, but as a criticism of who I am. So, in relation to *Tongues Untied* and *Looking for Langston*, I would adopt an anticelebration position, because I want to emphasize that these rich, provocative, and important works do indeed "make a difference" not because of who or what the filmmakers are, but because of what they do, and above all because of the freaky way they do it.

## NOTES

1. Stuart Hall, "Cultural Identity and Cinematic Representation," *Framework*, no. 36 (1989) pp. 68–81; reprinted in Jonathan Rutherford, ed., *Identity: Community, Culture, Difference* (London: Lawrence and Wishart, 1990) p. 225.

2. James Snead, "Black Independent Film: Britain and America," in Kobena Mercer, ed., *Black Film/British Cinema*, ICA Document 7, (London: Institute of Contemporary Arts, 1988) p. 47.

3. Sankofa Film and Video Collective comprises Isaac Julien, Maureen Blackwood, Nadine Marsh Edwards, and Robert Crusz. It was formed in 1984 in London with the aims of developing an independent black film culture in the areas of production, exhibition, and audience discussions. Under the aegis of the ACTT Workshop Declaration, the Collective has been funded from a variety of sources, including the Greater London Council, the British Film Institute and Channel Four. For background information on their work, and that of the Black Audio Film Collective, see interviews in Coco Fusco, ed., *Young, British and Black* (Buffalo Contemporary Hallwalls Arts Center, 1988).

4. See Kobena Mercer and Isaac Julien, "De Margin and De Centre," introduction to *Screen* vol. 29 no. 4 (Autumn, 1988) pp. 2–10, and Kobena Mercer, "Black Art and the Burden of Representation," *Third Text*, no. 10 (Spring, 1990) pp. 61–78.

5. Martina Attille in Jim Pines, "The Passion of Remembrance: Background and Interview with Sankofa," *Framework*, no. 32/33 (1986) p. 101.

6. Marlon Riggs in Ron Simmons, "Tongues Untied: An Interview with Marlon Riggs," *Black Film Review*, vol. 5, no. 3 (1989); reprinted in Essex Hemphill, ed., *Brother to Brother: New Writing by Black Gay Men* (Boston: Alyson, 1991) p. 191.

7. See Benedict Anderson, *Imagined Communities: Reflections on the Origin and Spread of Nationalism* (London: Verso, 1983).

# YVONNE TASKER

# Dumb Movies for Dumb People: Masculinity, the Body, and the Voice in Contemporary Action Cinema

Yvonne Tasker (b. 1964), Professor of Film and Television Studies at the University of East Anglia, is instrumental in the development of an analysis of "postfeminism," a cultural assumption that the goals of feminist social transformation have been achieved, even as popular culture shows that fundamental tensions and inequities remain. Tasker's work focuses on the role of genre (action films in particular) in the construction of gendered identities, drawing on feminist theory and cultural studies to explore the links between representation, politics, and pleasure. In her influential work *Spectacular Bodies: Gender, Genre and the Action Cinema* (1993), Tasker examines the ambivalence of supposedly secure categories in popular cinema and film criticism, exploring how contemporary action cinema reconstitutes gendered identities through the shifting categories of race, class, ethnicity, nation, and sexuality. She continues her intervention into feminist debates through the study of popular culture in *Working Girls: Gender and Sexuality in Popular Cinema* (1998) and *Action and Adventure Cinema* (2004). More recently, Tasker edited *Interrogating Postfeminism: Gender and the Politics of Popular Culture* (2007, with Diane Negra), a collection on the social and political implications of the feminist critique of contemporary mass media culture.

Starting with Laura Mulvey's "Visual Pleasure and Narrative Cinema" (p. 713), film theory of the 1970s and 1980s devoted much attention to analyzing classical Hollywood cinema

as a pleasure machine that manufactures a masculinized viewer through its ideological apparatus and cinematic strategies. While expanding on and complicating Mulvey's thesis about visual pleasure, most film criticism retained the binary opposition of male subject (associated with activity, voyeurism, fetishism, and story) and female object (associated with passivity, exhibitionism, masochism, and spectacle). Most film criticism also focused primarily on the cinematic representation of the female body, and not much attention was paid to the dynamics of representation of masculinity. Tasker's work questions this premise and argues that the male image in cinema is not only as significant as the female image but also that it is not nearly as stable and unproblematic as it is often assumed to be. Thus, in her early work on American action cinema of the 1980s (a genre often dismissed as too obvious in its pleasure politics), Tasker focuses on the male action hero and argues that the gender anxieties of the 1980s were played out on the tortured figure of the white male body as a way of figuring out national identity, an identity that was under attack from various discourses of exclusion along racial and national lines. In action cinema, the male, rather than powerful and active, is often rendered helpless and passive, his excessive bodybuilder physique serving as a form of compensation for this unstable subject position.

In the 1993 essay "Dumb Movies for Dumb People," Tasker looks at how popular action films such as *Die Hard* (1988) and *Tango and Cash* (1989) distanced their male hero/stars from traditional macho roles and physical display. She analyzes this transformation from the perspective of the marketability of the male body in consumer culture, and she places the start of this shift in the late 1980s, when gender roles in the workplace also began changing. The anxieties produced by this culture manifested themselves in these films as an excessive male body commodified as spectacle, with "an awareness of masculinity as performance." The excessively masculine body of the hero is subjected to humiliation and mockery at some level, and rather than signifying stability and power, it demonstrates that masculinity is an enactment and performance. Tasker's work opens up a significant space within the study of gender identity and genre and lays the groundwork for further research on the complex and diverse ways in which Hollywood cinema makes masculinity central to the politics of gendered representations.

## READING CUES & KEY CONCEPTS

■ Much of Tasker's argument about masculinity in action film relies on what she sees as the inherent paradox embodied in the visibility of muscles. How would you explain this paradox?

■ The redefinition of the male hero/star is achieved, Tasker maintains, not only through the body but also through the voice. What is the significance of this "shift away from the physical" and "move into the verbal"?

■ Consider how, and to what extent, Tasker's argument about masculinity subverts Mulvey's position on the relationship between masculinity/femininity in narrative cinema (see Mulvey, p. 713).

■ **Key Concepts:** Action Cinema; Performative Masculinity; Star Image; Commodification as Spectacle

# Dumb Movies for Dumb People: Masculinity, the Body, and the Voice in Contemporary Action Cinema

. . . . . . . . . . . . . .

The status of masculinity within Hollywood's representational system is explored here through an analysis of four films and their stars: Bruce Willis in *Die Hard* (1988) and *Die Hard 2* (1990), Sylvester Stallone in *Lock Up* (1989), Stallone and Kurt Russell in *Tango and Cash* (1989). These films and stars exemplify, in different ways, a tendency of the Hollywood action cinema toward the construction of the male body as spectacle, together with an awareness of masculinity as performance. Also evident in these films is the continuation and amplification of an established tradition of the Hollywood cinema—play upon images of power and powerlessness at the center of which is the male hero.

Within this structure suffering—torture, in particular—operates as both a set of narrative hurdles to be overcome, tests that the hero must survive, and as a set of aestheticized images to be lovingly dwelt on. Whilst numerous studies have commented on the construction of woman as victim within the American cinema, sometimes speculating on the masochistic pleasures this may offer to female viewers, few studies seem to comment in any depth on the figure of the male hero in this context, pursued and punished as he so often is. It is in thinking about such questions that a consideration of the action film may also allow a wider discussion of masculinity and sexuality within the Hollywood cinema, particularly in thinking through the significance of what critics have increasingly come to see as its performative status.

Indeed talking about men in the Hollywood cinema as "performing the masculine" seems to be *de rigueur* these days, a critical vogue that is both fruitful and intensely problematic. In quite another context, that of commenting on the self-representations of academic Frank Lentricchia, Lee Edelman poses a question: "might it not be useful," he asks, "to inquire just what, if anything, is getting subverted here or to ask how the miming of heterosexual privilege by a heterosexual male differs from the persistently oppressive enactment of that privilege in the culture at large?" (Boone and Cadden 1990: 44). Rather arch this, but Edelman's impatience, his irritation with a criticism vaguely based in the terms of supposedly self-reflexive "performance," does indicate the importance of, if not refusing an optimistic address to the cinema, then retaining an awareness of the complexities of representations, of their operation within wider systems than the cinematic. I'm not so bold as to seek for subversion here, being in any case unsure as to what it might look like. Paradox and contradiction though, with which Hollywood has always been replete, do come into the equation.

## *Performing Masculinity*

That masculinity can be seen as performative, as insistently denaturalized, has been something of a touchstone in recent discussions of the Hollywood cinema. A variety of formulations of postmodernism and postmodernity have been invoked in this critical development. Suspicious critics have tended to perceive postmodernism

and its associated buzzwords as providing a depoliticized catch-all framework for cultural analysis. This is an important qualification given the tendency, sometimes manifest in models constructed within the framework of postmodernism, to forget about the operations of power.

It does seem important to ask what is the status of this performativity, a quality which some are keen to embrace and others to refute. How would we account, for example, for the undoubtable marketability of the male body in the 1980s? One context is offered by the changing definitions, within a shifting economy, of the roles that men and women have been called upon to perform, particularly in that crucial arena of gender definition, the world of work.

Richard Dyer notes the tendency of male stars such as Clint Eastwood and Harrison Ford "either to give their films a send-up or tongue-in-cheek flavour . . . or else a hard, desolate, alienated quality." Dyer speculates that in a world "of microchips and a large scale growth (in the USA) of women in traditionally male occupations" the adoption of such tones suggests that the "values of masculine physicality are harder to maintain straightfacedly and unproblematically" (Dyer 1987: 12).[1]

Scott Benjamin King's analysis of the American cop show *Miami Vice*, a series which has attracted much critical attention and is perhaps the original "Armani with a badge," echoes Dyer's comments on the world of work. King offers a critique of those who understood the stylized visual beauty of the show and of its male protagonists, via postmodernism, as a narrative emptiness, seeing such perspectives as, at worst, a rather alarmingly literal interpretation of the "end of narrative." Instead of seeing the show as pure spectacle, as a refusal of narrative, King points out that *Vice* offered the repeated re-enactment of narratives of failure, the significance of which he locates within the context of contemporary articulations of masculinity. A reorientation of the relationship between men, masculinity, and consumption in the West necessarily affects those definitions of male identity achieved through production. King surmises that "if postmodernism is a crisis of the excess of consumption, and, further, a crisis related to shifting definitions of masculinity, it is also a crisis in the concept of work" (King 1990: 286). In particular King signals the importance, in the construction of Sonny Crockett's character, of failure within the realm of work. Crockett's work consists of getting the bad guys, work that he is unable to perform effectively, work that is carried out in a context over which he has no control. It is such a lack of control that is in turn crucial to the scenario of the two *Die Hard* films, where the hero finds himself in impossible situations controlled by incompetent bureaucracies.

Barbara Creed situates the pin-up muscleman star within the critical frameworks of postmodernism in her comments on the tendency of images and texts in the 1980s to "play with the notion of manhood." Creed suggests that Stallone and Schwarzenegger, the muscular stars of the decade, could only be described as "performing the masculine."

> Both actors often resemble an anthropomorphised phallus, a phallus with muscles, if you like . . . They are simulacra of an exaggerated masculinity, the original completely lost to sight, a casualty of the failure of the paternal signifier and the current crisis in master narratives.

> (Creed 1987: 65)

The "current crisis in master narratives" is seen by Creed not as the inability to tell a good story, but in terms of the failings of the key terms around which stories are constructed, terms which include a coherent white male heterosexuality along with the rationality and binary structures it is often taken to propose. For Creed it is the sheer physical excess of the muscular stars that indicates the performative status of the masculinity they enact, an excess quite different, indeed rather more obvious, to the qualities of tone, say a sense of parody or of alienation, that Dyer refers to in passing.

Muscles raise a familiar paradox over the coming together of naturalness and performance which Dyer has characterized in terms of the way in which muscles can function as both a naturalization of "male power and domination" and as evidence precisely of the labor that has gone into that effect (Dyer 1982: 71). The "strain" that Dyer identifies in the male pin-up stems from this paradox, from the self-conscious performance of qualities assumed to be natural. Dyer warns us against the dangers of "causal logic," the temptation to read images of men in terms only of male power. The performance of a muscular masculinity within the cinema draws attention to both the restraint and the excess involved in "being a man," the work put into the male body and the poses that it strikes. But if the cinematic hero is in the business of performing manliness not only at the level of physique, what is the significance of this performance, and what is the nature of the charade that he is acting out? The movies considered here insistently work through a set of motifs related to sexuality and authority, motifs which are mapped on to both narrative structure and the body of the male hero. Linking the questions of the male hero's effectivity at work, the embodiment of an excessive physical performance and an anxious narrative of male sexuality, is the crisis of the paternal signifier to which Creed refers.

## *"Rambo Is a Pussy": Stars and Masculinity*

The phenomenon of stardom provides a useful starting point for thinking about the performative aspects of masculinity in the cinema, perhaps because spectacle, performance, and acting all function as both constitutive components of stardom and significant terms in those writings concerned with the sexual politics of representation. Within the action cinema the figure of the star as hero, larger than life in his physical abilities and pin-up good looks, operates as a key aspect of the more general visual excess that this particular form of Hollywood production offers to its audience. Along with the visual pyrotechnics, the military array of weaponry and hardware, the arch-villains and the staggering obstacles the hero must overcome, the overblown budgets, the expansive landscapes against which the drama is acted out, and the equally expansive soundtracks, is the body of the star as hero, characteristically functioning as spectacle.[2]

Richard Dyer locates the "central paradox" of stardom as the instability of "the whole phenomenon" which is "never at a point of rest or equilibrium, constantly lurching from one formulation of what being human is to another" (Dyer 1987: 18). Particular star images are no more stable than the phenomenon as a whole. Embracing contradictory elements and constantly shifting the ground, star images present themselves as composed of so many layers, as so many slippages. Performances in films, gossip in newspapers and magazines, publicity that is both sought and

unlooked for: all these elements work to constantly displace and reconfirm our understanding in an endlessly played out revelation of "the truth behind the image."

In this sense the territory of the star image is also the territory of identity, the process of the forging and reforging of ways of "being human" in which a point of certainty is never ultimately arrived at. Inevitably the ongoing formulation and reformulation of ways of "being a man" constitutes an important part of this process. Paradoxically this process sits alongside the absolute certainty with which we often feel able to identify a particular type and to speak about what it may mean—in the context of debates around masculinity John Wayne provides perhaps the most longstanding and oft-cited example, a figure whose meaning seems absolutely fixed.

The two Stallone pictures considered here are more than exemplary since, while any film redefines and works over star images, these movies set out, more or less explicitly, to rewrite their hero/star. Both *Tango and Cash* and *Lock Up* operate in part as attempts to shift the grounding of Sylvester Stallone's star image. The star's publicity began to use new strategies after a series of dents to his public persona: *Rambo III* (1988), something of a disaster with the "untimely" Russian withdrawal from Afghanistan where the film was set, the break-up of his marriage to Brigitte Nielsen, and a wave of bad publicity about being a wimp over his failure to turn up at Cannes, allegedly through fear of becoming a target for terrorism, as well as the accusations that Stallone dodged the draft during the Vietnam War. With a spectacular economy Stallone's image absorbed the wimp tag, using the associations to distance the star from his Rambo persona and present him as a softer, more likeable guy both in "real life" and his films. *Lock Up* was to be an "action picture with heart," something it was felt *Rambo III* hadn't been, whilst *Tango and Cash* was to emphasize a more sophisticated Stallone. His character, Ray Tango, wears suits and spectacles, deals in stocks and early on sets out the terms of a new image by delivering the joke line "Rambo is a pussy."

An attempted redefinition of Stallone's star image in these films is conducted through both the body and the voice. A shift away from the physical, the body as the central component of Stallone's image, is also a move into the verbal and this emphasis, basically the shock value of the fact that the hulk could talk, was echoed and exploited in the surrounding publicity. An *American Film* feature sets about this sort of renegotiation, suggesting that although "you think of Stallone as a heavyweight, up close he appeared more of a middleweight, with quick moves and a light, almost spritely grace." We also learn that for the interview Stallone "spoke quickly," that he wore glasses, was "well-tailored, well-barbered and very smooth of face," and that his voice "was a little higher pitched than usually heard in his movies." The smaller build, the clothed body, the higher pitched voice—all these aspects of Stallone's dress, speech, body, and his new movies are used in this feature-interview in order to distance the star from the macho roles and physical display which made him famous. That these marks of a new image are distinctly feminizing provides a significant gloss on how to sell a male star as something other than a hunk/hulk. With more or less degrees of cynicism and humor, magazine features laid the pitch of a new sensitive Stallone who appeared as an art collector and as an artist, exhibiting and selling his paintings. Within the terms of pop discussions of masculinity at the time the shift can be expressed as one from Neanderthal man to New man.

*Tango and Cash* sets out to be humorous, taking swipes at Stallone's he-man image within a buddy movie format. The film can work with such a redefinition of Stallone's seemingly well-established strong silent type persona, partly because of the presence of Kurt Russell, and also because of its comic tone. *Tango and Cash* plays off two male types in its buddy pairing from the "bad cop, worse cop" scene which serves partly to tell us that, despite the glasses, Tango is no softy, to the boldly (or crudely, depending on your point of view) drawn contrast between the two men's styles. Russell plays out a well-established persona, the macho slob sent up in Carpenter's *Big Trouble in Little China* (1986), worshipped in *Backdraft* (1991). An extraordinary but regular guy, Russell retains a tough guy aura whilst exuding those qualities that pass for normality. The opening sequences of *Tango and Cash* are concerned to establish the differences between the two cop heroes—their offices, guns, clothes, appearance, eating habits, and social graces. Both Ray Tango and Gabriel Cash are media stars, cops who get very public results and who, whilst they have never met, maintain a rivalry over their respective press coverage. Cash dismisses Tango, whose picture is featured in the newspaper, as "Armani with a badge," and Tango's captain paraphrases the press coverage as "Down Town Clown versus Beverly Hills Wop," which about sums it up.

As the film progresses Tango and Cash move from rivalry to friendship, partly drawn together by the plot to frame them, and partly through the character of Kiki/Katherine, Tango's sister. They survive the ordeal of prison together, escape together, and proceed to unmask the conspiracy of drug dealers orchestrated by arch-villain Perret. From the separate press photos we see at the beginning of the film they progress to the final newspaper image, a take-off of *Desperately Seeking Susan*, with the two clasping raised hands. By the end of the film they are finishing each other's sentences. Russell's presence allows for repartee between the two tough guys, swapping jokes in the shower and so on. Giving Stallone a chance to talk and dress up, it is Russell who gets his shirt off within the first few minutes of the film. And it is also Kurt Russell who ends up in female drag, posing as the butch "property" of Tango's sister in order to make a getaway from the club where she is a dancer. Because this is a comic film and there is thus an implicit promise that nothing too "dreadful" is going to happen, there is a space for male and female drag and for jokes about the male image and sexuality which are not permissible within the earnest prison drama of *Lock Up*. Playing upon notions of dressing up and acting out different star images, Tango and Cash are offered as good to look at, "two of the department's most highly decorated officers."

## *Men Without Women:* Lock Up

Of course "men without women" is somewhat misleading since there is a woman in *Lock Up*—there is a woman in all four films, a figure who seems to be necessary even if she has little to say or do. Anxieties to do with difference and sexuality increasingly seem to be worked out over the body of the male hero—an economy in which the woman has little space or function. In *Die Hard 2* Holly McClane (Bonnie Bedelia) is literally suspended in the air until the final minutes of the film, trapped in a stranded plane which circles the airport where the action takes place. If we are seeing the performance of masculinity in these films, the action cinema for the

most part prefers all-male environments as the stage for such a performance, arenas such as sport, prison, and the world of work, including the military and the police force. The family is generally avoided, only rarely occupying much screen time.

*Lock Up* works through some of the most privileged sites for the performance of masculinity, sites which are also charged with homoeroticism. The opening sequence maps out these sites. We see Stallone as Frank Leone at home, a popular local figure with a loving girl friend, Melissa. Light in tone, the opening sequences joke with images of Leone going "to work," his friendly repartee with the prison guard at Norwood playing off what we already know from the film's publicity—that his role in the film is that of a convict rather than a prison guard. The opening credits offer us both Leone's past and his present as he cleans up old framed photographs which offer a nostalgic history of his place within male arenas—messing around with cars, playing football, drinking beer, father and son poses. Through these pictures we see Leone growing up as a regular guy. The activities imaged here are all reprised, in distorted form, on the inside.

*Lock Up* sets out to dramatize brutality and the conflict between desire and the law. Leone, a model prisoner, is abruptly transferred from the relatively open regime of Norwood to the monstrous Gateway prison run by Warden Drumgoole (Donald Sutherland), an old adversary. Drumgoole declares that "You have no rights unless I give them to you. You feel no pleasure unless I tell you you can." Defining hard time as "hell" he promises Leone the "guided tour." A demanding and irrational father, Drumgoole asserts his complete control over the situation. The narrative from this point consists of Drumgoole's attempts to push Leone to the edge, looking for a violation that will keep him in prison, as state (and as Drumgoole's) property. Much of the film consists of outlining Leone's physical and psychological torture, his struggle against this regime and the rules of prison life. One familiar cinematic definition of masculinity constructs restraint, a control over the emotions, as providing a protective performance. Such a pattern quickly becomes apparent in *Lock Up* in which the rules of prison life involve not betraying emotion, looking away—refusing, for the sake of survival, the challenge that a look proposes.

If anxieties to do with sexuality and difference are increasingly worked out over the male body and its commodification as spectacle, then there seem to be two dominant strategies in the action cinema. Resorting either to images of physical torture and suffering or to comedy, the body of the hero, his excessive "masculinity," is subjected to humiliation and mockery at some level. In this sense action movies which echo with straightfaced sincerity and those which resort to comedy may well be operating on similar terrain. *Tango and Cash* and the two *Die Hard* films incorporate comedy, as do action films such as *Lethal Weapon* (1987) and its sequel or those in which Arnold Schwarzenegger dispenses his notorious one-liners. *Lock Up*, by way of contrast, relentlessly stresses the hero's suffering, amplifying a tendency evident in many of Stallone's films.

Within the walls of Gateway the sequences which opened the film and which defined Leone's "normality" are grotesquely reprised. A football game played with the neighborhood kids becomes the vicious game in the prison yard, not a game but a lesson. Leone's work as a car mechanic, signaled both in the photos and in the garage location in which he cleans them, is paraphrased in the cons' loving restoration and the warden's destruction of an old Mustang. It is not the gruesome spell in

solitary that finally drives Leone into an escape attempt, but the threats to those he loves. In Gateway the role of Melissa is taken up by the character of First Base—so named because of his naivety in relation to the prison system, but not without a sexualized overlay. Indeed given the scenario—pin-up bodybuilder type in jail—it's hardly surprising that *Lock Up* draws heavily on homoeroticism. Yet in the action movie the threat of prison is, more or less explicitly, the threat of a homosexuality expressed in terms of violence, rather than the tenderness seen in Leone's friendship with First Base. Spotting a sign of weakness, Drumgoole attempts to use this affection, employing a group of convicts to kill First Base. The scene for this drama is the gym where First Base has his chest crushed by a set of weights. The threatening aspects of these masculine arenas—the football field, the gym—are brought out. With First Base dead, Melissa resumes her role as threatened object. Whilst the film borrows from homoeroticism, delighting in lingering shots of the star's body, physical contact is something else, and Leone can only bring himself to walk around First Base's dead body, reaching out to touch him and pulling away.

Emphasizing the visual at the expense of dialogue—the body of the hero and the prison environment rendered in dramatic lighting, bright and artificial or filtering through from the world outside, with rapid editing, extreme close-ups, and long lingering shots—creates a space in which to enact an intensified emotional drama. One reviewer smirked over Stallone's "fatal fondess for naff montage," referring to the central section in which the cons fix up an old motor car, and the scene in which it is destroyed, both of which are rendered through music and montage. It is only within the montage that Leone and First Base get to touch each other, playing games and spraying each other with water as they work together. One wonders, however, what there is to say within this situation, and also what is unsayable.

## *Problems of Place:* Die Hard

The primacy of the body and of the voice, and the different masculine identities they propose, are played off against each other in these four films. In conceptualizing the relationship between masculinity and power the ability to speak is fundamental. Securing a position to speak from is crucial in order to invest the voice with authority. It is in part the search for such a position, one that John McClane ultimately usurps, that is enacted in both *Die Hard* and *Die Hard 2.*

In the action cinema struggles over position and authority, military rank for example, serve metaphorically as a space for the problematics of class. Such an articulation is reasserted and modified through the body of the hero, a uniform which may protect him. In this sense the body of the hero, produced as spectacle, is invested with potent signifiers of class. Commenting on Stallone's *Rocky* cycle of films, Valerie Walkerdine speaks of boxing as turning "oppression into a struggle to master it, seen as spectacle" (Burgin et al. 1986: 172). This production of both struggle and labor as spectacle is central to the articulation of a class-based definition of masculinity in the action cinema. If muscles are signifiers of both struggle and traditional forms of male labor, then for many critics the muscles of male stars seem repulsive and ridiculous precisely because they seem to be dysfunctional, "nothing more" than decoration, a distinctly unmanly designation. The body of the hero may seem dysfunctional, given a decline in the traditional forms of labor that he is called

on to perform, but also essential in a last stand, operating as both affirmation and decoration. A paradox is played out through the figure of the powerful hero who operates in a situation beyond his control, in which he is in many senses powerless.

A rather different set of negotiations is at work over Bruce Willis's star image in *Die Hard*, a film which capitalizes on the wise-cracking persona derived from his role in the hit TV series *Moonlighting*. This comedy/drama/detective series centered on the Blue Moon detective agency, though little in the way of detection ever happened, and the action consisted mostly of verbal confrontations between Willis and Cybill Shepherd in a variety of guises. Whilst *Die Hard* gives us Bruce Willis as action hero pin-up, his persona is very much defined through the voice, more wise-guy than tough-guy. Willis scored a huge success, for example, as the voice of baby Mikey in *Look Who's Talking* (1989). Indeed the particular type of masculine identity that Willis enacts as John McClane in these films has something childlike about it, a trait shared with his role in *Moonlighting*. A perpetual adolescent, even if a knowing one, there is a sense in which he seems to be playing games (cops and robbers, cowboys and Indians). *Die Hard* has Willis/McClane cracking jokes to himself along with a facial expression which carries a sense of surprise and confusion that these explosive events are happening to him.

For much of the film he communicates with both the "terrorists" and the world outside through a radio taken off one of the bodies. Not wishing to reveal his name over the air, he is asked to choose an identity for himself. The chief "terrorist," Hans Gruber (Alan Rickman), taunts McClane in an attempt to discover his identity— "Just another American who saw too many movies as a child. An orphan of a bankrupt culture who thinks he's John Wayne, Rambo, Marshall Dillon?"—before finally settling on a contemptuous "Mr. Cowboy." Searching for an appropriate reference point, and refusing those that are offered to him, McClane styles himself as Roy Rogers, the singing cowboy. McClane acts out this role and keeps up a running commentary at the same time—a variety of self-aware performance which fits well with Willis's image, his self-mocking macho bravado.

It is perhaps the failure of work, the lack of effectivity with which his efforts are greeted that, as much as anything, allows an understanding of the cynical vision of the populist hero that emerged in the 1960s and 1970s and which is crucial to the characterization of John McClane in the two *Die Hard* films. This characterization is marked by both the hero's frustration and his ultimate triumph. In *Die Hard* John McClane is a New York cop in Los Angeles and, while he has transferred to the LAPD for *Die Hard 2*, the drama is enacted in Washington. In both cases he has no official place, as a stream of officials and bureaucrats insist on pointing out.

The narrative of *Die Hard* operates around the terms of performance with a mis-recognition at its heart. The film centers on the Nakatomi Corporation's building in Los Angeles which is taken over by a group of assorted European "terrorists." McClane happens to be in the building attempting a reconciliation with his wife, Holly, who is Nakatomi's number two executive. McClane's interventions are unwelcome not only to the "terrorists" but to the Los Angeles police and the FBI gathered outside. The terrorists' entire plan revolves around their faith in the FBI machine. Sticking to a well-worn operational routine for dealing with a hostage situation, the FBI cut all power to the building, thus breaking the final time-lock on the company safe which the gang can't crack from within. The FBI, assuming the gang are terrorists, act according to the book

and in the process play their part in the heist. Both groups attempt a double-cross, and the lone cop hero is stranded in the middle. Such a structure is also used in McTiernan's earlier film *Predator* (1987) in which Schwarzenegger's crack military squad, thinking they're being tracked by enemy agents as they plough through an unspecified jungle location, act accordingly. Not realizing that they are in a science-fiction movie and that what's killing them off is a chameleon-like monster, they are unable to take effective action.

*Die Hard 2*, set in Dulles International Airport, continues the double bluff used by its predecessor, so that the crack military team brought in to deal with the evolving terrorist crisis are themselves in on the caper. The plot centers on the attempts of a military group led by Col. Stewart to prevent the film's Noriega figure from being put on trial in the United States. Once more bureaucracy seems to present insurmountable obstacles for the hero. The airport police and authorities exclude him from their discussions; having him removed from the center of operations by security guards, they effectively attempt to prevent him from being heroic. McClane needs the help of the janitor, located in a private subterranean realm below the airport itself, to save the day. After his exploits at Nakatomi McClane is now a media star, as is his opponent Col. Stewart, and he is told not to "believe his own press," articulating a suspicion that McClane is acting up to a fabricated image of himself as hero. In a further layer of complexity the head of the anti-terrorist unit, Major Grant (John Amos), initially gains McClane's trust precisely by playing the anti-bureaucracy card so effectively as a cover, presenting himself as a no-nonsense soldier. McClane himself uses the jargon in order to fingerprint a corpse, telling the bemused orderlies that he's "Got a new SOP for DOA's from the FAA."

By and large the hero of the recent action cinema is not an emissary of the State or, if he is, the State is engaged in a double-cross, as in *Rambo* (1985). The hero may be a policeman or a soldier but he more often than not acts unofficially, against the rules and often in a reactive way, responding to attacks rather than initiating them. The hero recognizes that he is, as Rambo puts it, "expendable." Representatives of the State utter myriad variants on the line, "this mission never existed." In the *Die Hard* films McClane, like so many action heroes, opposes himself to authorities that are both bureaucratic and duplicitous.

The body of the hero, though it may be damaged, represents almost the last certain territory of the action narrative. In hits like *Robocop* (1987) and *Total Recall* (1989) neither the body nor the mind is certain, both being subject to State control within a science-fiction dystopia. There is a moment in *Total Recall* when Schwarzenegger's character is asked to step back and consider his position—is he an intergalactic spy caught up in an intergalactic conspiracy as he claims, or is he just an ordinary manual laborer with paranoid delusions as they claim? The moment is funny partly because we don't know very certainly as viewers ourselves, though we can guess what Arnie's reaction is likely to be, but also because as a star and as a character within the film Schwarzenegger inhabits both positions—an extraordinary ordinary guy caught up in a nightmare narrative.

Similar problems of identity afflict Murphy/Robocop in Verhoeven's earlier film. Such images draw on the generic currency of science fiction, and whilst the films considered here emerge from the tradition of the war film and the political thriller, they are similarly conspiratorial. When all else fails, the body of the hero,

and not his voice, his capacity to make a rational argument, is the place of last resort. That the body of the hero is the sole narrative space that is safe, that even this space is constantly under attack, is a theme repeatedly returned to within the action cinema.

## Performance, Identity, and the Cinematic: Some Conclusions

The action cinema is often seen as the most "Neanderthal," the most irredeemably macho of Hollywood products. I've tried to argue that the films considered here work out a series of problematics to do with class and with sexuality, and that this is situated within a cultural context in which masculinity has been, to an extent, denaturalized. The psychoanalytic notion of homeovestism, defined as "a perverse behaviour involving wearing clothes of the same sex," is useful in this respect (Zavitzianos 1977: 489). In the cases Zavitzianos describes the use of garments associated with paternal authority, and most particularly uniforms associated with sports and the military, provides a way to stabilize body image, to relieve anxiety and to raise self-esteem. Of course Zavitzianos, in an all too familiar clinical tone, tells us that with treatment "the homeovestite may improve and evolve from a homosexual object to a heterosexual one." Maybe it is precisely because the boundaries between different categories come so close in this structure that talk of improvement is felt to be necessary. The paraphernalia of masculine uniforms and identities is nonetheless seen as part of a fantasy structure which is invented. Psychoanalysis, at least potentially, offers a structure which allows for the possibility of moving beyond any simple opposition between perversion and normality as they are commonly construed.

A less pathologizing version of this notion is to be found in Lacan's concept of male parade, in which the accoutrements of phallic power, the finery of authority, belie the very lack that they display. In a similar way the muscular male body functions as a powerful symbol of desire and lack, heroism as a costume. Within the narratives which I have discussed here the position of the father, a position of authority, lacks credibility in various ways. This lack of credibility is part of a denaturalization of masculinity and its relation to power, a shift that can be seen to be enacted in the virtually woman-free zone of the action narrative. Whilst it is played out on a huge stage, McClane's despairing struggle is also a small drama, a family drama. Both *Die Hard* and *Die Hard 2* draw to a close with McClane searching for his wife amongst the debris, covered in blood and crying out her name, seeming like nothing so much as a child. Indeed while Holly McClane provides the term which holds the narrative together, since neither the job of cop nor patriotism provides the hero's motivation, they are rarely together, the moment of reunion constantly postponed. Only once, in the first film, do we see the family together, with McClane as a father—glimpsed as an image, a framed photograph in Holly's office.

Postmodernity, whatever else it is taken to designate, signals significant shifts in the definition of work and the masculine identity that it proposes. Postmodernism also calls into question the production and status of knowledge and categories of truth. These developments help to situate and historicize the shifts in Hollywood's representation of the male hero. In turn Andy Medhurst has characterized postmodernism as the heterosexual version of camp, a discourse in which both the play of multiple identities and acts of appropriation are fundamental. Sincerity, says Medhurst, is

"the ultimate swearword in the camp vocabulary" since while it "implies truth; camp knows that life is composed of different types of lie" (Medhurst 1990: 19).

This suggestion returns me to those suspicions that cast doubt on the possibility of making a distinction between a parodic performance of masculinity and the oppressive enactment of that performance. To say that the enactments of masculinity seen in the action cinema seem like nothing so much as a series of exercises in male drag could well fall foul of such a criticism, since it is the awareness of performance that distinguishes the masquerade from sociological conceptions of social roles. Yet, within the cinema, whose awareness are we speaking about—the producers', the stars', the audience's? When Rae Dawn Chong, watching Schwarzenegger strut his stuff in *Commando* (1985), sighs "I don't believe this macho bullshit," whom is she speaking to? There are a whole range of experiences and identities—those of lesbian and gay audiences, of black and Asian audiences, of all the margins that make up the center—that are rarely addressed directly by the Hollywood cinema in the way that white men seem to be.[3] Yet the enactment of a drama of power and powerlessness is intrinsic to the anxieties about masculine identity and authority that are embodied in the figure of the struggling hero.

## NOTES

My thanks to Val Hill for all her help in thinking through these ideas.

1. Obviously these comments apply most particularly to big-budget action movies.

2. Though it is important to note that the success of action pictures, such as the *Rambo* series, is not limited to the West.

3. Of course Hollywood doesn't constitute the totality of cinema, though it provides the focus for this essay. We should also note that there is an important tradition of black American action narratives, made both within Hollywood formulas and in modes derived from the Hong Kong cinema. The Hong Kong martial arts tradition itself, as well as the white western versions of it that have appeared through the 1980s, remain immensely popular. In my experience these films are often only accessible through the video market. Generally made on relatively low budgets and often falling foul of the British censors, such films nevertheless provide an important counterpoint to Hollywood's action entertainment tradition.

## BIBLIOGRAPHY

Boone, J. and Cadden, M., eds (1990) *Engendering Men: the Question of Male Feminist Criticism*, London: Routledge.

Burgin, V., Donald, J. and Kaplan, C., eds (1986) *Formations of Fantasy*, London: Routledge.

Creed, B. (1987) "From Here to Modernity: Feminism and Postmodernism," *Screen* 28, 2: 47–67.

Dyer, R. (1982) "Don't Look Now," *Screen* 23, 3–4: 61–73.

____ (1987) *Heavenly Bodies: Film Stars and Society*, London: BFI/Macmillan.

King, S. B. (1990) "Sonny's Virtues: the Gender Negotiations of *Miami Vice*," *Screen* 31, 3: 281–95.

Medhurst, A. (1990) "Pitching Camp," *City Limits*, May 10–17: 19.

Zavitzianos, G. (1977) "The Object in Fetishism, Homeovestism and Transvestism," *International Journal of Psycho-Analysis* 58: 487–95.

# B. RUBY RICH

## New Queer Cinema

B. Ruby Rich is Professor of Community Studies and the head of the Social Documenta-
tion Program at the University of California, Santa Cruz, having entered academia after
a distinguished career working in independent film as an exhibitor, funder, curator, and
critic. She is well known for her writing on lesbian, gay, bisexual, and transgender (LGBT)
film in the *Village Voice*, *Sight & Sound*, and other publications; she has also published
widely on documentary and Latin American and Latino/a cinema. Her groundbreaking
work in feminist film theory and criticism is gathered in her book *Chick Flicks: Theories and
Memories of the Feminist Film Movement* (1998).

Always a keen trend-spotter, Rich coined the term "New Queer Cinema" in this 1992
essay after a panel she moderated at the Sundance Film Festival. Important gay directors
like Derek Jarman and Isaac Julien were in attendance, and films by self-identified queer
directors Tom Kalin and Gregg Araki premiered that year at the influential independent
film festival, following the breakout success of Todd Haynes's *Poison* (1991) and Jennie
Livingston's *Paris Is Burning* (1990) there the year before. These often formally challeng-
ing and politically daring films flourished in the context of a burgeoning international
LGBT film festival network, AIDS media activism, and the emergence of queer theory in
the academy. It was also a moment in the American film industry when "mini-majors"—
independent distributors like Miramax and specialty arms of the studios—were willing
to take risks on gay films for the arthouse market for the first time. Despite the continu-
ing visibility of cutting-edge films by producer Christine Vachon (*Boys Don't Cry* [1999],
*Hedwig and the Angry Inch* [2001]) and breakthrough features by lesbians of color (*Go
Fish* [1994], *The Watermelon Woman* [1996]), critics soon perceived that the experimental
edge of the movement had been blunted by market success, with premium cable and then
network television producing gay programming by the end of the 1990s. A number of
books on the topic of New Queer Cinema have since appeared, and Rich herself revisits
the moment in a later essay, "Queer and Present Danger."

In her manifesto, "New Queer Cinema," Rich identifies queer sexuality with chal-
lenges to film form, acknowledging the long history of affinity between sexual dissidents
and experimental film (exemplified by Jean Cocteau, Andy Warhol, and R. W. Fassbinder).
She applauds the new works' defiance of previous efforts simply to promote "positive"
gay and lesbian images in the media and identifies a common interest in rewriting history
along with narrative norms. However, as a feminist critic, she is also attuned to the fact
that most of the successful films of the movement were theatrically released feature films
directed by men. Lesbian artists like Sadie Benning, also on the 1992 Sundance panel,
tended to work in the cheaper format of video, addressing community (and, perhaps
ironically, art museum) audiences rather than mainstream ones. The adoption of digital
video formats later in the decade would transform the dichotomy Rich sees between the
prestigious medium of film and do-it-yourself analog video. Rich's piece, exemplary of the
kind of engaged writing that exciting developments in film culture can foster, brings film
theory into the public sphere. It also serves as a tribute to Jarman, who died in 1994.

## READING CUES & KEY CONCEPTS

■ Rich cites a long tradition of queer involvement in the film underground. How does she link formal with sexual experimentation?

■ "The tragedy and trauma of AIDS" drove queer cultural production in the 1980s and 1990s. What are some of the connections between political activism and media access?

■ What are some of the divisions and compromises brought about by economic success for gay films, according to Rich? Consider them in relation to recent examples of mainstream media featuring LGBT themes and characters.

■ **Key Concepts:** Queer; Independent Film; AIDS Activism; Historiography; Video

# New Queer Cinema

A nyone who has been following the news at film festivals over the past few months knows, by now, that 1992 has become a watershed year for independent gay and lesbian film and video. Early last spring, on the very same day, Paul Verhoeven's *Basic Instinct* (1992) and Derek Jarman's *Edward II* (1991) opened in New York City. Within days, the prestigious New Directors/New Films Festival had premiered four new "queer" films: Christopher Münch's *The Hours and Times* (1991), Tom Kalin's *Swoon* (1992), Gregg Araki's *The Living End* (1992) and Laurie Lynd's *R.S.V.P.* (1991). Had so much ink ever been spilled in the mainstream press for such a cause? *Basic Instinct* was picketed by the self-righteous wing of the queer community (until dykes began to discover how much fun it was), while mainstream critics were busily impressed by the "queer new wave" and set to work making stars of the new boys on the block. Not that the moment isn't contradictory: this summer's San Francisco Gay and Lesbian Film Festival had its most successful year in its sixteen-year history, doubling attendance from 1991, but the National Endowment for the Arts pulled its funding anyway.

The queer film phenomenon was introduced a year ago at Toronto's Festival of Festivals, the best spot in North America for tracking new cinematic trends. There, suddenly, was a flock of films that were doing something new, renegotiating subjectivities, annexing whole genres, revising histories in their image. All through the winter, spring, summer, and now autumn, the message has been loud and clear: queer is hot. Check out the international circuit, from Park City to Berlin to London. Awards have been won, parties held. At Sundance, in the heart of Mormon country, there was even a panel dedicated to the queer subject, hosted by yours truly.

The Barbed Wire Kisses panel put eight panelists on stage, with so many queer filmmakers in the audience that a roll call had to be read. Filmmakers stood, one by one, to applause from the matinee crowd. "Sundance is where you see what the industry can bear," said panelist Todd Haynes, there to talk about *Poison*'s year on the firing-line. He stayed to be impressed by earnest eighteen-year-old Wunderkind Sadie Benning, whose bargain-basement videos, shot with a Fisher-Price Pixelvision

and produced for less than $20 apiece, have already received a retrospective at MoMA.

Isaac Julien was suddenly cast in the role of the older generation. Summarizing the dilemmas of marketing queer product to general audiences, he described a Miramax Prestige advertising campaign for his *Young Soul Rebels* (1991) that used a bland image of guys and gals hanging out, like a Newport ad gone Benetton. Julien got them to change to an image of the black and white boyfriends, Caz and Billibud, kissing on a bed. The box office improved.

Tom Kalin struggled to reconcile his support for the disruptions of *Basic Instinct*'s shoot last spring with his film *Swoon*'s choice of queer murderers as subjects. Australian filmmakers Stephen Cummins and Simon Hunt related the censorship of an episode of *The Simpsons* down under, where a scene of Homer kissing a swish fellow at the plant was cut. The panel turned surprisingly participatory. One Disney executive excoriated the industry. A filmmaker called for a campaign to demand that Oliver Stone not direct his announced biopic of Harvey Milk (now being directed by Gus Van Sant, with Stone as co-producer). Meanwhile, Derek Jarman, the grand old man in his fourth decade of queer activity, beamed. He'd never been on a panel of queers at a mainstream festival.

Try to imagine the scene in Park City. Robert Redford holds a press conference and is asked, on camera, why there are all these gay films at his festival. Redford finesses: it is all part of the spectrum of independent film that Sundance is meant to serve. He even allows that the awards last year to *Poison* (1991) and Jennie Livingston's *Paris Is Burning* (1990) might have made the festival seem more welcoming to gays and lesbians. He could just as easily have said: these are simply the best films being made.

Of course, the new queer films and videos aren't all the same, and don't share a single aesthetic vocabulary or strategy or concern. Yet they are nonetheless united by a common style. Call it "Homo Pomo": there are traces in all of them of appropriation and pastiche, irony, as well as a reworking of history with social constructionism very much in mind. Definitively breaking with older humanist approaches and the films and tapes that accompanied identity politics, these works are irreverent, energetic, alternately minimalist and excessive. Above all, they're full of pleasure. They're here, they're queer, get hip to them.

All the same, success breeds discontent, and 1992 is no different from any other year. When the ghetto goes mainstream, malaise and paranoia set in. It can be ideological, or generational, or genderational. Consider the issues that might disturb the peace. What will happen to the lesbian and gay filmmakers who have been making independent films, often in avant-garde traditions, for decades already? Surprise, all the new movies being snatched up by distributors, shown in mainstream festivals, booked into theaters, are by the boys. Surprise, the amazing new lesbian videos that are redefining the whole dyke relationship to popular culture remain hard to find.

Amsterdam's Gay and Lesbian Film Festival made these discrepancies plain as day. The festival was staged last November, wedged between Toronto and Sundance. It should have been the most exciting place to be, but wasn't, not at all. And yet, that's where the girls were. Where the videos were. Where the films by people of color and ex-Iron Curtain denizens were. But the power brokers were missing.

Christine Vachon, co-producer of *Swoon* and *Poison*, is sure that the heat this year has been produced by money: "Suddenly there's a spotlight that says these films can be commercially viable." Still, everyone tries to guess how long this moment of fascination will last. After all, none of this is taking place in a vacuum: celebrated in the festivals, despised in the streets. Review the statistics on gay-bashing. Glance at would-be presidential candidate Pat Buchanan's demonizing of Marlon Riggs' *Tongues Untied*. Check out U.S. immigration policy. Add the usual quota of internecine battles: girls against boys, narrative versus experimental work, white boys versus everyone else, elitism against populism, expansion of sights versus patrolling of borders. There's bound to be trouble in paradise, even when the party's just getting going.

## *Dateline: Toronto*

Music was in the air in Toronto in September 1991, where the reputation of queer film and video started to build up. Or maybe I just loved Laurie Lynd's *R.S.V.P.* because it made my elevator ride with Jessye Norman possible. Lynd's film uses Norman's aria from Berlioz's *Les Nuits d'été* as its madeleine—supposedly Lynd sent Norman the finished film as a belated form of asking permission, and she loved it so much she agreed to attend the world premiere at Toronto (with red carpet in place and a packed house going wild, she sat through the screening holding Lynd's hand). *R.S.V.P.* suggests that the tragedy and trauma of AIDS have led to a new kind of film and video practice, one which takes up the aesthetic strategies that directors have already learned and applies them to a greater need than art for its own sake. This time, it's art for our sake, and it's powerful: no one can stay dry-eyed through this witty elegy.

Lynd was there as a producer, too, having worked on fellow-Canadian John Greyson's *The Making of "Monsters."* In it, George Lukács comes out of retirement to produce a television movie and hires Bertolt Brecht to direct it. Along with the comedy and boys in briefs, there's a restaging of the central aesthetic argument of the Frankfurt School as it might apply to the crises of representation engendered by today's antigay backlash, violence, and television treatments of the AIDS era.

Both low-budget and high-end filmmaking showed up in Toronto. Not surprisingly, the guys were high end, the gals low. Not that I'd begrudge Gus Van Sant one penny or remove a single frame from *My Own Private Idaho*—a film that securely positions him as heir-apparent to Fassbinder. So what if it didn't get a single Oscar nomination? At the other end of the spectrum was veteran avant-gardist Su Friedrich, whose latest film, *First Comes Love*, provoked catcalls from its largely queer audience. Was it because its subject was marriage, a topic on which the film is healthily ambivalent, mingling resentment with envy, anger with yearning? Or was it an aesthetic reaction, since Friedrich returns to a quasi-structuralist mode for her indictment of institutionalized heterosexuality and thus possibly alienates audiences accustomed to an easier queer fix? Was it because the director was a woman, since the only other lesbian on hand was Monika Treut, who by now should probably be classified as post-queer? Whatever the reason, Friedrich's elegant short stuck out, a barometer in a pack of audience-pleasers.

The epiphanic moment, if there was one, was the screening of Jarman's *Edward II*, which reinscribed the homosexuality so integral to its sixteenth-century source via a syncretic style that mixed past and present in a manner so arch that the film easily

fits its tag, the "QE2." Think pastiche, as OutRage demos and gay-boy calisthenics mix with minimalist period drama. Homophobia is stripped bare as a timeless occupation, tracked across centuries but never lacking in historical specificity. Obsessive love, meanwhile, is enlarged to include queer desire as a legitimate source of tragedy.

For women, *Edward II* is a bit complicated. Since the heroes are men and the main villain is a woman, some critics have condemned it as misogynist. Indeed, Tilda Swinton's brilliance as an actor—and full co-creator of her role—invests her character with more weight, and thus more evil, than anyone else on screen. But the film is also a critique of heterosexuality and of a world ruled by royals and Tories, and Isabella seems more inspired by Thatcher than woman-hating. Annie Lennox is clearly meant to be on the side of girls and angels. Her solo "Every Time We Say Goodbye" accompanies Edward and Gaveston's last dance, bringing grandeur, modernity, even postmodernity, to their tragedy. The song comes from the AIDS-benefit album, *Red Hot and Blue*, in which video Lennox inscribed images of Jarman's childhood in a tribute to his activism and HIV status. Thus does Jarman's time travel insist on carrying the court into today's gay world.

## Dateline: Amsterdam

The official car showed up at the airport with the festival's own steamy poster of girls in heat and boys in lust plastered all over it. Amsterdam, city of lights for faggots and dykes, offered the promise of an event purely one's own in the city celebrated for queerness. Expectations were running high, but in fact the festival showed all the precious advantages and irritating problems that life in the ghetto entails. It was a crucible for queer work, all right, but some got burned. How does this event fit into the big picture set by the "big" festivals? Well, it doesn't. The identity that elsewhere becomes a badge of honor here became a straitjacket. But would "elsewhere" exist without the "here"?

Amsterdam was an exercise in dialectics in action, with both pleasures and dangers. Filmmaker Nick Deocampo from the Philippines was planning his country's first gay festival and hoping that the "war of the widows" wouldn't forestall it. Race, status, romance, gender, even the necessity of the festival came up for attack and negotiation, on those few occasions when the public got to talk back. Pratibha Parmar affirmed the importance of a queer circuit—"my lifeline"—sure that it's key to the work. Jarman disagreed: "Perhaps their time is up," maybe life in the ghetto now offers diminished returns. So though Jarman and Ulrike Ottinger got awards here, and though Jarman used the opening night to call for the decriminalization of Oscar Wilde, the meaning of such an event remained contested.

Not that there weren't good films at Amsterdam. But the best work seemed to come from long ago or far away, like the great shows of German cross-dressing movies or the Mary Wings tribute to "Greta Garbo's lesbian past" or the extraordinary '60s fantasy from Japan, *Funeral [Parade] of Roses*. There were even two terrific new lesbian films, both deserving of instant cult status. Cleo Uebelmann's *Mano Destra* brought bondage and domination straight to the viewer, serving up knot-fetishism and the thrills of specular anticipation with an uncanny understanding of cinema's own powers. From a trio of Viennese filmmakers (Angela Hans Scheirl, Dietmar Schipek, Ursula Puerrer) came *Flaming Ears*, a surreal fable that draws on comics and sci-fi traditions for a near-human love story visualized in an atmosphere of

cabaret, rubble and revenge. Its fresh "cyberdyke" style reflects Austrian sources as diverse as Valie Export and Otto Muehle, but shot through with Super-8 visual rawness and a script that could have been written by J. G. Ballard himself.

It was a shame that the Dutch press marginalized the festival, because the kind of "scoop" that the *New York Times* and *Newsweek* would later find in Utah could have been theirs right at home. A new kind of lesbian video surfaced here, and with it emerged a contemporary lesbian sensibility. Like the gay male films now in the limelight, this video has everything to do with a new historiography. But where the boys are archaeologists, the girls have to be alchemists. Their style is unlike almost anything that's come before. I would call it lesbian camp, but the species is, after all, better known for camping. And historical revisionism is not a catchy term. So just borrow from Hollywood, and think of it as the Great Dyke Rewrite.

Here's a taste of the new genre. In Cecilia Dougherty's *Grapefruit*, white San Francisco dykes unapologetically impersonate John, Yoko and the Beatles—proving that appropriation and gender-fuck make a great combination. Cecilia Barriga's *The Meeting of Two Queens* re-edits Dietrich and Garbo movies to construct the dyke fan's dream narrative: get the girls together, help them get it on. It's a form of Idolatry that takes the feminist lit-crit practice of "reading against the grain" into new image territory, blasting the results on to the screen (or monitor, to be exact). In one episode of Kaucylia Brooke and Jane Cottis' *Dry Kisses Only*, Anne Baxter's backstage meeting with Bette Davis in *All About Eve* is altered, inserting instead of Baxter a dyke who speaks in direct address to the camera about her tragic life, her life working in a San Francisco lesbian bar, her love lost to Second World War combat. She's cross-cut with Bette's reaction shots, culminating with Davis taking her arm (and taking her home).

Apart from the videos, festival lesbians pinned all voyeuristic hopes on the "Wet" Party, where they would finally get to the baths. Well, sort of. Everyone certainly tried. Outfits ranged from the campiness of childhood-at-the-beach to show-your-leather seriousness. Women bobbed in the pool, playing with rubber rafts and inflated black and white fuck-me dolls. (Parmar would later note that there were more inflatables of color in attendance than actual women of color.) San Francisco sex-stars Shelly Mars and Susie Bright both performed, though the grand moment in which Bright seemed to be lecturing us on "Oedipal underwear" turned out to be a cruel acoustical joke: she was actually extolling the virtue of *edible* underwear. But the back rooms were used for heart-to-hearts, not action. Caught between the states of dress-up and undress, everyone waited for someone else to do something.

Other parties offered other pleasures. At one, Jimmy Somerville, unscheduled, did a Sylvester homage. At another, Marilyn Monroe appeared, frosted on to a giant cake, clutching her skirt, only to be carved up by a gaggle of male chefs. In the end, somehow, Amsterdam was the festival you loved to hate, the place where everyone wanted the world and wouldn't settle for less, where dirty laundry could be washed in public and anyone in authority taken to task, where audiences were resistant to experimental and non-narrative work, and where criticisms were bestowed more bountifully than praise. Still, while the market place might be seductive, it's not yet democratic. Amsterdam was the place where a "Wet" Party could at least be staged, where new works by women and people of color were accorded pride of place, where video was fully integrated into the programming. Amsterdam was a ritual gathering of the tribe and, like a class reunion, filled with ambivalence.

## *Park City, Utah*

Everything came together at the Sundance Film Festival in Park City. Christopher Münch's *The Hours and Times* is a good example. Audiences fell in love with this imaginary chronicle of Brian Epstein and John Lennon's last tango in Barcelona. Münch's camera style and script are a reprise of *cinéma vérité*, as though some dusty reels had been found in a closet in Liverpool and expertly edited, as though Leacock or Pennebaker had turned gay-positive retroactively. Epstein tries to get Lennon into bed, using old-world angst, homo-alienation, Jewish charm. Lennon tries to sort out his life, balancing wife Cynthia against groupie against Epstein, trying to have it all and to figure out whatever will come next. Just a simple view of history with the veil of homophobia pulled back. It's rumored that the dramatic jury at Sundance loved it so much, they wanted to give it the Grand Prize—but since it wasn't feature length they settled on a special jury award.

"Puts the Homo back in Homicide" is the teaser for Tom Kalin's first feature, *Swoon*, but it could easily apply to Gregg Araki's newest, *The Living End*, as well. Where Kalin's film is an interrogation of the past, Araki's is set resolutely in the present. Or is it? Cinematically, it restages the celluloid of the '60s and '70s: early Godard, *Bonnie and Clyde*, *Badlands*, *Butch Cassidy and the Sundance Kid*, every pair-on-the-run movie that ever penetrated Araki's consciousness. Here, though, the guys are HIV positive, one bored and one full of rage, both of them with nothing to lose. They could be characters out of a porn flick, the stud and the john, in a renegotiated terrain. Early Araki films are often too garage-band, too boychick, too far into visual noise, but this one is different. Camera style and palette update the New Wave. Araki's stylistic end runs have paid off, and this time he's got a queers-on-the-lam portrait that deserves a place in movie history—an existential film for a post-porn age, one that puts queers on the map as legitimate genre subjects. It's quintessentially a film of its time.

And so is *Swoon*, though it might seem otherwise, what with the mock-period settings, the footage purloined from the '20s, and the courtroom-accurate script, based on the 1924 Chicago trial of Leopold and Loeb, the pair of rich Jewish boys who bonded, planned capers, and finally killed a boy. In the wake of the Dahmer case, it would be easy to think of this as a film about horrific acts. *Swoon*, however, deals in different stakes: it's the history of discourses that's under Kalin's microscope, as he demonstrates how easily mainstream society of the '20s could unite discrete communities of outsiders (Jews, queers, blacks, murderers) into a commonality of perversion. The whole look of the film—director of photography Ellen Kuras won the prize for cinematography in dramatic film in Park City—emphasizes this view with the graphic quality of its anti-realism, showing how much Kalin, Kuras and co-producer Vachon tailored its look.

As part of a new generation of directors, Kalin isn't satisfied to live in the past, even a post-modern past. No, *Swoon* takes on the whole enterprise of "positive images," definitively rejecting any such project and turning the thing on its head. I doubt that anyone who damned *The Silence of the Lambs* for toxic homophobia will swallow *Swoon* easily, but hopefully the film will force a rethinking of positions. Claim the heroes, claim the villains, and don't mistake any of it for realness.

Throughout Sundance, a comment Richard Dyer made in Amsterdam echoed in my memory. There are two ways to dismiss gay film: one is to say, "Oh, it's just a gay film"; the other, to proclaim, "Oh, it's a great film, it just happens to be gay." Neither

applied to the films in Park City, since they were great precisely because of the ways in which they were gay. Their queerness was no more arbitrary than their aesthetics, no more than their individual preoccupations with interrogating history. The queer present negotiates with the past, knowing full well that the future is at stake.

Like film, video is a harbinger of that future, even more so. Yet Sundance, like most film festivals, showed none. To make a point about the dearth of lesbian work in feature film and to confront the industry with its own exclusions, the Barbed Wire Kisses panel opened with a projected screening of Sadie Benning's videotape *Jollies*—and brought down the house. With an absolute economy of means, Benning constructed a *Portrait of the Artist as a Young Dyke* such as we've never seen before. "I had a crush. It was 1978, and I was in kindergarten." The lines are spoken facefront to the camera, black-and-white images floating into the frame alongside the words enlisted to spell out her emotions on screen, associative edits calling settled assumptions into question.

The festival ended, of course. Isaac Julien returned to London to finish *Black and White in Colour*, his documentary on the history of blacks in British television. High-school dropout Sadie Benning left to show her tapes at Princeton, and to make another one, *It Wasn't Love*, that proves she's no fluke. Derek Jarman and Jimmy Somerville were arrested for demonstrating outside parliament. Christopher Münch and Tom Kalin picked up prizes in Berlin. Gregg Araki found himself a distributor. New work kept getting produced: the San Francisco festival found its submissions up by 50 percent in June. The Queer New Wave has come full circle: the boys and their movies have arrived.

But will lesbians ever get the attention for their work that men get for theirs? Will queers of color ever get equal time? Or video achieve the status reserved for film? Take, for example, Cheryl Dunye, a young video-maker whose *She Don't Fade* and *Vanilla Sex* put a sharp, satiric spin on black romance and cross-race illusions. Or keep an eye out for Jean Carlomusto's *L is For the Way You Look*, to catch a definitive portrait of dyke fandom and its importance for, uh, subject position.

For one magical Saturday afternoon in Park City, there was a panel that traced a history: Derek Jarman at one end on the eve of his fiftieth birthday, and Sadie Benning at the other, just joining the age of consent. The world had changed enough that both of them could be there, with a host of cohorts in between. All engaged in the beginnings of a new queer historiography, capable of transforming this decade, if only the door stays open long enough. For him, for her, for all of us.

# LINDA WILLIAMS

# Porn Studies: Proliferating Pornographies On/Scene

Professor of Film Studies and Rhetoric at the University of California, Berkeley, Linda Williams (b. 1946) is a leading scholar in cinema studies, whose book *Hard Core: Power, Pleasure, and the "Frenzy of the Visible"* (second edition, 1999) is one of the earliest and most important discussions of pornography in the academic field. While Williams's scholarly interests

branch in other directions, specifically examining questions of film genre and race (see p. 725 for Williams's other publications), her work on sexuality in film, which continues with *Screening Sex* (2008) and the edited collection *Porn Studies* (2004), is in many ways responsible for mapping a new theoretical field inside and outside the classroom.

While sexually explicit films have been part of film history since the late nineteenth century, recent decades have seen a proliferation and increased visibility of these films. As Williams recognizes, the relaxation of film censorship in the 1960s and, since then, the spread of film culture through videos, DVDs, and the Internet has made both soft-core and hard-core films more accessible and more common. In addition, public sexual scandals (in politics, entertainment, and daily life) now dominate much of the media, making it virtually impossible to ignore the presence and disturbance of sex as a major part of contemporary social life. Besides the massive growth of the pornographic film industry itself, relatively mainstream films, such as *Showgirls* (1995) and *Monster* (2003), and celebrated international auteur movies, such as Stanley Kubrick's *Eyes Wide Shut* (2006) and Lars von Trier's *Antichrist* (2009), have also embraced and pushed the limits of the explicit representation of sexual desires and practices. While these films may not be pornographic per se, as part of a larger culture they call attention to the central importance of examining and discussing the representation of explicit sexuality today.

As an introduction to an anthology of essays on pornography and the media, Williams's "Porn Studies: Proliferating Pornographies On/Scene" provides an excellent framework for theoretically considering and debating pornography. On the one hand, the essay identifies many of the contemporary social debates around the issue, both liberal and conservative, such as whether or not pornography incites violence against women. On the other hand, it sketches a theoretical path whereby we can begin "to take pornography seriously" as a cultural form. As the foundation for this effort, Williams insists that what was once considered obscene (literally, "off scene") should now be re-engaged as fully visible within the public sphere, as a kind of "on/scenity" where traditionally taboo images, facts, and questions become an open and visible part of culture. Finally, this essay offers a too rare example of how historical and theoretical debates can be made part of a college classroom, that is, how a theoretical argument might be tested and adjusted as part of everyday pedagogy. Pedagogical experience suggests that even a relatively provocative topic necessarily, if implicitly, builds on and rethinks a variety of other positions in contemporary film and media theory, including the work of theorists like Laura Mulvey (p. 713), Carol J. Clover (p. 511), and B. Ruby Rich (p. 767).

## READING CUES & KEY CONCEPTS

■ According to Williams, how has the notion of pornography changed historically, and how might its definition change from culture to culture?

■ To what extent does a feminist position offer a productive perspective on pornography— or not?

■ Consider what the challenges and advantages of teaching pornography as a theoretical and cultural issue might be. What are its advantages and limits within a classroom?

■ **Key Concepts:** On/Scene; Ob/Scene; Good Eroticism versus Bad Pornography; The Pedagogy of Pornography

# Porn Studies: Proliferating Pornographies On/Scene

. . . . . . . . . . . . .

Where once it seemed necessary to argue vehemently against pro-censorship, antipornography feminism for the value and importance of studying pornography (see, for example, the 1990s anthologies *Sex Exposed* and *Dirty Looks*), today porn studies addresses a veritable explosion of sexually explicit materials that cry out for better understanding. Feminist debates about whether pornography should exist at all have paled before the simple fact that still and moving-image pornographies have become fully recognizable fixtures of popular culture.

To me, the most eye-opening statistic is the following: Hollywood makes approximately 400 films a year, while the porn industry now makes from 10,000 to 11,000. Seven hundred million porn videos or DVDs are rented each year. Even allowing for the fact that fewer viewers see any single work and that these videos repeat themselves even more shamelessly than Hollywood (e.g., *Co-ed Cocksuckers 21*, *Talk Dirty to Me 13*, *Dirty Little Sex Brats 14*), this is a mind-boggling figure. Pornography revenues—which can broadly be construed to include magazines, Internet Web sites, magazines, cable, in-room hotel movies, and sex toys—total between 10 and 14 billion dollars annually. This figure, as *New York Times* critic Frank Rich has noted, is not only bigger than movie revenues; it is bigger than professional football, basketball, and baseball put together. With figures like these, Rich argues, pornography is no longer a "sideshow" but "the main event" (2001, 51).[1]

Who is watching all this pornography? Apparently all of us. As the editor of *Adult Video News* puts it: "Porn doesn't have a demographic—it goes across all demographics." The market is "as diverse as America" (Rich 2001, 52). Porn videos are remarkably diverse as well, ranging from the rarefied (S/M, bondage, amputees, geriatric, fat, ethnic, interracial, etc.) to the mainstream hetero product and the enduringly popular gay videos (whose appeal and numbers far exceed the category of a niche market and which are awash with inventive auteurs like Kristen Bjorn, Wash West, Matt Sterling, and others). Along the way there is the smaller niche of lesbian porn (Shar Rednour and Jackie Strano), the seat-of-the-pants, low-budget gonzo of John Stagliano and Ed Powers, and the woman-friendly "erotica" of Candida Royalle.

Mainstream or margin, pornography is emphatically part of American culture, and it is time for the criticism of it to recognize this fact. If feminist debates about the propriety or danger of pornography marked the 1980s and 1990s, along with larger societal debates about censorship in general, the new millennium, in the wake of a remarkably pornographic tale about a president and an intern, has become increasingly used to, if never fully comfortable with, "speaking sex." This is not to say, as I have noted elsewhere, that sexually explicit talk and representation takes place without controversy or embarrassment.[2] We have certainly not attained the "end of obscenity" once optimistically predicted in the late sixties by Charles Rembar (1969). It is to say, however, that long before it surfaced as news from the oval office, speaking sex had ceased to be a private, bedroom-only matter. Today, the very practice of American politics requires a familiarity with the alleged explicit sex acts of Gary Hart, Clarence Thomas, Bill Clinton, Gary Condit, and a great many priests of the Catholic Church. We are compelled to speak sex, whether to protect ourselves

or our children from AIDS or other sexually transmitted diseases, or simply as a result of watching *The Sopranos, Sex in the City*, or *Queer as Folk*. If *Deep Throat* (dir. Gerard Damiano, 1972) and a range of other films discussed by Eric Schaefer, inaugurated a pornographic speaking sex in the early seventies, today, a wide variety of different media have become the venue for the public representation of sex acts. Recently it was possible to view, for example, rock star Tommy Lee and former *Playboy* model Pam Anderson having sex on their honeymoon as still images in *Penthouse* magazine, as streaming video on the Internet Entertainment Group's Web site, and as a home video, *Pam and Tommy: Uncensored and Hardcore*.

Discussions and representations of sex that were once deemed obscene, in the literal sense of being off (*ob*) the public scene, have today insistently appeared in the new public/private realms of Internet and home video. The term that I have coined to describe this paradoxical state of affairs is on/scenity: the gesture by which a culture brings on to its public arena the very organs, acts, bodies, and pleasures that have heretofore been designated ob/scene and kept literally off-scene. In Latin, the accepted meaning of the term *obscene* is quite literally "off-stage," or that which should be kept "out of public view" (*OED*). On/scene is one way of signaling not just that pornographies are proliferating but that once off (*ob*) scene sexual scenarios have been brought onto the public sphere. On/scenity marks both the controversy and scandal of the increasingly public representations of diverse forms of sexuality *and* the fact that they have become increasing available to the public at large.

To me, the most eloquent example of the paradox of on/scenity was staged in the spectacle of Jesse Helms, standing in the U.S. Senate in 1989, waving the "dirty" photographs by Robert Mapplethorpe, which had been funded by the National Endowment for the Arts (NEA), for all to see.[3] Helms implored his fellow senators to "look at the pictures!", yet at the same time requested that "all the pages, all the ladies, and maybe all the staff" leave the chamber so that the "senators can see what they are voting on" (de Grazia 1992, 637). This spectacle of bringing *on* the obscenity in order to keep it *off*—of Helms exhorting (male) senators to look, even as he tries to keep others (women and young pages) from looking—exemplifies one side of the paradox of on/scenity. It is the side those in favor of more diverse forms of speaking sex tend to relish because it demonstrates the extreme futility of censorship. Jesse Helms in 1989, like Kenneth Starr in 1998, became an unwitting pornographer, pandering the very material he would censor.

However, there is another side of this on/scenity paradox, one not so easily appreciated by civil libertarians. This occurs when those in favor of free speech and speaking sex nevertheless themselves censor some of its more sensational elements. Consider a recent collection of essays on pornography, the very well-meaning, liberal volume, *Porn 101: Eroticism, Pornography, and the First Amendment*, a compendium of articles originally presented in 1998 at the pro–free speech World Conference on Pornography, whose title suggests, but whose presentation contradicts, the arrival of pornography as a legitimate academic subject. This conference, one of whose keynote speakers was American Civil Liberties Union (ACLU) president Nadine Strossen, enthusiastically defended pornography's right to exist and championed its study from a wide variety of legal, cultural, sociological, and sexological perspectives. Conference sessions overflowed with videos, slides, photos, and other visual exemplars of its topic, not to mention the amusing, genial spectacle of the porn stars in attendance rubbing elbows in the lobby of the Sheraton Universal Hotel

with families setting out on tours of Universal Studios. However, in the proceedings of the conference published by Prometheus, the exuberant visuals disappeared. Except for a few antique lithographs, the volume is shockingly denuded of the very illustration that had made the conference so lively.

For example, the very first article, by Jennifer Yamashiro of the Kinsey Institute, describes a breakthrough 1957 legal ruling, eloquently dubbed *U.S. v. 31 Photographs*, that allowed the Kinsey Institute to build its collections of visual erotica and other sexually explicit materials. The article, however, fails to illustrate even one of the famously censored photographs, censoring them, in effect, all over again. Never mind that the article's very point is the importance of the acceptance of such images "on the scene" of the American academic study of sexuality—the very scene of the conference proceedings themselves—and never mind that the slides of these thirty-one photographs occupied the very center of the talk given at the conference.[4] Here is a mirror reversal of the kind of on/scenity displayed by Helms and Starr: a whole conference invoking the visual artifacts of the history and sociology of pornography, which, either due to the timidity of publishers or to that of the book's editors, are not shown.

If *obscenity* is the term given to those sexually explicit acts that once seemed unspeakable, and were thus permanently kept off-scene, *on/scenity* is the more conflicted term with which we can mark the tension between the speakable and the unspeakable which animates so many of our contemporary discourses of sexuality. In Judith Butler's terms, it is both the regulation that inevitably states what it does not want stated (1997, 130) and the opposition to regulation that nevertheless censors what it wants to say. On/scenity is thus an ongoing negotiation that produces increased awareness of those once-obscene matters that now peek out at us from under every bush.

*Porn Studies* differs from previous anthologies about pornography—including those that purport to legitimize its academic study—in its effort to take pornography seriously as an increasingly on/scene cultural form that impinges on the lives of a wide variety of Americans and that matters in the evaluation of who we are as a culture. It is serious about installing the critical and historical study of pornography in the academic curriculum. To further that end, authors included images to illustrate their chapters, and a selected annotated bibliography of readings important to the study of pornography as a cultural form—not just as a legal or sociological issue—was added, along with information on how to locate hard-core materials. In other words, the volume tries to help the teacher and student of pornography roll up their sleeves to begin work in this field rather than to pose the genre as the limit case of cultural analysis—the thing about which there is really nothing to say. Even Frank Rich, author of the *New York Times Magazine* article quoted above, which makes a major economic and social claim for the importance of pornography as a cultural "main event," dismisses its enactments of sexual performances. To Rich, the sex acts are Kabuki-like rituals that bring narrative to a halt, "like the musical numbers in a 30s Hollywood musical" (2001, 92). Rich's point seems to be that these rituals interrupt the more important narrative mission of film. To my mind, however, his analogy misses its point because there is so very much to say about the ritualistic "musical number" quality of the sexual representations of pornographic film and video. I have argued elsewhere that this comparison actually constitutes the inception of an important insight into how we might begin to understand the choreography of performing and laboring bodies in these works (Williams [1989] 1999).

This tendency to dismiss the textual working of popular pornographies is endemic, and not only to journalists like Frank Rich. Slavoj Žižek (1989), for example, argues that "in a 'normal,' non-pornographic film, a love scene is always built around a certain insurmountable limit; 'all cannot be shown'; at a certain point, the image blurs, the camera moves off, the scene is interrupted, we never see directly 'that' (the penetration of sexual organs, etc.)" (1989, 33). Thus a certain "limit of representability" defines the "'normal' love story or melodrama," while pornography by definition "*goes too far*" and thus misses what remained concealed in the "'normal,' nonpornographic love scene" (33). Žižek effectively dismisses the texts of pornography as abnormal representations doomed perpetually to "go too far." By showing "it," pornography becomes simply a "pretext for introducing acts of copulation," "instead of the sublime Thing, we are stuck with a vulgar groaning and fornication" (33). But as many of the essays in the volume argue, there is a great deal to say about the quality and kind of the generic deployments, including the sublimity of precisely these performed acts of copulation. How, in fact, do these performed acts construct the "it" that they purport to reveal? Is it perhaps the critic who has not gone far enough in analyzing this construction?

In yet another example of a respected culture critic using pornography as a limit text, Roland Barthes cites a self-portrait by Robert Mapplethorpe as an instance of "blissful eroticism" that leads Barthes to "distinguish the 'heavy' desire of pornography from the 'light' (good) desire of eroticism" (1981, 59). Here, too, the critic works hard to distinguish the (bad) pornographic from the (good) erotic, as if there were never anything erotic in the pornographic. [*Porn Studies*] does not seek to illustrate the distinction between a "good" eroticism and a "bad" pornography. It is no more interested in these distinctions than it is interested in the related debates about pornography within feminism, in which a "bad," androcentric pornography is often opposed to a "good," gynocentric eroticism. Indeed, there are some forms of pornography which either have no interest whatsoever in women's bodies—for example, the vast arena of gay porn (see essays by Tom Waugh, Hoang Tan Nguyen, and Rich Cante and Angelo Restivo)—or which are so exclusively oriented toward these bodies that questions of objectification by male viewers do not apply—as in the much smaller arena of lesbian or dyke porn. As a cultural form that is "as diverse as America," pornography deserves both a serious and extended analysis that reaches beyond polemics and sensationalism.

[ · · · ]

## *The Porn Classroom*

One of the marks of pornography's on/scenity is its recent appearance in the academic curriculum. Because the question of pornography's place in the university has been a source of some controversy,[5] and because I hope that [*Porn Studies*][5] can become a useful tool for those who elect to teach and learn about pornography, I would like to begin by explaining my own personal and professional reasons for bringing it on/scene in the classroom. [ . . . ]

In 1989, I published *Hard Core: Power, Pleasure, and the "Frenzy of the Visible,"* a book that examined the genre of heterosexual film pornography from a feminist, Foucaultian perspective. Although I had experimented with teaching some pornographic

film in the past in the context of a literature class, and though it was already clear to me that moving-image pornography was the most enduringly popular of all the film (and now video, DVD, and Internet) genres, it was not immediately apparent to me that it belonged in the classroom. It was especially not apparent that I should teach it to young and impressionable undergraduates. Could one ask students to analyze, historicize, and theorize moving images whose very aim was to put them into the throes of sexual arousal? When I teach other film genres (melodrama or horror), analysis of our responses of pity or fear form part of what we examine. Although I knew that it was possible to transcend the initial embarrassment of talking about sexual representations, I was not convinced that even the most highly motivated undergraduates could handle watching and analyzing moving-image or other forms of visual pornography.

Until 1993, the above had seemed compelling enough reasons *not* to teach pornography. However, in that year, Catherine MacKinnon wrote an article for *Ms.* that entirely changed my mind. She argued that the Serbian rapes of Muslim and Croatian women in Bosnia constituted an unprecedented policy of extermination caused by pornography: "The world has never seen sex used this consciously, this cynically, this elaborately, this openly, this systematically, with this degree of technological and psychological sophistication, as a means of destroying a whole people. . . . With this war, pornography emerges as a tool of genocide" (27). Reports by Muslim women that some of the rapes had been videotaped transformed ordinary rape, MacKinnon believed, into a historically unprecedented atrocity. The real culprit in these rapes was, for MacKinnon, not the Serbian rapists, but the supposed saturation of Yugoslavia with pornography. Such an argument encourages us to shift attention from the real crime of politically motivated rape to the supposedly more heinous crime of filming it. Instead of concentrating on how Muslim and Croatian women became the targets of sexual crimes, MacKinnon preferred to blame pornography as their cause. We come away from her article with the impression that it is pornography that we must fight, not rape.

The notion that pornography raises the misogynist crime of rape to a new level of technically unprecedented genocide is also the premise of MacKinnon's 1993 book *Only Words*. As in the case of Bosnia, it is the mechanically or electronically reproduced images, not the acts themselves, that are taken to be the most reprehensible. Pornography is conflated with genocidal rape, degradation, and abuse. It is never for an instant taken to be a genre for the production of sexual viewing pleasure. For MacKinnon, pornography *is* sexual abuse, pure and simple.

Now these are the kinds of arguments that can only work if one has little knowledge about moving-image pornography, its history, its conventions, and its various uses among very different kinds of viewers. For example, a look at the history of the representation of rape in hard-core, moving-image pornography, teaches that where rape was once represented from a masculinist "lie back and enjoy it" perspective in the old illegal stag films and in the early features, it has increasingly become taboo as women have become a component of the audience (Williams [1989] 1999, 164–65). Indeed, most forms of violence are now strictly taboo, to the extent that the usual fictional fistfights and gunfights of feature films are rarely seen in pornography.

I had endured the argument of *Only Words* without being moved to teach pornography, but the argument about rape in Bosnia was the last straw. This was not a theoretical argument about the evils of porn, it was an argument that encouraged taking action against pornography as if it were the same thing as taking action against rape. As such, it seemed to me to be thoroughly inimical to the goal

of feminism. Though I could take satisfaction in Erika Munk's subsequent, well-informed response to MacKinnon's specious arguments, I knew that what had not been adequately countered was a facile fantasy about the root evil of pornography, one that can only persist in ignorance of the genre's history and its close analysis. As a feminist scholar of moving-image pornography, I realized that I had an obligation to do more than write about, or engage in polemics about, pornography. As one of the relatively few scholars in the United States with some expertise in this area, I needed to do what other scholars have done: integrate my scholarship into my teaching. I did not do this lightly, for I was acutely aware of the aforementioned problem of the status of texts that seek to sexually arouse viewers. I resolved nevertheless to teach a course that would approach the history, theory, and analysis of the genre of moving-image pornographies as a way of understanding the various constructions of sexuality and the history of the representations of sexual pleasure. The goal was never to defend pornography against the sex-negative, sex-scapegoating MacKinnons and Andrea Dworkins of this world, but to promote a more substantive, critical and textually aware critique of the most popular moving-image genre on earth.

I cannot say that that first upper-division undergraduate class, offered in the spring of 1994 at UC Irvine, in the heart of conservative Orange County, California, was all that successful. Nor can I say that my experience was at all typical. Nevertheless, it is the story of that class that I would like to tell, since its partial failures seem to me instructive and to offer some examples of the difficulties of bringing this material on/scene. I defined the class from the beginning as an experiment to determine whether the textual study of moving-image pornography had a place in the university curriculum—a question the class would take up at the end of the ten-week quarter. Aware that they were part of an experiment, students were on especially good behavior.

The course was designed to survey the history of American moving-image pornography from early, underground stag films for all-male audiences to the quasi-legitimate couples films of the seventies to the proliferating varieties of gay male, lesbian, bisexual, straight, sadomasochistic, fetishist pornographies available now that low-budget video shooting and home VCR viewing predominate. Casually curious students were warned away by an unusually heavy workload, the inclusion of feminist concerns about power, as well as the genre's concerns about pleasure, and the cross-listing of the course between film studies and women's studies. Thus after an unusually high initial enrollment of over sixty students for a class with no teaching assistants, the course settled down to a comfortable thirty film studies, women's studies, and a few other students.

I began with the premise that since moving-image pornographies existed, we would not take up the question of whether they should exist before we had considered their form and content. Though I was considerably emboldened by the success of my UC Santa Barbara colleague Constance Penley's strategy of teaching pornography as simply another film genre, my own plan was to return to the feminist arguments against pornography once we had actually learned something about the genre. Thus we read MacKinnon's *Only Words* toward the end of the course and attempted to debate the anticensorship, antipornography positions at that time. We saw a group of hard-core stag films the very first day, and we continued to see at least one work of hard-core feature-length pornography each week, and sometimes twice a week. I always showed the films first, then introduced readings about them. We eventually read all of *Hard Core*, many essays from the anthology *Dirty Looks* (Gibson and Gibson, 1993); parts of Foucault's *The History of Sexuality* (1978), and about twelve photocopied

articles. Students wrote book reports on a wide bibliography of works related to pornography, took a mid-term, made formal group presentations to the class, and wrote a variety of final projects, including some pornographic screenplays, which grew out of their own dissatisfaction with the quality of the scripts in most contemporary porn. One group also made a video of the class as part of our ongoing self-scrutiny. We had three guest speakers: Constance Penley, who spoke on slash fanzines, a man from the Los Angeles chapter of People against Pornography, and Kelly Dennis, a Ph.D. student completing a dissertation on pornographic painting and photography.

Because they had to do group presentations, students began working together to understand difficult material and quickly overcame any embarrassment discussing sex acts in class. These discussions were some of our best. The first five weeks of the class, in which we read *Hard Core* and screened a collection of stag films, *Deep Throat, Behind the Green Door* (Mitchell Bros., 1972), *The Opening of Misty Beethoven* (Radley Metzger, 1975), *In the Realm of the Senses* (Nagisa Oshima, 1976), and a selection of films by Candida Royalle, including what was then her new feature, *Revelations* (1993), were lively and, to my mind, very successful. The second half of the course was less so. The main reason, I think, was the difficulty of teaching the "controversy" of pornography when I and the rest of the students were already so emphatically on the side of anticensorship. Throughout the class, students had been more than willing to criticize pornography, but they were understandably unwilling to challenge its right to exist since the very course they had signed up for was exercising the kind of tolerance of and even frank interest in sexual representation that the MacKinnon position wanted to revoke. So the debates about pornography turned out not to hold great interest for students—which is not to say that we did not have our own debates of what constituted offensive material!

The course syllabus had contained a fairly conventional, boldface warning that I had intended to warn away the squeamish: "Many of the films, videos, and images we will see in this class are bound to be offensive to some viewers. Please do not take this class unless you are willing to look closely at a wide variety of explicit, hardcore pornographic sexual representations and to discuss and write about them with the same kind of attention you would give to any other popular cultural form." I had considered other ways of dealing with this problem. It is common in some women's studies classes presenting images, though not teaching the genre, of pornography to ask students to sign a consent form saying that they are warned that they may be viewing some possibly horrendous materials, but then to provide for the possibility for students to excuse themselves from screenings or images that offend them too much. This tactic seems to me counterproductive. It assumes that the topic of hardcore pornography is beyond the pale, ob/scene not on/scene. The consent approach tends to make the course all about finding that moment of most extreme offense, when the offensive text does what it is all along expected to do.

I did not want to set myself up for such reactions since our main object was to study the genre closely. However, I did try, in my boldfaced first sentence, to steer away those students able to judge that they might take offense. I knew, of course, that my warning itself constituted an invitation to be on the lookout for what is most offensive and to register it with dramatic means. What I did not anticipate was that it would be the men in the class who would eventually register offense most dramatically. For the most part, however, and certainly in the first half of the class, students

tended to use journals effectively as a way of expressing both offense and occasional pleasure in often quite lengthy daily entries. This way of letting off steam seemed to work well for the first half of the class.

The stag films that occupied us first, although often quite misogynist, seemed, because of their distance in time, merely quaint. Students marveled at black-and-white, silent-movie sex. They did not seem to bother too much about the sexual politics of this sex. They were more amazed, I think, at the fact that people back then *had* sex, especially non–missionary position sex. Even pornography from the seventies still had a patina of age—those sideburns, that hair! Although *Deep Throat* and *Behind the Green Door* certainly proved offensive to many of the women in the class, they watched with interest and simply vented their objections to the disregard of female pleasure and autonomy in articulate discussions of plot, motive, and the mise-en-scène of sexual positions. They voiced anger at the archaic representation of "ravishment" in *Behind the Green Door,* the ubiquity of "money shots" throughout the feature-length form of the genre, and the frequent lack of convincing female orgasm. But as we moved into the eighties and nineties, and pornography went from relatively high-budget film to low-budget video, and as students began to see reflected in these videos corporeal styles closer to their own, distance became harder to achieve.

As it turned out, however, it was the women in the class who were much better able to handle offense and to keep a critical distance on the material, even as it got closer to home. Many of these women, although heterosexuals, found the woman-oriented porn of Candida Royalle too tame, while they enjoyed the butch/femme roles of *Suburban Dykes* and the fluidities of bisexual porn. Female-to-female sex outside the context of "the male gaze" seemed exhilarating to them, even if it did not appeal to their own propensities. On the other hand, while the men in the class had nodded in agreement with the women's criticism of heterosexual pornography geared to men, they did not express any deeply felt offense themselves. They also nodded in agreement at the greater empowerment of women in lesbian pornography. But as might have been predicted, they were not themselves similarly exhilarated by gay male porn. The sense of offense from these (presumably straight) undergraduate males almost became palpable as we screened William Higgins's *The Young and the Hung* (1985) and, later, *Bi and Beyond: The Ultimate Sexual Union* (1986) and a few men made dramatic, door-slamming exits. In the discussion that followed the screening, tensions were exacerbated by the fact that some of the women students took this opportunity to take revenge on the males who had finally been made to squirm by the use of male bodies as sexual objects of desire. For example, here is a journal entry by the woman student who wreaked the most revenge:

> I believe what I liked so much about this movie was the thought that after all these screenings, finally "our guys" would feel a little uncomfortable. This time, *male* bodies were used as masturbation aids. . . . Did it turn them on? If it did, did they spend the rest of the weekend worrying about their "proper hetero-sexuality"? If yes, would they EVER admit it in class?? What does that say about the way society still constructs "lesbianism" as foreplay and homosexuality as a major taboo? *Finally, what is the role of homoeroticism in a patriarchal, ho-mophobic culture*; i.e., . . . is not any kind of extreme male sexism and phallocentrism merely disguised homo-sexuality? I think my head is gonna explode.

This same student then precipitated the most traumatic of our class discussions by pointedly asking the men in the class how they felt in response to the gay porn. Up until this moment, no one had asked this question. Though there had been ample discussion of the political implications of various sexual acts and positions, no one had been willing to say publicly either "this turns me on" or "this disgusts me" without giving either a safe political or aesthetic reason for such a reaction (nor did I ever ask anyone to say what turned them on, though the issue was lurking in the background throughout the class). Though the question was obvious and important, it thus represented something of a breach of class etiquette, made no less serious by the fact that it was uttered, and was understood to be uttered, in a spirit of revenge. Since almost all the pornography we had seen up to that point had concentrated, at least ostensibly and despite the obsession with money shots, on women being fucked, and on women voicing pleasure at being fucked, the woman who asked the question was saying, by implication, "If you don't like the spectacle of a man being fucked, now you know how we women feel." But she was also saying, somewhat more tauntingly, what if you *do* like seeing a man being fucked? All but one of the men denied feeling anything but a healthy, virile disgust either at the aesthetic crudeness of the film or at what today are judged unsafe sex practices. The exception was a young biology major, new to the kind of media study conducted in this class, who admitted, with disarming honesty, that the film made him uncomfortable because he was afraid that if he liked it, it would mean he was gay.

What is the proper "pedagogy of pornography" at a moment like this? This was a class that had shown quite a bit of respect and honesty up until this point. Yet here was a strong expression of homophobia. Was it my job to "correct" the homophobia of the fearful males, to take the side of the more tolerant women in pouncing on their reactions? I knew that if I simply corrected the male homophobia and continued with our screening of gay and bisexual pornographies as scheduled, we would no longer be able to talk honestly as a class. The offended heterosexual males would simply clam up. Perhaps ironically, I had taken it as a good sign that the male students had felt free to express their homophobia in the midst of so much politically correct position taking. I was actually pleased that at least one male had expressed what seemed to me the root cause of homophobia, not irrational fear of homosexuality, but fear of becoming homosexual. Should I press on with more films and threaten these males more? In the end, I decided to cancel further examination of gay and bisexual pornography.

Looking back on it today, I feel this was a mistake. In effect, I fostered an atmosphere in which a fear of homosexuality could be expressed in order to curtail what seemed to me a worse evil: the sort of pseudosophisticated condemnations of unsafe sex practices or critiques of silly plots that the majority of the straight men voiced, but really only to cover up deeper anxieties. The danger was that feminist political correctness would make it impossible for homophobic males to say what they honestly felt. Here is an example of the kind of reasoning that arose in the face of the women's criticism of overt homophobia:

> Today we covered a tough topic, gay male sex. A lot of people left when the film started. I said earlier I'd sit through it all to learn but this was hard. I did stay and found it very offensive. But not in the way you would think. I found it offensive in the same way I find straight porn offensive. It is how the men talk. "Fuck me up the ass," "harder" all that crap. Even when guys talk to women in films like that it bothers me. The act of anal sex doesn't shock me cause we've seen it with women.

It was just the way they talked to each other I disliked. I figure if it doesn't turn you on it may work for someone else. The basic plot was ridiculous and so thats [sic] not a good start. . . . A big offense was also the fact that there were no condoms in sight. That's bad, especially in these times. You've got to send the right message.

Now, this was a fairly savvy male film studies major who knew it would be un-cool to say he was offended by male anal penetration. What he says instead is that he takes offense by a ridiculous plot (hardly the strong feature of any porn) and that he does not like the "dirty talk" (also true of much heterosexual porn) or the lack of condoms (in 1986, condoms were not yet *de rigueur* in gay porn). Notice also how this student rather enigmatically approaches the question of turn-on: "I figure if it doesn't turn you on it may work for someone else." I think this could be translated as saying that he is not turned on, but if someone else is, that may mean that this per-son is gay. Any vulnerability to or any pleasure taken in these images clearly fright-ens this student. There is nowhere to go in a class discussion with such a defensive attitude. Although this student is full of a sense of the *offense* of this work, he is not willing to attribute it to a sexuality he personally finds threatening. The feminist ethic of the classroom had made this too unpopular. Only the less sophisticated biology major was willing to confront his own vulnerability.

In response to this kind of stonewalling from most of the males, the female stu-dent who had precipitated the crisis wrote:

Today's in-class discussion was *exactly* what I had expected. . . . Don't I sound in-credibly smug? [In the margin I noted that another student's journal had accused her of being smug when she asked the question in class, and though I was glad she precipitated our discussion by asking how the men felt in response to the film, that I wished she could ask it non-smugly so as to make them less defensive] . . . I *do* respect the honesty of some of our male fellow students. But here were also some remarks that frightened me: "Anal penetration isn't meant to be," "I found the gay porn offensive . . . but of *course*, I've also found the other screenings of-fensive!" etc. I am frightened because these remarks are not made by crusading fundamentalists, but by young, bright college students in the 90s. . . . For them *it is okay* to talk about the "abnormal character" of anal penetration. It *is okay* to point out the glorification of promiscuity only in gay porn. It *is okay* to "feel more offended" by this alternative than by any other. And finally, it is okay to say, "Of course I wasn't turned on, because *I'm not like this*," without ever stopping to question one's motivations to say so. . . . I'm afraid if we ever want to make prog-ress on this matter, we will have to have many, many more discussions like the one we had today. Sometimes, these discussions could be very ugly. We could end up at each others' throats. But it might be worth it.

Because I was worried that at this point in the class, students *were* about to end up at each other's throats, I became, like the publisher of the World Conference on Pornography, the censor of the visual material of the class. This actually only amounted to the cancellation of one screening, but the class experienced it as my retreat from the presentation of controversial material. I doubt that this was the right thing to do, but I was concerned that members of the class be able to keep talking to one another. I did, however, try to point out in discussion some of the fragilities of sexual identity and that

what was at stake for a heterosexual man was not the same as what was at stake for heterosexual women in watching hard core. I appealed to psychoanalytic theory to explain what in heterosexual female gender identification is not threatened by seeing women in sexual connection and what in heterosexual male gender identification is threatened by seeing men in sexual connection. However, I made a decision not to press the comfort level of the class any further, thereby incurring the (fortunately temporary) wrath of the brave student who had precipitated our best, and our most disturbing, discussions.

We had a long discussion instead of another film. We continued to talk about pornography. We discussed and read about erotica. We had a debate and several guest lectures. Some students went on to see more pornography outside of class as they wrote their final papers, but we did not see any more pornography. I may have been guilty of pampering the sensibilities of "our guys," but my goal in offering the class had been to expose students to diversities of pornography and the dynamics of the genre so as to make them aware that the appeal to the censorship of pornography is an appeal to the censorship of diverse sexualities. I think everyone in the class saw that.

In the end, all students decided, in an anonymous evaluation, that pornography *could* be part of the university curriculum, though certainly not required. Some said it could be because they learned a lot about feminism, some because they learned about a popular film genre, some because it was intense and controversial and therefore engaging, some because it shed light on antiporn dogma, one person even said it changed his/her life and made him/her realize that pornography was not one "big Pavlovian turn-on." But by far the most frequent reason given had nothing to do with the film genre or the controversies of pornography—and everything to do with finding in those difficult and fraught class discussions of pornography an unexpectedly fruitful forum for the discussion of sex and sexualities: "It brings out all the issues that are addressed rather indirectly in other classes. It also offers the opportunity to be (at times painfully) honest—the journal was a real 'emotional outlet.'"

In a final class discussion, several students also suggested that what the class needed was simply more discussion of sexuality. As a final paper, one student designed a course that would mix science and pornography to achieve a kind of sexology. The one thing these students were not very interested in pursuing was thus what had motivated me to teach the class in the first place: the feminist debates and controversies surrounding pornography. To them, pornography was much more interesting as a springboard for discussion and demystification of the sex acts and sexualities we always seem to talk around in other contexts. This constituted my most important lesson from this class. My way into the teaching of pornography through the feminist controversies did not prove helpful in organizing an effective course, but it was my way in. Students tolerated this, but they were less interested in feminist position taking than they were in finding ways for talking about sex. What a course like this can give them are certain discursive ways of speaking sex: Freudian, Foucaultian, and feminist. Feminist perspectives—whether antipornography or anticensorship—did not impede this discussion if they were brought in at certain points, but they tended not to be useful when they determined the entire agenda of the class. In a second attempt at teaching this undergraduate-level class, I found that when I made less of a fuss about potential offense taken at the material—whether that offense be feminist outrage or male homophobia—none was demonstrated. The lesson here is that it can prove all-too-easy for a teacher to set up students to act out offense, but that dramatic demonstrations of offense are not useful to further

discussion. I also learned that it was better to show contemporary pornography and diverse kinds of pornography early in a course lest students think they will only be regarding the more safely distanced "antique" and heterosexual varieties. Undergraduate students, even at Irvine, became more tolerant and more interested in diverse forms of pornography in my second version of the class. They became more adept at speaking sex while being respectful to one another. It could be that this was the inevitable result of the very process of on/scenity that I have been describing above; it could be that I was no longer signaling my own difficulty with the material; or it could just be that times had changed.

I have given up on framing the teaching of pornography primarily through feminist debates. At UC Berkeley I now teach occasional graduate and advanced undergraduate courses on pornography and other sex genres. It is comparatively easy to teach this material at such a notably liberal institution, where students often urge me to find more challenging—less normative and heteronormative—material, but it is still a challenge. I now believe that it was not wise of me to let students accept the challenge of creating better pornographies than those that already existed, as I did when I permitted a few students to write screenplays. Although I encourage students in every other sort of course to try their hands at "doing" the mode or genre we are studying, it is a mistake in the current climate for a teacher of pornography to do the same. It leaves one vulnerable to the charge of encouraging students to become pornographers; it may lead very young students into a world for which they are not prepared; and it can only bring oneself, and one's institution, bad publicity. It is already hard enough to justify the importance of this field of study to colleagues, administrators, and the general public; why complicate this difficulty with even the appearance of involving students in the profession? It is also worth noting that male teachers need to exercise special discretion in teaching this material because of longstanding presumptions, feminist and otherwise, that pornography is *for* men and only *about* women. I do not think this should deter male teachers, but it does mean that they need to take different sorts of precautions that are probably best acknowledged up front. A tone of frank sexual interest accepting the fact that sexuality and sexual representation have become compelling to all, but tempered by an awareness that we are still learning a proper pedagogy of pornography, seems the best course.

[ · · · ]

## NOTES

1. He writes: "At $10 billion, porn is no longer a sideshow to the mainstream like, say, the $600 million Broadway theater industry—it *is* the mainstream" (Rich 2001, 51).

2. "Speaking sex," as I have argued in *Hard Core* ([1989] 1999), is the particularly modern compulsion to confess the secrets of sex described by Michel Foucault in his *History of Sexuality.* Pornography, I have argued, is one such discourse of sexuality. It is emphatically not a form of speech that liberates or counters repression. Speaking sex, and the related idea of on/scenity explained in the next several paragraphs, are reworkings of ideas from this book, especially pages 282–84 of the 1999 edition.

3. I discuss this episode in the 1999 edition of *Hard Core* (Williams, 285–86).

4. The same fate befell another talk by David Sonnenschein, whose very subject was the censorship of a number of extremely innocent photographs of a nude adult male next to a boy of about five years. The boy points inquiringly at the man's penis, looking at it with curiosity.

In a subsequent picture, he looks at his own penis, then in another, back at the man's. The photos were shown in an art exhibit, then withdrawn when complaints about child pornography were registered. Subsequently, Sonnenschein was not able to print these photos in his book. He was censored again when the photos about which he was speaking, and which are referred to in his contribution to the world conference book as figures 1, 2, and so on, are simply missing. Once again, Sonnenschein's whole point was the complete innocence of the photos and the child's natural, comparative curiosity. See Sonnenschein 1999. In the case of my own contribution to the conference, I withdrew it from the volume when I learned that my talk would not be published with its illustrations.

5. See, for example, the discussion of the controversies surrounding the teaching of pornography in articles by Lord 1997 and Atlas 1999. See as well the controversies generated by Chicago School of Art Institute professor Kelly Dennis (Leatherman 1999) and Wesleyan professor Hope Weissman. David Austin (1999) has also written usefully about the use of pornography in the university classroom. More recently, and not very thoughtfully, see Abel 2001.

## WORKS CITED

Abel, David. 2001. "Porn Is Hot Course on Campus." *Boston Globe*, August 25.

Atlas, James. 1999. "The Loose Canon." *New Yorker*, March 29, 60–65.

Austin, David J. 1999. "Sexual Quotation without (Sexual) Harassment? Educational Use of Pornography in the University Classroom." In *Porn 101: Eroticism, Pornography, and the First Amendment*, ed. James Elias et al. Amherst, N.Y.: Prometheus.

Barthes, Roland. 1981. *Camera Lucida: Reflections on Photography*. Trans. Richard Howard. New York: Hill and Wang.

Butler, Judith. 1997. *Excitable Speech: A Politics of the Performative*. New York: Routledge.

de Grazia, Edward. 1992. *Girls Lean Back Everywhere: The Law of Obscenity and the Assault on Genius*. New York: Random House.

Hunt, Lynn. 1993. *The Invention of Pornography: Obscenity and the Origins of Modernity, 1500– 1800*. New York: Zone Books.

Leatherman, Courtney. 1999. "Conflict over a Divisive Scholar Combines Issues of Art, Sexuality, and Teaching Style." *Chronicle of Higher Education*, August 13, A14–A16.

Lord, M. G. 1997. "Pornutopia." *Lingua Franca*, April-May, 40–48.

MacKinnon, Catherine. 1993a. *Only Words*. Cambridge, Mass.: Harvard University Press.

———. 1993b. "Turning Rape into Pornography." *Ms.*, July-August, 24–40.

Munk, Erika. 1994. "What's Wrong with This Picture?" *Women's Review of Books*, July-August, 5–6.

Rembar, Charles. 1969. *The End of Obscenity: The Trials of "Lady Chatterly," "Tropic of Cancer," and "Fanny Hill."* New York: Random House.

Rich, Frank. 2001. "Naked Capitalists." *New York Times Magazine*, May 20, sec. 6, 51–92.

Sonnenschein, David. 1999. "Sources of Reaction to 'Child Pornography.'" In *Porn 101: Eroticism, Pornography, and the First Amendment*, ed. James Elias et al. Amherst, N.Y.: Prometheus.

Williams, Linda. [1989] 1999. *Hard Core: Power, Pleasure, and "the Frenzy of the Visible."* Berkeley: University of California Press.

Yamashiro, Jennifer. 1999. "In the Realm of the Sciences: The Kinsey Institute's *31 Photographs*." In *Porn 101: Eroticism, Pornography, and the First Amendment*, ed. James Elias et al. Amherst, N.Y.: Prometheus.

Žižek, Slavoj. 1989. "Looking Awry." *October* 50: 31–35.

# PART 9

# RACE AND ETHNICITY IN CINEMA: FROM STEREOTYPES TO SELF-REPRESENTATION

*Pierre Delacroix, a Harvard-educated television writer and executive at CNS, is under pressure to produce a hit. In an effort to break with his white boss, Dunwitty, who has previously dismissed his efforts as irrelevant, Delacroix conceives an outrageously racist TV show.* Mantan: The New Millennium Minstrel Show *is set on an Alabama plantation with two black performers, Mantan and Eat-n-Sleep, in blackface. Delacroix hopes that the show's blatant racism will guarantee its failure, but his satire is lost on the audience; the show becomes a network hit, trapping him in his own joke.*

From Spike Lee's *Bamboozled* (2000)

Spike Lee's *Bamboozled* effectively explores the multilayered nature of racial identity, particularly in one of the key early sequences where Delacroix pitches the show to Dunwitty. Dunwitty, a white man for whom "blackness" is a fad, claims to be more in touch with the black community than Delacroix and boasts, "Brother man—I'm blacker than you." Delacroix, with his Ivy-League education and meticulously crafted and sophisticated speech, is at odds with the stereotypical image of a black man in popular culture.

789

On the most immediate level, Delacroix and Dunwitty's identities are marked by the color of their skin, what Frantz Fanon would call the empirical "fact of blackness" or "whiteness." On the other hand, their identities are created through signs and performances, the roles that the two characters are playing, which can both transcend and perpetuate already existing stereotypes. However, the sequence also makes clear that their racial identities are discursive, shaped and established by institutions to which they belong. It is this institutional—and in this case cinematic—space that frames Dunwitty with the "brothers on the wall" behind him and marks his self-perception as an authority on black American culture, while Delacroix, framed tightly by the desk and the ceiling, appears to lack this power of cultural and institutional backing, despite all his efforts.

The two intricately connected levels of racial identity construction, representational on the one hand and institutional or discursive on the other, also determine how the issue of race has shaped, and been shaped by, film history and film studies. Crucial aspects of race in cinema are institutional, such as issues of ownership, creative control, and participation in the process of production and distribution of film. The history of African American cinema, which very much informs the narrative trajectory of *Bamboozled*, is a significant case in point. Throughout most of Hollywood history, African Americans were excluded from creative control and participation in the dominant filmmaking process, which represented them within a limited repertoire of demeaning stereotypes. The sustained efforts and achievements of figures like Oscar Micheaux—who directed the first African American feature film and operated his own production company from 1918 to 1948—and writer/director/actor Spencer Williams, carved out a significant space for black independent cinema later in the twentieth century. However, such figures were rare, relegated to the segregated sphere of "race movies," featuring African American casts and addressing audiences within the limits of race. Even as the studio system gathered strength and Hollywood went through a series of changes in terms of ownership, diversification, and realignment, African American entrepreneurs occupied a very limited space in this boom. If by World War II the studios themselves were eager to update the stereotypes of the 1930s, this often meant showcasing black actors (Sidney Poitier defines this era with his charismatic onscreen presence) rather than employing African American creative personnel. Ironically, this effort to enhance the portrayal of blacks contributed to the waning of the alternative culture of films about, for, and by African Americans.

The great strides made by the civil rights movement in the 1960s lent urgency to claims for an equal share in cultural production. While the rise of world cinema, with its strong aesthetic and political claims, added to the development of African American cinema in the United States, this development was mainly propelled by specific factors such as the decline of the studio system, the rise of independent financing practices, and growing urban audiences for films made by directors who were rooted in black culture and shared a sensitivity toward racial struggle. In the early 1970s, "blaxploitation" films unseated the thinking that only putting forth positive images and authentic representations of race could counter the stereotypes in mainstream cinema. However, it wasn't until the 1980s that black independent cinema emerged as a significant movement, collectively claiming its own space. Filmmakers like Spike Lee, Charles Burnett, John Singleton, Ernest Dickerson, Julie Dash, and others forged a distinct aesthetic and cultivated an audience while also making their cinema attractive for mainstream, large-budget establishments. Long in the making

and sustained in its approach, American black independent cinema in large part inspired other independent cinema movements and subsequent multicultural filmmaking.

While discrimination and exclusion have tainted the institutional history of cinema, issues of race have also been defined by the practices of representation on screen. In fact, much of twentieth-century theories of language, semiotics, and psychoanalysis, all of which have informed significant developments in film theory, may be seen as an attempt to define the struggle over representation. The dominant American cinema afforded only a limited range of representations for Africans, Asians, Latinos, and Native Americans, who were either absent from the screen altogether or confined to limited and mostly demeaning stereotypes. For example, early representation of blacks fell into a few racist caricatures: the docile and dutiful "Uncle Tom" type; its comic flipside "the coon," which was popular in minstrel theater; the mulatto; the mammy; or the brutal buck cliché. Most of the early work on racial/ethnic issues dealt with these filmic representations within Hollywood cinema; invocation of these images as well as a racially charged past in film and other forms of art continued to be an area of provocation in the works of Spike Lee, Marlon Riggs, and others. In *Bamboozled*, the montages of archival images of blackface performers and TV shows portraying African Americans in stereotypical roles serve both as a pedagogical strategy to contextualize current practices of representation and as a statement on the difficulty of overcoming this legacy in cinema and other forms of expression.

However, *Bamboozled* not only foregrounds the persistence of these negative images but also the fact that they are integrally linked to the dynamics of power relationships between social groups. The theorists included in this part use this insight as a jumping-off point for their explorations of race in cinema. The section begins with the great Martinican thinker FRANTZ FANON, who observes in his seminal *Black Skin, White Masks*: "I cannot go to a film without seeing myself. I wait for me. In the interval, just before the film starts, I wait for me. The people in the theater are watching me, examining me, waiting for me." In this incisive and provocative observation, Fanon reveals how his sense of "I" is defined not merely by the empirical reality of his skin color—the "fact of blackness"—but also by how this blackness is seen, interpreted, and represented by others, as well as how this representation is shaped and perpetuated by institutions such as cinema.

Following Fanon's discussion of race within the larger context of colonialism, ELLA SHOHAT and ROBERT STAM assert in "Stereotype, Realism, and the Struggle over Representation" that the problem of racial stereotypes in cinema goes well beyond negative images and arises out of the "powerlessness of historically marginalized groups to control their own representation." Considering this, it should be no surprise that the main producers of cinema in the late nineteenth and early twentieth centuries were also imperial powers (Britain, France, Germany, and the United States) and that the trajectory of international cinema's origins paralleled the expansion of European imperialism. Although it is clear from the very early experiments into ethnography on camera and D. W. Griffith's depictions of the social "realities" of his time, that representation of race in film was intricately tied to the imbalance of power in social relations, official film theory remained silent and was slow in responding to this subject. Shohat and Stam also argue that stereotypes or "image studies," while a useful first tool of analysis, tend to be reductive. For them, examining representation in a broader, discursive context brings many methodological advantages. It allows film theory to move beyond racial binaries; to consider historically and

contextually varying manifestations of race; and to place the issue of race within a larger framework of multiculturalism and ethnicity.

The growing presence of diverse social groups on screen has broadened and introduced new complexities to studies of race. An important aspect of revisionist work on racial representations is "whiteness studies," which first emerged in the 1980s. In "White," a pioneering essay in this field, RICHARD DYER questions whiteness as an unmarked and often invisible, yet powerful, norm. He asserts that framing "whiteness" as a constructed category is crucial to deconstructing the binary nature of racial representations. Only by *seeing* whiteness as an ethnicity, Dyer argues, can we subvert the common practice of racializing "the ethnic other" while positing whites as raceless.

Linking the issue of representing race on screen with the issue of discursive and institutional constructions of the "other" allows film theory to make important connections to disciplines or methodologies where the concept of the "other" is also essential, including ethnography and anthropology, psychoanalysis, and linguistics. Such connections were explored by many critics in the 1990s who used an interdisciplinary approach to move beyond ghettoized studies of isolated groups. In their respective work, FATIMAH TOBING RONY and ANA M. LÓPEZ not only show the complexity of ethnic and racial representations on screen, but they also highlight how representing ethnicity on film is a project that is ethnographic and colonial. In "*King Kong* and the Monster in Ethnographic Cinema," Rony shows how photographic realism contributed to scientific notions of evolution and race. She looks at films ranging from *Nanook of the North* (1922) to *King Kong* (1933) to show how cinema utilizes anthropological elements in its representations of race, appropriating and inscribing the "other" or the "ethnographic subject" in terms of dangerous abnormality or monstrosity. It is at the very moment of visual appropriation, Rony argues, that the ethnographic becomes monstrous, and this monstrosity is coded in racial terms.

Similarly based on the link between ethnographic and cinematic discourses, López's essay "Are All Latins from Manhattan?" examines the shifting parameters of ethnic "otherness" in Hollywood, exploring how representations of Latin Americans changed from the 1920s to the 1940s, when social and political circumstances required that the perceived ethnic and sexual threat of Latin American "otherness" be translated into a peaceful "good neighborliness." Her analysis of three emblematic Latin American stars, Dolores del Río, Lupe Vélez, and Carmen Miranda, shows how filmic assimilation of ethnicity is more than a matter of images; it is an "ethnographic textual creation that must be analyzed as a political co-production of representations of difference."

Significantly, both Rony and López also reveal in their analyses that the relationship between stereotype and self-representation in cinema is a complex and ambiguous one. For example, Carmen Miranda's textual persona and her excessive, self-conscious performance of Brazilian stereotypes validates but also subverts the very discourse that defines her as the "other," highlighting its status "as a discursive construct." A similar dynamic can be seen in *Mantan: The New Millennium Minstrel Show* in *Bamboozled*. On the one hand the show exposes the historical legacy of racist representations and repeats the familiar litany of stereotypes, but on the other hand the success of the show is due to the enormous talent of the performers—talent that almost cancels out assumptions about the racist stereotypical roles. This is precisely the burden of what W. E. B. Du Bois calls "double consciousness," the dual level of identity that permeates

most racial/ethnic self-representations and complicates the straightforward notion of the stereotype.

Theorists who call for a more sophisticated approach to analyzing racial/ethnic representations note that an obsession with exclusively adhering to "reality" and the "truth" has long dominated analyses of black cinema. As many critics have recently pointed out, this approach is problematic because it undervalues the complexity with which black cinema has dealt with the issue of realism. In Part 6, Manthia Diawara (p. 594) argues that while black cinema does adopt verisimilar conventions to counter hegemonic representations, it deploys different modes of narration to achieve its "reality effect" for black spectators. Likewise, for TONI CADE BAMBARA, the significance of black independent cinema—represented in her essay by Julie Dash's landmark film, *Daughters of the Dust* (1991)—lies not in its verisimilitude but rather in its delegation of voice. In "Reading the Signs, Empowering the Eye," Bambara shows how the recovery and validation of black women's gaze, voice, culture, and experience in *Daughters of the Dust* is informed by narrative as well as by the composition, framing, and music. She supports Shohat and Stam's claim that "while film is. . . representation, it is also utterance, an act of. . . interlocution between socially situated producers and receivers." This is precisely Spike Lee's position in *Bamboozled*—while he is certainly concerned with "telling the truth" about the black experience, he also suspends the film's concern with authenticity and realism in black cultural production and reframes it as a question of voice. In interactions between Mantan, Delacroix, and Dunwitty, the authenticity of what they represent is quickly bracketed as a secondary concern, and what really matters are the questions: Who is speaking? Who is asking? To what end?

This emphasis on the control over the creation of discourses is also seen in the emergence of indigenous media, that is, forms of expression conceived and produced by indigenous peoples around the world. As indigenous media from locally based production centers became part of global media networks, their reach and visibility increased significantly, and indigenous artists have begun to receive wide reception and recognition (most notably Zacharias Kunuk's *Atanarjuat* [*The Fast Runner*] [2001], a cornerstone of a new Inuit film practice). Parallel to this development, indigenous media studies—bridging the disciplines of cinema, television studies, visual anthropology, cultural studies, and communications—began to explore a unique set of conflicts that underlie the relationship between indigenous peoples and media. Focusing on the case of Inuit television development and Aboriginal media in Australia, FAYE GINSBURG explores the tensions between the deliberate past "erasure of indigenous ethnographic subjects" as participants in their own representations, and their current visibility. In "Screen Memories and Entangled Technologies," Ginsburg contends that these tensions are central to aboriginal mediamakers engaged in creating what she calls "screen memories." Working as activists in local broadcasting initiatives or as media professionals within national production structures, indigenous filmmakers have used the power of media as an essential tool to produce new memories for their own people as well as for larger communities. In an argument that is significant to various aspects of race/ethnicity discussed in the section, Ginsburg shows how the very power of media that erased the subjectivity of indigenous peoples from dominant narratives can be used to recuperate their own collective histories and create new "screen memories."

As studies of race and ethnicity in cinema have evolved beyond binary paradigms to reveal more complex and hybrid racial/ethnic identities and positions, they have also revealed more interactive (rather than oppositional or exclusive) relations between dominant Hollywood and multiple formations of alternative (including ethnic, diasporic, and indigenous) cinemas. These relations are formed in a two-way exchange process that not only affects the "marginal" but also changes the complexion of Hollywood's master narrative.

# FRANTZ FANON

......................................................................................................

# The Fact of Blackness

FROM *Black Skin, White Masks*

Born on the island of Martinique, then a French colony in the West Indies, in 1925, Frantz Fanon died of leukemia in 1961, just weeks after the publication of his most famous work, *The Wretched of the Earth* (trans. 1963), widely considered the theoretical blueprint for Third World anticolonial struggle in the 1960s and after. While serving in World War II and studying medicine in France, Fanon experienced the racism that inspired the writing of *Black Skin, White Masks,* which was first published in 1952 as *Peau noire, masques blancs* (trans. 1967) after being rejected as his doctoral thesis. Working as a psychiatrist in Algeria, Fanon became convinced that colonialism was itself a form of pathology, and he was swept up in the Algerian struggle for independence, which was finally achieved in 1962 shortly after his death.

The seeds of the civil rights and Black Power movements in the United States and the anticolonial struggles in Africa, Asia, and Latin America were sown in the immediate postwar period during which *Black Skin, White Masks* was written. Influenced by poet and politician of the "négritude" movement, Aimé Césaire, and in dialogue with French intellectuals Jean-Paul Sartre and Simone de Beauvoir, Fanon was also one of the first theorists to employ psychoanalysis to analyze race and gender together. But it was his strong anticolonial position in *The Wretched of the Earth,* especially his thoughts on the necessity of violence, that made the most immediate impact politically as well as on the work of such filmmakers and theorists of Third Cinema (a term describing political cinema from Third World nations) as Fernando Solanas and Octavio Getino (p. 924), whose legendary documentary, *Hour of the Furnaces* (1968), quotes directly from Fanon's text.

The extract from Chapter 5 of *Black Skin, White Masks* entitled "The Fact of Blackness" begins with a shocking racial epithet, followed by the milder, but still stinging, "Look, a Negro!" immediately drawing attention to the chapter's narrator, at whom it is directed. The fact that the person uttering this phrase is a white child highlights the power disparities between the two. Just in this opening scene, Fanon captures how one's subjectivity can be transformed into a position of objecthood by an outsider's culturally validated

gaze, a painful experience that he explores throughout the rest of the chapter. Film studies has drawn from this work a foundational description of the operation of stereotyping—the image of the black body conjures a whole chain of primitivist associations in viewers, and oppression is enacted through the very act of gazing.

Elsewhere in the text, Fanon describes black spectatorship as a complex process of identification and alienation: "Attend showings of a Tarzan film in the Antilles and in Europe. In the Antilles, the young Negro identifies himself *de facto* with Tarzan against the Negroes. This is much more difficult for him in a European theater, for the rest of the audience, which is white, automatically identifies him with the savages on the screen" (152–153, n. 15). Fanon's insightful accounts of the visual dynamics and psychic consequences of racial identification and discrimination, as well as his brief comments on film stereotyping, have made an increasingly acknowledged contribution to understanding the colonization of minds through images.

## READING CUES & KEY CONCEPTS

▨ Consider how Fanon's writing style brings home the experience of being objectified as a black man. How does the essay encourage you to identify with the narrator?

▨ Fanon wrote of primitive stereotypes of people of African descent in the 1950s. Are there current movies that recycle or challenge these stereotypes?

▨ **Key Concepts:** Colonialism; Negritude; Existentialism; Primitivism; The Other

# The Fact of Blackness

. . . . . . . . . . . . . .

"Dirty nigger!" Or simply, "Look, a Negro!"

I came into the world imbued with the will to find a meaning in things, my spirit filled with the desire to attain to the source of the world, and then I found that I was an object in the midst of other objects.

Sealed into that crushing objecthood, I turned beseechingly to others. Their attention was a liberation, running over my body suddenly abraded into nonbeing, endowing me once more with an agility that I had thought lost, and by taking me out of the world, restoring me to it. But just as I reached the other side, I stumbled, and the movements, the attitudes, the glances of the other fixed me there, in the sense in which a chemical solution is fixed by a dye. I was indignant; I demanded an explanation. Nothing happened. I burst apart. Now the fragments have been put together again by another self.

As long as the black man is among his own, he will have no occasion, except in minor internal conflicts, to experience his being through others. There is of course the moment of "being for others," of which Hegel speaks, but every ontology is made unattainable in a colonized and civilized society. It would seem that this fact has not been given sufficient attention by those who have discussed the question. In the *Weltanschauung* of a colonized people there is an impurity, a flaw that outlaws

any ontological explanation. Someone may object that this is the case with every individual, but such an objection merely conceals a basic problem. Ontology—once it is finally admitted as leaving existence by the wayside—does not permit us to understand the being of the black man. For not only must the black man be black; he must be black in relation to the white man. Some critics will take it on themselves to remind us that this proposition has a converse. I say that this is false. The black man has no ontological resistance in the eyes of the white man. Overnight the Negro has been given two frames of reference within which he has had to place himself. His metaphysics, or, less pretentiously, his customs and the sources on which they were based, were wiped out because they were in conflict with a civilization that he did not know and that imposed itself on him.

The black man among his own in the twentieth century does not know at what moment his inferiority comes into being through the other. Of course I have talked about the black problem with friends, or, more rarely, with American Negroes. Together we protested, we asserted the equality of all men in the world. In the Antilles there was also that little gulf that exists among the almost-white, the mulatto, and the nigger. But I was satisfied with an intellectual understanding of these differences. It was not really dramatic. And then. . . .

And then the occasion arose when I had to meet the white man's eyes. An unfamiliar weight burdened me. The real world challenged my claims. In the white world the man of color encounters difficulties in the development of his bodily schema. Consciousness of the body is solely a negating activity. It is a third-person consciousness. The body is surrounded by an atmosphere of certain uncertainty. I know that if I want to smoke, I shall have to reach out my right arm and take the pack of cigarettes lying at the other end of the table. The matches, however, are in the drawer on the left, and I shall have to lean back slightly. And all these movements are made not out of habit but out of implicit knowledge. A slow composition of my *self* as a body in the middle of a spatial and temporal world—such seems to be the schema. It does not impose itself on me; it is, rather, a definitive structuring of the self and of the world—definitive because it creates a real dialectic between my body and the world.

For several years certain laboratories have been trying to produce a serum for "denegrification"; with all the earnestness in the world, laboratories have sterilized their test tubes, checked their scales, and embarked on researches that might make it possible for the miserable Negro to whiten himself and thus to throw off the burden of that corporeal malediction. Below the corporeal schema I had sketched a historico-racial schema. The elements that I used had been provided for me not by "residual sensations and perceptions primarily of a tactile, vestibular, kinesthetic, and visual character,"[1] but by the other, the white man, who had woven me out of a thousand details, anecdotes, stories. I thought that what I had in hand was to construct a physiological self, to balance space, to localize sensations, and here I was called on for more.

"Look, a Negro!" It was an external stimulus that flicked over me as I passed by. I made a tight smile.

"Look, a Negro!" It was true. It amused me.

"Look, a Negro!" The circle was drawing a bit tighter. I made no secret of my amusement.

"Mama, see the Negro! I'm frightened!" Frightened! Frightened! Now they were beginning to be afraid of me. I made up my mind to laugh myself to tears, but laughter had become impossible.

I could no longer laugh, because I already knew that there were legends, stories, history, and above all *historicity*, which I had learned about from Jaspers. Then, assailed at various points, the corporeal schema crumbled, its place taken by a racial epidermal schema. In the train it was no longer a question of being aware of my body in the third person but in a triple person. In the train I was given not one but two, three places. I had already stopped being amused. It was not that I was finding febrile coordinates in the world. I existed triply: I occupied space. I moved toward the other . . . and the evanescent other, hostile but not opaque, transparent, not there, disappeared. Nausea. . . .

I was responsible at the same time for my body, for my race, for my ancestors. I subjected myself to an objective examination, I discovered my blackness, my ethnic characteristics; and I was battered down by tom-toms, cannibalism, intellectual deficiency, fetishism, racial defects, slave-ships, and above all else, above all: "Sho' good eatin'."

On that day, completely dislocated, unable to be abroad with the other, the white man, who unmercifully imprisoned me, I took myself far off from my own presence, far indeed, and made myself an object. What else could it be for me but an amputation, an excision, a hemorrhage that spattered my whole body with black blood? But I did not want this revision, this thematization. All I wanted was to be a man among other men. I wanted to come lithe and young into a world that was ours and to help to build it together.

But I rejected all immunization of the emotions. I wanted to be a man, nothing but a man. Some identified me with ancestors of mine who had been enslaved or lynched: I decided to accept this. It was on the universal level of the intellect that I understood this inner kinship—I was the grandson of slaves in exactly the same way in which President Lebrun was the grandson of tax-paying, hard-working peasants. In the main, the panic soon vanished.

In America, Negroes are segregated. In South America, Negroes are whipped in the streets, and Negro strikers are cut down by machine-guns. In West Africa, the Negro is an animal. And there beside me, my neighbor in the university, who was born in Algeria, told me: "As long as the Arab is treated like a man, no solution is possible."

"Understand, my dear boy, color prejudice is something I find utterly foreign. . . . But of course, come in, sir, there is no color prejudice among us. . . . Quite, the Negro is a man like ourselves. . . . It is not because he is black that he is less intelligent than we are. . . . I had a Senegalese buddy in the army who was really clever. . . ."

Where am I to be classified? Or, if you prefer, tucked away?

"A Martinican, a native of 'our' old colonies."

Where shall I hide?

"Look at the nigger! . . . Mama, a Negro! . . . Hell, he's getting mad. . . . Take no notice, sir, he does not know that you are as civilized as we. . . ."

My body was given back to me sprawled out, distorted, recolored, clad in mourning in that white winter day. The Negro is an animal, the Negro is bad, the Negro is mean, the Negro is ugly; look, a nigger, it's cold, the nigger is shivering, the nigger is shivering because he is cold, the little boy is trembling because he is afraid of the nigger, the

nigger is shivering with cold, that cold that goes through your bones, the handsome little boy is trembling because he thinks that the nigger is quivering with rage, the little white boy throws himself into his mother's arms: Mama, the nigger's going to eat me up.

All round me the white man, above the sky tears at its navel, the earth rasps under my feet, and there is a white song, a white song. All this whiteness that burns me. . . .

I sit down at the fire and I become aware of my uniform. I had not seen it. It is indeed ugly. I stop there, for who can tell me what beauty is?

Where shall I find shelter from now on? I felt an easily identifiable flood mounting out of the countless facets of my being. I was about to be angry. The fire was long since out, and once more the nigger was trembling.

"Look how handsome that Negro is! . . ."

"Kiss the handsome Negro's ass, madame!"

Shame flooded her face. At last I was set free from my rumination. At the same time I accomplished two things: I identified my enemies and I made a scene. A grand slam. Now one would be able to laugh.

The field of battle having been marked out, I entered the lists.

What? While I was forgetting, forgiving, and wanting only to love, my message was flung back in my face like a slap. The white world, the only honorable one, barred me from all participation. A man was expected to behave like a man. I was expected to behave like a black man—or at least like a nigger. I shouted a greeting to the world and the world slashed away my joy. I was told to stay within bounds, to go back where I belonged.

They would see, then! I had warned them, anyway. Slavery? It was no longer even mentioned, that unpleasant memory. My supposed inferiority? A hoax that it was better to laugh at. I forgot it all, but only on condition that the world not protect itself against me any longer. I had incisors to test. I was sure they were strong. And besides. . . .

What! When it was I who had every reason to hate, to despise, I was rejected? When I should have been begged, implored, I was denied the slightest recognition? I resolved, since it was impossible for me to get away from an *inborn complex*, to assert myself as a BLACK MAN. Since the other hesitated to recognize me, there remained only one solution: to make myself known.

In *Anti-Semite and Jew* (p. 95), Sartre says: "They [the Jews] have allowed themselves to be poisoned by the stereotype that others have of them, and they live in fear that their acts will correspond to this stereotype. . . . We may say that their conduct is perpetually overdetermined from the inside."

All the same, the Jew can be unknown in his Jewishness. He is not wholly what he is. One hopes, one waits. His actions, his behavior are the final determinant. He is a white man, and, apart from some rather debatable characteristics, he can sometimes go unnoticed. He belongs to the race of those who since the beginning of time have never known cannibalism. What an idea, to eat one's father! Simple enough, one has only not to be a nigger. Granted, the Jews are harassed—what am I thinking of? They are hunted down, exterminated, cremated. But these are little family quarrels. The Jew is disliked from the moment he is tracked down. But in my case everything takes

on a *new* guise. I am given no chance. I am overdetermined from without. I am the slave not of the "idea" that others have of me but of my own appearance.

I move slowly in the world, accustomed now to seek no longer for upheaval. I progress by crawling. And already I am being dissected under white eyes, the only real eyes. I am *fixed*. Having adjusted their microtomes, they objectively cut away slices of my reality. I am laid bare. I feel, I see in those white faces that it is not a new man who has come in, but a new kind of man, a new genus. Why, it's a Negro!

I slip into corners, and my long antennae pick up the catch-phrases strewn over the surface of things—nigger underwear smells of nigger—nigger teeth are white—nigger feet are big—the nigger's barrel chest—I slip into corners, I remain silent, I strive for anonymity, for invisibility. Look, I will accept the lot, as long as no one notices me!

"Oh, I want you to meet my black friend.... Aimé Césaire, a black man and a university graduate.... Marian Anderson, the finest of Negro singers.... Dr. Cobb, who invented white blood, is a Negro. . . . Here, say hello to my friend from Martinique (be careful, he's extremely sensitive). . . ."

Shame. Shame and self-contempt. Nausea. When people like me, they tell me it is in spite of my color. When they dislike me, they point out that it is not because of my color. Either way, I am locked into the infernal circle.

[ · · · ]

The Negro is a toy in the white man's hands; so, in order to shatter the hellish cycle, he explodes. I cannot go to a film without seeing myself. I wait for me. In the interval, just before the film starts, I wait for me. The people in the theater are watching me, examining me, waiting for me. A Negro groom is going to appear. My heart makes my head swim.

The crippled veteran of the Pacific war says to my brother, "Resign yourself to your color the way I got used to my stump; we're both victims."[2]

Nevertheless with all my strength I refuse to accept that amputation. I feel in myself a soul as immense as the world, truly a soul as deep as the deepest of rivers, my chest has the power to expand without limit. I am a master and I am advised to adopt the humility of the cripple. Yesterday, awakening to the world, I saw the sky turn upon itself utterly and wholly. I wanted to rise, but the disemboweled silence fell back upon me, its wings paralyzed. Without responsibility, straddling Nothingness and Infinity, I began to weep.

## NOTES

1. Jean Lhermitte, *L'Image de notre corps* (Paris, Nouvelle Revue critique, 1939), p. 17.

2. *Home of the Brave.*

# ELLA SHOHAT AND ROBERT STAM

## Stereotype, Realism, and the Struggle over Representation

FROM *Unthinking Eurocentrism*

Ella Shohat, a professor in the departments of Art and Public Policy and Middle Eastern Studies at New York University, is an author and activist who has published and lectured extensively on issues in cultural studies, postcolonial theory, and visual culture. Her award-winning work includes *Israeli Cinema: East/West and the Politics of Representation* (1989), the edited collection *Talking Visions: Multicultural Feminism in a Transnational Age* (1998), and numerous widely anthologized essays. Robert Stam, University Professor at the Tisch School of Arts at New York University, has edited important volumes in film theory and has authored numerous books that cover a broad range of topics in film history and theory, film and literature, international cinema, and cultural studies (see p. 541). Together, Stam and Shohat co-authored the groundbreaking work *Unthinking Eurocentrism: Multiculturalism and the Media* (1994), from which this excerpt is drawn, and edited the volume *Multiculturalism, Postcoloniality, and Transnational Media* (2000).

Following the impact of feminist film theory and its concern with gender construction, theorists in the 1980s adopted a broader perspective suggested by cultural studies and postcolonial theory and began focusing on other axes of identity and social representation, such as sexuality, nationality, and race. Shohat and Stam's work took an additional step by bringing these different issues under the same umbrella and emphasizing the importance of discussing them in relation to each other, in temporal, geographical, and disciplinary terms. Their approach forges links among usually compartmentalized academic fields (film, media studies, literary theory, visual culture, critical anthropology) and areas of inquiry, especially postcolonial, diasporic, and ethnic studies. In *Unthinking Eurocentrism*, the first comprehensive study of its kind, Shohat and Stam shape a theoretical model for looking at Hollywood, mass media, and alternative cultural practices that they term "multicultural media studies." With this model, they aim to unpack the epistemic logic of Eurocentrism, a perspective in which Europe is seen as the center of the world and a unique source of meaning.

In Chapter 5 of *Unthinking Eurocentrism*, "Stereotype, Realism, and the Struggle over Representation," Shohat and Stam redefine the question of the stereotype, moving it beyond positive or negative images that either reflect or fail to reflect "reality" or "truth," and thinking about it in terms of self-representation. They argue that because marginalized groups have historically been powerless to control their own representation, it is crucial to understand not just the representation or image itself but also the institutions that disseminate mass media texts and the audiences that receive them. In film, emphasizing the discursive rather than image analysis not only reveals cinematic dimensions beyond the question of realism and character (such as narrative structure, visual style, voice), but it also allows us to understand filmic representation as part of a continuum and connected to other socially circulated discourses. Finally, their relational approach to

representation extends the issue of race and racial binaries to explorations of what they call "cultural syncretism"—the interplay of cultural communities and identities within and across borders. A remarkably influential work, *Unthinking Eurocentrism* helped inaugurate the now-burgeoning field of world cinema studies. Shohat and Stam's idea of "polycentric multiculturalism" acknowledges the plurality and diversity of film products and their conditions not just around the globe but also within seemingly homogeneous countries.

## READING CUES & KEY CONCEPTS

■ Consider Shohat and Stam's critique of the "obsession with realism" in relation to ethnic/racial representation. How do they reconcile the view that on the one hand, film is only representation with no direct access to the real, and on the other hand the fact that film impacts social reality and is crucial in the struggle over meaning?

■ Think of a film you've seen recently and explore its circumstances of production. What do Stam and Shohat mean when they say that a film "mirrors its own processes of production as well as larger social processes"?

■ Shohat and Stam argue for a methodological approach that would speak less of "images" and more of "voices." How do you understand their concept of "voice"?

■ **Key Concepts:** Stereotype; Mimesis; Representation/Self-Representation; Voice/Discourse; Race/Ethnicity; Hegemony; Polyvocality

# Stereotype, Realism, and the Struggle over Representation

. . . . . . . . . . . . . .

Much of the work on ethnic/racial and colonial representation in the media has been "corrective," devoted to demonstrating that certain films, in some respect or other, "got something wrong" on historical, biographical, or other grounds of accuracy. While these "stereotypes and distortions" analyses pose legitimate questions about social plausibility and mimetic accuracy, about negative and positive images, they are often premised on an exclusive allegiance to an esthetic of verisimilitude.[1] An obsession with "realism" casts the question as simply one of "errors" and "distortions," as if the "truth" of a community were unproblematic, transparent, and easily accessible, and "lies" about that community easily unmasked. Debates about ethnic representation often break down on precisely this question of "realism," at times leading to an impasse in which diverse spectators or critics passionately defend their version of the "real."

## *The Question of Realism*

These debates about realism and accuracy are not trivial, not just a symptom of the "veristic idiocy," as a certain poststructuralism would have it. Spectators (and critics) are invested in realism because they are invested in the idea of truth, and

reserve the right to confront a film with their own personal and cultural knowledge. No deconstructionist fervor should induce us to surrender the right to find certain films sociologically false or ideologically pernicious, to see *Birth of a Nation* (1915), for example, as an "objectively" racist film. That films are only representations does not prevent them from having real effects in the world; racist films can mobilize for the Ku Klux Klan, or prepare the ground for retrograde social policy. Recognizing the inevitability and the inescapability of representation does not mean, as Stuart Hall has put it, that "nothing is at stake."

The desire to reserve a right to judgment on questions of realism comes into play especially in cases where there are real-life prototypes for characters and situations, and where the film, whatever its conventional disclaimers, implicitly makes, and is received as making, historical-realist claims. (Isaac Julien's *Looking for Langston*, 1989, dodges the problem through a generic "end run" by labeling itself as a "meditation" on Langston Hughes.) The veterans of the 1960s civil rights struggle are surely in a position to critique *Mississippi Burning* (1988) for turning the movement's historical enemy—the racist FBI which harassed and sabotaged the movement—into the film's heroes, while turning the historical heroes—the thousands of African-Americans who marched and braved beatings and imprisonment and sometimes death—into the supporting cast, passive victim-observers waiting for official White rescue.[2] This struggle over meaning matters because *Mississippi Burning* might induce audiences unfamiliar with the facts into a fundamental misreading of American history, idealizing the FBI and regarding African-Americans as mute witnesses of history rather than its makers.[3] Thus although there is no absolute truth, no truth apart from representation and dissemination, there are still contingent, qualified, perspectival truths in which communities are invested.

Poststructuralist theory reminds us that we live and dwell within language and representation, and have no direct access to the "real." But the constructed, coded nature of artistic discourse hardly precludes all reference to a common social life. Filmic fictions inevitably bring into play real-life assumptions not only about space and time but also about social and cultural relationships. Films which represent marginalized cultures in a realistic mode, even when they do not claim to represent specific historical incidents, still implicitly make factual claims. Thus critics are right to draw attention to the complacent ignorance of Hollywood portrayals of Native Americans, to the cultural flattening which erases the geographical and cultural differences between Great Plains tribes and those from other regions, which have Indians of the northeast wearing Plains Indians clothing and living in Hopi dwellings, all collapsed into a single stereotypical figure, the "instant Indian" with "wig, war bonnet, breechclout, moccasins, phony beadwork."[4]

Many oppressed groups have used "progressive realism" to unmask and combat hegemonic representations, countering the objectifying discourses of patriarchy and colonialism with a vision of themselves and their reality "from within." But this laudable intention is not always unproblematic. "Reality" is not self-evidently given and "truth" is not immediately "seizable" by the camera. We must distinguish, furthermore, between realism as a goal—Brecht's "laying bare the causal network"—and realism as a style or constellation of strategies aimed at producing an illusionistic "reality effect." Realism as a goal is quite compatible with a style which is reflexive

and deconstructive, as is eloquently demonstrated by many of the alternative films discussed in [our] book.

In his work, Mikhail Bakhtin reformulates the notion of artistic representation in such a way as to avoid both a naive faith in "truth" and "reality" and the equally naive notion that the ubiquity of language and representation signifies the end of struggle and the "end of history." Human consciousness and artistic practice, Bakhtin argues, do not come into contact with the "real" directly but rather through the medium of the surrounding ideological world. Literature, and by extension cinema, do not so much refer to or call up the world as represent its languages and discourses. Rather than directly reflecting the real, or even refracting the real, artistic discourse constitutes a refraction of a refraction; that is, a mediated version of an already textualized and "discursivized" socioideological world. This formulation transcends a naive referential verism without falling into a "hermeneutic nihilism" whereby all texts become nothing more than a meaningless play of signification. Bakhtin rejects naive formulations of realism, in other words, without abandoning the notion that artistic representations are at the same time thoroughly and irrevocably social, precisely because the discourses that art represents are *themselves* social and historical. Indeed, for Bakhtin art is incontrovertibly social, not because it represents the real but because it constitutes a historically situated "utterance"—a complex of signs addressed by one socially constituted subject or subjects to other socially constituted subjects, all of whom are deeply immersed in historical circumstance and social contingency.

The issue, then, is less one of fidelity to a preexisting truth or reality than one of a specific orchestration of ideological discourses and communitarian perspectives. While on one level film is mimesis, representation, it is also utterance, an act of contextualized interlocution between socially situated producers and receivers. It is not enough to say that art is constructed. We have to ask: Constructed for whom? And in conjunction with which ideologies and discourses? In this sense, art is a representation not so much in a mimetic as a political sense, as a delegation of voice.[5] Within this perspective, it makes more sense to say of *The Gods Must Be Crazy* (1984) not that it is untrue to "reality," but that it relays the colonialist discourse of official White South Africa. The racist discourse of the film posits a Manichean binarism contrasting happy and noble but impotent Bantustan "Bushmen," living in splendid isolation, with dangerous but incompetent mulatto-led revolutionaries. Yet the film camouflages its racism by a superficial critique of White technological civilization. A discursive approach to *First Blood (Rambo)* (1983), similarly, would not argue that it "distorts" reality, but rather that it "really" represents a rightist and racist discourse designed to flatter and nourish the masculinist fantasies of omnipotence characteristic of an empire in crisis. By the same token, representations can be convincingly verisimilar, yet Eurocentric, or conversely, fantastically "inaccurate," yet anti-Eurocentric. The analysis of a film like *My Beautiful Laundrette* (1985), sociologically flawed from a mimetic perspective—given its focus on wealthy Asians rather than more typically working-class Asians in London—alters considerably when regarded as a constellation of discursive strategies, as a provocative symbolic inversion of conventional expectations of a miserabilist account of Asian victimization.

That something vital is at stake in these debates becomes obvious in those instances when entire communities passionately protest the representations that are made of them in the name of their own experiential sense of truth. Hollywood

stereotypes have not gone unremarked by the communities they portrayed. Native Americans, very early on, vocally protested misrepresentations of their culture and history.[6] A 1911 issue of *Moving Picture World* (August 3) reports a Native American delegation to President Taft protesting erroneous representations and even asking for a Congressional investigation. In the same vein, the National Association for the Advancement of Colored People (NAACP) protested *Birth of a Nation*, Chicanos protested the *bandido* films, Mexicans protested *Viva Villa!* (1934), Brazilians protested *Rio's Road to Hell* (1931), Cubans protested *Cuban Love Song* (1931), and Latin Americans generally protested the caricaturing of their culture. The Mexican government threatened to block distribution of Hollywood films in Mexico if the US film industry did not stop exporting films caricaturing Mexico, Mexican Americans, and the Mexican revolution. More recently, Turks protested *Midnight Express* (1978), Puerto Ricans protested *Fort Apache the Bronx* (1981), Africans protested *Out of Africa* (1985) and Asian-Americans protested *The Year of the Dragon* (1985). Native Americans so vigorously protested the TV series *Mystic Warrior*, based on Ruth Beebe Hill's Ayn Rand-inflected pseudo-Indian saga *Hanta Yo* (1979), that the film version could not be made in the US. One American Indian Movement pamphlet distributed during protests offered ironic guidelines on "How to Make an Indian Movie":

> How to make an Indian Movie. Buy 40 Indians. Totally humiliate and degrade an entire Indian nation. Make sure all Indians are savage, cruel and ignorant . . . Import a Greek to be an Indian princess. Introduce a white man to become an "Indian" hero. Make the white man compassionate, brave and understanding . . . Pocket the profits in Hollywood.

Critical spectators can thus exert pressure on distribution and exhibition, and even affect subsequent productions. While such pressure does not guarantee sympathetic representations, it does at least mean that aggressively hurtful portrayals will not go unchallenged.

Although total realism is a theoretical impossibility, then, spectators themselves come equipped with a "sense of the real" rooted in their own experience, on the basis of which they can accept, question, or even subvert a film's representations. In this sense, the cultural preparation of a particular audience can generate counter-pressure to a racist or prejudicial discourse. Latin American audiences laughed Hollywood's know-nothing portrayals of them off the screen, finding it impossible to take such misinformed images seriously. The Spanish-language version of *Dracula*, for example, made concurrently with the 1931 Bela Lugosi film, mingled Cuban, Argentine, Chilean, Mexican, and peninsular Spanish in a linguistic hodge-podge that struck Latin American audiences as ludicrous. At the same time, spectators may look beyond caricatural representations to see the oppressed performing self. African-Americans were not likely to take Step'n Fetchit as a typical, synecdochic sample of Black behavior or attitudes; Black audiences knew he was acting, and understood the circumstances that led him to play subservient roles. In the same vein, in a kind of double consciousness, spectators may enjoy what they know to be misrepresentations; Baghdadi spectators could enjoy *The Thief of Baghdad* (1940), for example, because they took it as an escapist fantasy, as a Western embroidery of an already fantastic tale from *A Thousand and One Nights*, with no relation to the "real" historical Baghdad.

## *The Burden of Representation*

The hair-trigger sensitivity about racial stereotypes derives partly from what has been labeled the "burden of representation." The connotations of "representation" are at once religious, esthetic, political, and semiotic. On a religious level, the Judeo-Islamic censure of "graven images" and the preference for abstract representations such as the arabesque cast theological suspicion on directly figurative representation and thus on the very ontology of the mimetic arts.[7] Representation also has an esthetic dimension, in that art too is a form of representation, in Platonic or Aristotelian terms, a mimesis. Representation is theatrical too, and in many languages "to represent" means "to enact" or play a role. The narrative and mimetic arts, to the extent that they represent ethos (character) and ethnos (peoples) are considered representative not only of the human figure but also of anthropomorphic vision. On another level, representation is also political, in that political rule is not usually direct but representative. Marx said of the peasantry that "they do not represent themselves; they must be represented." The contemporary definition of democracy in the West, unlike the classical Athenian concept of democracy, or that of various Native American communities, rests on the notion of "representative government," as in the rallying cry of "No taxation without representation." Many of the political debates around race and gender in the US have revolved around the question of self-representation, seen in the pressure for more "minority" representation in political and academic institutions. What all these instances share is the semiotic principle that something is "standing for" something else, or that some person or group is speaking on behalf of some other persons or groups. On the symbolic battlegrounds of the mass media, the struggle over representation in the simulacral realm homologizes that of the political sphere, where questions of imitation and representation easily slide into issues of delegation and voice. (The heated debate around which celebrity photographs, whether of Italian-Americans or of African-Americans, will adorn the wall of Sal's Pizzeria in Spike Lee's *Do the Right Thing*, 1989, vividly exemplifies this kind of struggle within representation.)

Since what Memmi calls the "mark of the plural" projects colonized people as "all the same," any negative behavior by any member of the oppressed community is instantly generalized as typical, as pointing to a perpetual backsliding toward some presumed negative essence. Representations thus become allegorical; within hegemonic discourse every subaltern performer/role is seen as synecdochically summing up a vast but putatively homogenous community. Representations of dominant groups, on the other hand, are seen not as allegorical but as "naturally" diverse, examples of the ungeneralizable variety of life itself.[8] Socially empowered groups need not be unduly concerned about "distortions and stereotypes," since even occasionally negative images form part of a wide spectrum of representations. A corrupt White politician is not seen as an "embarrassment to the race;" financial scandals are not seen as a negative reflection on White power. Yet each negative image of an underrepresented group becomes, within the hermeneutics of domination, sorely overcharged with allegorical meaning as part of what Michael Rogin calls the "surplus symbolic value" of oppressed people; the way Blacks, for example, can be made to stand for something beside themselves.[9]

This sensitivity operates on a continuum with other representations and with everyday life, where the "burden" can indeed become almost unbearable. It is this

continuum that is ignored when analysts place stereotypes of so-called ethnic Americans, for example, on the same level as those of Native Americans or African-Americans. While all negative stereotypes are hurtful, they do not all exercise the same power in the world. The facile catch-all invocation of "stereotypes" elides a crucial distinction: stereotypes of some communities merely make the target group uncomfortable, but the community has the social power to combat and resist them; stereotypes of other communities participate in a continuum of prejudicial social policy and actual violence against disempowered people, placing the very body of the accused in jeopardy. Stereotypes of Polish-Americans and Italian-Americans, however regrettable, have not been shaped within the racial and imperial foundation of the US, and are not used to justify daily violence or structural oppression against these communities. The media's tendency to present all Black males as potential delinquents, in contrast, has a searing impact on the actual lives of Black people. In the Stuart case in Boston, the police, at the instigation of the actual (White) murderer, interrogated and searched as many Black men as they could in a Black neighborhood, a measure unthinkable in White neighborhoods, which are rarely seen as representational sites of crime. In the same way, the 1988 Bush campaign's "allegorical" deployment of the "Black buck" figure of Willie Horton to trigger the sexual and racial phobias of White voters, dramatically sharpened the burden of representation carried by millions of Black men, and indirectly by Black women.

The sensitivity around stereotypes and distortions largely arises, then, from the powerlessness of historically marginalized groups to control their own representation. A full understanding of media representation therefore requires a comprehensive analysis of the institutions that generate and distribute mass-mediated texts as well as of the audience that receives them. Whose stories are told? By whom? How are they manufactured, disseminated, received? What are the structural mechanisms of the film and media industry? Who controls production, distribution, exhibition? In the US, in 1942, the NAACP made a compact with the Hollywood studios to integrate Blacks into the ranks of studio technicians, yet very few have become directors, scriptwriters, or cinematographers. Minority directors of *all* racial groups constitute less than 3 per cent of the membership of the almost 4,000-member Directors' Guild of America.[10] An agreement between several film unions and the US Justice Department in 1970 required that minorities be integrated into the industry's general labor pools, but the agreement's good intentions were undercut by growing unemployment throughout the industry and by a seniority system that favored older (therefore White male) members. The most recent report on Hollywood employment practices released by the NAACP reveals that Blacks are underrepresented in "each and every aspect" of the entertainment industry. The 1991 study, entitled "Out of Focus—Out of Synch," claims that Blacks are unable to make final decisions in the motion picture process. Despite the success of people like Oprah Winfrey, Bill Cosby, and Arsenio Hall, only a handful of African-Americans hold executive positions within film studios and television networks. Although Blacks purchase a disproportionate share of domestic movie tickets, nepotism, cronyism, and racial discrimination combine to bar Blacks and Black-owned businesses from the industry.[11] Spike Lee speaks of a "glass ceiling" restricting how much money will be spent on Black-made films, based on the assumption that Blacks cannot be trusted with large sums of money.[12] And Blacks are not the only disadvantaged group in this respect. While producers assume

that Italian-American directors should direct films about Italian Americans, for example, they choose Anglos to direct films about Latinos.[13]

[ · · · ]

The production processes of individual films, their means of production and relations of production, bring up questions concerning the filmmaking apparatus and the participation of "minorities" within that apparatus. It seems noteworthy, for example, that in multiethnic but White-dominated societies such as South Africa, Brazil, and the US, Blacks have tended to participate in the filmmaking process mainly as performers rather than as producers, directors, and scriptwriters. In South Africa, Whites finance, script, direct, and produce films with all-Black casts. In the US in the 1920s, all-White filmmaking crews shot all-Black musicals like *Hearts in Dixie* (1929) and *Hallelujah* (1929). Blacks appeared in these films, just as women still frequently do in Hollywood, as images in spectacles whose social thrust is primarily shaped by others: "Black souls as White man's artifact" (Fanon). And since commercial films are designed to make profits, we must also ask to whom these profits go. J. Uys, the director of *The Gods Must Be Crazy*, paid his star actor N!Xau only 2,000 Rand for *Gods I* and 5,000 Rand for *Gods II*.[14] Similarly, it was not blacks who profited from the American blaxploitation films of the early 1970s; these films were financed, produced, and packaged by the same Whites who received the lion's share of the profits. The thousands of Black Brazilians who played at an out-of-season carnival, with virtually no pay, for the benefit of Marcel Camus' French cameras, never saw any of the millions of dollars that *Black Orpheus* (1959) made around the world.[15]

To a certain extent, a film inevitably mirrors its own processes of production as well as larger social processes. At times, minoritarian filmmakers directing films about police harassment have themselves been harassed by police. During the making of Haile Gerima's *Bush Mama* (1975), a film partly about police repression in the inner cities, the crew members themselves became police targets; Black men with cameras, the police assumed, like Black men with guns, could be up to no good.[16] In other cases, we find a contradiction between a film's overt politics and its politics of production. The presumably anticolonial film *Gandhi* (1982), dedicated to the patron saint of non-violent struggle, deployed a differential pay scale that favored European technicians and performers. In *Hearts of Darkness* (1989), the documentary about the production of *Apocalypse Now* (1979), Francis Ford Coppola speaks of the low cost of Filipino labor. In this sense he inherits the same privileges accorded the corporate manager who relocates to the Third World to take advantage of local cheap labor.

Victor Masayesva's *Imagining Indians* (1992) explores the commodification inflicted on Native American culture when it is filtered through a Eurocentric industry, even when those doing the filtering are "sympathetic to the Indian." More precisely, the film examines the problematic negotiations between the Hopi and the producers of *Dark Wind*, a film shot on Hopi land (not yet released at the time of writing). Combining interviews with native extras on Hollywood films, excerpts from the films discussed, sequences showing sacred sites, and a staged story of a native woman's encounter with a condescending White dentist, the film shows the tribal elders raising objections to the project but ultimately going along with

it, in a process that recalls the treaty negotiations between indigenous nations and the US government. At times, native resistance has been more aggressive. When Werner Herzog tried to film *Fitzcarraldo* (1982) with Aguaruna Indians, the newly formed Aguaruna Council objected, refusing to be represented in the way Herzog planned, and even surrounded Herzog's camp and forced the crew to move downriver.[17]

The importance of the participation of colonized or formerly colonized people in the process of production becomes obvious when we compare Gillo Pontecorvo's *La Battaglia di Algeria* (Battle of Algiers, 1966) to his later *Burn* (1970). In the former film, a relatively low-budget ($800,000) Italian-Algerian co-production, Algerian non-professional actors represent themselves in a staged reconstruction of the Algerian war of independence. The Algerians were intimately involved in every aspect of the production, with actors often playing their own historical roles at the very sites where the events took place. They collaborated closely with screenwriter Franco Solanas, who rewrote the scenario numerous times in response to their critiques and observations. As a result, the Algerians exist as socially complex people, and as agents of national struggle. Pontecorvo's multimillion dollar *Burn*, on the other hand, involved no such collaboration. An Italo-French co-production, the film casts Marlon Brando as a British colonial agent against Evaristo Marques, a non-professional actor of peasant background. By pitting one of the First World's most charismatic actors against a completely inexperienced Third World non-professional actor, chosen only for his physiognomy, Pontecorvo, while on one level subverting the star system, on another disastrously tips the scales of spectatorial fascination in favor of the colonizer, in a film whose didactic intention, ironically, was to support anti-colonial struggle. The lack of Caribbean participation in the film's production leads to a one-dimensional portrayal of the colonized, seen as shadowy figures devoid of cultural definition.

[ · · · ]

## *The Limits of the Stereotype*

We would like both to argue for the importance of the study of stereotyping in popular culture and to raise some methodological questions about the underlying premises of character- or stereotype-centered approaches. [ . . . ] To begin, the stereotype-centered approach, the analysis of repeated, ultimately pernicious constellations of character traits, has made an indispensable contribution by:

1. revealing oppressive patterns of prejudice in what might at first glance have seemed random and inchoate phenomena;

2. highlighting the psychic devastation inflicted by systematically negative portrayals on those groups assaulted by them, whether through internalization of the stereotypes themselves or through the negative effects of their dissemination; and

3. signaling the social functionality of stereotypes, demonstrating that they are not an error of perception but rather a form of social control, intended as what Alice Walker calls "prisons of image."[18]

The call for "positive images," in the same way, corresponds to a profound logic which only those accustomed to having their narcissism stroked can fail to understand. Given a dominant cinema that trades in heroes and heroines, "minority" communities rightly ask for their fair share of the representational pie as a simple matter of representational parity.

At the same time, the stereotype approach entails a number of theoretical-political pitfalls. First, the exclusive preoccupation with images, whether positive or negative, can lead to a kind of *essentialism*, as less subtle critics reduce a complex variety of portrayals to a limited set of reified formulae. Such criticism is procrustean; the critic forces diverse fictive characters into preestablished categories. Behind every Black child performer the critic discerns a "pickaninny"; behind every sexually attractive Black actor a "buck"; behind every corpulent or nurturing Black female a "mammy." Such reductionist simplifications run the risk of reproducing the very racial essentialism they were designed to combat.

This essentialism generates in its wake a certain *ahistoricism*; the analysis tends to be static, not allowing for mutations, metamorphoses, changes of valence, altered function; it ignores the historical instability of the stereotype and even of language. Some of the basic terminology invoked by [Donald] Bogle in *Toms, Coons, Mulattoes, Mammies, and Bucks* was not always anti-Black. The word "coon," for example, originally referred to rural Whites, becoming a racial slur only around 1848. At the time of the American revolution, the term "buck" evoked a "dashing, virile young man"; and became associated with Blacks only after 1835.[19] Stereotype analysis also fails to register the ways that imagery might be shaped, for example, by structural changes in the economy. How does one reconcile the "lazy Mexican" from the "greaser films" with the media's present-day "illegal alien" overly eager to work long hours at half pay? On the other hand, images may change, while their function remains the same, or vice versa. Riggs' *Ethnic Notions* explains that the role of the Uncle Tom was not to represent Blacks but rather to reassure Whites with a comforting image of Black docility, just as the role of the Black buck, ever since Reconstruction, has been to frighten Whites in order to subordinate them to elite manipulation, a device invented by southern Dixiecrats but subsequently adopted by the Republican Party. The positive images of TV sitcoms with Black casts, such as *Different Strokes* and *The Jeffersons*, Herman Gray argues, idealize "racial harmony, affluence, and individual mobility" and thus "deflect attention from the persistence of racism, inequality, and differential power."[20] The Huxtables' success, as Jhally and Lewis put it, "implies the failure of the majority of black people."[21] Contemporary stereotypes, moreover, are inseparable from the long history of colonialist discourse. The "sambo" type is on one level merely a circumscribed characterological instantiation of the infantilizing trope. The "tragic mulatto," in the same vein, is a cautionary figure premised on the trope of purity, the loathing of mixing characteristics of a certain racist discourse. Similarly, many of the scandalously racist statements discussed in the media are less eccentric views than throwbacks to colonialist discourses. Seen in historical perspective, TV commentator Andy Rooney's widely censured remark that Blacks had "watered down their genes" is not a maverick "opinion" but rather a return to the nostrums of "racial degeneracy" theories.

A recent *Tom Brokaw Report* (April 1993) on the subject of immigration illustrates the need to historicize the discussion of stereotyping and media racism. In

the report, we accompany the efforts of the border police to catch "illegal aliens" coming from Mexico. In the greenish light of surveillance cameras, we see the "aliens" making their way over fences, across highways, through cracks. The portrayal suggests a kind of ineradicable vermin who proliferate like mice and are just as difficult to stomp out. One of "them" appears briefly, not to explain their perspective but only to warn that nothing will stop them, that arrest and expulsion are not major obstacles. There is no historicization, nothing about the brutality of the border police, and no explanation that this entire area was once part of Mexico, that "illegal" Mexicans were there before "legal" Anglos, and that many Chicanos and Mexicans regard themselves as part of a transborder nation. We then move to New York, where a Black Dominican medic reports on the high levels of crime in the neighborhood he serves; he calls for more "selective" immigration. After hearing about the "bad" ethnics (predictably Black and Latino), we meet the "good ethnics": this time Russian Jews who work hard, do not complain, and are deeply appreciative of America's gifts. The same signs shift valence according to an ethnic hierarchy. Both Dominicans and Russians are shown dancing, for example, but only with the Russians does the voice-over "anchor" the dancing as a sign of *joie de vivre*. Then we meet another "model minority," a Korean businessman who "teaches discipline" to young Blacks, who praise the Korean for improving their neighborhood. The Koreans, we are told, work long hours, respect their elders, and get ahead, but their success causes resentment. (Given the LA rebellions, we suspect that the "resenters" might be Blacks and Latinos.) Three White male "experts" address us: one, a liberal, argues for tolerance; the other two argue for greater restrictions. The few Black voices in the program speak up not for their community but rather for other communities (the Koreans) or for stricter immigration policy; no one speaks up for the Blacks. Not a word about racism, about widely divergent histories and relations to colonialism, slavery, or capitalism.

A moment's reflection reveals why this scenario seems so familiar. We are hearing echoes of the nineteenth-century racial hierarchy theories developed by such thinkers as Hegel, Gobineau, and Renan, now embedded in "culture of poverty" ideology. For Gobineau, Blacks are on the lowest rung, incapable of development, while the "Yellow" race is superior to the Black, but still passive and susceptible to despotism. The White race, characterized by intelligence, orderliness, and a taste for liberty, occupies the top position. For Renan too, Blacks (along with indigenous peoples) are at the bottom, with Asians as an "intermediate race" and White Europeans positioned at the top. In the Brokaw program, the qualities posited have changed (the Asians are no longer passive but rather hardworking; European Jews, once the object of anti-Semitic hostility, have been promoted), yet the basic hierarchizing mechanism remains intact. White superiority is not so much asserted as assumed—Whites are the objective ones, the experts, the uncontroversial ones, those who cause no problems, those who judge, those "at home" in the world, whose prerogative it is to create laws in the face of alien disorder.

The focus on "good" and "bad" characters in image analysis confronts racist discourse on that discourse's favored ground. It easily slides into *moralism*, and thus into fruitless debates about the relative virtues of fictive characters (seen not as constructs but as if they were real flesh-and-blood people) and the correctness

of their fictional actions. This kind of anthropocentric moralism, deeply rooted in Manichean schemas of good and evil, leads to the treatment of complex political issues as if they were matters of individual ethics, in a manner reminiscent of the morality plays staged by the right, in which virtuous American heroes do battle against demonized Third World villains. Thus Bush/Reagan regime portrayals of its enemies drew on the "Manichean allegories" (in the words of Abdul Jan Mohamed) of colonialism: the Sandinistas were portrayed as latter-day bandidos, the *mestizo* Noriega was made to incarnate Anglo phobias about Latino men (violent, drug-dealing, voodoo-practicing), and Saddam Hussein triggered the intertextual memory of Muslim fanatics and Arab assassins.

The media discussion of racism often reflects this same personalistic bias. Mass-media debates often revolve around sensational accusations of *personal* racism; the accusation and the defense are framed in individual terms. Accused of racism for exploiting the image of Willie Horton, Bush advertised his personal animosity toward bigotry and his tenderness for his little brown grandchildren, exemplifying an ideological penchant for personalizing and moralizing essentially political issues. The usual sequence in media accusations of racism, similarly, is that the racist statement is made, offense is expressed, punishment is called for: all of which provokes a series of counter-statements—that the person in question is not racist, that some of the person's best friends belong to the race in question, and so forth. The process has the apparently positive result of placing certain statements beyond the pale of civil speech; blatant racism is stigmatized and punished. But the more subtle, deeper forms of discursively and institutionally structured racism remain unrecognized. The discussion has revolved around the putative racism of a single individual; the problem is assumed to be personal, ethical. The result is a lost opportunity for antiracist pedagogy: racism is reduced to an individual, attitudinal problem, distracting attention from racism as a systematic self-reproducing discursive apparatus that itself shapes racist attitudes. Stereotypic analysis is likewise covertly premised on *individualism* in that the individual character, rather than larger social categories (race, class, gender, nation, sexual orientation), remains the point of reference. Individual morality receives more attention than the larger configurations of power. This apolitical approach to stereotypes allows pro-business "content analysts" to lament without irony the TV's "stereotyping" of American businessmen, forgetting that television as an institution, at least, is permeated by the corporate ethos, that its commercials and even its shows are commercials *for* business.

The focus on individual character also misses the ways in which social institutions and cultural practices, as opposed to individuals, can be misrepresented without a single character being stereotyped. The flawed mimesis of many Hollywood films dealing with the Third World, with their innumerable ethnographic, linguistic, and even topographical blunders, has less to do with stereotypes *per se* than with the tendentious ignorance of colonialist discourse. The social institutions and cultural practices of a people can be denigrated without individual stereotypes entering into the question. The media often reproduce Eurocentric views of African spirit religions, for example, by regarding them as superstitious cults rather than as legitimate belief-systems, prejudices enshrined in the patronizing vocabulary ("animism," "ancestor worship," "magic") used to discuss the religions.[22] Within

Eurocentric thinking, superimposed Western hierarchies work to the detriment of African religions:

1. oral rather than written, they are seen as lacking the cultural imprimatur of the religions "of the Book" (when in fact the text simply takes distinct, oral-semiotic form, as in Yoruba praise songs);

2. they are regarded as polytheistic rather than monotheistic (a debatable hierarchy and in any case a misrepresentation of most African religions);

3. they are viewed as superstitious rather than scientific (an inheritance from the positivist view of religion as evolving from myth to theology to science), when in fact all religions involve a leap of faith;

4. they are considered disturbingly corporeal and ludic (danced) rather than abstractly and austerely theological;

5. they are thought insufficiently sublimated (for example, involving actual animal sacrifice rather than symbolic or historically commemorative sacrifice); and

6. they are seen as wildly gregarious, drowning the personality in the collective transpersonal fusions of trance, rather than respecting the unitary, bounded individual consciousness. The Christian ideal of the *visio intellectualis*, which Christian theology inherited from the neo-Platonists, flees in horror from the plural trances and visions of the "transe" religions of Africa and of many indigenous peoples.[23] In a less Eurocentric perspective, all these "deficiencies" become advantages: the lack of a written text precludes fundamentalist dogmatism; the multiplicity of spirits allows for historical change; bodily possession betokens an absence of puritanical asceticism; the dance and music are an aesthetic resource.

Diasporic syncretic religions of African origin are almost invariably caricatured in dominant media. The affiliation of such "voodoo" films as *Voodoo Man* (1944), *Voodoo Woman* (1957), and *Voodoo Island* (1957) with the horror genre already betrays a viscerally phobic attitude to African religion. But in recent films positivist phobias about "magical" practices, coupled with monotheist diabolization of "godless" rituals, still surface. *The Believers* (1986) presents Santeria as a cult dominated by ritual child-murderers, in a manner reminiscent of the "unspeakable rites" invoked by colonialist literature. Any number of films eroticize African religion in a way that betrays ambivalent attraction and repulsion. *Angel Heart* (1987) has Lisa Bonet, as Epiphany Proudfoot the voodoo priestess, thrash around with Mickey Rourke in a sanguinary love scene. Another Mickey Rourke vehicle, *Wild Orchid* (1989), exploits the religious atmosphere of the Afro-Brazilian religion Candomblé as what Tomas Lopez-Pumarejo calls an "Afro-dysiac." And the Michael Caine comedy *Blame it on Rio* (1984) stages Umbanda as a frenetic orgy in which the priestess (*mae de santo*) doles out amorous advice in English to tourists.[24] The electronic media also participate in these defamatory portrayals. Local "Eyewitness News" reports, in New York at least, present Santeria as a problem for law enforcement, or as an issue of "cruelty to animals." Habitual chicken-eaters, forgetful of the scandalous conditions of commercial poultry production, become horrified at the ritual slaughter of small numbers of chickens, while officials openly call for an "end to Santeria," a call unthinkable in the

case of "respectable" religions.[25] In sum, Eurocentric procedures can treat complex cultural phenomena as deviant without recourse to a character stereotype.

A moralistic and individualistic approach also ignores the contradictory nature of stereotypes. Black figures, in Toni Morrison's words, come to signify polar opposites: "On the one hand, they signify benevolence, harmless and servile guardianship and endless love," and on the other "insanity, illicit sexuality, chaos."[26] A moralistic approach also sidesteps the issue of the relative nature of "morality," eliding the question: positive for whom? It ignores the fact that oppressed people might not only have a *different* vision of morality, but even an *opposite* vision of a hypocritical moralism which not only covers over institutional injustice but which is also oppressive in itself. Even the Decalogue becomes less sacrosanct in bitter situations of social oppression. Within slavery, for example, might it not be admirable and therefore "good" to lie to, manipulate, and even murder a slave-driver? The "positive image" approach assumes a bourgeois morality intimately linked to status quo politics. What is seen as "positive" by the dominant group, for instance the acts of those "Indians" in westerns who spy for the Whites, might be seen as treason by the dominated group. The taboo in Hollywood was not so much on "positive images" but rather on images of racial anger, revolt, and empowerment.

The privileging of character over narrative and social structure places the burden on oppressed people to be "good" rather than on the privileged to remove the knife from the back. The counterpart of the "good Black" on the other side of the racial divide is the pathologically vicious racist: Richard Widmark in *No Way Out* (1950) or Bobby Darin in *Pressure Point* (1962). Such films let "ordinary racists" off the hook, unable to recognize themselves in the raving maniacs on the screen. And in order to be equal, the oppressed are asked to be better, whence all the stoic "ebony saints" (Bogle's words) of Hollywood, from Louise Beavers in *Imitation of Life* (1934 version), through Sidney Poitier in *The Defiant Ones* (1961), to Whoopi Goldberg in *Clara's Heart* (1988). Furthermore, the saintly Black forms a Manichean pair with the demon Black, in a moralistic schema reminiscent of that structuring *Cabin in the Sky*. Saints inherit the Christian tradition of sacrifice and tend to be desexualized, deprived of normal human attributes, along the lines of the "Black eunuch," cast in decorative or subservient poses.[27] The privileging of positive images also elides the patent differences, the social and moral heteroglossia (Bakhtin's term signifying "many-languagedness"), characteristic of any social group. A cinema of contrivedly positive image betrays a lack of confidence in the group portrayed, which usually itself has no illusions concerning its own perfection. A cinema in which all the Black characters resembled Sidney Poitier might be as much a cause for alarm as one in which they all resembled Step'n Fetchit. It is often assumed, furthermore, that control over representation leads automatically to the production of "positive images." But films made by Africans like *Laafi* (1991) and *Finzan* (1990) do not offer positive images of African society; rather, they offer critical African perspectives on African society. The demand that Third World or minoritarian filmmakers produce only "positive images," in this sense, can be a sign of anxiety. Hollywood, after all, has never worried about sending films around the world which depict the US as a violent land. Rather than deal with the contradictions of a community, "positive image" cinema prefers a mask of perfection.

Image analysis, furthermore, often ignores the issue of function. Tonto's "positive" image, in the *Lone Ranger* series, is less important than his structural subordination to the White hero and to expansionist ideology. Similarly, a certain cynical integrationism simply inserts new heroes and heroines, this time drawn from the ranks of the oppressed, into the old functional roles that were themselves oppressive, much as colonialism invited a few assimilated "natives" to join the club of the "elite." *Shaft* (1971) simply inserts Black heroes into the actantial slot formerly filled by White ones to flatter the fantasies of a certain sector (largely male) of the Black audience. Even the South African film industry under apartheid could entertain with Black Rambos and Superspades.[28] Other films, such as *In the Heat of the Night* (1967), *Pressure Point*, the *Beverly Hills Cop* series with Eddie Murphy (1984, 1987), and, more complexly, *Deep Cover* (1992), place Black characters in highly ambiguous roles as law-enforcers. The television series *Roots*, finally, used positive images as part of a cooptive version of Afro-American history. The series' subtitle—"The Saga of an American Family"—signals an emphasis on the European-style nuclear family (retrospectively projected on to Kunta's life in Africa) in a film which casts Blacks as just another immigrant group making its way toward freedom and prosperity in democratic America. As Riggs' *Color Adjustment* points out, *Roots* paved the way for *The Cosby Show* by placing an upscale Black family in the preexisting "slot" of the idealized white family sitcom, with Cliff Huxtable as benevolent *paterfamilias*; a liberal move in some respects but one still tied to a conservative valorization of family. John Downing, in contrast, finds *The Cosby Show* more ideologically ambiguous, on the one hand offering an easy pride in African-American culture, and on the other celebrating the virtues of middle class existence in order to obscure structural injustice and racial discrimination.[29]

[ · · · ]

## *Cinematic and Cultural Mediations*

A privileging of social portrayal, plot and character often leads to a slighting of the specifically cinematic dimensions of the films; often the analyses might as easily have been of novels or plays. A throughgoing analysis has to pay attention to "mediations": narrative structure, genre conventions, cinematic style. Eurocentric discourse in film may be relayed not by characters or plot but by lighting, framing, *mise-en-scène*, music. Some basic issues of mediation have to do with the *rapports de force*, the balance of power as it were, between foreground and background. In the visual arts, space has traditionally been deployed to express the dynamics of authority and prestige. In pre-perspectival medieval painting, for example, size was correlated with social status: nobles were large, peasants small. The cinema translates such correlations of social power into registers of foreground and background, on screen and off screen, speech and silence. To speak of the "image" of a social group, we have to ask precise questions about images. How much space do they occupy in the shot? Are they seen in close-ups or only in distant long shots? How often do they appear compared with the Euro-American characters and for how long? Are they active, desiring characters or decorative props? Do the eyeline matches identify us with one gaze rather than another? Whose looks are reciprocated, whose ignored? How do character positionings communicate social distance or

differences in status? Who is front and center? How do body language, posture, and facial expression communicate social hierarchies, arrogance, servility, resentment, pride? Which community is sentimentalized? Is there an esthetic segregation whereby one group is haloed and the other villainized? Are subtle hierarchies conveyed by temporality and subjectivization? What homologies inform artistic and ethnic/political representation?

A critical analysis must also be alive to the contradictions between different registers. For Ed Guerrero, Spike Lee's *Jungle Fever* (1991) rhetorically condemns interracial love, yet "spreads the fever" by making it cinematically appealing in terms of lighting and *mise-en-scène*.[30] Ethic/ethnic perspectives are transmitted not only through character and plot but also through sound and music. As a multi-track audio-visual medium, the cinema manipulates not only point-of-view but also what Michel Chion calls "point-of-hearing" (*point-d'écoute*).[31] In colonial adventure films, the environment and the "natives" are heard as if through the ears of the colonizers. When we as spectators accompany the settlers' gaze over landscapes from which emerge the sounds of native drums, the drum sounds are usually presented as libidinous or threatening. In many Hollywood films, African polyrhythms become aural signifiers of encircling savagery, acoustic shorthand for the racial paranoia implicit in the phrase "the natives are restless." What is seen within Native American, African, or Arab cultures as spiritual and musical expression becomes in the western or adventure film a stenographic index of danger, a motive for fear and loathing. In *Drums along the Mohawk* (1939), the "bad" Indian drums are foiled by the "good" martial Euro-American drums which evoke the beneficent law and order of White Christian patriarchy. Colonialist films associate the colonized with hysterical screams, nonarticulate cries, the yelping of animal-like creatures; the sounds themselves place beast and native on the same level, not just neighbors but species-equals.

Music, both diegetic and non-diegetic, is crucial for spectatorial identification. Lubricating the spectatorial psyche and oiling the wheels of narrative continuity, music "conducts" our emotional responses, regulates our sympathies, extracts our tears, excites our glands, relaxes our pulses, and triggers our fears, in conjunction with the image and in the service of the larger purposes of the film. In whose favor do these processes operate? What is the emotional tonality of the music, and with what character or group does it lead us to identify? Is the music that of the people portrayed? In films set in Africa, such as *Out of Africa* (1985) and *Ashanti* (1979), the choice of European symphonic music tells us that their emotional "heart" is in the West. In *The Wild Geese* (1978), classicizing music consistently lends dignity to the White mercenary side. The Roy Budd score waxes martial and heroic when we are meant to identify with the Whites' aggressivity, and sentimental when we are meant to sympathize with their more tender side. The Borodin air commonly called "This Is My Beloved," associated in the film with the mercenary played by Richard Harris, musically "blesses" his demise with a tragic eulogy.

Alternative films deploy sound and music quite differently. A number of African and Afro-diasporic films, such as *Faces of Women* (1985), *Barravento* (1962), and *Pagador de Promessas* (The Given Word, 1962), deploy drum ouvertures in ways that affirm African cultural values. The French film *Noir et Blanc en Couleur* (Black and White in Color, 1976) employs music satirically by having the African colonized carry

their colonial masters on their backs, but satirize them through the songs they sing: "My master is so fat, how can I carry him?... Yes, and mine has stinky feet..." Films by African and Afro-diasporic directors like Sembene, Cisse, and Faye not only use African music but celebrate it. Julie Dash's *Daughters of the Dust* (1990) deploys an African "talking drum" to drive home, if only subliminally, the Afrocentric thrust of a film dedicated to the diasporic culture of the Gullah people.

Another key mediation has to do with genre. A film like Preston Sturges' *Sullivan's Travels* (1942) raises the question of what one might call the "generic coefficient" of racism. In this summa of cinematic genres, Blacks play very distinct roles, each correlated with a specific generic discourse. In the slapstick land-yacht sequences, the Black waiter conforms to the prototype of the happy-go-lucky servant/buffoon; he is sadistically "painted" with whiteface pancake batter, and excluded from the charmed circle of White sociality. In the documentary-inflected sequences showing masses of unemployed, meanwhile, Blacks are present but voiceless, very much in the left-communist tradition of class reductionism; they appear as anonymous victims of economic hard times, with no racial specificity to their oppression. The most remarkable sequence, a homage to the "all-Black musical" tradition, has a Black preacher and his congregation welcome the largely White prison-inmates to the screening of an animated cartoon. Here, in the tradition of films like *Hallelujah* (1929), the Black community is portrayed as the vibrant scene of expressive religiosity. But the film complicates conventional representation: first, by desegregating the genre; second, by having Blacks exercise charity toward Whites, characterized by the preacher as "neighbors less fortunate than ourselves." The preacher exhorts the congregation not to act "high-toned," for "we is all equal in the sight of God." When congregation and prisoners sing "Let My People Go," the music, the images, and the editing forge a triadic link between three oppressed groups: Blacks, the prisoners, and the Biblical Israelites in the times of the Pharaoh, here assimilated to the cruel warden. The Sturges who directs the "Black musical" sequence radically complicates the Sturges who directs the slapstick sequence; racial attitudes are generically mediated.

The critique-of-stereotypes approach is implicitly premised on the desirability of "rounded" three-dimensional characters within a realist-dramatic esthetic. Given the cinema's history of one-dimensional portrayals, the hope for more complex and "realistic" representations is completely understandable, but should not preclude more experimental, anti-illusionistic alternatives. Realistic "positive" portrayals are not the only way to fight racism or to advance a liberatory perspective. Within a Brechtian esthetic, for example, (non-racial) stereotypes can serve to generalize meaning and demystify established power, at the same time that the characters are never purely positive or negative but rather are the sites of contradiction. Parody of the kind theorized by Bakhtin, similarly, favors decidedly negative, even grotesque images to convey a deep critique of societal structures. At times, critics have mistakenly applied the criteria appropriate to one genre or esthetic to another. A search for positive images in shows like *In Living Color*, for example, would be misguided, for that show belongs to a carnivalesque genre favoring anarchic bad taste and calculated exaggeration, as in the parody of *West Side Story* where the Black woman sings to her Jewish orthodox lover: "Menahem, Menahem, I just met a man named Menahem." (The show is of course open to other forms of critique.) Satirical

or parodic films may be less concerned with constructing positive images than with challenging the stereotypical expectations an audience may bring them. The performance piece in which Coco Fusco/Guillermo Gomez Peña exhibit themselves as "authentic aborigines" to mock the Western penchant for exhibiting non-Europeans in zoos, museums, and freak shows, prods the art world audience into awareness of its own complicity. The question, in such cases, lies not in the valence of the image but rather in the drift of the satire.

What one might call the generic defense against accusations of racism—"It's only a comedy!," "Whites are equally lampooned!," "All the characters are caricatures!," "But it's a parody!"—is highly ambiguous, since it all depends on the modalities and the objects of the lampoon, parody, and so forth. The classic Euro-Israeli film on Asian and African Jews, *Sallah Shabbati* (1964), for example, portrays a Sephardi protagonist, but from a decidedly unSephardi perspective. As a naif, Sallah on one level exemplifies the perennial tradition of the uninitiated outsider figure deployed as an instrument of social and cultural critique or distanciation. But in contrast with other naif figures such as Candide, Schweik, or Said Abi al Nakhs al Mutasha'il (in Emil Habibi's *Pesoptimist*), who are used as narrative devices to strip bare the received wisdom and introduce a fresh perspective, Sallah's naiveté functions less to attack Euro-Israeli stereotypes about Sephardi Jews than to mock Sallah himself and what he supposedly represents—the "oriental," or "black," qualities of Sephardim. In other words, unlike Jaroslav Hašek, who exploits the constructed naiveté of his character to attack European militarism rather than using it as a satire of Schweik's backwardness, the director, Kishon, molds Sallah in conformity with socially derived stereotypes in a mockery of the Sephardi "minority" (in fact the majority) itself. The grotesque character of Sallah was not designed, and was not received by Euro-Israeli critics, as a satire of an individual but rather as a summation of the Sephardi "essence." And within the Manichean splitting of affectivity typical of colonialist discourse, we find the positive—Sephardim are warm, sincere, direct, shrewd—and negative poles—they are lazy, irrational, unpredictable, primitive, illiterate, sexist. Accordingly, Sallah (and the film) speaks in the first-person plural "we," while the Ashkenazi characters address him in the second-person plural, "you all." Kishon's anti-Establishment satire places on the same level the members of the Establishment and those outside it and distant from real power. Social satire is not, then, an immediate guarantor of multiculturalism. It can be retrograde, perpetuating racist views, rather than deploying satire as a community-based critique of Eurocentric representations.[32]

The analysis-of-stereotypes approach, in its eagerness to apply an *a priori* grid, often ignores issues of cultural specificity. The stereotypes of North American Blacks, for example, are only partly congruent with those of other multiracial New World societies like Brazil. Both countries offer the figure of the noble, devoted slave: in the US the Uncle Tom, in Brazil the *Pai João* (Father John). Both also offer the female counterpart, the devoted woman slave or servant: in the US the "mammy," in Brazil the *mae preta* (Black mother), both products of a plantation slavery where the children of the master were nursed at the Black mammy's breast. With other stereotypes, however, the cross-cultural analogies become more complicated. Certain characters in Brazilian films (Tonio in *Bahia de Todos os Santos*, 1960; Jorge in *Compasso de Espera*, Making Time, 1973) at first glance recall the tragic mulatto

figure common in North American cinema and literature, yet the context is radically different. First, the Brazilian racial spectrum is not binary (Black or White) but nuances its shades across a wide variety of racial descriptive terms. Although color varies widely in both countries, the social construction of race and color is distinct, despite the fact that the current "Latinization" of American culture hints at a kind of converging. Second, Brazil, while in many ways oppressive to Blacks, has never been a rigidly segregated society; thus no figure exactly corresponds to the North American "tragic mulatto," schizophrenically torn between two radically separate social worlds. The "passing" notion so crucial to American films such as *Pinky* and *Imitation of Life* had little resonance in Brazil, where it is often said that all Brazilians have a "foot in the kitchen"; in other words, that they all have a Black ancestor somewhere in the family. This point is comically demonstrated in the film *Tendados Milagres* (Tent of Miracles, 1977), when Pedro Arcanjo reveals his racist adversary Nilo Argilo, the rabid critic of "mongrelization," to be himself part Black. The mulatto figure can be seen as dangerous only in an apartheid system and not in a system dominated by an official, albeit hypocritical, integrationist ideology like Brazil's. In Brazil, the figure of the mulatto became surrounded with a different set of prejudicial connotations, such as that of the mulatto as "uppity" or pretentious. On the other hand, this constellation of associations is not entirely foreign to the US; Griffith's *Birth of a Nation*, for example, repeatedly pinpoints mixed-race mulattos as ambitious and dangerous to the system.

**[ · · · ]**

## *The Orchestration of Discourses*

One methodological alternative to the mimetic "stereotypes-and-distortions" approach, we would argue, is to speak less of "images" than of "voices" and "discourses." The very term "image studies" symptomatically elides the oral and the "voiced." A predilection for aural and musical metaphors—voices, intonation, accent, polyphony—reflects a shift in attention, as George Yudice suggests, from the predominantly visual logical space of modernity (perspective, empirical evidence, domination of the gaze) to a "postmodern" space of the vocal (oral ethnography, a people's history, slave narratives), as a way of restoring voice to the voiceless.[33] The concept of voice suggests a metaphor of seepage across boundaries that, like sound in the cinema, remodels spatiality itself, while the visual organization of space, with its limits and boundaries and border police, forms a metaphor of exclusions and hierarchical arrangements. It is not our purpose merely to reverse existing hierarchies—to replace the demogoguery of the visual with a new demogoguery of the auditory—but to suggest that voice (and sound) and image be considered together, dialectically and diacritically. A more nuanced discussion of race and ethnicity in the cinema would emphasize less a one-to-one mimetic adequacy to sociological or historical truth than the interplay of voices, discourses, perspectives, including those operative within the image itself. The task of the critic would be to call attention to the cultural voices at play, not only those heard in aural "close-up" but also those distorted or drowned out by the text. The analytic work would be analogous to that of a "mixer" in a sound studio, whose responsibility it is to perform a series of compensatory operations, to heighten the

treble, deepen the bass, amplify the instrumentation, to "bring out" the voices that remain latent or displaced.

Formulating the issue as one of voices and discourses helps us get past the "lure" of the visual, to look beyond the epidermic surface of the text. The question, quite literally, is less of the color of the face in the image than of the actual or figurative social voice or discourse speaking "through" the image.[34] Less important than a film's "accuracy" is that it relays the voices and the perspectives—we emphasize the plural—of the community or communities in question. While the word "image" evokes the issue of mimetic realism, "voice" evokes a realism of delegation and interlocution, a situated utterance of "speaking from" and "speaking to." If an identification with a community voice/discourse occurs, the question of "positive" images falls back into its rightful place as a subordinate issue. We might look at Spike Lee's films, for example, not in terms of mimetic "accuracy"—such as the lament that *Do the Right Thing* portrays an inner city untouched by drugs—but rather in terms of voices/discourses. We can regret the absence of a feminist voice in the film, but we can also note its repeated stagings of wars of community rhetorics. The symbolic battle of the boomboxes featuring African-American and Latino music, for example, evokes larger tensions between cultural and musical voices. And the final quotations from Martin Luther King and Malcolm X leave it to the spectator to synthesize two complementary modalities of resistance, one saying: "Freedom, as you promised," the other saying: "Freedom, by any means necessary!"

It might be objected that an analysis of textual "voices" would ultimately run into the same theoretical problems as an analysis centered on "images." Why should it be any easier to determine an "authentic voice" than to determine an "authentic image"? The point, we would argue, is to abandon the language of "authenticity" with its implicit standard of appeal to verisimilitude as a kind of "gold standard," in favor of a language of "discourses" with its implicit reference to community affiliation and to intertextuality. Reformulating the question as one of "voices" and "discourses" disputes the hegemony of the visual and of the image-track by calling attention to its complication with sound, voice, dialog, language. A voice, we might add, is not exactly congruent with a discourse, for while discourse is institutional, transpersonal, unauthored, voice is personalized, having authorial accent and intonation, and constitutes a specific interplay of discourses (whether individual or communal). The notion of voice is open to plurality; a voice is never merely a voice; it also relays a discourse, since even an individual voice is itself a discursive sum, a polyphony of voices. What Bakhtin calls "heteroglossia," after all, is just another name for the socially generated contradictions that constitute the subject, like the media, as the site of conflicting discourses and competing voices. A discursive approach also avoids the moralistic and essentialist traps embedded in a "negative-stereotypes" and "positive-images" analysis. Characters are not seen as unitary essences, as actor-character amalgams too easily fantasized as flesh-and-blood entities existing somewhere "behind" the diegesis, but rather as fictive-discursive constructs. Thus the whole issue is placed on a socioideological rather than on an individual-moralistic plane. Finally, the privileging of the discursive allows us to compare a film's discourses not with an inaccessible "real" but with other socially circulated cognate discourses forming part of a continuum—journalism, novels, network news, television shows, political speeches, scholarly essays, and popular songs.[35]

A discursive analysis would also alert us to the dangers of the "pseudo-polyphonic" discourse that marginalizes and disempowers certain voices, then pretends to dialog with a puppet-like entity already maneuvered into crucial compromises. The film or TV commercial in which every eighth face is Black, for example, has more to do with the demographics of market research and the bad conscience of liberalism than with substantive polyphony, since the Black voice, in such instances, is usually shorn of its soul, deprived of its color and intonation. Polyphony does not consist in the mere appearance of a representative of a given group but rather in the fostering of a textual setting where that group's voice can be heard with its full force and resonance. The question is not of pluralism but of multivocality, an approach that would strive to cultivate and even heighten cultural difference while abolishing socially-generated inequalities.

## NOTES

1. Steve Neale points out that stereotypes are judged simultaneously in relation to an empirical "real" (accuracy) and an ideological "ideal" (positive image). See Neale, "The Same Old Story: Stereotypes and Difference," *Screen Education*, Nos 32–3 (Autumn/Winter 1979–80).

2. For more on FBI harassment of civil rights activists, see Kenneth O'Reilly, *"Racial Matters": The FBI's Secret File on Black America, 1960–1972* (New York: Free Press, 1989).

3. Pam Sporn, a New York City educator, had her high-school students go to the south and video-interview civil rights veterans about their memories of the civil rights struggle and their reactions to *Mississippi Burning.*

4. See Gretchen Bataille and Charles Silet, "The Entertaining Anachronism: Indians in American Film," in Randall M. Miller, ed., *The Kaleidoscopic Lens: How Hollywood Views Ethnic Groups* (Englewood, NJ: Jerome S. Ozer, 1980).

5. Kobena Mercer and Isaac Julien, in a similar spirit, distinguish between "representation as a practice of depicting" and "representation as a practice of delegation." See Kobena Mercer and Isaac Julien, "Introduction: De Margin and De Centre," *Screen*, Vol. 29, No. 4 (1988), pp. 2–10.

6. An article in *Moving Picture World* (July 10, 1911), entitled "Indians Grieve over Picture Shows," reports on protests by Native Americans from southern California concerning Hollywood's portrayal of them as warriors when in fact they were peaceful farmers.

7. Religious tensions sometimes inflect cinematic representation. A German film company plan in 1925 to produce *The Prophet*, with Muhammad as the main character, shocked the Islamic University Al Azhar, since Islam prohibits representation of the Prophet. Protests prevented the film from being made. Moustapha Aaqad's *The Message* (Kuwait, Morocco, Libya, 1976), in contrast, tells the story within Islamic norms, respecting the prohibition of graven images of the Prophet, representation of God and holy figures. The film traces the life of the Prophet from his first revelations in AD 610 to his death in 632, in a style which rivals Hollywood Biblical epics. Yet the Prophet is never seen on the screen; when other characters speak to him they address the camera. The script was approved by scholars from the Al Azhar University in Cairo.

8. Judith Williamson makes a similar point in her essay in *Screen*, Vol. 29, No. 4 (1988), pp. 106–12.

9. See Michael Rogin, "Blackface, White Noise: The Jewish Jazz Singer Finds his Voice," *Critical Inquiry*, Vol. 18, No. 3 (1992), pp. 417–44.

10. Michael Dempsey and Udayan Gupta, "Hollywood's Color Problem," *American Film* (April 1982).

11. See *New York Times* (Sept. 24, 1991).

12. See interview with Spike Lee, "Our Film Is Only a Starting Point," *Cineaste*, Vol. XIX, No. 4 (March 1993).

13. See Gary M. Stern, "Why the Dearth of Latino Directors?," *Cineaste*, Vol. XIX, Nos 2–3 (1992).

14. Reported in *Vrye Weekblod* (Nov. 17, 1989), cited in Keyan Tomaselli, "Myths, Racism and Opportunism: Film and TV Representations of the San," in Peter Ian Crawford and David Turton, eds, *Film as Ethnography* (Manchester: University of Manchester Press, 1992), p. 213.

15. The White Brazilian musicians who worked on *Black Orpheus* were also exploited. The French producer Sacha Gordine refused songs already written for the source play in order to be able to copyright the songs in French, with a contract that gave him 50 per cent of the profits on highly popular songs, while the composer and lyricists (Tom Jobim and Vinicius de Moraes) got only 10 per cent. See Rui Castro, *Chega de Saudade* (São Paulo: Companhia das Letras, 1992).

16. See Clyde Taylor, "Decolonizing the Image," in Peter Steven, ed., *Jump Cut: Hollywood, Politics and Counter Cinema* (Toronto: Between the Lines, 1985), p. 168.

17. See Jean Franco, "High-Tech Primitivism: the Representation of Tribal Societies in Feature Films," in John King, Ana Lopez, and Manuel Alvarado, eds, *Mediating Two Worlds* (London: BFI, 1993).

18. Quoted in *Prisoners of Image: Ethnic and Gender Stereotypes* (New York: Alternative Museum, 1989).

19. See David R. Roediger, *The Wages of Whiteness: Race and the Making of the American Working Class* (London: Verso, 1991), pp. 88–9.

20. Herman Gray, "Television and the New Black Man: Black Male Images in Prime-Time Situation Comedy," *Media, Culture and Society*, No. 8 (1986), p. 239.

21. See Sut Jhally and Justin Lewis, *Enlightened Racism: The Cosby Show, Audiences and the Myth of the American Dream* (Boulder, Colo.: Westview Press, 1992), p. 137.

22. For a critique of Eurocentric language concerning African religions, see John S. Mbiti, *African Religions and Philosophy* (Oxford: Heinemann, 1969).

23. See also Alfredo the Bosi's brilliant analysis of the confrontation between Catholicism and the Tupi-Guarani religion in his *Dialetica da Colonização* (São Paulo: Companhia das Letras, 1992).

24. For positive portrayals of African religions, we must look to African (*A Deusa Negra*, 1979), Brazilian (*A Force de Xango*: The Force of Xango, 1977) and Cuban (*Patakin*, 1980) features, and to documentaries such as Angela Fontanez's *The Orixa Tradition*, Lil Fenn's *Honoring the Ancestors*, Maya Deren's *The Divine Horsemen*, and Gloria Rolando's *Oggun* (1991).

25. The 1993 Supreme Court decision allowing the animal sacrifices associated with Santeria was in this sense a landmark affirmation of religious rights.

26. Toni Morrison, ed., *Race-ing Justice, En-gendering Power: Essays on Anita Hill, Clarence Thomas, and the Construction of Social Reality* (New York: Pantheon, 1992), p. xv.

27. See Jan Pieterse, *White on Black: Images of Africa and Blacks in Western Popular Culture* (New Haven, Conn.: Yale University Press, 1992), p. 207.

28. Ibid., p. 106.

29. On *The Cosby Show*, see John D.H. Downing, "*The Cosby Show* and American Racial Discourse," in Geneva Smitherman-Donaldson and Teun A. van Dijk, eds, *Discourse and Discrimination* (Detroit: Wayne State University Press, 1988); Gray, "Television and the New Black Man," in Todd Gitlin, ed., *Watching Television* (New York: Pantheon, 1987), pp. 223–42; Mark Crispin Miller, "Deride and Conquer," in Gitlin, ed., *Watching Television*; and Mike Budd and Clay Steinman, "White Racism and the Cosby Show," *Jump Cut*, No. 37 (July 1992).

30. See Ed Guerrero, "Fever in the Racial Jungle," in Jim Collins, Hilary Radner, and Ava Preacher Collins, eds, *Film Theory Goes to the Movies* (London: Routledge, 1993).

31. Michel Chion, *Le Son au Cinéma* (Paris: Cahiers, 1985).

32. For more on the fissures between the ethnic-racial and the national in Israeli cultural practices, see Shohat, *Israeli Cinema.*

33. See George Yudice, "Bakhtin and the Subject of Postmodernism," unpublished paper.

34. Two of Clyde Taylor's defining traits of New Black Cinema—the link to the Afro-American oral tradition, and the strong articulation of Black musicality—are aural in nature, and both are indispensable in Black Cinema's search for what Taylor himself calls "its voice." See Clyde Taylor, "Les Grands Axes et les Sources Africaines du Nouveau Cinema Noir," *CinemAction*, No. 46 (1988).

35. James Naremore's analysis of *Cabin in the Sky* deploys this kind of discursive analysis with great precision and subtlety. Naremore sees the film as situated uneasily among "four conflicting discourses about blackness and entertainment in America": a vestigial "folk-loric" discourse about rural Blacks; NAACP critique of Hollywood imagery; the collaboration between mass entertainment and government; and the "posh Africanism of high-toned Broadway musicals." See James Naremore, *The Films of Vincent Minnelli* (Cambridge: Cambridge University Press, 1993).

# RICHARD DYER

# White

Richard Dyer (b. 1945), currently Professor of Film Studies at Kings College in London, is one of the most prolific figures in English-language cinema studies. His research interests and work ranges from studying the cultural meaning and function of stars (see p. 401) to exploring entertainment genres like the musical (see p. 465). He also organized one of the first gay cinema events at the National Film Theatre in 1977, regularly contributed to the journal *Gay Left*, and remains today one of the most effective critics writing within the ever-growing field of LGBT film studies. His interest in issues of representation of race in cinema and culture led to his deeply influential study *White: Essays on Race and Culture*, which was published in 1997.

Film theory in the 1980s was energized by tensions around class, gender, sexual orientation, colonialism, and race. While important work was done on issues of ethnic and racial representations within Hollywood cinema, many early studies focused on filmic representations of people of color, using the approach of "image studies" and stereotype analysis that revolved around the critique of positive or negative images in race representation. By the mid-1980s, many critical race scholars began pointing out the theoretical and methodological limitations of such an approach. Their revisionist work focused on an expanded and relational approach to issues of race and ethnicity. Whiteness studies emerged as part of this effort, calling for analyses of the overpowering yet invisible concept of whiteness and questioning its positioning as an unmarked norm. Though a nascent interest in whiteness goes as far back as James Baldwin and Ralph Ellison, its recent genealogy can be traced to the work of contemporary cultural critics like bell

hooks, Cornel West, and Stuart Hall. Whiteness studies "outed" whiteness as merely another, albeit privileged, socially constructed ethnicity and therefore subverted the common practice of racializing "the ethnic other" while positing whites as raceless.

Pioneering such studies, Richard Dyer's essay "White" first appeared in *Screen* in 1988 and was later expanded into the book-length study *White*. In this essay, Dyer establishes the need for critical analyses of "whiteness" as a colorless and normative category. He argues that the invisibility of whiteness masks it as a constructed category, in turn making it difficult to "see" or to analyze. In his deconstruction of representations of whiteness, Dyer looks at radically different examples of mainstream cinema—*Simba* (1955), *Jezebel* (1938), and *Night of the Living Dead* (1969). He finds a common thread in the way these diverse films connect whiteness with order, rationality, and rigidity, and associate blackness with disorder, irrationality, and looseness. Establishing this binary opposition, Dyer also shows how these films attempt to contest white domination and expose the idea that while white people hold power, they are materially and emotionally dependent upon black people.

Dyer's essay, together with the work of such cultural critics as Coco Fusco and George Lipsitz, among others, reoriented studies of ethnicity, offering theoretical tools for interrogating whiteness in areas such as literature, fine arts, history, pedagogy, and television.

## READING CUES & KEY CONCEPTS

■ Writing as a white person about whiteness, Dyer problematizes his own enunciative position. How does he deal with what he terms as "guilt and me too-ism"?

■ What does Dyer mean by his claim that the strength of white representation is "the apparent absence altogether of the typical"?

■ Dyer's analysis of the three films reveals both the binary nature of their racial representations and their expressions of "progressive ideas on race." Consider to what extent (if at all) these "progressive ideas" dislodge the normative position of whiteness.

■ **Key Concepts:** Whiteness; White Representation; Stereotyping; Racial Binarism

# White

. . . . . . . . . . . . . .

This is an article about a subject that, much of the time as I've been writing it, seems not to be there as a subject at all. Trying to think about the representation of whiteness as an ethnic category in mainstream film is difficult, partly because white power secures its dominance by seeming not to be anything in particular, but also because, when whiteness *qua* whiteness does come into focus, it is often revealed as emptiness, absence, denial or even a kind of death.

It is, all the same, important to try to make some headway with grasping whiteness as a culturally constructed category. "Images of" studies have looked at groups defined as oppressed, marginal or subordinate—women, the working class, ethnic and other minorities (e.g., lesbians and gay men, disabled people, the elderly). The

impulse for such work lies in the sense that how such groups are represented is part of the process of their oppression, marginalisation or subordination. The range and fertility of such work has put those groups themselves centre-stage in both analytical and campaigning activity, and highlighted the issue of representation as politics. It has, however, had one serious drawback, long recognised in debates about women's studies. Looking, with such passion and single-mindedness, at non-dominant groups has had the effect of reproducing the sense of the oddness, differentness, exceptionality of these groups, the feeling that they are departures from the norm. Meanwhile the norm has carried on as if it is the natural, inevitable, ordinary way of being human.

Some efforts are now being made to rectify this, to see that the norm too is constructed, although only with masculinity has anything approaching a proliferation of texts begun. Perhaps it is worth signalling here, before proceeding, two of the pitfalls in the path of such work, two convolutions that especially characterise male writing about masculinity—guilt and me too-ism. Let me state that, while writing here as a white person about whiteness, I do not mean either to display the expiation of my guilt about being white, nor to hint that it is also awful to be white (because it is an inadequate, limiting definition of being human, because feeling guilty is such a burden). Studies of dominance by the dominant should not deny the place of the writer in relation to what s/he is writing about it, but nor should they be the green light for self-recrimination or trying to get in on the act.

Power in contemporary society habitually passes itself off as embodied in the normal as opposed to the superior.[1] This is common to all forms of power, but it works in a peculiarly seductive way with whiteness, because of the way it seems rooted, in common-sense thought, in things other than ethnic difference. The very terms we use to describe the major ethnic divide presented by Western society, "black" and "white," are imported from and naturalised by other discourses. Thus it is said (even in liberal text books) that there are inevitable associations of white with light and therefore safety, and black with dark and therefore danger, and that this explains racism (whereas one might well argue about the safety of the cover of darkness and the danger of exposure to the light); again, and with more justice, people point to the Judaeo-Christian use of white and black to symbolise good and evil, as carried still in such expressions as "a black mark," "white magic," "to blacken the character" and so on.[2] I'd like to look at another aspect of commonsensical conflations of black and white as natural and ethnic categories by considering ideas of what colour is.

I was taught the scientific difference between black and white at primary school. It seemed a fascinating paradox. Black, which, because you had to add it to paper to make a picture, I had always thought of as a colour, was, it turned out, nothingness, the absence of all colour; whereas white, which looked just like empty space (or blank paper), was, apparently, all the colours there were put together. No doubt such explanations of colour have long been outmoded; what interests me is how they manage to touch on the construction of the ethnic categories of black and white in dominant representation. In the realm of categories, black is always marked as a colour (as the term "coloured" egregiously acknowledges), and is always particularising; whereas white is not anything really, not an identity, not a particularising quality, because it is everything—white is no colour because it is all colours.

This property of whiteness, to be everything and nothing, is the source of its representational power. On the one hand, as one of the people in the video *Being White*[3] observes, white domination is reproduced by the way that white people "colonise the definition of normal." Paul Gilroy similarly spells out the political consequences, in the British context, of the way that whiteness both disappears behind and is subsumed into other identities. He discusses the way that the language of "the nation" aims to be unifying, permitting even socialists an appeal in terms of "we" and "our" "beyond the margins of sectional interest," but goes on to observe that:

> there is a problem in these plural forms: who do they include, or, more precisely for our purposes, do they help to reproduce blackness and Englishness as mutually exclusive categories? . . . why are contemporary appeals to "the people" in danger of transmitting themselves as appeals to the white people?[4]

On the other hand, if the invisibility of whiteness colonises the definition of other norms—class, gender, heterosexuality, nationality and so on—it also masks whiteness as itself a category. White domination is then hard to grasp in terms of the characteristics and practices of white people. No one would deny that, at the very least, there are advantages to being white in Western societies, but it is only avowed racists who have a theory which attributes this to inherent qualities of white people. Otherwise, whiteness is presented more as a case of historical accident, rather than a characteristic cultural/historical construction, achieved through white domination.

The colourless multi-colouredness of whiteness secures white power by making it hard, especially for white people and their media, to "see" whiteness. This, of course, also makes it hard to analyse. It is the way that black people are marked as black (are not just "people") in representation that has made it relatively easy to analyse their representation, whereas white people—not there as a category and everywhere everything as a fact—are difficult, if not impossible, to analyse *qua* white. The subject seems to fall apart in your hands as soon as you begin. Any instance of white representation is always immediately something more specific—*Brief Encounter* is not about white people, it is about English middle-class people; *The Godfather* is not about white people, it is about Italian-American people; but *The Color Purple* is about black people, before it is about poor, southern US people.

This problem clearly faced the makers of *Being White*, a pioneering attempt to confront the notion of white identity. The opening vox pop sequence vividly illustrates the problem. Asked how they would define themselves, the white interviewees refer easily to gender, age, nationality or looks but never to ethnicity. Asked if they think of themselves as white, most say that they don't, though one or two speak of being "proud" or "comfortable" to be white. In an attempt to get some white people to explore what being white means, the video assembles a group to talk about it and it is here that the problem of white people's inability to see whiteness appears intractable. Sub-categories of whiteness (Irishness, Jewishness, Britishness) take over, so that the particularity of whiteness itself begins to disappear; then gradually, it seems almost inexorably, the participants settle in to talking with confidence about what they know: stereotypes of black people.

Yet perhaps this slide towards talking about blackness gives us a clue as to where we might begin to see whiteness—where its difference from blackness is inescapable and at issue. I shall look here at examples of mainstream cinema whose narratives are marked by the fact of ethnic difference. Other approaches likely to yield interesting results include: the study of the characterisation of whites in Third World or diaspora cinema; images of the white race in avowedly racist and fascist cinema; the use of the "commutation test,"[5] the imaginary substitution of black for white performers in films such as *Brief Encounter*, say, or *Ordinary People* (if these are unimaginable played by black actors, what does this tell us about the characteristics of whiteness?) or, related to this, consideration of what ideas of whiteness are implied by such widespread observations as that Sidney Poitier or Diana Ross, say, are to all intents and purposes "white." What all these approaches share, however, is reference to that which is not white, as if only non-whiteness can give whiteness any substance. The reverse is not the case—studies of images of blacks, Native Americans, Jews and other ethnic minorities do not need the comparative element that seems at this stage indispensable for the study of whites.

The representation of white *qua* white begins to come into focus—in mainstream cinema, for a white spectator—in films in which non-white characters play a significant role. I want to look at three very different examples here—*Jezebel* (USA, Warner Brothers, 1938), *Simba* (GB, Rank Studios, 1955) and *Night of the Living Dead* (USA, 1969). Each is characteristic of the particular genre and period to which it belongs. *Jezebel* is a large-budget Hollywood feature film (said to have been intended to rival *Gone with the Wind*) built around a female star, Bette Davis; its spectacular pleasures are those of costume and decor, of gracious living, and its emotional pleasures those of tears. *Simba* is a film made as part of Rank's bid to produce films that might successfully challenge Hollywood at the box office, built around a male star, Dirk Bogarde; its spectacular pleasures are those of the travelogue, its emotional ones excitement and also the gratification of seeing "issues" (here, the Mau-Mau in Kenya) being dealt with. *Night of the Living Dead* is a cheap, independently-produced horror film with no stars; its spectacular and emotional pleasures are those of shock, disgust and suspense, along with the evident political or social symbolism that has aided its cult reputation.

The differences between the three films are important and will inform the ways in which they represent whiteness. There is some point in trying to see this continuity across three, nonetheless significantly different, films. There is no doubt that part of the strength and resilience of stereotypes of non-dominant groups resides in their variation and flexibility—stereotypes are seldom found in a pure form and this is part of the process by which they are naturalised, kept alive.[6] Yet the strength of white representation, as I've suggested, is the apparent absence altogether of the typical, the sense that being white is coterminous with the endless plenitude of human diversity. If we are to see the historical, cultural and political limitations (to put it mildly) of white world domination, it is important to see similarities, typicalities, within the seemingly infinite variety of white representation.

All three films share a perspective that associates whiteness with order, rationality, rigidity, qualities brought out by the contrast with black disorder, irrationality and looseness. It is their take on this which differs. *Simba* operates with a clear black-white binarism, holding out the possibility that black people can learn white

values but fearing that white people will be engulfed by blackness. *Jezebel* is far more ambivalent, associating blackness with the defiance of its female protagonist—whom it does not know whether to condemn or adore. *Night* takes the hint of critique of whiteness in *Jezebel* and takes it to its logical conclusion, where whiteness represents not only rigidity but death.

What these films also share, which helps to sharpen further the sense of whiteness in them, is a situation in which white domination is contested, openly in the text of *Simba* and explicitly acknowledged in *Jezebel*. The narrative of *Simba* is set in motion by the Mau-Mau challenge to British occupation, which also occasions set pieces of debate on the issues of white rule and black responses to it; the imminent decline of slavery is only once or twice referred to directly in *Jezebel*, but the film can assume the audience knows that slavery was soon ostensibly to disappear from the southern states. Both films are suffused with the sense of white rule being at an end, a source of definite sorrow in *Simba*, but in *Jezebel* producing that mixture of disapproval and nostalgia characteristic of the white representation of the ante-bellum South. *Night* makes no direct reference to the state of ethnic play but, as I shall argue below, it does make implicit reference to the black uprisings that were part of the historical context of its making, and which many believed would alter irrevocably the nature of power relations between black and white people in the USA.

The presence of black people in all three films allows one to see whiteness as whiteness, and in this way relates to the existential psychology that is at the origins of the interest in "otherness" as an explanatory concept in the representation of ethnicity.[7] Existential psychology, principally in the work of Jean-Paul Sartre, had proposed a model of human growth whereby the individual self becomes aware of itself as a self by perceiving its difference from others. It was other writers who suggested that this process, supposedly at once individual and universal, was in fact socially specific—Simone de Beauvoir arguing that it has to do with the construction of the male ego, Frantz Fanon relating it to the colonial encounter of white and black. What I want to stress here is less this somewhat metaphysical dimension,[8] more the material basis for the shifts and anxieties in the representation of whiteness suggested by *Simba*, *Jezebel* and *Night*.

The three films relate to situations in which whites hold power in society, but are materially dependent upon black people. All three films suggest an awareness of this dependency—weakly in *Simba*, strongly but still implicitly in *Jezebel*, inescapably in *Night*. It is this actual dependency of white on black in a context of continued white power and privilege that throws the legitimacy of white domination into question. What is called for is a demonstration of the virtues of whiteness that would justify continued domination, but this is a problem if whiteness is also invisible, everything and nothing. It is from this that the films' fascinations derive. I shall discuss them here in the order in which they most clearly attempt to hang on to some justification of whiteness, starting, then, with *Simba* and ending with *Night*.

## *"Simba"*

*Simba* is a characteristic product of the British cinema between about 1945 and 1965—an entertainment film "dealing with" a serious issue.[9] It is a colonial adventure film, offering the standard narrative pleasures of adventure with a tale of personal

growth. The hero, Alan (Bogarde), arrives in Kenya from England to visit his brother on his farm, finds he has been killed by the Mau-Mau and stays to sort things out (keep the farm going, find out who killed his brother, quell the Mau-Mau). Because the Mau-Mau were a real administrative and ideological problem for British imperialism at the time of the film's making, *Simba* also has to construct a serious discursive context for these pleasures (essentially a moral one, to do with the proper way to treat native peoples; toughness versus niceness). It does this partly through debates and discussions, partly through characters clearly representing what the film takes to be the range of possible angles on the subject (the bigoted whites, the liberal whites, the British-educated black man, the despotic black chief) but above all through the figure of the hero, whose adventures and personal growth are occasioned, even made possible, through the process of engaging with the late colonial situation. The way this situation is structured by the film and the way Alan/Bogarde rises to the occasion display the qualities of whiteness.

*Simba* is founded on the "Manicheism delirium" identified by Frantz Fanon as characteristic of the colonialist sensibility;[10] it takes what Paul Gilroy refers to as an "absolutist view of black and white cultures, as fixed, mutually impermeable expressions of racial and national identity, [which] is a ubiquitous theme in racial 'common sense.' "[11] The film is organised around a rigid binarism, with white standing for modernity, reason, order, stability, and black standing for backwardness, irrationality, chaos and violence. This binarism is reproduced in every detail of the film's *mise-en-scène*. A sequence of two succeeding scenes illustrates this clearly—a meeting of the white settlers to discuss the emergency, followed by a meeting of the Mau-Mau. The whites' meeting takes place in early evening, in a fully lit room; characters that speak are shot with standard high key lighting so that they are fully visible; everyone sits in rows and although there is disagreement, some of it hottempered and emotional, it is expressed in grammatical discourse in a language the British viewer can understand; moreover, the meeting consists of nothing but speech. The black meeting, on the other hand, takes place at dead of night, out of doors, with all characters in shadow; even the Mau-Mau leader is lit with extreme sub-Expressionist lighting that dramatises and distorts his face; grouping is in the form of a broken, uneven circle; what speech there is is ritualised, not reasoned, and remains untranslated (and probably in no authentic language anyway), and most vocal sounds are whooping, gabbling and shrieking; the heart of the meeting is in any case not speech, but daubing with blood and entrails and scarring the body. The return to whiteness after this sequence is once again a return to daylight, a dissolve to the straight lines of European fencing and vegetable plots.

The emphasis on the visible and bounded in this *mise-en-scène* (maintained throughout the film) has to do with the importance of fixity in the stereotyping of others—clear boundaries are characteristic of things white (lines, grids, not speaking till someone else has finished and so on), and also what keeps whites clearly distinct from blacks. The importance of the process of boundary establishment and maintenance has long been recognised in discussions of stereotyping and representation.[12] This process is functional for dominant groups, but through it the capacity to set boundaries becomes a characteristic attribute of such groups, endlessly reproduced in ritual, costume, language and, in cinema, *mise-en-scène*. Thus, whites and men (especially) become characterised by "boundariness."[13]

*Simba*'s binarism is in the broadest sense racist, but not in the narrower sense of operating with a notion of intrinsic and unalterable biological bases for differences between peoples.[14] It is informed rather by a kind of evolutionism, the idea of a path of progress already followed by whites, but in principle open to all human beings— hence the elements in the binarism of modernity versus backwardness. Such evolutionism raises the possibility of blacks becoming like whites, and it is the belief in this possibility that underpins the views of the liberal characters in the film, Mary (Virginia McKenna) and Dr Hughes (Joseph Tomelty), the latter pleading with his fellow settlers at the meeting to "reason," not with the Mau-Mau but with the other Africans, who are not beyond the reach of rational discussion. The possibility is further embodied in the character of Peter Karanja (Earl Cameron), the son of the local chief (Orlando Martins), who has trained to be a doctor and is now running a surgery in the village. The film is at great pains to establish that Peter is indeed reasonable, rational, humane, liberal. It is always made quite clear to the viewer that this is so and the representatives of liberalism always believe in him; it is the whites who do not trust him, and one of Alan's moral lessons is in learning to respect Peter's worth. It seems then that part of the film is ready to take the liberal evolutionist position. Yet it is also significant that the spokespeople for liberalism (niceness and reason) are socially subordinate; a woman and an Irish doctor (played for comic eccentricity most of the time), and that liberalism fails, with its representatives (Mary, Peter and now won-over Alan) left at the end of the film crouched in the flames of Alan's farm, rescued from the Mau-Mau in the nick of time by the arrival of the white militia, and Peter dying from wounds inflicted on him by the Mau-Mau (represented as a black mob). Although with its head, as it were, the film endorses the possibility of a black person becoming "white," this is in fact deeply disturbing, setting in motion the anxiety attendant on any loosening of the fixed visibility of the colonised other. This anxiety is established from the start of the film and is the foundation of its narrative.

As is customary in colonial adventure films, *Simba* opens wth a panoramic shot of the land, accompanied here by birdsong and the sound of an African man singing. While not especially lush or breathtaking, it is peaceful and attractive. A cry of pain interrupts this mood and we see the man who has been singing stop, get off his bicycle and walk towards its source to find a white man lying covered in blood on the ground. The black man kneels by his side, apparently about to help him, but then, to the sound of a drum-roll on the soundtrack, draws his machete and plunges it (off screen) into the wounded man. He then walks back to his bike and rides off. Here is encapsulated the fear that ensues if you can't see black men behaving as black men should, the deceptiveness of a black man in Western clothes riding a bike. This theme is then reiterated throughout the film. Which of the servants can be trusted? How can you tell who is Mau-Mau and who not? Why should Alan trust Peter?

This opening sequence is presented in one long take, using panning. As the man rides off, the sound of a plane is heard, the camera pans up and there is the first cut of the film, to a plane flying through the clouds. There follows (with credits over) a series of aerial shots of the African landscape, in one of which a plane's shadow is seen, and ending with shots of white settlement and then the plane coming to land. Here is another aspect of the film's binarism. The credit sequence uses the dynamics of editing following the more settled feel of the pre-credit long take; it uses aerial

shots moving through space, rather than pans with their fixed vantage point; it emphasises the view from above, not that from the ground, and the modernity of air travel after the primitivism of the machete. It also brings the hero to Africa (as we realise when we see Bogarde step off in the first post-credit shot), brings the solution to the problems of deceptive, unfixed appearances set up by the pre-credit sequence.

*Simba*'s binarism both establishes the differences between black and white and creates the conditions for the film's narrative pleasures—the disturbance of the equilibrium of clear-cut binarism, the resultant conflict that the hero has to resolve. His ability to resolve it is part of his whiteness, just as whiteness is identified in the dynamism of the credit sequence (which in turn relates to the generic expectations of adventure) and in the narrative of personal growth that any colonial text with pretensions also has. The Empire provided a narrative space for the realisation of manhood, both as action and maturation.[15] The colonial landscape is expansive, enabling the hero to roam and giving us the entertainment of action; it is unexplored, giving him the task of discovery and us the pleasures of mystery; it is uncivilised, needing taming, providing the spectacle of power; it is difficult and dangerous, testing his machismo, providing us with suspense. In other words, the colonial landscape provides the occasion for the realisation of white male virtues, which are not qualities of being but of doing—acting, discovering, taming, conquering. At the same time, colonialism, as a social, political and economic system, even in fictions, also carries with it challenges of responsibility, of the establishment and maintenance of order, of the application of reason and authority to situations. These, too, are qualities of white manhood that are realised in the process of the colonial text, and very explicitly in *Simba*. When Alan arrives at Nairobi, he is met by Mary, a woman to whom he had proposed when she was visiting England; she had turned him down, telling him, as he recalls on the drive to his brother's farm, that he had "no sense of responsibility." Now he realises that she was right; in the course of the film he will learn to be responsible in the process of dealing with the Mau-Mau, and this display of growth will win him Mary.

But this is a late colonial text, characterised by a recognition that the Empire is at an end, and not unaware of some kinds of liberal critique of colonialism. So *Simba* takes a turn that is far more fully explored by, say, *Black Narcissus* (1947) or the Granada TV adaptation of *The Jewel in the Crown* (1982). Here, maturity involves the melancholy recognition of failure. This is explicitly stated, by Sister Clodagh in *Black Narcissus*, to be built into the geographical conditions in which the nuns seek to establish their civilising mission ("I couldn't stop the wind from blowing"); it is endlessly repeated by the nice whites in *The Jewel in the Crown* ("There's nothing I can do!") and symbolised in the lace shawl with butterflies "caught in the net" that keeps being brought out by the characters. I have already suggested the ways in which liberalism is marginalised and shown to fail in *Simba*. More than this, the hero also fails to realise the generically promised adventure experiences: he is unable to keep his late brother's farm going, nor does he succeed in fighting off a man stealing guns from his house; he fails to catch the fleeing leader of the Mau-Mau, and is unable to prevent them from destroying his house and shooting Peter. The film ends with his property in flames and—a touch common to British social conscience films—with a shot of a young black boy who symbolises the only possible hope for the future.

The repeated failure of narrative achievement goes along with a sense of white helplessness in the face of the Mau-Mau (the true black threat), most notably in the transition between the two meeting scenes discussed above. Alan has left the meeting in anger because one of the settlers has criticised the way his brother had dealt with the Africans (too soft); Mary joins him, to comfort him. At the end of their conversation, there is a two-shot of them, with Mary saying of the situation, "it's like a flood, we're caught in it." This is accompanied by the sound of drums and is immediately followed by a slow dissolve to black people walking through the night towards the Mau-Mau meeting. The drums and the dissolve enact Mary's words, that the whites are helpless in the face of the forces of blackness.

*Simba* is, then, an endorsement of the moral superiority of white values of reason, order and boundedness, yet suggests a loss of belief in their efficacy. This is a familiar trope of conservatism. At moments, though, there are glimpses of something else, achieved inadvertently perhaps through the casting of Dirk Bogarde. It becomes explicit in the scene between Mary and Alan just mentioned, when Alan says to Mary, "I was suddenly afraid of what I was feeling," referring to the anger and hatred that the whole situation is bringing out in him and, as Mary says, everyone else. The implication is that the situation evokes in whites the kind of irrational violence supposedly specific to blacks. Of course, being white means being able to repress it and this is what we seem to see in Alan throughout the film. Such repression constitutes the stoic glory of the imperial hero, but there is something about Bogarde in the part that makes it seem less than admirable or desirable. Whether this is suggested by his acting style, still and controlled, yet with fiercely grinding jaws, rigidly clenched hands and very occasional sudden outbursts of shouting, or by the way Rank was grooming him against the grain of his earlier, sexier image (including its gay overtones),[16] it suggests a notion of whiteness as repression that leads us neatly on to *Jezebel*.

## "Jezebel"

Like *Simba*, *Jezebel* depicts a white society characterised by order and rigidity, here expressed principally through codes of behaviour and rules of conduct embodied in set-piece receptions, dinner parties and balls. This does contrast with the bare glimpses we get of black life in the film, but *Jezebel* also explores the ways in which whiteness is related to blackness, materially and emotionally dependent on it yet still holding sway over it.

Compositionally, *Jezebel* frequently foregrounds black people—scenes often open with the camera moving from a black person (a woman selling flowers in New Orleans, a servant carrying juleps, a boy pulling on a rope to operate a ceiling fan) across or towards white characters; black people often intrude into the frame while white characters talk. This is particularly noticeable during a dinner-table discussion of the future of slavery; when one of the characters, Pres (Henry Fonda), says that the South will be defeated by machines triumphing over "unskilled slave labour," the chief black character, Cato (Lou Payton), leans across our field of vision to pour Pres' wine, literally embodying the fact of slave labour. The film's insistence upon the presence of black people is important in its perception and construction of the white South. As Jim Pines puts it, "black characters do not occupy a significant

dramatic function in the film, but their social role nevertheless plays an explicit and relevant part in the conflict that arises between the principal white characters."[17]

*Jezebel* is distantly related, through the sympathies of its stars, director and production studio, to progressive ideas on race, making it, as Pines says, "within the plantation movie tradition . . . undoubtedly the most liberal-inclined."[18] These ideas have to do with the belief or suspicion that black people have in some sense more "life" than whites. This idea, and its ambivalences, have a very long history which cannot detain us here. It springs from ideas of the closeness of non-European (and even non-metropolitan) peoples to nature, ideas which were endemic to those processes of European expansion variously termed exploration, nation-building and colonialism.[19] Expansion into other lands placed the humans encountered there as part of the fauna of those lands, to be construed either as the forces of nature that had to be subjugated or, for liberals, the model of sweet natural Man uncontaminated by civilisation. At the same time, ideas of nature have become central to Western thought about being human, such that concepts of human life itself have become inextricable from concepts of nature. Thus the idea that non-whites are more natural than whites also comes to suggest that they have more "life," a logically meaningless but commonsensically powerful notion.

*Jezebel* relates to a specific liberal variation on this way of thinking, a tradition in which *Uncle Tom's Cabin* and the Harlem Renaissance are key reference points,[20] as is the role of Annie in Sirk's *Imitation of Life*.[21] Ethel Mannin's statement may be taken as emblematic:

> It is of course that feeling for life which is the secret of the Negro people, as surely as it is the lack of it, and slow atrophy of the capacity to live emotionally, which will be the ultimate decadence of the white civilised people.[22]

"Life" here tends to mean the body, the emotions, sensuality and spirituality; it is usually explicitly counterposed to the mind and the intellect, with the implication that white people's over-investment in the cerebral is cutting them off from life and leading them to crush the life out of others and out of nature itself. The implicit counterposition is, of course, "death," a point to which I shall return in the discussion of *Night of the Living Dead*.

*Jezebel* is generally, and rightly, understood to be about the taming of a woman who refuses to live by the Old South's restrictive codes of femininity. It is a clear instance of Molly Haskell's characterisation of one of the available models for strong women's roles in classic Hollywood movies, the "superfemale," who is "too ambitious and intelligent for the docile role society has decreed she play" but remains "exceedingly 'feminine' and flirtatious" and "within traditional society," turning her energies on those around her, "with demonic results."[23] Davis' character, Julie, is strong, defiant of convention (for example, striding into the bank, a place that women do not enter), refusing to behave in the genteel way her fiancé, Pres, requires of her. The trajectory of the narrative is her punishment and moral growth, in two stages. She learns to conceal her defiance and energy beneath an assumption of femininity, but this is still not enough, since it is still there in the malignant form indicated by Haskell; it is only by literally sacrificing herself (accompanying Pres, who has caught yellow jack fever, to Red Island, where fever victims are isolated) that the film is able to reach a satisfactory, transcendantly punishing climax. All of this is entirely understandable

within a gender frame of reference; but the film also relates Julie's energies to blackness, suggesting that her trajectory is a specifically white, as well as female, one.

The most famous scene in the film is the Olympus Ball, at which all the unmarried women wear white. Julie, to embarrass Pres and to cock a snook at out-dated convention ("This is 1852, not the Dark Ages—girls don't have to simper about in white just 'cos they're not married"), decides to wear a red dress. The immediate scandal is not just the refusal to conform and uphold the celebration of virginity that the white dress code represents, but the sexual connotations of the dress itself, satin and red, connotations made explicit in a scene at the dress-maker's ("Saucy, isn't it?," says Julie; "And vulgar," says her aunt, with which Julie enthusiastically concurs). This is the dress of Julie's that her black maid Zette (Theresa Harris) most covets, and after the ball, Julie gives it to her. It is precisely its *colourfulness* that, stereotyping informs us, draws Zette—the dress is "marked" as coloured, a definite, bold colour heightened by a flashy fabric, just as black representation is. Thus what appears to be symbolism (white for virginity, colour for sex) within a universally applicable communication circuit becomes ethnically specific. The primary association of white with chastity is inextricably tied to not being dark and colourful, not being non-white, and the defiance and vitality narratively associated with Julie's wearing of the dress is associated with the qualities embodied by black women, qualities that Julie as a white woman must not display, or even have. Of course, the red dress looks merely dark in this black and white film.

Wearing the dress causes a rift between Julie and Pres; shortly after, he leaves for the North on business. By the time he returns, Julie has learned to behave as a white woman should. Once again, the specific whiteness of this is revealed through the figure of Zette. There is, for instance, a scene in which Julie is getting ready for the arrival of Pres at a house party at her aunt's plantation. In her room she moves restlessly about, with Zette hanging on to her as she tries to undo Julie's dress at the back; Zette's movements are entirely determined by Julie's but Zette is attending to the basic clothing while Julie is just fussing about. When Julie thinks she hears a carriage coming, she sends Zette to check; Zette runs from the room, and the film cuts to the huge hallway, showing us all of Zette's rapid descent of the stairs and run to the door, before cutting again to show her calling out to the man and boy in livery waiting for carriages at the gate. This apparently unnecessarily elongated sequence not only helps whip up excitement and anticipation at Pres' arrival, but also gives Julie time to take off one dress and put on another, a potentially titillating sight that would not be shown in this kind of film in this period. But using a sequence centred on a black woman is not only a device to heighten suspense and by-pass a taboo image—it works as seamlessly well as it does because it is also appropriate to show a black woman here.

By this stage in the film, Julie has learned the behaviour appropriate to a white woman in her position. Earlier in the film she openly expressed her passion and defiance; now, awaiting Pres, she has learned to behave as she should. She no longer expresses feeling—she "lives" through Zette. Zette has to express excited anticipation, not in speech, but in physical action, running the length of a long stair and spacious hallway. It is Zette's excited body in action that we see, instead of Julie's body disrobed and enrobed. When Julie hears the servants at the gate call out, "Carriage is coming!," she sends Zette to the window to see if it is Pres. The excitement mounts

as the carriage draws near. There is a rapid montage of black people: Zette shot from below at a dynamic angle looking for the carriage, the servants at the gate no longer still but the man moving about, the boy leaping in anticipation, and crowds of hitherto unseen black children running to the gate, jumping and cavorting. Meanwhile Julie remains perfectly still, only her eyes, in characteristic Davis fashion, darting and dilating with suspense; perfectly, luminously lit, she says nothing, expresses nothing with her body—it is black people who bodily express her desire.

This use of black people to express, to "live," the physical dimension of Julie's life is found throughout the film, most notably after her manipulations have gone awry to the point that one of her old flames, Buck (George Brent), is now about to duel with Pres' brother. The black plantation workers have gathered at the house to entertain the white guests ("a quaint old custom down here," says Julie to Pres' new, and Northern, wife, Amy). As they arrive they sing a song about marrying, heard over shots of Julie, a bitterly ironic counterpoint. She shushes the chorus and tells them to start singing, "Gonna Raise a Ruckus To-night," then goes to the edge of the verandah and sits down, beckoning the black children to gather close round her, before joining in with the singing. The song is a jolly one and the shots of the black singers show them in happy-go-lucky Sambo style, but the last shot of the sequence closes on Julie, near to tears against the sound of this cheerful singing. The power of the sequence does not come from this ironic counterpoint alone, but also from the way that Julie, by merging as nearly as possible with the singers and joining in the song, is able to express her pent-up feelings of frustration, anger, jealousy and fear, feelings for which there is no white mode of expression, which can only be lived through blacks.

The point of *Jezebel* is not that whites are different from blacks, but that whites live by different rules. Unlike the two women with whom she is compared, her aunt and Amy, Julie cannot be "white." It is her aunt and Amy who confirm that whites are calm, controlled, rational; Julie transgresses, but in the process reveals white calm as an imposition, a form of repression of life. The film's ambivalence lies in its being a vehicle for Davis. She/Julie is a "Jezebel," a by-word for female wickedness, but nonetheless a star with a huge female following, and who is shot here with the kind of radiance and glow Hollywood reserved for its favoured women stars. There is no doubt that what Julie does is wicked and that her punishment is to be understood as richly deserved; but there is also no doubt that she is to be adored and precisely, as I've tried to argue, because she does not conform to notions of white womanhood.

## "Night of the Living Dead"

If blacks have more "life" than whites, then it must follow that whites have more "death" than blacks. This thought has seldom been explored so devastatingly as in the living dead films directed by George Romero—*Night of the Living Dead* (1968), *Dawn of the Dead* (1978) and *Day of the Dead* (1985).

The *Dead* films are unusual among horror films for the explicitness of their political allegory and unique for having as their heroes "positive" black men. In general, the latter have been applauded merely as an instance of affirmative action, casting colour blind a black man in a part which could equally well have gone to a white actor. As Robin Wood notes, however, "it is not true that [their] colour is arbitrary and

without meaning"; Ben's blackness in *Night* is used "to signify his difference from the other characters, to set him apart from their norms,"[24] while Peter's in *Dawn* again indicates "his separation from the norms of white-dominated society and his partial exemption from its constraints."[25] In all three films, it is significant that the hero is a black man, and not just because this makes him "different," but because it makes it possible to see that whites are the living dead. I shall confine detailed discussion here to the first film of the trilogy.

All the dead in *Night* are whites. In a number of places, the film shows that living whites are like, or can be mistaken for, the dead. The radio states that the zombies are "ordinary looking people," and the first one we see in the film does look in the distance like some ordinary old white guy wandering about the cemetery, somehow menacing, yet not obviously abnormal. John, the brother in the opening sequence, recalls pretending to be something scary to frighten Barb when they visited the grave-yard as children; he imitates the famous zombie voice of Boris Karloff to scare her now. Halfway through the film, Barb becomes catatonic, like a dead person. The other developed white characters emerge from where they have been hiding, "bur-ied" in the cellar. Towards the end of the film, there is an aerial shot from the point of view of a helicopter involved in the destruction of the zombies; it looks down on a straggling line of people moving forward uncertainly but inexorably, in exactly the same formation as earlier shots of the zombies. It is only with a cut to a ground level shot that we realise this is a line of vigilantes, not zombies.

Living and dead whites are indistinguishable, and the zombies' sole *raison d'être*, to attack and eat the living, has resonances with the behaviour of the living whites. The vigilantes shoot and destroy the zombies with equanimity ("Beat 'em or burn 'em—they go up pretty good," says their leader, Chief McLelland), finally including the living—the hero, Ben (Duane Jones)—in their single-minded opera-tions. Brother John torments Barb while living, and consumes her when he is dead. Helen and Harry Cooper bicker and snipe constantly, until their dead daughter Carrie first destroys, then eats them. The young couple, Tom and Judy, destined generically to settle down at the end of the film, instead go up in flames through Tom's stupidity and Judy's paralysed response to danger.

If whiteness and death are equated, both are further associated with the USA. That the film can be taken as a metaphor for the United States is established right at the start of the film. It opens on a car driving through apparently unpopulated back roads suggesting the road tradition of 1950s and '60s US culture—the novel *On the Road* (1957), the film *Easy Rider* (1969) with its idea of the "search for America." When the car reaches the graveyard (the US?), a Stars and Stripes flag flutters in the foreground. The house in which the characters take shelter is archetypally middle, backwoods North American—a white wooden structure, with lace cur-tains, cut-glass ornaments, chintz armchairs. It, too, is immediately associated with death, in a series of shock cuts from Barb, exploring the house, to stuffed animal heads hung on the walls. Casting further heightens the all-Americanness of these zombie-like living whites. Barb is ultra-blonde and pale, and her name surely suggests the USA's best-selling doll; John is a preppy type, clean cut with straight fair hair, a white shirt with pens in the pocket, straight out of a Brooks Brothers advertisement. Judy too is dazzlingly blonde, though Tom and the Coopers are more nondescript whites.

What finally forces home the specifically white dimension of these zombie-US links are the ways in which the zombies can be destroyed. The first recalls the liberal critique of whites as ruled by their heads; as the radio announcer says, "Kill the brain and you kill the ghoul" since, it seems, zombies/whites are nothing but their brains. The film diverges from earlier representations of the black/white, life/death opposition by representing Ben's "life" quality in terms of practical skill, rather than innate qualities of "being." Particularly striking is a scene in which Ben talks about what they need to do as he dismantles a table to make boards for the windows, while Barb takes the lace cloth from it, folds and cradles it, hanging on uselessly to this token of gentility while Ben tries to ensure their survival.

The alternative way of destroying the zombies is burning. Some of the imagery, particulary the molotov cocktails going up around empty cars, seems to recall, in its grainy black-and-white texture, newspaper coverage of the ghetto uprisings of the late '60s, and the "fire," as an image of Black Power's threat to white people, had wide currency (most notably in the title of James Baldwin's 1963 *The Fire Next Time*). The zombies are scared of light as well as fire, and Ben is associated with both, not only because of his skill in warding off the zombies with torches, but in the way he is introduced into the film. Barb wanders out of the house into the glare of a car's headlights, out of which Ben seems to emerge; a shot of the lights glaring into the camera is followed by another with Ben moving into the frame, his white shirt first, then his black face filling the frame in front of the light, in a reversal of the good/bad, white/black, light/darkness antinomies of Western culture.

The film ends with the white vigilantes (indistinguishable from the zombies, remember) killing Ben, the representative of life in the film. Much of the imagery of *Night* carries over into *Dawn*, despite their many differences (most notably the latter's strong vein of humour). The opening sequence has white militia gleefully destroying living blacks and Hispanics who refuse to leave their tenement homes during the zombie emergency; as in *Night*, the black hero, Peter (Ken Foree), emerges from the light (this time from behind a white sheet with strong, bright light flooded unnaturalistically behind it); it is his practical skills that enable him to survive, skills that only the white woman, Fran (Gaylen Ross), is ultimately able to emulate. Zombieness is still linked with whiteness, even though some of the dead are black or Hispanic—a black zombie who attacks a living black man in the tenement is whited up, the colour contrast between the two emphasised in a shot of the whitened black zombie biting the living black man's neck; in the shopping mall, an overt symbol of the US way of life, editing rhymes the zombies with the shop mannequins, all of whom are white.

*Day* extends the critique of US values to the military-industrial complex, with its underpinnings in masculine supremacy.[26] As Robin Wood argues, the white men and the zombies alike are characterised by "the conditioned reflex," the application to human affairs of relentless rationality; the scientist, Logan, teaches one of the zombies to be human again, which in practice means killing the military leader, Rhodes, out of atavistic loyalty to Logan. When Logan earlier tells Rhodes that what he is teaching the zombies is "civility," to make them like the living, there is a sudden cut to a sequence of the men gleefully, sadistically corralling the zombies to be specimens for Logan's crazed experiments. The whiteness of all this is pointed, as before, by the presence of a black character, John (Terry Alexander), who is even

more dissociated from both zombies and white male values than were Ben and Peter in the earlier films. He is not only black but West Indian, and he offers the idea of finding an island as the only hope for the two white characters (a WASP woman, Sarah, and an Irish man, Billy) not irrevocably implicated in white male values. He and Billy are not only socially marginal, but also live separately from the soldiers and scientists, having set up a mock home together in the outer reaches of the underground bunker they all share. All the other living characters are redneck males, and although there is a power struggle between them, they are both more like each other and like the zombies than they are like John, Sarah or Billy. At the end of one scene, where Rhodes has established his authority over Logan, there is a final shot of John, who has looked on saying nothing; he rubs the corner of his mouth with his finger ironically, then smiles sweetly at Rhodes, an expression of ineffably insolent refusal of the white boys' games.

The *Dead* films are of course horror movies and there is a danger, as Pete Boss has pointed out, that the kind of political readings that I and others have given them may not be easy "to integrate . . . with the fantasies of physical degradation and vulnerability" characteristic of the contemporary horror film.[27] However, the use of "body horror" in the *Dead* films to represent whiteness is not simply symbolism, making use of what happens to the genre's current conventions. On the contrary, body horror is the horror of whiteness and the films' gory pleasures are like an inverted reprise of the images of whiteness that are touched on in *Simba* and *Jezebel*.

The point about Ben, Peter and John is that in their different ways they all have control over their bodies, are able to use them to survive, know how to do things with them. The white characters (with the exception of Fran, Sarah and Billy) lose that control while alive, and come back in the monstrously uncontrolled form of zombieness. The hysterical boundedness of the white body is grotesquely[28] transgressed as whites/zombies gouge out living white arms, pull out organs, munch at orifices. The spectre of white loss of control is evoked by the way the zombies stumble and dribble in their inexorable quest for blood, often with intestines spilling out or severed limbs dangling. White overinvestment in the brain is mercilessly undermined as brains spatter against the wall and zombies flop to the ground. "The fear of one's own body, of how one controls it and relates to it"[29] and the fear of not being able to control other bodies, those bodies whose exploitation is so fundamental to capitalist economy, are both at the heart of whiteness. Never has this horror been more deliriously evoked than in these films of the *Dead*.

Because my aim has been to open up an area of investigation, I shall not even attempt a rounded conclusion. Instead, let me start off again on another tack, suggested by the passing references to light and colour above. I suspect that there is some very interesting work to be done on the invention of photography and the development of lighting codes in relation to the white face, which results in the technicist ideology that one sometimes hears of it being "more difficult" to photograph black people. Be that as it may, it is the case that the codes of glamour lighting in Hollywood were developed in relation to white women, to endow them with a glow and radiance that has correspondences with the transcendental rhetoric of popular Christianity.

Of no woman star was this more true than Marilyn Monroe, known by the press at the time as "the Body." I've argued elsewhere that her image is an inescapably and

necessarily white one;[30] in many of her films this combines with the conventions of glamour lighting to make her disappear as flesh and blood even more thoroughly than is the case with other women stars. Her first appearance in *The Seven Year Itch* (1955), for instance, is a classic instance of woman as spectacle caught in a shot from the male protagonist's point of view. It opens on Richard (Tom Ewell), on his hands and knees on the floor looking for something, bottom sticking up, a milk bottle between his legs—the male body shown, as is routine in sex comedies, as ludicrously grotesque; he hears the door-bell and opens the door to his flat; as the door opens light floods in on him; he looks and there is a cut to the hall doorway, where the curvy shape of a woman is visible through the frosted glass. The woman's shape is placed exactly within the frame of the door window, the doorway is at the end of the hall, exactly in the centre of the frame; a set of enclosing rectangles create a strong sense of perspective, and emphasise the direction of Richard's/our gaze. The colouring of the screen is pinky-white and light emanates from behind the doorway where the woman is. All we see of her is her silhouette, defining her proportions, but she also looks translucent. The film cuts back to Richard, his jaw open in awe, bathed in stellar light. Later in the film, when the Monroe character's tomato plant crashes onto Richard's patio, we have another shot of her from Richard's point of view. He looks up, and there is a cut to Monroe looking down from her balcony, apparently nude; the wall behind her is dark, as is the vegetation on the balcony, so her face and shoulders stand out as white. Such moments conflate unreal angel-glow with sexual aura.

*The Seven Year Itch* is a very smart film. Through innumerable gags and cross-references, it lets on that it knows about male fantasy and its remote relation to reality. Yet it is also part of the Monroe industry, peddling an impossible dream, offering another specifically white ideal as if it embodies all heterosexual male yearning, offering another white image that dissolves in the light of its denial of its own specificity.

White women are constructed as the apotheosis of desirability, all that a man could want, yet nothing that can be had, nor anything that a woman can be. But, as I have argued, white representation *in general* has this everything-and-nothing quality.

## NOTES

1. cf, Herbert Marcuse, *One Dimensional Man*, Boston, Beacon Press, 1964.

2. cf, Winthrop Jordan, *White over Black*, Harmondsworth, Penguin, 1969; Peter Fryer, *Staying Power*, London, Pluto, 1984.

3. Made by Tony Dowmunt, Maris Clark, Rooney Martin and Kobena Mercer for Albany Video, London.

4. Paul Gilroy, *There Ain't No Black in the Union Jack*, London, Hutchinson, 1987, pp 55–56. See also the arguments about feminism and ethnicity in Hazel Carby, "White Woman Listen! Black Feminism and the Boundaries of Sisterhood" in Centre for Contemporary Cultural Studies, *The Empire Strikes Back*, London, Hutchinson, 1982, pp 212–23.

5. John O Thompson, "Screen Acting and the Commutation Test," *Screen* Summer 1978, vol 19 no 2, pp 55–70.

6. See T E Perkins, "Rethinking Stereotypes" in Michele Barrett et al (eds), *Representation and Cultural Practice*, New York, Croom Helm, pp 135–59; Steve Neale, "The Same Old Story,"

*Screen Education* Autumn/Winter 1979/80, nos 32–33, pp 33–38. For a practical example see the British Film Institute study pack, *The Dumb Blonde Stereotype*.

7. See Frantz Fanon, *Black Skin, White Masks*, London, Pluto, –1986; Edward Saïd, *Orientalism*, London, Routledge and Kegan Paul, 1978; Homi K Bhabha, "The Other Question—the Stereotype and Colonial Discourse," *Screen* November–December 1983, vol 24 no 6, pp 18–36.

8. See Benita Parry, "Problems in Current Theories of Colonial Discourse," *Oxford Literary Review*, vol 9, nos 1–2, 1987, pp 27–58.

9. See John Hill, *Sex, Class and Realism*, London, British Film Institute, 1986, chaps 4 and 5.

10. Frantz Fanon, op cit, p 183.

11. Paul Gilroy, op cit, p 61; see Errol Lawrence, "In the Abundance of Water the Fool is Thirsty: Sociology and Black Pathology," in Centre for Contemporary Cultural Studies, op cit, pp 95–142.

12. e.g., Homi Bhabha, op cit; Richard Dyer, "Stereotyping" in Richard Dyer (ed), *Gays and Film*, London, British Film Institute, 1977, pp 27–39; Sandor L Gilman, *Difference and Pathology*, Ithaca, Cornell University Press, 1985.

13. cf, Nancy Chodorow, *The Reproduction of Mothering*, Berkeley, University of California Press, 1978.

14. Michael Banton, *The Idea of Race*, London, Tavistock, 1977; this restrictive definition of racism has been disputed by, inter alia, Stuart Hall, "Race, Articulation and Societies Structured in Dominance" in UNESCO, *Sociological Theories: Race and Colonialism*, Paris, UNESCO, 1980.

15. cf, Stuart Hall, "The Whites of their Eyes: Racist Ideologies and the Media" in George Bridges and Rosalind Brunt (eds), *Silver Linings*, London, Lawrence and Wishart, 1981, pp 28–52.

16. See Andy Medhurst, "Dirk Bogarde" in Charles Barr, *All Our Yesterdays*, London, British Film Institute, 1986, pp 346–54.

17. Jim Pines, *Blacks in Films*, London, Studio Vista, 1975, p 54.

18. ibid, p 55. See also Thomas Cripps, *Slow Fade to Black*, New York, Oxford University Press, 1977, pp 299, 304.

19. See Cedric Robinson, *Black Marxism*, London, Zed Books, 1983.

20. See George Frederickson, *The Black Image in the White Mind*, New York, Harper and Row, 1972; David Levering Lewis, *When Harlem Was in Vogue*, New York, Knopf, 1981.

21. I have discussed this in "Four Films of Lana Turner," *Movie*, no 25, pp 30–52.

22. Ethel Mannin, *Confessions and Impressions*, New York, Doubleday, Doran, 1930, p 157.

23. Molly Haskell, *From Reverence to Rape*, New York, Holt, Rinehart and Winston, p 214.

24. Robin Wood, *Hollywood from Vietnam to Reagan*, New York, Columbia University Press, 1986, p 116.

25. ibid, p 120.

26. Robin Wood, "The Woman's Nightmare: Masculinity in 'The Day of the Dead,'" *CineAction!*, no 6, August 1986, pp 45–49.

27. Pete Boss, "Vile Bodies and Bad Medicine," *Screen* January–February 1986, vol 27 no l, p 18.

28. cf the discussion of the grotesque carnivalesque body in Mikhail Bakhtin, *Rabelais and His World*, Bloomington, Indiana University Press, 1984.

29. Philip Brophy, "Horrality—the Textuality of Contemporary Horror Films," *Screen* January–February 1986, vol 27 no 1, p 8.

30. Richard Dyer, *Heavenly Bodies*, London, Macmillan, 1986, pp 42–45.

# FATIMAH TOBING RONY

. . . . . . . . . . . . . . . . . . . . . . . . . . . . . . . . . . . . . . . . . . . . . . . . . . . . . . . . . . . . . . . . . . .

## *King Kong* and the Monster in Ethnographic Cinema

FROM *The Third Eye*

Fatimah Tobing Rony (b. 1963) is Associate Professor of Film and Media Studies at the University of California, Irvine, and an active filmmaker and writer. Her first book, *The Third Eye: Race, Cinema, and Ethnographic Spectacle* (1996), received the Katherine Singer Kovacs Prize from the Society for Cinema and Media Studies and made a significant impact on both scholarship and cultural production at the intersection of art history, visual ethnography, and film history. Rony's academic and creative work cross disciplinary and cultural boundaries and the poetic nature of her academic writing is complemented by the exploration of similar ideas and theories in her films. Her short video *On Cannibalism* (1994) acts as a counterpart to her book's argument, exploring the resonances between King Kong as ethnographic spectacle, early photographic and exhibition practices that attempted to establish racial difference visually, and her own identity and family history as an Indonesian American. Her most recent film, *Chants of Lotus* (2007), was made in collaboration with three other young women directors and explores contemporary women's lives in Indonesia.

Like that of other contemporary film theorists, Rony's work encourages a more inter-disciplinary study of film. This shift overlaps with film history's growing awareness of the need to represent multiple histories—like the important and fraught histories of race and racial representation in the United States. At the same time, movies themselves began to address more explicitly racial questions and their connection to film representation. As discussed in the introduction to this section, Spike Lee's *Bamboozled* (2000) is one of many African American films that confront the dynamics of racism in the cinema, calling attention to how audiences' "desire to see" can, sometimes unwittingly, create complex racist situations. As part of the same cultural and cinematic landscape, Rony's writing mirrors, complements, and extends these cinematic investigations of race in a more theoretical and historical way. Here, as elsewhere, film practice and film theory often move hand-in-hand.

"*King Kong* and the Monster in Ethnographic Cinema" is a detailed cultural analysis of the historical context that surrounded and produced *King Kong* (1933). Moving between discussions of ethnography and film genre, Rony demonstrates how the links among 1930s documentary films about "exotic" people, scientific attitudes toward race, and nineteenth-century notions of horror and monstrosity have led to the formation of an association between horror and the racial "other" or, more specifically, of the monstrous with races outside white European/American cultures. Rony's essay provides a unique perspective on how racial politics and representation in *King Kong* make it "a carnivalesque version of early ethnographic cinema." Rony also links this association between race and horror to the representation of women in *King Kong*—Fay Wray's

sexuality becomes both a bond with Kong and a threat to the prominent male quest in the film. This highlights cinema's fascination with placing beautiful white women on a pedestal as an attempt to visually and narratively control a sexuality that threatens male power and order while at the same time marginalizing women of color. Rony's essay is in line with other film theories on race, such as the work of Stuart Hall (p. 77) and Manthia Diawara (p. 594), and this essay can be productively contrasted with other readings of film genre, such as those of Rick Altman (p. 487) and Carol J. Clover (p. 511).

## READING CUES & KEY CONCEPTS

▓ Consider the connection between ethnography and race that Rony establishes in her essay. How does she use the depiction of monsters in horror films to explore that connection?

▓ According to Rony, how exactly do women become associated with the "monstrous"? Think about how this becomes part of the dynamics of seeing and being seen.

▓ **Key Concepts:** Ethnographic Cinema; Hybridity; Monstrosity; Native Woman; Primative Other; Teratology

# *King Kong* and the Monster in Ethnographic Cinema

. . . . . . . . . . . . . .

*Qui dédaigne* King Kong *n'entendra jamais rien au cinéma.*

André Falk[1]

*If Poe were alive, he would not have to invent horror; horror would invent him.*

Richard Wright

At the beginning of the century, a Chirichiri man named Ota Benga from the Kasai region of what is now Zaire was exhibited at the Bronx Zoo. He and other Batwa were brought to the United States by missionary anthropologist Samuel P. Verner at the request of William John McGee, director of the Smithsonian Institution. After "exhibiting" Ota Benga and others at the 1904 St. Louis Exposition as anthropological specimens, Verner, unlike his predecessors such as Arctic explorer Robert Peary, ensured their return back to their homeland.

One man, Ota Benga, chose to come back to the United States. It is unclear why. Housed first at the American Museum of Natural History in New York City, where Minik Wallace had also stayed, Ota Benga was one of several Africans "exhibited" at the St. Louis World's Fair. In one incident, Benga and other African performers attacked a photographer who had taken their photograph without asking first for their permission: they demanded that he pay for the privilege. Benga was later put in a cage at the Monkey House at the Bronx Zoo, rendered a zoological spectacle for the hungry public and press. Contemporary press accounts reported that Ota Benga could not be differentiated from the other monkeys. What Ota Benga thought about his experience is unknown. The few documents that remain of his time in the zoo

include photographs of him looking seriously at the camera, posed in characteristic anthropometric style: he is photographed frontally, from the back, and in profile, holding props—a monkey in one arm and a club in another—which reinforced his publicized "missing link" status.

One may surmise from what happened later that the experience of being a zoological exhibit destroyed Ota Benga's mind if not his soul. Protests by African American ministers probably led to his release from the Monkey House, and he was allowed to walk freely about the grounds of the zoo. Ota Benga ended his time at the zoo when he brandished a knife at one of the zoo keepers. After this incident, Ota Benga left the zoo and in 1910 moved to Lynchburg, Virginia. Six years later, he committed suicide.[2]

## King Kong *and Ethnographic Spectacle*

In Merian C. Cooper and Ernest B. Schoedsack's film *King Kong* (1933), the giant prehistoric gorilla Kong is captured and made into a lucrative Broadway attraction by the jungle picture filmmaker Carl Denham (Robert Montgomery). Kong then escapes, creating terror in the metropolis; he stalks the blonde heroine Ann Darrow (Fay Wray) and carries her off to the top of the Empire State Building where Kong is killed by an incessant barrage of bullets from fighter airplanes. The incredibly polysemous quality of *King Kong*, which has assured its continuing widespread popularity, has also led to a multitude of interpretations of the film—as dream, capitalist fairy tale, imperialist metaphor, allegory for the unconscious, and repressed spectacle for racial taboos. Its status as cinematic *fantasy*, as "a modern, movie-born myth" without historical antecedents, remains, however, largely unquestioned.[3] But *King Kong* is not merely a classic Hollywood film, it is a work which in significant respects builds on and redeploys themes borrowed from the scientific time machine of anthropology.

The lineage of *King Kong* should be obvious: the filming, capture, exhibition, photographing, and finally murder of Kong takes its cue from the historic exploitation of native peoples as freakish "ethnographic" specimens by science, cinema, and popular culture. Critics have consistently passed lightly over the fact that, in the 1920s, Cooper and Schoedsack were well-known ethnographic filmmakers, producing and directing both *Grass* (1925) and *Chang* (1927). *King Kong*, moreover, begins with an expedition, fully equipped with film camera, to a remote tropical island: *King Kong* is literally a film about the making of an ethnographic film. As exaggerated and baroque as *King Kong* may appear compared with [Félix-Louis] Regnault's chronophotography or Robert Flaherty's *Nanook of the North*, the film makes reference to many of the themes that characterized the construction of the "ethnographic" in early cinema. If, as Cooper had complained, there were no longer any remote, genuinely alien cultures left to be discovered, monsters still lurked in the imagination of interwar ethnographic cinema. In the spectacular commercial cinema of this period, monstrosity was the mode of representation of the Ethnographic.

Pierre Leprohon writes that the cinema of exoticism—and under this rubric he includes both the research films of an anthropologist like Marcel Griaule and falsified documentaries like the film *Ingagi* (1933)—partakes at the same time of science and of dream: as scientific document, it furthers the pursuit of knowledge; as poetry, it is the food of dreams.[4] In this chapter, I will show how the monster is both the subject of scientific representation, as was the case with the Komodo dragon, the object of W. Douglas Burden's museum expedition in 1927, and of fantastic cinematic

representation, as in Cooper and Schoedsack's *The Most Dangerous Game* (1932) and Erle C. Kenton's *The Island of Lost Souls* (1933), horror films which explore the notion of hybridity in teratological terms. Whether the monster was the object of science or fantasy, and whether shot with rifle or camera, it was a mode of representation inextricably linked with sex, power, and death.

Unlike most of the films of the "racial" genre, *King Kong* was a sound film. With the advent of sound technology in the early 1930s, the "racial film" genre ironically lost one of the dimensions of its "realism." André F. Liotard, Samivel, and Jean Thévenot note, "Even if it doesn't have dialogue, the exotic sound film always risks being betrayed by its noises, and especially by its music and its voiceover."[5] What propels *King Kong* forward is not the voice-over or intertitles of the scientific research film or lyrical ethnographic film, but sound of a different sort—the blonde heroine's screams, the giant gorilla Kong's roar, the lush Wagnerian score of Max Steiner—and *movement*—the longboat rushes to Skull Island to save Ann, the crew runs through the jungle in order to save her, and later the heroes run through Manhattan in an attempt to save Ann from Kong again. *King Kong* is not a film of poetic juxtaposition like *Nanook*, but of frenetic braggadocio, clunking the viewer over the head visually and aurally, a tone set by the very title of the film with its alliteration and rough-hewn rhythm. *King Kong* is the ultimate carnivalesque version of early ethnographic cinema.

## Teratology and Fantasy: The Science Expedition and the Horror Film

My notion that the mode of representation of the "ethnographic" in spectacular commercial cinema takes the form of *teratology*—the study of monstrosity—derives once again from Stephen Bann's study of the rhetoric of history-writing in nineteenth-century France and Great Britain. Emphasizing the parallel between monstrosity and taxidermy, Bann points out that the monster is "the composite, incongruous beast which . . . simulated the seamless integrity of organic life."[6] It is thus not surprising that *King Kong* emerges in large part out of the "racial film" genre initiated by *Nanook*. *Nanook* was a work of taxidermy, inspired by the politics and aesthetics of reconstruction, and *King Kong* is not only a film about a monster—the film itself is a monster, a hybrid of the scientific expedition and fantasy genres.

Bann states that the "very anxiety to establish [the] distinction between 'all' imagination and invention, on the one hand, and on the other the facts, is of course the evidence of a desire to repress the rhetorical status of historical writing."[7] The desire to find true representation of the real, or true inscription, was characteristic of Regnault's work, and his writings and chronophotography betray a deep-seated anxiety with differentiating fact from imagination, the normal from the pathological. Teratology was an important aspect of early anthropology: the "monster," like the Primitive Other, was of keen interest because it could be used to study and define the normal. In *The Normal and the Pathological*, historian of science Georges Canguilhem describes how abnormality is necessary to constitute normality: "The abnormal, as ab-normal, comes after the definition of the normal, it is its logical negation. . . . The normal is the effect obtained by the execution of the normative project, it is the norm exhibited in the fact. . . . It is not paradoxical to say that the abnormal, while logically second, is existentially first."[8]

The Ethnographic, as we have seen, could be romanticized as authentic culture and/or as "pathological" culture, as in Margaret Mead's representation of the Balinese as schizoid. But one need not seek out extreme examples: the notion of the "ethnographic" as monster was only an exaggeration of the common propensity to see native peoples as strange, bizarre, and abhorrent. As I have already noted, it is significant that anthropologist Bronislaw Malinowski's infamous invocation of *Heart of Darkness*—"exterminate the brutes"—comes out of his exasperation at the refusal of the Trobrianders to sit still long enough to be photographed. The Ethnographic becomes monstrous at the very moment of visual appropriation.[9]

Noël Carroll has explained that, in the horror film, the two essential characteristics of the monster are its impurity and its dangerousness. Borrowing from Mary Douglas's analysis in *Purity and Danger* (1966), he explains that monsters are impure in that, as hybrids, they are not easily categorized, and thus cross the boundaries of cultural schemas. Monsters are, Carroll emphasizes, interstitial. Kong, neither human nor ape, is impure in this sense. Thus the monster is not just physically threatening, but also cognitively threatening: its existence threatens cultural boundaries. As Carroll suggests, this cultural dangerousness explains why the geography of horror often involves lost continents and outer space.[10]

The Ethnographic is seen as monstrous because he or she is human and yet radically different. Early examples of the monstrosity of the Ethnographic include Regnault's association of race and cranial deformation; Spencer's description of "naked, howling savages;" the Johnsons' coding of Western Pacific peoples as lascivious cannibals; the obsessive filming of trance (a ubiquitous subject in ethnographic cinema); and the plethora of ways in which indigenous peoples were, through the use of cinematic spectacle, made into Savages, a term which still had credence in anthropology as late as 1930.[11] Monstrosity is essentially visual, an aspect of "seeing anthropology" that involves a search for visual evidence of the pathological, a theme made evident in both Paul Broca's and Franz Boas's recommendations that anthropologists observe the indigenous person as a patient.[12] Because the image in ethnographic film is taken as "real," footage of a person in trance frothing at the mouth and biting off a chicken head, or of a person slicing open a seal and eating raw meat, often is read by the intended viewer of ethnographic film, the Western viewer, as evidence of the essential savagery of the Ethnographic. As Wilson Martinez and Asen Balikci have explained and documented, cultures in ethnographic films are usually seen by students and other audiences as aberrant, bizarre, and even repulsive, unless the culture on display is similar to the culture of the audience.[13] Such audience studies raise questions about the ethics of filming acts which were never meant to be seen by outsiders, and showing the films in contexts in which—even with extensive commentary from anthropologists—abhorrence is aroused. Brazilian ethnographic filmmaker Jorge Preloran explains:

> After seeing dozens of films on ethnographic subjects, one thing stands out clearly for me: the majority of [the films] create a gulf between us and the "primitive" people they usually depict. This to me is a racist approach because unless we have a chance to listen firsthand to those people, letting them explain to us WHY they act as they do, WHY they have those extraordinary rituals, those fantastic, colorful, exotic, disgusting, fascinating—you label it—ceremonies that are shown to us, we will only think of them as savages.[14]

Several different tendencies converged to produce the image of the Ethnographic as monstrous. First, the great variety of indigenous societies continually destabilized the Modern/Primitive dichotomy. Second, the perception of indigenous peoples as a link between the ape and the white man, as in between animal and "human" (white), made the Ethnographic always already monstrous. Third, the image betrays anthropology's obsession with hybridity. The concern with hybridity manifested itself both through an abhorrence of interracial intercourse and "blood mixing," reflected in Paul Broca's influential research purportedly establishing that the offspring of blacks and whites were infertile,[15] and through notions of salvage ethnography, the belief that the "ethnographic" as embodiment of an earlier, purer humanity, would spoil upon contact with the West, a conceit which was played out in the "racial film" genre. This latter form of hybridity is best expressed cinematically in the scene of clashing styles of dancing in Murnau's *Tabu*, described in chapter 5 of *The Third Eye*.

Its literary counterpart to the spoils-upon-contact theme is exemplified in Lévi-Strauss's description of the society of Brazilian Indian rubber tappers in *Tristes Tropiques*. He explains that if the Nambikwara had taken him to the Stone Age, and the Tupi-Kawahib to the sixteenth century, then the society of the *seringal* (rubber plantation) in the Brazilian Amazon brought him to the eighteenth century. It is worth quoting his description of the Indian women at length:

> Under a layer of rouge and powder they were hiding syphilis, tuberculosis and malaria. They came in high-heeled shoes from the *barracão*, where they lived with "the man," their *seringueiro*, and, although ragged and dishevelled all the rest of the year, for one evening they appeared spick and span; yet they had had to walk two or three kilometres in their evening dresses along muddy forest paths. And in order to get ready, they had washed in darkness in filthy *igarapés* (streams), and in the rain, since it had poured all day. There was a staggering contrast between these flimsy appearances of civilization and the monstrous reality which lay just outside the door.[16]

Although with greater pathos, Lévi-Strauss, like Murnau, mourns the passage of time: acculturation brings disease and despair, and indigenous culture cannot withstand the onslaught. Mixture, whether it takes the form of miscegenation or acculturation, produces monsters.

Stephen Neale's description of the monster in the horror film reveals a direct similarity between screen monsters and the Ethnographic rendered as monster. In both cases, the focus is on bodily disruption:

> The monster, and the disorder it initiates and concretises, is always that which disrupts and challenges the definitions and categories of the "human" and the "natural." Generally speaking, it is the monster's body which focuses the disruption. Either disfigured, or marked by a heterogeneity of human and animal features, or marked only by a "non-human" gaze, the body is always in some way signalled as "other," signalled, precisely, as monstrous.[17]

Not surprisingly, the archetypal narrative of many forms of ethnographic cinema, but especially of the expedition film, mirrors that of the horror film. Carroll points out that the horror film uses variations on the "complex discovery" plot: the monster first appears or is created (onset); it is then noticed by the human protagonists

(discovery); its horrible existence is acknowledged (confirmation); and the film ends with a fight to the death between human and monster (confrontation).[18] As Neale explains, the narrative process in the horror film is "marked by a search for that specialized form of knowledge which will enable human characters to comprehend and control that which simultaneously embodies and causes its 'trouble.'"[19] Similarly, the plot of expedition films like *Grass* and *Moana* is structured around the discovery and confirmation of a being (whether zoological rarity or group of people) with incongruous features or habits.

[ · · · ]

In his discussion of *King Kong*, J. P. Telotte has argued that an effective horror film draws the viewer into its world of excitement and terror through its manipulation of boundaries: "The horror film can play most effectively on its boundary position; monsterlike, it can simply reach into our world and make us part of its nightmarish realm, forcing us to complete horrific sequences."[20] Similarly, citing Tzvetan Todorov, Noël Carroll explains that the fantastic in cinema is produced by allowing for a vacillation between supernatural and naturalistic explanations. Many horror stories begin as narratives purporting to offer rational explanations for the fantastic, but then build up to a confrontation with the monster, a supernatural being that cannot be explained by science.[21] Above all, Carroll adds, the horror film demands proof, proof of the monster's existence and a clear explanation of why it exists. The horror film genre works because the audience is fascinated by the monster's impurity, its hybridity, and because it is curious to get at the heart of this unknowable: the audience follows the narrative until it discloses all the secrets of the monster.[22] This knowledge is arrived at only by observation. It is this desire for proof by observation that links the ethnographic film to the horror film: from its inception, the efficacy of ethnographic film was believed to derive from its status as pure observation, pure inscription, evidence for the archive. But this logic linking vision to knowledge, producing an incessant desire to see, is not without its attendant dangers.

## King Kong: *A Close Analysis*

In a scene about two-thirds of the way through *King Kong*, a disheveled young couple—Ann Darrow, a pale blonde woman, and Jack Driscoll, her virile male lover—flee on foot from the giant ape-monster Kong through a jungle of enormous, primordial vegetation. As they run we see their wide-eyed but grimly set expressions as they frantically brush aside the leaves of the jungle that hang in their way, the young man pulling on the woman to run even faster as she becomes progressively weaker, until she is so exhausted that she has to be carried to safety in the man's arms. This scene of the two running, running, forever running, is full of suspense—Will Kong catch up? Will they make it? Moreover, will they make it back to Civilization? Their running is a literal embodiment of the race of history, a race which is a locus of ethnographic cinema. The outcome is known—the monster will be destroyed, and the heroic whites will triumph—but there is always a tension, an element of uncertainty, a possibility that the race may go either way.

## 1. AT DOCK: THE WHITE MALE ELITE—HUNTERS, FILMMAKERS, VOYAGERS, HEROES

*King Kong* begins and ends as a tribute to the Empire State Building, the triumph of modernity. After credits with graphics of the facade of the building, the film introduces the viewer to the humans whom anthropology had glorified as being at the "head of the steeplechase" of history: the white male, specifically the adventurous white male elite. We meet first the white male crew of the moving picture ship: the mastermind of the spectacle of the white beauty and the beast is a character named Carl Denham, labeled a jungle filmmaker, and his colleague Jack Driscoll, first mate of the ship and later the fiancé of the Fay Wray character, Ann Darrow. In addition to the model of Douglas Burden, Carl Denham was closely modeled on Cooper, Jack Driscoll on Schoedsack, and Ann Darrow on Schoedsack's wife, Ruth Rose, as well as Katherine Burden (Rose, in fact, was one of the screenwriters for *King Kong*).[23] Denham was apparently also modeled on the brash showman Frank Buck, who made films about capturing animals for zoos, such as *Bring 'Em Back Alive* (1932).

Noël Carroll writes, "No other film has ever been as self-congratulatory as *Kong*. It is a swaggering, arrogant film that spends much of its time telling us how great it is. . . . *Kong* is the quintessential American film—its self-image is so enormous."[24] The self-referential tenor of the film does not arise solely because of *King Kong*'s many references to film history, a point made by James Snead,[25] but also because self-referentiality is central to ethnographic cinema.

## 2. IN DEPRESSION-ERA MANHATTAN: THE WHITE WOMAN—CRIMINAL, TROUBLE, OBJECT OF EXCHANGE

The second scene of the film takes us down one level in the evolutionary taxonomy of race and gender to the white woman—Ann Darrow—the forever fainting, screaming blonde heroine of *King Kong*. If necessary for the propagation of the "race" and the furtherance of Civilization, she is, as Jack says, always trouble. She is the object of the film spectacle, recognized as a necessary accessory because, as Denham explains wryly, "The public, Bless 'em! Must have a pretty face to look at." *King Kong* begins then as the hunt for an appropriate "pretty face" for the expedition—a white woman—just as it later becomes a hunt for Kong.

The film is set contemporaneously at the height of the Great Depression. Curiously, criticism of *King Kong* rarely mentions Ann's poverty and her implied criminal status. In the taxonomic classification system of early anthropology—and Regnault's conception of race as pathology provides an excellent illustration of this theme—the interest in indigenous peoples as Primitive was closely allied to the study of "sociological" types such as the prostitute, the criminal, the ethnic immigrant, laborers, homosexuals, and the Irish. All of these marginal groups were seen as deficient both morally and intellectually.[26]

Denham espies Ann Darrow when she is caught trying to steal an apple from a vendor; the heroine-to-be is an Eve who has already fallen. He takes Ann to a coffee shop to explain his intentions, and the audience as well as Denham gets to scrutinize her under the bright lights of the interior. In several close-ups from the chest up, Ann sits eagerly with her back against a wall lined like a Cartesian grid; she is posed in the

manner of anthropological as well as criminal photographs. The lines of the wall imprison Ann as a type; it is Denham who has saved her from criminal punishment, but he will entrap her, even while elevating her, as object of trade and of spectacle. If, as a criminal in the darkened streets of Manhattan, Ann is first associated with darkness, she also represents lightness: as Cooper told Fay Wray, he wanted Ann to be a blonde beauty in order to highlight the contrast with Kong (Cooper referred to Kong as the darkest leading man she would ever have).[27] Throughout the film, Ann is compared implicitly to Kong. Cooper had his own notions about woman as beast:

> Woman has retained, fortunately, the fighting, dominant blood of the savage. . . . She would have perished as a distinctive individual long ago had it not been for her own rights. This quality can be found in the most fragile of women. For a long time I always thought that "the most dangerous" game naturally would be one in which a woman was involved.[28]

Cinema works as a time machine not only in the scientific research film, the romantic ethnographic reconstruction, or the Hollywood horror film: as this "racializing" of gender reveals, white women as well as people of color are "evolutionized." If the 1930s was the era of Frankenstein, Dracula, and King Kong, it was also the period which saw Lota the Panther Woman, Nina the Fetish in *Trader Horn* (1931), the gorilla-suited Helen Faraday (Marlene Dietrich) in Josef von Sternberg's *Blonde Venus* (1932), and the incessantly screaming characters played by Fay Wray.

The figure of the white woman is thus another object of knowledge needing to be explored, understood, and tamed. In *Trader Horn*, for example, a film by W. S. van Dyke (who also made *White Shadows in the South Seas* [1929] and *Tarzan the Ape Man* [1932]), the legendary Trader Horn and his sidekick Peru soon embark on a mission to save the young white woman Nina, who as a child had been abducted in an African raid and who has become a "fetish" for an African tribe. The characterization of Nina is ambiguous and strangely charged. Speaking no English, and with her wild, frizzy blond hair and skimpy feathered outfit, she is initially perceived as being "as great a savage" as the Africans with whom she lives. Like Lota the Panther Woman in *Island of Lost Souls*, Nina has the crackling long hair and the blazing, darting eyes of a creature who is half-animal, half-human. But while Lota is, in a sense, racially coded as a *mulatta*, Nina is coded as a true white woman capable of dominating the African men of her village, through shouting at them and whipping them. At the film's end she and Peru leave Africa to get married, effectively marking Nina's entry into Civilization as a proper wife. Ranchero, Trader Horn's African assistant, becomes feminized and is made into the object of desire for the Great White Hunter, as seen in the death scene where Trader Horn embraces the dying Ranchero.[29]

Similarly in Josef von Sternberg's *Blonde Venus* (1932), it is unmistakably the white woman who is the enticing object of inquiry. The film begins when a group of students of science unexpectedly come across Helen and her actress friends swimming nude in a secluded lake in Germany. Helen later marries one of these men—Faraday, an American scientist—and they have a son named Johnny. The image of Helen frolicking in the water is reminiscent of the South Seas bathing beauties who represent a Golden Age of Innocence in *Tabu* and *White Shadows in the South Seas*. Helen, a theater actress, is brought out of nature and thus "civilized." Because Faraday is in need of money to pay for a medical operation, Helen returns to the theater. Her fall to a more "savage" state

is indicated by her famous "Hot Voodoo" number. In a fancy nightclub for an audience of rich white men, the act begins with shots of the smiling gestures of the black orchestra leader, while a conga line of white women wearing dark makeup and black Afro wigs weave their way on stage, swaying in their grass skirts, leading a squatting gorilla on a chain. Suddenly a pale blonde apparition with long white arms emerges from the black hairy gorilla suit: it is Helen, singing how "she wants to be bad," how she is "beginning to feel like an African queen." This "Hot Voodoo" number highlights how White Woman, as object of spectacle, was seen as savage, part of her appeal her inherent bestiality. But it is the myth of Africa which lends the image of Helen her "savagery": the image of Africa and blackness—the orchestra leader, the black stuttering man at the bar, the conga line, and Helen's gorilla/African queen stance—is exploited in order to spectacularize Helen's sexuality. The aristocratic society of the nightclub is seen as wickedly decadent, and Broadway becomes a present-day jungle.

The depiction of Ann Darrow, like that of her screen sisters Lota, Nina, and Helen, reveals a cinematic fascination with beautiful white women as unconscious source of disorder. The double-edged representation of the White Woman—as pillar of the white family, superior to non-white indigenous peoples, but also as a possibly Savage creature, inferior to white men—is expressed in the parallels drawn between Ann and Kong as objects of spectacle, and by Jack Driscoll's simultaneous fear of and lust for her.

Even as the White Woman is made into the visual object par excellence, her wildness is linked to her desire to know through seeing. As the object of the camera and of the viewer's gaze, Ann is punished for wanting to be an active viewer. It is Ann's curiosity to *see* that repeatedly gets her into trouble. Her own gaze must be continually frustrated, for the gaze has been established as allied with the camera, and thus with Carl Denham—the White Male.

### 3. ON DECK AT SEA: THE CHINESE MAN—BARBARIC, COMICAL, FEMINIZED

The film crew together with Ann then embark on their voyage to a mysterious island. One scene aboard the ship magnificently coalesces into a racial tableau. On deck, Ann waits for her screen test to begin, while Charlie (Victor Wong)—the Chinese cook for the ship—peels potatoes. Ann laughs at Charlie's pidgin English. He is firmly established as a guest worker, not the agent of a cross-racial relationship. Charlie never really looks at Ann: he is a looking glass for Ann, a means to establish what Laura Mulvey has called her "to-be-looked-at-ness."[30] Moreover, Charlie is feminized by his position as cook and by his body language. Any possible hint of sexual tension between Ann and Charlie is diffused by the sudden appearance of Jack who looks actively at Ann's face, alternately telling her he approves of her looks, and complaining that she is trouble. Ann retorts, "Iggy's nice to me. Iggy likes me better than he likes anyone else on board," at which point the film cuts to reveal the identity of Iggy, a pet monkey on a string, a kind of miniature precursor to Kong. This scene establishes an evolutionary and thus anthropological hierarchy: Iggy the monkey jerks frantically on the ground, Charlie the Chinese man sits peeling potatoes in the background, Ann is standing and thus is higher than Charlie, and Jack stands over them all, looking intently at Ann.[31]

The character of Charlie, his lowered posture and pidgin English, draws attention to the place of Asia in the cinematic imagination. Films during this period shown in the bigger movie houses were often accompanied by acts labeled "exotic" such as a Siamese twins act. As evidenced by the fact that many early movie houses were built as faux Egyptian or Chinese palaces, East Asia, Egypt, and cinema were firmly intertwined: cinema could take the traveler/viewer either to the past and beyond to Savagery, or through the present to the future.[32] East Asia is seen as an intermediate point between the West and "the Rest," as midway between Savagery and Civilization. In a scene in *King Kong*, for example, the wall which prevents Kong from escaping from the jungle is described both as Egyptian and as akin to Angkor Wat. Asia is thus seen as an impenetrable wall, one side facing the future, one side opening onto prehistory. The prototypical Chinese in cinema—Chan, "the Yellow Man" of D. W. Griffith's film *Broken Blossoms* (1919), for example—was a liminal being, neither a real man nor a real woman, trapped in the role of looking glass, a reflecting surface.

After the racial tableau of the potato-peeling scene, Denham reveals to Jack and the Captain the destination of the voyage—a forgotten land called Skull Island off the coast of Sumatra. The next scene on deck emphatically locates Ann as spectacle for a sadistic white male gaze. Ann is implicitly compared to a charging rhino in Denham's explanation to her of why he shoots wild animals. Ann shivers and raises her hands as Denham's voice continues, "You're amazed!"

> You can't believe it! Your eyes open wider! It's horrible Ann but you can't look away. There's no chance for you Ann. No escape. You're helpless Ann. Helpless. There's just one chance. If you could scream, but your throat's paralyzed. Try to scream Ann. Try! Perhaps if you didn't see it you could scream. Throw your arms across your eyes and scream. Ann, scream for your life!

Ann is seen to be enjoying the attentions of the camera and the crew, and Fay Wray herself described the filming as "a kind of pleasurable torment."[33]

## 4. AT THE VILLAGE ON SKULL ISLAND: INDIGENOUS ISLANDERS— SAVAGE, SUPERSTITIOUS, BESTIAL, CHILDLIKE, EVIL

Cutting through the water in dense blinding fog, the sound of drums beating in the distance, the moving picture ship arrives at Skull Island. When the fog clears, "seeing is believing," Denham exclaims, as he gloats to the Captain of how closely the island resembles the map of the island he had shown the Captain. Denham and the crew, including Ann, sneak on to the island, and see in the distance an enormous wall. Denham explains that the natives have "slipped back" and are inferior to the higher civilization that once inhabited the island and made the wall. The island is constructed as a feminine space with a wall which must be penetrated before male glory can be attained.[34]

The Skull Islanders—dark-skinned, fierce, lustful, and yet childlike, afraid of guns—are represented as the most Savage of men. Both David Rosen and James Snead have pointed out the racial politics played out in *King Kong* by way of the Skull Islanders, emphasizing that the portrayal of the Islanders built on racist fears of miscegenation by whites during the period of the great African American migration to the North.[35] James Snead also refers to Denham's voyage as "optical-colonialism" and sees Kong's capture as an ideological screen for the European-American slave trade.[36]

But the common interpretation that the natives are coded as black, merely derogatory stereotypes for African Americans, fails to take seriously the way that *King Kong* engages the racial discourse of ethnographic cinema. Just as Malinowski described the Trobriand Islanders using a racial slur for blacks in his diaries, the natives of Skull Island who are coded as black are also explicitly geographically situated off the coast of Sumatra, in what today is called Indonesia. Many Indonesians have been and are seen by the West as black or, to use the scientific category, "Oceanic Negroid."[37] Thus the use of African American extras to play the role of Indonesian islanders underlines how in the popular as well as scientific imagination dark skin was fully synonymous with Savagery. Anthropological accounts of Sumatran groups such as the Nias Islanders (whose dialect the Skull Islanders speak) and of the Dayak groups of Kalimantan and Sarawak (i.e., the Wild Man of Borneo) also painted the groups as dark-skinned Savages, Animists, Warlike Cannibals. *King Kong* is merely a baroque version of this image of the "ethnographic."

The arbitrariness of ethnic distinctions in Hollywood is reflected in the choice of the actor Noble P. Johnson to play the Chief of this Malayo-Polynesian island. Johnson, a light-skinned African American actor and a pioneer producer of black film (in 1916, he founded the Lincoln Motion Picture Company), also played Ivan, the Cossack servant in Cooper and Schoedsack's *The Most Dangerous Game*.[38] Similarly, the Yaqui actor Steve Clemente played the evil Mongolian servant in *The Most Dangerous Game*, and in *King Kong* he appears as the Medicine Man.

The representation of the native in *King Kong* is therefore extremely complex: it is true that, in the context of black/white relations in the United States, whites undoubtedly were intended to see the Islanders as black, but it is also true that the Islanders are clearly defined as being from the Indonesian archipelago. An African American viewer could thus locate the Skull Islanders as Sumatrans and still register them as Other. The curious obsession with authenticity in the use of the Nias language—the actors speak a few heavily American-accented phrases of the language—calls attention to the fact that these cinematic natives have a referent out in the real world, for Nias is an island off the coast of Sumatra.

One figure in the great island spectacle is practically erased. Ann is the Other to the white man, and the native man is the Other to Ann, but the native woman—the *bride* of Kong (when the film crew arrives on the island, the Islanders are preparing a ceremonial "bride" offering to Kong)—has no Other: timid, naked, docile, and mute, she is firmly established as less worthy of spectacle, a mere shadow next to Ann, and far less desirable as a commodity. Indeed, Kong's bride never speaks in the film, only looking up once at the moment that Denham and his crew are spotted. In the evolutionary schema of *King Kong* she hardly exists. As cultural critic Michele Wallace has pointed out, in racialized ideology there is no Other to the woman of color; she is denied a space of agency.[39] However, within the racial and gender economy of *King Kong*, it is impossible to imagine that a man be sacrificed in her place: the centerpiece of the spectacle must be female, to be visually possessed and violated by men.

Although we remember the name of Fay Wray and forget her character's name in *King Kong*, Ann Darrow, we remember the name Nanook, and never think of Allakariallak. Nobody deigned to ask if Nanook was the actor's real name in *Nanook of the North*, or to question the ethics of ventriloquism and taxidermy in romantic ethnography: the Native Man in ethnographic cinema is not even perceived as being an actor: his performance is always "real." At the other extreme is the White Woman.

Fay Wray becomes, in the public's eye, the screaming heroine that she played; by identifying the heroine with the "real" name of the actress, the feminine is revealed as pure spectacle. The White Woman in ethnographic cinema cannot, like Allakariallak, be renamed, for she is the *star*, already a signifier, for beauty, glamour, the feminine, but also the unknown.

By contrast, the Native Woman almost always remains *unnamed*: she is typified by the compliant, silent, staring bride of Kong. This is not to say that there are no exceptions—*Tabu*'s Reri, or *Goona Goona*'s Dasnee, for example—but she largely remains mute, a type. As exemplified by the character of Cunayou in *Nanook of the North*, the Native Woman is the silent, figure of maternity, and through the kind of "girlie" photos displayed by Burden, to take another example, she is the figure of eroticism, of *goona goona*. The Native Woman is silent because, as Michele Wallace has pointed out, there is no other for the other. If the White Woman is the other to the White Man, and the Native Man the other to the White Woman, the Native Woman is excluded from the space of production. Just as anthropology describes women as objects of exchange which enable kinship systems to function, cinema circulates the native woman as pure signifier, or as Wallace puts it, as a black hole, in a system that is largely one of male transaction.

Ann is kidnapped and replaces the bride of Kong, for the Skull Island Chief recognizes that she is six times more valuable than an indigenous woman (the Chief offers to purchase Ann from Denham at this price). Soon thereafter, however, Kong's arrival at the wall is announced with the striking of the gong, the three coups de théâtre announcing that the drama is to begin. A roar is heard, the natives silently watch, and Kong pushes the trees apart to get a better look at Ann.

### 5. THE JUNGLE: KING KONG—THE MISSING LINK

Kong is a cinematic fantasy of the Darwinian link between the anthropoid ape and man. As Donna Haraway explains in her brilliant analysis of the narratives implicit in Jane Goodall's primatological research project, the burden of the ideology of race after World War II was often placed on the anthropoid ape rather than on indigenous peoples.[40] Cooper's explanation for creating a monster Missing Link stemmed from his lament that there were no more places to discover. Perhaps even at the height of imperialism, the viability of representing native peoples as static Ethnographic beings was seen as impossible: there was always the problem that these colonial subjects spoke, and spoke quite vehemently. Apes, however, do not speak. And so the voyage of the moving picture ship culminates with an encounter with the prehistoric Kong.

[ · · · ]

Although Kong is monstrous—both in size and by virtue of his hybrid status as man/ape—Kong is a Noble Savage as well. Noble Savagery, as emphasized earlier, was important to the romantic ethnographic cinema of filmmakers like Flaherty and Murnau. There is a noble side to Kong: as in the ethnographic exposition, the boundaries between viewer and viewed were at times broken through, allowing the viewer of *King Kong* to see the world from Kong's eyes. This play with boundaries is made possible by the way that Kong is filmed. For example, in the scenes where Kong views Ann

for the first time, there are shot/reaction shots of Kong and of what Kong sees. Similarly the viewer experiences Kong's view of the audience when he is later exhibited in the Broadway theater. As these shots suggest, Kong is decidedly anthropomorphized. He fights dinosaurs like a human prizefighter, is tender toward Ann, and is tragically defiant at the end of the film, his back arched like a diva just before he falls from the Empire State Building. On Skull Island, moreover, Kong is in control of the gaze; Ann, who "just wants to see," is identified only by her scream, and by her persistent inability to use her legs to stand up and run away whenever Kong is in the vicinity.

Both the desire to see and the dangers of seeing, essential to the horror film, are foregrounded in *King Kong*. The forbidden, what "no white man has seen," is above all the interracial, interspecies intercourse of Ann and Kong. This titillation propels the narrative forward. *King Kong* the film, like its eponymous character, is a monster, a hybrid of the ethnographic film and the science fiction film. [ . . . ] The white woman is a lure, an object to stimulate the beast's willingness to come out into the open and be seen. Kong sees Ann and immediately wants to possess her. Ann collapses: incapable of movement, she is an object to be possessed, an object of circulation; but it is Kong who must be captured.

## 6. THE JUNGLE: DINOSAURS AND THE PREHISTORIC AGE

Kong leaves the scene at the wall after taking possession of Ann, and the camera follows Kong beyond the wall to a "forgotten land": here the time voyage reaches its destination—a place where time has stopped and dinosaurs still roam, a prehistoric jungle of giant trees and plants. In his design for the opening shot of this scene, Willis O'Brien drew on nineteenth-century images of fantasy landscapes, inspired particularly by Arnold Böcklin's painting *The Isle of the Dead* (1880), and by Gustave Doré's illustrations of purgatories, hells, and wild landscapes.[41] O'Brien's animation is almost seamless, and its jarring sizes and spaces add up to a pastiche which is quite compelling. Using optical tricks such as projected backdrops and painted glass plates, Willis O'Brien created a hyperreal space.[42] As Denham, Jack, and the crew, Lilliputian in contrast to the giant vegetation; fire at a huge dinosaur in the background, the viewer has a sense that they are firing into a museum dinosaur display.

In one key scene, fantasy literally bumps up against reality. Kong places Ann on top of a tree in the foreground, and we see him dueling with a tyrannosaurus. Ann must sit and watch, rooted to the scene. The fighting beasts then literally bump into Ann's space, knocking down the tree on which she sits. Ann falls precipitously farther into the foreground: in a sense, she falls into our space, the space of the audience.

[ · · · ]

As Noël Carroll has suggested, the dinosaur, though always used to invoke prehistory, was paradoxically a modern monster. The dinosaur, only made fashionable beginning in the mid–nineteenth century, soon became an object of study and of museum spectacle for those fascinated by the implications of time and evolution. Carroll explains why dinosaurs and warring tribes were key to the literature of such writers as Jules Verne and Edgar Rice Burroughs: "as symbols, dinosaurs and their fictional lost world are rather modern, i.e., as modern as our concept of prehistory."[43] Carroll argues

that, from the turn of the century, the jungle metaphor referred to the necessarily savage character of economic competition, an economic survival of the fittest:

> The combination of dinosaurs with the biologically charged characterization of battling nation/tribes (in which the "humans" were aided by Europeans) is a recurring motif in prehistoric tales; it registers the application of intrinsically nondramatic biological concepts like "competition" and "survival" to social concepts where the biological concepts become particularized, dramatized, literalized. . . . This tendency to translate the terms of pure biological theory into vivid, combatoriented metaphors for picturing society was rife at the turn of the century and prehistoric tales may, therefore, be seen in conjunction with the currency of Social Darwinism.[44]

In the jungle, Kong—the Missing Link—always wins in the eat-or-be-eaten world of ruthless competition for Ann.

### 7. BROADWAY: THE WHITE BOURGEOIS AUDIENCE—SURAFFINÉ, CONSUMERIST, COWED

When Kong is finally subdued by Jack and Carl, felled by a gas bomb, and is brought to Manhattan, *King Kong* reverses itself and returns forward in time to the present. Although situated in the present, however, Manhattan is a city in which all is not in order (recall the early, dark scene of desperate women waiting in a soup line).[45] There is stylistic and narrative symmetry between Manhattan and Skull Island: it is not surprising then that the wall of Skull Island is mirrored in the theater wall in Manhattan which Kong crushes down, or that the serpent-like body of the dinosaur foreshadows the snaking, elevated train, or that Kong should crunch a Skull Islander in his mouth in the same way that he does a New Yorker. Even the audience for the formal unveiling of Kong, made up of white theatergoers in formal evening dress, mirrors the Skull Islanders: both are hungry for the spectacle, and on Broadway, as on Skull Island, the spectacle is a subdued (placated or captive) Kong.

The fascinating cannibalism of the audience, its greedy desire to see Kong, is the subject matter of the next sequence. The desire of the audience is a mirror of our own desire to see. Depression Manhattan is portrayed as a harsh jungle in the beginning of *King Kong*, but for the bourgeois white theater audience awaiting the unveiling of Kong, the jungle must be brought closer, an example of what Haraway has called the entertainment of violated boundaries.[46] Like the nightclub crowd in *Blonde Venus*, or the members of the audience waiting for Kong, we, the viewers of the film, are also implicitly criticized for our voracious appetite to see the "real" thing, even though we already know that what we take for real is now only film, a simulacrum. As the theatergoers take their seats, one elderly, crotchety woman with spectacles complains, "I can't sit so near the screen. It hurts my eyes." To which the usher informs her, "This is not a moving picture, madam," She huffs, "well! I never! I thought I was going to *see* something!" In this comic aside, the referent itself is secondary to the representation; the woman's comment, however, plays on the audience's desire to see the conflation of film and reality. Kong, of course, is an animated monster created through the use of eighteen-inch full-body models, and of separate models of his head and paws: the monster himself is not even whole, but made of

pieces, already fetishized. Like Disneyland, Kong is presented as imaginary in order that we more firmly believe that the rest of the world is real.[47]

Denham tells the eager audience that he has "a story so strange that no one will believe it." He continues,

> But ladies and gentlemen, *seeing is believing*. And we, my partners and I, have brought back the living proof of our adventure. An adventure in which twelve of our party met horrible death. . . . I'm going to show you the greatest thing your eyes have ever beheld. He was a king and a god in the world he knew. But now he comes to civilization. Merely a captive. A show to gratify your curiosity.

Again the audience's desire to see is made visible. The curtain is pulled back and Kong appears, manacled as if crucified (Ann was also manacled on Skull Island). Next we see a reaction shot of the audience from Kong's (as well as Denham's) perspective. Denham then explains that he wants to allow the audience the privilege of witnessing the first photographs taken of Kong and his captors.

### [ · · · ]

*King Kong*'s subject matter was complicit with the avant-garde's love of Primitivism, its tendency to look at the Primitive as a figure of the unconscious, as a limit to the *ratio* of the West. Kong is a cinematic visualization of the male beast which the Surrealists so longed to unleash. In *King Kong*, visualization is a hunt which involves titillation, capture, spectacle, and death: *King Kong* is a mix of the surrealist ingredients of the erotic, the exotic, and the unconscious.[48] James Clifford suggests surrealism is in this sense a modern sensibility: "Reality is no longer a given, a natural, familiar environment. The self, cut loose from its attachments, must discover meaning where it may—a predicament, evoked at its most nihilistic, that underlies both surrealism and modern ethnography."[49] Clifford calls the object of this ethnographic/surrealist attitude—non-Western peoples, and women—the other.[50] If we take Lévy seriously and consider *King Kong* as, among other things, a surrealist text, the object of the ethnographic surrealist attitude of the film is thus the Ethnographic itself, King Kong as Other, and Woman—Ann—as Other.

## 8. AT THE PINNACLE OF THE EMPIRE STATE BUILDING: THE WHITE MALE MILITARY PROGRESS, TECHNOLOGY, IMPERIALISM, THE FUTURE

*King Kong*, which has taken us back in time and returned us to the present, now lurches forward and upwards—up to the future. Ann is seized by the rampaging Kong. The searchlights of the city keep Kong in sight, and all watch as he climbs to the top of the Empire State Building. Completed in 1932, the Empire State Building was, at the time of the film, the ultimate U.S. symbol of progress, technology, and Civilization. Like the Eiffel Tower at the turn of the century, perceived as embodying French greatness, and which provided the perfect contrast to the so-called "simple" cultures represented in the ethnographic expositions Regnault frequented, the Empire State Building provided the perfect contrast to the monster Kong. Ultimately only the most sophisticated technology can stop Kong—gas bombs subdue him on Skull Island, warplanes shoot him down in New York. Even as Kong meets his fate,

the play with the boundaries between observer and observed continues: we see the action both from the point of view of Kong as the airplanes swoop toward him, and from the point of view of the planes as they gun him down. Ironically, two of the gunners were reportedly played by Cooper and Schoedsack themselves.[51]

[ · · · ]

*King Kong* celebrates its own technology: although the film glorifies the Empire State Building, its greatest boast is its own technology, the very ability of animator Willis O'Brien to create a cinematic monster like Kong, the monster of evolutionary nightmare. *King Kong* thus ultimately celebrates cinema's tendency to create monsters which mirror the anxieties of any given age. In so doing, it screens from our vision the historical cannibalisms which turned West Africans into hieroglyphs for medical science, stole the bones of Minik Wallace's father for a museum display, and led a Chirichiri man named Ota Benga to commit suicide.

[ · · · ]

## NOTES

1. Quoted in Tristan Renaud, "King-Kong: le roi est nu," *Cinéma* 218 (February 1977): 44.

2. Much of the above information on Ota Benga was communicated to me by Robert Bieder. See also Phillips Verner Bradford and Harvey Blume, *Ota Benga: The Pygmy in the Zoo* (New York: St. Martin's Press, 1992). I thank Robert Bieder for first telling me about Ota Benga.

3. J. P. Telotte, "The Movies as Monster: Seeing in *King Kong*," *Georgia Review* 42, no. 2 (summer 1988): 390.

4. Pierre Leprohon writes that cinema of exoticism "participe à la fois de la science et du rêve. . . . Sa valeur documentaire est élément de connaissance; sa poésie est aliment de rêve" (participates at the same time in science and in dream. . . . Its documentary value is the element of knowledge; its poetry is the food of dream) (Pierre Leprohon, *L'exotisme et le cinéma* [Paris: J. Susse, 1945], 12–13). *Ingagi* (1930), an infamous documentary hoax, used footage from an old Lady McKenzie expedition film and featured the sacrifice of an African woman to a gorilla, a scene staged by actresses in black face at the Selig Zoo (Gerald Peary, "Missing Links: The Jungle Origins of *King Kong*," in *The Girl in the Hairy Paw*, ed. Ronald Gottesman and Harry Geduld [New York: Avon Books, 1976], 41–42).

5. André F. Liotard, Samivel, and Jean Thévenot, *Cinéma d'exploration, cinéma au long cours* (Paris: P.-A. Chavane, 1950), 61.

6. Stephen Bann, *The Clothing of Clio: A Study of the Representation of History in Nineteenth-century Britain and France* (Cambridge: Cambridge University Press, 1984), 22.

7. Ibid., 23.

8. Georges Canguilhem, *The Normal and the Pathological*, trans. Carolyn R. Fawcett (New York: Zone Books, 1991), 243.

9. Bronislaw Malinowski, *A Diary in the Strict Sense of the Term* (Stanford: Stanford University Press, 1989; orig. publ. 1967), 69.

10. Noël Carroll, *The Philosophy of Horror* (New York: Routledge, 1990), 31–34.

11. George W. Stocking Jr., *Victorian Anthropology* (New York: Free Press, 1987), xv.

12. See chapter 1 [of *The Third Eye*] for Broca's analogy of the anthropological subject to the patient. Boas advised his student Margaret Mead that the anthropological method is to set "the individual against the [cultural] background"—a method which he compared to "the method that is used by medical men in their analysis of individual cases on which is built up the general picture of the pathological cases that they want to describe." See Margaret Mead Papers at the Library of Congress, Franz Boas to Margaret Mead, 15 February 1926, quoted in George W. Stocking Jr., "The Ethnographic Sensibility of the 1920s and the Dualism of the

Anthropological Tradition," in *Romantic Motives: Essays on Anthropological Sensibility*, ed. George W. Stocking Jr., *History of Anthropology*, vol. 6 (Madison: University of Wisconsin Press, 1989), 243.

13. Wilson Martinez, "Critical Studies and Visual Anthropology: Aberrant vs. Anticipated Readings of Ethnographic Film," *CVA Review* (spring 1990): 34–47, Asen Balikci, "Anthropology, Film and the Arctic Peoples," *Anthropology Today* 5, no. 2 (April 1989): 4–10.

14. Jorge Preloran, "Documenting the Human Condition," in *Principles of Visual Anthropology*, ed. Paul Hockings (The Hague: Mouton, 1975), 105.

15. William B. Cohen, *The French Encounter with Africans: White Response to Blacks, 1530–1880* (Bloomington: Indiana University Press, 1980), 234.

16. Claude Lévi-Strauss, *Tristes Tropiques*, trans. John and Doreen Weightman (Paris: Librairie Plon, 1955; repr., New York: Penguin Books, 1981), 371.

17. Stephen Neale, *Genre* (London: British Film Institute, 1980), 21.

18. Carroll, *Philosophy of Horror*, 99.

19. Neale, 22.

20. Telotte, 395.

21. Carroll, *Philosophy of Horror*, 145.

22. Ibid., 182–93, 157.

23. Orville Goldner and George E. Turner, eds., *The Making of King Kong: The Story behind a Film Classic* (South Brunswick, N.J.: A. S. Barnes, 1975), 80.

24. Noël Carroll, "King-Kong: Ape and Essence," in *Planks of Reason: Essays on the Horror Film*, ed. Barry Keith Grant (Metuchen, N.J.: Scarecrow Press, 1984), 228.

25. James Snead, "Spectatorship and Capture in *King Kong:* The Guilty Look," *Critical Quarterly* 33, no. 1 (spring 1991): 58.

26. Stocking, *Victorian Anthropology*, 229–30.

27. Fay Wray, "How Fay Met Kong, or the Scream That Shook the World," *New York Times*, 21 September 1969, D17.

28. Merian C. Cooper, as quoted in George Turner, "Hunting 'The Most Dangerous Game,'" *American Cinematographer* 68 (September 1987): 41–42.

29. Like most films of the genre, however, *Trader Horn* depicts Africans as servile fools, evil cannibals, and bait for hungry crocodiles. Van Dyke uses the iconography of anthropology to good effect in this film: we see African "natives" pounding rice in a reconstruction of a "native village," and, in a scene in which Trader Horn confronts unfriendly Africans, the camera frames the Africans in anthropological head shots, panning from head to head. The homoerotic elements are pronounced: the bond between Trader Horn and the African "gunboy," as Trader Horn calls the solemn, tall Ranchero, is close, and as they are trying to escape the "angry savages," the wounded Ranchero is carried to safety by Trader Horn. Trader Horn exploits Ranchero as a servant—calling him half-bulldog, half-watchful mother—and has him perform such menial chores as taking out chiggers from Trader Horn's toenails. When Ranchero dies, however, Trader Horn cradles him in his arms. This closeness is reminiscent of Daniel Defoe's *Robinson Crusoe:* Crusoe makes very little mention of his own wife, but devotes pages to the physical appearance of Friday, and goes out of his way to stress that Friday is not really black. (I am indebted to Robert Stam for this insight on *Robinson Crusoe*.)

30. Laura Mulvey, "Visual Pleasure and Narrative Cinema," in *Narrative, Apparatus, Ideology: A Film Theory Reader*, ed. Phil Rosen (New York: Columbia University Press, 1986), 203.

31. The hierarchy of observers watching Ann being filmed reinforces the subordinate position of Charlie: he is the lowest person on the ladder watching. Similarly, when Charlie muses about whether or not Denham might be willing to take his picture, another sailor replies, "Them cameras cost money. Shouldn't think he'd risk it." In light of the fact that, more often than not, Chinese characters were played by whites in Hollywood, this

seemingly offhand comment is telling. "China" was a useful marker of time and difference, but not an image to be entrusted to Chinese-American hands.

32. *King Kong* opened at Grauman's Chinese Theater in Los Angeles and shared the bill with an act with a prophesizing fortune-teller: Gin Chow, Chinese philosopher ("Gin Chow at Chinese," *Los Angeles Times*, 1 April 1933).

33. Wray, D17.

34. Leprohon wrote, "Devant l'Asie, on a l'impression d'un mur. On découvre un monde fermé, impénétrable" (Before Asia, one has the impression of a wall. One discovers a closed world, impenetrable)(74).

35. David N. Rosen, "Race, Sex and Rebellion," *Jump Cut* 6 (March–April 1975): 8–10; and Snead, 53–69.

36. Snead, 64–66.

37. The bewilderment Indonesians present to the categories of race is present even today, as may be seen by the fact that V. S. Naipaul refers to Batak writer Sitor Sitomorang as a "Chinese-Negrito" and as "tribal," but never as Batak. See V. S. Naipaul, *Among the Believers: An Islamic Journey* (New York: Alfred A. Knopf, 1981), 305–17.

38. Johnson also played a Chinese in *The Mysterious Dr. Fu Manchu*, a Nubian in *The Mummy*, a Polynesian in *Moby Dick*, a Persian prince in *The Thief of Baghdad*, and a Cuban zombie in *The Ghost Breakers* (Goldner and Turner, 84). For more on Johnson's company, the Lincoln Motion Picture Company which Johnson ran with his brother George, see Donald Bogle, *Toms, Coons, Mulattoes, Mammies, and Bucks: An Interpretive History of Blacks in American Films* (New York: Continuum Publishing, 1991), 103, 110.

39. Michele Wallace, "Variations on Negation and the Heresy of Black Feminist Creativity," in *Invisibility Blues: From Pop to Theory* (London: Verso, 1990), 213–40.

40. Donna Haraway, "The Promises of Monsters: A Regenerative Politics for Inappropriate/d Others," in *Cultural Studies*, ed. Lawrence Grossberg, Cary Nelson, and Paula Treichler (New York: Routledge, 1992), 306–9.

41. Jean Boullet, "Willis O'Brien, or the Birth of a Film from Design to Still," in *The Girl in the Hairy Paw*, ed. Ronald Gottesman and Harry Geduld (New York: Avon Books, 1976), 107–10.

42. At the time *King Kong* was made, O'Brien was already famous for dinosaur films like *The Dinosaur and the Missing Link* (1916) and *The Lost World* (1925), as well as for his 1930 semidocumentary film about evolution, *Creation* (Joseph E. Sanders, "O'Brien and Monsters from the Id," in *The Scope of the Fantastic—Culture, Biography, Themes, Children's Literature: Selected Essays from the First International Conference on the Fantastic in Literature and Film*, ed. Robert A. Collins and Howard D. Pearce [Westport, Conn.: Greenwood Press, 1985], 11:207–9).

43. Carroll, "King-Kong: Ape and Essence," 217.

44. Ibid., 219–20. Carroll, as well as Terry Heller and Gerald Peary, argue that the jungle of *King Kong* is a metaphor for the capitalist, "eat or be eaten" consumerist economy. Peary also sees Kong as a metaphor for Franklin Delano Roosevelt, a representation of the then newly elected president as a destructive force (Terry Heller, *The Delights of Terror: An Aesthetics of the Tale of Terror* [Urbana: University of Illinois Press, 1987], 46; and Gerald Peary, "The Historicity of *King Kong*," *Jump Cut* 4 [November–December 1974]: 11–12).

45. Judith Mayne argues that the savage force of the environment Kong creates is a metaphor for an image of Manhattan as chaotically destructive. See "'King Kong' and the Ideology of Spectacle," *Quarterly Review of Film Studies* 1, no. 4 (November 1976): 373–87.

46. The "entertainment of violated boundaries" occurs when elements constructed as inherent opposites—nature and society, the Primitive and the Modern—are juxtaposed. Haraway writes that the Kayapó with the camera is no longer" an entertaining contradiction," if one no longer conceives of the world as a polarized realm between nature and society. She continues, "Where there is no nature or society, there is no pleasure, no entertainment to

be had in representing the violation of the boundary between them" (Haraway, *The Promises of Monsters*, 314).

47. Indeed, King Kong has become a sort of national monster fetish, everywhere reproduced and adored: King Kong names a ride in the MGM tourist park as well as a recent sculpture on the Empire State Building. Kong is its own perfect Ethnographic simulacrum, or, as Jean Baudrillard would say, an instance of the "hyperreal" (Jean Baudrillard, "The Precession of Simulacra," in *Simulations,* trans. Paul Foss, Paul Patton, and Philip Beitchman [New York: Semiotext(e), 1983], 25).

48. Levy, S. Joseph E. Sanders saw Kong as "a monster from the Id" (214). William Grimes sees the film as a metaphor for "repressed sexual drive." See William Grimes, "Buried Themes: Psychoanalyzing Movies," *New York Times,* 23 December 1991, Crr.

49. James Clifford, "On Ethnographic Surrealism," in *The Predicament of Culture: Twentieth-century Ethnography. Literature, and Art* (Cambridge, Mass.: Harvard University Press, 1988), 119.

50. Ibid., 120.

51. "King Kong," *Films in Review* (June 1975): 61. Cooper was anti-Communist and a war fanatic; he later became the president of Pan American Airlines. For *King Kong*, Cooper and Schoedsack arranged to borrow four planes from the U.S. Navy, and twenty-eight different scenes in the film include footage of actual aircraft maneuvers. See Lawrence Suid, "King Kong and the Military," *American Classic Screen* (July–August 1977); 14–16.

# ANA M. LÓPEZ

# Are All Latins from Manhattan? Hollywood, Ethnography and Cultural Colonialism

Ana M. López (b. 1956) is Associate Provost, Director of the Cuban Studies Institute, and Associate Professor of Communications at Tulane University, where she teaches film and cultural studies with a Latin American focus. She has written extensively on Latin American film, media, and Latino(a) representation, focusing particularly on the conflicted images of Latin America in Hollywood that have shaped the "imaginary of the Other" and its changing modes of representation. She has also co-edited various groundbreaking collections, including *Mediating Two Worlds: Cinematic Encounters in the Americas* (1993), *The Ethnic Eye: Latino Media Arts* (1996), and *Encyclopedia of Contemporary Latin American and Caribbean Cultures* (2000).

In her explorations of the history and development of Latin American cinema, López largely aligns herself with the broader perspective of postcolonial and cultural studies. This interdisciplinary approach to film sees film as a site of conflict within a larger social field, dominated by power and marked by tensions of class, gender, sexuality, and race. In this context, film is not merely a system of representation but rather an active participant in the creation of discourses of power and social/cultural relations. Thus López argues that the role of cinema, and particularly Hollywood, in representing ethnicity, is not merely mimetic or representational; rather, it participates in *creating* ethnicity.

In "Are All Latins from Manhattan?" López charts the shift in Hollywood's "ethnographic" view of Latin America from the 1920s to the mid-1940s, when a host of films featuring Latin

American stars, music, and locations appeared in the U.S. market and reflected a new sensitivity to the geographical and national specificities of Latin America. López points out that in the wake of the "Good Neighbor Policy" implemented in 1940 to promote cooperation and non-aggression during World War II, the "other" in these films was portrayed as non-threatening and "fun-loving," which contrasts sharply with previous portrayals of Latin Americans as "lazy peasants and wily señoritas who inhabited an undifferentiated backward land."

López analyzes these shifting parameters of ethnic otherness by tracing the work of three emblematic crossover stars: Dolores del Río and Lupe Vélez, actresses whose otherness was located both on a register of untamable, aggressive sexuality and often unspecified ethnicity; and Carmen Miranda, who reflected what López calls the "double ethnographic imperative," translating the ethnic and sexual threat of Latin American otherness into peaceful good neighborliness. López argues that while the excessiveness of Miranda's acts and their emphasis on performativity can serve as a representation of the ethnic fetish, they also expose the artificiality of "otherness," thus simultaneously submitting to and rejecting the totalizing search for truth implied in the ethnographic project. As several other essays in this part point out, the relationship between stereotype and self-representation in cinema is a complex and ambiguous one, often complicating the simple formation of a stereotype and breaking down the ethnographic project by both participating in and resisting it.

## READING CUES & KEY CONCEPTS

■ What is the significance, for López, in going beyond the representational aspects of film and seeing it as an "ethnographer"? Can you think of differences between these two discourses (cinema and ethnography) that would trouble their assumed alliance?

■ The value of Miranda's performance, López says, lies in how she manipulates and transcends the very stereotype she represents. Identify some contemporary "ethnic" performers in Hollywood and think about their relationship to stereotypes and self-representation.

■ **Key Concepts:** Ethnographic Discourse; Ethnicity; Mimetic; Fetishism

# Are All Latins from Manhattan? Hollywood, Ethnography and Cultural Colonialism

. . . . . . . . . . . . . .

*She's a Latin from Manhattan*
*I can tell by her mañana*
*She's a Latin from Manhattan*
*And not Havana.*

Al Jolson in *Go Into Your Dance* (1935)

## *Hollywood as Ethnographer of the Americas*

To presume that Hollywood has served as an ethnographer of American culture means, first of all, to conceive of ethnography, not as a positivist methodology that unearths truths about "other" cultures,[1] but as a historically determined practice of

cultural interpretation and representation from the standpoint of participant observation.[2] It also means to think of Hollywood not as a simple reproducer of fixed and homogeneous cultures or ideologies, but as a producer of some of the multiple discourses that intervene in, affirm and contest the socio-ideological struggles of a given moment. To think of a classic Hollywood film as ethnographic discourse is to affirm its status as an authored, yet collaborative, enterprise, akin in practice to the way contemporary ethnographers like James Clifford have redefined their discipline.[3]

When ethnographers posit their work as "the mutual, dialogical production of a discourse" about culture that "in its ideal form would result in a polyphonic text," we also approach a description of the operations of an ideal, albeit not of Hollywood's, cinema.[4] The difference lies in the deployment of power relations, what Edward Said calls the "effect of domination," or the ethnographic, cinematic, and colonial process of designing an identity for the "other" and, for the observer, a standpoint from which to see without being seen.[5] Obviously, neither ethnography nor the cinema have achieved that ideal state of perfect polyphony or perspectival relativity where the observer/observed dichotomy can be transcended and no participant has "the final word in the form of a framing story or encompassing synthesis."[6] Power relations always interfere. However, both ethnographic and cinematic texts, as discourses, carry the traces of this dialogic process and of the power relations that structure it.

Thinking of Hollywood as ethnographer, as co-producer in power of cultural texts, allows us to reformulate its relationship to ethnicity. Hollywood does not represent ethnics and minorities: it creates them and provides its audience with an experience of them. Rather than an investigation of mimetic relationships, then, a critical reading of Hollywood's ethnographic discourse requires the analysis of the historical-political construction of self-"other" relations—the articulation of forms of difference, sexual and ethnic—as an inscription of, among other factors, Hollywood's power as ethnographer, creator and translator of "otherness."

The way the history of Hollywood's representations of Hispanics has been told privileges a near-golden moment when Hollywood apparently became temporarily more sensitive and produced less stereotypical, almost positive, images of Latin Americans. I shall focus upon this period—the "Good Neighbor Policy" years (roughly 1939–47)—in order to analyze the moment's historical coherence and its function for Hollywood as an ethnographic institution, that is as creator, integrator, and translator of "otherness." What happens when Hollywood self-consciously and intentionally assumes the role of cultural ethnographer? My emphasis is on three stars whose ethnic "otherness" was articulated according to parameters that shifted as Hollywood's ethnographic imperative became clear: Dolores del Río, Lupe Vélez, and Carmen Miranda. That these three figures are Latin American and female is, as will become apparent, much more than a simple coincidence, for the Latin American woman poses a double threat, sexual and racial, to Hollywood's ethnographic and colonial authority.

## The Good Neighbor Policy: Hollywood Zeroes in on Latin America

After decades of portraying Latin Americans lackadaisically and sporadically as lazy peasants and wily señoritas who inhabited an undifferentiated backward land, Hollywood films between 1939 and 1947 featuring Latin American stars, music,

locations and stories flooded US and international markets. By February 1943, for example, 30 films with Latin American themes or locales had been released and 25 more were in production. By April 1945, 84 films dealing with Latin American themes had been produced.[7] These films seemed to evidence a new-found sensibility, most notably a sudden respect for national and geographical boundaries. At the simplest level, for example, it seemed that Hollywood was exercising some care to differentiate between the cultural and geographic characteristics of different Latin American countries by incorporating general location shots, specific citations of iconographic-sites (especially Rio de Janeiro's Corcovado Mountain), and some explanations of the cultural characteristics of the inhabitants.

Why did Hollywood suddenly become interested in Latin America? In economic terms, Latin America was the only foreign market available for exploitation during the Second World War. However, pan-Americanism was also an important key word for the Roosevelt administration, the Rockefeller Foundation, and the newly created (1940) State Department Office of the Coordinator for Inter-American Affairs (CIAA) headed by Nelson Rockefeller. Concerns about America's southern neighbors' dubious political allegiances and the safety of US investments in Latin America led to the resurrection of the long-dormant Good Neighbor Policy and to the official promotion of hemispheric unity, cooperation, and non-aggression (in part, to erase the memories of the not-so-distant military interventions in Cuba and Nicaragua). Charged with the responsibility of coordinating all efforts to promote inter-American understanding, the CIAA set up a Motion Picture Section and appointed John Hay Whitney, vice-president and director of the film library of the Museum of Modern Art (MOMA) in New York, as its director.[8]

The CIAA sponsored the production of newsreels and documentaries for Latin American distribution that showed "the truth about the American way," contracted with Walt Disney in 1941 to produce a series of 24 shorts with Latin American themes that would "carry the message of democracy and friendship below the Rio Grande," sponsored screenings of films that celebrated the "democratic way" in what became known as the South American embassy circuit, and, together with the Hays Office's newly appointed Latin American expert, began to pressure the studios to become more sensitive to Latin issues and portrayals.[9] This impetus, when coupled with the incentive of Latin America's eminently exploitable 4240 movie theaters, was sufficient to stimulate Hollywood to take on the project of educating Latin America about the democratic way of life and its American audience about its Latin American neighbors.

This self-appointed mission, however, needs to be questioned more closely. How does Hollywood position itself *and* Americans in relation to the southern neighbors? How is its friendliness constituted? How does it differ from Hollywood's prior circulation of so-called stereotypes and its negligent undifferentiation of the continent?

Three basic kinds of Good Neighbor Policy films were produced. First, there were a number of standard, classic Hollywood genre films, with American protagonists set in Latin America with some location shooting, for example, Irving Rapper's *Now Voyager* (1942), with extensive footage shot in Rio de Janeiro; Edward Dmytryk's *Cornered* (1945), shot totally on location in Buenos Aires; and Alfred Hitchcock's *Notorious* (1946), with second-unit location shots of Rio de Janeiro. Then there were B-productions set and often shot in Latin America that featured mediocre US actors and Latin entertainers in either musicals or pseudo-musical formats: for example,

*Mexicana* (1945) starring Tito Guizar, Mexico's version of Frank Sinatra, and the 16-year-old Cuban torch singer Estelita Rodríguez; Gregory Ratoff's *Carnival in Costa Rica* (1947) starring Dick Haymes, Vera-Ellen, and Cesar Romero; and Edgar G. Ulmer's remake of *Grand Hotel, Club Havana* (1945), starring the starlet Isabelita, Tom Neil, and Margaret Lindsay. Finally, the most successful and most self-consciously "good-neighborly" films were the mid-to-big-budget musical comedies set either in Latin America or in the USA but featuring, in addition to recognizable US stars, fairly well-known Latin American actors and entertainers.

Almost every studio produced its share of these films between 1939 and 1947, but 20th Century-Fox, RKO, and Republic specialized in "good neighborliness" of the musical variety. Fox had Carmen Miranda under contract and produced nine films that featured her between 1940 and 1946; RKO followed the Rockefeller interest in Latin America by sending Orson Welles on a Good Neighbor tour of Brazil to make a film about Carnival, and with films such as *Pan-Americana* (1945); Republic exploited contract players—Tito Guizar and Estelita, for example—in a number of low-budget musicals such as *The Thrill of Brazil* (1946).

Notwithstanding the number of films produced, and the number of Latin American actors contracted, by the studios in this period, it is difficult to describe Hollywood's position with regard to these suddenly welcomed "others" as respectful or reverent.[10] Hollywood (and the United States) needed to posit a complex "otherness" as the flip side of wartime patriotism and nationalism and in order to assert and protect its economic interests. A special kind of "other" was needed to reinforce the wartime national self, one that—unlike the German or Japanese "other"—was non-threatening, potentially but not practically assimilable (that is, non-polluting to the purity of the race), friendly, fun-loving, and not deemed insulting to Latin American eyes and ears. Ultimately, Hollywood succeeded in all except, perhaps, the last category.

## The Transition: From Indifference to "Difference" across the Bodies of Women

Before the Good Neighbor Policy period, few Latin Americans had achieved star status in Hollywood. In fact, most of the "vile" Latin Americans of the early Hollywood cinema were played by US actors. In the silent period, the Mexican actor Ramón Novarro, one of the few Latin American men to have had a consistent career in Hollywood, succeeded as a sensual yet feminized "Latin lover" modeled on the Valentino icon,[11] but the appellation "Latin" always connoted Mediterranean rather than Latin American. Ostensibly less threatening than men, Latin American women fared differently, particularly Dolores del Río and Lupe Vélez.

Del Río's Hollywood career spanned the silent and early sound eras. Although considered exotic, del Río appeared in a variety of films, working with directors as diverse as Raoul Walsh, King Vidor, and Orson Welles.[12] After a successful transition to talkies in Edwin Carewe's *Evangeline* (1929), her place in the Hollywood system was unquestionable and further legitimised by her marriage to the respected MGM art director Cedric Gibbons. Undeniably Latin American, del Río was not, however, identified exclusively with Latin roles. Hers was a vague upper-class exoticism articulated within a general category of "foreign/other" tragic sensuality. This sensual "other," an object of sexual fascination, transgression, fear, and capitulation

not unlike Garbo or Dietrich, did not have a specific national or ethnic provenance, simply an aura of foreignness that accommodated her disruptive potential. Her "otherness" was located and defined on a sexual rather than an ethnic register, and she portrayed, above all, ethnically vague characters with a weakness for American "white/blond" men: Indian maidens, South Seas princesses, Mexican señoritas, and other aristocratic beauties. Although she often functioned as a repeatable stereotype, her undifferentiated sexuality was not easily tamed by the proto-colonial ethnographic imperatives of Hollywood's Good Neighbor period. In a precursor of the Good Neighbor films like *Flying Down to Rio* (1933), the explicit and irresistible sensuality of her aristocratic Carioca character (all she has to do is look at a man across a crowded nightclub and he is smitten for ever) could be articulated because it would be tamed by marriage to the American hero. However, in the films of the Good Neighbor cycle, that resolution and partial appeasement of the ethnically undifferentiated sexual threat of "otherness" she unleashed was no longer available. As Carlos Fuentes has remarked, del Río was "a goddess threatening to become a woman,"[13] and neither category—goddess nor woman—was appropriate to Hollywood's self-appointed mission as goodwill imperialist ethnographer of the Americas. Del Río's persona and her articulation in Hollywood films, in fact, constitute a perfect cinematic example of what Homi K. Bhabba has described as the phenomenon of the colonial hybrid, a disavowed cultural differentiation necessary for the existence of colonial-imperialist authority, where "what is disavowed [difference] is not repressed but repeated as something different—a mutation, a hybrid."[14]

Del Río chose to return to Mexico in 1943 and dedicated herself (with a few returns to Hollywood, most notably to appear in John Ford's *The Fugitive* (1947) and *Cheyenne Autumn* (1964)) to the Mexican cinema and stage, where she assumed a legendary fame inconceivable in Hollywood. The impossibility of her status for Hollywood in 1939–47 was, however, literally worked through the body of another Mexican actress, Lupe Vélez.

Like del Río's, Vélez's career began in the silent period, where she showed promise working with D. W. Griffith in *Lady of the Pavements* (1929) and other directors. But Vélez's position in Hollywood was defined not by her acting versatility, but by her smoldering ethnic-identifiability. Although as striking as del Río's, Vélez's beauty and sexual appeal were aggressive, flamboyant, and stridently ethnic. Throughout the 30s she personified the hot-blooded, thickly accented, Latin temptress with insatiable sexual appetites, on screen—in films such as *Hot Pepper* (1933), *Strictly Dynamite* (1934), and *La Zandunga* (1938)—and with her star persona—by engaging in much-publicized simultaneous affairs with Gary Cooper, Ronald Colman, and Ricardo Cortez, and marrying Johnny Weismuller in 1933.[15] (Impossible to imagine a better match between screen and star biographies: Tarzan meets the beast of the Tropics.) Vélez was, in other words, outrageous, but her sexual excessiveness, although clearly identified as specifically ethnic, was articulated as potentially subsumable. On and off screen, she, like del Río, was mated with and married American men.

The dangers of such explicit on-screen ethnic miscegenation became apparent in RKO's *Mexican Spitfire* eight-film series (1939–43), simultaneously Vélez's most successful films and an index of the inevitability of her failure. Vélez portrayed a Mexican entertainer, Carmelita, who falls in love and marries—after seducing him away from his legitimate Anglo fiancée—Dennis Lindsay, a nice New England man. Much to the dismay of his proper Puritan family, Dennis chooses to remain

with Carmelita against all obstacles, including, as the series progressed, specific references to Carmelita's mixed blood, lack of breeding and social unacceptability, her refusal to put the entertainment business completely behind her to become a proper wife, her inability to help further his (floundering) advertising career, and her apparent lack of desire for offspring. Although the first couple of installments were very successful, the series was described as increasingly redundant, contrived, and patently "absurd" by the press and was cancelled in 1943. Not only had it begun to lose money for RKO, but it also connoted a kind of Latin American "otherness" anathema to the Good Neighbor mission. Summarily stated, the question that the series posed could no longer be tolerated because there were no "good-neighborly" answers. The ethnic problematic of the series—intermarriage, miscegenation and integration—could not be explicitly addressed within the new, friendly climate. Ironically highlighting this fictional and ideological question, Vélez, out of wedlock and five months pregnant, committed suicide in 1944.

Neither del Río nor Vélez could be re-created as Good Neighbor ethnics, for their ethnic and sexual power were not assimilable within Hollywood's new, ostensibly friendly, and temperate regime. Del Río was not ethnic enough and too much of an actress; Vélez was too "Latin" and untameable. Hollywood's new position was defined by a double ethnographic imperative, that is, by its self-appointed mission as translator of the ethnic and sexual threat of Latin American "otherness" into peaceful good neighborliness *and* by its desire to use that translation to make further inroads into the resistant Latin American movie market without damaging its national box office. Therefore, it could not advantageously promote either a mythic, goddess-like actress with considerable institutional clout (del Río) or an ethnic volcano (Vélez) that was not even subdued by that most sacred of institutions, marriage to an American. What Hollywood's good neighbor regime demanded was the articulation of a different female star persona that could be readily identifiable as Latin American (with the sexual suggestiveness necessary to fit the prevailing stereotype) but whose sexuality was neither too attractive (to dispel the fear or attraction of miscegenation) nor so powerful as to demand its submission to a conquering American male.

## The Perfect "Good Neighbor": Fetishism, Self and "Other(s)"

Hollywood's lust for Latin America as ally and market—and its self-conscious attempt to translate and tame the potentially disturbing radical (sexual and ethnic) "otherness" that the recognition of difference (or lack) entails—are clearest within the constraints of the musical comedy genre. Incorporated into the genre as exotic entertainers, Latin Americans were simultaneously marginalized and privileged. Although they were denied valid narrative functions, entertainment, rather than narrative coherence or complexity, is the locus of pleasure of the genre. Mapped on to the musical comedy form in both deprivative (the denial of a valid narrative function) and supplemental (the location of an excess pleasure) terms, this Hollywood version of Latin Americanness participates in the operations of fetishism and disavowal typical of the stereotype in colonial discourses.[16] This exercise of colonial or imperialist authority would peak, with a significant twist, in the Carmen Miranda films at 20th Century-Fox, a cycle which produced a public figure, Miranda, that lays bare, with surreal clarity, the scenario of Hollywood's own colonial fantasy and the problematics of ethnic representation in a colonial or imperialist context.[17]

In these films, Carmen Miranda functions, above all, as a fantastic or uncanny fetish. Everything about her is surreal, off-center, displaced on to a different regime: from her extravagant hats, midriff-baring multi-colored costumes, and five-inch platform shoes to her linguistic malapropisms, farcical sexuality, and high-pitched voice, she is an "other," everyone's "other." Not even Brazilian-born (she was born in Portugal to parents who emigrated to Brazil), she became synonymous with cinematic "Latin Americanness," with an essence defined and mobilized by herself and Hollywood throughout the continent. As the *emcee* announces at the end of her first number in Busby Berkeley's *The Gang's All Here*, "Well, there's your Good Neighbor Policy. Come on, honey, let's Good Neighbor it."

Miranda was "discovered" by Hollywood "as is," that is, after her status as a top entertainer in Brazil (with more than 300 records, 5 films—including her first sound feature—and 9 Latin American tours) brought her to the New York stage, where her six-minute performance in *The Streets of Paris* (1939) transformed her into "an overnight sensation."[18] Her explicit Brazilianness (samba song-and-dance repertoire, Carnival-type costumes) was transformed into the epitome of *latinidad* by a series of films that "placed" her in locales as varied as Lake Louise in the Canadian Rockies, Havana, or Buenos Aires.

Her validity as "Latin American" was based on a rhetoric of visual and performative excess—of costume, sexuality, and musicality—that carried over on to the mode of address of the films themselves. Of course, since they were produced at Fox, a studio that depended on its superior Technicolor process to differentiate its product in the market-place,[19] these films are also almost painfully colorful, exploiting the technology to further inscribe Latin Americanness as tropicality. For example, although none of the Fox films were shot on location, *all* include markedly luscious travelogue-like sections justifying the authenticity of their locales. Even more interestingly, they also include the visual representation of travel, whether to the country in question or "inland," as further proof of the validity of their ethno-presentation within a regime that privileges the visual as the only possible site of knowledge.

*Weekend in Havana* (1941) is a prototypical example. The film begins by introducing the lure of the exotic in a post-credit, narrative-establishment montage sequence that situates travel to Latin America as a desirable sightseeing adventure: snow on the Brooklyn bridge dissolves to a brochure of leisure cruises to Havana, to a tourist guide to "Cuba: The Holiday Isle of the Tropics," to a window display promoting "Sail to Romance" cruises featuring life-sized cardboard cut-outs of Carmen Miranda and a band that come to life and sing the title song (which begins, "How would you like to spend the weekend in Havana . . ."). Immediately after, the romantic plot of the musical is set up: Alice Faye plays a Macy's salesgirl whose much-scrimped-for Caribbean cruise is ruined when her ship runs aground. She refuses to sign the shipping company's release and is appeased only with the promise of "romance" in an all-expenses-paid tour of Havana with shipping-company executive John Payne.

The trip from the marooned cruise ship to Havana is again represented by an exuberantly colorful montage of the typical tourist sights of Havana—el Morro Castle, the Malecón, the Hotel Nacional, Sloppy Joe's Bar—with a voice-over medley of "Weekend in Havana" and typical Cuban songs. Finally, once ensconced in the most luxurious hotel in the city, Faye is taken to see the sights by John Payne. They travel by taxi to a sugar plantation, where Payne's lecture from a tourist book,

although it bores Faye to yawns, does serve as a voice-over narration for the visual presentation of "Cubans at work": "Hundreds of thousands of Cubans are involved with the production of this important commodity . . ." These three sequences serve important narrative and legitimising functions, testifying to the authenticity of the film's ethnographic and documentary work, although the featured native entertainer, Rosita Rivas (Miranda), is neither Cuban nor speaks Spanish.

More complexly, all the Fox films depend upon Miranda's performative excess to validate their authority as "good-neighborly" ethnographic discourses. The films' simple plots—often remakes of prior musical successes and most commonly involving some kind of mistaken identity or similar snafu—further highlight the importance of the Miranda-identified visual and musical regime rather than the legitimizing narrative order. The beginning of *The Gang's All Here*, for example, clearly underlines this operation by presenting a narrativized representation of travel, commerce, and ethnic identity. After the credits, a half-lit floating head singing Ary Barroso's "Brasil" in Portuguese suddenly shifts (in a classic Busby Berkeley syntactical move) to the hull of a ship emblazoned with the name *SS Brazil*, docking in New York and unloading typical Brazilian products: sugar, coffee, bananas, strawberries, and Carmen Miranda. Wearing a hat featuring her native fruits, Miranda finishes the song, triumphantly strides into New York, switches to an English tune, and is handed the keys to the city by the mayor as the camera tracks back to reveal the stage of a nightclub, an Anglo audience to whom she is introduced *as* the Good Neighbor Policy and whom she instructs to dance the "Uncle Sam-ba."

The Fox films' most amazing characteristic is Miranda's immutability and the substitutability of the narratives. Miranda travels and is inserted into different landscapes, but she remains the same from film to film, purely Latin American. Whether the action of the film is set in Buenos Aires, Havana, the Canadian Rockies, Manhattan, or a Connecticut mansion, the on-screen Miranda character—most often named Carmen or Rosita—is remarkably coherent: above all, and against all odds, an entertainer and the most entertaining element in all the films.[20] While the American characters work out the inevitable romance plot of the musical comedy, Miranda (always a thorn to the budding romance) puts on a show and dallies outrageously with the leading men. Normally not permanently mated with an American protagonist (with the notable exception of *That Night in Rio*, where she gets to keep Don Ameche, but only because his identical double gets the white girl played by Alice Faye), Miranda nevertheless gets to have her fun along the way and always entices and almost seduces with aggressive kisses and embraces at least one, but most often several, of the American men.

Miranda's sexuality is so aggressive, however, that it is diffused, spent in gesture, innuendo, and salacious commentary. Unlike Vélez, who can seduce and marry a nice WASP man, Miranda remains either contentedly single, attached to a Latin American Lothario (for example, the womanizing manager-cum-gigolo played by Cesar Romero in *Weekend in Havana*), or in the permanent never-never land of prolonged and unconsummated engagements to unlikely American types (for example, in *Copacabana* she has been engaged for ten years to Groucho Marx and, at the end of the film, they still have separate hotel rooms and no shared marriage vows).

Miranda, not unlike other on-screen female performers (Dietrich in the Sternberg films, for example), is meant to function narratively and discursively as a sexual fetish, freezing the narrative and the pleasures of the voyeuristic gaze and provoking

a regime of spectacle and specularity. She acknowledges and openly participates in her fetishization, staring back at the camera, implicating the audience in her aggressive sexual display. But she is also an ethnic fetish. The look she returns is also that of the ethnographer and its colonial spectator stand-in. Her Latin Americanness is displaced in all its visual splendor for simultaneous colonial appropriation and denial.

Although Miranda is visually fetishized within filmic systems that locate her metaphorically as the emblem of knowledge of Latin Americanness, Miranda's voice, rife with cultural impurities and disturbing syncretisms, slips through the webs of Hollywood's colonial and ethnographic authority over the constitution and definition of "otherness." It is in fact within the aural register, constantly set against the legitimacy of the visual, that Hollywood's ethnographic good neighborliness breaks down in the Fox Miranda films. In addition to the psychosexual impact of her voice, Miranda's excessive manipulation of accents—the obviously shifting registers of tone and pitch between her spoken and sung English and between her English and Portuguese—inflates the fetish, cracking its surface while simultaneously aggrandizing it. Most obvious in the films where she sings consecutive numbers in each language (*Weekend in Havana* and *The Gang's All Here* are two examples), the tonal differences between her sung and spoken Portuguese and her English indicate the possibility that her excessive accent and her linguistic malapropisms are no more than a pretense, a nod to the requirements of a conception of foreignness and "otherness" necessary to maintain the validity of the text in question as well as her persona as a gesture of good neighborliness. That the press and studio machinery constantly remarked upon her accent and problems with English further highlight their ambiguous status.[21] At once a sign of her "otherness" as well as of the artificiality of all "otherness," her accent ultimately became an efficient marketing device, exploited in advertisements and publicity campaigns.[22]

Throughout the Good Neighbor films, Miranda remains a fetish, but a surreal one that self-consciously underlines the difficult balance between knowledge and belief that sustains it and that lets us hear the edges of an unclassifiable difference, product of an almost indescribable *bricolage*, that rejects the totalizing search for truth of the good-neighborly Hollywood ethnographer while simultaneously submitting to its designs.

### *"Are All Latins from Manhattan?"*

Miranda's Hollywood career was cut short both by the demise of Hollywood's good neighborliness in the post-war era as well as by her untimely death in 1955.[23] However, Hollywood's circulation and use of her persona as the emblem of the Good Neighbor clearly demonstrates the fissures of Hollywood's work as Latin American ethnographer in this period. With Miranda's acquiescence and active participation, Hollywood ensconced her as the essence of Latin American "otherness" in terms that, on the surface, were both non-derogatory and simultaneously non-threatening. First, as a female emblem, her position was always that of a less-threatening "other." In this context, the potential threat of her sexuality (that which was troubling in Vélez, for example) was dissipated by its sheer visual and performative narrative excess. Furthermore, her legitimizing ethnicity, exacerbated by an aura of the carnivalesque and the absurd, could be narratively relegated to the stage, to the illusory (and tameable) world of performance, theater, and movies. This is perhaps most conclusively illustrated by the frequency with which her persona is used as the emblem

of Latin American "otherness" and exoticism in Hollywood films of the period: in *House Across the Bay* (Archie Mayo, 1940), Joan Bennett appears in a Miranda-inspired *baiana* costume; in *Babes in Arms* (Busby Berkeley, 1939), Mickey Rooney does a number while dressed like her; in *In This Our Life* (John Huston, 1942), Bette Davis plays and hums along to a Miranda record; and, in *Mildred Pierce* (Michael Curtiz, 1945), Jo Ann Marlow does a fully costumed Miranda imitation.

At the same time, however, Miranda's textual persona escapes the narrow parameters of the Good Neighbor. As a willing participant in the production of these self-conscious ethnographic texts, Miranda literally asserted her own voice in the textual operations that defined her as *the* "other." Transforming, mixing, ridiculing, and redefining her own difference against the expected standards, Miranda's speaking voice, songs, and accents create an "other" text that is in counterpoint to the principal textual operations. She does not burst the illusory bubble of the Good Neighbor, but by inflating it beyond recognition she highlights its status as a discursive construct, as mimetic myth.

When we recognize that Hollywood's relationship to ethnic and minority groups is primarily ethnographic—that is, one that involves the co-production in power of cultural texts—rather than merely mimetic, it becomes possible to understand the supposed Good Neighbor break in Hollywood's history of (mis)representations of Latin Americans textually as well as in instrumental and ideological terms. It is particularly important to recognize that Hollywood (and, by extension, television) fulfills this ethnographic function, because we are in an era that, not unlike the Good Neighbor years, is praised for its "Hispanization." While the media crows about the successes of films like *La Bamba, Salsa: The Motion Picture,* and the lambada cycle, and a special issue of *Time* not too long ago proclaimed "Magnifico! Hispanic Culture breaks out of the Barrio,"[24] it might prove enlightening to analyze this particular translation, presentation, and assimilation of Latin American "otherness" as yet another ethnographic textual creation that must be analyzed as a political co-production of representations of difference and not as a mimetic narrative challenge.

## NOTES

1. This is, for example, how Karl G. Heider describes it in *Ethnographic Film* (Austin: University of Texas Press, 1976), one of the few texts to express the relationship between ethnography and the cinema directly (see especially, pp. 5–12).

2. See James Clifford, *The Predicament of Culture: Twentieth-century Ethnography, Literature, and Art* (Cambridge, Mass: Harvard University Press, 1988).

3. James Clifford, "On Ethnographic Authority," in *The Predicament of Culture: Twentieth-century Ethnography, Literature, and Art* (Cambridge, Mass: Harvard, 1988), p. 41.

4. Stephen A. Tyler, "Post-modern Ethnography: From Document of the Occult to Occult Document," in James Clifford and George Marcus (eds), *Writing Culture: The Poetics and Politics of Ethnography* (Berkeley: University of California Press, 1986), p. 126.

5. Edward Said, *Orientalism* (New York: Random House, 1979).

6. Tyler, op. cit., p. 126.

7. Donald W. Rowland, *History of the Office of the Coordinator of Inter-American Affairs* (Washington: Government Printing Office, 1947), pp. 68, 74.

8. For a popular assessment of the power of the cinema as democratic propaganda for the American way of life in South America, see, from the many possible examples, Florence

Horn, "Formidavel, Fabulosissimo," *Harpers' Magazine*, no. 184 (December 1941), pp. 59–64. Horn glowingly describes how well a young Brazilian boy and her housewife "friends" understand and recognize "America" because of their constant exposure to US films. After reading the following sentence, one wonders whether Orson Welles might have also read this piece before setting off on his CIAA-sponsored Brazilian project in 1942: "He [the Brazilian boy] returns home, almost without exception, to tell his friends that it's all true— and even more so" (p. 60). For self-assessments of the power and efficacy of the Good Neighbor Policy, see, in particular, Nelson Rockefeller, "Fruits of the Good Neighbor Policy," *New York Times Magazine* (14 May 1944), p. 15, and "Will we remain Good Neighbors after the War? Are we killing our own Markets by promoting Industrialization in Latin America?," *Saturday Evening Post*, vol. 216 (6 November 1943), pp. 16–17.

9. See Allen L. Woll, *The Latin Image in American Film* (Los Angeles: UCLA Latin American Center Publication, 1977) and Gaizka S. de Usabel, *The High Noon of American Films in Latin America* (Ann Arbor, Mich: UMI Research Press, 1982).

10. As does Allen Woll's analysis of this period in *The Latin Image in American Film* (and a number of other texts). In particular, he praises the "unheard of" cultural sensitivity of RKO's 1933 *Flying Down to Rio*, a film that featured the Mexican actress Dolores del Río as a Carioca enchantress and Rio de Janeiro as a city defined by its infinite romantic possibilities and as the South American meeting-place of new US communication technologies and capital: airplanes for southern travel, telegraphs for speedy communication, records and movies for music and romance. See Sergio Augusto, "Hollywood looks at Brazil: From Carmen Miranda to *Moonraker*," in Randal Johnson and Robert Stam (eds.) *Brazilian Cinema* (Austin: University of Texas Press, 1988), pp. 352–61.

11. See Miriam Hansen on the Valentino legend in "Pleasure, Ambivalence, Identification: Valentino and Female Spectatorship," *Cinema Journal*, vol. 25, no. 4 (1986), pp. 6–32.

12. Del Río's Hollywood filmography includes, among other titles: *What Price Glory?* (1926, *d*. Raoul Walsh); *Loves of Carmen* (1927, *d*. Raoul Walsh); *Ramona* (1928, *d*. Edwin Carewe); *The Red Dance* (1928, *d*. Raoul Walsh); *The Trail of '98* (1929, *d*. Clarence Brown); *Evangeline* (1929, *d*. Edwin Carewe); *Bird of Paradise* (1932, *d*. King Vidor), *Flying Down to Rio* (1933, *d*. Thornton Freeland), *Wonder Bar* (1934, *d*. Lloyd Bacon); *Madame Du Barry* (1934, *d*. William Dieterle); *In Caliente* (1935, *d*. Lloyd Bacon); *Lancer Spy* (1937, *d*. Gregory Ratoff); *Journey into Fear* (1943, *d*. Norman Foster). In *Journey into Fear*, del Río worked closely with Orson Welles (the first director of the film), with whom she had previously collaborated in the Mercury Theater production *Father Hidalgo* (1940) and during the production of *Citizen Kane* (1941).

13. Carlos Fuentes, "El Rostro de la Escondida," in Luis Gasca (ed.) *Dolores del Río* (San Sebastian, Spain: XXIV Festival Internacional de Cine, 1976), p. 10: my translation.

14. Homi K. Bhabha, "Signs Taken for Wonders: Questions of Ambivalence and Authority under a Tree outside Delhi, May 1917," in Henry Louis Gates, Jr. (ed.), *Race, Writing, and Difference* (Chicago: University of Chicago Press, 1986), p. 172.

15. For the best summary and analysis of Vélez's career, see Gabriel Ramírez, *Lupe Vélez: la mexicana que escupía fuego* (Mexico City: Cineteca Nacional, 1986).

16. See Homi K. Bhabha's discussion of this process in his "The Other Question . . . ," *Screen*, vol. 24, no. 6 (1983), pp. 18–36.

17. Between 1940 and her death in 1955, Miranda made 14 films: 10 for 20th Century-Fox, one for UA, two for MGM, and one for Paramount. The Fox "cycle," between 1940 and 1946, consisted of: *Down Argentine Way* (1940, *d*. Irving Cummings), *That Night in Rio* (1941, *d*. Irving Cummings), *Week-end in Havana* (1941, *d*. Walter Lang), *Springtime in the Rockies* (1942, *d*. Irving Cummings), *The Gang's All Here* (1943, *d*. Busby Berkeley), *Four Jills in a Jeep* (1944, *d*. William A. Seiter), *Greenwich Village* (1944, *d*. Walter Lang), *Something for the Boys* (1944, *d*. Lewis Seiler), *Doll Face* (1946, *d*. Lewis Seiler), and *If I'm Lucky* (1946, *d*. Lewis Seiler).

18. See Rodolfo Konder, "The Carmen Miranda Museum: The Brazilian Bombshell is still Box Office in Rio," *Americas*, vol. 34, no. 5 (1982), pp. 17–21.

19. See Douglas Gomery, *The Hollywood Studio System* (New York: St Martin's Press, 1986), pp. 76–100.

20. Among others, see, for example, the *Variety* reviews of her Fox films—especially of *Down Argentine Way* (9 October 1940), *Springtime in the Rockies* (24 November 1937) and *That Night in Rio* (12 March 1941)—which specifically comment upon the weakness of the romance/narratives and the strength of her musical/comedic performances.

21. See *New York Post*, 30 November 1955; cited by Allen L. Woll, *The Hollywood Musical goes to War* (Chicago: Nelson Hall, 1983), pp. 114–15. According to Woll, Fox encouraged Miranda to learn English on a "fiscal" basis: a fifty cents raise for each word she added to her vocabulary. Miranda's quoted response again subverts the intended effect of Fox's integrationist efforts: "I know p'raps one hondred words—preety good for Sous American girl, no? Best I know ten English words: men, men, men, men, and monee, monee, monee, monee, monee, monee."

22. See, for example the full-page advertisement for Piel's Light Beer in the New York *Daily Mirror*, 25 July 1947: "A lightning flash along Broadway means Carmen Miranda! That luscious, well-peppered dish! She glitters like a sequin, with her droll accent and spirited dances. And Carmen goes for Piel's— with all its sparkle and tang! 'I tell everyone I know to *DREENK* Piel's' she exclaims."

23. Miranda died at the age of 44, of a heart attack, on 5 August 1955, after taping a TV program with Jimmy Durante. By 1955, Miranda's screen presence had waned considerably, and, although she was still a recognizable star, she had begun to work far more for television than for the cinema.

24. Special issue of *Time*, 11 July 1988.

# TONI CADE BAMBARA

# Reading the Signs, Empowering the Eye: *Daughters of the Dust* and the Black Independent Cinema Movement

Toni Cade Bambara (1939–1995), the celebrated African American author of *Gorilla, My Love* (1972) and *The Salt Eaters* (1980), was also a feminist and antiracism educator and activist. Her interests extended to independent film—she wrote and narrated *The Bombing of Osage Avenue* (1986) and parts of *W. E. B. Du Bois: A Biography in Four Voices*, both directed and produced by Louis Massiah, founding director of Scribe Video, the Philadelphia community-based organization where Bambara taught. Before her death she was conducting research on the involvement of African American inventors in early film history.

Bambara's experience in the black arts and feminist movements informed much of her work, including "Reading the Signs, Empowering the Eye," a study of Julie Dash's *Daughters of the Dust* (1991), the first feature-length film by an African American woman director to be released theatrically. As a novelist, Bambara has a deep understanding of the narrative traditions and women's texts that influenced Dash, and, in a sense, Bambara melds her voice with those of the many women storytellers in Dash's film in her reading of it. Bambara also illuminates the reception contexts of Dash's work, which was released

at a time when audiences were becoming awakened to the political, literary, and artistic contributions of African American women, but when the new wave of African American cinema consisted almost exclusively of urban dramas directed by men.

Dash is one of a group of black filmmakers trained at UCLA in the 1980s—including Charles Burnett and Haile Gerima—whose approach to filmmaking was inspired by their political commitments and by alternative aesthetics such as Third Cinema rather than by an interest in Hollywood genre filmmaking. *Daughters of the Dust* is set in 1903 among an extended Gullah family (descendants of slaves living on the Sea Islands off the coast of Georgia and South Carolina who developed their own distinctive language and culture) gathering on the eve of the migration North of some family members. Tracing the film's influences from Yoruba tales and local cuisine to Dash's collaborators in the black independent cinema movement, Bambara demonstrates that *Daughters of the Dust* is firmly grounded in history, community, and other cinematic, literary, and material texts. In her essay, Bambara also encourages viewers of the film actively to decipher the different aesthetic traditions and possibilities through their own "empowered eye." Bambara brings to light an alternative U.S. film culture, where a variety of pleasures and ways of communicating are cultivated, and the perspectives and cultural traditions of African American women—including filmmakers—are celebrated.

## READING CUES & KEY CONCEPTS

■ Reflect on what Bambara says about the importance of nonlinear narrative traditions in *Daughters of the Dust*, and demonstrate how her own essay uses cyclical structure and intertextuality.

■ Bambara stresses the connections between black women's literature and *Daughter of the Dust*. How does she break down the boundaries between texts in her analysis?

■ Consider the centrality of technology, including photography, to Bambara's reading of the film. What is the importance of the visual record of black history, and how does Bambara argue that the film incorporates this history?

■ **Key Concepts:** Afrafemcentrist; Black Arts Movement; Nommo; Intertextuality; Diaspora

# Reading the Signs, Empowering the Eye: *Daughters of the Dust* and the Black Independent Cinema Movement

. . . . . . . . . . . .

## *Cultural Work Ain't All Arts and Leisure*

In 1971, Melvin Van Peebles dropped a bomb. *Sweet Sweetback's Baadasss Song* was not polite. It raged, it screamed, it provoked. Its reverberations were felt throughout the country. In the Black community it was both hailed and denounced for its sexual rawness, its macho hero, and its depiction of the community as downpressed and in need of rescue. Film buffs vigorously invented language to distinguish the film's

avant-garde techniques and thematics from the retrograde ideology espoused. Was *Sweetback* a case of Stagolee Meets Fanon or Watermelon Man Plays Bigger Thomas?

Hollywood noted that Van Peebles' *Sweetback* was making millions and that the low-budget detective flick *Shaft* by Gordon Parks, Sr., also released that year, was cleaning up too. By 1972, headlines in the trade papers were echoing those from the twenties—"H'wood Promises the Negro a Better Break." I could wallpaper the bathroom with *Variety* headlines from the days of *Hallelujah!*, through the forties accord between DuBois/NAACP and Hollywood, through the "Blaxplo" era, to this summer's edition covering Cannes and the release of works by Lee, Rich, Vasquez, Duke, and Singleton and still ask the question: Never mind occasional trends, when is the policy going to change? Some fine works got produced despite the "Blaxplo" formula: revolution equals criminality, militants sell dope and women, the only triumph possible is in a throw-down with Mafia second-stringers and bad-apple cops on the take, the system is eternal.

Nowhere would the debate over *Sweetback* prove more fruitful to the development of the Black independent sphere than at the UCLA film school. By 1971, a decentering of Hollywood had already taken place there, courtesy of a group of Black students who recognized cinema as a site of struggle. A declaration of independence had been written in the overturning of the film school curriculum and in the formation of student-generated alternatives, such as the Ethnocommunications Program and off-campus study groups. The significance of the LA rebellion to the development of the multicultural film phenomena of recent years has been the subject of articles, lectures, interviews, program notes, and informal talks by Sylvia Morales, Rene Tajima, Charlie Burnett, Julie Dash, Montezuma Esparza, and most especially, most consistently, and most pointedly in connection with the development of Black independent film, by Clyde Taylor. Some of *Sweetback*'s techniques and procedures were acceptable to the insurgents, but its politics were not. The film, nonetheless, continued to exert an influence as late as 1983, as is observable in Gerima's *Ashes and Embers*, in which an embittered and haunted 'Nam vet is continually running, finding respite for a time with folks in the community. The film closes not with "The End," but "Second Coming," as in *Sweetback*.

The Black insurgents at UCLA had a perspective on film very much informed by the movements of the sixties (1954–1972) both in this country and on the Continent. Their views differed markedly with the school's orientation:

- accountability to the community takes precedence over training for an industry that maligns and exploits, trivializes and invisibilizes Black people;

- the community, not the classroom, is the appropriate training grounds for producing relevant work;

- it is the destiny of our people(s) that concerns us, not self-indulgent assignments about neurotic preoccupations;

- our task is to reconstruct cultural memory not slavishly imitate white models; our task leads us to our own suppressed bodies of literature, lore, and history, not to the "classics" promoted by Eurocentric academia;

- students should have access to world film culture—African, Asian, and Latin America cinema—in addition to Hitchcock, Ford, and Renoir.

The off-campus study group, which included cadres from two periods—Charles Burnett, Haile Gerima, Ben Caldwell, Alile Sharon Larkin, and Julie Dash—engaged in interrogating conventions of dominant cinema, screening films of socially conscious cinema, and discussing ways to alter previous significations as they relate to Black people. In short, they were committed to developing a film language to respectfully express cultural particularity and Black thought. The "Watts Films," as their output was called in the circles I moved in then, began with Gerima's 1972 *Child of Resistance*, in homage to Angela Davis, an instructor at UCLA before the state sent her on the run, and his 1974 feature *Bush Mama*. Both starred Barbara O (then Barbara O. Jones), an actress who hooked up with insurgents early on and has been with the independents since, working as performer, technician, and now as filmmaker (*Sweatin' a Dream*).

In 1977, the insurgents' thematic foci became discernible: family, women, history and folklore. Larry Clark's *Passing Through*, Charles Burnett's *Killer of Sheep*, and two shorts by Julie Dash, *Diary of an African Nun*, based on a short story by Alice Walker, and *Four Women*, based on the musical composition of Nina Simone, made it a bumper-crop year. The edible metaphor is deliberate, and ironic. Proponents of "Third Cinema" around the world were working then, as now, to advance a cinema that would prove indigestible to the imperialist system that relentlessly promotes a consumerist ethic. And the works of the LA rebels reflected radical cultural/political theories of the day. The Black community-as-colony theorem, for example, informs Burnett's portrayal of both the protagonist's family and Watts. The omnipresence of sirens, cruisers, and cops define the neighborhood(s) as occupied territory. The family is portrayed as a potential liberation zone. In *Bush Mama*, the besieged Dorothy comes to consciousness through her daughter's questioning. While filming, Gerima's crew became the target of the LAPD, who equate Black men with expensive equipment with criminality; the attempted arrest was filmed, and the documented incident on screen in the fictional feature provides a compelling argument. This treatment of family and setting continued to inform the later films of Gerima, Burnett, and Billy Woodbury.

Alile Sharon Larkin's treatment of terrain in her 1982 *A Different Image* is the same. She uses the landscape (billboards and other ads that commercialize women's images), though, to highlight the impact sexist representations have on behavior in general (passers-by who regard the heroine as a sex object) and on intimate relationships in particular (the heroine's boyfriend fails to see the connection between racism and sexism). Larkin's film demonstrates the difficulty in and the necessity for smashing the code, transforming previous significations as they relate to Black women.

Three shorts by Julie Dash—*Diary of an African Nun*, *Four Women*, and the 1982 *Illusions*—are in line with this agenda. We note four things in them that will culminate in her more elaborate text of 1991, her feature *Daughters of the Dust*: women's perspective, women's validation of women, shared space rather than dominated space (Mignon Dupree in *Illusions* presses for the inclusion of Native Americans in the movie industry, and she stands in solidarity with Ester, the hidden "voice" of the Euro-American movie star), and glamour/attention to female iconography.

In *Daughters of the Dust*, the thematics of colonized terrain, family as liberated zone, women as source of value, and history as interpreted by Black people are central. The Peazant family gather for a picnic reunion at Ibo Landing, an area they call

"the secret isle." It is "secret" for two reasons, for the land is both bloody and blessed. A port of entry for the European slaving ships, the Carolina Sea Islands (Port Royal County) were where captured Africans were "seasoned" for servitude. Even after the trade was outlawed, traffickers used the dense and marshy area to hide forbidden cargo. But the difficult terrain was also a haven for both self-emancipated Africans and indigenous peoples, just as the Florida Everglades and the Louisiana Bayous were for Africans and Seminoles, and for the Filipinos conscripted by the French to fight proxy wars (French and Indian wars). Dash's Peazant family is imperiled by rape and lynch-mob murder (whites are ob-skene in *DD*), but during their reunion picnic they commandeer the space to create a danger-free zone. Music cues and resonating lines of dialogue in *DD* link the circumstances of the Peazants at the turn of the century to our circumstances today. Occupying the same geographical terrain are both the ghetto, where we are penned up in concentration-camp horror, and the community, wherein we enact daily rituals of group validation in a liberated zone—a global condition throughout the African diaspora, the view informs African cinema.

## [ · · · ]

Dash's *Daughters of the Dust* is an historical marker. It not only promotes a back glance, it demands an appraisal of ground covered in the past twenty years, and in doing so helps clarify what we mean by "independent Black cinema." In its formal practices and thematics, *DD* is the maturation of the LA rebellion agenda. By centralizing the voice, experience, and culture of women, most particularly, it fulfills the promise of Afrafemcentrists who choose film as their instrument for self-expression. *DD* inaugurates a new stage.

> I'm trying to teach you how to track your own spirit. I'm trying to give you something to take north besides big dreams
>
> Nana

We meet the Peazants in a defining moment—a family council. Democratic decision-making, a right ripped from them by slavery and regained through emancipation, hallmarks the moment. The Peazants and guests gather on the island at Ibo Landing for a picnic at a critical juncture in history—they are one generation away from the Garvey and the New Negro movements, a decade short of the Niagara/NAACP merger. They are in the midst of rapid changes; Black people are on the move North, West, and back to Africa (the Oklahoma project, for instance). Setting the story amid oak groves, salt marshes, and a glorious beach is not for the purpose of presenting a nostalgic community in a pastoral setting. They are an imperiled group. The high tide of bloodletting has ebbed for a time, thanks to the activism of Ida B. Wells, but there were racist riots in 1902; in New Orleans, for example, Black schools were the paramount target for torchings, maimings, and murder. Unknown hazards await the Peazants up North. The years ahead will require political, economic, social, and cultural lucidity. Nommo, from an older and more comprehensive belief system than meanings produced by the European traditions of rationalism and empiricism, may prove their salvation.

The Peazants, as the name suggests, are peasants. Their characterizations, however, are not built on a deficit model. It is the ethos of cultural resistance, not the ethos of rehabilitation, that informs their portraiture. They are not victims.

Objectively, they are bound to the land as sharecroppers. Subjectively, they are bound to the land because it is an ancestral home. They tend the graves of relatives. Family memorabilia is the treasure they carry in their pockets and store in tins, not coins. They are accountable to the orishas, the ancestors, and each other, not to employers. *DD* is not, then, an economically determined drama in conventional terms, wherein spectators are encouraged to identify with feudal positions—the privileged overlord or the exploited victim, and then close the mind as though no alternative social modes exist or are possible. The Peazants are self-defining people. Unlike the static portraits of reactionary cinema—a Black woman is a maid and remains a maid even after becoming a "liberated woman" through the influence of a White feminist, and even after making a fortune with a pancake recipe (*Imitation of Life*), and a Black woman is prostitute and remains a prostitute in the teeth of other options (*Mona Lisa*)—the Peazants have a belief in their own ability to change and in their ability to transform the social relations of status quo.

While *DD* adheres to the unities of time, place, and action—the reunion takes place in one day in one locale scripted on an arrival-departure grid—the narrative is not "classical" in the Western-specific sense. It is classic in the African sense. There are digressions and meanderings—as we may be familiar with from African, Persian, Indian, and other cinemas that employ features of the oral tradition. *DD* employs a folktale in content and schema.

Instead of a "pidgin" effect, what the eye and ear have been conditioned to expect from the unlettered, the Ibo Landing characters use an imaginative and varied language—poetic, signifying, rhetorical, personal—in keeping with the productive artistry we're accustomed to outside Eurocentral institutions. In addition to affirming the culture, *DD* advances the idea that African culture can subvert the imposed one. Nana, the family elder, binds up the Bible with her mojo in a reverse order of syncretism. Continuum is the theme. The first voice we hear on the sound track is chanting in Ibo; the one discernible word is "remember."

A striking image greets us in the opening—a pair of hands, as in the laying on of hands, as in handed down. They're a working woman's hands. Grandma's hands. They seem to be working up soil, as in cultivation, or maybe it's sand, certainly apropos for any presentation of an African worldview. And there's water, as in rivers. Then two voice-overs introduce the story. One belongs to Nana, the elder of the family, we will discover later: first, we see and hear her in sync during the film's present; later we see her in a flashback memory of bondage days, her hands sculling the dark steamy water of the dye vats then, together with other enslaved African women, wringing out yards of indigo-dyed cloth. The second voice is that of the Unborn Child; we will see her later on screen, too, as a visitor from that realm that supports the perceived world. The dual narration pulls together the past, present, and future—a fitting device for a film paying homage to African retention, to cultural continuum. The duet also prepares us for the film's multiple perspectives. Communalism is the major mode of the production. There's something else to notice about the dual voice-over narration. The storytelling mode is indabe my children and crik-crak, the African-derived communal, purposeful handing down of group lore and group values in a call-and-response circle.

The story opens with the arrival of two relatives, Yellow Mary and Viola, accompanied by Yellow Mary's woman friend from Nova Scotia and a photographer hired by Viola to document the reunion of the Geechee family, whose homestead is in Gullah

country. The family already onshore is introduced by the thud-pound of mortar and pestle, as in the pounding of yam—an echo of the opening of Sembene's *Ceddo*, also a drama about cultural conversion and cultural resistance; in *Ceddo*, which portrays forced conversion, the daily routine of the village, as represented by the pounding of yam, will be disrupted, as signalled by the next shot, a cross mounted atop one of the buildings. The pounding and the drums in *DD* also evoke a Dash antecedent about imposed religious-cultural conflict. In *Diary of an African Nun* a convert to Christianity hears sounds from the village and can't see she can continue to teach her people to smother the drums, stifle the joy, and pray (she realizes) to an empty sky. Shrouded in white she chants, "I am the wife of Christ—barren and . . . I am the wife of Christ," as snow melts on the mountain revealing the rich, black, ancient earth.

Nana Peazant has called a family council because values are shifting. There's talk of migration. The ancestral home is being rejected on the grounds of limited educational and job opportunities. Haagar, one of Nana's daughters-in-law, is particularly fed up with the old-timey, backward values of the "salt-water Negroes" of the island. Her daughter, on the other hand, longs to stay; Ione's lover, a Native American in the area, has sent her a love letter in the hopes that she'll remain. Viola, the Christianized granddaughter, views her family in much the way Haagar does; Viola avers that it is her Christian duty to take the young heathen children in hand, which she does the minute she steps ashore. Nana struggles to keep intact that African-derived institution that has been relentlessly under attack through kidnap, enslavement, Christianization, peonage, forced labor gangs, smear campaigns, and mob murder—the family.

Nana and one of the male relatives of this multigenerational community do persuade several to stay, but realizing that breakup is imminent, that the lure of new places is great, Nana offers a combination of things for folks to take with them as protection on their journey, so that relocation away from the ancestral place will not spell cultural dispossession. As relatives wash the elder's feet, she assembles an amulet made up of bits and scraps. "My mother cut this from her hair before they sold her away from me," she says, winding the charm and binding twine around a Bible. Each member has a character-informed reaction to her request to kiss the amulet, the gesture a vow to struggle against amnesia, to resist the lures and bribes up North that may cause them to betray their individual and collective integrity. The double ritual performed, some Peazants depart and others remain.

Like many independent works of the African diaspora that conceptualize critical remembrance—Med Hondo's *West Indies*, the Sankofa Collective's *Passion of Remembrance*, Rachel Gerber/Beatriz de Nasciamento's *Ori*—*DD*'s drama hinges on rituals of loss and recovery. The film, in fact, invites the spectator to undergo a triple process of recollecting the dismembered past, recognizing and reappraising cultural icons and codes, and recentering and revalidating the self. One of the values of its complexity and its recognition of Black complexity is to prompt us, anew, to consider our positions and our power in the USA.

While presenting the who o' we to ourselves, Dash also critiques basic tenets of both domination ideology and liberation ideology. An exchange illustrating the former occurs in a scene between Nana, the elder, and Eli, a young man fraught with doubt that his pregnant wife, Eula, may be carrying some White man's child. Their lines of dialogue don't mesh at first because each is caught up in her and his own

distress—Nana is anxious lest Eli not be up to holding the family together in the North; Eli is too obsessed with doubt about the unborn child to be reasoned with. But then their speeches mesh.

> "Call on the ancestors, Eli. We need to be strong again."
> "It happened to my wife."
> " 'My wife.' Eli, you don't own Eula. She *married* you."

Yellow Mary relates two stories that illustrate the latter point. Strolling along the beach with her friend and Eula, Yellow Mary recalls a box she once saw on the mainland, a music box. It was a bad time for her then, and she wanted that box to lock up her sorrow in the song. In the briefest of anecdotes, the process from sensation to perception to self-understanding to decision-is-mapped. Self-possession is a trait in Yellow Mary's unfolding of character; cultural autonomy is a motif in the entire *DD* enterprise. The allusion to both the sorrow-song and blues traditions in Yellow Mary's art-of-living anecdote sets the stage for a mini-essay on desire. Yellow Mary's walk, posture, and demeanor are in stark contrast to that of the Christianized cousin Viola. The careers of women blues singers in the twenties and thirties showed that Black women need not repress sexuality to be acceptable to the community. Unlike Yellow Mary, who must continually claim her sexuality, Viola has buried hers in Christian duty—that is, until perhaps, Snead the photographer, thrilled to be part of the family circle, in a moment of exuberance kisses her.

Yellow Mary's second story is about a time worse than bad, the death of her baby. Her arms were empty but her breasts were full. The White family she worked for used her to wet-nurse their children. "I wanted to come home, but they wouldn't let me. I tied up my breasts. They let me go." The allusion here is to Toni Morrison's 1987 novel *Beloved*. While Paul D is remembering the scourgings and humiliations of manhood, Sethe is caught up in the memory of gang rape in which the young White men of the plantation suckled her. "They took my milk," Sethe repeats throughout Paul D's cataloguing of atrocities. The yoking of Black women's sexuality and fertility to the capitalist system of exploitation was a theme in Dash's work prior to Morrison's *Beloved*, however. *Four Women*, based on the Simone text, relates the tragedy of three women in history—Saphronia, enslaved; Aunt Sarah, mammified; and Sweet Thing, lecherized. The fourth woman is Peaches, politicized: "I'm very bitter these days because my people were slaves—What do they call me? They call me Peee-Chezzz!"

The struggle for autonomy (or, how many forces do we have to combat to reclaim our body/mind/spirits and get our perspective and agenda respected?) is the concern of numerous Black women filmmakers—Camille Billops, Zeinabu Davis, Cheryl Chisholm, Ayoka Chenzira, Michelle Parkerson, Barbara McCullough, numerous others, and of course, Dash. What the Yellow Mary stories point to is the limitations of radical discourse that dichotomizes culture and politics, that engenders oppression and resistance as male, and that defines resistance as a numbered, organized, leader-led (male) action that is sweeping in process and effect. In tying up her breasts, Yellow Mary is a factory worker on strike.

Any ordinary day offers an opportunity to practice freedom, to create revolution internally, to rehearse for governance, the film promotes. A deepening of the message is achieved by having both Barbara O and Verta Mae Smart-Grosvenor, author

of *Thursday and Every Other Sunday Off*, on screen. O's personal act of resistance in *Bush Mama* carries over to *DD* through the actress playing Yellow Mary, a domestic and a prostitute. The perspective of domestics, who are in a better position than most workers to demystify White supremacy, as Smart-Grosvenor's book indicates, is a still-untapped resource for Black political theorists (including Afrafemcentrists). Likewise the prostitute's.

The thesis of daily resistance spreads from scene to scene. Eula's silence about the White rapist, for example, is a weapon; it shields Eli from highly probably violence. However, as a metaphor for cultural rape, silence must be overcome; the film *DD* is the voice. Speaking Gullah is also resistance; it combats assimilationist designs. Gullah is an Afrish first created by Mandinkas, Yorubas, Ibos, and others to facilitate intercontinental trade long before the African Holocaust. The bridge language on this side of the waters was recreolized with English. The authenticity of languages spoken by the Peazants, by Bilal, a Muslim on the island, by the indigo dyers and the Wallahs (met in flashbacks to slavery times) is one of the ways the film compels belief. The film's respectful attention to language, codes of conduct, food preparation, crafts, chair caning, hair sculptures, quilt making, and mural painting constitutes a praise song to the will and imagination of a diasporized and besieged people to forge a culture that can be sustained.

**[ · · · ]**

The figure is claimed for an emancipatory purpose. The boat steers us away from the narrows of Hollywood towards salt-marshy waters that only look like the shallows. Bobbing near shore is a carving, the head and torso of an African rendered in wood. From the shape of it, we surmise that it was a "victory," a figure that rode the prow of a slaving ship. (In a later scene, Eli, husband of Eula, will baptize the "'victory" and push it out into the depths.) The boat docks in an area richer still in meaning. A title comes onto the screen: "Ibo Landing, 1902." The date is important. The people whose stories will be told are one generation out of bondage. The date lingers on the screen six beats longer than the date in the 1985 Hollywood/Spielberg version of Alice Walker's *The Color Purple*, which is set in the same period.

In *Purple* "Winter, 1909" flashes over Celie bolting upright in bed in extreme foreground, screaming, in terror, in labor. The flash of the date fails to orient sufficiently. The spectator needs a moment to assemble the history: chains, branding irons, whips, rape, metal depressors on the tongue, bits in the mouth, iron gates on the face in the cane brakes that prevent one from eating the sweetness and prevent one from breathing in the sweltering blaze that scalds the mask that chars the flesh. The brutalized and brutalizing behaviors of *Purple*'s main characters have a source. That Spielberg did not appreciate the impact of the date is our first clue that *Purple* will be hobbled in fundamental ways—the cartoon view of Africa, for example, which is in keeping with the little-bluebird journey of the flyer that covers the passage of years and announces that Shug Avery's hit town. *Purple*, nonetheless, was/is of critical importance to at least one sector of the community who draw strength from it—incest survivors, who need permission to speak of intracommunity violation.

The place name in *DD*, Ibo Landing, conjures up a story still told both in the Carolina Sea Islands and in the Caribbean. In Toni Morrison's 1981 cautionary tale, the novel *Tar Baby*, set in the Caribbean, it becomes the story of the hundred blind

Africans who ride the hills. On deck, barely surviving the soul-killing crossing from the Tropic of Capricorn to the Horse Latitudes, the Africans took one look at the abomination on shore and were struck blind. They flung themselves over the side, swam to shore, climbed the rocks, and can be heard to this day thundering in the hills on wild horses. Haunting hoofbeats are a reminder to cherish the ancient properties and resist amnesia/assimilation/fragmentation. Paule Marshall also uses the tale to warn us not to bargain away wisdom for goods and "acceptance." The functioning of the Ibo tale in Marshall's 1984 novel *Praisesong For the Widow* is more precisely parallel to its role in *DD*.

*Praisesong* invites the reader to undergo a grounding ritual via Avey Johnson. A middle-aged widow living in White Plains, New York, Avey has all the trappings of success—stocks and bonds, wall-to-wall carpet, car, house, matching luggage. She's planning a trip to the Caribbean. She suffers, though, from a severe sense of loss. It registers as more than the loss of her husband. Like Jardine in the Morrison novel, Avey and Jay have been in flight; the fear of poverty and humiliation drove them to jettison cultural "baggage" for a fleeter, unencumbered, foot up the ladder. Avey receives visitations from her dead elder, Great Aunt Cuney, who directs her to *remember*. Avey's journey toward wholeness begins with remembering the story of the Ibos as handed down through generations in the Carolina Sea Islands where she spent her girlhood summers. In short, in order to move forward, Avey has to first go backwards.

The Ibos, brought ashore from the ships in a boat, stepped out on the land, saw what the Europeans had in store for them and turned right around and walked all the way home to the motherland. Once just a tale, fantastic in its account of people in irons walking thousands of miles on the water, the account of the Ibos' deep vision becomes an injunction to Avey. She must learn to see, to name, to reconnect. Great Aunt Cuney used to say of her grandmother, who handed down the tale, that her body might have been in Tatum, South Carolina but her mind was long gone with the Ibos. Avey finds strength in the tale and continues her journey; its success rests on her ability to read the signs that speak to the persistence of the ancient world(s) in the so-called New World. This practice of reading and naming releases nommo—that harmonizing energy that connects body/mind/spirit/self/community with the universe. Avey "crosses over" to her center, her authentic self, her real name, and her true work. As Avatara she assumes the task of warning others away from *eccentricity*. She stands watch in luxury highrises for buppie types with a deracinated look. She collars them and tells her story.

[ · · · ]

"Crossing over," a term steeped in religion, as in crossing over into Jordan (Baptist and other), crossing over into sainthood (Sanctified, Pentecostal), crossing to or coming through religion (Country Baptist and AME Zion) crops up frequently in the speech of those on Ibo Island. Used by Haagar, the daughter-in-law eager to get her family off the island to more sophisticated environs, it suggests that she may fall victim to the worship of Mammon. Used by one of the men trying to persuade Eli, the distraught husband of Eula, to stay and be an anti-lynching activist, it equates responsibility with sacred work. The phrase "making the crossing," spoken by several characters, carries two meanings: being double-crossed, as in being rounded up for the Middle Passage; and being Ibo-like by sending the soul home to the original ancestral place, Africa.

"Crossing over" also calls to mind the contemporary phrase "crossover" as in "Whitening" a Black film project, or yoking a Black box office star to a White one in order to attract a wider, or Whiter, audience. *DD* is not a crossover project.

## Empowering Signs

The TV experiment *All in the Family* proved that commercial success was/is in the offing for those who would pitch to a polarized national audience. White and other bigots were affirmed by the prime-time Archie Bunker show. White and other liberals read the comedy as an expose and applauded its creators for their wit. Black and other downpressed folks, eager for any sign of American Bunkerism being defanged, tuned in to crack.

There is no evidence in *DD* of trying to position a range of spectators, as many filmmakers find it expedient to do. *DD* demands some work on the part of the spectator whose ear and eye have been conditioned by habits of viewing industry fare that masks history and addicts us to voyeurism, fetishism, mystified notions of social relations, and freakish notions of intimate relations. Most spectators are used to performing work in the dark. But usually, after fixing inconsistencies in plot and character and rescripting to make incoherent texts work out, our reward is a mugging. *DD* asks that the spectator honor multiple perspectives rather than depend on the "official" story offered by a hero; it asks too that we note what particular compositions and framing mean in terms of human values. The reward is an empowered eye.

In *DD*, the theme of cultural resiliency determines composition, framing, music, and narrative. In conventional cinema, symbol, style, and thematics are subordinated to narrative drive; except, of course, that an ideological imperative overrides it all: to construct, reinforce, and "normalize" the domination discourse of status quo that posits people of color as less than ("minority," as they say).

Snead the photographer is a reminder of how ritualized a form of behavior taking pictures is, and that it need not be aggressive. His character changes in the course of the film. Initially bemused, curious about the backwoods folk Viola regards as heathens, he becomes the anthropologist who learns from "his photographic subjects." After interviewing people on the island, Snead discovers a more profound sense of his own self. The photographer character, the camera, the stereopticon, and kaleidoscope function in *DD* as cameras and video monitors do in *The Passion of Remembrance* by the Black British collective Sankofa. The film-within-a-film device, as Maggie Baptiste works in front of the monitor, accomplishes in the independent Black Brit film what shifting sight lines and the behavior of Snead do in *DD*—to call attention to the fact that in conventional films we're seduced by technique and fail to ask what's being filmed and in whose interest, and by failing to remain critical, become implicated in the reconstruction/reinforcement of an hierarchical ideology.

Dash not only expresses solidarity with international cadres whose interrogations have been throwing all codified certainties about film into crisis for the past twenty years, she also contracted as director of cinematography a filmmaker who questions even the 24-frames-per-second convention. In the early forties, when Dizzy Gillespie announced that 3/4 and 4/4 time signatures were not adequate for rendering the Black experience, Bebop was ushered in. It didn't arrive in a tux. It came to overhaul the tenets of Black improvisational music making and music listening. Arthur Jafa Fiedler, as his film shorts such as "P. F." indicate, is announcing no less.

Frame rates, the speed at which the sprocket-driven gears push film stock through the chamber of a camera, include, among others, 16 frames per second, 18, 24, 25, and so on. Of these technological possibilities—and even these are fairly arbitrary—24 has been the standard since the "talkies," not, apparently, because the synchronization of sound and visuals requires it, but because findings in the fields of kinesics and psychophysiology suggest that the 24-frame rate gives a pleasurable illusion of reality. In "P.F.," by orchestrating frame rates, Fiedler gives us something else; he multiplies the possibilities for multiple-channeled perception on the part of the spectator. For a project, namely *DD*, that asks the spectator to do as Avey did, read the signs, Fiedler is the perfect practitioner.

By the by: a number of Black psychologists and forensic lawyers are working in the combined field of kinesics and psychophysiology to explore the virulent and criminal impact of racist stressors (a sense of entitlement, belief in Black inferiority, a predisposition to hog space, to break through a line, presume, engage in demonic-oriented Black/White discourse, complain about the music, set the pace) on Black individual and communal health.

One of the "signs" is signing, which the children do in games, and which Eli and several men do to talk across distances. The film poses the question asked of inventor Lewis Lattimore by Pan-African-minded folks at the turn of the century: How shall a diasporized people communicate? Answer: independent films. Trula Hoosier (Yellow Mary's woman friend) from Charles Lane's independent silent film *Sidewalk Stories* (mother of the little girl) has very few lines in *DD* but is in a great many scenes. Her silence is initially disconcerting but then seems functional, drawing attention to both the Gullah language and signing. In the woods where Eli (played by Adisa Anderson, the boyfriend from *A Different Image*) and his cousin (played by Tony King who, in *Sparkle*, beat up on Lonette McKee, who later starred in Dash's *Illusions*) silently performs an African martial art known in Afribrasilia as capoeira (the subject of a film by Warrington Hudlin, founder of the Black Filmmaker's Foundation which distributes, among other films, *A Different Image* and *Illusions*), cousin Peazant's reading of the signs of the time is what prompts him to speak, in order to persuade Eli to stay and be an activist. "They're opening up Seminole land," Cuz says, "for White settlers and Northern industrialists, not for we": a sure sign that there'll be an escalation of White-on-Black and White-on-Red crimes. Geraldine Dunston, who plays the mother of the christianized Viola, is an actress who appeared in Iverson White's independent film about lynching, resistance, and migration, *Dark Exodus*. Her presence adds weight to the anti-lynching campaign argument of Eli's cousin. The presence of a Native American in the cast, lover of one of the Peazant's granddaughters, drives home the multicultural solidarity theme, earlier sounded in Dash's *Illusions*.

There's a particularly breathtaking moment that occurs on the beach shortly after Nana has stressed the necessity of honoring the ancestors. It's a deep-focus shot. Close in the foreground are the grown-ups. They are facing our way. The men are in swallowtail coats. Some have on homburgs as well. Some are sitting, others standing. Two or three move across the picture plane, coattails buffeted by the breeze. They are talking about the importance of making right choices. Someone says that for the sake of the children they must. We see, across a stretch of sand glinting in the sun in midground, the children playing along the shore. Several of the grown-ups turn to look over their shoulders and in turning, form an open "door."

The camera moves through, maintaining crisp focus, and approaches the children, except that the frame rate has slowed, just enough for us to register that the children are the future. For a split second, we seem to go beyond time to a realm where children are eternally valid, are eternally *the* reason for right action. The camera then pulls back, still maintaining crisp focus, as we backtrack across the sand, entering present time again as the grown-ups' conversation claims our attention again. Not virtuosity for virtuosity's sake, the past/present/future confluence is in keeping with film's motive impulse to celebrate continuum.

There are two things remarkable about the take. One, the camera is not stalking the children. I do not know how that usual predatory menace was avoided, but one contributing factor is that the camera is not looking down on them. Two, no blur occurs as is usual in conventional cinema. Throughout *DD*, no one is background scenery for foregrounded egos. The camera-work stresses the communal. Space is shared, and the space (capaciousness) is gorgeous. In conventional cinema, camera-work stresses hierarchy. Space is dominated by the hero, and shifts in the picture plane are most often occasioned by a blur, directing the spectator eye, controlling what we may and may not see, a practice that reinscribes the relationships of domination ideology.

**[ · · · ]**

For all the long shots, neither a picture-book nor an unduly distanced feel results. The spaciousness in *DD* is closer to African cinema than to European and Euro-American cinema. People's circumstances are the focus in African cinema, rather than individual psychology. The emphasis placed on individual psychology in dominating cinema deflects our attention away from circumstance. Social inequities, systemic injustices, doctrines and policies of supremacy are reduced to personal antagonisms. Conflict, then, can be resolved by a shrink, a lawyer, a cop, or a bullet. Not, for example, by revolution.

By the time the unborn Peazant child will come of age in the twenties, the subversive potential of cinema will be in the process of being tapped in this country, by African-Americans in Philadelphia, Kansas, New York, and Texas, and by European-Americans in New York, Philadelphia, and California. By the time US cinema becomes industrialized in California, that potential will have been tamed, will have been brought into line with structures of domination and oppression. But the camera in the hands of Snead, a character who undergoes a transformation from estranged scientist to engaged humanist, and the other two pre-kinescope props, the stereopticon and the kaleidoscope, in the hands of the Peazant women, prompt us to envision what popular narrative, for example, might be like were dread, sin, and evil not consistently and perniciously signified in dominating cinema within a matrix of darkness, blackness, and femaleness. The props and their attachment to particular characters in *DD* keep central the distinctiveness of conscious Black cinematistes in opposition to commercial filmmakers, and in relation to independent Black filmmakers who regard the contemporary independent sphere as a training ground or stepping-stone to the industry, rather than as a space for contestation, a liberated zone in which to build a cinema for social change.

**[ · · · ]**

The late pioneer black woman filmmaker Kathy Collins Prettyman was a liberating sign. And the fact that a number of sisters have found their voices in film augers well for community mental health. The task now is to crash through the cultural embargo that separates those practitioners from both their immediate authenticating audiences and worldwide audiences.

## Are Ee Es Pee Ee Cee Tee

<div align="right">

Aretha

</div>

One of the highpoints in *DD* is a women's validation ceremony. Several characters in the drama need it. Two expressly seek it—Eula, "ruined," and Yellow Mary, despised. From the start, Nana and Eula welcome Yellow Mary into the circle. The other women relatives roll their eyes and mutter at the approach of Yellow Mary and her companion. Actress Verta Mae Smart-Grosvenor (author of the classic cookbook *Kitchen Vibrations: Travel Notes of a Geechee Girl* and librettoist of *Nyam: A Food Opera*; the presence of the culinary anthropologist gives authenticity to the Geechee Girl Productions project, not to mention the merciless preparation and presentation of food) delivers the line, "All that yalla wasted," which the others take up to shut their relative out. There are beautiful interactions between Nana and Yellow Mary, in the way they look at each other and touch. The two actresses appeared together fifteen years ago in Gerima's *Bush Mama*. Dorothy, played by Barbara O, rattled by the noise of sirens, neighbors, social workers, and the police, found little comfort in the niggers-ain't-shit-talking neighbor played by Cora Lee Day. And there's a great moment between Yellow Mary and Haagar that comes straight out of Gerima's *Harvest: 3,000 Years*. One of the many memorable scenes in *Harvest* is the long-take walk of the peasant summoned from the fields by the landlord. The camera is at the top of a hill, to the right and slightly behind the murder-mouthing landlord. Without a cut, the peasant tramps across the fields, trudges over to the hill, scrambles up, grabbing at scrub brush, boosting himself on the rocks, and reaches the top, where he's tongue lashed by the landlord. In *DD*, Haagar stands arms akimbo at the top of a sand dune, giving Yellow Mary what-for. The take is not a long one, but the camera placement is the same as Gerima's. Yellow Mary comes up the dune while the older, married, mother of two, who outranks her in this age-respect society, mouths off. Just as Yellow Mary reaches the top, a hundred possibilities registering in her face (will she knock Haagar down, spit in her face, or what?), she gives Haagar a look and keeps on stepping. Hmph.

Eula initiates the validation ritual by chiding the relatives who were ready enough to seek Yellow Mary's help when a cousin needed bailing out of jail, but now slander her. "Say what you got to say," Eli interrupts, impatient. "We couldn't think of ourselves as pure women," Eula recounts, "knowing how our mothers were ruined. And maybe we think we don't deserve better, but we've got to change our way of thinking." Nana contributes wisdom about the scars of the past, then Eula continues, "We all good women." She presents Yellow Mary to the family circle and continues her appeal. "If you love yourself, then love Yellow Mary." Both women are embraced by the family. Then the wind comes up, rippling the water in the basin the elder's feet are being washed in, rippling the waters where the boat awaits for the departing Peazants.

Dash's sisters-seeing-eye-to-eye ritual has its antecedents in *Illusions*. Mignon Dupree (Lonette McKee) is a production executive in a Hollywood studio during the forties. Because of the draft and because she's mistaken for White, the Black woman has an opportunity to advance a self-interested career. That is not her agenda. She proposes that the studio, cranking out movies to boost the war being fought "to make the world safe for democracy," make movies about the Native American warrior clans in the US armed services. The studio heads's got no eyes for such a project. All attention is on a problem—the White, blonde bombshell star can't sing. A Black woman, Ester Jeeter (Roseanne Katon), is brought in as "the voice." Ester sees Mignon and recognizes who she is. Mignon sees Ester and does not disacknowledge her. Ester is placed behind a screen, in the dark, in a booth, to become the singing voice of the larger-than-life, illuminated starlet on the silver screen. Mignon stands in solidarity with Ester. Unlike the other executives who see the Black woman as an instrument, a machine, a solution to a problem, Mignon openly acknowledges her personhood and their sisterhood.

The genre that Dash subverts in her indictment of an industry that projects false images (democracy, US fighting troops, the starlet) is the Hollywood story musical, specifically *Singin' in the Rain*, a comic treatment of the Hollywood careers ruined by the "talkies." In *Singin'* there is the obligatory ritual that informs the history of commercial cinema—the humiliation of a (White) woman. While the nonsinging star, played by Jean Hagen, is "singing" at a show biz benefit, the stage hands, who resent her fame and fortune, raise the curtain to reveal the singer, played by Debbie Reynolds. Does the Reynolds character stand in solidarity with the humiliated woman? Hell no, its her big career break. *Singin'* provides Dash with a cinematic trope. Victoria Spivey, Blue Lu Barker, Lena Horne and other musicians contracted by Hollywood for on-screen and off-screen work provide the actual historical trope, for the Reynolds character image is false too. Behind that image, in the dark, behind a screen, in a booth, was a Black woman. Dash's indictment, as well as her thesis about what cinema could be, carries over from *Illusions* to *DD*. The validation of Black women is a major factor in the emancipatory project of independent cinema.

[ · · · ]

The next stage of development of new US cinema will most certainly be characterized by an increased pluralistic, transcultural, and international sense and by an amplified and indelible presence of women.

## BRIEF NOTES RE: PROGRAMMING WITH *DAUGHTERS OF THE DUST*

Progressive Representations of the Black Woman in Features

Haile Gerima's 1974 *Bush Mama* (Ethiopia/US)
Sharon Alile Larkin's 1982 *A Different Image* (US)
Menelik Shabazz's 1981 *Burning an Illusion* (UK)
Sankofa Collective's 1987 *The Passion of Remembrance* (UK)
(EuraAm) Lizzie Borden's 1983 *Born In Flames* (US)
Julie Dash's 1991 *DD* (US)

Mapping History from the Continent to Watts

Ousman Sembene's 1977 *Ceddo* (Senegal)
Sergio Giral's 1976 *The Other Francisco* (Cuba)

Med Hondo's 1982 *West Indies* (Mauritania/France)
Raquel Gerber's 1989 *Ori* (Brazil)
Ayoka Chenzira's 1989 *Zajota & the Boogie Spirit* (US)
Julie Dash's 1991 *DD* (US)
Charles Burnett's 1990 *To Sleep With Anger* (US)

Ancestral Figures: "An elder dying is a library burning down"–Fye

Safi Fye's 1979 *Fad Jal* (Senegal)
Med Hondo's 1982 *West Indies* (Mauritania/France)
Euzhan Palcy's 1986 *Sugar Cane Alley* (Martinique/France)
Larry Clark's 1977 *Passing Through* (US)
Haile Gerima's 1983 *Ashes and Embers* (Ethiopia/US)
Julie Dash's 1991 *DD* (US)

Woman to Woman: 5 Documentaries and 3 Features

Julie Dash's 1983 *Illusions* (US)
Camille Billops' 1988 *Suzanne, Suzanne* (US)
Cheryl Chisholm's/National Black Women's Health Project's 1986 *On Becoming a Woman* (US)
Ngozi Onwurah's 1989 *Body Beautiful* (UK)
Camille Billops' 1988 *Older Women Talking About Sex* (US)
Michelle Parkerson's 1980 *. . . But then, she's Betty Carter* (US)
Julie Dash's 1991 *Daughters of the Dust*
Julie Dash's 1991 *Praise House*

## ACKNOWLEDGMENTS

Texts referred to:

Toni Morrison's *Tar Baby*, New York: Knopf, 1981
Paule Marshall's *Praisesong for the Widow*, New York: Dutton, 1984
Toni Morrison's *Beloved*, New York: Knopf, 1987
Abbey Lincoln's "Who Will Revere the Black Woman," *Negro Digest*, September, 1966: also in Toni Cade's *The Black Woman*, New American Library/Signet, 1970

Written Texts That Inform My Text:

Zeinabu Davis' interview with Julie Dash in *Wide Angle*, Vol. 13, Nos. 3 & 4 (1991)
Gregg Tate's interview with Julie Dash in *The Village Voice*, June, 1991 issue
Pat Collins' *Black Feminist Thought: Knowledge, Consciousness and the Politics of Empowerment*, Boston: Unwin Hyman, Inc. 1990
bell hooks' *Yearning: Race, Gender, and Cultural Politics*, Boston: South End Press, 1990
Bettina Aptheker's *Tapestries of Life: Women's Work, Women's Consciousness, and the Meaning of Daily Experience*, Amherst: U of Mass Press, 1989

Spoken Texts by and Gab-fests with:

Cheryl Chishom on the empowered eye and on colonialist metaphors
Francoise Pfaff on Tarzan and ethno footage
Eleanor Traylor on the ancestral place motif in African American literature
Zeinabu Davis on women paying tribute to women artists
Clyde Taylor (talks, Whitney Museum Program Notes, articles in *Black Film Review* and elsewhere) on the LA Rebellion.
A.J. Fiedler's lecture demonstration/screening at the Scribe Video Center's Producers Showcase program in Philly, 1991
Ayida Tengeman Mthembe, who will be doing forums on the relationship between US policy toward Africa and the representation of Africa, Africans, and African Diasporic people on the commercial screen

# FAYE GINSBURG

. . . . . . . . . . . . . . . . . . . . . . . . . . . . . . . . . . . . . . . . . . . . . . . . . . . . . . . . . . . . . . . . . . . . . . .

## Screen Memories and Entangled Technologies: Resignifying Indigenous Lives

Faye Ginsburg (b. 1952) is David B. Kreiser Professor of Anthropology and the founding director of the Center for Media, Culture, and History at New York University, where she directs the Program in Culture and Media. She is a key figure in the convergence of critical anthropology and media studies. She has written influentially on reproductive rights and the media and on indigenous media production, particularly Aboriginal media in Australia. In 1994, she was the recipient of a prestigious MacArthur Fellowship.

After the first gains in civil rights for Native Americans and indigenous people across the Americas and in the settler nations of Australia and New Zealand in the 1960s and 1970s, questions of representation and cultural production came to the fore. While this history resembles that of other historically marginalized or underrepresented groups whose images have been stereotyped and used as a means of disenfranchisement, a unique set of conflicts arises in the interaction of Native peoples and the media. Traditional lifestyles are often altered by modern technology and images imposed from the outside, and some belief systems entail that traditional practices not be observed or recorded by outsiders. These contradictions often result in what Ginsburg calls the "Faustian bargain" between indigenous producers and the media, and her work focuses particularly on the ways that cultural insiders have used the media to their advantage.

In "Screen Memories and Entangled Technologies" Ginsburg surveys important developments in mediamaking initiatives from the Inuit Broadcasting System in the Arctic region of Canada to the first theatrically released feature by Native Americans in the United States, *Smoke Signals* (Chris Eyre, 1998), before turning to the Australian Aboriginal context of her own fieldwork for an in-depth case study. She asserts that indigenous mediamakers, whether they are activists working in local broadcasting initiatives or media professionals working within national producing and programming structures, have seized the power to create memories for their own people and for wider national and transnational communities. One strong example Ginsburg cites is Zacharias Kunuk's *Atanarjuat (The Fast Runner)* (2000), a feature film that reenacts an Igloolik myth using the latest digital technology, introducing younger generations to traditional customs by creating images where only oral tales existed before. Such television, radio, film, and video initiatives, sometimes referred to as Fourth Cinema, extend the political aesthetics promoted in Third Cinema (see Solanas and Getino, p. 924) to Native peoples, combining premodern and postmodern cultural practices. Ginsburg's wide-ranging theoretical and ethnographic work explores the strategies of indigenous producers as they interact with their worlds.

## READING CUES & KEY CONCEPTS

■ In this essay, what does the story of the introduction of satellite television to the Canadian North reveal about the contradictions of media access for indigenous communities?

■ How does Ginsburg illustrate the use of media for communication among Aboriginal peoples in the Americas and the Pacific?

■ Consider the account of the media's role in establishing land claim issues. How do political and aesthetic concepts of "representation" come together in this instance?

■ **Key Concepts:** Aboriginal Media; Ethnographic Film; Salvage Anthropology

# Screen Memories and Entangled Technologies: Resignifying Indigenous Lives

I n the summer of 1998, I found myself in the midst of paparazzi, limousines, and Native Americans, for the opening of *Smoke Signals* at the New York City branch of the National Museum of the American Indian. The film, directed by Chris Eyre, the only Cheyenne descendant to attend NYU film school, is the first independent narrative fiction feature created and acted by Native Americans. It tells a latter-day coming of age saga of two young Coeur d'Alene men tied by the loss of their fathers and their dilemmas of cultural identity, a story adapted by screenwriter Sherman Alexie (Spokane) from his book, *The Lone Ranger and Tonto Fistfight in Heaven* (1994). *Smoke Signals* opened to critical acclaim, got picked up by Miramax, a major American film distributor, and played in major theaters throughout the United States, an unqualified cross-cultural success on any culture's terms.

When I arrived on a balmy June night for the opening at the museum, I was stunned and amused to have to make my way through a line of slickly dressed handlers and pushy journalists who were there as part of the entourage of the two movie stars in attendance, Matt Damon and Winona Ryder (who had recently come out as a strong supporter of Native American causes). While the patina of glamour was exciting, the event's great appeal was the convergence of that glitter with the more grounded spirit of community celebration. In an evening filled with both cultural pride and irreverence, people who had worked on the film joked with, thanked, and praised one another in an auditorium filled with Native American performers and artists and many other fellow travelers and supporters. Author and co-producer Sherman Alexie looked around him at the posh auditorium and offered an impeccably gauged moment of sardonic "Indian humor" that spoke volumes about the distance between the "here" of the evening and the "there" of the film (and his youth) set on an economically marginal "res" (reservation). Gesturing to the elegant stage and screen of the museum, Alexie suggested that an "authentic" viewing of the film would require an old black-and-white television on the stage, topped by rabbit ears covered with tin foil to help capture the signal. After the screening, the Native American a capella women's singing group Ulali performed, followed by a traditional men's drum group.

The sense of community accomplishment that accompanied the opening of *Smoke Signals* was heightened by the unspoken recognition that American Indians are finally able to produce their own images and narratives that can effectively

speak back to a U.S. cinema industry that has flourished on the marketing of stereotyped depictions of their lives, cultures, and histories. In a poignantly reflexive moment in the film, the philosophical character Thomas, one of the movie's two young protagonists, comments wryly on the costs of that circumstance to Native American subjectivity: "The only thing more pathetic than seeing Indians on TV is seeing Indians sitting around watching Indians on TV." Nonetheless, Thomas admits, reluctantly, to having watched *Dances With Wolves* multiple times. The film also provides a way to speak to audiences from the dominant culture for whom the lives and sensibilities of native peoples are a cipher; and finally, to speak for and about Native American communities, through the compelling voices of a generation of cultural activists who are finally "wiping the warpaint off the lens," the apt phrase that is the title of a forthcoming book on native media by Santa Clara Pueblo scholar and filmmaker Beverly Singer (2002). This anecdote indicates how crucial it is to understand these media not just as texts but also as embedded in a world of cultural production, tracking how they acquire meaning and value over time through multiple circuits of social circulation.

## *Cultural Activism and the Activist Imaginary*

The opening of *Smoke Signals* is one particularly public event in a much more long-standing process in which indigenous and minority peoples have begun to take up a range of media in order to "talk back" to structures of power that have erased or distorted their interests and realities. The work they have been producing might be considered cultural activism, a term that underscores the sense of both political agency and cultural intervention that people bring to these efforts, part of a spectrum of practices of self-conscious mediation and mobilization of culture that took particular shape beginning in the late twentieth century. Indigenous media[1] developed in response to the entry of mass media into the lives of First Nations people, primarily through the imposition of satellites and commercial television. In almost every instance, they have struggled to turn that circumstance to their advantage, a point effectively made by activist researcher Eric Michaels in the central desert of Australia where, in the 1980s, he worked with Warlpiri people to develop their own low-power television—what he called *The Aboriginal Invention of Television in Central Australia* (1986)—as an alternative to the onslaught of commercial television.[2] Such formations are typically small in scale and offer an alternative to the mass media industries that dominate late capitalist societies; they occupy a comfortable position of difference from dominant cultural assumptions about media aesthetics and practices.

The range of the work is wide, moving from small-scale community-based videos, to broadcast quality television, to major independent art and feature films. Indigenous people who live in or closer to metropoles, such as the urban Australian Aboriginal filmmakers discussed in this essay, participate in a wider world of media imagery production and circulation (e.g., national film and television industries), and feel their claim to an indigenous identity within a more cosmopolitan framework is sometimes regarded as inauthentic. Debates about such work reflect the changing status of "culture," which is increasingly objectified and mediated as it becomes a source of claims for political and human rights both nationally and on the world

stage. As Terry Turner has shown regarding the work of Kayapo mediamakers living in the Brazilian Amazon, cultural claims "can be converted into political assets, both internally as bases of group solidarity and mobilization, and externally as claims on the support of other social groups, governments and public opinion all over the globe" (1993, p. 424). Appadurai (1996) suggests the word *culturalism* to denote the mobilization of identities in which mass media and the imagination play an increasingly significant role. This activist objectification of culture encompasses not only indigenous work but media being produced by other colonized and minority subjects who have become involved in creating their own representations as a counter to dominant systems, a framework that includes work being done by people with AIDS (Juhasz, 1995), Palestinians in Israel's occupied territories (Kuttab 1993); the transnational Hmong refugee community (Schein, 2002), and African American musicians (Mahon, 2000).

The broader questions this work raises—whether minority or dominated subjects can assimilate media to their own cultural and political concerns or are inevitably compromised by its presence—still haunts much of the research and debate on the topic of the cross-cultural spread of media. In the context of indigenous peoples, some anthropologists have expressed alarm at these developments (Faris, 1992); they see these new practices as destructive of cultural difference and the study of such work as "ersatz anthropology" (Weiner, 1997), echoing the concerns over the destructive effects of mass culture first articulated by intellectuals of the Frankfurt School.[3] Other scholars actively support indigenous media production while recognizing the dilemmas that it presents. Roth, for example, queries whether a state supported Aboriginal Peoples Television Network in Canada is a breakthrough or a "media reservation" (Roth, 2002), presenting a kind of Faustian contract with the technologies of modernity, enabling some degree of agency to control representation under less than ideal conditions (Ginsburg, 1991). However, the capacity to narrate stories and retell histories from an indigenous point of view—"screen memories"—through media forms that can circulate beyond the local has been an important force for constituting claims for land and cultural rights, and for developing alliances with other communities. The anthropologist and filmmaker Harald Prins, who has catalyzed indigenous filmmaking for Native American claims to land and cultural rights, nonetheless points out "the paradox of primitivism" in which traditional imagery of indigenous people in documentaries about native rights, while effective and perhaps even essential as a form of political agency, may distort the cultural processes that indigenous peoples are committed to preserving (Prins, 1997). Others, on the other hand, make a compelling argument that despite the colonial origins of film and photography, it is now so firmly inserted into everyday practice that it is best seen at the confluence of overlapping visual regimes rather than the province of one (Pinney, 1998, p. 112).

Meanwhile, as anthropologists and media scholars debate the impact that media technologies might have on the communities with which they work, indigenous mediamakers are busy using the technologies for their own purposes. Activists are documenting traditional activities with elders; creating works to teach young people literacy in their own languages; engaging with dominant circuits of mass media to project political struggles through mainstream as well as alternative arenas; communicating among dispersed kin and communities on a range of issues;

using video as legal documents in negotiations with states; presenting videos on state television to assert their presence televisually within national imaginaries; or creating award-winning feature films.

Rather than casting judgment on these efforts to use media as forms of expressive culture and political engagement, a number of us see in the growing use of film and other mass media an increasing awareness and strategic objectification of culture. As Daniel Miller has argued regarding the growing use of media more generally,

> These new technologies of objectification [such as film, video, and television] . . . create new possibilities of understanding at the same moment that they pose new threats of alienation and rupture. Yet our first concern is not to resolve these contradictions in theory but to observe how people sometimes resolve or more commonly live out these contradictions in local practice. (1995, p. 18)

Whatever the contradictions, as new technologies have been embraced as powerful forms of collective self-production, they have enabled cultural activists to assert their presence in the polities that encompass them, and to enter more easily into much larger movements for social transformation for the recognition and redress of human and cultural rights, processes in which media play an increasingly important role (Castels, 1997). Yet, it is important to recognize that these processes are deeply rooted in some of the earliest cinematic cross-cultural encounters.

## Entangled Technologies

In a familiar moment in the history of ethnographic film,[4] a well-known scene in Robert Flaherty's 1922 classic *Nanook of the North*, the character identified on the intertitle as "Nanook, Chief of the Ikivimuits" (played by Flaherty's friend and guide Allakariallak) is shown being amazed by a gramophone. He laughs and tests the record three times with his mouth. We now recognize the scene as a performance rather than documentation of first contact, an image that contradicts Flaherty's journals describing the Inuit's sophisticated response to these new recording technologies, as well as their technical expertise with them by the time the scene was filmed (Rotha, 1980). Like the gramophone scene, the film itself obscures the engagement with the cinematic process by Allakariallak and others who worked on the production of Flaherty's film in various ways as, in today's parlance, we might call technicians, camera operators, film developers, and production consultants. Not long after the character of Nanook had achieved fame in the United States and Europe, the person Allakariallak died of starvation in the Arctic. While he never passed on his knowledge of the camera and filmmaking directly to other Inuit, the unacknowledged help he gave Flaherty haunts Inuit producers today as a paradigmatic moment in a history of unequal-looking relations (Gaines, 1988). Their legendary facility with the camera—from imagining and setting up scenes, to helping develop rushes, to fixing the Aggie, as they called the camera—foreshadows their later entanglement with mediamaking on their own terms.

The Nanook case reminds us that the current impact of media's rapidly increasing presence and circulation in the lives of people everywhere and the globalization of media that it is part of—whether one excoriates or embraces it—is not simply a phenomenon of the past two decades.[5] The sense of its contemporary novelty is in part the product of the deliberate erasure of indigenous ethnographic subjects as actual or potential participants in their own screen representations in the past century. These tensions between the past erasure and the current visibility of indigenous participation in film and video is central to the work of the Aboriginal mediamakers who are engaged in making what I call *screen memories*. Here I invert the sense in which Freud used this term to describe how people protect themselves from their traumatic past through layers of obfuscating memory (Freud, 1975, p. 247).[6] By contrast, indigenous people are using screen media not to mask but to recuperate their own collective stories and histories—some of them traumatic— that have been erased in the national narratives of the dominant culture, and are in danger of being forgotten within local worlds as well. Of course, retelling stories for the media of film, video, and television often requires reshaping them, not only within new aesthetic structures but in negotiation with the political economy of state-controlled as well as commercial media, as the following case makes clear.

## *The Development of Inuit Television*

Half a century after *Nanook* was made, in the 1970s, the Inuit Tapirisat, a pan-Inuit activist organization, began agitating for a license from the Canadian government to establish their own Arctic satellite television service, the Inuit Broadcast Corporation (IBC), which was eventually licensed in 1981 (Marks, 1994). The Tapirisat's actions were a response to the launching over their remote lands of the world's first geostationary satellite to broadcast to northern Canada, *Anik B* (David, 1998). Unlike the small-scale encounter with Flaherty's film apparatus, Canadian Broadcast Corporation (CBC) television programming was dumped suddenly into Inuit lives and homes, as the government placed Telsat receiving dishes in nearly every northern community, with no thought to or provision for aboriginal content or local broadcast (Lucas, 1987, p. 15). The Inuit Tapirisat fought this imposition and eventually succeeded in gaining a part of the spectrum for their own use. The creation of the IBC—a production center for Inuit programming of all sorts—became an important development in the lives of contemporary Canadian Arctic people, as well as a model for the possibilities of the repurposing of communications technologies for indigenous peoples worldwide.

By 1983, it became apparent that while IBC programming was remarkably successful, distribution was still problematic, as Inuit work was slotted into the temporal margins of the CBC late-night schedules. In 1991, after considerable effort,[7] a satellite-delivered northern aboriginal distribution system, TV Northern Canada (TVNC), went to air, the first unified effort to serve almost 100 northern communities in English, French, and twelve aboriginal languages (Meadows, 1996; Roth, 1994). By 1997, TVNC, seeking ways to hook up with aboriginal producers in southern Canada, responded to a government call for proposals for a third national cable-based network that would expand beyond northern communities to reach all of Canada. The group was awarded the license and formed the Aboriginal Peoples Television

Network (APTN). This publicly supported and indigenously controlled national aboriginal television network, the first of its kind in the world, officially went to air in September 1999 (David, 1998, p. 39).[8]

Rather than destroying Inuit cultures as some predicted would happen,[9] these technologies of representation—beginning with the satellite television transmission to Inuit communities of their own small-scale video productions—have played a dynamic and even revitalizing role for Inuit and other First Nations people, as a self-conscious means of cultural preservation and production, as well as a form of political mobilization. Repurposing satellite signals for teleconferencing also provides a practical vehicle for a range of community needs served by the acceleration of long-distance communication across vast Arctic spaces for everything from staying in touch with children attending regional high schools to the delivery of health care information (Brisebois, 1991; Marks, 1994).

Prominent among those producing work for these new aboriginal television networks is Inuit director and producer Sak Kunuk, a carver and former Inuit Broadcast Corporation producer. Kunuk has developed a community-based production group in Igloolik, the remote Arctic settlement where he lives, through a process that, ironically, evokes the method used by Robert Flaherty in *Nanook*. Kunuk works collaboratively with people of Igloolik, in particular elders, to create dramatic stories about life in the area around Igloolik in the 1930s, prior to settlement. Along with his partners, cultural director and lead actor Paloussie Quilitalik (a monolingual community elder) and technical director Norman Cohen, a Brooklynite relocated to Nunavut, who together make up the production group Igloolik Isuma, Sak has produced tapes such as *Qaggiq* (Gathering Place) (1989, 58 min.), which depicts a gathering of four families in a late winter Inuit camp in the 1930s; or *Nunavut* (Our Land) (1993–1995), a thirteen-part series of half-hour dramas that re-create the lives of five fictional families (played by Igloolik residents) through a year of traditional life in 1945, when the outside world is at war and a decade before government settlements changed that way of life forever.[10]

These screen memories of Inuit life are beloved locally and in other Inuit communities. They also have been admired in art and independent film circles in metropolitan centers for their beauty, ethnographic sensibility, humor, intimacy, and innovative improvisational method.[11] While reinforcing Inuktitut language and skills for younger members of the community, at a more practical and quotidian level, the project provides interest and employment for people in Igloolik (Berger, 1995a, b; Fleming, 1991, 1996; Marks, 1994). For Inuit participants and viewers, Igloolik Isuma serves as a dynamic effort to resignify cultural memory on their own terms. Not only is their work providing a record of a heretofore undocumented legacy at a time when the generation still versed in traditional knowledge is rapidly passing, but by involving young people in the process, the production of these historical dramas requires that they learn Inuktitut and a range of other skills tied to their cultural legacies, thus helping to mitigate a crisis in the social and cultural reproduction of Inuit life. In the words of an Igloolik elder posted on their web site, "We strongly believe this film has helped in keeping our traditional way of life alive and to our future generations it will make them see how our ancestors used to live."[12] In December 2000, they premiered *Atanarjuat* (The Fast Runner), the world's first feature-length dramatic film written, produced, and acted by Inuit, based on a traditional Igloolik legend, set in sixteenth-century Igloolik. Since then, *Atanarjuat* went on to take the Camera D'Or prize at the

2001 Cannes Film Festival (awarded to the best first film), picking up more prizes as it circulated around the globe; it finally opened in March 2002 in New York City as part of the prestigious New Directors/New Films series.

There are those who argue that television of any sort is inherently destructive to Inuit (and other indigenous) lives and cultural practices. This is despite the fact that many of those participating in it had themselves been critical of the potential deleterious effects of media, and sought ways to engage with media that would have a positive effect on local life. They are also acutely aware of the necessity of such work in a wider context in which native minorities in Canada are struggling for self-determination. For them, these media practices are part of a broader project of constituting a cultural future in which their traditions and contemporary technologies are combined in ways that can give new vitality to Inuit life. This is apparent not only in the narrative constructions of Inuit history on their own terms, but in the social practice of making the work, and in seeing it integrated with Canadian modernity, embodied in the flow of television. One outside observer, after spending time in the Arctic in the 1980s in a number of settlements where Inuit were making community-based videos about their lives for the IBC, concluded that

> The most significant aspect of the IBC's progammes is that they are conceived and produced by the Inuit themselves . . . and it brings a new authority to the old oral culture. . . . When IBC producers first approached elders in order to record songs and stories from their childhood, they took a lot of persuading because many believed that these activities had been officially banned by missionaries. But now, as old crafts and skills have appeared on the IBC screens, so they have proliferated in the settlements. Watching the fabric of their everyday lives, organized into adequate if not glossy TV packages introduced by titles set in Inuktitut syllabics, has helped to weaken for the Inuit the idea that only the whites, with the unrelenting authority of the literate and educated south, can make the final decisions on the value of the Inuit lifestyle. (Lucas, 1987, p. 17)

This effort to turn the tables on the historical trajectory of the power relations embedded in research monographs, photography, and ethnographic practice is intentional, a deeply felt response to the impact of such representational practices on Inuit society and culture. Thus, it is not only that the *activity* of mediamaking has helped to revive relations between generations and skills that had nearly been abandoned. The *fact* of their appearance on television on *Inuit* terms, inverts the usual hierarchy of values attached to the dominant culture's technology, conferring new prestige to Inuit "culture-making."

## Claims to the Nation: Aboriginal Media in Australia

A decade after the Inuit postwar encounter with televisual media, indigenous Australians faced a similar crossroads. In part due to their early consultation with Inuit producers and activists, they too decided to "invent Aboriginal television" (Michaels, 1986), initially by making video images and narratives about and for themselves, shown locally via illegal low-power outback television similar to the Inuit projects described above. By the late 1990s, Aboriginal media production had expanded

from very local television in remote settlements to feature films made by urban film-makers that have premiered at the Cannes Film Festival. Today, the people who are engaged in media work across many divisions within Aboriginal life are themselves influenced by the shifting structures of the Australian polity that have provided resources and ideological frameworks for the development of indigenous media.[13]

The embrace of media—film, video, television—as a form of indigenous expression coincided with an increasing sense of empowerment for Aboriginal people that has accelerated since the 1960s. Until the 1996 elections, which brought in the conservative government headed by John Howard, Australian social policy under Labor Party leadership had made a commitment to social justice for indigenous Australians, establishing in 1990 an indigenous body, the Aboriginal and Torres Straits Islanders Commission (ATSIC)—a complex and sometimes controversial Aboriginal bureaucracy—to govern the affairs of Aboriginal people.[14] In these kinds of formations, media played an increasingly important role in dramatizing Aboriginal claims on the nation. By the 1980s, as part of their demands, both remote living and urban activists increasingly insisted on Aboriginal control over media representation of their lives and communities, which quickly escalated into explicit interest in gaining access to production. At the same time, Aboriginal culture was becoming critical to a distinctive Australian national imaginary linked to its land and oriented away from its European origins. The evident and often conflicting interests of both Aboriginal Australians and the Australian state in media as a site for the production of local identity and sociality as well as claims to a presence in the national imaginary is apparent in the extraordinary development of indigenous media over the past two decades.[15]

Questions about the impact of mass media on Aboriginal lives first received widespread public attention in the mid-1980s with plans for the launching of Australia's first communications satellite over central Australia. As in the Inuit case, its launch generated considerable debate among Aboriginal people, policy makers, and academics about the impact of "dumping" mainstream television signals into traditional indigenous communities in this remote desert area (Ginsburg, 1991, 1993, Michaels, 1986). To preempt the impact of the satellite, the Warlpiri-speaking Aboriginal community of Yuendumu, with the help of American adviser and researcher Eric Michaels, developed its own video production and low-power television station, enabling it to make and show its own productions, in place of the imposition of mainstream Australian television via satellite. It became a model for government efforts to duplicate its success through some not very effective schemes to bureaucratize efforts to bring indigenously governed small media to other Aboriginal outback settlements.[16] Through Michaels' writing, scholars alarmed at the wasteland of television took Warlpiri low-power television as exemplary of the possibilities of alternative TV production, distribution, and reception, although few seem concerned with what has actually happened either to WMA or with Aboriginal media more generally since the late 1980s, despite considerable changes that have occurred.

Since its inception in 1983, WMA has had an unpredictable life based on the presence or absence of certain key players in the community such as Michaels, as well as the variable reliability of white advisers whose crucial impact on these operations—both negative and positive—has been neglected in the analysis of

these projects. Frances Jupurrurla Kelly, the Warlpiri man with whom Eric Michaels worked very closely (1994), carried on the work of WMA for a number of years after Michael's death in 1988, but increasingly acquired other responsibilities in his community that made it difficult for him to sustain the same level of activity and interest. It was only in the late 1990s that WMA was reactivated with the presence for a few years of an energetic and entrepreneurial young white adviser and the renewed interest of community members, especially women, in using video to record their efforts to solve some of their community problems. Most recently, radio has become a focus of community interest.

Since the late 1990s, with the growth of the indigenous media sector across Australia, WMA has been involved intermittently with co-productions. In 1997, WMA worked with two other groups—a regional as well as a national indigenous media association—to produce a piece for a new initiative, the National Indigenous Documentary Series,[17] meant to reflect media being produced in Aboriginal communities throughout Australia and broadcast in late 1997 on the Australian Broadcasting Corporation (ABC), Australia's prestigious state-sponsored channel. Such efforts are much applauded for supporting cooperation between remote and urban Aboriginal people. However, attention to the production process reveals some of the tensions inherent in trying to bring remote Aboriginal media, produced at its own pace for members of the Warlpiri community, into the domain of broadcast television's relentless, industrially driven programming schedules and the imperative to attract mass audiences.

In this case, WMA decided to create a piece about the activities of some of the senior women at Yuendumu who had organized what they had called Munga Wardingki Partu (Night Patrol) to control drinking, abuse, and petrol sniffing at Yuendumu.[18] For a community used to producing video on its own terms and time frame, outside the industrial logics of dominant television practice, the need to have a work on schedule for the anticipated national air date on the ABC and one that could be understood by diverse television audiences created considerable tension during the production process. Indeed, during the delay from the time the proposal had to be submitted to the ATSIC bureaucracy until the project was approved and funding was available, the night patrol had become relatively inactive (in part due to its success) although it managed to reconstitute itself for the documentary. Still, WMA was having difficulty meeting the broadcast deadlines.

Eventually, Rachel Perkins, a Sydney-based Aboriginal filmmaker and executive producer of the series, called in Pat Fiske, an experienced and sympathetic white documentary filmmaker, to help WMA complete the piece on schedule, with a time frame of only three weeks and a small budget. The working style required by such constraints was a source of friction; what in the dominant culture is regarded as a normal production schedule under such circumstances—twelve hours a day—was not appropriate to the pace of life at Yuendumu. To complicate things further, every senior woman who had served on the night patrol insisted on being interviewed (and paid) although it wasn't possible to include them all in the half hour of time they were allotted for the show. Decisions had to be made as well as to how to show some of the scenes where violence occurs, finally agreeing to stylize them in a way that obscured the identity of the people involved. In the end, it is one of the few works of indigenous media that address these kinds of community-based

problems positively by focusing on efforts to solve them internally. Despite the difficulties in making it, people at Yuendumu now proudly claim *Munga Wardingki Partu* as their own.[19] It was considered one of the more innovative pieces in the national series and has translated successfully to non-Aboriginal audiences abroad as well.[20]

## *Aboriginality and National Narratives*

Aboriginal participation and visibility in the Australian mediascape has developed not only for local access to video in remote areas, but also for more Aboriginal representation on national television and, most recently in Australia's lively independent film culture, which is one of the nation's most visible exports. The concern to be included in that dimension of Australia's culture industries is not simply about equal access to the professional opportunities but a recognition that distortion or invisibility of Aboriginal realities for the wider Australian public and even international audiences can have potentially powerful effects on political culture. Aboriginal activists from urban areas were particularly vocal in demanding a positive and creative presence on state-run national television such as Australia's ABC and its alternative multicultural channel, the SBS. The indigenous units that were established out of that moment became an important base for a small and talented group of young urban Aboriginal cultural activists—many of them children of the leaders of the Aboriginal civil rights movement—to forge a cohort and gain the professional experience and entree that is placing them and their work onto national and international stages.

The twenty or so urban Aboriginal people who have entered filmmaking recognize the potential their work has to change the way that Aboriginal realities are understood for the wider Australian public and even international audiences. As a case in point, I want briefly to track the career of Rachel Perkins. The daughter of the late Charlie Perkins, a well-known Aboriginal activist/politician and former sports hero, she exemplifies those most active on the indigenous media scene today, a generation of cultural activists who came of age when the struggle for Aboriginal civil rights was already a social fact, due in large measure to the efforts of their parents. She grew up with new political possibilities in place, but a recognition that the world of representations and the cultural spaces available for them were not so easily changed. For example, when she was born in 1970, just after citizenship was granted to Aboriginal Australians in 1967, blacks and whites were still segregated in cinemas in some parts of Australia.

In 1988, at the age of eighteen, hoping to gain some skills in media and make some contact with Arrernte people, from which her family was descended, Rachel trained originally at a regional Aboriginal media association[21] that serves both remote communities and the small towns and cities that dot Australia's Northern Territory. Once there, she worked her way up to produce and direct language and current affairs programs. In 1991, Rachel came to Sydney to head the indigenous unit of the Special Broadcast Service (SBS), Australia's state-run multicultural television station.[22] While there, she commissioned and produced *Blood Brothers* (1992), a series of four one-hour documentaries focused on different aspects of Aboriginal history and culture told through the personal lives of four prominent

Aboriginal men. Her agenda was, in a sense, to find a way to create "screen memories" for the majority of Australians—black and white—who knew virtually nothing of the role of Aboriginal people in the formation of modern Australia. The first was about her father Charles Perkins, a national soccer champion who became the first Aboriginal student at Sydney University. In 1965, he worked with other student activists to organize "freedom rides" to challenge the racist conditions under which Aboriginal people lived in rural towns at the time. The documentary retraces the history of this initial stage of the Aboriginal civil rights movement through the retrospective accounts by Perkins and his fellow protesters, both black and white, as they revisit the places where they had carried out civil disobedience over twenty-five years ago.

**[ · · · ]**

In 1993, frustrated by lack of funds and compromises she had to make, Rachel left the SBS.[23] Eventually, she formed her own production company, Blackfella Films, in order to complete her first feature film, *Radiance* (1997). Adapted from a work by Euro-Australian playwright Louis Nowra, the story unfolds as unspoken complex secrets are revealed about the relationships among three Aboriginal sisters, each of whom embodies a different relationship to her cultural identity, and who reunite after the death of their mother. The film was a major success in Australia, and in the summer of 1997, it screened at the Cannes Film Festival in France.

Rachel Perkins's work as filmmaker, producer, and activist is exemplary of a young Aboriginal cultural elite engaged in constituting a vital Aboriginal modernity through a variety of media, including music, visual arts, film, and drama. These forms provide vehicles for new narrations of the place of Aboriginality in the nation—*Freedom Ride, Night Patrol*, and *Radiance* are but three examples—that are not tied to traditional practices. This work has helped to establish and enlarge a counter public sphere in which Aboriginality is central and emergent, especially in the context of the changed circumstances signified by the 1993 Australian High Court Mabo decision recognizing Native Title.

**[ · · · ]**

Historic legislation overturn[ed] 200 years of *terra nullius*, recognizing prior indigenous ownership of so-called Crown Land. Part of the evidence for rights to land on Mer Island (north of Australia), was footage of one of the first films ever made of indigenous people: English anthropologist Alfred Court Haddon's documentary of Mer (Murray) Islanders performing dances in 1898 that are still in use today, proving continuity of tradition. There is some irony in this resignification, since Haddon, in the tradition of his day, was interested in capturing images of these people before they disappeared from the face of the earth (Holgate, 1994). Instead, the Haddon footage provided the visible evidence—the screen memories—that proved the very opposite: that they are still very much alive and continue to occupy the land that has been part of their cultural legacy. The use of this ethnographic footage for the purpose of a land claim reversed its status as a late-nineteenth-century sign of the imagined extinction of Aboriginal culture. It turned the footage instead into an index of their cultural persistence and a basis for indigenous claims to their land and cultural rights in the present. This reversal

stands, metaphorically, for the ways in which indigenous people have been using the inscription of their screen memories in media to "talk back" to structures of power and state that have denied their rights, subjectivity, and citizenship for over 200 years.

## Alternative Accountings

Film, video, and television—as technologies of objectification as well as reflection—contain within them a doubled set of possibilities. They can be seductive conduits for imposing the values and language of the dominant culture on minoritized people, what some indigenous activists have called a potential cultural "neutron bomb," the kind that kills people and leaves inanimate structures intact (Kuptana cited in David, 1998, p. 36). On the other hand, these technologies—unlike most others—also offer possibilities for "talking back" to and through the categories that have been created to contain indigenous people. It is not the technologies themselves, of course, that produce the latter possibility, but the timing and social location of their arrival. Despite his facility with the camera, Allakariallak's participation in Flaherty's film was not acknowledged, nor were the structures in place that would have enabled him to really make use of the "Aggie." For Inuit fifty years later, politically mobilized and subject to the regimes of the state in their lives, access to a satellite has been crucial, linking communities across the Arctic (and Canada) in ways that are culturally and politically powerful.

Similarly, after a long history as objects of photographic representation, media was first embraced by Aboriginal people at a particular historical conjuncture in Australia. In the 1980s, progressive state policy, indigenous activists, an independent and alternative film culture, and remote and urban Aboriginal people all became interested—sometimes for different reasons—in how these media could be indigenized formally and substantively to give objective form to efforts for the expression of cultural identity, the preservation of language and ritual, and the telling of indigenous histories.

[ · · · ]

By the mid-1990s, when a new cohort started to leave the confines of documentary and work in dramatic genres, they found yet another mode of expressive possibility. These more recent fictional works offer self-conscious, alternative, and multiple accountings of indigenous life-worlds, as in the complex gendered, cultural landscape given almost surreal shape in feature films such as Rachel Perkins's *Radiance* (1997), or in the stark, supernatural Inuit universe invoked in the retelling of the ancient Inuit legend *Atanarjuat* (The Fast Runner, 2001). These works are, increasingly, circulating on a world stage.

[ · · · ]

Positioned somewhere between the phenomenological life-worlds of their everyday lives, the colonial categories through which they have been constituted, and a globalizing image economy that is increasingly receptive to their work, the making of these media are part of a broader set of practices through [which] they are reflecting on and transforming the conditions of their lives.

## NOTES

This essay is expanded from an earlier one, "Screen Memories: Resignifying the Traditional in Indigenous Media," published in *Media Worlds: Anthropology on New Terrain*, ed. Faye Ginsburg, Lila Abu-Lughod, and Brian Larkin (Berkeley, Calif., 2002). Thanks to Bob Stam and Ella Shohat for their comments for this version, and Lila Abu-Lughod, Brian Larkin, Fred Myers, Barbara Abrash, and Jay Ruby for their helpful readings of earlier versions of this draft; and to the many people engaged in indigenous media in Australia and Canada who have generously shared their time and insights with me while I was there, including Brian Arley, Philip Batty, Norman Cohen, Brenda Croft, Graham Dash, Jennifer Deger, Francoise Dussart, Pat Fiske, Melinda Hinkson, David Jowsey, Tom Kantor, Zack Kunuk, Frances Jupurrurla Kelley, Brett Leavy, Marcia Langton, Mary Laughren, Michael Leigh, Rachel Perkins, Frances Peters, Catriona McKenzie, Michael Meadows, Helen Molnar, Nicki McCoy, Michael Riley, Sally Riley, Lorna Roth, Walter Saunders, and many others. Support for travel for this research has come in part from Guggenheim and MacArthur Fellowships.

1. While *indigenous* can index a social formation "native" to a particular area (e.g., "I Love Lucy" is indigenous to America), we use it here in the strict sense of the term, as interchangeable with the neologism *First Peoples* to indicate the original inhabitants of areas later colonized by settler states (Australia, the United States, New Zealand, Canada, most of Latin America). These people, an estimated 5 percent of the world's population, are struggling to sustain their own identities and claims to culture and land, surviving as internal colonies within encompassing nation-states.

2. *Bad Aboriginal Art: Tradition, Media, and Technological Horizons*, a posthumous collection of Eric Michaels's writings based on his activist research in Australia, was published in 1994.

3. For this debate in the context of indigenous media, see the spring 1997 issue of *Current Anthropology* (Weiner et al.) and the spring 1998 issue of *Lingua Franca* (Palatella).

4. *Nanook* is discussed in nearly every book written on documentary, as well as in much of the revisionist scholarship on the genre. For other discussions of the gramophone scene, see Rony (1996), Ruby (2000), Taussig (1995).

5. In the case of *Nanook*, for example, in terms of the broader political economy, the film bears traces of the end of the global fur trade that fueled much of the settlement of North America. *Nanook* was sponsored by Revillon Freres, the French fur company that owned the trading post in the film, and was completed in 1922 at a historical moment when the fur of Arctic foxes, which Nanook hunts in the film and brings to the post, graced many a Parisian shoulder. These global trading processes underwrote and set the stage for the initial engagement of Allakariallak and others with the technologies of cinematic objectification (Ray, 2000).

6. Through processes of displacement and condensation, Freud writes: "what is important is replaced in memory by something else which appears unimportant" (1975, p. 248). For a fuller discussion of his concept of screen memory, see Chapter V in *The Psychopathology of Everyday Life* (1901/1975).

7. A 1986 report by the Federal Task Force on Broadcasting Policy, in its support of aboriginal broadcasting as an integral part of the Canadian broadcasting system, called for a separate satellite distribution system to carry aboriginal language programming (David, 1998).

8. The APTN is a unique TV experiment in many ways. The Canadian government has ordered cable systems to carry it as part of their basic package, a mandate that has met with some opposition from the Canadian Cable Television Association; "guilt tax," although others have been more enthusiastic. For further information, see their web site at www.aptn.ca.

9. Jerry Mander (1991), for example, argues that video and television technologies are irredeemably destructive to native life. His argument, as Laura Marks pointed out in her overview of Inuit media, "equates tradition with rigidity, rather than understand adaptability itself as a longstanding value" (1994, p. 6) and also fails to account for what kind of media are actually being made. A more recent example is anthropologist James Weiner's 1997 polemic, "Televisualist Anthropology," directed against indigenous media, which he calls "ersatz culture," and those who study it, including myself. We argue that far from being subsumed by contact with mass cultural forms, as these critics have argued, indigenous mediamakers have taken on Western media technologies to defend themselves against what they see as the culturally destructive effects of mass media, producing work about their own lives, a strategy some have called "innovative traditionalism." A more poetic phrasing, "Starting Fire With Gunpowder," used for the title of a film made about the IBC (Poisey and Hansen, 1991), captures the sense of turning a potentially destructive Western form into something useful to the lives of indigenous people.

10. Their works are produced in the Inuktitut language and syllabics (for titling) and are subtitled in English and French. For those interested in finding out more about the work of this extraordinary group, I recommend their web site, www.isuma.ca.

11. Produced with the support of Canada Council, National Film Board, and Government of the Northwest Territories, the work of Igloolik Isuma has been seen on TVNC and in screenings at many institutions, including the National Gallery of Canada, the Museum of Modern Art in New York, the American Film Institute, Musée d'art moderne, Paris, and the Museum of Northern Peoples, Hokkaido, Japan. Reviews from mainstream papers have been appreciative to laudatory.

12. See comments by T. Nasook on www.isuma.ca.

13. Elsewhere, I situate the work within more global developments, from the marketing of satellites and small media technologies, to the growth of transnational political networks supporting the rights of indigenous peoples, to more specialized cultural arenas such as international indigenous film festivals, which have become important sites for constituting linkages among indigenous mediamakers worldwide (Ginsburg, 1993).

14. These state policies and bureaucracies must be understood in part as an outgrowth of modern movements for Aboriginal rights. The expansion of indigenous political and cultural activism—inspired in part by the civil rights and Black Power movements in the United States—helped catalyze constitutional changes that granted Aboriginal Australian voting rights in 1962 and Australian citizenship in 1967, and set the stage for the developing recognition of Aboriginal claims for land rights and cultural autonomy beginning in the 1970s.

15. In 1980, only a few radio shows existed. In a 1994 survey of indigenous involvement in media (not including the growth in radio), remote communities had 150 local media associations, eighty small-scale television stations, and two satellite television services with indigenous programming. By 1993, a representative body, the National Indigenous Media Association of Australia (NIMAA), was formed to advocate for and help to link the hundreds of indigenous broadcasters working in radio, video, and television throughout Australia. Additionally, the creation of Indigenous Program Units at the state-sponsored television stations, ABC and SBS in 1989, helped create a base for a strong urban cohort of mediamakers that came into their own a decade later.

16. For scholars alarmed at the "wasteland" of TV, the Yuendumu experiment acquired the aura of a plucky outback David whose tiny satellite dishes and culturally distinctive video productions served as a kind of well-targeted epistemological slingshot against globalizing satellites and mass media programming (e.g., Hebdige, 1994). This valorization of circumstances in which indigenous people are represented as existing comfortably with both their own traditions and Western technologies is embodied not only in state policy,

but also in popular media, a particular embrace of Aboriginal modernity that elsewhere I have called hi-tech primitivism (Ginsburg. 1993, p. 562).

17. WMA has worked with the regional group the Central Australian Aboriginal Media Association (CAAMA), based in Alice Springs, as well as the national indigenous advocacy organization, the National Indigenous Media Association of Australia (NIMAA), which sponsored the series with support from the Aboriginal bureaucracy ATSIC, as well as the ABC and the Olympic Arts Festival.

18. The video project about the night patrol was directed by a Warlpiri woman, Valerie Martin, who worked with the help of WMA's white adviser, the late Tom Kantor.

19. While some of this was going on while I was in Central Australia in 1997, I am also grateful to Pat Fiske and Tom Kantor for providing me with their views of the situation.

20. For example, it was one of two works from the series selected for the Margaret Mead Film Festival in New York City and was warmly received at the screenings I attended there.

21. The station she trained at was CAAMA, located in Alice Springs. For an account of the formation of this station, see Ginsburg (1991). Rachel's knowledge of work from remote communities and regional media associations was influential in bringing that work into urban Aboriginal settings; she has continued to play a key role in programming work from both remote and urban Aboriginal communities on national television.

22. Faced with a small budget and few resources, she created work at SBS but also brought in material from regional and local Aboriginal media associations through her links to CAAMA and more remote groups in its orbit, such as the Warlpiri Media Association (WMA) at Yuendumu.

23. The next year, she was recruited to head up the Indigenous Programs Unit at the ABC where, in addition to continuing their Aboriginal cultural affairs show, "Blackout," she produced a series on Aboriginal music, "Songlines," and negotiated the agreement with NIMAA to act as executive producer for the eight works for the National Indigenous Documentary Series—*Night Patrol* was one—made in 1997 and screened on the ABC later that year. During that period, Rachel took a temporary leave from the ABC in order to complete *Radiance* with her partner, Euro-Australian filmmaker Ned Lander.

## REFERENCES

Alexie, Sherman. *The Lone Ranger and Tonto Fistfight in Heaven*. New York: Harper Perennial, 1994.

Appadurai, Arjun. *Modernity at Large: Cultural Dimensions of Globalization*. Minneapolis: University of Minnesota Press, 1996.

Berger, Sally. "Move Over Nanook." *Wide Angle* 17, nos. 1–4 (1995a): 177–192.

———. "Time Travellers." *Felix: A Journal of Media Arts and Communication* 2 no. 1 (1995).

Brisebois, Deborah. *Whiteout Warning: Courtesy of the Federal Government*. Inuit Broadcasting Corporation, 1991.

Castels, Manuel. *The Rise of the Network Society*. Oxford: Blackwell, 1997.

David, Jennifer. "Seeing Ourselves, Being Ourselves: Broadcasting Aboriginal Television in Canada." *Cultural Survival Quarterly* 22, no. 2 (summer 1998): 36–39.

Faris, James. "Anthropological Transparency, Film, Representation and Politics." In *Film as Ethnography*, ed. P. Crawford and D. Turton, pp. 171–182. Manchester: University of Manchester Press, 1992.

Fleming, Kathleen. "Igloolik Video: An Organic Response from a Culturally Sound Community." *Inuit Art* 11, no. 2 (1996): 30–38.

Freud, Sigmund. *Abstracts of The Standard Edition of the Complete Psychological Works of Sigmund Freud*, ed. Carrie Lee Rothgeb. Rockville, Md: NIMH, 1975.

Gaines, Jane. "White Privilege and Looking Relations: Race and Gender in Feminist Film Theory." *Screen* 29, no. 4 (1998): 12–27.

Ginsburg, Faye. "Indigenous Media: Faustian Contract or Global Village?" *Cultural Anthropology* 6 no. 1 (1991): 92–12.

———. "Aboriginal Media and the Australian Imaginary." *Public Culture* 5, no. 3 (1993). Special Issue, Screening Politics in a World of Nations, ed. Lila Abu-Lughod, 557–578.

———. "Culture/Media: A (Mild) Polemic." *Anthropology Today* (1994).

Hebdige, Dick. Foreword. In *Bad Aboriginal Art: Tradition, Media, and Technological Horizons*. Minneapolis: University of Minnesota Press, 1994.

Hendrick, Stephen, and Kathleen Fleming. "Zacharias Kunuk: Video Maker and Inuit Historian." *Inuit Art* 6, no. 3 (1991): 24–28.

Holgate, Ben. "Now For a Celluloid Dreaming." *Sydney Morning Herald*, November 23, 1994.

Juhasz, Alexandra. *Aids TV: Identity, Community, and Alternative Video*. Durham, N.C.: Duke University Press, 1995.

Kuttab, Daoud. "Grass Roots TV Production in the Occupied Territories." In *Channels of Resistance: Global Television and Local Empowerment*, ed. Tony Downmunt. London: British Film Institute, 1993.

Lucas, Martin. "TV on Ice." *New Society* 9 (1987): 15–17.

Mahon, Maureen. "Black Like This: Race, Generation, and Rock in the Post-Civil Rights Era." *American Ethnologist* 27, no. 2 (2000): 283–311.

Mander, Jerry. *In the Absence of the Sacred: The Failure of Technology and the Survival of the Indian Nations*. San Francisco: Sierra Club Books, 1991.

Marks, Laura. "Reconfigured Nationhood: A Partisan History of the Inuit Broadcasting Corporation." *Afterimage* (March): 4–8.

Meadows, Michael. "Indigenous Cultural Diversity: Television Northern Canada." *Culture and Policy* 7, no. 1 (1996): 25–44.

Michaels, Eric. *The Aboriginal Invention of Television in Central Australia: 1982–1986*. Canberra: Australian Institute of Aboriginal Studies.

———. *Bad Aboriginal Art: Tradition, Media, and Technological Horizons*. Minneapolis: University of Minnesota Press, 1994.

Miller, Daniel. Introduction: Anthropology, Modernity, Consumption. In *Worlds Apart: Modernity Through The Prism of the Local*, ed. Daniel Miller, pp. 1–23, London: Routledge, 1995.

Miller, Toby. "Exporting Truth from Aboriginal Australia: Portions of Our Past Become Present Again, Where Only the Melancholy Light of Origin Shines." *Media Information Australia* 76 (1995): 7–17.

Muecke, Stephen. "Narrative and Intervention: Aboriginal Filmmaking and Policy." *Continuum* 8, no. 2 (1994): 248–57.

Pinney, Chris. *Camera Indica: The Social Life of Photographs*. London: Blackwell, 1998.

Poisey, David, and William Hansen. 1991. *Starting Fire with Gunpowder*. Video by Tamarack Productions, Edmonton, Canada.

Prins, Harald. "The Paradox of Primitivism: Native Rights and the Problem of Imagery in Cultural Survival Films." *Visual Anthropology* 9, no. 3–4 (1997): 243–266.

Rony, Fatimah. *The Third Eye: Race, Cinema, and Ethnographic Spectacle*. Durham, N.C.: Duke University Press, 1996.

Roth, Lorna. *Northern Voices and Mediating Structures: The Emergence and Development of First Peoples' Television Broadcasting in the Canadian North.* Unpublished dissertation, Concordia University, Montreal, Canada, 1994.

————. *Something New in the Air: Indigenous Television in Canada.* Montreal: McGill Queens University Press, 2002.

Roth, Lorna, and Gail Valaskakis. "Aboriginal Broadcasting in Canada: A Case Study in Democratization." In *Communication for and Against Democracy*, ed. Marc Raboy and Peter Bruck, pp. 221–234. Montreal: Black Rose Books, 1989.

Rotha, Paul, with Basil Wright. "Nanook and the North." *Studies in Visual Communication* 6, no. 2 (summer 1980): 33–60.

Ruby, Jay. "Introduction: Nanook and the North." *Studies in Visual Communication* 6, no. 2 (summer 1980).

————. *Picturing Culture: Explorations of Film and Anthropology.* Chicago: University of Chicago Press, 2000.

Schein, Louisa. "Mapping Among Media in Diasporic Space." In *Media Worlds: Anthropology on New Terrain*, ed. Faye Ginsburg, Lila Abu-Lughod, and Brian Larkin. Berkeley: University of California Press, 2002.

Singer, Beverly. *Wiping the Warpaint off the Lens: Native American Film and Video.* Minneapolis: University of Minnesota Press, 2001.

Taussig, Michael. *Mimesis and Alterity.* New York: Routledge, 1994.

Turner, Terence. "Anthropology and Multiculturalism; What is Anthropology That Multiculturalists Should Be Mindful of It?" *Cultural Anthropology* 8, no. 4 (1993): 411–429.

Weiner, James. "Televisualist Anthropology: Representation, Aesthetics, Politics," *Current Anthropology* 38, no. 2 (1997): 197–236.

# PART 10
# NATIONAL AND TRANSNATIONAL FILM HISTORIES

*Three Algerian women who are dressed as Frenchwomen manage to pass through the French checkpoints and plant three bombs in the European sector. The scene depicts both the Algerian women's preparations and the activities of their soon-to-be victims. A series of close-ups of the women individualizes them, and the sexist comments of the French soldiers heard from the women's aural perspective make us sympathize with them. By the time they plant the bombs, our identification with the three women is so complete that camera shots of the potential victims—a man having a drink at a bar, people dancing, a child eating ice cream—do not turn us against the Algerians. The bombing is portrayed as an expression of the rage of an entire people rather than that of a fanatical minority, a necessary political act rather than an erratic and random outburst.*

From Gillo Pontecorvo's *The Battle of Algiers* (Italy/Algeria, 1965)

One of the most influential political films in history, and the most famous example of the revolutionary filmmaking movement known as Third Cinema, *The Battle of Algiers* by Gillo Pontecorvo reenacts events during the Algerian war for independence that raged from 1954 to 1962. The film in many ways embodies the questions and contradictions that have shaped the relationship between cinema and the nation in film studies. In this remarkable, documentary-like film of the Algerian revolution, clear boundaries are drawn between the French part of the city and the Algerian casbah, with barbed wire and barracks as dividing line between the two worlds. The film clearly deploys mechanisms of

905

identification on behalf of the colonized, establishing an integral link between the cultural dignity and agency of Algerian people and their struggle for independence. As such, the film points to the central role of cinema in (re)drawing national boundaries and shaping national consciousness. Produced by the postrevolutionary government, the film stands as an important example of national cinema. Yet the film was directed by an Italian director, and its aesthetic model—which deploys many Italian neorealist techniques—as well as the story of its reception and distribution, makes its status as Third Cinema ambiguous, as that concept is associated with the Third World. Moreover, its 2003 screening at the Pentagon during the Iraq War showed how the film's ideological position could be appropriated by opposing interests, which questions altogether the adequacy of the concept of national cinema to describe the film and aligns it more with the contradictory and hybrid nature of transnational cinema.

While both cinema and the concept of the nation are relatively recent phenomena in the larger scheme of history, they have always had a close but problematic relationship to one another and to the larger cultural sphere. On the one hand, cinema has been an international medium from its very beginning; as a visual medium, it transcends the boundaries of nations and the limitations of languages. However, cinema has also always played a key role in shaping, affirming, negotiating, or subverting the construction of nationhood and national identity, as well as the drawing of national barriers (literal or imaginary). D. W. Griffith's *The Birth of a Nation* (1915), one of the first American feature films, provides an epic and mythical account of the history of the American nation—a nation whose birth is predicated on demarcating African Americans as the inferior "Other" against whom white "superiority" is defined. In the Soviet Union during the 1920s, Lenin famously proclaimed cinema to be "the most important of all arts" and used it strategically to spread the message of the revolution and to reunify and consolidate his shattered nation. Inspired by Lenin, the German government of the 1930s realized the enormous propaganda value of film and skillfully manipulated it to objectify their fascist ideals; *Triumph of the Will* (1935), the most famous film of the period, quickly became a model for film propaganda among the Allies during World War II.

Post–World War II international new wave movements, such as Italian neorealism, reacted to how cinema had been manipulated to serve nationalist projects and again deployed cinema in the service of nation building, but this time remaining faithful to contemporary social reality. The collapse of European empires and the emergence of independent Third World nation-states led to an explosion of cinema internationally. As shown by *The Battle of Algiers*, the cinema of these new nations not only played a key role in shaping their emerging identities but also provided a political and cinematic counter-telling to Western metanarratives. In the current age of globalization, there is the dissolution of national boundaries on the one hand and global eruptions of ethnic nationalism on the other. Analyses of national cinema and its relationship to the concept of world cinema are all the more urgent, and the relationship between cinema and the nation remains at the forefront of the debates in film studies.

Despite this close relationship, understanding and defining either "nation" or "national cinema" has been a fruitful but messy business. "Nation" is an abstract notion, the essence of which has been impossible to determine. Accordingly, there exist various approaches to the concept of the nation in critical theory, including nation as a nation-state; nation as the linking of state and culture; nation as a common cultural destiny; nation as a soul; nation as

a narrative; and nation as a symbol. Defining "national cinema," as so many scholars have acknowledged, has been no less difficult. For example, how can we say that *The Battle of Algiers* is Algerian? Because it was made in Algeria? Because its actors are Algerian? Or because the film is about Algerian history? And how does the fact that its director and screenwriter are Italian, or that its exhibition largely depended on the European festival circuit, change its national label? These questions about the production, distribution, exhibition, and aesthetic aspects of the film show that cinema can be "national" in numerous ways.

A standard point of departure for new approaches to the concept of the nation is BENEDICT ANDERSON's groundbreaking study *Imagined Communities* (1983). Refusing to define a nation by a set of external, objective social facts, Anderson proposes a definition of the nation as "an imagined political community—and imagined as both inherently limited and sovereign." This seemingly simple but deeply influential thesis changed the course of study of nationhood. Perhaps even more significant than his assertion that the nation is "thought out" and "created" is Anderson's argument that national consciousness is a product of the social changes of the nineteenth century, such as communication and transportation technology, the development of specific linguistic cultures, and print capitalism. Thus, for Anderson, nationalism is secularized (as opposed to being based on cosmological or religious knowledge), as well as distinguished from the notion of a geographically and politically defined nation-state, emerging instead in a cultural realm.

This insight, that national imaginings are always shaped in, and by, a form (in Anderson's account, this form is the novel and newspaper), that nations are imaginary constructs whose existence is dependent on the apparatus of cultural fictions, was particularly salient for film studies. Cinema has assumed the status of a dominant medium of communication and thus plays a crucial role in conjuring up the narratives of an imagined community. Questions about how film narrates this imagined community and the awakening to the notion of the "national" have determined some of the most significant debates, methodological approaches, and fields of specialization in film studies.

Another implication of Anderson's emphasis on form for film studies was that studies of national cinema should include not only the body of films produced and circulated within a specific nation-state but also different *aesthetic* models of national cinema. The two manifestos included here, while representing two important national film movements, also point to the extent to which national cinema production is predicated on the *form* of national imagining—in this case aesthetic models that are distinct from those of Hollywood. CESARE ZAVATTINI's "Some Ideas on the Cinema" presents a theoretical foundation for Italian neorealism, calling for a new kind of Italian film that would abolish contrived plots, do away with professional actors, and establish direct contact with contemporary reality. The new realism that Zavattini championed defines itself against both the myths and ideals of Fascist propaganda films and the dominant Hollywood mode of production. The cinematic ideals proposed by Zavattini would later become part of the larger European art cinema model that flourished in the 1960s and 1970s that also defined itself against Hollywood, both textually and in terms of distribution and exhibition channels.

Rejecting the conventional narrative syntax of Hollywood and the elitism of European art cinema, Argentine filmmakers FERNANDO SOLANAS and OCTAVIO GETINO's manifesto, "Towards a Third Cinema," embodies this revolutionary movement. The authors championed a militant, oppositional cinema that would play an active part in the anti-imperialist struggle

for national liberation. Seeing Hollywood and European art cinema as expressions of bourgeois individualism, Solanas and Getino called for cinema to be used as a means of raising consciousness rather than providing entertainment. The emphasis on aesthetic form in both Zavattini's and Solanas and Getino's manifestos casts doubt on the concept of unity and coherence implied in national cinema, since aesthetic categories are highly permeable and transcend national boundaries.

Since the 1980s, accounts of national cinemas have gone much further in questioning the concept of the "national," seeing it as incapable of acknowledging the diversity that marks the members of both the nation-state and more geographically dispersed communities. STEPHEN CROFTS does not abandon outright the concept of national cinema in his essay "Reconceptualizing National Cinema/s." Rather, he reconceives the concept to offer an account of the global reach of national cinemas in terms of "the multiple politics of their production, distribution, and reception, their textuality, their relations with the state and with multiculturalism." In fact, most comprehensive studies of national cinemas have taken up these categories in their analysis of national film cultures.

One of the positive consequences of expanding and reconceptualizing national cinema, considering it in "non-First World terms," as Crofts says, has been an acknowledgment of a wider range of national cinemas over the last twenty years. One example of this is the publication of monograph studies on Australian, Canadian, Filipino, Iranian, and Turkish national cinema, among others. It has also meant paying attention to popular, commercial cinemas within specific countries, which were too often ignored by previous studies that tended to focus only on cinema produced for export. Thus, national cinema was for a long time synonymous with European art cinema, and film festivals, a major site of circulation of national cinemas, have nurtured this aestheticizing of culturally specific films. Meanwhile, commercial cinemas that compete with Hollywood in domestic markets are not exported and thus less known and not considered by film cultures that define the critical terms of national cinema.

Studies of popular cinemas and their ambivalent relationship to the "national" have thus been an important methodological step beyond an exclusive focus on art cinema. JYOTIKA VIRDI's analysis of popular Hindi film in post-independence India, *The Cinematic ImagiNation*, shows how cinema bears out a unique cultural history and both reflects and deflects breakdowns in the notion of the nation. In the context of India's unique diversity and postcolonial history, Virdi shows how popular film takes on the function of creating a national imaginary, but also how this image of the nation collapses under the contradictions of gender, class, and religious communities that "crosshatch the nation" and disrupt official national narration.

The 1980s and 1990s put further pressure on the concept of the "national" due to the consolidation of global markets, advances in the technology of communications, and further weakening of national and economic boundaries. New models that accounted for these developments emphasized the deterritorialized character of supranational imagined communities. Rather than seeing multicultural issues in a national or postnational context, these models see them in a transnational or global context, abandoning the concept of the "national" as obsolete and inadequate. Increasingly, the concept of the transnational is used to understand the hybrid ways in which filmmakers imagine today's world as a global system rather than a collection of autonomous nations. Fundamental to this new understanding of how global forces change the way films are produced, received, and circulated, as well as how they reimagine national identities, are the emerging studies in

exilic and diasporic cinemas. HAMID NAFICY's *An Accented Cinema* is a groundbreaking account of how such cinemas urge us to rethink traditional categories in film such as production, consumption, and spectatorship. At once local and global, and at the same time allegorizing and critiquing the deterritorialized condition of its filmmakers, "accented cinema" grounds the concept of "transnational" in situations where displacement becomes a permanent condition rather than a temporary crisis.

The global nature of film production, consumption, and distribution has encouraged renewed attention to world cinema as a major cultural force and as an expanding academic field, rapidly gaining scholarly respectability and inspiring new academic and educational initiatives. In recent discussions and studies, the most pressing questions revolve around defining world cinema and around methodology. How can we approach the study of world cinema beyond the rather random and compulsory surveys of film? DUDLEY ANDREW's "An Atlas of World Cinema" is an influential intervention into these debates, defining world cinema not as a sum of all national cinemas or cinemas in opposition to Hollywood, but in terms of its "situatedness." From this perspective, world cinema, rather than being a positivist category, represents a specific vision of the world from the perspective of the West. Andrew utilizes the political, demographic, linguistic, orientational, and topographical aspects of mapping to draw his "atlas" of world cinema. He argues that studying world cinema should not function as a ticket to foreign nations but instead "put [us] inside unfamiliar conditions of viewing" and "let us know the territory differently, whatever territory it is that the film comes from or concerns." Emphasizing perspective, Andrew points to the invaluable potential that the discipline of world cinema brings to methodologies and critical approaches to film.

The following selections demonstrate that the lines delineating the national, which were clearly drawn in *The Battle of Algiers*, have become more elusive and complex. Similarly, the parameters for studying national cinema have expanded and evolved. In this age of unprecedented exposure and global circulation of film, the pressing question we should be asking ourselves is not how many films from which countries did I see? but rather from what position are we seeing, understanding, and theorizing film, and how does our perspective impact how cinema is made, circulated, and discussed around the world?

# BENEDICT ANDERSON

## From *Imagined Communities*

Benedict Anderson (b. 1936) is Professor Emeritus of International Relations, Government, and Asian Studies at Cornell University, specializing in Indonesia. His book *Imagined Communities: Reflections on the Origin and Spread of Nationalism*, first published in 1983 and revised in 1991, is a central text in contemporary understandings of nationalism, and his emphasis on the role of print in defining national belonging has made his account very useful to media studies scholars.

Anderson argues that although national origins are often represented as ancient or outside of history, our understanding of the nation is actually a modern invention, developed

from the imperial expansion of the eighteenth century and derived from the relations of power and exchange established by capitalism. Writing in the Marxist historical tradition, Anderson seeks to understand why twentieth-century revolutions were nationalist in nature. These questions were given new relevance with the collapse of the Soviet Union in 1991 and the rise of new nationalisms, as mentioned in the preface to the second edition of *Imagined Communities*. World cinema at the end of the twentieth century and the beginning of the twenty-first century exhibited similar contradictions. Films illuminated myths of national origins as well as ethnic and border tensions, while the availability of co-production funds and global distribution provided new transnational resources and opportunities.

This excerpt begins with Anderson's influential definition of a nation from the book's short introduction: "an imagined political community—and imagined as both inherently limited and sovereign." The imaginary nature of this relationship is evident in the fact that, while it is impossible to know all of one's fellow citizens, one nevertheless feels a sense of comradeship with them. Anderson later argues that this national consciousness was facilitated by the advent of print, which standardized a national language and offered a sense of simultaneous, shared experience to citizens as potential readers of the same book or newspaper. However, Anderson does call this understanding of nation "limited," implying that there are outsiders and insiders, and thus territories and values to be defended. Anderson also argues that in the modern political order, the nation achieves sovereignty by becoming coupled with the state. Nationalisms are consolidated and challenged through stories and symbols of national belonging. Although Anderson does not address cinema directly, it is clear that the medium has played an important role in these vital dramas over the last century.

## READING CUES & KEY CONCEPTS

◼ What is Anderson's definition of the nation, and how can terms like "nationality" and "nationalism" be clarified through this definition?

◼ Reflect on Anderson's understanding of the imaginary bonds created by media in relation to television networks like NBC (National Broadcasting Company), or BBC (British Broadcasting Corporation) that, whether private or state-owned, provide programming for a national audience.

◼ Consider how films like *The Birth of a Nation* use myths of origin to create limits to national belonging.

◼ **Key Concepts:** Nation; Nationalism; Sovereignty; Imagined Community

# From *Imagined Communities*

. . . . . . . . . . . . . .

My point of departure is that nationality, or, as one might prefer to put it in view of that word's multiple significations, nation-ness, as well as nationalism, are cultural artefacts of a particular kind. To understand them properly we need to consider carefully how they have come into historical being, in what ways

their meanings have changed over time, and why, today, they command such profound emotional legitimacy. I will be trying to argue that the creation of these artefacts towards the end of the eighteenth century[1] was the spontaneous distillation of a complex "crossing" of discrete historical forces; but that, once created, they became "modular," capable of being transplanted, with varying degrees of self-consciousness, to a great variety of social terrains, to merge and be merged with a correspondingly wide variety of political and ideological constellations. I will also attempt to show why these particular cultural artefacts have aroused such deep attachments.

## *Concepts and Definitions*

Before addressing the questions raised above, it seems advisable to consider briefly the concept of "nation" and offer a workable definition. Theorists of nationalism have often been perplexed, not to say irritated, by these three paradoxes: 1. The objective modernity of nations to the historian's eye vs. their subjective antiquity in the eyes of nationalists. 2. The formal universality of nationality as a socio-cultural concept—in the modern world everyone can, should, will "have" a nationality, as he or she "has" a gender—vs. the irremediable particularity of its concrete manifestations, such that, by definition, "Greek" nationality is sui generis. 3. The "political" power of nationalisms vs. their philosophical poverty and even incoherence. In other words, unlike most other isms, nationalism has never produced its own grand thinkers: no Hobbeses, Tocquevilles, Marxes, or Webers. This "emptiness" easily gives rise, among cosmopolitan and polylingual intellectuals, to a certain condescension. Like Gertrude Stein in the face of Oakland, one can rather quickly conclude that there is "no there there." It is characteristic that even so sympathetic a student of nationalism as Tom Nairn can nonetheless write that: "'Nationalism' is the pathology of modern developmental history, as inescapable as 'neurosis' in the individual, with much the same essential ambiguity attaching to it, a similar built-in capacity for descent into dementia, rooted in the dilemmas of helplessness thrust upon most of the world (the equivalent of infantilism for societies) and largely incurable."[2]

Part of the difficulty is that one tends unconsciously to hypostasize the existence of Nationalism-with-a-big-N—rather as one might Age-with-a-capital-A—and then to classify "it" as *an* ideology. (Note that if everyone has an age, Age is merely analytical expression.) It would, I think, make things easier if one treated it as if it belonged with "kinship" and "religion," rather than with "liberalism" or "fascism."

In an anthropological spirit, then, I propose the following definition of the nation: It is an imagined political community—and imagined as both inherently limited and sovereign.

It is *imagined* because the members of even the smallest nation will never know most of their fellow-members, meet them, or even hear of them, yet in the minds of each lives the image of their communion.[3] Renan referred to this imagining in his suavely back-handed way when he wrote that "Or l'essence d'une nation est que tous les individus aient beaucoup de choses en commun, et aussi que tous aient oublié bien des choses."[4] With a certain ferocity Gellner makes a comparable point when he rules that "Nationalism is not the awakening of nations to self-consciousness:

it *invents* nations where they do not exist."[5] The drawback to this formulation, however, is that Gellner is so anxious to show that nationalism masquerades under false pretences that he assimilates "invention" to "fabrication" and "falsity," rather than to "imagining" and "creation." In this way he implies that "true" communities exist which can be advantageously juxtaposed to nations. In fact, all communities larger than primordial villages of face-to-face contact (and perhaps even these) are imagined. Communities are to be distinguished, not by their falsity/genuineness, but by the style in which they are imagined. Javanese villagers have always known that they are connected to people they have never seen, but these ties were once imagined particularistically—as indefinitely stretchable nets of kinship and clientship. Until quite recently, the Javanese language had no word meaning the abstraction "society." We may today think of the French aristocracy of the *ancien régime* as a class; but surely it was imagined this way only very late.[6] To the question "Who is the Comte de X?" the normal answer would have been, not "a member of the aristocracy," but "the lord of X," "the uncle of the Baronne de Y," or "a client of the Duc de Z."

The nation is imagined as *limited* because even the largest of them, encompassing perhaps a billion living human beings, has finite, if elastic boundaries, beyond which lie other nations. No nation imagines itself coterminous with mankind. The most messianic nationalists do not dream of a day when all the members of the human race will join their nation in the way that it was possible, in certain epochs, for, say, Christians to dream of a wholly Christian planet.

It is imagined as *sovereign* because the concept was born in an age in which Enlightenment and Revolution were destroying the legitimacy of the divinely-ordained, hierarchical dynastic realm. Coming to maturity at a stage of human history when even the most devout adherents of any universal religion were inescapably confronted with the living *pluralism* of such religions, and the allomorphism between each faith's ontological claims and territorial stretch, nations dream of being free, and, if under God, directly so. The gage and emblem of this freedom is the sovereign state.

Finally, it is imagined as a *community*, because, regardless of the actual inequality and exploitation that may prevail in each, the nation is always conceived as a deep, horizontal comradeship. Ultimately it is this fraternity that makes it possible, over the past two centuries, for so many millions of people, not so much to kill, as willingly to die for such limited imaginings.

These deaths bring us abruptly face to face with the central problem posed by nationalism: what makes the shrunken imaginings of recent history (scarcely more than two centuries) generate such colossal sacrifices? I believe that the beginnings of an answer lie in the cultural roots of nationalism.

[ · · · ]

Before proceeding to a discussion of the specific origins of nationalism, it may be useful to recapitulate the main propositions put forward thus far. Essentially, I have been arguing that the very possibility of imagining the nation only arose historically when, and where, three fundamental cultural conceptions, all of great antiquity, lost their axiomatic grip on men's minds. The first of these was the idea that a particular script-language offered privileged access to ontological truth, precisely because

it was an inseparable part of that truth. It was this idea that called into being the great transcontinental sodalities of Christendom, the Islamic Ummah, and the rest. Second was the belief that society was naturally organized around and under high centres–monarchs who were persons apart from other human beings and who ruled by some form of cosmological (divine) dispensation. Human loyalties were necessarily hierarchical and centripetal because the ruler, like the sacred script, was a node of access to being and inherent in it. Third was a conception of temporality in which cosmology and history were indistinguishable, the origins of the world and of men essentially identical. Combined, these ideas rooted human lives firmly in the very nature of things, giving certain meaning to the everyday fatalities of existence (above all death, loss, and servitude) and offering, in various ways, redemption from them.

The slow, uneven decline of these interlinked certainties, first in Western Europe, later elsewhere, under the impact of economic change, "discoveries" (social and scientific), and the development of increasingly rapid communications, drove a harsh wedge between cosmology and history. No surprise then that the search was on, so to speak, for a new way of linking fraternity, power and time meaningfully together. Nothing perhaps more precipitated this search, nor made it more fruitful, than print-capitalism, which made it possible for rapidly growing numbers of people to think about themselves, and to relate themselves to others, in profoundly new ways.

[ · · · ]

Print-languages laid the bases for national consciousnesses in three distinct ways. First and foremost, they created unified fields of exchange and communication below Latin and above the spoken vernaculars. Speakers of the huge variety of Frenches, Englishes, or Spanishes, who might find it difficult or even impossible to understand one another in conversation, became capable of comprehending one another via print and paper. In the process, they gradually became aware of the hundreds of thousands, even millions, of people in their particular language-field, and at the same time that *only those* hundreds of thousands, or millions, so belonged. These fellow-readers, to whom they were connected through print, formed, in their secular, particular, visible invisibility, the embryo of the nationally imagined community.

Second, print-capitalism gave a new fixity to language, which in the long run helped to build that image of antiquity so central to the subjective idea of the nation. As Febvre and Martin remind us, the printed book kept a permanent form, capable of virtually infinite reproduction, temporally and spatially. It was no longer subject to the individualizing and "unconsciously modernizing" habits of monastic scribes. Thus, while twelfth-century French differed markedly from that written by Villon in the fifteenth, the rate of change slowed decisively in the sixteenth. "By the 17th century languages in Europe had generally assumed their modern forms."[7] To put it another way, for three centuries now these stabilized print-languages have been gathering a darkening varnish; the words of our seventeenth-century forebears are accessible to us in a way that to Villon his twelfth-century ancestors were not.

Third, print-capitalism created languages-of-power of a kind different from the older administrative vernaculars. Certain dialects inevitably were "closer" to each print-language and dominated their final forms. Their disadvantaged cousins, still assimilable to the emerging print-language, lost caste, above all because they were unsuccessful (or only relatively successful) in insisting on their

own print-form. "Northwestern German" became Platt Deutsch, a largely spoken, thus sub-standard, German, because it was assimilable to print-German in a way that Bohemian spoken-Czech was not. High German, the King's English, and, later, Central Thai, were correspondingly elevated to a new politico-cultural eminence. (Hence the struggles in late-twentieth-century Europe by certain "sub-" nationalities to change their subordinate status by breaking firmly into print—and radio.)

## NOTES

1. As Aira Kemiläinen notes, the twin "founding fathers" of academic scholarship on nationalism, Hans Kohn and Carleton Hayes, argued persuasively for this dating. Their conclusions have, I think, not been seriously disputed except by nationalist ideologues in particular countries. Kemiläinen also observes that the word "nationalism" did not come into wide general use until the end of the nineteenth century. It did not occur, for example, in many standard nineteenth century lexicons. If Adam Smith conjured with the wealth of "nations," he meant by the term no more than "societies" or "states." Aira Kemiläinen, *Nationalism*, pp. 10, 33, and 48–49.

2. *The Break-up of Britain*, p. 359.

3. Cf. Séton-Watson, *Nations and States*, p. 5: "All that I can find to say is that a nation exists when a significant number of people in a community consider themselves to form a nation, or behave as if they formed one." We may translate "consider themselves" as "imagine themselves."

4. ["Thus the essence of a nation is that all individuals have many things in common, and also that everyone has forgotten things." — Eds.] Ernest Renan, "Qu'est-ce qu'une nation?" in *Oeuvres Complètes*, I, p. 892.

5. Ernest Gellner, *Thought and Change*, p. 169. Emphasis added.

6. Hobsbawm, for example, "fixes" it by saying that in 1789 it numbered about 400,000 in a population of 23,000,000. (See his *The Age of Revolution*, p. 78). But would this statistical picture of the noblesse have been imaginable under the *ancien régime*?

7. *The Coming of the Book*, p. 319.

## BIBLIOGRAPHY

Eistenstein, Elizabeth L. "Some Conjectures about the Impact of Printing on Western Society and Thought: A Preliminary Report." *Journal of Modern History*, 40:1 (March 1968). pp. 1–56.

Febvre, Lucien, and Henri-Jean Martin. *The Coming of the Book: The Impact of Printing, 1450–1800*. London: New Left Books. 1976.

Gellner, Ernest. *Thought and Change*. London: Weidenfeld and Nicholson. 1964.

Hobsbawm, Eric. "Some Reflections on 'The Break-up of Britain.'" *New Left Review*, 105 (September–October 1977). pp. 3–24.

Kemiläinen, Aira. *Nationalism: Problems Concerning the Word, the Concept and Classification*. Jyväskylä: Kustantajat. 1964.

Nairn, Tom. *The Break-up of Britain*. London: New Left Books. 1977.

Steinberg, S.H. *Five Hundred Years of Printing*. Rev. ed. Harmondsworth: Penguin. 1966.

# CESARE ZAVATTINI

## Some Ideas on the Cinema

After earning a law degree from University of Parma, Cesare Zavattini (1902–1989) worked for the Milan book publisher Rizzoli, then turned to screenwriting in the 1930s. In 1939, he met director Vittorio De Sica, an encounter that resulted in a partnership that produced some of the most important films of the Italian neorealist period. Like many European artists and intellectuals of his age, Zavattini experienced firsthand the crisis of World War II and, in his case, the repressions and violence of Benito Mussolini's fascist Italy that preceded it. With these global, political, and social crises as an integral part of their personal experience, Zavattini and De Sica wrote and directed four of the landmark films of Italian neorealism: *Shoeshine* (1946), *Bicycle Thieves* (1948), *Miracle in Milan* (1951), and *Umberto D.* (1952).

There were two broad trends in film history occurring during the 1930s in Italy and elsewhere. First, mainstream films were largely escapist fare found not only in Hollywood imports but also locally in Italy's so-called white telephone films that depicted the frothy worlds of the rich. Second, many film dramas and documentaries acted as vehicles for different political positions, creating stories and even fabricating "factual" events to promote specific political ideologies. In response to this recent heritage, the neorealist movement aimed to stay absolutely true to the harsh realities of the 1940s and to eschew the fictional distortions associated with glamorous stars, manufactured sets, and made-up story lines. In 1945, Roberto Rossellini's *Rome, Open City*, a documentary-like tale of the violence and suffering of a group of Roman citizens resisting the Nazis in the last days of World War II, announced the arrival of this powerful new vision.

Written in 1953, nearly a decade after the horrors of World War II, "Some Ideas on the Cinema" is a manifesto for neorealist cinema. It argues specifically for a cinema that breaks with the fantasies of lavish Hollywood films and instead creates images of the world that are truer to life post-1945. To achieve this, Zavattini argues that films should minimize interpreting the world through narratives, and instead should rely on real locations, employ non-actors as the focus of actions, and as much as possible, eliminate elaborate technical strategies. Following these precepts becomes, then, not simply an important innovation in the techniques of modern filmmaking but also a way to infuse the art of filmmaking with social ethics. Many film practices from film noir to numerous new wave films apply versions of Zavattini's call for a more honest realism, and film theories like André Bazin's essays (p. 309) and the Dogme 95 manifesto (p. 688) reflect or reformulate some of Zavattini's arguments.

## READING CUES & KEY CONCEPTS

■ How are Zavattini's formulas for neorealism's aesthetic different from assumptions about documentary filmmaking?

■ Why does Zavattini privilege "poverty" as the most fertile ground for neorealist films? How might that position be countered and also remain true to neorealism?

◼ Zavattini's manifesto places significant emphasis on the conclusion of a movie. Explain how his sense of an ending carries a particular moral weight.

◼ **Key Concepts:** Neorealism; Social Attention; Interior Value; Location Shooting; Collective Social Situations

# Some Ideas on the Cinema

. . . . . . . . . . . . . .

## I

No doubt one's first and most superficial reaction to everyday reality is that it is tedious. Until we are able to overcome some moral and intellectual laziness, in fact, this reality will continue to appear uninteresting. One shouldn't be astonished that the cinema has always felt the natural, unavoidable necessity to insert a "story" in the reality to make it exciting and "spectacular." All the same, it is clear that such a method evades a direct approach to everyday reality, and suggests that it cannot be portrayed without the intervention of fantasy or artifice.

The most important characteristic, and the most important innovation, of what is called neorealism, it seems to me, is to have realised that the necessity of the "story" was only an unconscious way of disguising a human defeat, and that the kind of imagination it involves was simply a technique of superimposing dead formulas over living social facts. Now it has been perceived that reality is hugely rich, that to be able to look directly at it is enough; and that the artist's task is not to make people moved or indignant at metaphorical situations, but to make them reflect (and, if you like, to be moved and indignant too) at what they and others are doing, on the real things, exactly as they are.

For me this has been a great victory. I would like to have achieved it many years earlier. But I made the discovery only at the end of the war. It was a moral discovery, an appeal to order. I saw at last what was in front of me, and I understood that to have evaded reality had been to betray it.

Example: Before this, if one was thinking over the idea of a film on say, a strike, one was immediately forced to invent a plot. And the strike itself became only the background to the film. Today, our attitude would be one of "revelation": we would describe the strike itself, try to work out the largest possible number of human, moral, socioeconomic, poetic values from the bare documentary fact.

We have passed from an unconsciously rooted mistrust of reality, from illusory and equivocal evasion, to an unlimited trust in things, facts and people. Such a position requires us, in effect, to excavate reality, to give it a power, a communication, a series of reflexes, which until recently we had never thought it had. It requires, too, a true and real interest in what is happening, a search for the most deeply hidden human values, which is why we feel that the cinema must recruit not only intelligent people, but, above all, "living" souls, the morally richest people.

## II

The cinema's overwhelming desire to see, to analyse, its hunger for reality, is an act of concrete homage towards other people, towards what is happening and existing in the world. And, incidentally, it is what distinguishes "neorealism" from the American cinema.

In fact, the American position is the antithesis of our own: while we are interested in the reality around us and want to know it directly, reality in American films is unnaturally filtered, "purified," and cored out at one or two removes. In America, lack of subjects for films causes a crisis, but with us such a crisis is impossible. One cannot be short on themes while there is still plenty of reality. Any hour of the day, any place, any person, is a subject for narrative if the narrator is capable of observing and illuminating all these collective elements by exploring their interior value.

So there is no question of a crisis of subjects, only of their interpretation. This substantial difference was nicely emphasised by a well-known American producer when he told me: "This is how *we* would imagine a scene with an aeroplane. The 'plane passes by . . . a machine-gun fires . . . the 'plane crashes . . . And this is how *you* would imagine it. The 'plane passes by . . . The 'plane passes by again . . . the 'plane passes by once more . . ."

He was right. But we have still not gone far enough. It is not enough to make the aeroplane pass by three times; we must make it pass by twenty times.

What effects on narrative, then, and on the portrayal of human character, has the neorealist style produced?

To begin with, while the cinema used to make one situation produce another situation, and another, and another, again and again, and each scene was thought out and immediately related to the next (the natural result of a mistrust of reality), today, when we have thought out a scene, we feel the need to "remain" in it, because the single scene itself can contain so many echoes and reverberations, can even contain all the situations we may need. Today, in fact, we can quietly say: give us whatever "fact" you like, and we will disembowel it, make it something worth watching.

While the cinema used to portray life in its most visible and external moments— and a film was usually only a series of situations selected and linked together with varying success—today the neorealist affirms that each one of these situations, rather than all the external moments, contains in itself enough material for a film.

Example: In most films, the adventures of two people looking for somewhere to live, for a house, would be shown externally in a few moments of action, but for us it could provide the scenario for a whole film, and we would explore all its echoes, all its implications.

Of course, we are still a long way from a true analysis of human situations, and one can speak of analysis only in comparison with the dull synthesis of most current production. We are, rather, still in an "attitude" of analysis; but in this attitude there is a strong purpose, a desire for understanding, for belonging, for participating—for living together, in fact.

## III

Substantially, then, the question today is, instead of turning imaginary situations into "reality" and trying to make them look "true," to make things as they are, almost by themselves, create their own special significance. Life is not what is invented in "stories"; life is another matter. To understand it involves a minute, unrelenting, and patient search.

Here I must bring in another point of view. I believe that the world goes on getting worse because we are not truly aware of reality. The most authentic position

anyone can take up today is to engage himself in tracing the roots of this problem. The keenest necessity of our time is "social attention."

Attention, though, to what is there, *directly*: not through an apologue, however well conceived. A starving man, a humiliated man, must be shown by name and surname; no fable for a starving man, because that is something else, less effective and less moral. The true function of the cinema is not to tell fables, and to a true function we must recall it.

Of course, reality can be analysed by ways of fiction. Fictions can be expressive and natural; but neorealism, if it wants to be worthwhile, must sustain the moral impulse that characterised its beginnings, in an analytical documentary way. No other medium of expression has the cinema's original and innate capacity for showing things that we believe worth showing, as they happen day by day—in what we might call their "dailiness," their longest and truest duration. The cinema has everything in front of it, and no other medium has the same possibilities for getting it known quickly to the greatest number of people.

As the cinema's responsibility also comes from its enormous power, it should try to make every frame of film count, by which I mean that it should penetrate more and more into the manifestations and the essence of reality.

The cinema only affirms its moral responsibility when it approaches reality in this way.

The moral, like the artistic, problem lies in being able to observe reality, not to extract fictions from it.

## *IV*

Naturally, some film-makers, although they realise the problem, have still been compelled, for a variety of reasons (some valid, others not), to "invent" stories in the traditional manner, and to incorporate in these stories some fragments of their real intuition. This, effectively, has served as neorealism for some film-makers in Italy.

For this reason, the first endeavour was often to reduce the story to its most elementary, simple, and, I would rather say, banal form. It was the beginning of a speech that was later interrupted. *Bicycle Thieves* provides a typical example. The child follows his father along the street; at one moment, the child is nearly run over, but the father does not even notice. This episode was "invented," but with the intention of communicating an everyday fact about these people's lives, a little fact—so little that the protagonists don't even care about it—but full of life.

In fact *Paisà, Open City, Sciuscià, Bicycle Thieves, La terra trema,* all contain elements of an absolute significance—they reflect the idea that everything can be recounted; but their sense remains metaphorical, because there is still an invented story, not the documentary spirit. In other films, such as *Umberto D.,* reality as an analysed fact is much more evident, but the presentation is still traditional.

We have not yet reached the centre of neorealism. Neorealism today is an army ready to start; and there are the soldiers—behind Rossellini, De Sica, Visconti. The soldiers have to go into the attack and win the battle.

We must recognize that all of us are still only starting, some farther on, others farther behind. But it is still something. The great danger today is to abandon that

position, the moral position implicit in the work of many of us during and immediately after the war.

## V

A woman is going to buy a pair of shoes. Upon this elementary situation it is possible to build a film. All we have to do is to discover and then show all the elements that go to create this adventure, in all their banal "dailiness," and it will become worthy of attention, it will even become "spectacular." But it will become spectacular not through its exceptional, but through its *normal* qualities; it will astonish us by showing so many things that happen every day under our eyes, things we have never noticed before.

The result would not be easy to achieve. It would require an intensity of human vision both from the creator of the film and from the audience. The question is: how to give human life its historical importance at every minute.

## VI

In life, in reality today, there are no more empty spaces. Between things, facts, people, exists such an interdependence that a blow struck for the cinema in Rome could have repercussions all over the world. If this is true, it must be worthwhile to take any moment of a human life and show how "striking" that moment is: to excavate and identify it, to send its echo vibrating into other parts of the world.

This is as valid for poverty as for peace. For peace, too, the human moment should not be a great one, but an ordinary daily happening. Peace is usually the sum of small happenings, all having the same moral implications at their roots.

It is not only a question, however, of creating a film that makes its audience understand a social or collective situation. People understand themselves better than the social fabric; and to see themselves on the screen, performing their daily actions—remembering that to see oneself gives one the sense of being unlike oneself—like hearing one's own voice on the radio—can help them to fill up a void, a lack of knowledge of reality.

## VII

If this love for reality, for human nature directly observed, must still adapt itself to the necessities of the cinema as it is now organised, must yield, suffer and wait, it means that the cinema's capitalist structure still has a tremendous influence over its true function. One can see this in the growing opposition in many places to the fundamental motives of neorealism, the main results of which are a return to so-called "original" subjects, as in the past, and the consequent evasion of reality, and a number of bourgeois accusations against neorealist principles.

The main accusation is: *neorealism only describes poverty.* But neorealism can and must face poverty. We have begun with poverty for the simple reason that it is one of the most vital realities of our time, and challenge anyone to prove the contrary. To believe, or to pretend to believe, that by making half a dozen films on poverty we have finished with the problem would be a great mistake. As well

believe that, if you have to plough up a whole country, you can sit down after the first acre.

The theme of poverty, of rich and poor, is something one can dedicate one's whole life to. We have just begun. We must have the courage to explore all the details. If the rich turn up their noses especially at *Miracolo a Milano*, we can only ask them to be a little patient. *Miracolo a Milano* is only a fable. There is still much more to say. I put myself among the rich, not only because I have some money (which is only the most apparent and immediate aspect of wealth), but because I am also in a position to create oppression and injustice. That is the moral (or immoral) position of the so-called rich man.

When anyone (he could be the audience, the director, the critic, the State, or the Church) says, "STOP the poverty," i.e. stop the films about poverty, he is committing a moral sin. He is refusing to understand, to learn. And when he refuses to learn, consciously, or not, he is evading reality. The evasion springs from lack of courage, from fear. (One should make a film on this subject, showing at what point we begin to evade reality in the face of disquieting facts, at what point we begin to sweeten it.)

If I were not afraid of being thought irreverent, I should say that Christ, had He a camera in His hand, would not shoot fables, however wonderful, but would show us the good ones and the bad ones of this world—in actuality, giving us close-ups of those who make their neighbours' bread too bitter, and of their victims, if the censor allowed it.

To say that we have had "enough" films about poverty suggests that one can measure reality with a chronometer. In fact, it is not simply a question of choosing the theme of poverty, but of going on to explore and analyse the poverty. What one needs is more and more knowledge, precise and simple, of human needs and the motives governing them. Neorealism should ignore the chronometer and go forward for as long as is necessary.

*Neorealism*, it is also said, *does not offer solutions. The end of a neorealist film is particularly inconclusive.* I cannot accept this at all. With regard to my own work, the characters and situations in films for which I have written the scenario, they remain unresolved from a practical point of view simply because "this is reality." But every moment of the film is, in itself, a continuous answer to some question. It is not the concern of an artist to propound solutions. It is enough, and quite a lot, I should say, to make an audience feel the need, the urgency, for them.

In any case, what films *do* offer solutions? "Solutions" in this sense, if they are offered, are sentimental ones, resulting from the superficial way in which problems have been faced. At least, in my work I leave the solution to the audience.

The fundamental emotion of *Miracolo a Milano* is not one of escape (the flight at the end), but of indignation, a desire for solidarity with certain people, a refusal of it with others. The film's structure is intended to suggest that there is a great gathering of the humble ones against the others. But the humble ones have no tanks, or they would have been ready to defend their land and their huts.

## VIII

The true neorealistic cinema is, of course, less expensive than the cinema at present. Its subjects can be expressed cheaply, and it can dispense with capitalist resources on the present scale. The cinema has not yet found its morality, its necessity,

its quality, precisely because it costs too much; being so conditioned, it is much less an art than it could be.

## IX

The cinema should never turn back. It should accept, unconditionally, what is contemporary. *Today, today, today.*

It must tell reality as if it were a story; there must be no gap between life and what is on the screen. To give an example:

A woman goes to a shop to buy a pair of shoes. The shoes cost 7,000 lire. The woman tries to bargain. The scene lasts, perhaps, two minutes. I must make a two-hour film. What do I do?

I analyse the fact in all its constituent elements, in its "before," in its "after," in its contemporaneity. The fact creates its own fiction, in its own particular sense.

The woman is buying the shoes. What is her son doing at the same moment? What are people doing in India that could have some relation to this fact of the shoes? The shoes cost 7,000 lire. How did the woman happen to have 7,000 lire? How hard did she work for them, what do they represent for her?

And the bargaining shopkeeper, who is he? What relationship has developed between these two human beings? What do they mean, what interests are they defending, as they bargain? The shopkeeper also has two sons, who eat and speak: do you want to know what they are saying? Here they are, in front of you . . .

The question is, to be able to fathom the real correspondences between facts and their process of birth, to discover what lies beneath them.

Thus to analyse "buying a pair of shoes" in such a way opens to us a vast and complex world, rich in importance and values, in its practical, social, economic, psychological motives. Banality disappears because each moment is really charged with responsibility. Every moment is infinitely rich. Banality never really existed.

Excavate, and every little fact is revealed as a mine. If the gold-diggers come at last to dig in the illimitable mine of reality, the cinema will become socially important.

This can also be done, evidently, with invented characters; but if I use living, real characters with which to sound reality, people in whose life I can directly participate, my emotion becomes more effective, morally stronger, more useful. Art must be expressed through a true name and surname, not a false one.

I am bored to death with heroes more or less imaginary. I want to meet the real protagonist of everyday life, I want to see how he is made, if he has a moustache or not, if he is tall or short, I want to see his eyes, and I want to speak to him.

We can look at him on the screen with the same anxiety, the same curiosity as when, in a square, seeing a crowd of people all hurrying up to the same place, we ask, What is happening? What is happening to a real person? Neorealism has perceived that the most irreplaceable experience comes from things happening under our own eyes from natural necessity.

I am against "exceptional" personages. The time has come to tell the audience that they are the true protagonists of life. The result will be a constant appeal to the responsibility and dignity of every human being. Otherwise the frequent habit of identifying oneself with fictional characters will become very dangerous. We must

identify ourselves with what we are. The world is composed of millions of people thinking of myths.

## X

The term neorealism—in a very Latin sense—implies, too, elimination of technical-professional apparatus, screen-writer included. Handbooks, formulas, grammars, have no more application. There will be no more technical terms. Everybody has his personal shooting-script. Neorealism breaks all the rules, rejects all those canons which, in fact, exist only to codify limitations. Reality breaks all the rules, as can be discovered if you walk out with a camera to meet it.

The figure of a screen-writer today is, besides, very equivocal. He is usually considered part of the technical apparatus. I am a screen-writer trying to say certain things, and saying them in my own way. It is clear that certain moral and social ideas are at the foundation of my expressive activities, and I can't be satisfied to offer a simple technical contribution. In films which do not touch me directly, also, when I am called in to do a certain amount of work on them, I try to insert as much as possible of my own world, of the moral emergencies within myself.

On the other hand, I don't think the screenplay in itself contains any particular problems; only when subject, screenplay and direction become three distinct phases, as they so often do today, which is abnormal. The screen-writer as such should disappear, and we should arrive at the sole author of a film.

Everything becomes flexible when only one person is making a film; everything continually possible, not only during the shooting, but during the editing, the laying of tracks, the post-synchronisation, to the particular moment when we say, "Stop." And it is only then that we put an end to the film.

Of course, it is possible to make films in collaboration, as happens with novels and plays, because there are always numerous bonds of identity between people (for example, millions of men go to war, and are killed for the same reasons), but no work of art exists on which someone has not set the seal of his own interests, of his own poetic world. There is always somebody to make the decisive creative act, there is always one prevailing intelligence, there is always someone who, at a certain moment, "chooses," and says, "This, yes," and "This, no," and then resolves it: reaction shot of the mother crying Help!

Technique and capitalist method, however, have imposed collaboration on the cinema. It is one thing to adapt ourselves to the imposed exigencies of the cinema's present structure, another to imagine that they are indispensable and necessary. It is obvious that when films cost sixpence and everybody can have a camera, the cinema would become a creative medium as flexible and as free as any other.

## XI

It is evident that, with neorealism, the actor—as a person fictitiously lending his own flesh to another—has no more right to exist than the "story." In neorealism, as I intend it, everyone must be his own actor. To want one person to play another implies the calculated plot, the fable, and not "things happening." I attempted such a film with Caterina Rigoglioso; it was called "the lightning film." But unfortunately

at the last moment everything broke down. Caterina did not seem to "take" to the cinema. But wasn't she "Caterina"?

Of course, it will be necessary to choose themes excluding actors. I want, for example, to make a report on children in the world. If I am not allowed to make it, I will limit it to Europe, or to Italy alone. But I will make it. Here is an example of the film not needing actors. I hope the actors' union will not protest.

## XII

Neorealism does not reject psychological exploration. Psychology is one of the many premises of reality. I face it as I face any other. If I want to write a scene of two men quarrelling, I will not do so at my desk. I must leave my den and find them. I take these men and make them talk in front of me for one hour or for twenty, depending on necessity. My creative method is first to call on them, then to listen to them, "choosing" what they say. But I do all this not with the intention of creating heroes, because I think that a hero is not "certain men" but "every man."

Wanting to give everyone a sense of equality is not levelling him down, but exalting his solidarity. Lack of solidarity is always born from presuming to be different, from a *But*: "Paul is suffering, it's true. I am suffering, too, *but* my suffering has something that . . . my nature has something that . . ." and so on. The *But* must disappear, and we must be able to say: "That man is bearing what I myself should bear in the same circumstances."

## XIII

Others have observed that the best dialogue in films is always in dialect. Dialect is nearer to reality. In our literary and spoken language, the synthetic constructions and the words themselves are always a little false. When writing a dialogue, I always think of it in dialect, in that of Rome or my own village. Using dialect, I feel it to be more essential, truer. Then I translate it into Italian, thus maintaining the dialect's syntax. I don't, therefore, write dialogue in dialect, but I am interested in what dialects have in common: immediacy, freshness, verisimilitude.

But I take most of all from nature. I go out into the street, catch words, sentences, discussions. My great aids are memory and the shorthand writer.

Afterwards, I do with the words what I do with the images. I choose, I cut the material I have gathered to give it the right rhythm, to capture the essence, the truth. However great a faith I might have in imagination, in solitude, I have a greater one in reality, in people. I am interested in the drama of things we happen to encounter, not those we plan.

In short, to exercise our own poetic talents on location, we must leave our rooms and go, in body and mind, out to meet other people, to see and understand them. This is a genuine moral necessity for me and, if I lose faith in it, so much the worse for me.

I am quite aware that it is possible to make wonderful films, like Charlie Chaplin's, and they are not neorealistic. I am quite aware that there are Americans, Russians, Frenchmen and others who have made masterpieces that honour humanity, and, of course, they have not wasted film. I wonder, too, how many more great works they

will again give us, according to their particular genius, with actors and studios and novels. But Italian film-makers, I think, if they are to sustain and deepen their cause and their style, after having courageously half-opened their doors to reality, must (in the sense I have mentioned) open them wide.

# FERNANDO SOLANAS AND OCTAVIO GETINO

## Towards a Third Cinema: Notes and Experiences for the Development of a Cinema of Liberation in the Third World

Argentine filmmakers Fernando Solanas (b. 1936) and Octavio Getino (b. 1935) were part of a leftist underground collective calling themselves "Grupo Cine Liberación." They collaborated on the legendary four-hour film on Latin American politics and revolutionary violence, *La hora de los hornos* (*Hour of the Furnaces*, 1968)—some of its production and exhibition history is detailed in their manifesto "Towards a Third Cinema." Solanas and Getino were supporters of former Argentine president Juan Perón and his party and went into exile after the military coup in 1976. Solanas, known as "Pino," returned in 1983 to become one the country's most prominent filmmakers; his works include the highly respected *Tangos: The Exile of Gardel* (1985), *Sur* (1988), and, more recently, *Memoria del saqueo* (2004). Politically outspoken, Solanas was shot and severely injured in 1991, and in 2009 he was elected National Deputy for the city of Buenos Aires. After living in Peru and Mexico, Getino returned to Argentina where he briefly served as the head of the National Film Institute (INC). He is a scholar who has written authoritative works in Spanish on Argentine film and television.

Solanas and Getino's polemical essay "Towards a Third Cinema" was first published in 1969, during a remarkably fertile period of political filmmaking—mostly collaborative and much of it using inexpensive 16mm means of production—what Solanas and Getino call "cinema of liberation." Besides *Hour of the Furnaces*, a notable example of this movement is Patricio Guzmán's three-part documentary *Battle of Chile* (1976) chronicling Augusto Pinochet's bloody coup d'état. Out of this, a Pan-Latin movement emerged under the name "Tercer Cine," or "Third Cinema," encompassing filmmakers from Brazil, Bolivia, and Cuba. In post-revolutionary Cuba, cinema was considered crucial to the new cultural epoch; films like Tomás Gutiérrez Alea's *Memories of Underdevelopment* (1968) were produced at the new film institute (ICAIC) and manifestos such as Julio García Espinosa's "For an Imperfect Cinema" (1969) echoed Solanas and Getino's position. Third Cinema became a key concept within cinema studies, growing to encompass works made in Africa, Asia, and even within the United States (like Charles Burnett's *Killer of Sheep* [1977]). In fact, the term's Latin American origin has been obscured to an extent, in part due to the inaccessibility of many of the key films.

However, Solanas and Getino argue in "Towards a Third Cinema" that irregular distribution paths are part of what distinguishes a cinema of the people from dominant models. They even describe sharing their film with audiences as a work in progress. First Cinema—Hollywood productions, state-sponsored, and other commercial film industries—is ubiquitous. Second Cinema is rarefied and lauded for its artistic quality, which blunts its political effectiveness; it supports the myth of the artist as separate from the people and it is available only to the elite. Third Cinema combines First Cinema's appeal to the masses with Second Cinema's reflexive modernism, but it innovates by changing the circuits of distribution/exhibition as well as the relations of production. These decentralized notions of media circulation will resonate, for contemporary viewers, with practices made possible on the Internet. Solanas and Getino conclude with the question, "why cinema?" and the assertion that "the birth of a third cinema means ... the most important revolutionary artistic event of our times." Like the Soviets in an earlier revolutionary moment, Solanas and Getino see the cinema as a populist and *mass* medium that transcends barriers of language and literacy.

## READING CUES & KEY CONCEPTS

■ Consider whether or not the concept of "Third Cinema" is relevant in contemporary world cinema after the fall of the Soviet Union and the accompanying shift in political rhetoric. If not, what concepts might replace it? If so, what films might it designate?

■ Consider the critique of Second Cinema. Is it necessarily the case that artistic cinema is compromised politically? Can you think of examples that refute this claim?

■ How do cinematic practice and critical writing complement each other in Solanas and Getino's view? Why is each necessary to the other?

■ **Key Concepts:** First Cinema; Second Cinema; Third Cinema; Neocolonialism; Revolutionary Cinema; Cinema of Subversion; Decolonization; Film Act

# Towards a Third Cinema: Notes and Experiences for the Development of a Cinema of Liberation in the Third World

. . . . . . . . . . . . .

*. . . we must discuss, we must invent . . .*

Frantz Fanon

Just a short time ago it would have seemed like a Quixotic adventure in the colonized, neocolonized, or even the imperialist nations themselves to make any attempt to create *films of decolonization* that turned their back on or actively opposed the System. Until recently, film had been synonymous with spectacle or entertainment: in a word, it was one more *consumer good*. At best, films succeeded in bearing witness to the decay of bourgeois values and testifying to social injustice. As a rule, films only dealt with effect, never with cause; it was cinema of mystification or anti-historicism. It was *surplus value* cinema. Caught up in these conditions, films,

the most valuable tool of communication of our times, were destined to satisfy only the ideological and economic interests of the *owners of the film industry*, the lords of the world film market, the great majority of whom were from the United States.

Was it possible to overcome this situation? How could the problem of turning out liberating films be approached when costs came to several thousand dollars and the distribution and exhibition channels were in the hands of the enemy? How could the continuity of work be guaranteed? How could the public be reached? How could System-imposed repression and censorship be vanquished? These questions, which could be multiplied in all directions, led and still lead many people to skepticism or rationalization: "revolutionary cinema cannot exist before the revolution"; "revolutionary films have been possible only in the liberated countries"; "without the support of revolutionary political power, revolutionary cinema or art is impossible." The mistake was due to taking the same approach to reality and films as did the bourgeoisie. The models of production, distribution, and exhibition continued to be *those of Hollywood* precisely because, in ideology and politics, films had not yet become the vehicle for a clearly drawn differentiation between bourgeois ideology and politics. A reformist policy, as manifested in dialogue with the adversary, in coexistence, and in the relegation of national contradictions to those between two supposedly unique blocs—the U.S.S.R. and the U.S.A.—was and is unable to produce anything but a cinema within the System itself. At best, it can be the *"progressive" wing of Establishment cinema.* When all is said and done, such cinema was doomed to wait until the world conflict was resolved peacefully in favor of socialism in order to change qualitatively. The most daring attempts of those filmmakers who strove to conquer the fortress of official cinema ended, as Jean-Luc Godard eloquently put it, with the filmmakers themselves "trapped inside the fortress."

But the questions that were recently raised appeared promising; they arose from a new historical situation to which the filmmaker, as is often the case with the educated strata of our countries, was rather a late-comer; ten years of the Cuban Revolution, the Vietnamese struggle, and the development of a worldwide liberation movement whose moving force is to be found in the Third World countries. *The existence of masses on the worldwide revolutionary plane was the substantial fact without which those questions could not have been posed.* A new historical situation and a new man born in the process of the anti-imperialist struggle demanded a new, revolutionary attitude from the filmmakers of the world. The question of whether or not militant cinema *was possible* before the revolution began to be replaced, at least within small groups, by the question of *whether or not such a cinema was necessary to contribute to the possibility of revolution.* An affirmative answer was the starting point for the first attempts to channel the process of seeking possibilities in numerous countries. Examples are Newsreel, a U.S. New Left film group, the *cinegiornali* of the Italian student movement, the films made by the *Etats Généraux du Cinéma Français*, and those of the British and Japanese student movements, all a continuation and deepening of the work of a Joris Ivens or a Chris Marker. Let it suffice to observe the films of a Santiago Alvarez in Cuba, or the cinema being developed by different filmmakers in "the homeland of all," as Bolivar would say, as they seek a revolutionary Latin American cinema.

A profound debate on the role of intellectuals and artists before liberation is today enriching the perspectives of intellectual work all over the world. However,

this debate oscillates between two poles: one which proposes to *relegate* all intellectual work capacity to a *specifically* political or political-military function, denying perspectives to all artistic activity with the idea that such activity must ineluctably be absorbed by the System, and the other which maintains an inner duality of the intellectual: on the one hand, the "work of art," "the privilege of beauty," an art and a beauty which are not necessarily bound to the needs of the revolutionary political process, and, on the other, a political commitment which generally consists in signing certain anti-imperialist manifestos. In practice, this point of view means the *separation of politics and art.*

This polarity rests, as we see it, on two omissions: first, the conception of culture, science, art, and cinema as univocal and universal terms, and, second, an insufficiently clear idea of the fact that the revolution does not begin with the taking of political power from imperialism and the bourgeoisie, but rather begins at the moment when the masses sense the need for change and their intellectual vanguards begin to study and carry out this change *through activities on different fronts.*

**[ · · · ]**

The placing of the cinema within U.S. models, even in the formal aspect, in language, leads to the adoption of the ideological forms that *gave rise to precisely that language and no other.* Even the appropriation of models which appear to be only technical, industrial, scientific, etc., leads to a conceptual dependency, due to the fact that the cinema is an industry, but differs from other industries in that it has been created and organized in order *to generate certain ideologies.* The 35mm camera, 24 frames per second, arc lights, and a commercial place of exhibition for audiences were conceived not to gratuitously transmit any ideology, but to satisfy, in the first place, the cultural and surplus value needs *of a specific ideology, of a specific world-view: that of U.S. finance capital.*

The mechanistic takeover of a cinema conceived as a show to be exhibited in large theatres with a standard duration, hermetic structures that are born and die on the screen, satisfies, to be sure, the commercial interests of the production groups, but it also leads to the *absorption of forms of the bourgeois world-view* which are the continuation of 19th century art, of bourgeois art: man is accepted only as a passive and consuming object; *rather than having his ability to make history recognized, he is only permitted to read history, contemplate it, listen to it, and undergo it. The cinema as a spectacle aimed at a digesting object is the highest point that can be reached by bourgeois filmmaking.* The world, experience, and the historic process are enclosed within the frame of a painting, the stage of a theater, and the movie screen; man is viewed as a *consumer of ideology*, and not as the creator of ideology. This notion is the starting point for the wonderful interplay of bourgeois philosophy and the obtaining of surplus value. The result is a cinema studied by motivational analysts, sociologists and psychologists, by the endless researchers of the dreams and frustrations of the masses, all aimed at selling *movie-life*, reality as it is conceived by the ruling classes.

The first alternative to this type of cinema, which we could call the *first cinema*, arose with the so-called "author's cinema," "expression cinema," "*nouvelle vague*," "*cinema novo*," or, conventionally, the *second cinema*. This alternative signified a step

forward inasmuch as it demanded that the filmmaker be free to express himself in nonstandard language and inasmuch as it was an attempt at cultural decolonization. But such attempts have already reached, or are about to reach, the outer limits of what the system permits. The *second cinema filmmaker* has remained "trapped inside the fortress" as Godard put it, or is on his way to becoming trapped. The search for a market of 200,000 moviegoers in Argentina, a figure that is supposed to cover the costs of an independent local production, the proposal of developing a mechanism of industrial production parallel to that of the System but which would be distributed by the System according to its own norms, the struggle to better the laws protecting the cinema and replacing "bad officials" by "less bad," etc., is a search lacking in viable prospects, unless you consider viable the prospect of becoming institutionalized as "the youthful, angry wing of society"—that is, of neocolonialized or capitalist society.

Real alternatives differing from those offered by the System are only possible if one of two requirements is fulfilled: *making films that the System cannot assimilate and which are foreign to its needs, or making films that directly and explicitly set out to fight the System.* Neither of these requirements fits within the alternatives that are still offered by the *second cinema*, but they can be found in the revolutionary opening towards a cinema outside and against the System, in a cinema of liberation: the *third cinema*.

One of the most effective jobs done by neocolonialism is its cutting off of intellectual sectors, especially artists, from national reality by lining them up behind "universal art and models." It has been very common for intellectuals and artists to be found at the tail end of popular struggle, when they have not actually taken up positions against it. The social layers which have made the greatest contribution to the building of a national culture (understood as an impulse towards decolonization) have not been precisely the enlightened elites but rather the most exploited and uncivilized sectors. Popular organizations have very rightly distrusted the "intellectual" and the "artist." When they have not been openly used by the bourgeoisie or imperialism, they have certainly been their indirect tools; most of them did not go beyond spouting a policy in favor of "peace and democracy," fearful of anything that had a national ring to it, afraid of contaminating art with politics and the artists with the revolutionary militant. They thus tended to obscure the inner causes determining neocolonialized society and placed in the foreground the outer causes, which, while "they are the condition for change, can never be the basis for change":[1] in Argentina they replaced the struggle against imperialism and the native oligarchy with the struggle of democracy against fascism, suppressing the fundamental contradiction of a neocolonialized country and replacing it with "a contradiction that was a copy of the worldwide contradiction."[2]

This cutting off of the intellectual and artistic sectors from the processes of national liberation—which, among other things, helps us to understand the limitations in which these processes have been unfolding—today tends to disappear to the extent that artists and intellectuals are beginning to discover the impossibility of destroying the enemy without first joining in a battle for their common interests. The artist is beginning to feel the insufficiency of his nonconformism and individual rebellion. And the revolutionary organizations, in turn, are discovering the vacuums that the struggle for power creates in the cultural sphere. The problems of

filmmaking, the ideological limitations of a filmmaker in a neocolonialized country, etc., have thus far constituted objective factors in the lack of attention paid to the cinema by the people's organizations. Newspapers and other printed matter, posters and wall propaganda, speeches and other verbal forms of information, enlightenment, and politicization are still the main means of communication between the organizations and the vanguard layers of the masses. But the new political positions of some filmmakers and the subsequent appearance of films useful for liberation have permitted certain political vanguards to discover the importance of movies. This importance is to be found in the specific meaning of films as a form of communication and because of *their particular characteristics*, characteristics that allow them to draw audiences of different origins, many of them people who might not respond favorably to the announcement of a political speech. Films offer an effective pretext for gathering an audience, in addition to the ideological message they contain.

The capacity for synthesis and the penetration of the film image, the possibilities offered by the *living document*, and *naked reality*, and the power of enlightenment of audiovisual means make the film far more effective than any other tool of communication. It is hardly necessary to point out that those films which achieve an intelligent use of the possibilities of the image, adequate dosage of concepts, language and structure that flow naturally from each theme, and counterpoints of audiovisual narration achieve effective results in the politicization and mobilization of cadres and even in work with the masses, where this is possible.

The students who raised barricades on the Avenida 18 de Julio in Montevideo after the showing of *La hora de los hornos* (*The Hour of the Furnaces*), the growing demand for films such as those made by Santiago Alvarez and the Cuban documentary film movement, and the debates and meetings that take place alter the underground or semi-public showings of *third cinema* films are the beginning of a twisting and difficult road being travelled in the consumer societies by the mass organizations (*Cinegiornali liberi* in Italy, Zengakuren documentaries in Japan, etc.). For the first time in Latin America, organizations are ready and willing to employ films for political-cultural ends: the Chilean *Partido Socialista* provides its cadres with revolutionary film material, while Argentine revolutionary Peronist and non-Peronist groups are taking an interest in doing likewise. Moreover, OSPAAAL (Organization of Solidarity of the People of Africa, Asia and Latin America) is participating in the production and distribution of films that contribute to the anti-imperialist struggle. The revolutionary organizations are discovering the need for cadres who, among other things, know how to handle a film camera, tape recorders, and projectors in the most effective way possible. The struggle to seize power from the enemy is the meeting ground of the political and artistic vanguards engaged in a common task which is *enriching to both*.

Some of the circumstances that delayed the use of films as a revolutionary tool until a short time ago were lack of equipment, technical difficulties, the compulsory specialization of each phase of work, and high costs. The advances that have taken place within each specialization; the simplification of movie cameras and tape recorders; improvements in the medium itself, such as rapid film that can be shot in normal light; automatic light meters; improved audiovisual synchronization; and the spread of know-how by means of specialized magazines with large circulations

and even through nonspecialized media, have helped to demystify filmmaking and divest it of that almost magic aura that made it seem that films were only within the reach of "artists," "geniuses," and "the privileged." Filmmaking is increasingly within the reach of larger social layers. Chris Marker experimented in France with groups of workers whom he provided with 8mm equipment and some basic instruction in its handling. The goal was to have the worker film *his way of looking at the world, just as if he were writing it.* This has opened up unheard-of prospects for the cinema; above all, *a new conception of filmmaking and the significance of art in our times.*

Imperialism and capitalism, whether in the consumer society or in the neo-colonialized country, veil everything behind a screen of images and appearances. *The image of reality* is more important than reality itself. It is a world peopled with fantasies and phantoms in which what is hideous is clothed in beauty, while beauty is disguised as the hideous. On the one hand, fantasy, the imaginary bourgeois universe replete with comfort, equilibrium, sweet reason, order, efficiency, and the possibility to "be someone." And, on the other, the phantoms, we the lazy, we the indolent and underdeveloped, we who cause disorder. When a neocolonialized person accepts his situation, he becomes a Gungha Din, a traitor at the service of the colonialist, an Uncle Tom, a class and racial renegade, or a fool, the easy-going servant and bumpkin; but, when he refuses to accept his situation of oppression, then he turns into a resentful savage, a cannibal. Those who *lose sleep from fear of the hungry,* those who comprise the System, see the revolutionary as a bandit, robber, and rapist; the first battle waged against them is thus not on a political plane, but rather in the police context of law, arrests, etc. The more exploited a man is, the more he is placed on a plane of insignificance. The more he resists, the more he is viewed as a beast. This can be seen in *Africa Addio*, made by the fascist Jacopetti: the African savages, killer animals, wallow in abject anarchy once they escape from white protection. Tarzan died, and in his place were born Lumumbas and Lobegulas, Nkomos, and the Madzimbamutos, and this is something that neocolonialism cannot forgive. Fantasy has been replaced by phantoms and man is turned into an extra who dies so Jacopetti can comfortably film his execution.

*I make the revolution; therefore I exist.* This is the starting point for the disappearance of fantasy and phantom to make way for living human beings. The cinema of the revolution is at the same time one of *destruction and construction*: destruction of the image that neocolonialism has created of itself and of us, and construction of a throbbing, living reality which recaptures truth in any of its expressions.

The restitution of things to their real place and meaning is an eminently subversive fact both in the neocolonial situation and in the consumer societies. In the former, the seeming ambiguity or pseudo-objectivity in newspapers, literature, etc., and the relative freedom of the people's organizations to provide their own information cease to exist, giving way to overt restriction, when it is a question of television and radio, the two most important System-controlled or monopolized communications media. Last year's May events in France are quite explicit on this point.

In a world where the unreal rules, artistic expression is shoved along the channels of fantasy, fiction, language in code, sign language, and messages whispered between the lines. Art is cut off from the concrete facts—which, from the neocolonialist standpoint, are accusatory testimonies—to turn back on itself, strutting

about in a world of abstractions and phantoms, where it becomes "timeless" and historyless. Vietnam can be mentioned, but only far from Vietnam; Latin America can be mentioned, but only far enough away from the continent to be effective, in places *where it is depoliticized* and where it does not lead to action.

The cinema known as documentary, with all the vastness that the concept has today, from educational films to the reconstruction of a fact or a historical event, is perhaps the main basis of revolutionary filmmaking. Every image that documents, bears witness to, refutes or deepens the truth of a situation is something more than a film image of purely artistic fact; it becomes something which the System finds indigestible.

Testimony about a national reality is also an inestimable means of dialogue and knowledge on the world plane. No internationalist form of struggle can be carried out successfully if there is not a mutual exchange of experiences among the people, if the people do not succeed in breaking out of the Balkanization on the international, continental, and national planes which imperialism is striving to maintain.

There is no knowledge of a reality as long as that reality is not acted upon, *as long as its transformation is not begun on all fronts of struggle.* The well-known quote from Marx deserves constant repetition: *it is not sufficient to interpret the world; it is now a question of transforming it.*

With such an attitude as his starting point, it remains to the filmmaker to discover his own language, a language which will arise from a militant and transforming world-view and from the theme being dealt with. Here it may well be pointed out that certain political cadres still maintain old dogmatic positions, which ask the artist or filmmaker to provide an apologetic view of reality, *one which is more in line with wishful thinking than with what actually is.* Such positions, which at bottom mask a lack of confidence in the possibilities of reality itself, have in certain cases led to the use of film language as a mere idealized illustration of a fact, to the desire to remove reality's deep contradictions, its dialectic richness, which is precisely the kind of depth which can give a film beauty and effectiveness. The reality of the revolutionary processes all over the world, in spite of their confused and negative aspects, possesses a dominant line, a synthesis which is so rich and stimulating that it does not need to be schematized with partial or sectarian views.

Pamphlet films, didactic films, report films, essay films, witness-bearing films— any militant form of expression is valid, and it would be absurd to lay down a set of aesthetic work norms. *Be receptive to all that the people have to offer, and offer them the best!*; or, as Che put it, *respect the people by giving them quality.* This is a good thing to keep in mind in view of those tendencies which are always latent in the revolutionary artist to lower the level of investigation and the language of a theme, in a kind of *neopopulism*, down to levels which, while they may be those upon which the masses move, do not help them to get rid of the stumbling blocks left by imperialism. The effectiveness of the best films of militant cinema show that social layers considered backward are able to capture the exact meaning of an association of images, an effect of staging, and any linguistic experimentation placed within the context of a given idea. Furthermore, revolutionary cinema is not fundamentally one which illustrates, documents, or passively establishes a situation: *rather, it attempts to intervene in the situation as an element providing thrust or rectification.* To put it another way, it provides *discovery through transformation.*

The differences that exist between one and another liberation process make it impossible to lay down supposedly universal norms. A cinema which in the consumer society does not attain the level of the reality in which it moves can play a stimulating role in an underdeveloped country, just as a revolutionary cinema in the neocolonial situation will not necessarily be revolutionary if it is mechanically taken to the metropolitan country.

Teaching the handling of guns can be revolutionary where there are potentially or explicitly viable leaders ready to throw themselves into the struggle to take power, but ceases to be revolutionary where the masses still lack sufficient awareness of their situation or where they have already learned to handle guns. Thus, a cinema which insists upon the denunciation of the *effects* of neocolonial policy is caught up in a reformist game if the consciousness of the masses has already assimilated such knowledge; then the revolutionary thing is to examine the *causes*, to investigate the ways of organizing and arming for the change. That is, imperialism can sponsor films that fight illiteracy, and such pictures will only be inscribed within the contemporary need of imperialist policy, but, in contrast, the making of such films in Cuba after the triumph of the Revolution was clearly revolutionary. Although their starting point was just the fact of teaching, reading and writing, they had a goal which was radically different from that of imperialism: the training of people for liberation, not for subjection.

The model of the perfect work of art, the fully rounded film structured according to the metrics imposed by bourgeois culture, its theoreticians and critics, has served to inhibit the filmmaker in the dependent countries, especially when he has attempted to erect similar models in a reality which *offered him neither the culture, the techniques, nor the most primary elements for success.* The culture of the metropolis kept the age-old secrets that had given life to its models; the transposition of the latter to the neocolonial reality was always a mechanism of alienation, *since it was not possible for the artist of the dependent country to absorb, in a few years, the secrets of a culture and society elaborated through the centuries in completely different historical circumstances.* The attempt in the sphere of filmmaking to match the pictures of the ruling countries generally ends in failure, given the existence of two disparate historical realities. And such unsuccessful attempts lead to feelings of frustration and inferiority. Both these feelings arise in the first place from the fear of taking risks along completely new roads *which are almost a total denial of "their cinema."* A fear of recognizing the particularities and limitations of dependency in order to discover the *possibilities inherent in that situation,* by finding ways of overcoming it *which would of necessity be original.*

The existence of a revolutionary cinema is inconceivable without the constant and methodical exercise of practice, search, and experimentation. It even means committing the new filmmaker to take chances on the unknown, to leap into space at times, exposing himself to failure as does the guerrilla who travels along paths that he himself opens up with machete blows. The possibility of discovering and inventing film forms and structures that serve a more profound vision of our reality resides in the ability to place oneself on the outside limits of the familiar, to make one's way amid constant dangers.

Our time is one of hypothesis rather than of thesis, a time of works in progress—unfinished, unordered, violent works made with the camera in one hand and a rock

in the other. Such works cannot be assessed according to the traditional theoreti-
cal and critical canons. The ideas for *our* film theory and criticism will come to life
through inhibition-removing practice and experimentation. "Knowledge begins
with practice. After acquiring theoretical knowledge through practice, it is neces-
sary to return to practice."[3] Once he has embarked upon this practice, the revolu-
tionary filmmaker will have to overcome countless obstacles; he will experience the
loneliness of those who aspire to the praise of the System's promotion media only
to find that those media are closed to him. As Godard would say, he will cease to
be a bicycle champion to become an anonymous bicycle rider, Vietnamese-style,
submerged in a cruel and prolonged war. But he will also discover that there is a
receptive audience that looks upon his work as something of its own existence, and
that is ready to defend him in a way that it would never do with any world bicycle
champion.

In this long war, with the camera as our rifle, we do in fact move into a guerrilla
activity. This is why the work of a *film-guerrilla* group is governed by strict disciplin-
ary norms as to both work methods and security. A revolutionary film group is in the
same situation as a guerrilla unit: it cannot grow strong without military structures
and command concepts. *The group exists as a network of complementary responsibil-
ities, as the sum and synthesis of abilities, inasmuch as it operates harmonically with
a leadership that centralizes planning work and maintains its continuity.* Experience
shows that it is not easy to maintain the cohesion of a group when it is bombarded
by the System and its chain of accomplices frequently disguised as "progressives,"
when there are no immediate and spectacular outer incentives and the members
must undergo the discomforts and tensions of work that is done underground and
distributed clandestinely. Many abandon their responsibilities because they under-
estimate them or because they measure them with values appropriate to System
cinema and not underground cinema. The birth of internal conflicts is a reality
present in any group, whether or not it possesses ideological maturity. The lack of
awareness of such an inner conflict on the psychological or personality plane, etc.,
the lack of maturity in dealing with problems of relationships, at times leads to ill
feeling and rivalries that in turn cause real clashes going beyond ideological or ob-
jective differences. All of this means that a basic condition is an awareness of the
problems of interpersonal relationships, leadership and areas of competence. What
is needed is to speak clearly, mark off work areas, assign responsibilities and take on
the job as a rigorous militancy.

Guerrilla filmmaking proletarianizes the film worker and breaks down the in-
tellectual aristocracy that the bourgeoisie grants to its followers. In a word, it *de-
mocratizes.* The filmmaker's tie with reality makes him more a part of his people.
Vanguard layers and even masses participate collectively in the work when they re-
alize that it is the continuity of their daily struggle. *La hora de los hornos* shows how
a film can be made in hostile circumstances when it has the support and collabora-
tion of militants and cadres from the people.

The revolutionary filmmaker acts with a radically new vision of the role of the
producer, team-work, tools, details, etc. Above all, he supplies himself at all levels
in order to produce his films, he equips himself at all levels, he learns how to handle
the manifold techniques of his craft. His most valuable possessions are the tools of
his trade, which form part and parcel of his need to communicate. The camera is

the inexhaustible *expropriator of image-weapons*; the projector, *a gun that can shoot 24 frames per second.*

Each member of the group should be familiar, at least in a general way, with the equipment being used: he must be prepared to replace another in any of the phases of production. The myth of irreplaceable technicians must be exploded.

The whole group must grant great importance to the minor details of the production and the security measures needed to protect it. A lack of foresight which in conventional filmmaking would go unnoticed can render virtually useless weeks or months of work. And a failure in guerrilla cinema, just as in the guerrilla struggle itself, can mean the loss of a work or a complete change of plans. "In a guerrilla struggle the concept of failure is present a thousand times over, and victory a myth that only a revolutionary can dream."[4] Every member of the group must have an ability to take care of details, discipline, speed, and, above all, the willingness to overcome the weaknesses of comfort, old habits, and the whole climate of pseudonormality behind which the warfare of everyday life is hidden. Each film is a different operation, a different job requiring variation in methods in order to confuse or refrain from alerting the enemy, especially since the processing laboratories are still in his hands.

The success of the work depends to a great extent on the group's ability to remain silent, on its permanent wariness, a condition that is difficult to achieve in a situation in which apparently nothing is happening and the filmmaker has been accustomed to telling all and sundry about everything that he's doing because the bourgeoisie has trained him precisely on such a basis of prestige and promotion. The watchwords "constant vigilance, constant wariness, constant mobility" have profound validity for guerrilla cinema. You have to give the appearance of working on various projects, split up the material, put it together, take it apart, confuse, neutralize, and throw off the track. All of this is necessary as long as the group doesn't have its own processing equipment, no matter how rudimentary, and there remain certain possibilities in the traditional laboratories.

Group-level co-operation between different countries can serve to assure the completion of a film or the execution of certain phases of work that may not be possible in the country of origin. To this should be added the need for a filing center for materials to be used by the different groups and the perspective of coordination, on a continent-wide or even worldwide scale, of the continuity of work in each country: periodic regional or international gatherings to exchange experience, contributions, joint planning of work, etc.

At least in the earliest stages the revolutionary filmmaker and the work groups will be the sole producers of their films. They must bear the responsibility of finding ways to facilitate the continuity of work. Guerrilla cinema still doesn't have enough experience to set down standards in this area; what experience there is has shown, above all, the *ability to make use of the concrete situation of each country.* But, regardless of what these situations may be, the preparation of a film cannot be undertaken without a parallel study of its future audience and, consequently, a plan to recover the financial investment. Here, once again, the need arises for closer ties between political and artistic vanguards, since this also serves for the joint study of forms of production, exhibition, and continuity.

A guerrilla film can be aimed only at the distribution mechanisms provided by the revolutionary organizations, including those invented or discovered by the

filmmakers themselves. Production, distribution, and economic possibilities for survival must form part of a single strategy. The solution of the problems faced in each of these areas will encourage other people to join in the work of guerrilla film-making, which will enlarge its ranks and thus make it less vulnerable.

The distribution of guerrilla films in Latin America is still in swaddling clothes while System reprisals are already a legalized fact. Suffice it to note in Argentina the raids that have occurred during some showings and the recent film suppression law of a clearly fascist character; in Brazil the ever-increasing restrictions placed upon the most militant comrades of *Cinema Novo*; and in Venezuela the banning of *La hora de los hornos*; over almost all the continent censorship prevents any possibility of public distribution.

Without revolutionary films and a public that asks for them, any attempt to open up new ways of distribution would be doomed to failure. But both of these already exist in Latin America. The appearance of these films opened up a road which in some countries, such as Argentina, occurs through showings in apartments and houses to audiences of never more than 25 people; in other countries, such as Chile, films are shown in parishes, universities, or cultural centers (of which there are fewer every day); and, in the case of Uruguay, showings were given in Montevideo's biggest movie theatre to an audience of 2,500 people, who filled the theatre and made every showing an impassioned anti-imperialist event. But the prospects on the continental plane indicate that the possibility for the continuity of a revolutionary cinema rests upon the strengthening of rigorously underground base structures.

Practice implies mistakes and failures.[5] Some comrades will let themselves be carried away by the success and impunity with which they present the first show-ings and will tend to relax security measures, while others will go in the opposite direction of excessive precautions or fearfulness, to such an extent that distribution remains circumscribed, limited to a few groups of friends. Only concrete experience in each country will demonstrate which are the best methods there, which do not always lend themselves to application in other situations.

In some places it will be possible to build infrastructures connected to political, student, worker, and other organizations, while in others it will be more suitable to sell prints to organizations which will take charge of obtaining the funds necessary to pay for each print (the cost of the print plus a small margin). This method, wher-ever possible, would appear to be the most viable, because it permits the decentral-ization of distribution; makes possible a more profound political use of the film; and permits the recovery, through the sale of more prints, of the funds invested in the production. It is true that in many countries the organizations still are not fully aware of the importance of this work, or, if they are, may lack the means to under-take it. In such cases other methods can be used: the delivery of prints to encourage distribution and a box-office cut to the organizers of each showing, etc. The ideal goal to be achieved would be producing and distributing guerrilla films with funds obtained from expropriations from the bourgeoisie—that is, *the bourgeoisie would be financing guerrilla cinema with a bit of the surplus value that it gets from the peo-ple.* But, as long as the goal is no more than a middle- or long-range aspiration, the alternatives open to revolutionary cinema to recover production and distribution costs are to some extent similar to those obtained for conventional cinema: every spectator should pay the same amount as he pays to see System cinema. Financing,

subsidizing, equipping, and supporting revolutionary cinema are political responsibilities for organizations and militants. A film can be made, but if its distribution does not allow for the recovery of the costs, it will be difficult or impossible to make a second film.

The 16mm film circuits in Europe (20,000 exhibition centers in Sweden, 30,000 in France, etc.) are not the best example for the neocolonialized countries, but they are nevertheless a complementary source for fund raising, especially in a situation in which such circuits can play an important role in publicizing the struggles in the Third World, increasingly related as they are to those unfolding in the metropolitan countries. A film on the Venezuelan guerrillas will say more to a European public than twenty explanatory pamphlets, and the same is true for us with a film on the May events in France or the Berkeley, U.S.A., student struggle.

*A Guerrilla Films International?* And why not? Isn't it true that a kind of new International is arising through the Third World struggles; through OSPAAAL and the revolutionary vanguards of the consumer societies?

A guerrilla cinema, at this stage still within the reach of limited layers of the population, is, nevertheless, *the only cinema of the masses possible today*, since it is the only one involved with the interests, aspirations, and prospects of the vast majority of the people. Every important film produced by a revolutionary cinema will be, explicitly, or not, *a national event of the masses*.

This *cinema of the masses*, which is prevented from reaching beyond the sectors representing the masses, provokes with each showing, as in a revolutionary military incursion, a liberated space, *a decolonized territory*. The showing can be turned into a kind of political event, which, according to Fanon, could be "a liturgical act, a privileged occasion for human beings to hear and be heard."

Militant cinema must be able to extract the infinity of new possibilities that open up for it from the conditions of proscription imposed by the System. The attempt to overcome neocolonial oppression calls for the invention of forms of communication; *it opens up the possibility*.

Before and during the making of *La hora de los hornos* we tried out various methods for the distribution of revolutionary cinema—the little that we had made up to then. Each showing for militants, middle-level cadres, activists, workers, and university students became—without our having set ourselves this aim beforehand—a kind of enlarged cell meeting of which the films were a part but not the most important factor. We thus discovered a new facet of cinema: the *participation* of people who, until then, were considered *spectators*.

At times, security reasons obliged us to try to dissolve the group of participants as soon as the showing was over, and we realized that the distribution of that kind of film had little meaning if it was not complemented by the participation of the comrades, if a debate was not opened on the themes suggested by the films.

We also discovered that every comrade who attended such showings did so with full awareness that he was infringing the System's laws and exposing his personal security to eventual repression. This person was no longer a spectator; on the contrary, from the moment he decided to attend the showing, *from the moment he lined himself up on this side* by taking risks and contributing his living experience to the meeting, he became an actor, a more important protagonist than those who appeared in the films. Such a person was seeking other committed people like himself

while he, in turn, became committed to them. *The spectator made way for the actor, who sought himself in others.*

Outside this space which the films momentarily helped to liberate, there was nothing but solitude, noncommunication, distrust, and fear; within the freed space the situation turned everyone into accomplices of the act that was unfolding. The debates arose spontaneously. As we gained in experience, we incorporated into the showing various elements (a *mise en scène*) to reinforce the themes of the films, the climate of the showing, the "disinhibiting" of the participants, and the dialogue: recorded music or poems, sculpture and paintings, posters, a program director who chaired the debate and presented the film and the comrades who were speaking, a glass of wine, a few *mates*,[6] etc. We realized that we had at hand three very valuable factors:

1. *The participant comrade*, the man-actor-accomplice who responded to the summons;

2. *The free space* where that man expressed his concerns and ideas, became politicized, and started to free himself; and

3. *The film*, important only as a detonator or pretext.

We concluded from these data that a film could be much more effective if it were fully aware of these factors and took on the task of subordinating its own form, structure, language, and propositions to that act and to those actors—to put it another way, *if it sought its own liberation in its subordination to and insertion in others, the principal protagonists of life.* With the correct utilization of the *time* that that group of actor-personages offered us with their diverse histories, the use of the *space* offered by certain comrades, and of the *films* themselves, *it was necessary to try to transform time, energy, and work into freedom-giving energy.* In this way the idea began to grow of structuring what we decided to call the *film act*, the *film action*, one of the forms which we believe assumes great importance in affirming the line of a *third cinema*. A cinema whose first experiment is to be found, perhaps on a rather shaky level in the second and third parts of *La hora de los hornos* ("*Acto para la liberacion*"; above all, starting with "*La resistencia*" and "*Violencia y liberacion*").

> Comrades [we said at the start of "Acto para la liberacion"], this is not just a film showing, nor is it a show; rather, it is, above all A MEETING—an act of anti-imperialist unity; this is a place only for those who feel identified with this struggle, because here there is no room for spectators or for accomplices of the enemy; here there is room only for the authors and protagonists of the process which the film attempts to bear witness to and to deepen. The film is the pretext for dialogue, for the seeking and finding of wills. It is a report that we place before you for your consideration, to be debated after the showing.
>
> The conclusions [we said at another point in the second part] at which you may arrive as the real authors and protagonists of this history are important. The experiences and conclusions that we have assembled have a relative worth; they are of use to the extent that they are useful to you, who are the present and future of liberation. But most important of all is the action that may arise from these conclusions, the unity on the basis of the facts. This is why the film stops here; it opens out to you so that you can continue it.

The film act means an open-ended film; it is essentially a way of learning.

The first step in the process of knowledge is the first contact with the things of the outside world, the stage of sensations [*in a film, the living fresco of image and sound*]. The second step is the synthesizing of the data provided by the sensations; their ordering and elaboration; the stage of concepts, judgements, opinions, and deductions [*in the film, the announcer, the reportings, the didactics, or the narrator who leads the projection act*]. And then comes the third stage, that of knowledge. The active role of knowledge is expressed not only in the active leap from sensory to rational knowledge, but, and what is even more important, in the leap from rational knowledge to revolutionary practice . . . The practice of the transformation of the world . . . This, in general terms, is the dialectical materialist theory of the unity of knowledge and action[7] [*in the projection of the film act, the participation of the comrades, the action proposals that arise, and the actions themselves that will take place later*].

Moreover, each projection of a film act presupposes a *different setting*, since the space where it takes place, the materials that go to make it up (actors-participants), and the historic time in which it takes place are never the same. This means that the result of each projection act will depend on those who organize it, on those who participate in it, and on the time and place; the possibility of introducing variations, additions, and changes is unlimited. The screening of a film act will always express in one way or another the historical situation in which it takes place; its perspectives are not exhausted in the struggle for power but will instead continue after the taking of power to strengthen the revolution.

The man of the *third cinema*, be it *guerrilla cinema* or a *film act*, with the infinite categories that they contain (film letter, film poem, film essay, film pamphlet, film report, etc.), above all counters the film industry of a cinema of characters with one of themes, that of individuals with that of masses, that of the author with that of the operative group, one of neocolonial misinformation with one of information, one of escape with one that recaptures the truth, that of passivity with that of aggressions. To an institutionalized cinema, it counterposes a guerrilla cinema; to movies as shows, it opposes a film act or action; to a cinema of destruction, one that is both destructive and constructive; to a cinema made for the old kind of human being, for *them*, it opposes a *cinema fit for a new kind of human being, for what each one of us has the possibility of becoming.*

The decolonization of the filmmaker and of films will be simultaneous acts to the extent that each contributes to collective decolonization. The battle begins without, against the enemy who attacks us, but also within, *against the ideas and models of the enemy to be found inside each one of us.* Destruction and construction. Decolonizing action rescues with its practice the purest and most vital impulses. It opposes to the colonialization of minds the revolution of consciousness. The world is scrutinized, unravelled, rediscovered. People are witness to a constant astonishment, a kind of second birth. They recover their early simplicity, their capacity for adventure; their lethargic capacity for indignation comes to life.

Freeing a forbidden truth means setting free the possibility of indignation and subversion. Our truth, that of the new man who builds himself by getting rid of all

the defects that still weigh him down, is a bomb of inexhaustible power and, at the same time, *the only real possibility of life.* Within this attempt, the revolutionary filmmaker ventures with *his subversive observation, sensibility, imagination, and realization.* The great themes—the history of the country, love and unlove between combatants, the efforts of a people who are awakening—all this is reborn before the lens of the decolonized camera. The filmmaker feels for the first time. He discovers that, within the System, nothing fits, while outside of and against the System, everything fits, because everything remains to be done. What appeared yesterday as a preposterous adventure, as we said at the beginning, is posed today as *an inescapable need and possibility.*

Thus far, we have offered ideas and working propositions, which are the sketch of a hypothesis arising from our personal experience and which will have achieved something positive even if they do no more than serve to open a heated dialogue on the new revolutionary film prospects. The vacuums existing in the artistic and scientific fronts of the revolution are sufficiently well known so that the adversary will not try to appropriate them, while we are still unable to do so.

Why films and not some other form of artistic communication? If we choose films as the center of our propositions and debate, it is because that is our work front and because the birth of a *third cinema* means, at least for us, *the most important revolutionary artistic event of our times.*

[TRANSLATION FROM *CINEASTE* REVISED BY JULIANNE BURTON AND EDITOR]

## NOTES

1. Mao Tse-tung, *On Practice.*
2. Rodolfo Puigross, *The Proletariat and National Revolution.*
3. Mao Tse-tung, op. cit.
4. Che Guevara, *Guerrilla Warfare.*
5. The raiding of a Buenos Aires union and the arrest of dozens of persons resulting from a bad choice of projection site and the large number of people invited.
6. A traditional Argentine herb tea, *hierba mate.*
7. Mao Tse-tung, op. cit.

# STEPHEN CROFTS

# Reconceptualizing National Cinema/s

Stephen Crofts is an independent scholar and was Honorary Research Associate at the Centre for Critical and Cultural Studies at University of Queensland, Australia. Crofts has taught film and media studies at universities in Britain, Australia, and New Zealand, and has published extensively on film history, theory, and television studies. He is the author of *Identification, Gender and Genre: The Case of* Shame (1998) and *Programmed Politics* (with Philip Bell and Kathe Boehringer, 1982) on the televisual construction of politics.

Crofts's influential "Reconceptualizing National Cinema/s" presents an important intervention into debates on the concept of national cinema.

The resurgence of international cinema in the 1980s and its increasing visibility at international film festivals were paralleled by the surge in the studies of various national cinemas and sustained analytic work on the concept of national cinema itself. Most early studies were still based on the idea of a centralized nation—that films were essentially "French" or "German," for example. However, the historical conditions of globalization and gradually weakening economic and national boundaries urged critics to reconsider the stability of the "national." Permutations of the term, such as multinationalism and transnationalism, threw concepts of the nation and national cinema under serious critical scrutiny.

Seeking to generate a categorical framework for the different manifestations of national cinema, "Reconceptualizing National Cinema/s" (originally published in 1993 in *Quarterly Review of Film and Video*) offers an account of the global reach of national cinemas. While Crofts does not see national cinema as a seamless totality that simply expresses the features of a given national character, he does warn against the complete abandonment of the concept of the national. Rather, he highlights the relevance of national cinema while acknowledging its limitations and accounting for the hybridity of national cultures and their cinemas, expanding the concept of national cinema into what he calls "varieties of national cinema production." Crofts not only looks at production and distribution but also engages categories such as audiences, discourses, textuality, and specific national cinema movements to explain the various forms of national cinema as well as the ways in which a specific national context contributes to the development of a certain cinematic production. This essay raises important methodological issues for the development of the resurgent field of "world cinema." Moreover, by questioning the politics of canon formation in national cinema studies, Crofts advances a consideration of national cinema "in non-First World terms."

## READING CUES & KEY CONCEPTS

▪ While Crofts carefully defines his categorical framework for varieties of national cinema, he also acknowledges the permeable nature of these categories. Think of some films that are "cross-breeds," and identify the features that put them into more than one category.

▪ Crofts acknowledges that the "major changes which have recently affected world cinema" have undermined the concept of the national, and yet the term "national" stays central to his analysis. What are the advantages and disadvantages of not replacing the concept of the national with terms such as "transnational" or "global"?

▪ One of Crofts's categories of national cinema is a rare case of "cinemas which ignore Hollywood," such as Hong Kong and Indian cinema. In what ways does the recent commercial success of these two national cinemas in the West, and their increasing presence at European film festivals, change their relationship to Hollywood?

▪ **Key Concepts:** National Cinema; European-Model Art Cinema; Third Cinema; Commercial Cinema; Regional/Ethnic Cinema

# Reconceptualizing National Cinema/s

## Part I: Introduction

1992: quincentenary of Europe's invasion of the Americas, year of Europe's anticipated economic union, year of fierce ethnic-religious conflicts in what were Yugoslavia and the Soviet "Union," and the year of Afro-American outrage at its abuse by a white American judicial system. A year, then, which exposes the exploitation of indigenous peoples, the perceived importance of supra-national trading blocs, the imposition of nationalisms on sub-national populations, and the violence inflicted on such groups in the name of "national unity." As a post-Enlightenment organizer of populations, the nation has recently been seriously frayed at its edges under the pressure of ethnic, religious, democratic and other forms of dissent, in particular consequent upon the disintegration of Soviet Communism and Pax Americana.

Analysis of national cinemas is the more urgent in the face of other major changes which have recently affected world cinema: the global spread of corporate capital, the consolidation of global markets, the speed and range of electronic communications (Hebdige 1990:v–vi). This essay seeks to theorize the global range of national cinemas in terms of the multiple politics of their production, distribution, and reception, their textuality, their relations with the state and with multi-culturalism. These terms and their interactions constitute the basis of a project of disaggregating the term "national cinema" (the "national" especially should perhaps carry mental quotation marks throughout what follows). The essay limits itself to the feature film, and historically goes back to 1945, focusing in particular on recent years. This reconceptualization takes as axiomatic the issues set out by Andrew Higson as requiring address in considering national cinemas: the range of films in circulation within a nation-state, the range of sociologically specific audiences for different types of film, and the range of discourses circulating about film (1989:44–45), while recognizing that the second of these is amenable only to micro-analyses inappropriate to a synoptic essay such as this.[1]

## Part II: Varieties of National Cinema Production

Especially in the West, national cinema production is usually defined against Hollywood. This extends to such a point that in Western discussions, Hollywood is hardly ever spoken of as a national cinema, perhaps indicating its transnational reach. That Hollywood has dominated most world film markets since as early as 1919 is well known (Thompson 1985; Guback 1976; Sklar 1975). Whereas in 1914 90% of films shown worldwide were French, by 1928, 85% were American (Moussinac 1967 [1925]:238). And for all the formal disinvestiture secured domestically by the 1948 Paramount Decree, transnationally Hollywood still operates effectively as a vertically integrated business organization.

Throughout most film-viewing countries outside South and Southeast Asia, Hollywood has successfully exported and naturalized its construction of the cinema as fictional entertainment customarily requiring narrative closure and

assuming a strong individual—usually male—hero as the necessary agent of that closure. In anglophone markets especially, Hollywood interests have often substantially taken control of the distribution and exhibition arms of the domestic industry. Elsaesser can thus comment: "Hollywood can hardly be conceived . . . as totally other, since so much of any nation's film culture is implicitly 'Hollywood'" (1987:166).

In the context of such unequal cultural and economic exchange, most national cinema producers have to operate in terms of an agenda set by Hollywood—though, as indicated by the fourth variety of national cinema listed below, some Asian cinemas significantly maintain their own terrain. The political, economic and cultural regimes of different nation-states license some seven varieties of "national cinema" sequenced in rough order of decreasing familiarity to the present readership: 1) cinemas which differ from Hollywood, but do not compete directly, by targeting a distinct, specialist market sector; 2) those which differ, do not compete directly *but* do directly *critique* Hollywood; 3) European and Third World entertainment cinemas which struggle against Hollywood with limited or no success; 4) cinemas which ignore Hollywood, an accomplishment managed by few; 5) anglophone cinemas which try to beat Hollywood at its own game; 6) cinemas which work within a wholly state-controlled and often substantially state-subsidized industry; and, 7) regional or national cinemas whose culture and/or language take their distance from the nation-states which enclose them.

It should be noted at the outset that, as in most taxonomies, these categories are highly permeable. Not only do individual films cross-breed from between different groups, but a given national cinema, operating in different production sectors, will often straddle these groupings. Thus French cinema operates in the first and third fields, with exceptional forays into the second, and Australian in the fifth and first with yet rarer excursions into the second, while India produces in the fourth, the first and the second. Moreover, the export of a given text may shift its category, most commonly recycling films of the second and sixth groupings as the first, as art cinema. In such cases, distribution and reception criteria supplant production and textual criteria. Part Three below will amplify the frequently depoliticizing effects of this shift.

## A. EUROPEAN-MODEL ART CINEMAS

This is, to most of the present readership, the best-known form of national cinema. Indeed, it constitutes the limits of some accounts of national cinema which collapse national cinema into the European art film flourishing in the 1960s and 1970s (Neale 1981). This model aims to differentiate itself textually from Hollywood, to assert explicitly or implicitly an indigenous product, and to reach domestic and export markets through those specialist distribution channels and exhibition venues usually called "arthouse." Outside Europe, the model includes, for example, the art cinema of India exemplified by Satyajit Ray, as well as the Australian period film.

Insofar as the discourses supporting such a model of national cinema are typically bourgeois-nationalist, they also subtend the European popular cinemas considered below. Those of the former are more elitist and more targeted at export

markets for financial and cultural reasons. (This is not to say, of course, that popular cinemas do not seek out foreign markets.) National pride and the assertion at home and abroad of national cultural identity have been vital in arguing for art cinemas. Central, too, have been arguments about national cultural and literary traditions and quality as well as their consolidation and extension through a national cinema; hence the frequent literary sources and tendencies in this European model of national cinema (Elsaesser 1989:108,333).

Such arguments have issued in and maintained legislation for European cinemas of quality as well as European popular cinemas. The most meaningful legislation has been that for state subvention, directly via grants, loans, prizes and awards, or indirectly through taxation (the state in the post–World War Two period replaces the private patronage which outside Russia substantially supported the art/avant-garde cinema of the 1920s). State legislation has also been used to govern quotas and tariffs on imported films. These various legislative and financial arrangements allow for the establishment of what Elsaesser calls a "cultural mode of production" (1989:41–3) as distinct from the industrial mode of Hollywood. Though it depends on state subsidies—increasingly via television—this production mode is successful because of a meshing, often developed over decades, between economic and cultural interests in the country concerned. Such a mesh is less common in other modes of national cinemas considered below. Significantly, as elucidated by Colin Crisp, the French cinema—that most successfully nationalist of national cinemas—became so in the post-1945 era by virtue of its cinema workers' vigorous campaign against the post-Vichy influx of Hollywood films which obliged the government to impose a quota on Hollywood imports as well as box-office taxes to subsidize indigenous feature film production. A key variant affecting the success of an art cinema is the cultural status of cinema relative to other artistic practices in the country concerned. France rates cinema more highly than West Germany, for instance, with Britain in between, and Australia, adopting a European funding model, hovers near the bottom.

Textually, European-model art cinema has been typified by features such as the psychologized characterization, narrational ambiguity and objective verisimilitude noted by David Bordwell (1979 and 1985). And in defiance of claims that art cinema died with Tarkovsky, such textual features survive, with the metaphysics and the high-cultural address, in the work of Resnais, Rivette, Rohmer and newcomers like Kieslowski and Greenaway. But Bordwell's schema is modified by two factors. The supersession of early 1960s existentialism by later 1960s political radicalism and subsequent apoliticisms is one, pursued later. The other is Hollywood's development of its own art cinema. This has contributed to a blurring of boundaries between specialist and entertainment market sectors in its own market and abroad, and has weakened the assertions of independence made by other art cinemas. The generic mixing of Hollywood from, say, the early 1960s has been complicated by its interchange with European art cinema developments. Hollywood has developed its own art cinema after and alongside the spaghetti Western, Nouvelle Vague *homages* to Hollywood genres and directors, Fassbinder's recasting of Hollywood melodrama and gangster genres and the adoption by such directors as Schlöndorff, Hauff and Jodrell of Hollywood genres and modes of character identification to deal with nationally specific, West German and Australian issues.

Penn, Altman, Schrader and Allen in the first wave all had their own favorite European influences, while a later star such as Lynch arrives with a more postmodernist pedigree, and Soderberg, Hartley and Stilman have more modest projects. A principal upshot has been a blurring of national cinema differences. Coupled with the aging market demographics of the European art film—the babyboomers forsake the cinema for their families—this blurring leaves these production sectors less able to differentiate their product from Hollywood's. Such insecurity is compounded by substantial American successes at recent Cannes festivals, long the preserve of European films.

While a politicized art cinema diverges from the metaphysical orientation of the textual norms cited above, state subsidy does impose limitations. Elsaesser neatly pinpoints the contradictions ensuing from state subsidy of a cultural mode of film production: it encourages aesthetic difference from the dominant (Hollywood) product, but discourages biting the hand that feeds it (1989:44). In the West German instance, this tension explains the adoption of political allegory as a mode of self-censorship, as variously seen in *Artists at the Top of the Big Top: Disoriented* (as regards state funding of film), *The American Friend* (American cultural influences in West Germany) and *Germany, Pale Mother* (recent German history and feminist readings of it). Left political films found their way through the liberal pluralist interstices of such cultural funding arrangements: for example, the critical realism of a Rosi or a Rossellini and the critical anti-realism of Kluge and Straub-Huillet. Godard, in the heady affluent days of turn-of-the-70s New Leftism, constituted a limit-case: on the basis of his cultural prestige as renowned art film director, he persuaded four television stations to finance ultra-leftist films, only one of which was then screened (Crofts 1972:37). Such explicit leftism partly borrows its discourses from, and marks a border zone between a European art cinema and the second mode of national cinema.

## B. THIRD CINEMA

1960s–1970s Third Cinema opposed the USA and Europe in its anti-imperialist insistence on national liberation, and in its insistence on the development of aesthetic models distinct from those of Hollywood and European art cinema. As Getino and Solanas proclaimed in their famous 1969 manifesto, "Towards a Third Cinema":

> While, during the early history . . . of the cinema, it was possible to speak of a German, an Italian or a Swedish cinema clearly differentiated from, and corresponding to, specific national characteristics, today such differences have disappeared. The borders were wiped out along with the expansion of US imperialism and the film model that it imposed: Hollywood movies . . . The first alternative to this type of cinema . . . arose with the so-called "author's cinema" . . . the second cinema. This alternative signified a step forward inasmuch as it demanded that the film-maker be free to express him/herself in non-standard language . . . But such attempts have already reached, or are about to reach, the outer limits of what the system permits . . . In our times it is hard to find a film within the field of commercial cinema . . . in both the capitalist and socialist countries, that manages to avoid the models of Hollywood pictures. (1969:20–21)

From the perspective of revolutionary, national liberation movements in Latin American, African and Asian nations, such an identification of "first" with "second" cinemas has an understandable basis in a critique of bourgeois individualism. For the existentialist-influenced "universal" humanism of much 1960s art cinema (canonically Bergman, Antonioni, Resnais) shares a Western individualism with the achieving heroes of Hollywood who resolve plots within the global-capitalist terms of a US world view.

Third Cinema has proven to be one of the more elastic signifiers in the cinematic lexicon. Some writers have tried to homogenize the enormously diverse range of Third World film production under its rubric (see Burton 1985:6–10 and Willemen 1987:21–23 discussing Gabriel 1982), while others have sought to build on the 1960s liberationist political moment of Getino and Solanas's manifesto, a moment extending well into the 1980s in ex-Portuguese colonies in Africa. Insofar as Third Cinema distinguishes itself politically and largely aesthetically from Hollywood and European art cinema models, its history has been a fitful one. In its concern with "a historically analytic yet culturally specific mode of cinematic discourse" (Willemen 1987:8), its radical edge distinguished it also from the bulk of Third World production, primarily devoted to comedies, action genres, musicals and varieties of melodrama/romance/titillation. Especially in the 1960s, such radicalism rendered Third Cinema liable to ferocious censorship. More recently, Third Cinema abuts and overlaps with art film's textual norms and, its militant underground audience lost, seeks out art cinema's international distribution-exhibition channels. Names such as those of Solanas, Mrinal Sen, Tahimik, Sembene and Cissé serve notice of the ongoing importance of Third Cinema as a cinema of political and aesthetic opposition.

It follows from its political oppositionality and Third World "national [cultural] powerlessness" (Stam, 1991:227) that funding for such cinema is highly unreliable. In the instance of films from impoverished, black African one-party states with few cinemas and minimal film culture, film subsidy is easier found in France, in Switzerland, or from the UK's Channel 4 and BBC2. Such production conditions give Third Cinema a more urgent intensity than the political allegories of West German cinema and raise vital questions about the cultural role played by First World financing of Third World cinemas. Rod Stoneman of Channel Four sounds an appropriate warning note on international co-productions: "Vital though the input of hard currency from European television may be, it is important that it does not distort the direction of African cinema" (quoted in Leahy 1991:65).

Discourses on Third Cinema undo many First World notions of national cinema, perhaps most strikingly the notion of national cultural sovereignty. As polemically adopted by the 1986 Edinburgh Film Festival Special Event on the topic, Third Cinema offered a particular reconceptualization of national cinema. It became a means of disaggregating the congealed stolidity of a British film culture unwilling to recognize in its midst a plethora of ethnic, gender, class and regional differences (Pines and Willemen 1989). The Event extended the definition of Third Cinema to take in, for instance, black British cinema. Another conceptual dividend of Third Cinema is its decisive refutation of the easy Western assumption of the coincidence of ethnic background and home. Pinochet's military dictatorship in Chile, for example, produced a diasporic cinema. As Zuzana Pick notes: "The dispersal of filmmakers [ . . . ] made problematic their identification within the Chilean national and cultural formation" (1987:41).

Similarly exiled have been such erstwhile Fifth Generation Chinese filmmakers as Wu Tianming, Chen Kiage, Huang Jianxin and Zhang Yimou, whose *Ju Dou*, co-produced with a Japanese company, is still banned in China, probably for its allegorical resonances of the 1960s–1989 period as well as for the expressed concern that it is a "foreign exposé" of a "backward China." And within their "own" countries filmmakers such as Paradjanov and Yilmaz Güney have been exiled and/or imprisoned. Such troublings of First World homogenizing concepts of nation will be pursued later.

## C. THIRD WORLD AND EUROPEAN COMMERCIAL CINEMAS

Art cinema and Third Cinema, the two best known reactions to Hollywood, do not exhaust the field. Both Europe and the Third World produce commercial cinemas which compete, with varying degrees of success, with Hollywood product in domestic markets. These cinemas, and all those considered henceforth, are less well-known than the first two because they are less exported to the European and anglophone film cultures which largely define the critical terms of national cinemas.

Much Third World production, as distinct from Third Cinema, aims, like European art cinema, to compete with Hollywood in indigenous markets—or, in Africa, with Indian cinema too—but it differs from European art cinema in being populist. This may be explained, in part, by lesser degrees of American cultural influence (that is, there is more screen space) and by the fact that local cultural elites outside Latin America are weaker and little concerned with cinema, thus encouraging lesser art cinemas. (Third World cinema here excludes China and Russia, considered later.)

European commercial cinema, however, should be treated here. It targets a market sector somewhat distinct from European-model art cinema, and thus vies more directly with Hollywood for box-office. Its most successful country has been France, where until 1986 indigenous cinema won out over Hollywood at the local box-office. French production, it might be noted, has partly dissolved the industrial/cultural distinction by successfully promoting *auteurs* within an industrial context. Other European commercial/art cinemas such as Holland's and Ireland's, based on small language communities, have a much more parlous existence, with production levels often tailing off to zero per year and with few exports. Typical genres of a European commercial cinema include the thriller, comedy and, especially in the 1960s, soft-core.

Excluding the booming economies of East Asia, the dependent capitalist status of most Third World countries, with stop-go economies and vulnerability to military dictatorships with short cultural briefs, rarely provides the continuous infrastructural support which nurtures indigenous cinemas. Economic dependency and hesitant cultural commitment typically promote private over public forms of investment which further weaken indigenous film production. John King notes the common failure in Latin America to bite the bullet for import quotas:

> [I]n general the state has been more successful in stimulating production than in altering distribution and exhibition circuits. The transnational and local monopolies have strongly resisted any measures to restrict the free entry of foreign films and have grudgingly obeyed, or even ignored, laws which purport to guarantee screen time to national products . . . [T]he logic of state investment was largely economic: to protect the profits of dominantly private investors. There are fewer examples of what Thomas Elsaesser calls a "cultural mode of production." (1990:248–9)

Throughout the Third World, with exceptions noted below, foreign (mainly Hollywood) films dominate local screens. Even in Turkey, where "film production was [ . . . ] neither dominated by foreign companies nor supported or tightly controlled by the state [ . . . ] the market was still dominated by the four or five hundred imported films (mostly Hollywood movies)" (Armes 1987:195–6). Uruguay represents an extreme instance, insofar as it has a dynamic film culture and almost no local production (King 1990:97). Yet that same film culture afforded more admissions to Solanas's *Tangos: El Exilio de Gardel* than to *Rambo* (Solanas 1990:115). Slightly differently, Tunisia has since 1966 hosted the significant Carthage Film Festival while having only some seventy film theaters, insufficient to sustain regular local production. In francophone black Africa, only recently has the French distribution duopoly been displaced, allowing the screening of more African films on African screens (Armes 1987:212, 223).

Countries of the East Asian economic boom clearly differ. While Japan is Hollywood's largest overseas market, in 1988 domestic product retained 49.7% of box-office (Lent 1990:47), specializing largely in softcore and adolescent melodramas (Yoïchi 1990:110). And South Korea in the same year battled the MPEAA to reduce Hollywood imports to roughly five per year (Lent 1990:122–3). As such, it broaches the category of "Ignoring Hollywood."

## D. IGNORING HOLLYWOOD

In Paul Willemen's gloss, "some countries (especially in Asia) have managed to prevent Hollywood from destroying their local film industry" (1987:25). This option is open only to nation-states with large domestic markets and/or effective trade barriers, such as India and Hong Kong (there are some similarities between these countries and totalitarian cinemas considered below). In these Asian countries, culturally specific cinemas can arise and flourish. In Hong Kong, the national cinema outsells Hollywood by a factor of four to one. And in India the national cinema sells four times as many tickets per year as does Hollywood in the US. In 1988, a typical year, the Indian industry produced 773 films, 262 more than Hollywood. That Indian features are produced in some 20 languages for local consumption protects Indian films very ably from foreign competition (Lent 1991:230–1). And in the Hollywood vein—if less expansively—Bombay exports its product to Indian communities worldwide, just as Hong Kong exports through East Asia, dominating the Taiwan market, for instance, and to Chinatowns throughout the Western world. Furthermore, Indian cinema long colonized Ceylon (now Sri Lanka). All Sinhalese films prior to 1956 were made in South India, and "local actors were decked out as Indian heroes and heroines who mouthed Sinhalese" (Coorey and Jayatilaka 1974:303).

## E. IMITATING HOLLYWOOD

Some sectors of some national cinemas have sought to beat Hollywood at its own game—and overwhelmingly failed. Such aspirations have emanated largely from anglophone countries: Britain, Canada, Australia. In the memorable dictum of British producer, Leon Clore, "If the United States spoke Spanish, we would have a film industry" (quoted by Roddick 1985:5). State investment in the countries' film

industries has secured relatively stable production levels, but has not guaranteed a culturally nationalist product. Anglophony has encouraged these nations to target the West's largest, most lucrative—and well-protected—market, that of the US. But these national cinemas have already had their indigenous cultural bases modified, if not undercut, by the substantial inroads made into domestic distribution and exhibition by Hollywood interests and product. Geoffrey Nowell-Smith's provocative remarks on British cinema are yet more pertinent to Canada and Australia: "British cinema is in the invidious position of having to compete with an American cinema which, paradoxical as this may seem, is by now far more deeply rooted in British cultural life than is the native product" (1985:152). Already weaker than those of major European countries, the local film cultures of these anglophone nations have been further weakened through the 1980s by the unequal economic exchanges which have locked British, Canadian and Australian film production increasingly into dependence on the US market through pre-sales and distribution guarantees. For each success story like *A Fish Called Wanda* and *Crocodile Dundee* which have drawn on some local cultural values, there have been hundreds of films made in these lesser-player countries which, in trying to second-guess the desires of the US market, have produced pallid imitations. An index of the price exacted for the American/world distribution of *Crocodile Dundee* can be seen in the re-editing required by Paramount, which quickened the narrative pace and made the film look more like a wholesome family entertainment (Crofts 1990). A fantasy of a foreign market can, then, exercise an inordinate influence over "national" product.

The logic of such blithe bleaching-out of domestic cultural specificity can have two further consequences: the country may become an offshore production base for Hollywood—witness Britain, Canada, and Australia's branch of Warner Brothers' "Hollywood on the Gold Coast"—or Hollywood may exercise its longstanding vampirism of foreign talent (Prédal 1990). In the Australian case, all the major name directors of the 1980s have now moved to Hollywood, most without returning to Australia: the two George Millers, Peter Weir, Gillian Armstrong, Fred Schepisi, Bruce Beresford, Phil Noyce, Carl Schultz, Simon Wincer. Four leading Australian actors have now made the Hollywood grade: Mel Gibson, Judy Davis, Bryan Brown, Colin Freils. Even that stalwart of Australian cultural nationalism, playwright and scriptwriter David Williamson, has been writing a script in Hollywood. Similarly Bangladeshi and Indian talent.

### F. TOTALITARIAN CINEMAS

Sixthly, there is the national cinema of the totalitarian state: Fascist Germany and Italy, Chinese cinema between 1949 and the mid-1980s, and, of course, the Stalinist regimes of the Soviet bloc. By far the predominant mode of the Communist brand of such national cinemas has been socialist realism, which sought to convince viewers of the virtues of the existing political order (Crofts 1976). Peripheral to this core production has been the often political art cinema of Tarkovsky, Jancsó, Makaveyev, Wajda, various proponents of the Cuban and Czech New Waves, and Chinese Fifth Generation cinema. Such peripheral production has been conditional upon the liberalism or otherwise of national policies at the time, both as regards cultural production and the cultural diplomacy of products exported. A further aspect of any

analysis of this mode of national cinema might seek to disentangle cultural speci-
ficities from the homogenizing fictions of nationalism. As Chris Berry notes in sur-
veying Fifth Generation departures from the Han Chinese norm, there are "56 races
in the People's Republic" (Berry 1992:47). The undoubted popularity of such Com-
munist and also fascist cinemas might need to be mapped against the discursive
regimes and the range of other entertainment, within and outside the home, offered
by such nation-states.

## G. REGIONAL/ETHNIC CINEMAS

Given the historical recency of the disintegration of the nation-state and its force-
fully homogenizing discourses and political sanctions, it is not surprising that eth-
nic and linguistic minorities have generally lacked the funds and infrastructure to
support regional cinemas or national cinemas distinct from the nation-states which
enclose them. Marvin D'Lugo has written of Catalan cinema as "something like a na-
tional cinema" (1991:131), but perhaps the best-known regional cinema, the Québecois,
has benefitted from cultural and political support strong enough to propel its major
name director, Denys Arcand, into international fame. Cinemas such as the Welsh
have not achieved such prominence nor, within settler societies, have Aboriginal,
Maori or Native American cinemas, nor indeed, within an immigrant society, has
Chicano cinema, though Afro-American cinema reaches back to Oscar Micheaux
and has broken into the mainstream with Spike Lee and others.

## Part III: Marketing Options for National Cinemas

I separate out this topic from production to counter the still widespread tendency
of film histories and theories to gloss over what for almost all cinema producers is a
vital, if not the paramount factor in their calculations: namely, markets. While some
sectors of national cinema production do not seek export—witness the German
*arbeiterfilm*, most Chinese film and most "poor cinema"—a great deal of national cin-
ema is produced for export as well as domestic consumption. National cinemas thus
compete in export markets with each other and with the big other of Hollywood.

## A. EXPORTING NATIONAL CINEMAS

Whereas Hollywood markets itself through well-established transnational net-
works and with relatively standardized market pitches of star, genre and production
values, the export operations of (other) national cinemas are far more hit-and-miss
affairs. Their three principal modes of marketing or product differentiation are by
the nation of production, with different national labels serving a sub-generic func-
tion; by authorship; and for portions of art cinema, by less censored representations
of sexuality, especially in the Bardot days of the 1950s and 1960s, but still now, as
witness Almodóvar. All three modes of differentiation were, and remain, defined
against Hollywood, promising varieties of authenticity and frisson which Hollywood
rarely offered. As Hollywood sets the terms of national cinemas' self-marketing, so
too does its market power and pervasive ideology of entertainment limit the circu-
lation of national cinemas. In foreign, if not also in their domestic markets, national

cinemas are limited to specialist exhibition circuits traditionally distinct from those of Hollywood product. These comprise arthouse cinemas—themselves recently increasingly blurred with mainstream outlets—film festivals, specialist television slots addressing middle- to high-brow viewers, and minority video and laser-disc product, not to mention other, rarer exhibition modes such as community, workplace and campus screenings.

Even for as grand a player as Hollywood, export markets can impose some limitations. Roger Ebert reports that Hollywood's persisting reluctance to figure non-white heroes is attributed within the business to the fact that export markets—despite often being less white than the domestic one—lag behind the temper of the US market (1990). So much the worse, then, for the export aspirations of culturally specific national cinema product. Few states substantially underwrite their export market operations. (The operations of, say, SovExportFilm until 1989 would repay detailed attention.) Distributor take-up of foreign film material for arthouse circulation frequently excludes the culturally specific. Thus New German Cinema is exported largely without Schroeter or Kluge, and Australian cinema almost entirely without the social realist film. Such exclusions can enable the resultant cultural constructions of the exporting country in terms of the sun-tinted spectacles of armchair tourism. At film festivals, a major meeting point of national cinema product and potential foreign buyers, the dominant film-critical discourse is the depoliticizing one of an essentialist humanism ("the human condition") complemented by a tokenist culturalism ("very French") and an aestheticizing of the culturally specific ("a poetic account of local life") (Boehringer and Crofts 1980). With its emphasis on "originality" and "creativity," it is this discourse of art cinema which can facilitate the representation of political film in the tamer terms of art cinema (Crofts and Ros 1977:52–4). As indicated above in "Imitating Hollywood," national cinema producers often cautiously bank on their foreign markets' imputed uninterest in the culturally specific. Without cross-cultural contextualization—a broadly educational project—foreign distribution of national cinemas, then, will tend to erase the culturally specific. One shrewd and successful strategy has been the combination of cultural universals (family madness, artistic ambition, rape) with specific local inflections effected by several Australian films of the last few years—*Sweetie, Shame, High Tide* and *Celia*—which successfully target European film and TV markets.

## B. READING FOREIGN NATIONAL CINEMAS

The foregoing comments on the cultural selectivity of distributors' choices of films to import point to various possibilities of cross-cultural reception. Three features will be noted here: blank incomprehension; misreadings, usually projected appropriations; and the responses of producing countries to foreign praise.

Firstly, some local cultures can remain impervious to outside readings because producer and consumer share few or no cultural knowledges. A striking instance is the films made by the Navajo Indians with the anthropologists Sol Worth and John Adair (Worth and Adair 1960). Unexposed to film and television, the Navajos' innocence of close-ups gave non-indigenous American viewers no understanding of the need to focus on, say, a saddle blanket in the middle distance of a long-shot, while non-indigenous viewers' ignorance of the blanket's cultural significance

gave them no purchase on the scene's Navajo meaning. Other examples include the rich cultural mythology of Latin American or Chinese films, religious emblems in Algerian or Iranian Muslim cinema, dance customs in Indonesian cinema, the cultural density of local reference in Kluge, or indeed the knowledge of African colonial French which enables one to know that the title of the film, *Chocolat*, is slang for both "black" and "screwing."

The second feature has been well characterized in Elsaesser's and Rentschler's analyses of the US appropriation of the New German Cinema (Elsaesser 1980:80; Rentschler 1982). Rentschler, for example, remarks on the tripartite process of US reviewers' ignoring both the cultural specificities and the production processes of the texts concerned, together with their corollary elevation of the author as prime source of meaning. As I have noted elsewhere, *Crocodile Dundee* offered its US viewers a new set on which to inscribe American frontier myths and to re-discover an age of innocence (Crofts 1992).

Finally, the third feature can be illustrated by two samples of producing countries' responses to foreign praise of their product. When a 1980 Cannes Prize for Supporting Actor was awarded to Jack Thompson for his role in *Breaker Morant*, the film was re-released, after an indifferent run in Australia, to unanimous critical praise, and went on to scoop 11 of 15 Australian Film Institute Awards that year (Crofts 1980). *Red Sorghum*'s winning of the 1988 Berlin Film Festival's Golden Bear gave a fillip to its wide popularity with Chinese students and youth (Tian 1989).

Foreign constructions of nations will be crucially affected by national cinematic representations—alongside those of cuisines, football teams and so on. In line with Benedict Anderson, Philip Rosen has observed that "identifying the . . . coherences [of] a 'national cinema' [and] of a nation . . . will always require sensitivity to the countervailing, dispersive forces underlying them" (Rosen 1984:71). The nation can subsume into a fictional entity all manner of differences, across axes of class, gender, sexual preference, ethnicity, cultural capital, religion, and so on. Discourses of national cinema reception tend to effect similar homogenizations, if only insofar as each film is seen as representative of the producing nation (desolate sunburnt landscape as a prime marker of Australian-ness, melancholic engagement with a traumatic history as index of German-ness, etc.). Such reductive national-cultural symbolizations crowd out more complex articulations of national identity. This tendency is challenged only at limit-case points where a politicized cinema explores differences of class, gender, ethnicity, region, etc., within say, the "United" Kingdom.

## Part IV: Conclusions

Several film-historiographical and film-theoretical conclusions can be developed from the foregoing. In general, this essay seeks to enable a consideration of national cinemas in non-First World terms. This firstly requires acknowledging a wider range of national cinemas than is regularly treated under that rubric. Film scholars' mental maps of world film production are often less than global. Even as assiduously encyclopedic an historian as George Sadoul devotes more pages of his *Histoire du Cinéma* to the Brighton School and the beginnings of Pathé than he does to the whole of Latin American cinema between 1900 and 1962 (1962: 43–64, 421–37). As Edward Said magisterially demonstrates with reference to "Orientalism"

as academic discipline and world-view, so the world-views of different national film cultures are substantially informed by their country's relations—military, economic, diplomatic, cultural, ethnic—with other parts of the globe (1985). Thus Sadoul, informed by French colonialism, knows more of African cinema than of Latin American, while an American scholar, informed by the US imperium and substantial Hispanic immigration, knows more of Latin American than African cinema, and a British scholar, informed by European and American cultural influences, may not see much outside that transatlantic axis. At the other end of the East-West axis, a hybrid, non-Eurocentric film culture such as the Thai—even if it does not as yet support substantial film scholarship—draws substantially on both Hong Kong and Hollywood sources as well as local production. Annette Hamilton thus remarks that "the average viewer in Thailand or Singapore has been exposed to a much wider range of visual material in style, genre, and cultural code than is the case for any 'average Western viewer'" (1992:91).

Such skewed world views will demonstrably influence canon formation in the country concerned. And given that Third World production—for that is the prime excluded category—is more plentiful than European and North American by a factor of more than 2 to 1 (Sadoul 1962:530–1), Luis Buñuel's trenchant comments on the canon of world literature could justly apply to that of world cinema:

> It seems clear to me that without the enormous influence of the canon of American culture, Steinbeck would be an unknown, as would Dos Passos and Hemingway. If they'd been born in Paraguay or Turkey, no one would ever have read them, which suggests the alarming fact that the greatness of a writer is in direct proportion to the power of his/her country. Galdós, for instance, is often as remarkable as Dostoevski, but who outside Spain ever reads him? (1984[1982]:222).

To pursue the question of canon formation in relation to national cinemas demands examination not only of historically changing international relations of the kinds set out above, and of the force of such institutions as SovExportFilm and the European Film Development Office in cultural diplomacy, but also of the taste-brokering functions of film festivals and film criticism.

The ongoing critical tendency to hypostatize the "national" of national cinema must also be questioned in non-First World terms. Not only do regional and diasporic cinema production challenge notions of national cinemas as would-be autonomous cultural businesses. So, too, Hollywood's domination of world film markets renders most national cinemas profoundly unstable market entities, marginalized in most domestic and all export markets, and thus readily susceptible, *inter alia*, to projected appropriations of their indigenous cultural meanings. Witness the discursive (re)constructions of national cinemas in the process of their being exported. Ahead of India and Hong Kong, Hollywood remains the big(est) other, the world's only film producer to have anything like transnational vertical integration of its industry. Study of any national cinema should include distribution and exhibition as well as production within the nation-state.

The nation-state itself has for a while been manifestly losing its sovereignty. It has been pressured both by transnational forces—canonically American in economic and

cultural spheres, and Japanese in economic, and more recently, cultural spheres—and simultaneously by the sub-national, sometimes called the local. The multiculturalism, the cultural hybridity of the nation-state has increasingly to be recognized. Recent instances of assertion of ethnicity, for instance, center on linguistic rights and cultural protection: from the Spanish regular in public notices in American cities to people from the Iberian Peninsula who describe themselves as Basque or Catalan rather than Spanish; from the nationalism of Québecois cinema and Welsh programs for S4C in the UK to the substantial Greek video markets throughout Australia, especially in Melbourne, the third largest Greek city in the world. Minorities or majorities defined by political dissent, class, ethnicity, gender, religion or region are the everyday stuff of many people's lives: witness the five nations, three religions, four languages and two alphabets which went to constitute the "nation" Yugoslavia. Recall, also, from a 1962 essay by Leroi Jones (later Amira Baraka) called "'Black' is a Country": "[T]he Africans, Asians, and Latin Americans who are news today because of their nationalism [ . . . ] are exactly the examples the black man [sic] in this country should use in his struggle for *independence*." (1968[1962]:84). Alongside such sub- and supra-national emphases, however, it is vital to recognize the political significance in other contexts, especially in developing countries, of rhetorics of nation and nationalism as means of fighting for independence from imperialist powers. Recall here the dominant genre of Vietnamese cinema, anti-imperialist propaganda.

Politics, in other words, is a matter of unequal distributions of power across axes of nation as well as of class, gender, ethnicity, etc. The political engagements that people do (or do not) make will vary with their social and political contexts, and their readings of those contexts. In considering national cinemas, this implies the importance of a political flexibility able, in some contexts, to challenge the fictional homogenizations of much discourse on national cinema, and in others to support them. And it would be foolhardy to underestimate the continuing power of the nation-state. To acknowledge these powers, by the same token, is not to disavow the cultural hybridity of nation-states; nor to unconditionally promote national identities over those of ethnicity, class, gender, religion, and the other axes of social division which contribute to those identities; nor, finally, to buy into originary fantasies of irrecoverable cultural roots, or into the unitary, teleological and usually masculinist fantasies in which nationalisms display themselves. That said, the struggle of many national cinemas has been one for cultural, if not also economic, self-definition against Hollywood or Indian product.

While cultural specificity, then, is by no means defined exclusively by the boundaries of that recent Western political construct, the nation-state, at certain historical moments—often moments when nationalism connects closely with genuinely populist movements, often nation-building moments (Hinde 1981)—national developments can occasion specifically national filmic manifestations which can claim a cultural authenticity or rootedness. Examples include some of the best known cinema "movements." Italian Neo-Realism, Latin American Third Cinema and Fifth Generation Chinese Cinema all arose on the crest of waves of national-popular resurgence. The French Nouvelle Vague marked a national intellectual-cultural recovery in the making since the late 1940s, whereas the events of May 1968 were more nationally divisive, leaving a clear political imprint in the works of Marker, Karmitz and Godard and Gorin markedly absent from the films of Rohmer or Malle.

New German Cinema drew much of its strength, as Elsaesser has shown, from a 1960–1970s student audience and an allied concern to make sense of the traumas of recent German history (1989). The Australian feature film revival took off on a surge of cultural nationalism developing through the 1960s (Crofts forthcoming). Interestingly, such cinema "movements" occupy a key position in conventional histories of world cinema, whose historiography is not only nationalist but also elitist in its search for the "best" films, themselves often the product of such vital politico-cultural moments. As such, these are the films most frequently exported, and thus often occlude critical attention to films which may well be more popular.

In the context of the relations of unequal economic and cultural exchange obtaining between Hollywood and (other) national cinemas, the generation and/or survival of indigenous genres is a gauge of the strength and dynamism of a national cinema. Outstanding instances in non-Hollywood post-1945 cinema would be the Hong Kong martial arts film, the French (stylish) thriller of Chabrol, Beneix, and others, and in Britain, the Gothic horror film and the Ealing comedy. Less stable indigenous genres include the *Heimat* film in West Germany and the period film and social-realist film in Australia. A vital research area concerns the intersections between given genres and the national. A range of questions present themselves. For example: Under what conditions do culturally specific genres arise? How do imported (usually Hollywood) genres affect the generic range of a given national production sector? Does Chinese production even have genres?

The production category which most obviously confounds any attempts at a neat parcelling of "national" cinemas is of course the international co-production. This is more likely than not—and regularly so at the upper end of the budget range—to encourage the culturally bland. Nowell-Smith cites *Last Tango in Paris* as one of "a number of recent major films [that] have had no nationality in a meaningful sense at all" (1985:154). And Rentschler develops a pointed comparison between *The Tin Drum*'s easy generalities and the more demanding cultural specificities of *The Patriot* (1984:58–9).

Gloomy prognostications for a "Europudding" future of European co-production may well be exaggerated. For alongside directors such as Annaud, Besson, and Wenders, who, in *Variety*-speak are "a chosen few Euro helmers able to finesse international pics" (Williams 1992:31), there are to be reckoned the strong successes of such culturally specific product (co-produced or not) as *Toto le Héros* and *The Commitments*. While countries with smaller local markets will often use co-production agreements to recoup costs, in the lower and middle budget ranges this need not necessarily work against culturally specific interests. Co-productions are actively encouraged by the European Film Development Office's promotional support for films financed from three or more member countries, and the Office argues its respect for national cultural specificities (Schneider 1992). And international co-productions do positively facilitate the treatment of such supra-national ethnic/religious issues as are dealt with in *Europa, Europa*. The mesh, or conflict, between economic and culturally specific interests will vary with the interests concerned at a given point in time.

Latent in preceding sections of this essay have been some key theoretical assumptions, and this is the third respect in which cinemas need to be thought of less in First World terms. Gabriel and Stam have both critiqued the imperialist *données* of center/periphery theories as applied to film theory (Gabriel 1986; Stam 1991)—though

it has to be said that, provided multiple centers be recognized, such theories are still crucial to understanding global economic *Realpolitik*.

Underpinning First World approaches to national cinemas is the master antinomy of self/other (the linguistic sexism, as will be seen, is adopted advisedly). This essay suggests the inappropriateness, in theorizing differences of nations and national cinemas, of what Homi Bhabha calls the "exclusionary imperialist ideologies of self and other" (1989:111). National cinematic self-definition, like *national* self-definition, likes to pride itself on its distinctiveness, on its standing apart from other(s). Such a transcendental concept of an ego repressing its other(s) urges abandonment of the self/other model as an adequate means of thinking national cinemas. For this dualist model authorizes only two political stances: imperial aggression and defiant national chauvinism. It can account neither for Third Cinema's move beyond what Solanas calls its "experimental" phase, nor for the existence of such projects as those of "Imitating Hollywood." Still less can it make sense of the hybridity of national cultures, including those of the notionally most pristine imperial centers. Trinh T. Minh-ha well characterizes the fluid, labile, hybrid nature of cultural identities:

> [D]ifference in this context undermines opposition as well as separatism. Neither a claim for special treatment, nor a return to an authentic core (the "unspoiled" Real Other), it acknowledges in each of its moves, the coming together and drifting apart both within and between identity/identities. What is at stake is not only the hegemony of Western cultures, but also their identities as unified cultures; in other words, the realization that there is a Third World in every First World, and vice-versa. The master is made to recognize that His Culture is not as homogeneous, not as monolithic as He once believed it to be; He discovers, often with much reluctance, that He is just an other among others. (1987:3)

With the recognition of ethnic-cultural hybridity, Bhabha notes, "the threat of cultural difference is no longer a problem of other people. It becomes a question of the otherness of the people-as-one." (1990:301).

Along these lines, Rey Chow has made explicit the feminization of the oriental other which was implicit in Said (Chow 1991; Said 1985: 6,309). And from her work around *Yellow Earth* it is possible to elaborate a kind of hierarchy of othering processes which affect a Western reading of this film's Chinese 1930s female peasant protagonist: Western over Chinese, male over female, urban over peasant, present over past (1990:84). Such work offers sophisticated methodological counters to the projected appropriateness of most taste-brokers of foreign cinemas, who usually promote individual artistic creativity, and at a different discursive level, of Fredric Jameson's blithe determination that "all third world texts are necessarily . . . to be read as . . . national allegories," which elides not only individual creativity but also almost all local cultural specificities (1986:69).

## NOTE

1. As regards the advisability of placing film within the "mediascape" of audio-visual provision in given countries, it should be said that the variety of such provision is enormous. While it may be relatively straightforward to map the cinema/television/video nexus in

Western Europe—television being increasingly the primary producer and exhibitor of European-model art cinemas, with video as supplementary to theatrical screenings of a range of types of other films—other countries operate within quite different and less stable co-ordinates. Witness the rarity of broadcast television in poorer Asian, Pacific, and African countries, or the flourishing videotheques in Pakistan, Taiwan, Burma, Kampuchea and Vietnam which screen black market videos of films smuggled out of Thailand. These and subsequent examples point to very considerable national "mediascape" variations, but the scholarship which would support a fuller questioning here of the "cinema" in "national cinemas" is both too massive and too dispersed for the present project. I would like to acknowledge Thomas Elsaesser's raising of this issue when I presented an earlier version of this essay at his kind invitation at the University of Amsterdam, 16 January 1992.

## WORKS CITED

Anderson, Benedict. 1983. *Imagined Communities*, London: Verso.

Armes, Roy. 1987. *Third World Film Making and the West*, Berkeley and London: University of California Press.

Berry, Chris. 1992. "Race, Chinese Film and the Politics of Nationalism," *Cinema Journal* vol 31, no. 2, Winter.

Bhabha, Homi. 1989. "The Commitment to Theory," in Jim Pines and Paul Willemen, eds., *Questions of Third Cinema*, London: British Film Institute.

———. 1990. "DissemiNation," in Homi Bhabha, ed., *Nation and Narration*, London and New York: Routledge.

Boehringer, Kathe and Stephen Crofts. 1980. "The Triumph of Taste," *Australian Journal of Screen Theory* no. 8.

Bordwell, David. 1979. "Art Film as a Mode of Film Practice," *Film Criticism* vol 4, no 1.

———. 1985. *Narration in the Fiction Film*, London: Methuen.

Buñuel, Luis. 1984 [1982]. *My Last Sigh*, London: Jonathan Cape.

Burton, Julianne. 1985. "Marginal Cinemas and Mainstream Critical Theory," *Screen* vol 26, no. 3–4, May–August.

Chow, Rey. 1990. "Silent is the Ancient Plain: Music, Filmmaking and the Conception of Reform in Chinese New Cinema," *Discourse* vol 12, no. 2, Spring–Summer.

———. 1991. *Women and Chinese Modernity*, Minnesota: University of Minnesota Press.

Coorey, Philip and Amarnath Jayatilaka. 1974. "Sri Lanka (Ceylon)," in Peter Cowie, ed., *International Film Guide*, London: Tantivy Press.

Crisp, Colin. forthcoming. *Classic French Cinema, 1930–1960*, Bloomington: Indiana University Press.

Crofts, Stephen. 1972. *Jean-Luc Godard*, London: British Film Institute.

———. 1976. "Ideology and Form: Soviet Socialist Realism and Chapayev," *Film Form* no 1.

———. 1980. "Breaker Morant Rethought," *Cinema Papers* no 30, December.

———. 1990. "Crocodile Dundee Overseas," *Cinema Papers* no 77, January.

———. 1991. "Shifting Paradigms in the Australian Historical Film," *East-West Film Journal* vol 5, no 2, July.

———. 1992. "Cross-Cultural Reception Studies: Culturally Variant Readings of *Crocodile Dundee*," *Continuum*, vol 6, no. 1.

———. forthcoming. *Australian Cinema as National Cinema*, New York: Columbia University Press.

D'Lugo, Marvin. 1991. "Catalan Cinema: Historical Experience and Cinematic Practice," *Quarterly Review of Film and Video* vol 13, no. 1–3.

Ebert, Roger. 1990. Public Lecture, University of Honolulu, Hawaii, 28 November.

Elsaesser, Thomas. 1980. "Primary Identification and the Historical Subject: Fassbinder and Germany," *Cine-Tracts* no 11, Fall.

———. 1987. "Chronicle of a Death Retold," *Monthly Film Bulletin* vol 54, no. 641, June.

———. 1989. *New German Cinema: A History,* London: Macmillan.

Gabriel, Teshome. 1982. *Third Cinema in the Third World,* Ann Arbor: UMI Research Press.

———. 1986. "Colonialism and 'Law and Order' Criticism," *Screen* vol 27, nos. 3–4, May–August.

Getino, Octavio and Fernando Solanas. 1969. "Towards a Third Cinema," *Afterimage* no 3.

Guback, Thomas. 1976. "Hollywood's International Market," in Tino Balio, ed., *The American Film Industry,* University of Wisconsin Press.

Hamilton, Annette. 1992. "The Mediascape of Modern Southeast Asia," *Screen* vol 33, no. 1, Spring.

Hebdige, Dick. 1990. "Subjects in Space," *New Formations* no 11, Summer.

Higson, Andrew. 1989. "The Concept of National Cinema," *Screen* vol 30, no 4, Autumn.

Hinde, John. 1981. *Other People's Pictures.* Sydney: Australian Broadcasting Commission.

Jameson, Fredric. 1986. "Third World Literature in the Era of Multinational Capital," *Social Text* no. 15, Fall.

Jones, Leroi. 1968 [1962]. "Black is a Country," in *Home: Social Essays,* London: MacGibbon and Kee.

King, John. 1990. *Magical Reels: A History of Cinema in Latin America,* London: Verso.

Leahy, James. 1991. "Beyond the Frontiers," *Monthly Film Bulletin* vol 58, no. 686, March.

Lent, John. 1990. *The Asian Film Industry,* Austin, Texas: University of Texas Press.

Moussinac, Leon. 1967 [1925]. *L'Age Ingrat du Cinéma,* Paris: EFR.

Neale, Steve. 1981. "Art Cinema as Institution," *Screen* vol 22, no 1, Spring.

Nowell-Smith, Geoffrey. 1985. "But Do We Need It?" in Martin Auty and Nick Roddick, eds., *British Cinema Now,* London: British Film Institute.

Pick, Zuzana. 1987. "Chilean Cinema in Exile," *Framework* no 34.

Pines, Jim and Paul Willemen. 1989. *Questions of Third Cinema,* London: British Film Institute.

Prédal, René. 1990. "Un rassemblement mondial de talents," in Francis Bordat, ed., *L'amour du cinéma Américain,* Paris: Cinémaction/Corlet/Télérama.

Rentschler, Eric. 1982. "American Friends and the New German Cinema," *New German Critique* nos 24–5, Fall–Winter.

———. 1984. *New German Cinema in the Course of Time,* Bedford Hills, New York: Redgrave.

Roddick, Nick. 1985. "If the United States Spoke Spanish We Would Have a Film Industry," in Martin Auty and Nick Roddick, eds., *British Cinema Now,* London: British Film Institute.

Rosen, Philip. 1984. "History, Textuality, Nation: Kracauer, Burch, and Some Problems in the Study of National Cinemas," *Iris* vol 2, no 2.

Sadoul, Georges. 1962. *Histoire du Cinéma,* Paris: Flammarion.

Said, Edward. 1985 [1978]. *Orientalism,* London: Penguin.

Schneider, Ute. 1992. Seminar, Sydney Film Festival, 9 June.

Sklar, Robert. 1975. *Movie-Made America,* New York: Random House.

Solanas, Fernando. 1990. "Amérique Latine: le point de vue d'un cinéaste," in Francis Bordat, ed., L'amour du cinéma américain, Paris: Cinémaction/Corlet/Télérama.

Stam, Robert. 1991. "Eurocentrism, Afrocentrism, Polycentrism," Quarterly Review of Film and Video vol 13, no 1–3.

Thompson, Kristin. 1985. Exporting Entertainment: America in the World Film Market 1907–34, London: British Film Institute.

Tian Zhuangzhuang. 1985. Seminar, Brisbane, June 7.

Trinh T. Minh-ha. 1987. "Introduction," Discourse no 8, Fall–Winter.

Willemen, Paul. 1987. "The Third Cinema Question: Notes and Reflections," Framework no 34.

Williams, Michael. 1992. "Films without Frontiers?" Variety, 10 February.

Worth, Sol, and John Adair. 1972. Through Navajo Eyes, Bloomington: Indiana University Press.

Yoïchi, Umemoto. 1990. "Quelles images pour le Japan?" in Francis Bordat, ed., L'amour du cinéma américain, Paris: Cinémaction/Corlet/Télérama.

# JYOTIKA VIRDI

. . . . . . . . . . . . . . . . . . . . . . . . . . . . . . . . . . . . . . . . . . . . . . . . . . . . . . . . . . . . . . . . . . . . . .

# Nation and Its Discontents

FROM *The Cinematic ImagiNation*

Jyotika Virdi (b. 1962) teaches communication, film, and media studies at the University of Windsor, Canada. She has published essays on popular Hindi cinema in a variety of scholarly journals, including *Screen* and *Visual Anthropology*. Her study of Indian cinema, *The Cinematic ImagiNation* (2003), is the first systematic attempt to read Indian popular films as social history. Virdi's book is an important part of a growing body of work on Indian cinema and contributes to the broader fields of Asian film studies, cultural and postcolonial studies, and gender studies.

Work on Indian popular cinema offers a unique and important intervention into studies of national cinemas and into the criteria that designate the concept of the national. First, India produces more films than any other country in the world, and cinema is *the* dominant institution and product in India. It is also consumed by cultures in Africa, Eastern Europe, and the Middle East, as well as by Indian communities in Malaysia, Australia, Britain, the Caribbean Islands, and North America. Despite the influence of Hollywood styles and genres on Indian cinema, the large output of India's popular cinema industries has allowed India to remain one of the few nations to resist the dominance of Hollywood—significant given that the process of designating national cinema is often based on some kind of negotiation with Hollywood. Second, traditional approaches to nation or national cinema rely on a relative homogeneity of nation-states. Virdi explains that India, with its astounding cultural and linguistic diversity, "falls right through the cracks in this theory of centralized homogeneity." The question of how Hindi films attain the status of national cinema and transregional mass popularity in a country with twenty-two official languages, as well as how they construct a coherent "fictional nation" in the

face of considerable caste, class, gender, religious, and regional divisions, makes Hindi cinema more than just an interesting case study in national cinema.

Drawing on film theory, cultural studies, and postcolonial theory, Virdi reads the representational and narrative strategies of post-independence Hindi cinema against its sociocultural and political context in "Nation and Its Discontents." On the most basic level, Virdi demonstrates that the utmost task of Hindi cinema is the creation of a utopian, unified Indian nation. To do so, Hindi cinema dramatizes social conflicts by using family as the primary trope and by narrating nation as family. In these films, family provides a useful site of negotiation that draws upon intense affective relationships among its members. However, Virdi warns, it also depends on the "sharp hierarchy of institutionalized gender inequality," which subordinates and domesticates women's agency. In her analysis of films that narrate the tensions of the new postcolonial nation, *Aan* (1952) and *Pratighaat* (1987) in particular, Virdi shows how the gender dynamic, the different ways in which men and women are called upon to serve the 'nation,' becomes crucial to the nation-formation process.

Virdi's work represents a broader tendency in film studies since the 1990s to dislodge Hollywood's hegemony in film studies and adopt a multiculturalist approach to film. Her work stands in conversation with other scholarly efforts that explore the role of popular cinema in the imagination of the Indian nation: Madhav Prasad's *Ideology of the Hindi Film* (1998), Vijay Mishra's *Bollywood Cinema* (2002), and Lalitha Gopalan's *Cinema of Interruptions* (2003), among others. These studies can help us understand not only the specificity of Hindi cinema as national cinema but also the increasing impact of Indian cinema and its aesthetic on the world cinema stage, as demonstrated by the unprecedented success of *Slumdog Millionaire* (2008).

## READING CUES & KEY CONCEPTS

▣ Virdi argues that the resolution of tensions that threaten to fracture the nation is the central goal of Hindi film. What narrative and stylistic features are deployed in Hindi cinema to meet the narrative demands of this "fictional nation"?

▣ How does Virdi redefine the concepts of "the national" and "national cinema"?

▣ In her analysis of *Pratighaat* (1987), Virdi suggests that women are relegated to the stereotypical role of mothers or sexual objects, but at the same time they serve as active agents, "saviors who will deliver the nation into the future." How might you explain this contradiction?

▣ **Key Concepts:** National Cinema; National/Popular; Hegemony; ImagiNation; Hindi Cinema; Family Topos; Partition; Communalism

# Nation and Its Discontents

· · · · · · · · · · · · · ·

To say that Hindi cinema is a national cinema at once begs several questions: What is a nation? What are the criteria by which we designate a cinema "national"? We also need to ask what the basis is for designating Hindi cinema a

national cinema, or the "national-popular." And in a multilingual nation like India, film raises questions about the role of language in the nation's formation.

The popularity of Hindi cinema has to do with its unique regime of narrative and theme, tradition of spectacle, and its aesthetics and stylistic conventions. It is a cinematic apparatus that draws upon the literary and nonliterary creative imagination, both contemporary and historical. This imagination is also intrinsically tied to—in fact constructs—the nation, a political formation that arrived in India at about the same time as film technology. Here I discuss the nation Hindi cinema imagines and popularizes, film's place within the national-popular, and the extent to which films are constituted by other forms that service the nation-making process.

## *The Nation, in Theory*

Nation and nationalism are particularly troubled concepts for historians and political theorists alike. It is a constantly shifting entity that first emerged in the eighteenth century; it offers a primary form of identification, yet it is difficult to establish the criteria on which it is based: "All . . . objective definitions have failed."[1] Nation is an abstract notion, a myth that cannot be scientifically defined.[2] Neither race, geography, nor language are sufficient to determine the nation's essence. Yet people are willing to die, fight wars, or write fiction on its behalf. Human consciousness invents a nation where such a thing does not exist.[3]

Nationalism arguably emerged in Europe as a powerful ideology in the late seventeenth century, arising within a specific social formation and sustained by culture, a force at once cohesive and fractious. The concept of "nation" spread globally, and it continues to this day in full strength as a prime player in contemporary geopolitics. Fictional and mythic representations construct nations in art and literature, spurring nationalist sentiments, while nations popularize and favor particular myths and fantasies.

Benedict Anderson has argued that the "dawn of nationalism at the end of the eighteenth century coincided with the dusk of religious modes of thought."[4] Nationalism is a mode of thinking that has impacted our social, political, literary, and fictional imagination, even our deepest psychological being—our very sense of personal identity. The nation is the most resilient form of community imagined, and the devotion it elicits from followers is next only to the intensity religion evokes.[5] Nationalism, in fact, effectively replaced religion in seventeenth-century Europe.[6]

The development of nations in the nineteenth and twentieth centuries is integrally bound to capitalist development, and the modern world economy is shaped by its link to national economies. Nation states protect contracts and the accumulation of wealth; in the nineteenth century, national economy implied protectionism.[7] Ernest Gellner's theory is that "the economy needs both the new type of central culture and the central state; the culture needs the state; and the state probably needs the homogeneous cultural branding of the flock."[8] The Indian case, however, falls right through the cracks in this theory of centralized homogeneity. India's most striking aspect is the flexibility with which it accommodates diverse cultural units under its umbrella of nation. However, a sense of unity is derived from various other factors: a state-imposed unified system of law, language, and education; the constitution; one monetary currency; and the creation of a national

imaginary. The latter, I contend, is sustained in no small part by the visionary nature of Hindi cinema.

Nationalism took root in India among a small, westernized elite at the beginning of the nineteenth century. Inspired by the French Revolution, the American War of Independence, and the Enlightenment ideals of freedom, liberty, and the right to self-determination (which ran counter to political subjugation and economic exploitation), Indian politics moved toward imagining a nation marshaled by cultural revivalism and historical reinterpretation. Throughout the nineteenth and early twentieth centuries the nationalist movement coalesced into a process ridden with paradoxes: it invented "Indian" traditions to distinguish itself from the white colonizer. Like other anti-imperialist struggles (but distinct from western nationalism), Indian nationalism adapted "ancient" culture and tradition into a modern concept of "nation."[9] Paralleling bourgeois democratic revolutions in Europe, where a powerful mercantile class displaced monarchical and ecclesiastical authority, in India the nation was an intangible ideal, a chimera, fought for and won against British imperialism.

The Indian nation is a political entity, its state dominated by a class of people extending their power over a determinate geographic boundary. It was power won and sustained through a discursive apparatus deploying various modes of dissemination—through the fictional and literary imagination and the writing of history, enabled by print, communication, and an educational system. No single institution is the harbinger of the nation without also being shaped by it. Cinema, with its preeminence in the world of visual images, has been seriously under-represented and underestimated as a locus of both imagining the nation and creating a national imaginary. Particularly in India, film supplanted a long-standing oral tradition and assumed the status of the "national-popular." Hindi film draws on all the elements of the discursive nation-making apparatus while constituting one in its own right.

## *The Creative ImagiNation*

Fiction, history, print, and telecommunication—common discursive modes imbricated in nation-making strategies—have all had effects on Hindi cinema. It has been said that nations "are imaginary constructs that depend for their existence on an apparatus of cultural fiction in which imaginative literature plays a decisive role."[10] And Timothy Brennan has argued that in third world fiction after World War II,

> the uses of "nation" and "nationalism" are most pronounced. The nation is precisely what Foucault has called a "discursive formation"—not simply an allegory or imaginative vision, but a gestative political structure which the Third World artist is either consciously building or suffering the lack of. The literary act and the institution of literary production, are not only part of the nation-forming process, but are its realization. . . . The rise of modern nation-states in Europe in the late eighteenth and early nineteenth century is inseparable from the form and subject of imaginative literature.[11]

Nations, therefore, are nothing more than the fictional fancies of their creators. Brennan goes on to quote Victoria Glendinning, who comments specifically about

the case of the Indian subcontinent. Pakistan, she says, is a nation "insufficiently imagined . . . India was a fiction invented by the British in 1947. Even the British had never ruled over more than sixty percent of India. But it was a dream that everyone agreed to dream. And now I think there is actually a country called India."[12]

There are two movements that explain, in literary terms, the development of the national in fiction. The first is a search for a common history, what has been called an "anti-death process": it pinpoints a movement of origin, a beginning, an irreversible continuity that is the birth. The second movement strives to delimit the nation within an enclosed space.[13] Several factors contribute to nation making, but the first one is often considered the most important: providing a sense of the past, a historic association with the current state. Territorial nation-states search the past for a common history, often inverting contemporary events to explain it. As Ernest Gellner puts it, writing history is a form of narration that effects a fusion of "will, culture and polity."[14] Hugh Seton-Watson says that "various governments invent tradition to give permanence and solidity to a transient political form."[15] The past, or tradition, becomes what E. J. Hobsbawm calls a "usable past," a way of "creating a people." And the origin of European nationalism is patterned on Judeo-Christian principles: "the idea of a chosen people, emphasis on common stock of memory of the past and hopes for the future, and finally national messianism."[16]

Sudipta Kaviraj points to the discursive nature of the writing of history that constructs the "Imaginary Institution of India." He argues that "India" is the effect of a narrative that performs the political function of imposing cohesion among a number of groups that otherwise do not share a common political identity.[17] Quoting Antonio Gramsci's writings about the eminent falsity of a unilinear history, Kaviraj says that "history was political propaganda, it aimed to create national unity— that is, the nation. . . . It was a wish, not a move based on already existing conditions."[18] He goes on to explain that in societies where tradition is the only legitimizing criterion, the nation attempts to disguise the past in order to pass off its modernity, which it justifies through a falsified version of antiquity. In the case of India:

> The naming of the Indian nation, I wish to suggest, happens in part through a narrative contract. To write a history of India beginning with a civilization of the Indus valley is marked by impropriety. An India internally defined, an India of a national community, simply did not exist before the nineteenth century; there is therefore, an inevitable element of "fraudulence" . . . in all such constructions. "The history of India" is the mark of an ideological construct.[19]

This powerful force of nationalist ideology permeates every institution and discourse, and is marshaled to build the "imagined community." Print media, for example, enables an "ideological insemination" by which "people . . . begin to think of themselves as a nation." People can read a novel alone, knowing that millions of others are doing the same. The novel brings together readers from both "high" and "low" cultures and from different ethnic and regional groups.[20] The narratives— whether they adopt the disciplinary mantle of history, literature, general pulp, the novel, or newspaper—all contribute to shaping the imagined nation and the national imaginary, and each of these rely on print technology.

What role does language play in all this? In India, Hindi, a regional language among many others, was ascribed the status of a national language in the course of the nation-making process. Yet the coercion a national language implies, an aspect of nation-making strategies, is not associated with Hindi cinema. Unlike other regional-language cinemas, Hindi cinema appeals to and is embraced by people from all linguistic regions in the country. Consequently, Hindi cinema is one of the constitutive forces in popularizing the national.

That the nation pervades every institution, mechanism, discourse, and discipline, and in turn is constituted by these, leaves little doubt about the extent of its influence in public life. The question at hand is this: To what extent does the nation influence cultural forms that carry its imaginative figuration? And what are the mechanics of its configuration in Hindi cinema?

## *Theorizing National Cinema*

Focusing on the sense viewers make of films, and demarcating and defining the scope of "national cinema," Andrew Higson applies the term to films identified by a common site of production and consumption. Such a classification includes where the films are made, by whom, and under whose ownership. It simultaneously enables a text-based approach that examines the content, style, world-view, "projections of a national character," and construction of the nation in the films. To attribute national identity to a range of industrial and textual practices implies that audiences and producers have expectations of that cinema's coherence, unity, unique identity, and "stable set of meanings."[21]

Hindi cinema derives its coherence from the many creative forms it draws upon.[22] In the late nineteenth century, as the nationalist movement gained momentum and intensified cultural revivalism, art forms were regenerated and deployed through new interpretations. Cinema of course deploys a unique apparatus that relies heavily on the other cultural forms imbricated in the nation-making process. Hindi film's visual aesthetic, narrative form, and audio style have been influenced by nineteenth-century Parsi and Urdu theatrical traditions, with an emphasis on song and dance, disregard for unity of time and space, and an emphasis on "frontality" in painting; and by literary forms such as the epic and the romance, as well as the novel.[23]

If the novel is a recent western art form, film is of course even more recent.[24] Notwithstanding the "high" and "low" distinctions within the reading public, the novel is, relatively speaking, an elitist form—especially compared to television, film, song, and poetry. Timothy Brennan notes that the novel "has been the form through which a thin, foreign educated stratum . . . has communicated to metropolitan reading publics, often in translation. It has been . . . allowed to play a national role . . . in an international arena."[25] Popular Hindi films, in contrast, are consumed almost entirely by the indigenous public, although viewership in nonwestern cultures and among the Indian diaspora is growing.[26] Structurally, Hindi film adopts elements of both the epic and romance—although it has a greater penchant for sagas, plots with a multitude of events, rather than a focus on character interiority. If the novel is a form that represents and is produced by bourgeois individualism, Hindi films focus not so much on individual characters but on complex plots and events—what happens, and how.

The novel did have an unmistakable impact on Hindi films, however, and many novelists wrote screenplays for films in the 1950s. The novel in India was not a simple British legacy; it arose from a complex cultural development. Several factors led to the novel's emergence, notably the growth of the bourgeoisie and modern capitalism. The novel is "a genre generated and sustained by the middle class . . . against the feudal values of the epic or romance."[27] Hindi films have adopted a peculiar hybrid form with elements of the epic and the novel.

At the heart of all Hindi films lies the "fictional nation." Serious tensions that threaten to fracture the nation are obsessively manifested in film as moral conflicts or ethical dilemmas. Resolution of these dilemmas is the central goal of the "national fiction," the Hindi film. Form and style in the films are streamlined to meet the narrative demand of the fictional nation, which requires nonparticularized references to time and place. Thus Hindi films tend to be general in description, scrupulously nonspecific, and parsimonious in detail, providing a deft but sketchy idea of the setting. For example, a rich or poor house, urban or rural, feudal-aristocratic, western or traditional setting is suggested with minimal elaboration.

Indian writers were slow to develop interest in the perceptible physical reality of their surroundings. While stylized descriptions of the landscape or physical beauty of the heroine are easy to come by, "a realistic presentation of actual people or objects, interiors or buildings, [is] either absent or rare."[28] Likewise, films absorbed the didactic tenor assumed by early novels in India, with the great divide between good and evil mapped in favor of patriotism against treason, democratic against feudal, and indigenous against foreign.

The most striking feature of the nation is homogeneity among heterogeneous ideological strains, interests, and groups. They consent to share a common identity and accept the hegemony of the privileged class. It is important to examine the "process by which cultural hegemony is achieved" in and through cinematic representations. A coherent national identity comes about by naturalizing a particular cultural formation; nationhood and film histories are produced by repressing internal differences among groups criss-crossed by hierarchical relationships—in terms of gender, ethnicity, community, religion and class. Nations are not a "given" but something that is "gained," and cinema is one of the means by which this happens. By constructing an imaginary homogeneity, film represents the interests of one group while marginalizing others. It has been argued that national cinema is a form of "internal colonization," offering up a contradictory unity and privileging a limited range of subject positions.[29]

In postcolonial territories the nation had to subsume class disparities. The neocolonial writer had to create an "aura of a national community," even through forms of cultural expression significantly eroded by imperial culture. A new indigenous dominant elite used the colonial legacy and continually renewed its identity to establish legitimacy. Brennan, invoking Horace Davis, says that "State and nation build each other. . . . the state *predates* or precedes nationalist sentiments, which are then called in after the fact, so to speak."[30] In India, literary production musters nationalist sentiment, which provides a cultural imagination to support, service, and uphold the state.

Hindi cinema, a catalyst in the nation's homogenizing mission, appeals to the underprivileged by building faith in the nation-state's protective beneficence.

Differences—economic and cultural—are repressed as the nation positions itself as representing the common unity and interests of all groups.[31] Nationalism faces the difficult challenge of maintaining the allegiance of the uprooted and alienated rural population as it migrates to urban shantytown ghettoes. As critics we bear the burden of explaining how Hindi cinema secures the nation—privileging a few—while attaining mass popularity. This calls for unraveling the process by which pleasure in hegemony works. This means understanding how cinematic narratives successfully repress and conceal contradictions among differentially privileged groups, offering audiences unity and universal identification.

A number of films narrate the "nation and/as family," troubled by conflicts yet repeatedly rescued by adopting a devotional stance to the fiction called nation.[32] These films directly or indirectly address the onerous task of nation-building: the continuous process of preserving and protecting it from potential ruptures caused by linguistic differences, regionalism, communalism, the opposition of ethnic minorities to nationalism, and the struggle of reactionary feudalism against democracy. The tropes of masculinity and femininity incessantly deployed in Hindi cinema are the compass I use to negotiate and deconstruct the topos of the nation.

## Nation and Its Embodiments

I begin with *Henna* (1991), among the first popular films to openly acknowledge the birth of two nations from one. On August 15, 1947, the Indian subcontinent was declared independent of its two hundred years of British rule. Two nations, India and Pakistan, came into being with Hindu and Muslim majorities respectively. Large-scale violence erupted as migrants crossed the new border in either direction. Literature from the 1950s is filled with despair about the senseless Partition, but open mention of it in popular culture is more or less completely repressed.

More than forty years later, *Henna* harks back to the originary moment of the Indian nation, arbitrarily divided by and contained within imaginary "boundary" lines. In lieu of veiled references to the "enemy" across the border, the film candidly refers to the twin nation, Pakistan. *Henna* was Hindi cinema's great master Raj Kapoor's grand finale, completed by his son Randhir Kapoor after his father's sudden death. The film is an appeal for unity and Hindu/Muslim amity within the nation. It is also ostensibly an antiwar film, promoting peace between India and Pakistan. Yet the text's rhetoric and narrative strategy reveals an uneasy fit between the two levels of appeal, pointing to a fault line in the imagined nation.

The film's protagonist, Chander Prakash (played by Rishi Kapoor) runs a lumber industry in Srinagar, Kashmir. His impending marriage to his girlfriend, Chandini, is thwarted by an accident: his jeep rolls into the Jhelum river and he is presumed dead. But Chander's body, swept along by the river, is discovered in a hamlet on the other side of the nation's border, in Pakistan. Khan (Saeed Jaffery), his daughter Henna (Zeba), and widow friend Gul Chaachi (Farida Jalal) nurse him back to health against the admonitions of Khan's son, Ashraf. Ashraf fears Shahbaaz Khan (Kiran Kumar), the notorious local army officer, who terrorizes the villagers and patrols the border for spies sent by the Indian army.

Chander regains consciousness but suffers a complete loss of memory. Henna falls in love with him and they are about to be married when Chander regains his

memory during the frenzied wedding festivities. Khan's plan to help Chander cross the border and return home is foiled by Shahbaaz Khan, who demands Henna in marriage as the price for ensuring Chander's safe passage. After several reversals, Henna successfully helps Chander cross the border, but dies in the crossfire between the two border armies. Chander reunites with his former fiancée, Chandini, who faithfully awaits his return.

The film is prefaced with a slow pan of a river flowing through a picturesque valley, over which the narration tells us: "This story is set on the bank of the Jhelum river, which begins in India and flows through Pakistan. On one side, Hindus worship it, praying to the rising sun, and on the other side Muslims offer prayers to their Allah at sunset. The water doesn't make distinctions between different human beings. Then why do people observe difference in their hearts?" Nature and culture are invoked together, and the film unequivocally asserts that "difference" is a cultural construct. After Chander's accident, a simple physical map marking the India-Pakistan border, and Captain Shahbaaz Khan's exposition on torturing "spies" who infiltrate these borders, become loaded with meaning.

Khan ruminates about man-made, lifeless lines drawn on paper that erase "God-given love in peoples' hearts." His words echo the film's theme: it is absurd to make difference a source of strife. The Captain responds: "These are not personal matters. These are matters of the state you don't understand." Khan's poignant and ironic answer rings through the remaining text: "Yes, humane people will not understand state politics." At the end of the film, Chander stands over Henna's dead body, making an impassioned speech for a world without borders, without war games, and for lasting peace. Yet despite the film's appeal to secular principles and Hindu-Muslim amity, the narrative as a whole belies this message, pointing instead to the impossibility of Hindu-Muslim romantic love, permitted only briefly in a moment of amnesia.

Romantic love in Hindi films has transgressed divisions between all endogamous groups and communities except the Hindu and Muslim communities. This was true until Mani Ratnam's 1995 film *Bombay*, originally made in Tamil (also released in Telegu) and dubbed for the national audience in Hindi.[33] Manmohan Desai's *Amar, Akbar, Anthony* (1977) is more typical of Hindi cinema's style of secularism, where references to the nation and appeal for communal amity remain oblique. In *Amar, Akbar, Anthony*, a family of three boys and their parents are separated on August 15 (Independence Day). Each boy meets a different fate: the oldest, Amar (Vinod Khanna) is raised by a Hindu police officer; the middle child, Anthony Gonsalves (Amitabh Bachchan) is adopted by a Catholic priest; and the youngest is adopted by a Muslim man and grows up to be a *qawali* singer, Akbar Allahbadi (Rishi Kapoor). Twenty-two years later, the brothers and their parents reunite. Meanwhile each son has found his life partner—miraculously, all women of their own community. Amar, the Hindu, marries Laksmi (Shabana Azmi); Akbar, raised as a Muslim, is with Salma (Neetu Singh); and Anthony finds Jenny (Parveen Babi). The nation and its fragments—the three brothers—unite to fight the villainous Robert, the man behind the family's (read: nation's) disintegration.

These films are testimonials to the limits of the Nehruvian secular nationalism practiced by all classes and communities in Indian society, scrupulously mindful of religious, ethnic, and caste identity—distinctions observed even by those who pay lip service to secular principles. Films such as *Henna* and *Amar, Akbar, Anthony*

trace the religious divide between communities that is central to national politics—a schism that constantly threatens stability. Hindi cinema's appeal for secular unity, a plea to break through the confining communal animus, is accompanied by terrible uneasiness and a fear of violating rules of communal endogamy— even though the films violate every other social norm that divides the rich from the poor, the upper from the lower caste, the rural from the urban, and the virgin from the whore.

Although community identity and differential treatment of religious groups is central to the political agenda of the Right, which has gained significant ground since the late 1980s, there are many other tensions that keep the nation in a state of perpetual instability. Actor-director Manoj Kumar's films *Upkaar* (Benefaction, 1967) and *Roti, Kapada aur Makaan* (Food, Clothes and Shelter, 1974) are inflected by contemporary political turmoil that seized the nation's attention. *Upkaar* articulates the great rural-urban divide and is a legitimate protest against the urban bias in development planning.[34] Made on the heels of the Indo-Pakistan war in 1965, it turned into a propagandist film, drumming up patriotic sentiments at a critical moment among viewers facing food shortages and a war-torn economy. *Jai jawaan, jai kisaan* (Hail soldier, hail peasant) was the national slogan of the late 1960s, coined to forge an expedient alliance between two key constituencies called upon to serve the nation in its hour of need. The state demanded sacrifice while venerating the soldier and the peasant.

*Upkaar* is the story of two brothers, Bharat (Manoj Kumar) and Puran (Prem Chopra). In the course of a family feud their evil uncle, Charandas, kills their father, leaving Bharat, the older brother, to head the family. Bharat, a peasant, works hard on the land, while Puran, sent to the city to study, learns the ways of decadent westernized urban life. Buying into the slander Charandas and the village moneylender/trader, Lalaji, spread to drive a wedge between the two brothers, Puran suspects that Bharat reaps a major profit from the land and demands to see the accounts. Bharat places the entire land in the name of Puran's future children, leaves the village, and joins the Indian army in its war effort.

Puran, Charandas, and Lalaji use the war for personal profiteering and are caught by the police. When Puran learns his partners lied to him about Bharat, he returns home. Bharat returns home, too, wounded in action, hanging between life and death. In the end, as the family reunites, Puran marries the girl from the village, engaged to him since childhood, and Bharat marries Kavita, a doctor from the city who chooses to practice medicine in the village clinic.

Apart from being stylistically well-crafted, *Upkaar*'s real success lies in the powerful signifiers it uses to imagine the nation: *dharti* (land), *mitti* (soil), *dharti maata* (mother earth), *khoon* (blood), *paseena* (sweat), *hul* (plough), *bandook* (gun), and *tiranga jhanda* (tricolor flag). These symbols are strung together in a semiotic chain to invoke powerful patriotic sentiments. Earth, soil, and mother conjoin to become mother earth, cultivated with the peasant's plough and sweat and protected with the gun by the soldier willing to sacrifice his life for the nation. The peasant and soldier are strategically honored subject-citizens whose sacrifices virtually equal a sacred act.

When Puran demands to divide the land, Bharat replies, "The land is our mother. We don't divide our mother." Later, when he gives Puran the land, an emotionally overwrought Bharat pontificates: the land bears their mother's tears, their ancestors' sweat, and the wealth of coming generations. To protect it is their *dharma* (religion/

lifestyle); to work it with the plough, their duty. Therefore, they must promise never to turn away from the land. The mix of metaphors here is deliberate—a peasant's capital, his land, is purposefully made interchangeable with national territory, a semiological stroke that equates it with "motherland." When Bharat seeks employment from an army captain, he argues that the plough and the gun are related to the soil, and later when he prepares to go to the front after war is declared, he explains this connection to his mother. He asks for her blessing to protect Mother India, which until then he's served as a peasant.

Service to the nation becomes service to the mother, naturalizing it like the family, a trope for nation. Family relationships are central to constructing the nation in film narratives. The men are split between the good and bad son or brother; another tack is for the essentially good son to turn bad by succumbing to the underworld, only to return to the point of origin, suitably chastened.

[ · · · ]

Characters in Hindi cinema inevitably stand in for specific classes, groups, and professions, brought together through kinship ties. The family and family ties figure prominently in nearly every Hindi film. The centrality of the family in Hindi cinema may be ascribed to migration from rural to urban centers, the attendant dislocation, and the need to give concrete shape to the "faceless authority of the state." The citizen-subject's relationship with the nation is modeled on filial relationships and, by implication, the state is cast as the idealized parental authority figure. In effect, family and state power is fused.[35]

Social institutions such as family and state are ubiquitous in both city and country. Rather than an interchange or fusion of authority, the authority inscribed within them represents a concatenation of power to which individual subjects become accustomed. The family in Hindi film is often a metonym for the nation. The emotional force associated with it makes it the site for dramatic emotional conflict. This is projected on the nation, and becomes the most immediate and effective way of enabling identification and eliciting the subjects' loyalty. For example, the father/judge character dispenses justice in the case of the protagonist/son/outlaw, or the brother/police officer brings to book the protagonist/brother/outlaw.

Along the topos of familial conflicts the central confrontation is between good and evil, which are mapped onto national and anti-national opposition. The principal purpose for staging this contest is to rescue the always endangered imagined community, the nation. The nation and its discontent are central to almost all Hindi films, which relentlessly focus on problems of disunity, poverty, white-collar crime, corruption in high places, regionalism, communalism, modernity, tradition, and feudalism.

As a means of arousing patriotism and consolidating the nation against another nation, an unidentified "enemy" hovers at the margin of the screen. In *Henna*, perhaps for the first time ever, the "enemy," Pakistan, is given a face—even a humane one. The film makes a distinction between the state's subjects' spirit of love and peace and the Pakistani state's hostility, embodied in the diabolical Pakistani army officer, Shahbaaz Khan. References to war—the 1965 Indo-Pakistan war in *Upkaar* and the 1971 war for an independent Bangladesh in *Roti Kapada aur Makaan*—are invoked to evince a nationalist spirit. These films vary in the intensity of their critique of war with all its machinery, propaganda, and loss of innocent lives.

If *Henna* is unequivocally antiwar in spirit, *Upkaar* reflects confusion in its simultaneously nationalist and antiwar sensibility. Bharat's relentless homilies about serving the nation as a soldier and peasant legitimize jingoist sentiments that build consensus for war, death, and killing. Madan Chaacha (Pran), the wise village old-man figure, makes an impassioned speech toward the end of the film destabilizing the earlier prowar, pronationalist rhetoric. Bharat, severely wounded, limps back to his burnt-down village and pleads for a drink of water. But the water Madan pulls out of the well is bloodied, leaving Bharat's thirst unquenched. Looking upward at the dark sky, Madan demands an answer from the warmongers whose thirst for blood is insatiable.

## *Pleasure and Terror of the Feminine*

In other films in which the nation is central, it is metonymically figured as a fascinating but horrific woman who is at once terrorized, terrifying, dreadful, and pleasurable. Mehboob Khan's *Aan* (Oncoming, 1952), Bimal Roy's *Madhumati* (1958), and N. Chandra's *Pratighaat* (Retribution, 1987) are films in which the woman signifies the nation in sharp—even contradictory—ways to air dilemmas that plague India's postcolonial life. Specifically, these films expose contradictions between feudalism and democracy, the marginalization and virtual genocide of ethnic tribes, and the general escalation of corruption and violence in public life.

I begin with *Aan*, made by Mehboob, an avowed nationalist who shared Nehru's vision of India's socialist future. Mehboob's studio logo, the hammer and sickle, valorizes the worker-peasant alliance as the backbone of the nation, yet the film accommodates an "Indian" faith in destiny. The voiceover narrates alongside the logo: "Only what's acceptable to god happens." This opening is followed by an homage to the "peasant-cum-soldier" on the audio track: "This is the peasant who through the ages has seared the earth for food, and during war, turned his plough into a sword to protect the kingdom." The film is dedicated to the serf, exploited uniformly over centuries, notwithstanding political upheaval and changing monarchs.

*Aan* dramatizes the revolutionary moment in history when feudal forces fought to retain authoritarian control against the sweeping force of democracy and the rule of law. Textually, it is easy to read the film's depiction of feudalism as an unspoken reference to colonialism. This slippage is significant because of the curious silence Hindi cinema maintains about colonialism and the elaborate subterfuge it uses to refer to it.[36] The semiology of signs mobilized in the film coincides with a general social euphoria about a new independent state and its constitution. These signs make the text susceptible to a more open reading, allowing a critique of feudal aristocracy to stand for a critique of colonial rule.

Perhaps the level of abstraction demanded by the political theory invoked in *Aan* tailors a rather unusual narrative; set in a nonspecific time and place, the narrative resembles a "once upon a time" fairy tale. Members of the aristocracy—the king, the prince, and princess—literally represent the last anguished gasps of the feudal-monarchical order dismantled after independence. Figuratively, they are symbols—stand-ins for British rulers. The aptly named heroine, Raj (Nadira)—a word that means "rule"—is an autocratic, repressed princess who wants to continue her family's totalitarian rule over its subjects.[37] In this effort her corrupt brother

(Prem Nath) supports her; but a commoner, the hero Jai (Dilip Kumar)—a name meaning "victory"—and his village friend, Mangla, challenge Raj.

Narrative tension centers around the contest between the feudal and democratic forces, and the powerful heterosexual attraction/repulsion between which Raj vacillates in her relation to Jai. The storyline culminates in Jai taming the shrew and sealing his victory over her. The density and layered meaning embedded in this seemingly simple, fairy-tale-like text derive from the ingenious mapping of political concepts onto the topos of gender and sexuality. The film is instructive because of the transparency with which it plots embattled political conflicts on the body of the woman: Raj battles to contain her repressed libidinal energy and maintain her aura of stern authority and distance. She fails because of the overpowering force of her attraction and passion for Jai. The analogy here is clearly not the unlikely love interest between feudalism and democracy, but the coupling of female tyranny with narcissistic feudal aristocracy and the gentle, firm, but powerful male with the liberal, progressive, and ultimately successful forces of democracy.

Clearly, two parallel strains run throughout the film: Raj and Jai's hostilities that conceal feelings of romantic love, and feudalism's inimical relation to democracy, which will completely overrun the former. When Raj insists on holding on to her ancestors' traditions, her father, the benign king, reminds her that rulers who use force must remember that victims of injustice are more powerful than its perpetrators. No authority can trample the awakening of the subjects. This ode to democracy—faith in the might of the ruled—parallels the unequivocal celebration of ending authoritarian aristocracy and the demise of colonial authority, the British Raj. At the end, when the king, assumed to be dead, is found, the crowds animatedly shout, "Victory to the king—no, no, victory to the subjects!"

The domestication of Raj serves as an exorbitant metaphor for subduing and controlling feudalism, read here as routing colonialism. The female protagonist is mobilized as a sign not of the colonized nation but of the colonizer: a neurotic masculinized figure, the antonym of all things considered essentially feminine—harsh, arrogant, fractious, rebellious, intractable. As the film proceeds, the viewer enjoys witnessing the intensity of the passion and tensions engendered by Jai and Raj's contest for power. Raj's character signifies sadomasochistic feudal power assailed, broken down, and ultimately conquered by Jai.

The contest's stage is set when Jai makes a sexual advance to Raj. She responds, disingenuously as we soon find out, by threatening to have him lashed in public. He then threatens to teach her to live like and love the common people she despises. "I will make you Mangla," he warns elliptically, referring to her status as a common woman and potentially his wife.

Politically, Jai is the harbinger of the rule of law—one law before which all, rulers and ruled alike, are equal. His victory is complete when the masculinized Raj, dressed in a western pants suit ("warrior clothing," as Jai's mother describes it), is slowly transformed. She succumbs to heterosexual passion and accepts her feminine role signified by the bridal attire she finally wears.

Raj's western attire constitutes part of a chain of signs that let us read the film as Mehboob's attack on colonial rule. This can also be inferred from other signifiers of modernization (old-fashioned cars and guns) that frame the narrative within a more specific period. Even more significant is the moment when the king abdicates

his throne, announcing that he is not leaving his kingdom to his heirs, the prince and princess, but to his subjects, the *praja*. A close-up reveals the words of the decree being penned: "Rights, social and political to one and all, discrimination against religious. . . . " Access to the rest of the declaration is obscured by the hand that moves the pen to inscribe it. If indeed this is a metonym for the nation and the declaration of its constitution, by inadvertently concealing a critical aspect—the status of religion—the declaration speaks volumes about the ambiguous space religion occupies in the new nation.

On the other hand, what the film sustains is its use of woman as insignia of colonial rule. Raj's body registers excitement, pain, and sadomasochistic pleasure when she attacks Jai. Initially unable to aim the gun at him, she fires a shot in the air. Soon after, when he is injured, her body betrays her feelings. As she heaves, flinches, and winces when Jai is in pain, we become aware of Raj losing control over her repressed sexual energy, leaving her vulnerable before a common man. The heterosexual male's charisma is equated here to democratic forces, before which a tough woman, even a feudal aristocrat, becomes weak-kneed.

Democracy's irrepressible victory (and thus tyrannical feudalism/colonialism's defeat) is complete. Although rarely cast as an insignia of the colonizer, always metonymic of the Indian nation, the Indian woman character is also marked by the universal split between Madonna and whore. It appears impossible to mobilize her in the cultural imaginary as anything beyond these two incarnates. Representing Raj as the raj (British rule) justifies the pleasure in seeing the woman—a symbol of threat and power—domesticated. Her taming is performed literally in a montage sequence where she painfully learns arduous housework—pounds grain, lights the stove, makes bread, fetches water, sews clothes—and inhabits the domestic space Mangla would have. *Aan* projects a gender economy that reverses the traditional coupling of woman with victim/nation, hinging her instead on the demonized figuration of colonial tyranny. She is not the powerless creature who needs rescuing, but a titan who has to be contained. The male hero enjoys agency to stage the requisite action—taming instead of rescuing the victim. This feature recurs in other narrative scenarios as well.

**[ · · · ]**

The film *Pratighaat* (1987), directed by N. Chandra, appeared forty years after independence. [ . . . ] Here [the protagonist] is Laxmi (Sujata Mehta), a college lecturer in provincial Dharma Pura. Laxmi grows steadily indignant as she discovers the level of violence the hoodlum Kali and his mob unleash. Kali's excesses are endless: kidnapping and murdering the lunatic Karam Vir's wife, Janaki; displacing five thousand weavers with a cloth mill employing only two hundred workers; killing Durga's husband, a weaver, for refusing to pay the illegal *hafta*; and murdering the upright cop, Ajay Srivastava, who was plucky enough to arrest him.[38] When Laxmi shows gumption by reporting the incident to the police, her lawyer husband, Satya Prakash, and her in-laws demand she withdraw the report for fear of reprisal. Kali arrives and teaches Laxmi a lesson by disrobing her in public. A crowd gathers to observe the spectacle in stunned silence. The screen turns white; the audience sees only her silhouette in film negative. The lunatic Karam Vir arrives with Durga to cover her naked body with the national flag; Durga and Laxmi forge an alliance.

When Kali attacks a senior freedom fighter, Gopal Dada, for opposing his candidacy for the Member of the Legislative Assembly (MLA) ticket, Laxmi rallies around Gopal Dada and stands for election against Kali. A band of supportive college students, the dislocated weavers, and marginalized workers add to the groundswell of her campaign. The prospect of losing the election sends Kali and his hoodlums on a rampage, and they rig the polls to win. In the last scene Laxmi appears in a red saree, ostensibly to make her congratulatory speech at a large victory meeting. After the speech, she presents Kali with a garland from a large platter. Then, raising an ax from the same gift platter, she kills him. The police arrive and arrest her, despite protests from the crowd. As the police whisk her away, her husband arrives, tells her how proud he is of her, apologizes for his own cowardice, and promises to be a worthier husband.

The most dramatic aspect of the leap from [the 1958 film] *Madhumati* to *Pratighaat*, a period spanning thirty postindependence years, is the depth of cynicism, the transformation of public life, and its representation in Hindi films—"the nation's storytelling in an attempt to make symbolic sense of itself."[39] The film documents the extent and spread of the rot, the reign of mafia terror. It exposes the complicity of the state (the police and judiciary) that can no longer be relied upon to arbitrate matters of social justice. Karam Vir, the lunatic, once a dutiful police constable, reveals the pervasiveness of the malaise. Reminiscent of eminent mid-twentieth-century writer Saadat Hasan Manto's protagonist, Toba Tek Singh—the lunatic who sees with perspicacious clarity—Karam Vir stands at the main *chowk* (crossroad) in the town, identifies the city's elite members, and exposes their crimes and misdemeanors.[40]

Kali, the local mafia don, attempts to gain legitimacy by entering electoral politics. He is abetted by politicians and appeased by weak-kneed police officials; worse, he is endorsed by citizen apathy: the fearful business community, Laxmi's students, her complacent middle-class neighbors, even her husband. Karam Vir's courageous remonstrance against Kali's last act of desperation, "capturing (voting) booths," ends with his death. Stabbed in the back by Kali, Karam Vir falls on the ground. His daughter runs toward him against the screen that turns white, her little figure rushing toward the viewers in slow motion, screaming heartrendingly, "*Bapu, Bapu . . .* " (Father, Father). She is equivocally invoking her father and Mahatma Gandhi, "the father of the nation," and the traumatic massacre of nationalist principles he stood for.

N. Chandra set a new benchmark for the level of violence in films. *Pratighaat*, an example par excellence, uses violence against women as an index of the suffusion of violence in public life. As if the molestation of Karam Vir's wife and the murder of a cop in full view of the public were not enough, the violence escalates until the shocking scene when Laxmi is publicly disrobed and humiliated.

When Laxmi returns to teach, to her dismay she finds nude female figure sketches on the blackboard while her male students mock her with their gaze. (Earlier, the same students hostile to her authority in the classroom had attempted to embarrass her by making her translate the word "breast" from the Sanskrit classic she teaches. On that occasion she deflected the fetishized sexualization of the female body, deeroticizing breasts by invoking women as mother figures.) This time, she breaks into a song exhorting her male students (and all men in the audience) to look upon women not as sex objects, but as life-givers, nurturers who have sustained

them. Her resistance takes the form of pitting *mamta* (nurturance) against *vasana* (lust/desire). Her students are eventually chastened by this plea.

This dichotomy in Indian culture between venerating and protecting women by appealing to their role as real or potential mothers on the one hand, and as sexual objects on the other, is striking, particularly since nurture and desire are irrevocably interconnected in the Freudian order of things.[41] *Pratighaat* suggests that violence against women is affected by commodifying women's bodies; it places the unwanted male gaze and the disrobing incident on a continuum. And yet, ironically, the film suggests also that women are subjects with their own desires. Laxmi inverts the traditional mode of sexual play by openly expressing desire for her husband.

Women here are not so much a trope for the nation, but active agents—saviors who will deliver the nation into the future. Initially Laxmi is a figure similar to Rajni, the protagonist of a television serial by the same name, extremely popular in the mid-1980s. Rajni is an urban middle-class woman with a civic conscience and in each episode she tackles corruption in the bureaucracy. Laxmi goes on to challenge not just constables who do not do their job and students who molest women, but Kali himself. She foils his agenda for legitimacy by entering electoral politics. For this she unites with Durga, and here the figures of Madhumati and Madhavi [from the earlier film] are, in a wishful move, brought together across class boundaries.

The film makes an obvious reference to Durga and Laxmi, goddesses in the Hindu pantheon. Using such icons might read as a strategy of containment that ascribes unique mythic qualities to gods and "heroes" who are distinct from ordinary folk.[42] However, it is also possible to read a very different form of social victimization the two women represent. Durga's means of livelihood—like Madhumati's community's land—is snatched away. For Laxmi, silence in the face of social injustice occasions a moral crisis. The principled stand she takes destabilizes her relationship with her husband and his family.[43] Middle and working-class women uniting—Madhavi and Madhumati, Laxmi and Durga—seem to dissolve class boundaries and offer up a sign of hope in women as bearers of a new liberatory potential.

The most troubling feature of the film, however, is the "masculinized" discourse that identifies society's ailment as a "lack" of potent male power. Even more disconcerting is the fact that female subjects articulate this prognosis. Masculinity is equated with strength and valor, and cowardice with sexual impotence. A minor subplot in the film focuses on a wrestler who spends hours exercising his body and yet is unable to challenge Kali, or inseminate his wife. Karam Vir declares (in English) at the end of Laxmi's charged disrobing incident that the inability of the people to respond is a sign of "the impotence of the intelligentsia."

Laxmi displaces the figure of Anand *babu*, who signified a generation of men now scorned as effete and mocked for their cowardice in failing to live up to the hopes and expectations they once represented. At the same time the voice of Madhumati, temporarily erased, returns to join the urban middle-class woman set forth as the new conscience and savior of a nation besieged by corruption and sustained by violence and terror. Villains are no longer the invisible aristocracy, feudal kings or landlords, but the politician king and his hoodlums who affect every aspect of urban life.

The film is unambiguous in its effort to replace one hero with another. Rather than place faith in collective action, the "new woman" is expected to become the

nation's conscience. In the last shot, a low-angle shot of Karam Vir's daughter, a little girl holding the national flag fills the screen. She represents hope in a new generation that will replace Anand and Karam Vir, men without an alibi for the failures of the entire postindependence era.

## NOTES

1. E. J. Hobsbawm, *Nation and Nationalism Since 1780: Programme, Myth, Reality*. 2nd ed. (Cambridge: Cambridge University Press, 1992), 5.

2. José Carlos Mariátegui's *Seven Interpretive Essays on Peruvian Reality*, trans. Marjory Urquidi (Austin: University of Texas Press, 1971), 187–188, qtd. in Timothy Brennan, *Salman Rushdie and the Third World* (New York: St. Martin's Press, 1989), 7.

3. Benedict Anderson, *Imagined Communities: Reflections on the Origin and Spread of Nationalism* (London: Verso, 1990), 15.

4. Ibid., 19.

5. In an appraisal of several master-codes Fredric Jameson favors Northrop Frye's reading of religion—a mode through which a community thinks of and celebrates its unity. Jameson takes Frye a step further, arguing that literature is a "weaker form of myth or a later stage of ritual," informed by a political unconscious: "All literature must be read as a symbolic mediation on the destiny of the community." *The Political Unconscious* (Ithaca: Cornell University Press, 1981), 69–70.

6. In India the formation of the nation did not displace religion in the same way. Instead, it came to reside beside it, and religious identity gets called upon to seek the subject-citizens' allegiance in support of or against the nation.

7. Hobsbawm, *Nation and Nationalism*, 25, 28–29.

8. Ernest Gellner, *Nations and Nationalism* (Ithaca: Cornell University Press, 1983), 140.

9. Partha Chatterjee, *Nationalist Thought and the Colonial World: A Derivative Discourse* (Minneapolis: University of Minnesota Press, 1993).

10. Anderson, *Imagined Communities*, 15.

11. Brennan, *Salman Rushdie*, 4, 7.

12. Victoria Glendinning's "A Novelist in the Country of the Mind," *The Sunday Times* 23 Oct. 1981: 38, qtd. in Brennan, *Salman Rushdie*, 123.

13. Brennan, *Salman Rushdie*, 10–11.

14. Gellner offers his own answer to the question, "What is a nation?" Will and culture, he says, are two ways of theorizing a nation—but "neither is remotely adequate." In all group formations "will," "identification," "loyalty," and "solidarity" work as catalysts. But "will" and "identification" are too wide a category. So is culture for that matter, as its boundary can be "sharp" or "fuzzy." Standardization, literacy, and communication create the impression that nationality is based on shared culture. When an educated and elite notion of culture spreads among the majority, it evokes identification and cultures become "the natural repositories of political legitimacy. . . . Polities then will extend their boundaries to the limits of their cultures, and to protect and impose their culture within the boundaries of their power. The fusion of will, culture and polity becomes the norm, and one not easily or frequently defied" (Gellner, *Nations and Nationalism*, 55).

15. Hugh Seton-Watson, *Nation and States: An Inquiry into Nations and the Politics of Nationalism* (Boulder: Westview Press, 1977), 5, qtd. in Brennan, *Salman Rushdie*, 5.

16. Hans Kohn, *Nationalism: Its Meaning and History* (Cincinnati: D. Van Norstrand, 1965), 11, qtd. in Brennan, *Salman Rushdie*, 21.

17. Kaviraj compares thinkers, writers, and intellectuals with a political consciousness in the early nineteenth century in the entity now called India to those in the later part of the same century. The former, even if they were anti-imperialist, could never imagine independence, autonomy, or a separate nation in the manner fashioned by the conscious nationalist movement produced by the contingencies of the late nineteenth and early twentieth centuries. Yet history today is written as a linear account in which the early period is presented quite simply as a paler version of its later development. Kaviraj maps the transformation between these two periods—from a negative reaction to colonialism, to a positive consciousness of a new identity, a "we" forged from fragmented identities, enunciated by a collective. Sudipta Kaviraj, "Imaginary Institution of India," *Subaltern Studies* 7 (1992): 1–49.

18. Antonio Gramsci, *Selections from Cultural Writings* (London: Lawrence and Wishart, 1985), 253, qtd. in Kaviraj, "Imaginary Institution," 9.

19. Kaviraj, "Imaginary Institution," 16.

20. Brennan, *Salman Rushdie*, 11–12.

21. Andrew Higson, "The Concept of National Cinema," *Screen* 30.4 (1989): 36–37.

22. In fact, Higson suggests two methods of establishing this coherence. One, to compare one nation's cinema to another. The second is to compare cinema to other cultural forms within the nation state. "The Concept of National Cinema," 38.

23. On song and dance see Erik Barnouw and S. Krishnaswamy, *Indian Film* (New York: Oxford University Press, 1980). On time and space see Mukul Kesavan, "Urdu, Awadh and the Tawaif: the Islamicate Roots of Hindi Cinema," *Forging Identities: Gender, Communities and the State*, ed. Zoya Hasan (New Delhi: Kali for Women, 1994), 244–257. And there are many sources on frontality, among them Ratnabali Chattopadhyay, "Nationalism and Form in Indian Painting: A Study of the Bengal School," *Journal of Arts and Ideas* 14–15 (1987): 5–46; Geeta Kapur, "Mythic Material in Indian Cinema," *Journal of Arts and Ideas* 14–15 (1987): 79–108; Gulam Mohammed Sheikh, "Viewer's View: Looking at Pictures," *Journal of Arts and Ideas* 3 (1983): 5–20; Tapati Guha-Thakurta, "Recovering the Nation's Art," *Texts of Power: Emerging Disciplines in Colonial Bengal*, ed. Partha Chatterjee (Minneapolis: University of Minnesota Press, 1995), 63–92 and "The ideology of the 'aesthetic': the purging of visual tastes and the campaign for a new Indian art in late nineteenth/early twentieth century Bengal," *Studies in History* 8, 2, n.s. (1992): 237–281. On photography see Judith Mara Gutman, *Through Indian Eyes: Nineteenth and Twentieth Century Still Photography in India* (New York: Oxford University Press, 1982) and Christopher Pinney, *Camera Indica: The Social Life of Indian Photographs* (Chicago: University of Chicago Press, 1997).

24. Meenakshi Mukherjee, *Realism and Reality: The Novel and Society in India* (New Delhi: Oxford University Press, 1985), 3.

25. Brennan, *Salman Rushdie*, 18.

26. Distinctions of taste stratify Hindi films in general. "Art," "parallel," and "middle" cinema are identified with "high" culture, while popular cinema is the lowest denominator.

27. Mukherjee, *Realism and Reality*, 4.

28. Ibid., 10.

29. Higson, "The Concept of National Cinema," 43–44.

30. Brennan, *Salman Rushdie*, 19–20.

31. Gellner defends nationalism as that which does not impose cultural homogeneity. Rather, he argues, there is an "objective need for homogeneity which is reflected in nationalism. If . . . a modern industrial state can only function with a mobile, literate, culturally standardized, interchangeable population, . . . then the illiterate, half-starved population sucked from the erstwhile rural cultural ghettoes into the melting-pot of shanty-towns yearns for incorporation into some one of those cultural pools which already has, or looks

as if it might acquire, a state of its own, with the subsequent promise of full cultural citizenship, access to primary school, employment and all. Often, these alienated, uprooted, wandering populations may vacillate between diverse options, and they may often come to a provisional rest at one or another temporary and transitional cultural resting place." Gellner, *Nations and Nationalism*, 46.

32. I thank Gina Marchetti for this succinct formulation.

33. Back in 1992 in an interview with Yash Chopra, a leading Bombay industry filmmaker, I asked why Hindi films, otherwise presumed to have a secular sensibility, had never represented Hindu-Muslim romance stories. Slightly alarmed by the question, Chopra speculated such a representation would provoke riots. Ironically, *Bombay*, the first film to transgress the rigid Hindu-Muslim divide, was made on the heels of the worst riots since Partition, in the aftermath of the desecration of the fifteenth-century Muslim mosque, the Babri Masjid, in Ayodhya.

34. The farmers' movement gathered momentum in several states beginning in the late 1970s (despite differences among them). Maharashtra's Sharad Joshi articulates its views most clearly: the acutely uneven development of urban and rural areas is built into national plans, siphoning off resources from the countryside, concentrating wealth in urban centers, and impoverishing the majority in the countryside. This sentiment is echoed by the anti-Narmada dam movement that gained international attention in the 1990s.

35. Sumita Chakravarty, *National Identity in Indian Popular Cinema, 1947–87* (Austin: University of Texas Press, 1993), 141.

36. Colonial history began to be used as the central narrative only in the 1990s. *1942 A Love Story* (Vinod Vidhu Chopra, 1994) is a significant example. Covertly, of course, anything western, perhaps due to the colonial past, is constantly vilified through portrayals of hedonism and decadence. This is consistent with Hindi cinema's elliptical references to the political sphere.

37. Akbar S. Ahmed points out that Nadira's performance in *Aan* is fashioned after Marlene Dietrich's in *Kismet* (1944). See his "Bombay Films: The Cinema as Metaphor for Indian Society and Politics," *Modern Asian Studies* 26, 2 (1992): 291.

38. *Hafta* is money extorted by gangsters from their constituency marking their territory and sphere of influence.

39. Rameshwari and Angela Koreth, "The Mother Image and the National Ethos in Four Recent Mainstream Hindi Films: *Pratighaat* (Retribution, 1987), *Haq* (Rights, 1990), *Amba* (1990) and *Prahaar* (Attack, 1991)." Paper presented at the Miranda House College Seminar, University of Delhi, April 1992.

40. In the short story "Toba Tek Singh," set in the days leading to the Partition, the eponymous protagonist is located in a Pakistani asylum, which ironically appears saner than the rest of the subcontinent. The two states decide to transfer asylum inmates to the country of their relatives' choosing. Toba Tek Singh resists the transfer to an asylum in India but dies in a no-man's-land between the two borders that is neither India nor Pakistan.

41. Women who are sexually harassed by men on the streets often succeed in chastising them by invoking men's relationships with their mothers and sisters.

42. As Rameshwari and Angela Koreth argue, "What seems enabling in *Pratighaat* could also be disturbing . . . the overvaluation which arises from deification . . . the mythic substructure which ensures the success and glorification of an action or individual, also sets it apart as . . . special, as something that only the unique individual marked by divinity is capable of. It could signal passivity and meek compliance for the rest who are not marked by divine charisma." Paper presented at the Miranda House College Seminar, University of Delhi, April 1992.

43. It is perhaps this urban middle-class bias in the women's movement that prompts women politically active in rural areas to begrudge the disproportionate attention paid to domestic violence—dowry and dowry deaths, rather than land and property rights.

# HAMID NAFICY

# Situating Accented Cinema

FROM *An Accented Cinema*

Born in Iran, Hamid Naficy (b. 1944) emigrated to the United States in 1964 and is currently John Evans Professor of Communication at Northwestern University School of Communication, where he holds a joint appointment in the Department of Art History. A leading authority on Middle Eastern cinema and television, he has been awarded fellowships from the American Council of Learned Societies, the National Endowment for Humanities, and the Social Science Research Council. He edited the critically acclaimed volume *Home, Exile, Homeland: Film, Media, and the Politics of Place* (1998) and is the author of *The Making of Exile Cultures: Iranian Television in Los Angeles* (1993) and *An Accented Cinema: Exilic and Diasporic Filmmaking* (2001).

   Naficy's work reflects the growing importance of global—or more exactly, transnational—cinema today. While Hollywood films continue to dominate cinema in most of the world, the increasing number of world film festivals and the wide availability of films through DVD distribution and other technologies have added exponentially to the circulation of films from a considerable variety of cultures. This new visibility and popularity includes emerging, and previously marginalized, cinemas, such as those from Senegal, Iran, South Korea, and Latin American nations, bringing into view the films of Ousmane Sembène, Abbas Kiarostami, Lucrecia Martel, and many others. In addition, transnational films by directors working outside their country of origin like the work of Armenian Canadian Atom Egoyan, New Zealand's Jane Campion, Taiwanese American director Ang Lee, and Danish filmmaker Lars von Trier have entered the mainstream. In very different ways, international co-productions travel the globe for locations, themes, and distinctive styles, creating perspectives that cross borders in many different ways.

   In the introduction to *An Accented Cinema*, "Situating Accented Cinema," Naficy considers filmmakers from emerging or postcolonial countries that have moved to "northern cosmopolitan centers" since the 1960s and established innovative, often critical, perspectives on their new cultures. For Naficy, "accented cinema" is a distinctive branch of postmodern film, one that typically enacts what he calls the "politics of the hyphen," that is, a doubly defined identity and perspective. Still, while some versions of postmodernism describe a fully destabilized world without origins or certainties, accented films often retain and rely on a sense of a past homeland that anchors their visions. Historically, Naficy distinguishes two periods of accented filmmaking: the 1950s to the 1970s, when decolonization around the world transformed many nations and cultures; and the 1980s

through the 1990s, when postindustrial economies around the world reconfigured global populations. Naficy then suggests that there are three types of accented cinema and film-makers, particularly evident in the latter phase: exilic filmmakers who were forced to leave their native country; diasporic filmmakers who retain a sense of loss or nostalgia for their homeland; and postcolonial ethnic filmmakers who see themselves as both displaced and placed within a new homeland.

If Fernando Solanas and Octavio Getino's "Towards a Third Cinema" (p. 924) inaugurated postcolonial cinema studies, Naficy's work attends to the complex cultural forms that have arisen in the wake of neocolonialism, globalization, migration, and technological change. Trinh T. Minh-ha (p. 691) is an example of the filmmakers whose work Naficy illuminates.

## READING CUES & KEY CONCEPTS

■ What does Naficy mean by his suggestion that mainstream Hollywood films are "accent free"?

■ While we all recognize accented speech, consider carefully and describe concretely what it means to describe a narrative or visual style as accented.

■ Consider Naficy's claim that "exilic and diasporic accent permeates the film's deep structure: its narrative, visual style, characters, subject matter, theme, and plot." What does he mean by this statement?

■ **Key Concepts:** Subaltern; Internal Exile; External Exile; Chronotope; Diaspora; Politics of the Hyphen; Hybridity; Accented Style; Group Style

# Situating Accented Cinema

. . . . . . . . . . . . . .

## *Accented Filmmakers*

The exilic and diasporic filmmakers discussed here are "situated but universal" figures who work in the interstices of social formations and cinematic practices. A majority are from Third World and postcolonial countries (or from the global South) who since the 1960s have relocated to northern cosmopolitan centers where they exist in a state of tension and dissension with both their original and their current homes. By and large, they operate independently, outside the studio system or the mainstream film industries, using interstitial and collective modes of production that critique those entities. As a result, they are presumed to be more prone to the tensions of marginality and difference. While they share these characteristics, the very existence of the tensions and differences helps prevent accented filmmakers from becoming a homogeneous group or a film movement. And while their films encode these tensions and differences, they are not neatly resolved by familiar narrative and generic schemas—hence, their grouping under accented style. The variations among the films are driven by many factors, while their similarities stem principally from what the filmmakers have in common: liminal subjectivity and interstitial location in society and the film industry. What

constitutes the accented style is the combination and intersection of these varia-
tions and similarities.

Accented filmmakers came to live and make films in the West in two general
groupings. The first group was displaced or lured to the West from the late 1950s to
the mid-1970s by Third World decolonization, wars of national liberation, the Soviet
Union's invasions of Poland and Czechoslovakia, Westernization, and a kind of
"internal decolonization" in the West itself, involving various civil rights, counter-
culture, and antiwar movements. Indeed, as Fredric Jameson notes, the beginning
of the period called "the sixties" must be located in the Third World decolonization
that so profoundly influenced the First World sociopolitical movements (1984, 180).
The second group emerged in the 1980s and 1990s as a result of the failure of na-
tionalism, socialism, and communism; the ruptures caused by the emergence of
postindustrial global economies, the rise of militant forms of Islam, the return of
religious and ethnic wars, and the fragmentation of nation-states; the changes in the
European, Australian, and American immigration policies encouraging non-Western
immigration; and the unprecedented technological developments and consolida-
tion in computers and media. Accented filmmakers are the products of this dual
postcolonial displacement and postmodern or late modern scattering. Because of
their displacement from the margins to the centers, they have become subjects in
world history. They have earned the right to speak and have dared to capture the
means of representation. However marginalized they are within the center, their
ability to access the means of *reproduction* may prove to be as empowering to the
marginalia of the postindustrial era as the capturing of the means of *production*
would have been to the subalterns of the industrial era.

It is helpful, when mapping the accented cinema, to differentiate three types
of film that constitute it: exilic, diasporic, and ethnic. These distinctions are not
hard-and-fast. A few films fall naturally within one of these classifications, while
the majority share the characteristics of all three in different measures. Within each
type, too, there are subdivisions. In addition, in the course of their careers, many
filmmakers move not only from country to country but also from making one type
of film to making another type, in tandem with the trajectory of their own travels of
identity and those of their primary community.

## EXILIC FILMMAKERS

Traditionally, exile is taken to mean banishment for a particular offense, with a
prohibition of return. Exile can be internal or external, depending on the location
to which one is banished. The tremendous toll that internal exile, restrictions, de-
privations, and censorship in totalitarian countries have taken on filmmakers has
been widely publicized. What has been analyzed less is the way such constraints,
by challenging the filmmakers, force them to develop an authorial style. Many film-
makers who could escape internal exile refuse to do so in order to fight the good
fight at home—a fight that often defines not only their film style but also their iden-
tity as oppositional figures of some stature. By working under an internal regime of
exile, they choose their "site of struggle" and their potential social transformation
(Harlow 1991, 150). When they speak from this site at home, they have an impact,
even if, and often because, they are punished for it. In fact, interrogation, censorship,

and jailing are all proof that they have been heard. But if they move out into external exile in the West, where they have the political freedom to speak, no one may hear them among the cacophony of voices competing for attention in the market. In that case, Gayatri Spivak's famous question "Can the subaltern speak?" will have to be reworded to ask, "Can the subaltern be heard?" Because of globalization, the internal and external exiles of one country are not sealed off from each other. In fact, there is much traffic and exchange between them.

In this study, the term "exile" refers principally to external exiles: individuals or groups who voluntarily or involuntarily have left their country of origin and who maintain an ambivalent relationship with their previous and current places and cultures. Although they do not return to their homelands, they maintain an intense desire to do so—a desire that is projected in potent return narratives in their films. In the meantime, they memorialize the homeland by fetishizing it in the form of cathected sounds, images, and chronotopes that are circulated intertextually in exilic popular culture, including in films and music videos. The exiles' primary relationship, in short, is with their countries and cultures of origin and with the sight, sound, taste, and feel of an originary experience, of an elsewhere at other times. Exiles, especially those filmmakers who have been forcibly driven away, tend to want to define, at least during the liminal period of displacement, all things in their lives not only in relationship to the homeland but also in strictly political terms. As a result, in their early films they tend to represent their homelands and people more than themselves.

The authority of the exiles as filmmaking authors is derived from their position as subjects inhabiting interstitial spaces and sites of struggle. Indeed, all great authorship is predicated on distance—banishment and exile of sorts—from the larger society. The resulting tensions and ambivalences produce the complexity and the intensity that are so characteristic of great works of art and literature. In the same way that sexual taboo permits procreation, exilic banishment encourages creativity.[1] Of course, not all exilic subjects produce great or lasting art, but many of the greatest and most enduring works of literature and cinema have been created by displaced writers and filmmakers. But exile can result in an agonistic form of liminality characterized by oscillation between the extremes. It is a slipzone of anxiety and imperfection, where life hovers between the heights of ecstasy and confidence and the depths of despondency and doubt.[2]

For external exiles the descent relations with the homeland and the consent relations with the host society are continually tested. Freed from old and new, they are "deterritorialized," yet they continue to be in the grip of both the old and the new, the before and the after. Located in such a slipzone, they can be suffused with hybrid excess, or they may feel deeply deprived and divided, even fragmented. Lithuanian filmmaker and poet Jonas Mekas, who spent some four years in European displaced persons camps before landing in the United States, explained his feelings of fragmentation in the following manner:

> Everything that I believed in shook to the foundations—all my idealism, and my faith in the goodness of man and progress of man—all was shattered. Somehow, I managed to keep myself together. But really, I wasn't one piece any longer; I was one thousand painful pieces. . . . And I wasn't surprised when, upon my arrival in New York, I found others who felt as I felt. There were poets, and film-makers, and painters—people who were also walking like one thousand painful pieces. (quoted in O'Grady 1973, 229)

Neither the hybrid fusion nor the fragmentation is total, permanent, or painless. On the one hand, like Derridian "undecidables," the new exiles can be "both and neither": the pharmacon, meaning both poison and remedy; the hymen, meaning both membrane and its violation; and the supplement, meaning both addition and replacement (quoted in Bauman 1991, 145–46). On the other hand, they could aptly be called, in Salman Rushdie's words, "at once plural and partial" (1991, 15). As partial, fragmented, and multiple subjects, these filmmakers are capable of producing ambiguity and doubt about the taken-for-granted values of their home and host societies. They can also transcend and transform themselves to produce hybridized, syncretic, performed, or virtual identities. None of these constructed and impure identities are risk-free, however, as the Ayatollah Khomeini's death threat against Salman Rushdie glaringly pointed out.[3]

Not all transnational exiles, of course, savor fundamental doubt, strive toward hybridized and performative self-fashioning, or reach for utopian or virtual imaginings. However, for those who remain in the enduring and endearing crises and tensions of exilic migrancy, liminality and interstitiality may become passionate sources of creativity and dynamism that produce in literature and cinema the likes of James Joyce and Marguerite Duras, Joseph Conrad and Fernando Solanas, Ezra Pound and Trinh T. Minh-ha, Samuel Beckett and Sohrab Shahid Saless, Salman Rushdie and Andrei Tarkovsky, García Márquez and Atom Egoyan, Vladimir Nabokov and Raúl Ruiz, Gertrude Stein and Michel Khleifi, Assia Djebar and Jonas Mekas.

Many exilic filmmakers and groups of filmmakers are discussed in [*An Accented Cinema*]—Latin American, Lithuanian, Iranian, Turkish, Palestinian, and Russian. They are not all equally or similarly exiled, and there are vast differences even among filmmakers from a single originating country.

## DIASPORIC FILMMAKERS

Originally, "diaspora" referred to the dispersion of the Greeks after the destruction of the city of Aegina, to the Jews after their Babylonian exile, and to the Armenians after Persian and Turkish invasions and expulsion in the mid-sixteenth century. The classic paradigm of diaspora has involved the Jews, but as Peters (1999), Cohen (1997), Tölölyan (1996), Clifford (1997, 244–77), Naficy (1993a), and Safran (1991) have argued, the definition should no longer be limited to the dispersion of the Jews, for myriad peoples have historically undergone sustained dispersions—a process that continues on a massive scale today. The term has been taken up by other displaced peoples, among them African-Americans in the United States and Afro-Caribbeans in England, to describe their abduction from their African homes and their forced dispersion to the new world (Gilroy 1993, 1991, 1988; Mercer 1994a, 1994b, 1988; Hall 1988). In these and other recodings, the concept of diaspora has become much closer to exile. Consequently, as Khachig Tölölyan notes, "diaspora" has lost some of its former specificity and precision to become a "promiscuously capacious category that is taken to include all the adjacent phenomena to which it is linked but from which it actually differs in ways that are constitutive" (1996, 8).

Here I will briefly point out the similarities and differences between exile and diaspora that inform this work. Diaspora, like exile, often begins with trauma, rupture, and coercion, and it involves the scattering of populations to places outside their

homeland. Sometimes, however, the scattering is caused by a desire for increased trade, for work, or for colonial and imperial pursuits. Consequently, diasporic movements can be classified according to their motivating factors. Robin Cohen (1997) suggested the following classifications and examples: victim/refugee diasporas (exemplified by the Jews, Africans, and Armenians); labor/service diasporas (Indians); trade/business diasporas (Chinese and Lebanese); imperial/colonial diasporas (British, Russian); and cultural/hybrid diasporas (Caribbeans). Like the exiles, people in diaspora have an identity in their homeland *before* their departure, and their diasporic identity is constructed in resonance with this prior identity. However, unlike exile, which may be individualistic or collective, diaspora is necessarily collective, in both its origination and its destination. As a result, the nurturing of a collective memory, often of an idealized homeland, is constitutive of the diasporic identity. This idealization may be state-based, involving love for an existing homeland, or it may be stateless, based on a desire for a homeland yet to come. The Armenian diaspora before and after the Soviet era has been state-based, whereas the Palestinian diaspora since the 1948 creation of Israel has been stateless, driven by the Palestinians' desire to create a sovereign state.

People in diaspora, moreover, maintain a long-term sense of ethnic consciousness and distinctiveness, which is consolidated by the periodic hostility of either the original home or the host societies toward them. However, unlike the exiles whose identity entails a vertical and primary relationship with their homeland, diasporic consciousness is horizontal and multisited, involving not only the homeland but also the compatriot communities elsewhere. As a result, plurality, multiplicity, and hybridity are structured in dominance among the diasporans, while among the political exiles, binarism and duality rule.

These differences tend to shape exilic and diasporic films differently. Diasporized filmmakers tend to be centered less than the exiled filmmakers on a cathected relationship with a single homeland and on a claim that they represent it and its people. As a result, their works are expressed less in the narratives of retrospection, loss, and absence or in strictly partisanal political terms. Their films are accented more fully than those of the exiles by the plurality and performativity of identity. In short, while binarism and subtraction in particular accent exilic films, diasporic films are accented more by multiplicity and addition. Many diasporic filmmakers are discussed here individually, among them Armenians. Black and Asian British filmmakers are discussed collectively.

## POSTCOLONIAL ETHNIC AND IDENTITY FILMMAKERS

Although exilic, diasporic, and ethnic communities all patrol their real and symbolic boundaries to maintain a measure of collective identity that distinguishes them from the ruling strata and ideologies, they differ from one another principally by the relative strength of their attachment to compatriot communities. The postcolonial ethnic and identity filmmakers are both ethnic and diasporic; but they differ from the poststudio American ethnics, such as Woody Allen, Francis Ford Coppola, and Martin Scorsese, in that many of them are either immigrants themselves or have been born in the West since the 1960s to nonwhite, non-Western, postcolonial émigrés. They also differ from the diasporic filmmakers in their emphasis on their ethnic and racial identity within the host country.

The different emphasis on the relationship to place creates differently accented films. Thus, exilic cinema is dominated by its focus on there and then in the homeland, diasporic cinema by its vertical relationship to the homeland and by its lateral relationship to the diaspora communities and experiences, and postcolonial ethnic and identity cinema by the exigencies of life here and now in the country in which the filmmakers reside. As a result of their focus on the here and now, ethnic identity films tend to deal with what Werner Sollors has characterized as "the central drama in American culture," which emerges from the conflict between descent relations, emphasizing bloodline and ethnicity, and consent relations, stressing self-made, contractual affiliations (1986, 6). In other words, while the former is concerned with being, the latter is concerned with becoming; while the former is conciliatory, the latter is contestatory. Although such a drama is also present to some extent in exilic and diasporic films, the hostland location of the drama makes the ethnic and identity films different from the other two categories, whose narratives are often centered elsewhere.

Some of the key problematics of the postcolonial ethnic and identity cinema are encoded in the "politics of the hyphen." Recognized as a crucial marker of ethnicity and authenticity in a multicultural America, group terms such as black, Chicano/a, Oriental, and people of color have gradually been replaced by hyphenated terms such as African-American, Latino-American, and Asian-American. Identity cinema's adoption of the hyphen is seen as a marker of resistance to the homogenizing and hegemonizing power of the American melting pot ideology. However, retaining the hyphen has a number of negative connotations, too. The hyphen may imply a lack, or the idea that hyphenated people are somehow subordinate to unhyphenated people, or that they are "equal but not quite," or that they will never be totally accepted or trusted as full citizens. In addition, it may suggest a divided allegiance, which is a painful reminder to certain groups of American citizens.[4] The hyphen may also suggest a divided mind, an irrevocably split identity, or a type of paralysis between two cultures or nations. Finally, the hyphen can feed into nativist discourses that assume authentic essences that lie outside ideology and predate, or stand apart from, the nation.

In its nativist adoption, the hyphen provides vertical links that emphasize descent relations, roots, depth, inheritance, continuity, homogeneity, and stability. These are allegorized in family sagas and mother-daughter and generational conflict narratives of Chinese-American films such as Wayne Wang's *Eat a Bowl of Tea* (1989) and *The Joy Luck Club* (1993). The filmmakers' task in this modality, in Stuart Hall's words, is "to discover, excavate, bring to light and express through cinematic representation" that inherited collective cultural identity, that "one true self" (1994, 393). In its contestatory adoption, the hyphen can operate horizontally, highlighting consent relations, disruption, heterogeneity, slippage, and mediation, as in Trinh T. Minh-ha's *Surname Viet Given Name Nam* (1985) and Srinivas Krishna's *Masala* (1990). In this modality, filmmakers do not recover an existing past or impose an imaginary and often fetishized coherence on their fragmented experiences and histories. Rather, by emphasizing discontinuity and specificity, they demonstrate that they are in the process of becoming, that they are "subject to the continuous 'play' of history, culture and power" (Hall 1994, 394). Christine Choy and Rene Tajima's award-winning film *Who Killed Vincent Chin?* (1988) is really a treatise on the

problematic of the hyphen in the Asian-American context, as it centers on the murder of a Chinese-American by out-of-work white Detroit autoworkers who, resentful of Japanese car imports, mistook him for being Japanese.

Read as a sign of hybridized, multiple, or constructed identity, the hyphen can become liberating because it can be performed and signified upon. Each hyphen is in reality a nested hyphen, consisting of a number of other intersecting and overlapping hyphens that provide inter- and intraethnic and national links. This fragmentation and multiplication can work against essentialism, nationalism, and dyadism. Faced with too many options and meanings, however, some have suggested removing the hyphen, while others have proposed replacing it with a plus sign.[5] Martin Scorsese's *ITALIANAMERICAN* (1974) cleverly removes the hyphen and the space and instead joins the "Italian" with the "American" to suggest a fused third term. The film title by this most ethnic of New Hollywood cinema directors posits that there is no Italianness that precedes or stands apart from Americanness. I have retained the hyphen, since this is the most popular form of writing these compound ethnic designations.

The compound terms that bracket the hyphen also present problems, for at the same time that each term produces symbolic alliance among disparate members of a group, it tends to elide their diversity and specificity. "Asian-American," for example, encompasses people from such culturally and nationally diverse roots as the Philippines, Vietnam, Cambodia, Korea, Japan, Thailand, China, Laos, Taiwan, Indonesia, Malaysia, India, Bangladesh, and Pakistan. To calibrate the term, such unwieldy terms as "Southeast Asian diasporas" have also been created. Similar processes and politics of naming have been tried for the "black" British filmmakers.

Independent film distributors, such as Third World Newsreel, Icarus-First Run Films, and Women Make Movies, exploit the hyphen and the politics of the identity cinema by classifying these films thematically or by their hyphenated designation. Such classifications create targets of opportunity for those interested in such films, but they also narrow the marketing and critical discourses about these films by encouraging audiences to read them in terms of their ethnic content and identity politics more than their authorial vision and stylistic innovations. Several postcolonial ethnic and identity filmmakers are discussed individually and collectively.

Diaspora, exile, and ethnicity are not steady states; rather, they are fluid processes that under certain circumstances may transform into one another and beyond. There is also no direct and predetermined progression from exile to ethnicity, although dominant ideological and economic apparatuses tend to favor an assimilationist trajectory—from exile to diaspora to ethnic to citizen to consumer.

[ · · · ]

## *The Stylistic Approach*

How films are conceived and received has a lot to do with how they are framed discursively. Sometimes the films of great transplanted directors, such as Alfred Hitchcock, Luis Buñuel, and Jean-Luc Godard, are framed within the "international"

cinema category.[6] Most often, they are classified within either the national cinemas of their host countries or the established film genres and styles. Thus, the films of F. W. Murnau, Douglas Sirk, George Cukor, Vincent Minnelli, and Fritz Lang are usually considered as exemplars of the American cinema, the classical Hollywood style, or the melodrama and noir genres. Of course, the works of these and other established directors are also discussed under the rubric of "auteurism." Alternatively, many independent exiled filmmakers who make films about exile and their homelands' cultures and politics (such as Abid Med Hondo, Michel Khleifi, Mira Nair, and Ghasem Ebrahimian) or those minority filmmakers who make films about their ethnic communities (Rea Tajiri, Charles Burnett, Christine Choy, Gregory Nava, Haile Gerima, and Julie Dash) are often marginalized as merely national, Third World, Third Cinema, identity cinema, or ethnic filmmakers, who are unable to fully speak to mainstream audiences. Through funding, festival programming, and marketing strategy, these filmmakers are often encouraged to engage in "salvage filmmaking," that is, making films that serve to preserve and recover cultural and ethnic heritage. Other exilic filmmakers, such as Jonas Mekas, Mona Hatoum, Chantal Akerman, Trinh T. Minh-ha, Isaac Julien, and Shirin Neshat, are placed within the avant-garde category, while some, such as Agnès Varda and Chris Marker, are considered unclassifiable.

Although these classificatory approaches are important for framing films to better understand them or better market them, they also serve to overdetermine and limit the films' potential meanings. Their undesirable consequences are particularly grave for the accented films because classification approaches are not neutral structures. They are "ideological constructs" masquerading as neutral categories (Altman 1989, 5). By forcing accented films into one of the established categories, the very cultural and political foundations that constitute them are bracketed, misread, or effaced altogether. Such traditional schemas also tend to lock the filmmakers into discursive ghettos that fail to reflect or account for their personal evolution and stylistic transformations over time. Once labeled "ethnic," "ethnographic," or "hyphenated," accented filmmakers remain discursively so even long after they have moved on. On the other hand, there are those, such as Gregory Nava, Spike Lee, Euzhan Palcy, and Mira Nair, who have made the move with varying degrees of success out of ethnic or Third World filmmaking and into mainstream cinema by telling their ethnic and national stories in more recognizable narrative forms.

One of the key purposes of this study is to identify and develop the most appropriate theory to account for the complexities, regularities, and inconsistencies of the films made in exile and diaspora, as well as for the impact that the liminal and interstitial location of the filmmakers has on their work. Occasionally, such a theory is explicitly embedded in the films themselves, such as in Jonas Mekas's *Lost, Lost, Lost* (1949–76), Fernando Solanas's *Tangos: Exile of Gardel* (1985), and Prajna Parasher's *Exile and Displacement* (1992). More often, however, the theory must be discovered and defined as the film moves toward reception, by marketers, reviewers, critics, and viewers. Such a deductive process presents a formidable challenge. It requires discovering common features among disparate products of differently situated displaced filmmakers from varied national origins who are living and making films in the interstices of divergent host societies, under unfamiliar, often

hostile, political and cinematic systems. I have opted to work with a stylistic approach, designating it the "accented style."[7] Stylistic history is one of the "strongest justifications for film studies as a distinct academic discipline" (Bordwell 1997, 8). But stylistic study is not much in vogue today. Fear of formalism, lack of knowledge of the intricacies of film aesthetics and film production techniques, the importation of theories into film studies with little regard for the film's specific textual and spectatorial environments—all these can share the blame.

In the narrowest sense, style is the "patterned and significant use of technique" (Bordwell and Thompson 1993, 337). Depending on the site of the repetition, style may refer to a film's style (patterns of significant techniques in a single film), a filmmaker's style (patterns repeated in unique ways in a filmmaker's oeuvre), or a group style (consistent use of technique across the works of several directors). Although attention will be paid here to the authorial styles of individual filmmakers, the group style is the central concern of this book. In general, the choice of style is governed by social and artistic movements, regulations governing censorship, technological developments, the reigning mode of production (cinematic and otherwise), availability of financial resources, and the choices that individual filmmakers make as social and cinematic agents. Sometimes group style is formed by filmmakers who follow certain philosophical tendencies and aesthetic concerns, such as German expressionism and Soviet montage. The accented group style, however, has existed only in a limited, latent, and emergent form, awaiting recognition. Even those who deal with the accented films usually speak of exile and diaspora as themes inscribed in the films, not as components of style. In addition, the overwhelming majority of the many valuable studies of filmmaking in exile and diaspora have been narrowly focused on the works of either an individual filmmaker or a regional group of filmmakers. There are, for example, studies (both lengthy and brief) devoted to the filmmakers Raúl Ruiz, Fernando Solanas, Valeria Sarmiento, Amos Gitai, Michel Khleifi, Abid Med Hondo, Chantal Akerman, Jonas Mekas, Atom Egoyan, and Trinh T. Minh-ha, and there are studies centered on Chilean exile films, Arab exile cinema, *beur* cinema, Chicano/a cinema, Iranian exile cinema, and black African, British, and American diasporic cinemas. While these works shed light on the modus operandi, stylistic features, politics, and thematic concerns of specific filmmakers or of regional or collective diasporic films, none of them adequately addresses the theoretical problematic of an exilic and diasporic cinema as a category that cuts across and is shared by all or by many of them.[8] My task here is to theorize this cinema's existence as an accented style that encompasses characteristics common to the works of differently situated filmmakers involved in varied decentered social formations and cinematic practices across the globe—all of whom are presumed to share the fact of displacement and deterritorialization. Such a shared accent must be discovered (at least initially) at the films' reception and articulated more by the critics than by the filmmakers.

The components of the accented style include the film's visual style; narrative structure; character and character development; subject matter, theme, and plot; structures of feeling of exile; filmmaker's biographical and sociocultural location; and the film's mode of production, distribution, exhibition, and reception. I have devoted entire chapters to some of these components or their subsidiary elements, while I have dealt with others in special sections or throughout [*An Accented Cinema*].

Earlier, I divided accented cinema into exilic, diasporic, and postcolonial ethnic films—a division based chiefly on the varied relationship of the films and their makers to existing or imagined homeplaces. Now I draw a further stylistic distinction, between feature and experimental films. The accented feature films are generally narrative, fictional, feature-length, polished, and designed for commercial distribution and theatrical exhibition. The accented experimental films, on the other hand, are usually shot on lower-gauge film stock (16mm and super-8) or on video, making a virtue of their low-tech, low-velocity, almost homemade quality. In addition, they are often nonfictional, vary in length from a few minutes to several hours, and are designed for nontheatrical distribution and exhibition. The feature films are generally more exilic than diasporic, and they are often made by older émigré filmmakers. On the other hand, the experimental films and videos are sometimes more diasporic than exilic, and are made by a younger generation of filmmakers who have been born or bred in diaspora. The experimental films also tend to inscribe autobiography or biography more, or more openly, than the feature films.[9] In them, the filmmakers' own voice-over narration mediates between film types (documentary, fictional) and various levels of identity (personal, ethnic, gender, racial, national). Although narrative hybridity is a characteristic of the accented cinema, the experimental films are more hybridized than the feature films in their intentional crossing and problematization of various borders, such as those between video and film, fiction and nonfiction, narrative and nonnarrative, social and psychic, autobiographical and national.[10]

## Accented Style

If the classical cinema has generally required that components of style, such as mise-en-scène, filming, and editing, produce a realistic rendition of the world, the exilic accent must be sought in the manner in which realism is, if not subverted, at least inflected differently. Henry Louis Gates Jr. has characterized black texts as "mulatto" or "mulatta," containing a double voice and a two-toned heritage: "These texts speak in standard Romance and Germanic languages and literary structures, but almost always speak with a distinct and resonant accent, an accent that Signifies (upon) the various black vernacular literary traditions, which are still being written down" (1988, xxiii). Accented films are also mulatta texts. They are created with awareness of the vast histories of the prevailing cinematic modes. They are also created in a new mode that is constituted both by the structures of feeling of the filmmakers themselves as displaced subjects and by the traditions of exilic and diasporic cultural productions that preceded them. From the cinematic traditions they acquire one set of voices, and from the exilic and diasporic traditions they acquire a second. This double consciousness constitutes the accented style that not only signifies upon exile and other cinemas but also signifies the condition of exile itself. It signifies upon cinematic traditions by its artisanal and collective modes of production, which undermine the dominant production mode, and by narrative strategies, which subvert that mode's realistic treatment of time, space, and causality. It also signifies and signifies upon exile by expressing, allegorizing, commenting upon, and critiquing the conditions of its own production, and deterritorialization. Both of these acts of signifying and signification are constitutive

of the accented style, whose key characteristics are elaborated upon in the following. What turns these into attributes of style is their repeated inscription in a single film, in the entire oeuvre of individual filmmakers, or in the works of various displaced filmmakers regardless of their place of origin or residence. Ultimately, the style demonstrates their dislocation at the same time that it serves to locate them as authors.

## LANGUAGE, VOICE, ADDRESS

In linguistics, accent refers only to pronunciation, while dialect refers to grammar and vocabulary as well. More specifically, accent has two chief definitions: "The cumulative auditory effect of those features of pronunciation which identify where a person is from, regionally and socially" and "The emphasis which makes a particular word or syllable stand out in a stream of speech" (Crystal 1991, 2). While accents may be standardized (for example, as British, Scottish, Indian, Canadian, Australian, or American accents of English), it is impossible to speak without an accent. There are various reasons for differences in accent. In English, the majority of accents are regional. Speakers of English as a second language, too, have accents that stem from their regional and first-language characteristics. Differences in accent often correlate with other factors as well: social and class origin, religious affiliation, educational level, and political grouping (Asher 1994, 9). Even though from a linguistic point of view all accents are equally important, all accents are not of equal value socially and politically. People make use of accents to judge not only the social standing of the speakers but also their personality. Depending on their accents, some speakers may be considered regional, local yokel, vulgar, ugly, or comic, whereas others may be thought of as educated, upper-class, sophisticated, beautiful, and proper. As a result, accent is one of the most intimate and powerful markers of group identity and solidarity, as well as of individual difference and personality. The flagship newscasts of mainstream national television and radio networks have traditionally been delivered in the preferred "official" accent, that is, the accent that is considered to be standard, neutral, and value-free.

Applied to cinema, the standard, neutral, value-free accent maps onto the dominant cinema produced by the society's reigning mode of production. This typifies the classical and the new Hollywood cinemas, whose films are realistic and intended for entertainment only, and thus free from overt ideology or accent. By that definition, all alternative cinemas are accented, but each is accented in certain specific ways that distinguish it. The cinema discussed here derives its accent from its artisanal and collective production modes and from the filmmakers' and audiences' deterritorialized locations. Consequently, not all accented films are exilic and diasporic, but all exilic and diasporic films are accented. If in linguistics accent pertains only to pronunciation, leaving grammar and vocabulary intact, exilic and diasporic accent permeates the film's deep structure: its narrative, visual style, characters, subject matter, theme, and plot. In that sense, the accented style in film functions as both accent and dialect in linguistics. Discussions of accents and dialects are usually confined to oral literature and to spoken presentations. Little has been written—besides typographical accentuation of words—about what Taghi Modarressi has called "writing with an accent":

The new language of any immigrant writer is obviously accented and, at least initially, inarticulate. I consider this "artifact" language expressive in its own right. Writing with an accented voice is organic to the mind of the immigrant writer. It is not something one can invent. It is frequently buried beneath personal inhibitions and doubts. The accented voice is loaded with hidden messages from our cultural heritage, messages that often reach beyond the capacity of the ordinary words of any language. . . . Perhaps it is their [immigrant and exile writers'] personal language that can build a bridge between what is familiar and what is strange. They may then find it possible to generate new and revealing paradoxes. Here we have our juxtapositions and our transformations— the graceful and the awkward, the beautiful and the ugly, sitting side by side in a perpetual metamorphosis of one into the other. It is like the Hunchback of Notre Dame trying to be Prince Charming for strangers. (1992, 9)

At its most rudimentary level, making films with an accent involves using on-camera and voice-over characters and actors who speak with a literal accent in their pronunciation. In the classical Hollywood cinema, the characters' accents were not a reliable indicator of the actors' ethnicity.[11] In accented cinema, however, the characters' accents are often ethnically coded, for in this cinema, more often than not, the actor's ethnicity, the character's ethnicity, and the ethnicity of the star's persona coincide. However, in some of these films the coincidence is problematized, as in the epistolary films of Chantal Akerman (*News from Home*, 1976) and Mona Hatoum (*Measures of Distance*, 1988). In each of these works, a filmmaking daughter reads in an accented English voice-over the letters she has received from her mother. The audience may assume that these are the voices of the mothers (complete coincidence among the three accents), but since neither of the films declares whose voice we are hearing, the coincidence is subverted and the spectators must speculate about the true relationship of the accent to the identity, ethnicity, and authenticity of the speaker or else rely on extratextual information.

One of the greatest deprivations of exile is the gradual deterioration in and potential loss of one's original language, for language serves to shape not only individual identity but also regional and national identities prior to displacement. Threatened by this catastrophic loss, many accented filmmakers doggedly insist on writing the dialogues in their original language—to the detriment of the films' wider distribution. However, most accented films are bilingual, even multilingual, multivocal, and multiaccented, like Egoyan's *Calendar* (1993), which contains a series of telephonic monologues in a dozen untranslated languages, or Raúl Ruiz's *On Top of the Whale* (1981), whose dialogue is spoken in more than a half dozen languages, one of them invented by Ruiz himself. If the dominant cinema is driven by the hegemony of synchronous sound and a strict alignment of speaker and voice, accented films are counterhegemonic insofar as many of them de-emphasize synchronous sound, insist on first-person and other voice-over narrations delivered in the accented pronunciation of the host country's language, create a slippage between voice and speaker, and inscribe everyday nondramatic pauses and long silences.

At the same time that accented films emphasize visual fetishes of homeland and the past (landscape, monuments, photographs, souvenirs, letters), as well

as visual markers of difference and belonging (posture, look, style of dress and behavior), they equally stress the oral, the vocal, and the musical—that is, accents, intonations, voices, music, and songs, which also demarcate individual and collective identities. These voices may belong to real, empirical persons, like Mekas's voice narrating his diary films; or they may be fictitious voices, as in Marker's *Letter from Siberia* (1958) and *Sunless* (1982); or they may be accented voices whose identity is not firmly established, as in the aforementioned films by Akerman and Hatoum. Sergeï Paradjanov's four feature films are not only intensely visual in their tableau-like mise-en-scène and presentational filming but also deeply oral in the way they are structured like oral narratives that are told to the camera.

Stressing musical and oral accents redirects our attention from the hegemony of the visual and of modernity toward the acousticity of exile and the commingling of premodernity and postmodernity in the films. Polyphony and heteroglossia both localize and locate the films as texts of cultural and temporal difference.

Increasingly, accented films are using the film's frame as a writing tablet on which appear multiple texts in original languages and in translation in the form of titles, subtitles, intertitles, or blocks of text. The calligraphic display of these texts de-emphasizes visuality while highlighting the textuality and translational issues of intercultural art. Because they are multilingual, accented films require extensive titling just to translate the dialogues. Many of them go beyond that, however, by experimenting with on-screen typography as a supplementary mode of narration and expression. Mekas's *Lost, Lost, Lost*, Trinh's *Surname Viet Given Name Nam*, and Tajiri's *History and Memory* (1991) experiment with multiple typographical presentations of English texts on the screen linked in complicated ways to the dialogue and to the voice-overs, which are also accented in their pronunciation. In cases where the on-screen text is written in "foreign" languages, such as in Suleiman's *Homage by Assassination* (1991) and Hatoum's *Measures of Distance*, both of which display Arabic words, the vocal accent is complemented by a calligraphic accent. The inscription of these visual and vocal accents transforms the act of spectatorship, from just watching to watching *and* literally reading the screen.

By incorporating voice-over narration, direct address, multilinguality, and multivocality, accented films, particularly the epistolary variety, destabilize the omniscient narrator and narrative system of the mainstream cinema and journalism. Film letters often contain the characters' direct address (usually in first-person singular), the indirect discourse of the filmmaker (as the teller of the tale), and the free indirect discourse of the film in which the direct voice contaminates the indirect. Egoyan's *Calendar* combines all three of these discourses to create confusion as to what is happening, who is speaking, who is addressing whom, where the diegetic photographer and his on-screen wife (played by Egoyan and his real-life wife) leave off and where the historical persons Atom Egoyan and Arsinée Khanjian begin. The accented style is itself an example of free indirect discourse in the sense of forcing the dominant cinema to speak in a minoritarian dialect.

[ · · · ]

## BORDER EFFECTS, BORDER WRITING

Border consciousness emerges from being situated at the border, where multiple determinants of race, class, gender, and membership in divergent, even antagonistic, historical and national identities intersect. As a result, border consciousness, like exilic liminality, is theoretically against binarism and duality and for a third optique, which is multiperspectival and tolerant of ambiguity, ambivalence, and chaos.

The globalization of capital, labor, culture, and media is threatening to make borders obsolete and national sovereignty irrelevant. However, physical borders are real and extremely dangerous, particularly for those who have to cross them. In recent years no region in the world has borne deadlier sustained clashes over physical (and discursive) borders than the Middle East and the former Yugoslavia. The collisions over physical and literal lands, even over individual houses and their symbolic meanings, are also waged in the accented films. Since their widely received formulation by Anzaldúa (1987), borderland consciousness and theory have been romanticized, universalized, and co-opted by ignoring the specific dislocatory and conflictual historical and territorial grounds that produce them. However, borders are open, and infected wounds and the subjectivity they engender cannot be post-national or post-al, but interstitial. Unequal power relations and incompatible identities prevent the wound from healing.

Since border subjectivity is cross-cultural and intercultural, border filmmaking tends to be accented by the "strategy of translation rather than representation" (Hicks 1991, xxiii). Such a strategy undermines the distinction between autochthonous and alien cultures in the interest of promoting their interaction and intertextuality. As a result, the best of the border films are hybridized and experimental—characterized by multifocality, multilinguality, asynchronicity, critical distance, fragmented or multiple subjectivity, and transborder amphibolic characters—characters who might best be called "shifters." Of these characteristics, the latter bears discussion at this point.

In linguistics, shifters are words, such as "I" and "you," whose reference can be understood only in the context of the utterance. More generally, a shifter is an "operator" in the sense of being dishonest, evasive, and expedient, or even being a "mimic," in the sense that Homi Bhabha formulated, as a producer of critical excess, irony, and sly civility (1994). In the context of border filmmaking, shifters are characters who exhibit some or all of these registers of understanding and performativity. As such, they occupy a powerful position in the political economy of both actual and diegetic border crossings. For example, in Nava's *El Norte*, a classic border film, the shifters consist of the following characters: the *pollo* (border-crossing brother and sister, Enrique and Rosa); the coyote (the Mexican middleman who for a fee brings the *pollo* across), the *migra* (the U.S. immigration officers who chase and arrest Enrique); the *pocho* (Americans of Mexican descent who speak Mexican Spanish imperfectly, the man in the film who turns Enrique in to the immigration authorities); the *chola/cholo* and *pachuca/pachuco* (young inhabitants of the border underworld who have their own dialect called *caló*); and the U.S.-based Mexican or Hispanic contractors who employ border crossers as day laborers (among them, Enrique).[12] The power of these border shifters comes from their situationist existence,

their familiarity with the cultural and legal codes of interacting cultures, and the way in which they manipulate identity and the asymmetrical power situations in which they find themselves.

Accented films inscribe other amphibolic character types who are split, double, crossed, and hybridized and who perform their identities. As liminal subjects and interstitial artists, many accented filmmakers are themselves shifters, with multiple perspectives and conflicted or performed identities. They may own no passport or hold multiple passports, and they may be stranded between legality and illegality. Many are scarred by the harrowing experiences of their own border crossings. Some may be energized, while others may be paralyzed by their fear of partiality. Their films often draw upon these biographical crossing experiences.

## THEMES

Understandably, journeys, real or imaginary, form a major thematic thread in the accented films. Journeys have motivation, direction, and duration, each of which impacts the travel and the traveler. Three types of journeys are explored in this book: outward journeys of escape, home seeking, and home founding; journeys of quest, homelessness, and lostness; and inward, homecoming journeys. Depending on their directions, journeys are valued differently. In the accented cinema, westering journeys are particularly valued, partly because they reflect the filmmakers' own trajectory and the general flow of value worldwide. The westering journey is embedded, in its varied manifestations, in Xavier Koller's *Journey of Hope* (1990), Nizamettin Ariç's *A Cry for Beko* (1992), and Ghasem Ebrahimian's *The Suitors* (1989). In Nava's *El Norte*, a south-north journey lures the Mayan Indians from Guatemala to the United States.

There are many instances of empowering return journeys: to Morocco in Faridah Ben Lyazid's *Door to the Sky* (1989), to Africa in Raquel Gerber's *Ori* (1989), and to Ghana in Haile Gerima's *Sankofa* (1993). When neither escape nor return is possible, the desire for escape and the longing for return become highly cathected to certain icons of homeland's nature and to certain narratives. These narratives take the form of varied journeys: from the dystopic and irresolute journey of lostness in Tarkovsky's *Stalker* (1979) to the nostalgically celebratory homecoming journey in Mekas's *Reminiscences of a Journey to Lithuania* (1971–72) to the conflicting return journey to Japan and China in Ann Hui's *Song of the Exile* (1990).

Not all journeys involve physical travel. There also are metaphoric and philosophical journeys of identity and transformation that involve the films' characters and sometimes the filmmakers themselves, as in Mekas's films or in Ivens and Loridan's *A Tale of the Wind*.

## AUTHORSHIP AND AUTOBIOGRAPHICAL INSCRIPTION

If prestructuralism considered authors to be outside and prior to the texts that uniquely express their personalities, and if cinestructuralism regarded authors as structures within their own texts, poststructuralism views authors as fictions within their texts who reveal themselves only in the act of spectating. Post-structuralist theory of authorship is thus embedded in theories of ideology and subject formation,

and it privileges spectatorial reading over that of authoring. Roland Barthes went so far as to declare that "the birth of the reader must be at the cost of the death of the Author" (1977, 148). In this figuration, the author as a biographical person exercising parentage over the text disappears, leaving behind desiring spectators in search of an author. This author whom they construct is neither a projection nor a representation of a real author but a fictive figure within the text (Barthes 1975, 27). According to this formulation, the fictional structure or subject "Atom Egoyan" whom the spectators discover in the films of Atom Egoyan is not the same as, and does not necessarily map out onto, the empirical person named Atom Egoyan. Since texts create subject positions for both authors and spectators, poststructural theory must deal with the construction of both authors and spectators. Spectators, however, like authors, are not only subjects of texts but also—Barthes to the contrary—subjects in history, negotiating for positions within psychosocial formations, producing multiple readings and multiple author and spectator effects. The classical Hollywood cinema's invisible style creates filmic realism by promoting the impression of cohesiveness of time, space, and causality. As a result, diegetic reality appears to be authorless, natural, and mimetic, in an organic relationship to the profilmic world. As John Caughie notes, "The removal or suppression of the clear marks of 'authored discourse' transforms ideology from something produced out of a locatable, historical, determined position into something natural to the world" (1981, 202).

My project is precisely to put the locatedness and the historicity of the authors back into authorship. To that extent, accented cinema theory is an extension of the authorship theory, and it runs counter to much of the postmodern theory that attempts to either deny authorship altogether or multiply the authoring parentage to the point of "de-originating the utterance."[13] However, film authors are not autonomous, transcendental beings who are graced by unique, primordial, and originary sparks of genius. Accented film authors are literally and figuratively everyday journeymen and journeywomen who are driven off or set free from their places of origin, by force or by choice, on agonizing quests that require diplacements and emplacements so profound, personal, and transformative as to shape not only the authors themselves and their films but also the question of authorship. Any discussion of authorship in exile needs to take into consideration not only the individuality, originality, and personality of unique individuals as expressive film authors but also, and more important, their (dis)location as interstitial subjects within social formations and cinematic practices.

Accented films are personal and unique, like fingerprints, because they are both authorial and autobiographical. Exile discourse needs to counter the move by some postmodern critics to separate the author of the film from the enunciating subject in the film, for exile and authorship are fundamentally intertwined with historical movements of empirical subjects across boundaries of nations— not just texts.

To be sure, there are postmodern accented filmmakers, such as Egoyan and Caveh Zahedi, in whose films the relationship of the authoring filmmaker to both the text and the authoring structure within the text is one not of direct parentage but of convoluted performance. However, the questioning of the bond linking autobiography to authorship should not be used as a postmodernist sleight of hand to dismiss the specificity of exilic conditions or to defuse their subversive and empowering potentiality. Such

a move comes at the very moment that, for the diasporized subalterns of the world, history, historical agency, and autobiographical consciousness have become significant and signifying components of identity, artistic production, and social agency. Accented authors are empirical subjects who exist outside and prior to their films.

In the accented cinema, the author is in the text in multiple ways, traversing the spectrum of authorship theories, from prestructuralism to poststructuralism. In a longitudinal and intertextual study of the films of individual filmmakers, we may discover certain consistencies from which we can construct an authorial presence within the films. It is thus that authors become discursive figures (Foucault 1977) who inhabit and are constructed not only by history but also by their own filmic texts. How they inhabit their films, or, in Bordwell's term (1989, 151–68), how they are "personified" varies: they may inhabit them as real empirical persons, enunciating subjects, structured absences, fictive structures, or a combination of these. In the accented films, determining the mode of habitation of the author within the text is a complex task, even in films in which the filmmakers appear as empirical persons and as themselves either audiovisually (Mekas's films, including *Lost, Lost, Lost*), or only visually (Suleiman's *Chronicle of Disappearance*), or only vocally and as the film's addressee (Akerman's *News from Home*), or as fictional characters (Egoyan's *Calendar*), or as author surrogates (Naderi's *Manhattan by Numbers* and Shahid Saless's *Roses for Africa*, 1991). In all these cases, filmmakers are engaged in the performance of the self. In short, because of their interstitiality, even in situations of self-inscription exilic authors tend to create ambiguity regarding their own real, fictive, or discursive identities, thus problematizing Phillipe Lejeune's "autobiographical pact," which requires that the author, the narrator, and the protagonist be identical (1989, 5).

Exilic authorship is also a function of the filmmakers' mode of production. In fact, in their multiple incarnations or personifications, the authors are produced by their production mode. If the cinema's dominant postindustrial production modes privilege certain kinds of authorship, then the artisanal accented production modes must favor certain other authorial signatures and accents. It is worth bearing in mind that such signatures or accents signify both the various incarnations of their authors and the conditions of exile and diaspora. The interpretation of these signatures and accents depends on the spectators, who are themselves often situated astride cultures and within collective formations. Hence, the figures they cut in their spectating of the accented filmmakers as authors are nuanced by their own extratextual tensions of difference and identity.

[ · · · ]

CLOSE-UP: ATOM EGOYAN'S ACCENTED STYLE

Like all approaches to cinema, the accented style attempts to reduce and to channel the free play of meanings. But this approach is driven by its sensitivity to the production and consumption of films and videos in conditions of exilic liminality and diasporic transnationality. The style designation also allows us to reclassify films or to classify certain hitherto unclassifiable films. Thus, Mekas's *Lost, Lost, Lost*, which has been variously regarded as documentary, avant-garde, or diary film, will yield new insights if reread as an accented film. If one thinks of Buñuel as an exilic filmmaker, as does Marsha Kinder (1993), further understanding about his films,

hitherto unavailable, will be produced. Likewise, a rereading of Miguel Littín's docudrama *The Jackal of Nahueltoro* (*El Chacal de Nahueltoro*, 1969), turns it into a protoexilic film containing many components of the accented style in emergent form, even though at first blush the story does not warrant such an interpretation.

The accented style helps us to discover commonalities among exilic filmmakers that cut across gender, race, nationality, and ethnicity, as well as across boundaries of national cinemas, genres, and authorship. References to filmmakers range far and wide, from Godard to Mekas, from Akerman to Med Hondo, and from Solanas to Trinh. Approached stylistically, films can be read, reread, and back-read not only as individual texts but also as sites of struggle over meanings and identities. By problematizing the traditional schemas and representational practices, this approach blurs the distinction, often artificially maintained, among various film types such as documentary, fictional, and avant-garde. All of these types are considered here.

The accented style is not a fully recognized and sanctioned film genre, and the exilic and diasporic filmmakers do not always make accented films. In fact, most of them would wish to be in Egoyan's place, to move out of marginal cinema niches into the world of art cinema or even popular cinema. Style permits the critics to track the evolution of the work of not only a single filmmaker but also a group of filmmakers. As I discuss in [*An Accented Cinema*'s] chapters on mode of production, Asian Pacific American filmmaking has gradually evolved away from an ethnic focus toward diasporic and exilic concerns, while Iranian exilic filmmakers have evolved toward a diasporic sensibility. These evolutions signal the transformation of both filmmakers and their audiences. They also signal the appropriation of the filmmakers, their audiences, and certain features of the accented style by the mainstream cinema and by its independent offspring. Because it goes beyond connoisseurship to situate the cinéastes within their changing social formations, cultural locations, and cinematic practices, the accented style is not hermetic, homogeneous, or autonomous. It meanders and evolves. It is an inalienable element of the social material process of exile and diaspora and of the exilic and diasporic mode of production.

## NOTES

1. I thank Bill Nichols for suggesting the parallel between exile and taboo. Also, see exile as "aesthetic gain" in Kaplan 1996, 33–41.

2. I have incorporated these and other attributes of exile and alterity to formulate a "paradigm of exile" (Naficy 1993a).

3. If Rushdie is an example of exilic hybridity, F. M. Esfandiary is an example of exilic virtuality. In the 1960s, Esfandiary wrote novels from exile about the horror of life in his homeland Iran (*The Identity Card* [1966]), but in the late 1980s he changed his name to FM-2030 and developed the concept of transhumanism, which dismissed all usual markers of continuity and identity. To be a transhuman is to be a universal "evolutionary being" (FM-2030 1989, 205).

4. This is particularly true for the Japanese-Americans whose loyalty to the United States was questioned during World War II and to the Muslim Americans whose loyalty is often questioned in contemporary times.

5. Peter Feng suggests removing the hyphen from "Asian-American," while Gustavo P. Firmat recommends replacing it with a plus sign for "Cuban + American" (1994, 16). Some insert a forward slash between the two terms. On the politics of the hyphen, especially for Asian-Americans, see Feng 1995, 1996; Lowe 1991.

6. Although "international," even "transnational," these directors—whom Douglas Gomery (1991) labels "the individual as international film artist"—are not considered "exilic" or "diasporic" by the definition used here.

7. In an earlier publication, I explored the promise of theorizing these films as a transnational "genre" (Naficy 1996g).

8. On regional exilic filmmaking, the following are notable studies: on Latin-American exile filmmakers, see Pick (1993, 157–85) and Burton (1986); on Chilean exile films, see King (1990); on Cuban exile films, see Lopez (1996); on cinemas of the black diaspora, see Martin (1995) and Ukadike (1994); on black British independent films, see Mercer (1994a), Diawara (1993b), and Fusco (1988); on black American diaspora films, see Diawara (1993a) and Reid (1991); on postcolonial and multicultural diasporic films, see Shohat and Stam (1994) and Sherzer (1996); on women and African and Asian diaspora films, see Foster (1997); on Caribbean exilic films, see Cham (1992); on Asian-American films, see Leong (1991); on Chicano/a cinemas, see Fregoso (1993) and Noriega (1992a); on Middle Eastern exile films, see Friedlander (1995) and Naficy (1995e); on Yiddish films, see Hoberman (1991a); on Iranian exile films, see Naficy (1993a); on Turkish exile films, see Naficy (1996g); on Soviet and Eastern European filmmakers in the West, see Petrie and Dwyer (1990); on exile and émigré cinema, particularly in France and Europe, including extensive filmographies, see the following special issues of *CinémAction* magazine: no. 7, "Cinéma contre racisme" (n.d.); no. 8, "Cinémas de l'émigration" (summer 1979); no. 24, "Cinémas de l'émigration" (n.d.); no. 56, "Cinémas métis: De Hollywood aux films beurs" (July 1990). On individual exilic filmmakers, consult the index or the close-up sections throughout [*An Accented Cinema*].

9. On experimental diaspora cinema, see Marks 1994.

10. Even these two types of accented films are not fixed, for the works of some filmmakers may fall only partially into one or share attributes of both. This is another way in which these films are hybrid. For example, Solanas's *Tangos: Exile of Gardel* and Krishna's *Masala* may be categorized as hybrid films in their crossing of the boundaries and the mixing of elements of musical and melodrama, tragedy and comedy, narrative and nonnarrative, fictional and nonfictional, realism and surrealism, personal and national. However, both Solanas and Krishna make feature-length films, have high ambitions, and have large markets in mind. A key difference between them is that while *Masala* is a diaspora film, *Tangos* remains exilic, for it is focused solely on exile and on a binary relationship with the homeland. Likewise, Mekas's films share some of the characteristics of both feature films (their length) and experimental films (their aesthetics).

11. In the classical Hollywood cinema, the stars who retained their "foreign" accents fared differently. Some could not get parts because of their heavy accents. Scandinavian stars, particularly Greta Garbo, Sonja Henie, and Ingrid Bergman, were usually cast as European and Soviet foreign characters. Some British-born stars, such as Cary Grant, acquired a "transatlantic accent," so named perhaps because it was both readily comprehensible and hard to place (Jarvie 1991, 93).

12. Other middlemen figures in the border drama include sanctuary movement advocates who assist potential refugees to gain asylum in the United States.

13. I have borrowed this phrase from Pfeil 1988, 387.

## BIBLIOGRAPHY

Altman, Rick. 1989. *The American Film Musical*. Bloomington: Indiana University Press.

Barthes, Roland. 1977. *Image, Music, Text*. Trans. Stephen Heath. New York: Hill and Wang.

Bauman, Zygmunt. 1991. "Modernity and Ambivalence." In *Global Culture: Nationalism, Globalization and Modernity*, edited by Mike Featherstone, 143–69. London: Sage.

Bhabha, Homi K. 1994. *The Location of Culture.* London: Routledge.

Bordwell, David. 1989. *Making Meaning: Inference and Rhetoric in the Interpretation of Cinema.* Cambridge, Mass.: Harvard University Press.

———. 1997. *On the History of Film Style.* Cambridge, Mass.: Harvard University Press.

Bordwell, David, and Kristin Thompson. 1993. *Film Art: An Introduction.* 4th ed. New York: McGraw-Hill.

Burton, Julianne, ed. 1986. *Cinema and Social Change in Latin America: Conversations with Filmmakers.* Austin: University of Texas Press.

Caughie, John, ed. 1981. *Theories of Authorship: A Reader.* London: Routledge and Kegan Paul.

Clifford, James. 1977. *Routes: Travel and Translation in the Late Twentieth Century.* Cambridge, Mass.: Harvard University Press.

Cohen, Robin. 1997. *Global Diasporas: An Introduction.* London: UCL Press.

Crystal, David. 1991. *A Dictionary of Linguistics and Phonetics.* 3d ed. New York: Blackwell.

Diawara, Manthia. 1993. *Black American Cinema.* New York: Routledge.

Feng, Peter. 1996. "Being Chinese American, Becoming Asian American: Chan Is Missing." *Cinema Journal* 35, no. 4:88–118.

Foucault, Michel. 1977. *Language, Memory, Practice.* Ed. D. F. Bouchard. Oxford: Basil Blackwell.

Fusco, Coco. 1988. *Young British and Black: A Monograph on the Work of Sankofa Film/Video Collective and Black Audio Film Collective.* Buffalo, N.Y.: Hallwalls.

Gates, Henry Louis, Jr. 1988. *The Signifying Monkey: A Theory of African-American Literary Criticism.* New York: Oxford University Press.

Gilroy, Paul. 1993. *The Black Atlantic: Modernity and Double Consciousness.* Cambridge, Mass.: Harvard University Press.

———. 1991. *"There Ain't No Black in the Union Jack": The Cultural Politics of Race and Nation.* Chicago: University of Chicago Press.

———. 1988. "Nothing But Sweat inside My Hand: Diaspora Aesthetics and Black Arts in Britain." *ICA Documents,* no. 7: 44–46. [Special issue on black film, British cinema.]

Gomery, Douglas. 1991. *Movie History: A Survey.* Belmont, Calif.; Wadsworth.

Hall, Stuart. 1988. "New Ethnicities." *ICA Documents,* no. 7: 27–31. [Special issue on Black film, British cinema.]

Harlow, Barbara. 1991. "Sites of Struggle: Immigration, Deportation, Prison, and Exile." In *Criticism in the Borderlands,* edited by Héctor Caldrón and José David Saldívar, 149–63. Durham, N.C.: Duke University Press.

Hicks, D. Emily. 1991. *Border Writing: The Multidimensional Text.* Minneapolis: University of Minnesota Press.

Jameson, Fredric. 1984. "Periodizing the 60s." In *The 60s without Apology,* edited by Sohnya Sayers et al., 178–209. Minneapolis: University of Minnesota Press.

Jarvie, Ian C. 1991. "Stars and Ethnicity: Hollywood and the United States, 1932–51." In *Unspeakable Images: Ethnicity and the American Cinema,* edited by Lester Friedman, 82–111. Urbana: University of Illinois Press.

Kaplan, Caren. 1996. *Questions of Travel: Postmodern Discourses of Displacement.* Durham, N.C.: Duke University Press.

King, John. 1990. "Chilean Cinema in Revolution and Exile." In *Magic Reels: A History of Cinema in Latin America,* 169–87. New York: Verso.

Lejeune, Phillipe. 1989. *On Autobiography.* Ed. Paul Eakin. Minneapolis: University of Minnesota Press.

Lopez, Ana M. 1966. "Greater Cuba." In *The Ethnic Eye: Latino Media Arts*, edited by Chon A. Noriega and Ana M. Lopez, 38–58. Minneapolis: University of Minnesota Press.

Lowe, Lisa. 1991. "Heterogeneity, Hybridity, Multiplicity: Making Asian American Difference." *Diaspora* 1, no. 1:24–44.

Martin, Michael. 1995. *Cinemas of the Black Diaspora: Diversity, Dependence, and Oppositionality.* Detroit: Wayne State University Press.

Mercer, Kobena. 1994a. "Diaspora Culture and the Dialogic Imagination: The Aesthetics of Black Independent Film in Britain." In *Welcome to the Jungle: New Positions in Black Cultural Studies*, 53–68. London: Routledge.

———. 1994b. *Welcome to the Jungle: New Positions in Black Cultural Studies.* London: Routledge.

———. 1988. "Recoding Narratives of Race and Nation." *ICA Documents*, no. 7: 4–14. [Special issue on black film, British cinema.]

Modarressi, Taghi. 1992. "Writing with an Accent." *Chanteh* 1, no. 1:7–9.

Naficy, Hamid. 1996. "Phobic Spaces and Liminal Panics: Independent Transnational Film Genre." In *Golbal/Local: Cultural Productions and the Transnational Imaginary*, edited by Rob Wilson and Wimal Dissanayake, 119–44. Durham, N.C.: Duke University Press.

———. 1993. *The Making of Exile Cultures: Iranian Television in Los Angeles.* Minneapolis: University of Minnesota Press.

O'Grady, Gerald. 1973. "Our Space in Our Time: The New American Cinema." In *The American Cinema*, edited by Donald E. Staples, 228–44. Washington, D.C.: U.S. Information Agency.

Peters, John. 1999. "Exile, Nomadism, and Diaspora: The Stakes of Mobility in the Western Canon." In *Home, Exile, Homeland: Film, Media, and the Politics of Place*, edited by Hamid Naficy, 17–41. New York: Routledge.

Pick, Zuzana M. 1993. "Exile and Displacement." In *The New Latin American Cinema: A Continental Project*, 157–85. Austin: University of Texas Press.

Reid, Mark A. 1993. *Redefining Black Films.* Berkeley: University of California Press.

———. 1991. "African and Black Diaspora Film/Video." *Jump Cut*, no. 36: 43–46.

Rushdie, Salman. 1991. *Imaginary Homelands: Essays and Criticism, 1981–1991.* London: Granta.

Safran, William. 1991. "Diasporas in Modern Societies: Myths of Homeland and Return." *Diaspora* 1 no. 1:83–99.

Sollors, Werner. 1986. *Beyond Ethnicity: Consent and Descent in American Culture.* New York: Oxford University Press.

Spivak, Gayatri Chakravotry. 1988. "Can the Subaltern Speak?" In *Marxism and the Interpretation of Culture*, edited by Cary Nelson and Lawrence Grossberg, 271–313. Urbana: University of Illinois Press.

Tölölyan, Khachig. 1996. "Rethinking Diaspora(s): Stateless Power in the Transnational Moment." *Diaspora* 5, no. 1:3–36.

Ukadike, Nwachukwu Frank. 1994. *Black African Cinema.* Berkeley: University of California Press.

Willemen, Paul. 1989. "The Third Cinema Question: Notes and Reflections." In *Questions of Third Cinema*, edited by Jim Pines and Paul Willemen, 1–29. London: British Film Institute.

Williams, Raymond. 1977. "Structure of Feeling." In *Marxism and Literature*, 128–35. London: Oxford University Press.

# DUDLEY ANDREW

# An Atlas of World Cinema

An expert in French cinema and culture and a keystone figure in film studies in the United States, Dudley Andrew (b. 1945) trained many of the country's influential theorists during his long tenure at the University of Iowa. Since 2000, Andrew has been R. Selden Rose Professor of Film and Comparative Literature at Yale University. His books *The Major Film Theories* (1976) and *Concepts in Film Theory* (1984) synthesized continental film theory for English-speaking readers, and his 1978 study of André Bazin retains definitive status. He is also well known for his work on adaptation, aesthetics, and world cinema, with several books on French cinema and works on Japanese, Irish, and West African film.

While film festivals and university curricula still foreground national cinemas and auteurs, an understanding of the complicated ecology of world cinema can link film practices and help displace the notion of Hollywood as the center of image culture. At a juncture when Korean horror cinema attracts fan sites all over the world and Iranian auteurs rank alongside the Italian neorealists and Japan's postwar masters, a more cosmopolitan approach is required. Andrew's own expertise in the cinema of France, a former colonial power and an important source of film financing in francophone Africa, informs his study of the latter region's film production. If we must increasingly think of national cinema in transnational terms, what concepts of world cinema are most relevant?

In "An Atlas of World Cinema," originally published in 2004, Andrew interrogates longstanding "connoisseur" approaches to "foreign film" fostered by the elite postwar film festivals and "survey" models of course design. He recommends putting these approaches alongside a number of different models, invoking the analogy of an atlas that allows different features to come forward depending on the "mapping" criteria. For example, "demographic" maps show that a nation's cinema culture is defined as much by film reception—what people watch, which may be domestic films, Hollywood blockbusters, or something else—as it is by the country's production. "Topographical" maps show the "depth" or cultural rootedness of certain film practices as well as the formations that cross national boundaries. Andrew's erudite and conceptually supple essay matches the exciting changes in the twenty-first-century globalization of cinema with an equally challenging advance in the responsibility of film studies.

## READING CUES & KEY CONCEPTS

- How does Andrew position commercial Hollywood production in his "atlas of world cinema"? Does the term "world cinema" apply to Hollywood?

- Look at a contemporary film festival program. How would the "political" map of world cinema look according to its programming?

- Andrew writes that "every film implies a geopolitical orientation." Think of a film that illuminates his argument.

■ Andrew insists on the pedagogical necessity of world cinema. What are the consequences of ignoring the global for U.S. film studies?

■ **Key Concepts:** World Cinema; Demographic Maps; Orientation Maps; Cosmopolitanism; Vernacular; Nomadology

# An Atlas of World Cinema

. . . . . . . . . . . . . .

The term "world cinema" is now permanently with us: in our classes, our textbooks, the popular press. It names the global reach of Hollywood, beginning with *Jaws* (1975) and *Star Wars* (1977), and it names the resistance to Hollywood evident in the GATT debates over a decade ago. Sometimes postcolonial critics mobilize the term, as nations vie for recognition at film festivals. "World cinema" replaces the "foreign art film" which first slipped through heavily guarded university doors in the 1960s. We used to teach foreign films as autonomous masterworks in "film as art" courses or as addenda to the sanctioned national literatures. Today national literature departments are shrinking while the number of films begging for study and the places they come from increases. The old ways do justice neither to this variety, nor to the international interdependence of images. The rubric that I, like so many others, employed for years, "Survey of film," does an injustice to the situation and to students. For a "survey" suggests a distant gaze, panoptically monitoring the foreign for our convenience and use. A course of study in world cinema, however, should instead be ready to travel more than to oversee, should put students inside unfamiliar conditions of viewing rather than bringing the unfamiliar handily to them. This is the pedagogical promise of a discipline such as World Cinema, a manner of treating foreign films systematically, transcending the vagaries of taste; taking the measure of "the foreign" in what is literally a freshly recognized global dimension. Such an approach examines overriding factors, then zeroes in on specific "cinema sites"—provides coordinates for navigating this world of world cinema. No need to dock in every port as if on a *tour du monde* with some "Michelin guide" textbook. Displacement, not coverage, matters most; let us travel where we will, so long as every local cinema is examined with an eye to its complex ecology.

My approach might best be conceived as an atlas of types of maps, each providing a different orientation to unfamiliar terrain, bringing out different aspects, elements and dimensions. Each approach, or map, models a type of view: hence, the *Atlas*. Film festivals long ago came up with a basic map as they sought top products to be put in competition each year as in a Miss Universe contest. For a long while the cognoscenti did little more than push colored pins onto a map to locate the national origin of masterpieces. This appreciation of cut flowers adorned film study in its first years but required a more systematic account (call it botanical or ecological) of the vitality of privileged examples. What political and cultural soil nourished these films and their makers? Today's impulse—more ambitious because more dynamic and comparative—would track a process of cross-pollination that bypasses national directives. To begin to encompass all this material in this confusing "field" of study

an historical atlas would seem a sensible first step. Yet my course is neither a gazetteer nor an encyclopedia, futilely trying to do justice to cinematic life everywhere. Its essays and materials model a set of approaches, just as an atlas of maps opens up a continent to successive views: political, demographic, linguistic, topographical, meteorological, marine, historical.

## Political Maps

Pushing pins onto a spread of countries marked by borders has its uses. In high school all of us pored over successive shapes of world power: the Greeks, the Romans, various barbarian kingdoms, Islam's arms reaching through Africa and girdling Europe. What would a map of cinematic power show? With global feature film output at around three thousand titles a year, we might indicate filmmaking hotspots, using a gray-scale of production density that could be keyed to Hollywood—a dark constant. Competitors would be variably less dark: since 1930 France has put out over a hundred features a year except during the German occupation. Japan, more like three hundred. And India, at least since the 1950s, has increased from three hundred to its current eight hundred. The surprise would be Egypt, Turkey and Greece, all making hundreds of films each year after World War Two until television undercut them in the 1980s. Were one to graph world output at ten-year intervals, significant pulsations would appear: Brazilian production, for instance, phases in and out with shifts in government; Hong Kong emerges with Run Run Shaw's operation in the 1950s, then dominates East Asia after the 1970s; and of course there is Iran. Like Mali and Burkina Faso in West Africa, Iran in the 1980s surges ahead of surrounding nations.

Iran and Burkina Faso remind us, however, that national prestige in cinema comes more by way of critical assessment and festival performance than by sheer quantity of titles. It was Abbas Kiarostami and Idrissa Ouedraogo who put these nations on the map at Cannes. Similarly Edward Yang and Hou Hsiao-Hsien raised Taiwan to a par with Hong Kong (they receive equal space in the *Encyclopedia of Chinese Film* and in *The Oxford History of World Cinema*) despite Taiwan's lesser output and popularity. Nor can we forget Denmark, which in the past decade or so has become a European colossus compared to Germany despite being out-produced annually by a factor of three. As a first clarifying step, we need to analyze production and prestige across the century, with particular attention to the years since 1975, when "world cinema" came to attention.

## Demographic Maps

Apportioning the world's annual three thousand feature films by place of origin makes the globe appear to spin more smoothly than it really does. For Hollywood's lopsided economic mass (bags of box-office receipts returning to it from nearly everywhere but India) pulls it out of true. Such domination of distribution includes both theatrical exhibition and video dissemination (except for the black-market economy rampant particularly in Africa and China). To represent not the production, but the availability of images region by region, the grayscale no longer suffices. These displays must be chromatic: red daubs for Hollywood films playing in

theaters and taking up space on video shelves, blue for indigenous images. Speckles of yellow and green would suggest diversity—yellow for images imported from neighboring countries, green for those coming from afar. Take Ireland, the European country with the highest per capita attendance. Lately Hollywood has colonized some 76 per cent of its screen space and time; local productions (over 20 films a year) garner 3–4 per cent. The rest come mainly from the UK (15 per cent) and European Union countries. Now in France, Hollywood last year dipped below 50 per cent for the first time in two decades. The French have a taste for Italian and Asian films, but mainly their own products prevail, set up by intensive promotions and economic incentives.

Since the real film wars have been waged less over production than competition for audiences, demographic studies serve as military maps in strategy sessions at the boardrooms of CEOs or of cultural ministers. Nation-states have frequently protected their workforce and the minds of their citizens from carefully calculated foreign invasion. Unlike literary fiction where the native product has been provisionally secure behind the Great Wall of the native language, films from the outset invaded foreign screens. The Lumière brothers dispatched camera crews around the world before their invention was two years old, showing films shot in one place to audiences in another. And Pathé, as Richard Abel (1999) has shown, was a feared imperial image power by 1913, with offices everywhere. Taken to be an international concern, Pathé provoked local competitors to call upon loyalty to "national cinema." Critics were enlisted to invent and uphold something newly baptised, "the American cinema," "the Japanese cinema," and so forth. By 1920 Hollywood had replaced France as the Emperor of Images. The tables now turned, the Parisian press of the 1920s invented a national tradition of French cinema that demanded (as it does today) the support of the government and of citizen-spectators.

Nationalists imagine a simple competition between *our* images and *theirs*. However, following Fredric Jameson, we should be alert to a dialectic that often produces a synthetic form combining both (1993: xiii). For example, the name of the key compromise form in France of the 1920s is "narrative avant-garde." "Narrative" signals the common shape given to films everywhere by D. W. Griffith and Thomas Ince, while "avant-garde" announces the native aesthetic impulse that made France the center of successive movements in fiction and the fine arts from impressionism to symbolism, cubism and beyond. The overall study of French cinema of the 1920s, then, should take imports into account, because Hollywood films constituted 50 per cent of the images occupying the country's screens, that is, occupying the minds of those who made and watched films. It should also consider other imports, German expressionism in this case, which provided the French an alternative model to that of Hollywood. By triangulating French cinema in relation to America and Germany, the presumed singularity of a national movement can be much more accurately plotted.

No study of French cinema, my own on the 1930s included, has attended to imports in this way. To use Franco Moretti's analogy, national cinema studies have by and large been genealogical trees, one tree per country (2000: 67). Their elaborate root and branch structures are seldom shown as intermingled. A "world systems" approach, on the other hand, demands a different analogy, that of "waves" which

roll through adjacent cultures whose proximity to one another promotes propagation that not even triangulation can adequately measure. Moretti's term attracts one of world cinema's best examples: for the New Wave that buoyed French film in 1959 rolled around the world, affecting in different ways and under dissimilar circumstances the cinema lives of Britain, Japan, Cuba, Brazil, Argentina, Czechoslovakia, Yugoslavia, Hungary and later Taiwan. As we know, its so-called original undulation in Paris owed much to the Hollywood films that came ashore behind the Normandy invasion of 1944, literally rejuvenating a tired French culture. The New Wave passed first through youth fads in fashion, design and the novel before cresting at Cannes in 1959 where its effects were patently international.

Demographic studies of box-office and video-store statistics can devolve quickly into assessments of audience predilection. Important for some questions, such sheer sociology generally results in predictable stereotypes. In a survey of 46 countries, called "Planet Hollywood," Moretti (2001) finds what we would expect: that Asians are drawn to action films, that wealthier nations watch a lot of children's films, that comedies are more often home-grown, and so on. Overviews like this do not begin to give us the feel for the varieties of cinematic cultures on the planet; one might as well study breakfast cereals. Fortunately, Moretti, a brilliant literary historian, has invented far more intricate maps.

## Linguistic Maps

In his *Atlas of the European Novel 1800–1900* (1999) and the five-volume history of the "World Novel," Moretti explicitly puts into play a Darwinian hypothesis that should apply to feature films as well. To map the growth and withering of novelistic trends around the globe, he employs a law he gleaned from Fredric Jameson: "In cultures that belong to the periphery of the literary system, the modern novel first arises not as an autonomous development but as a compromise between a Western formal influence (usually French or English) and local materials" (2000: 58). Moretti maps the flow of translations and booksellers from an English/French power source to literary hotspots springing up later in Russia, India, and so on. This dialectical law nicely accounts for Hollywood's dominance of the form of films made everywhere, especially after Moretti rightly complicates this crude "form/content" binary with a third factor, indigenous local narration (ibid.).[1] For novelists and filmmakers may have learned a successful formula from Charles Dickens or D. W. Griffith, but they adapt it to their culture's experience in a homegrown manner. This "manner" inflects the standard form with the register of traditional oral or theatrical storytelling. In West African film, in the Korean hit *Chunhyang* (Im Kwon-Taek, 2001), in Kenji Mizoguchi's long-take "theatrical" *mise-en-scène*, the cinema grafts rather than mulches cultural roots. The cohabitation of this (European) medium and local traditions produces compromise film forms that are often as hybrid and ambivalent as the subjects that such movies represent.

Moretti's hypothesis for the novel upholds the colonialist map of cinema attacked by Ella Shohat and Robert Stam in *Unthinking Eurocentrism* (1994). This first and crucial "World Cinema" textbook, alerted us all to cultural wars fought with the weapon of style and theme. But their rather moralistic approach upholds a set of smart, politically correct films standing against Eurocentric global media forces. As

proper as this may be, an evolutionary map of film history requires a larger view, one capable of accounting for popular genres and failed heritage films as well as critical successes. This is precisely what Miriam Hansen has proposed in a far-reaching article on "Classical Cinema as Vernacular Modernism" (2000). Classical Hollywood, the dominant and dominating force in the entertainment world from World War One at least through the Korean conflict, was always both "international" and "vernacular" in promoting a modernist sensibility that derived from popular rather than official or elite origins. All films minted in Hollywood have been ubiquitously accepted as legal currency, stamped with the logo of "Universal Pictures" or of Paramount's mountain (which dissolved into the Andes in the first frames of *Indiana Jones and the Temple of Doom* [Steven Spielberg, 1984]). That currency underwrites a stock market of stars and a narrative economy that the entire world has apparently bought into, aside from the fringe market where Shohat and Stam's alternative films trade. But buying into classical cinema does not mean digesting its values whole, for its universal language breaks apart on national or regional shorelines into a Babel of varied receptions.

I am inclined to take Hansen's vocabulary rather more literally than she does. Classical cinema would thus be the medium's classical language, that is, Latin. By 1920 Hollywood was, first of all, unapologetically imperial, literally colonizing countries and continents and setting up administrative institutions to govern these. Latin preceded vernacular languages that were formed through its contact with local ways of speaking, including residual tribal languages. In a similar way, and as Moretti has noted, most national cinemas came into existence through a process of differentiation from an already well-situated Classical Hollywood. Hansen would call Shanghai melodramas of the 1930s and Mexican cinema of the 1940s "dialects" of a universal vernacular modernism whose cinematic center was Hollywood. Because I have my eye on more recent developments, on the achievement of putatively homegrown cinemas after 1975 in Africa, Ireland and Mainland China, I am inclined to call them actual vernaculars, related to, but set against the one universally recognized language of the movies, Classical Hollywood's Latin, no longer spoken purely today in the post-classical age, but still fondly remembered.

Hansen properly inflates the importance of Hollywood as "vernacular modernism," since this allies it to the power of the high modernism of Proust, Joyce, Picasso and Le Corbusier, while trumping all these through its popular appeal. Uncredited, Hollywood participated in the momentum we attribute to the privileged discourses of art, and it did so internationally as metropolitan peoples around the globe responded immediately to its attractions: speed, narrative disjunction, primacy of the visual, surveillance, excessive stimulation, negotiated ethics, and more. Hollywood, more than the intellectual pioneers we always adulate, brought modernism into the world. But Moretti's study of the novel alerts us to watch for the way each country both read and rewrote (in their own productions) this classical form. A close analysis of key films from any locale should reveal a conflicted cinematic vocabulary and grammar, as my recent examination of East Asian cinemas is revealing. Where Hansen insists on a dyadic pattern involving Hollywood with each of innumerable peripheral cinemas, I would complicate the map by tracing the regional interaction that is particularly visible when storytelling traditions are in focus. Thus a description

of Hong Kong and Taiwanese cinema today must include not just their obvious ways of adopting and transforming Hollywood; it must account for the presence of various Asian characters in their plots and of Chinese and Japanese theatrical forms in their style. Vernaculars alter each other. Just look at *Crouching Tiger, Hidden Dragon* (Ang Lee, 2000). Better still, look at it from the perspective of Mainland Chinese audiences who had the pleasure or annoyance of rectifying three distinct acting styles and accents, which came across the subtitles in such a unified way for us in the West, ignorant of the sounds of the language.

## *Orientation Maps*

Thus the idea of the atlas aspires to totality through an accretion of multiple yet differentiated maps that apportion objects and views. Even an immense sum of maps does not afford that captious, final perspective one relishes when spinning a globe at arm's length. Still, the atlas' thwarted totalization encourages a dialectical understanding of culture and of one's place in it. This makes historicity possible, according to Jameson, since every view is local and, thereby, partial; and an acknowledgement of partiality underwrites the historical struggle over "the territory" one inhabits. Moretti gave us just the ocular tool needed when he added "indigenous narration" to Jameson's dialectical process of hegemonic form meeting local material. For is not narration precisely the mechanism by which totality is imagined and managed from such and such a place? In cinema something as technical as "point of view" asserts an ideological and political claim, literally orienting a culture to a surrounding world.

And yet Moretti backs away from the analysis of point of view in texts, backs away from texts altogether, retreating to the distance demanded by the protocols of social science (2000: 56).[2] How odd, when he has in front of him Jameson's plea for "cognitive mapping" (1988). Should not the next shift in the dialectic take him from the sociological perspective to precisely the "perspective of *perspective*," that is, to the interior map that the text itself can be said to draw? All films by definition—and ambitious works by design—contain and dramatically coordinate the various forces that the social scientist plots on graphs. Why not examine the film as map—cognitive map—while placing the film *on* the map. How does a fictional universe from another part of the world orient its viewers to their global situation?

Every film implies a geopolitical orientation, even if some Hollywood films assume that this question is obviated by their putatively universal perspective. But in other places—in Ireland, for instance—orientation is exactly what is at stake in representation. To account for the local/global *transfocus* that so many Irish films employ, I have invented the term "demi-emigration" (see Andrew 2002), trying to point to the complex way in which a culture can be itself without turning in on itself. Whether or not Irish films deal explicitly with global issues, the place of the culture in the world is visible to the careful analyst. Look at the recent film *The Mapmaker* (Johnny Gogan, 2001), set at Ireland's interior border, separating off the six counties. In fact it concerns a single county, Leitrum, which, with its divided populace, becomes a figure of the nation. At whatever level, the border literally contains the forces that mount up against and among one another under the centripetal pressure

borders naturally exert. Those forces and pressures may often be uncomfortable, even repressive, and today they may be (or seem) arbitrary and dismissible, but borders provide constant orientation; for most citizens within them, they are like the walls of a house, reassuring rather than confining. You can usually open a window or walk out the door in times of stress. Most important, the continuity and definition they give to an otherwise unlimited space, trades extension for depth. There is an Irish atlas that marks an amazing number of distinctive features, county by county, district by district (Aelen, Whelan & Stout 1997). Natural and man-made marks atop the landscape are openings that allow local people and historians to tunnel into a past, in what amounts to a historical dictionary of the Earth. The same holds true for ways of speech and behavior; restricted in space for generations, these ingrained habits absorb history in each performance of them, lending its weight to the everyday. Natural borders such as the sea-girdle surrounding the two Irelands make this obvious; historical borders, like the one between those Irelands, are only "marginally" different. The fact is that every citizen knows what it feels like to arrive on the other side of passport control coming back from a trip. The sense of freedom abroad, the observations of differences and similarities, recede as we sink again into "being back home," with all the conflicts included. We can recognize the habits of our home as a "habitus," appreciating or mocking their peculiarities, understanding their connection to time and place. Films make palpable collective habits and a collective sensibility. In their inclusions and exclusions, in their scope and style, films project cognitive maps by which citizens understand both their bordered world and the world at large.

## Topographical Maps

What do we do with the nomadic refusal of maps? The Nomad, at least as he has been famously figured by Gilles Deleuze and Felix Guattari (1987), snaps the tether tied to the tree of history, and skips along the surface toward a fluctuating horizon. Protean and quick, he evades the mapping prowess of the colonialist, the tax collector and the academic researcher who would position him; he loses himself in unmappable terrains, a force outside representation. Raised on postwar art cinema, Deleuze prized "deeply foreign" films for these qualities, for resisting the imperial administration of audio-visual entertainment that goes under the flag of Hollywood.

The term "world cinema" vibrates with this nomadic energy; many of us sidle close, curious, tempted to try it out. Usually we demand the best films brought to us conveniently. Metropolitan connoisseurs, we cultivate alluring, sometimes aggressively dangerous species of exotic films. How to give back to such films the force to disturb us? Can films refuse to be mapped, refuse representation in the way nomads are said to do? Can films still strike with the force of the unexpected the way Akira Kurosawa, Satyajit Ray and Jerzy Kawalerovicz did in the 1950s? Relief maps suggest uneven contours on the globe, including layers. When we add to these the geological and marine dimensions, topographical maps represent the struggle to represent depth, that which is hidden. Deleuze's notions of "smooth nomadic space" founder when one looks at deeply "rooted" cultures, including those that have escaped our attention.

Since 1990 hundreds of Nigerian scripts (over 500 last year) have been shot direct-to-video in Yoruba and Ibo; VHS tapes (their sole mode of existence) are traded in the urban market, then bicycled along old trading routes to villages throughout the country. No festivals feature these films; no critics review them. Their reputation travels by word of mouth, and within national, often tribal borders. This, the most successful image market on the entire African continent, has been invisible to us . . . unrepresented on our screens and until a few years ago unmentioned in our scholarly literature. One of the only viable non-subsidized image industries in the world, Nigerian video films are off the map. They have not sought our interest, not yet at least; however, they must concern anyone who scans screens for a different vision of the world or a different function of the medium. Not long ago, I concluded a long discussion of African cinema and its rapport with Deleuze's "nomadology" by mentioning these films as precisely unmentionable, unviewable, unmappable (Andrew 2000). I saw this phenomenon as the proper but self-negating conclusion of Deleuze's flight of thought, a limit that contested his ideas. But that was before copies of such videos began to appear in London and other diasporic communities, and before Nigerian scholars touted their indigenous success. Now California Newsreel, a counter-culture distributor in the US, has picked one example, *Thunderbolt* (Tunde Kelani, 2001), the most complex they could find of course. They expect to market it to professors of African Studies and anthropology and to those film scholars ever on the lookout for a different cinema, whether in the hope that a purer vision may be available, or a purer people. Many of us will be racing to examine this vibrant phenomenon, to be the first to tell our peers about it, the first to explore its (hopefully idiosyncratic) use of the medium, its special cultural function—in short, the first to map it.

## *Conclusion*

Let me not be coy. We still parse the world by nations. Film festivals identify entries by country, college courses are labelled "Japanese Cinema," "French Film," and textbooks are coming off the presses with titles such as *Screening Ireland, Screening China, Italian National Cinema,* and so on. But a wider conception of national image culture is around the corner, prophesied by phrases like "rooted cosmopolitanism" and "critical regionalism" (Andrew 2002). Such terms insist upon the centrifugal dynamic of images, yet without surrendering the special cohesion that films bring to specific cultures.

In this perpetual push-pull between local conditions and broader cosmos, I throw my slight weight behind the latter for strategic reasons, certain that American students are primed to celebrate identity far too uncritically, applauding its certitudes wherever they may be found, as a guarantee for that most important identity, their own as Americans. Behind the acclamation accorded recently exported Indian films, for example, you can hear overtones of relief from critics and spectators, who welcome the chance to cheer for the local, even the familial. It is hard not to get behind music, genre, dance and custom, particularly when hundreds of millions of people celebrate exactly these things far from the clutches of Hollywood. Yet, given the treatment of the British in *Lagaan* (Ashutosh Gowariker, 2003) and of those outside the bride's family in *Monsoon Wedding* (Mira Nair, 2001), the politics

of Bollywood seems exclusionary. A larger globe may surround these dramas, but it does so nefariously—with wicked England in the first case, immoral America in the second. Propriety remains with family, to which one belongs by birth and to which one owes allegiance. Without dismissing the communal feeling such films foster, should we empathize with the way they bask, so self-satisfied, in this unapologetic promotion of self-identity? A larger vision would place communal allegiance within a social and geographical landscape accessible to other points of view. Take the legendary, though hotly-debated, *Sholay* (1975), which uses song and local ritual to build community from a spectrum of villagers, bandits and government officials, even foreigners.[3] In *Sholay*, the India one belongs to is more inclusive than that of *Lagaan*; its characters relate to each other less as family members than as fellow citizens. Their negotiations, compromises and even juridical conflicts represent a self-differentiated India to which all characters feel conflicted allegiance, but allegiance all the same. Such an India operates and cooperates more dextrously and critically in a highly differentiated world than would a unified and self-satisfied nation-family.

Or take *Amélie* (Jean-Pierre Jeunet, 2001), which has endeared itself to the public and to so many critics. The comfort it undeniably offers is the comfort of the known. No foreigners muddy the "ethnically cleansed" Paris of Montmartre and of the quintessential corner café, whose little people enjoy their distinctive French likes and dislikes. By contrast, *Jules et Jim* (François Truffaut, 1961), an image of which is directly cited in *Amélie*, announces a tension in its very title. Its classic love story has a geopolitical dimension. Catherine has an English mother, we are told, and studied in Munich. World War One splits the action in half, while Austria and France comprise its two epicenters. Indicatively, the *détente* Jules, Jim and Catherine have brought forward from *la belle epoche* comes to an end once all three characters watch a newsreel of Germans celebrating national unity by burning books, cleansing the dirt of difference.

Permit me one final look back at Irish cinema where you can readily calculate the extent to which each product turns inward or outward. Homecoming films like *Far and Away* (Ron Howard, 1992) or *This is My Father* (Paul Quinn, 1998) figure Mother Ireland as a tribe if not a family. On the other hand, *The Crying Game* (Neil Jordan, 1992), no matter what one thinks of it, can claim to look out from a distinctly Irish view onto a multi-dimensional world, a world troubled by class, religion, sexuality and national obsession. Neil Jordan is a demi-emigrant, Irish but worldly.

My preferences are clear: American students need continually to be alerted to the international dimension implied in, or smothered by, the films they are shown from abroad. The same may not be true for spectator-citizens from those foreign countries. Citizens of India, France and Ireland instead may need to maintain a focus on the distinctiveness (that is, the nationality) of the international perspective implied by films made within their borders. Borders are thresholds as much as walls. National cinema studies should take account of what borders make possible, as well as how films enter and exit. Hence Ireland's border, like the glass of a hothouse, retains the heat of all films projected and discussed within the nation, most of which have entered from outside. Indigenous productions may take only a small percentage of the box office, but the critical attention they

receive in addressing local issues increases their heat coefficient to a potentially incendiary level. Even so, such a thing as Irish national cinema, whether studied in the US or in Irish universities, must be seen from a geopolitical perspective that takes in not just Hollywood and Britain but Continental Europe as well. And Asia too. For images trade in a global currency even when they represent a restricted neighborhood of characters and situations, like Cathal Black's drama set in the 1950s in a Donegal village, titled *Korea* (Cathal Black, 1995). Under the pressure of national borders, strong films reach toward and respond to an international gaze. Such is the dialectic of cinema these days, and I would argue such it has always been.

Brian Friel's rich play, *Translations* (1980), names in its title and models in its plot just this give and take. It is set in Ireland in 1833, when for reasons of taxation and military security the British commissioned the very first complete land survey ever undertaken. The dialogue between British surveyors and Irish citizens over what constitutes a place, a name, a geological feature, a boundary or a value directly dramatizes questions that concern world cinema: the struggle over language, education, land, religion, literal surveillance and identity. Friel's play effectively maps attitudes toward mapping, and in a highly contested space. Each party knew the territory differently.

The study of world cinema should let us *know the territory differently*, whatever territory it is that the film comes from or concerns. Today, amid digital confections tempting filmmakers and audiences to escape to the land of the virtual, world cinema brings us back precisely to Earth, on which many worlds are lived and perceived concurrently. A certain cinema continues to remind us of the intricate rapport, both tactile and relational, that makes up "Life on Earth," the title, by the way, of an African film worthy of starting or concluding any study of this immense and tempting subject.

## NOTES

1. See especially footnote 25 relating to African oral traditions.
2. Moretti calls for "distant reading," as a necessary and desirable concomitant attitude that his sociological mapping project brings about (2000: 56).
3. Even when this film occasions animosity, the terms of the debate are large. See Z. Saddar (1998) "Dilip Kumar made me do it," in A. Nandy (ed.) *Secret Politics of Our Desires: Innocence, Culpability, and Indian popular cinema*. New York: Zed Books, 19–91.

## WORKS CITED

Abel, R. (1999) *The Red Rooster Scare*. Berkeley: University of California Press.

Aelen, F. H. A., K. Whelan and M. Stout (eds) (1998) *Atlas of the Irish Rural Landscape*. Cork: Cork University Press.

Andrew, D. (2000) "The Roots of the Nomadic: Gilles Deleuze and the Cinema of West Africa," in G. Flaxman (ed.) *The Brain is the Screen*. Minneapolis: University of Minnesota Press, 215–49.

——— (2002) "The Theater of Irish Cinema," *Yale Journal of Criticism*, 15, 1, 24–58.

Deleuze G. and F. Guattari (1987) "A Treatise on Nomadology," in *A Thousand Plateaus*. Minneapolis: University of Minnesota Press, 351–423.

Hansen, M. B. (2000) "The Mass Production of Senses: Classical Cinema as Vernacular Modernism," in C. Gledhill and L. Williams (eds) *Reinventing Film Studies*. London: Arnold, 332–50.

Jameson, F. (1988) "Cognitive Mapping," in C. Nelson and L. Grossberg (eds) *Marxism and the Interpretation of Culture*. Urbana: University of Illinois Press, 347–58.

—— (1993) "In the Mirror of Alternate Modernities," in K. Kojin (ed.) *Origins of Modern Japanese Literature*. Durham, NC: Duke University Press, vii–xxii.

Moretti, F. (1999) *Atlas of the European Novel 1800–1900*. London: Verso.

—— (2000) "Conjectures on World Literature," *New Left Review*, 1, 54–68.

—— (2001) "Planet Hollywood," *New Left Review*, 9, 90–102.

Shohat, E. and R. Stam (1994) *Unthinking Eurocentrism: Multiculturalism and the Media*. London and New York: Routledge.

# PART 11
# SCREEN CULTURES: CURRENT DEBATES

*A rundown corner video store is raided on piracy charges, its well-used VHS inventory seized and destroyed. Mike (Mos Def) and Jerry (Jack Black) protest; the videos were original creations—albeit shot on re-used stock and rented out under their original titles. Mike and Jerry decide instead to make a movie from scratch, involving the neighborhood to tell the story of its past—so what if that history, too, is an invented one?*

From Michel Gondry's *Be Kind Rewind* (2008)

In the twenty-first century, the fundamentals of film theory have been questioned both by the rise of digital media and by methodologies skeptical about film theory's overarching claims and established approaches. While so-called new media ultimately have much in common with "old" media forms, the different ontology, social practices, and implications of digital media have magnified challenges to film's centrality as an object of inquiry. Film studies needs to confront what cinema has in common with other screen cultures—television, the Internet, and video games—as well as determine what makes it unique. The theories of spectatorship and signification emphasizing the singular experience and unique features of a subject or text that arose in the 1970s and 1980s gave way to accounts of fragmented or "niche" experiences of reception and multiple iterations and uses of media artifacts in today's networked, globalized era. Far from indicating the wane of film theory, such questioning has enriched the endeavor by renewing its commitment to self-reflection.

*Be Kind Rewind*, Michel Gondry's modest comedy about gentrification in Passaic, New Jersey, is not a high-tech movie; in fact, with the do-it-yourself special effects Mike and Jerry use to make movies (buckets of ketchup, primitive pyrotechnics) it seems to advocate for a return to "analog" culture. The elderly Mr. Fletcher (Danny Glover) has refused the city's offer buy him out and demolish his rundown video store. When he leaves his surrogate son, Mike, in charge for a few days with the plea not to let Jerry, the neighborhood

kook, in the store, the worst happens: Jerry, who has become magnetized in an attempt to sabotage the local power plant, accidentally erases all the tapes. Forced to improvise their own version when a customer requests *Ghost Busters* (1984), the pair is pleasantly surprised when their "remix" is a hit. Soon they are filling orders for the diverse group of customers—African American youth, older white residents, hipsters—who populate their neighborhood. The film explores social ties and experiences—actual, virtual, and historical—as mediated by moving images, usefully framing important contemporary debates on cinema's relationship to other screen cultures.

An inquiry into film's autonomous status finds no better point of departure than THEODOR W. ADORNO and MAX HORKHEIMER's classic critique, "The Culture Industry: Enlightenment as Mass Deception," which regards modern mass media as identical to other industrial products of capitalism, an idea that the rows of videotape boxes in Mr. Fletcher's store help make concrete. In their monolithic conception of the media and its effects, Adorno and Horkheimer left little room for individual dissent. Published just as television was rapidly being adopted in American homes, "The Culture Industry" addressed film in the framework of other media (print, radio, and recording; soon to be joined by video, computing, and gaming) and anticipated the corporate consolidation that was fully evident by the end of the twentieth century. Though it criticizes modernity's failed claim to rationality (given the distortion of technological "progress" by World War II), Adorno and Horkheimer's argument remains invested in modernism. For them, "difficult" modernist texts preserve art's function of social critique, a dialectical "negation" of the easily enjoyed products of the culture industry. Several decades later, theorists began identifying the rapid social and cultural changes of the post–World War II period that Adorno and Horkheimer predicted as *postmodern*. The "copies" of studio hits produced by Mike and Jerry might be seen as evidence that their creators are cultural dupes lacking originality, or as examples of postmodern pastiche (cobbled together from a variety of stylistic sources) and simulacra (copies without originals).

One of the key theorists of the postmodern, FREDRIC JAMESON, insists in his "Postmodernism and Consumer Society" that the aesthetic characteristics and subjective experiences of postmodernism correlate with the historical and technological changes of "late capitalism"—the global system in which the circulation of financial capital and information supersedes industrial production. He defines postmodernism as the "cultural logic" of this era's transformations of space, time, and subjectivity as well as a movement in art and architecture characterized by the eclectic juxtaposition of styles and the mixing of high and low culture (embodied in the fake films by Mike and Jerry, and in *Be Kind Rewind* itself). For Jameson, postmodernism entails a feeling of disorientation in space and a sense of perpetually being in the present that he calls "schizophrenia." An example of this is the idea that we can only access history through the nostalgia of period movies. In *Be Kind Rewind*, Mr. Fletcher confesses that his stories about Passaic's "authentic" past as Fats Waller's birthplace were made up, composed of bits and pieces of history filtered through the culture industry. Yet, contrary to Jameson's critical assessment, these stories have an authentic value for the residents of Passaic. Thus, postmodernism can have more hopeful connotations. It has been described by philosopher Jean-François Lyotard as "an end to master narratives." In this decentering of power, new populations and cultures are represented; meaningful differences of race, sexuality, gender, ethnicity, and nation are brought to light by the proliferating differences that make up postmodern style. Passaic's urban

mix of African Americans, Puerto Ricans, and nonaffluent whites join forces against the city's development plans, and they do this not in the traditional way of public protest but through their own form of cultural production.

A sense of new possibilities for access and expression is represented for many by the rapid technological changes of the late twentieth century. The Internet offers new ways to connect and to imagine online identities. Both the utopian idea of democratic access afforded by new media and the dystopian fear of loss of control and authentic experience in an information society are reflected in film culture at the turn of the millennium. In "The Social Optics of Race," Internet theorist Lisa Nakamura discusses how the worlds of *The Matrix Reloaded* (2003) and *Minority Report* (2002) represent the user interface with technology and how these imaginings give form to social understandings of, and anxieties about, race, class, gender, and power. She concludes that technology may offer the capacity to enhance one's body or to leave it behind, but only for some users, and always in relation to existing social constructions of identity.

Of course, movies like *The Matrix* (1999) not only depict new technologies, they are made possible by them, relying heavily on CGI (computer-generated imagery) to shape their worlds. Lev Manovich's "What Is Digital Cinema?" echoes the work of André Bazin (p. 309) in its concern with ontology, while offering a practical account of the components of digital filmmaking. Digital cinema's basis in computation—algorithms of zeros and ones—diverges from the indexical nature of photographically based or analog cinema. The image or sign is no longer dependent on its referent having been there to be photographed. As Manovich points out, what used to be the defining quality of cinema—a "lens-based recording of reality"—is now only a particular instance of it. Indeed, because digital cinema is manually constructed using image processing, compositing, and animation techniques, it can be considered a subset of painting. For Manovich, the most recent forms of cinema actually return us to its history—even to its nineteenth-century prehistory in hand-drawn animated images.

Alexander R. Galloway also draws our attention to the edges of film history in his work on video games in "Origins of the First-Person Shooter." Video games threaten the hegemony of cinema not only in sales but also in the degree of interactivity they afford. As Galloway demonstrates, the place of the game player is subjectively rendered through camera shots in ways that would be considered much more unusual and disruptive in film. The gaze of the first-person shooter in a video game is different from something like a monster's subjective shot in a horror movie because it commands an "actionable space" in the game world. This experience changes the relationship to the "apparatus" (see Christian Metz, p. 17, and Jean-Louis Baudry, p. 34) and the embodied experience of the user (see Vivian Sobchack, p. 62). In much the same way, Jerry delights in reenacting scenes from *Ghost Busters* because he can enter the space of the story and even change the ending.

Although the gamer's agency remains limited—indeed in first-person shooter games, the sole objective is to shoot things—it still allows for a more participatory relationship to screen culture than traditional film and television afford. Media scholars have long looked to reception (see Stuart Hall, p. 77, and Judith Mayne, p. 88) as a challenge to top-down models of the culture industry, and since the advent of the Internet, opportunities for users to be creators have proliferated. The remakes in *Be Kind Rewind* are the low-tech kin of the digitally created "mash-ups" found on YouTube and strike a similar balance of parody and affection.

In "RW, Revived," activist lawyer LAWRENCE LESSIG addresses a wide, rather than a strictly academic, audience and describes the many ways that new digital technologies are being used creatively to "remix" culture. Using music sampling, fan "vidding," and online parody as examples of read/write (RW) rather than read-only (RO) culture, he argues that such activities have community-building and pedagogical value. For Lessig, the participatory, creative, and social uses of media made possible by new technology and embraced by an entire generation are unduly restricted by intellectual property and anti-piracy laws that serve private interests. In his essay, Lessig argues for a different, less panicked attitude toward copyright and intellectual property.

LAURIE OUELLETTE's "'Take Responsibility for Yourself': *Judge Judy* and the Neoliberal Citizen" also touches on media policy, namely the U.S. Telecommunications Act of 1996 that deregulated broadcasting, leading to the proliferation of cable networks and inexpensive reality programming. In her analysis of the consumption and reach of reality television, Ouellette asserts that such shows encourage private individuals to take care of their own needs instead of relying on public mechanisms, an ideology that is compatible with neoliberalism's faith in the market above government intervention. Feminist television scholars have long contrasted the domestic consumption and consumer address of television with the public dimensions of film viewing to reveal women's central role in the television audience. Reaching citizens in their homes, makeover and courtroom shows "govern" by encouraging women to take responsibility for themselves rather than seek public forms of redress or social change. Ouellette is more skeptical than Lessig about the ideas of participation, freedom, and choice in the new media environment, as these are precisely the marketplace values encouraged by neoliberalism.

In *Be Kind Rewind*, Mr. Fletcher finally accepts the city's offer to relocate, even though the demolition of the corner video store means that the neighbors will lack a physical space in which to convene to socialize or to protest local government. However, the film implies that their shared memories and emotions, including those that the cassettes they once rented invoked, will continue to link them. Film, television, computers, and video games engage viewers in their everyday lives through the affects they evoke and the social ties they form. While media does not completely control audience responses in a uniform, top-down fashion as Adorno and Horkheimer implied, all of the theorists in this section acknowledge that the powers of media technologies are developed and deployed in relation to capitalism—whether by making image and reality indistinguishable or by regulating pleasure along with self-governance.

Film theory emerged with the advent of cinema and, as we argued in Part 3, provided a means of reflection on modernity. Today's film—or more accurately, screen—theory must contend with the more fragmented and still unfolding period some call postmodernity. D. N. RODOWICK's "An Elegy for Theory" brings many of the concerns raised by other essays, such as ontological insecurity and epistemological doubt, to bear on the project of theory itself. Rodowick draws from the writings of philosophers Gilles Deleuze (p. 185) and Stanley Cavell to emphasize that moving images and cinema as an aesthetic practice continue to have key social and humanistic roles that help us understand and engage with the world. The digital revolution raises the question "What is cinema?" with new urgency, while (as the many perspectives included in this anthology indicate) any aspiration to a single "grand theory" of film must be relinquished. This is both disquieting—what is left for theory?—and energizing, because isn't theory precisely about speculation?

# THEODOR W. ADORNO
# AND MAX HORKHEIMER

## The Culture Industry: Enlightenment as Mass Deception

FROM *Dialectic of Enlightenment*

Theodor W. Adorno (1903–1969) and Max Horkheimer (1895–1973) were German philosophers and key figures in the Frankfurt School of critical theory. Adorno obtained a degree in philosophy and taught at the University of Frankfurt, where Horkheimer served as chair of social philosophy and head of the Institute for Social Research. The two would become lifelong friends and successful collaborators. In the mid-1930s they both left Germany to escape the Nazi persecution of Jews (Adorno went to England and Horkheimer to Switzerland) and eventually emigrated to the United States. Adorno worked at Princeton and then served as co-director of the Research Project on Social Discrimination at the University of California, Berkeley, from 1941–1948; Horkheimer was at Columbia University and then edited *Studies in Philosophy and Social Science* in Los Angeles. It was there, in the heart of the culture industry at the height of studio-era Hollywood, that their collaboration would yield their most influential work, *Dialectic of Enlightenment* (1944). Adorno and Horkheimer returned to Frankfurt in 1949 to rebuild the Institute of Social Research. As its director, Adorno was central to the German intellectual revival after World War II as well as a figure of controversy in the student protest movements of the late 1960s.

The 1930s, when Adorno and Horkheimer began their intellectual careers, was a period of intense anxiety and pessimism about the social effects of mass media, as Nazism, Fascism, and Stalinism (and in a different way, the Hollywood studio system) put a halt to various modernist art movements that had thrived in the 1920s. These historical developments, as well as the defeat of working-class movements after World War I, had a profound effect on the Frankfurt School, which inaugurated critical studies on popular culture and mass media. Though influenced by Walter Benjamin (p. 229), another Frankfurt School affiliate, Adorno and Horkheimer were skeptical of his argument for the progressive and liberating possibilities of new technologies such as cinema. They studied cinema in the shadow of World War II as part of a larger apparatus of capitalist mass culture and instead emphasized its potential for alienation and commodification. They replaced the concept of mass culture with that of the "culture industry" to refer to the standardization of cultural forms and the regulation of how they are promoted and distributed.

Adorno and Horkheimer's critique of mass culture is outlined in their seminal work "The Culture Industry: Enlightenment as Mass Deception," first published in 1944 as the final chapter of *Dialectic of Enlightenment* but not translated into English until 1972. Their book presents a larger critique of the Enlightenment and its unfulfilled promise of liberation. Drawing on the Marxist idea of the alienation of labor, Adorno and Horkheimer

analyze the culture industry as a regressive site and a danger to high art. They argue that while the egalitarian principles of the Enlightenment are still alive and propagated by mass media, the culture industry—driven by instrumental rationality that dictates and channels public desires—produces new and oppressive forms of domination. Analyzing issues of aesthetics, politics, and audience reception, they stress that the various forms of popular culture, including cinema, are mass-produced, standardized cultural goods that deceive the masses into passivity and contentment, creating and cultivating false needs that serve to legitimize consumer capitalism. For them, only challenging, modernist art forms foster the development of critically engaged audiences that are necessary for a truly democratic society. Their critique of the culture industry, while subsequently criticized as monolithic, became and still remains central to debates on popular culture and mass media. It anticipates key critical concepts of postmodernism, such as Guy Debord's "society of the spectacle" or Jean Baudrillard's "simulacrum," as well as more recent debates on new media and convergence culture.

## READING CUES & KEY CONCEPTS

■ To what extent, if at all, do Adorno and Horkheimer allow for resistance from within the institutions of popular culture?

■ Adorno and Horkheimer assert that "real life is becoming indistinguishable from the movies." What do they mean, and what forms of cinema are they referring to?

■ In what ways does their critique of the culture industry inform our current society, with its ever-increasing diversity, market segmentation, and various forms of interactive technologies?

■ **Key Concepts:** Culture Industry; Consumption; Mass Culture; Mechanical Reproduction; Entertainment Industry; Amusement; Style

# The Culture Industry: Enlightenment as Mass Deception

. . . . . . . . . . . . . .

The sociological view that the loss of support from objective religion and the disintegration of the last precapitalist residues, in conjunction with technical and social differentiation and specialization, have given rise to cultural chaos is refuted by daily experience. Culture today is infecting everything with sameness. Film, radio, and magazines form a system. Each branch of culture is unanimous within itself and all are unanimous together. Even the aesthetic manifestations of political opposites proclaim the same inflexible rhythm. The decorative administrative and exhibition buildings of industry differ little between authoritarian and other countries. The bright monumental structures shooting up on all sides show off the systematic ingenuity of the state-spanning combines, toward which the unfettered entrepreneurial system, whose monuments are the dismal residential and commercial blocks in the

surrounding areas of desolate cities, was already swiftly advancing. The older build-
ings around the concrete centers already look like slums, and the new bungalows on
the outskirts, like the flimsy structures at international trade fairs, sing the praises
of technical progress while inviting their users to throw them away after short use
like tin cans. But the town-planning projects, which are supposed to perpetuate indi-
viduals as autonomous units in hygienic small apartments, subjugate them only more
completely to their adversary, the total power of capital. Just as the occupants of city
centers are uniformly summoned there for purposes of work and leisure, as produc-
ers and consumers, so the living cells crystallize into homogenous, well-organized
complexes. The conspicuous unity of macrocosm and microcosm confronts human
beings with a model of their culture: the false identity of universal and particular.
All mass culture under monopoly is identical, and the contours of its skeleton, the
conceptual armature fabricated by monopoly, are beginning to stand out. Those in
charge no longer take much trouble to conceal the structure, the power of which
increases the more bluntly its existence is admitted. Films and radio no longer need
to present themselves as art. The truth that they are nothing but business is used as an
ideology to legitimize the trash they intentionally produce. They call themselves in-
dustries, and the published figures for their directors' incomes quell any doubts about
the social necessity of their finished products.

Interested parties like to explain the culture industry in technological terms.
Its millions of participants, they argue, demand reproduction processes which in-
evitably lead to the use of standard products to meet the same needs at countless
locations. The technical antithesis between few production centers and widely dis-
persed reception necessitates organization and planning by those in control. The
standardized forms, it is claimed, were originally derived from the needs of the con-
sumers: that is why they are accepted with so little resistance. In reality, a cycle of
manipulation and retroactive need is unifying the system ever more tightly. What is
not mentioned is that the basis on which technology is gaining power over society is
the power of those whose economic position in society is strongest. Technical ratio-
nality today is the rationality of domination. It is the compulsive character of a so-
ciety alienated from itself. Automobiles, bombs, and films hold the totality together
until their leveling element demonstrates its power against the very system of injus-
tice it served. For the present the technology of the culture industry confines itself
to standardization and mass production and sacrifices what once distinguished the
logic of the work from that of society. These adverse effects, however, should not
be attributed to the internal laws of technology itself but to its function within the
economy today. Any need which might escape the central control is repressed by
that of individual consciousness. The step from telephone to radio has clearly dis-
tinguished the roles. The former liberally permitted the participant to play the role
of subject. The latter democratically makes everyone equally into listeners, in order
to expose them in authoritarian fashion to the same programs put out by differ-
ent stations. No mechanism of reply has been developed, and private transmissions
are condemned to unfreedom. They confine themselves to the apocryphal sphere
of "amateurs," who, in any case, are organized from above. Any trace of sponta-
neity in the audience of the official radio is steered and absorbed into a selection
of specializations by talent-spotters, performance competitions, and sponsored
events of every kind. The talents belong to the operation long before they are put

on show; otherwise they would not conform so eagerly. The mentality of the public, which allegedly and actually favors the system of the culture industry, is a part of the system, not an excuse for it. If a branch of art follows the same recipe as one far removed from it in terms of its medium and subject matter; if the dramatic denouement in radio "soap operas" is used as an instructive example of how to solve technical difficulties—which are mastered no less in "jam sessions" than at the highest levels of jazz—or if a movement from Beethoven is loosely "adapted" in the same way as a Tolstoy novel is adapted for film, the pretext of meeting the public's spontaneous wishes is mere hot air. An explanation in terms of the specific interests of the technical apparatus and its personnel would be closer to the truth, provided that apparatus were understood in all its details as a part of the economic mechanism of selection. Added to this is the agreement, or at least the common determination, of the executive powers to produce or let pass nothing which does not conform to their tables, to their concept of the consumer, or, above all, to themselves.

If the objective social tendency of this age is incarnated in the obscure subjective intentions of board chairmen, this is primarily the case in the most powerful sectors of industry: steel, petroleum, electricity, chemicals. Compared to them the culture monopolies are weak and dependent. They have to keep in with the true wielders of power, to ensure that their sphere of mass society, the specific product of which still has too much of cozy liberalism and Jewish intellectualism about it, is not subjected to a series of purges. The dependence of the most powerful broadcasting company on the electrical industry, or of film on the banks, characterizes the whole sphere, the individual sectors of which are themselves economically intertwined. Everything is so tightly clustered that the concentration of intellect reaches a level where it overflows the demarcations between company names and technical sectors. The relentless unity of the culture industry bears witness to the emergent unity of politics. Sharp distinctions like those between A and B films, or between short stories published in magazines in different price segments, do not so much reflect real differences as assist in the classification, organization, and identification of consumers. Something is provided for everyone so that no one can escape; differences are hammered home and propagated. The hierarchy of serial qualities purveyed to the public serves only to quantify it more completely. Everyone is supposed to behave spontaneously according to a "level" determined by indices and to select the category of mass product manufactured for their type. On the charts of research organizations, indistinguishable from those of political propaganda, consumers are divided up as statistical material into red, green, and blue areas according to income group.

The schematic nature of this procedure is evident from the fact that the mechanically differentiated products are ultimately all the same. That the difference between the models of Chrysler and General Motors is fundamentally illusory is known by any child, who is fascinated by that very difference. The advantages and disadvantages debated by enthusiasts serve only to perpetuate the appearance of competition and choice. It is no different with the offerings of Warner Brothers and Metro Goldwyn Mayer. But the differences, even between the more expensive and cheaper products from the same firm, are shrinking—in cars to the different number of cylinders, engine capacity, and details of the gadgets, and in films to the different number of stars, the expense lavished on technology, labor and costumes, or

the use of the latest psychological formulae. The unified standard of value consists in the level of conspicuous production, the amount of investment put on show. The budgeted differences of value in the culture industry have nothing to do with actual differences, with the meaning of the product itself. The technical media, too, are being engulfed by an insatiable uniformity. Television aims at a synthesis of radio and film, delayed only for as long as the interested parties cannot agree. Such a synthesis, with its unlimited possibilities, promises to intensify the impoverishment of the aesthetic material so radically that the identity of all industrial cultural products, still scantily disguised today, will triumph openly tomorrow in a mocking fulfillment of Wagner's dream of the total art work. The accord between word, image, and music is achieved so much more perfectly than in *Tristan* because the sensuous elements, which compliantly document only the surface of social reality, are produced in principle within the same technical work process, the unity of which they express as their true content. This work process integrates all the elements of production, from the original concept of the novel, shaped by its sidelong glance at film, to the last sound effect. It is the triumph of invested capital. To impress the omnipotence of capital on the hearts of expropriated job candidates as the power of their true master is the purpose of all films, regardless of the plot selected by the production directors.

Even during their leisure time, consumers must orient themselves according to the unity of production. The active contribution which Kantian schematism still expected of subjects—that they should, from the first, relate sensuous multiplicity to fundamental concepts—is denied to the subject by industry. It purveys schematism as its first service to the customer. According to Kantian schematism, a secret mechanism within the psyche preformed immediate data to fit them into the system of pure reason. That secret has now been unraveled. Although the operations of the mechanism appear to be planned by those who supply the data, the culture industry, the planning is in fact imposed on the industry by the inertia of a society irrational despite all its rationalization, and this calamitous tendency, in passing through the agencies of business, takes on the shrewd intentionality peculiar to them. For the consumer there is nothing left to classify, since the classification has already been preempted by the schematism of production. This dreamless art for the people fulfils the dreamy idealism which went too far for idealism in its critical form. Everything comes from consciousness—from that of God for Malebranche and Berkeley, and from earthly production management for mass art. Not only do hit songs, stars, and soap operas conform to types recurring cyclically as rigid invariants, but the specific content of productions, the seemingly variable element, is itself derived from those types. The details become interchangeable. The brief interval sequence which has proved catchy in a hit song, the hero's temporary disgrace which he accepts as a "good sport," the wholesome slaps the heroine receives from the strong hand of the male star, his plain-speaking abruptness toward the pampered heiress, are, like all the details, ready-made clichés, to be used here and there as desired and always completely defined by the purpose they serve within the schema. To confirm the schema by acting as its constituents is their sole *raison d'être*. In a film, the outcome can invariably be predicted at the start—who will be rewarded, punished, forgotten—and in light music the prepared ear can always guess the continuation

after the first bars of a hit song and is gratified when it actually occurs. The average choice of words in a short story must not be tampered with. The gags and effects are no less calculated than their framework. They are managed by special experts, and their slim variety is specifically tailored to the office pigeonhole. The culture industry has developed in conjunction with the predominance of the effect, the tangible performance, the technical detail, over the work, which once carried the idea and was liquidated with it. By emancipating itself, the detail had become refractory; from Romanticism to Expressionism it had rebelled as unbridled expression, as the agent of opposition, against organization. In music, the individual harmonic effect had obliterated awareness of the form as a whole; in painting the particular detail had obscured the overall composition; in the novel psychological penetration had blurred the architecture. Through totality, the culture industry is putting an end to all that. Although operating only with effects, it subdues their unruliness and subordinates them to the formula which supplants the work. It crushes equally the whole and the parts. The whole confronts the details in implacable detachment, somewhat like the career of a successful man, in which everything serves to illustrate and demonstrate a success which, in fact, it is no more than the sum of those idiotic events. The so-called leading idea is a filing compartment which creates order, not connections. Lacking both contrast and relatedness, the whole and the detail look alike. Their harmony, guaranteed in advance, mocks the painfully achieved harmony of the great bourgeois works of art. In Germany even the most carefree films of democracy were overhung already by the graveyard stillness of dictatorship.

The whole world is passed through the filter of the culture industry. The familiar experience of the moviegoer, who perceives the street outside as a continuation of the film he has just left, because the film seeks strictly to reproduce the world of everyday perception, has become the guideline of production. The more densely and completely its techniques duplicate empirical objects, the more easily it creates the illusion that the world outside is a seamless extension of the one which has been revealed in the cinema. Since the abrupt introduction of the sound film, mechanical duplication has become entirely subservient to this objective. According to this tendency, life is to be made indistinguishable from the sound film. Far more strongly than the theatre of illusion, film denies its audience any dimension in which they might roam freely in imagination—contained by the film's framework but unsupervised by its precise actualities—without losing the thread; thus it trains those exposed to it to identify film directly with reality. The withering of imagination and spontaneity in the consumer of culture today need not be traced back to psychological mechanisms. The products themselves, especially the most characteristic, the sound film, cripple those faculties through their objective makeup. They are so constructed that their adequate comprehension requires a quick, observant, knowledgeable cast of mind but positively debars the spectator from thinking, if he is not to miss the fleeting facts. This kind of alertness is so ingrained that it does not even need to be activated in particular cases, while still repressing the powers of imagination. Anyone who is so absorbed by the world of the film, by gesture, image, and word, that he or she is unable to supply that which would have made it a world in the first place, does not need to be entirely transfixed by the special operations of the machinery at the moment of the performance. The required qualities of attention have become so familiar from other films and other culture products already

known to him or her that they appear automatically. The power of industrial society is imprinted on people once and for all. The products of the culture industry are such that they can be alertly consumed even in a state of distraction. But each one is a model of the gigantic economic machinery, which, from the first, keeps everyone on their toes, both at work and in the leisure time which resembles it. In any sound film or any radio broadcast something is discernible which cannot be attributed as a social effect to any one of them, but to all together. Each single manifestation of the culture industry inescapably reproduces human beings as what the whole has made them. And all its agents, from the producer to the women's organizations, are on the alert to ensure that the simple reproduction of mind does not lead on to the expansion of mind.

<p align="center">[ · · · ]</p>

Amusement and all the other elements of the culture industry existed long before the industry itself. Now they have been taken over from above and brought fully up to date. The culture industry can boast of having energetically accomplished and elevated to a principle the often inept transposition of art to the consumption sphere, of having stripped amusement of its obtrusive naiveties and improved the quality of its commodities. The more all-embracing the culture industry has become, the more pitilessly it has forced the outsider into either bankruptcy or a syndicate; at the same time it has become more refined and elevated, becoming finally a synthesis of Beethoven and the Casino de Paris. Its victory is twofold: what is destroyed as truth outside its sphere can be reproduced indefinitely within it as lies. "Light" art as such, entertainment, is not a form of decadence. Those who deplore it as a betrayal of the ideal of pure expression harbor illusions about society. The purity of bourgeois art, hypostatized as a realm of freedom contrasting to material praxis, was bought from the outset with the exclusion of the lower class; and art keeps faith with the cause of that class, the true universal, precisely by freeing itself from the purposes of the false. Serious art has denied itself to those for whom the hardship and oppression of life make a mockery of seriousness and who must be glad to use the time not spent at the production line in being simply carried along. Light art has accompanied autonomous art as its shadow. It is the social bad conscience of serious art. The truth which the latter could not apprehend because of its social premises gives the former an appearance of objective justification. The split between them is itself the truth: it expresses at least the negativity of the culture which is the sum of both spheres. The antithesis can be reconciled least of all by absorbing light art into serious or vice versa. That, however, is what the culture industry attempts. The eccentricity of the circus, the peep show, or the brothel in relation to society is as embarrassing to it as that of Schönberg and Karl Kraus. The leading jazz musician Benny Goodman therefore has to appear with the Budapest String Quartet, more pedantic rhythmically than any amateur clarinetist, while the quartet play with the saccharine monotony of Guy Lombardo. What is significant is not crude ignorance, stupidity or lack of polish. The culture industry has abolished the rubbish of former times by imposing its own perfection, by prohibiting and domesticating dilettantism, while itself incessantly committing the blunders without which the elevated style cannot be conceived. What is new, however, is that the irreconcilable elements of culture, art, and amusement have been subjected equally to the concept of purpose and thus

brought under a single false denominator: the totality of the culture industry. Its element is repetition. The fact that its characteristic innovations are in all cases mere improvements to mass production is not extraneous to the system. With good reason the interest of countless consumers is focused on the technology, not on the rigidly repeated, threadbare and half-abandoned content. The social power revered by the spectators manifests itself more effectively in the technically enforced ubiquity of stereotypes than in the stale ideologies which the ephemeral contents have to endorse.

Nevertheless, the culture industry remains the entertainment business. Its control of consumers is mediated by entertainment, and its hold will not be broken by outright dictate but by the hostility inherent in the principle of entertainment to anything which is more than itself. Since the tendencies of the culture industry are turned into the flesh and blood of the public by the social process as a whole, those tendencies are reinforced by the survival of the market in the industry. Demand has not yet been replaced by simple obedience. The major reorganization of the film industry shortly before the First World War, the material precondition for its expansion, was a deliberate adaptation to needs of the public registered at the ticket office, which were hardly thought worthy of consideration in the pioneering days of the screen. That view is still held by the captains of the film industry, who accept only more or less phenomenal box-office success as evidence and prudently ignore the counterevidence, truth. Their ideology is business. In this they are right to the extent that the power of the culture industry lies in its unity with fabricated need and not in simple antithesis to it—or even in the antithesis between omnipotence and powerlessness. Entertainment is the prolongation of work under late capitalism. It is sought by those who want to escape the mechanized labor process so that they can cope with it again. At the same time, however, mechanization has such power over leisure and its happiness, determines so thoroughly the fabrication of entertainment commodities, that the off-duty worker can experience nothing but after-images of the work process itself. The ostensible content is merely a faded foreground; what is imprinted is the automated sequence of standardized tasks. The only escape from the work process in factory and office is through adaptation to it in leisure time. This is the incurable sickness of all entertainment. Amusement congeals into boredom, since, to be amusement, it must cost no effort and therefore moves strictly along the well-worn grooves of association. The spectator must need no thoughts of his own: the product prescribes each reaction, not through any actual coherence—which collapses once exposed to thought—but through signals. Any logical connection presupposing mental capacity is scrupulously avoided. Developments are to emerge from the directly preceding situation, not from the idea of the whole. There is no plot which could withstand the screenwriters' eagerness to extract the maximum effect from the individual scene. Finally, even the schematic formula seems dangerous, since it provides some coherence of meaning, however meager, when only meaninglessness is acceptable. Often the plot is willfully denied the development called for by characters and theme under the old schema. Instead, the next step is determined by what the writers take to be their most effective idea. Obtusely ingenious surprises disrupt the plot. The product's tendency to fall back perniciously on the pure nonsense which, as buffoonery and clowning, was a legitimate part of popular art up to Chaplin and the Marx brothers, emerges

most strikingly in the less sophisticated genres. Whereas the films of Greer Garson and Bette Davis can still derive some claim to a coherent plot from the unity of the socio-psychological case represented, the tendency to subvert meaning has taken over completely in the text of novelty songs, suspense films, and cartoons. The idea itself, like objects in comic and horror films, is massacred and mutilated. Novelty songs have always lived on contempt for meaning, which, as both ancestors and descendants of psychoanalysis, they reduce to the monotony of sexual symbolism. In crime and adventure films the spectators are begrudged even the opportunity to witness the resolution. Even in nonironic examples of the genre they must make do with the mere horror of situations connected in only the most perfunctory way.

Cartoon and stunt films were once exponents of fantasy against rationalism. They allowed justice to be done to the animals and things electrified by their technology, by granting the mutilated beings a second life. Today they merely confirm the victory of technological reason over truth. A few years ago they had solid plots which were resolved only in the whirl of pursuit of the final minutes. In this their procedure resembled that of slapstick comedy. But now the temporal relations have shifted. The opening sequences state a plot motif so that destruction can work on it throughout the action: with the audience in gleeful pursuit the protagonist is tossed about like a scrap of litter. The quantity of organized amusement is converted into the quality of organized cruelty. The self-elected censors of the film industry, its accomplices, monitor the duration of the atrocity prolonged into a hunt. The jollity dispels the joy supposedly conferred by the sight of an embrace and postpones satisfaction until the day of the pogrom. To the extent that cartoons do more than accustom the senses to the new tempo, they hammer into every brain the old lesson that continuous attrition, the breaking of all individual resistance, is the condition of life in this society. Donald Duck in the cartoons and the unfortunate victim in real life receive their beatings so that the spectators can accustom themselves to theirs.

The enjoyment of the violence done to the film character turns into violence against the spectator; distraction becomes exertion. No stimulant concocted by the experts may escape the weary eye; in face of the slick presentation no one may appear stupid even for a moment; everyone has to keep up, emulating the smartness displayed and propagated by the production. This makes it doubtful whether the culture industry even still fulfils its self-proclaimed function of distraction. If the majority of radio stations and cinemas were shut down, consumers probably would not feel too much deprived. In stepping from the street into the cinema, they no longer enter the world of dream in any case, and once the use of these institutions was no longer made obligatory by their mere existence, the urge to use them might not be so overwhelming. Shutting them down in this way would not be reactionary machine-wrecking. Those who suffered would not be the film enthusiasts but those who always pay the penalty in any case, the ones who had lagged behind. For the housewife, despite the films which are supposed to integrate her still further, the dark of the cinema grants a refuge in which she can spend a few unsupervised hours, just as once, when there were still dwellings and evening repose, she could sit gazing out of the window. The unemployed of the great centers find freshness in summer and warmth in winter in these places of regulated temperature. Apart from that, and even by the measure of the existing order, the bloated entertainment

apparatus does not make life more worthy of human beings. The idea of "exploiting" the given technical possibilities, of fully utilizing the capacities for aesthetic mass consumption, is part of an economic system which refuses to utilize capacities when it is a question of abolishing hunger.

The culture industry endlessly cheats its consumers out of what it endlessly promises. The promissory note of pleasure issued by plot and packaging is indefinitely prolonged: the promise, which actually comprises the entire show, disdainfully intimates that there is nothing more to come, that the diner must be satisfied with reading the menu. The desire inflamed by the glossy names and images is served up finally with a celebration of the daily round it sought to escape. Of course, genuine works of art were not sexual exhibitions either. But by presenting denial as negative, they reversed, as it were, the debasement of the drive and rescued by mediation what had been denied. That is the secret of aesthetic sublimation: to present fulfillment in its brokenness. The culture industry does not sublimate: it suppresses. By constantly exhibiting the object of desire, the breasts beneath the sweater, the naked torso of the sporting hero, it merely goads the unsublimated anticipation of pleasure, which through the habit of denial has long since been mutilated as masochism. There is no erotic situation in which innuendo and incitement are not accompanied by the clear notification that things will never go so far. The Hays Office merely confirms the ritual which the culture industry has staged in any case: that of Tantalus. Works of art are ascetic and shameless; the culture industry is pornographic and prudish. It reduces love to romance. And, once reduced, much is permitted, even libertinage as a marketable specialty, purveyed by quota with the trade description "daring." The mass production of sexuality automatically brings about its repression. Because of his ubiquity, the film star with whom one is supposed to fall in love is, from the start, a copy of himself. Every tenor now sounds like a Caruso record, and the natural faces of Texas girls already resemble those of the established models by which they would be typecast in Hollywood. The mechanical reproduction of beauty—which, admittedly, is made only more inescapable by the reactionary culture zealots with their methodical idolization of individuality—no longer leaves any room for the unconscious idolatry with which the experience of beauty has always been linked.

[ · · · ]

The more strongly the culture industry entrenches itself, the more it can do as it chooses with the needs of consumers—producing, controlling, disciplining them; even withdrawing amusement altogether: here, no limits are set to cultural progress. But the tendency is immanent in the principle of entertainment itself, as a principle of bourgeois enlightenment. If the need for entertainment was largely created by industry, which recommended the work to the masses through its subject matter, the oleograph through the delicate morsel it portrayed and, conversely, the pudding mix through the image of a pudding, entertainment has always borne the trace of commercial brashness, of sales talk, the voice of the fairground huckster. But the original affinity between business and entertainment reveals itself in the meaning of entertainment itself: as society's apologia. To be entertained means to be in agreement. Entertainment makes itself possible only by insulating itself from the totality of the social process, making itself stupid and perversely renouncing

from the first the inescapable claim of any work, even the most trivial: in its restrict-
edness to reflect the whole. Amusement always means putting things out of mind,
forgetting suffering, even when it is on display. At its root is powerlessness. It is in-
deed escape, but not, as it claims, escape from bad reality but from the last thought
of resisting that reality. The liberation which amusement promises is from thinking
as negation. The shamelessness of the rhetorical question "What do people want?"
lies in the fact that it appeals to the very people as thinking subjects whose subjec-
tivity it specifically seeks to annul. Even on those occasions when the public rebels
against the pleasure industry it displays the feebleness systematically instilled in it
by that industry. Nevertheless, it has become increasingly difficult to keep the pub-
lic in submission. The advance of stupidity must not lag behind the simultaneous
advance of intelligence. In the age of statistics the masses are too astute to identify
with the millionaire on the screen and too obtuse to deviate even minutely from the
law of large numbers. Ideology hides itself in probability calculations. Fortune will
not smile on all—just on the one who draws the winning ticket or, rather, the one
designated to do so by a higher power—usually the entertainment industry itself,
which presents itself as ceaselessly in search of talent. Those discovered by the tal-
ent scouts and then built up by the studios are ideal types of the new, dependent
middle classes. The female starlet is supposed to symbolize the secretary, though
in a way which makes her seem predestined, unlike the real secretary, to wear the
flowing evening gown. Thus she apprises the female spectator not only of the pos-
sibility that she, too, might appear on the screen but still more insistently of the dis-
tance between them. Only one can draw the winning lot, only one is prominent, and
even though all have mathematically the same chance, it is so minimal for each in-
dividual that it is best to write it off at once and rejoice in the good fortune of some-
one else, who might just as well be oneself but never is. Where the culture industry
still invites naïve identification, it immediately denies it. It is no longer possible to
lose oneself in others. Once, film spectators saw their own wedding in that of others.
Now the happy couple on the screen are specimens of the same species as everyone
in the audience, but the sameness posits the insuperable separation of its human
elements. The perfected similarity is the absolute difference. The identity of the
species prohibits that of the individual cases. The culture industry has sardonically
realized man's species being. Everyone amounts only to those qualities by which he
or she can replace everyone else: all are fungible, mere specimens. As individuals
they are absolutely replaceable, pure nothingness, and are made aware of this as
soon as time deprives them of their sameness. This changes the inner composition
of the religion of success, which they are sternly required to uphold. The path *per
aspera ad astra*, which presupposes need and effort, is increasingly replaced by the
prize. The element of blindness in the routine decision as to which song is to be a hit,
which extra a heroine, is celebrated by ideology. Films emphasize chance. By impos-
ing an essential sameness on their characters, with the exception of the villain, to
the point of excluding any faces which do not conform—for example, those which,
like Garbo's, do not look as if they would welcome the greeting "Hello, sister"—the
ideology does, it is true, make life initially easier for the spectators. They are assured
that they do not need to be in any way other than they are and that they can suc-
ceed just as well without having to perform tasks of which they know themselves
incapable. But at the same time they are given the hint that effort would not help

them in any case, because even bourgeois success no longer has any connection to the calculable effect of their own work. They take the hint. Fundamentally, everyone recognizes chance, by which someone is sometimes lucky, as the other side of planning. Just because society's energies have developed so far on the side of rationality that anyone might become an engineer or a manager, the choice of who is to receive from society the investment and confidence to be trained for such functions becomes entirely irrational. Chance and planning become identical since, given the sameness of people, the fortune or misfortune of the individual, right up to the top, loses all economic importance. Chance itself is planned; not in the sense that it will affect this or that particular individual but in that people believe in its control. For the planners it serves as an alibi, giving the impression that the web of transactions and measures into which life has been transformed still leaves room for spontaneous, immediate relationships between human beings. Such freedom is symbolized in the various media of the culture industry by the arbitrary selection of average cases. In the detailed reports on the modestly luxurious pleasure trip organized by the magazine for the lucky competition winner—preferably a shorthand typist who probably won through contacts with local powers-that-be—the powerlessness of everyone is reflected. So much are the masses mere material that those in control can raise one of them up to their heaven and cast him or her out again: let them go hang with their justice and their labor. Industry is interested in human beings only as its customers and employees and has in fact reduced humanity as a whole, like each of its elements, to this exhaustive formula. Depending on which aspect happens to be paramount at the time, ideology stresses plan or chance, technology or life, civilization or nature. As employees people are reminded of the rational organization and must fit into it as common sense requires. As customers they are regaled, whether on the screen or in the press, with human interest stories demonstrating freedom of choice and the charm of not belonging to the system. In both cases they remain objects.

The less the culture industry has to promise and the less it can offer a meaningful explanation of life, the emptier the ideology it disseminates necessarily becomes. Even the abstract ideals of the harmony and benevolence of society are too concrete in the age of the universal advertisement. Abstractions in particular are identified as publicity devices. Language which appeals to mere truth only arouses impatience to get down to the real business behind it. Words which are not a means seem meaningless, the others seem to be fiction, untruth. Value judgments are perceived either as advertisements or as mere chatter. The noncommittal vagueness of the resulting ideology does not make it more transparent, or weaker. Its very vagueness, the quasiscientific reluctance to be pinned down to anything which cannot be verified, functions as an instrument of control. Ideology becomes the emphatic and systematic proclamation of what is. Through its inherent tendency to adopt the tone of the factual report, the culture industry makes itself the irrefutable prophet of the existing order. With consummate skill it maneuvers between the crags of demonstrable misinformation and obvious truth by faithfully duplicating appearances, the density of which blocks insight. Thus the omnipresent and impenetrable world of appearances is set up as the ideal. Ideology is split between the photographing of brute existence and the blatant lie about its meaning, a lie which is not articulated directly but drummed in by suggestion. The mere cynical reiteration of the real is

enough to demonstrate its divinity. Such photological proof may not be stringent, but it is overwhelming. Anyone who continues to doubt in face of the power of monotony is a fool. The culture industry sweeps aside objections to itself along with those to the world it neutrally duplicates. One has only the choice of conforming or being consigned to the backwoods: the provincials who oppose cinema and radio by falling back on eternal beauty and amateur theatricals have already reached the political stance toward which the members of mass culture are still being driven. This culture is hardened enough either to poke fun at the old wishful dreams, the paternal ideal no less than unconditional feeling, or to invoke them as ideology, as the occasion demands. The new ideology has the world as such as its subject. It exploits the cult of fact by describing bad existence with utmost exactitude in order to elevate it into the realm of facts. Through such elevation existence itself becomes a surrogate of meaning and justice. Beauty is whatever the camera reproduces. The disappointed hope that one might oneself be the employee who won the world trip is matched by the disappointing appearance of the exactly photographed regions through which the journey might have led. What is offered is not Italy but evidence that it exists. The film can permit itself to show the Paris in which the young American woman hopes to still her longing as a desolately barren place, in order to drive her all the more implacably into the arms of the smart American boy she might equally well have met at home. That life goes on at all, that the system, even in its most recent phase, reproduces the lives of those who constitute it instead of doing away with them straight away, is even credited to the system as its meaning and value. The ability to keep going at all becomes the justification for the blind continuation of the system, indeed, for its immutability. What is repeated is healthy—the cycle in nature as in industry. The same babies grin endlessly from magazines, and endlessly the jazz machine pounds. Despite all the progress in the techniques of representation, all the rules and specialties, all the gesticulating bustle, the bread on which the culture industry feeds humanity, remains the stone of stereotype. It lives on the cyclical, on the admittedly well-founded amazement that, in spite of everything, mothers still give birth to children, that the wheels have not yet come completely to a halt. All this consolidates the immutability of the existing circumstances. The swaying cornfields at the end of Chaplin's film on Hitler give the lie to the antifascist speech about freedom. They resemble the blond tresses of the German maidens whose outdoor life in the summer wind is photographed by Ufa. Nature, in being presented by society's control mechanism as the healing antithesis of society, is itself absorbed into that incurable society and sold off. The solemn pictorial affirmation that the trees are green, the sky is blue, and the clouds are sailing overhead already makes them cryptograms for factory chimneys and gasoline stations. Conversely, wheels and machine parts are made to gleam expressively, debased as receptacles of that leafy, cloudy soul. In this way both nature and technology are mobilized against the alleged stuffiness, the faked recollection of liberal society as a world in which people idled lasciviously in plush-lined rooms instead of taking wholesome open-air baths as they do today, or suffered breakdowns in antediluvian Benz models instead of traveling at rocket speed from where they are in any case to where it is no different. The triumph of the giant corporation over entrepreneurial initiative is celebrated by the culture industry as the perpetuity of entrepreneurial initiative. The fight is waged against an enemy who has already been

defeated, the thinking subject. The resurrection of *Hans Sonnenstößer*, the enemy of bourgeois philistines, in Germany, and the smug coziness of *Life with Father* have one and the same meaning.

[ · · · ]

Culture is a paradoxical commodity. It is so completely subject to the law of exchange that it is no longer exchanged; it is so blindly equated with use that it can no longer be used. For this reason it merges with the advertisement. The more meaningless the latter appears under monopoly, the more omnipotent culture becomes. Its motives are economic enough. That life could continue without the whole culture industry is too certain; the satiation and apathy it generates among consumers are too great. It can do little to combat this from its own resources. Advertising is its elixir of life. But because its product ceaselessly reduces the pleasure it promises as a commodity to that mere promise, it finally coincides with the advertisement it needs on account of its own inability to please. In the competitive society advertising performed a social service in orienting the buyer in the market, facilitating choice and helping the more efficient but unknown supplier to find customers. It did not merely cost labor time, but saved it. Today, when the free market is coming to an end, those in control of the system are entrenching themselves in advertising. It strengthens the bond which shackles consumers to the big combines. Only those who can keep paying the exorbitant fees charged by the advertising agencies, and most of all by radio itself, that is, those who are already part of the system or are co-opted into it by the decisions of banks and industrial capital, can enter the pseudo-market as sellers. The costs of advertising, which finally flow back into the pockets of the combines, spare them the troublesome task of subduing unwanted outsiders; they guarantee that the wielders of influence remain among their peers, not unlike the resolutions of economic councils which control the establishment and continuation of businesses in the totalitarian state. Advertising today is a negative principle, a blocking device: anything which does not bear its seal of approval is economically suspect. All-pervasive advertising is certainly not needed to acquaint people with the goods on offer, the varieties of which are limited in any case. It benefits the selling of goods only directly. The termination of a familiar advertising campaign by an individual firm represents a loss of prestige, and is indeed an offence against the discipline which the leading clique imposes on its members. In wartime, commodities which can no longer be supplied continue to be advertised merely as a display of industrial power. At such times the subsidizing of the ideological media is more important than the repetition of names. Through their ubiquitous use under the pressure of the system, advertising techniques have invaded the idiom, the "style" of the culture industry. So complete is their triumph that in key positions it is no longer even explicit: the imposing buildings of the big companies, floodlit advertisements in stone, are free of advertising, merely displaying the illuminated company initials on their pinnacles, with no further need of self-congratulation. By contrast, the buildings surviving from the nineteenth century, the architecture of which still shamefully reveals their utility as consumer goods, their function as accommodation, are covered from basement to above roof level with hoardings and banners: the landscape becomes a mere background for signboards and symbols. Advertising becomes simply the art with which Goebbels presciently equated it, *l'art pour*

*l'art*, advertising for advertising's sake, the pure representation of social power. In the influential American magazines *Life* and *Fortune* the images and texts of advertisements are, at a cursory glance, hardly distinguishable from the editorial section. The enthusiastic and unpaid picture story about the living habits and personal grooming of celebrities, which wins them new fans, is editorial, while the advertising pages rely on photographs and data so factual and lifelike that they represent the ideal of information to which the editorial section only aspires. Every film is a preview of the next, which promises yet again to unite the same heroic couple under the same exotic sun: anyone arriving late cannot tell whether he is watching the trailer or the real thing. The montage character of the culture industry, the synthetic, controlled manner in which its products are assembled—factory-like not only in the film studio but also, virtually, in the compilation of the cheap biographies, journalistic novels, and hit songs—predisposes it to advertising: the individual moment, in being detachable, replaceable, estranged even technically from any coherence of meaning, lends itself to purposes outside the work. The special effect, the trick, the isolated and repeatable individual performance have always conspired with the exhibition of commodities for advertising purposes, and today every close-up of a film actress is an advert for her name, every hit song a plug for its tune. Advertising and the culture industry are merging technically no less than economically. In both, the same thing appears in countless places, and the mechanical repetition of the same culture product is already that of the same propaganda slogan. In both, under the dictate of effectiveness, technique is becoming psychotechnique, a procedure for manipulating human beings. In both, the norms of the striking yet familiar, the easy but catchy, the worldly wise but straightforward hold good; everything is directed at overpowering a customer conceived as distracted or resistant.

Through the language they speak, the customers make their own contribution to culture as advertising. For the more completely language coincides with communication, the more words change from substantial carriers of meaning to signs devoid of qualities; the more purely and transparently they communicate what they designate, the more impenetrable they become. The demythologizing of language, as an element of the total process of enlightenment, reverts to magic. In magic word and content were at once different from each other and indissolubly linked. Concepts like melancholy, history, indeed, life, were apprehended in the word which both set them apart and preserved them. Its particular form constituted and reflected them at the same time. The trenchant distinction which declares the word itself fortuitous and its allocation to its object arbitrary does away with the superstitious commingling of word and thing. Anything in a given sequence of letters which goes beyond the correlation to the event designated is banished as unclear and as verbal metaphysics. As a result, the word, which henceforth is allowed only to designate something and not to mean it, becomes so fixated on the object that it hardens to a formula. This affects language and subject matter equally. Instead of raising a matter to the level of experience, the purified word exhibits it as a case of an abstract moment, and everything else, severed from now defunct expression by the demand for pitiless clarity, therefore withers in reality also. The outside-left in football, the blackshirt, the Hitler Youth member, and others of their kind are no more than what they are called. If, before its rationalization, the word had set free not only longing but lies, in its rationalized form it has become a straightjacket more for longing than

for lies. The blindness and muteness of the data to which positivism reduces the world passes over into language itself, which is limited to registering those data. Thus relationships themselves become impenetrable, taking on an impact, a power of adhesion and repulsion which makes them resemble their extreme antithesis, spells. They act once more like the practices of a kind of sorcery, whether the name of a diva is concocted in the studio on the basis of statistical data, or welfare government is averted by the use of taboo-laden words such as "bureaucracy" and "intellectuals," or vileness exonerates itself by invoking the name of a homeland. The name, to which magic most readily attaches, is today undergoing a chemical change. It is being transformed into arbitrary, manipulable designations, the power of which, although calculable, is for that reason as willful as that of archaic names. First names, the archaic residues, have been brought up to date either by stylizing them into advertising brands—film stars' surnames have become first names—or by standardizing them collectively. By contrast, the bourgeois, family name which, instead of being a trademark, individualized its bearers by relating them to their own prehistory, sounds old-fashioned. In Americans it arouses a curious unease. To conceal the uncomfortable distance existing between particular people they call themselves Bob and Harry, like replaceable members of teams. Such forms of interaction reduce human beings to the brotherhood of the sporting public, which protects them from true fraternity. Signification, the only function of the word admitted by semantics, is consummated in the sign. Its character as sign is reinforced by the speed with which linguistic models are put into circulation from above. Whether folksongs are rightly or wrongly called upper-class culture which has come down in the world, their elements have at least taken on their popular form in a long, highly mediated process of experience. The dissemination of popular songs, by contrast, is practically instantaneous. The American term "fad" for fashions which catch on epidemically—inflamed by the action of highly concentrated economic powers—referred to this phenomenon long before totalitarian advertising bosses had laid down the general lines of culture in their countries. If the German fascists launch a word like "intolerable" [*Untragbar*] over the loudspeakers one day, the whole nation is saying "intolerable" the next. On the same pattern, the nations against which the German *Blitzkrieg* was directed have adopted it in their own jargon. The universal repetition of the term denoting such measures makes the measures, too, familiar, just as, at the time of the free market, the brand name on everyone's lips increased sales. The blind and rapidly spreading repetition of designated words links advertising to the totalitarian slogan. The layer of experience which made words human like those who spoke them has been stripped away, and in its prompt appropriation language takes on the coldness which hitherto was peculiar to billboards and the advertising sections of newspapers. Countless people use words and expressions which they either have ceased to understand at all or use only according to their behavioral functions, just as trademarks adhere all the more compulsively to their objects the less their linguistic meaning is apprehended. The Minister of Public Education speaks ignorantly of "dynamic forces," and the hit songs sing endlessly of "reverie" and "rhapsody," hitching their popularity to the magic of the incomprehensible as if to some deep intimation of a higher life. Other stereotypes, such as "memory," are still partly comprehended, but become detached from the experience which might fulfill them. They obtrude

into the spoken language like enclaves. On the German radio of Flesch and Hitler they are discernible in the affected diction of the announcer, who pronounces phrases like "Goodnight, listeners," or "This is the Hitler Youth speaking," or even "the *Führer*" with an inflection which passes into the mother tongue of millions. In such turns of phrase the last bond between sedimented experience and language, which still exerted a reconciling influence in dialect in the nineteenth century, is severed. By contrast, in the hands of the editor whose supple opinions have promoted him to the status of *Schriftleiter*, German words become petrified and alien. In any word one can distinguish how far it has been disfigured by the fascist "folk" community. By now, of course, such language has become universal, totalitarian. The violence done to words is no longer audible in them. The radio announcer does not need to talk in an affected voice; indeed, he would be impossible if his tone differed from that of his designated listeners. This means, however, that the language and gestures of listeners and spectators are more deeply permeated by the patterns of the culture industry than ever before, in nuances still beyond the reach of experimental methods. Today the culture industry has taken over the civilizing inheritance of the frontier and entrepreneurial democracy, whose receptivity to intellectual deviations was never too highly developed. All are free to dance and amuse themselves, just as, since the historical neutralization of religion, they have been free to join any of the countless sects. But freedom to choose an ideology, which always reflects economic coercion, everywhere proves to be freedom to be the same. The way in which the young girl accepts and performs the obligatory date, the tone of voice used on the telephone and in the most intimate situations, the choice of words in conversation, indeed, the whole inner life compartmentalized according to the categories of vulgarized depth psychology, bears witness to the attempt to turn oneself into an apparatus meeting the requirements of success, an apparatus which, even in its unconscious impulses, conforms to the model presented by the culture industry. The most intimate reactions of human beings have become so entirely reified, even to themselves, that the idea of anything peculiar to them survives only in extreme abstraction: personality means hardly more than dazzling white teeth and freedom from body odor and emotions. That is the triumph of advertising in the culture industry: the compulsive imitation by consumers of cultural commodities which, at the same time, they recognize as false.

# FREDRIC JAMESON

## Postmodernism and Consumer Society

Currently William A. Lane Professor of Comparative Literature and Romance Studies at Duke University, Fredric Jameson (b. 1934) was educated at Haverford College and Yale University and has taught at Harvard, Yale, and the University of California, Santa Cruz. He has authored numerous books, including: *Valences of the Dialectic* (2009), *Postmodernism, or, The Cultural Logic of Late Capitalism* (1991), *The Geopolitical Aesthetic: Cinema and Space*

*in the World System* (1995), and *The Political Unconscious* (1982). Jameson is one of the leading contemporary scholars of Marxist literary theory and cultural studies.

After the political crisis of the Vietnam War (1959–1975) and during the politically conservative era of the Ronald Reagan presidency (1981–1989), American culture, along with those of other nations, entered a period of dramatic changes. This era seemed to forsake or refuse earlier assumptions about the coherence of individual identity, the logic of history and progress, and the ability to confidently represent truth and reality. This shift in cultural and epistemological ideas is often referred to as postmodernism, whose distinctions were reflected in dramatically new forms of literature, architecture, art, and even politics. Film also depicted this cultural shift: for instance, in the unsettling personality of Travis Bickle in *Taxi Driver* (1976) and the surreal history of the Vietnam War in *Full Metal Jacket* (1987). While both those films might be thought of as strenuous reflections on the postmodern subject, other postmodern representations appear within the heyday of the contemporary blockbuster in films like *The Godfather* (1972), *American Graffiti* (1973), *Chinatown* (1974), and *Star Wars* (1977), very different films whose exaggerated visions of history acknowledge the complicated and problematic symptoms of a postmodern America.

In "Postmodernism and Consumer Society," a 1988 essay combining elements of essays published in 1983 and 1984, Jameson considers music, literature, architecture, and films as they operate in the framework of "late capitalism," a system determined by the global circulation of finances and information. Within this cultural system, individuality—or more exactly, subjectivity—becomes characterized as a form of disorientation in time and space that seems to approach a state of "schizophrenia." This condition is then expressed or represented as forms of "pastiche"—texts, sounds, and images that seem to drift and collide because they lack the anchor of realism or coherent logic. This crisis of the subject may, for Jameson, be most visibly evident in movies because of their prominent place as cultural barometer. He thus finds a symptomatic abundance in the 1970s and 1980s of what he calls "nostalgia films" that map the desire to understand a historical present and past but reflect the continued difficulty in achieving that understanding except as a kind of mixed blend of images, like the kind of nostalgic pastiche of Westerns and science fiction images seen in *Star Wars*. Because Jameson's argument here is at once influential and contestable, it is worth comparing his positions with those of other theorists who also write on postmodern or contemporary culture such as Timothy Corrigan (p. 416), Faye Ginsburg (p. 887), and Dudley Andrew (p. 999).

## READING CUES & KEY CONCEPTS

◾ What are the chief distinguishing features of Jameson's postmodern subject?

◾ Identify a film that you would consider a parody and then a second which is a pastiche. What characteristics of each film lead you to choose it as an example?

◾ Distinguish what Jameson means by nostalgia films from other kinds of films that deal with history.

◾ **Key Concepts:** Periodization; Pastiche; Parody; Schizophrenia; Modernism; Postmodernism; Nostalgia Film

# Postmodernism and Consumer Society

· · · · · · · · · · · · ·

The concept of postmodernism is not widely accepted or even understood today. Some of the resistance to it may come from the unfamiliarity of the works it covers, which can be found in all the arts: the poetry of John Ashbery, for instance, as well as the much simpler talk poetry that came out of the reaction against complex, ironic, academic modernist poetry in the 1960s; the reaction against modern architecture and in particular against the monumental buildings of the International Style; the pop buildings and decorated sheds celebrated by Robert Venturi in his manifesto *Learning from Las Vegas*; Andy Warhol, pop art and the more recent Photorealism; in music, the moment of John Cage but also the later synthesis of classical and "popular" styles found in composers like Philip Glass and Terry Riley, and also punk and new wave rock with such groups as the Clash, Talking Heads and the Gang of Four; in film, everything that comes out of Godard—contemporary vanguard film and video—as well as a whole new style of commercial or fiction films, which has its equivalent in contemporary novels, where the works of William Burroughs, Thomas Pynchon and Ishmael Reed on the one hand, and the French new novel on the other, are also to be numbered among the varieties of what can be called postmodernism.

This list would seem to make two things clear at once. First, most of the postmodernisms mentioned above emerge as specific reactions against the established forms of high modernism, against this or that dominant high modernism which conquered the university, the museum, the art gallery network and the foundations. Those formerly subversive and embattled styles—Abstract Expressionism; the great modernist poetry of Pound, Eliot or Wallace Stevens; the International Style (Le Corbusier, Gropius, Mies van der Rohe); Stravinsky; Joyce, Proust and Mann—felt to be scandalous or shocking by our grandparents are, for the generation which arrives at the gate in the 1960s, felt to be the establishment and the enemy—dead, stifling, canonical, the reified monuments one has to destroy to do anything new. This means that there will be as many different forms of postmodernism as there were high modernisms in place, since the former are at least initially specific and local reactions against those models. That obviously does not make the job of describing postmodernism as a coherent thing any easier, since the unity of this new impulse—if it has one—is given not in itself but in the very modernism it seeks to displace.

The second feature of this list of postmodernisms is the effacement of some key boundaries or separations, most notably the erosion of the older distinction between high culture and so-called mass or popular culture. This is perhaps the most distressing development of all from an academic standpoint, which has traditionally had a vested interest in preserving a realm of high or elite culture against the surrounding environment of philistinism, of schlock and kitsch, of TV series and *Reader's Digest* culture, and in transmitting difficult and complex skills of reading, listening and seeing to its initiates. But many of the newer postmodernisms have been fascinated precisely by that whole landscape of advertising and motels, of the Las Vegas strip, of the Late Show and B-grade Hollywood film, of so-called paraliterature with its airport paperback categories of the gothic and the romance,

the popular biography, the murder mystery and the science fiction or fantasy novel. They no longer "quote" such "texts" as a Joyce might have done, or a Mahler; they incorporate them, to the point where the line between high art and commercial forms seems increasingly difficult to draw.

A rather different indication of this effacement of the older categories of genre and discourse can be found in what is sometimes called contemporary theory. A generation ago there was still a technical discourse of professional philosophy—the great systems of Sartre or the phenomenologists, the work of Wittgenstein or analytical or common language philosophy—alongside which one could still distinguish that quite different discourse of the other academic disciplines—of political science, for example, or sociology or literary criticism. Today, increasingly, we have a kind of writing simply called "theory" which is all or none of those things at once. This new kind of discourse, generally associated with France and so-called French theory, is becoming widespread and marks the end of philosophy as such. Is the work of Michel Foucault, for example, to be called philosophy, history, social theory or political science? It's undecidable, as they say nowadays, and I will suggest that such "theoretical discourse" is also to be numbered among the manifestations of postmodernism.

Now I must say a word about the proper use of this concept: it is not just another word for the description of a particular style. It is also, at least in my use, a periodizing concept whose function is to correlate the emergence of new formal features in culture with the emergence of a new type of social life and a new economic order—what is often euphemistically called modernization, post-industrial or consumer society, the society of the media or the spectacle, or multinational capitalism. This new moment of capitalism can be dated from the post-war boom in the United States in the late 1940s and early 1950s or, in France, from the establishment of the Fifth Republic in 1958. The 1960s are in many ways the key transitional period, a period in which the new international order (neo-colonialism, the Green Revolution, computerization and electronic information) is at one and the same time set in place and is swept and shaken by its own internal contradictions and by external resistance. I want here to sketch a few of the ways in which the new postmodernism expresses the inner truth of that newly emergent social order of late capitalism, but will have to limit the description to only two of its significant features, which I will call pastiche and schizophrenia; they will give us a chance to sense the specificity of the postmodernist experience of space and time respectively.

## Pastiche Eclipses Parody

One of the most significant features or practices in postmodernism today is pastiche. I must first explain this term (from the language of the visual arts), which people generally tend to confuse with or assimilate to that related verbal phenomenon called parody. Both pastiche and parody involve the imitation or, better still, the mimicry of other styles and particularly of the mannerisms and stylistic twitches of other styles. It is obvious that modern literature in general offers a very rich field for parody, since the great modern writers have all been defined by the invention or production of rather unique styles: think of the Faulknerian long sentence or of D. H. Lawrence's characteristic nature imagery; think of Wallace Stevens's peculiar

way of using abstractions; think also of mannerisms of the philosophers, of Heidegger for example, or Sartre; think of the musical styles of Mahler or Prokofiev. All of these styles, however different from one another, are comparable in this: each is quite unmistakable; once one of them is learned, it is not likely to be confused with something else.

Now parody capitalizes on the uniqueness of these styles and seizes on their idiosyncrasies and eccentricities to produce an imitation which mocks the original. I won't say that the satiric impulse is conscious in all forms of parody: in any case, a good or great parodist has to have some secret sympathy for the original, just as a great mimic has to have the capacity to put himself/herself in the place of the person imitated. Still, the general effect of parody is—whether in sympathy or with malice—to cast ridicule on the private nature of these stylistic mannerisms and their excessiveness and eccentricity with respect to the way people normally speak or write. So there remains somewhere behind all parody the feeling that there is a linguistic norm in contrast to which the styles of the great modernists can be mocked.

But what would happen if one no longer believed in the existence of normal language, of ordinary speech, of the linguistic norm (the kind of clarity and communicative power celebrated by Orwell in his famous essay "Politics and the English Language," say)? One could think of it in this way: perhaps the immense fragmentation and privatization of modern literature—its explosion into a host of distinct private styles and mannerisms—foreshadows deeper and more general tendencies in social life as a whole. Supposing that modern art and modernism—far from being a kind of specialized aesthetic curiosity—actually anticipated social developments along these lines; supposing that in the decades since the emergence of the great modern styles society had itself begun to fragment in this way, each group coming to speak a curious private language of its own, each profession developing its private code or idiolect, and finally each individual coming to be a kind of linguistic island, separated from everyone else? But then in that case, the very possibility of any linguistic norm in terms of which one could ridicule private languages and idiosyncratic styles would vanish, and we would have nothing but stylistic diversity and heterogeneity.

That is the moment at which pastiche appears and parody has become impossible. Pastiche is, like parody, the imitation of a peculiar or unique style, the wearing of a stylistic mask, speech in a dead language: but it is a neutral practice of such mimicry, without parody's ulterior motive, without the satirical impulse, without laughter, without that still latent feeling that there exists something *normal* compared with which what is being imitated is rather comic. Pastiche is blank parody, parody that has lost its sense of humor: pastiche is to parody what that curious thing, the modern practice of a kind of blank irony, is to what Wayne Booth calls the stable and comic ironies of the eighteenth century.[1]

## *The Death of the Subject*

But now we need to introduce a new piece into this puzzle, which may help to explain why classical modernism is a thing of the past and why postmodernism should have taken its place. This new component is what is generally called the "death of the subject" or, to say it in more conventional language, the end of individualism as

such. The great modernisms were, as we have said, predicated on the invention of a personal, private style, as unmistakable as your fingerprint, as incomparable as your own body. But this means that the modernist aesthetic is in some way organically linked to the conception of a unique self and private identity, a unique personality and individuality, which can be expected to generate its own unique vision of the world and to forge its own unique, unmistakable style.

Yet today, from any number of distinct perspectives, the social theorists, the psychoanalysts, even the linguists, not to speak of those of us who work in the area of culture and cultural and formal change, are all exploring the notion that this kind of individualism and personal identity is a thing of the past; that the old individual or individualist subject is "dead"; and that one might even describe the concept of the unique individual and the theoretical basis of individualism as ideological. There are in fact two positions on all this, one of which is more radical than the other. The first one is content to say: yes, once upon a time, in the classic age of competitive capitalism, in the heyday of the nuclear family and the emergence of the bourgeoisie as the hegemonic social class, there was such a thing as individualism, as individual subjects. But today, in the age of corporate capitalism, of the so-called organization man, of bureaucracies in business as well as in the state, of demographic explosion—today, that older bourgeois individual subject no longer exists.

Then there is a second position, the more radical of the two—what one might call the poststructuralist position. It adds: not only is the bourgeois individual subject a thing of the past, it is also a myth; it never really existed in the first place; there have never been autonomous subjects of that type. Rather, this construct is merely a philosophical and cultural mystification which sought to persuade people that they "had" individual subjects and possessed some unique personal identity.

For our purposes, it is not particularly important to decide which of these positions is correct (or rather, which is more interesting and productive). What we have to retain from all this is rather an aesthetic dilemma: because if the experience and the ideology of the unique self, an experience and ideology which informed the stylistic practice of classical modernism, is over and done with, then it is no longer clear what the artists and writers of the present period are supposed to be doing. What is clear is merely that the older models—Picasso, Proust, T. S. Eliot—do not work any more (or are positively harmful), since nobody has that kind of unique private world and style to express any longer. And this is perhaps not merely a "psychological" matter: we also have to take into account the immense weight of seventy or eighty years of classical modernism itself. This is yet another sense in which the writers and artists of the present day will no longer be able to invent new styles and worlds—they've already been invented; only a limited number of combinations are possible; the unique ones have been thought of already. So the weight of the whole modernist aesthetic tradition—now dead—also "weighs like a nightmare on the brain of the living," as Marx said in another context.

Hence, once again, pastiche: in a world in which stylistic innovation is no longer possible, all that is left is to imitate dead styles, to speak through the masks and with the voices of the styles in the imaginary museum. But this means that contemporary or postmodernist art is going to be about art itself in a new kind of way; even more, it means that one of its essential messages will involve the necessary failure of art and the aesthetic, the failure of the new, the imprisonment in the past.

## *The Nostalgia Mode*

As this may seem very abstract, I want to give a few examples, one of which is so om-
nipresent that we rarely link it with the kinds of developments in high art discussed
here. This particular practice of pastiche is not high-cultural but very much within
mass culture, and it is generally known as the "nostalgia film" (what the French
neatly call *la mode rétro*—retrospective styling). We must conceive of this category
in the broadest way. Narrowly, no doubt, it consists merely of films about the past
and about specific generational moments of that past. Thus, one of the inaugural
films in this new "genre" (if that's what it is) was Lucas's *American Graffiti*, which in
1973 set out to recapture all the atmosphere and stylistic peculiarities of the 1950s
United States: the United States of the Eisenhower era. Polanski's great film *Chinatown*
(1974) does something similar for the 1930s, as does Bertolucci's *The Conformist* (1969)
for the Italian and European context of the same period, the fascist era in Italy; and
so forth. We could go on listing these films for some time. But why call them pas-
tiche? Are they not, rather, work in the more traditional genre known as the his-
torical film—work which can more simply be theorized by extrapolating that other
well-known form, the historical novel?

I have my reasons for thinking that we need new categories for such films. But
let me first add some anomalies: supposing I suggested that *Star Wars* (George Lucas,
1977) is also a nostalgia film. What could that mean? I presume that we can agree
that this is not a historical film about our own intergalactic past. Let me put it some-
what differently: one of the most important cultural experiences of the generations
that grew up from the 1930s to the 1950s was the Saturday afternoon serial of the
Buck Rogers type—alien villains, true American heroes, heroines in distress, the
death ray or the doomsday box, and the cliff-hanger at the end whose miraculous
solution was to be witnessed next Saturday afternoon. *Star Wars* reinvents this ex-
perience in the form of a pastiche; there is no point to a parody of such serials, since
they are long extinct. Far from being a pointless satire of such dead forms, *Star Wars*
satisfies a deep (might I even say repressed?) longing to experience them again: it
is a complex object in which on some first level children and adolescents can take
the adventures straight, while the adult public is able to gratify a deeper and more
properly nostalgic desire to return to that older period and to live its strange old
aesthetic artefacts through once again. This film is thus *metonymically* a historical
or nostalgia film. Unlike *American Graffiti*, it does not reinvent a picture of the past
in its lived totality; rather, by reinventing the feel and shape of characteristic art
objects of an older period (the serials), it seeks to reawaken a sense of the past asso-
ciated with those objects. *Raiders of the Lost Ark* (1981), meanwhile, occupies an in-
termediary position here: on some level it is about the 1930s and 1940s, but in reality
it too conveys that period metonymically through its own characteristic adventure
stories (which are no longer ours).

Now let me discuss another anomaly which may take us further towards un-
derstanding nostalgia film in particular and pastiche generally. This one involves
a recent film called *Body Heat* (Lawrence Kasdan, 1981), which, as has abundantly
been pointed out by the critics, is a kind of distant remake of *Double Indemnity*
(1944). (The allusive and elusive plagiarism of older plots is, of course, also a feature
of pastiche.) Now *Body Heat* is technically not a nostalgia film, since it takes place

in a contemporary setting, in a little Florida village near Miami. On the other hand, this technical contemporaneity is most ambiguous indeed: the credits—always our first cue—are all lettered in a 1930s Art-Deco style which cannot but trigger nostalgic reactions (first to *Chinatown*, no doubt, and then beyond it to some more historical referent). Then the very style of the hero himself is ambiguous: William Hurt is a new star but has nothing of the distinctive style of the preceding generation of male superstars like Steve McQueen or Jack Nicholson, or rather, his persona here is a kind of mix of their characteristics with an older role of the type generally associated with Clark Gable. So here too there is a faintly archaic feel to all this. This spectator begins to wonder why this story, which could have been situated anywhere, is set in a small Florida town, in spite of its contemporary reference. One begins to realize after a while that the small town setting has a crucial strategic function: it allows the film to do without most of the signals and references which we might associate with the contemporary world, with consumer society—the appliances and artefacts, the high rises, the object world of late capitalism. Technically, then, its objects (its cars, for instance) are 1980s products, but everything in the film conspires to blur that immediate contemporary reference and to make it possible to receive this too as nostalgia work—as a narrative set in some indefinable nostalgic past, an eternal 1930s, say, beyond history. It seems to me exceedingly symptomatic to find the very style of nostalgia films invading and colonizing even those movies today which have contemporary settings, as though, for some reason, we were unable today to focus our own present, as though we had become incapable of achieving aesthetic representations of our own current experience. But if that is so, then it is a terrible indictment of consumer capitalism itself—or, at the very least, an alarming and pathological symptom of a society that has become incapable of dealing with time and history.

So now we come back to the question of why nostalgia film or pastiche is to be considered different from the older historical novel or film. I should also include in this discussion the major literary example of all this, to my mind: the novels of E. L. Doctorow—*Ragtime*, with its turn-of-the-century atmosphere, and *Loon Lake*, for the most part about our 1930s. But these are, in my opinion, historical novels in appearance only. Doctorow is a serious artist and one of the few genuinely left or radical novelists at work today. It is no disservice to him, however, to suggest that his narratives do not represent our historical past so much as they represent our ideas or cultural stereotypes about that past. Cultural production has been driven back inside the mind, within the monadic subject: it can no longer look directly out of its eyes at the real world for the referent but must, as in Plato's cave, trace its mental images of the world on its confining walls. If there is any realism left here, it is a "realism" which springs from the shock of grasping that confinement and of realizing that, for whatever peculiar reasons, we seem condemned to seek the historical past through our own pop images and stereotypes about the past, which itself remains forever out of reach.

## Postmodernism and the City

Now, before I try to offer a somewhat more positive conclusion, I want to sketch the analysis of [Los Angeles's Bonaventure Hotel,] a full-blown postmodern building—a work which is in many ways uncharacteristic of that postmodern architecture whose

principal names are Robert Venturi, Charles Moore, Michael Graves and more recently Frank Gehry, but which to my mind offers some very striking lessons about the originality of postmodernist space. Let me amplify the figure which has run through the preceding remarks, and make it even more explicit: I am proposing the notion that we are here in the presence of something like a mutation in built space itself. My implication is that we ourselves, the human subjects who happen into this new space, have not kept pace with that evolution; there has been a mutation in the object, unaccompanied as yet by any equivalent mutation in the subject; we do not yet possess the perceptual equipment to match this new hyperspace, as I will call it, in part because our perceptual habits were formed in that older kind of space I have called the space of high modernism. The newer architecture—like many of the other cultural products I have evoked in the preceding remarks—therefore stands as something like an imperative to grow new organs to expand our sensoria and our bodies to some new, as yet unimaginable, perhaps ultimately impossible, dimensions.

[ · · · ]

## The Aesthetic of Consumer Society

Now I must try, very rapidly, in conclusion, to characterize the relationship of cultural production of this kind to social life in this country today. This will also be the moment to address the principal objection to concepts of postmodernism of the type I have sketched here: namely that all the features we have enumerated are not new at all but abundantly characterized modernism proper or what I call high modernism. Was not Thomas Mann, after all, interested in the idea of pastiche, and is not "The Oxen of the Sun" chapter of *Ulysses* its most obvious realization? Can Flaubert, Mallarmé and Gertrude Stein not be included in an account of postmodernist temporality? What is so new about all of this? Do we really need the concept of postmodernism?

One kind of answer to this question would raise the whole issue of periodization and of how a historian (literary or other) posits a radical break between two henceforth distinct periods. I must limit myself to the suggestion that radical breaks between periods do not generally involve complete changes of content but rather the restructuring of a certain number of elements already given: features that in an earlier period or system were subordinate now become dominant, and features that had been dominant again become secondary. In this sense, everything we have described here can be found in earlier periods and most notably within modernism proper. My point is that until the present day those things have been secondary or minor features of modernist art, marginal rather than central, and that we have something new when they become the central features of cultural production.

But I can argue this more concretely by turning to the relationship between cultural production and social life generally. The older or classical modernism was an oppositional art; it emerged within the business society of the gilded age as scandalous and offensive to the middle-class public—ugly, dissonant, bohemian, sexually shocking. It was something to make fun of (when the police were not called in to seize the books or close the exhibitions): an offense to good taste and to common sense, or, as Freud and Marcuse would have put it, a provocative challenge to the reigning reality- and performance-principles of early twentieth-century middle-class

society. Modernism in general did not go well with overstuffed Victorian furniture, with Victorian moral taboos, or with the conventions of polite society. This is to say that whatever the explicit political content of the great high modernisms, the latter were always in some mostly implicit ways dangerous and explosive, subversive within the established order.

If then we suddenly return to the present day, we can measure the immensity of the cultural changes that have taken place. Not only are Joyce and Picasso no longer weird and repulsive, they have become classics and now look rather realistic to us. Meanwhile, there is very little in either the form or the content of contemporary art that contemporary society finds intolerable and scandalous. The most offensive forms of this art—punk rock, say, or what is called sexually explicit material—are all taken in its stride by society, and they are commercially successful, unlike the productions of the older high modernism. But this means that even if contemporary art has all the same formal features as the older modernism, it has still shifted its position fundamentally within our culture. For one thing, commodity production and in particular our clothing, furniture, buildings and other artefacts are now intimately tied in with styling changes which derive from artistic experimentation; our advertising, for example, is fed by modernism in all the arts and inconceivable without. For another, the classics of high modernism are now part of the so-called canon and are taught in schools and universities—which at once empties them of any of their older subversive power. Indeed, one way of marking the break between the periods and of dating the emergence of postmodernism is precisely to be found there: at the moment (the early 1960s, one would think) in which the position of high modernism and its dominant aesthetics become established in the academy and are henceforth felt to be academic by a whole new generation of poets, painters and musicians.

But one can also come at the break from the other side, and describe it in terms of periods of recent social life. As I have suggested, Marxists and non-Marxists alike have come around to the general feeling that at some point following World War Two a new kind of society began to emerge (variously described as post-industrial society, multinational capitalism, consumer society, media society and so forth). New types of consumption; planned obsolescence; an ever more rapid rhythm of fashion and styling changes; the penetration of advertising, television and the media generally to a hitherto unparalleled degree throughout society; the replacement of the old tension between city and country, center and province, by the suburb and by universal standardization; the growth of the great networks of superhighways and the arrival of automobile culture—these are some of the features which would seem to mark a radical break with that older pre-war society in which high modernism was still an underground force.

I believe that the emergence of postmodernism is closely related to the emergence of this new moment of late consumer or multinational capitalism. I believe also that its formal features in many ways express the deeper logic of this particular social system. I will only be able, however, to show this for one major theme: namely the disappearance of a sense of history, the way in which our entire contemporary social system has little by little begun to lose its capacity to retain its own past, has begun to live in a perpetual present and in a perpetual change that obliterates traditions of the kind which all earlier social information have had, in one way or another, to preserve. Think only of the media exhaustion of news: of how Nixon and,

even more so, Kennedy, are figures from a now distant past. One is tempted to say that the very function of the news media is to relegate such recent historical experiences as rapidly as possible into the past. The informational function of the media would thus be to help us forget, to serve as the very agents and mechanisms for our historical amnesia.

But in that case the two features of postmodernism on which I have dwelt here— the transformation of reality into images, the fragmentation of time into a series of perpetual presents—are both extraordinarily consonant with this process. My own conclusion here must take the form of a question about the critical value of the newer art. There is some agreement that the older modernism functioned against its society in ways which are variously described as critical, negative, contestatory, subversive, oppositional and the like. Can anything of the sort be affirmed about postmodernism and its social moment? We have seen that there is a way in which postmodernism replicates or reproduces—reinforces—the logic of consumer capitalism; the more significant question is whether there is also a way in which it resists that logic. But that is a question we must leave open.

## NOTES

1. Wayne C. Booth, *The Rhetoric of Irony* (Chicago, 1975).

# LISA NAKAMURA

......................................................

# The Social Optics of Race and Networked Interfaces in *The Matrix* Trilogy and *Minority Report*

FROM *Digitizing Race*

Lisa Nakamura (b. 1965) is Professor in the Institute of Communication Research and Media Studies Program and Professor of Asian American Studies at the University of Illinois, Urbana-Champaign. She is a crucial figure in highlighting the importance of race, gender, and social identity in digital media studies, particularly through her work on "identity tourism" on the Internet. Nakamura is co-editor of *Race in Cyberspace* (with Beth Kolko and Gilbert Rodman, 2000) and the author of *Cybertypes: Race, Ethnicity and Identity on the Internet* (2002) and *Digitizing Race: Visual Cultures of the Internet* (2008), from which this selection is drawn. Her current research interests include exploring race and gender in online social spaces such as Massively Multiplayer Online Role-Playing Games (MMORPGs) and avatars in a "postracial" world.

The terms "digital divide" and "information gap" have been widely used to explain the way that the adoption of, and access to, new information technologies tend to reinforce

existing social hierarchies and inequities along lines of race, class, and education. Yet as African Americans and Latinos become the fastest-growing group of Internet users, Nakamura calls for more nuanced critiques of online practices and ideals. Rather than considering the Internet a text-based system, Nakamura urges scholars to approach it as a visual culture that displays gender, race, and ethnicity and encourages their consumption, challenging the utopian ideal of cyberspace as a place where our bodies are left behind.

In "The Social Optics of Race," Nakamura looks at representations of the networked interface in popular science fiction films and argues that technology use is racialized through these representations. Drawing on Richard Dyer's "White" (p. 822), she shows how whiteness is coded as a disembodied abstraction through themes of transparency, gesture, and replication, while in *The Matrix* trilogy (1999, 2003, 2003), blackness connotes "authenticity" through its association with older and heavier interfaces. In both the trilogy and *Minority Report* (2002), Asian Americans facilitate white use of technology. Nakamura's essay complements Henry Jenkins's study of convergence culture around *The Matrix* (p. 619), uniting film and digital media not in terms of their overlapping commercial strategies and user experiences, but in showing how mainstream films grapple with the social and subjective meanings of technologies such as the interface. To address this convergence, Nakamura argues that Internet scholars' contribution to film studies is essential.

## READING CUES & KEY CONCEPTS

▣ How does *The Matrix* trilogy associate the threats of machine culture with "whiteness," according to Nakamura? Think of examples from the film to support or challenge this reading.

▣ If Asian American identities are sometimes marginalized by conceptualizations of race in black-and-white terms, how do representations of science fiction and technology complicate such representations?

▣ Nakamura argues for "assessments of power relations regarding interface use." How do her readings of popular films help with this project?

▣ **Key Concepts:** New Media; Interface; Informational Capitalism; Racialization; Dataveillance; Fourth World

# The Social Optics of Race and Networked Interfaces in *The Matrix* Trilogy and *Minority Report*

. . . . . . . . . . . . .

Computer interfaces and their theatricalized use have become increasingly common in contemporary film and television. The massification of the Internet as an everyday technology for many people has resulted in the creation and exhibition of innumerable telegenic fictional and "real" interfaces as a ubiquitous feature in genres like science fiction, action/thriller, and military films, and they are

increasingly common in mainstream film genres like romances, such as in *You've Got Mail* and *Something's Got to Give*, music videos, and dramas set in contemporary times. These scenes allow insight into both the characters that use them and the ways in which information, surveillance, and visualization function in the realm of the film and in society at large. The proper relationship to the interface is codified quite clearly: competency or mastery is defined by the level of immediacy the user experiences in relation to it. Eugene Thacker defines immediacy as follows: it "involves the use of new media to the extent that the media themselves—the 'window'— disappear, bringing forth a kind of direct experience where technology is transparent and unnoticed by the subject."[1] This is an eloquent formulation of entitlement regarding the new media interface. Internet users all engage with interfaces over which they have more or less control, experience more or less comfort or alienation, more or less immediacy, more or less ability to create or produce, more or less investment in the interface's content and forms of representation. *The Matrix* trilogy and the 2002 film *Minority Report* racialize digital information access and production by depicting scenes of white and male users experiencing "direct" or immediate relations with computer interfaces, while users of color are relegated to the background, depicted with truncated and relatively distant, highly technologically mediated relationships to their hardware and software. These users are visible reminders of the necessity of human objects to support and underwrite others' sublime experience of "transparent" and direct interactions with digital technology; they supply the marginal blackness in the *Matrix* films and *Minority Report* against which whiteness stands in sharp relief. And in both films, Asians and Asian Americans function as the material base for technologies of digitized vision and surveillance. These films, along with the extremely successful Apple iPod advertising campaign that began in 2004 depicting dancing silhouetted bodies, create a visual culture that reflects highly codified conditions of labor, race, and the body under informational capitalism.

[ · · · ]

A key sequence of chapter 10 of the DVD edition of *The Matrix Reloaded* intercuts images of Link (the *Nebuchadnezzar*'s pilot and operator, here depicted guiding the

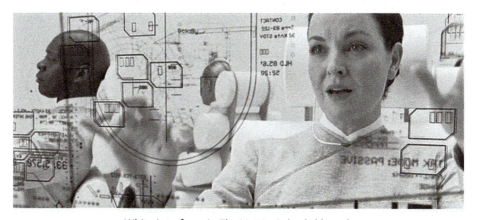

White interfaces in *The Matrix: Reloaded* (2003).

ship into port) with images of the Zion gate operator, a white woman. As the two converse, two competing image sets of interface design are put into conversation as well.

These images literally contrast "black" and "white" interface culture—while the Zion gate operator's clothing, monitor, and face are all white, transparent, and futuristically modern in the classic visual style of science fiction from *2001: A Space Odyssey* (1968) to *Space: 1999* (1975–77) and onward, Link and the *Nebuchadnezzar* are part of the Afro-futuristic visual culture that the trilogy has exploited so effectively throughout.[2] Link wears dreadlocks and a grubby, semi-unraveled sweater; his ship is dark and shadowy; and his black padded analog-style headset resembles equipment you might see in the past rather than in the future. The Zion gate operator wears blindingly white and tailored clothes, occupies a spotlessly clean space, wears her hair in a tight bun, and is herself smooth and pale. Most importantly, she has a radically different relation to the computer and its interface than does Link. While he types commands on an antiquated keyboard, she is jacked in differently. Her body is linked to the computer through a more direct means: gesture. While it has been a familiar trope for cyberpunk narratives to deploy pastiches of historical and sartorial styles to depict an unevenly developed and dystopic technological future, this scene superimposes the two contrastingly racialized visual styles of the interface to invoke the crucial difference in this film: that between white culture and black culture. Indeed, as Roger Ebert writes, "The population of Zion [and the film] is largely black," and "a majority of the characters were played by African Americans." This is extremely unusual for science fiction narrative, in which people of color are largely absent as main characters. Ebert addresses this anomaly as follows: "It has become commonplace for science fiction epics to feature one or two African American stars but we've come a long way since Billy Dee Williams in *The Return of the Jedi*. The films abound with African Americans not for their box office appeal—because the Matrix is *the* star of the movie—and not because they are good actors (which they are) but because to the white teenagers who are their primary audience for this movie, African Americans embody a cool, a cachet, an authenticity. Morpheus is the power center of the movie, and Neo's role is essentially to study under him and absorb his mojo."[3]

Black interfaces in *The Matrix: Reloaded* (2003).

When we oppose the multicultural "earth tone natural fiber fashions"[4] of the Zionites with the minimalistic, ultramodern interfaces and styles of generic computer culture, as depicted in the white interface image, we can see why these two competing visual fields are intercut with each other: the mojo effected by both the trilogy's black characters and its forging of a new Afro-futurist cinematic mise-en-scène is posed as a solution to the problem of fractious machines, machines that we know are machines because they are identical to each other, infinitely replicable, and spread in a viral fashion. So too do we know that they are inhuman because they are represented by white men, the "agents," most notably Agent Smith, who embody the uniformity of white male culture and equate it to machine culture. This is how the films portray their strong critique of information society, post-Internet, as well as how they pose their solution to this problem—while machine culture is viral, oppressive, and assimilative, Afro-futurist mojo and black identity are generally depicted as singular, "natural," and, as Ebert puts it, unassimilable and "authentic."

[ · · · ]

*The Matrix: Reloaded* depicts a racialized division of labor in which white users interface with computers either with gestural computing or in even more direct ways, by being "the One" who needs only to think a command for it to be done. Neo, the former "Mr. Anderson," embodies the power user, the person whose interactions with digital interfaces are supremely transparent and intuitive. Similarly, *Minority Report* depicts its own scenes of computing privilege, as John Anderton, played by Tom Cruise, uses gestural computing in some of the most beautiful and memorable scenes in this extremely stylized film.

The film's images of a transparent interface, controlled by gestures of the hands rather than a keyboard, are modeled after an MIT Media Lab experiment. The interfaces are literally transparent: we can see through them; we are on the other side of the looking glass, occupying the point of view of the computer itself, were this a traditional setup. As Anderton "scrubs" and manipulates the image, we hear classical music, which reinforces the idea of the interface user as a conductor, a master of digital production.

[ · · · ]

Transparent interfaces are represented as intuitive, universal, pre- or postverbal, white, translucent, and neutral—part of a visual digital aesthetic code embodied by the Apple iPod. The Apple iPod advertising campaign, which took the form of both television and Internet video commercials, print advertisements, and posters that were highly visible on subway and BART station walls as well as in other urban public spaces during Christmas 2004, features dancing black silhouettes against a solid colored background, with the image of the white iPod clearly contrasted against these two fields of color and noncolor.

The negative space of the alpha channel employed in creating the silhouetted digital images depicts the iPod user's body as a black void into which a viewer's identity can be transported.[5] The visual culture of the iPod, itself a product celebrated as much for its sleek, white, spare good looks in terms of material culture artifacts as for its "easy to use" intuitive interface, is oriented around conveying a sense of neutrality, modernism, and negative space. In *Minority Report* and *The Matrix* trilogy, this

modernist revival is depicted as a "white" style: transparent, neutral, "clean," and modern. Apple's trademark "iWorld," the logic that brings together the company's diverse product lines in music (iTunes), music hardware (iPod), laptop computers (iBook), and eye-catching design in desktop computers (iMac), invokes the notion of an "eye-world," a world of specific digital visual cultures, on the level of both the interface and the hardware. The title of Apple's iLife multimedia software suite posits an all-encompassing lifestyle defined by the visual spectacle of literally empty bodies and their heedless enjoyment of consumer choice and privilege, customization, and its implication with other forms of geopolitical domination and entitlement. Apple's iPod campaign is an example of the proliferation of niche digital visual cultures. The "iWorld" maintains its focus on the "i" prefix, which implies a constant focus on the user, the unique individual and neoliberal consumer for whom color blindness is a part of a conscious political ideology, and for whom information and communications technologies and the Internet are a means of enhancing customer choice and audience choice. The iWorld sells the user the glories of customization and putting one's own mark on things that are produced in a mass fashion, specifically to be altered, "burned," or ripped. The iPod is the object of desire because though each of them looks exactly the same, they are meant to be written on, to be shared with others, to contain subjectivity in a way that clothes or furniture cannot. Thus the iPod embodies this kind of digital privilege that is invisible or transparent, the alpha channel of the i-strategy. This is part of the strategy that the iPod ads use to get potential users to insert themselves into iWorld.

Random access is an essential principle of the structure and logic of new media that respatializes media experiences: rather than needing to wait until a tape or other physical medium rewinds to get to the beginning of its contents, random access allows us to get there immediately, if we know where we want to go. As Lev Manovich puts it, random access is symptomatic of the "decline of the field of rhetoric in the modern era," for in contrast to modes of information presentation that rely on argument, narrative progression, and other systems of sequential arrangement, new media culture is better conceived of as "an infinite flat surface where individual texts are placed in no particular order."[6] This "flattening" of the data produces a user who is defined by "spatial wandering"; in the absence of an author or writer to order the media experience for her, the postmodern subject produced by random-access environments like digital gaming and use of hyperlinks and other interactive computer media is one defined by its freedom. The iPod's rhetoric of freedom from bulky hardware and the confining paradigm of music that possesses a material form rather than existing as an abstract information file (and in some cases the implied freedom from paying for music that comes from the MP3 file-sharing culture) is paralleled by its depictions of visualized freedom through linkages between race, dance, and musical genre in the iPod advertisements. The iPod offers the consumer volitional mobility not only on the level of device portability; she can either use the LCD display to navigate through customized playlists and program selections, or if she owns an iPod "shuffle," she can toggle it to "shuffle" and let the machine "randomly" decide what to play. Though the iPod's employment of random-access technology positions all its available musical selections on a "flat plane" in relation to each other, with any one song as equally and quickly accessible as any other through the medium of the interface, the visual language of the advertisements works to reinforce the idea of distinct visual and racial music styles. The "flatness" of the media form is

counterbalanced by the creation of extremely well-differentiated visual styles that trace out different options in terms of race and ethnicity: the iPod advertising campaign creates volitional ethnicity as an option for the user in much the same way that interfaced networked visual environments accomplish this goal in the Jennifer Lopez video "If You Had My Love." Just as J. Lo is shown to "shuffle" between different racial, ethnic, and musical identities in response to the click-mediated desires of a projected normative user, so too does the iPod campaign produce racialized bodies that correspond to specific typed genres of music.

In the visual culture of the iPod ads, access to music styles is not seen as random at all; on the contrary, it is a specific media-searching technique mediated by the visual presence of both invisible and hypervisible black bodies. While the blacking out of the silhouettes conceals individual identity by making it impossible to see *who* they are, it becomes centrally the point *what* they are. The iPod ads often depict black people dancing because, as in *The Matrix* trilogy, black people dancing visually signifies desire that the white body cannot feel and cannot express visually. Sexuality, dread-locked silhouettes, and musical genres like hip-hop [ . . . ] and dance genres like break dancing are all depicted together in a way that functions as a lesson in musical genre in an age when the demise of album-oriented rock has made such definitions problematic. The notion that one can click through musical genres using software like Apple's iTunes and download music to correspond to the omnipresent racialized bodies in the ads links together the volitional mobility of the interfaced music shop with that of the consumer of the hipness and coolness of black expressive culture itself. Though the silhouettes of the dancers are an empty "alpha" channel devoid of color, they are paradoxically full of racialized color: as in *The Matrix* trilogy, black expressive styles are referenced via signifiers such as dreadlocks, Afros, and pheno/stereo/typically black profiles and bodies and serve to intensify the way that the iPod sells choice and random access in genres: musical genres, of course, but also the way that identities can be chosen and stepped into and out of through the medium of music. As in *The Matrix*, Afro-futuristic style is appropriated to signify both sexuality and "cool" in the context of regimes of hypervisuality and selective interracial power differentials. As Claudia Springer points out in "Playing It Cool in the Matrix": "Thomas A. Anderson's transformation into Neo in the Matrix recalls the fifties' appropriation of black cool by whites, for the film relies on black characters to guide its white protagonist toward truth and fashion flair." And in a humorous essay by Donnell Alexander, provocatively titled "Cool like Me (Are Black People Cooler than White People?)," he asserts:

> Cool derived from having to survive as far as can be imagined from the ideal of white culture, with little more than a spiritual dowry for support. It's about living on the cusp, on the periphery, diving for scraps. . . . Cool, the basic reason blacks remain in the American cultural mix, is an industry of style that everyone in the world can use.[7]

The modularity and cross-platform salability of black culture guarantee the continued valuation of cool, particularly in representational practices associated with technologies that are feared to be dehumanizing. Apple, in particular, has always positioned itself as more "human" than other personal computer manufacturers. In "After 20 Years, Finally Capitalizing on Cool," the technology journalist Eric

Stross asserts that the ineffable commodity that has distinguished Apple from other computer hardware companies is its coolness. He writes that though Microsoft has a near monopoly on operating system software and Google has a lock on the digital library business, "Apple has an absolute monopoly on the asset that is the most difficult for competitors to copy: cool."[8] Apple sold ten million units of the iPod product as of January 2005 not because it possessed superior hardware or a competitive price but because of its "yet-to-be-matched software and essential cool." Stross credits Apple's mastery of the "metaphysical mystery of cool" with its success as "the company that best knows how to meld hardware and software, the company embodied in the ecstatically happy hipster silhouette. The company that is, in a word, cool." Apple relies heavily on advertising to create this invaluable and inimitable commodity; the language and images of interfaces employed in media objects like online and print advertisements create an identity for a product that is itself about the consumption of media.

[ · · · ]

Similarly, *The Matrix* trilogy and *Minority Report* depict blackness as a decorative strategy in their digital epic narratives. The struggle over control and mastery of the interface and thus the digital world must end in the same way: with white hackers in control and black characters as marginal figures who bring "cool" with them. *The Matrix* trilogy's critique of whiteness situates user entitlement in relation to the computer interface as a highly visible and theatrical means by which masculinity and whiteness are allied with mastery over transparent interfaces. [ . . . ] Marginal blacks are literally in the margins of these images—witness to the digital image production that threatens to smudge the line between reality and virtuality. And for many critics, the contrast between the real and the virtual is the most important issue to consider in the films.[9]

However, this question cannot be considered without reference to the visual culture of computing that occupies every frame of these films. This visual culture, which contrasts black and white interface styles so strongly, insists that it is race that is real. In this way the process of new media as a cultural formation that produces race is obscured; instead race functions here as a way to visualize new media image production. What color are the bodies of those who will be making images using computer interfaces? And what color are those bodies who will be taking care of the bodies (and houses, yards, pets, and children) of those people who are jacked in, busy scrubbing, manipulating, buying, selling, and transmitting these images? Considerations of the racialized political economies of computer culture are inseparable from the ways in which we ought to read these texts. Postmillennial science fiction texts provide us with a plethora of images of race in relation to computing and interface culture, the scene of new media image production. In this representational economy, images of blacks serve as talismans to ward off the consuming power of the interface, whose transparent depths, like Narcissus's pool, threaten to fatally immerse its users.

*Minority Report* (2002), directed by Steven Spielberg, also dramatizes the scene of interface use and posits whites as uniquely privileged subjects of interactivity because of their transparent and thus privileged relations to the computer. However, *Minority Report* dramatizes the ways that the post-millennial social body has

become an object of surveillance via biometrics and crime databases. Networked digital imaging devices that perform retinal scans in public spaces like subways and department stores set in motion a web of state and commercial disciplinary mechanisms. While *The Matrix* is concerned with real versus unreal bodies, singular versus replicated bodies, *Minority Report* envisions the future regulation of the criminal body as the work of dataveillance, and the gradual interpellation of its white hero into this system's critique and destruction as part of a process of re-racialization that calls the notion of the "whole" or singularly racialized body into question. *Minority Report* was released in the same year as Stephen Frears's independent film *Dirty Pretty Things*, which is set in present-day London and concerns the doings of African and Turkish illegal immigrants who are involved in the world of organ harvesting and trafficking. The biotechnological revolution, part of the network economy that grew to maturity during the same period as the Internet did, has borne fruit in the world of *Minority Report*: human organs can be bought and sold using conventional credit cards, and there is a thriving black as well as white market in such commodities. It is when the technology of state-controlled vision extends into the organs of vision themselves that we can see the way that whiteness is also critiqued in this film, replaced with a resistant image of a transplanted, patched-together, socially marginal body that opposes itself to the dataveillant systems that demand, create, and control singular bodies. The social optics of race are hacked in this film, a film that posits a visual culture in which the act of seeing itself has become inseparable from the political economies of race, retailing, crime, and surveillance. Seeing is always seeing in relation to the state; attempts to break this deadlock result in the loss of all personhood, a condition under which one enters the dead space or alpha channel of sociality.

"Hello, Mr. Yakamoto! Welcome back to the Gap. How did those assorted tank tops work for you?" These words are addressed to policeman John Anderton, played by Tom Cruise, as he walks into a Gap store in the year 2054. The voice that pronounces them is a synthetic, digitized one that issues from a virtual greeter depicted on a large wall screen which has scanned his retinas to determine his identity. This episode, which occurs about halfway through the film, is one that the *New York Times* film critic Elvis Mitchell describes as "a laugh-producing sequence set in a Gap store." Mitchell says that "the movie is filled with fictional commercials and the onslaught is presented as intrusive; each has been geared to speak directly to the individual consumer." Indeed, the scene in which the character's eyes are read by the film's omnipresent retinal scanners and identified as belonging to "Mr. Yakamoto" is played for comedy. The joke is that John Anderton, a policeman on the run from the law after having been fingered by a trio of future-seeing mutants, or Precognitives, for a murder they predict he will commit, has had his eyes replaced to hide his identity from digital surveillance methods, and the sleazy black-market doctor who performed the work replaced his original eyes with a set of Asian eyes. The Gap's retinal scanners, initially employed to scan a person's identity so as to market commodities to them more precisely, reveal to Anderton what he himself could not know any other way: his eyes, obtained illegally from the "secondary market" in transplantable body parts, originally belonged to someone of a different race. The joke is on Anderton: as he walks away from the scanners, he mutters in disgust and disbelief, "Mr. Yakamoto!" Within the logic of the film, the doctor's implantation of

Asian eyes into the famous face of Tom Cruise is on the order of a prank. The doctor, who had previously been arrested by Anderton, is having his revenge.

Why is it funny that Tom Cruise should be identified as "Mr. Yakamoto"? This seemingly throwaway moment elegantly illustrates what Paul Gilroy calls the "crisis of raciology" engendered by the biotechnological revolution in tandem with digital image-processing technologies such as CGI, Photoshop, Final Cut Pro, and their progeny. As Gilroy writes: "Bodies may still be the most significant determinants in fixing the social optics of 'race,' but black bodies are now being seen—figured and imaged—differently."[10] Technologies of "figuring and imaging" race are central to the visual culture of race in *Minority Report*. Optical scanners matched to networked databases can "see" who you are and can figure out what to sell you, as in the case of the Gap episode. However, other digital imaging applications, such as the technology that enables the Precognitives to project their visions of who will commit which murders onto giant cinema screens in the Precrime company's "temple" brings to a mind another kind of computerized profiling that echoes the new social optics of race in America post 9/11: racial profiling. As the *Newsweek* critic David Ansen writes of Spielberg: "The director couldn't have known . . . how uncannily [this] tale of 2054 Washington D.C. would resonate in the current political climate, where our jails fill up with suspects who've been arrested for crimes they haven't yet committed."[11] The unprecedented access to the suspect's personal information, remote geographic imaging, and militarized rapid response combined with the Precognitives' visions allow the police to concatenate multiple sources of visual and textual information together to profile people who are about to commit murders and arrest them before they can do so, without needing to go through anything but a pro forma trial via videoconference in advance of the crime, but after watching the footage. In other words, it works exactly as does the juridico-legal system in an informational post-terror state.

"[Computers] simulate surveillance in the sense that they precede and redouble the means of observation. Computer profiling . . . is understood best not just as a technology of surveillance, but as a kind of *surveillance in advance of surveillance*, a technology of 'observation before the fact.'"[12] The narrative of inadvertent cross-racial passing that is so much a part of *Minority Report* is enabled by the replacement of the physical body by the databody as a subject (and product) of surveillance. The retinal scanners read Anderton as Yakamoto because they are keyed to databases that look only at his eyes and the information that they are linked to. The science fiction film *Gattaca* (1997) extends the notion of dataveillance to the level of the gene, positing a future in which humans are heavily genetically engineered.[13] In "Closely Belated? Thoughts on Real-Time Media Publics and *Minority Report*," Mark Williams draws connections between the film's handling of time and prediction through data profiling and what he terms "real time desire." *Minority Report*'s "belated thematics" or hypervaluation of mediated time shifting, as in the use of the personal video recorder or TiVo, is evident in the police's possession of "the capacity to allow one to 'freeze' the 'live' image, and then fast-forward through 'real time' to the now, and resynchronize with the 'live,' represent[ing] the newest wrinkle of temporal frenzy within mediated culture."[14] These scenes of mediated video manipulation are among the film's most telegenic and striking. The surveillance perspective most often seen in science fiction or techno-thriller films of the

nineties is the aerial shot from the "eye in the sky" or satellite, as shown in the film *Enemy of the State* (1998) and the television show *24* (2001–). *Minority Report* replaces the eye in the sky with surveillance images that are keyed to the deployment, scanning, and use of the eye itself, as photographed at ground level, as a means of data profiling and surveillance. Retinal scans determine what characters in *Minority Report* see in quite a literal way: just as grocery store checkout registers keep consumer purchases in a database to decide what kinds of coupons to print for customers, so too are advertisements in public spaces determined by past purchases. When the Gap virtual greeter asks Anderton how he liked "those assorted tank tops," it is querying Yakamoto's past purchases in order to decide where to direct his vision in the store. As Williams puts it, the "contemporary mediated public sphere" identifies Anderton through the use of optical biometrics, thus incorporating him into "the mobile, interactive consumerist public sphere, which is premised upon one's movement through a persistent 'now' of being hailed into recognition (as a consumer)." As Anderton is hailed by the Gap greeter as "Mr. Yakamoto," it is evident, however, that the modularity of body parts (which constitutes both a privilege and an act of utter desperation or brutality depending on one's position in the transaction) engenders a case of mistaken identity. Anderton has purchased a new identity by taking another person's eyes. There is an uncanny scene, unfathomably played for comedy in the film, in which Anderton saves his old eyes to use to fool the retinal scanner at Precrime into letting him into the building, and as he removes them from the dirty plastic bag in his pocket, he drops them and pursues them across a concrete floor as they roll toward a drain. As he manages to snatch one right before it disappears, his relief mirrors the exigencies of life in a dataveillant society, a life in which a citizen's claim to citizenship can roll down a drain. *Minority Report* depicts a datasociety in which a citizen's "profile" is that of either a consumer or a criminal, thus throwing into relief Kelly Oliver's conception of subjectivity as defined by ownership in the context of a market economy: "Subjects are capable of ownership, of having their own, of being 'ownness,' while those who are not capable of ownership become objects to be seen or not by propertied subjects."[15] When Anderton becomes a fugitive, he must adopt another citizen's identity to become a propertied subject who owns freedom of movement in the public sphere. While identity theft and identity hacking figure largely, this is not the crime that the film foresees—in this film, the racialized state is the thief, stealing the freedom and agency of large numbers of members of its underclass. Though the conceit of the film is that crime can be predicted through the use of mutants hooked up to powerful computers used by skilled interface operators, computer profiling is itself a "technology of observation before the fact," and like the Precogs, it can *only* see crime, not the future generally. Dataveillant technologies that profile users' engagements with consumer databases in effect predict what we will buy, and in the case of the preprinted coupons, turn that prediction into fact (users are much more likely to use coupons that they already own). Computing profiling or "surveillance in advance of surveillance" maps well onto the operations of our contemporary informational state, one that asserts its color blindness but continues to racially profile citizens and noncitizens, often with fatal results.

Indeed, one of the most remarkable aspects of *Minority Report* is the way in which it manages so effectively to evade direct discussion of race (reviewers of the

film in the popular press have failed to mention race in relation to the movie at all, though most noted that it performs a social critique of technology and advertising) in its discussion of criminal profiling, identity scanning and surveillance technologies, and political economies of labor and capital. It is as if the film itself were, like the title of Paul Gilroy's book, "against race" (though of course for much different reasons) in its effort to limn a future in which race is forcibly elided. However, the film is set in Washington, D.C., one of America's most multicultural cities, and one of the few where African Americans are a large and powerful political and cultural force. In the world of the film, murders predicted by the Precognitives are prevented by arresting their future perpetrators. They are "disappeared," as is a direct confrontation with the question of race in the film. However, race has been ported from the realm of the visible to the realm of vision itself: Cruise's black-market Asian eyes signify a specific set of concerns regarding the status of race in the biotechnological and technoscientific present and future. "Race" has literally become a networked commodity in this instance: Cruise buys these eyes with his credit card just before the operation. In addition, the significance of eyes in cyberpunk narrative, from *Blade Runner* on, gestures toward another convention of this most technoscientific of genres: the fetishization of the Orient as a signifier of the future.

As David Palumbo-Liu writes in *Asian/American*, the Asian eye with its distinctive epicanthic fold has long been seen as the defining feature of the Asian physiognomy: eyelid surgery to "correct" this feature is an example of the new "technologically driven malleability" of race.[16] *Minority Report* remolds race using a radical new form of surgery—total eye replacement—but to different ends. Endowing Tom Cruise with brown Asian eyes allows the film to hide race in plain sight, within the body of its hero. In addition, this move references the ways in which the "biotechnological revolution demands a change in our understanding of 'race,' species, embodiment, and human specificity," in Gilroy's words. One of his specific examples of this revolution's recasting of race is "the international and therefore necessarily 'transracial' trade in internal organs and other body parts for transplant, sometimes obtained by dubious means."[17] The anthropologist Nancy Scheper-Hughes observes the geopolitical racialization of the traffic in organs: "The flow of organs follows the modern routes of capital; from South to North, from Third to First World, from poor to rich, from black and brown to white, and from female to male."[18] As mentioned earlier, *Dirty Pretty Things*, released the same year as *Minority Report*, traces the chain of supply and demand for body parts through a network of misery, disenfranchisement, and terror concealed under the surface of official institutions such as London hotels, hospitals, apartment buildings, airports, and cab companies. The global demand for kidneys drives the exploitation of recently arrived immigrants by more established ones: the pressure to sell organs as a way to secure the lives and safety of distant relatives is impossible to resist, given the brutal economies of power and economic differentials in what Manuel Castells dubs the "Black Holes" produced by informational capitalism. These Black Holes are everywhere: rather than existing only in extremely informationally deprived places such as Africa, the informational economy that has created them ensures that they exist, though in more covert fashion, in global capitals as well.[19] Castells writes: "The rise of informationalism at the turn of the millennium is intertwined with rising inequality and social exclusion throughout the world."[20] The "rise" of a new category of persons under informational capitalism, a group that

Castells calls the Fourth World, is defined by the condition of being forced to sell the only thing that they have that is of even limited value in the informational economy, that is, their bodies. In a section titled "Why Children Are Wasted," Castells notes that while children have always been exploited, the network society and the "new geography of social exclusion" it produces has exacerbated their misery. Children are "ready-to-use, disposable labor . . . the last frontier of renewed over-exploitation under networked, global capitalism." And Castells is also very much of the opinion that race is not irrelevant in this scheme: "Racial discrimination and spatial segregation are still major factors in the formation/enforcement of ghettos as systems of social exclusion. But their effects take new meaning, and become increasingly devastating, under the conditions of informationalism."[21]

*Minority Report* takes up Castells's premise that the rise of informationalism has produced a Fourth World that sustains it, "populated by millions of homeless, incarcerated, prostituted, criminalized, brutalized, stigmatized, sick, and illiterate persons," and visualizes it as a narrative of detection. The Fourth World of *Minority Report* is composed of an underclass that includes drug addicts and their families, criminals, black-market doctors and organ traffickers, drug dealers, and other persons excluded from power and subjectivity in the informational economy. And just as Castells writes, their hidden labor and misery are both produced by and underwrite the glossy world that Anderton inhabits as a respected member of the police force and the possessor of a specialized skill in relation to the informational economy: he is a master of the Precrime imaging system that allows him to cut together, suture, composite, and manipulate images of crimes and interlink them with state databases that contain addresses, profiles, mug shots, and other personal information belonging to citizens. In some of the film's most telegenic sequences, Anderton uses gestural digital video editing technology to manipulate images of crimes shortly before they are about to occur. As he waves his arms and sweeps the images to and fro, "scrubbing the image," as one observer describes it, he asserts the primacy of *his* vision, and the power that computers and their operators have to make visual objects fungible, modular, and scalable. We, the viewer, see the images *as* he sees them: magnified, turned back in time, rotated several degrees, out of sequence, sutured, cut, pasted, and imported from other screens. Detection, always a visual trope, has literally become an act of computer-aided vision in this film, a kind of privileged seeing through postproduction. Like the Zion gate operator in *The Matrix*, Anderton is engaging in a transparent relationship with the interface that confirms his privilege in the racial landscape. Anderton has the privileged view that comes with a proprioceptive, immediate relationship to networked digital imaging. As Aylish Wood puts it: "In *Minority Report* the interaction of the detective with the images is distinct in that the haptic, or touch-based, dimension is absent."[22] While other characters slave over keyboards or peer through monoculars, like Anderton's black assistant, Jad, the detective enjoys an interactive, performative relationship to data images. Just as in the *Matrix* films, the male protagonist is gifted with the ability to move freely and directly into interfaces, in a performance of mastery and immediacy that circumvents the ordinary rules of input/output established by lesser users. Anderton and Anderson are superusers; as Tom Foster notes: "Neo becomes the only character who has a direct, unmediated relationship to the mediating structures and languages that allow the Matrix to exist. None of the other characters

possess this ability." Echoing the visual setup of *Minority Report*, Foster notes: "The [Matrix] films then define a new ideology of transparency, associated not with the unthinking acceptance of surface appearances, but with the ability to see through such realistic illusions. While immersion in the illusion naturalizes appearances, Neo's ability to perceive their constructedness naturalizes that ability as a function of the unaided critical faculties of the human mind, independent of any technological prosthesis or interface."[23] Wood argues that the scenes depicting the "detecting wall" are demonstrations of interactive media that have more in common with digital games, MUDs and MOOs, and other immersive environments that are more frequently studied. Indeed, if photography as a mode of identifying and categorizing criminals was characteristic of the early twentieth century's efforts to regulate "the new world of mobility and rapid circulation . . . in which signs of class and occupation have moved below the threshold of immediately recognized conventional signs to reach the level of unintentional—and often unrecognized—symptoms," we can assert that interactive digital surveillance video functions in a similar way at the turn of our own century. Tom Gunning's brilliant essay "Tracing the Visible Body: Photography, Detectives, and Early Cinema" explains the ways in which photography became part of a complex of identifying techniques that "became necessary in the new world of rapid circulation" and helped to create "an archive of information on individuals which became the basic tool for the assertion of control in modern society."[24] The assertion of control in network society involves privileged, transparent interfaced relations to immersive digital environments. This hypervaluation of the transparent is echoed in the visual setup of *Minority Report*. As Wood notes: "The plastic boxes of computers and plasma or tube-screens familiar from the late twentieth and early twenty-first century have given way to clear Perspex curves and flat screens on which the image is visible from either side,"[25] and the filmmakers' use of bypass bleaching, choice of camera lens, film stock, and post-production manipulation result in a visual field that appears cool, silvery, washed-out, desaturated, and colorless. This seems particularly appropriate in a film with an extremely occluded relation to racial politics and its place in dataveillant societies.

Anderton's performances at the interactive detecting wall strongly mirror another much-commented-on scene in *Blade Runner*, one of several resonances between the two films. In the scene in which Deckard uses an Esper imaging computer to see into a photograph he has taken from a replicant, he manipulates the image by orally instructing the computer to "pan right, magnify, stop," and so on. Both characters are engaging with the computer by means other than through a hardware interface: Deckard uses voice recognition, a technique that hails the computer as an interlocutor, and Anderton and the Zion gate operator use gesture, a performative and proprioceptive means of command and control. And in addition, both are engaging in digital image processing and enhancement as a way to "see" or detect the truth about a crime. Both *Blade Runner* and *Minority Report* begin with extreme close-up shots of eyes, and as Kaja Silverman writes of *Blade Runner*: "However, if the opening shots work in an anticipatory way to break down the dichotomy between replicants and humans by focusing on an eye which could represent either, it is because that organ represents precisely the site at which difference is ostensibly discernible within the world of *Blade Runner*."[26] *Minority Report*'s ubiquitous shots of eyes being scanned in shopping malls, subways, housing projects, and workplaces expands this notion of

retinal surveillance to the public sphere in its entirety. The eye becomes the sole sig-nifier of identity in this panoptic future. Hence the positioning of Anderton's eye as an Asian one allows the notion of hybrid forms of subjectivity to come into play. Far from the celebratory mestiza subject of Gloria Anzaldúa's writings, however, this one comes from a lack of empathy rather than a plurality of it—Anderton only needs to take the position of the raced, hunted, marginalized person of color into account, he only needs to really see it, at the moment that he begins his new life as a fugitive from justice. Hence cyberculture enables a privileged view of image and race as code and takes it away: the same computers that allow Anderton to "scrub" the image make him permanently vulnerable to their surveillance. This unprecedented vulnerabil-ity to techno-surveillance is, however, part of what it means to be a person of color in the "integrated circuit," to use Haraway's eloquent formulation. Donna Haraway and Paul Gilroy both strongly insist on the revisioning of race as code, genome, and restlessly interrogate this system: the visuality of race has retreated from pencil tests, paper bag tests, and other naked-eye optical assessments and now resides in acro-nyms like ART, DNA, IVF, and HGP.[27] The primacy of vision reigns unchallenged but only on a level so microscopic that only machines can "see" it.

[ · · · ]

This type of hybrid identity enabled by the literal incorporation of differently raced genetic material by a consuming Western subject presents a distinctively technoscientific solution to the "problem" of miscegenation. Miscegenation has long been figured as a colonial solution to the problem of the Other; as Benedict Anderson writes, "liberal" colonists in the early nineteenth century such as Pedro Fermin de Vargas believed that "the Indian is ultimately redeemable—by impregnation with white, 'civilized' semen, and the acquisition of private property, like everyone else (how different Fermin's attitude is from the later European imperialist's prefer-ence for 'genuine' Malays, Gurkhas, and Hausas over 'half breeds,' 'semi educated natives,' 'wogs,' and the like)."[28] In *Minority Report*, Asian Americans cannot be visu-ally assimilated into mainstream culture, as they will always look different and thus be visually profiled differently from "real" Americans, so they are assimilated as instruments or commodities of vision. This formulation goes beyond a convenient pun, for the trope of vision in the context of techno-science and film is central, and in ways that are currently under revision as genomic means of understanding the body and the digital production of film replace older paradigms. Both race and the media image are being configured as code or "information" at the same historical moment, which makes them both subject to a new logic of transcoding.[29]

The last scene of *Minority Report* shows us a tableau of Anderton reunited with his formerly estranged and now pregnant wife as they gaze out a window at the rain from their cozy apartment. Though reinstated in the police force and in his family, he still has Yakamoto's eyes, a souvenir of his sojourn in the Fourth World. His own eyes are gone. If, as Oliver writes, only "the self-possessed enjoy the sense of entitlement to exercise control over themselves and their bodies," and "the notion of self-possession takes on new meaning when bodies and body parts can be bought and sold on the market,"[30] Anderton has literally redeemed himself by assuming control of his data-body. There are associated losses, for after purchasing Yakamoto's eyes, he is never again depicted using the gestural Precrime interface. Precrime has been shut down

and the Precogs freed, but more importantly, Anderton's integration with the Fourth World, however temporary, has precluded an engagement with informational white privilege in the context of the police state. He cannot engage with the interface as a superuser with Asian eyes, and in the eyes of the dataveillant state he will always be "Yakamoto." He is, however, shown as having gained another sort of potency; in impregnating his wife, he is replacing the lost child, a boy, whose death he mourns throughout most of the film. Reproductive ability stands in to replace the masculine power that has been lost by his alienation from privileged scenes of interface use.

When the Precrime system is first described in the film, within its first half hour, we are also told that the ACLU opposes it. The digital visual culture of race in these popular visual narratives figures the digital image as scrubbable, manipulable, and mobile in ways and by means that encourage assessments of power relations regarding interface use. Rather than focusing mainly on the role of racialized digital content, these narratives urge us to consider the contexts of image exhibition, preparation, and consumption and how these contexts reflect racialized positions. Information machines are the sole means of vision in digital visual culture, but as the body itself becomes socially defined and handled as information, there is even more at stake in paying attention to the incursions of machines in everyday life and the forms of resistance available to us.

## NOTES

1. Thacker, *Biomedia*, 8.
2. See Nelson, "Introduction: Future Texts," for an excellent description of Afro-futurism.
3. Ebert, "*The Matrix Reloaded*."
4. Scott, "*The Matrix: Revolutions*."
5. The Apple iPod advertisements were created by Chiat/Day. The photoshopsupport.com Web site features a tutorial that instructs users how to use the application to create their own iPod-style images. The article, titled "I See Ipod People: The Photoshop Silhouette," explains that "if you're crazy about those ipod ads and want to make one yourself, it's actually pretty easy." See http://www.photoshopsupport.com/tutorials/jennifer/ipod.html.
6. Manovich, *The Language of New Media*, 77.
7. Springer, "Playing It Cool in the Matrix," 91; Alexander, "Cool like Me," 49.
8. Stross, "After 20 years, Finally Capitalizing on Cool." See also Liu, *The Laws of Cool*, on the intimate association of "cool" with digital networked technologies: "Cool is (and is not) an ethos, style, feeling and politics of information" (179).
9. See Shaviro, *Connected*, and Pisters, *The Matrix of Visual Culture*, for examples of this type of critique.
10. Gilroy, *Against Race*, 23.
11. Ansen, "Murder on the Spielberg Express."
12. Elmer, *Profiling Machines*, 73 (italics mine).
13. See Matrix, *Cyberpop*, for an incisive reading on the ways in which *Gattaca* comments on racial identity in relation to biometrics, passing, and genetic engineering.
14. Mark Williams, "Closely Belated?"
15. Oliver, *Witnessing*, 151.
16. Palumbo-Liu, *Asian/American*, 93.
17. Gilroy, *Against Race*, 19.

18. Scheper-Hughes, "The Global Traffic in Human Organs," 193. Fears that traffic in human organs will reflect geopolitical power imbalances and perpetuate racism have been evident in literature such as the work of the Ghanaian novelist and theorist Ama Ata Aidoo since the 1970s. In *Our Sister Killjoy*, Aidoo confronts techno-utopians by writing: "Anyway, the Christian Doctor has himself said that in his glorious country, niggerhearts are so easy to come by. . . . Yet she had to confess she still had not managed to come round to seeing Kunle's point: that cleaning the Baas's chest of its rotten heart and plugging in a brand-new, palpitatingly warm kaffirheart, is the surest way to usher in the Kaffirmillennium" (100–101).

19. See Sassen, *Globalization and Its Discontents*.

20. Castells, *End of Millennium*, 68.

21. Ibid.

22. Wood, "The Metaphysical Fabric That Binds Us," 11.

23. Foster, "The Transparency of the Interface," 70.

24. Gunning, "Tracing the Individual Body," 29.

25. Wood, "The Metaphysical Fabric That Binds Us," 9.

26. Silverman, "Back to the Future," 111.

27. Advanced reproductive technology (ART), in vitro fertilization (IVF), and the Human Genome Project (HGP). The pencil test and the paper bag test both employ everyday household objects to classify people based on phenotype. In the American South, an African American with a skin tone lighter than a brown paper grocery bag was considered "light" enough to participate in privileged social groups and activities, and in South Africa, the admixture of "black blood" was judged partially by whether a person's hair would cling to a pencil if wound around it or would spring away from it. Haraway is seldom cited as a critic on the topic of race despite her long-standing and very public discussion of such matters in the "The Cyborg Manifesto," a foundational text for cyberculture studies, and in *Modest_Witness*, which contains a whole chapter on race and technoscience. Conversely, Gilroy is rarely noted as a commentator on cyberculture and network society despite his intense interest in it as a driving force behind the crisis in raciology.

28. Anderson, *Imagined Communities*, 13.

29. See Manovich, *The Language of New Media*, 46; and also see Manovich, "Image after *The Matrix*," for a longer discussion of the ways that digital film production, as exemplified by techniques used in the *Matrix* films, is built on a radically different "base" from analog film; while its "surface" appears photographic in the same way that viewers are used to, the structure of the image itself is coded and informationally formatted for optimal modularity and compositing, rather than being all of a piece or continuous like an analog image.

30. Oliver, *Witnessing*, 153.

## BIBLIOGRAPHY

Anderson, Benedict. *Imagined Communities*. London; Verso, 1991.

Ansen, David. "Murder on the Spielberg Express." *Newsweek*, July 1, 2002. http://www.msnbc.com/news/841231.asp=BODY (accessed February 5, 2003).

Castells, Manuel. *End of Millennium*. 2nd ed. Malden, Mass.: Blackwell, 2000.

Ebert, Roger. "The Matrix Reloaded." *Chicago Sun-Times*, May 14, 2003.

Elmer, Greg. *Profiling Machines: Mapping the Personal Information Economy*. Cambridge: MIT Press, 2004.

Foster, Tom. "The Transparency of the Interface: Reality Hacking and Fantasies of Resistance." In *The Matrix Trilogy: Cyberpunk Reloaded*, ed. Stacy Gillis. London: Wallflower Press, 2005.

Gilroy, Paul. *Against Race: Imagining Political Culture beyond the Color Line.* Cambridge: Belknap Press, 2000.

Gunning, Tom. "Tracing the Individual Body: Photography, Detectives, and Early Cinema." In *Cinema and the Invention of Modern Life,* ed. Leo Charney and Vanessa R. Schwartz, 15–45. Berkeley: University of California Press, 1995.

Manovich, Lev. "Image after *The Matrix.*" http://www.manovich.net (accessed July 5, 2005).

———. *The Language of New Media.* Cambridge: MIT Press, 2001.

Nelson, Alondra. "Introduction: Future Texts." *Social Text* 20, no. 2 (2002): 1–15.

Oliver, Kelly. *Witnessing: Beyond Recognition.* Minneapolis: University of Minnesota Press, 2001.

Palumbo-Liu, David. *Asian/American: Historical Crossings of a Racial Frontier.* Stanford, Calif.: Stanford University Press, 1999.

Pisters, Patricia. *The Matrix of Visual Culture: Working with Deleuze in Film Theory.* Stanford, Calif.: Stanford University Press, 1999.

Sassen, Saskia. *Globalization and Its Discontents: Essays on the New Mobility of People and Money.* New York: New Press, 1998.

Scheper-Hughes, Nancy. "The Global Traffic in Human Organs." *Current Anthropology* 41, no. 2 (2000) 191–221.

Shaviro, Steven. *Connected; or, What It Means to Live in Network Society.* Electronic Mediations, vol. 9. Minneapolis: University of Minnesota Press, 2003.

Silverman, Kaja. "Back to the Future." *Camera Obscura,* no. 27 (September 1991): 109–32.

Springer, Claudia. "Playing It Cool in the Matrix." In *The Matrix Trilogy: Cyberpunk Reloaded,* ed. Stacy Gillis, 89–100. London: Wallflower Press, 2005.

Stross, Randall. "After 20 Years, Finally Capitalizing on Cool." *New York Times,* January 16, 2005, B5.

Thacker, Eugene. *Biomedia.* Minneapolis: University of Minnesota Press, 2004.

Williams, Mark. "Closely Belated? Thoughts on Real-Time Media Publics and *Minority Report.*" Paper presented at the Futures of American Studies Institute, Dartmouth College, 2004.

Wood, Aylish. "'The Metaphysical Fabric That Binds Us': Proprioceptive Coherence and Performative Space in *Minority Report.*" *New Review of Film and Television Studies* 2, no. 1 (2004): 1–18.

# LEV MANOVICH

## What Is Digital Cinema?

Born in Moscow, Russia, in 1960, Lev Manovich studied fine arts, architecture, and computer programming. After moving to the United States in 1981, he became Professor in the Visual Arts Department at the University of California, San Diego, and director of the Software Studies Initiative at California Institute for Telecommunications and Information Technology. He is the author of several books, including *Software Takes Command* (2008),

*Black Box—White Cube* (2001), and *The Language of New Media* (2001). In addition, Manovich works as a computer media artist, programmer, designer, and animator—his works have been presented at the Walker Art Center, Centre Pompidou in Paris, and the Institute of Contemporary Arts (ICA) in London. He has been the recipient of fellowships from the National Endowment for the Arts, the Guggenheim Foundation, the Mellon Foundation, and other organizations.

Manovich is one of the earliest and most recognized spokespersons for the so-called digital revolution that defined film and media culture of the 1990s and 2000s. During this period, the transition from celluloid and analog videotape began to change not only how films and other media products are made but, equally importantly, how they are seen by audiences. Many of these changes can be seen in the production process of animated films of the period, such as *Beauty and the Beast* (1991), *Aladdin* (1992), *The Lion King* (1994), and especially in *Toy Story* (1995), the first feature film released that used only computer-generated imagery. Digital technologies would also play a key role in more traditional blockbuster narratives of the period, such as the celebrated experiments with image manipulation in *The Matrix* (1999), *The Lord of the Rings: The Fellowship of the Ring* (2001), and *Sin City* (2005).

In "What Is Digital Cinema?" (2002), Manovich is less interested in the interactivity that other theorists, such as Lawrence Lessig (p. 1083), see as the heart of digital media than in the way digital representation challenges live-action narrative, that foundation of traditional movies. For Manovich, digital cinema has the power to overthrow film's reliance on live action and its physical relationship to reality through the vast resources of computer-generated imagery that can create imaginative new worlds. With some historical irony, Manovich sees the digital transformation of cinema as a return to its roots in the nineteenth and early twentieth century when pre-cinematic toys, early movies, and later avant-garde films drew attention to the material manipulation of the image. Like these early image machines, digital films now do not simply record physical realities but also re-create and transform different realities, so that special effects, in the broadest sense, become the norm for movies. Manovich's essay obviously overlaps with those of other writers about the contemporary digital revolution, including Alexander Galloway (p. 1070), but it is also useful to consider his claims for the digital alongside other theoreticians, such as Dziga Vertov (p. 257), André Bazin (p. 309), and Cesare Zavattini (p. 915), who argue for new forms of realism made available through the cinema.

## READING CUES & KEY CONCEPTS

■ What does Manovich mean when he calls the linking of digital cinema with much earlier forms of filmmaking a return to "the repressed of the cinema"?

■ How, according to Manovich, has digital cinema changed the relationship between production and postproduction in filmmaking?

■ What is the relationship between digital filmmaking and painting? Can you cite a recent film that seems to take advantage of this "painterly" connection?

■ **Key Concepts:** Indexicality; Automatic Projection; Animation; Elastic Reality; Avant-Garde; Kino-Brush

# What Is Digital Cinema?

. . . . . . . . . . . . . .

## Cinema, the Art of the Index

Most discussions of cinema in the computer age have focused on the possibilities of interactive narrative. It is not hard to understand why: since the majority of viewers and critics equate cinema with storytelling, computer media is understood as something which will let cinema tell its stories in a new way. Yet as exciting as the ideas of a viewer participating in a story, choosing different paths through the narrative space and interacting with characters may be, they only address one aspect of cinema which is neither unique nor, as many will argue, essential to it: narrative.

The challenge which computer media poses to cinema extends far beyond the issue of narrative. Computer media redefines the very identity of cinema. In a symposium which took place in Hollywood in the spring of 1996, one of the participants provocatively referred to movies as "flatties" and to human actors as "organics" and "soft fuzzies."[1] As these terms accurately suggest, what used to be cinema's defining characteristics have become just the default options, with many others available. When one can "enter" a virtual three-dimensional space, to view flat images projected on the screen is hardly the only option. When, given enough time and money, almost everything can be simulated in a computer, to film physical reality is just one possibility.

This "crisis" of cinema's identity also affects the terms and the categories used to theorize cinema's past. The French film theorist Christian Metz wrote in the 1970s that "Most films shot today, good or bad, original or not, 'commercial' or not, have as a common characteristic that they tell a story; in this measure they all belong to one and the same genre, which is, rather, a sort of 'super-genre' ['sur-genre']."[2] In identifying fictional films as a "super-genre" of twentieth-century cinema, Metz did not bother to mention another characteristic of this genre because at that time it was too obvious: fictional films are *live action* films, i.e. they largely consist of unmodified photographic recordings of real events which took place in real physical space. Today, in the age of photorealistic 3D computer animation and digital compositing, invoking this characteristic becomes crucial in defining the specificity of twentieth-century cinema. From the perspective of a future historian of visual culture, the differences between classical Hollywood films, European art films and avant-garde films (apart from abstract ones) may appear to have less significance than this common feature: that they relied on lens-based recordings of reality. This chapter is concerned with the effect of computerization on cinema as defined by its "super genre" as fictional live action film.[3]

During cinema's history, a whole repertoire of techniques (lighting, art direction, the use of different film stocks and lenses, etc.) was developed to modify the basic record obtained by a film apparatus. And yet behind even the most stylized cinematic images we can discern the bluntness, the sterility, the banality of early nineteenth-century photographs. No matter how complex its stylistic innovations, the cinema has found its base in these deposits of reality, these samples obtained by a methodical and prosaic process. Cinema emerged out of the same impulse which engendered naturalism, court stenography and wax museums. Cinema is the art of the index; it is an attempt to make art out of a footprint.

Even for the director Andrei Tarkovsky, film-painter par excellence, cinema's identity lay in its ability to record reality. Once, during a public discussion in Moscow sometime in the 1970s, he was asked whether he was interested in making abstract films. He replied that there can be no such thing. Cinema's most basic gesture is to open the shutter and to start the film rolling, recording whatever happens to be in front of the lens. For Tarkovsky, an abstract cinema is thus impossible.

But what happens to cinema's indexical identity if it is now possible to generate photorealistic scenes entirely in a computer using 3D computer animation; to modify individual frames or whole scenes with the help of a digital paint program; to cut, bend, stretch and stitch digitized film images into something which has perfect photographic credibility, although it was never actually filmed?

This article will address the meaning of these changes in the film-making process from the point of view of the larger cultural history of the moving image. Seen in this context, the manual construction of images in digital cinema represents a return to nineteenth-century pre-cinematic practices, when images were hand-painted and hand-animated. At the turn of the twentieth century, cinema was to delegate these manual techniques to animation and define itself as a recording medium. As cinema enters the digital age, these techniques are again becoming the commonplace in the film-making process. Consequently, cinema can no longer be clearly distinguished from animation. It is no longer an indexical media technology but, rather, a subgenre of painting.

This argument will be developed in two stages. I will first follow a historical trajectory from nineteenth-century techniques for creating moving images to twentieth-century cinema and animation. Next I will arrive at a definition of digital cinema by abstracting the common features and interface metaphors of a variety of computer software and hardware which are currently replacing traditional film technology. Seen together, these features and metaphors suggest a distinct logic of a digital moving image. This logic subordinates the photographic and the cinematic to the painterly and the graphic, destroying cinema's identity as a media art.

## A Brief Archaeology of Moving Pictures

As testified by its original names (kinetoscope, cinematograph, moving pictures), cinema was understood, from its birth, as the art of motion, the art which finally succeeded in creating a convincing illusion of dynamic reality. If we approach cinema in this way (rather than the art of audio-visual narrative, or the art of a projected image, or the art of collective spectatorship, etc.), we can see it superseding previous techniques for creating and displaying moving images.

These earlier techniques shared a number of common characteristics. First, they all relied on hand-painted or hand-drawn images. The magic lantern slides were painted at least until the 1850s; so were the images used in the Phenakistoscope, the Thaumatrope, the Zootrope, the Praxinoscope, the Choreutoscope and numerous other nineteenth-century pro-cinematic devices. Even Muybridge's celebrated Zoopraxiscope lectures of the 1880s featured not actual photographs but colored drawings painted after the photographs.[4]

Not only were the images created manually, they were also manually animated. In Robertson's Phantasmagoria, which premiered in 1799, magic lantern operators

moved behind the screen in order to make projected images appear to advance and withdraw.[5] More often, an exhibitor used only his hands, rather than his whole body, to put the images into motion. One animation technique involved using mechanical slides consisting of a number of layers. An exhibitor would slide the layers to animate the image.[6] Another technique was slowly to move a long slide containing separate images in front of a magic lantern lens. Nineteenth century optical toys enjoyed in private homes also required manual action to create movement—twirling the strings of the Thaumatrope, rotating the Zootrope's cylinder, turning the Viviscope's handle.

It was not until the last decade of the nineteenth century that the automatic generation of images and their automatic projection were finally combined. A mechanical eye became coupled with a mechanical heart; photography met the motor. As a result, cinema—a very particular regime of the visible—was born. Irregularity, non-uniformity, the accident and other traces of the human body, which previously inevitably accompanied moving image exhibitions, were replaced by the uniformity of machine vision.[7] A machine which, like a conveyer belt, was now spitting out images, all sharing the same appearance, all the same size, all moving at the same speed, like a line of marching soldiers.

Cinema also eliminated the discrete character of both space and movement in moving images. Before cinema, the moving element was visually separated from the static background as with a mechanical slide show or Raynaud's Praxinoscope Theater (1892).[8] The movement itself was limited in range and affected only a clearly defined figure rather than the whole image. Thus, typical actions would include a bouncing ball, a raised hand or eyes, a butterfly moving back and forth over the heads of fascinated children—simple vectors charted across still fields.

Cinema's most immediate predecessors share something else. As the nineteenth-century obsession with movement intensified, devices which could animate more than just a few images became increasingly popular. All of them—the Zootrope, the Phonoscope, the Tachyscope, the Kinetoscope—were based on loops, sequences of images featuring complete actions which can be played repeatedly. The Thaumatrope (1825), in which a disk with two different images painted on each face was rapidly rotated by twirling a string attached to it, was in its essence a loop in its most minimal form: two elements replacing one another in succession. In the Zootrope (1867) and its numerous variations, approximately a dozen images were arranged around the perimeter of a circle.[9] The Mutoscope, popular in America throughout the 1890s, increased the duration of the loop by placing a larger number of images radially on an axle.[10] Even Edison's Kinetoscope (1892–6), the first modern cinematic machine to employ film, continued to arrange images in a loop.[11] Fifty feet of film translated to an approximately twenty-second-long presentation—a genre whose potential development was cut short when cinema adopted a much longer narrative form.

## From Animation to Cinema

Once the cinema was stabilized as a technology, it cut all references to its origins in artifice. Everything which characterized moving pictures before the twentieth century—the manual construction of images, loop actions, the discrete nature of space and movement—all of this was delegated to cinema's bastard relative, its supplement, its shadow—animation. Twentieth-century animation became a depository for nineteenth-century moving image techniques left behind by cinema.

The opposition between the styles of animation and cinema defined the culture of the moving image in the twentieth century. Animation foregrounds its artificial character, openly admitting that its images are mere representations. Its visual language is more aligned to the graphic than to the photographic. It is discrete and self-consciously discontinuous: crudely rendered characters moving against a stationary and detailed background; sparsely and irregularly sampled motion (in contrast to the uniform sampling of motion by a film camera—recall Jean-Luc Godard's definition of cinema as "truth 24 frames per second"), and finally space constructed from separate image layers.

In contrast, cinema works hard to erase any traces of its own production process, including any indication that the images which we see could have been constructed rather than recorded. It denies that the reality it shows often does not exist outside of the film image, the image which was arrived at by photographing an already impossible space, itself put together with the use of models, mirrors, and matte paintings, and which was then combined with other images through optical printing. It pretends to be a simple recording of an already existing reality—both to a viewer and to itself.[12] Cinema's public image stressed the aura of reality "captured" on film, thus implying that cinema was about photographing what existed before the camera, rather than "creating the 'never-was'" of special effects.[13] Rear projection and blue screen photography, matte paintings and glass shots, mirrors and miniatures, push development, optical effects and other techniques which allowed film-makers to construct and alter the moving images, and thus could reveal that cinema was not really different from animation, were pushed to cinema's periphery by its practitioners, historians and critics.[14]

In the 1990s, with the shift to computer media, these marginalized techniques moved to the center.

## Cinema Redefined

A visible sign of this shift is the new role which computer-generated special effects have come to play in Hollywood industry in the 1990s. Many blockbusters have been driven by special effects, feeding on their popularity. Hollywood has even created a new mini-genre of "The Making of . . . " videos and books which reveal how special effects are created.

I will use special effects from 1990s Hollywood films to illustrate some of the possibilities of digital film-making. Until recently, only Hollywood studios had the money to pay for digital tools and for the labor involved in producing digital effects. However, the shift to digital media affects not just Hollywood, but film-making as a whole. As traditional film technology is universally being replaced by digital technology, the logic of the film-making process is being redefined. What I describe below are the new principles of digital film-making which are equally valid for individual or collective film productions, regardless of whether they are using the most expensive professional hardware and software or its amateur equivalents.

Consider, then, the following principles of digital filmmaking:

1. Rather than filming physical reality, it is now possible to generate film-like scenes directly in a computer with the help of 3D computer animation. Therefore, live action footage is displaced from its role as the only possible material from which the finished film is constructed.

2. Once live action footage is digitized (or directly recorded in a digital format), it loses its privileged indexical relationship to pro-filmic reality. The computer does not distinguish between an image obtained through the photographic lens, an image created in a paint program or an image synthesized in a 3D graphics package, since they are made from the same material—pixels. And pixels, regardless of their origin, can be easily altered, substituted one for another, and so on. Live action footage is reduced to be just another graphic, no different from images created manually.[15]

3. If live action footage was left intact in traditional film-making, now it functions as raw material for further compositing, animating and morphing. As a result, while retaining visual realism unique to the photographic process, film obtains the plasticity which was previously only possible in painting or animation. To use the suggestive title of a popular morphing software, digital film-makers work with "elastic reality." For example, the opening shot of *Forrest Gump* (Robert Zemeckis, Paramount Pictures, 1994; special effects by Industrial Light and Magic) tracks an unusually long and extremely intricate flight of a feather. To create the shot, the real feather was filmed against a blue background in different positions; this material was then animated and composited against shots of a landscape.[16] The result: a new kind of realism, which can be described as "something which is intended to look exactly as if it could have happened, although it really could not."

4. Previously, editing and special effects were strictly separate activities. An editor worked on ordering sequences of images together; any intervention within an image was handled by special effects specialists. The computer collapses this distinction. The manipulation of individual images via a paint program or algorithmic image processing becomes as easy as arranging sequences of images in time. Both simply involve "cut and paste." As this basic computer command exemplifies, modification of digital images (or other digitized data) is not sensitive to distinctions of time and space or of differences of scale. So, re-ordering sequences of images in time, compositing them together in space, modifying parts of an individual image, and changing individual pixels become the same operation, conceptually and practically.

Given the preceding principles, we can define digital film in this way:

$$\text{digital film} = \text{live action material} + \text{painting} + \text{image processing} +$$
$$\text{compositing} + \text{2D computer animation} + \text{3D computer}$$
$$\text{animation}$$

Live action material can either be recorded on film or video or directly in a digital format.[17] Painting, image processing and computer animation refer to the processes of modifying already existent images as well as creating new ones. In fact, the very distinction between creation and modification, so clear in film-based media (shooting versus darkroom processes in photography, production versus post-production in cinema) no longer applies to digital cinema, since each image, regardless of its origin, goes through a number of programs before making it to the final film.[18]

Let us summarize these principles. Live action footage is now only raw material to be manipulated by hand: animated, combined with 3D computer-generated

scenes and painted over. The final images are constructed manually from different elements; and all the elements are either created entirely from scratch or modified by hand. Now we can finally answer the question "What is digital cinema?" *Digital cinema is a particular case of animation which uses live action footage as one of its many elements.*

This can be reread in view of the history of the moving image sketched earlier. Manual construction and animation of images gave birth to cinema and slipped into the margins . . . only to reappear as the foundation of digital cinema. The history of the moving image thus makes a full circle. *Born from animation, cinema pushed animation to its boundary, only to become one particular case of animation in the end.*

The relationship between "normal" film-making and special effects is similarly reversed. Special effects, which involved human intervention into machine recorded footage and which were therefore delegated to cinema's periphery throughout its history, become the norm of digital film-making.

The same logic applies for the relationship between production and post-production. Cinema traditionally involved arranging physical reality to be filmed through the use of sets, models, art direction, cinematography, etc. Occasional manipulation of recorded film (for instance, through optical printing) was negligible compared to the extensive manipulation of reality in front of a camera. In digital film-making, shot footage is no longer the final point but just raw material to be manipulated in a computer where the real construction of a scene will take place. In short, the production becomes just the first stage of post-production.

The following example illustrates this new relationship between different stages of the film-making process. Traditional on-set filming for *Stars Wars: Episode I—The Phantom Menace* (George Lucas, 1999) was done in just sixty-five days. The post-production, however, stretched over two years, since 95 percent of the film (approximately 2,000 shots out of the total 2,200) was constructed on a computer.[19]

Here are two more examples further to illustrate the shift from re-arranging reality to re-arranging its images. From the analog era: for a scene in *Zabriskie Point* (1970), Michelangelo Antonioni, trying to achieve a particularly saturated color, ordered a field of grass to be painted. From the digital era: to create the launch sequence in *Apollo 13* (Universal Studios, 1995; special effects by Digital Domain), the crew shot footage at the original location of the launch at Cape Canaveral. The artists at Digital Domain scanned the film and altered it on computer workstations, removing recent building construction, adding grass to the launch pad and painting the skies to make them more dramatic. This altered film was then mapped onto 3D planes to create a virtual set which was animated to match a 180-degree dolly movement of a camera following a rising rocket.[20]

The last example brings us to another conceptualization of digital cinema—as painting. In his book-length study of digital photography, William J. Mitchell focuses our attention on what he calls the inherent mutability of a digital image: "The essential characteristic of digital information is that it can be manipulated easily and very rapidly by computer. It is simply a matter of substituting new digits for old. . . . Computational tools for transforming, combining, altering, and analyzing images are as essential to the digital artist as brushes and pigments to a painter."[21] As Mitchell points out, this inherent mutability erases the difference between a photograph and a painting. Since a film is a series of photographs, it is appropriate to extend

Mitchell's argument to digital film. With an artist being able easily to manipulate digitized footage either as a whole or frame by frame, a film in a general sense becomes a series of paintings.[22]

Hand-painting digitized film frames, made possible by a computer, is probably the most dramatic example of the new status of cinema. No longer strictly locked in the photographic, it opens itself towards the painterly. It is also the most obvious example of the return of cinema to its nineteenth-century origins—in this case, to hand-crafted images of magic lantern slides, the Phenakistoscope, the Zootrope.

We usually think of computerization as automation, but here the result is the reverse: what was previously automatically recorded by a camera now has to be painted one frame at a time. But not just a dozen images, as in the nineteenth century, but thousands and thousands. We can draw another parallel with the practice, common in the early days of silent cinema, of manually tinting film frames in different colors according to a scene's mood.[23] Today, some of the most visually sophisticated digital effects are often achieved using the same simple method: painstakingly altering by hand thousands of frames. The frames are painted over either to create mattes ("hand-drawn matte extraction") or to directly change the images, as, for instance, in *Forrest Gump*, where President Kennedy was made to speak new sentences by altering the shape of his lips, one frame at a time.[24] In principle, given enough time and money, one can create what will be the ultimate digital film: ninety minutes, i.e., 129,600 frames, completely painted by hand from scratch, but indistinguishable in appearance from live photography.

The concept of digital cinema as painting can be also developed in a different way. I would like to compare the shift from analog to digital film-making to the shift from fresco and tempera to oil painting in the early Renaissance. A painter making fresco has limited time before the paint dries; and once it is dried, no further changes to the image are possible. Similarly, a traditional film-maker has limited means to modify images once they are recorded on film. In the case of medieval tempera painting, this can be compared to the practice of special effects during the analog period of cinema. A painter working with tempera could modify and rework the image, but the process was quite painstaking and slow. Medieval and early Renaissance masters would spend up to six months on a painting a few inches tall. The switch to oils greatly liberated painters by allowing them to quickly create much larger compositions (think, for instance, of the works by Veronese and Titian) as well as to modify them as long as necessary. This change in painting technology led the Renaissance painters to create new kinds of compositions, new pictorial space and even narratives. Similarly, by allowing a film-maker to treat a film image as an oil painting, digital technology redefines what can be done with cinema.

If digital compositing and digital painting can be thought of as an extension of the cell animation techniques (since composited images are stacked in depth parallel to each other, as cells on an animation stand), the newer method of computer-based post-production makes film-making a subset of animation in a different way. In this method the live action, photographic stills and/or graphic elements are positioned in a 3D virtual space. This gives the director the ability freely to move the virtual camera through this space, dollying and panning. Thus cinematography is subordinated to 3D computer animation. We may think of this method as an extension of multiplane animation camera. However, if the camera mounted over a multiplane stand

could only move perpendicularly to the images, now it can move in an arbitrary trajectory. The example of a commercial film which relies on this newer method which one day may become the standard of film-making (because it gives the director most flexibility) is Disney's *Aladdin*; the example of an independent work which fully explores the new aesthetic possibilities of this method without subordinating it to the traditional cinematic realism is *The Forest* by Tamas Waliczky (1994).

The reader who followed my analysis of the new possibilities of digital cinema may wonder why I have stressed the parallels between digital cinema and the pre-cinematic techniques of the nineteenth century but did not mention twentieth-century avant-garde film-making. Did not the avant-garde film-makers already explore many of these new possibilities? To take the notion of cinema as painting, Len Lye, one of the pioneers of abstract animation, was painting directly on film as early as 1935; he was followed by Norman McLaren and Stan Brakhage, the latter extensively covering shot footage with dots, scratches, splattered paint, smears and lines in an attempt to turn his films into equivalents of abstract expressionist painting. More generally, one of the major impulses in all of avant-garde film-making, from Léger to Godard, was to combine the cinematic, the painterly and the graphic—by using live action footage and animation within one film or even a single frame, by altering this footage in a variety of ways, or by juxtaposing printed texts and filmed images.

When the avant-garde film-makers collaged multiple images within a single frame, or painted and scratched film, or revolted against the indexical identity of cinema in other ways, they were working against "normal" film-making procedures and the intended uses of film technology. (Film stock was not designed to be painted on.) Thus they operated on the periphery of commercial cinema not only aesthetically but also technically.

One general effect of the digital revolution is that avant-garde aesthetic strategies became embedded in the commands and interface metaphors of computer software.[25] In short, *the avant-garde became materialized in a computer*. Digital cinema technology is a case in point. The avant-garde strategy of collage re-emerged as a "cut and paste" command, the most basic operation one can perform on digital data. The idea of painting on film became embedded in paint functions of film editing software. The avant-garde move to combine animation, printed texts and live action footage is repeated in the convergence of animation, title generation, paint, compositing and editing systems into single all-in-one packages. Finally, another move to combine a number of film images together within one frame (for instance, in Leger's 1924 *Ballet Mécanique* or in *A Man with a Movie Camera*) also become legitimized by technology, since all editing software, including Photoshop, Premiere, After Effects, Flame and Cineon, by default assumes that a digital image consists of a number of separate image layers. All in all, what used to be exceptions for traditional cinema became the normal, intended techniques of digital film-making, embedded in technology design itself.[26]

## *From Kino-Eye to Kino-Brush*

In the twentieth century, cinema has played two roles at once. As a media technology, cinema's role was to capture and to store visible reality. The difficulty of modifying images once they were recorded was exactly what gave cinema its

value as a document, assuring its authenticity. The same rigidity of the film image has defined the limits of cinema as I defined it earlier, i.e. the super-genre of live action narrative. Although it includes within itself a variety of styles—the result of the efforts of many directors, designers and cinematographers—these styles share a strong family resemblance. They are all children of the recording process which uses lens, regular sampling of time and photographic media. They are all children of a machine vision.

The mutability of digital data impairs the value of cinema recordings as documents of reality. In retrospect, we can see that twentieth-century cinema's regime of visual realism, the result of automatically recording visual reality, was only an exception, an isolated accident in the history of visual representation which has always involved, and now again involves the manual construction of images. Cinema becomes a particular branch of painting—painting in time. No longer a kino-eye, but a kino-brush.[27]

The privileged role played by the manual construction of images in digital cinema is one example of a larger trend: the return of pre-cinematic moving images techniques. Marginalized by the twentieth-century institution of live action narrative cinema which relegated them to the realms of animation and special effects, these techniques re-emerge as the foundation of digital film-making. What was supplemental to cinema becomes its norm; what was at its boundaries comes into the center. Computer media returns to us the repressed of the cinema.

As the examples discussed in this article suggest, the directions which were closed off at the turn of the century when cinema came to dominate the modern moving image culture are now again beginning to be explored. Moving image culture is being redefined once again; the cinematic realism is being displaced from being its dominant mode to become only one option among many.

## NOTES

1. Scott Billups, presentation during "Casting from Forest Lawn (future of performers)" panel at "The Artists Rights Digital Technology Symposium '96," Los Angeles, Directors Guild of America, February 16, 1996. Billups was a major figure in bringing Hollywood and Silicon Valley together by way of the American Film Institute's Apple Laboratory and Advanced Technologies Programs in the late 1980s and early 1990s. See Paula Parisi, "The New Hollywood Silicon Stars," *Wired* 3.12 (December, 1995), 142–5; 202–10.

2. Christian Metz, "The Fiction Film and its Spectator: A Metapsychological Study," in *Apparatus*, edited by Theresa Hak Kyung Cha (New York: Tanam Press, 1980), 402.

3. Cinema as defined by its "super-genre" of fictional live action film belongs to media arts which, in contrast to traditional arts, rely on recordings of reality as their basis. Another term which is not as popular as "media arts" but perhaps is more precise is "recording arts." For the use of this term, see James Monaco, *How to Read a Film*, revised edition (New York and Oxford: Oxford University Press, 1981), 7.

4. Charles Musser, *The Emergence of Cinema: The American Screen to 1907* (Berkeley and Los Angeles: University of California Press, 1990), 49–50.

5. Musser, *The Emergence of Cinema*, 25.

6. C.W. Ceram, *Archeology of the Cinema* (New York: Harcourt, Brace & World, 1965), 44–5.

7. The birth of cinema in the 1890s is accompanied by an interesting transformation: while the body as the generator of moving pictures disappears, it simultaneously becomes their

new subject. Indeed, one of the key themes of early films produced by Edison is a human body in motion: a man sneezing, a famous bodybuilder Sandow flexing his muscles, an athlete performing a somersault, a woman dancing. Films of boxing matches play a key role in the commercial development of Kinetoscope. See Musser, *The Emergence of Cinema*, 72–9; David Robinson, *From Peep Show to Palace: the Birth of American Film* (New York: Columbia University Press, 1996), 44–8.

8. Robinson, *From Peep Show to Palace*, 12.

9. This arrangement was previously used in magic lantern projections; it is described in the second edition of Athanasius Kircher's *Ars magna* (1671). See Musser, *The Emergence of Cinema*, 21–2.

10. Ceram, *Archeology of the Cinema*, 140.

11. Musser, *The Emergence of Cinema*, 78.

12. The extent of this lie is made clear by the films of Andy Warhol from the first part of the 1960s—perhaps the only real attempt to create cinema without a language.

13. I have borrowed this definition of special effects from David Samuelson, *Motion Picture Camera Techniques* (London: Focal Press, 1978).

14. The following examples illustrate this disavowal of special effects; other examples can be easily found. The first example is from popular discourse on cinema. A section entitled "Making the movies" in Kenneth W. Leish, *Cinema* (New York: Newsweek Books, 1974) contains short stories from the history of the movie industry. The heroes of these stories are actors, directors, and producers; special effects artists are mentioned only once. The second example is from an academic source: the authors of the authoritative *Aesthetics of Film* (1983) state that "the goal of our book is to summarize from a synthetic and didactic perspective the diverse theoretical attempts at examining these empirical notions [terms from the lexicon of film technicians], including ideas like frame vs. shot, terms from production crews' vocabularies, the notion of identification produced by critical vocabulary, etc." The fact that the text never mentions special effects techniques reflects the general lack of any historical or theoretical interest in the topic by film scholars. Bordwell and Thompson's *Film Art: An Introduction*, which is used as a standard textbook in undergraduate film classes, is a little better as it devotes three out of its five hundred pages to special effects. Finally, a relevant piece of statistics: a library of University of California, San Diego contains 4,273 titles catalogued under the subject "motion pictures" and only 16 titles under "special effects cinematography." For the few important works addressing the larger cultural significance of special effects by film theoreticians, see Vivian Sobchack and Scott Bukatman (see below). Norman Klein is currently working on a history of special effects environments.

      Kenneth W. Leish, *Cinema* (New York: Newsweek Books, 1974); Jacques Aumont, Alain Bergala, Michel Marie, and Marc Vernet, *Aesthetics of Film*, trans. Richard Neupert (Austin: University of Texas Press, 1992), p. 7; David Bordwell and Kristin Thompson, *Film Art: An Introduction*, 4th edn (New York: McGraw-Hill, 1993); Vivian Sobchack, *Screening Space: The American Science Fiction Film*, 2nd edn (New York: Ungar, 1987); Scott Bukatman, "The Artificial Infinite," in *Visual Display*, eds Lynne Cooke and Peter Wollen (Seattle: Bay Press, 1995).

15. For a discussion of the subsumption of the photographic to the graphic, see Peter Lunenfeld, "Art Post-History: Digital Photography and Electronic Semiotics," *Photography After Photography*, eds V. Amelunxen, Stefan Iglhaut, Florian Rötzer, 58–66. München: Verlag der Kunst, 1995.

16. For a complete list of people at ILM who worked on this film, see *SIGGRAPH '94 Visual Proceedings* (New York: ACM SIGGRAPH, 1994), 19.

17. In this respect 1995 can be called the last year of digital media. At the 1995 National Association of Broadcasters convention Avid showed a working model of a digital video camera which records not on a video cassette but directly onto a hard drive. Once digital

cameras become widely used, we will no longer have any reason to talk about digital media since the process of digitization will be eliminated.

18. Here is another, even more radical definition: digital film = $f(x, y, t)$. This definition would be greeted with joy by the proponents of abstract animation. Since a computer breaks down every frame into pixels, a complete film can be defined as a function which, given horizontal, vertical, and time location of each pixel, returns its color. This is actually how a computer represents a film, a representation which has a surprising affinity with a certain well-known avant-garde vision of cinema! For a computer, a film is an abstract arrangement of colors changing in time, rather than something structured by "shots," "narrative," "actors," and so on.

19. Paula Parisi, "Grand illusion," *Wired* 7.05 (May 1999), 137.

20. Sec Barbara Robertson, "Digital Magic: Apollo 13," *Computer Graphics World* (August 1995), 20.

21. Mitchell, *The Reconfigured Eye*, Cambridge, Mass.: MIT Press, 7.

22. The full advantage of mapping time into 2-D space, already present in Edison's first cinema apparatus, is now realized: one can modify events in time by literally painting on a sequence of frames, treating them as a single image.

23. See Robinson, *From Peep Show to Palace*, 165.

24. See "Industrial Light & Magic alters history with MATADOR," promotion material by Parallax Software, SIGGRAPH 95 Conference, Los Angeles, August 1995.

25. See my "Avant-Garde as Software," in *Ostranenie*, edited by Stephen Kovats (Frankfurt and New York: Campus Verlag, 1999). (http://www.manovich.net)

26. For the experiments in painting on film by Lye, McLaren, and Brakhage, see Robert Russett and Cecile Starr, *Experimental Animation* (New York: Van Nostrand Reinhold, 1976), 65–71, 117–28; P. Adams Smith, *Visionary Film*, 2nd edn (Oxford: Oxford University Press), 230, 136–227.

27. Dziga Vertov coined the term "kino-eye" in the 1920s to describe the cinematic apparatus's ability "to record and organize the individual characteristics of life's phenomena into a whole, an essence, a conclusion." For Vertov, it was the presentation of film "facts," based as they were on materialist evidence, that defined the very nature of the cinema. See *Kino-Eye: The Writings of Dziga Vertov*, ed. Annette Michelson, trans. Kevin O'Brien (Berkeley: University of California Press, 1984). The quotation above is from "Artistic Drama and Kino-Eye" (originally published in 1924), 47–9.

# ALEXANDER R. GALLOWAY

## Origins of the First-Person Shooter

### FROM *Gaming*

Author and programmer Alexander R. Galloway (b. 1974) is one of the most important voices in recent debates in new media and gaming theory. Associate Professor in the Department of Media, Culture, and Communications at New York University, he is also a founding member of the software collective RSG and creator of the *Carnivore* data surveillance engine. He writes on a variety of issues concerning aesthetics, digital media,

film, video games, and networks. He is the author of *Protocol: How Control Exists After Decentralization* (2004), and *Gaming: Essays on the Algorithmic Culture* (2006), from which this chapter is excerpted. He is also co-author of *The Exploit: A Theory of Networks* (2007), a study of how networks operate and emerge as a new form of power.

Over the past two decades, cinema has been absorbed into the larger world of audiovisual media, competing with television, video games, computers, and other digital communication technologies. The expanding field of new media studies explores the dramatic impact these new technologies and screen cultures have on our social world, as well as on cinema and such key issues in film theory as cinematic specificity, aesthetics, spectatorship, the apparatus, and realism. Gaming studies, a significant part of the field of new media, has emerged as an independent yet interdisciplinary field to account for the phenomenon of video games, which have become a central feature of the cultural landscape and a formidable industry that is larger than television and film combined. Galloway approaches video games as an independent medium and a distinct cultural form that demands a new interpretive framework. For Galloway, video games radically reframe the problematic nature of representation because games are not merely watched (as film is) but also *played*. Traditional debates in film studies on visuality have to be supplemented with the phenomenon of *action* to account for the kinetic and affective nature of video games. Yet, Galloway also acknowledges the overlap between the conventions of film and video games; the affinity between video games and the commercial film industry, as well as what used to be considered avant-garde film practices, is crucial to understanding the aesthetic nature, cultural status, and political implications of video games.

In "Origins of the First-Person Shooter," the second chapter of *Gaming*, Galloway considers the history of "the subjective shot" in film and follows the mutation of this relatively rare kind of shot into the predominant point-of-view mode of shooter games like *Doom*. In film, it is very common to see things from the character's point-of-view (POV), but this POV shot is not an exact re-creation of the character's vision; rather, it is an abstract approximation of it, functioning as its substitute. On the other hand, the subjective shot, which merges the look of the character with that of the camera, is used rarely in cinema and is associated with difficulty, detachment, alienation, or with robotic vision in science fiction film. First-person shooter games, explains Galloway, incorporate the subjective shot, a marginalized filmic shot, as their dominant visual mode. These games can do so successfully because they are not based on the more passive act of seeing but rather on active movement through space. Since gamic vision requires "fully rendered, actionable space" and demands full freedom of movement, the subjective shot in video games facilitates "an active subject position that enables and facilitates the gamic apparatus." Galloway's study not only offers an important account of the parameters of the new media environment in which we live but it also opens up intriguing possibilities for both film and film theory.

## READING CUES & KEY CONCEPTS

■ In what ways does the progressive nature of "gamic vision" described by Galloway also imply some form of creative resistance?

■ What consequences does Galloway's account of "actionable space" have for the notion of cinematic realism?

■ Consider the different ways in which film and video games construct reality, as well as what the relationship of depicted reality is to social reality.

■ **Key Concepts:** First-Person Shooter; Point-of-View Shot; Subjective Shot; Gamic Vision; Actionable Space; Affective Vision

# Origins of the First-Person Shooter

. . . . . . . . . . . . . .

The beginning of a medium is that historical moment when something ceases to represent itself. "The theater brings onto the rectangle of the stage, one after the other, a whole series of places that are foreign to one another," wrote Foucault in one of his infrequent forays into aesthetics. "Thus it is that the cinema is a very odd rectangular room, at the end of which, on a two-dimensional screen, one sees the projection of a three-dimensional space."[1] The movie theater is a complex intersection of seemingly incommensurate media environments: a three-dimensional space is used for viewing a two-dimensional plane that in turn represents the illusion of another three-dimensional space. Likewise today the cinema is butting up against another seemingly incommensurate medium, the video game. They are no less different as two dimensions are from three. Yet it is a cliché today to claim that movies are becoming more and more like video games. What exactly does such a claim mean? Today video games and film are influencing and incorporating each other in novel ways. Through a historical transformation that he calls the "automation of sight," Lev Manovich writes how the camera has adopted a more and more machinic gaze with the passage into the digital.[2] One witnesses this transformation firsthand in the clinical, disembodied tracking shots in *Panic Room*, or in the digital effects of *The Matrix*, itself often criticized for looking too much like a video game.

But ignoring for a moment all the pizzazz of digital effects in moviemaking, there exists a much simpler visual technique that one may use to examine how cinema and gaming are constituted as similar and dissimilar media formats: the use of the first-person subjective camera angle. I would like to explore this shift through the following proposition: In film, the subjective perspective is marginalized and used primarily to effect a sense of alienation, detachment, fear, or violence, while in games the subjective perspective is quite common and used to achieve an intuitive sense of motion and action in gameplay. This claim will most certainly rankle some readers, so I should first clarify a few things before continuing.

## *The Subjective Shot*

Generally speaking, film technique involves the staging of action by characters and the recording of that action by elements of the film apparatus. Paul Willemen, in his essay "The Fourth Look," has described the various visual axes that exist in a typical filmic scenario: the camera's look, the audience's look, the intradiegetic

look between characters, and the fourth look, "the look at the viewer" by an on-screen character.[3] In the classical Hollywood style, the first and second looks are often subordinated to the third. The fourth look is generally avoided, since it forces the viewer to confront his or her own voyeuristic position.[4] However, occasionally the strict separation of these four looks is not so carefully observed. Occasionally, two of the looks—the look of the camera and the look of a single character—merge together, so that the camera lens and the eyes of a character become one. This results in a rather extreme first-person point-of-view shot, where the camera pans and tracks as if it were mounted on the neck of a character. When the camera fuses with a character's body, the viewer sees *exactly* what the character sees, as if the camera "eye" were the same as the character "I." The camera merges with the character both visually and subjectively. In a sense, this type of first-person shot is the spatial opposite of Willemen's fourth look. They are like two vectors, one pointing outward and one pointing inward. They constitute a grand axis that extends outward from the viewer's eyes, pierces the screen, enters the diegesis of the film, and backs out again. It is this grand axis that creates so much difficulty in cinema. The difficulty is so great that both types of shot are largely avoided, and when they are used, they signify a problematic form of vision (which I will describe later).

It is important to stress the difference between the subjective shot (when the camera shows what the actual eyes of a character would see) and the more general point-of-view (POV) shot. POV shots show approximately what a character would see. They show the perspective more or less from the character's vantage point. Yet subjective shots mean to show the exact physiological or emotional qualities of what a character would see. In other words, the POV shot tends to hover abstractly in space at roughly the same diegetic location of a character. But the subjective shot very precisely positions itself inside the skull of that character. It is a question less of type than of degree.

The POV shot is most commonly illustrated by considering the shot/reverse-shot sequence in which a character is first shown looking at something, and then the camera swings in reverse to a POV shot to see what he or she was looking at. Correct eyeline matching is employed to create the illusion of a coherent visual space. The POV shot is nothing more than an approximation of a character's vision. It is not an exact re-creation of that vision, for it does not resemble human vision in any physiological or subjective sense. If it did, it would not be stationary but would flit and jostle around; it would be interrupted by blinking eyelids, blurrings, spots, tears, and so on. In conventional filmmaking, the POV shot always ignores the physiology of vision. What happens instead is a sort of surrogate point of view, a shot that has the same vector as the character's line of sight but in reality is more like a camera on a tripod rather than the character's true vision. The POV shot is an abstract shot, an iconographic substitute for the character's vision. It pretends to be from the character's *point* of view, from a perspective, not verily through his or her own eyes, with all the blinks, blurs, and jiggles—not to mention raw subjectivity—that that would entail.

Another usage is the "masked POV" shot, often used to represent binocular vision (or vision through a telescope, camera, or keyhole). This shot is easy to notice: the edge of the frame is obfuscated with a curved, black masking. The masking acts as visual proof that the audience is seeing exactly what the character is seeing

through his or her own eyes. These shots are generally very short takes. They serve simply to offer some piece of visual evidence to the viewer. But their relationship to the subjective shot is flimsy at best, for the cinema's binocular shot doesn't accurately capture what it looks like to peer through binoculars—in human vision, the two lens images tend to overlap and fuse into a single circle. Moreover, because real human vision does not come in a tidy, rectangular aspect ratio, one never actually notices the blackness at the edge of the image. The sideways figure-eight masking is simply the best that cinema can muster to approximate what binocular vision looks like. Cinema's binocular shot, then, is a type of icon for binocular vision, not an honest-to-goodness substitute for it.

The collection of visible evidence is often crucial in films, and the POV shot is commonly used to present to the audience evidence necessary to the film's narrative. The binocular shot is almost always used to convey some sort of visual fact to the viewer. Letters, telegrams, and notes are similar, as in *Casablanca* when Ilsa's good-bye note is pasted flat on the screen for the audience to read and then yanked back into diegetic space by a dusting of heavy raindrops. These shots are a holdover from the intertitles of the silent era. They walk the line between being a POV shot and being a subjective shot. Films like Antonioni's *Blow-Up*, Hitchcock's *Rear Window*, or Greenaway's *The Draughtsman's Contract* all rely on the collection and analysis of visible evidence. Further, one might also consider films focusing on audio evidence, such as De Palma's *Blow Out* or Coppola's *The Conversation*, or the subjective evidence of memory, as in Kurosawa's *Rashomon*, or even the evidentiary gaze of video games like *Ico*. As Grace Kelly says at the narrative crossroads of *Rear Window*, "Tell me everything you saw . . . and what you think it means."

But certain critical observations, like this one written in passing by Fredric Jameson, complicate the discussion so far on the POV shot:

> "Point of view" in the strictest sense of seeing through a character's eyes—as in Delmar Daves's *Dark Passage* [1947] or Robert Montgomery's *The Lady in the Lake* [1946]—has been a very marginal narrative procedure indeed.[5]

Or as David Bordwell and his coauthors put it, very few films are dominated by a single character's perspective, much less a character's subjective perspective:

> If we take point-of-view to be an *optical* subjectivity, no classical film, not even the vaunted but misdescribed *Lady in the Lake* (1947), completely confines itself to what a character sees. If we regard a character's point-of-view as comprising what the character knows, we still find very few classical films that restrict themselves to this degree. . . . The classical film typically contains a few subjective point-of-view shots (usually of printed matter read by a character), but these are firmly anchored in an "objective" frame of reference.[6]

Let us consider in greater detail the type of POV shot that does pretend to emanate from the eyes of a particular character: the subjective shot. Like POV shots, subjective shots happen when two of the looks, the look of the camera and the look of a single character, merge together as one. Yet subjective shots are more extreme in their physiological mimicking of actual vision, for, as stated, they pretend to peer outward from the eyes of an actual character rather than simply to approximate a

similar line of sight. Thus subjective shots are much more volatile. They pitch and lurch. They get blinded by light or go blurry. And within the diegesis, they elicit Willemen's "fourth look" often, as other characters address the camera directly (in an attempt to maintain the illusion that the camera is actually another character). As Jameson writes, subjective shots are marginal, and I can see two reasons why he would think so: they are materially marginalized in that they happen relatively infrequently within the apparatus of filmmaking, and they are aesthetically marginalized in that they represent only specific moods and situations.

As both Jameson and Bordwell suggest, Robert Montgomery's noir experiment *Lady in the Lake* is the most fully formed early example of the subjective shot.[7] In this film, the camera becomes one with the main character, Marlowe. Nearly every shot in the film is shot as if it were from the eyes of Marlowe. Thus the typical Hollywood conventions of shot/reverse shot, continuity editing, and so forth are shed to facilitate a new experimental convention, the merging of two "looks." The film attempts to move in real time—not true, we learn upon discovery of carefully hidden ellipses and cuts—but nevertheless, as Marlowe sees events in the world, the viewer sees them too. Images become evidence. (Indeed, the film eventually turns on a visual trick in which the viewer, as Marlowe, sees the cops approaching from a fire escape behind the crooked cop—a fact that the crooked cop is not willing to believe, since he is not privy to the special merging of looks afforded the viewer.)

Unfortunately the visual experiment of *Lady in the Lake* made identification problematic. Critics at the time called the subjective shot "gimmicky" and "flawed." Pascal Bonitzer called it "more tiring than fascinating."[8] (The early 1950s television cop show *The Plainclothesman* used the same conceit with slightly more success.) Each time Marlowe's body is also shown onscreen—in a mirror, when smoking, when crawling, being kissed, and so on—the illusion of the subjective shot is broken, and the viewer is reminded of the camera lens's failure to merge fully with Marlowe's own optics. The audience is thus trapped inside a sort of failed formal experiment, and the suturing together of the filmic apparatus begins to fray.

J. P. Telotte describes the detached, dreamlike quality of the film in which the viewer's avatar (Marlowe) both acts and sees itself acting:

> As the film opens, Marlowe is the sole object in the image field, as he comments upon the role of the detective. With our incarnation in his presence, through that pervasive subjective camera, he also becomes that which is, after a fashion, "lost" for most of the narrative and thus the object of our own searching throughout the film, although most obviously when that absence is underscored by the many acknowledgements of Marlowe's presence, such as the mirror reflections or the guns aimed at his off-screen perspective. That enigmatic detachment, of course, as we both act and see ourselves in action, again typifies the dream experience.[9]

The same sense of detachment, claustrophobia, and nonidentification pervades the first hour of *Dark Passage* in which the main character, played by Humphrey Bogart, moves and talks in the first person, not unlike the technique used in *Lady in the Lake*. But the subjective perspective is only a ploy in this film, as the taxi scene demonstrates with Bogart's face deliberately bathed in shadow. The first section of

the film is a cinematic conceit for not showing Bogart's presurgery face, and in that sense it is better motivated by the narrative than was Montgomery's film. But the subjective shots end after the plastic surgery, and the film returns to the shot conventions of classical Hollywood. It seems that only a scalpel can rid this film of the subjective camera angle.

While *Lady in the Lake* and *Dark Passage* are fascinating examples, they are not indicative of the vast majority of subjective shots used in the cinema. Edward Branigan is authoritative in this area. He contrasts the POV shot with the subjective shot (which he terms the "perception" shot), claiming that one is characterized by relative clarity, while the other is characterized by difficulty:

> In the case of character *sight*, what is important is not so much that a character sees something, but that he experiences difficulty *in seeing*. What is revealed is not the external object of a glance nor an internal state of the character, but a condition of sight itself. This feature of character vision is exploited in the perception [i.e., subjective] structure which differs from the POV structure in one important respect: In POV there is no indication of a character's mental condition—the character is only "present"—whereas in the perception [i.e., subjective] shot a signifier of mental condition has been *added* to an optical POV.[10]

Thus, to facilitate a deeper analysis of the subjective shot, there are two general observations worth mentioning. First, while POV shots are ubiquitous, subjective shots are much less common in narrative filmmaking. *Lady in the Lake* and *Dark Passage* notwithstanding, most narrative films don't include a single subjective shot, and in the films that do, there are generally only a handful of subjective shots used to achieve very specific results. Second, when a subjective shot is used, it generally signifies some type of negative vision. This is the "difficulty" that Branigan mentioned. It is sometimes an evil vision, or an inhuman one, or simply a moment of alienation or detachment within a character. Few other shot styles are as closely associated with such a specifically defined mood. Yes, there are exceptions to these rules: for example, there is nothing inhuman or evil about Peter O'Toole's director's-eye shot of a bitten apple near the beginning of *The Stunt Man*, but the image is too quick to render much cinematic affect; likewise the use of the first person for a Steadicam shot at the start of *Wild Things* does little more than forecast the twists and turns of the film as a whole.

[ · · · ]

## *Action as Image*

So far I have considered a specific and somewhat rare type of shot used in narrative filmmaking, the subjective shot. But let me make this discussion slightly more specific, first by making reference to a different medium altogether, the video game, and second by adding another piece of visual iconography to the frame, a weapon. Video games are wildly diverse in their formal grammar, but in the specific gaming genre known as the first-person shooter (FPS), a gaming genre invented in the 1970s and perfected by Id Software in the early 1990s with games like *Wolfenstein 3D* and *Doom*, there are several formal conventions that appear over and over. First, FPS games are played in the subjective, or first-person, perspective and therefore are the visual progeny of subjective

camera techniques in the cinema. But perhaps equally essential to the FPS genre is the player's *weapon*, which generally appears in the right foreground of the frame. While a more detailed analysis would certainly include other elements such as the heads-up display, for simplicity's sake let me claim that these two elements alone—a subjective camera perspective, coupled with a weapon in the foreground—constitute the kernel of the image in the FPS genre. (Let me also underscore that the analysis of gamic visuality in this section is relevant only to first-person, and to a certain extent third-person, shooter games. An entirely different theory of visuality would need to be developed for RTS [real-time strategy] games, turn-based RPGs [role-playing games], and other genres.

Perhaps not surprisingly, even the precise visual idiom of the FPS video game appears decades before in the cinema. In 1925, for example, Buster Keaton used a prototypical FPS shot in the film *Go West*. As in *Jaws*, the perspective comes from the point of view of a predatory animal. In Keaton's case, the animal is a stampeding bull, and the bull's horns are the weapon that appears hovering in the foreground of the shot. While the shot is technically in a third-person (bovine) perspective—the camera is mounted on the head of the bull, not where its eyes would be—the generic conventions are all there: an affective ego perspective, with a weapon in the foreground. Other examples appear here and there in the early history of cinema.

So while video games are responsible for mainstreaming the FPS shot, it is clear that the shot itself was invented in the cinema. Twenty years after the Keaton film, Hitchcock presented a fully articulated FPS shot in the finale of his film *Spellbound*. Following a complex set of movements, the shot begins in FPS perspective as a gun is trained on Constance Petersen (Ingrid Bergman). Then the gun is turned back onto the camera, and in a brutal reworking of Willemen's "fourth look," as well as an allusion to the famous final shot of *The Great Train Robbery*, the subjective character fires back at the subjective camera. It is suicide for the character and for the image (the masochism suggested by Clover). Hitchcock punctuates the bullet's explosion with a full-screen flash of red color in this otherwise black-and-white movie. Earlier, during the film's famous dream sequence, an enigmatic deck of cards serves as a prop in a second, much shorter, subjective shot. And in a brief flashback, when Anthony Edwardes (Gregory Peck) recalls how he killed his brother as a youth, another FPS shot is used to show the fatal accident. All three uses of the subjective shooter perspective serve to heighten specific emotions in the viewer: confusion during the dream sequence, trauma during the death sequence, and shock during the finale. The shots form a trio of grief: first affective, then expressive, and finally reflexive. In this sense, the FPS perspective is the visual pivot for all of Hitchcock's suspense in the film. And he would flirt with the FPS again in a later film, using an FPS shot in the duel at the end of *Topaz* (an alternate ending that, due to preview audience dislike, was banished and replaced with milder fare in the theatrical release).

The real-time, over-the-shoulder tracking shots of Gus Van Sant's *Elephant* evoke third-person shooter games like *Max Payne*, a close cousin of the FPS. Then the film shifts into a proper FPS perspective at a few crucial moments to depict actual gun violence. Additionally, the film uses a boxy 1:33 frame shape, rather than the wide aspect ratio often used in feature films, to reference the boxy shape of television monitors and the console game systems that rely on them. That the 1999 Columbine

massacre was blamed on such games remains present but unexamined in this taut, pensive film. Van Sant is clearly cognizant of the visual idiom of gaming, as illustrated in the campfire monologue on a fictional, *Civilization*-like game in his earlier film *Gerry*, a filmic landscape that reappears as a game called "GerryCount" played on a laptop in *Elephant*. "In *Elephant*, one of the killers is briefly playing a video game," explains Van Sant. "We couldn't get rights to *Doom* so we designed one ourselves that resembles *Gerry*, with two guys walking in a desert."[11] Additionally Van Sant used a first-person subjective shot during the penultimate sequence of his *Psycho* remake. While there is no expressed allusion to gaming, the quick shot illustrates the paralysis of the first person in film as Norman Bates reels inside of mental disorientation and confinement in the hands of the law and his mother's psychic grip. The shot is not in Hitchcock's original, suggesting that our general regime of vision has changed subtly in the decades since the earlier film—decades coinciding exactly with the invention and development of video gaming as a medium.

A few dozen other FPS shots appear here and there in other films. My unscientific survey recorded the following instances: midway through *Goodfellas*, a gun is trained on Ray Liotta's character in a subjective shot as he lies in bed; an FPS shot appears at the forty-eight-minute mark of *High Plains Drifter*; *Aguirre: The Wrath of God* and *Damn the Defiant!* both have FPS shots, using a cannon as the foreground weapon; *Treasure Island* (1950) contains an FPS rifle shot; *What's Up, Doc?* contains an FPS pistol shot; *Magnum Force* contains a series of FPS pistol shots; the night-vision sequence at the end of *The Silence of the Lambs* also shifts into the idiom of the first-person shooter for a brief second as the killer draws a bead on his would-be victim.

## *Gamic Vision*

We have seen how filmmaking predates and predicts certain visual styles that would later become central for first-person shooter video games. Yet game design is also influencing filmmaking in certain fundamental ways, as well as deviating from it. Neo's training scenes in *The Matrix* mimic the training levels that commonly appear at the opening of many games. These training levels can be incorporated into the narrative of the game (*Metroid Prime*) or disconnected from the narrative of the game (*Half-Life*). They simply allow the gamer to become familiar with the controller and learn basic game rules. Neo must do the same before he plunges headlong into the Matrix for real. But beyond the transfection of gamic conventions into film *narrative*, there also exist several instances, in this movie and others, where specific formal innovations from games have migrated into the formal grammar of filmmaking. This could be called a *gamic cinema*.

The subjective shot is not just about seeing, as Steven Shaviro explains, but rather primarily about motion through space. He writes on the subjective shots in *Strange Days*:

> Events unfold in real time, in a single take, from a single point of view. These sequences are tactile, or haptic, more than they are visual. The subjective camera doesn't just look at a scene. It moves actively through space. It gets jostled, it stops and starts, it pans and tilts, it lurches forward and back. It follows the rhythms of the whole body, not just that of the eyes. This is a presubjective, affective and not cognitive, regime of vision.[12]

What video games teach cinema is that the camera can be subjective with regard to a specific character, as I have already discussed, but further *that the camera can be subjective with regard to computerized space.* If computers have a gaze of their own, it is this. Is "bullet time" in *The Matrix* a subjective shot? Certainly not, using the traditional definition of the subjective shot by Bordwell et al. But if one considers the "gaze" of the three-dimensional rendering technology itself as it captures and plots physical spaces in Euclidean geometry, which is nothing but an avatar for the first-person perspective of the viewer or gamer, then the answer is certainly yes. To this extent, I agree with Vivian Sobchack when she writes that "electronic presence has neither a point of view nor a visual situation, such as we experience, respectively, with the photograph and the cinema."[13] Or as Manovich claims: computerized visuality, while still a way of seeing, is no longer about *light* but is instead about space. The traditional cinematic POV has fallen away, and an electronic one has taken its place. In other words, shooter games (and the digital apparatus behind them) have expanded the definitional bounds of the subjective shot. The reason is that, with FPS games, the first-person subjective perspective is so omnipresent and so central to the grammar of the entire game that it essentially becomes coterminous with it. This is what Shaviro means by the term "affective regime of vision." FPS games use almost nothing else, and this regime of vision is seeping back into filmmaking as movies become more and more digital.

This point can be summarized in an initial claim: *gamic vision requires fully rendered, actionable space.* Traditional filmmaking almost never requires the construction of full spaces. Set designers and carpenters build only the portion of the set that will appear within the frame. Because a director has complete control over what does appear within the frame, this task is easy to accomplish. The camera positions are known in advance. Once the film is complete, no new camera positions will ever be included. (Even a film shot on location will use a specific subset of the spatial environment. Only in special cases, as in the 360-degree pan shot at the start of *Cobra Verde* or in the twirling sets in films like *Lola Montes*, is a full landscape ever captured on film. But even then the spatial environment is *recorded*, not rendered, and can never be repenetrated, zoomed, moved, or reinitialized as is doable in a three-dimensional model.) The fascinating "100 cameras" video technique used by Lars von Trier in *Dancer in the Dark*, whereby dozens of small cameras are embedded in the shooting location to record, in parallel, an entire scene from all angles simultaneously, is an ingenious approximation of digital rendering; yet despite its unique polyvisuality, the technique remains essentially a throwback to older cinematic conventions of distinct shots sewn together via montage. By contrast, game design explicitly requires the construction of a complete space in advance that is then exhaustively explorable without montage. In a shooter, because the game designer cannot restrict the movement of the gamer, the complete play space must be rendered three-dimensionally in advance. The camera position in many games is not restricted. The player is the one who controls the camera position, by looking, by moving, by scrolling, and so on. Jay Bolter and Richard Grusin put the matter quite clearly when they contrast a film like *Lady in the Lake* with the game *Myst*:

> *Myst* is an interactive detective film in which the player is cast in the role of detective. It is also a film "shot" entirely in the first person, in itself a remediation of the Hollywood style, where first-person point of view is used only sparingly— except in special cases, such as *Strange Days* recently and some film noir in the

> 1940s. . . . Like many of the other role-playing games, *Myst* is in effect claiming that it can succeed where film noir failed: that it can constitute the player as an active participant in the visual scene.[14]

So fifty years later, the failed experiment of *Lady in the Lake* has finally found some success, only it required the transmigration from one medium to another entirely.

A corollary of my previous claim about actionable space is that gaming *makes montage more and more superfluous*. The montage technique, perfected by the cinema, has diminished greatly in the aesthetic shift into the medium of gaming. The cinematic interludes that appear as cut scenes in many games do indeed incorporate montage, but gameplay itself is mostly edit free. Counterexamples include cutting between various visual modes: opening the map in *World of Warcraft*; the use of a sniper rifle or night-vision goggles; cutting between different camera positions, as with looking in the rearview mirror in driving games like *True Crime*. A game like *Manhunt* uses montage, but only when it explicitly copies the conventions of video. So while there may exist montage between different modes of the game, there is little montage inside the distinct modes of gameplay. In this sense, the preponderance of continuous-shot filmmaking today (*Timecode, Russian Ark*) is essentially a sublimation of the absence of montage in digital poetics (i.e., not the increased availability of long-format recording techniques, as the technological determinists would lead one to believe). Game designers never had to stop and change reels (as Hitchcock had to in *Rope*), yet they still marginalized montage from the beginning, removing it from the core formal grammar of video games. Ingenious tricks are used instead, as in a game like *Metroid Prime*, where the transition from third person to first person is accomplished not with an edit but with a swooping fly-through shot where the camera, in third person, curves around to the rear of the player character and then tracks forward, swiftly passing through the back of the cranium to fuse instantly the first-person optics of the character with the first-person optics of the player. Tricks like this help attain a level of fluidity not seen in previous visual media like film or television. Abandoning montage creates the conditions of possibility for the first-person perspective in games. The lack of montage is necessary for the first-person way of seeing, even if the game itself is a side-scroller, or a top-view shooter, or otherwise *not* rendered in the first person. Where film montage is fractured and discontinuous, gameplay is fluid and continuous. Hence the gamic way of seeing is similar to human vision in ways that film, and television and video, for that matter, never were.

Following from the first two claims, one can observe that in gamic vision *time and space are mutable within the diegesis in ways unavailable before*. Games have the luxury of being able to exist outside real, optical time. Games pause, speed up, slow down, and restart often. But more than that, they can also transpire in moments of suspended time, as in turn-based role-playing games (RPGs) where the player plays (sets up actions, inspects statistics, rearranges character formations) solely during the *interstices* between other actions. Film has never had this luxury. Films are time based and must transpire through time in order to be played, to be experienced. Thus "bullet time" in *The Matrix* is one of those rare moments of cinematic illusion where the digital aesthetics of gaming actually penetrate and influence the aesthetic

of the film. During bullet time, the time of the action is slowed or stopped, while the time of the film continues to proceed. As the film continues moving at speed, the action onscreen is artificially retarded into what Jameson calls "the great leaps and somersaults of these henceforth supernatural bodies across space itself."[15] This is something that, traditionally, only video games (or any medium using computer-driven, three-dimensional models) have been able to do, not classical cinema. Thus it might make sense to think of bullet time as a brief moment of gamic cinema, a brief moment where the aesthetic of gaming moves in and takes over the film, only to disappear seconds later. Of course, the poetic irony of bullet time is that technologically it relies on an older medium, still photography, rather than a newer one; an amateur could reproduce the special effect using an arc of a few dozen still cameras, a film camera on each end of the arc, and a cutting suite. The use of a series of still-photographic cameras is merely the technological trick that produces the synchronic illusion of a three-dimensionally rendered physical space.

As in *The Matrix* series, the "virtual" is often used as a sort of narrative camouflage applied to films to explain why time and space have suddenly become so mutable. This is illustrated by the rash of films in recent years dwelling on the difference between the so-called real world and an imaginary world existing in parallel to it (*Fight Club, The Sixth Sense, The Others,* and so on). Quite often the plots turn on the inability to distinguish one from the other. Particularly striking examples include *Strange Days* and Tarsem Singh's singular effort *The Cell*. The techniques of digital cinema made it possible to realize more fully the aesthetic vision of virtuality, in ways that were more difficult in the past. With the preponderance of digital cinema techniques in Singh (and we can only assume in Bigelow as well), gamelike moments exist throughout both films. As discussed, the subjective shots in *Strange Days* are directly connected to FPS games. But *The Cell* goes the route of *The Matrix* instead, as illustrated in the "Pantheon dive" where Catherine falls downward through space and is arrested midair in a slow-motion, waterlike gesture. This approximates part of the visual technique in "bullet time," and it is a technique that has been repeated many times over in everything from car commercials to music videos.

A final claim is that the new influence of gaming *elevates the status of artificiality as an aesthetic.* Cronenberg's *eXistenZ*, which couldn't be more different from *The Matrix*, is remarkable for its ability to eschew computer graphics and digital processing, yet still capture some of gaming's specific qualities. Unlike *The Matrix*, where the inclusion of gaming is accomplished via visual effects, Cronenberg's film alludes to gaming in its mise-en-scène, particularly in the film's staging of action and dialogue. The conceit of the film is that all the action transpires inside a game, which the viewer is led to believe is also titled "eXistenZ." But then one learns that this might also be a game-within-a-game with the real world somewhere yet outside of it, the discernment of which is not clear, leaving the film characters in some final spiral of psychosis. Yes, the narrative of the film is about gaming, but it is the stilted dialogue and deliberately affected filmmaking in *eXistenZ* that is gamelike. Turn-based games such as RPGs have a different way of pacing and presenting dialogue. The rhythm of language is unique in this type of game. Language is transactional. It is repeated in simple branching, or hypertextual, structures. Language is often more utilitarian than narrative oriented. Game interludes often exist to give clues to the players for what they must do next. Often these written or spoken clues are then

excerpted and repeated as briefs or strategy notes for the gamers to consult as they play the level. In games, language is used to relay facts or to summarize scores and statistics. The language in *eXistenZ* follows a game logic for dialogue rather than a film logic. The stilted dialogue that permeates many of the scenes references the way that textual and spoken dialogue is delivered in games. The film often repeats canned dialogue, both within the diegesis of the "eXistenZ" game when incidental characters fall into holding patterns and must be addressed by name and prompted for their queues in the game to continue talking, but also outside the game (which might be a game too; one does not know), as when several characters repeat the phrase "eXistenZ by Antenna . . . eXistenZ by Antenna" in the same machinelike monotone. "These *eXistenZ* characters are parodies of computer generated characters," writes Eddo Stern. They follow "autistic conversational algorithms."[16]

To end, let me restate that the subjective optical perspective is one of the least common ways of seeing in narrative film. The subjective camera is largely marginalized in filmmaking and used primarily to effect a sense of alienated, disoriented, or predatory vision. Yet with the advent of video games, a new set of possibilities were opened up for the subjective shot. In games the first-person perspective is not marginalized but instead is commonly used to achieve an intuitive sense of affective motion. It is but one of the many ways in which video games represent action. In other words, video games are the first mass media to effectively employ the first-person subjective perspective, whereas film uses it only for special occasions. Certainly some of the same violence of the filmic first person lingers, and hence many FPS games—*Quake, America's Army, Half-Life*, and on and on—involve large amounts of killing. But at the same time, many shooters, like *Metal Gear Solid* or *Thief*, require the player to *avoid* violence as much as confront it. Plus, game violence is just as common in non-first-person games. So I argue that it is the affective, active, mobile quality of the first-person perspective that is key for gaming, not its violence. Unlike film before it, in gaming there is no simple connection to be made between the first-person perspective and violent vision. What was predatory vision in the cinema is now simply "active" vision. As far as identification is concerned, film failed with the subjective shot, but where film failed, games succeed (due primarily to the fact that games have controllers and require player action). Where film uses the subjective shot to represent a problem with identification, games use the subjective shot to *create* identification. While film has thus far used the subjective shot as a corrective to break through and destroy certain stabilizing elements in the film apparatus, games use the subjective shot to facilitate an active subject position that enables and facilitates the gamic apparatus.

## NOTES

1. Michel Foucault, "Of Other Spaces," *Diacritics* 16, no. 1 (Spring 1986): 25.
2. See Lev Manovich, "The Automation of Sight: From Photography to Computer Vision," in *Electronic Culture* (New York: Aperture, 1996), 229–39.
3. See Paul Willemen, *Looks and Frictions* (Indianapolis: Indiana University Press, 1994).
4. For more on this type of look, see Marc Vernet, "The Look at the Camera," *Cinema Journal* 28, no. 2 (Winter 1989): 48–63.
5. Fredric Jameson, *Signatures of the Visible* (New York: Routledge, 1992), 112.

6. David Bordwell, Janet Staiger, and Kristin Thompson, *The Classical Hollywood Cinema* (New York: Columbia University Press, 1985), 31–32.

7. For discussion of subjective and POV shots in early cinema, see Bordwell et al., *The Classical Hollywood Cinema*, 32–33. J. P. Telotte notes the use of subjective shot effects before *Lady in the Lake* in the 1944 film *Murder, My Sweet*, as well as Orson Welles's unrealized prewar plan to film *Hearts of Darkness* in a subjective camera. See Telotte, *Voices in the Dark: The Narrative Patterns of Film Noir* (Urbana: University of Illinois Press, 1989), 104.

8. Bonitzer continues: "There is a misinterpretation [in the film] which fails to understand that it is not at the place of the subject that the camera operates, but at the place of the Other." Bonitzer, "Partial Vision: Film and the Labyrinth," *Wide Angle* 4, no. 4 (1981): 58.

9. J. P. Telotte, "The Detective as Dreamer: The Case of *The Lady in the Lake*," *Journal of Popular Film and Television* 12, no. 1 (Spring 1984): 13.

10. Edward Branigan, *Point of View in the Cinema* (New York: Mouton, 1984), 80. For an altogether different approach to the subjective idiom in filmmaking, see Bruce Kawin, *Mindscreen: Bergman, Godard, and First-Person Film* (Princeton: Princeton University Press, 1978). For a discussion of these issues in the documentary film, see Barry Grant, "Point of View and Spectator Position in Wiseman's *Primate* and *Meat*," *Wide Angle* 13, no. 2 (April 1999): 56–67.

11. Cited in Gerald Peary, "Cinema Verity: *Elephant* and *Shattered Glass* Focus on the Truth," http://www.bostonphoenix.com/boston/movies/film/documents/03313411.asp (accessed April 15, 2005).

12. Steven Shaviro, "Regimes of Vision: Kathryn Bigelow, *Strange Days*," *Polygraph* 13 (2001): 62.

13. Vivian Sobchack, "The Scene of the Screen: Envisioning Cinematic and Electronic 'Presence,'" in *Electronic Media and Technoculture*, ed. John Caldwell (New Brunswick: Rutgers University Press, 2000), 151.

14. Jay Bolter and Richard Grusin, *Remediation* (Cambridge: MIT Press, 1999), 97.

15. Fredric Jameson, "The Iconographies of Cyberspace," *Polygraph* 13 (2001): 126.

16. Stem, "A Touch of Medieval."

# LAWRENCE LESSIG

## RW, Revived

### FROM *Remix*

Director of the Edmond J. Safra Foundation Center for Ethics, and Professor of Law at Harvard Law School, Lawrence Lessig (b. 1961) is an American academic and activist best known as a proponent of reduced legal restrictions on copyright, particularly in technology applications. A graduate of the University of Pennsylvania, Cambridge University, and Yale Law School, he is also the founder of Stanford University's Center for Internet and Society. In addition to *Remix: Making Art and Culture Thrive in the Hybrid Economy* (2008), his publications include *Code and Other Laws of Cyberspace* (2000), *The Future of Ideas* (2001), *Free Culture* (2004), and *Code: Version 2.0* (2006). Lessig received the Award for the Advancement of Free Software from the Free Software Foundation in 2002.

Lessig's writings and political activities take place as the twenty-first century becomes saturated with new media cultures that challenge and redefine some of the primary assumptions of older media, including film and television. As digital technologies become more and more sophisticated and the Internet increasingly becomes the central forum for communication and representation, both media theoreticians and politicians wrestle with the new freedoms these technologies make available. Who should have access to these materials and what, if any, limits should there be on how those materials are used by the public? These questions challenge older assumptions about the ownership and control of electronic images and other products, as well as what it means to be creative or to acquire knowledge. In movie culture especially, this new digital world has raised major issues about the piracy of film images and the authorized or unauthorized viewing and manipulation of movies on the Internet.

In this selection from *Remix*, Lessig draws the distinction between Read/Only (RO) and Read/Write (RW) technologies as a way to describe and promote the new creative possibilities that are part of the digital revolution. While RO technologies might be seen as a dynamic extension of older forms of communication, such as books and newspapers, RW activities take it one step further by allowing users to actively engage with, respond to, and often remake source texts or images. One example Lessig gives of a RW activity is blogging. Lessig also champions the creative "mashing" or re-creation and recombination of music and videos to produce variations and reinterpretations of original material. Like Henry Jenkins (p. 619), Lessig sees these activities as more than digital amusement. Rather, they identify possibilities for particular social networks and communities that may even align these digital visions with earlier work such as Walter Benjamin's (p. 229) on film, spectators, and social revolutions.

## READING CUES & KEY CONCEPTS

■ Are there precedents for RW activities in older forms of communication, such as print media? What advantages and disadvantages did these precedents have?

■ Can Lessig's notion of remixed collages be found in more mainstream film or video practices? Do they activate viewers in a similar way?

■ What does Lessig mean by "good remix" and "bad remix" as a way of discussing remix as education?

■ **Key Concepts:** RO Culture; RW Culture; Ecosystem of Reputation; Ethics of Democracy; RW Media; Collage

# RW, Revived

. . . . . . . . . . . . .

[ · · · ]

## *Remixed: Media*

For most of the Middle Ages in Europe, the elite spoke and wrote in Latin. The masses did not. They spoke local, or vernacular, languages—what we now call French, German, and English. What was important to the elites was thus inaccessible to the masses. The most "important" texts were understood by only a few.

Text is today's Latin. It is through text that we elites communicate (look at you, reading this book). For the masses, however, most information is gathered through other forms of media: TV, film, music, and music video. These forms of "writing" are the vernacular of today. They are the kinds of "writing" that matters most to most. Nielsen Media Research, for example, reports that the average TV is left on for 8.25 hours a day, "more than an hour longer than a decade ago."[1] The average American watches that average TV about 4.5 hours a day.[2] If you count other forms of media— including radio, the Web, and cell phones—the number doubles.[3] In 2006, the U.S. Bureau of the Census estimated that "American adults and teens will spend nearly five months" in 2007 consuming media.[4] These statistics compare with falling numbers for text. Everything is captured in this snapshot of generations:

> Individuals age 75 and over averaged 1.4 hours of reading per weekend day and 0.2 hour (12 minutes) playing games or using a computer for leisure. Conversely, individuals ages 15 to 19 read for an average of 0.1 hour (7 minutes) per weekend day and spent 1.0 hour playing games or using a computer for leisure.[5]

It is no surprise, then, that these other forms of "creating" are becoming an increasingly dominant form of "writing." The Internet didn't make these other forms of "writing" (what I will call simply "media") significant. But the Internet and digital technologies opened these media to the masses. Using the tools of digital technology— even the simplest tools, bundled into the most innovative modern operating systems— anyone can begin to "write" using images, or music, or video. And using the facilities of a free digital network, anyone can share that writing with anyone else. As with RW [Read/Write] text, an ecology of RW media is developing. It is younger than the ecology of RW texts. But it is growing more quickly, and its appeal is much broader.[6] These RW media [ . . . ] remix, or quote, a wide range of "texts" to produce something new. These quotes, however, happen at different layers. Unlike text, where the quotes follow in a single line—such as here, where the sentence explains, "and then a quote gets added"—remixed media may quote sounds over images, or video over text, or text over sounds. The quotes thus get mixed together. The mix produces the new creative work—the "remix."

These remixes can be simple or they can be insanely complex. At one end, think about a home movie, splicing a scene from *Superman* into the middle. At the other end, there are new forms of art being generated by virtuosic remixing of images and video with found and remade audio. Think about Girl Talk [a one-man band], remixing between 200 and 250 samples from 167 artists in a single CD. This is not simply copying. Sounds are being used like paint on a palette. But all the paint has been scratched off of other paintings.

So how should we think about it? What does it mean, exactly?

However complex, in its essence remix is, as Negativland's Don Joyce described to me, "just collage." Collage, as he explained,

> [e]merged with the invention of photography. Very shortly after it was invented . . . you started seeing these sort of joking postcards that were photo composites. There would be a horse-drawn wagon with a cucumber in the back the size of a house. Things like that. Just little joking composite photograph things. That impressed painters at the time right away.

But collage with physical objects is difficult to do well and expensive to spread broadly. Those barriers either kept many away from this form of expression, or channeled collage into media that could be remixed cheaply. As Mark Hosler of Negativland described to me, explaining his choice to work with audio,

> I realized that you could get a hold of some four-track reel-to-reel for not that much money and have it at home and actually play around with it and experiment and try out stuff. But with film, you couldn't do that. It was too expensive. . . . So that . . . drove me . . . to pick a medium where we could actually control what we were doing with a small number of people, to pull something off and make some finished thing to get it out there.[7]

With digital objects, however, the opportunity for wide-scale collage is very different. "Now," as filmmaker Johan Söderberg explained, "you can do [video remix] almost for free on your own computer."[8] This means more people can create in this way, which means that many more do. The images or sounds are taken from the tokens of culture, whether digital or analog. The tokens are "blaring at us all the time," as Don Joyce put it to me: "We are barraged" by expression intended originally as simply RO. Negativland's Mark Hosler:

> When you turn around 360 degrees, how many different ads or logos will you see somewhere in your space? [O]n your car, on your wristwatch, on a billboard. If you walk into any grocery store or restaurant or anywhere to shop, there's always a soundtrack playing. There's always . . . media. There's ads. There's magazines everywhere. . . . [I]t's the world we live in. It's the landscape around us.

This "barrage" thus becomes a source.[9] As Johan Söderberg says, "To me, it is just like cooking. In your cupboard in your kitchen you have lots of different things and you try to connect different tastes together to create something interesting."

The remix artist does the same thing with bits of culture found in his digital cupboard.

My favorites among the remixes I've seen are all cases in which the mix delivers a message more powerfully than any original alone could, and certainly more than words alone could.

For example, a remix by Jonathan McIntosh begins with a scene from *The Matrix*, in which Agent Smith asks, "Do you ever get the feeling you're living in a virtual reality dream world? Fabricated to enslave your mind?" The scene then fades to a series of unbelievable war images from the Fox News Channel—a news organization that arguably makes people less aware of the facts than they were before watching it.[10] Toward the end, the standard announcer voice says, "But there is another sound: the sound of good will." On the screen is an image of Geraldo Rivera, somewhere in Afghanistan. For about four seconds, he stands there silently, with the wind rushing in the background. (I can always measure the quickness of my audience by how long it takes for people to get the joke: "the sound of good will" = silence.) The clip closes with a fast series of cuts to more Fox images, and then a final clip from an ad for the film that opened McIntosh's remix: "The Matrix Has You."

Or consider the work of Sim Sadler, video artist and filmmaker. My favorite of his is called "Hard Working George." It builds exclusively from a video of George Bush in

one of his 2004 debates with John Kerry. Again and again, Sadler clips places where Bush says, essentially, "it's hard work." Here's the transcript:

> Sir, in answer to your question I just know how this world works. I see on TV screens how hard it is. We're making progress; it is hard work. You know, it's hard work. It's hard work. A lot of really great people working hard, they can do the hard work. That's what distinguishes us from the enemy. And it's hard work, but it's necessary work and that's essential, but again I want to tell the American people it's hard work. It is hard work. It's hard work. There is no doubt in my mind that it is necessary work. I understand how hard it is, that's my job. No doubt about it, it's tough. It's hard work which I really want to do, but I would hope I never have to—nothing wrong with that. But again I repeat to my fellow citizens, we're making progress. We're making progress there. I reject this notion. It's ludicrous. It is hard work. It's hard work. That's the plan for victory and that is the best way. What I said was it's hard work and I made that very clear.

Usually, the audience breaks into uncontrolled laughter at "I would hope I never have to—nothing wrong with that," so people don't hear the rest of the clip. But by the end, the filter Sadler has imposed lets us understand Bush's message better.

Some look at this clip and say, "See, this shows anything can be remixed to make a false impression of the target." But in fact, the "not working hard" works as well as it does precisely because it is well known that at least before 9/11, Bush was an extremely remote president, on vacation 42 percent of his first eight months in office.[11] The success of the clip thus comes from building upon what we already know. It is powerful because it makes Bush himself say what we know is true about him. The same line wouldn't have worked with Clinton, or Bill Gates. Whatever you want to say about them, no one thinks they don't work hard.

My favorite of all these favorites, however, is still a clip in a series called "Read My Lips," created by Söderberg. Söderberg is an artist, director, and professional video editor. He has edited music videos for Robbie Williams and Madonna and, as he put it, "all kinds of pop stars." He also has an Internet TV site—soderberg.tv—that carries all his own work. That work stretches back almost twenty years.

"Read My Lips" is a series Söderberg made for a Swedish company called Atmo, in which famous people are lip-synched with music or other people's words. They all are extraordinarily funny (though you can't see all of them anymore because one, which mixed Hitler with the song "Born to Be Alive," resulted in a lawsuit).

The best of these (in my view at least) is a love song with Tony Blair and George Bush. The sound track for the video is Lionel Richie's "Endless Love." Remember the words "My love, there's only you in my life." The visuals are images of Bush and Blair. Through careful editing, Söderberg lip-synchs Bush singing the male part and Blair singing the female part. The execution is almost perfect. The message couldn't be more powerful: an emasculated Britain, as captured in the puppy love of its leader for Bush.

The obvious point is that a remix like this can't help but make its argument, at least in our culture, far more effectively than could words. (By "effectively," I mean that it delivers its message successfully to a wide range of viewers.) For anyone who has lived in our era, a mix of images and sounds makes its point far more powerfully than any eight-hundred-word essay in the *New York Times* could. No one can

deny the power of this clip, even Bush and Blair supporters, again in part because it trades upon a truth we all—including Bush and Blair supporters—recognize as true. It doesn't assert the truth. It shows it. And once it is shown, no one can escape its mimetic effect. This video is a virus; once it enters your brain, you can't think about Bush and Blair in the same way again.

But why, as I'm asked over and over again, can't the remixer simply make his own content? Why is it important to select a drumbeat from a certain Beatles recording? Or a Warhol image? Why not simply record your own drumbeat? Or paint your own painting?

The answer to these questions is not hard if we focus again upon why these tokens have meaning. Their meaning comes not from the content of what they say; it comes from the reference, which is expressible only if it is the original that gets used. Images or sounds collected from real-world examples become "paint on a palette." And it is this "cultural reference," as coder and remix artist Victor Stone explained, that "has emotional meaning to people. . . . When you hear four notes of the Beatles' 'Revolution,' it means something."[12] When you "mix these symbolic things together" with something new, you create, as Söderberg put it, "something new that didn't exist before."

The band Negativland has been making remixes using "found culture"—collected recordings of RO [Read/Only] culture—for more than twenty-five years. They first became (in)famous when they were the target of legal action brought by Casey Kasem and the band U2 after Negativland released a mash-up of Casey Kasem's introduction of U2 on his Top 40 show. So why couldn't Negativland simply have used something original? Why couldn't they rerecord the clip with an actor? Hosler explained:

> We could have taken these tapes we got of Casey Kasem and hired someone who imitated Casey Kasem, you know, and had him do a dramatic re-creation. Why did we have to use the actual original . . . the actual thing? Well, it's because the actual thing has a power about it. It has an aura. It has a magic to it. And that's what inspires the work.

Likewise with their remarkable, if remarkably irreverent, film, *The Mashin' of the Christ*. This five-minute movie is made from remixing the scores of movies made throughout history about Jesus' crucifixion. The audio behind these images is a revivalist preacher who repeatedly says (during the first minute), "Christianity is stupid." The film then transitions at about a minute and a half when the preacher says, "Communism is good." The first quote aligns Christians, at least, against the film. But the second then reverses that feeling, as the film might also be seen as a criticism of Communism. As Hosler explained the work:

> *The Mashin' of the Christ* just came out of an idle thought that crossed my mind one day when I was flipping around on Amazon.com. I thought, "How many movies have been made about the life of Jesus, anyway?" I came up with thirty or forty of them and I started thinking about [how] every one of those films has similar sequences of Jesus being beaten, flogged, whipped, abused. There's always a shot where he's carrying the cross and he stumbles and he falls. And it just occurred to me . . . I thought that would make an interesting montage of stuff.

This montage's point could not have been made by simply shooting crucifixion film number forty-one.

## The Significance of Remix

I've described what I mean by remix by describing a bit of its practice. Whether text or beyond text, remix is collage; it comes from combining elements of RO culture; it succeeds by leveraging the meaning created by the reference to build something new.

But why should anyone care about whether remix flourishes, or even exists? What does anyone gain, beyond a cheap laugh? What does a society gain, beyond angry famous people?

There are two goods that remix creates, at least for us, or for our kids, at least now. One is the good of community. The other is education.

### COMMUNITY

Remixes happen within a community of remixers. In the digital age, that community can be spread around the world. Members of that community create in part for one another. They are showing one another how they can create, as kids on a skateboard are showing their friends how they can create. That showing is valuable, even when the stuff produced is not.

Consider, for example, the community creating anime music videos (AMV). Anime are the Japanese cartoons that swept America a few years ago. AMVs are (typically) created by remixing images from these cartoons with a music track or the track from a movie trailer. Each video can take between fifty and four hundred hours to create. There are literally thousands that are shared non-commercially at the leading site, animemusicvideos.org.

The aim of these creators is in part to learn. It is in part to show off. It is in part to create works that are strikingly beautiful. The work is extremely difficult to do well. Anyone who does it well also has the talent to do well in the creative industries. This fact has not been lost on industry, or universities training kids for industry. After I described AMVs at one talk, a father approached me with tears in his eyes. "You don't know how important this stuff is," he told me. "My kid couldn't get into any university. He then showed them his AMVs, and now he's at one of the best design schools in America."

AMVs are peculiarly American—or, though they build upon Japanese anime, they are not particularly Japanese. This is not because Japanese kids are not remixers. To the contrary, Japanese culture encourages this remixing from a much younger age, and much more broadly. According to cultural anthropologist Mimi Ito,

> Japanese media have really been at the forefront of pushing recombinant and user-driven content starting with very young children. If you consider things like *Pokémon* and *Yu-Gi-Oh!* as examples of these kinds of more fannish forms of media engagement, the base of it is very broad in Japan, probably much broader than in the U.S. Something like *Pokémon* or *Yu-Gi-Oh!* reached a saturation point of nearly 100 percent within kids' cultures in Japan.[13]

But the difference between cultures is not just about saturation. Henry Jenkins quotes education professors David Buckingham and Julia Sefton-Green, "*Pokémon* is something you do, not just something you read or watch or consume," and continues:

> There are several hundred different *Pokémon*, each with multiple evolutionary forms and a complex set of rivalries and attachments. There is no one text where one can go to get the information about these various species; rather, the child assembles what they know about the *Pokémon* from various media with the result that each child knows something his or her friends do not and thus has a chance to share this expertise with others.[14]

"Every person," Ito explains, thus "has a personalized set of *Pokémon*. That is very different from [American media, which are] asking kids to identify with a single character."

*Pokémon* is just a single example of a common practice in Japan. This more common practice pushes "kids to develop more persona lives, and remix-oriented pathways to the content." Kids in the second and third grades, for example, will all

> carry around just a little sketchbook . . . with drawings of manga [cartoon] characters in them. That's what [Japanese] kids do. Then by fourth or fifth grade there are certain kids that get known to be good at drawing and then they actually start making their original stories. Then at some point there needs to be an induction into the whole *doujinshi* scene, which is its own subculture. That usually happens through knowing an older kid who's involved in that.

American kids have it different. The focus is not: "Here's something, do something with it." The focus is instead: "Here's something, buy it." "The U.S. has a stronger cultural investment in the idea of childhood innocence," Ito explains, "and it also has a more protectionist view with respect to media content." And this "protectionism" extends into schooling as well. "Entertainment" is separate from "education." So any skill learned in this "remix culture" is "constructed oppositionally to academic achievement." Thus, while "remix culture" flourishes with adult-oriented media in the United States, "there's still a lot of resistance to media that are coded as children's media being really fully [integrated] into that space."

Yet the passion for remix is growing in American kids, and AMVs are one important example. Ito has been studying these AMV creators, getting a "sense of their trajectories" as creators. At what moment, she is trying to understand, does "a fan see [himself] as a media producer and not just a consumer"? And what was the experience (given it was certainly not formal education) that led them to this form of expression?

Ito's results are not complete, but certain patterns are clear. "A very high proportion of kids who engage in remix culture," for example, "have had experience with interactive gaming formats." "The AMV scene is dominated by middle-class white men"—in contrast to the most famous remixers in recent Japanese history, the "working-class girls" who produced *doujinshi*. Most "have a day job or are full-time students but . . . have an incredibly active amateur life. . . . [They] see themselves as producers and participants in a culture and not just recipients of it." That participation happens with others. They form the community. That community supports itself.

## EDUCATION

A second value in remix extends beyond the value of a community. Remix is also and often, as Mimi Ito describes, a strategy to excite "interest-based learning." As the name suggests, interest-based learning is the learning driven by found interests. When kids get to do work that they feel passionate about, kids (and, for that matter, adults) learn more and learn more effectively.

I wrote about this in an earlier book, *Free Culture*. There I described the work of Elizabeth Daley and Stephanie Barish, both of whom were working with kids in inner-city schools. By giving these kids basic media literacy, they saw classes of students who before could not retain their focus for a single period now spending every free moment of every hour the school was open editing and perfecting video about their lives, or about stories they wanted to tell.

Others have seen the same success grow from using remix media to teach. At the University of Houston—a school where a high percentage of the students don't speak English as their first language—the Digital Storytelling project has produced an extraordinary range of historical videos, created by students who research the story carefully, and select from archives of images and sounds the mix that best conveys the argument they want their video to make.

As Henry Jenkins notes, "[M]any adults worry that these kids are 'copying' preexisting media content rather than creating their own original works."[15] But as Jenkins rightly responds, "More and more literacy experts are recognizing that enacting, reciting, and appropriating elements from preexisting stories is a valuable and organic part of the process by which children develop cultural literacy."[16] Parents should instead, Jenkins argues, "think about their [kids'] appropriations as a kind of apprenticeship."[17] They learn by remixing. Indeed, they learn more about the form of expression they remix than if they simply made that expression directly.

This is not to say, of course, that however they do this remix, they're doing something good. There's good and bad remix, as there's good and bad writing. But just as bad writing is not an argument against writing, bad remix is not an argument against remix. Instead, in both cases, poor work is an argument for better education. As Hosler put it to me:

> Every high school in America needs to have a course in media literacy. We're buried in this stuff. We're breathing it. We're drinking it constantly. It's 24/7 news and information and pop culture. . . . If you're trying to educate kids to think critically about history and society and culture, you've got to be encouraging them to be thoughtful and critical about media and information and advertising.

Doing something with the culture, remixing it, is one way to learn.

## The Old in the New

To many, my description of remix will sound like something very new. In one sense it is. But in a different, perhaps more fundamental sense, we also need to see that there's nothing essentially new in remix. Or put differently, the interesting part of

remix isn't something new. All that's new is the technique and the ease with which the product of that technique can be shared. That ease invites a wider community to participate; it makes participation more compelling. But the creative act that is being engaged in is not significantly different from the act [John Philip] Sousa described when he recalled the "young people together singing the songs of the day or the old songs."

For as I've argued, remix with "media" is just the same sort of stuff that we've always done with words. [ . . . ] It is how lawyers argue. It is how we all talk all the time. We don't notice it as such, because this text-based remix, whether in writing or conversation, is as common as dust. We take its freedoms for granted. We all expect that we can quote, or incorporate, other people's words into what we write or say. And so we do quote, or incorporate, or remix what others have said.

The same with "media." Remixed media succeed when they show others something new; they fail when they are trite or derivative. Like a great essay or a funny joke, a remix draws upon the work of others in order to do new work. It is great writing without words. It is creativity supported by a new technology.

Yet though this remix is not new, for most of our history it was silenced. Not by a censor, or by evil capitalists, or even by good capitalists. It was silenced because the economics of speaking in this different way made this speaking impossible, at least for most. If in 1968 you wanted to capture the latest Walter Cronkite news program and remix it with the Beatles, and then share it with your ten thousand best friends, what blocked you was not the law. What blocked you was that the production costs alone would have been in the tens of thousands of dollars.

Digital technologies have now removed that economic censor. The ways and reach of speech are now greater. More people can use a wider set of tools to express ideas and emotions differently. More can, and so more will, at least until the law effectively blocks it.

## NOTES

1. "To the Point; Trends & Innovations," *Investor's Business Daily*, September 26, 2006.

2. Ibid.

3. Gail Koch, " '800-Pound Gorilla' Still Rules for Most," *Star Press* (Muncie, Ind.), September 28, 2005.

4. Xinhua News Agency, "Census Bureau: Americans to Spend More Time on Media Next Year," December 15, 2006.

5. U.S. Fed News, "American Time Use Survey—2006 Results," *U.S. Fed News*, June 28, 2007.

6. This is not to say that before the Internet, there was nothing like this RW-media culture. Indeed, for almost a half century, beginning with the *Star Trek* series, there has been a rich "fan fiction" culture, in which fans take popular culture and remix it. Rebecca Tushnet, "Legal Fictions; Copyright, Fan Fiction, and a New Common Law," *Loyola of Los Angeles Entertainment Law Journal* 17 (1997): 655, citing Henry Jenkins and John Tulloch, eds., *"At Other Times, Like Females": Gender and* Star Trek *Fan Fiction*, in *Science Fiction Audiences: Watching* Dr. Who *and* Star Trek (London: Routledge, 1995), 196. Some trace the history of fan fiction back even earlier, to "metanovels" written in response to classic works of fiction such as *Pride and Prejudice* (Sharon Cumberland, "Private Uses of Cyberspace: Women, Desire and Fan Culture," in *Rethinking Media Change: The Aesthetics of Transition*, ed. David Thorburn and Henry Jenkins (Cambridge, Mass.: MIT Press, 2003), 261. An

Internet commentator known as Super Cat argues that the first fan fiction was John Lydgate's *The Siege of Thebes*, a continuation of *The Canterbury Tales* circa 1421: Super Cat, "A (Very) Brief History of Fanfic," Fanfic Symposium, available at link #36 (last visited August 11, 2007). Many believe that the contemporary online fan fiction community is predominantly composed of women, and the genre addresses topics traditionally marginalized in the commercial media, including "the status of women in society, women's ability to express desire, [and] the blurring of stereotyped gender lines" (Cumberland, "Private Uses," 265). In addition to traditional textual fan fiction, cyberspace has spawned an active culture of fan filmmaking. See Henry Jenkins, "Quentin Tarantino's Star Wars? Digital Cinema, Media Convergence, and Participatory Culture," in *Rethinking Media Change: The Aesthetics of Transition*, ed. David Thorburn and Henry Jenkins (Cambridge, Mass.: MIT Press, 2003), 281–84 (offering a case study of *Star Wars* fan fiction, which began in textual form with the first official film, and developed into digital film distributed on independent creators' Web sites). There is a comprehensive study of fan fiction in chapters 5–8 of Henry Jenkins, *Textual Poachers: Television Fans and Participatory Culture* (New York: Routledge, 1992).

7. All quotes from Mark Hosler taken from an interview conducted May 1, 2007, by telephone.

8. All quotes from Johan Söderberg taken from an interview conducted February 15, 2007, by telephone.

9. Telephone interview with Don Joyce, March 20, 2007.

10. "Misperceptions, the Media, and the Iraq War," Program on International Policy Attitudes and Knowledge Networks, available at link #37 (last visited January 18, 2008).

11. Charles Krauthammer, "A Vacation Bush Deserves," *Washington Post*, August 10, 2001.

12. All quotes from Victor Stone taken from an interview conducted February 15, 2007, by telephone.

13. All quotes from Mimi Ito taken from an interview conducted January 24, 2007, by telephone. For more, see Mimi Ito, "Japanese Media Mixes and Amateur Cultural Exchange," in *Digital Generations*, ed. David Buckingham and Rebekah Willett (Mahwah, N.J.: Lawrence Erlbaum, 2006), 49–66.

14. Jenkins, *Convergence Culture*, 128.

15. Ibid., 182.

16. Ibid., 177.

17. Ibid., 182.

# LAURIE OUELLETTE

# "Take Responsibility for Yourself": *Judge Judy* and the Neoliberal Citizen

Laurie Ouellette (b. 1966) is Associate Professor in the Department of Communication at University of Minnesota. She has written widely on television and consumer culture, social class and media, media and citizenship, and cultural policy. She is the author of *Viewers Like You?: How Public TV Failed the People* (2002) and co-author of *Better Living Through*

*Reality TV: Television and Post-Welfare Citizenship* (with James Hay, 2008). She is also the co-editor of *Reality TV: Remaking Television Culture* (with Susan Murray, 2nd ed., 2008). Ouellette is also a regular commentator on the politics of media and popular culture for local and national media, including the *New York Times*, the *Boston Globe*, and NPR.

In the late 1980s, several factors contributed to the boom in reality television, including a shifting regulatory climate; television network financial troubles; the expansion of cable television; and the rapid development of new media technologies. Although the origins of reality television can be traced back to the quiz shows of the late 1950s, or staged prank shows such as *Candid Camera*, the current form of the genre came about with the premiere of *The Real World* on MTV in 1991, a show that prefigured other successful reality programs like *Survivor* and *Big Brother*. Reality television has since moved from the fringes of television culture to its very core and is no longer limited to cable stations; a considerable amount of network programming is reality television based. With their promise to provide an unmediated look into the "real," the proliferation of these shows also reveals the complex ways in which authenticity is produced and received, effortlessly blending manufactured artifice with truth claims, calculated marketing with the spontaneity of "real" life. As reality television has grown in sophistication and changed business practices and audience expectations, it has also urged television scholars to study the various implications of this phenomenon and the emerging screen culture it has brought about.

Laurie Ouellette's " 'Take Responsibility for Yourself': *Judge Judy* and the Neoliberal Citizen" (2004) demonstrates how reality television demands new levels of cultural participation from its viewers, and how the connection of reality television to new forms of "governing at a distance" is central to its concept of the "true" and the "real." Ouellette draws on Michel Foucault's theory of power relations and institutional discourses of normality and abnormality to demonstrate how courtroom programs like *Judge Judy* function as substitute institutions of the state, a form of cultural training that governs under the presumption of "free will." Using real people (especially lower-income women) experiencing the drama of everyday life, such shows train television viewers to function as self-disciplining, responsible citizens without state supervision or assistance. In this manner, the courtroom genre of reality television exemplifies what Ouellette calls "neoliberal forms of governance" and constructs a model of citizenship that is aligned with the privatization of public life, the collapse of the welfare state, and the discourse of personal responsibility. Ouellette's study enhances our understanding of reality television and the culture it represents, and like other essays in this section, it also points to the significance of new cultural forms as a testing ground for emerging technologies and a forum for important institutional and social developments.

## READING CUES & KEY CONCEPTS

■ In what ways do courtroom shows such as *Judge Judy* present themselves as a cultural and moral corrective to the genre of reality television that they are a part of?

■ According to Ouellette, what are some of the problematic assumptions about gender, race, and class embodied in the "idealized citizen subject" constructed by *Judge Judy*?

■ To what extent and how do the logic of "governing at a distance" and principles of personal responsibility and self-discipline apply to other reality formats, such as makeover programs and gamedocs?

■ **Key Concepts:** Reality Television; Courtroom Program; Neoliberalism; Technology of Citizenship

# "Take Responsibility for Yourself": *Judge Judy* and the Neoliberal Citizen

. . . . . . . . . . . . . .

*A woman drags her ex-boyfriend to court over an overdue adult movie rental and unpaid loan. A woman is heartbroken when her best friend betrays her and ruins her credit. A smooth-talking ex-boyfriend claims money from his ex was a gift.* Welcome to *Judge Judy,* queen of the courtroom program, where judges resolve "real-life" disputes between friends, neighbors, family members, roommates, and lovers on national television. For critics who equate television's role in democracy with serious news and public affairs, altercations over broken engagements, minor fender benders, carpet stains, unpaid personal loans, and the fate of jointly purchased household appliances may seem like crass entertainment or trivial distractions. But such dismissals overlook the "governmental" nature of courtroom programs like *Judge Judy,* which gained cultural presence—and a reputation for "zero tolerance when it comes to nonsense"—alongside the neoliberal policies and discourses of the 1990s.[1]

*Judge Judy* took the small claims–based court format from the fringes of commercial syndication to an authoritative place on daytime schedules when it debuted in 1996, the same year the U.S. Telecommunications Act was passed.[2] While the legislation has been critiqued for its deregulatory ethos as well as its affinity with the broader neoliberal forces behind welfare reform and the privatization of public institutions from the penal system to the post office, the cultural dimensions of these parallels remain less examined.[3] There is a tendency within policy studies to take the cultural impact of neoliberalism as self-evident—to presume that the laissez-faire principles codified by the Act will erode democracy in predictable ways that typically involve the decline of journalism, documentaries, and other "substantial" information formats found unprofitable by the culture industries. While such concerns have some validity, the metaphor of subversion needs to be jettisoned, for it reifies untenable cultural hierarchies, and neglects neoliberalism's productive imprint on contemporary television culture and the "idealized" citizen subjectivities that it circulates.

Reality programming is one site where neoliberal approaches to citizenship have in fact materialized on television. From makeover programs (such as *What Not to Wear* and *Trading Spaces*) that enlist friends, neighbors, and experts in their quest to teach people how to make "better" decorating and fashion choices, to gamedocs (like *Survivor* and *Big Brother*) that construct community relations in terms

of individual competition and self-enterprising, neoliberal constructions of "good citizenship" cut across much popular reality television. The courtroom program is a particularly clear example of this broader trend because it draws from the symbolic authority of the state to promote both the outsourcing of its governmental functions and the subjective requirements of the transition to a neoliberal society. *Judge Judy* and programs like it do not subvert elusive democratic ideals, then, as much as they *construct* templates for citizenship that complement the privatization of public life, the collapse of the welfare state, and most important, the discourse of individual choice and personal responsibility.

This chapter situates *Judge Judy* as a neoliberal technology of everyday citizenship, and shows how it attempts to shape and guide the conduct and choices of lower-income women in particular. As we shall see, *Judge Judy* draws from and diffuses neoliberal currents by fusing an image of democracy (signified in the opening credits by a gently flapping U.S. flag, stately public courthouse, and gavel-wielding judge) with a privatized approach to conflict management and an intensified government of the self. *Judge Judy* and programs like it supplant institutions of the state (for instance, social work, law and order, and welfare offices), and using real people caught in the drama of ordinary life as raw material, train TV viewers to function without state assistance or supervision as self-disciplining, self-sufficient, responsible, and risk-averting individuals. In this way, the courtroom subgenre of reality TV exemplifies what James Hay has called a cultural apparatus for "neoliberal forms of governance."[4]

## Neoliberalism and Television Culture

To understand *Judge Judy's* neoliberal alignments, a brief detour through the concept of neoliberalism is in order. My understanding of neoliberalism begins with political economy and the activism it inspires. From this vantage point, neoliberalism is generally understood as a troubling worldview that promotes the "free" market as the best way to organize every dimension of social life. According to activists Elizabeth Martinez and Arnoldo Garcia, this worldview has generated five trends that have accelerated globally since the 1980s: the "rule" of the market; spending cuts on public services; deregulation (including the deregulation of broadcasting); the privatization of state-owned institutions, "usually in the name of efficiency"; and "eliminating the concept of the public good or community and replacing it with individual responsibility."[5] For critics like Robert McChesney, the upshot of neoliberalism and the reforms it has spawned is that a "handful of private interests are permitted to control as much as possible of social life in order to maximize their personal profit."[6]

While I share these concerns, I have found Foucauldian approaches particularly useful for analyzing the subjective dimensions of neoliberalism that circulate on reality TV. Drawing from Michel Foucault, Nikolas Rose theorizes neoliberalism less as a simple opposition between the market (bad) and welfare state (good) than as a "changing network" of complex power relations. If neoliberal regimes have implemented an "array of measures" aimed at downsizing the welfare state and dismantling the "institutions within which welfare government had isolated and managed their social problems," they still rely on "strategies of government."[7] This

manifests as various forms of "cultural training" that govern indirectly in the name of "lifestyle maximization," "free choice," and personal responsibility, says Rose. This diffused approach to the "regulation of conduct" escapes association with a clear or top-down agenda, and is instead presented as the individual's "own desire" to achieve optimum happiness and success. As Rose points out, the "enterprising" individual crafted by this discourse has much in common with the choice-making "customer" valorized by neoliberal economics. Both presume "free will," which means that those individuals who fail to thrive under neoliberal conditions can be readily cast as the "author of their own misfortunes."[8]

Rose makes several additional observations that can help to illuminate neoliberalism's cultural manifestations. First, he contends that the ideal of citizens working together to fulfill mutual and "national obligations" has given way to the "ideal of citizens seeking to fulfill and protect themselves within a variety of micro-moral domains." Second, he observes that the requirements of "good" citizenship have come to include adopting a "prudent" relationship to fate, which includes avoiding "calculable dangers and avertable risks." Finally, Rose cites the media as a cultural technology operating outside "public powers" that works to govern the "capacities, competencies and wills of subjects," and in so doing, translate the goals of "authorities" into the "choices and commitments of individuals."[9]

James Hay has extended this argument to television studies specifically. Because a "neoliberal form of governance assumes that social subjects are not and should not be subject to direct forms of state control, it therefore relies on mechanisms for governing at a distance," through the guiding and shaping of "self-disciplining subjects," Hay explains. Television plays an important role in this governmental process, he contends, one that is not limited to sanctioned forms of news and public affairs. In fact, popular reality TV may be better suited to the indirect, diffuse mode of cultural governmentality that Hay describes. The court program is an acute and therefore symptomatic example of popular reality TV's role in mediating, as Hay puts it, "a kind of state control that values self-sufficiency and a kind of personal freedom that requires self-discipline."[10]

While Hay theorizes television's part in bringing neoliberal techniques of "governmentality" into the home, feminist scholars have shown the extent to which neoliberal policies intersect with an acceleration of self-help discourse aimed at women. From advice books on intimate relationships to self-esteem-building initiatives for welfare mothers, this discourse has been critiqued for presuming to "solve social problems from crime and poverty to gender inequality by waging a social revolution, not against capitalism, racism and inequality, but against the order of the self and the way we govern the self."[11] As Barbara Cruikshank has pointed out, the solution to women's problems is construed as having the right attitude, making smart decisions, and taking responsibility for one's life in the name of personal "empowerment."[12] In this sense, self-help is a cultural manifestation of neoliberalism, a technology of citizenship that encourages women to "evaluate and act" on themselves so that the social workers, medical establishment, and police "do not have to."[13]

*Judge Judy* fuses television, neoliberalism, and self-help discourse in a governmental address to women living out what feminist philosopher Nancy Fraser has called the "postsocialist" condition.[14] The program presents the privatized space of the TV courtroom as the most "efficient" way to resolve microdisputes steeped in

the unacknowledged politics of gender, class, and race, but it also classifies those individuals who "waste the court's time" as risky deviants and self-made victims who create their own misfortunes by making the "wrong" choices and failing to manage their lives properly. The imagined TV viewer is the implied beneficiary of this litany of mistakes, for one's classification as "normal" hinges on both recognizing the pathos of "others" and internalizing the rules of self-government spelled out on the program. The courtroom program has, for precisely this reason, been institutionally positioned as a moral and educational corrective to "permissive" entertainment, suggesting that the discourse of the "public interest" in broadcasting has not been squashed but rather reconfigured by neoliberal reforms. Indeed, it could be that television is increasingly pivotal to neoliberal approaches to government and the citizen subjectivities on which they depend.

## *"The Cases Are Real, the Rulings Are Final"*

*Judge Judy* is not the first television program to resolve everyday microconflicts in simulated courtroom settings. The genre can be traced to 1950s programs like *People in Conflict* and *The Verdict Is Yours*. In the 1980s, retired California Superior Court judge Joseph Wapner presided over *The People's Court*, while *Divorce Court* used actors to dramatize "real" legal proceedings.[15] *Judge Judy* did, however, rework and revitalize the format, and the program's "no-nonsense" approach to family and small claims disputes generated notoriety and imitators (examples include *Judge Joe Brown, Judge Mathis, Judge Hatchet, Curtis Court*, a revitalized *People's Court*, and *Moral Court*). Well into the new millennium, courtroom programs abound on television, competing with talk shows, game shows, and soap operas for a predominantly female audience.

On *Judge Judy*, real-life litigants are offered travel costs and court fees to present their cases on national television. The price is to drop out of the public judicial process and submit to the private ruling of Judith (Judy) Sheindlin. A former New York family court judge, Sheindlin was recruited for the "tough-love" philosophy she first spelled out in an influential *60 Minutes* profile, and later expanded on in her best-selling book *Don't Pee on My Leg and Tell Me It's Raining*, which faulted the overcrowded court system as a lenient bureaucracy that reflects "how far we have strayed from personal responsibility and old-fashioned discipline."[16] Spotting ratings potential, Larry Lyttle, president of Big Ticket Television, a Viacom company, invited Sheindlin to preside over "real cases with real consequences in a courtroom on television." Called a "swift decision maker with no tolerance for excuses" by the program's publicity, Sheindlin claims to bring to her TV show the same message she advocated in the courts: "Take responsibility for yourself, your actions and the children you've brought into the world."[17] In interviews, she situates *Judge Judy* as a public service that can solve societal problems by instilling the right attitudes and choices in individuals:

> It's a much larger audience. Whatever message I spew—"Take responsibility for your life. If you're a victim, it's your fault. Stop being a victim. Get a grip! You're the one who's supposed to make a direction in your life." All those messages I tried in Family Court to instill in people—primarily women. [The TV show] sounded like something that would not only be fun, but worthwhile as well.[18]

Like other TV judges, Sheindlin now hears noncriminal disputes that rarely exceed several hundred dollars or the equivalent in personal property. While these conflicts often speak to broader social tensions and inequalities, the program's governmental logic frames the cases as "petty squabbles" brought about by the deficiencies of individuals. Sheindlin's courtroom is filled with feuding relations and typically devoid of people who wish to sue businesses, bosses, or least of all, big corporations. This focus makes perfect sense, for the program's impetus as a technology of citizenship is to scrutinize ordinary people who require state mediation of everyday affairs, a process that hinges more on the moral radar Sheindlin claims to have developed in the public court system than on time-consuming democratic processes (she has been known to snap, "I don't have time for beginnings" and "I don't read documents"). While TV viewers are situated outside Sheindlin's disciplinary address to litigants derided as losers, cheaters, liars, and "gumbos," their status as "good" citizens presumes the desire to adhere to the neoliberal templates for living she espouses.

While the opening credits promise "real people" involved in "real cases," a male narrator differentiates the program from the public court system with the reminder: "This is Judy's courtroom," where the "decisions are final." Onscreen, Sheindlin plays judge, prosecutor, professional expert, and punctilious moral authority, handling an average of two cases per thirty-minute episode and dispensing justice at "lightning speed" according to the program's publicity. Participants must abide by the program's rules, which include speaking only when spoken to, accepting the authority of the judge ("Just pay attention, I run the show," she tells litigants), and taking humiliating remarks and reprimands without rebuttal or comment ("Are you all nuts" and "I'm smarter than you" are typical examples). More important than the details of any particular case is Sheindlin's swift assessment of the choices and behaviors of the people involved in them. Just as, according to Foucault, the delinquent is characterized not so much by their "acts" as by their life biography, Sheindlin questions litigants about their employment history, marital and parental status, income, drug habits, sexual practices, incarceration record, and past or present "dependency" on public welfare.[19] Such information transcends the evaluation of evidence as the principal means whereby Sheindlin determines who is at fault in the citizenship lesson that accompanies every ruling. Sheindlin is also known to belittle the accents of non-English speakers, accuse litigants of lying and abusing the "system," and order individuals to spit out gum, stand up straight, and "control" bodily functions to her liking. In one episode, a male litigant who denied her accusations of pot smoking was ordered to take a live drug test. *Judge Judy* thus both duplicates and extends the surveillance of the poor and working class carried out by welfare offices, unemployment centers, and other social services.[20]

*Judge Judy* is part of the current wave of reality TV in that "real" people (not actors) involved in "authentic" disagreements are used as a selling point to differentiate the show from fictional entertainment. While scripts are not used, reality is, as John Fiske reminds us, "encoded" at every level.[21] The program scours small claims dockets for potentially "interesting" cases; would-be litigants must complete a questionnaire, and only those "actual" disputes that can be situated within the program's logic are presented on television. Offscreen narration, graphic titles, video replays, and teasers further frame the meaning of the cases by labeling the

litigants, characterizing their purportedly real motivations to viewers and high-lighting scenes from the program that reiterate Sheindlin's governmental authority. Due to increased competition for conflicts among the growing cadre of courtroom programs, viewers are now invited to bypass the courts altogether and submit their everyday disputes directly to *Judge Judy*. On-air solicitations like "Are You in a Family Dispute? Call Judy" promise an efficient, private alternative to public mediation of conflicts—and yet, individuals who accept the invitations are ultimately held responsible for their "mistakes" on cases like "The Making of a Family Tragedy."

*Judge Judy*'s focus on everyday domestic conflicts has led some critics to de-nounce the courtroom program as a new twist on the sensational "lowbrow" day-time talk show.[22] Yet Sheindlin insists that her program is a somber alternative to the participatory, carnivalesque atmosphere of the genre it now rivals in the ratings. Indeed, the court setting and overtly disciplinary address of the *Judge Judy* program "code" it in distinct ways that are easily distinguishable to TV viewers. Sheindlin's strict demeanor and authoritative place on the bench are accentuated by camera-work that magnifies her power by filming her from below. The silence of the studio audience, the drab, institutional-like setting of the simulated courtroom, and the presence of a uniformed bailiff also separate the court program from talk shows, a format that feminist scholars have characterized as a tentative space for oppressed groups (women, people of color, and the working classes) to discuss the politics of everyday life. Jane Shattuc, for example, sees talk shows as an offshoot of the social movements of the 1960s to the extent that they draw from (but also commercially exploit) identity politics, consciousness-raising techniques, and an awareness that the "personal is political."[23] For Sonia Livingstone and Peter Lunt, talk shows offer a counterpoint to the white, male, bourgeois-dominated sphere of "serious" news and public affairs; talk shows provide a popular forum that enables women in particular to participate, however haltingly, in democratic processes.[24] Of course, talk shows also operate with their own disciplinary dynamics, as Janice Peck has shown. Rely-ing on psychosocial experts (such as health workers, therapists, or self-help gurus), talk shows present a "televised talking cure" that "manages conflict and crisis" by folding women's personal stories into a "confessional" discourse and "therapeutic" narratives, she contends.[25]

As Mimi White has observed in her analysis of *Divorce Court*, court programs reconfigure the confessional/therapeutic orientation of the talk show in subtle, but important ways: "To the extent that the couple no longer confesses with ease, the injunction to confess must be enforced through the agencies of the . . . legal establishment."[26] On *Judge Judy*, the authority represented by the simulated court-room setting is often enlisted to "force" such confessions. Sheindlin claims that her past experience as a frustrated state official has enabled her to "see through the bull" ("She can always tell if you're lying. All she has to do is make eye contact," reported *USA Today*). Litigants who refuse to "confess" to suspected actions have been subjected to live background checks, but more often than not Sheindlin sim-ply discounts "false" confessions and replaces the version of events offered by the litigant with an expert interpretation gleaned through biographical information as much as "evidence."

Court programs also magnify the disciplinary logic present on the talk show by disallowing audience participation, controlling the flow of personal revelations,

and fusing the therapeutic ethos of the "clinic" with the surveillance of the welfare office and the authoritative signifiers of law and order. This distinction, as much as the absence of the carnivalesque, is what has allowed courtroom programs to be institutionally positioned as a cultural corrective to "tabloid" television. *Judge Judy* is the "antithesis of Jerry Springer," insists Sheindlin. "Jerry Springer encourages people to show off their filthiest laundry, to misbehave. I scrupulously avoid doing that. I cut them off."[27]

The television industry has also been quick to assert that courtroom television "educates" as well as entertains—a claim to public service that is rarely made of most popular reality formats. Big Ticket's Larry Lyttle maintains that courtroom programs function as a positive moral force because unlike on talk shows, where "conflicts are aired and tossed around," a court show like *Judge Judy* "ends with a decision that someone was right and someone was wrong."[28] WCHS-TV in Charleston, West Virginia, similarly praises the program's "unique ability to act as a true moral compass for people seeking guidance, insight and resolution."[29] Characterizing the courtroom genre as a technology of citizenship that can temper the "effects" of fictional television, one TV judge explained in an interview that

> America's been looking at soap operas for going on 50 some years, and they le-gitimize the most back-stabbing, low-down, slimeball behavior. That's gotten to be acceptable behavior. . . . We find ourselves confronted with a lot of soap-opera behavior in our courtrooms. And we resolve them and say, no, we know you may have seen this, but it's not right.[30]

## *Privatizing Justice, Stigmatizing "Dependency"*

*Judge Judy's* claim to facilitate "justice at lightning speed" boldly implies that com-mercial television can resolve problems faster and more efficiently than the public sector. In this sense, the program affirms neoliberal rationales for "outsourcing" state-owned institutions and services. *Judge Judy* also complements neoliberal policies by conveying the impression that democracy (exemplified by the justice system) is overrun by individuals embroiled in petty conflicts and troubles of their own making. If the program feeds off of real-life microdisputes, Sheindlin chastises litigants for failing to govern their "selves" and their personal affairs. In addition to lecturing guests about their personal history, she often accuses participants of "wasting the court's time," conveying the idea that "normal" citizens do not depend on the supervision of the judiciary or any public institution for that matter. People who rely on professional judges (including TV judges) to mediate everyday problems are cast as inadequate individuals who lack the capacity or, worse, desire to func-tion as self-reliant and personally responsible citizens.

On *Judge Judy*, citizenship lessons are often directed at people who reject marriage, the nuclear family, and traditional values; unmarried couples who live together are of particular concern. While Sheindlin (who is divorced) does not con-demn such behavior as moral misconduct, she does present rules and procedures for navigating modern relationships, which include getting personal loans in writ-ing, not "living together for more than one year without a wedding band," and not "purchasing homes, cars, boats or animals with romantic partners outside of

wedlock."[31] On *Judge Judy*, individuals are told that they must impose these rules on themselves—both for their own protection and because, as Sheindlin explains, there is "no court of people living together. It's up to you to be smart. Plan for the eventualities before you set up housekeeping." When former lovers dispute an unpaid car loan, Sheindlin takes the disagreement as an opportunity to explain the dos and don'ts of cohabitation without marriage. Sheindlin finds the couple incompatible and "irresponsible," and rules that it was an "error of judgment" for them to share an apartment together. This judgment is tied to a broader failure of appropriate citizenship when Sheindlin lectures the pair for then "asking the courts" to resolve a domestic property dispute. "You're not married—there is a different set of rules for people who choose to live together without marriage," she asserts, reiterating that people who stray from state-sanctioned conventions have a particular duty to monitor their own affairs.

If the idealized citizen-subject constructed by *Judge Judy* complements the choice-making neoliberal customer discussed by Rose, that individual is also a self-supporting worker. People who receive any form of public assistance are cast as deviants in particular need of citizenship lessons. The advice they receive evokes Nancy Fraser and Linda Gordon's observation that welfare has become cloaked in a stigmatizing discourse of "dependency" that presumes gender, class, and racial parity. As Fraser and Gordon point out, women (including single mothers) are now held accountable to the white, middle-class, male work ethic, even as they lack the advantages and resources to perform as traditionally male breadwinners. While this marks a shift away from the patronizing assumption that all women are helpless and therefore "naturally" dependent on men or, in their absence, the state, it conceals the structural inequalities that lower-income women in particular continue to face.[32] On *Judge Judy*, all women are presumed to be capable of supporting themselves and their children financially; accepting welfare is construed not as a reflection of gender or economic inequality but as a character flaw. Women are routinely asked to disclose their past or present reliance on government "handouts," and those who admit to receiving benefits are subsequently marked as irresponsible and lazy individuals who "choose" not to work for a living. Welfare recipients are also constructed as morally unsound citizens who cheat taxpayers, as was the case in an episode where Sheindlin demanded to know whether an unmarried woman with three children by the same father had "avoided" marriage merely to qualify for welfare benefits. In another episode, an unemployed twenty-something mother being sued by her baby's would-be adoptive parents was scolded for relying on public assistance to raise the child she had decided not to give up for adoption. While adoption law doesn't allow adoptive parents to reclaim monetary "gifts" to birth mothers, Sheindlin stressed the woman's "moral" obligation to repay them. Presuming that the mother had chosen poverty, Sheindlin also sternly advised her to get a job and "not have more babies she can't take care of." *Judge Judy*'s disdain for so-called welfare dependency extends to charity and other forms of assistance. If individuals are told to take care of themselves and their families, empathy and social responsibility for others are discouraged. "No good deed goes unpunished," Sheindlin advised a family friend who took in a homeless woman who had spent some time in jail. At the societal and community level, the public good is cast in neoliberal terms, as a system of individual responsibilities and rewards.

According to Rose, neoliberal citizens are conceived of as private individuals who must ensure their own well-being through risk management strategies and prudent "acts of choice."[33] *Judge Judy* instills this template for citizenship by discouraging personal contact with deviant and allegedly risky individuals, and by instructing women to make "smart" choices to avoid "victimization." The program functions as a "panoptic" device to the extent that it classifies and surveils individuals deemed unsavory and dangerous.[34] This same point has also been made of reality-based crime shows like *Cops* and *America's Most Wanted*.[35] Sheindlin contends that criminals are largely unreformable, and *Judge Judy* extends this philosophy to people who are not official criminals but are nonetheless judged to possess amoral tendencies, psychological imbalances, drug addictions, and other character flaws. The more pressing message, however, is that all citizens must take personal responsibility for protecting themselves from con artists, "manipulators," abusers, and other risky individuals. In this sense, one of the program's most important governmental roles is to instruct TV viewers how to detect and avoid the risks that certain individuals are shown to represent.

Since the litigants on *Judge Judy* are introduced by name and occupation—this information also appears in onscreen titles—viewers know that individuals cast as risky are often working-class men who drive trucks, wait on tables, enter data, do construction, or perform low-paying forms of customer service. If female welfare recipients are cast as irresponsible nonworkers, men lacking middle-class occupations and salaries are routinely scorned for "choosing" a life of poverty, as was the case when Sheindlin lectured a middle-aged male Wal-Mart cashier for failing to obtain more lucrative employment. In the adoption episode mentioned above, a similar evaluation of male employment was tied to a failure of citizenship. The infant's father, who had worked on and off as a gas station attendant but was currently unemployed, was characterized as a personal failure and societal menace, not just because he refused to admit "personal moral responsibility" to repay the money to the adoptive parents but because he "refused" to enterprise himself in accordance with the middle-class work ethic.

Cases involving men who manipulate women out of money, gifts, rent, or property are a staple on *Judge Judy*, and in these cases, male unemployment and insolvency are closely tied to the detection and avoidance of romantic risk. In a case where a woman met a man on the Internet, loaned him money, and was dumped, Sheindlin fused a harsh judgment of the boyfriend's opportunism and dishonesty in his romantic relationship to an undeveloped work ethic. Demanding to know when he last "held a full-time job," she swiftly identified the man as a freeloader and "con artist," implying that men without economic means are especially dangerous and therefore not to be trusted when it comes to intimate relationships. Female litigants can also be categorized as identifiable romantic risks, as was the case in "Opportunity Knocks," where Sheindlin accused an attractive young woman in court to resolve whether money from her ex-boyfriend was a gift or loan of "using" the man financially with "no intention of marrying him." In most cases, though, it is lower-income men who play this role in a gender reversal of the gold digger stereotype that complements the program's focus on solving the problem of female victimization through better self-management.

Women are typically cast as "self-created" victims in terms that articulate neoliberal currents to female self-help culture. Rejecting what she terms the "disease of

victimization" or tendency to blame society for one's hardships, Sheindlin claims, in her books and on her TV program, that all women can achieve happiness and success with a little knowledge along with the right attitude. On *Judge Judy*, women's problems are blamed on their own failure to make good decisions, whether that means pulling one's self up from a life of poverty, "preparing" wisely for financial independence, or avoiding entanglements with unstable, manipulative, or abusive individuals. In her book *Beauty Fades, Dumb Is Forever*, Sheindlin elaborates on the value of personal responsibility, contending that

> victims are self-made. They aren't born. They aren't created by circumstances. There are many, many poor, disadvantaged people who had terrible parents and suffered great hardships who do just fine. Some even rise to the level of greatness. You are responsible for nurturing your roots, for blooming. No one can take that away from you. If you decide to be a victim, the destruction of your life will be by your own hand.[36]

In some cases, female "victims" are lectured for allowing themselves to be mistreated by other women. In "The Kool-Aid Debacle," where a young waitress sued her female ex-roommate over Kool-Aid stains on the carpet and a couch that got smelly, Sheindlin scolded the plaintiff for getting herself into such a situation: "You make a mistake when you let someone into your house who is a slob," she explained. Other times, women are deemed responsible for making their own misfortunes. In a case involving former lovers at odds over an unpaid loan, the program's neoliberal dismissal of female victimization is spelled out. The woman claims that her ex-boyfriend helped cover her hospital bill when she miscarried their baby. The man asserts that she promised to pay him back. As is typical, Sheindlin focuses less on the details of the loan than on the moral and behavioral lessons she discerns from the case. She lectures the young woman (but not the man) for not using birth control, and attributes her "situation" to her own unwise and irresponsible conduct. Refusing to accept this ruling, the young woman insists that the ex-boyfriend should help pay for the cost of the miscarriage since she was uninsured and it "was his baby too." Defying Sheindlin's orders to speak only when addressed, she demands to know what *she* as a woman would do in such circumstances. Rejecting the female litigant's appeal to a sense of female solidarity on the question—and ignoring the broader issue of health care access raised by the episode—Sheindlin tells the litigant that she wouldn't be in her shoes because she's "smarter than that."

Women who claim to have been abused by men appear frequently on *Judge Judy*, where they too are lectured for creating their circumstances. Domestic abuse is never the basis of a legal case, but is typically revealed in the course of Sheindlin's interrogation of the participants involved. In a case involving cousins fighting over a family collection of knickknacks, Sheindlin determines that the man is a deranged and unstable individual, while the woman he bullied and harassed is an "adult" who has "chosen to let someone do this to her." When Sheindlin learns that an ex-boyfriend in court over a minor car accident has battered his former teenage girlfriend, she maintains that the girl made unwise "choices," sternly advising, "Never let a man put his hands on you." In a case involving former lovers disputing overdue phone and gas bills, the woman reveals that in refusing to pay household expenses, her former boyfriend was addicted to heroin and had spent time in jail

for assaulting a minor. She also implies that he physically abused her. Typifying the program's neoliberal solution to the problem of domestic violence as well as the complexities of gender and class, Sheindlin faults the woman for failing to accept responsibility for her own conduct. Taking the troubled relationship as the raw material for a citizenship lesson aimed at women, Sheindlin determines that "being with him doesn't speak well of your judgment." As "young as you are, you allowed someone with a criminal history and no job to live with you . . . and you want the courts to fix that?"

*Judge Judy* seeks to instill in women a desire to avoid the "disease" of victimization along with the overreliance on state assistance and intervention it is said to have spawned. This message carries traces of liberal feminist discourse to the extent that it promotes female independence and agency. Presuming that barriers to social and gender equality have long been dismantled, the program places the onus to achieve these goals on individuals. Sheindlin, who considers herself a positive female role model, contends that all "women have the power to make decisions, to call it as they see it, to take no gruff."[37] She claims that all women, however positioned by an unequal capitalist society, can reap the benefits of happiness and success so long as they exercise good judgment and cultivate self-esteem. Economic security and "feeling good about yourself" are thus closely bound in Sheindlin's blueprint for successful female citizenship. The responsibility for cultivating self-esteem is placed not on society but on individual women, whose job it is to train themselves and their daughters "to have a profession, have a career . . . so they will never be dependent on anybody."[38] On *Judge Judy*, female litigants are advised to avoid "depending" on boyfriends and husbands for financial assistance in particular. This message has less to do with dismantling dominant ideologies and institutions than it does with ensuring that women "take care of themselves" so that the state doesn't have to. *Judge Judy* conveys the idea that women can no longer "claim" a victim status rooted in bifurcated and hierarchical gender roles; nor, however, can they expect public solutions to the inequalities that structure women's lives.

Sheindlin presents "independence" as a responsibility that all women must strive to achieve, but she also promotes the hegemony of the nuclear family, reconstituted as a two-wage-earning unit. Family troubles underscore many of the cases heard on *Judge Judy*, where mothers suing daughters, children suing their parents, and parents suing each other are the norm. This steady stream of feuding relations paints a portrait of a troubled institution that clearly isn't working, yet Sheindlin uses her authority to promote the sacred importance of family bonds. The contradiction exists in perpetual tension, as illuminated by the treatment of family in two key episodes. In the first, a male cashier is suing his unemployed ex-fiancée for bills paid when they lived together; she is countersuing for "mental distress." After Sheindlin interrogates the woman about why she wasn't working at the time, the woman replies that she quit her job to "build a home together." She also tells Sheindlin that her fiancé stalked her and threatened to come after her with a gun when they broke up. Although this scenario contains the material to cast the male as a deviant individual, Sheindlin rejects the woman's story as an "excuse" smacking of victimization. Comparing her own success as a married working woman who didn't "quit her job to pick out furniture and dishes" to the failure of the "alleged

victim of harassment," she orders the woman to pay the back rent. In this episode, the female litigant's embrace of traditional family values is denounced because it includes the desire for "dependency" on a male breadwinner, thereby violating the neoliberal mantra of self-sufficiency that *Judge Judy* espouses. In a dispute involving an estranged mother and daughter, though, the nuclear family is valorized against a woman's quest for independence. The mother, who divorced her husband when she came out as a lesbian, is implicitly cast as selfish and irresponsible for abandoning the heterosexual family unit to pursue her own personal fulfillment. While Sheindlin doesn't condemn the woman's homosexuality, she harshly criticizes her performance and "choices" as a mother, and recommends family counseling to repair the damage. As these examples attest, *Judge Judy*'s advice to women does not seek to expand women's choices, it merely guides them in particular directions. Operating as a technology of citizenship, the program steers women toward neoliberal reforms that are presented as their own responsibilities and in their own "best interests." In this sense, *Judge Judy* seeks to transform what Rose calls the "goals of authorities" into the "choices and commitments of individuals."[39]

## Judge Judy *and the Normative Citizen*

*Judge Judy* constitutes the normative citizen—the TV viewer at home—in opposition to both risky deviants and "self-made" victims. By scrutinizing the dos and don'ts of everyday life as it is presumed to be lived by "troubled" populations, it promotes neoliberal policies for conducting one's self in private. It scapegoats the uneducated and unprivileged as "others" who manufacture their hardships, and thus require nothing more than personal responsibility and self-discipline in the wake of shrinking public services. Those who reject this logic are deemed abnormal and often unreformable: "I'm not going to get through to her. I have a sense that she's a lost cause at fourteen," Sheindlin once said of a female litigant.[40] TV viewers are encouraged to distance themselves from the "deficient" individuals who seep into Sheindlin's courtroom, therefore avoiding any recognition of the societal basis of women's problems and concerns. While Sheindlin's harshest derision is aimed at the socially "unrespectable," her governmental advice is intended for all women—particularly middle-class viewers—for according to the program's neoliberal logic, their happiness and success hinges on it.

It is untenable to presume that viewers respond to *Judge Judy* in seamless or uniform ways. The program can be read as an authoritarian spectacle that unravels what Foucault has called the "ideology of bourgeois justice." The running parody of *Judge Judy* on *Saturday Night Live*, where Sheindlin is portrayed as an exaggerated version of her insulting, authoritarian television persona, suggests that *Judge Judy* may partly dislodge an image of the courts as inherently objective and fair.[41] Women on the wrong end of unequal class and gender relations may also see in *Judge Judy* a glaring example of class prejudice and professional gumption. Yet these possibilities do not prevent the program from exemplifying a neoliberal form of governing that in various dimensions and forms, cuts across the newest wave of reality TV.

We can see variations of the neoliberal currents examined here in makeover programs, gamedocs, and other reality formats that "govern at a distance" by instilling the importance of self-discipline, the rewards of self-enterprise, and the

personal consequences of making the "wrong" choices. *Judge Judy* represents one of the clearest examples of this trend because it articulates neoliberal templates for citizenship to the privatization of public life while self-consciously bringing what Foucault called "the minute disciplines" and "panopticisms of the everyday" into the home.[42] The citizen subjectivities constructed on *Judge Judy* complement a model of government that disdains state authority and intervention, but demands a heightened form of personal responsibility and self-discipline from individuals. Reality TV as exemplified by the courtroom program is not outside democracy, then, but is an active agent in its neoliberal transformation.

## NOTES

1. The popular press has emphasized the "no tolerance" ethos of the programs, contributing to the cultural context in which they are received. See, in particular, Melanie McFarland, "Tough Judges Show There's Justice in Watching Television," *Seattle Times*, 30 November 1998, http://archives.seattletimes.

2. See ibid.

3. For a critical analysis of the Telecommunications Act of 1996, see Patricia Aufderheide, *Communications Policy and the Public Interest* (New York: Guilford, 1999); and Robert McChesney, *Rich Media, Poor Democracy: Communication Politics in Dubious Times* (New York: New Press, 2000).

4. James Hay, "Unaided Virtues: The (Neo)-Liberalization of the Domestic Sphere," *Television and New Media* 1, no. 1 (2000): 56.

5. Elizabeth Martinez and Arnoldo Garcia, "What Is Neoliberalism?" *Corpwatch*, 1 January 1997, www.corpwatch.org.

6. Robert McChesney, introduction to *Profit over People: Neoliberalism and Global Order*, by Noam Chomsky (New York: Seven Stories Press, 1999), 7, 11.

7. Nikolas Rose, "Governing 'Advanced' Liberal Democracies," in *Foucault and Political Reason: Liberalism, Neoliberalism, and Rationalities of Government*, ed. Andrew Barry, Thomas Osborne, and Nikolas Rose (Chicago: University of Chicago Press, 1996), 55, 58–59. For a Foucauldian approach to "governmentality" see also Graham Bruchell, Colin Gordon, and Peter Miller, eds., *The Foucault Effect: Studies in Governmentality* (Chicago: University of Chicago Press, 1991). I have also found Toby Miller's analysis of citizenship and subjectivity helpful for thinking through neoliberal modes of government. See his *The Well-Tempered Self: Citizenship, Culture, and the Postmodern Subject* (Baltimore, Md.: Johns Hopkins University Press, 1993).

8. Rose, "Governing 'Advanced' Liberal Democracies," 57–59.

9. Ibid., 57, 58.

10. Hay, "Unaided Virtues," 54.

11. Barbara Cruikshank, "Revolutions Within: Self-Government and Self-Esteem" in *Foucault and Political Reason: Liberalism, Neoliberalism, and Rationalities of Government*, ed. Andrew Barry, Thomas Osborne, and Nikolas Rose (Chicago: University of Chicago Press, 1996), 231.

12. In addition to Cruikshank, "Revolutions Within," see Heidi Marie Rimke, "Governing Citizens through Self-Help Literature," *Cultural Studies* 14, no. 1 (2000): 61–78.

13. Cruikshank, "Revolutions Within," 234.

14. Nancy Fraser, *Justice Interruptus: Critical Reflections on the "Postsocialist" Condition* (New York: Routledge, 1997).

15. Judge Wapner was brought back to resolve disputes between pet owners on the Animal Channel's *Animal Court*.

16. Luaine Lee, "Judge Judy Has Always Believed in the Motto 'Just Do It,'" *Nando Media*, 28 November 1998, www.nandotimes.com; and Judy Sheindlin, *Don't Pee on My Leg and Tell Me It's Raining* (New York: HarperPerennial, 1997), 3.

17. Cited on www.judgejudy.com.

18. Cited in Lee, "Judge Judy."

19. Michel Foucault, "Complete and Austere Institutions," in *The Foucault Reader*, ed. Paul Rabinow (New York: Pantheon, 1984), 219–20. See also Michel Foucault, *Discipline and Punish* (New York: Random House, 1995).

20. See Frances Fox Piven, *Regulating the Poor: The Functions of Public Welfare* (New York: Random House, 1971); and John Gillion, *Overseers of the Poor* (Chicago: University of Chicago Press, 2001).

21. John Fiske, *Television Culture* (New York: Routledge, 1987).

22. Michael M. Epstein, for example, argues that courtroom programs are an extension of the talk show to the extent that they use law and order to legitimate a sensationalist focus on personal conflict. Epstein also points out that the judge figure is construed as an "ultimate" moral authority less concerned with legal procedures than with the evaluation of personal behaviors. Presuming the "low" status of the genre and concentrating on its misrepresentation of the actual law, however, his critique overlooks the governmental nature and implications of this focus on everyday conduct and behavior. See Michael M. Epstein, "Judging Judy, Mablean, and Mills: How Courtroom Programs Use Law to Parade Private Lives to Mass Audiences," *Television Quarterly* (2001), http://www.emmyonline.org/tvq/articles/32-1-1.asp.

23. Jane Shattuc, *The Talking Cure: TV Talk Shows and Women* (New York: Routledge, 1997).

24. Sonia Livingstone and Peter Lunt, *Talk on Television: Audience Participation and Public Debate* (London: Routledge, 1994).

25. Janice Peck, "The Mediated Talking Cure: Therapeutic Framing of Autobiography in TV Talk Shows" in *Gender, Race, and Class in Media*, ed. Gail Dines and Jean Humez (Thousand Oaks, Calif.: Sage, 2002), 538, 545.

26. Mimi White, *Tele-Advising: Therapeutic Discourse in American Television* (Chapel Hill: University of North Carolina Press, 1992), 69.

27. Cited in Barbara Lippert, "Punchin' Judy," *New York Magazine*, 15 June 2001, www.newyorkmetro.com.

28. Cited in *Judge Judy* publicity, www.wchstv.com/synd_prog/judy.

29. Cited on www.wchstv.com/synd_prog/judy.

30. Cited in McFarland, "Tough Judges Show There's Justice."

31. Judy Sheindlin, *Keep It Simple Stupid* (New York: Cliff Street Books, 2000), 2.

32. Nancy Fraser and Linda Gordon, "A Genealogy of 'Dependency": Tracing a Keyword of the U.S. Welfare State," in Fraser, *Justice Interruptus*.

33. Rose, "Governing 'Advanced' Liberal Democracies," 58.

34. Michel Foucault defines panoptism as surveillance or "systems of marking and classifying" (*Power/Knowledge: Selected Interviews*, ed. Colin Gordon [New York: Pantheon, 1977], 71).

35. See Elayne Rapping's essay in this volume; and Anna Williams, "Domestic Violence and the Aetiology of Crime in America's Most Wanted," *Camera Obscura* 31 (1995): 65–117.

36. Judy Sheindlin, *Beauty Fades, Dumb Is Forever* (New York: Cliff Street Books, 1999), 112-13.

37. Ibid., 105.

38. Sheindlin, cited in Lee, "Judge Judy."

39. Rose, "Governing 'Advanced' Liberal Democracies," 58.

40. The clip was replayed during an interview with Sheindlin on *Larry King Live*, CNN, 12 September 2000.

41. Michel Foucault, "On Popular Justice," in Gordon, *Power/Knowledge*, 27.

42. Michel Foucault, "Panopticism," in *The Foucault Reader*, ed. Paul Rabinow (New York: Pantheon, 1984), 212.

# D. N. RODOWICK

## An Elegy for Theory

Professor of Visual and Environmental Studies and director of the graduate program in Film and Visual Studies at Harvard University, D. N. Rodowick (b. 1952) has also headed the film studies programs at University of London, Kings College, the University of Rochester, and Yale University. His books address most of the key junctures in the development of contemporary film theory, including the dominance of ideological critique after 1968; the conundrums of psychoanalysis for feminist theory; and the impact of digital culture on the questions and project of film theory. Over the course of his research, Rodowick has become increasingly engaged with the discourse of philosophy; the distinction between philosophy and theory is in part what the current selection addresses.

The development of the discipline of film studies in the 1970s was profoundly influenced by political and intellectual currents that emerged during the 1960s. The term "theory" encompassed a range of inquiries into signification, spectatorship, difference, and power that accompanied critiques of realist cinema and favored self-reflexive filmmaking. In the 1990s, challenges to "theory" came from research into film history, the methods of cultural studies, and the philosophical critiques traced in Rodowick's "An Elegy for Theory." That theory has a history is one of the principle tenets of this selection, which reviews and critiques the vicissitudes of film theory in the past decade not as an exercise in self-justification but to stress that cultural changes—such as the digital revolution or globalization—demand an ethical engagement from the field.

In "An Elegy for Theory," originally published in 2007, Rodowick situates theoretical inquiry in relation to epistemology (knowledge) and ethics (moral evaluation). His review of the challenges to so-called Grand Theory from cognitivist and analytical philosophy leads him to plea for a philosophy of the humanities, a way of knowing the changing world that is distinct from scientific certainty. Through his explanation of the work of philosophers Stanley Cavell and Gilles Deleuze (p. 185) on cinema, Rodowick argues that philosophy's generation of concepts complements art's generation of aesthetic experience. Concluding that "theory" is all the more necessary in the time of its apparent passing, this "elegy" is as much a song of praise as it is one of mourning.

## READING CUES & KEY CONCEPTS

■ Consider the causes for the decline of theory in film studies in the 1990s according to Rodowick. Why is it so important to historicize the discipline?

■ Rodowick outlines pleas for a film theory based in scientific method. How does his distinction between the practices of art, philosophy, and science clarify and challenge these positions?

■ Rodowick claims that images may "create new powers of thinking." How does he use Gilles Deleuze's and Stanley Cavell's inquiries into cinema to make this claim?

■ **Key Concepts:** Metacritical; Epistemology; Ethics; Scientific Method; Philosophy of the Humanities; Ontology; Skepticism

# An Elegy for Theory

**Éloge.** n. m. *(1580: lat.* elogium, *pris au sens gr.* eulogia). *1. Discours pour célébrer qqn. ou qqch.* Éloge funèbre, académique. Éloge d'un saint.
*Le Petit Robert*

*He sent thither his Theôry, or solemn legation for sacrifice, decked in the richest garments.*
George Grote, *A History of Greece* (1862)

From the late 1960s and throughout the 1970s, the institutionalization of cinema studies in universities in North America and Europe became identified with a certain idea of *theory*. This was less a "theory" in the abstract or natural scientific sense than an interdisciplinary commitment to concepts and methods derived from literary semiology, Lacanian psychoanalysis, and Althusserian Marxism, echoed in the broader influence of structuralism and post-structuralism on the humanities.

However, the evolution of cinema studies since the early 1980s has been marked both by a decentering of film with respect to media and visual studies and by a retreat from theory. No doubt this retreat had a number of salutary effects: a reinvigoration of historical research, more sociologically rigorous reconceptualizations of spectatorship and the film audience, and the placement of film in the broader context of visual culture and electronic media. But not all of these innovations were equally welcome. In 1996, the Post-Theory debate was launched by David Bordwell and Noël Carroll, who argued for the rejection of 1970s Grand Theory as incoherent. Equally suspicious of cultural and media studies, Bordwell and Carroll insisted on anchoring the discipline in film as an empirical object subject to investigations grounded in natural scientific methods. Almost simultaneously, other philosophical challenges to theory came from film scholars influenced by analytic philosophy and the later philosophy of Ludwig Wittgenstein. These debates emerged against the vexed backgrounds both of the culture wars of the 1990s and the rise of identity politics and cultural studies.

Confusing "theory" with Theory, often lost in these debates is the acknowledgment that judgments advanced—in history, criticism, or philosophy—in the absence of qualitative assessments of our epistemological commitments are ill-advised. To want to relinquish theory is more than a debate over epistemological standards; it is a retreat from reflection on the ethical stances behind our styles of knowing. In this respect, I want to argue not for a return to the 1970s concept of theory, but rather for a vigorous debate on what should constitute a philosophy of the humanities critically and reflexively attentive in equal measure to its epistemological and ethical commitments.

A brief look at the history of theory is no doubt useful for this project. Retrospectively, it is curious that early in the twentieth century film would become associated with theory, rather than with aesthetics or the philosophy of art. Already in 1924, Béla Balázs argues in *Der sichtbare Mensch* for a film theory as the compass of artistic development guided by the construction of concepts.[1] The evocation of theory here is already representative of a nineteenth-century tendency in German philosophies of art to portray aesthetics as a *Wissenschaft*, comparable in method and epistemology to the natural sciences. From this moment forward, one would rarely speak of film aesthetics or a philosophy of film, but rather, always, of film *theory*.

"Theory," however, has in the course of centuries been a highly variable concept. One finds the noble origins of theory in the Greek sense of *theoria* as viewing, speculation, or the contemplative life. For Plato it is the highest form of human activity; in Aristotle, the chief activity of the Prime Mover. For the Greeks, theory was not only an activity, but also an *ethos* that associated love of wisdom with a style of life or mode of existence.[2]

Bringing together *thea* [sight] and *theoros* [spectator], theory has often been linked to vision and spectacle. (Perhaps this is what Hegel meant in the *Aesthetics* when he names sight as the most theoretical of the senses.) In *Keywords*, Raymond Williams identifies four primary senses of the term emerging by the seventeenth century: spectacle, a contemplated sight, a scheme of ideas, and an explanatory scheme. With its etymological link to theater, no doubt it was inevitable that the young medium of film should call for theory. However, although the persistence of associating thought about film with theory might be attributed to the derivations of the term from spectating and spectacle, a contemporary commonsensical notion follows from the last two meanings. Theories seek to explain, usually by proposing concepts, but in this they are often distinguished from doing or practice. In this manner, Williams synthesizes "a scheme of ideas which explains practice."[3] This is certainly the way in which someone like Balázs or Sergei Eisenstein invoked the notion of theory.

In *The Virtual Life of Film*, I argue that one powerful consequence of the rapid emergence of electronic and digital media is that we can no longer take for granted what "film" is—its ontological anchors have come ungrounded—and thus we are compelled to revisit continually the question, What is cinema? This ungroundedness is echoed in the conceptual history of contemporary film studies by what I call the "metacritical attitude" recapitulated in cinema studies' current interest both in excavating its own history and in reflexively examining what film theory is or has been. The reflexive attitude toward Theory began, perhaps, with my own *Crisis of Political Modernism* and throughout the 1980s and '90s manifested itself in a

variety of conflicting approaches: Carroll's *Philosophical Problems of Classical Film Theory* and *Mystifying Movies*, Bordwell's *Making Meaning*, Judith Mayne's *Cinema and Spectatorship*, Richard Allen's *Projecting Illusions*, Bordwell and Carroll's *Post-Theory: Reconstructing Film Studies*, Allen and Murray Smith's *Film Theory and Philosophy*, Francesco Casetti's *Theories of Cinema, 1945–1995*, Allen and Malcolm Turvey's *Wittgenstein, Theory and the Arts*, and so on.[4]

In detaching "theory" as an object available for historical and theoretical examination, these books take three different approaches. Natural scientific models inspire one approach, both philosophical and analytic, which posit that the epistemological value of a well-constructed theory derives from a precise conceptual framework defined in a limited range of postulates. This approach assumes there is an ideal model from which all theories derive their epistemological value. Alternatively, Casetti's approach is both historical and sociological. Agnostic with respect to debates on epistemological value, it groups together statements made by self-described practitioners of theory, describing both the internal features of those statements and their external contexts. In *The Crisis of Political Modernism*, my own approach, inspired by Michel Foucault's *Archaeology of Knowledge*, assumes that the conditioning of knowledge itself is historically variable. Discourse *produces* knowledge. Every theory is subtended by enunciative modalities that regulate the order and dispersion of statements by engendering or making visible groups of objects, inventing concepts, defining positions of address, and organizing rhetorical strategies. This approach analyzes how knowledge is produced in delimited and variable discursive contexts.

As a first move, it might indeed seem strange to associate theory with history. Introducing a series of lectures at the Institute for Historical Research at the University of Vienna in 1998, I astonished a group of students by asserting that film theory *has* a history, indeed multiple histories. Here the analytic approach to theory, on one hand, and sociological and archaeological approaches on the other, part ways. The fact of having a history already distinguishes film theory, and indeed all aesthetic theory, from natural scientific inquiry, for natural and cultural phenomena do not have the same temporality. Aesthetic inquiry must be sensitive to the variability and volatility of human culture and innovation; their epistemologies derive from (uneven) consensus and self-examination of what we already know and do in the execution of daily life. Examination of the natural world may presume a teleology where new data are accumulated and new hypotheses refined in modeling processes for which, unlike human culture, we have no prior knowledge.

I believe we need a more precise conceptual picture of how film became associated with theory in the early twentieth century, and how ideas of theory vary in different historical periods and national contexts. But let us return to the more recent, meta-critical attitude toward theory.

By the mid-1990s, film theory and indeed the concept of "theory" itself were challenged from a number of perspectives. This contestation occurs in three overlapping phases. The first phase is marked by Bordwell's call throughout the 1980s for a "historical poetics" of film and culminates in the debates engendered by the publication of *Making Meaning: Inference and Rhetoric in the Interpretation of Cinema* and by the special issue of *iris* on "Cinema and Cognitive Psychology," both published

in 1989. The capstone of the second phase is the 1996 publication of *Post-Theory*. Subtitled *Reconstructing Film Studies*, the book represents an attempt to establish film studies as a discipline modeled on cognitivist science and historical poetics, and to recenter "theory" according to the epistemological ideals of natural scientific reasoning. If the second phase may be characterized by the attempt to return theory to a model of "scientific" investigation and explanation, the third phase subjects the association of theory with science to philosophical critique. As found in the recent work of Allen and Turvey, and deeply influenced by Wittgenstein's critique of theory in the *Philosophical Investigations*, this perspective calls for a new orientation in the examination of culture and the arts through a philosophy of the humanities. In this manner, throughout the 1980s and '90s there is a triple displacement of theory—by history, science, and finally, philosophy.

It is important to appreciate Bordwell's contribution to what I have characterized as the metacritical or metatheoretical attitude in cinema studies. Among his generation, Bordwell was among the first to exhibit fascination with the history of film study itself, and to focus attention on problems of methodology with respect to questions of historical research and the critical analysis of film form and style. Throughout the 1980s, Bordwell produced a number of path-breaking methodological essays promoting a "historical poetics" of cinema. From *Narration and the Fiction Film* (1985) to *Making Meaning*, the broad outlines of his approach are made apparent. Bordwell cannot be accused of a retreat from theory—no one's commitment to good theory building is greater or more admirable.[5] Instead, he wants to recast theory as *history*, or rather, to ground theory in the context of empirical historical research. In this way, Bordwell responds to what he perceives as the twin threats of cultural and media studies. On the one hand, there is a risk of methodological incoherence for a field whose interdisciplinary commitments had become too broad; on the other, the risk of diffusing, in the context of media studies, cinema studies' fundamental ground—film as a formal object delimiting specifiable effects. The aim of historical poetics, then, is to project a vision of methodological coherence onto a field of study perceived to be losing its center, and to restore an idea of film as a specifiable form to that center. In this respect, *poetics* concerns questions of form and style. It deals with concrete problems of aesthetic practice and describes the specificity of film's aesthetic function while recognizing the importance of social convention in what a culture may define as a work of art. In *Narration and the Fiction Film*, the *historical* side of poetics addresses the proliferation of distinct modes of narration (classical Hollywood, Soviet or dialectical materialist, postwar European art cinema, etc.) as delimitable in time and sensitive to national and/or cultural contexts. Here Bordwell makes his best case for basing the analysis of individual works upon sound historical investigation and explicit theoretical principles in a way that avoids arbitrary boundaries between history, analysis, and theory.

By 1989, however, Bordwell's attack on interpretation and his promotion of cognitivism as a model of "middle-level research" recast theory with respect to three particular propositions. First, his appeal to middle-level research calls for pulling back from broader concerns of ideology and culture to refocus attention on film's intrinsic structure and functions. Second, he promotes a comparable turn from psychoanalytic theories of the subject to the study of filmic comprehension as grounded in empirically delimitable mental and perceptual structures. Finally, his

renewed emphasis on history also signals a withdrawal from high-level conceptual concerns to refocus research on the fundamental data of films themselves and the primary documentation generated from their production contexts. Thus, Bordwell accuses interpretation of reaching too high in grasping for abstract concepts to map semantically onto its object. Here the film-object itself disappears in its particularity, becoming little more than the example of a concept. Moreover, the interpreters are reflexively insensitive to the cognitive operations they execute. They produce no new knowledge, but rather only repetitively invoke the same heuristics to model different films.

The sometimes unruly responses to *Making Meaning* and *Cinema and Cognitive Psychology* demonstrate that Bordwell's criticisms touched a nerve, and there is little doubt that these works are a genuine and important response to the impasse in theory that cinema studies began to confront by the end of the 1980s. In the critique of so-called Grand Theory, what is most interesting here is the implicit alliance between historical poetics and analytical philosophy. In the two introductions to *Post-Theory*, Bordwell and Carroll promote strong views of what comprises good theory building in stark contrast to the then current state of contemporary film and cultural theory. Here I am less concerned with assessing their critique of contemporary film theory than in evaluating the epistemological ideals embodied in their common appeal to natural scientific models.[6] Looking at the reverse side of Bordwell and Carroll's criticisms, I think it is important to examine their ideal projection of "good theory" as the ethical appeal for a new mode of existence where, in their view, politics or ideology has not supplanted reason. Here "dialectics," as Carroll presents it, become the basis of an ideal research community of rational agents working on common problems and data sets with results that are falsifiable according to "ordinary standards" of truth and error.[7] But these ideals, I would argue, rest on no firmer philosophical grounds than the ideological theories they critique. For example, while Grand Theory is criticized for its obsession with an irrational and unconscious subject that cannot account for its actions, Bordwell promotes a "rational agent" theory of mental functioning, which is in fact the subject of good theory recognizing itself in the object it wants to examine.[8] The concept of the rational agent functions tautologically here as a projection where the ideal scientific subject seeks the contours of its own image in the model of mind it wishes to construct or to discover. In a perspective that strives to be free of ideological positioning and to assert an epistemology that is value-neutral, the introductions to *Post-Theory* nonetheless express the longing for a different world modeled on an idealized vision of scientific research: a community of researchers united by common epistemological standards who are striving for a universalizable and truthful picture of their object.

Richard Allen and Murray Smith's critique of contemporary film theory in *Film Theory and Philosophy* echoes Bordwell and Carroll's perspective. Accusing Theory of an "epistemological atheism" powered by an exaggerated ethical concern with the critique of a capitalist modernity, Allen and Smith's criticisms make clear a number of philosophical assumptions absent from the Post-Theory critique. From the analytic point of view, arguments for and against "theory" take place against the background of a philosophy of *science*. One engages in theory building or not according to an epistemological ideal based on natural scientific models. In employing the methods and forms of scientific explanation, however, philosophy

becomes indistinguishable from science, at least with respect to theory construction. Philosophy disappears into science as "theory" becomes indistinguishable from scientific methodology.

In this manner, I want to argue that from the beginning of the twentieth century analytic philosophy has been responsible for projecting an epistemological ideal of theory derived from natural scientific methods. This ideal produced a disjunction between philosophy's ancient concern for balancing epistemological inquiry with ethical evaluation.[9] Here, theory, at least as it is generally conceived in the humanities, disappears in two ways. Not only is the activity of theory given over to science, but philosophy itself begins to lose its autonomy and self-identity—it would seem to have no epistemological function save in the light reflected from scientific ideals. Analytic philosophy attacks theory on more than one front. There is the implicit tendency to delegitimate extant *film* theory to the extent that it draws on concepts and methodologies influential in the humanities that fall outside of the reigning norm of what W. V. Quine would call a "naturalized philosophy." Consequently, because so little aesthetic thought on film conforms to scientific models, Carroll concludes that, for the most part, a *theory* of film does not yet exist, though it might at some future date. The conflict over theory in film studies thus reproduces in microcosm a more consequential debate, one that concerns both the role of epistemology and epistemological critique in the humanities and the place of philosophy with respect to science. Analytic philosophy wants to redeem "theory" for film by placing it in the context of a philosophy of science. At the same time, this implies that the epistemologies that were characteristic of the humanities for a number of decades are neither philosophically nor scientifically legitimate. And so the contestation of theory becomes a de facto epistemological dismissal of the humanities.

Throughout the 1990s, then, in cinema studies philosophy allies itself with science as a challenge to theory. In this phase of the debate, "theory" is the contested term. Very quickly, however, "science" becomes the contested term, as a philosophy of the humanities gives over theory to science and opposes itself to both. Important keys to this transition are the late works of Wittgenstein, especially his *Philosophical Investigations*, as well as G. H. von Wright's calls for a philosophy of the humanities in works like *The Tree of Knowledge, and Other Essays* (1993).

The interest of the later Wittgenstein for my project, and for the humanities in general, concerns his attack on the identification of philosophy with science. In asserting that "Philosophy is not one of the natural sciences" (*Tractatus Logico-Philosophicus* 4.111), he presents a formidable challenge to Bertrand Russell's conception of philosophy as allied with epistemological models drawn from the natural sciences. In contrast to Russell, Wittgenstein argues that science should not be the only model of explanation and knowledge, and so he insists on the specificity of philosophy as a practice. It is important to examine carefully Wittgenstein's attack on "theory" as an inappropriate form of explanation for the arts and humanities. However, my central concern here will be to explore arguments favoring a philosophy of the humanities as distinguishable from both science and theory.

If philosophy involves another mode of explaining and knowing, why does the alternative not amount to a theory? As Allen and Turvey summarize in their introduction to *Wittgenstein, Theory and the Arts*, philosophy differs from science in that its subject matter is not empirical in nature—only nature is subject to investigation by empirical

methods. "Empirical" has a precise definition here as that of which we can have no prior knowledge. Alternatively, philosophy is concerned with problems of sense and meaning, and these problems are not empirical in the sense that language use and creative expression are already part of a commonly accessible stock of human knowledge.

This involves a second criterion: statements about empirical phenomenon are, and must be, necessarily falsifiable. Philosophical investigation, however, only concerns testing the limits of sense and meaning of given propositions. In this way, Wittgenstein's case for philosophy as the best alternative to theory for studying human behavior and creativity is based on what he calls the "autonomy of linguistic meaning." This concept is exemplified in the distinction between reasons and causes. In a causal explanation, each effect is presumed to have a cause identified by a hypothesis, which may and must be rejected or revised in light of further evidence. Causal explanations are legitimate in scientific contexts because actions have origins that derive from states of affairs of which we have no prior knowledge. Most human action and behavior, however, is ill served by causal explanation, for agents have the capacity to justify their behaviors with reasons. "Autonomy" now indicates that agents have the capacity for authoritative self-examination and self-justification. Therefore, a key difference between scientific and philosophical inquiry is that science tests its hypotheses against external phenomena, that is, the natural world. But philosophy admits only to internal or self-investigation. This is less a question of truth and error than judgments concerning the "rightness" of a proposition tested against prior experience and knowledge.

This is one way to begin to unravel the conceptual confusions surrounding the idea of theory in cinema studies; for example, why Bordwell and Carroll have been so wedded to a certain idea of science, but also why theory, even from a cultural or psychoanalytic perspective, remains so compelling for a great many fairly intelligent people. As Turvey puts the question, "Why is there a lack of basic empirical research in film theory if the nature and functions of cinema are like the laws governing natural phenomena? Why does such research, somehow, seem unnecessary to film theorists? And how is it that film theories ever convince anyone that they are plausible in the absence of such sustained research?"[10] Because these criteria are irrelevant for cultural investigation. Film theories, like all humanistic investigation, concern human activities and thus presume a high degree of prior, even self-, knowledge and examination. Like any cultural activity, cinema is a human creation and thus is embedded in practices and institutions that form the basis of our quotidian existence. We may not have conscious knowledge of these practices and institutions, nor any desire to construct theories about them in the form of propositions or concepts, yet we act on and through them in coherent and consistent ways. This is why cultural theories are able to solicit agreement in the absence of empirical research and experimentation. Their power and plausibility is based on the extent to which they seem to clarify for us what we already know and do on a daily basis. Here we need no external examination beyond the critical investigation of our own practices as they evolve historically. However, what film studies has called theory, in its multiple and variegate guises, might more appropriately be called aesthetics or philosophy. And indeed, perhaps we could achieve much methodological and conceptual clarification by setting aside "theory" provisionally in order to examine what a philosophy of the humanities, and, indeed, what a film philosophy might look like.

I would prefer to title this essay *Éloge de la théorie*, for in composing an elegy for theory I have kept in mind the subtle variations present in French. Combining the English sense of both eulogy and elegy, and something more besides, an *éloge* can be both praise song and funereal chant, panegyric and *chanson d'adieu*. (In addition, it conveys the second meaning of a legal judgment expressed in someone's favor.) Certainly I think the enterprise of theory is still a worthy one. Yet why, in contemporary critical discourse, are there so few left to praise and none to love it?

We must first examine the debate on theory from the point of view of competing epistemological stakes. Accused of "epistemological atheism," theory as a concept has been wrested from the Continent to be returned semantically to the shores of science and the terrain of British and American analytical philosophy. Initially, this debate was posed as a conflict between theory and philosophy. But the late Wittgenstein took this argument in another direction, one that also questioned theory but as a way of turning philosophy from science to restore it to the humanities. In so doing, Wittgenstein was less concerned with the epistemological perfectibility of philosophical language than with reclaiming philosophy's ancient task of *theoria*. If the politics and epistemology of theory have been subject to much soul searching and epistemological critique, it is important nonetheless to find and retain in theory the distant echo of its connection to philosophy, or to *theoria*, as restoring an ethical dimension to epistemological self-examination. As Wittgenstein tried to teach us, what we need after theory is not science, but a renewed dialogue between philosophy and the humanities wherein both refashion themselves in original ways.

Ultimately, I want to argue that Wittgenstein's attack on theory is both too broad and too restrictive, but here it is more important to foreground what the later Wittgenstein brings to a philosophy of the humanities. In liberating humanistic inquiry from the bonds of empirical and causal explanation, a philosophy of humanities may make propositional claims, but these claims need not be fallible—they only require suasion and clear, authoritative self-justification. This is because humanistic theories are culture-centered. Unlike the investigation of natural phenomena, philosophical investigations examine what human beings already know and do, and this knowledge is in principle public and accessible to all. In Bordwell's sense of the term, "naturalization," whether good or bad, has little relevance here as humanistic (self-) inquiry does not require finding new information, but rather only clarifying and evaluating what we already know and do, or know how to do, and understanding why it is of value to us. In its descriptive emphasis, Wittgenstein's philosophical investigations do support strongly one important aspect of historical poetics—the analysis of the internal norms of cultural objects and of our everyday sense-making activities in relation to those objects. Nonetheless, a "nonempirical" notion of history is wanted here, and for specific philosophical reasons. Natural laws are time-independent, at least in a human context, and thus are appropriately explored through falsifiable causal explanations. Alternatively, cultural knowledge is historical in a particular sense. It emerges and evolves in the context of multiple, diverse, and conflicting social interactions that require constant reevaluation on a human time scale. Human history and natural history may not be investigated by the same means, even if, with respect to certain problems, their domains may overlap. Unlike the scientist, the humanist must examine phenomena that may be shifting before her very eyes. She must account for change in the course of its becoming, while she herself might be in a process of self-transformation.

To what extent, then, is the enterprise of theory still possible? And how might we return to philosophy the specificity of its activity? The two questions are different yet related, and both are linked to the fate of humanities in the twenty-first century and the place of film in the future of the humanities. Possible answers begin in recognizing that epistemological atheism does not follow from an ethical critique of modernity. And indeed what links philosophy today to its most ancient origins are the intertwining projects of evaluating our styles of knowing with the examination of our modes of existence and their possibilities of transformation. I want to conclude by briefly exploring these questions in discussing two contemporary philosophers as exemplars of the twinned projects of ethical and epistemological evaluation: Gilles Deleuze and Stanley Cavell. Deleuze and Cavell are the two contemporary philosophers with the strongest commitment to cinema, yet with distinctly original conceptions of the specificity of philosophy and of philosophical expression in relation to film. Though an unlikely pairing, reading these two philosophers together can deepen and clarify their original contributions to our understanding of film and of contemporary philosophy. Here I want to make the case that a (film) philosophy may and should be distinguished from theory. At the same time, I want to distinguish for the humanities a fluid metacritical space of epistemological and ethical self-examination that we may continue to call "theory" should we wish to do so.

Deleuze's cinema books present two pairs of elements that show what a film philosophy might look like. These elements recur throughout Deleuze's philosophical work. On one hand, there is the relation of Concept to Image. Here the creation of Concepts defines the autonomy of philosophical activity, while the Image becomes the key to understanding subjectivity and our relation to the world. The second set involves Deleuze's original reconsideration of Nietzsche's presentation of ethical activity as philosophical interpretation and evaluation.

Deleuze ends *Cinema 2: The Time-Image* with a curious plaint for theory. Already in 1985, he argues, theory had lost its pride of place in thought about cinema, seeming abstract and unrelated to practical creation. But theory is not separate from the practice of cinema, for it is itself a practice or a constructivism of concepts.

> For theory too is something which is made, no less than its object. . . . A theory of cinema is not "about" cinema, but about the concepts that cinema gives rise to and what are themselves related to other concepts corresponding to other practices. . . . The theory of cinema does not bear on the cinema, but on the concepts of cinema, which are no less practical, effective or existent than cinema itself. . . . Cinema's concepts are not given in cinema. And yet they are cinema's concepts, not theories about cinema. So that there is always a time, midday-midnight, when we must no longer ask ourselves, "What is cinema?" but "What is philosophy?" Cinema itself is a new practice of images and signs, whose theory philosophy must produce as a conceptual practice.[11]

A slippage is obvious here with theory standing in for philosophy. But that being said, what does Deleuze wish to imply in complaining that the contemporary moment is weak with respect to creation and concepts? The most replete response comes from the most obvious successor to the problems raised in the cinema books—Deleuze and Félix Guattari's *What Is Philosophy?*

For Deleuze and Guattari, the three great domains of human creation are art, philosophy, and science. These are relatively autonomous domains, each of which involves acts of creation based on different modes of expression—perceptual, conceptual, or functional. The problem confronted in *What Is Philosophy?* is knowing how philosophical expression differs from artistic or scientific expression, yet remains in dialogue with them. Percepts, concepts, and functions are different expressive modalities, and each may influence the other, but not in a way that affects the autonomy of their productive activity. An artist or scientist no doubt profoundly engages in conceptual activity, and so is influenced by philosophy. Yet the outputs of that activity—percepts, functions—retain their autonomy and specificity.

From one perspective, the distinctiveness of these outputs is easy to explain. The aim of science is to create functions, of art to create sensuous aggregates, and of philosophy to create concepts, but the devil is in the details. In art, percepts refer to the creation of affective experience through constructions of sensuous materials. In painting, these expressive materials may be blocks of lines/colors; in cinema, blocks of movements/durations/sounds. Alternatively, the role of functions helps clarify the relation of philosophy to theory in the scientific sense. There is a function, Deleuze explains, as soon as two wholes are put into a fixed correspondence. Newton's inverse square law provides an apposite example. A function is a mathematical expression orienting thought (first whole) to a natural phenomenon (the propagation of energy). As expression, the function is not the specific phenomenon, of course, nor is it analogous to thinking. The function is a descriptor or algorithm. Its descriptiveness of behaviors in the natural world is important, but this is not the key to its specificity. It is abstract and general, and its generality derives from its time-independence. It produces descriptions, and these descriptions are valid for all times and all places—thus, the proposal of a second whole. In its predictiveness of future behaviors, then, the function is exemplary of what science calls "theory," and when this predictiveness becomes regular, functions become "laws."

Contrariwise, the concept is abstract yet singular—it relates to thought in its own temporality and human specificity. For these reasons, philosophy is much closer to art than it is to science. The expressiveness of art finds its instantiation in the sensuous products of art and its human affects, and the expressiveness of science finds its confirmation in the predicted behaviors of natural phenomena. But concepts express only thought and acts of thinking. Does this mean that thinking is purely an interior activity cut off from the sensuous and material world? Art provides important answers to this question in relating concepts to ideas, signs, and images.

In 1991, Deleuze gave an important lecture at FEMIS [*École nationale supérieure des métiers de l'image et du son*], the French national film and television school, an excerpt of which was published as "Having an Idea in Cinema." What does it mean to have an Idea in art and how do Ideas differ from Concepts? Ideas are specific to a domain, a milieu, or a material. And so Deleuze writes, "Ideas must be treated as potentials that are already engaged in this or that mode of expression and inseparable from it, so much so that I cannot say I have an idea in general. According to the techniques that I know, I can have an idea in a given domain, an idea in cinema or rather an idea in philosophy."[12] Now, ideas in philosophy are already oriented by a certain kind of image, what Deleuze calls the "image of thought," and so a connection or relation must link them. In *What Is Philosophy?* the image of thought is

defined as the specific terrain or plane of immanence from which ideas emerge as preconceptual expression, or as "the image thought gives itself of what it means to think, to orient one's self in thought."[13] To have an idea, then, is to express thought through particular constructions, combinations, or linkages—what Deleuze calls signs. As Spinoza insisted, signs are not an expression of thought, but rather of our *powers* of thinking. Ideas are not separable from an autonomous sequence or sequencing of ideas in thought, what Spinoza calls *concatenatio*. This concatenation of signs unites form and material, constituting thought as a spiritual automaton whose *potentia* expresses our powers of thinking, action, or creation.

The importance of Deleuze's cinema books is that they present his most complete account of a philosophical semiotic modeled on movement and time and show how images and signs in movement or time are conceptually innovative; that is, how they renew our powers of thinking. In this manner, art relates to philosophy in that images and signs involve preconceptual expression in the same way that the image of thought involves a protoconceptual expression—they prepare the terrain for new concepts to emerge. The cinema may be best able to picture thought and to call for thinking because like thought its ideas are comprised of movements, both spatial and temporal, characterized by connections and conjunctions of particular kinds. Every instance of art is expressive of an idea which implies a concept, and what philosophy does with respect to art is to produce new constructions or assemblages that express or give form to the concepts implied in art's ideas. It renders perspicuous and in conceptual form the automatisms that make a necessity of art's generative ideas.

There is also an ethical dimension to the various ways Deleuze characterizes image and concept in relation to the image of thought. For Deleuze, this implies a Nietzschean ethics encompassing two inseparable activities: interpretation and evaluation. "To interpret," Deleuze writes, "is to determine the force which gives sense to a thing. To evaluate is to determine the will to power which gives value to a thing."[14] What bridges Deleuze and Cavell here are not only their interest in Nietzsche, but also their original concept of ontology. Though Cavell uses the word and Deleuze does not, both are evaluating a particular way of Being. This is not the being or identity of film or what identifies film as art, but rather the ways of being that art provokes in us—or more deeply, how film and other forms of art express for us or return to us our past, current, and future states of being. In both philosophers, the ethical relation is inseparable from our relation to thought. For how we think, and whether we sustain a relation to thought or not, is bound up with our modes of existence and our relations with others and to the world.

The key to grasping this relation in Deleuze is to understand the originality of his characterization of the image as both an ontological and ethical concept. Especially in the cinema books, the image is not the product of cinematic creation but rather its raw material, the worldly substance that it forms and to which it gives expression. Hence the key place of Henri Bergson's assertion from *Matter and Memory* that there is already photography in things. Like energy, images can neither be created nor destroyed—they are a state of the universe, an asubjective universal perception or luminosity that evolves and varies continuously. Human perception is therefore largely a process of subtraction. Because we must orient ourselves in this vast regime of universal change according to our limited perceptual context, we

extract and form special images or perceptions according to our physiological limits and human needs. This image is the very form of our subjectivity and persists in the crossroads between our internal states and our external relations with the world.

The image is thus in relation with ourselves (interiority) and in relation with the world (exteriority) in an intimately interactive way. It is absurd to refer to subjectivity as pure interiority as it is ceaselessly engaged with matter and with the world. By the same token, thought is not interiority but our way of engaging with the world, orienting ourselves there and creating from the materials it offers us. Thus, another way of considering the autonomy of art, philosophy, and science is to evaluate the different though related images of thought they offer us. The percept is visually and acoustically sensuous, provoking affects or emotions in us. Concepts and functions are more abstract. What the function is to scientific expression, the sign is to aesthetic expression. Art's relation to thought, then, lies not in the substance of images, but in the logic of their combination and enchainment. No doubt every artistic image is an image of thought, a physical tracing and expression of thought given sensual form, no matter how incoherent or inelegant. However, while the aesthetic sign may imply a precise concept, it is nonetheless entirely affective and preconceptual. Yet there is a philosophical power in images. The artist's idea is not necessarily the philosopher's. But images not only trace thoughts and produce affects; they may also provoke thinking or create new powers of thinking. In so doing, we are thrown from sensuous to abstract thought, from an image of thought to a thought without image—this is the domain of philosophy. And in moving from one to the other, art may inspire philosophy to give form to a concept.

What does philosophy value in art? To ask this question is to demand what forces expressed in art, in images and signs, call for thinking? Philosophy parts ways with science to the extent that time is taken as an independent variable—in fact, the simplest way of describing Deleuze's (or Bergson's) philosophical project is as the will to reintroduce time and change to philosophy's image of thought. Philosophy finds inspiration in art because there the will to create is brought to its highest powers. Here, as in many other ways, Deleuze goes against the grain of contemporary philosophy. While happily science has never renounced its powers of creation, it has become less and less conceptual. And of course, it does not need concepts as philosophy does. Contrariwise, philosophy has moved closer and closer to art, and vice versa. This is the great untold story of twentieth-century philosophy that the twenty-first century must recount: that philosophy's greatest innovations were not made with respect to science, but in dialogue with art. And further, that the modern arts came closer and closer to philosophical expression while nonetheless amplifying their aesthetic powers.

That art may be considered philosophical expression is an important link between Deleuze and Cavell's interest in film. Like Deleuze, Cavell's cinema books are not studies of film but rather *philosophical* studies—they are works of philosophy first and foremost. Nonetheless, it may also be reasonable to read them as studies of film culture in their deep awareness of how cinema has penetrated the daily life of the mind and of being in the twentieth century. Though in very different ways, both Deleuze and Cavell comprehend cinema as expressing ways of being in the world and of relating to the world. In this respect, cinema is already philosophy, and a philosophy intimately connected to our everyday life. Deleuze exemplifies this

idea in pairing Bergson's *Matter and Memory* with the early history of cinema. At the moment when philosophy returns to problems of movement and time in relation to thought and the image, the cinematic apparatus emerges neither as an effect of these problems nor in analogy with them. In its own way, it is the aesthetic expression of current and persistent philosophical problems. Nor should one say that Deleuze's thought is simply influenced by cinema. Rather, it is the direct philosophical expression, in the form of concepts and typologies of signs, of problems presented preconceptually in aesthetic form.

Cavell presents a similar perspective, though one more clearly framed by problems of ontology and ethics. In my view, Cavell's work is exemplary of a philosophy of and for the humanities, particularly in his original attempt to balance the concerns of epistemology and ethics. In this respect, two principal ideas unite Cavell's philosophical and film work. Moreover, these are less separate ideas than iterations of the same problem that succeed one another more or less chronologically, namely, the philosophical confrontation with skepticism and the concept of moral perfectionism. The question here is why film is so important as the companion or exemplification of this confrontation. One clue resides in the title of an important Cavell essay, "What Photography Calls Thinking."[15] What does it mean to say that art or images *think*, or that they respond to philosophical problems as a way of thinking or a style of thought? In the first phase of Cavell's film philosophy, represented by the period surrounding the publication of *The World Viewed*, the responses to this question are ontological and epistemological. But this ontology refers neither to the medium of art nor the identity of art works, but rather to how art expresses our modes of existence or ways of being in the world as the fall into and return from skepticism.

Here an ontology of film is less concerned with identifying the medium of film than with understanding how our current ways of being in the world and relating to it are "cinematic." In its very conditions of presentation and perception, cinema expresses a particular philosophical problem, that of skepticism and its overcoming. If, as Cavell argues, cinema presents "a moving image of skepticism," it neither exemplifies nor is analogous to the skeptical attitude.[16] Rather, cinema expresses both the problem and its possible overcomings. The quality of "movement" in this philosophical image is temporal or historical in a specific sense. In its very *dispositif* for viewing and encountering the world, cinema presents philosophy's historical dilemma (skepticism's perceptual disjunction from the world) as past, while orienting the modern subject toward a possible future. That skepticism should reproduce itself in a technology for seeing might mean that it is no longer the ontological air we breathe, but a passing phase of our philosophical culture. If, as Cavell argues, the reality that film holds before us is that of our own perceptual condition, then it opens the possibility of once again being present to self or acknowledging how we may again become present to ourselves. (Indeed Cavell's examination of cinema's relation to the fate of skepticism helps clarify a Deleuzian cinematic ethics as faith in this world and its possibilities for change.[17]) For these reasons, film may already be the emblem of skepticism in decline. Cinema takes up where philosophy leaves off, as the preconceptual expression of the passage to another way of being. This is why cinema is both a presentation of and withdrawal from skepticism—the almost perfect realization of the form of skeptical perception as a way, paradoxically, of reconnecting us to the world and asserting its existential force as past presence in

time. The irony of this recognition now is that modernity may no longer characterize our modes of being or of looking, and we must then anticipate something else.

In the major books that follow, culminating in *Cities of Words*, the temporality of this epistemological condition is reconsidered as a question of art and ethical evaluation. The key concept of ethical evaluation is what Cavell calls moral perfectionism. Moral perfectionism is the nonteleological expression of a desire for change or becoming. Here our cinematic culture responds not to a dilemma of perception and thought, but rather a moral imperative. This trajectory from ontological to ethical questions is exemplary of how Cavell uses cinema to deepen his description of the subjective condition of modernity as itself suspended between a worldly or epistemological domain and a moral domain. In both cases, cinema confronts the problem of skepticism. In the first instance, this is an epistemological disappointment, in that we are disconnected from the world by our own subjectivity—all we can know of the world is from behind the screen of our consciousness. The second responds to a moral disappointment in the state of the world or with my current mode of existence. This division is not only formal; it is also, and perhaps primarily, temporal. As Kant posed the problem, the province of understanding, of knowledge of objects and their causal laws, defines the modern scientific attitude whose formidable power derives from making time an independent variable. What is unknown in the natural world could not become known through the powers of causal reasoning if the rules could change in the course of time. But the problem that so provoked Kant was that atemporal reason was in conflict with moral freedom. To be human is to experience change. So how might philosophy characterize humanity as at once subject of understanding and of reason, as subject to causal relations *and* expressive of moral freedom? Given that as material creatures we are in bondage to the empirical world and its causal laws, philosophy's task is to explain how we are also free to experience and to anticipate change in the projection of future existences.

Therefore, in Cavell's account moral perfectionism takes us from the form of skepticism to the possibilities of human change, and to the deeper moral problem of evaluating our contemporary mode of existence and transcending it in anticipation of a better, future existence. In the first stage, the problem is to overcome my moral despair of ever knowing the world; in the second, my despair of changing it and myself. Thus, Cavell's interest in Emerson (or in Wittgenstein, Nietzsche, or Freud) is to heal this rift in philosophy exemplified by Wittgenstein's disappointment with knowledge as failing to make us better than we are or to give us peace. Alternatively, moral perfectionism begins with this sense of ethical disappointment and ontological restlessness, catching up the modern subject in a desire for self-transformation whose temporality is that of a becoming without finality. "In Emerson and Thoreau's sense of human existence," Cavell writes, "there is no question of reaching a final state of the soul, but only and endlessly taking the next step to what Emerson calls 'an unattained but attainable self'—a self that is always and never ours—a step that turns us not from bad to good, or wrong to right, but from confusion and constriction toward self-knowledge and sociability."[18]

This idea forms the basis of Cavell's later books on comedies of remarriage and melodramas of the unknown woman. The interest of film here is to show it as the ordinary or quotidian expression of the deepest concerns of moral philosophy. And just as Wittgenstein sought to displace metaphysical expression into ordinary

language and daily concerns, film brings moral philosophy into the context of quotidian dramatic expression:

> These films are rather to be thought of as differently configuring intellectual and emotional avenues that philosophy is already in exploration of, but which, perhaps, it has cause sometimes to turn from prematurely, particularly in its forms since its professionalization, or academization. . . . The implied claim is that film, the latest of the great arts, shows philosophy to be the often invisible accompaniment of the ordinary lives that film is so apt to capture.[19]

Where contemporary philosophy has reneged on its promise of moral perfectionism, film has responded, though in the preconceptual manner of all art and sensuous expression. Thus the great project of film philosophy today is not only to help reinvigorate this moral reflection, but to heal by example the rift in philosophy's relation to everyday life.

In the prologue to *Cities of Words*, Cavell reprises Thoreau's lament that "There are nowadays professors of philosophy, but not philosophers. Yet it is admirable to profess because it was once admirable to live." How well Thoreau foresaw the difficult life of philosophy in the twentieth and twenty-first centuries. If one must compose an elegy for theory, let us hope it awakens a new life for philosophy in the current millennium.

## NOTES

This essay was originally prepared as a keynote lecture for the *Framework* conference on "The Future of Theory," Oklahoma State University, Stillwater, November 3–4, 2006. I would like to thank Brian Price for his invitation and perceptive comments. I would also like to thank the participants at the Radcliffe Exploratory Seminar on "Contesting Theory," co-organized by Stanley Cavell, Tom Conley, and myself at the Radcliffe Institute for Advanced Study, May 4–5, 2007—including Richard Allen, Sally Banes, Dominique Bluher, Edward Branigan, Noël Carroll, Francesco Casetti, Joan Copjec, Meraj Dhir, Allyson Field, Philip Rosen, Vivian Sobchack, Malcolm Turvey, and Thomas Wartenberg—for their challenging discussions of these and other matters.

1. Béla Balázs, *Der sichtbare Mensch* (Frankfurt am Main: Suhrkamp, 2001). The original citation is: "Die Theorie ist, wenn auch nicht das Steuerruder, doch zumindest der Kompass einer Kunstentwicklung. Und erst wenn ihr euch einen Begriff von der guten Richtung gemacht habt, dürft ihr von Verirrungen reden. Diesen Begriff: die Theorie des Films, müsst ihr euch eben machen" (p. 12). Balázs does, however, associate this theory with a "film philosophy of art" (p. 1).

2. On the question of ethics as the will for a new mode of existence, see Pierre Hadot, *What Is Ancient Philosophy?*, trans. Michael Chase (Cambridge, Mass.: Harvard University Press, 2002). An influence on Michel Foucault's later works on the "care of the self," Hadot argues that the desire for a philosophical life is driven first by an ethical commitment or a series of existential choices involving the selection of a style of life where philosophical discourse is inseparable from a vision of the world and the desire to belong to a community.

3. Raymond Williams, *Keywords: A Vocabulary of Culture and Society* (New York: Oxford University Press, 1976), p. 267.

4. See D. N. Rodowick, *Crisis of Political Modernism: Criticism and Ideology in Contemporary Film Theory* (1988; Berkeley and Los Angeles: University of California Press, 1994); Noël

Carroll, *Philosophical Problems of Classical Film Theory* (Princeton, N.J.: Princeton University Press, 1988); Noël Carroll, *Mystifying Movies* (New York: Columbia University Press, 1998); David Bordwell, *Making Meaning* (Cambridge, Mass.: Harvard University Press, 1989); Judith Mayne, *Cinema and Spectatorship* (London: Routledge, 1993); Richard Allen, *Projecting Illusions* (Cambridge: Cambridge University Press, 1995); David Bordwell and Noël Carroll, eds., *Post-Theory: Reconstructing Film Studies* (Madison: University of Wisconsin Press, 1996); Richard Allen and Murray Smith, eds., *Film Theory and Philosophy* (Oxford: Clarendon Press, 1997); Francesco Casetti, *Theories of Cinema, 1945–1995* (Austin: University of Texas Press, 1999); and Richard Allen and Malcolm Turvey, eds., *Wittgenstein, Theory and the Arts* (London: Routledge, 2001).

5. See especially Bordwell's introduction to *Cinema and Cognitive Psychology*, "A Case for Cognitivism," *iris* 5, no. 2 (1989), pp. 11–40. Here I am especially interested in Bordwell's characterization of theory as "good naturalization."

6. Ironically, one consequence of this appeal, strongly implicit in Carroll's contribution, is that film *theory* does not yet exist. Carroll, for example, criticizes both classical and contemporary film theory according to three basic arguments: they are essentialist or foundationalist, taking films as examples of a priori conditions; they are doctrine driven rather than data driven, meaning not susceptible to empirical examination and verification; and finally, they deviate too widely from *film*-based problems, that is, the concrete particularity of filmic problems disappears when they are taken up to illustrate broader concepts of ideology, subjectivity, or culture. Characterized by "ordinary standards of truth" as a regulative ideal, good theory seeks causal reasoning, deduces generalities by tracking regularities and the norm, is dialectical and requires maximally free and open debate, and, finally, is characterized by fallibilism. In this sense, good theory is "historical" in the sense of being open to revision through the successive elimination of error. In this respect, middle-level research presents the provisional ground for a theory or theories of film projected forward in a teleology of debate, falsification, and revision. The "post" in Post-Theory is a curious misnomer, then. For what has been characterized as Theory is epistemologically invalid, and, ironically, what comes after may only appear after a period of long debate and revisionism. A legitimate film theory remains to be constructed, the product of an indefinite future.

7. In a so-far-unpublished essay, "Film Theory and the Philosophy of Science," Meraj Dhir has presented an excellent defense of Carroll's position.

8. For related arguments, see Richard Allen's essay, "Cognitive Film Theory," in *Wittgenstein, Theory and the Arts*, pp. 174–209.

9. Bertrand Russell's 1914 essay "On Scientific Method in Philosophy" presents a succinct definition of this ideal: "A scientific philosophy such as I wish to recommend will be *piecemeal* and tentative like other sciences; above all, it will be able to *invent hypotheses* which, even if they are not wholly true, will yet remain fruitful after the necessary corrections have been made. This possibility of *successive approximations of the truth* is, more than anything else, the source of the triumphs of science, and to transfer this possibility to philosophy is to ensure a progress in method whose importance it would be almost impossible to exaggerate." In *Mysticism and Logic: and Other Essays* (New York: Longmans, Green and Co., 1918), p. 113 (my emphases). This is an admirably succinct summary of the epistemology to which Carroll subscribes. Theories are built piecemeal out of preliminary and falsifiable hypotheses, and one must establish the factual character of the parts before the whole can be understood. The theory then advances teleologically as successively closer approximations to the truth as hypotheses are further tested, refined, or rejected in light of new evidence.

10. Malcolm Turvey, "Can Science Help Film Theory?," *Journal of Moving Image Studies* 1, no. 1 (2001), http://www.uca.edu/org/ccsmi/journal/issue1_table_contents.htm. The passage reads differently in the latest published version of the essay. See Turvey, "Can Scientific

Models of Theorizing Help Film Theory?," in *The Philosophy of Film: Introductory Texts and Readings*, ed. Angela Curren and Thomas E. Wartenberg (London: Blackwell, 2005), p. 25.

11. Gilles Deleuze, *Cinema 2: The Time-Image*, trans. Hugh Tomlinson and Robert Galeta (Minneapolis: University of Minnesota Press, 1989), p. 280.

12. Gilles Deleuze, "Having an Idea in Cinema," trans. Eleanor Kaufman, in *Deleuze and Guattari: New Mappings in Politics, Philosophy, and Culture*, ed. Eleanor Kaufman and Kevin Jon Heller (Minneapolis: University of Minnesota Press, 1998), p. 14.

13. Gilles Deleuze, *What Is Philosophy?*, trans. Hugh Tomlinson and Graham Burchell (New York: Columbia University Press, 1994), p. 37.

14. Gilles Deleuze, *Nietzsche and Philosophy*, trans. Hugh Tomlinson (New York: Columbia University Press, 1983), p. 54.

15. Stanley Cavell, "What Photography Calls Thinking," in *Cavell on Film*, ed. William Rothman (Albany: State University of New York Press, 2005), pp. 115–34.

16. Stanley Cavell, *The World Viewed: Reflections on the Ontology of Film*, enlarged edition (1971; Cambridge, Mass.: Harvard University Press, 1979), p. 188.

17. See my essay, "A World, Time," in *The Afterimage of Gilles Deleuze's Film Philosophy*, ed. D. N. Rodowick (Minneapolis: University of Minnesota Press, forthcoming).

18. Stanley Cavell, *Cities of Words: Pedagogical Letters on a Register of the Moral Life* (Cambridge, Mass.: Belknap Press of Harvard University Press, 2004), p. 13.

19. Ibid., p. 6.

# APPENDIX A
# ALTERNATIVE TABLES OF CONTENTS

Film theory courses can be structured in a variety of different ways, and film theory can also be incorporated in a number of different courses across the curriculum. Following are several streamlined collections of readings.

## Periodized Theory: Key Documents in Film Studies

These essays represent a historicized approach to some of the most important positions in film and media theory.

## Film Theory and Other Disciplines

These essays are grouped according to their shared concerns with other subjects and areas of thought.

## Introducing Film Theory

The following highlights primary readings from each part of this anthology that instructors can use to supplement an introduction to film survey courses.

## Teaching American Cinema with *Critical Visions*

Many film studies programs include courses on Hollywood cinema or American film history that can be supplemented with the following readings.

# Teaching Gender and Sexuality with *Critical Visions*

This volume includes a unit on gender and sexuality, but this wider range of readings will prove useful for courses approaching cinema through the lens of gender and sexuality.

# APPENDIX B

# FILM PAIRINGS FOR STUDYING FILM THEORY

The study of film theory can be enhanced through the use of concrete examples that show the connections and interplay between theoretical texts and films. This appendix pairs readings from this anthology with films, organized around topical units that represent common approaches to film theory. The readings selected for each topic bridge different parts of the book. Some of the films paired with the readings are those directed by the writers themselves; some are analyzed explicitly in the texts or illuminate ideas in them. These suggested films can be used by instructors in class or to provide students with inspiration for paper topics and further study.

## Adaptation

Adaptation has been a centerpiece in film history since 1900, confirming and questioning the relationship between literary narratives and film narratives. Today film adaptations and adaptation studies are livelier and more varied than ever before, exploring the relationships not only between film and various literatures but also between film and painting, music, and video games.

**READINGS**

- James Naremore, from *Acting in the Cinema*  202
- Robert Stam, "Beyond Fidelity: The Dialogics of Adaptation"  541

**FILMS**

- *Henry V* (Laurence Olivier, 1944)
- *Adaptation* (Spike Jonze, 2002)

## The American Avant-Garde

While the European avant-garde movement flourished in cinema in the 1920s in conjunction with other artistic movements, the American avant-garde emerged later, taking advantage of new, lightweight 16mm technology for individual poetic expression. Maya Deren and Stan Brakhage are two of the most expressive voices in American experimental film.

## READINGS

- Maya Deren, "Cinematography: The Creative Use of Reality"  144
- Stan Brakhage, "In Consideration of Aesthetics"  667

## FILMS

- *Meshes of the Afternoon* (Maya Deren, 1943)
- *Dog Star Man* (Stan Brakhage, 1962–1964)

# Black Independent Cinema

From the 1910s until the attempted integration of Hollywood beginning in the 1940s, African American directors such as Oscar Micheaux and Spencer Williams forged an independent cinema serving African American audiences. In the 1990s, urban films by African American directors became commercially viable, while directors like Julie Dash looked to other storytelling traditions to redress historical omissions.

## READINGS

- Manthia Diawara, "Black American Cinema: The New Realism"  594
- Toni Cade Bambara, "Reading the Signs, Empowering the Eye: *Daughters of the Dust* and the Black Independent Cinema Movement"  871

## FILMS

- *The Blood of Jesus* (Spencer Williams, 1941)
- *Daughters of the Dust* (Julie Dash, 1991)

# Body Genres

All genres evolve over film history, serving different ideological and even visceral functions. Linda Williams refers to melodrama, horror, and pornography as "body genres." How does the appeal of the horror film relate to other bodily experiences of spectatorship, such as those evoked by pornography? Are the gender relations involved in both genres predictable ones?

## READINGS

- Carol J. Clover, "Her Body, Himself"  511
- Linda Williams, "Porn Studies: Proliferating Pornographies On/Scene"  774

**FILMS**

- *Scream* (Wes Craven, 1996)
- *The Descent* (Neil Marshall, 2005)

## The Cinema of Attractions and the Avant-Garde

Avant-garde directors such as Jean Epstein and Germaine Dulac brought forward properties of early film, such as spectacle and wonder, which were neglected in the developing narrative tradition.

**READINGS**

- Tom Gunning, "The Cinema of Attractions: Early Film, Its Spectator and the Avant-Garde"   69
- Jean Epstein, "*Photogénie* and the Imponderable"   252
- Germaine Dulac, "The Avant-Garde Cinema"   651

**FILMS**

- *The European Pioneers* and *The Magic Méliès* from the Kino box set The Movies Begin (1894–1913)
- *The Seashell and the Clergyman* (Germaine Dulac, 1928)
- *The Fall of the House of Usher* (Jean Epstein, 1928)

## Cultural Studies and American Identities

Interdisciplinary, contextual, and cultural approaches supplement formal analysis in making sense of direct and indirect cinematic representations of race and ethnicity in classical Hollywood cinema.

**READINGS**

- Ella Shohat and Robert Stam, "Stereotype, Realism, and the Struggle over Representation"   800
- Richard Dyer, "White"   822
- Fatimah Tobing Rony, "*King Kong* and the Monster in Ethnographic Cinema"   840

**FILMS**

- *The Cheat* (Cecil B. DeMille, 1915)
- *King Kong* (Merian C. Cooper and Ernest B. Schoedsack, 1933)
- *Jezebel* (William Wyler, 1938)

## Documentary Truths

Since the 1920s, documentary films have been a central part of film history and theory. While those of John Grierson and Robert Flaherty represent early versions of documentary filmmaking, later documentaries have explored a myriad of strategies and subject matters and today represent a prominent part of contemporary film and video cultures around the world.

### READINGS

- John Grierson, "First Principles of Documentary"   657
- Bill Nichols, "Performing Documentary"   672

### FILMS

- *Night Mail* (Harry Watt and Basil Wright, 1936)
- *History and Memory: For Akiko and Takashige* (Rea Tajiri, 1991)

## Feminist Criticism of Classical Hollywood Cinema

Feminist approaches to the gendered visual and narrative patterns and the spectatorial relationships of studio-era Hollywood constitute one of the richest strands of contemporary criticism. Debates over which films or genres offered most room for women's expression helped foster experiments in a new women's cinema.

### READINGS

- Tania Modleski, "Hitchcock, Feminism, and the Patriarchal Unconscious"   375
- Laura Mulvey, "Visual Pleasure and Narrative Cinema"   713
- Linda Williams, " 'Something Else Besides a Mother': *Stella Dallas* and the Maternal Melodrama"   725

### FILMS

- *Stella Dallas* (King Vidor, 1937)
- *Vertigo* (Alfred Hitchcock, 1958)
- *Thriller* (Sally Potter, 1983)

## Film Manifestos

Throughout the history of cinema, filmmakers have used film manifestos as a means of stating their aesthetic and political goals. Varied in nature and purpose, these texts (and films) can act as a form of film theory; as a call to revolution; or as an announcement

for artistic and political movements outside of commercial narrative cinema. In various historical and cultural contexts, manifestos aim to redefine cinema and the culture in which it exists, proclaiming the end of old regimes and the need to begin anew.

### READINGS

- Cesare Zavattini, "Some Ideas on the Cinema"   915
- Fernando Solanas and Octavio Getino, "Towards a Third Cinema: Notes and Experiences for the Development of a Cinema of Liberation in the Third World"   924
- Dogme 95, "Manifesto" and "Vow of Chastity"   688

### FILMS

- *Bicycle Thieves* (Vittorio De Sica, 1948)
- *Hour of the Furnaces* (Octavio Getino and Fernando Solanas, 1968)
- *The Celebration* (Thomas Vinterberg, 1998)

## Histories of Animation

Animation has always defied the premise that the movies are based in photography. With the advent of digital cinema, the marginalized practice of animation is redefining the mainstream.

### READINGS

- Paul Wells, "Notes Towards a Theory of Animation"   213
- Lev Manovich, "What Is Digital Cinema?"   1058

### FILMS

- *Duck Amuck* (Chuck Jones, 1953)
- *Toy Story 3* (Lee Unkrich, 2010)

## New Hollywood Auteurs

The approach to cinema that privileged the director as the film's ultimate source of meaning took hold at a time when the Hollywood studio system was being shaken by new postwar realities. A New Hollywood soon emerged in which maverick young directors paid homage to the great directors of Hollywood genre films and incorporated influences from the French New Wave.

### READINGS

- Peter Wollen, "The Auteur Theory"   361
- Timothy Corrigan, "The Commerce of Auteurism"   416

**FILMS**

- *The Searchers* (John Ford, 1956)
- *Apocalypse Now* (Francis Ford Coppola, 1979)

## The Progressive Hollywood Text

Ideological critique of dominant Hollywood cinema ushered in by the social upheaval of the late 1960s spurred a remarkably productive period in film criticism. Critics read Hollywood genre films "against the grain" to see how their directors or use of form implicitly critiqued repressive aspects of American society. Auteurs like Douglas Sirk and Nicolas Ray and intense genres like melodrama were especially scrutinized.

**READINGS**

- Jean-Louis Comolli and Jean Narboni, "Cinema/Ideology/Criticism"  478
- Thomas Elsaesser, "Tales of Sound and Fury: Observations on the Family Melodrama"  496

**FILMS**

- *Rebel without a Cause* (Nicolas Ray, 1955)
- *Written on the Wind* (Douglas Sirk, 1956)

## Queer Cinema

While gay and lesbian representations were censored in studio-era Hollywood, gay men and lesbians contributed to film production and found subcultural definition in aspects of film reception. As gay and lesbian filmmakers began making independent movies in greater numbers in the 1980s, mainstream film and television began exploring non-normative gender and sexuality in more interesting ways.

**READINGS**

- B. Ruby Rich, "New Queer Cinema"  767
- Kobena Mercer, "Dark and Lovely Too: Black Gay Men in Independent Film"  739

**FILMS**

- *Looking for Langston* (Isaac Julien, 1988)
- *The Crying Game* (Neil Jordan, 1992)

## Soviet Montage

The period after the 1919 Russian Revolution was one of the most exciting in film history, with filmmakers experimenting in film form and debating theories of montage as the basis of film language.

**READINGS**

- Lev Kuleshov, "The Principles of Montage"   135
- Dziga Vertov, "Film Directors: A Revolution"   257
- Sergei Eisenstein, "The Dramaturgy of Film Form"   262

**FILMS**

- *The  Extraordinary Adventures of Mr. West in the Land of the Bolsheviks* (Lev Kuleshov, 1924)
- *Battleship Potemkin* (Sergei Eisenstein, 1925)
- *The Man with a Movie Camera* (Dziga Vertov, 1929)

## Special Effects and New Media

At the turn of the millennium, special effects dominated mainstream blockbuster movies, allowing for more fanciful and imaginary settings. Media convergence and the way in which movies are marketed globally today also mean that video games and other storytelling forms (including those generated by fans) are becoming increasingly important in the study of film culture and theory.

**READINGS**

- Lisa Nakamura, "The Social Optics of Race and Networked Interfaces in *The Matrix* Trilogy and *Minority Report*"   1041
- Henry Jenkins, "Searching for the Origami Unicorn: *The Matrix* and Transmedia Storytelling"   619
- Alexander R. Galloway, "Origins of the First-Person Shooter"   1070

**FILMS**

- *Minority Report* (Steven Spielberg, 2002)
- *The Matrix* (Wachowskis, 1999)
- *Elephant* (Gus Van Sant, 2003)

## Star Studies

Among the most recognizable contributions of movies to cultural life, stars and celebrities are meaningful aspects of texts, as well as points of identification for

spectators and important players in film industries. Which stars are important and popular has a great deal to say about national identity, gender, and power, and even about which kinds of bodies are visible and valued.

**READINGS**

- Richard Dyer, from *Stars*   401
- Ana M. López, "Are All Latins from Manhattan? Hollywood, Ethnography and Cultural Colonialism"   859
- Yvonne Tasker, "Dumb Movies for Dumb People: Masculinity, the Body, and the Voice in Contemporary Action Cinema"   754

**FILMS**

- *Die Hard* (John McTiernan, 1988)
- *Carmen Miranda: Bananas Is My Business* (Helena Solberg, 1995)

# PERMISSIONS
# ACKNOWLEDGMENTS

Theodor W. Adorno and Max Horkheimer, "The Culture Industry," from *Dialectic of Enlightenment*, trans. Edmund Jephcott. Copyright © 1944 by Social Studies Association, NY. New edition: © S. Fischer Verlag GmbH, Frankfurt am Main, 1969; English translation © 2002 Stanford University. Used with permission of Stanford University Press, www.sup.org.

Rick Altman, "A Semantic/Syntactic/Pragmatic Approach to Film Genre," from *Film/Genre*, pp. 207–227. Copyright © 1999 BFI Publishing. Reprinted with permission.

Benedict Anderson, from *Imagined Communities: Reflections on the Origin and Spread of Nationalism*, 2nd ed., Copyright © 1991. Reprinted by permission of Verso.

Dudley Andrew, "An Atlas of World Cinema," pp. 19–28 of *Remapping World Cinema: Identity, Culture and Politics in Film*, ed. Stephanie Dennison and Song Hwee Lim. Copyright © 2006 Wallflower Press. Reprinted with permission of Wallflower Press.

Aristotle, from Poetics *I: With the* Tractatus Coislinianus, *a Hypothetical Reconstruction of* Poetics *II, and the Fragments of the* On Poets, trans. Richard Janko, pp. 4–15. Copyright © 1987 Hackett Publishing Company. Reprinted with permission.

Rudolf Arnheim, "Film and Reality," from *Film as Art*. Copyright © 1957 by University of California Press. Reprinted by permission of University of California Press via Copyright Clearance Center.

Alexandre Astruc, "The Birth of a New Avant-Garde: La Caméra-Stylo," from *The New Wave*, ed. Peter Graham, pp. 17–23. Copyright © 1968.

Béla Balázs, from *Theory of the Film: Character and Growth of a New Art*, trans. Edith Bone. Copyright © 1970 Dover Publications. Reprinted by permission of Dover Publications, Inc.

Toni Cade Bambara, "Reading the Signs, Empowering the Eye," from *Black American Cinema*, ed. Manthia Diawara, pp. 118–127, 130–137, 139–141, 143–144. Copyright © 1993. Reproduced by permission of Taylor and Francis Group, LLC, a division of Informa plc.

Roland Barthes, "The Death of the Author," from *Image/Music/Text*, trans. Stephen Heath. English translation copyright © 1977 by Stephen Heath. Reprinted by permission of Hill and Wang, a division of Farrar, Straus and Giroux, LLC.

Charles Baudelaire, "The Salon of 1859: The Modern Public and Photography," from *Baudelaire, Selected Writings on Art and Artists*, trans. P. E. Charvet. Copyright © 1972. Reprinted with permission of Penguin UK, a division of The Penguin Group.

Jean-Louis Baudry, "Ideological Effects of the Basic Cinematographic Apparatus," from *Film Quarterly* 28, 2 (1974): 40–47. Copyright © 1974 by University of California Press. Reprinted by permission of University of California Press via Copyright Clearance Center.

André Bazin, "The Evolution of the Language of Cinema" and "The Ontology of the Photographic Image," from *What Is Cinema?*, trans. and ed. Hugh Gray. Copyright © 1967 by University of California Press. Reprinted by permission of University of California Press via Copyright Clearance Center.

# INDEX

Note: All film titles are listed under their director. Page numbers in *italic* type indicate pages for contributor essays.

CHARLES BAUDELAIRE JEAN-LOUIS BAUDRY ANDRÉ BAZIN WALTER BENJAMIN JOHN BERGER DAV

AN-LOUIS COMOLLI & JEAN NARBONI TIMOTHY CORRIGAN STEPHEN CROFTS GREGORY CURRIE GILLES DELEU

HOMAS ELSAESSER JEAN EPSTEIN FRANTZ FANON JANE FEUER SIGMUND FREUD ALEXAND

IRIAM HANSEN FREDRIC JAMESON HENRY JENKINS SIEGFRIED KRACAUER LEV KULESHOV TERES

CHRISTIAN METZ TANIA MODLESKI LAURA MULVEY HUGO MÜNSTERBERG HA

ICH D. N. RODOWICK FATIMAH TOBING RONY ANDREW SARRIS THOMAS SCHATZ EI

TAM YVONNE TASKER TZVETAN TODOROV TRINH T. MINH-HA DZIGA VERT

HEODOR ADORNO & MAX HORKHEIMER RICK ALTMAN BENEDICT ANDERSON DUDLEY ANDREW ARISTO

HARLES BAUDELAIRE JEAN-LOUIS BAUDRY ANDRÉ BAZIN WALTER BENJAMIN JOHN BERGER DAV

AN-LOUIS COMOLLI & JEAN NARBONI TIMOTHY CORRIGAN STEPHEN CROFTS GREGORY CURRIE GILLES DELEU

HOMAS ELSAESSER JEAN EPSTEIN FRANTZ FANON JANE FEUER SIGMUND FREUD ALEXANI

IRIAM HANSEN FREDRIC JAMESON HENRY JENKINS SIEGFRIED KRACAUER LEV KULESHOV TERES

CHRISTIAN METZ TANIA MODLESKI LAURA MULVEY HUGO MÜNSTERBERG HA

ICH D. N. RODOWICK FATIMAH TOBING RONY ANDREW SARRIS THOMAS SCHATZ E

TAM YVONNE TASKER TZVETAN TODOROV TRINH T. MINH-HA DZIGA VERT

HEODOR ADORNO & MAX HORKHEIMER RICK ALTMAN BENEDICT ANDERSON DUDLEY ANDREW ARIST

HARLES BAUDELAIRE JEAN-LOUIS BAUDRY ANDRÉ BAZIN WALTER BENJAMIN JOHN BERGER DA

AN-LOUIS COMOLLI & JEAN NARBONI TIMOTHY CORRIGAN STEPHEN CROFTS GREGORY CURRIE GILLES DELEU

HOMAS ELSAESSER JEAN EPSTEIN FRANTZ FANON JANE FEUER SIGMUND FREUD ALEXAN.

IRIAM HANSEN FREDRIC JAMESON HENRY JENKINS SIEGFRIED KRACAUER LEV KULESHOV TERE

CHRISTIAN METZ TANIA MODLESKI LAURA MULVEY HUGO MÜNSTERBERG HA

ICH D. N. RODOWICK FATIMAH TOBING RONY ANDREW SARRIS THOMAS SCHATZ E

TAM YVONNE TASKER TZVETAN TODOROV TRINH T. MINH-HA DZIGA VERT

HEODOR ADORNO & MAX HORKHEIMER RICK ALTMAN BENEDICT ANDERSON DUDLEY ANDREW ARIST

HARLES BAUDELAIRE JEAN-LOUIS BAUDRY ANDRÉ BAZIN WALTER BENJAMIN JOHN BERGER DA

N-LOUIS COMOLLI & JEAN NARBONI TIMOTHY CORRIGAN STEPHEN CROFTS GREGORY CURRIE GILLES DEL